# The Thomas International Photo Directory of Antique Cameras

by
**Douglas B. Thomas**

**First Edition**

Published and Distributed by
Thomas International
P.O. Box 6376
Washington, D.C. 20015

THIS BOOK IS DEDICATED TO THE FOUR MEN
WHO MADE THE MOST SIGNIFICANT CONTRIBUTIONS
TO THE INVENTION OF PHOTOGRAPHY:

THOMAS WEDGWOOD (1771–1805)
JOSEPH NICÉPHORE NIÉPCE (1765–1833)
LOUIS JACQUES MANDÉ DAGUERRE (1787–1851)
WILLIAM HENRY FOX TALBOT (1800–1877)

PRINTED BY:  KINGSPORT PRESS
            AN ARCATA COMPANY
            KINGSPORT, TENNESSEE

# TABLE OF CONTENTS

# PREFACE

The Thomas International Photo Directory of Antique Cameras was published in response to a need by camera collectors, museum curators, and historians for a comprehensive directory of antique cameras. A number of quality books have been published on antique cameras and while most provide considerable information about specific types or classes of cameras, almost all are limited in scope. Some books, for example, provide extensive information about one specific make of cameras such as Leicas, while other books cover a limited scope of rare cameras. Some books have limited use because they lack an index or cross-reference between model names and manufacturers.

The Thomas Directory provides detailed information on 3905 camera models manufactured in the United States and European countries between 1840 and 1940—the first 100-years of camera manufacturing. The book also includes 2348 photographs and illustrations of cameras. It is estimated that the Directory lists approximately 80% of all still camera models manufactured between 1840 and 1940.*

Each camera model description includes basic information such as the model name and type i.e., single-lens reflex, stereo, etc.; date(s) of manufacture; lens type and make; lens focal length and aperture; shutter type, make, and speeds; type of film and exposure size; unique accessories; and unique operations. Not all of the above information is provided in each model description.

The information provided in the Directory represents a six-year effort to collect as much information about pre-1940 cameras as possible and present it accurately and in an organized manner which would be most useful to the user. Entries are listed first by the name of the country where the cameras were manufactured, then by the manufacturer's name, and finally by the camera model name with the subject entries in alphabetical order. In some instances, the camera model names are not in strict alphabetical order since it was necessary to change the order to make maximum use of column space. The first section of the Directory lists camera models manufactured in the major manufacturing countries—America, Great Britain, France, and Germany. The second section lists models manufactured in Austria, Belgium, Czechoslovakia, Italy, Latvia, and Switzerland. The third section includes models that could not be identified with respect to a specific country where they were manufactured. All camera models are numbered sequentially as listed in the Directory.

A variety of resources were used in acquiring information for the Directory. A considerable number of private collectors furnished information and photographs of specific camera models which otherwise were unavailable to us. We greatly appreciate the contributions by these collectors and have identified their photographs by a two-letter designation following each respective camera model description. The *References for Photographs and Illustrations* section lists the two-letter designations in alphabetical order and the names and addresses of the respective contributors. The same two-letter system is used to identify (a) photographs that were submitted by museums and (b) other references that contain photographs of camera models which are listed in the Directory without a corresponding photograph. The two-letter designations for (a) and (b) above are included in the *References for Photographs and Illustrations* section. Not all contributors of photographs are listed since some chose to remain anonymous.

Most of the descriptive information in the Directory was obtained from camera manufacturers' catalogs and publications which were printed during the era when the respective camera models were manufactured. These publications not only provided detailed information about specific camera models but generally contained quality photographs or illustrations which were reproduced for presentation in the Directory. Some of the photographs and illustrations were of poor quality due to aging and general deterioration over the years.

In compiling information on the camera models listed, every effort was made to include only the most accurate information available. In some cases where the information for a specific camera model was obtained from several sources, some contradictions were evident when the information from each source was compared. In these cases, the source having the least overall inaccuracies when compared to the overall inaccuracies of all other sources was selected for the information used in the Directory.

In spite of our efforts to present the Directory information as accurately as possible, there are, undoubtedly, errors in some of the camera descriptions. The manufacturing dates given for the various camera models present a degree of uncertainty which generally increases for the older cameras. With some exceptions, the dates given for cameras manufactured prior to 1885 probably represent the largest uncertainty. We would welcome any information from users of the Directory concerning inaccuracies or typographical errors. Such information should be fully documented to ensure validity and accuracy. This information will be included in any succeeding editions of the Directory in an effort to provide collectors, curators, and historians with a comprehensive Directory of the highest quality.

Thomas International

---

* This estimate does not include cameras that were manufactured without a name-plate or any other identification which can be related to a specific manufacturer or model name.

# THE EARLY HISTORY OF PHOTOGRAPHY

## 1. THE CAMERA OBSCURA

The photographic camera was derived directly from the camera obscura which in its original form was, as its name implies, a dark enclosure or room with a tiny hole. Light that enters the small hole forms an inverted image on the opposite wall of objects outside of the enclosure. An application of this principle is the familiar pin-hole box camera. No one knows who first observed this fundamental principle of the camera. Perhaps it was first observed by cave-men who, in the darkness of a cave, noticed that light entering a small hole in the cave wall produced an image of outside objects on the opposite wall.

The earliest record of the camera obscura principle was found in the words of Aristotle (384–322 B.C.) who mentioned the formation of pictures projected through a small aperture.

The Arabian savant Ibn al Haitam (d. 1039) mentioned the formation of a sickle-shaped image of the sun during an eclipse. In his essay, "On the Form of the Eclipse," he wrote, "The image of the sun at the time of the eclipse, unless it is total, demonstrates that when its light passes through a narrow, round hole and is cast on a plane opposite to the hole, it takes on the form of a moonsickle."

manuscripts of Leonardo da Vinci (1452–1519). In his "Codex Atlanticus," he wrote; "If the facade of a building, place, or landscape is illuminated by the sun and a small hole is drilled in the wall of a room in a building facing this, which is not directly lighted by the sun, then all objects illuminated by the sun will send their images through this aperture and will appear, upside down, on the wall facing the hole."

da Vinci's detailed description and documentation of the principle of the camera obscura certainly represents strong evidence that he was the inventor. Even if da Vinci had learned of the camera obscura principle from others by verbal exchange or demonstration, the credit for invention should go to the person who documents the principle in detail.

In the first half of the sixteenth century, a number of scientists and notables experimented with or wrote about the camera obscura. In Germany, Erasmus Reinhold (1540) and his pupils Gemma Frisius, Moestlin, and others observed the eclipse of the sun with the aid of a pin-hole camera obscura.

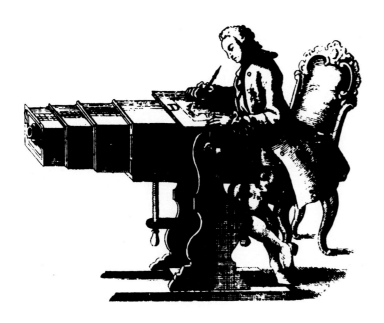

Camera obscura, c. 1768.

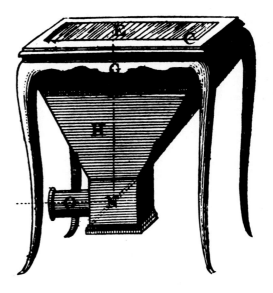

Camera obscura, c. 1770.

Some historians maintain that Roger Bacon (1214–1294), the English Franciscan Friar, invented the camera obscura. Bacon made the following remark about the projection of images. "The images appear at the point of contact of the light rays with the perpendicular plane, and things appear there, where there was nothing." Although Bacon was one of the most ingenious philosophers and scientists of his time, no facts have been produced which support the contention that he invented the camera obscura.

The first detailed description of the camera obscura is found in the

The Italian Giovanni Baptista della Porta (1538–1615) in his widely read book; "Magiae Naturalis; sive, De Miraculis Rerum Naturalium," first edition, 1553, gave a clear, detailed description of the pin-hole camera obscura. Since da Vinci's description of the camera obscura was written in cipher (mirror writing) and not published for several centuries, it is probable that

Porta knew nothing of da Vinci's invention. Because of the long delay in publishing da Vinci's writings, Porta had the distinction of having the first widely published description of the camera obscura and probably considered himself the inventor of the device.

The person who probably should be credited with the first description of the use of the biconvex lens in the camera obscura is the Venetian nobleman Daniel Barbaro. In his work, "La Prattica della Perspettiva" (1568), Barbaro describes the combination of the lens and the camera obscura. The replacement of the "pin-hole" in the camera obscura with a lens represented a significant improvement. The focusing power of the lens resulted in a greater amount of light at the focal plane and, thus, a brighter image. Barbaro had also discussed the use of a lens diaphragm to improve the sharpness of the image.

During the time of Porta and Barbaro, both the pin-hole and lens-type camera obscura were the size of a small room. The room was essentially light-tight with the pin-hole or lens located in one wall of the room. It was during this period that the use of the camera obscura for drawing or tracing images became well known. Since the room-size camera obscura was usually not movable or portable, the variety of images that could be traced was limited.

The first description of a small, portable camera obscura was mentioned by the famous monk Johann Zahn in his "Oculus artificialis teledioptricus; sive, Telescopium ex abditis rerum natur alium et artificialium . . . adeoque telescopium" (Herbipoli, 1665). Zahn described several types of cameras including one with lenses mounted in a tube and one with a slanting mirror placed between the lens and image plane for reversing the inverted image. This method of image reversal became the unique feature of the modern reflex camera.

Camera obscura, c. 1810.

Another type of portable camera obscura was described in 1671 by the Jesuit scholar, Father Athanasius Kircher who was well known for his knowledge of optics. In his book "Ars Magna Lucis et Umbrae" (Amsterdam), he mentions a camera obscura which was designed for setting up in the open air and used for drawing or painting landscapes.

Very few improvements were made in the camera obscura from 1670 until it became obsolete in the mid-nineteenth century. Most of the designs used the sliding-box-within-a-box method as a means of focusing. From the early camera obscura which was as large as a room, the sizes of succeeding models decreased to grand piano size, then shipping trunk size, and eventually to handbag size.

## 2. LIGHT-SENSITIVE COMPOUNDS

One could write a book on the many early reports of the effects of light on various chemical compounds. Many experimenters from the days of the ancient Greeks to the middle of the eighteenth century were aware that light effects a change in many substances. However, these early observations cannot be considered the germ idea of photography. The concept of photography came about through the association of the camera obscura with light sensitive compounds such as silver nitrate and silver chloride.

The darkening of silver nitrate by the action of light was reported as early as 1694 by the German chemist Wilhelm Homberg. He used a silver nitrate solution to produce a marbled appearance on dried bone. After the bone was dipped in the solution and placed in the sunlight to darken, the bone was turned on a lathe until portions of the white bone and the darkened area blended to produce a marbled appearance. Apparently, Homberg did not understand the nature of the darkening of the bone due to sunlight. He probably thought that the heat of the sun and not the spectral rays caused the darkening effect.

In 1727, Dr. John Hermann Schulze of Altdorf, Germany wrote a short paper titled, "Scotophorus pro phosphoro inventus; seu, Experimentum curiosum de effectu radiorum solarium," in which he described the effect of light upon a mixture of silver nitrate and chalk. He made this mixture in a bottle and described how he was able to show the effect of light on the mixture by laying cutout patterns, stencil fashion, on the outside of the bottle. However, Dr. Schulze's paper made no suggestion of using this phenomenon as a means of recording the shape of the stencils on the light-sensitive mixture. Instead, he merely used the stencils in order to trace more clearly the effect of light on the powdered mixture.

In his paper, Schulze describes one of his experiments as follows. "I shook up the precipitate of chalk [chalk and silver nitrate] in the tube until it was thoroughly mixed with the supernatant water, so that the mixture showed no difference in color in any of its parts. Then, dividing the liquid. . . , I filled a glass with one part and put it in a dark spot where no sunlight could reach it, while I kept the remaining portion for further experiment. I exposed the first portion to sunlight, suspending a thin string perpendicularly from the mouth of the center of the glass, so that the part exposed to the sun was divided almost in half, and left it exposed for hours to the strongest sunlight, undisturbed and untouched in any way. When we returned to inspect it, we found the liquid thoroughly imbued with the color. When the string was slowly withdrawn, we noticed to our delight that the part covered by the string showed the same color as the back of the glass which was not reached by the sunlight; we tested the same result with horse hair, with human hair, and with a very fine silver wire; so that there was no doubt that the change of color resulted solely from sunlight, and that it is not in any way dependent on warmth, not even the heat of the sun."

Schulze also demonstrated that sunlight reflected from a mirror or from a white wall caused his silver nitrate mixture to darken and that the darkening was much more rapid when a convex burning glass was used to focus the sunlight.

The experiments conducted by the Frenchman Jean Hellot and communicated to the Académie des Sciences de Paris in 1737 involved the use of a silver nitrate solution on paper. Hellot used the solution as an invisible ink. A message could be written on paper by candle light and then kept in a light-tight box. On exposing the paper to the sunlight, the message became visible.

The Italian physicist Giacomo Battista Beccarius presented a paper to the Academy of Sciences of Bologna in 1757 in which he described the action of light on silver chloride. He observed this phenomenon by placing

a black strip of paper on a bottle containing freshly precipitated silver chloride. When the bottle was placed in a well-lighted window, the silver chloride protected by the paper remained whitish while the remaining portion turned violet blue.

The Swedish chemist Carl Wilhelm Scheele described experiments he had conducted in 1777 on the effects of light on silver chloride. He determined that silver chloride was darkened by the action of light and not heat. He extended these studies to show that the violet rays of the sun's spectrum darkened the silver chloride salts much faster than the red rays. Of equal importance were his experiments that showed that silver chloride darkened by light was nothing more than reduced silver.

In his famous dissertation, "Aeris atque ignis examen chemicum," Scheele described the important work he conducted in the field of photochemistry. He also made numerous contributions in the broad field of chemistry. He discovered oxygen independently of Priestley and Lavoisier as well as other substances such as oxalic acid, citric acid, malic acid, gallic acid, molybdic acid, tungstic acid, and glycerine.

Scheele was the first to provide definitive statements on the photochemistry of silver chloride and used silver chloride paper in his experiments. He recognized the difference in the behavior of silver chloride blackened by light and the unchanged silver chloride in the presence of ammonia. This correlation was one of the first hints of a fixing agent for silver chloride but remained unnoticed for many decades.

## 3. THOMAS WEDGWOOD

The person credited with the original idea of obtaining a permanent image with the aid of the camera obscura is the Englishman, Thomas Wedgwood. He was born at Etruria, Staffordshire, England on May 14, 1771, and was the fourth son of Josiah Wedgwood, the famous potter. There are no records to provide insight as to what induced Wedgwood to experiment with the formation of images on light-sensitive materials or use the camera obscura in his experiments. It is known that Josiah Wedgwood had obtained a camera obscura for the purpose of sketching drawings which were copied on the surface of china pieces and burned in.

The only connection between the experiments conducted by Schulze and those of Wedgwood can be traced through their relationships with the Englishman Dr. William Lewis and an assistant by the name of Chisholm. Dr. Lewis had repeated a number of the experiments conducted by Schulze. After Lewis' death, Josiah Wedgwood bought the notebooks which described Lewis' experiments and also hired Chisholm to be his secretary and chemical assistant. Chisholm also tutored young Thomas Wedgwood.

Thomas Wedgwood attended Edinburgh University from 1786 to 1788 and spent several years conducting chemical experiments and investigating the relations between heat and light. In 1792, he communicated his experiments to the Royal Society in his paper, "Experiments and Observations on the Production of Light from Different Bodies by Heat and Attrition."

Young Wedgwood established close friendships with eminent scientists through his studies and experiments. Also, the acquaintances of his father with such distinguished scientists as Joseph Priestley, chemist; James Watt, improver of the steam engine; Erasmus Darwin, grandfather of Charles Darwin; William Herschel, astronomer; and Joseph Black, chemist; provided Thomas with influential contacts in the scientific society.

While on a winter visit to Penzance for health reasons in 1797–8, Thomas became acquainted with Sir Humphry Davy the famous chemist. Wedgwood had discussed with Davy some early experiments he had done with light-sensitive compounds. There is some evidence that Wedgwood ex-

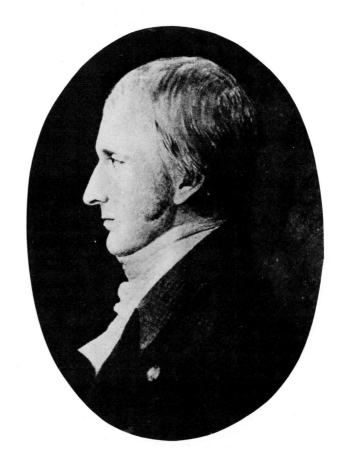

**THOMAS WEDGWOOD**
Photo courtesy of the Smithsonian
Institution, Washington, D.C.

perimented with these compounds as early as 1792. In 1801, Davy was appointed director of the chemical laboratory at the Royal Institution in London. While at the institution, Davy repeated and extended some of the experiments conducted by Wedgwood.

Wedgwood's experiments were not publically announced until 1802 when a short paper appeared in the *Journal of the Royal Institution of Great Britain*. The paper was titled, "An Account of a Method of Copying Paintings Upon Glass and of Making Profiles by the Agency of Light Upon Nitrate of Silver." The author was not Wedgwood but Davy who was the co-editor of the Journal. At the time the paper was published, neither Davy nor the Journal readers were aware of the potential of this epoch-making idea. Davy's writings about the Wedgwood experiments described the light-sensitive materials as white paper or white leather moistened with a silver nitrate solution. He also described how the sensitized materials darkened in direct sunlight in two or three minutes or in several hours in the shade.

Wedgwood used his sensitized materials to make images of various shaped objects including leaves and insect wings which were placed on the surface of the materials and then exposed to sunlight. After exposure, the image of each object appeared as a "light" area, whereas the remaining portion of the material became dark due to the sunlight. Since Wedgwood

could not find a way to fix the images, they would soon darken even in shaded light until the entire sensitized material became dark.

In Davy's article, he commented on Wedgwood's failure to achieve a "fixing" process in the statement, "Nothing but a method of preventing the unshaded parts of the delineation being coloured by exposure to the day is wanting to render the process as useful as it is elegant." Davy wrote that Wedgwood had tried to preserve the images by various means such as coating with varnish or repeated washings, but none were effective.

Wedgwood also experimented with filtered light and found that red light had very little effect in the darkening of silver nitrate. This phenomenon which was also reported by Scheele had significant importance in later years as a means of illuminating a light-sensitive film or plate without it becoming "fogged." The red developing light used in darkrooms and the "little red window" on the back of early black and white roll film cameras became very important applications of this discovery.

Wedgwood used the camera obscura in an effort to form an image on paper coated with silver nitrate. However, he found the images were very faint due to the slow reaction of the chemical to the limited amount of light provided by the camera obscura lens. In his Journal paper, Davy mentioned Wedgwood's unsuccessful attempts to produce camera obscura images on silver nitrate. He wrote, "The images formed by means of a camera obscura, have been found too faint to produce, in any moderate time, an effect upon the nitrate of silver. To copy these images, was the first objective of Mr. Wedgwood . . . , but all his numerous experiments as to this primary end proved unsuccessful."

Wedgwood had experienced ill health most of his adult life and on July 10, 1805, at the age of 34, died at Eastbury, Dorsetshire, England. Thus, the experiments by a man who came so close to producing the world's first photograph came to an end.

## 4. JOSEPH NICÉPHORE NIÉPCE

Joseph Nicéphore Niépce was born in 1765 in Chalon-sur-Saóne, about 145 miles southeast of Paris. He served in Napoleon's army, became a lieutenant in May 1793, and took part in the Italian campaign of 1794. He contracted typhoid fever which forced him to resign his commission, thus ending his military career. After his military discharge, he settled in Nice and married. In 1801, he returned to Chalon-sur-Saóne and spent the rest of his life in research.

In collaboration with his brother Claude, Nicéphore invented a type of internal combustion engine which they named the "pyrelophore" which is a composit of Greek meaning "fire," "wind," and "I produce." The engine consisted of a cylinder fitted with a piston and a flame located at the bottom of the cylinder. Air and a combustible powder, when forced into the cylinder, exploded and forced the piston upward. The first fuel used in the engine was lycopodium powder which is highly flammable plant spores. Later, they used a mixture of lampblack and finely ground resin. The engine proved to be successful enough to power a small boat up the Seine River at a speed "twice that of the current."

In 1816, Claude, with hope of exploiting the pyrelophore engine, left Chalon for Paris and then England where he settled at Kew. His efforts to commercialize the engine were unsuccessful due to a lack of financial support and his failing health. Thus, nothing ever came of this ingenious invention which so closely resembled the gasoline engine.

The many letters that were exchanged between Nicéphore and his brother Claude in England represent the best source of information concerning Nicéphore's extensive work which led to the invention of photo-engraving and ultimately, the world's first photograph. Before Niépce perfected his photo-engraving process, he conducted a number of experiments using light-sensitive materials such as silver chloride.

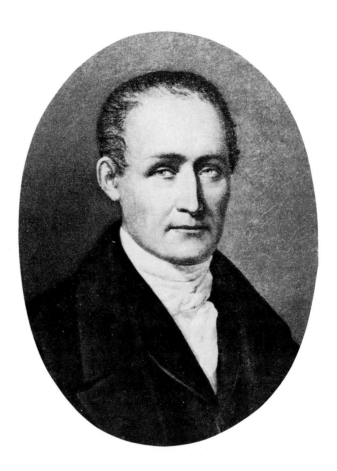

**JOSEPH NICÉPHORE NIÉPCE**
Photo courtesy of the Smithsonian
Institution, Washington, D.C.

In 1816, Nicéphore had written to his brother that he had assembled an apparatus consisting of a square box six-inches on each side fitted with an extension tube and a lens. He had placed a paper coated with silver chloride in the box and described the experiment as follows. "I put the apparatus in the room where I work in front of the window opposite the birdhouse. I made the experiment with the process that you know, cher ami, and I saw on the white paper all the parts of the birdhouse that can be seen from the window and a faint image of the windowsills which are less illuminated than the objects outside. . . . This is still but an imperfect attempt. . . . The possibility of printing this way seems to be almost demonstrated. . . . What you expected happened. The background of the picture is black, and the objects are white, that is to say, lighter than the background."

In a letter to his brother a few weeks later, Nicéphore stated that his experiment needed three improvements: greater sharpness of image, transposition of colors (a positive image instead of negative), and a means of making the colors permanent (fixing the image). While he was successful in sharpening the image by putting a circular mask on the lens to reduce its aperture, his efforts to realize the other improvements were unsuccessful.

He found that the black oxide of manganese (manganese dioxide) became white in contact with chlorine. In an attempt to use this phenomenon to produce positive images, he built a "camera" that was air-tight as well as light-tight and pumped chlorine into it while the manganese dioxide was exposed to light. The experiment did not work.

He tried other substances in an effort to perfect a positive image. He had learned that the resin guaiacum, which is yellowish-gray, becomes light green when exposed to light. Phosphorus, which has a natural yellow color, becomes almost white and clear as glass when heated in hot water. He conducted a number of experiments using these substances but without success. Apparently, Niépce also conducted experiments to find some means of fixing the images he produced in his "cameras." He conducted experiments on silver chloride treated paper but none was successful.

In a letter dated April 20, 1817, Nicéphore wrote to his brother, "I have given up the use of muriate of silver (silver chloride)." Thus, Niépce's efforts to make permanent images on silver chloride treated paper ended less than two decades before another man, William Talbot, would conduct similar experiments and meet with success.

Following the years Niépce conducted his experiments using "cameras" and sensitized paper, be became interested in a relatively new process called lithography. Lithography was invented by the Bohemian Alois Senefelder in Munich in 1797. This new process was quite revolutionary in that any drawing by an artist could be etched into a lithographic stone or metal plate and numerous prints could be made from the stone or plate. A copper plate, for example, was prepared by first coating it with ground consisting of wax, gum, and bitumen (asphalt). The artist then drew on the coated plate with a stylus making a narrow cut through the ground and exposing the copper plate. Nitric acid was then poured on the plate. The acid would react with the copper forming furrows wherever the artist had drawn lines. The ground was then removed and the copper plate was polished. In the printing process, the plate was first coated with ink, then the polished surface was wiped clean leaving ink in the etched furrows. When a paper was pressed against the plate, it absorbed the ink resulting in a reproduction of the artist's drawing.

The novel idea of etching metal plates for the purpose of reproducing an artist's drawing apparently prompted Niépce to consider a similar process for producing prints by the action of light (photo-engraving). He discovered that bitumen of Judea is light sensitive. Normally, this bitumen is soluble in lavender oil, but when it is exposed to light it becomes insoluble. This discovery enabled Niépce to use light instead of an artist to make an engraved plate. At first he used stone for making "plates" but later used pewter or copper. To prepare a plate, he first coated it with bitumen of Judea and then placed a picture or lithograph in contact with the bitumen. The picture had to be transparent or translucent which was accomplished by varnishing or waxing. When the picture was exposed to light, the light passed through the transparent areas but not through the dark areas. Thus, the areas of the bitumen that received light became insoluble in lavender oil. When the plate was washed with the oil, the bitumen not exposed to light was washed away leaving a bare metal surface. The plate was then treated with acid for etching, cleaned, and inked the same as a lithographic plate.

In January, 1826, Niépce received a letter from a stranger in Paris, Louis Daguerre, who had been given Niépce's address by their mutual lens maker, Chevalier. Daguerre stated that he too was conducting experiments with light to produce images but was not having much success. He wondered whether Niépce was having better luck. Since Niépce knew nothing about this stranger, he wrote a polite but evasive acknowledgment and assumed that would end their correspondence. However, a year later, Daguerre wrote again asking for a sample picture. Niépce was bothered by this request and asked his engraver friend Augustin Franqois Le-

maitre whether he knew Daguerre and what his work involved. Lemaitre answered that he was aware of Daguerre's interest in cameras (obscura) but did not know in detail what he was doing with them. He advised Niépce to break communications with Daguerre because of the possibility of someone infringing on his discovery.

In the summer of 1827, Nicéphore and his wife set off on a trip to England to visit Claude who was in poor health. On the way, they stopped in Paris where Niépce had arranged to meet Daguerre for the first time. Daguerre and Charles Marie Bouton were proprietors of the Diorama, a large theater which used 45½ by 71½ foot paintings of both indoor and outdoor scenes. By using special painting and lighting techniques, the paintings gave an illusion of such real-life quality that the theater audiences viewed the scenes with disbelief. (See the Daguerre biography for details of the Diorama.)

Daguerre took Niépce on a tour of the Diorama and Niépce was so impressed with the theater, and particularly the painted scenes, that he later wrote to his son, Isidore; "I have seen nothing here that impressed me more, that gave me more pleasure, than the Diorama. We were taken through it by M. Daguerre and could contemplate at our ease the magnificant pictures which are exhibited there. . . . Nothing is superior to the two views painted by M. Daguerre: one of Edinburgh by moonlight during a fire; the other of a Swiss village [showing] the end of a wide street, facing a mountain of tremendous height, covered with eternal snow. These representations are so real, even in their smallest detail that one believes that he actually sees rural and primeval nature, with all the illusion with which the charm of color and the magic of chiaroscuro can endow it. The illusion is even so great that one attempts to leave one's box in order to wander out into the open and climb to the summit of the mountain. I assure you there is not the least exaggeration on my part, the objects are, or seem to be, of natural size."

In addition to taking Niépce on a tour of the Diorama, Daguerre also showed him some of the results of his photographic experiments. Niépce commented on these experiments which he had found quite different from his own. In a letter to his son, he wrote, "M. Daguerre has succeeded in fixing on his chemical substance some of the colored rays of the prism; he has already fixed four and is working to fix three more to have the seven primary colors."

Daguerre did not discuss the details of his experiments with Niépce but he guessed that the process made use of some phosphorescent powder such as calcined barium sulfate, which was called *Bologna stone*. Niépce wrote about this phosphorescent powder saying, "It has a great attraction for light but cannot hold it long. . . . From what he (Daguerre) said to me, he had little hope of success and his research is little more than a curiosity. My process seems to him preferable and much more satisfactory. . . ."

Niépce and his wife left Paris and continued their trip to Kew for their planned visit with Claude. They found Claude in worse health than they had expected. He was suffering from what was described as dropsy and was also mentally disturbed.

While in Kew, Niépce met Francis Bauer, a Fellow at the Royal Society, who suggested that Niépce present a paper to the Society describing his heliographic process as he called it. Niépce did not want to reveal details of his process, and thus his paper to the Society was not accepted.

Niépce gave Bauer four heliographs, three of which were copies of prints. The fourth heliograph, made with a camera on a pewter plate 6½ by 8½ inches, shows the courtyard of Niépce's estate at Gras, near Chalon-sur-Saóne. An inscription on the back of the plate reads (in French and English), "Monsieur Niépce's first successful experiment of fixing permanently the image from Nature. 1827." This plate exists today at the University of Texas.

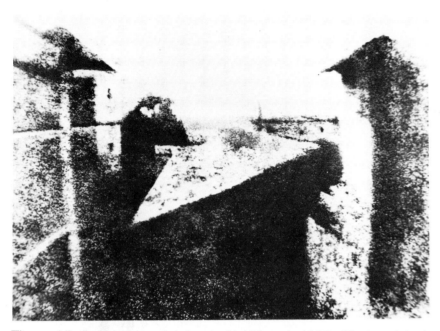

The world's first photograph taken by N. Niépce in 1827. Photo courtesty of the University of Texas.

Through a letter of introduction from Bauer, Niépce became acquainted with Thomas Young, secretary of the Royal Society. Young, whose famous experiments established the wave property of light, reported on Niépce's invention.

"Mr Nepce's [sic] invention appears to me to be very neat and elegant and I have no knowledge of any similar method having been before employed. How far it may become practically useful hereafter is impossible for me to judge, especially without knowing the whole of the secret. But I see no reason to doubt of its utility, except that all novelties are liable to unforeseen difficulties."

Niépce also contacted R. Achermann, publisher of the first English translation of Senefelder's, "A Complete Course of Lithography," and proprietor of the Repository of the Arts, the leading art supply house in London. Niépce proposed to Ackermann the formation of a company to exploit his heliographic process, but nothing came of the proposal. In an effort to gain support for his process, Niépce contacted other scientists and noblemen but only met with disappointment and frustration.

On February 3, 1828, Niépce received a friendly letter from Daguerre. Daguerre wrote, "I am sorry to see . . . that you have had nothing but discouragement in England, but be consoled; it is not possible that it should be the same here, especially if you arrive at the results that you have every right to hope for. . . . It would be a real pleasure to me, if you would find it agreeable, to show you how to get the most from your discovery. I cannot hide the fact that I am burning with desire to see your experiments from nature." A few days after receiving this letter, Niépce and his wife left England and returned to their home in France. On the way, Niépce stopped in Paris to meet with Daguerre and discuss the ways Daguerre might be able to assist him. On February 10, 1828, only a few days after Niépce and his wife left England, Claude died.

At his home near Chalon-sur-Saóne, Niépce decided it was time to write a book about his discoveries. He began writing the first drafts in 1829 and planned to describe his experiments with various light-sensitive substances such as iodine, silver chloride, bitumen of Judea (asphalt), guaiacum, etc. Niépce had written to Daguerre about his plans to write a book, but months went by before he received a reply. Daguerre finally wrote

and apologized for his delay. Daguerre explained he had been busy working on his experiments with light, taking business trips, and painting the enormous canvases for the Diorama. He advised Niépce not to write the book he had started since he felt there were other ways of exploiting his discoveries. Instead, Daguerre suggested that one of Niépce's plates be sent to him for criticism. Niépce sent a plate (made with a camera) and asked if he would also show it to Lemaitre. The criticism Niépce received was specific and constructive. Daguerre pointed out that the process needed improvement to get better tone reproduction. Also, better optics were required and the exposure time must be reduced. During the long exposure (at least 12-hours), the parallel walls of objects became equally lighted during the passage of the sun across the sky. This results in a false representation of brightness and shadows. Both Daguerre and Lemaitre offered help to improve the quality of the plates.

The correspondence between Niépce and Daguerre which followed resulted in a proposal by Niépce that the three of them; Niépce, Daguerre, and Lemaitre form a partnership. Daguerre and Lemaitre agreed and Niépce had his lawyer draw up the necessary papers. On receiving the papers, Daguerre suggested that Lemaitre be excluded from the partnership since he felt that Lemaitre's skill as an engraver was not needed. Niépce discussed the suggestion with Lemaitre who agreed to forego the partnership provided he was given the exclusive right to do whatever engraving was needed by the partnership. On December 14, 1829, Daguerre left Paris for Chalon to sign the partnership contract. Daguerre immediately returned to Paris never to see Niépce again. Collaboration involving their partnership was conducted entirely by correspondence.

One of the first things Daguerre did to ensure secrecy in the newly formed partnership was to set-up a code system of substituting numbers for specific words in their correspondence. Instead of using basic words such as silver, pewter, oil of lavender, wax, light, etc., a number was substituted for each word. Each letter of correspondence was headed by a list of new words. These words were not numbered but were added in chronological order to the basic list.

On May 10, 1831, Daguerre made an important observation which would be vital to the process that made him famous. In a letter to Niépce dated May 31, 1831, Daguerre described his new experiment with iodine and silver. "I think after many tests that we ought to concentrate our researches on iodine. This substance is highly light sensitive when it is in contact with a silver plate. But there is a degree which should not be exceeded, that is to say, the silver plate should be taken out as soon as it has a beautiful and uniform gold tint because it then passes to different blue and bronze colors which do not have the same sensitivity to light. I have obtained in this gold tint on the silver plate results of satisfying speed, that is, less than three-minutes in the camera, engravings in the sun in one-minute, and in the microscope in two-minutes." Although Daguerre was pleased with the images he obtained, he realized that they were quite faint, the tones were reversed, and he had not found a way to fix the images.

Niépce had conducted a number of experiments with iodine and silver and had mentioned them in the book he planned to write. However, Niépce had mistakenly believed that iodine itself was sensitive to light. To make an iodized plate, Niépce first coated a silver plate with bitumen of Judea. After exposure, the plate was washed in lavender oil which dissolved the bitumen on the areas of the plate not exposed to light. The dissolved bitumen was washed away leaving the bare silver areas of the plate exposed. The plate was then exposed to iodine vapor which combined with the silver to form silver iodide. The silver iodide immediately darkened by the action of light. When the insoluable bitumen was removed from the plate using alcohol, the light areas of the image were represented by shiny silver and the dark areas by the darkened silver iodide.

Niépce had wrote to Daguerre about his experiments with iodine as

follows. "I had dealt with this same experiment before having become associated with you, but with no hope of success, because I considered it an almost impossible matter to fix the exposed images in a lasting manner, even if we should succeed in keeping light and shade in their proper arrangement. . . . I made new experiments with iodine last year, after your departure from here, but according to another procedure; after I had reported the results to you and received your unsatisfactory reply, I decided to discontinue my experiments. It seems that you meanwhile regard this question from a more hopeful point of view. . . ."

In a letter dated October 3, 1832, Daguerre wrote that he had designed a new two-element cemented achromat lens. He stated that the sharpness of an image formed by this lens surpassed the sharpness of an image obtained by contact printing (engravings). Daguerre liked the new lens so much that he put away all of the other lenses he had been using. He sent a sketch of the lens to Niépce and pointed out that the convex side of the lens should face the object and the concave side the plate.

Daguerre discussed the use of glass plates in a letter to Niépce dated June 6, 1833. He found that glass plates were better suited for their experiments than silver plates since the latter tend to oxidize. Daguerre regretted that things were going so poorly with the Diorama that he could not afford to travel.

On June 5, 1833, Niépce died suddenly of a stroke. He was 69 years old.

It should be noted that after the partnership between Niépce and Daguerre was established in 1829, Niépce wrote a complete description of his bitumen heliographic process in a noted title, "Notice sur l'Heliographe," and presented it to Daguerre. It remained unpublished during Niépce's lifetime. It was not until 1839 when Daguerre published his own photographic method that he mentioned Niépce's work. The description of Niépce's work included a number of footnotes by Daguerre, the general tone of which was disparaging to his late partner.

On May 9, 1835, a contract was drawn up between Isidore Niépce and Daguerre recognizing Isidore as the sole heir to his father and replacing his father in the original contract of December 14, 1829. The contract stipulated that the name of the partnership should be changed from "Niépce–Daguerre" to "Daguerre and Isidore Niépce."

Probably the most complete description of the photographic experiments, apparatus, and letters of Niépce was published in 1867 by Victor Fouque in his book, "La Vérité sur l'Invention de la Photographie."

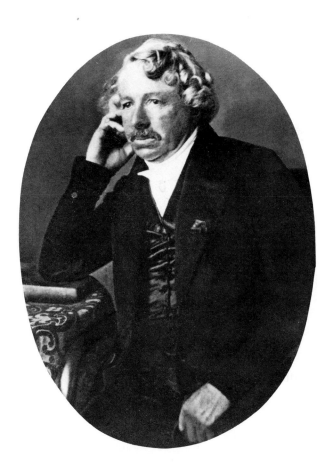

**LOUIS JACQUES MANDÉ DAGUERRE**
Photo courtesy of the Smithsonian
Institution, Washington, D.C.

## 5. LOUIS JACQUES MANDÉ DAGUERRE

Louis Jacques Mandé Daguerre was born in Cormeilles-en-Paris, France on November 18, 1787. During his childhood, he showed considerable talent for drawing and was apprenticed to an architect at the age of thirteen. At seventeen, he became a pupil of Degotti, the scene painter at the Paris Opera. He began his early career by independently designing the décor for several Paris theater productions and painting a number of large panoramas in collaboration with Pierre Prévost.

In 1822, Daguerre, in association with the painter Charles Bouton, established the Diorama. The Diorama, a theater without actors, used hugh paintings (45½ x 71½ feet) to create illusions of both indoor and outdoor scenes with extraordinary reality. The paintings were mounted on three separate stages in a circular arrangement with the audience seated in the center of the theater. Different scenes were painted on both sides of transparent screens. When the front, back, or both front and back of each screen was lighted by window-light or skylights, the audience would see a scene appear or disappear in accordance with the lighting. For one particular scene, a view of the inside of an empty church was painted on one side of a screen with the figures of people painted on the opposite side. As the lighting was changed from the front to the back of the screen and with the lighting of alter lamps and candles behind the screen, the empty church soon appeared to be filled with people. The scenes appeared so real that when Charles X visited the Diorama, he threw a two-franc piece into the scene to convince himself that it was painted.

In order to achieve the realism of the Diorama scenes which made the theater famous, it was necessary for Daguerre to paint the scenes in accurate detail. To this end, Daguerre used the camera obscura to draw scenes as they actually appeared in nature and then transposed them to the Diorama screens. The time-consuming task of drawing the scenes using the camera obscura probably encouraged Daguerre to find a means of fixing a scene permanently by the action of light on a photosensitive material.

Daguerre set up a laboratory at the Diorama and carried out mysterious experiments, sometimes shutting himself in the laboratory for days on end. One day, Daguerre's wife related to the famous chemist, J. B. Dumas, that her husband was obsessed with the idea of fixing images in the camera obscura. She lamented, "He is always at the thought; he cannot sleep at night for it. I am afraid he is out of his mind. Do you, as a man of science, think it can be done, or is he mad?" Dumas replied, "It cannot be done, but I cannot say it will always remain impossible, nor set the man down as mad who seeks to do it."

In January 1826, Daguerre began his correspondence with Niépce which

has been described. During the nearly four years of correspondence which led to the Niépce–Daguerre partnership in December, 1829, Daguerre had not succeeded in producing a single photograph—not even one which was unfixed. In 1831, Daguerre became aware of the light sensitivity of silver iodide but found that it was not sensitive enough to produce an image. In the spring of 1835, Daguerre's discovery of a process for developing a latent image formed on a silver iodized plate came about completely be accident. Daguerre had placed in his chemical cupboard a silver iodized plate which he had "underexposed" in the camera obscura with the intention of later repolishing it for reuse. A few days later when he opened the cabinet, he found, to his amazement, that a very distinct image had developed on the plate. He quickly made a number of other underexposed plates and placed them in the cupboard one at a time, while each time he removed one of the chemicals he had stored in the cupboard. By the process of elimination, he found that a small basin filled with mercury was the answer to the mystery. From this experience, Daguerre concluded that a silver iodized plate only needed a relatively short (15 to 30-seconds) exposure and that the latent image could be made visible by an after process.

While both Niépce and Daguerre used iodized silver in their experiments, the way it was used was quite different. Niépce used the silver salt as a means of darkening the unexposed areas of his bitumen plates while Daguerre tried to use it exclusively for producing an image by the action of light. Daguerre was unsuccessful in producing a satisfactory image on iodized silver but deserves full credit for developing the first latent image on iodized silver using mercury vapor. Although Daguerre had discovered a unique method of developing a latent image, he was unable at that time to fix the image. He was, however, so pleased with the new process that he asked Isidore Niépce to come to Paris to see the images. Since Daguerre felt that this new process was such an improvement over Niépce's heliographic process, he suggested to Isidore that the original Niépce–Daguerre contract of 1829 be amended. Daguerre proposed that the partnership be called "Daguerre and Isidore Niépce." Isidore was not happy about this change, but because he needed money and saw the potential of this new process, he reluctantly signed the amendment on May 9, 1835.

It was not until the spring of 1837 that Daguerre found a method of fixing his images using a solution of common salt and hot water. Daguerre presented his first successfully fixed image, a still life taken in his studio, to the Curator of the Louvre, M. de Cailleux. This image is now preserved at the Société de Photographie in Paris.

After discovering a method of fixing images, Daguerre wasted no time in exploiting his new process. He discussed his ideas with Isidore and insisted that this new process be referred to by his name alone—*daguerreotype* and that his new process and the Niépce heliographic process be published separately. Isidore was reluctant to accept this but agreed after realizing that there would be very little commercial interest in his father's slower process. The proposals by Daguerre represented his concern that he alone should receive the honor of being the inventor of this new process. However, he still agreed with the provisions of the original contract that profits from the new process should be divided equally.

In Daguerre's first attempt to exploit the heliography and daguerreotype processes, he suggested to Isidore that a public subscription be offered. The subscription would run from March 15 to August 15, 1838, calling for four-hundred subscribers at 1,000 francs each, and stipulating that the processes not be made public unless there were at least one-hundred subscribers. If sold outright, the price for the inventions should be at least 200,000 francs. In order to publicize the daguerreotype process, Daguerre placed his apparatus on a cart and photographed monuments and buildings along the streets of Paris. People who saw his photographs were greatly impressed but very few were willing to purchase a subscription for 1,000 francs.

Daguerre soon realized that his idea of offering subscriptions would not be successful and pursued other possibilities. Daguerre and Niépce decided to offer their inventions to the French government. They arranged meetings with a number of leading scientists including J. B. Dumas, John Biot, Alexander Humboldt, and Francois Arago. Arago, who was a member of the Chamber of Deputies and a distinguished physicist and astronomer, was greatly impressed by the inventions and became a valuable influential ally. On January 7, 1839, Arago gave the Daguerre-Niépce inventions official status by making a brief announcement of the inventions, without details, before the Académié des Sciences.

A few months later, Daguerre suffered a considerable financial loss. On March 8, 1839, a careless worker at the Diorama brought a lighted taper near a recently varnished painting, setting it ablaze, and thus ignited the combustible scenery. The fire spread so quickly that the Diorama was destroyed in less than thirty-minutes. Fortunately, Daguerre's apartment on the sixth floor of an adjacent building was not badly damaged and a portfolio of Daguerre's photographic research notes was saved. The fire was a crushing blow to Daguerre who depended on the Diorama for his living and the financing of his photographic work.

The loss of the Diorama further induced Daguerre to exploit his invention. Through the efforts of Arago and other influential persons, Daguerre and Niépce were able to meet with the Minister of Interior, Duchâtel. Soon after, an undated letter from Arago to the Minister reiterated the proposal that the Government acquire the Daguerre–Niépce inventions. A bill was presented in the Chamber of Deputies proposing that the Government grant annual pensions of 6,000 francs for Daguerre and 4,000 francs for Isidore Niépce for their photographic inventions. The extra 2,000 francs for Daguerre was for his disclosure of the method of painting the Diorama scenes. On July 3, 1839, the bill was passed by the Chamber of Deputies and on July 30, it was passed by the upper Chamber. At a session of the Paris Academy of Sciences, on August 19, 1839, Arago described the details of the Daguerre and Niépce processes. An enormous crowd received the presentation with enthusiasm.

Once the daguerreotype process was made public, the news spread quickly throughout Europe. European nobility and influential people who were fortunate to acquire some of the first daguerrotype samples made by Daguerre or his pupils praised Daguerre for perfecting a process which was so perfect and detailed that "nature itself could not improve it." Recipients of daguerreotype samples studied them with magnifying lenses and were astonished to find that "every brick in every building and every tree leaf were reproduced beyond what the best artist could render with the finest brush."

Probably the first monarch outside France to receive a daguerreotype from Daguerre was Emperor Ferdinand I of Austria. He was greatly impressed with the sample and in appreciation, ordered Count Czernin on September 2, 1839, to send an artist's metal, 18-ducats in weight, and an initialed snuffbox valued at 1200 florins to Daguerre. The first daguerreotypes sent to Vienna were exhibited at the Wiener Maler—Akademie in 1839. The Academy proposed to the government that Daguerre be made an honorary member of the Vienna Academy. However, the proposal was not granted until 1843.

Other honors were bestowed on Daguerre. He became an Officer of the Legion of Honor, was elected an honorary member of the Royal Society of London, and the National Academy of Design, New York. In 1843, at the request of Humboldt, he received the order of "Pour le Mérite" from King Frederick William IV of Prussia.

The first official description of the daguerreotype process was made public in 1839 in the handbook, "Historique et description des procédés

du daguerréotypie et du diorama," written by Daguerre. The handbook included six illustrations of the apparatus required for the process. A second edition, corrected and enlarged, included a portrait of Daguerre as frontispiece and was published by Alphonse Giroux et Cie of Paris in 1839. The same year, a third edition was published with an imprint of F. Mollet of Paris. The first English description of the process was published in 1839 by McLean and Nutt of London with the same translated title as the French publication. Also, the same year, the first German description was published by Schlesinger in Berlin.

The daguerreotypes made by Daguerre until the middle of 1839 were fixed with a warm solution of common salt which gave the image a mottled appearance. The quality and texture of the image was greatly improved when Daguerre learned that hyposulphite of soda (hypo) was superior to common salt as a fixing agent. Actually, Sir John Herschel had suggested to Talbot the use of hypo to fix his calotype images (see the Talbot biography). Talbot used hypo as early as May 1, 1839 which preceeded Daguerre's use of the chemical by at least several months.

The procedures for employing the Daguerre process are relatively straightforward. A silvered copper plate is carefully polished and then exposed to the vapors of iodine at normal temperatures. This forms a very thin coat of silver iodide which must be protected from light until it is placed in a camera for exposure. The first daguerreotypes required exposure times of from 15 to 30-minutes depending on the amount of light for illumination. Because of the long exposures, the subjects photographed were usually architecture, works of art, or landscapes. A few portraits were attempted but were not very successful since the subject had to remain motionless during the long exposure. Also, the blinking of the eyes during the exposure resulted in strange facial expressions.

After the plate is exposed, it is subjected to the vapor of mercury. The exposed plate is placed in a box at a 45-degree angle to the horizontal with the silver iodide surface facing downward. A saucer-like vessel of mercury is placed in the box directly beneath the plate with a thermometer mounted in contact with the vessel to measure its temperature. A candle or alcohol lamp is placed beneath the vessel for heating the mercury. As the mercury vapor begins to coat the plate, the process can be viewed through a small window in the side of the box to determine when the image is adequately developed. The plate is then carefully immersed in a solution of hyposulphite of soda to fix the image.

In 1840, the beauty and permanence of daguerreotypes were improved by adding a small amount of gold chloride to the "hypo" during the fixing process. Also, all of the early daguerreotype images were reversed (left to right) due to the reversing effects of the camera lens. In 1841, Chevalier marketed a prism which could be attached to a camera lens for correcting the reversed image.

Probably the first person who tried to shorten the exposure time of daguerreotypes so they could be used for portraiture was Johann Baptist Isenring, a painter and engraver of St. Gallen, Switzerland. After failing to find a way of shortening the exposures, he learned of a process published on January 19, 1841 by Franz Kratochwila in the Wienner Zeitung. The fuming of the daguerreotype with bromine after iodizing reduced the exposure time to 30–60 seconds. Isenring set up a portraiture booth at the Munich fair in July 1841 and became one of the first, if not the first, professional portrait photographer.

In spite of the beauty and elegance of the daguerreotype, it had a number of disadvantages. The image had a mirror-like surface which was difficult to see if the light was not reflected at just the right angle and the image was damaged if it was touched. (Most daguerreotypes were placed in frame holders with thin glass covers.) Also, the daguerreotype could not be used as a negative to print copies and the image was reversed (left to right) unless a prism was placed on the camera lens.

The success of the daguerreotype process prompted Daguerre to establish a camera manufacturing business. In June 1839, he entrusted his relative Alphonse Giroux with the exclusive manufacture of his cameras which would soon be in great demand. The Giroux camera was a sliding-box type with a ground glass for focusing. It had an f17 meniscus or plano-convex lens and took plates 6½ x 8¼ inches. An oval seal of guarantee was placed on the side of each camera bearing the Giroux name and Daguerre's signature.

In 1840, Daguerre retired and bought a small estate at Bry-sur-Marne. He received important visitors from all over the world and continued with his painting until his death on July 10, 1851. Daguerre left no will but a niece he had adopted, Eulalia Daguerre, later Madame Courtin, inherited his estate.

## 6. WILLIAM HENRY FOX TALBOT

William Talbot was born on February 11, 1800, at Melbury in Dorsetshire, England. His maternal grandfather was Earl of Ilchester and his father, William Davenport Talbot, was an officer of Dragoons. His mother was Lady Elisabeth Fox Strangways (maiden name). Young Talbot never knew his father who died when Henry was six months old. The Talbots lived in a large manor house, Lacock Abbey in Wiltshire, which the family had inhabited since the sixteenth century.

Until the age of eight, Talbot was tutored at home but then was enrolled at the boarding school Rottingdean. Talbot's tutors and school instructors recognized his intellect and profound interest in the study of diverse subjects. As a young man, he spent considerable time studying the wonders of nature by cultivating and analyzing plants, observing organisms and the shapes of crystals under a microscope, deriving mathematical formulas, reading Greek, translating cuneiform, and studying the properties of light. Talbot attended Harrow and Trinity College, Cambridge where his special interests were the classics and mathematics. He won the Porson Prize for translating Shakespeare's *Macbeth* into Greek verse and took his degree with honors in 1821. In 1831, he was elected a fellow of the Royal Society, the most prestigious scientific body at the time, on the basis of his mathematical papers and research.

During a trip to Italy in 1823 and 1824, Talbot used the camera obscura for sketching pictures on transparent paper but was not happy with the results. In October, 1833, while on a pleasure trip to Lake Como near Bellagio, he tried using a Wollaston's camera lucida* for sketching the shores of the lake. Again, Talbot was not pleased with his drawing ability. Apparently, his difficulty in accurately sketching scenes sparked his interest in trying to find a way to fix the images of the camera obscura by chemical means. Talbot was probably aware of the early work of Schulze and Scheele with light-sensitive compounds but there is no evidence that he had any knowledge of the work of Niépce and Daguerre until 1839.

In January, 1834, Talbot began experimenting with silver nitrate coatings on paper and then with silver chloride. In working with silver nitrate, he found that the rate at which the paper was darkened by the action of light was increased considerably if the paper was first coated with a dilute sodium chloride solution. He used this process to obtain good quality images of flat objects such as leaves or lace patterns placed in contact with the sensitized paper. However, these experiments were not unique since Wedgwood and others had made similar images as early as 1802. The real significance of Talbot's work was that he went one step further and was able to stop the action of light on his sensitized papers. He was the first to use the term "preserving process" to describe this technique

---

* The camera lucida is an optical device which superimposes the image of a scene (as viewed by an artist) onto a sketching pad by means of a prism.

of rendering the paper inactive to further action by light. To do this, he washed the paper with a potassium iodide solution. Although this method of fixing would be considered primitive in modern-day practice, it was very effective.

Early in 1835, Talbot also discovered that the image on a silver chloride coated paper could be fixed with a strong solution of sodium chloride. During this period, he also found that by repeatedly washing the paper alternately with sodium chloride and silver nitrate, he further increased the sensitivity of the paper, particularly if it was exposed in a moist state.

In the summer of 1835, Talbot obtained a photograph of his residence at Lacock using the camera obscura and a silver chloride coated paper. In August of that year, he also succeeded in obtaining a photograph, taken from indoors, of the window in the library of his residence. The window had a latticed design (squares of glass) which was clearly visible on the photograph. These images were fixed by using a strong solution of sodium chloride. A description of Talbot's first experiments with silver chloride coated paper was included in the Preface of his book published in 1844 titled, "Pencil of Nature."

During the next four years, apparently Talbot conducted no additional photographic experiments. If such experiments were conducted, they were either never recorded or the records were lost. Also, Talbot apparently felt there was no need to publicly announce the work he conducted in 1834 and 1835. His procrastination concerning the publicizing of his work caused him some regrets a few years later.

On January 7, 1839, Franqois Arago announced to the Académie des Sciences in France that a fellow countryman, Mandé Daguerre, had developed a method of producing very detailed, fine-lined pictures by the action of light on specially prepared plates. No one was more startled by the announcement than Talbot who immediately set out to prove that he, and not Daguerre, should receive credit for being the first to produce permanent images by light. Talbot felt that he must prove that he was an independent inventor and that his invention might be superior to Daguerre's.

Using the notes and photographs he had with him in London, Talbot gave a small exhibition of his "photogenic drawings," as he called them, at the Royal Institution on January 25, 1839. A few days later, he presented a paper to his fellow scientists at the Royal Society titled, "Some Account of the Art of Photogenic Drawing." In the paper, he stated, "In the spring of 1834, I began to put in practice a method which I had devised some time previously, for employing to purposes of utility the very curious property which has been long known to chemists to be possessed by the nitrate of silver; namely its discoloration when exposed to the violet rays of light." Talbot continued by saying, "The most transitory of things, a shadow, the proverbial emblem of all that is fleeting and momentary, may be fettered by the spells of our 'natural magic', and may be fixed forever in the position which it seemed only destined for a single instant to occupy."

In his presentation, Talbot gave no particulars concerning the preparation of his sensitized paper. However, he did announce that he had succeeded in rendering his images permanent which was a considerable advancement over the work carried out by Wedgwood. Talbot declared at the time he did his original work, he was unaware of Wedgwood's work.

A few months later in another presentation to the Royal Society, Talbot revealed the details of his process. He stated that as early as the spring of 1834, he found that by coating paper first with a weak solution of common salt and then with a solution of silver nitrate, the sensitivity of the paper to light was greatly improved. In describing his fixing process, he stated, "This chemical process which I call the *preserving process* is far more effectual than could have been anticipated. The paper, which had previously been so sensitive to light, becomes completely insensible to it, insomuch that I am able to show the Society specimens which have been

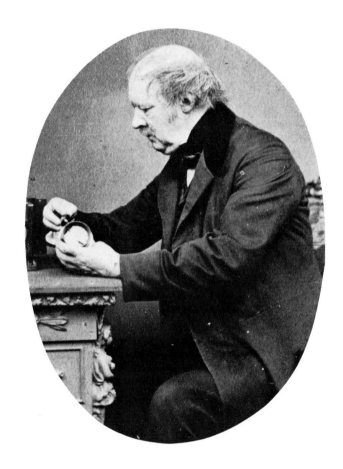

**WILLIAM HENRY FOX TALBOT**
Photo courtesy of the Smithsonian
Institution, Washington, D.C.

exposed for an hour to the full summer sun, and from which exposure the image has suffered nothing, but retains its perfect whiteness."

Prior to February 1835, all of the images produced by Talbot were negatives i.e., the areas of the sensitized paper exposed to light became the dark areas of the photograph. The idea of using transparent sensitized paper (made transparent by waxing or oiling) and then making positive copies of the original image was first documented by Talbot on February 28, 1835. He wrote the following in his notebook. "In the photogenic or sciagraphic process, if the paper is transparent, the first drawing may serve as an object to produce a second drawing, in which the lights and the shadows would be reversed." In the following months, Talbot made a number of respectable positive prints from negatives but was not the originator of the terms "positive" and "negative." Sir John Herschel first used these terms in his appraisal of Talbot's work.

By August of 1835, Talbot was making negatives using the camera obscura. The camera obscura in combination with a light sensitive paper placed in the focal plane represents all of the elements of the photographic process. Thus, the negatives made by Talbot using this combination represents the first camera images made by him. The cameras Talbot first used were very small in size. One measured three-inches on each side

and contained a lens taken from a microscope. Talbot's wife referred to these cameras as "mousetraps" since basically they were small wooden boxes with a hole in one end. Although the cameras used by Talbot and the images he obtained were quite small, the details of the images were superior to those made by Niépce eight years earlier.

In the years following, Talbot's efforts to produce photographic images using box cameras were hampered by the very long exposure times needed to produce acceptable images. His sensitized paper was so slow in forming high-contrast images that in some cases an exposure time of one-hour was required.

On September 20, 1840, Talbot made a brilliant discovery. He found that a short exposure produced a latent image on his sensitized paper which could be made visible by the use of gallic acid. Talbot was astonished by the appearance of an invisible image on a sensitized paper when a chemical solution was added. In his documentation of this unusual phenomenon, Talbot wrote, "I know of few things in the range of science more surprising than the gradual appearance of the picture on the blank sheet especially the first time the experiment is witnessed."

Talbot called this new process the *calotype* which is derived from the Greek word "kalos" meaning "beautiful." He sent a brief statement about his discovery to John Biot, the French physicist, who read it before the Académie des Sciences on January 18, 1841. Two months later, he was able to show the Académie a calotype photograph of the cloisters of Lacock Abbey, with the figure of a man, taken in one-minute. In February, 1841, Talbot obtained a patent for his process and later granted licenses for its use.

Talbot described the complete calotype process in a paper presented to the Royal Society on June 10, 1841. The process consists of first brushing the paper with a silver nitrate solution, drying, and then dipping into a solution of potassium iodide. This results in a coating of silver iodide which is virtually insensitive to light because of an excess of potassium iodide. In this state, the coated paper can be stored almost indefinitely. To prepare the paper for exposure, it is floated on a solution containing silver nitrate, acetic acid, and gallic acid. In this sensitized condition, the paper can be kept for months before exposure. As a fixing agent for his calotype, Talbot used a solution of potassium bromide which removed the excess silver nitrate by forming insoluble silver bromide. The new calotype process greatly reduced the long exposure times which Talbot agonized over for years. Using an f15 lens in strong sunlight, an exposure time of one-minute was sufficient to produce a high quality image.

The calotype process had some advantages over the Daguerre process which helped to increase its popularity. The calotype negatives could be used to make any number of positive prints which was not possible with the daguerreotypes. Also, the softness and impressionist-like quality of the calotype image was very pleasing to photographers who did not like the sharp-edged, fine-metallic detail of the daguerreotype for certain types of photography.

Talbot was the first to propose a method of making enlarged prints from his calotypes. In a patent he obtained in June, 1843, he states that an enlarged paper negative can be obtained from a small calotype positive using lenses. This was the beginning of the photographic enlarging process.

Although Talbot was not a good businessman, he initiated several business ventures in an effort to commercialize his calotype process and photography in general. Between 1844 and 1846, he published two books titled "The Pencil of Nature" and "Sun Pictures in Scotland" which included a number of his calotype prints. He also set up the Reading Establishment which was a printing firm in the community of Reading where prints from negatives could be made for use as illustrations in books. The Establishment also served as a "school" where people could learn photography and a manufacturing center for making photographic paper.

The last successful photographic experiment conducted by Talbot was in 1851. Talbot had learned of a new process for making photographic plates called Niépceotypes. The process was invented in 1847 by Claude Felix Abel Niépce de Saint-Victor, cousin of the late Nicéphore Niépce. The process consisted of the coating of a glass plate with a mixture of potassium iodide and albumen (white of an egg) and then immersing it in a silver nitrate bath. Talbot improved the process by using ferrous iodide and albumen. His albumen plates (as they were called) were so light sensitive that he conducted a novel experiment to test them. He fastened a page from a newspaper to a wheel which could be rotated rapidly. While the wheel was rotating, he photographed the page using a sudden electric flash. The albumen plate was sufficiently fast to produce a good quality image of the page.

Between 1849 and 1851, Talbot invented a photomechanical printing process based on the "cross-line screen" for holding ink on a printing plate. His process was based on the light-sensitivity of a mixture of potassium bichromate and gelatine which becomes soluble in water after it is exposed to light.

To make a photoengraving plate, Talbot coated a polished steel plate with the light-sensitive mixture and then dried it over an alcohol lamp. Next, he placed a fine black gauze over the coating and then a transparent positive image on top of the gauze. After placing the combination in the sunlight for a few minutes, he washed the coating with water. The water washed away the chromium salts affected by the sunlight. In the areas where the sunlight passed through the gauze, the washing process left a fine-screen pattern in the coating. Talbot then etched the coated plate with platinum perchloride (later he used iron chloride) which made very fine holes in the plate in the areas affected by the gauze. When the plate was inked, the small holes held enough ink to produce a half-tone picture. Talbot obtained a patent for this process on October 29, 1852. This process became the basis of all half-tone reproduction methods and revolutionized the printing industry nearly 50-years later.

Talbot occupied himself in his last years with unsuccessful experiments to obtain photographs in natural color. He died on September 17, 1877 at his Lacock Abbey estate.

## 7. REFERENCES

1. Eder, Josef Maria; *History of Photography*. Dover Publications, Inc., New York, 1978.
2. Photography, Past and Present; British J. of Photography, June 1914.
3. Gernsheim, Helmut; *The History of Photography*. Oxford University Press, London, 1955.
4. Newhall, Beaumont; *Latent Image—The Discovery of Photography*. Doubleday & Company, Inc., 1967.
5. Jenkins, Reese V.; *Images and Enterprise*. The Johns Hopkins Univ. Press, Baltimore, 1975.
6. Newhall, Beaumont; *The History of Photography from 1839 to the Present Day*. New York, 1939.
7. Moholy, Lucia; *A Hundred Years of Photography 1839–1939*. London, 1939.

# REFERENCES FOR PHOTOGRAPHS AND ILLUSTRATIONS

A portion of the photographs and illustrations presented in this Directory were obtained from various collectors, authors, museums, and historical societies. These photographs and illustrations are identified by a two-letter code immediately following the description of each respective camera model. These codes are identified below. The camera descriptions which are not accompanied by a photograph or illustration but which include the code BC, IH, or MA immediately following the description are camera models for which a photograph or illustration appears in the references: Coe, Brian; *Cameras from Daguerreotypes to Instant Pictures;* Crown Publishers, New York, 1978; Auer, Michel; *The Illustrated History of the Camera;* New York Graphic Society, Boston, Massachusetts, 1975; and Auer, Michel; *Catalog* and *Collection,* Impression, Blane Wittwer, Geneve, Switzerland respectively.

(BS) — Smith, Barrie; Crows Nest, New South Wales, Australia
(CE) — Epperson, Charles W.; Pendelton, Indiana
(CH) — Chicago Historical Society; Chicago, Illinois
(CT) — Everett, Charles; Denver, Colorado
(DB) — Breen, D. F.; Barre, Massachusetts
(DG) — Gibson, David A.; Eastman Kodak Company, Patent Dept. Museum; Rochester, New York
(DJ) — Jensen, DuWayne; Vallejo, California
(DS) — Simon, David; Bethesda, Maryland
(EB) — Brown, Edward E.; Hyattsville, Maryland
(EL) — Lauten, Edward; Antique Photographica, New Paltz, New York
(FL) — Lewis, Fred L.; Washington, D.C.
(FP) — Pomellitto, Frank; Albany, New York
(FZ) — Paca, Francis; Alexandria, Virginia

(GB) — Borland, Gary L.; Clearwater, Florida
(GE) — From the collection of the International Museum of Photography at the George Eastman House; Rochester, New York
(GS) — Spiegel, Gerard A.; Scarsdale, New York
(HA) — Abring, H. D.; *Von Daguerre bis Heute;* Herausgeber, Privates Foto-Museum, Herne, West Germany, 1977. Vol. 1
(HW) — Wyman, Harold R.; Canaan, New Hampshire
(JC) — Craig, John S.; *Northlight;* Journal of the Photographic Historical Society of America, 1975–76
(JP) — Powell, James R.; Toledo, Ohio
(JS) — Schiff, Joseph L.; Plattsburgh, New York
(JT) — Termini, Joseph; Bethesda, Maryland
(JW) — Williams, Jim; Milford, Ohio
(KC) — Carson, Kemp; New Orleans, Louisiana
(KR) — Rice, Kevin; Warwick, Rhode Island
(MB) — Baczynsky, Mark; Kingston, New York
(MF) — Friedman, Mort; Washington, D.C.
(MR) — Rudd, Eugene M.; Lincoln, Nebraska
(RL) — Lundbohm, Roger; St. Louis, Missouri
(RP) — Paine, Richard P.; Houston, Texas
(SC) — Czitronyi, Steven G.; Montreal, Quebec, Canada
(SG) — Guglielmi, Stephen; Houston, Texas
(SI) — The Smithsonian Institution, Division of Photographic History; Washington, D.C.
(SM) — Science Museum; London, England
(SW) — Wilensky, Stuart; Wurtsboro, New York
(TH) — Hindle, Thom; Dover, New Hampshire
(TS) — Stecher, Tom; Chevy Chase, Maryland
(VC) — Vintage Cameras; North Syracuse, New York

# DIRECTORY

## AMERICAN CAMERAS

### ACRO SCIENTIFIC COMPANY

**(1)** **ACRO MODEL R CAMERA.** C. 1940. SIZE 1⅛ X 1⅝ INCH EXPOSURES ON NO. 127 ROLL FILM. BUILT-IN RANGEFINDER AND EXPOSURE METER. F 3.5 OR F 4.5 ANASTIGMAT LENS. ARCO SHUTTER; ⅟₂₅ TO ⅟₂₀₀ SEC., B., T.

### ADAMS AND WESTLAKE COMPANY

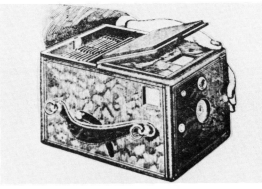

**(2)** **ADLAKE MAGAZINE BOX CAMERA.** C. 1898. SIZE 4 X 5 INCH PLATE EXPOSURES. THE MAGAZINE HOLDS 12 PLATES.

**(3)** **ADLAKE REGULAR BOX CAMERA.** C. 1899. TWO SIZES OF THIS CAMERA FOR 3¼ X 4¼ OR 4 X 5 INCH EXPOSURES ON PLATES. THE CAMERA HOLDS 12 PLATES. SINGLE ACHROMATIC LENS.

**(4)** **ADLAKE REPEATER BOX CAMERA.** C. 1899. TWO SIZES OF THIS CAMERA FOR 3¼ X 4¼ OR 4 X 5 INCH EXPOSURES ON PLATES. THE CAMERA HOLDS 12 PLATES. ADLAKE METAL SHUTTER. SINGLE ACHROMATIC LENS.

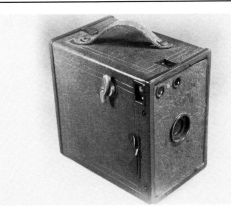

**(5)** **ADLAKE SPECIAL BOX CAMERA.** C. 1899. SIZE 4 X 5 INCH PLATE EXPOSURES. THE CAMERA HOLDS 12 PLATES IN ALUMINUM PLATE HOLDERS. ADLAKE METAL SHUTTER. SINGLE ACHROMATIC LENS.

### AGFA-ANSCO

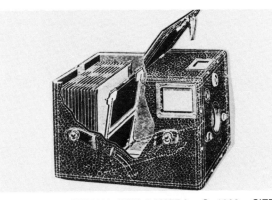

**(6)** **NO. 2A ANTAR BOX CAMERA.** C. 1928. SIZE 2½ X 4¼ INCH EXPOSURES ON ROLL FILM. INSTANT AND TIME ROTARY SHUTTER. (DJ)

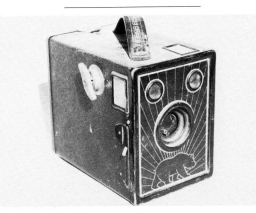

**(7)** **BEAR PHOTO SPECIAL BOX CAMERA.** C. 1935. SIZE 2¼ X 3¼ INCH EXPOSURES ON AGFA NO. B2 FILM. INSTANT AND TIME SHUTTER. (KC)

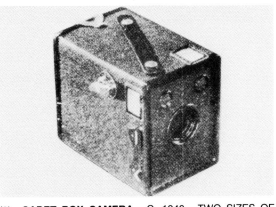

**(8)** **CADET BOX CAMERA.** C. 1940. TWO SIZES OF THIS CAMERA FOR 2¼ X 3¼ OR 2½ X 4¼ INCH EXPOSURES ON NO. 120 (B2) OR NO. 116 (D6) ROLL FILM, RESPECTIVELY. FIXED FOCUS LENS. SINGLE LEAF SHUTTER FOR INSTANT AND BULB EXPOSURES.

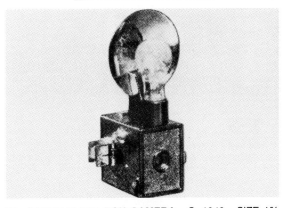

**(9)** **CADET FLASH BOX CAMERA.** C. 1940. SIZE 1⅝ X 2½ INCH EXPOSURES ON NO. 127 OR A8 ROLL FILM. MENISCUS LENS. INSTANT LEAF SHUTTER. FIXED FOCUS LENS. BUILT-IN FLASH SYNC.

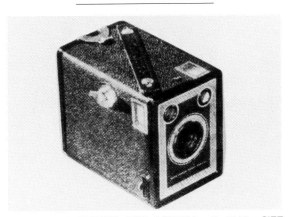

**(10)** **CADET SPECIAL BOX CAMERA.** C. 1940. SIZE 1⅝ X 2½ INCH EXPOSURES ON NO. 127 OR A8 ROLL FILM. MENISCUS LENS. INSTANT AND BULB LEAF SHUTTER.

## AGFA-ANSCO (*cont.*)

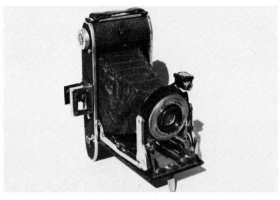

(11) **CAPTAIN FOLDING CAMERA.** C. 1935. SIZE 2½ X 4¼ INCH EXPOSURES ON AGFA PD-16 FILM. INSTANT AND TIME SHUTTER. (KC)

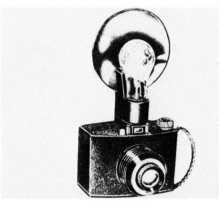

(12) **CHIEF CAMERA.** C. 1940. TWO SIZES OF THIS CAMERA FOR 2¼ X 3¼ OR 2½ X 4¼ INCH EXPOSURES ON ROLL FILM. INSTANT AND BULB SHUTTER. DETACHABLE FLASH. TWO-ZONE FOCUSING. BUILT-IN YELLOW FILTER.

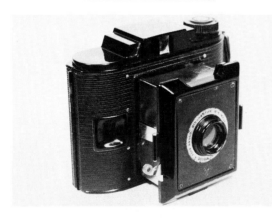

(13) **CLIPPER (PD-16) CAMERA.** C. 1939. SIXTEEN 2 X 2½ INCH (HALF-FRAME) EXPOSURES ON NO. 616 OR PD-16 ROLL FILM. DOUBLE LENS. INSTANT AND TIME SHUTTER. (JS)

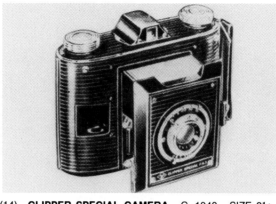

(14) **CLIPPER SPECIAL CAMERA.** C. 1940. SIZE 2¹⁄₁₆ X 2½ INCH EXPOSURES ON NO. 616 OR PD-16 ROLL FILM. F 6.3 AGFA ANASTIGMET LENS. LEAF SHUTTER; ⅟₂₅ TO ⅟₁₀₀ SEC., B., T.

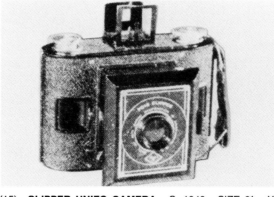

(15) **CLIPPER UNIFO CAMERA.** C. 1940. SIZE 2¹⁄₁₆ X 2½ INCH EXPOSURES ON NO. 616 OR PD-16 ROLL FILM. FIXED-FOCUS DOUBLET LENS. INSTANT AND BULB SHUTTER.

(16) **MEMO CAMERA.** C. 1928–33. SIZE 18 X 23 MM EXPOSURES ON "35 MM" ROLL FILM. FIFTY EXPOSURES PER ROLL OF FILM. F 6.3 CINEMAT OR BAUSCH & LOMB ANASTIGMAT FIXED FOCUS LENS. ALSO, F 3.5 OR F 6.3 WOLLENSAK VELOSTIGMAT OR F 3.5 OR F 6.3 BAUSCH & LOMB ANASTIGMAT FOCUSING LENS. ANSCO OR ILEX SHUTTER. SEE MEMO CAMERA UNDER ANSCO PHOTO PRODUCTS, INC. C. 1927.

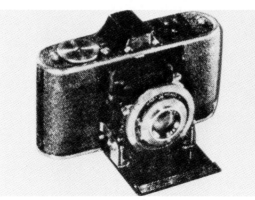

(17) **MEMO DOUBLE-FRAME CAMERA.** C. 1939. SIZE 24 X 36 MM EXPOSURES ON "35 MM" ROLL FILM

IN CARTRIDGES. F 3.5 OR F 4.5 ANASTIGMAT LENS. LEAF SHUTTER; ½ TO ⅟₂₀₀ SEC., B., T. HELICAL FOCUSING. EXPOSURE COUNTER. SELF-ERECTING FOLDING CONSTRUCTION.

(18) **NO. 2 MODEL G. BOX CAMERA.** C. 1933.

(19) **PIONEER CAMERA.** C. 1940. TWO SIZES OF THIS CAMERA FOR 2¼ X 3¼ OR 2½ X 4¼ INCH EXPOSURES ON ROLL FILM. SIMILAR TO THE CHIEF CAMERA WITH THE SAME LENS, SHUTTER, AND FLASH UNIT. FIXED FOCUS.

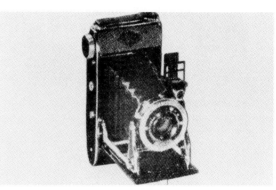

(20) **PLENAX ANTAR CAMERA.** C. 1940. TWO SIZES OF THIS CAMERA FOR 2¼ X 3¼ (1⅝ X 2¼ WITH MASK) OR 2½ X 4¼ (2⅛ X 2½ WITH MASK) INCH EXPOSURES ON ROLL FILM. F 14 ANTAR LENS. LEAF SHUTTER; INSTANT, B., T. FIXED FOCUS.

(21) **PLENAX HYPAR CAMERA.** C. 1940. TWO SIZES OF THIS CAMERA FOR 2¼ X 3¼ (1⅝ X 2¼ WITH MASK) OR 2½ X 4¼ (2⅛ X 2½ WITH MASK) INCH EXPOSURES ON ROLL FILM. SIMILAR TO THE PLENAX ANTAR CAMERA BUT WITH F 6.3 HYPAR ANASTIGMAT LENS AND LEAF SHUTTER SPEEDS OF ⅟₂₅, ⅟₅₀, ⅟₁₀₀, B., T. HELICAL FOCUS.

(22) **PLENAX TRIPAR CAMERA.** C. 1940. TWO SIZES OF THIS CAMERA FOR 2¼ X 3¼ (1⅝ X 2¼ WITH MASK) OR 2½ X 4¼ (2⅛ X 2½) INCH EXPOSURES ON ROLL FILM. SIMILAR TO THE PLENAX HYPAR CAMERA WITH F 11 RECTILINEAR LENS.

(23) **READYSET CAMERA.** C. 1940. TWO SIZES OF THIS CAMERA FOR 2¼ X 3¼ (OR HALF-FRAME) OR 2½ X 4¼ (OR HALF-FRAME) EXPOSURES ON ROLL FILM. SIMILAR TO THE PLENAX ANTAR CAMERA BUT WITH A SINGLE LENS AND READYSET SHUTTER FOR INSTANT AND TIME EXPOSURES.

(24) **READYSET SPECIAL CAMERA.** C. 1940. SIZE 2½ X 4¼ INCH EXPOSURES ON NO. 116 ROLL FILM. SIMILAR TO THE AGFA-ANSCO READYSET CAMERA.

## AGFA-ANSCO (cont.)

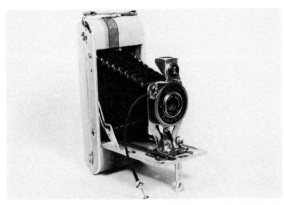

**(25) READYSET TRAVELER CAMERA.** C. 1928–30. SIZE 2½ X 4¼ INCH EXPOSURES ON NO. 116 ROLL FILM. F 8 LENS. INSTANT AND TIME SHUTTER. (JS)

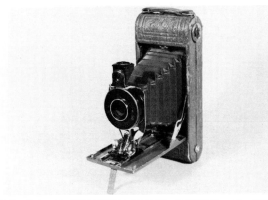

**(26) NO. 1A READYSET ROYAL CAMERA.** C. 1930. SIZE 2¼ X 4¼ INCH EXPOSURES ON NO. 116 ROLL FILM. ANTAR LENS. INSTANT AND TIME SHUTTER. (GB)

**(27) NO. 1 READYSET SPECIAL CAMERA.** C. 1928. SIZE 2¼ X 3¼ INCH EXPOSURES ON ROLL FILM. INSTANT AND TIME SHUTTER.

**(28) SEARS MARVEL S-16 BOX CAMERA.** (SOLD BY SEARS, ROEBUCK CO.) C. 1940. SIZE 2½ X 4¼ INCH EXPOSURES ON NO. 116 ROLL FILM. FIXED FOCUS LENS. INSTANT AND TIME SHUTTER.

**(29) SEARS MARVEL S-20 BOX CAMERA.** (SOLD BY SEARS, ROEBUCK CO.) C. 1940. SIZE 2¼ X 3¼ INCH EXPOSURES ON NO. 120 ROLL FILM. SIMILAR TO THE SEARS MARVEL S-16 BOX CAMERA WITH THE SAME LENS AND SHUTTER.

**(30) SEARS MARVEL VIEW CAMERA.** (SOLD BY SEARS, ROEBUCK CO.) C. 1940. SIZE 5 X 7 INCH EXPOSURES ON PLATES OR CUT FILM (WITH HOLDER). RISING, FALLING, AND SWINGING LENS MOUNT. TILTING, SWINGING, AND REVERSIBLE BACK.

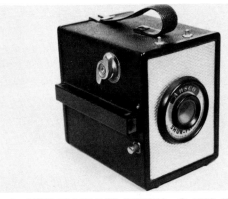

**(31) SHUR-FLASH BOX CAMERA.** C. 1932–40. EIGHT EXPOSURES SIZE 2¼ X 3¼ INCHES ON NO. B2 OR 120 ROLL FILM. MENISCUS LENS. INSTANT SHUTTER. FIXED FOCUS. BUILT-IN FILTER. FLASH SYNC. (JS)

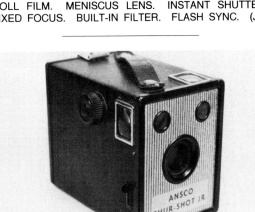

**(32) SHUR-SHOT-JUNIOR BOX CAMERA.** C. 1932. EIGHT EXPOSURES SIZE 2¼ X 3¼ INCHES ON NO. 120 ROLL FILM. INSTANT SHUTTER. (JS)

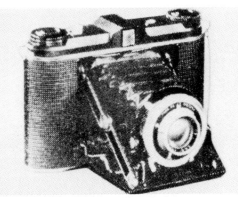

**(33) SPEEDEX CAMERA.** C. 1940. SIZE 2¼ X 2¼ INCH EXPOSURES ON NO. 120 OR B2 ROLL FILM. 85 MM/F 4.5 ANASTIGMAT LENS. COMPOUND SHUTTER: ½ TO ¼₅₀ SEC., B., T. HELICAL FOCUSING.

**(34) SUPRE-MACY M-20 BOX CAMERA.** C. 1940. SIZE 2¼ X 3¼ INCH EXPOSURES ON NO. 120 OR B-2 ROLL FILM. SIMILAR TO THE SUPRE-MACY M-16 BOX CAMERA WITH THE SAME LENS AND SHUTTER.

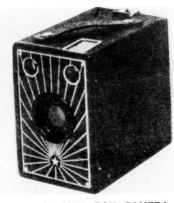

**(35) SUPRE-MACY M-16 BOX CAMERA.** C. 1940. SIZE 2½ X 4¼ INCH EXPOSURES ON NO. 116 OR D-6 ROLL FILM. SINGLE LENS. INSTANT AND BULB SHUTTER.

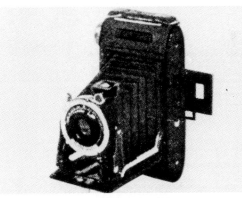

**(36) SUPRE-MACY FOLDING ROLL FILM CAMERA.** C. 1940. SIZE 2¼ X 3¼ INCH (1⅝ X 2¼ WITH MASK) EXPOSURES ON NO. 620 OR PB-20 ROLL FILM. F 6.3 ANASTIGMAT LENS IN SCREW MOUNT. SHUTTER SPEEDS FROM ¼₅ TO ¹⁄₂₀₀ SEC., B., T. MANUAL FOCUSING.

**(37) VIEW CAMERA.** C. 1928. SIZE 5 X 7 INCH EXPOSURES ON SHEET FILM. 7½ INCH/F 5.5 BAUSCH & LOMB OMNAR ANASTIGMAT LENS. WALLENSAK SHUTTER; 1 TO ¹⁄₁₀₀ SEC.

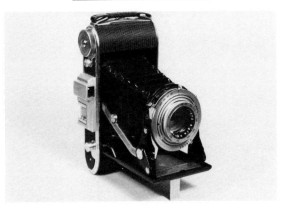

**(38) VIKING FOLDING CAMERA.** C. 1935. EIGHT EXPOSURES SIZE 6.5 X 9 CM ON NO. 120 ROLL FILM. F 4.5 LENS. SHUTTER SPEEDS FROM ¼₅ TO ¹⁄₂₀₀ SEC., B. (JS)

## AIKEN-GLEASON

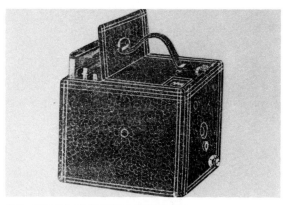

**(39) PEAK-A-BOO BOX CAMERA.** C. 1910. TWO SIZES OF THIS CAMERA FOR 3¼ X 4¼ OR 4 X 5 INCH EXPOSURES ON PLATES. MENISCUS ACHROMATIC LENS. AIKEN-GLEASON SAFETY SHUTTER FOR VARIABLE SPEEDS AND TIME EXPOSURE.

## AMERICAN ADVERTISING AND RESEARCH CORPORATION

**(40) CUB CAMERA.** C. 1940. SIZE 1³⁄₁₆ X 1⁹⁄₁₆ INCH EXPOSURES ON NO. 828 ROLL FILM. MENISCUS LENS. SIMPLE SHUTTER. (MA)

## AMERICAN CAMERA COMPANY (E. & H. T. ANTHONY & CO. AGENTS)

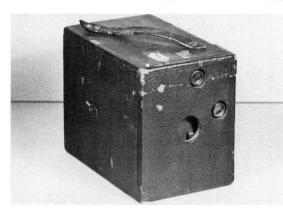

**(41) BUCKEYE BOX CAMERA.** C. 1895. SIZE 3¾ X 5 INCH EXPOSURES ON PLATES. ACHROMATIC LENS. ROTARY SHUTTER. (MR)

**(42) SPECIAL BUCKEYE BOX CAMERA.** C. 1898. TWO SIZES OF THIS CAMERA FOR 3½ X 3½ OR 4 X 5 INCH EXPOSURES ON PLATES OR SHEET FILM. SIMILAR TO THE BUCKEYE BOX CAMERA (C. 1898).

**(43) NO. 3 BUCKEYE HORIZONTAL FOLDING CAMERA.** C. 1898. SIZE 3¼ X 4¼ INCH EXPOSURES ON NO. 118 ROLL FILM. BAUSCH & LOMB RAPID RECTILINEAR LENS. INSTANT, B., T. SHUTTER.

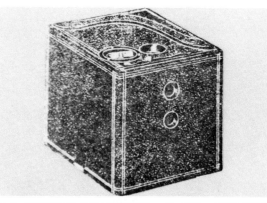

**(44) BUCKEYE BOX CAMERA.** C. 1898. TWO SIZES OF THIS CAMERA FOR 3½ X 3½ OR 4 X 5 INCH EXPOSURES ON SHEET FILM.

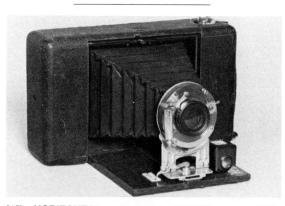

**(45) HORIZONTAL FOLDING CAMERA.** C. 1898. SINGLE PNEUMATIC SHUTTER; INSTANT, B., T. (TH)

## AMERICAN CAMERA COMPANY

**(46) PREMO TYPE CAMERA.** C. 1895. SIZE 4 X 5 INCH EXPOSURES ON PLATES.

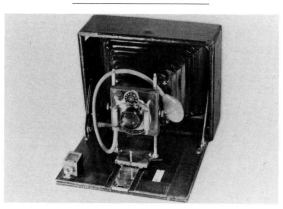

**(47) PREMO TYPE CAMERA.** C. 1901. SIZE 4 X 5 INCH EXPOSURES ON PLATES OR SHEET FILM. WOLLENSAK LENS. PNEUMATIC SHUTTER; 1 to ¹⁄₁₀₀ SEC., B., T. (HW)

## AMERICAN MINUTE PHOTO COMPANY

**(48) CHAMPION MINUTE PHOTO MACHINE CAMERA.** C. 1913. SIZE 1¾ X 2½, 2½ X 3½, OR 2½ INCH DIAMETER EXPOSURES.

## AMERICAN OPTICAL COMPANY

**(49) GEM BOX CAMERA.** C. 1880. NINE LENS STUDIO CAMERA FOR MAKING NINE EXPOSURES ON ONE PLATE.

**(50) JOHN STOCK'S PATENT VIEW CAMERA.** C. 1866. SIZE 10 X 10 INCH EXPOSURES ON WET PLATES.

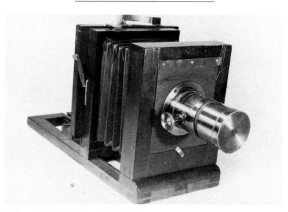

**(51) JOHN STOCK'S PATENT VIEW CAMERA.** C. 1868. SIZE 5½ X 5½ INCH EXPOSURES ON WET PLATES OR TIN TYPES. HOLMES, BOOTH & HAYDEN LENS. LENS CAP SHUTTER. (SW)

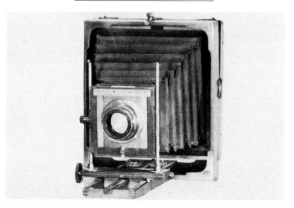

**(52) VIEW CAMERA.** C. 1880. SIZE 6½ X 8½ INCH EXPOSURES ON PLATES. (JW)

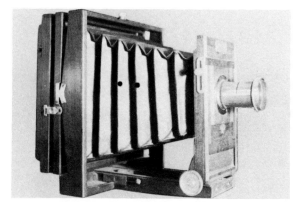

**(53) FOLDING VIEW CAMERA.** C. 1885. TWO SIZES OF THIS CAMERA FOR 6½ X 8½ OR 8 X 10 INCH EXPO-

## AMERICAN OPTICAL COMPANY (*cont.*)

SURES ON PLATES. RAPID RECTILINEAR LENS. SLOT FOR WATERHOUSE STOPS. REVOLVING BACK. (EL)

(54) **FOLDING VIEW CAMERA.** C. 1886. SIZE 3¼ X 4¼ INCH EXPOSURES ON PLATES. RODS AT THE REAR OF THE CAMERA ARE PUSHED OR PULLED FOR FO-CUSING.

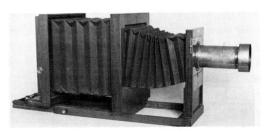

(55) **STUDIO VIEW CAMERA.** SIZE 16 X 18 INCH EXPO-SURES ON WET PLATES. ROSS LENS. (TH)

## AMERICAN RAYLO CORPORATION

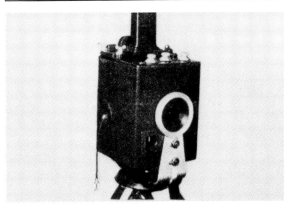

(56) **RAYLO COLOR CAMERA.** C. 1923. THE CAMERA PRODUCES THREE NEGATIVES ON A SINGLE COLOR PLATE. SHUTTER SPEEDS RANGE FROM ¼ TO 30 SECONDS.

## ANDERSON, J. A.

(57) **COMPACT FOLDING VIEW CAMERA.** C. 1888. SIZE 8 X 10 INCH EXPOSURES ON DRY PLATES. RACK AND PINION FOCUSING.

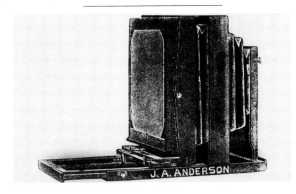

(58) **EXTRA QUALITY PORTRAIT VIEW CAMERA.** C. 1888. SEVEN SIZES OF THIS CAMERA FOR 11 X 14, 14 X 17, 17 X 20, 18 X 22, 20 X 24, 22 X 27, OR 25 X 30 INCH EXPOSURES ON PLATES. DOUBLE SWING BACK. TELESCOPIC BED.

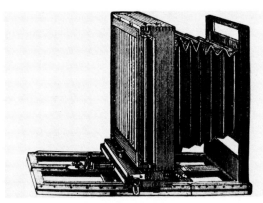

(59) **NEW VIEW CAMERA.** C. 1888. EIGHT SIZES OF THIS CAMERA FOR 6½ X 8½, 8 X 10, 10 X 12, 11 X 14, 14 X 17, 17 X 20, 18 X 22, OR 20 X 24 INCH EXPOSURES ON DRY PLATES. FOLDING BED.

(60) **PLAIN EXTRA QUALITY PORTRAIT VIEW CAMERA.** C. 1888. SIX SIZES OF THIS CAMERA FOR 6½ X 8½, 8 X 10, 10 X 12, 11 X 14, 14 X 17, OR 17 X 20 INCH EXPO-SURES ON PLATES. SOME MODELS WITHOUT SWING BACK. OTHER MODELS WITH SINGLE SWING OR DOU-BLE SWING BACK. SIMILAR TO THE EXTRA QUALITY PORTRAIT VIEW CAMERA.

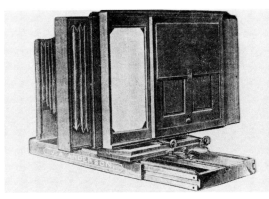

(61) **ROYAL VIEW CAMERA.** C. 1888. FOUR SIZES OF THIS CAMERA FOR 8 X 10, 10 X 12, 11 X 14, OR 14 X 17 INCH EXPOSURES ON PLATES. TELESCOPIC BED FOR THE 11 X 14 AND 14 X 17 INCH MODELS.

## ANSCO COMPANY

(62) **NO. 2 ANSCO BOX CAMERA.** C. 1908. SIZE 3¼ X 4¼ INCH EXPOSURES ON NO. 7A OR 7B ROLL FILM. SIMILAR TO THE NO. 1 ANSCO BOX CAMERA WITH THE SAME LENS AND SHUTTER.

(63) **NO. 3 ANSCO BOX CAMERA.** C. 1908. SIZE 4 X 5 INCH EXPOSURES ON NO. 10A OR 10B ROLL FILM. SIMILAR TO THE NO. 1 ANSCO BOX CAMERA WITH THE SAME LENS AND SHUTTER.

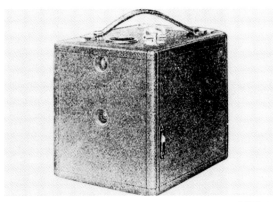

(64) **NO. 1 ANSCO BOX CAMERA.** C. 1908. SIZE 3½ X 3½ INCH EXPOSURES ON NO. 8A OR 8B ROLL FILM. FIXED FOCUS SINGLE ACHROMATIC LENS. INSTANT AND TIME EXPOSURES. THREE APERTURE STOPS.

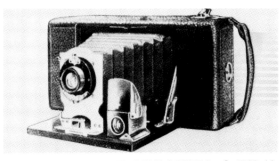

(65) **ANSCO JUNIOR (FOLDING) CAMERA.** C. 1908–11. SIZE 2½ X 4¼ INCH EXPOSURES ON NO. 6A OR 6B ROLL FILM. FIXED FOCUS RAPID RECTILINEAR LENS. WOLLENSAK SHUTTER; INSTANT, B., T.

(66) **AUTOMATIC CAMERA.** C. 1925. SIZE 2¼ X 4¼ INCH EXPOSURES ON ROLL FILM. 120 MM/F 6.3 ANSCO ANASTIGMAT LENS. ILEX UNIVERSAL SHUTTER; 1 TO ¹⁄₁₀₀ SEC. A SPRING DRIVES THE FILM ADVANCE. (MA)

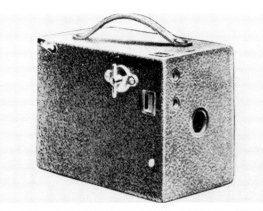

(67) **NO. 2 BUSTER BROWN BOX CAMERA. EARLY MODEL.** C. 1908. SIZE 2¼ X 3¼ INCH EXPOSURES ON NO. 4A ROLL FILM. INSTANT AND TIME SHUTTER.

(68) **NO. 2A BUSTER BROWN BOX CAMERA.** C. 1907–18. SIZE 2½ X 4¼ INCH EXPOSURES ON NO. 6A OR 6B ROLL FILM. MENISCUS ACHROMATIC LENS. IN-

## ANSCO COMPANY (*cont.*)

STANT AND TIME SHUTTER. SIMILAR TO THE NO. 2 BUSTER BROWN BOX CAMERA.

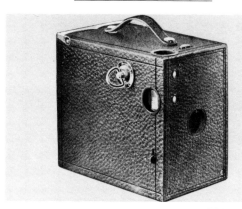

**(69) NO. 2 BUSTER BROWN BOX CAMERA.** C. 1920. SIZE 2¼ X 3¼ INCH EXPOSURES ON NO. 4A ROLL FILM. SIMPLE MENISCUS LENS. INSTANT AND TIME SHUTTER. THREE APERTURE STOPS.

**(70) NO. 2C BUSTER BROWN BOX CAMERA.** C. 1910–18. SIZE 2⅞ X 4⅞ INCH EXPOSURES ON NO. 26A OR 26B ROLL FILM. MENISCUS ACHROMATIC LENS. INSTANT AND TIME SHUTTER. SIMILAR TO THE NO. 2 BUSTER BROWN BOX CAMERA.

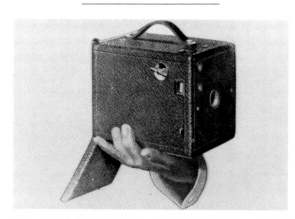

**(71) NO. 3 BUSTER BROWN BOX CAMERA. EARLY MODEL.** C. 1908. SIZE 3¼ X 4¼ INCH EXPOSURES ON ROLL FILM. INSTANT AND TIME SHUTTER.

**(72) NO. 3 BUSTER BROWN BOX CAMERA.** C. 1920. SIZE 3¼ X 4¼ INCH EXPOSURES ON NO. 7A OR 7B (NO. 118) ROLL FILM. MENISCUS ACHROMATIC LENS. INSTANT AND TIME SHUTTER. SIMILAR TO THE NO. 2 BUSTER BROWN BOX CAMERA, C. 1920.

**(73) NO. 2 FOLDING BUSTER BROWN CAMERA.** C. 1912. SIZE 2¼ X 3¼ INCH EXPOSURES ON ROLL FILM.

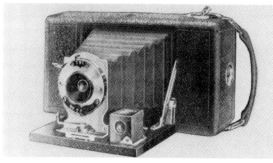

**(74) NO. 1 FOLDING BUSTER BROWN CAMERA.** C. 1908. SIZE 2¼ X 3¼ INCH EXPOSURES ON NO. 4A ROLL FILM. FIXED FOCUS MENISCUS LENS. INSTANT AND TIME SHUTTER. IRIS DIAPHRAGM.

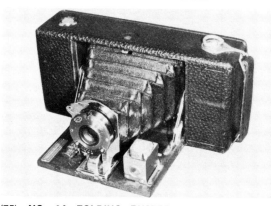

**(75) NO. 2A FOLDING BUSTER BROWN CAMERA.** C. 1910–12. SIZE 2½ X 4¼ INCH EXPOSURES ON NO. 116 FILM. WOLLENSAK SHUTTER FOR INSTANT, B., T. EXPOSURES.

**(76) NO. 2B FOLDING BUSTER BROWN CAMERA.** C. 1912.

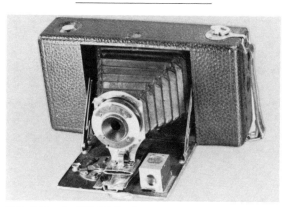

**(77) NO. 3 FOLDING BUSTER BROWN CAMERA.** C. 1912. SIZE 3¼ X 4¼ INCH EXPOSURES ON ROLL FILM. WOLLENSAK LENS. ACTUS SHUTTER; ¹⁄₂₅ TO ¹⁄₁₀₀ SEC., B., T. (HW)

**(78) NO. 3A FOLDING BUSTER BROWN CAMERA.** C. 1913. SIZE 3¼ X 5½ INCH EXPOSURES ON NO. 122 ROLL FILM. WOLLENSAK LENS AND DELTAX OR ACTUS SHUTTER.

**(79) CADET MODEL B-2 BOX CAMERA.** C. 1912.

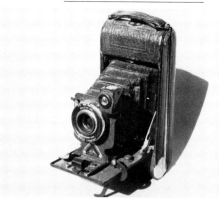

**(80) NO. 0 DELTAX CAMERA.** C. 1915. EXPOSURES ON ANSCO 4A FILM. WOLLENSAK LENS. (KC)

**(81) NO. 1 FOLDING DE LUXE CAMERA.** C. 1910–12. SIZE 2¼ X 3¼ INCH EXPOSURES ON ROLL FILM.

**(82) NO. 1A FOLDING CAMERA.** C. 1912–20. SIZE 2½ X 4¼ INCH EXPOSURES ON ROLL FILM. 4⅞ INCH/F 4 SYMMETRICAL LENS OR 4⅞ INCH/F 7.5 MODICO ANASTIGMAT LENS. BIONIC OR ILEX GENERAL SHUTTER; ¹⁄₁₀ TO ¹⁄₁₀₀ SEC., B., T. ALSO, CAPAX (1 TO ¹⁄₁₀₀ SEC., B., T.) OR ILEX UNIVERSAL (1 TO ¹⁄₁₅₀ SEC., B., T.) SHUTTER. SOME EARLY MODELS WITH BETAX SHUTTER FOR INSTANT AND TIME EXPOSURES.

**(83) NO. 3 FOLDING CAMERA.** C. 1918–20. SIZE 3¼ X 4¼ INCH EXPOSURES ON ROLL FILM. 4⅞ INCH/F 4 SYMMETRICAL LENS OR 4⅞ INCH/F 7.5 MODICO AN-

## ANSCO COMPANY (*cont.*)

ASTIGMAT LENS. BIONIC OR ILEX GENERAL SHUTTER; ⅒ TO ⅟₁₀₀ SEC., B., T. ALSO, CAPAX (1 TO ⅟₁₀₀ SEC., B., T.); ILEX UNIVERSAL (1 TO ⅟₁₀₀ SEC., B., T.); OR A SHUTTER FOR SPEEDS OF 1 TO ⅟₁₅₀ SEC., B., T.

(84) **NO. 3A FOLDING CAMERA.** C. 1918–20. SIZE 3¼ X 5½ INCH EXPOSURES ON ROLL FILM. 6½ INCH/F 4 SYMMETRICAL LENS OR 6½ INCH/F 7.5 MODICO ANASTIGMAT LENS. SIMILAR TO THE ANSCO NO. 3 FOLDING CAMERA WITH THE SAME SHUTTERS.

(85) **NO. 4 FOLDING POCKET CAMERA.** C. 1908. SIZE 3¼ X 4¼ INCH EXPOSURES ON NO. 7A OR 7B ROLL FILM. RAPID RECTILINEAR OR GOERZ DOUBLE ANASTIGMAT SERIES III LENS. SINGLE PNEUMATIC AUTOMATIC SHUTTER WITH IRIS DIAPHRAGM. SOME MODELS WITH PLATE ADAPTER.

(86) **NO. 5 FOLDING POCKET CAMERA.** C. 1908. SIZE 4 X 5 INCH EXPOSURES ON NO. 10A OR 10B ROLL FILM. SIMILAR TO THE NO. 4 FOLDING POCKET CAMERA WITH THE SAME LENSES AND SHUTTER.

(87) **NO. 6 FOLDING POCKET CAMERA.** C. 1908. SIZE 3¼ X 4¼ INCH EXPOSURES ON NO. 7A OR 7B ROLL FILM. RAPID RECTILINEAR OR GOERZ ANASTIGMAT LENS. DOUBLE PNEUMATIC AUTOMATIC SHUTTER; 1 TO ⅟₁₀₀ SEC., B., T. SOME MODELS WITH PLATE ADAPTER. RACK & PINION FOCUSING. RISING, FALLING, AND CROSSING LENS MOUNT.

(88) **NO. 7 FOLDING POCKET CAMERA.** C. 1908. SIZE 4 X 5 INCH EXPOSURES ON NO. 10A OR 10B ROLL

FILM. SIMILAR TO THE NO. 6 FOLDING POCKET CAMERA WITH THE SAME LENS AND SHUTTER.

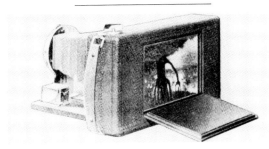

(89) **NO. 9 FOLDING POCKET CAMERA.** C. 1908. SIZE 3¼ X 5½ INCH EXPOSURES ON NO. 18A OR 18B ROLL FILM OR PLATES. RAPID RECTILINEAR OR GOERZ ANASTIGMAT SERIES III LENS. WINNER SHUTTER OR PNEUMATIC AUTOMATIC SHUTTER. GROUND GLASS FOCUSING WITH PLATES.

(90) **NO. 10 FOLDING POCKET CAMERA.** C. 1908. SIZE 3¼ X 5½ INCH EXPOSURES ON NO. 18A OR 18B ROLL FILM OR PLATES. RAPID RECTILINEAR OR GOERZ ANASTIGMAT SERIES III LENS. PNEUMATIC AUTOMATIC SHUTTER. RISING, FALLING, AND CROSSING LENS MOUNT. GROUND GLASS FOCUSING WITH PLATES.

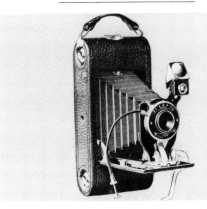

(91) **NO. 1A JUNIOR CAMERA.** C. 1918–20. SIZE 2½ X 4¼ INCH EXPOSURES ON NO. 6A OR 6B ROLL FILM. 4½ INCH ACHROMATIC, 4⅞ INCH RECTILINEAR, OR ANASTIGMAT LENS. MARVEL SHUTTER; ⅟₂₅ TO ⅟₁₀₀ SEC., B., T. ALSO, F 7.5 MODICO LENS IN AN EXTRA-SPEED BIONIC SHUTTER; ⅒ TO ⅟₂₀₀ SEC., B., T. SOME MODELS WITH ACTUS SHUTTER; ⅟₂₅, ⅟₅₀, ⅟₁₀₀ SEC., B., T.

(92) **NO. 2C JUNIOR CAMERA.** C. 1918. SIZE 2⅞ X 4⅞ INCH EXPOSURES ON NO. 26A OR 26B ROLL FILM. SIMILAR TO THE ANSCO NO. 1A JUNIOR CAMERA WITH THE SAME LENSES AND SHUTTERS.

(93) **NO. 3A JUNIOR CAMERA.** C. 1918–20. SIZE 3¼ X 5½ INCH EXPOSURES ON NO. 18A OR 18B ROLL FILM. SIMILAR TO THE ANSCO NO. 1A JUNIOR CAMERA WITH THE SAME LENSES AND SHUTTERS.

(94) **NO. 0 JUNIORETTE CAMERA.** C. 1920. SIZE 1½ X 2½ INCH EXPOSURES. WOLLENSAK LENS. INSTANT AND TIME SHUTTER.

(95) **NO. 1A READYSET FOLDING CAMERA.** C. 1918. SIZE 2½ X 4¼ INCH EXPOSURES ON ROLL FILM. ILEX SHUTTER; INSTANT AND TIME.

(96) **SEMI-AUTOMATIC FOLDING CAMERA.** C. 1920. SIZE 2½ X 4¼ INCH EXPOSURES ON ROLL FILM. 130 MM/F 7.5 ANSCO ANASTIGMAT LENS. FLEX SHUTTER; 1 TO ⅟₁₀₀ SEC. AUTOMATIC FILM TRANSPORT BY SPRING MOTOR. (MA)

(97) **SHUR-SHOT BOX CAMERA.** C. 1897. SIZE 2½ X 2½ INCH PLATE EXPOSURES. MENISCUS LENS. GRAVITY ACTIVATED GUILLOTINE SHUTTER. (MA)

(98) **NO. 1 SPECIAL FOLDING CAMERA.** C. 1910–16. SIZE 2¼ X 3¼ INCH EXPOSURES. F 7.5 ANSCO ANASTIGMAT LENS. ILEX GENERAL SHUTTER; ⅕ TO ⅟₁₀₀ SEC., B., T.

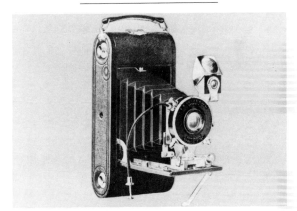

(99) **NO. 1A SPEEDEX CAMERA.** C. 1914–20. SIZE 2½ X 4¼ INCH EXPOSURES ON ROLL FILM. 4⅞ INCH/F 6.3 ANSCO ANASTIGMAT LENS. SPEEDEX OR ILEX ACME SHUTTER; 1 TO ⅟₃₀₀ SEC., B., T. ALSO, UNIVERSAL SHUTTER; 1 TO ⅟₁₀₀ SEC., B., T. GROUND GLASS FOCUS.

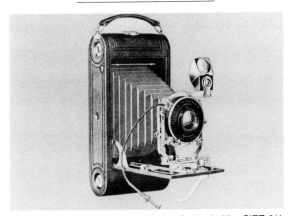

(100) **NO. 3 SPEEDEX CAMERA.** C. 1918–20. SIZE 3¼ X 4¼ INCH EXPOSURES ON ROLL FILM. 4⅞ INCH/F 6.3 ANSCO ANASTIGMAT LENS. SPEEDEX OR ILEX ACME SHUTTER; 1 TO ⅟₃₀₀ SEC., B., T.

(101) **NO. 3A SPEEDEX CAMERA.** C. 1918–20. SIZE 3¼ X 5½ INCH EXPOSURES ON ROLL FILM. 6½ INCH/F 6.3 ANSCO ANASTIGMAT LENS. SPEEDEX OR ILEX

## ANSCO COMPANY (*cont.*)

ACME SHUTTER; 1 TO ⅟₃₀₀ SEC., B., T. SIMILAR TO THE ANSCO NO. 3 SPEEDEX CAMERA.

(102) **V-P NO. 0 CAMERA. FIXED FOCUS MODEL.** C. 1918. SIZE 1⅝ X 2½ INCH EXPOSURES ON ROLL FILM. 2⅞ INCH/F 16 SINGLE ACHROMATIC OR RAPID RECTILINEAR LENS. ACTUS SHUTTER; ⅟₂₅, ⅟₅₀, ⅟₁₀₀ SEC., B., T.

(103) **V-P NO. 0 CAMERA. FOCUSING MODEL.** C. 1918. SIZE 1⅝ X 2½ INCH EXPOSURES ON ROLL FILM. 3⅜ INCH/F 6.3 ANSCO ANASTIGMAT, 3⅜ INCH/F 7.5 MODICO ANASTIGMAT, OR 3⅜ INCH/F 7.5 ILEX LENS. EXTRASPEED BIONIC SHUTTER; ⅟₁₀ TO ⅟₂₀₀ SEC., B., T.

(104) **V-P NO. 1 CAMERA.** C. 1918. SIZE 2¼ X 3¼ INCH EXPOSURES ON ROLL FILM. 3½ INCH/F 8 SIN-

GLE ACHROMATIC OR RAPID RECTILINEAR LENS. ACTUS SHUTTER; ⅟₂₅, ⅟₅₀, ⅟₁₀₀ SEC., B., T.

(105) **V-P NO. 2 CAMERA.** C. 1918. SIZE 2¼ X 3¼ INCH EXPOSURES ON ROLL FILM. 3½ INCH/F 6.3 ANSCO ANASTIGMAT OR 3½ INCH/F 7.5 MODICO ANASTIGMAT LENS. EXTRASPEED BIONIC SHUTTER; ⅟₁₀ TO ⅟₂₀₀ SEC., B., T.

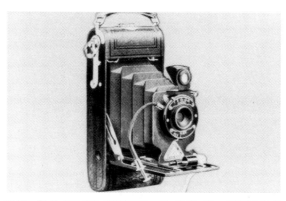

(106) **V-P JUNIOR CAMERA.** C. 1918–20. SIZE 2¼ X 3¼ INCH EXPOSURES ON NO. 4A (NO. 120) ROLL FILM. 3½ INCH SINGLE ACHROMATIC OR RAPID RECTILINEAR LENS IN ILEX MARVEL SHUTTER; ⅟₂₅, ⅟₅₀, ⅟₁₀₀ SEC., B., T. ALSO, 3½ INCH/F 7.5 MODICO ANASTIGMAT LENS IN BIONIC SHUTTER; ⅟₁₀ TO ⅟₂₀₀ SEC., B., T. SOME LATER MODELS WITH ACTUS SHUTTER; ⅟₂₅, ⅟₅₀, ⅟₁₀₀ SEC., B., T.

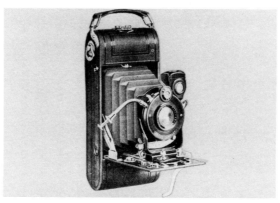

(107) **V-P SPEEDEX NO. 3 CAMERA.** C. 1918. SIZE 2¼ X 3¼ INCH EXPOSURES ON ROLL FILM. 3½ INCH/F 4.5 BAUSCH & LOMB TESSAR ANASTIGMAT OR ANSCO

ANASTIGMAT LENS. ALSO, 3½ INCH/F 6.3 ANSCO ANASTIGMAT OR 3½ INCH/F 7.5 MODICO ANASTIGMAT LENS. ACME SPEEDEX SHUTTER; 1 TO ⅟₃₀₀ SEC., B., T.

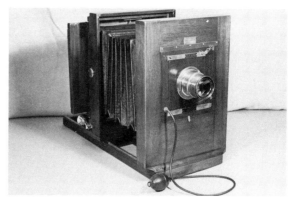

(108) **STUDIO TYPE VIEW CAMERA.** C. 1910. TWO SIZES OF THIS CAMERA FOR 5 X 7 OR 8 X 10 INCH EXPOSURES ON PLATES. F 6.3 VOIGTLANDER LENS. PACKARD PNEUMATIC SHUTTER. (MR)

## ANSCO PHOTOPRODUCTS, INC.

(109) **NO. 1A ADVANCED FOLDING CAMERA.** C. 1926. SIZE 2½ X 4¼ INCH EXPOSURES ON ROLL FILM. THIS CAMERA IS THE SAME AS THE NO. 1A SUPER SPEEDEX MODEL EXCEPT THE LENS IS AN F 7.5 ANSCO ANASTIGMAT IN A UNIVERSAL SHUTTER; 1 TO ⅟₁₀₀ SEC., B., T.

(110) **NO. 1A AUTOMATIC FOLDING CAMERA.** C. 1926. SIZE 2½ X 4¼ INCH EXPOSURES ON NO. 6A ROLL FILM. THIS CAMERA IS THE SAME AS THE NO. 1A FOLDING MODEL EXCEPT IT HAS THE ANSCO F 6.3 ANASTIGMAT LENS IN THE ILEX UNIVERSAL SHUTTER; 1 TO ⅟₁₅₀ SEC., B., T. AND A MECHANICAL SPRING DEVICE FOR AUTO-MATICALLY ADVANCING THE FILM WHEN THE SHUTTER IS RELEASED.

(111) **NO. 1A SEMI-AUTOMATIC FOLDING CAMERA.** C. 1926. SIZE 2½ X 4¼ INCH EXPOSURES ON NO. 6A ROLL FILM. THIS CAMERA IS THE SAME AS THE NO. 1A FOLDING MODEL EXCEPT IT HAS A MECHANICAL SPRING DEVICE THAT ADVANCES THE FILM WHEN A SEPARATE LEVER (NOT THE SHUTTER RELEASE) IS PUSHED. SOME MODELS HAVE AN ANSCO RAPID RECTILINEAR LENS WITH A SPECIAL SHUTTER.

## ANSCO PHOTOPRODUCTS, INC. (cont.)

(112) **NO. 2 BOX CAMERA.** C. 1926. SIZE 2¼ X 3¼ INCH EXPOSURES ON NO. 4A (NO. 120) ROLL FILM. INSTANT AND TIME SHUTTER.

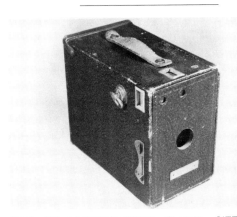

(113) **NO. 2A BOX CAMERA.** C. 1926. SIZE 2½ X 4¼ INCH EXPOSURES ON NO. 6A OR 6B (NO. 116) ROLL FILM. INSTANT AND TIME SHUTTER. (DJ)

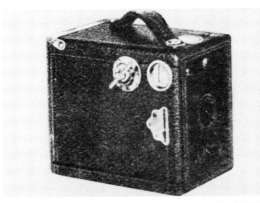

(114) **NO. 0 BUSTER BROWN SPECIAL BOX CAMERA.** C. 1926. SIZE 1⅝ X 2½ INCH EXPOSURES ON NO. 2C (NO. 127) ROLL FILM. INSTANT AND TIME SHUTTER.

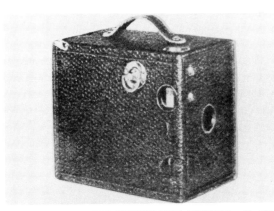

(115) **NO. 3 BUSTER BROWN BOX CAMERA.** C. 1926. SIZE 3¼ X 4¼ INCH EXPOSURES ON NO. 7A OR 7B (NO. 118) ROLL FILM. INSTANT AND TIME SHUTTER.

(116) **NO. 2A CRAFTSMAN BOX CAMERA.** C. 1926. SIZE 2½ X 4¼ INCH EXPOSURES ON NO. 6A (NO. 116) ROLL FILM. INSTANT AND TIME EXPOSURES.

(117) **NO. 2 SPECIAL BOX CAMERA.** C. 1926. SIZE 2¼ X 3¼ INCH EXPOSURES ON NO. 4A (NO. 120) ROLL FILM. SAME AS THE NO. 2 BOX CAMERA BUT COVERED WITH RED LEATHER.

(118) **NO. 2A SPECIAL BOX CAMERA.** C. 1926. SIZE 2½ X 4¼ INCH EXPOSURES ON NO. 6A OR 6B (NO. 116) ROLL FILM. SAME AS THE NO. 2A BOX CAMERA EXCEPT COVERED WITH RED LEATHER.

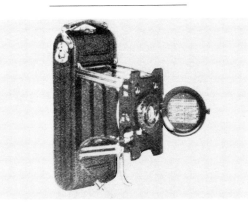

(119) **NO. 1 EXPERT CAMERA.** C. 1926. SIZE 2¼ X 3¼ INCH EXPOSURES ON NO. 4A (NO. 120) ROLL FILM. FAST FOCUS BY MEANS OF A FOCUSING DISK BEHIND THE LENS PLATE. 3½ INCH/F 6.3 ANSCO ANASTIGMAT LENS. GAMMAX SHUTTER; ⅒ TO ¹⁄₁₀₀ SEC.

(120) **NO. 1 FOLDING CAMERA.** C. 1926. SIZE 2¼ X 3¼ INCH EXPOSURES ON NO. 4A (NO. 120) ROLL FILM. F 7.5 ANSCO ANASTIGMAT LENS. ILEX GENERAL SHUTTER; ⅕ TO ¹⁄₁₀₀ SEC., B., T. SIMILAR TO THE NO. 1 JUNIOR MODEL.

(121) **GOODWIN NO. 3 CAMERA.** C. 1925.

(122) **NO. 1 JUNIOR CAMERA.** C. 1926. SIZE 2¼ X 3¼ INCH EXPOSURES ON NO. 4A (NO. 120) ROLL FILM. F 7.9 ANSCOMATIC LENS. ANSCO ILEX SHUTTER; ¹⁄₂₅, ¹⁄₅₀, ¹⁄₁₀₀ SEC., B., T.

(123) **NO. 1 JUNIOR DE LUXE CAMERA.** C. 1926.

SIZE 2¼ X 3¼ INCH EXPOSURES ON NO. 4A (NO. 120) ROLL FILM. THIS CAMERA IS THE SAME AS THE NO. 1 JUNIOR MODEL EXCEPT IT IS COVERED WITH BLUE LEATHER AND HAS LACQUERED BRASS TRIMMINGS.

(124) **NO. 1A JUNIOR CAMERA.** C. 1926. SIZE 2½ X 4¼ INCH EXPOSURES ON ROLL FILM. F 7.9 ANSCOMATIC LENS. DELTAX SHUTTER; ¹⁄₂₅, ¹⁄₅₀, ¹⁄₁₀₀ SEC., B., T.

(125) **NO. 3 JUNIOR CAMERA.** C. 1926. SIZE 3¼ X 4¼ INCH EXPOSURES ON NO. 7A OR 7B ROLL FILM. F 4 RECTILINEAR LENS. DELTAX SHUTTER; ¹⁄₂₅, ¹⁄₅₀, ¹⁄₁₀₀ SEC., T.

(126) **NO. 3A JUNIOR CAMERA.** C. 1926. SIZE 3¼ X 5½ INCH EXPOSURES ON NO. 18A OR 18B ROLL FILM. SIMILAR TO THE NO. 3 JUNIOR CAMERA WITH THE SAME LENS AND SHUTTER.

## ANSCO PHOTOPRODUCTS, INC. (cont.)

(127) **MEMO OFFICIAL BOY SCOUT CAMERA.** C. 1927. SIZE 18 X 23 MM EXPOSURES ON "35 MM" ROLL FILM. FIFTY EXPOSURES PER ROLL OF FILM. F 6.3 CINE-MAT OR BAUSCH & LOMB ANASTIGMAT FIXED-FOCUS LENS. ALSO, F 3.5 OR F 6.3 WOLLENSAK VELOSTIG-MAT OR F 3.5 OR F 6.3 BAUSCH & LOMB ANASTIGMAT FOCUSING LENS. ANSCO SHUTTER; ⅟₂₅ TO ⅟₁₀₀ SEC., B., T. OR ILEX SHUTTER. FILM ADVANCE BY LEVER. EXPOSURE COUNTER. IRIS DIAPHRAGM.

(128) **PHOTO VANITY CAMERA.** C. 1926. SIZE 1⅝ X 2½ INCH EXPOSURES ON NO. 127 ROLL FILM. THE VAN-ITY CASE CONTAINS CAMERA, MIRROR, COMB, AND MAKE-UP AIDS. (MA)

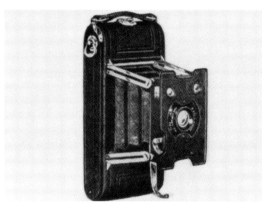

(129) **NO. 1 READYSET CAMERA.** C. 1924. SIZE 2¼ X 3¼ INCH EXPOSURES ON NO. 120 ROLL FILM. ANSCO ANASTIGMAT LENS. INSTANT AND TIME SHUT-TER.

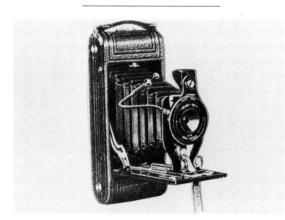

(130) **NO. 1A READYSET CAMERA.** C. 1926. SIZE 2½ X 4¼ INCH EXPOSURES ON NO. 6A OR 6B (NO. 116) ROLL FILM.

(131) **NO. 1 READYSET ROYAL CAMERA.** C. 1925. SIZE 2¼ X 3¼ INCH EXPOSURES ON ROLL FILM.

(132) **NO. 1A READYSET ROYAL CAMERA.** C. 1925. SIZE 2½ X 4¼ INCH EXPOSURES ON NO. 6A OR 6B (NO. 116) ROLL FILM.

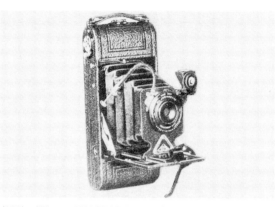

(133) **NO. 1 READYSET JUNIORETTE CAMERA.** C. 1926. SIZE 2¼ X 3¼ INCH EXPOSURES ON NO. 4A (NO. 120) ROLL FILM.

(134) **NO. 1 MASTER READYSET CAMERA.** C. 1926. SIZE 2¼ X 3¼ INCH EXPOSURES ON NO. 4A (NO. 120) ROLL FILM. ANSCO ANASTIGMAT LENS. SIMILAR TO THE NO. 1 READYSET CAMERA.

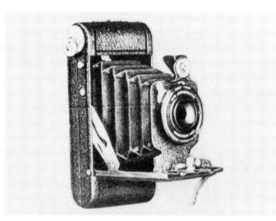

(135) **VEST-POCKET READYSET CAMERA.** C. 1926. SIZE 1⅝ X 2½ INCH EXPOSURES ON NO. 2C (NO. 127) ROLL FILM.

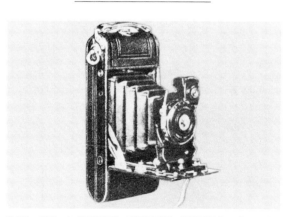

(136) **NO. 1 SPECIAL FOLDING CAMERA.** C. 1926. SIZE 2¼ X 3¼ INCH EXPOSURES ON NO. 4A (NO. 120) ROLL FILM. ANSCO F 7.5 ANASTIGMAT LENS. ILEX GENERAL SHUTTER; ⅛ TO ⅟₁₀₀ SEC., B., T.

(137) **NO. 1 SPEEDEX CAMERA.** C. 1926. SIZE 2¼ X 3¼ INCH EXPOSURES ON NO. 4A (NO. 120) ROLL FILM. ANSCO F 6.3 ANASTIGMAT LENS. ACME SPEEDEX SHUTTER; 1 TO ⅟₃₀₀ SEC., B., T. SIMILAR TO THE NO. 1 SUPER SPEEDEX CAMERA.

(138) **NO. 1A SPEEDEX CAMERA.** C. 1926. SIZE 2½ X 4¼ INCH EXPOSURES ON ROLL FILM. SIMILAR TO THE NO. 1A SUPER SPEEDEX EXCEPT THE LENS IS F 6.3 AND HAS A SPEEDEX OR UNIVERSAL SHUTTER.

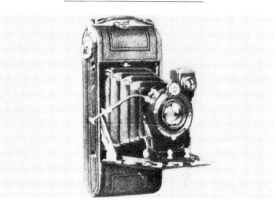

(139) **NO. 1 SUPER SPEEDEX CAMERA.** C. 1926. SIZE 2¼ X 3¼ INCH EXPOSURES ON NO. 4A (NO. 120) ROLL FILM. F 4.5 ILEX PARAGON ANASTIGMAT LENS. ACME SPEEDEX SHUTTER; 1 TO ⅟₃₀₀ SEC., B., T.

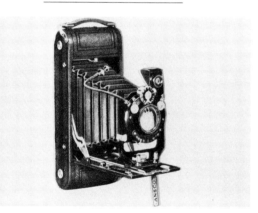

(140) **NO. 1A SUPER SPEEDEX CAMERA.** C. 1926. SIZE 2½ X 4¼ INCH EXPOSURES ON ROLL FILM. F 4.5 ILEX PARAGON ANASTIGMAT LENS. ACME SPEE-DEX SHUTTER; 1 TO ⅟₃₀₀ SEC., B., T. GROUND GLASS FOCUS.

(141) **VEST POCKET CAMERA.** C. 1926. SIZE 1⅝ X 2½ INCH EXPOSURES ON NO. 2C (NO. 127) ROLL FILM. NON-FOCUSING MODEL. F 7.5 ANSCO ANASTIGMAT LENS. SHUTTER SPEEDS OF ⅟₂₅, ⅟₅₀, ⅟₁₀₀ SEC., B., T.

(142) **UNIVERSAL VIEW CAMERA.** C. 1928. THREE SIZES OF THIS CAMERA FOR 4 X 5, 5 X 7, or 8 X 10 INCH EXPOSURES ON PLATES, FILM PACKS, OR CUT FILM. REVERSIBLE BACK. RISING, FALLING, AND CROSSING LENS MOUNT. VERTICAL AND HORIZONTAL SWING BACK.

## ANTHONY, E. & H. T., & COMPANY

**(143) ASCOT NO. 25 FOLDING PLATE CAMERA.** C. 1899. SIZE 4 X 5 INCH EXPOSURES.

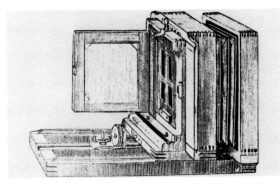

**(144) CINCINNATI GEM CAMERA.** C. 1888. SIZE ¼, ½, 4 X 4, 5 X 7, 7 X 10, OR 8 X 10 INCH EXPOSURES ON PLATES BY USING ONE, TWO, OR FOUR LENSES. DARLOT LENSES.

**(145) CLIMAX CINCINNATI GEM CAMERA (FERROTYPE COMBINATION BOX).** C. 1888. SIZE 8 X 10, 7 X 10, OR 5 X 7 INCH PLATE EXPOSURES CAN BE MADE BY USING ONE, TWO OR FOUR OF THE CAMERA'S LENSES. SOME MODELS WITHOUT SWING BACK. OTHER MODELS WITH SINGLE OR DOUBLE SWING BACK.

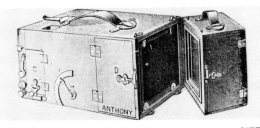

**(146) CLIMAX DETECTIVE CAMERA.** C. 1891. SIZE 4 X 5 INCH EXPOSURES ON PLATES. RAPID RECTILINEAR HEMISPHERICAL, DALLMEYER RAPID RECTILINEAR, OR LANDSCAPE LENS. VARIABLE SPEED GUILLOTINE SHUTTER. FOCUSING BY EXTERNAL LEVER AND DISTANCE INDICATOR. REMOVABLE REAR COMPARTMENT HOLDS FIVE DOUBLE PLATE HOLDERS. SINGLE VIEW FINDER.

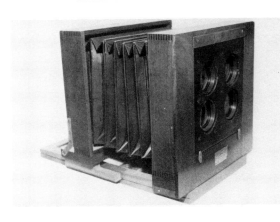

**(147) FOUR-TUBE DOUBLE STEREO CAMERA.** C. 1889. DOUBLE STEREO EXPOSURES ON SIZE 6½ X 8½ INCH PLATES. 5¼ INCH PETZVAL TYPE LENSES. (SG)

**(148) CLIMAX DETECTIVE CAMERA.** C. 1887. SIZE 4 X 5 INCH EXPOSURES ON PLATES. 125 MM/F 8 DOUBLE ACHROMATIC LENS. GUILLOTINE SHUTTER. FOCUSING BY INTERIOR SLIDING BOX. (MA)

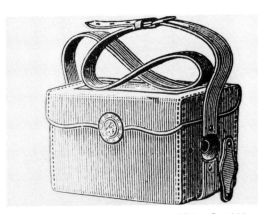

**(149) LILLIPUT DETECTIVE CAMERA.** C. 1889. SIZE 2½ X 2½ INCH EXPOSURES ON PLATES OR SHEET FILM. THE CAMERA MAGAZINE HOLDS SIX DOUBLE PLATES. 65 MM/F 8 RECTILINEAR LENS. INSTANT AND TIME SHUTTER. THE CAMERA SIZE IS 4 X 4 X 6 INCHES.

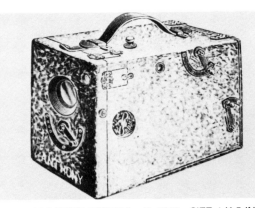

**(150) MAGAZINE CAMERA.** C. 1892. SIZE 4 X 5 INCH PLATE OR SHEET FILM EXPOSURES. THE CAMERA MAGAZINE HOLDS 12 PLATES OR 24 FILM SHEETS. DOUBLE ACHROMATIC LENS. INSTANT AND TIME SHUTTER. EXTERNAL FOCUSING LEVER. THE MAGAZINE IS ATTACHED TO THE CAMERA BACK TO EXCHANGE EXPOSED PLATES OR FILMS WITH FRESH PLATES OR FILMS FOR DAYLIGHT LOADING.

**(151) MARLBOROUGH CAMERA.** C. 1896. THREE SIZES OF THIS CAMERA FOR 5 X 7, 6½ X 8½, OR 8 X 10 INCH EXPOSURES ON PLATES. RAPID RECTILINEAR LENS. BAUSCH & LOMB SHUTTER. GROUND GLASS FOCUSING. REVERSIBLE SWING BACK. RISING AND SWING FRONT.

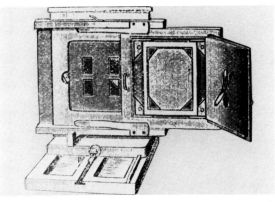

**(152) NEW YORK GEM CAMERA.** C. 1888. BY USING ONE, TWO, OR FOUR GEM LENSES, EITHER FOUR, EIGHT, OR SIXTEEN EXPOSURES CAN BE MADE ON HALF OR QUARTER PLATES. DARLOT LENSES.

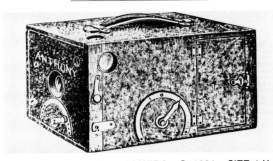

**(153) PDQ DETECTIVE CAMERA.** C. 1891. SIZE 4 X 5 INCH EXPOSURES ON SHEET OR PLATE FILM. ACHROMATIC LENS. VARIABLE-SPEED SHUTTER WITH TIME EXPOSURES. REMOVABLE GROUND GLASS FOR FOCUSING.

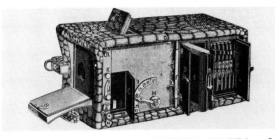

**(154) PATENT SATCHEL DETECTIVE CAMERA.** C. 1888. THE CAMERA IS CONTAINED INSIDE OF AN ALLIGATOR HAND SATCHEL AND CAN BE OPERATED WHILE A PERSON CARRIES THE SATCHEL. THE CAMERA HOLDS SIX DOUBLE PLATES AND HAS A VIEW FINDER. THE MAIN CAMERA IS AN ANTHONY CLIMAX DETECTIVE CAMERA. VARIABLE SPEED SHUTTER WITH APERTURE STOPS. EXTERNAL LEVER WITH DISTANCE SCALE FOR FOCUSING.

**(155) SCHMID'S PATENT DETECTIVE CAMERA.** C. 1883. SIZE 3¼ X 4¼ INCH EXPOSURES ON DRY PLATES. THE FIRST AMERICAN HAND DETECTIVE CAMERA. SIMILAR TO THE IMPROVED MODEL OF 1884 EXCEPT THE LEVER FOR VARYING THE SHUTTER TENSION IS LOCATED ON THE UNDERSIDE OF THE CAMERA AND THE CAMERA HAS NO EXTERIOR SHUTTER-COCKING BUTTON.

**ANTHONY, E. & H. T., & COMPANY** (*cont.*)

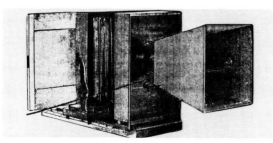

(156)  **PEARSALL VIEW CAMERA.**  C. 1878.

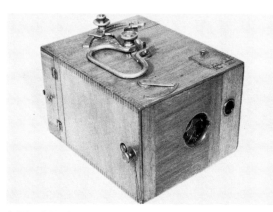

(157)  **SCHMID'S PATENT DETECTIVE CAMERA.  IM-PROVED MODEL.**  C. 1884.  TWO SIZES OF THIS CAMERA FOR 3¼ X 4¼ OR 4 X 5 INCH PLATE EXPOSURES.  ANTHONY RAPID RECTILINEAR LENS.  THE ROTARY SHUTTER IS COCKED BY PULLING THE BUTTON ON THE SIDE OF THE CAMERA.  THE SHUTTER IS RELEASED BY PRESSING ANOTHER BUTTON BEHIND THE COCKING BUTTON.  (GE)

(158)  **SCHMID'S PATENT DETECTIVE CAMERA.  IM-PROVED MODEL.**  C. 1887.  SIZE 3¼ X 4¼ INCH EXPOSURES ON PLATES OR ROLL FILM WITH THE EASTMAN-WALKER ROLL HOLDER.  OTHER FEATURES ARE SIMILAR TO THE 1884 MODEL.

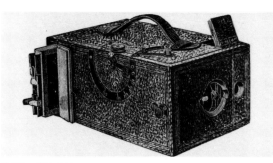

(159)  **SCHMID'S PATENT DETECTIVE CAMERA.**  C. 1891.  SIX SIZES OF THIS CAMERA FOR 3¼ X 4¼, 4 X 5, 4¼ X 6½, 5 X 8, 6½ X 8½, OR 8 X 10 INCH EXPOSURES ON PLATES.  EXTERNAL FOCUSING LEVER WITH INDICATED DISTANCES.  GROUND GLASS FINDER.  SOME MODELS WITH DALLMEYER RAPID RECTILINEAR LENS.

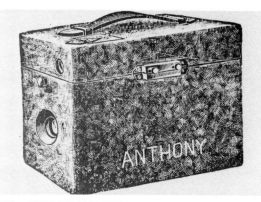

(160)  **SIMPLEX DETECTIVE CAMERA.**  C. 1891.  SIZE 2½ X 2½ INCH EXPOSURES ON SHEET FILM OR PLATES.  THE CAMERA HOLDS SIX DOUBLE-PLATE HOLDERS.  INSTANT AND TIME SHUTTER.  VIEW FINDER.

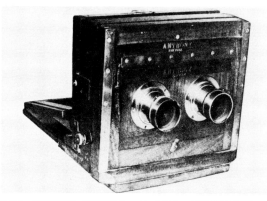

(161)  **STEREO CAMERA.**  C. 1862.  EXPOSURES ON WET PLATES.

(162)  **STEREO CAMERA.**  C. 1878.  THREE SIZES OF THIS CAMERA FOR 4 X 7, 4 X 8, OR 5 X 8 INCH STEREO EXPOSURES ON PLATES.

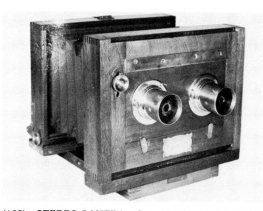

(163)  **STEREO CAMERA.**  C. 1888.  SIZE 5 X 8 INCH EXPOSURES ON DRY PLATES.  ANTHONY LENS.  GUNDLACH FOUR-SPEED SHUTTER PLUS B., T.  (SW)

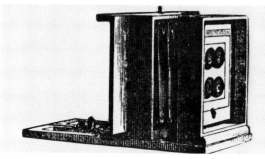

(164)  **VICTORIA GEM CAMERA.**  C. 1878.  ONE, TWO, FOUR, OR EIGHT EXPOSURES ON SIZE 5 X 7 INCH PLATES USING ONE TO FOUR LENSES.

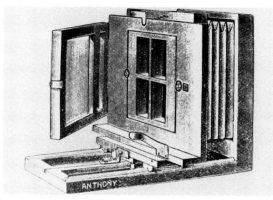

(165)  **VICTORIA GEM CAMERA.**  C. 1888.  FROM ONE TO EIGHT EXPOSURES CAN BE MADE ON A 5 X 7 INCH PLATE BY USING ONE OR MORE OF THE FOUR GEM DARLOT LENSES.

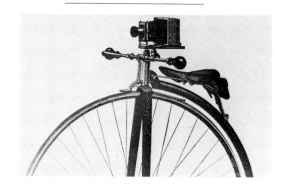

(166)  **BICYCLE VIEW CAMERA.**  C. 1891.  SIZE 3¼ X 4¼ INCH EXPOSURES ON PLATES.  SINGLE ACHROMATIC LENS.  GROUND GLASS FOCUSING.

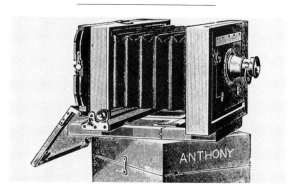

## ANTHONY, E. & H. T., & COMPANY (*cont.*)

**(167) CHAMPION VIEW CAMERA.** C. 1891. SIX SIZES OF THIS CAMERA FOR 4 X 5, 4¼ X 6½, 5 X 7, 5 X 8, 6½ X 8½, OR 8 X 10 INCH EXPOSURES ON PLATES. SINGLE ACHROMATIC LENS. RISING LENS MOUNT, FOLDING BED, AND SWING BACK. WATERHOUSE STOPS. GROUND GLASS FOCUSING.

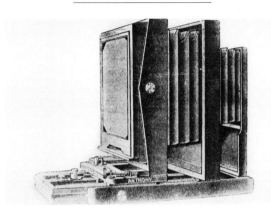

**(168) CLIMAX VIEW CAMERA.** C. 1888. SEVEN SIZES OF THIS CAMERA FOR 11 X 14, 14 X 17, 17 X 20, 18 X 22, 20 X 24, 22 X 27, and 25 X 30 INCH EXPOSURES ON DRY PLATES. DOUBLE-SWING BACK. TELESCOPIC BED.

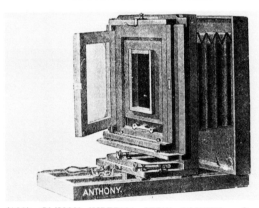

**(169) CLIMAX IMPERIAL VIEW CAMERA.** C. 1888. TWO SIZES OF THIS CAMERA FOR 8 X 10 OR 10 X 12 INCH EXPOSURES ON PLATES. SOME MODELS WITH DOUBLE-SWING BACK.

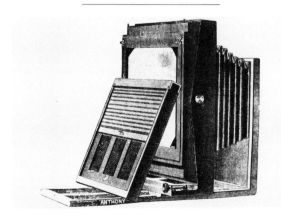

**(170) CLIMAX REVERSIBLE BACK VIEW CAMERA.** C. 1888. SEVEN SIZES OF THIS CAMERA FOR 6½ X 8½, 8 X 10, 10 X 12, 11 X 14, 14 X 17, 17 X 20, OR 18 X 22 INCH EXPOSURES ON DRY PLATES. VERTICAL SLIDING FRONT AND FOLDING BED.

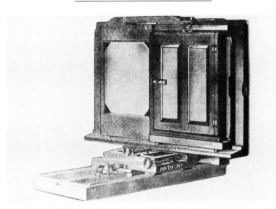

**(171) CLIMAX ROYAL VIEW CAMERA.** C. 1888. THREE SIZES OF THIS CAMERA FOR 8 X 10, 11 X 14, OR 14 X 17 INCH EXPOSURES ON PLATES. SLIDING BACK PLATE HOLDER.

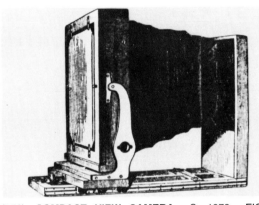

**(172) COMPACT VIEW CAMERA.** C. 1878. EIGHT SIZES OF THIS CAMERA FOR 4¼ X 5½, 6½ X 8½, 8 X 10, 10 X 12, 11 X 14, 14 X 17, 17 X 20 OR 20 X 24 INCH EXPOSURES ON PLATES. SINGLE OR DOUBLE SWING BACK. SOME MODELS WITH REVERSIBLE BACK.

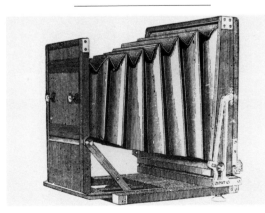

**(173) COMPACT VIEW CAMERA.** C. 1885. SAME EXPOSURE SIZES AND FEATURES AS THE 1878 COMPACT VIEW CAMERA.

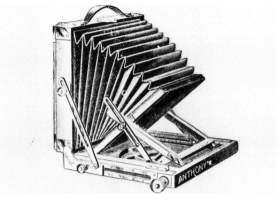

**(174) COMPACT VIEW CAMERA.** C. 1891. FOUR SIZES OF THIS CAMERA FOR 5 X 7, 5 X 8, 6½ X 8½ AND 8 X 10 INCH EXPOSURES ON PLATES. REVERSIBLE BACK. RACK & PINION FOCUS. TELESCOPIC BED. GROUND GLASS FOCUSING.

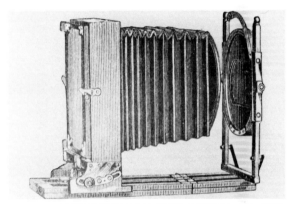

**(175) DUPLEX NOVELETTE VIEW CAMERA.** C. 1888. SIZE 5 X 8 INCH SINGLE OR STEREO EXPOSURES ON DRY PLATES WITH AN 8 X 10 BELLOWS AND BODY ATTACHMENT FOR MAKING SIZE 8 X 10 INCH EXPOSURES.

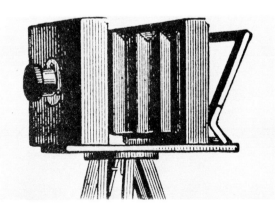

**(176) EUREKA SCHOOL OUTFIT VIEW CAMERA.** C. 1891. SIZE 4 X 5 INCH EXPOSURES ON PLATES. THE OUTFIT INCLUDES CAMERA, SENSITIZING AND DEVELOPING CHEMICALS, SENSITIZED PAPER, DEVELOPING TRAYS, AND MISCELLANEOUS ITEMS. GROUND GLASS FOCUSING.

## ANTHONY, E. & H. T., & COMPANY (*cont.*)

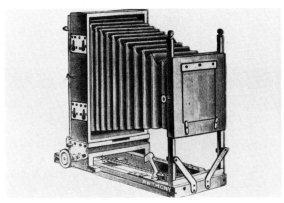

**(177) FAIRY VIEW CAMERA.** C. 1891. FIVE SIZES OF THIS CAMERA FOR 4 X 5, 4¼ X 6½, 5 X 8, 6½ X 8½, OR 8 X 10 INCH EXPOSURES ON DRY PLATES. RACK & PINION FOCUSING. GROUND GLASS FOCUSING.

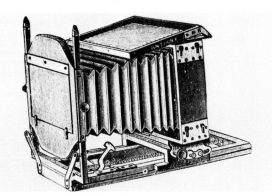

**(178) FAIRY STEREO VIEW CAMERA.** C. 1891. THREE SIZES OF THIS CAMERA FOR 5 X 8, 6½ X 8½, AND 8 X 10 INCH STEREO EXPOSURES ON DRY PLATES. SAME FEATURES AS THE FAIRY VIEW CAMERA, C. 1891.

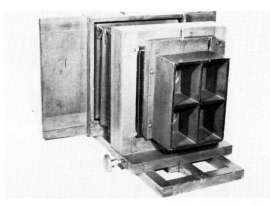

**(179) FERROTYPE MULTIPLE-LENS STUDIO VIEW CAMERA.** C. 1870. SIX TINTYPE OR WET COLLODION EXPOSURES CAN BE OBTAINED ON A SINGLE 6½ X 8½ INCH PLATE BY USING THE CAMERA'S FOUR LENSES AND A SLIDING PLATE HOLDER. 6½ INCH/F 4 PETZUAL TYPE DARLOT LENSES. VERTICAL GUILLOTINE SHUTTER FOR ALL FOUR LENSES. FRONT RACK & PINION FOR FOCUSING. (GE)

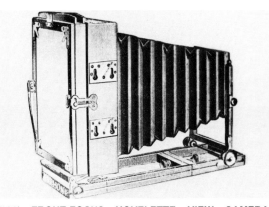

**(180) FRONT-FOCUS NOVELETTE VIEW CAMERA.** C. 1891. NINE SIZES OF THIS CAMERA FOR 4 X 5, 4¼ X 6½, 5 X 7, 5 X 8, 6½ X 8½, 8 X 10, 10 X 12, 11 X 14, AND 14 X 17 INCH EXPOSURES ON DRY PLATES. FRONT FOCUSING WITH RACK & PINION ADJUSTMENT. FOLDING BED, SINGLE OR DOUBLE SWING BACK, GROUND GLASS FOCUSING.

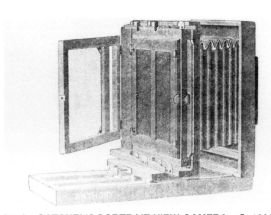

**(181) GATCHEL'S PORTRAIT VIEW CAMERA.** C. 1888. THE CAMERA WAS MANUFACTURED FOR W. D. GATCHEL BY ANTHONY. TWO SIZES OF THIS CAMERA FOR 6½ X 8½ OR 8 X 10 INCH EXPOSURES ON PLATES.

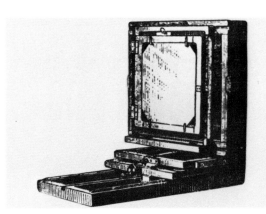

**(182) IMPERIAL AND CARD VIEW CAMERA.** C. 1878. ONE TO SIX EXPOSURES ON SIZE 8 X 10 INCH PLATES OR TWO EXPOSURES ON SIZE 4¼ X 6½ INCH PLATES.

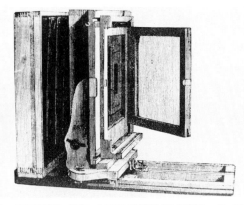

**(183) IMPERIAL AND CARD VIEW CAMERA.** C. 1885. ONE TO SIX EXPOSURES ON SIZE 8 X 10 INCH PLATES OR TWO EXPOSURES ON SIZE 4¼ X 6½ INCH PLATES.

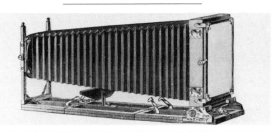

**(184) LONG-BELLOWS NOVELETTE VIEW CAMERA.** C. 1891. SIZE 8 X 10 INCH EXPOSURES ON DRY PLATES. REVERSIBLE BACK. RISING FRONT. EXTRA SUPPORT FOR LONG BELLOWS. MAXIMUM FOCAL LENGTH IS 32½ INCHES.

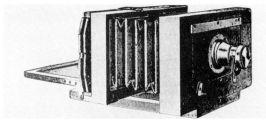

**(185) MANHATTEN VIEW CAMERA.** C. 1891. THREE SIZES OF THIS CAMERA FOR 4 X 5, 4¼ X 6½, OR 5 X 8 INCH EXPOSURES ON PLATES. SINGLE ACHROMATIC LENS. THE 5 X 8 INCH EXPOSURE CAMERA TAKES 5 X 8 INCH SINGLE EXPOSURES USING ONE LENS, TWO 4 X 5 INCH SINGLE EXPOSURES, OR ONE 5 X 8 STEREO EXPOSURE USING TWO LENSES. WATERHOUSE STOPS.

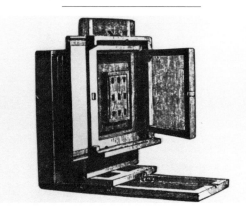

## ANTHONY, E. & H. T., & COMPANY (*cont.*)

(186) **MULTIPLYING GEM VIEW CAMERA.** C. 1878. THE CAMERA CAN MAKE FROM 18 TO 72 EXPOSURES ON A 7 X 10 INCH PLATE, 9 TO 36 EXPOSURES ON A 5 X 7 INCH PLATE, OR 1 TO 4 EXPOSURES ON AN 8 X 10 INCH PLATE USING FROM ONE TO NINE LENSES.

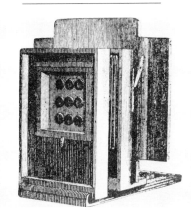

(187) **MULTIPLYING GEM VIEW CAMERA.** C. 1885. THE CAMERA CAN MAKE FROM 18 TO 72 EXPOSURES ON A 7 X 10 INCH PLATE, 9 TO 36 EXPOSURES ON A 5 X 7 INCH PLATE, OR 1 TO 4 EXPOSURES ON AN 8 X 10 INCH PLATE USING FROM ONE TO NINE LENSES.

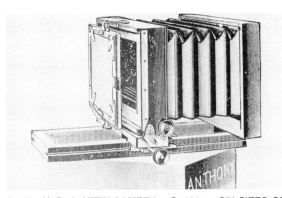

(188) **N. P. A. VIEW CAMERA.** C. 1891. SIX SIZES OF THIS CAMERA FOR 4 X 5, 4¼ X 6½, 5 X 7, 5 X 8, 6½ X 8½, OR 8 X 10 INCH EXPOSURES ON PLATES. SINGLE ACHROMATIC LENS. RISING LENS MOUNT. SWING BACK. FOLDING BED. GROUND GLASS FOCUSING.

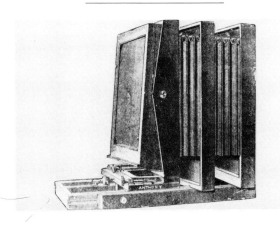

(189) **NEW YORK IMPERIAL VIEW CAMERA.** C. 1888. TWO SIZES OF THIS CAMERA FOR 11 X 14 OR 14 X 17 INCH EXPOSURES ON PLATES. DOUBLE-SWING BACK. TELESCOPIC BED.

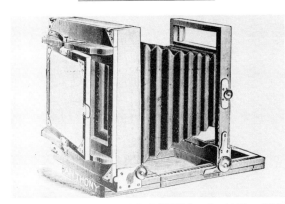

(190) **NORMANDIE VIEW CAMERA.** C. 1891. NINE SIZES OF THIS CAMERA FOR 4 X 5, 4¼ X 6½, 5 X 7, 5 X 8, 6½ X 8½, 8 X 10, 10 X 12, 11 X 14, OR 14 X 17 INCH EXPOSURES ON DRY PLATES. REVERSIBLE BACK. DROPPING BED. RACK & PINION FRONT FOCUSING. GROUND GLASS FOCUSING.

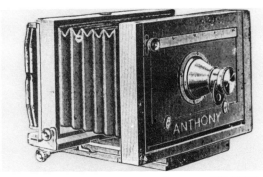

(191) **O. N. A. VIEW CAMERA.** C. 1891. SIX SIZES OF THIS CAMERA FOR 4 X 5, 4¼ X 6½, 5 X 7, 5 X 8, 6½ X 8½, OR 8 X 10 INCH EXPOSURES ON PLATES. SINGLE ACHROMATIC LENS. RISING LENS MOUNT. SWING BACK AND FOLDING BED. WATERHOUSE STOPS. GROUND GLASS FOCUSING.

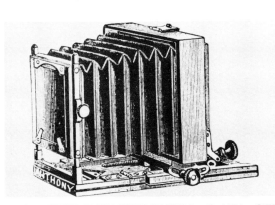

(192) **PATENT BIJOU VIEW CAMERA.** C. 1891. SIZE 3¼ X 4¼ INCH EXPOSURES ON DRY PLATES. FOLDING BED. GROUND GLASS FOCUSING.

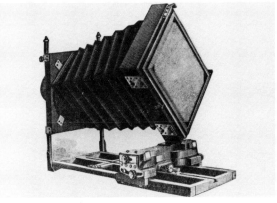

(193) **PATENT NOVEL VIEW CAMERA.** C. 1884–88. FIVE SIZES OF THIS CAMERA FOR 10 X 12, 11 X 14, 14 X 17, 17 X 20, OR 18 X 22 INCH EXPOSURES ON DRY PLATES. THE BACK OF THE CAMERA CAN BE REVOLVED BY PARTIALLY REVOLVING THE BELLOWS.

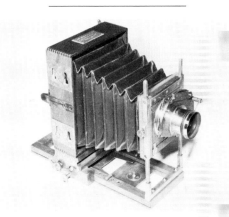

(194) **PATENT NOVELETTE VIEW CAMERA.** C. 1885–88. SIX SIZES OF THIS CAMERA FOR 4 X 5, 4¼ X 6½, 5 X 7, 5 X 8, 6½ X 8½, OR 8 X 10 INCH EXPOSURES ON PLATES. F 8 RAPID RECTILINEAR LENS. PROSCH DUPLEX THREE-SPEED SHUTTER WITH TIME EXPOSURE SETTING. FOLDING BED. GROUND GLASS FOCUSING. (GE)

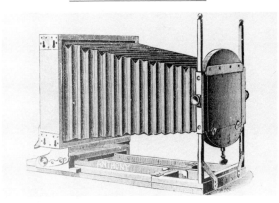

(195) **PATENT NOVELETTE VIEW CAMERA.** C. 1891. EIGHT SIZES OF THIS CAMERA FOR 4 X 5, 4¼ X 6½, 5 X 7, 5 X 8, 6½ X 8½, 8 X 10, 10 X 12, OR 11 X 14 INCH EXPOSURES ON DRY PLATES. FOLDING BED. RISING FRONT, SINGLE OR DOUBLE SWING BACK. GROUND GLASS FOCUSING.

## ANTHONY, E. & H. T., & COMPANY (*cont.*)

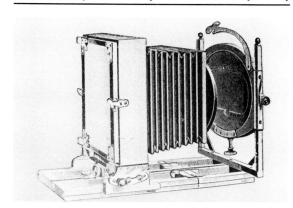

**(196) PATENT DUPLEX NOVELETTE VIEW CAMERA.** C. 1891. SIZE 8 X 10 INCH EXPOSURES ON DRY PLATES WITH A 11 X 14 BELLOWS AND BODY ATTACHMENT FOR MAKING SIZE 11 X 14 INCH EXPOSURES. GROUND GLASS FOCUSING.

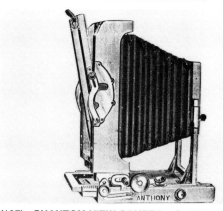

**(197) PHANTOM VIEW CAMERA.** C. 1891. FIVE SIZES OF THIS CAMERA FOR 4¼ X 6½, 5 X 7, 5 X 8, 6½ X 8½, OR 8 X 10 INCH EXPOSURES ON DRY PLATES. REVERSIBLE BACK. RISING LENS MOUNT.

**(198) PORTRAIT VIEW CAMERA.** FIVE SIZES OF THIS CAMERA FOR 8 X 10, 10 X 12, 11 X 14, 14 X 17 OR 17 X 20 INCH EXPOSURES ON PLATES.

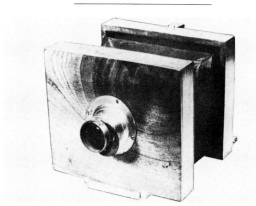

**(199) SQUARE-BELLOWS VIEW CAMERA.** C. 1883. SIZE 4 X 5 INCH EXPOSURES ON PLATES. SIMPLE ACHROMATIC LENS.

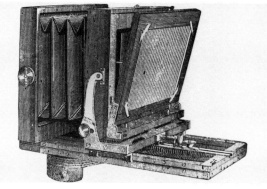

**(200) STEREOSCOPIC VIEW CAMERA.** C. 1885. SIZE 5 X 8 INCH STEREO EXPOSURES ON PLATES. SWING BACK.

**(201) STUDIO VIEW CAMERA.** C. 1870. SIZE 11 X 14 INCH EXPOSURES ON WET OR DRY PLATES.

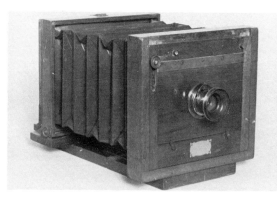

**(202) STUDIO VIEW CAMERA.** C. 1880. SIZE 5 X 7 INCH EXPOSURES ON PLATES. WATERHOUSE STOPS. (TH)

**(203) UNIVERSAL PORTRAIT AND FERROTYPE VIEW CAMERA.** C. 1878. THREE SIZES OF THIS CAMERA FOR 5 X 7, 7 X 10, OR 8 X 10 INCH EXPOSURES ON PLATES. VARIOUS MODELS OF THE CAMERA HAD EITHER ONE, FOUR, SIX, NINE, OR TWELVE LENSES FOR TAKING MULTIPLE EXPOSURES ON A SINGLE PLATE.

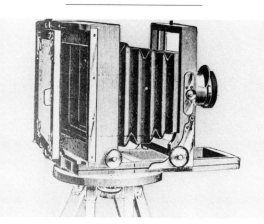

**(204) VICTOR VIEW CAMERA.** C. 1891. SIX SIZES OF THIS CAMERA FOR 4 X 5, 4¼ X 6½, 5 X 7, 5 X 8, 6½ X

8½, OR 8 X 10 INCH EXPOSURES ON PLATES. SINGLE ACHROMATIC LENS. RISING LENS MOUNT. SWING BACK. RACK & PINION FRONT FOCUS. FOLDING BED. GROUND GLASS FOCUSING. WATERHOUSE STOPS.

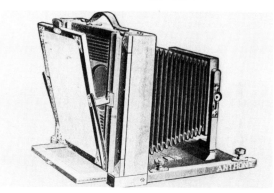

**(205) VINCENT VIEW CAMERA.** C. 1891. FOUR SIZES OF THIS CAMERA FOR 5 X 7, 5 X 8, 6½ X 8½, OR 8 X 10 INCH EXPOSURES. REVERSIBLE BACK. FOLDING BED. TELESCOPIC BED. GROUND GLASS FOCUSING.

**(206) VIEW CAMERA.** C. 1875. SIZE 10 X 10½ INCH WET PLATE EXPOSURES. SINGLE EXTENSION BELLOWS. VOIGTLANDER LENS. RACK & PINION FOCUSING. WATERHOUSE STOPS.

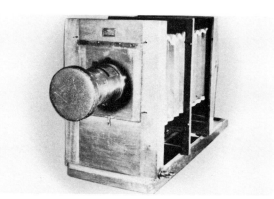

**(207) VIEW CAMERA.** C. 1875. SIZE 10 X 10½ INCH WET PLATE EXPOSURES. DOUBLE EXTENSION BELLOWS. DALLMEYER 3A LENS. RACK & PINION FOCUSING. WATERHOUSE STOPS (JW)

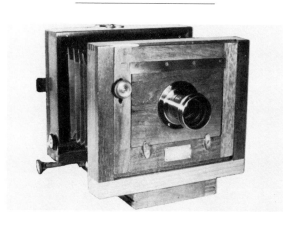

## ANTHONY, E. & H. T., & COMPANY (*cont.*)

(208) **VIEW CAMERA.** C. 1880–90. SIZE 4 X 5 INCH EXPOSURES ON DRY PLATES. ROCHESTER OPTICAL CO. LENS. (SW)

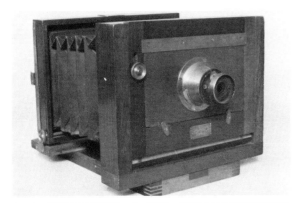

(209) **VIEW CAMERA.** C. 1885. SIZE 5 X 8 INCH EXPOSURES. ROTARY STOPS. (TH)

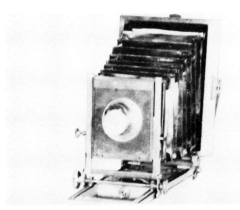

(210) **VIEW CAMERA.** C. 1887. SIZE 4¼ X 6½ INCH EXPOSURES ON GLASS PLATES. ANTHONY ACHROMATIC LENS. (JW)

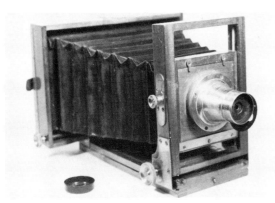

(211) **VIEW CAMERA.** C. 1888. SIZE 5 X 8 INCH EXPOSURES ON GLASS PLATES. SINGLE ACHROMATIC LENS. ROTARY STOPS. (JS)

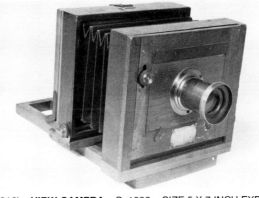

(212) **VIEW CAMERA.** C. 1890. SIZE 5 X 7 INCH EXPOSURES ON PLATES. GUNDLACH OPTICAL COMPANY LENS. (SW)

(213) **VISU SINGLE-LENS REFLEX CAMERA.** C. 1897. EXPOSURES ON PLATES OR ROLL FILM. FIXED-FOCUS LENS. (BC)

(214) **ZOKA MAGAZINE DETECTIVE CAMERA.** C. 1894. SIZE 4 X 5 INCH EXPOSURES ON PLATES OR SHEET FILM.

## ANTHONY & SCOVILL COMPANY

(215) **AMERICAN OPTICAL COMPANY'S PORTRAIT CAMERA.** C 1904. THE CAMERA WAS MADE IN THE FOLLOWING PLATE EXPOSURE SIZES. 3¼ X 4¼, 4¼ X 5½, 4¾ X 6½, 6½ X 8½, 8 X 10, 10 X 12, 11 X 14, 12 X 15, 14 X 17, 16 X 20, 17 X 20, 18 X 22, 20 X 24, 22 X 27, 25 X 30, AND 30 X 38 INCHES.

(216) **BOX CAMERA.** C. 1900. SIZE 4 X 5 INCH EXPOSURES ON ROLL FILM.

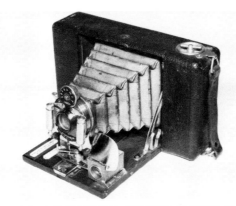

(217) **NO. 6 HORIZONTAL FOLDING POCKET ANSCO CAMERA.** C. 1904. SIZE 3¼ X 4¼ INCH EXPOSURES ON ROLL FILM. ACHROMATIZED PERISCOPIC LENS. DOUBLE PNEUMATIC OR FINGER RELEASE WOLLENSAK AUTOMATIC SHUTTER; 1 TO ⅟₁₀₀ SEC., B., T. THE CAMERA USED "VIDIL" ROLL FILM WHICH HAD PARCHMENT PAPER INTERSPACED BETWEEN SPECIFIC LENGTHS OF CONVENTIONAL PAPERBACKED ROLL FILM. THE PARCHMENT PAPER WAS USED AS FOCUSING SCREEN BETWEEN EACH EXPOSURE. (GE)

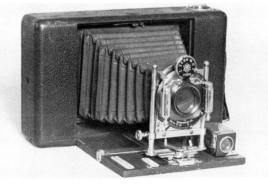

(218) **NO. 7 HORIZONTAL FOLDING POCKET ANSCO CAMERA.** C. 1902. EXPOSURES ON ROLL FILM. F 8 LENS. DOUBLE PNEUMATIC OR FINGER RELEASE ANSCO SHUTTER; 1 TO ⅟₁₀₀ SEC., B. T. (HT)

(219) **NO. 10 HORIZONTAL FOLDING POCKET ANSCO CAMERA.** C. 1907. SIZE 3¼ X 5½ INCH EXPOSURES ON "VIDIL" ROLL FILM. SIMILAR TO THE NO. 6 HORIZONTAL FOLDING POCKET ANSCO CAMERA.

## BLAIR CAMERA COMPANY

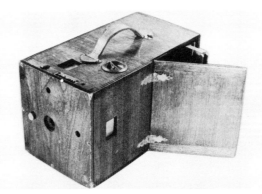

(220) **BOX CAMERA.** C. 1889. SIZE 4 X 5 INCH EXPOSURES ON PLATES. INTERIOR BELLOWS FOR FOCUSING. EXTERNAL FOCUSING KNOB. REMOVABLE REAR PANEL TO VIEW FOCUSING GROUND GLASS. SPRING LEVER SHUTTER, PATENT 1867. (HW)

(221) **DETECTIVE CAMERA.** C. 1895. SIZE 4 X 5 INCH EXPOSURES. ROTARY SHUTTER.

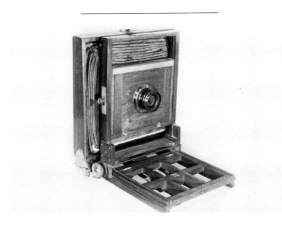

## BLAIR CAMERA COMPANY (*cont.*)

(222) **FIELD CAMERA.** C. 1890. SIZE 8 X 10 INCH EXPOSURES ON SHEET FILM OR PLATES. 6 INCH/F 16 TAYLOR & HOBSON LEICESTER LENS. LENS-CAP TYPE SHUTTER. (EB)

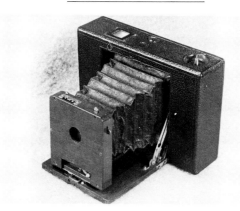

(223) **FOLDING POCKET ROLL FILM CAMERA.** C. 1895. SIZE 3 X 3 INCH EXPOSURES ON ROLL FILM. ACHROMATIC DOUBLET LENS. TWO-SPEED SHUTTER. (DB)

(224) **400 CAMERA.** C. 1893. SIZE 4 X 5 INCH EXPOSURES ON ROLL FILM. THIS BELLOWS CAMERA HAS RACK & PINION FOCUSING AND A BRILLIANT FINDER. (BC)

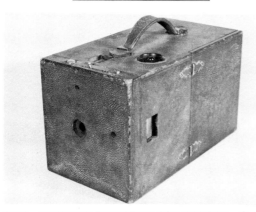

(225) **HAWKEYE DETECTIVE BOX CAMERA.** C. 1890. SIZE 4 X 5 INCH PLATE EXPOSURES. ACHROMATIC LENS. SECTOR VARIABLE-SPEED SHUTTER. INTERNAL SLIDING-BOX AND BELLOWS COMBINATION. (SW)

(226) **HAWKEYE DETECTIVE BOX CAMERA.** C. 1891. SIZE 3½ X 5 INCH EXPOSURES ON ROLL FILM. THREE-SPEED COCKING SHUTTER. INTERNAL BELLOWS WITH OUTSIDE LEVER FOR FOCUSING. DOORS ON TOP, BOTTOM, AND BACK. SIMILAR TO THE HAWKEYE DETECTIVE BOX CAMERA FOR SIZE 4 X 5 INCH EXPOSURE.

(227) **COMBINATION HAWKEYE SCREEN-FOCUSING CAMERA.** C. 1895.

(228) **HAWKEYE JUNIOR BOX CAMERA.** C. 1895. SIZE 3½ X 3½ INCH EXPOSURES ON PLATES OR SHEET FILM. SIMPLE LENS. THREE-SPEED SECTOR SHUTTER.

(229) **BABY HAWKEYE BOX CAMERA.** C. 1895. SIZE 2 X 2½ INCH EXPOSURES ON ROLL FILM. MENISCUS LENS. ROTARY SHUTTER.

(230) **NO. 3 COMBINATION HAWKEYE CAMERA.** C. 1899. SIZE 3¼ X 4¼ INCH EXPOSURES ON ROLL FILM OR PLATES. EXTRA RAPID RECTILINEAR LENS. BAUSCH & LOMB AUTOMATIC SHUTTER.

(231) **FOLDING HAWKEYE PLATE CAMERA.** C. 1890. SIZE 5 X 7 INCH EXPOSURES.

(232) **FOLDING HAWKEYE PLATE CAMERA.** C. 1891. SIZE 5 X 7 INCH EXPOSURES. SWING AND TILT BACK.

(233) **FOLDING HAWKEYE PLATE CAMERA.** C. 1895. SIZE 4 X 5 INCH EXPOSURES. RECTILINEAR LENS.

FOUR-SPEED BAUSCH & LOMB SHUTTER. ROTARY APERTURE STOPS. (MA)

(234) **NO. 3 FOLDING HAWKEYE CAMERA.** C. 1899. SIZE 3¼ X 4¼ INCH EXPOSURES ON ROLL FILM. BAUSCH & LOMB RAPID RECTILINEAR LENS. BLAIR PNEUMATIC SHUTTER; INSTANT, B., T. EXPOSURES. (HW)

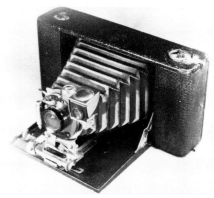

(235) **NO. 3B FOLDING HAWKEYE CAMERA.** C. 1904. SIZE 3¼ X 5½ INCH EXPOSURES ON ROLL FILM. BAUSCH & LOMB PNEUMATIC SHUTTER; INSTANT, B., T. (DJ)

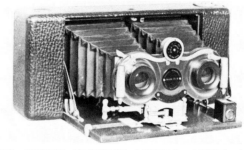

(236) **STEREO HAWKEYE CAMERA.** MODEL 4. C. 1899. SIZE 3¼ X 6½ INCH STEREO EXPOSURES ON ROLL FILM. DOUBLE PNEUMATIC OR FINGER RELEASE SHUTTER; 1 TO 1/100 SEC., B., T. (TH)

# AMERICAN CAMERAS

19

## BLAIR CAMERA COMPANY (*cont.*)

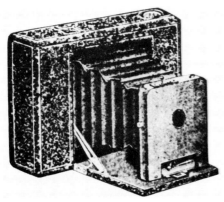

(237) **TOURIST HAWKEYE CAMERA.** C. 1898. SIZE 3½ X 3½ INCH EXPOSURES ON ROLL FILM.

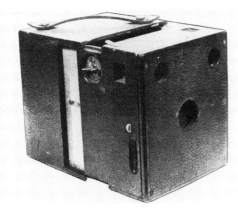

(238) **NO. 4 WENO HAWKEYE CAMERA.** C. 1899. EXPOSURES ON NO. 103 FILM.

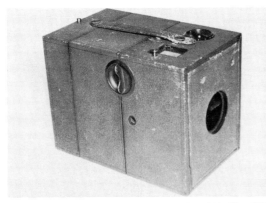

(239) **KAMARET BOX CAMERA.** C. 1892–95. SIZE 4 X 5 INCH EXPOSURES ON PLATES OR SHEET FILM OR 25, 50, OR 100 EXPOSURES ON ROLL FILM. DARLOT RECTILINEAR LENS. TWO-SPEED GUILLOTINE SHUTTER WITH TIME EXPOSURES. (GE)

(240) **PREMIER BOX CAMERA.** C. 1895. SIZE 4 X 5 INCH PLATE EXPOSURES. INTERNAL-FOCUS BELLOWS.

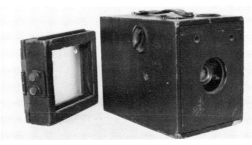

(241) **KAMARET BOX CAMERA.** C. 1893–96. SIZE 5 X 7 INCH EXPOSURES ON PLATES OR SHEET FILM OR 25 OR 50 EXPOSURES ON ROLL FILM. DARLOT RECTILINEAR LENS. TWO-SPEED GUILLOTINE SHUTTER WITH TIME EXPOSURES. (TH)

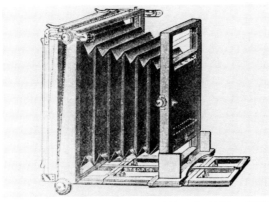

(242) **CHAMPION VIEW CAMERA.** C. 1888. THREE SIZES OF THIS CAMERA FOR 6½ X 8½, 5 X 8, OR 8 X 10 INCH EXPOSURES ON PLATES. RISING AND FALLING LENS MOUNT. SOME MODELS WITH SINGLE SWING BACK. OTHER MODELS WITH DOUBLE SWING. AN EXTENSION ATTACHMENT WITH BELLOWS COULD BE USED WITH THIS CAMERA FOR MAKING SIZE 11 X 14 OR 14 X 17 INCH EXPOSURES.

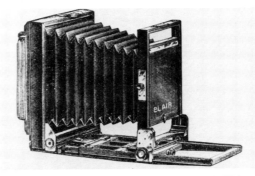

(243) **NEW REVERSIBLE-BACK VIEW CAMERA.** C. 1888. FOUR SIZES OF THIS CAMERA FOR 4¼ X 5½, 5 X 7, 6½ X 8½, OR 8 X 10 INCH EXPOSURES ON DRY PLATES. MODELS WITH SINGLE OR DOUBLE SWING BACK.

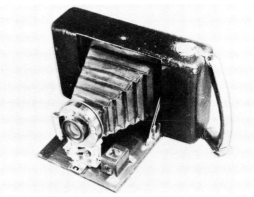

(244) **WENO FOLDING CAMERA.** C. 1898. SIZE 3¼ X 4¼ INCH EXPOSURES ON ROLL FILM. F 8 LENS. BAUSCH & LOMB SHUTTER; INSTANT, B., T. (DJ)

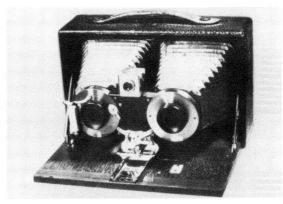

(245) **WENO STEREO CAMERA.** C. 1902. SIZE 3¼ X 6½ INCH STEREO EXPOSURES ON PLATES. RAPID RECTILINEAR LENSES. BAUSCH & LOMB SHUTTER. (HA)

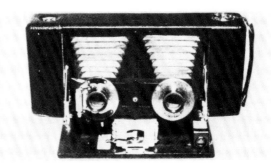

(246) **WENO STEREO CAMERA.** C. 1903. SIZE 3¼ X 6½ INCH STEREO EXPOSURES ON ROLL FILM. RECTILINEAR LENSES. BAUSCH & LOMB SHUTTER; INSTANT, B., T. (HA)

(247) **NO. 3 COMBINATION WENO CAMERA.** C. 1904. THE ROLL FILM AND HOLDER CAN BE REMOVED FROM THE FOCAL PLANE AND REPLACED WITH A FOCUSING SCREEN OR PLATE WITHOUT REWINDING THE ROLL FILM.

## BLAIR TOUROGRAPH AND DRY PLATE COMPANY

**(248) LUCIDOGRAPH CAMERA.** C. 1881. SIZE 5 X 7 INCH EXPOSURES ON PLATES.

**(249) LUCIDOGRAPH NO. 1 FOLDING PLATE CAMERA.** C. 1885.

**(250) LUCIDOGRAPH NO. 2 FOLDING PLATE CAMERA.** C. 1885.

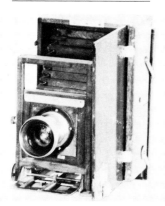

**(251) LUCIDOGRAPH NO. 3. FOLDING PLATE CAMERA.** C. 1885–86. SIZE 5 X 8 INCH EXPOSURES ON PLATES. BACK RECTILINEAR LENS. INSTANT SHUTTER.

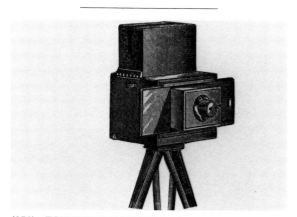

**(252) TOUROGRAPH CAMERA.** C. 1883. THREE SIZES OF THIS CAMERA FOR 4 X 5, 5 X 7, OR 5 X 8 INCH EXPOSURES ON DRY PLATES. BLAIR SINGLE ACHROMATIC LENS.

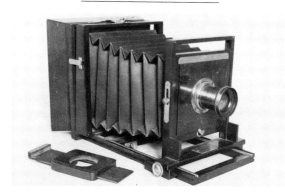

**(253) TOUROGRAPH CAMERA.** C. 1885. SIZE 5 X 7 INCH EXPOSURES WITH AN 8 X 10 INCH EXPOSURE EXTENSION. VOIGTLANDER 1-A LENS. WOODEN DROP SHUTTER. (TH)

**(254) VIEW CAMERA.** C. 1883. SIZE 6½ X 8½ INCH EXPOSURES ON PLATES. (JW)

## BLAND & COMPANY

**(255) COLLAPSIBLE STEREO SLIDING BOX CAMERA.** C. 1860.

## BORSUM CAMERA COMPANY

**(256) BORSUM REFLEX CAMERA.** C. 1897. SIZE 4 X 5 INCH EXPOSURES. FOCAL PLANE SHUTTER.

**(257) BORSUM REFLEX CAMERA.** C. 1900. SINGLE LENS REFLEX SIZE 5 X 7 INCH EXPOSURES. 16.5 INCH/F 7.7 GOERZ-DAGOR LENS. FOCAL PLANE SHUTTER.

**(258) BORSUM NEW MODEL REFLEX CAMERA.** C. 1904. SINGLE LENS REFLEX. SIZE 5 X 7 INCH EXPOSURES.

## BOSTON CAMERA COMPANY

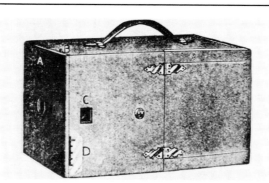

**(259) HAWKEYE DETECTIVE AND COMBINATION CAMERA.** C. 1888. SIZE 4 X 5 INCH EXPOSURES ON ROLL FILM. THE CAMERA HOLDS 100-EXPOSURE ROLL. 5½ INCH/F 12 ACHROMATIC LANDSCAPE LENS. SECTOR (NONCAPPING) SHUTTER FOR FIVE INSTANTANEOUS SPEEDS PLUS TIME. LATER MODELS HAVE A SELF-CAPPING SHUTTER. INTERNAL BELLOWS. GROUND GLASS FOCUSING.

## BOSTON CAMERA MANUFACTURING COMPANY

NOTE: THERE IS CONSIDERABLE EVIDENCE THAT THE BOSTON CAMERA MANUFACTURING COMPANY NEVER MANUFACTURED CAMERAS AND THAT ALL MANUFACTURING WAS DONE BY EITHER THE BLAIR CAMERA COMPANY OF BOSTON OR THE AMERICAN CAMERA MANUFACTURING COMPANY OF NORTHBORO, MASSACHUSETTS.

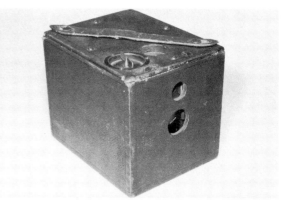

**(260) BULLSEYE BOX CAMERA.** C. 1892. ORIGINAL MODEL. SIZE 3½ X 3½ INCH EXPOSURES (OR 3½ INCH DIAMETER EXPOSURES) ON ROLL FILM. 5 INCH/F 18 ACHROMATIC MENISCUS LENS. SINGLE-SPEED, OSCILLATING SECTOR SHUTTER. THE RED WINDOW IN THE BACK OF THE CAMERA FOR VIEWING THE EXPOSURE NUMBERS ON THE FILM IS IN THE SHAPE OF A "D." THE CAMERA USED TURNER'S DAYLIGHT-LOADING ROLL FILM. (GE)

**(261) BULLSEYE BOX CAMERA.** C. 1894. SIZE 3½ X 3½ INCH EXPOSURES (OR 3½ INCH DIAMETER EXPOSURES) ON ROLL FILM. SIMILAR TO THE BULLSEYE BOX CAMERA, 1892, WITH SAME LENS BUT THE SHUTTER HAS A TIME EXPOSURE LEVER AND THE SHAPE OF THE RED WINDOW IN THE BACK OF THE CAMERA IS CIRCULAR INSTEAD OF "D" SHAPE. SOME OF THE 1894 MODELS WERE MADE OF A BLACK THERMO PLASTIC MATERIAL.

## BULLARD CAMERA COMPANY

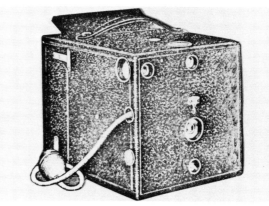

**(262) FIXED-FOCUS GROUND-GLASS MAGAZINE BOX CAMERA.** C. 1900. SIZE 4 X 5 INCH EXPOSURES ON PLATES. SINGLE ACHROMATIC LENS. AUTOMATIC PNEUMATIC SHUTTER. THE MAGAZINE HOLDS 12 PLATES.

## BULLARD CAMERA COMPANY (cont.)

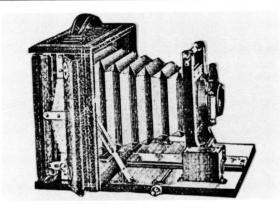

(263) **DOUBLE SWING CYCLE CAMERA.** C. 1901. SIZE 4 X 5 INCH EXPOSURES ON PLATES. RAPID SYMMETRICAL LENS. RAUBER & WOLLENSAK DOUBLE PNEUMATIC SHUTTER WITH SPEEDS TO ¹⁄₁₀₀ SEC., B., T. RISING, FALLING, AND CROSSING LENS MOUNT. RACK & PINION FOCUSING. DOUBLE SWING BACK.

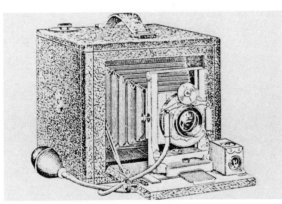

(264) **FOLDING MAGAZINE CAMERA.** SERIES A, 2A, AND B. C. 1901. SIZE 4 X 5 INCH EXPOSURES ON PLATES. THE SERIES 2A HAS A RAPID SYMMETRICAL LENS; DOUBLE PNEUMATIC SHUTTER; IRIS DIAPHRAGM; RISING, FALLING, AND CROSSING LENS MOUNT; RACK & PINION FOCUSING AND 18-PLATE MAGAZINE. THE SERIES A HAS A REGULAR SYMMETRICAL LENS AND NO RACK & PINION FOCUS BUT ALL OTHER FEATURES OF THE SERIES 2A. THE SERIES B HAS ALL OF THE FEATURES OF THE SERIES 2A EXCEPT A SPECIAL ACHROMATIC LENS, AUTOMATIC PNEUMATIC SHUTTER AND 12-PLATE MAGAZINE.

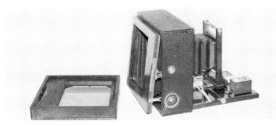

(265) **FOLDING PLATE CAMERA.** C. 1901. SIZE 4 X 5 INCH EXPOSURES ON PLATES. (DG)

(266) **LONG-FOCUS CAMERA.** C. 1901. THREE SIZES OF THIS CAMERA FOR 4 X 5, 5 X 7, OR 6½ X 8½ INCH EXPOSURES ON PLATES. RAPID SYMMETRICAL LENS. RAUBER & WOLLENSAK DOUBLE PNEUMATIC SHUTTER. IRIS DIAPHRAGM. REVERSIBLE SWING BACK. RISING, FALLING, AND CROSSING LENS MOUNT. RACK & PINION FOCUSING.

(267) **LONG-FOCUS MAGAZINE CYCLE CAMERA.** C. 1901. SIZE 4 X 5 INCH EXPOSURES ON PLATES. THE MAGAZINE HOLDS 12 PLATES. THE SAME LENS, SHUTTER, AND FEATURES AS THE BULLARD LONG-FOCUS CAMERA EXCEPT WITHOUT THE REVERSIBLE BACK.

(268) **MAGAZINE CAMERA.** C. 1898. SIZE 4 X 5 INCH EXPOSURES ON PLATES. THE CAMERA HOLDS EIGHTEEN PLATES AND HAS THE APPEARANCE OF A BOX CAMERA WHEN CLOSED. WHEN THE FRONT HINGED PANEL IS OPENED, THE BELLOWS AND LENS BOARD CAN BE EXTENDED. A PUSH-PULL ACTION TO THE BACK OF THE CAMERA ADVANCES THE PLATES.

(269) **REGULAR CYCLE CAMERA.** SERIES A, 2A, AND B. C. 1901. TWO SIZES OF THIS CAMERA FOR 4 X 5 OR 5 X 7 INCH EXPOSURES ON PLATES. THE SERIES A AND 2A HAVE A RAPID SYMMETRICAL LENS AND RAUBER & WOLLENSAK DOUBLE PNEUMATIC SHUTTER WITH SPEEDS TO ¹⁄₁₀₀ SEC., B., T. ALSO; IRIS DIAPHRAGM, RISING, FALLING, AND CROSSING LENS MOUNT. THE SERIES B HAS A SINGLE ACHROMATIC LENS AND SINGLE PNEUMATIC SHUTTER.

(270) **REGULAR FOLDING CAMERA.** SERIES A, 2A, AND B. C. 1901. TWO SIZES OF THIS CAMERA FOR 4 X 5 OR 5 X 7 INCH EXPOSURES ON PLATES. THE SERIES A, 2A, AND B REGULAR FOLDING CAMERAS ARE IDENTICAL TO THE REGULAR CYCLE CAMERAS (SERIES A, 2A, AND B) EXCEPT THE FOLDING CAMERAS HAVE A CHAMBER IN THE BACK FOR HOLDING THREE DOUBLE PLATE HOLDERS.

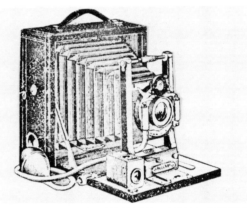

(271) **REVERSIBLE SWING-BACK CYCLE CAMERA.** SERIES A, 2A, AND 3A. C. 1901. TWO SIZES OF THIS CAMERA FOR 4 X 5 OR 5 X 7 INCH EXPOSURES ON PLATES. THE SERIES A AND 2A HAVE A SYMMETRICAL LENS AND DOUBLE PNEUMATIC RAUBER & WOLLENSAK SHUTTER EXCEPT THE SERIES A DOES NOT HAVE RACK & PINION FOCUSING. THE SERIES 3A HAS A RAPID SYMMETRICAL LENS WITH DOUBLE PNEUMATIC RAUBER & WOLLENSAK SHUTTER WITH IRIS DIAPHRAGM. THE SERIES 2A AND 3A HAVE RISING, FALLING, AND CROSSING LENS MOUNT.

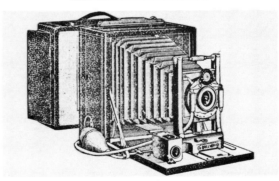

(272) **SEPARABLE MAGAZINE CYCLE CAMERA.** SERIES A, 2A, AND B. C. 1901. SIZE 4 X 5 INCH EXPOSURES ON PLATES. THE MAGAZINE HOLDS 12 PLATES. THE SERIES 2A HAS A RAPID SYMMETRI-

## BULLARD CAMERA COMPANY (*cont.*)

CAL LENS AND DOUBLE PNEUMATIC RAUBER & WOLLENSAK SHUTTER FOR SPEEDS TO ⅟₁₀₀ SEC., B., T. ALSO, IRIS DIAPHRAGM; RISING, FALLING, AND CROSSING LENS MOUNT; RACK & PINION FOCUS; AND SWING BACK. THE SERIES A HAS THE ABOVE FEATURES EXCEPT A FOCUSING SCREEN INSTEAD OF A PLATE HOLDER. THE SERIES B HAS A SINGLE ACHROMATIC LENS, SINGLE PNEUMATIC SHUTTER AND NO RACK & PINION FOCUS.

## BURKE & JAMES, INC.

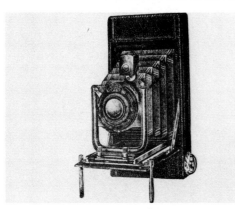

(273)  **FOLDING INGENTO CAMERA. MODELS 1 AND 2.** C. 1921. SIZE 2¼ X 3¼ INCH EXPOSURES ON ROLL FILM. MODEL 1: ACUTIC UNIVERSAL LENS WITH INGENTO AUTOMATIC SHUTTER; ½₅, ⅟₅₀ SEC., B., T. MODEL 2: ACUTIC RAPID RECTILINEAR LENS WITH THE SAME SHUTTER AS MODEL 1. RISING AND FALLING LENS MOUNT.

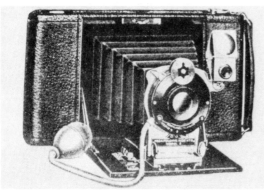

(274)  **NO. 3 FOLDING INGENTO CAMERA.** C. 1914. SIZE 3¼ X 4¼ INCH EXPOSURES ON ROLL FILM. RAPID SYMMETRICAL OR ACHROMATIC MENISCUS LENS. ILEX AUTOMATIC SHUTTER.

(275)  **NO. 3A FOLDING INGENTO CAMERA.** C. 1914. SIZE 3¼ X 5½ INCH EXPOSURES ON ROLL FILM. ILEX SHUTTER.

(276)  **NO. 3A FOLDING INGENTO JUNIOR CAMERA.** C. 1914. SIZE 3¼ X 5½ INCH EXPOSURES ON ROLL FILM.

(277)  **PRESS CAMERA.** C. 1920. SIZE 4 X 5 INCH EXPOSURES.

(278)  **REXO BOX CAMERA.** C. 1915. SIZE 2¼ X 3¼ INCH EXPOSURES ON ROLL FILM.

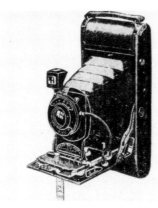

(279)  **NO. 1 REXO COAT POCKET CAMERA.** C. 1921. SIZE 2¼ X 3¼ INCH EXPOSURES ON ROLL FILM. ACHROMATIC, RAPID RECTILINEAR, OR F 7.5 ANASTIGMAT LENS. REXO-JUNIOR ILEX AUTOMATIC SHUTTER; ½₅, ⅟₅₀ SEC., B., T.

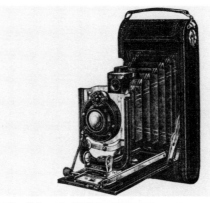

(280)  **NO. 1A REXO FOLDING CAMERA.** C. 1921. SIZE 2½ X 4¼ INCH EXPOSURES ON ROLL FILM. F 8 RAPID RECTILINEAR OR F 7.7 ANASTIGMAT LENS. ILEX GENERAL SHUTTER; ⅕ TO ⅟₁₀₀ SEC. OR ILEX SPECIAL SHUTTER; ½₅ TO ⅟₁₀₀ SEC.

(281)  **NO. 3 REXO FOLDING CAMERA.** C. 1921. SIZE 3¼ X 4¼ INCH EXPOSURES ON ROLL FILM. SIMILAR TO THE NO. 1A REXO FOLDING CAMERA WITH THE SAME LENSES AND SHUTTERS.

(282)  **NO. 3A REXO FOLDING CAMERA.** C. 1921. SIZE 3¼ X 5½ INCH EXPOSURES ON ROLL FILM. SIMILAR TO THE NO. 1A REXO FOLDING CAMERA WITH THE SAME LENSES AND SHUTTERS PLUS F 6.8 VOIGTLANDER RADIAR ANASTIGMAT LENS AND ILEX UNIVERSAL SHUTTER; ⅕ TO ⅟₁₅₀ SEC.

(283)  **NO. 1A REXO JUNIOR FOLDING CAMERA.** C. 1915. SIZE 2½ X 4¼ INCH EXPOSURES ON ROLL FILM. SIMILAR TO THE NO. 3 REXO JUNIOR FOLDING CAMERA WITH THE SAME LENSES AND SHUTTER.

(284)  **NO. 2C REXO JUNIOR FOLDING CAMERA.** C. 1915. SIZE 2⅞ X 4⅞ INCH EXPOSURES ON ROLL FILM. SIMILAR TO THE NO. 3 REXO JUNIOR FOLDING CAMERA WITH THE SAME LENSES AND SHUTTER.

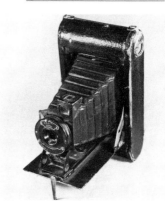

(285)  **NO. 3 REXO JUNIOR FOLDING CAMERA.** C. 1915. SIZE 3¼ X 4¼ INCH EXPOSURES ON ROLL FILM. SINGLE ACHROMATIC OR DOUBLE RECTILINEAR LENS. ILEX SHUTTER; ½₅ TO ⅟₁₀₀ SEC., B., T.  (DJ)

(286)  **REXO VEST POCKET CAMERA.** C. 1915. F 7.5 WOLLENSAK ANASTIGMAT LENS. ULTEX SHUTTER.

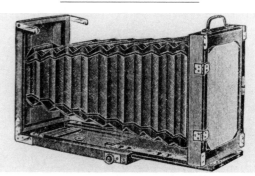

(287)  **REXO VIEW CAMERA.** C. 1932. SIZE 5 X 7 INCH EXPOSURES ON PLATES. F 8 VOLTAS, F 6.3 OR F 4.5 WOLLENSAK VELOSTIGMAT, F 4.5 SCHNEIDER XENAR, OR F 6.8 SCHNEIDER SYMMAR LENS. BETAX OR COMPOUND SHUTTER. RISING LENS MOUNT. DOUBLE SWING BACK. RACK & PINION FRONT AND REAR FRAMES. CENTER SWING GROUND GLASS FRAME.

(288)  **REXOETTE BOX CAMERA.** C. 1910. SIZE 2¼ X 3¼ INCH EXPOSURES.

(289)  **ROYAL PANORAM 120 CAMERA.**

(290)  **IDEAL VIEW CAMERA.** SIZE 6½ X 8½ INCH EXPOSURES. F 6.8 LENS.

(291)  **WATSON 35 CANDID CAMERA.** C. 1940. SIZE 24 X 36 MM EXPOSURES ON "35MM" ROLL FILM.

## BURKE & JAMES, INC. (cont.)

F 2 OR F 2.8 ZEISS BIOTAR, F 2 SCHNEIDER XENON, OR F 2.9 STEINHEIL CASSAR LENS. COMPUR-S SHUTTER; 1 TO 1/300 SEC., B., T. OR COMPUR RAPID SHUTTER; 1 TO 1/500 SEC., B., T. EXPOSURE COUNTER. PARALLAX ADJUSTMENT.

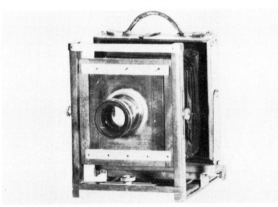

(292) **VIEW CAMERA.** C. 1915. SIZE 5 X 7 INCH EXPOSURES. (JW)

(293) **WATSON COMMERCIAL VIEW CAMERA.** C. 1940. SIZE 5 X 7 INCH DOWN TO SIZE 2¼ X 3¼ INCH EXPOSURES (BY MEANS OF REDUCING BACKS) ON CUT FILM. DOUBLE EXTENSION BELLOWS. GROUND GLASS FOCUSING. SWING BACK. RISING AND FALLING FRONT.

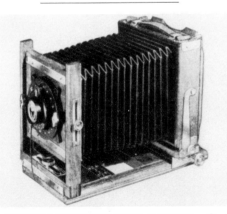

(294) **WATSON PORTRAIT VIEW CAMERA.** C. 1940. SIZE 5 X 7 INCH DOWN TO SIZE 2¼ X 3¼ INCH EXPOSURE (BY MEANS OF REDUCING BACKS) ON CUT FILM. F 7.5 SPECIAL ANASTIGMAT, F 6.8 GOERZ DAGOR, OR F 4.5 ANASTIGMAT LENS. SELF-COCKING SHUTTER; 1 TO 1/100 SEC., B., T. OR 1/25 TO 1/100 SEC., B., T. GROUND GLASS FOCUSING. SWING BACK. RACK & PINION FOCUSING. RISING, FALLING, AND CROSSING LENS MOUNT.

(295) **WESTON CANDID R.F. CAMERA.** C. 1940. TWO SIZES OF THIS CAMERA FOR 1⅝ X 2½ OR 1³⁄₁₆ X 1⁹⁄₁₆ INCH EXPOSURES ON ROLL FILM. F 3.5 TRIOPLAN LENS IN THE 1⅝ X 2½ INCH EXPOSURE MODEL. F 4.5 OR F 2.9 ANASTIGMAT LENS IN THE 1³⁄₁₆ X 1⁹⁄₁₆ INCH EXPOSURE MODEL. COMPUR SHUTTER; 1 TO 1/300 SEC., B., T. ALSO, VARIO SHUTTER FOR THE SMALL FORMAT MODEL.

## CANDID CAMERA CORPORATION OF AMERICA

(296) **PERFIX CAMERA.** C. 1936. SIZE 24 X 36 MM EXPOSURES ON "35MM" ROLL FILM. 50 MM/F 3.5 GRAF PERFEXA LENS. OPTICAL EXPOSURE METER. NONCOUPLED RANGEFINDER. (MA)

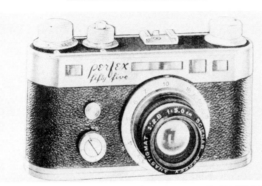

(297) **PERFEX FIFTY-FIVE CAMERA.** SINGLE LENS REFLEX. C. 1940. SIZE 24 X 36 MM EXPOSURES ON "35MM" ROLL FILM. F 2.8 OR F 3.5 SCIENAR ANASTIGMAT LENS. FOCAL PLANE SHUTTER; 1 TO 1/250 SEC., B., T. COUPLED RANGEFINDER. BUILT-IN EXPOSURE METER. BUILT-IN SYNC FLASH. INTERCHANGEABLE LENSES. AUTOMATIC FILM ADVANCE.

(298) **PERFEX FORTY-FOUR CAMERA.** C. 1939. SIZE 24 X 36 MM EXPOSURES ON "35MM" ROLL FILM. SIMILAR TO THE PERFEX FIFTY-FIVE CAMERA.

(299) **PERFEX THIRTY-THREE CAMERA.** C. 1940. SIZE 24 X 36 MM EXPOSURES ON "35MM" ROLL FILM. SIMILAR TO THE PERFEX FIFTY-FIVE CAMERA BUT WITH A 3.5 SCIENAR ANASTIGMAT LENS AND FOCAL PLANE SHUTTER FOR SPEEDS OF 1/25 TO 1/500 SEC.

## CANDID CAMERA SUPPLY COMPANY

(300) **MINIFOTO JUNIOR CAMERA.** C. 1938. SIZE 1¼ X 1⅝ INCH EXPOSURES ON NO. 127 ROLL FILM.

## CENTURY CAMERA COMPANY

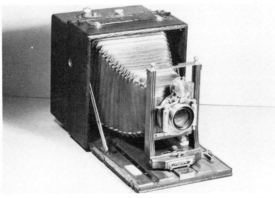

(301) **CIRKUT PANORAMIC CAMERA.** C. 1905. MODEL 46. FIVE-INCH WIDE PANORAMIC EXPOSURES. THE CAMERA IS MOUNTED ON A TRIPOD WITH A SPRING CLOCKWORK AND GEARS FOR ROTATING THE CAMERA AND MOVING THE FILM PAST THE FOCAL PLANE. THE CAMERA ALSO HAS A B & L SHUTTER WITH SPEEDS FROM 3 TO 1/100 SEC. (MR)

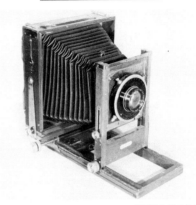

(302) **FIELD CAMERA.** C. 1900. SIZE 5 X 7 INCH EXPOSURES ON PLATES OR SHEET FILM. 8 INCH/F 5.6 COOKE ANASTIGMAT LENS. OPTIMO SHUTTER: 1 TO 1/300 SEC., B., T. (EB)

(303) **NO. 1 FOLDING FIELD CAMERA.** C. 1898. SIZE 4¼ X 6½ INCH EXPOSURES ON PLATES. F/8 NO. 2 HEMISPHERIQUE RAPIDE LENS. REGNO SHUTTER: 1 TO 1/100 SEC., B., T.

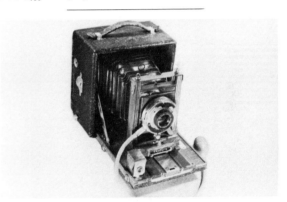

(304) **FOLDING PLATE CAMERA.** C. 1904. SIZE 4 X 5 INCH EXPOSURES ON PLATES. DOUBLE ANASTIGMAT LENS. VOLUTE PNEUMATIC SHUTTER TO 1/150 SEC., B., T. DROP BED. DOUBLE EXTENSION BELLOWS. REVOLVING BACK. (HW)

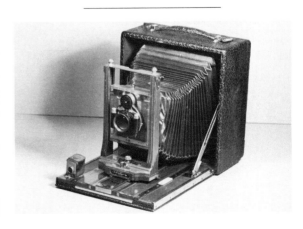

## CENTURY CAMERA COMPANY (*cont.*)

(305) **GRAND CAMERA.** C. 1904. SIZE 5 X 7 INCH EXPOSURES ON PLATES. CENTAR SERIES II LENS. CENTURY SHUTTER. (MR)

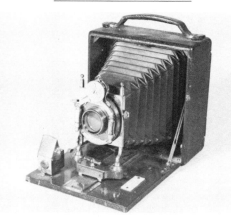

(306) **PREMO-TYPE PLATE CAMERA.** C. 1904. SIZE 4 X 5 INCH EXPOSURES ON PLATES. BAUSCH & LOMB LENS. VICTOR DOUBLE-PNEUMATIC SHUTTER. (SW)

(307) **SUPREME SPECIAL CAMERA.** C. 1900. SIZE 5 X 7 INCH EXPOSURES.

(308) **CENTURY NO. 2 VIEW CAMERA.** C. 1905. SIZE 5 X 7 INCH EXPOSURES.

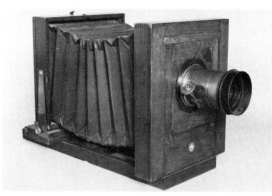

(309) **CENTURY NO. 6 VIEW CAMERA.** C. 1905. SIZE 8 X 10 INCH EXPOSURES. H. LAVERUE (PARIS) LENS. PACKARD SHUTTER. (TH)

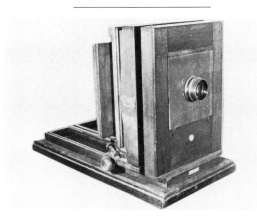

(310) **CENTURY NO. 7 VIEW CAMERA.** C. 1890. SIZE 5 X 7 INCH EXPOSURES ON SHEET FILM. 10¾ INCH/F 5 GOERZ CELOR LENS. LENS-CAP TYPE SHUTTER. (EB)

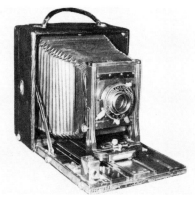

(311) **FOLDING VIEW CAMERA.** C. 1900. SIZE 6½ X 8½ INCH EXPOSURES ON PLATES. B & L ELASTIGMAT LENS. VOLUTE SHUTTER. TRIPLE EXTENSION BELLOWS. (FL)

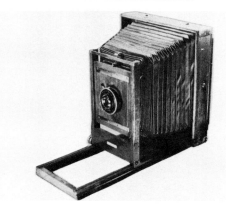

(312) **FOLDING VIEW CAMERA.** C. 1902. SIZE 8 X 10 INCH EXPOSURES ON PLATES. 135 MM/F 4.5 ZEISS TESSAR LENS. DECKEL MUNCHEN COMPUR SHUTTER. SWING BACK. REVERSIBLE BACK. (HW)

(313) **RB VIEW CAMERA.** C. 1895. SIZE 5 X 7 INCH PLATE EXPOSURES. BAUSCH AND LOMB OR CYKO LENS. REVOLVING BACK.

## CHICAGO CAMERA COMPANY

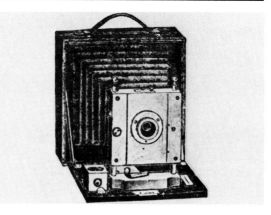

(314) **AMERICAN FOLDING PLATE CAMERA.** C. 1898. SIZE 4 X 5 INCH PLATE EXPOSURES. REVERSIBLE BACK. GROUND GLASS FOCUSING. ACHROMATIC LENS.

(315) **NO. 4 SPECIAL BOX CAMERA.** C. 1898. SIZE 4 X 5 INCH EXPOSURES ON PLATES. DOUBLE ACHROMATIC LENS.

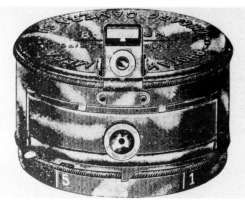

(316) **PHOTAKE CAMERA.** C. 1896. IMPROVED MODEL IN 1897. FIVE 2 X 2 INCH EXPOSURES ON GLASS PLATES. 4.5 INCH/F 14 ACHROMATIC LENS. GUILLOTINE SAFETY SHUTTER FOR INSTANT AND TIME EXPOSURES. THE FIVE PLATES ARE MOUNTED VERTICALLY SIDE-BY-SIDE AROUND THE INNER WALL OF THE CAMERA. BY ROTATING THE LOWER SECTION OF THE CAMERA WITH RESPECT TO THE UPPER SECTION, EACH PLATE IN TURN CAN BE POSITIONED OPPOSITE THE LENS FOR EXPOSURE.

## CHICAGO FERROTYPE COMPANY

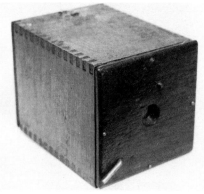

(317) **DAYDARK BOX CAMERA.** C. 1910. SIZE 2¼ X 2½ INCH EXPOSURES. F 11 LENS. INSTANT SHUTTER. (JS)

(318) **DAYDARK CAMERA.** C. 1910 TIN-TYPE BUTTON EXPOSURES.

## CHICAGO FERROTYPE COMPANY *(cont.)*

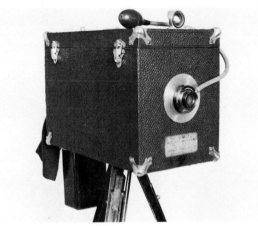

**(319)  MANDEL CAMERA.** C. 1910. FERROTYPE EXPO-SURES ARE DEVELOPED AND FIXED IN SOLUTIONS CONTAINED IN THE BOTTOM OF THE CAMERA. (TH)

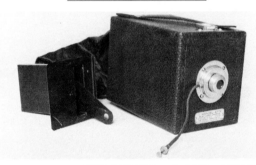

**(320)  MANDEL-ETTE CAMERA.** C. 1913. SIZE 2½ X 3½ INCH EXPOSURES ON DIRECT POSITIVE PAPER. 4-INCH/F 6 MENISCUS LENS. SCISSORS-TYPE TWO-LEAF SHUTTER FOR BULB EXPOSURES ONLY. THE EXPOSED PAPER CARDS ARE DROPPED THROUGH A SLOT IN THE BOTTOM OF THE CAMERA INTO A TANK CONTAINING DEVELOPING AND FIXING SOLUTIONS. (TH)

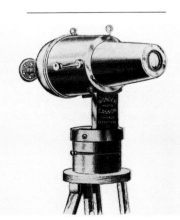

**(321)  WONDER CANNON FERROTYPE CAMERA.** C. 1910. THE CAMERA HOLDS 100 METAL FILM PLATES, ONE-INCH IN DIAMETER. AFTER EXPOSURE, EACH PLATE WAS DROPPED INTO THE TANK AT THE BASE OF THE CAMERA WHERE IT WAS DEVELOPED AND FIXED.

## CIRO INCORPORATED

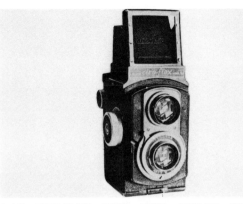

**(322)  CIRO-FLEX TWIN LENS REFLEX CAMERA.** C. 1940. ORIGINAL MODEL. SIZE 2¼ X 2¼ INCH EXPO-SURES ON NO. 120 ROLL FILM. VELOSTIGMAT LENS. ALPHAX SHUTTER: ⅒ to ¹⁄₂₀₀ SEC.

## CLAY, HENRY

**(323)  PLATE CAMERA.** C. 1892. SIZE 5 X 7 INCH EXPO-SURES. RISING, FALLING, CROSSING, TILTING, AND SWINGING LENS AND SHUTTER MOUNT.

## CONLEY CAMERA COMPANY

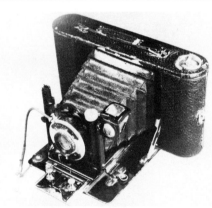

**(324)  AUTEX FOLDING CAMERA.** C. 1915. SIZE 3¼ X 4¼ INCH EXPOSURES ON ROLL FILM. F 8 EQUIVA-LENT FOCUS RAPID RECTILINEAR LENS. WOLLENSAK SHUTTER: 1 TO ¹⁄₁₀₀ SEC., B., T. (DJ)

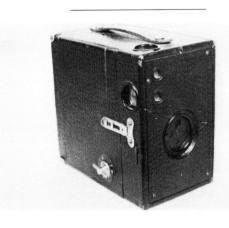

**(325)  NO. 2A KEWPIE BOX CAMERA.** C. 1920. SIZE 2½ X 4¼ INCH EXPOSURES ON ROLL FILM. INSTANT AND TIME SHUTTER. (JS)

**(326)  NO. 2 KEWPIE BOX CAMERA.** C. 1920. THE CAM-ERA USES NO. 120 ROLL FILM. FOUR ROTARY APER-TURE STOPS. SINGLE-SPEED SHUTTER.

**(327)  NO. 2C KEWPIE BOX CAMERA.** C. 1920.

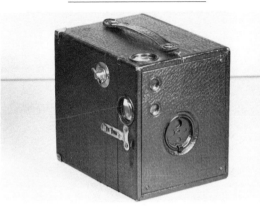

**(328)  NO. 3 KEWPIE BOX CAMERA.** C. 1920. SIZE 3¼ X 4¼ INCH EXPOSURES ON ROLL FILM. MENISCUS LENS. ROTARY SHUTTER. (MR)

**(329)  NO. 3A KEWPIE BOX CAMERA.** C. 1920. THE CAMERA USES NO. 122 ROLL FILM.

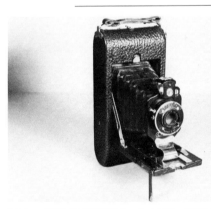

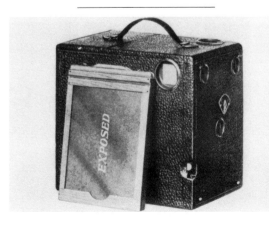

**(330)  JUNIOR CAMERA.** C. 1920. SIZE 2¼ X 3¼ INCH EXPOSURES ON ROLL FILM. 4¼ INCH/F 8 RAPID REC-TILINEAR LENS. VICTO SHUTTER. (MR)

## CONLEY CAMERA COMPANY (*cont.*)

**(331) MODEL I BOX CAMERA.** C. 1910. SIZE 4 X 5 INCH EXPOSURES ON PLATES. F 16 MENISCUS ACHROMATIC LENS. INSTANT AND TIME SHUTTER.

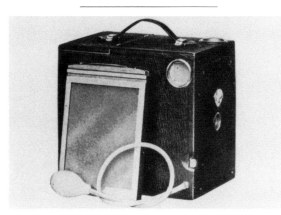

**(332) MODEL II BOX CAMERA.** C. 1910. SIZE 4 X 5 INCH EXPOSURES ON PLATES. F 16 UNIVERSAL FOCUS ACHROMATIC LENS. PNEUMATIC INSTANT AND TIME SHUTTER.

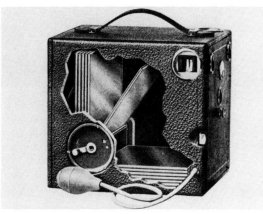

**(333) MODEL III MAGAZINE BOX CAMERA.** C. 1910. SIZE 4 X 5 INCH EXPOSURES ON PLATES. THE MAGAZINE HOLDS 12 PLATES. F 16 UNIVERSAL FOCUS ACHROMATIC LENS. PNEUMATIC INSTANT AND TIME SHUTTER.

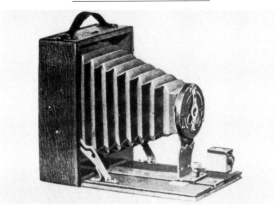

**(334) MODEL IV FOLDING CAMERA.** C. 1910. SIZE 4 X 5 INCH EXPOSURES ON PLATES. REAR GROUND

GLASS FOR FINE FOCUSING. F16 MENISCUS ACHROMATIC LENS. INSTANT AND TIME SHUTTER. THREE APERTURE STOPS.

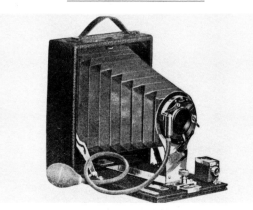

**(335) MODEL V FOLDING CAMERA.** C. 1910. TWO SIZES OF THIS CAMERA FOR 3¼ X 4¼ OR 4 X 5 INCH EXPOSURES ON PLATES. F 16 SINGLE ACHROMATIC LENS. WOLLENSAK JUNIOR AUTOMATIC PNEUMATIC SHUTTER FOR INSTANT, B., T. EXPOSURES. GROUND GLASS FOCUSING.

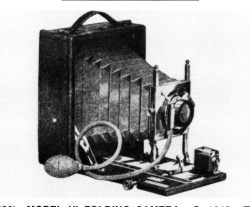

**(336) MODEL VI FOLDING CAMERA.** C. 1910. TWO SIZE OF THIS CAMERA FOR 3¼ X 5½ OR 4 X 5 INCH EXPOSURES ON PLATES. F 11 DOUBLE RAPID RECTILINEAR LENS. WOLLENSAK SENIOR AUTOMATIC SHUTTER; INSTANT, B., T. GROUND GLASS FOR FINE FOCUSING. RACK & PINION FOCUSING.

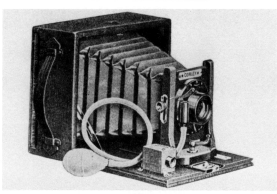

**(337) MODEL VII FOLDING CAMERA.** C. 1910. TWO SIZES OF THIS CAMERA FOR 4 X 5 OR 5 X 7 INCH EXPOSURES ON PLATES. F 11 DOUBLE RECTILINEAR LENS. WOLLENSAK JUNIOR PNEUMATIC SHUTTER FOR IN-

STANT, BULB, AND TIME EXPOSURES. GROUND GLASS FOCUSING.

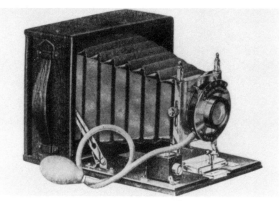

**(338) MODEL VIII FOLDING CAMERA.** C. 1910. TWO SIZES OF THIS CAMERA FOR 4 X 5 OR 5 X 7 INCH EXPOSURES ON PLATES. F 11 DOUBLE RECTILINEAR LENS. CONLEY JUNIOR AUTOMATIC PNEUMATIC SHUTTER; ⅟₂₅, ⅟₅₀, AND ⅟₁₀₀ SEC., B., T. GROUND GLASS FOR FINE FOCUSING.

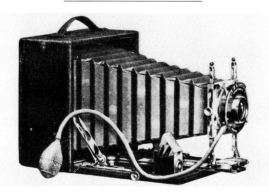

**(339) MODEL IX FOLDING CAMERA.** C. 1910. TWO SIZES OF THIS CAMERA FOR 4 X 5 OR 5 X 7 INCH EXPOSURES ON PLATES. F 11 DOUBLE SYMMETRICAL OR F 8 CONLEY RAPID ORTHOGRAPHIC LENS. CONLEY SAFETY PNEUMATIC OR FINGER RELEASE SHUTTER; 1 to ⅟₁₀₀ SEC., B., T. REVERSIBLE BACK. VERTICAL SWING BACK. RACK & PINION FOCUS. DOUBLE-EXTENSION BELLOWS.

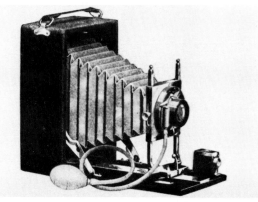

**(340) MODEL X CAMERA.** C. 1910. SIZE 3¼ X 5½ INCH EXPOSURES ON PLATES. F 11 DOUBLE RECTILINEAR LENS. WOLLENSAK JUNIOR SHUTTER WITH PNEU-

## CONLEY CAMERA COMPANY (*cont.*)

MATIC OR FINGER RELEASE; INSTANT, B., T. GLASS FOCUS.

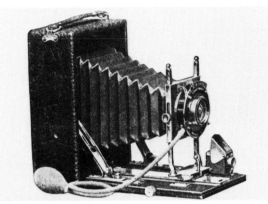

(341) **MODEL XI CAMERA.** C. 1910. SIZE 3¼ X 5½ INCH EXPOSURES ON PLATES. F 11 DOUBLE RAPID RECTILINEAR LENS. CONLEY SAFETY SHUTTER WITH PNEUMATIC OR FINGER RELEASE; 1 TO ⅟₁₀₀ SEC., B., T. RACK & PINION FOCUS. SINGLE SWING BACK. GROUND GLASS FOCUS.

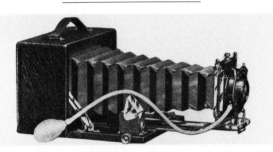

(342) **MODEL XII FOLDING CAMERA.** C. 1910. SIZE 3¼ X 5½ INCH EXPOSURES ON PLATES. F 8 SPECIAL RAPID RECTILINEAR LENS. CONLEY AUTOMATIC SHUTTER WITH PNEUMATIC OR FINGER RELEASE; 1 TO ⅟₁₀₀ SEC., B., T. DOUBLE EXTENSION BELLOWS. RACK & PINION FOCUS. GROUND GLASS FOCUS.

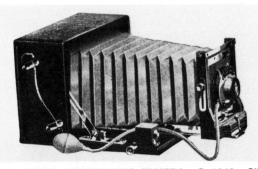

(343) **MODEL XIV FOLDING CAMERA.** C. 1910. SIZE 4¼ X 6½ INCH EXPOSURES ON PLATES. F 11 DOUBLE RAPID RECTILINEAR LENS. CONLEY SAFETY SHUTTER WITH PNEUMATIC OR FINGER RELEASE; 1 TO ⅟₁₀₀ SEC., B., T. DOUBLE EXTENSION BELLOWS. VERTICAL SWING BACK. RACK & PINION FOCUS. GROUND GLASS FOCUS.

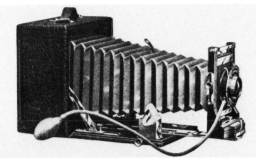

(344) **MODEL XV LONG FOCUS CAMERA.** C. 1910. SIX SIZES OF THIS CAMERA FOR 4 X 5, 3¼ X 5½, 4¼ X 6½, 5 X 7, 6½ X 8½, OR 8 X 10 INCH EXPOSURES ON PLATES. F 8 CONLEY RAPID ORTHOGRAPHIC LENS. CONLEY SAFETY SHUTTER WITH PNEUMATIC OR FINGER RELEASE; 1 TO ⅟₁₀₀ SEC., B., T. REVERSIBLE BACK. VERTICAL SWING BACK. RACK & PINION FOCUSING. DETACHABLE LENS BOARD. GROUND GLASS FOCUSING. DOUBLE EXTENSION BELLOWS.

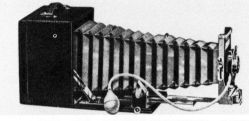

(345) **MODEL XVI DOUBLE-EXTENSION CAMERA.** C. 1910. THREE SIZES OF THIS CAMERA FOR 4 X 5, 5 X 7, OR 6½ X 8½ INCH EXPOSURES ON PLATES. F 8 THREE-FOCUS RAPID CONVERTIBLE OR SERIES V CONLEY ANASTIGMAT LENS. CONLEY AUTOMATIC SHUTTER WITH PNEUMATIC OR FINGER RELEASE; 1 TO ⅟₁₀₀ SEC., B., T. OR KOILOS SHUTTER; 1 TO ⅟₃₀₀ SEC., B., T. ALSO, OPTIMO SHUTTER. TRIPLE EXTENSION BELLOWS. REVERSIBLE BACK. VERTICAL SWING BACK. RACK & PINION FOCUS. DETACHABLE LENS BOARD. AUXILIARY BED. GROUND GLASS FOCUS.

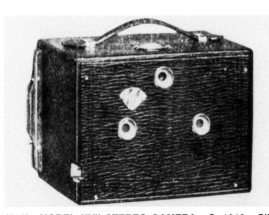

(346) **MODEL XVII STEREO CAMERA.** C. 1910. SIZE 4¼ X 6½ INCH STEREO EXPOSURES ON PLATES. MATCHED SINGLE ACHROMATIC, UNIVERSAL FOCUS LENSES. CONLEY FINGER RELEASE AUTOMATIC SHUTTER FOR INSTANT AND TIME EXPOSURES.

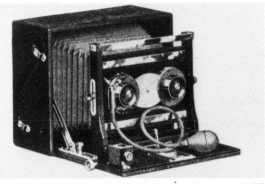

(347) **MODEL XVIII STEREO CAMERA.** C. 1910. SIZE 5 X 7 INCH STEREO EXPOSURES ON PLATES. F 11 HIGH GRADE RAPID RECTILINEAR LENSES. WOLLENSAK SENIOR AUTOMATIC SHUTTER WITH PNEUMATIC OR FINGER RELEASE; INSTANT, B., T. EXPOSURES. RACK & PINION FOCUS. DETACHABLE LENS BOARD. FOLDING AND REMOVABLE SEPTUM. GROUND GLASS FOCUS. A SINGLE LENS AND SHUTTER CAN BE MOUNTED ON THE LENS BOARD FOR TAKING SINGLE 5 X 7 INCH EXPOSURES.

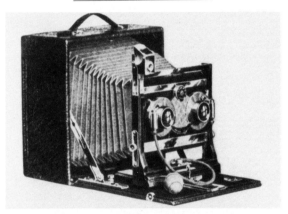

(348) **MODEL XIX STEREO CAMERA.** C. 1910. SIZE 5 X 7 INCH STEREO EXPOSURES ON PLATES. F 8 DOUBLE SYMMETRICAL SERIES V ANASTIGMAT OR CONLEY RAPID ORTHOGRAPHIC LENSES. WOLLENSAK REGULAR STEREOSCOPIC SHUTTER; 1 to ⅟₁₀₀ SEC., B., T. OR CONLEY SAFETY SHUTTER; 1 TO ⅟₁₀₀ SEC., B., T. REVERSIBLE BACK. RACK & PINION FOCUS. REMOVABLE LENS BOARD. REMOVABLE SEPTUM. A SINGLE LENS AND SHUTTER CAN BE MOUNTED ON THE LENS BOARD FOR TAKING SINGLE 5 X 7 EXPOSURES.

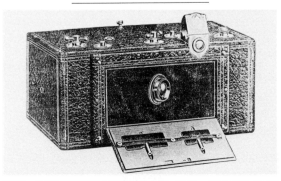

(349) **PANORAMIC CAMERA.** C. 1913. SIZE 3½ X 12 INCH PANORAMIC EXPOSURES ON ROLL FILM. RAPID

## CONLEY CAMERA COMPANY (cont.)

RECTILINEAR LENS. IRIS DIAPHRAGM. EXPOSURE SPEEDS OF ⅙, ¹⁄₁₂, ¹⁄₂₅, AND ¹⁄₅₀ SEC. BY USE OF AIR-BRAKE VANES.

(350) **SUCCESS MAGAZINE CAMERA.** C. 1904. SIZE 4 X 5 INCH PLATE EXPOSURES. SIMPLE LENS. SINGLE-SPEED ROTARY SHUTTER. DROP-PLATE CHANGE MAGAZINE. (MA)

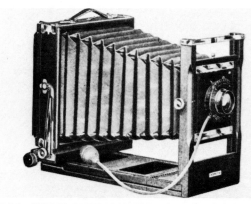

(351) **MODEL B VIEW CAMERA.** C. 1910. THREE SIZES OF THIS CAMERA FOR 5 X 7, 6½ X 8½, OR 8 X 10 INCH EXPOSURES ON PLATES. THREE-FOCUS RAPID RECTILINEAR LENS. CONLEY SAFETY SHUTTER; 1 to ¹⁄₁₀₀ SEC., B., T. REVERSIBLE BACK. VERTICAL SWING BACK. RACK & PINION FOCUS. DETACHABLE LENS BOARD. GROUND GLASS FOCUS.

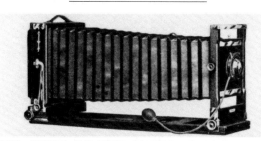

(352) **MODEL B.S. VIEW CAMERA.** C. 1910. THREE SIZES OF THIS CAMERA FOR 5 X 7, 6½ X 8½, OR 8 X 10 INCH EXPOSURES ON PLATES. THREE-FOCUS RAPID RECTILINEAR OR SERIES V ANASTIGMAT LENS. CONLEY SAFETY SHUTTER; 1 TO ¹⁄₁₀₀ SEC., B., T. OR KOILOS SHUTTER; 1 TO ¹⁄₃₀₀ SEC., B., T. ALSO, OPTIMO SHUTTER. REVERSIBLE BACK. DOUBLE SWING BACK. RACK & PINION FOCUS. DETACHABLE BED. QUARTER-PLATE EXPOSURE DIVIDER. GROUND GLASS FOCUS.

## CROWN CAMERA COMPANY

(353) **CROWN BOX CAMERA.** C. 1910. SIZE 1¼ X 1½ INCH EXPOSURES ON PLATES IN PAPER HOLDERS. MENISCUS LENS. SIMPLE SHUTTER.

## CURTIS, THOMAS C. LABORATORIES

(354) **CURTIS COLOR SCOUT 3-COLOR CAMERA.** C. 1939. SIZE 2¼ X 3¼ INCH EXPOSURES ON 3-COLOR FILM. F 6.3 BAUSCH & LOMB TESSAR OR F 4.5 GOERZ DOGMAR LENS. COMPUR OR COMPOUND SHUTTER.

## DEARDORFF, L. F. & SONS

(355) **PRECISION VIEW CAMERA.** C. 1940. SIZE 4 X 5 INCH EXPOSURES ON ROLL, SHEET, OR PLATE FILM. SIMILAR TO THE DEARDORFF TRIAMAPRO VIEW CAMERA. THE CAMERA IS USED FOR PRECISION COLOR PHOTOGRAPHY, COPYING, ETC.

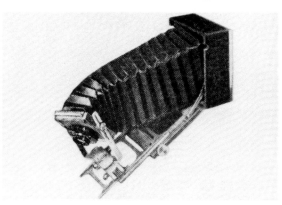

(356) **TRIAMAPRO VIEW CAMERA.** C. 1940. SIZE 4 X 5 INCH EXPOSURES ON PLATES, CUT FILM, FILM PACKS, OR ROLL FILM WITH ADAPTER. F 4.5 LENS. NO. 3 COMPOUND SHUTTER. SYNC. FLASH. RANGEFINDER. TRIPLE EXTENSION BELLOWS. RISING, FALLING, AND CROSSING LENS MOUNT. DROPPING BED. REVOLVING BACK.

(357) **VIEW CAMERA.** C. 1932. TWO SIZES OF THIS CAMERA FOR 5 X 7 OR 8 X 10 INCH EXPOSURES ON PLATES. F 4.5 WOLLENSAK, F 4.5 ZEISS TESSAR, F 6.8 SCHNEIDER SYMMAR, WOLLENSAK VELOSTIGMAT, OR TURNER-REICH SERIES II LENS. BETAX, COMPUR, OR UNIVERSAL SHUTTER.

## DETROLA CORPORATION

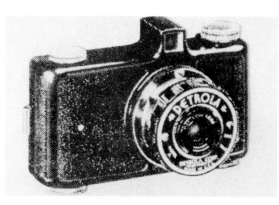

(358) **DETROLA MODEL A CAMERA.** C. 1940. SIZE 1⅝ X 1¼ INCH EXPOSURES ON NO. 127 OR A-8 ROLL FILM. MENISCUS LENS. FIXED FOCUS.

(359) **DETROLA MODEL B CAMERA.** C. 1940. SIZE 1⅝ X 1¼ INCH EXPOSURES ON NO. 127 OR A-8 ROLL FILM. SIMILAR TO THE DETROLA MODEL D BUT WITH F 7.9 FIXED-FOCUS LENS AND INSTANT, B., T. SHUTTER.

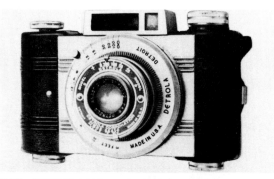

(360) **DETROLA MODEL D CAMERA.** C. 1938. SIZE 1⅝ X 1¼ INCH EXPOSURES ON NO. 127 ROLL FILM. F 4.5 DETROLA ANASTIGMAT LENS. ILEX SHUTTER; ¹⁄₂₅ TO ¹⁄₂₀₀ SEC., B., T. (TS)

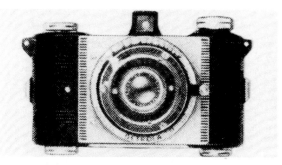

(361) **DETROLA MODEL G CAMERA.** C. 1940. SIZE 1⅝ X 1¼ INCH EXPOSURES ON NO. 127 OR A-8 ROLL FILM. F 4.5 ANASTIGMAT LENS. ILEX SHUTTER; ¹⁄₂₅ TO ¹⁄₂₀₀ SEC., B., T. HELICAL FOCUSING.

(362) **DETROLA MODEL GW CAMERA.** C. 1940. SIZE 1⅝ X 1¼ INCH EXPOSURES ON NO. 127 OR A-8 ROLL FILM. SAME AS THE MODEL G BUT WITH F 4.5 WOLLENSAK VELOSTIGMAT LENS.

(363) **DETROLA MODEL HW CAMERA.** C. 1940. SIZE 1⅝ X 1¼ INCH EXPOSURES ON NO. 127 OR A-8 ROLL FILM. SAME AS THE MODEL G BUT WITH BUILT-IN EXPOSURE METER.

(364) **DETROLA MODEL KW CAMERA.** C. 1940. SIZE 1⅝ X 1¼ INCH EXPOSURES ON NO. 127 OR A-8 ROLL FILM. SAME AS THE MODEL HW BUT WITH F 3.5 WOLLENSAK VELOSTIGMAT LENS.

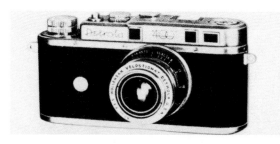

## DETROLA CORPORATION (*cont.*)

(365) **DETROLA "400" CAMERA.** C. 1940. SIZE 24 X 36 MM EXPOSURES ON "35MM" ROLL FILM. 50 MM/F 3.5 WOLLENSAK VELOSTIGMAT LENS. FOCAL PLANE SHUTTER; $\frac{1}{25}$ TO $\frac{1}{1500}$ SEC. COUPLED RANGEFINDER. INTERCHANGEABLE LENSES. AUTOMATIC FILM ADVANCE. EXPOSURE COUNTER.

## DEVIN COLORGRAPH COMPANY

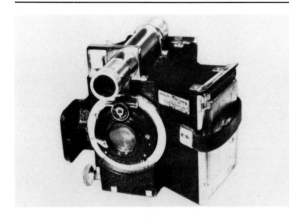

(366) **DEVIN ONE-SHOT COLOR CAMERA.** C. 1939. SIZE 2¼ X 3¼ INCH COLOR EXPOSURES ON PANCHROMATIC PLATES. 140 MM/F 4.5 GOERZ DAGOR OR 135 MM/F 4.5 MEYER ARISTOSTIGMAT LENS. COMPUR SHUTTER; 1 TO $\frac{1}{200}$ SEC., ST. COUPLED ACHROMATIC RANGEFINDER. OPTICAL GLASS FOR FOCUSING. (HA)

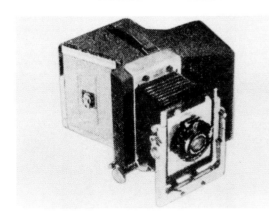

(367) **DEVIN ONE-SHOT COLOR CAMERA.** C. 1940. SIZE 5 X 7 INCH COLOR EXPOSURES ON PANCHROMATIC PLATES. RISING, FALLING, SWINGING, AND TILTING LENS MOUNT. OPTICAL PLATE FOR FOCUSING.

## DOWE, L.

(368) **DETECTIVE BOX CAMERA.** C. 1890.

## DRUCKER, ALBERT & COMPANY

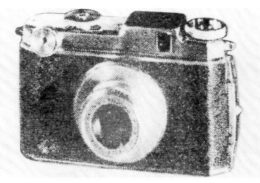

(369) **RANGER MODEL I CAMERA.** C. 1940. SIZE 1¼ X 1⅝ INCH EXPOSURES ON NO. 127 ROLL FILM. 50 MM/F 2.8 OR 50 MM/F 2 POLARIS ANASTIGMAT LENS. FOCAL PLANE SHUTTER; $\frac{1}{25}$ TO $\frac{1}{500}$ SEC. HELICAL FOCUSING. EYE-LEVEL FINDER.

## DUNKER'S VE-JA-DE PRODUCTS

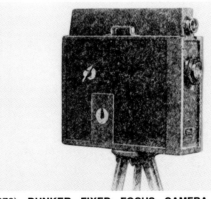

(370) **DUNKER FIXED FOCUS CAMERA.** C. 1932. SIZE 1⅜ X 2⅛ INCH EXPOSURES ON "35MM" ROLL FILM. THE CAMERA TAKES 950 EXPOSURES ON 200-FOOT FILM ROLLS. ONE LENS SERVES AS A FINDER AND A SECOND LENS AS THE TAKING LENS. F 4.5 VELOSTIGMAT LENS. BETAX SHUTTER; ½ TO $\frac{1}{100}$ SEC., B., T.

## EASTMAN DRY PLATE & FILM COMPANY

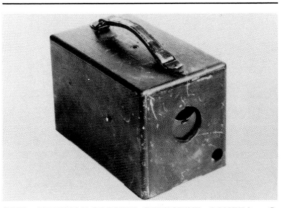

(371) **EASTMAN-COSSITT DETECTIVE CAMERA.** C. 1886. SIZE 4 X 5 INCH EXPOSURES ON PLATES OR ROLL FILM BY USE OF THE EASTMAN-WALKER ROLL HOLDER. THE UNIQUE BEHIND-THE-LENS SHUTTER CONSISTS OF A WEDGE-SHAPED CHAMBER WITH THE WIDE PART OF THE WEDGE POSITIONED JUST BEHIND THE LENS AND THE NARROW PART CLOSE TO

THE PLATE OR FILM SURFACE. WHEN THE SHUTTER IS RELEASED, THE NARROW PART OF THE WEDGE, CONTAINING A SLIT OPENING, SWEEPS ACROSS THE PLATE OR FILM AREA. FIFTY CAMERAS WERE MADE AND MOST WERE SOLD TO A DEALER NAMED W. H. WALMSLEY FOR $50 FOR THE LOT. THE ONLY KNOWN SAMPLE OF THIS CAMERA IS AT THE SMITHSONIAN INSTITUTION, WASHINGTON, D.C. (SI)

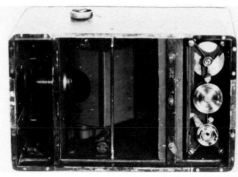

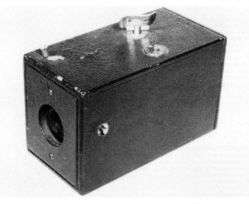

(372) **ORIGINAL MODEL KODAK BOX CAMERA.** C. 1888–89. SIZE 2½ INCH DIAMETER EXPOSURES ON ROLL FILM. THE CAMERA WAS FACTORY LOADED WITH ROLL FILM FOR 100 EXPOSURES. FIXED FOCUS 57 MM/F 9 RAPID RECTILINEAR LENS. STRING-SETTING BARREL-DESIGN SHUTTER FOR SINGLE SPEED EXPOSURE (ABOUT $\frac{1}{20}$ SECOND). THE CAMERA HAS NO VIEW FINDER. (GE)

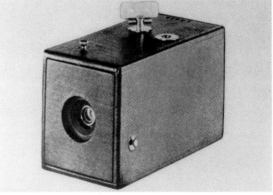

(373) **NO. 1 KODAK BOX CAMERA.** C. 1889. SIZE 2½ INCH DIAMETER EXPOSURES ON ROLL FILM. THE CAMERA WAS FACTORY LOADED WITH ROLL FILM FOR 100 EXPOSURES. PERISCOPIC LENS. STRING-SETTING SECTOR SHUTTER.

## EASTMAN DRY PLATE & FILM COMPANY (*cont.*)

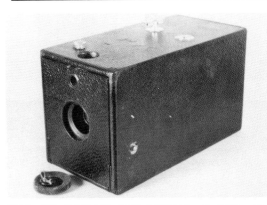

(374) **NO. 2 KODAK BOX CAMERA.** C. 1889. 60 OR 100 EXPOSURES, SIZE 3½ INCH DIAMETER ON ROLL FILM. THE CAMERA WAS FACTORY LOADED WITH ROLL FILM. PERISCOPIC LENS. STRING-SETTING SECTOR SHUTTER. THREE ROTARY APERTURE STOPS. EXPOSURE COUNTER. CIRCULAR GROUND GLASS VIEWER.

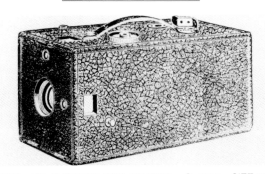

(375) **NO. 3 KODAK BOX CAMERA.** C. 1889. SIZE 3¼ X 4¼ INCH EXPOSURES ON ROLL FILM. THE CAMERA WAS FACTORY LOADED WITH FILM FOR 60 OR 100 EX-POSURES. BAUSCH & LOMB UNIVERSAL LENS. STRING-SETTING SECTOR SHUTTER. THREE ROTARY APERTURE STOPS. RACK & PINION FOCUSING.

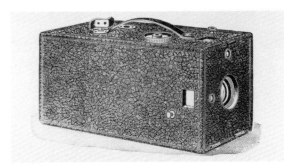

(376) **NO. 4 KODAK BOX CAMERA.** C. 1889. SIZE 4 X 5 INCH EXPOSURES ON ROLL FILM. THE CAMERA WAS FACTORY LOADED WITH FILM FOR 48 OR 100 EX-POSURES. BAUSCH & LOMB UNIVERSAL LENS. STRING-SETTING SECTOR SHUTTER. THREE ROTARY APERTURE STOPS. RACK & PINION FOCUS.

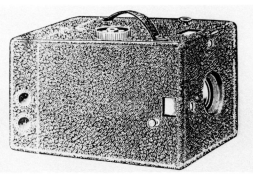

(377) **NO. 3 KODAK JUNIOR BOX CAMERA.** C. 1889. SIZE 3¼ X 4¼ INCH EXPOSURES ON ROLL FILM. THE CAMERA WAS FACTORY LOADED WITH FILM FOR 60 EXPOSURES. BAUSCH & LOMB UNIVERSAL LENS. STRING-SETTING SECTOR SHUTTER. THREE ROTARY APERTURE STOPS.

(378) **NO. 4 KODAK JUNIOR BOX CAMERA.** C. 1889. SIZE 4 X 5 INCH EXPOSURES ON ROLL FILM. THE CAM-ERA WAS FACTORY LOADED WITH FILM FOR 48 EXPO-SURES. BAUSCH & LOMB UNIVERSAL LENS. STRING-SETTING SECTOR SHUTTER. THREE ROTARY APER-TURE STOPS. RACK & PINION FOCUSING. SEE PHOTO UNDER EASTMAN COMPANY (THE).

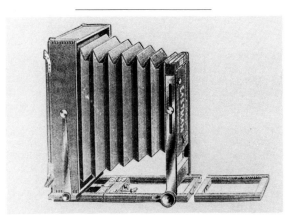

(379) **VIEW CAMERA.** C. 1885–89. THIS CAMERA WAS AVAILABLE IN TWELVE SIZES AS FOLLOWS: 4¼ X 5½, 4¼ X 6½, 5 X 7, 5 X 8, 6½ X 8½, 8 X 10, 10 X 12, 11 X 14, 14 X 17, 17 X 20, 18 X 22, AND 20 X 24 INCH EXPO-SURES. DOUBLE RACK & PINION FOCUS. ATTACHABLE ROLL HOLDER. REVERSIBLE BACK. DOUBLE-SWING BACK.

## EASTMAN COMPANY, THE

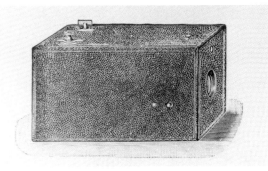

(380) **"A" DAYLIGHT KODAK CAMERA.** C. 1891–92. TWENTY-FOUR EXPOSURES, SIZE 2¾ X 3¼ INCHES ON ROLL FILM. ACHROMATIC LENS. STRING-SETTING SECTOR SHUTTER.

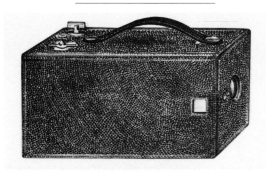

(381) **"B" DAYLIGHT KODAK CAMERA.** C. 1891–92. TWENTY-FOUR EXPOSURES, SIZE 3½ X 4 INCHES ON ROLL FILM. ACHROMATIC LENS. STRING-SETTING SECTOR SHUTTER.

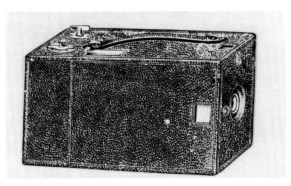

(382) **"C" DAYLIGHT KODAK CAMERA.** C. 1891–92. TWENTY-FOUR EXPOSURES, SIZE 4 X 5 INCHES ON ROLL FILM. ACHROMATIC LENS. STRING-SETTING SECTOR SHUTTER.

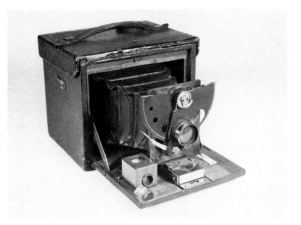

(383) **NO. 4 FOLDING KODAK CAMERA.** C. 1890–92. THE FIRST KODAK FOLDING CAMERA. FORTY-EIGHT EXPOSURES, SIZE 4 X 5 INCHES ON ROLL FILM. BAUSCH & LOMB LENS. BAKER SECTOR SHUTTER. ROTARY APERTURE STOPS. (SW)

## EASTMAN COMPANY, THE (cont.)

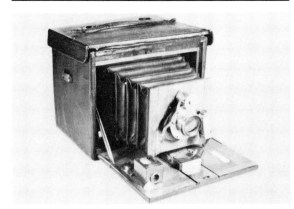

**(384) NO. 5 FOLDING KODAK CAMERA.** C. 1890–92. EARLY MODEL. SIZE 5 X 7 INCH EXPOSURES ON PLATES OR ROLL FILM. BAUSCH & LOMB LENS. BAKER SHUTTER; 5 TO ¹⁄₁₀₀ SEC., TIME. (SW)

**(385) NO. 1 KODAK BOX CAMERA.** C. 1889–92. SIZE 2½ INCH DIAMETER EXPOSURES ON ROLL FILM. THE CAMERA WAS FACTORY LOADED WITH ROLL FILM FOR 100 EXPOSURES. PERISCOPIC LENS. STRING-SETTING SECTOR SHUTTER. SEE PHOTO UNDER EASTMAN DRY PLATE & FILM COMPANY.

**(386) NO. 2 KODAK BOX CAMERA.** C. 1889–92. 60 OR 100 EXPOSURES, SIZE 3½ INCH DIAMETER ON ROLL FILM. THE CAMERA WAS FACTORY LOADED WITH ROLL FILM. PERISCOPIC LENS. STRING-SETTING SECTOR SHUTTER. THREE ROTARY APERTURE STOPS. EXPOSURE COUNTER. CIRCULAR GROUND GLASS VIEWER. SEE PHOTO UNDER EASTMAN DRY PLATE & FILM COMPANY.

**(387) NO. 3 KODAK BOX CAMERA.** C. 1889–92. SIZE 3¼ X 4¼ INCH EXPOSURES ON ROLL FILM. THE CAMERA WAS FACTORY LOADED WITH FILM FOR 60 OR 100 EXPOSURES. BAUSCH & LOMB UNIVERSAL LENS. STRING-SETTING SECTOR SHUTTER. THREE ROTARY APERTURE STOPS. RACK & PINION FOCUSING. SEE PHOTO UNDER EASTMAN DRY PLATE & FILM COMPANY.

**(388) NO. 4 KODAK BOX CAMERA.** C. 1889–92. SIZE 4 X 5 INCH EXPOSURES ON ROLL FILM. THE CAMERA WAS FACTORY LOADED WITH ROLL FILM FOR 48 OR 100 EXPOSURES. BAUSCH & LOMB UNIVERSAL LENS. STRING-SETTING SECTOR SHUTTER. THREE ROTARY APERTURE STOPS. RACK & PINION FOCUS. EXPOSURE COUNTER. SEE PHOTO UNDER EASTMAN DRY PLATE & FILM COMPANY.

**(389) NO. 3 KODAK JUNIOR BOX CAMERA.** C. 1889–92. SIZE 3¼ X 4¼ INCH EXPOSURES ON ROLL FILM. THE CAMERA WAS FACTORY LOADED WITH FILM FOR 60 EXPOSURES. BAUSCH & LOMB UNIVERSAL LENS. STRING-SETTING SECTOR SHUTTER. THREE ROTARY APERTURE STOPS. EXPOSURE COUNTER. SEE PHOTO UNDER EASTMAN DRY PLATE & FILM COMPANY.

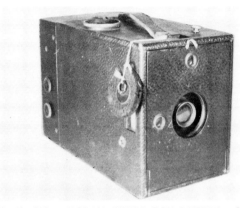

**(390) NO. 4 KODAK JUNIOR BOX CAMERA.** C. 1889–92. SIZE 4 X 5 INCH EXPOSURES ON ROLL FILM. THE CAMERA WAS FACTORY LOADED WITH FILM FOR 48 EXPOSURES. BAUSCH & LOMB UNIVERSAL LENS. STRING-SETTING SECTOR SHUTTER. THREE ROTARY APERTURE STOPS. RACK & PINION FOCUSING. EXPOSURE COUNTER. (SW)

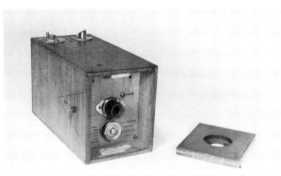

**(391) "A" ORDINARY KODAK BOX CAMERA.** C. 1891–92. TWENTY-FOUR EXPOSURES, SIZE 2¾ X 3¼ INCHES ON ROLL FILM. DARKROOM FILM-LOADING TYPE. ACHROMATIC LENS. STRING-SETTING SECTOR SHUTTER. (SW)

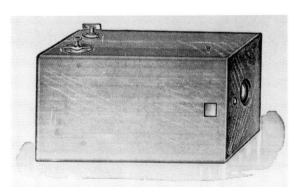

**(392) "B" ORDINARY KODAK BOX CAMERA.** C. 1891–92. TWENTY-FOUR EXPOSURES, SIZE 3½ X 4 INCHES ON ROLL FILM. DARKROOM FILM-LOADING TYPE. ACHROMATIC LENS. STRING-SETTING SECTOR SHUTTER.

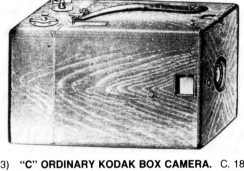

**(393) "C" ORDINARY KODAK BOX CAMERA.** C. 1891–92. TWENTY-FOUR EXPOSURES, SIZE 4 X 5 INCHES ON ROLL FILM. ACHROMATIC LENS. STRING-SETTING SECTOR SHUTTER.

**(394) SPECIAL GLASS PLATE KODAK CAMERA "C."** C. 1891–92. Size 4 X 5 INCH EXPOSURES ON GLASS PLATES.

**(395) VIEW CAMERA.** C. 1889–92. THIS CAMERA WAS AVAILABLE IN 12 MODEL SIZES AS FOLLOWS: 4¼ X 5½, 4¼ X 6½, 5 X 7, 5 X 8, 6½ X 8½, 8 X 10, 10 X 12, 11 X 14, 14 X 17, 17 X 20, 18 X 22, AND 20 X 24 INCH EXPOSURES. DOUBLE RACK & PINION FOCUS. ATTACHABLE ROLL HOLDER. REVERSIBLE BACK. DOUBLE SWING BACK. SEE PHOTO UNDER EASTMAN DRY PLATE & FILM COMPANY.

## EASTMAN KODAK COMPANY

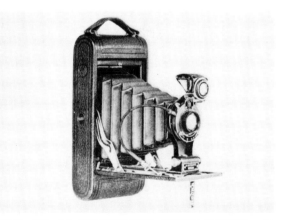

**(396) NO. 1A AUTOGRAPHIC KODAK CAMERA.** C. 1914–24. SIZE 2½ X 4¼ INCH EXPOSURES ON NO. A116 ROLL FILM. F 7.7 RAPID RECTILINEAR, F 7.7 OR F 8 KODAK ANASTIGMAT, OR F 6.3 COOKE KODAK ANASTIGMAT LENS. KODAK BALL-BEARING SHUTTER; ¹⁄₂₅ TO ¹⁄₁₀₀ SEC., B., T. KODAK AUTOMATIC SHUTTER; 1 TO ¹⁄₁₀₀ SEC., B., T. OR BAUSCH & LOMB COMPOUND SHUTTER.

## EASTMAN KODAK COMPANY (*cont.*)

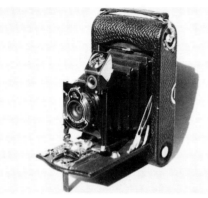

**(397)  NO. 3 AUTOGRAPHIC KODAK CAMERA.**  C. 1914–26.  SIZE 3¼ X 4¼ INCH EXPOSURES ON NO. A118 ROLL FILM.  F 7.7 RAPID RECTILINEAR, F 7.7 KODAK ANASTIGMAT, F 6.3 COOKE KODAK ANASTIGMAT, F 8 KODAK ANASTIGMAT, OR F 7.9 KODAK LENS.  KODAK BALL-BEARING SHUTTER; ¹⁄₂₅ TO ¹⁄₁₀₀ SEC., B., T., KODAK AUTOMATIC SHUTTER; 1 TO ¹⁄₁₀₀ SEC., B., T, BAUSCH & LOMB COMPOUND, KODEX, OR DIOMATIC SHUTTER.  (KC)

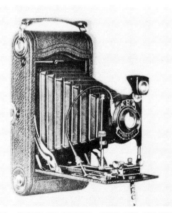

**(398)  NO. 3A AUTOGRAPHIC KODAK CAMERA.**  C. 1914–34.  SIZE 3¼ X 5½ INCH EXPOSURES ON NO. A122 ROLL, SHEET, OR PLATE FILM.  RAPID RECTILINEAR, F 6.3 COOKE KODAK ANASTIGMAT, F 7.7 KODAK ANASTIGMAT, F 7.9 KODAR, OR F 6.3 KODAK ANASTIGMAT LENS.  KODAK BALL-BEARING; ¹⁄₂₅ TO ¹⁄₁₀₀ SEC., B., T.  ALSO, BAUSCH & LOMB COMPOUND, KODAK AUTOMATIC, ILEX UNIVERSAL; 1 TO ¹⁄₁₀₀ SEC., B., T.; MULTIPLE SPEED, KODEX; ¹⁄₂₅, ¹⁄₅₀ SEC., B., T.; OR DIOMATIC SHUTTER; ¹⁄₁₀ TO ¹⁄₁₀₀ SEC., B., T.  INTERCHANGEABLE BACK FOR USE WITH SHEET OR PLATE FILM.

**(399)  NO. 1A AUTOGRAPHIC KODAK JUNIOR CAMERA.**  C. 1914–26.  SIZE 2½ X 4¼ INCH EXPOSURES ON NO. A116 ROLL FILM.  F 7.7 MENISCUS ACHROMATIC, F4 RAPID RECTILINEAR, F 7.7 KODAK ANASTIGMAT, OR F 7.9 KODAR LENS.  KODAK BALL-BEARING SHUTTER; ¹⁄₂₅, ¹⁄₅₀, ¹⁄₁₀₀ SEC., B., T.  ALSO, ILEX UNIVERSAL, MULTIPLE SPEED, KODEX, OR DIOMATIC SHUTTER.  SIMILAR TO THE NO. 1 AUTOGRAPHIC KODAK JUNIOR CAMERA.

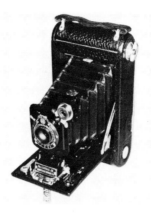

**(400)  NO. 1 AUTOGRAPHIC KODAK JUNIOR CAMERA.**  C. 1914–26.  SIZE 2¼ X 3¼ INCH EXPOSURES ON NO. A120 ROLL FILM.  ACHROMATIC (FIXED FOCUS), F 7.7 RAPID RECTILINEAR, F 7.7 KODAK ANASTIGMAT, OR F 7.9 RODAR LENS.  KODAK BALL-BEARING SHUTTER; ¹⁄₂₅, ¹⁄₅₀, SEC., B., T.  (PLUS ¹⁄₁₀₀ SEC., ON SOME MODELS).  ALSO, DIOMATIC OR KODEX SHUTTER.

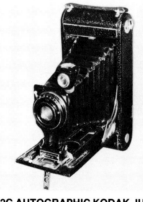

**(401)  NO. 2C AUTOGRAPHIC KODAK JUNIOR CAMERA.**  C. 1916–27.  SIZE 2⅞ X 4⅞ INCH EXPOSURES ON NO. A130 ROLL FILM.  SAME LENSES AND SHUTTERS AS THE NO. 1 AUTOGRAPHIC KODAK JUNIOR CAMERA.

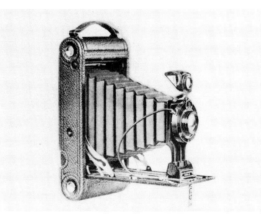

**(402)  NO. 3A AUTOGRAPHIC KODAK JUNIOR CAMERA.**  C. 1918–27.  SIZE 3¼ X 5½ INCH EXPOSURES ON NO. A122 ROLL FILM.  SAME LENSES AND SHUTTERS AS THE NO. 1 AUTOGRAPHIC KODAK JUNIOR CAMERA.

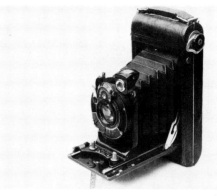

**(403)  NO. 1 AUTOGRAPHIC KODAK SPECIAL CAMERA.**  C. 1915–20.  SIZE 2¼ X 3¼ INCH EXPOSURES ON NO. A120 ROLL FILM.  F 6.3 ZEISS KODAK ANASTIGMAT OR COOKE KODAK ANASTIGMAT LENS.  ALSO, F 6.3 ZEISS TESSAR, KODAK ANASTIGMAT, OR BAUSCH & LOMB KODAK ANASTIGMAT LENS.  KODAMATIC SHUTTER; ½ to ¹⁄₂₀₀ SEC., B., T.,  OPTIMO SHUTTER TO ¹⁄₃₀₀ SEC., B., T., OR ILEX SHUTTER.  (TS)

**(404)  NO. 1 AUTOGRAPHIC KODAK SPECIAL CAMERA. MODEL A.**  C. 1921.  SIZE 2¼ X 3¼ INCH EXPOSURES ON NO. A120 ROLL FILM.  F 6.3 KODAK ANASTIGMAT, BAUSCH & LOMB KODAK ANASTIGMAT, OR BAUSCH & LOMB TESSAR LENS.  ALSO, F 4.5 BAUSCH & LOMB TESSAR LENS.  KODAMATIC SHUTTER; ½ TO ¹⁄₂₀₀ SEC., B., T. OR ILEX SHUTTER.  THE BACK OF THE CAMERA OVERLAPS THE SIDES.

**(405)  NO. 1 AUTOGRAPHIC KODAK SPECIAL CAMERA. MODEL B.**  C. 1922–26.  SIZE 2¼ X 3¼ INCH EXPOSURES ON NO. A120 ROLL FILM.  SAME LENSES AS THE MODEL A.  KODAMATIC SHUTTER.  (TS)

**(406)  NO. 1A AUTOGRAPHIC KODAK SPECIAL CAMERA.**  C. 1914–16.  SIZE 2½ X 4¼ INCH EXPOSURES ON NO. A116 ROLL FILM.  F 6.3 ZEISS KODAK ANASTIGMAT, F 6.3 ZEISS TESSAR, F 6.5 COOKE SERIES IIIA ANASTIGMAT, F 6.3 COOKE KODAK, OR F 6.3 BAUSCH & LOMB KODAK ANASTIGMAT LENS.  BAUSCH & LOMB COMPOUND SHUTTER; 1 TO ¹⁄₂₅₀ SEC., B., T., OR BAUSCH & LOMB COMPUR SHUTTER.  NO COUPLED RANGE FINDER.

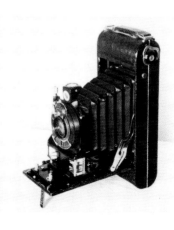

## EASTMAN KODAK COMPANY (cont.)

**(407) NO. 1A AUTOGRAPHIC KODAK SPECIAL CAMERA WITH COUPLED RANGEFINDER.** C. 1917–26. SIZE 2½ X 4¼ INCH EXPOSURES ON NO. A116 ROLL FILM. F 6.3 KODAK ANASTIGMAT, F 6.3 BAUSCH & LOMB KODAK ANASTIGMAT, OR F 6.3 BAUSCH & LOMB TESSAR LENS. OPTIMO SHUTTER; 1 TO ⅟₃₀₀ SEC., B., T., KODAMATIC SHUTTER; ½ TO ⅟₂₀₀ SEC., B., T., OR ILEX SHUTTER. (TS)

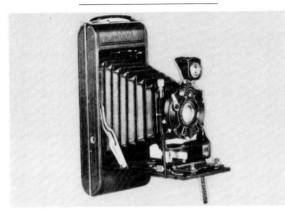

**(408) NO. 2C AUTOGRAPHIC KODAK SPECIAL CAMERA WITH COUPLED RANGEFINDER.** C. 1923–28. SIZE 2⅞ X 4⅞ INCH EXPOSURES ON NO. A130 ROLL FILM. 6 INCH/F 6.3 KODAK ANASTIGMAT LENS. KODAMATIC SHUTTER; ½ TO ⅟₁₅₀ SEC., B., T.

**(409) NO. 3 AUTOGRAPHIC KODAK SPECIAL CAMERA.** C. 1914–26. SIZE 3¼ X 4¼ INCH EXPOSURES ON NO. A118 ROLL FILM. 5 INCH/F 6.3 ZEISS KODAK ANASTIGMAT, COOKE KODAK ANASTIGMAT, BAUSCH & LOMB ZEISS TESSAR ANASTIGMAT, KODAK ANASTIGMAT, OR BAUSCH & LOMB KODAK ANASTIGMAT LENS. ALSO, F 6.5 COOKE SERIES IIIA ANASTIGMAT LENS. BAUSCH & LOMB COMPUR, ILEX, OR OPTIMO SHUTTER. ALSO, KODAMATIC SHUTTER; ½ TO ⅟₂₀₀ SEC., B., T., OR COMPOUND SHUTTER; 1 TO ⅟₂₅₀ SEC., B., T. SIMILAR TO THE NO. 3A AUTOGRAPHIC KODAK SPECIAL. SOME MODELS WITH SELF-TIMER.

**(410) NO. 3A AUTOGRAPHIC KODAK SPECIAL CAMERA WITHOUT COUPLED RANGEFINDER.** C. 1914–16. SIZE 3¼ X 5½ INCH EXPOSURES ON NO. A122 ROLL, SHEET, OR PLATE FILM WITH ADAPTER. F 6.3 ZEISS KODAK ANASTIGMAT, BAUSCH & LOMB ZEISS TESSAR OR COOKE KODAK ANASTIGMAT LENS. ALSO, F 6.5 COOKE SERIES IIIA LENS. BAUSCH & LOMB COMPOUND SHUTTER TO ⅟₂₀₀ SEC.

**(411) BANTUM MODEL F 6.3 CAMERA WITH RIGID OPTICAL FINDER.** C. 1935–37. EIGHT EXPOSURES SIZE 28 X 40 MM ON NO. 828 ROLL FILM. SIMILAR TO THE F 6.3 BANTUM WITH FOLDING OPTICAL FINDER WITH THE SAME LENS AND SHUTTER.

**(412) BANTUM MODEL F 6.3 CAMERA WITH FOLDING OPTICAL FINDER.** C. 1938–47. EIGHT EXPOSURES SIZE 28 X 40 MM ON NO. 828 ROLL FILM. 53 MM/F 6.3 KODAK ANASTIGMAT LENS. INSTANT AND TIME SHUTTER. FIXED FOCUS.

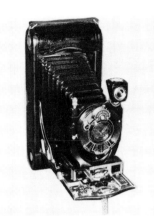

**(413) NO. 3A AUTOGRAPHIC KODAK SPECIAL CAMERA.** C. 1916–34. SIZE 3¼ X 5½ INCH EXPOSURES ON NO. A122 ROLL, SHEET, OR PLATE FILM WITH ADAPTER. 6¾ INCH/F 6.3 KODAK ANASTIGMAT, ZEISS KODAK ANASTIGMAT, BAUSCH & LOMB KODAK ANASTIGMAT, COOKE KODAK ANASTIGMAT, OR BAUSCH & LOMB ZEISS TESSAR SERIES IIB ANASTIGMAT LENS. KODAMATIC SHUTTER; ½ TO ⅟₁₅₀ SEC., B., T. ALSO, ILEX AND OPTIMO (1 TO ⅟₃₀₀ SEC., B., T.) SHUTTERS. FIRST KODAK WITH COUPLED RANGEFINDER. SOME MODELS WITH SELF-TIMER.

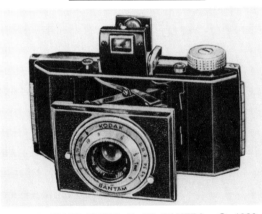

**(414) BANTUM MODEL F 4.5 CAMERA.** C. 1938–48. EIGHT EXPOSURES SIZE 28 X 40 MM ON NO. 828 ROLL FILM. 47 MM/F 4.5 KODAK ANASTIGMAT LENS. SHUTTER SPEEDS FROM ⅟₂₅ TO ⅟₂₀₀ SEC. MANUAL FOCUS.

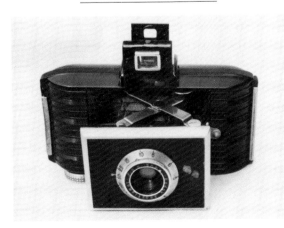

**(415) BANTUM MODEL F 5.6 CAMERA.** C. 1938–41. EIGHT EXPOSURES SIZE 28 X 40 MM ON NO. 828 ROLL

FILM. 50 MM/F 5.6 KODAK ANASTIGMAT LENS. ⅟₂₅ TO ⅟₁₀₀ SEC., B., T. SHUTTER. MANUAL FOCUS. (TS)

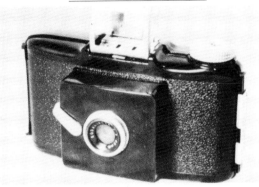

**(416) BANTUM MODEL F/8 CAMERA.** C. 1938–42. EIGHT EXPOSURES SIZE 28 X 40 MM ON NO. 828 ROLL FILM. 4 MM/F 8 KODALINEAR LENS. INSTANT AND TIME SHUTTER. FIXED FOCUS LENS. (TS)

**(417) BANTUM DOUBLET MODEL CAMERA.** C. 1935–38. EIGHT EXPOSURES SIZE 28 X 40 MM ON NO. 828 ROLL FILM. F 12.5 DOUBLET LENS. INSTANT AND TIME SHUTTER. FIXED FOCUS.

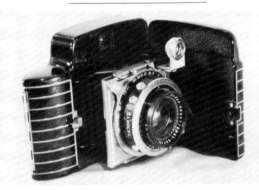

**(418) BANTUM SPECIAL CAMERA.** C. 1936–48. SIZE 28 X 40 MM EXPOSURES ON NO. 828 ROLL FILM. 45 MM/F 2 KODAK EKTAR LENS. SUPERMATIC SHUTTER; 1 TO ⅟₄₀₀ SEC., B., T., OR COMPUR RAPID SHUTTER; 1 TO ⅟₅₀₀ SEC., B., T. COUPLED RANGEFINDER. AUTOMATIC FILM TRANSPORT. (TS)

**(419) BOY SCOUT KODAK CAMERA.** C. 1930–34. SIZE 1⅝ X 2½ INCH EXPOSURES ON NO. 127 ROLL FILM. MENISCUS LENS. V. P. ROTARY SHUTTER.

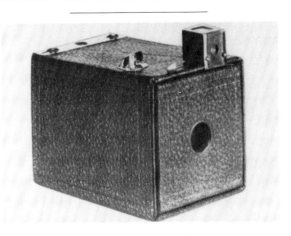

## EASTMAN KODAK COMPANY (*cont.*)

**(420) BROWNIE BOX CAMERA. ORIGINAL MODEL.** C. 1900–01. SIX EXPOSURES SIZE 2¼ X 2¼ INCHES ON NO. 117 ROLL FILM. 105 MM/F 17 SINGLE MENISCUS LENS. SELF-COCKING ROTARY SHUTTER FOR SINGLE SPEED OR TIME EXPOSURES. SELF-ATTACHING VIEW FINDER. (TH)

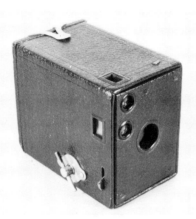

**(421) NO. 0 BROWNIE BOX CAMERA.** MODEL A. C. 1914–35. SIZE 1⅝ X 2½ INCH EXPOSURES ON NO. 127 ROLL FILM. MENISCUS LENS. INSTANT AND TIME ROTARY SHUTTER.

**(422) NO. 1 BROWNIE BOX CAMERA.** C. 1901–15. SIZE 1⅝ X 2½ INCH EXPOSURES ON ROLL FILM. MENISCUS LENS. ROTARY SHUTTER. SIMILAR TO THE ORIGINAL BROWNIE BOX CAMERA (C. 1900–01) EXCEPT THE SHUTTER RELEASE AND FILM WINDING KEY ARE ON THE SIDE OF THE CAMERA. THE CAMERA HAS A CARRYING HANDLE. VERTICAL AND HORIZONTAL VIEWERS ARE BUILT INTO THE CAMERA.

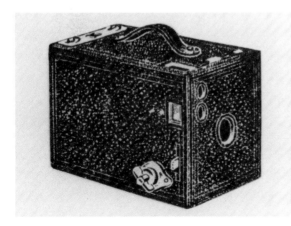

**(423) NO. 2 BROWNIE BOX CAMERA.** C. 1901–33. SIX EXPOSURES SIZE 2¼ X 3¼ INCH ON NO. 120 ROLL FILM. THE FIRST CAMERA TO USE NO. 120 ROLL FILM. MENISCUS LENS. INSTANT AND TIME ROTARY SHUTTER. ALUMINUM MODELS FROM 1924 TO 1933. COLOR MODELS FROM 1929 TO 1933.

**(424) NO. 2A BROWNIE BOX CAMERA.** C. 1907–33. SIZE 2½ X 4¼ INCH EXPOSURES ON NO. 116 ROLL FILM. MENISCUS ACHROMATIC LENS. INSTANT & TIME ROTARY SHUTTER. MODEL B; 1907–24. ALUMINUM MODEL; 1924–33. COLOR MODELS; 1929–33.

**(425) NO. 2 C BROWNIE BOX CAMERA.** C. 1917–34. SIZE 2⅞ X 4⅞ INCH EXPOSURES ON NO. 130 ROLL FILM. MENISCUS ACHROMATIC LENS. INSTANT AND TIME ROTARY SHUTTER.

**(426) NO. 3 BROWNIE BOX CAMERA.** C. 1908–34. SIZE 3¼ X 4¼ INCH EXPOSURES ON NO. 124 ROLL FILM. MENISCUS ACHROMATIC LENS. INSTANT AND TIME ROTARY SHUTTER.

**(427) BROWNIE SPECIAL 127 BOX CAMERA.** C. 1939. SIZE 1⅝ X 2½ INCH EXPOSURES ON NO. 127 ROLL FILM.

MENISCUS LENS. ROTARY SHUTTER WITH BUTTON FOR TIME EXPOSURES.

**(428) BABY BROWNIE CAMERA.** C. 1934–41. SIZE 1⅝ X 2½ INCH EXPOSURES ON NO. 127 ROLL FILM. MENISCUS LENS. ROTARY SHUTTER. SOME MODELS WITH A BUTTON FOR BULB EXPOSURES. (KC)

**(429) BABY BROWNIE SPECIAL CAMERA.** C. 1939–54. SIZE 1⅝ X 2½ INCH EXPOSURES ON NO. 127 ROLL FILM. MENISCUS LENS. ROTARY SHUTTER. SOME MODELS WITH BUTTON FOR TIME EXPOSURES.

**(430) NO. 2 BEAU BROWNIE BOX CAMERA.** C. 1930–32. SIZE 2¼ X 3¼ INCH EXPOSURES ON NO. 120 ROLL FILM. TWO-TONE COLORS. KODAK DOUBLET LENS. INSTANT AND TIME ROTARY SHUTTER.

**(431) NO. 2A BEAU BROWNIE BOX CAMERA.** C. 1930–32. SIZE 2½ X 4¼ INCH EXPOSURES ON NO. 116 ROLL FILM. SIMILAR TO THE NO. 2 BEAU BROWNIE CAMERA WITH THE SAME LENS AND SHUTTER.

**(432) BOY SCOUT BROWNIE CAMERA.** C. 1932. SIZE 2¼ X 3¼ INCH EXPOSURES ON NO. 120 ROLL FILM. MENISCUS LENS. ROTARY SHUTTER.

**(433) CENTURY OF PROGRESS WORLD FAIR SOUVENIR BROWNIE CAMERA.** C. 1933. SIZE 1⅝ X 1⅝ INCH EXPOSURES ON NO. 127 ROLL FILM. DOUBLET LENS. ROTARY SHUTTER.

## EASTMAN KODAK COMPANY (*cont.*)

**(434) NO. 2 FOLDING BROWNIE CAMERA.** C. 1904–07. SIZE 2¼ X 3¼ INCH EXPOSURES ON NO. 120 ROLL FILM. MENISCUS ACHROMATIC LENS. POCKET AUTOMATIC (1904–05) OR BROWNIE AUTOMATIC LENS. (SW)

**(435) NO. 2A FOLDING BROWNIE CAMERA.** C. 1910. SIZE 2½ X 4¼ INCH EXPOSURES ON NO. 116 ROLL FILM. SIMILAR TO THE NO. 2 FOLDING BROWNIE WITH THE SAME LENS AND SHUTTER.

**(436) NO. 3 FOLDING BROWNIE CAMERA.** C. 1905–15. SIZE 3¼ X 4¼ INCH EXPOSURES ON NO. 124 ROLL FILM. MENISCUS ACHROMATIC OR RAPID RECTILINEAR LENS. INSTANT, B., T. KODAK AUTOMATIC SHUTTER OR BROWNIE BALL-BEARING SHUTTER; ½₅, ⅟₅₀, AND ⅟₁₀₀ SEC., B., T.

**(437) NO. 3A FOLDING BROWNIE CAMERA.** C. 1909–15. SIZE 3¼ X 5½ INCH EXPOSURES ON NO. 122 ROLL FILM. MENISCUS ACHROMATIC, RAPID RECTILINEAR, OR BAUSCH & LOMB LENS. BROWNIE BALL-BEARING SHUTTER; ½₅, ⅟₅₀, AND ⅟₁₀₀ SEC., B., T. OR KODAK AUTOMATIC SHUTTER. (SW)

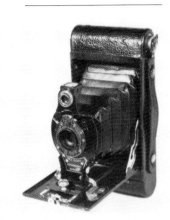

**(438) NO. 2 FOLDING AUTOGRAPHIC BROWNIE CAMERA.** C. 1915–26. SIZE 2¼ X 3¼ INCH EXPOSURES ON NO. A120 ROLL FILM. MENISCUS ACHROMATIC OR RAPID RECTILINEAR LENS. ALSO, F 7.9 KODAR LENS. BALL-BEARING SHUTTER; ½₅, ⅟₅₀ SEC., B., T. OR KODEX SHUTTER. SOME MODELS WITH SELF-TIMER. THE 1915–16 MODELS HAVE SQUARE ENDS WHILE THE 1917–26 MODELS HAVE ROUND ENDS. (GB)

**(439) NO. 2A FOLDING AUTOGRAPHIC BROWNIE CAMERA.** C. 1915–26. SIZE 2½ X 4¼ INCH EXPOSURES ON NO. A116 ROLL FILM. MENISCUS ACHROMATIC OR RAPID RECTILINEAR LENS. ALSO, F 7.9 KODAR LENS. BALL-BEARING SHUTTER; ½₅, ⅟₅₀, ⅟₁₀₀ SEC., B., T. OR KODEX SHUTTER. THE 1915–16 MODELS HAVE SQUARE ENDS WHILE THE 1917–26 MODELS HAVE ROUND ENDS.

**(440) NO. 2C FOLDING AUTOGRAPHIC BROWNIE CAMERA.** C. 1916–26. SIZE 2⅞ X 4⅞ INCH EXPOSURES ON NO. A130 ROLL FILM. MENISCUS ACHROMATIC OR RAPID RECTILINEAR LENS. ALSO, F 7.9 KODAR LENS. BALL-BEARING SHUTTER; ½₅, ⅟₅₀, ⅟₁₀₀ SEC., B., T. ALSO, KODEX OR ADJUSTABLE SPEED SHUTTER. THE 1916 MODELS HAVE SQUARE ENDS WHILE THE 1917–26 MODELS HAVE ROUND ENDS. SIMILAR TO THE NO. 3A FOLDING AUTOGRAPHIC BROWNIE.

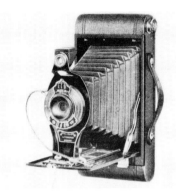

**(441) NO. 3A FOLDING AUTOGRAPHIC BROWNIE CAMERA.** C. 1916–26. SIZE 3¼ X 5½ INCH EXPOSURES ON NO. A122 ROLL FILM. SAME LENSES AND SHUTTERS AS THE NO. 2C FOLDING AUTOGRAPHIC BROWNIE CAMERA.

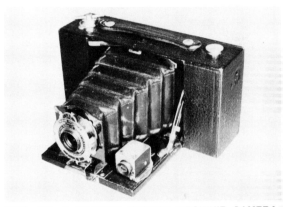

**(442) NO. 2 FOLDING POCKET BROWNIE CAMERA.** C. 1907–15. SIZE 2¼ X 3¼ INCH EXPOSURES ON NO. 120 ROLL FILM. MENISCUS ACHROMATIC LENS. BROWNIE AUTOMATIC SHUTTER; INSTANT, B., T.

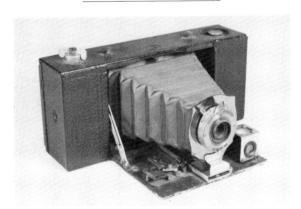

**(443) NO. 2A FOLDING POCKET BROWNIE CAMERA.** C. 1910–15. SIZE 2½ X 4¼ INCH EXPOSURES ON NO. 116 ROLL FILM. MENISCUS ACHROMATIC LENS. POCKET AUTOMATIC SHUTTER; INSTANT, B., T. (SW)

**(444) NEW YORK WORLD'S FAIR BABY BROWNIE CAMERA.** C. 1939–40. SIZE 1⅝ X 2½ INCH EXPOSURES ON NO. 127 ROLL FILM. MENISCUS LENS. ROTARY SHUTTER.

## EASTMAN KODAK COMPANY (cont.)

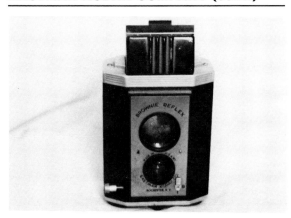

(445) **BROWNIE REFLEX CAMERA.** C. 1940–41. SIZE 1⅝ X 1⅝ INCH EXPOSURES ON NO. 127 ROLL FILM. MENISCUS LENS. ROTARY SHUTTER. NOT THE SYNCHRONOUS MODEL. (JT)

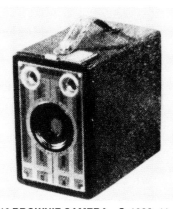

(446) **SIX-16 BROWNIE CAMERA.** C. 1933–41. SIZE 2½ X 4¼ INCH EXPOSURES ON NO. 616 ROLL FILM. DIWAY LENS. TWO-POSITION MANUAL FOCUS. INSTANT AND TIME ROTARY SHUTTER.

(447) **SIX-16 BROWNIE JUNIOR CAMERA.** C. 1934–42. SIZE 2½ X 4¼ INCH EXPOSURES ON NO. 616 ROLL FILM. SAME AS THE SIX-16 BROWNIE CAMERA EXCEPT IT HAS FIXED FOCUS.

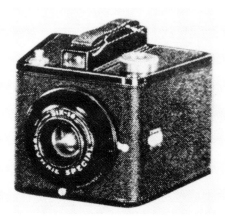

(448) **SIX-16 BROWNIE SPECIAL CAMERA.** C. 1938–42. SIZE 2½ X 4¼ INCH EXPOSURES ON NO. 616 ROLL FILM. DIWAY MENISCUS LENS. TWO-POSITION MANUAL FOCUSING. INSTANT AND TIME ROTARY SHUTTER.

(449) **SIX-20 BOY SCOUT BROWNIE CAMERA.** C. 1933–34. SIZE 2¼ X 3¼ INCH EXPOSURES ON NO. 620 ROLL FILM. MENISCUS LENS. ROTARY SHUTTER.

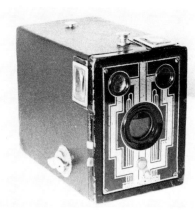

(450) **SIX-20 BROWNIE BOX CAMERA.** C. 1933–41. EIGHT EXPOSURES, SIZE 2¼ X 3¼ INCHES ON NO. 620 ROLL FILM. DIWAY LENS. INSTANT AND TIME ROTARY SHUTTER. (TS)

(451) **SIX-20 BROWNIE JUNIOR BOX CAMERA.** C. 1934–42. SIZE 2¼ X 3¼ INCH EXPOSURES ON NO. 620 ROLL FILM. SIMILAR TO THE SIX-16 BROWNIE JUNIOR CAMERA WITH THE SAME LENS AND SHUTTER.

(452) **SIX-20 BROWNIE SPECIAL BOX CAMERA.** C. 1938–42. SIZE 2¼ X 3¼ INCH EXPOSURES ON NO. 620 ROLL FILM. SIMILAR TO THE SIX-16 BROWNIE SPECIAL CAMERA WITH THE SAME LENS AND SHUTTER.

(453) **SIX-20 BULLSEYE BROWNIE CAMERA.** C. 1938–41. SIZE 2¼ X 3¼ INCH EXPOSURES ON NO. 620 ROLL FILM. MENISCUS LENS. SINGLE ACTION SHUTTER.

(454) **SIX-20 FLASH BROWNIE CAMERA.** C. 1940–46. SIZE 2¼ X 3¼ INCH EXPOSURES ON NO. 620 ROLL FILM. MENISCUS LENS. ROTARY SHUTTER.

(455) **NO. 2 STEREO BROWNIE CAMERA.** C. 1905–10. SIZE 3¼ X 5 INCH STEREO EXPOSURES ON NO. 125 ROLL FILM. MENISCUS ACHROMATIC LENS. BROWNIE AUTOMATIC SHUTTER IN THE 1905 MODEL ONLY. POCKET AUTOMATIC SHUTTER (INSTANT, B., T.) IN THE 1906 TO 1910 MODELS. (TH)

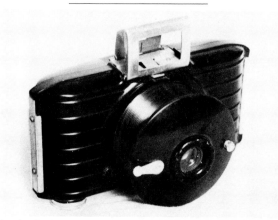

(456) **BULLET CAMERA.** C. 1936–42. SIZE 1⅝ X 2½ INCH EXPOSURES ON NO. 127 ROLL FILM. FIXED-FOCUS MENISCUS LENS. SINGLE SPEED AND BULB SHUTTER. (JT)

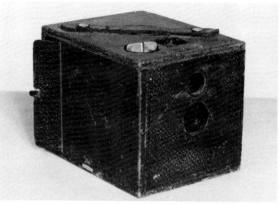

(457) **NO. 2 BULLET BOX CAMERA.** C. 1895–96. IMPROVED MODEL; 1896–1900. WITH BRILLIANT FINDER; 1900–02. TWELVE OR 18 EXPOSURES SIZE 3½ X 3½ INCHES ON ROLL FILM. ALSO, SIZE 3¼ X 3½ INCH EXPOSURES ON PLATES. ACHROMATIC OR MENISCUS LENS. TISDELL OR ROTARY SHUTTER. (TH)

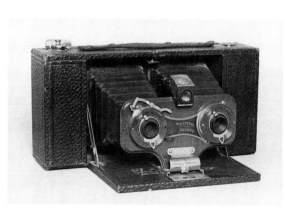

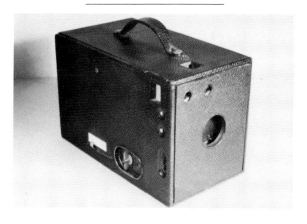

## EASTMAN KODAK COMPANY (cont.)

(458) **NO. 4 BULLET BOX CAMERA.** C. 1896–1900. SIZE 4 X 5 INCH EXPOSURES ON NO. 103 ROLL FILM OR PLATES. ACHROMATIC LENS. ROTARY SHUTTER. (MR)

(459) **NO. 2 BULLET SPECIAL BOX CAMERA.** C. 1898–1904. SIZE 3½ X 3½ INCH EXPOSURES ON NO. 101 ROLL FILM OR ON SINGLE PLATES. RAPID RECTILINEAR LENS. EASTMAN TRIPLE ACTION SHUTTER WITH IRIS APERTURE STOP.

(460) **NO. 4 BULLET SPECIAL BOX CAMERA.** C. 1898–1904. SIZE 4 X 5 INCH EXPOSURES ON CARTRIDGE ROLL FILM OR PLATES. SIMILAR TO THE NO. 4 BULLET BOX CAMERA WITH THE SAME LENS AND SHUTTER.

(461) **NO. 4 BULLET KODET CAMERA.** C. 1897–1900. SIZE 4 X 5 INCH EXPOSURES ON NO. 103 ROLL FILM OR SINGLE PLATES.

(462) **NO. 4 BULLET KODET SPECIAL CAMERA.** C. 1898–1904. SIZE 4 X 5 INCH EXPOSURES ON NO. 103 ROLL FILM OR SINGLE PLATES.

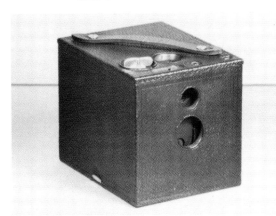

(463) **NO. 2 BULLSEYE BOX CAMERA.** C. 1895–1913. TWELVE EXPOSURES SIZE 3½ X 3½ INCHES ON NO. 101 ROLL FILM. ACHROMATIC LENS. ROTARY SHUTTER FOR INSTANT AND TIME EXPOSURES. (MR)

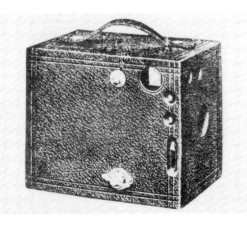

(464) **NO. 3 BULLSEYE BOX CAMERA.** C. 1908–13. SIZE 3¼ X 4¼ INCH EXPOSURES ON NO. 124 ROLL FILM. SIDE FILM LOADING. ACHROMATIC LENS. INSTANT AND TIME ROTARY SHUTTER.

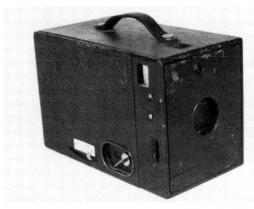

(465) **NO. 4 BULLSEYE BOX CAMERA.** C. 1896–1904. SIZE 4 X 5 INCH EXPOSURES ON NO. 103 ROLL FILM. INTERNAL BELLOWS. OUTSIDE FOCUSING LEVER. ACHROMATIC LENS. ROTARY SHUTTER. (SW)

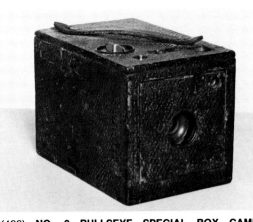

(466) **NO. 2 BULLSEYE SPECIAL BOX CAMERA.** C. 1898–1904. SIZE 3½ X 3½ INCH EXPOSURES ON NO. 101 ROLL FILM. RAPID RECTILINEAR LENS. IRIS APERTURE STOP. EASTMAN TRIPLE ACTION SHUTTER. (TH)

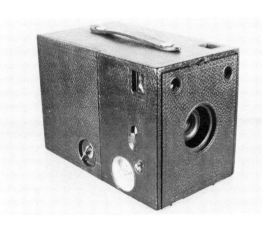

(467) **NO. 4 BULLSEYE SPECIAL BOX CAMERA.** C. 1898–1904. SIZE 4 X 5 INCH EXPOSURES ON NO. 103 ROLL FILM. BAUSCH & LOMB RAPID RECTILINEAR LENS. EASTMAN TRIPLE-ACTION SHUTTER; INSTANT, B., T. INTERNAL BELLOWS. OUTSIDE FOCUSING LEVER.

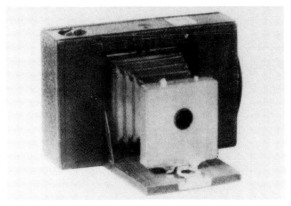

(468) **NO. 2 FOLDING BULLSEYE CAMERA.** C. 1899–1901. SIZE 3½ X 3½ INCH EXPOSURES ON NO. 101 ROLL FILM. ACHROMATIC LENS. ROTARY SHUTTER.

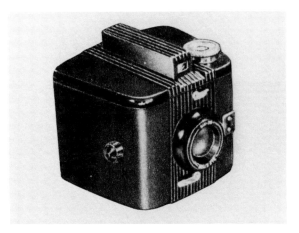

(469) **SIX-20 BULLSEYE CAMERA.** C. 1940. EIGHT EXPOSURES, SIZE 2¼ X 3¼ INCHES ON NO. 620 ROLL FILM. FIXED-FOCUS F 11 MENISCUS LENS. INSTANT AND TIME SHUTTER.

(470) **CAMPFIRE GIRL'S KODAK CAMERA.** C. 1931–34. SIZE 1⅝ X 2½ INCH EXPOSURES ON NO. 127 ROLL FILM. MENISCUS LENS. V.P. ROTARY SHUTTER.

(471) **NO. 3 CARTRIDGE KODAK CAMERA.** C. 1900–07. SIZE 3¼ X 4¼ INCH EXPOSURES ON NO. 119 ROLL FILM OR PLATES. F 8 BAUSCH & LOMB ZEISS ANASTIGMAT, F 6.8 GOERZ ANASTIGMAT, F 6.8 BAUSCH & LOMB PLASTIGMAT, F 6.3 ZEISS TESSAR, OR RAPID RECTILINEAR LENS. EASTMAN TRIPLE-ACTION, UNICUM, BAUSCH & LOMB AUTOMATIC, VOLUTE, OR KODAK AUTOMATIC SHUTTER. RACK & PINION FOCUS FROM 1901.

## EASTMAN KODAK COMPANY (*cont.*)

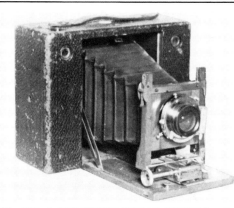

(472) **NO. 4 CARTRIDGE KODAK CAMERA.** C. 1897–1900. WOOD LENS BOARD. SIZE 4 X 5 INCH EXPOSURES ON NO. 104 ROLL FILM OR PLATES. F 8 BAUSCH & LOMB ZEISS ANASTIGMAT OR RAPID RECTILINEAR LENS. EASTMAN THREE-SPEED PNEUMATIC SHUTTER OR UNICUM SHUTTER WITH IRIS DIAPHRAGM. GROUND GLASS FOCUS FOR PLATES. (TH)

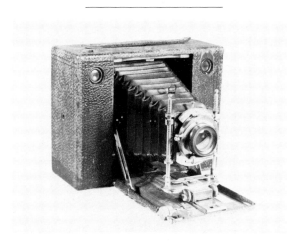

(473) **NO. 4 CARTRIDGE KODAK CAMERA.** C. 1900–07. METAL LENS BOARD. SIZE 4 X 5 INCH EXPOSURES ON NO. 104 ROLL FILM OR PLATES. RAPID RECTILINEAR, F 6.8 GOERZ ANASTIGMAT, F 6.8 BAUSCH & LOMB PLASTIGMAT, F 6.3 ZEISS TESSAR, OR F 6.5 COOKE ANASTIGMAT LENS. EASTMAN THREE-SPEED SHUTTER, BAUSCH & LOMB AUTOMATIC SHUTTER, VOLUTE OR KODAK AUTOMATIC SHUTTER. (SW)

(474) **NO. 5 CARTRIDGE KODAK CAMERA.** C. 1898–1900. WOOD LENS BOARD. SIZE 5 X 7 INCH EXPOSURES ON NO. 115 ROLL FILM OR PLATES. SIMILAR TO THE NO. 4 CARTRIDGE KODAK CAMERA (C. 1897–1900) WITH THE SAME LENSES AND SHUTTERS.

(475) **NO. 5 CARTRIDGE KODAK CAMERA.** C. 1900–07. METAL LENS BOARD. SIZE 5 X 7 INCH EXPOSURES ON NO. 115 ROLL FILM OR PLATES. SIMILAR TO THE NO. 4 CARTRIDGE KODAK (C. 1900–1907) WITH THE SAME LENSES AND SHUTTERS.

(476) **COMET BOX CAMERA.** C. 1896. ONE-INCH SQUARE OR ONE-INCH DIAMETER EXPOSURES.

(477) **COQUETTE CAMERA.** C. 1930–31. SIZE 1⅝ X 2½ INCH EXPOSURES ON NO. 127 ROLL FILM. MENISCUS LENS. V. P. ROTARY SHUTTER. THE ENSEMBLE CONSISTS OF THE KODAK PETITE CAMERA, LIPSTICK, AND COMPACT.

(478) **"A" DAYLIGHT KODAK CAMERA.** C. 1892–95. TWENTY-FOUR EXPOSURES, SIZE 2¾ X 3¼ INCHES ON ROLL FILM. ACHROMATIC LENS. STRING-SETTING SECTOR SHUTTER. EXPOSURE COUNTER. SEE PHOTO UNDER EASTMAN COMPANY (THE) CAMERAS.

(479) **"B" DAYLIGHT KODAK CAMERA.** C. 1982–95. TWENTY-FOUR EXPOSURES, SIZE 3½ X 4 INCHES ON ROLL FILM. ACHROMATIC LENS. STRING-SETTING SECTOR SHUTTER. EXPOSURE COUNTER. SEE PHOTO UNDER EASTMAN COMPANY (THE) CAMERAS.

(480) **"C" DAYLIGHT KODAK CAMERA.** C. 1982–95. TWENTY-FOUR EXPOSURES, SIZE 4 X 5 INCHES ON ROLL FILM. ACHROMATIC LENS. STRING-SETTING SECTOR SHUTTER. EXPOSURE COUNTER. SEE PHOTO UNDER EASTMAN COMPANY (THE) CAMERAS.

(481) **DUEX CAMERA.** C. 1940–46. SIZE 1⅝ X 2¼ INCH EXPOSURES ON NO. 620 ROLL FILM. DOUBLET PERISCOPIC LENS. BUILT-IN SHUTTER.

(482) **EASTMAN PINHOLE CAMERA.** C. 1930. SIZE 3¼ X 4¼ INCH EXPOSURES ON SHEET FILM. A PINHOLE IS USED IN PLACE OF A LENS. REVOLVING FLAP SHUTTER.

(483) **NO. 3 EASTMAN PLATE CAMERA.** C. 1902–04. SIZE 3¼ X 4¼ INCH EXPOSURES ON GLASS PLATES. F 6.8 PLASTIGMAT, F 6.8 GOERZ SERIES III, OR RAPID RECTILINEAR LENS. BAUSCH & LOMB AUTOMATIC UNICUM OR VOLUTE SHUTTER.

(484) **NO. 4 EASTMAN PLATE CAMERA.** C. 1902–04. SIZE 4 X 5 INCH EXPOSURES ON GLASS PLATES. SIMILAR TO THE NO. 3 EASTMAN PLATE CAMERA WITH THE SAME LENSES AND SHUTTERS.

(485) **NO. 5 EASTMAN PLATE CAMERA.** C. 1902–03. SIZE 5 X 7 INCH EXPOSURES ON GLASS PLATES. SIMILAR TO THE NO. 3 EASTMAN PLATE CAMERA WITH THE SAME LENSES AND SHUTTERS.

(486) **ENSEMBLE CAMERA.** C. 1929–33. SIZE 1⅝ X 2½ INCH EXPOSURES ON NO. 127 ROLL FILM. MENISCUS LENS. V. P. ROTARY SHUTTER. THE ENSEMBLE INCLUDES PETITE MODEL CAMERA, LIPSTICK, COMPACT, AND MIRROR. (MA)

(487) **NO. 2 EUREKA BOX CAMERA.** C. 1898–99. SIZE 3½ x 3½ INCH EXPOSURES ON NO. 106 ROLL FILM. ACHROMATIC LENS. INSTANT AND TIME ROTARY SHUTTER.

(488) **NO. 4 EUREKA BOX CAMERA.** C. 1899. SIZE 4 X 5 INCH EXPOSURES ON NO. 109 ROLL FILM. ACHROMATIC LENS. SINGLE-SPEED AND TIME ROTARY SHUTTER.

(489) **NO. 2 EUREKA JUNIOR BOX CAMERA.** C. 1898–99. SIZE 3½ X 3½ INCH PLATE EXPOSURES. ACHROMATIC LENS. ROTARY SHUTTER. SIMILAR TO THE NO. 2 EUREKA BOX CAMERA.

(490) **NO. 1 FALCON KODAK BOX CAMERA.** C. 1897–98. SIZE 2 X 2½ INCH EXPOSURES ON ROLL FILM. SIMILAR TO THE NO. 2 FALCON BOX CAMERA WITH THE SAME LENS AND SHUTTER.

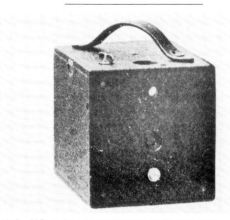

(491) **NO. 2 FALCON KODAK BOX CAMERA.** C. 1897–99. SIZE 3½ X 3½ INCH EXPOSURES ON NO. 101 ROLL FILM. ACHROMATIC LENS. ROTARY SHUTTER.

## EASTMAN KODAK COMPANY (cont.)

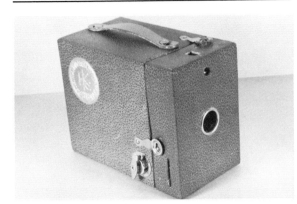

**(492) 50TH EASTMAN ANNIVERSARY BOX CAMERA.** C. 1930. A SPECIAL EDITION OF THE NO. 2 BROWNIE BOX CAMERA. TAN COLOR WITH A GOLD-COLORED FOIL SEAL ON THE UPPER CORNER. SIZE 2¼ X 3¼ INCH EXPOSURES ON NO. 120 ROLL FILM. MENISCUS LENS. ROTARY SHUTTER. 557,000 OF THESE CAMERAS WERE GIVEN FREE TO CHILDREN WHO WERE 12 YEARS OLD IN 1930.

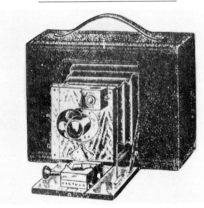

**(493) FLAT FOLDING KODAK CAMERA.** C. 1895. SIZE 4 X 5 INCH EXPOSURES ON ROLL FILM. FORTY-EIGHT EXPOSURES PER ROLL OF FILM. RECTILINEAR LENS. MULTI-SPEED SHUTTER. FOUR APERTURE STOPS IN REVOLVING DISC. RACK & PINION FOCUSING. EXPOSURE COUNTER. THIS CAMERA WAS MANUFACTURED EXCLUSIVELY FOR THE BRITISH MARKET.

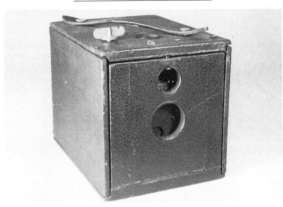

**(494) NO. 2 FLEXO BOX CAMERA.** C. 1899–1913. SIZE 3½ X 3½ INCH EXPOSURES ON NO. 101 ROLL FILM.

REMOVABLE SIDES AND BACK FOR FILM LOADING. ACHROMATIC LENS. ROTARY SHUTTER. (SW)

**(495) NO. 3 FLUSH-BACK CAMERA.** C. 1902. SIZE 3¼ X 4¼ INCH EXPOSURES ON NO. 118 ROLL FILM OR GLASS PLATES. THIS CAMERA WAS MANUFACTURED EXCLUSIVELY FOR THE BRITISH MARKET.

**(496) NO. 4 FOLDING KODAK CAMERA. ORIGINAL MODEL.** C. 1890–92. FORTY-EIGHT EXPOSURES, SIZE 4 X 5 INCHES ON ROLL FILM. BAUSCH & LOMB UNIVERSAL LENS. SPECIAL KODAK WINGED-TYPE SHUTTER OR BARKER SHUTTER.

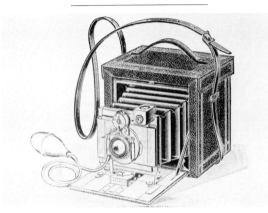

**(497) NO. 4 FOLDING KODAK CAMERA. IMPROVED MODEL.** C. 1893–97. FORTY-EIGHT EXPOSURES, SIZE 4 X 5 INCHES ON ROLL FILM OR PLATES. BAUSCH & LOMB UNIVERSAL LENS. BAUSCH & LOMB PNEUMATIC IRIS DIAPHRAGM SHUTTER; 3 TO ¹⁄₁₀₀ SEC., B. DOUBLE SWING BACK. DROPPING BED.

**(498) NO. 4A FOLDING KODAK CAMERA.** C. 1906–15. WOOD LENS BOARD MODEL. SIZE 4¼ X 6½ INCH EXPOSURES ON NO. 126 ROLL FILM. F 8 KODAK RAPID RECTILINEAR, F 6.3 BAUSCH & LOMB ZEISS TESSAR, F 6.8 GOERZ ANASTIGMAT, F 6.5 COOKE ANASTIGMAT, OR F 6.8 BAUSCH & LOMB PLASTIGMAT LENS. BAUSCH & LOMB AUTOMATIC, VOLUTE, OR KODAK AUTOMATIC SHUTTER. SIMILAR TO THE 1908–15 MODEL WITH METAL LENS BOARD.

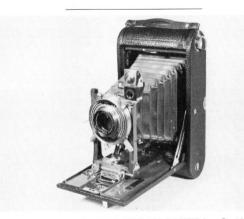

**(499) NO. 4A FOLDING KODAK CAMERA.** C. 1908–15. METAL LENS BOARD MODEL. SIZE 4¼ X 6½ INCH EXPOSURES ON NO. 126 ROLL FILM. F 6.3 ISOSTIGMAT, F 6.3 BAUSCH & LOMB ZEISS TESSAR, F 6.5 COOKE ANASTIGMAT, F 6.8 GOERZ DAGOR, OR F 6.3 ZEISS KODAK

ANASTIGMAT LENS. BAUSCH & LOMB AUTOMATIC, BAUSCH & LOMB COMPOUND, X.L. SECTOR, OR VOLUTE SHUTTER. (GB)

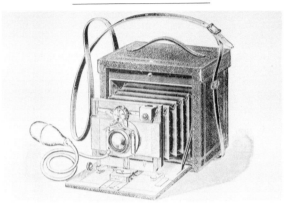

**(500) NO. 5 FOLDING KODAK CAMERA. IMPROVED MODEL.** C. 1893–97. SIZE 5 X 7 INCH EXPOSURES ON ROLL FILM. BAUSCH & LOMB UNIVERSAL LENS. BAUSCH & LOMB PNEUMATIC IRIS DIAPHRAGM SHUTTER; 3 TO ¹⁄₁₀₀ SEC., B. DOUBLE SWING BACK. DROPPING BED. RACK & PINION FOCUS.

**(501) NO. 6 FOLDING KODAK CAMERA. IMPROVED MODEL.** C. 1893–95. SIZE 6½ X 8½ INCH EXPOSURES ON ROLL FILM. SIMILAR TO THE NO. 5 FOLDING KODAK CAMERA, IMPROVED MODEL WITH THE SAME LENS AND SHUTTER.

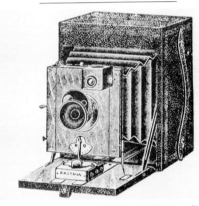

**(502) NO. 4 FOLDING KODET CAMERA.** C. 1894–97. SIZE 4 X 5 INCH EXPOSURES ON ROLL FILM (SPECIAL HOLDER). ACHROMATIC OR RAPID RECTILINEAR LENS. VARIABLE-SPEED SHUTTER IN LENS BOARD OR BAUSCH & LOMB KODAK SHUTTER. WATERHOUSE STOPS. GROUND GLASS FOCUS.

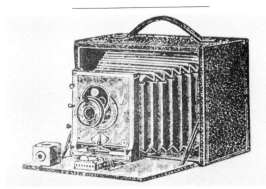

## EASTMAN KODAK COMPANY (*cont.*)

**(503) NO. 5 FOLDING KODET CAMERA.** C. 1895–97. SIZE 5 X 7 INCH EXPOSURES ON PLATES OR ROLL FILM. ACHROMATIC OR BAUSCH & LOMB RAPID RECTILINEAR LENS. KODET VARIABLE-SPEED SHUTTER IN LENS BOARD OR BAUSCH & LOMB SHUTTER WITH IRIS DIAPHRAGM. ADJUSTABLE SWING BACK. GROUND GLASS FOCUSING.

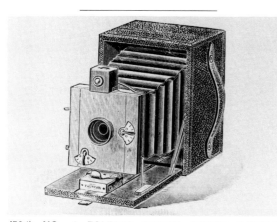

**(504) NO. 4 FOLDING KODET JUNIOR CAMERA.** C. 1894–97. SIZE 4 X 5 INCH EXPOSURES ON PLATES OR ROLL FILM. ACHROMATIC LENS WITH THREE APERTURE STOPS. KODET MULTISPEED SHUTTER IN THE LENS BOARD. GROUND GLASS FOCUSING.

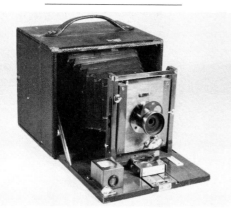

**(505) NO. 4 FOLDING KODET SPECIAL CAMERA.** C. 1895–97. SIZE 4 X 5 INCH EXPOSURES ON PLATES OR ROLL FILM. ACHROMATIC OR BAUSCH & LOMB RAPID RECTILINEAR LENS. KODET VARIABLE-SPEED SHUTTER IN LENS BOARD OR BAUSCH & LOMB KODAK SHUTTER WITH IRIS DIAPHRAGM. DOUBLE-SWING BACK. GROUND GLASS FOCUS. (SW)

**(506) NO. 5 FOLDING KODET SPECIAL CAMERA.** C. 1895–97. SIZE 5 X 7 INCH EXPOSURES ON PLATES OR ROLL FILM. SIMILAR TO THE NO. 4 FOLDING KODET SPECIAL CAMERA WITH THE SAME SHUTTERS BUT WITH A BAUSCH & LOMB RAPID RECTILINEAR LENS ONLY.

**(507) NO. 0 FOLDING POCKET KODAK CAMERA.** C. 1902–06. SIZE 1⅝ X 2½ INCH EXPOSURES ON NO. 121 ROLL FILM OR FILM CARTRIDGES. MENISCUS LENS. AUTOMATIC SHUTTER. SIMILAR TO THE NO. 1 FOLDING POCKET KODAK (C. 1897–1905).

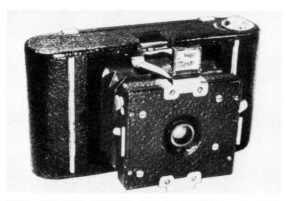

**(508) FOLDING POCKET KODAK CAMERA.** C. 1900. SIZE 2¼ X 3¼ INCH EXPOSURES ON ROLL FILM. TWO-SPEED SHUTTER. (HA)

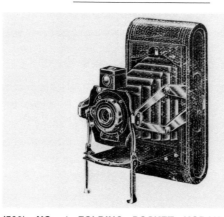

**(509) NO. 1 FOLDING POCKET KODAK CAMERA. IMPROVED MODEL.** C. 1905–15. SIZE 2¼ X 3¼ INCH EXPOSURES ON ROLL FILM. F 11 KODAK ACHROMATIC OR F 6.8 GOERZ DAGOR ANASTIGMAT LENS. POCKET AUTOMATIC SHUTTER FOR INSTANT, BULB, AND TIME EXPOSURES.

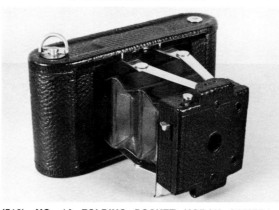

**(510) NO. 1A FOLDING POCKET KODAK CAMERA. MODEL A.** C. 1899–1905. SIZE 2½ X 4¼ INCH EXPOSURES ON NO. 116 ROLL FILM. F 11 ACHROMATIC LENS. EASTMAN AUTOMATIC SHUTTER.

**(511) NO. 1A FOLDING POCKET KODAK CAMERA. MODEL B.** C. 1905–06. SIZE 2½ X 4¼ INCH EXPOSURES ON ROLL FILM. F 11 ACHROMAT LENS. POCKET AUTOMATIC SHUTTER. (HA)

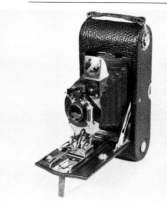

**(512) NO. 1A FOLDING POCKET KODAK CAMERA. IMPROVED MODEL.** C. 1905–15. SIZE 2½ X 4¼ INCH EXPOSURES ON NO. 116 ROLL FILM. F 11 ACHROMATIC OR BAUSCH & LOMB RAPID RECTILINEAR LENS. POCKET AUTOMATIC SHUTTER OR KODAK BALL-BEARING SHUTTER: ⅟₂₅, ⅟₅₀, ⅟₁₀₀ SEC., B., T. (GB).

**(513) NO. 2 FOLDING POCKET KODAK CAMERA.** C. 1899–1910. (THE MODEL WITH RAPID RECTILINEAR LENS FROM 1904–10). SIZE 3½ X 3½ INCH EXPOSURES ON NO. 101 ROLL FILM. MENISCUS ACHROMATIC OR RAPID RECTILINEAR LENS. EASTMAN AUTOMATIC (BUILT-IN) SHUTTER OR F.P.K. AUTOMATIC SHUTTER.

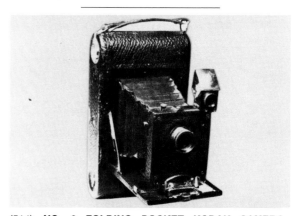

**(514) NO. 3 FOLDING POCKET KODAK CAMERA. EARLY MODEL.** C. 1900–03. SIZE 3¼ X 4¼ INCH EXPO-

## EASTMAN KODAK COMPANY (*cont.*)

SURES ON NO. 118 ROLL FILM. RAPID RECTILINEAR LENS. EASTMAN AUTOMATIC (BUILT-IN) SHUTTER.

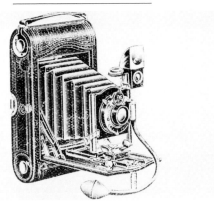

**(515) NO. 3 FOLDING POCKET KODAK CAMERA. IMPROVED MODEL.** C. 1903–15. SIZE 3¼ X 4¼ INCH EXPOSURES ON NO. 118 ROLL FILM. BAUSCH & LOMB RAPID RECTILINEAR, F 6.8 GOERZ ANASTIGMAT, F 6.8 BAUSCH & LOMB PLASTIGMAT, F 6.3 BAUSCH & LOMB ZEISS TESSAR, F 6.5 COOKE ANASTIGMAT, F 6.8 GOERZ DAGOR, F 6.3 BECK ISOSTIGMAR, F 6.3 ZEISS KODAK ANASTIGMAT, OR F 8 KODAK ANASTIGMAT LENS. BAUSCH & LOMB AUTOMATIC, UNICUM, VOLUTE, F.P.K. AUTOMATIC, KODAK AUTOMATIC, GOERZ X.L. SECTOR, BAUSCH AND LOMB COMPOUND, OR KODAK BALL-BEARING SHUTTER.

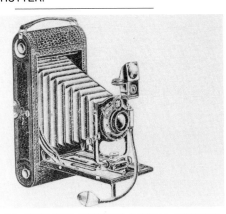

**(516) NO. 3A FOLDING POCKET KODAK CAMERA.** C. 1903–15. SIZE 3¼ X 5½ INCH EXPOSURES ON NO. 122 ROLL FILM. THE CAMERA HAS THE SAME LENSES AND SHUTTERS AS THE NO. 3 FOLDING POCKET KODAK CAMERA (IMPROVED MODEL).

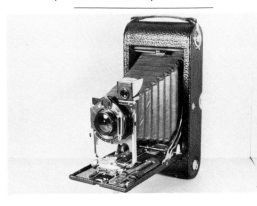

**(517) NO. 3A FOLDING POCKET KODAK CAMERA. MODEL B5 (AUTOGRAPHIC).** C. 1915. SIZE 3¼ X 5½ INCH EXPOSURES ON NO. A122 ROLL FILM. BAUSCH & LOMB RAPID RECTILINEAR LENS. BALL-BEARING SHUTTER, ⅟₂₅, ⅟₅₀, ⅟₁₀₀ SEC., B., T.

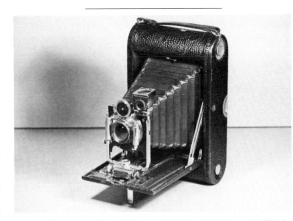

**(518) NO. 4 FOLDING POCKET KODAK CAMERA.** C. 1907–15. SIZE 4 X 5 INCH EXPOSURES ON NO. 123 ROLL FILM. SAME LENSES AND SHUTTERS AS THE NO. 3A FOLDING POCKET KODAK, C. 1903–15. (MR).

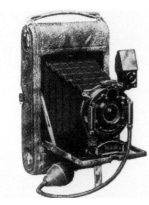

**(519) NO. 3 FOLDING POCKET KODAK DELUXE CAMERA.** C. 1901–03. SIZE 3¼ X 4¼ INCH EXPOSURES ON NO. 118 ROLL FILM OR FILM CARTRIDGES. BAUSCH & LOMB PLASTIGMAT LENS. BAUSCH & LOMB AUTOMATIC SHUTTER. PERSIAN MOROCCO LEATHER COVERED. SILK COVERED BELLOWS.

**(520) NO. 1A FOLDING POCKET KODAK-RR TYPE CAMERA.** C. 1912–15. SIZE 2½ X 4¼ INCH EXPOSURES ON NO. 116 ROLL FILM. F 6.3 ZEISS KODAK ANASTIGMAT, RAPID RECTILINEAR, F 6.3 BAUSCH & LOMB ZEISS TESSAR, F 6.5 COOKE ANASTIGMAT OR F 8 KODAK ANASTIGMAT LENS. BALL-BEARING, KODAK AUTOMATIC OR BAUSCH & LOMB COMPOUND SHUTTER.

**(521) NO. 1A FOLDING POCKET KODAK SPECIAL CAMERA.** C. 1908–12. SIZE 2½ X 4¼ INCH EXPOSURES ON NO. 116 ROLL FILM. SIMILAR TO THE NO. 1A FOLDING POCKET KODAK-RR TYPE CAMERA WITH THE SAME LENSES AND SHUTTERS PLUS F 6.3 ISOSTIGAT OR F 6.8 GOERZ DAGOR LENS AND F.P.K. AUTOMATIC OR BAUSCH & LOMB AUTOMATIC SHUTTER.

**(522) NO. 1A GIFT KODAK CAMERA.** C. 1930–31. SIZE 2½ X 4¼ INCH EXPOSURES ON NO. 116 ROLL FILM. ACHROMATIC LENS. KODO SHUTTER. PACKED IN GIFT CEDAR BOX.

**(523) GIRL SCOUT KODAK CAMERA.** C. 1929–34. SIZE 1⅝ X 2½ INCH EXPOSURES ON NO. 127 ROLL FILM. MENISCUS LENS. ROTARY SHUTTER. GREEN COLOR.

**(524) NO. 4 GLASS PLATE FOLDING KODAK CAMERA.** C. 1892–97. SIZE 4 X 5 INCH EXPOSURES ON GLASS PLATES. SIMILAR TO THE NO. 4 FOLDING KODAK, IMPROVED MODEL, WITH THE SAME LENS AND SHUTTER PLUS THE SPECIAL KODAK WINGED-TYPE SHUTTER OR THE BARKER SHUTTER.

**(525) NO. 5 GLASS PLATE FOLDING KODAK CAMERA.** C. 1892–97. SIZE 5 X 7 INCH EXPOSURES ON GLASS PLATES. SIMILAR TO THE NO. 5 FOLDING KODAK, IMPROVED MODEL, WITH THE SAME LENS AND SHUTTER PLUS THE SPECIAL KODAK WINGED-TYPE SHUTTER OR THE BARKER SHUTTER.

**(526) NO. 6 GLASS PLATE FOLDING KODAK CAMERA.** C. 1894–95. SIZE 6½ X 8½ INCH EXPOSURES ON GLASS PLATES. SIMILAR TO THE NO. 5 FOLDING KODAK, IMPROVED MODEL, WITH THE SAME LENS AND SHUTTER.

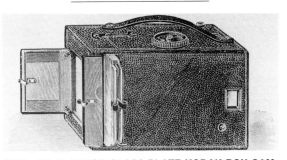

**(527) NO. 3 JUNIOR GLASS PLATE KODAK BOX CAMERA.** C. 1892–97. SIZE 3¼ X 4¼ INCH EXPOSURES ON GLASS PLATES. BAUSCH & LOMB UNIVERSAL LENS. STRING-SETTING SECTOR SHUTTER. THREE ROTARY APERTURE STOPS. RACK & PINION FOCUSING.

**(528) NO. 4 JUNIOR GLASS PLATE KODAK BOX CAMERA.** C. 1892–97. SIZE 4 X 5 INCH EXPOSURES ON GLASS PLATES. SIMILAR TO THE NO. 3 JUNIOR GLASS PLATE KODAK BOX CAMERA WITH THE SAME LENS AND SHUTTER.

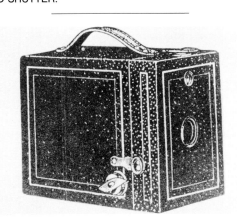

## EASTMAN KODAK COMPANY (*cont.*)

**(529) HAWKEYE BOX CAMERA.** C. 1929. SIZE 2¼ X 3¼ INCH EXPOSURES ON ROLL FILM. MENISCUS LENS. INSTANT SHUTTER.

---

**(530) SPECIAL GLASS PLATE KODAK CAMERA "C."** C. 1892–95. SIZE 5 X 5 INCH EXPOSURES ON GLASS PLATES. DOUBLE LENS WITH REVOLVING STOPS. SPECIAL SECTOR TYPE SHUTTER.

---

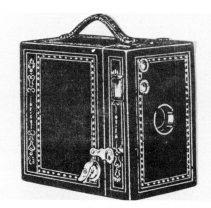

**(531) HAWKEYE MODEL B BOX CAMERA.** C. 1929. SIZE 2½ X 4¼ INCH EXPOSURES ON ROLL FILM. MENISCUS LENS. INSTANT AND TIME SHUTTER.

---

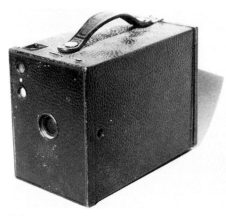

**(532) NO. 2 CARTRIDGE HAWKEYE BOX CAMERA. MODEL A.** C. 1918–27. SIZE 2¼ X 3¼ INCH EXPOSURES ON NO. 120 ROLL FILM. MENISCUS LENS, ROTARY SHUTTER. (KC)

---

**(533) NO. 2A CARTRIDGE HAWKEYE BOX CAMERA.** C. 1918–27. SIZE 2½ X 4¼ INCH EXPOSURES ON ROLL FILM. SIMILAR TO THE NO. 2 CARTRIDGE HAWKEYE BOX CAMERA.

---

**(534) NO. 2 FOLDING HAWKEYE CAMERA.** C. 1917. EIGHT EXPOSURES, SIZE 2¼ X 3¼ INCHES ON NO. 120 ROLL FILM. KODAK LENS AND SHUTTER. SHUTTER SPEEDS: ½₅, ⅟₅₀ SEC., B., T.

---

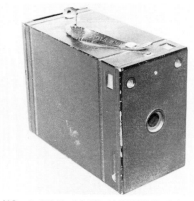

**(535) NO. 2 FILM PACK HAWKEYE BOX CAMERA.** SIZE 2¼ X 3¼ INCH FILM PACK EXPOSURES. ALL-METAL CONSTRUCTION. INSTANT AND TIME SHUTTER. (KC)

---

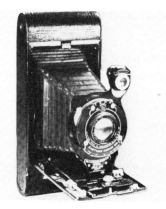

**(536) NO. 2A FOLDING HAWKEYE SPECIAL CAMERA.** C. 1927. SIZE 2½ X 4¼ INCH EXPOSURES ON ROLL FILM. 127 MM/F 6.3 KODAK ANASTIGMAT LENS. KODEX SHUTTER; ⅟₂₅, ⅟₅₀ SEC., B., T. (HA)

---

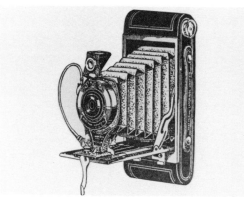

**(537) FOLDING CARTRIDGE HAWKEYE CAMERA.** C. 1929. THREE SIZES OF THIS CAMERA FOR 2¼ X 3¼, 2½ X 4¼, OR 3¼ X 5½ INCH EXPOSURES ON ROLL FILM. KODEX SHUTTER; ⅟₂₅, ⅟₅₀ SEC., B., T. (EH)

---

**(538) NO. 2 RAINBOW HAWKEYE BOX CAMERA.** C. 1933. SIZE 2¼ X 3¼ INCH EXPOSURES ON NO. 620 ROLL FILM. SINGLE LENS. INSTANT SHUTTER. VARIOUS COLORED MODELS.

---

**(539) NO. 2A RAINBOW HAWKEYE BOX CAMERA.** C. 1933. SIZE 2½ X 4¼ INCH EXPOSURES ON NO. 616 ROLL FILM. MENISCUS LENS. INSTANT SHUTTER. SIMILAR TO THE NO. 2 RAINBOW HAWKEYE BOX CAMERA. VARIOUS COLORED MODELS.

---

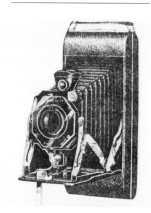

**(540) SIX-16 HAWKEYE FOLDING CAMERA.** C. 1933. SIZE 2½ X 4¼ INCH EXPOSURES ON NO. 616 ROLL FILM. KODAK SINGLE ACHROMATIC, DOUBLET, OR F 6.3 KODAK ANASTIGMAT LENS. KODAL, KODON, OR KODEX SHUTTER. (EH)

---

**(541) SIX-20 HAWKEYE FOLDING CAMERA.** C. 1933. SIZE 2¼ X 3¼ INCH EXPOSURES ON NO. 620 ROLL FILM. SIMILAR TO THE SIX-16 HAWKEYE FOLDING CAMERA WITH THE SAME LENSES AND SHUTTERS (EXCEPT NO KODEX SHUTTER).

---

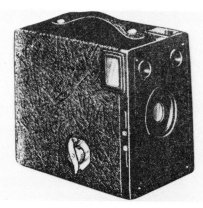

**(542) SIX-16 TARGET HAWKEYE BOX CAMERA.** C. 1933. SIZE 2½ X 4¼ INCH EXPOSURES ON NO. 616 ROLL FILM. INSTANT AND TIME ROTARY SHUTTER. BLACK, BROWN, OR BLUE COLOR. (EH)

---

**(543) SIX-20 TARGET HAWKEYE BOX CAMERA.** C. 1933. SIZE 2¼ X 3¼ INCH EXPOSURES ON NO. 620 ROLL FILM. SIMILAR TO THE SIX-16 TARGET HAWKEYE BOX CAMERA WITH THE SAME LENS AND SHUTTER.

---

**(544) JIFFY KODAK SIX-16 CAMERA.** C. 1933–37. SIZE 2½ X 4¼ INCH EXPOSURES ON NO. 616 ROLL FILM. SIMILAR TO THE JIFFY KODAK SIX-16 SERIES II MODEL WITH THE SAME LENS AND SHUTTER.

## EASTMAN KODAK COMPANY (cont.)

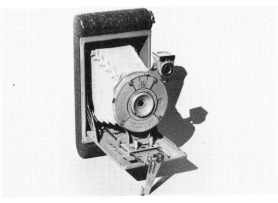

**(545) VEST POCKET HAWKEYE CAMERA.** C. 1930. SIZE 1⅝ X 2½ INCH EXPOSURES ON NO. 127 ROLL FILM. SINGLE LENS. INSTANT AND TIME SHUTTER. FOUR APERTURE STOPS. VARIOUS COLORED MODELS. (KC)

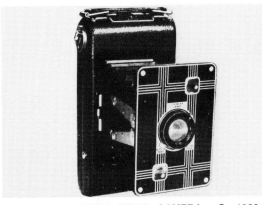

**(546) JIFFY KODAK SIX-20 CAMERA.** C. 1933–37. SIZE 2¼ X 3¼ INCH EXPOSURES ON NO. 620 ROLL FILM. TWINDAR LENS. TWO-SPEED SHUTTER. (HA)

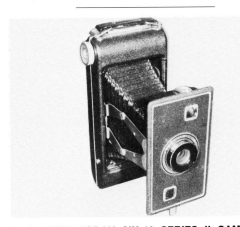

**(547) JIFFY KODAK SIX-16 SERIES II CAMERA.** C. 1937–42. SIZE 2½ X 4¼ INCH EXPOSURES ON NO. 616 ROLL FILM. TWINDAR LENS. INSTANT AND TIME SHUTTER.

**(548) JIFFY KODAK SIX-20 SERIES II CAMERA.** C. 1937–48. SIZE 2¼ X 3¼ INCH EXPOSURES ON NO. 620 ROLL FILM. TWINDAR LENS. INSTANT AND TIME SHUTTER. SIMILAR TO THE JIFFY KODAK SIX-16 SERIES II CAMERA.

**(549) JIFFY KODAK VEST POCKET CAMERA.** C. 1935–42. SIZE 1⅝ X 2½ INCH EXPOSURES ON NO. 127 ROLL FILM. DOUBLET LENS. INSTANT AND BULB SHUTTER. FIXED FOCUS.

**(550) NO. 1 KODAK BOX CAMERA.** C. 1892–95. 2½ INCH DIAMETER EXPOSURES ON ROLL FILM. THE CAMERA WAS FACTORY LOADED WITH ROLL FILM FOR 100 EXPOSURES. PERISCOPIC LENS. STRING-SETTING SECTOR SHUTTER. SEE PHOTO UNDER EASTMAN DRY PLATE & FILM COMPANY.

**(551) NO. 2 KODAK BOX CAMERA.** C. 1892–97. 60 OR 100 EXPOSURES, SIZE 3½ INCH DIAMETER ON ROLL FILM. THE CAMERA WAS FACTORY LOADED WITH ROLL FILM. PERISCOPIC LENS. STRING-SETTING SECTOR SHUTTER. EXPOSURE COUNTER. THREE ROTARY APERTURE STOPS. CIRCULAR GROUND GLASS VIEWER. SEE PHOTO UNDER EASTMAN DRY PLATE & FILM COMPANY.

**(552) NO. 3 KODAK BOX CAMERA.** C. 1892–97. SIZE 3¼ X 4¼ INCH EXPOSURES ON ROLL FILM. THE CAMERA WAS FACTORY LOADED WITH ROLL FILM FOR 60 OR 100 EXPOSURES. BAUSCH & LOMB UNIVERSAL LENS. STRING-SETTING SECTOR SHUTTER. THREE ROTARY APERTURE STOPS. RACK & PINION FOCUSING. SEE PHOTO UNDER EASTMAN DRY PLATE & FILM COMPANY.

**(553) NO. 4 KODAK BOX CAMERA.** C. 1892–97. SIZE 4 X 5 INCH EXPOSURES ON ROLL FILM. THE CAMERA WAS FACTORY LOADED WITH ROLL FILM FOR 48 OR 100 EXPOSURES. BAUSCH & LOMB UNIVERSAL LENS. STRING-SETTING SECTOR SHUTTER. THREE ROTARY APERTURE STOPS. RACK & PINION FOCUSING. EXPOSURE COUNTER. SEE PHOTO UNDER EASTMAN DRY PLATE & FILM COMPANY.

**(554) NO. 1 KODAK JUNIOR CAMERA.** C. 1914. SIZE 2¼ X 3¼ INCH EXPOSURES ON NO. 120 ROLL FILM. MENISCUS ACHROMATIC OR RAPID RECTILINEAR LENS. KODAK BALL-BEARING SHUTTER; ½₅, ⅟₅₀ SEC., B., T. SIMILAR TO THE NO. 1 AUTOGRAPHIC KODAK JUNIOR CAMERA.

**(555) NO. 1A KODAK JUNIOR CAMERA.** C. 1914. SIZE 2¼ X 4¼ INCH EXPOSURES ON NO. 116 ROLL FILM. MENISCUS ACHROMATIC OR RAPID RECTILINEAR LENS. KODAK BALL-BEARING SHUTTER. SIMILAR TO THE NO. 1A AUTOGRAPHIC KODAK JUNIOR CAMERA.

**(556) NO. 3 KODAK JUNIOR BOX CAMERA.** C. 1892–97. SIZE 3¼ X 4¼ INCH EXPOSURES. THE CAMERA WAS FACTORY LOADED WITH ROLL FILM FOR 60 EXPOSURES. BAUSCH & LOMB UNIVERSAL LENS. STRING-SETTING SECTOR SHUTTER. THREE ROTARY APERTURE STOPS. RACK & PINION FOCUSING. SEE PHOTO UNDER EASTMAN DRY PLATE & FILM COMPANY.

**(557) NO. 4 KODAK JUNIOR BOX CAMERA.** C. 1892–97. SIZE 4 X 5 INCH EXPOSURES. THE CAMERA WAS FACTORY LOADED WITH ROLL FILM FOR 48 EXPOSURES. BAUSCH & LOMB UNIVERSAL LENS. STRING-SETTING SECTOR SHUTTER. THREE ROTARY APERTURE STOPS. RACK & PINION FOCUS. EXPOSURE COUNTER. SEE PHOTO UNDER EASTMAN COMPANY (THE).

**(558) KODAK PETITE CAMERA.** C. 1929–34. SIZE 1⅝ X 2½ INCH EXPOSURES ON NO. 127 ROLL FILM. THE ENSEMBLE INCLUDES A V.P. MODEL B CAMERA, LIPSTICK, COMPACT, AND MIRROR. (EB)

**(559) NO. 3A KODAK SERIES II CAMERA.** C. 1936–41. SIX EXPOSURES SIZE 3¼ X 5½ INCHES ON NO. 122 ROLL FILM. 170 MM/F 4.5 OR F 6.3 KODAK ANASTIGMAT LENS. COMPUR SHUTTER TO ⅟₂₀₀ SEC., B., T., ST., OR DIODAK SHUTTER TO ⅟₁₀₀ SEC., B., T., ST. FOCAL PLANE MASK FOR TAKING SIZE 2½ X 3¼ INCH EXPOSURES.

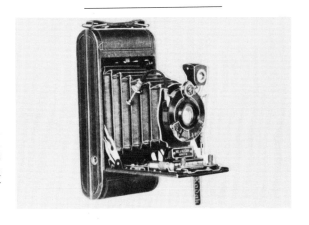

## EASTMAN KODAK COMPANY (*cont.*)

(560) **NO. 1 KODAK SERIES III CAMERA.** C. 1926–32. SIZE 2¼ X 3¼ INCH EXPOSURES ON NO. 120 ROLL FILM. F 6.3 KODAK ANASTIGMAT LENS. DIAMATIC SHUTTER; ⅒, 1⁄25, 1⁄50, 1⁄100 SEC., B., T.

(561) **NO. 1A KODAK SERIES III CAMERA.** C. 1924–31. SIZE 2½ X 4¼ INCH EXPOSURES ON NO. 116 ROLL FILM. SIMILAR TO THE NO. 2C KODAK SERIES III CAMERA WITH THE SAME LENSES AND SHUTTER.

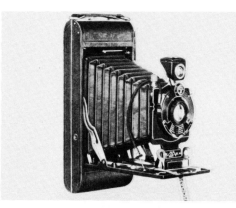

(562) **NO. 2C KODAK SERIES III CAMERA.** C. 1924–31. SIZE 2⅞ X 4⅞ INCH EXPOSURES ON NO. 130 ROLL FILM. F 5.6, F 6.3, OR F 7.7 KODAK ANASTIGMAT LENS. DIOMATIC SHUTTER; ⅒ TO 1⁄100 SEC., B., T.

(563) **NO. 3 KODAK SERIES III CAMERA.** C. 1926–33. SIZE 3¼ X 4¼ INCH EXPOSURES ON NO. 118 ROLL FILM. F 7.9 KODAR, F 5.6 OR F 6.3 KODAK ANASTIGMAT LENS. KODEX SHUTTER; 1⁄25, 1⁄50 SEC., B., T., OR DIOMATIC SHUTTER; ⅒ TO 1⁄100 SEC., B., T. SIMILAR TO THE NO. 2C KODAK SERIES III CAMERA.

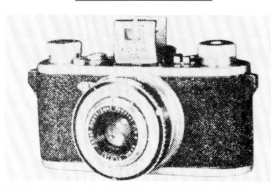

(564) **KODAK 35 CAMERA. ORIGINAL MODEL.** C. 1938–48. SIZE 24 X 36 MM EXPOSURES ON "35MM" ROLL FILM. 50 MM/F 3.5, F 4.5, OR F 5.6 KODAK ANASTIGMAT LENS. KODAMATIC SHUTTER; ⅒ TO 1⁄200 SEC., B., T.; DIOMATIC SHUTTER; ⅒ TO 1⁄150 SEC., T., OR KODEX SHUTTER; 1⁄25 TO 1⁄100 SEC., T. DELAYED TIMER ON SHUTTERS WITH F 3.5 OR F 4.5 LENSES.

(565) **MONITOR SIX-16 CAMERA.** C. 1939–48. SIZE 2½ X 4¼ INCH EXPOSURES ON NO. 616 OR PB-16 ROLL FILM. 103 MM/F 4.5 KODAK ANASTIGMAT OR F 4.5 SPE-

CIAL ANASTIGMAT LENS. KODAMATIC SHUTTER; ⅒ TO 1⁄200 SEC., B., T., ST. OR SUPERMATIC SHUTTER; 1 TO 1⁄400 SEC., B., T., ST. DOUBLE EXPOSURE PREVENTION. AUTOMATIC FILM STOP. EXPOSURE COUNTER.

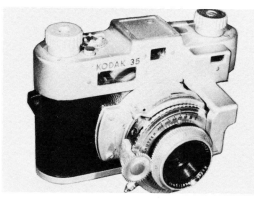

(566) **KODAK 35 RANGEFINDER MODEL CAMERA.** C. 1940–51. SIZE 24 X 36 MM EXPOSURES ON "35MM" ROLL FILM. 50 MM/F 3.5 KODAK ANASTIGMAT LENS. KODAMATIC SHUTTER; ⅒ TO 1⁄200 SEC., B., T. COUPLED RANGEFINDER. (FL)

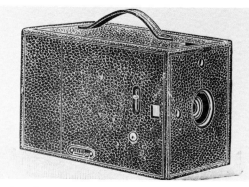

(567) **NO. 4 KODET BOX CAMERA.** C. 1894–97. SIZE 4 X 5 INCH EXPOSURES ON PLATES OR ROLL FILM. DOUBLET LENS. MULTI-SPEED SHUTTER. THREE ROTARY APERTURE STOPS. INDEX OR GROUND GLASS FOCUSING.

(568) **MONITOR SIX-20 CAMERA.** C. 1939–48. SIZE 2¼ X 3¼ INCH EXPOSURE ON NO. 620 OR PB-20 ROLL FILM. SIMILAR TO THE MONITOR SIX-16 CAMERA WITH THE SAME LENSES, SHUTTERS, AND FEATURES.

(569) **NEW YORK WORLD'S FAIR BULLET CAMERA.** C. 1939–40. SIZE 1⅝ X 2½ INCH EXPOSURES ON NO. 127 ROLL FILM. MENISCUS LENS. ROTARY SHUTTER.

(570) **"A" ORDINARY KODAK BOX CAMERA.** C. 1892–95. TWENTY-FOUR EXPOSURES, SIZE 2¾ X 3¼ INCHES ON ROLL FILM. DARKROOM FILM LOADING TYPE. SINGLE LENS. STRING-SET SECTOR SHUTTER. EXPOSURE COUNTER. SEE PHOTO UNDER EASTMAN COMPANY (THE).

(571) **"B" ORDINARY KODAK BOX CAMERA.** C. 1892–95. TWENTY-FOUR EXPOSURES, SIZE 3½ X 4 INCHES

ROLL FILM. DARKROOM FILM LOADING TYPE. SINGLE LENS. STRING-SETTING SECTOR SHUTTER. EXPOSURE COUNTER. SEE PHOTO UNDER EASTMAN COMPANY (THE).

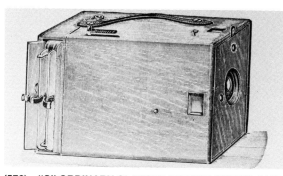

(572) **"C" ORDINARY GLASS PLATE KODAK BOX CAMERA.** C. 1892–95. SIZE 4 X 5 INCH EXPOSURES ON GLASS PLATES. SINGLE LENS. STRING-SETTING SECTOR SHUTTER. FOCUSING LEVER. REVOLVING APERTURE STOPS.

(573) **"C" ORDINARY KODAK BOX CAMERA.** C. 1892–95. TWENTY-FOUR EXPOSURES, SIZE 4 X 5 INCHES ON ROLL FILM. DARKROOM FILM LOADING TYPE. ACHROMATIC LENS. STRING-SETTING SECTOR SHUTTER. EXPOSURE COUNTER. SEE PHOTO UNDER EASTMAN COMPANY (THE).

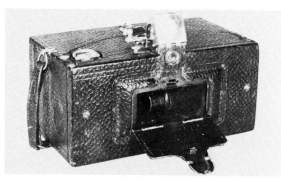

(574) **NO. 1 PANORAM KODAK CAMERA.** C. 1900–26. MODELS B, C, AND D. 112-DEGREE PANORAMIC EXPOSURES, SIZE 2¼ X 7 INCHES ON NO. 105 ROLL FILM. SIX EXPOSURES PER ROLL. MENISCUS OR RAPID RECTILINEAR LENS. FOCAL PLANE SWINGING-SLOT TYPE SHUTTER; SINGLE SPEED. (SW)

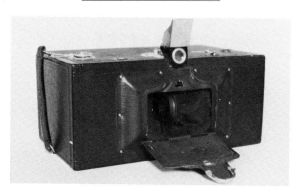

## EASTMAN KODAK COMPANY (*cont.*)

**(575) NO. 3A PANORAM KODAK CAMERA.** C. 1926–28. 120-DEGREE PANORAMIC EXPOSURES, SIZE 3¼ X 10⅜ INCHES ON NO. 122 ROLL FILM. 133 MM/F 12.8 MENISCUS LENS. FOCAL PLANE SWINGING-SLOT TYPE SHUTTER; ⅒ AND ⅙₀ SEC. (TH)

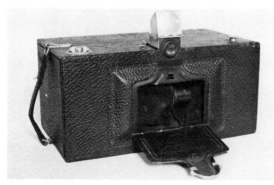

**(576) NO. 4 PANORAM KODAK CAMERA.** C. 1899–1924. MODELS B, C, AND D. 142-DEGREE PANORAMIC EXPOSURES, SIZE 3½ X 12 INCHES ON NO. 103 ROLL FILM. FOUR EXPOSURES PER ROLL. F 10 RAPID RECTILINEAR OR MENISCUS LENS. FIRST PANORAMIC CAMERA MADE BY KODAK. FOCAL PLANE SWINGING-SLOT TYPE SHUTTER; SINGLE SPEED. (TH)

**(577) POCKET KODAK BOX CAMERA.** C. 1895. EARLY MODEL. SIZE 1½ X 2 INCH EXPOSURES ON NO. 102 ROLL FILM OR SINGLE EXPOSURE ON DRY PLATES. 65 MM/F 10 FIXED FOCUS MENISCUS LENS. SELF-CAPPING SECTOR SHUTTER FOR SINGLE SPEED AND TIME EXPOSURES. THE SHUTTER HAS TO BE COCKED. ROUND VIEW FINDER. (IH)

**(578) POCKET KODAK BOX CAMERA.** C. 1896–1900. LATER MODEL. SIZE 1½ X 2 INCH EXPOSURES ON NO. 102 ROLL FILM. SAME AS THE 1895 MODEL BUT WITH IMPROVED ROTARY SHUTTER, THREE APERTURE STOPS, AND RECTANGULAR FINDER.

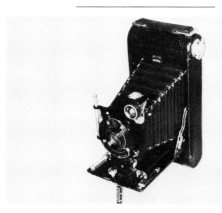

**(579) NO. 1 POCKET KODAK CAMERA.** C. 1926–32. SIZE 2¼ X 3¼ INCH EXPOSURES ON NO. 120 ROLL FILM. 4⅜ INCH/F 7.9 MENISCUS ACHROMATIC OR KODAR LENS. ALSO, 4¼ INCH/F 7.7 OR 4⅛ INCH/F 6.3 KODAK ANASTIGMAT LENS. KODEX SHUTTER; ⅟₂₅, ⅟₅₀ SEC., B., T. COLORED MODELS FROM 1929 TO 1931.

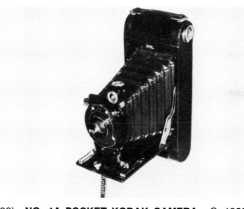

**(580) NO. 1A POCKET KODAK CAMERA.** C. 1926–32. SIZE 2½ X 4¼ INCH EXPOSURES ON NO. 116 ROLL FILM. 5⅛ INCH/F 7.9 MENISCUS ACHROMATIC OR KODAR LENS. ALSO, F 7.7 OR 6.3 KODAK ANASTIGMAT LENS. KODEX SHUTTER; ⅟₂₅, ⅟₅₀ SEC., B., T. COLORED MODELS FROM 1929 TO 1932.

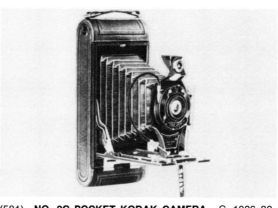

**(581) NO. 2C POCKET KODAK CAMERA.** C. 1926–32. SIZE 2⅞ X 4⅞ INCH EXPOSURES ON NO. 130 ROLL FILM. 6⅛ INCH/F 7.9 MENISCUS ACHROMATIC, OR KODAR 6 INCH/F 7.7 KODAK ANASTIGMAT OR 6 INCH/F 6.3 KODAK ANASTIGMAT LENS. KODEX SHUTTER; ⅟₂₅, ⅟₅₀ SEC., B., T., OR BALL-BEARING SHUTTER; ⅟₂₅, ⅟₅₀, ⅟₁₀₀ SEC., B., T.

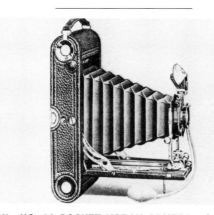

**(582) NO. 3A POCKET KODAK CAMERA.** C. 1927–33. SIZE 3¼ X 5½ INCH EXPOSURES ON NO. 122 ROLL FILM. 6⅞ INCH/F 7.9 MENISCUS ACHROMATIC OR KODAR, 6⅝ INCH/F 7.7 KODAK ANASTIGMAT, OR 6⅝ INCH/F 6.3 KODAK ANASTIGMAT LENS. KODEX SHUTTER; ⅟₂₅, ⅟₅₀ SEC., B., T., OR BALL-BEARING SHUTTER; ⅟₂₅, ⅟₅₀, ⅟₁₀₀ SEC., B., T.

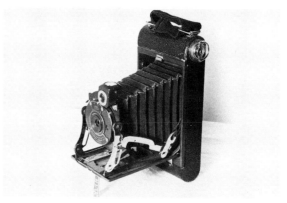

**(583) NO. 1 POCKET KODAK JUNIOR CAMERA.** C. 1929–32. SIZE 2¼ X 3¼ INCH EXPOSURES ON NO. 120 ROLL FILM. MENISCUS ACHROMATIC LENS. KODO SHUTTER FOR INSTANT AND TIME EXPOSURES. SOME COLORED MODELS. (TS)

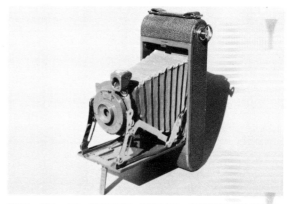

**(584) NO. 1A POCKET KODAK JUNIOR CAMERA.** C. 1929–32. SIZE 2½ X 4¼ INCH EXPOSURES ON NO. 116 ROLL FILM. ACHROMATIC LENS. INSTANT AND TIME KODO SHUTTER. (KC)

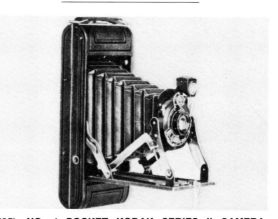

**(585) NO. 1 POCKET KODAK SERIES II CAMERA.** C. 1922–32. SIZE 2¼ X 3¼ INCH EXPOSURES ON NO. 120 ROLL FILM. 4⅜ INCH/F 7.9 MENISCUS ACHROMATIC, F 7.7 KODAK ANASTIGMAT OR F 7.9 KODAR LENS. DIOMATIC SHUTTER; ⅒ TO ⅟₁₀₀ SEC., B., T. OR KODAK BALL-BEARING SHUTTER.

**(586) NO. 1A POCKET KODAK SERIES II CAMERA.** C. 1923–31. SIZE 2½ X 4¼ INCH EXPOSURES ON NO.

## EASTMAN KODAK COMPANY (cont.)

116 ROLL FILM. SIMILAR TO THE NO. 1 POCKET KODAK SERIES II CAMERA WITH THE SAME LENSES AND SHUTTERS. COLORED MODELS FROM 1928 TO 1931.

**(587) NO. 1 POCKET KODAK SPECIAL CAMERA.** C. 1926–34. SIZE 2¼ X 3¼ INCH EXPOSURES ON NO. 120 ROLL FILM. F 4.5, F 5.6, OR F 6.3 KODAK ANASTIGMAT LENS. KODAMATIC SHUTTER; ½ TO 1/200 SEC., B., T. SIMILAR TO THE NO. 1A POCKET KODAK SPECIAL CAMERA.

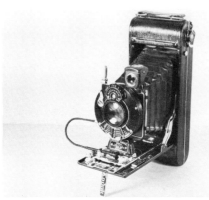

**(588) NO. 1A POCKET KODAK SPECIAL CAMERA.** C. 1926–34. SIZE 2½ X 4¼ INCH EXPOSURES ON NO. 116 ROLL FILM. SAME LENSES AND SHUTTER AS THE NO. 1 POCKET KODAK SPECIAL CAMERA.

**(589) NO. 2C POCKET KODAK SPECIAL CAMERA.** C. 1928–33. SIZE 2⅞ X 4⅞ INCH EXPOSURES ON NO. 130 ROLL FILM. SIMILAR TO THE NO. 1A POCKET KODAK SPECIAL CAMERA WITH THE SAME LENSES AND SHUTTER.

**(590) NO. 3 POCKET KODAK SPECIAL CAMERA.** C. 1926–33. SIZE 3¼ X 4¼ INCH EXPOSURES ON NO. 118 ROLL FILM. SIMILAR TO THE NO. 1A POCKET KODAK SPECIAL CAMERA WITH THE SAME LENSES AND SHUTTER.

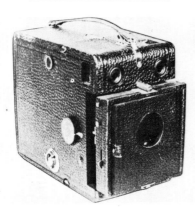

**(591) 3B QUICK-FOCUS BOX CAMERA.** C. 1906–11. SIZE 3¼ X 5½ INCH EXPOSURES ON NO. 125 ROLL FILM. RAPID FOCUS ADJUSTMENT BY A SPRING TENSION SYSTEM. 170 MM/F 13 MENISCUS ACHROMATIC LENS.

ROTARY SHUTTER FOR SINGLE-SPEED AND TIME EXPOSURES.

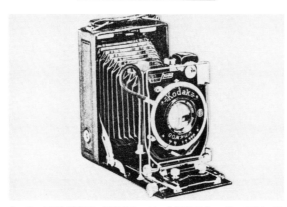

**(592) RECOMAR MODEL 18 CAMERA.** C. 1932–40. SIZE 6.5 X 9 CM EXPOSURES ON PLATES OR 2¼ X 3¼ INCH EXPOSURES ON FILM PACKS OR CUT FILM. 105 MM/F 4.5 KODAK ANASTIGMAT OR SCHNEIDER XENAR LENS. COMPUR SHUTTER; 1 TO 1/250 SEC., B., T. DOUBLE EXTENSION BELLOWS. RACK & PINION FOCUSING. RISING FRONT.

**(593) RECOMAR MODEL 33 CAMERA.** C. 1932–40. SIZE 9 X 12 CM EXPOSURES ON PLATES, CUT FILM, OR FILM PACKS (WITH ADAPTER). 135 MM/F 4.5 KODAK ANASTIGMAT OR SCHNEIDER XENAR LENS. COMPUR SHUTTER; 1 TO 1/200 SEC., B., T. (ST IN SOME MODELS). DOUBLE EXTENSION BELLOWS. RACK & PINION FOCUSING. RISING FRONT. SIMILAR TO THE RECOMAR MODEL 18 CAMERA.

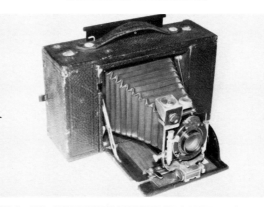

**(594) NO. 4 SCREEN FOCUS KODAK CAMERA.** C. 1904–10. SIZE 4 X 5 INCH EXPOSURES ON PLATES OR NO. 123 ROLL FILM. F 6.8 BAUSCH & LOMB PLASTIGMAT, RAPID RECTILINEAR, F 6.8 GOERZ ANASTIGMAT, F 6.3 BAUSCH & LOMB ZEISS TESSAR, F 6.5 COOKE ANASTIGMAT, F 6.8 GOERZ DAGOR, F 6.3 ISOSTIGMAT, OR F 6.3 ZEISS KODAK LENS. KODAK AUTOMATIC (1 TO 1/100 SEC., B., T.), BAUSCH & LOMB AUTOMATIC OR VOLUTE SHUTTER. THE ROLL HOLDER SECTION OF THE CAMERA CAN BE TILTED UPWARD FOR INSERTING A GROUND GLASS IN THE FOCAL PLANE FOR FOCUSING. DOUBLE EXTENSION BELLOWS. RACK & PINION FOCUSING. (GE)

**(595) SIX-16 KODAK CAMERA. FOCUSING MODEL.** C. 1932–36. SIZE 2¼ X 4¼ INCH EXPOSURES ON NO.

116 ROLL FILM. F 6.3 OR F 4.5 KODAK ANASTIGMAT OR DOUBLET LENS. DIODAK, KODON, COMPUR, OR DAKAR SHUTTER.

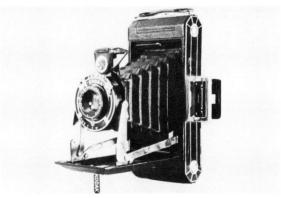

**(596) SIX-16 KODAK CAMERA. FIXED FOCUS MODEL.** C. 1932–33. SIZE 2½ X 4¼ INCH EXPOSURES ON NO. 116 ROLL FILM. MENISCUS ACHROMATIC OR DOUBLET LENS. KODAL SHUTTER: 1/25, 1/50 SEC., B., T. OR KODON SHUTTER; 1/25, 1/50, 1/100 SEC., B., T. (TS)

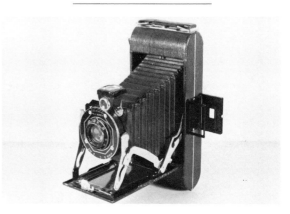

**(597) SIX-16 KODAK JUNIOR CAMERA.** C. 1935–37. SIZE 2½ X 4¼ INCH EXPOSURES ON NO. 616 ROLL FILM. 126 MM/F 6.3 KODAK ANASTIGMAT OR DOUBLET LENS. KODON OR KODEX SHUTTER; 1/25 TO 1/100 SEC., B., T.

**(598) SIX-16 KODAK JUNIOR SERIES II CAMERA.** C. 1937–40. SIZE 2½ X 4¼ INCH EXPOSURES ON NO. 616 FILM. FIXED-FOCUS SINGLET LENS OR THREE-POINT FOCUS BIMAT LENS. KODON SHUTTER; 1/25 TO 1/100 SEC., B., T. OR KODAL OR KODEX SHUTTER.

**(599) SIX-16 KODAK JUNIOR SERIES III CAMERA.** C. 1938–39. SIZE 2½ X 4¼ INCH EXPOSURES ON NO. 616 ROLL FILM. F 8.8, F 6.3, OR F 4.5 KODAK ANASTIGMAT LENS. KODEX OR DIOMATIC SHUTTER.

**(600) SIX-16 KODAK SENIOR CAMERA.** C. 1937–39. SIZE 2½ X 4¼ INCH EXPOSURES ON NO. 616 ROLL FILM. SIMILAR TO THE SIX-20 KODAK SENIOR CAMERA. WITH THE SAME LENSES AND SHUTTERS.

**(601) SIX-16 KODAK SPECIAL CAMERA.** C. 1937–39. SIZE 2½ X 4¼ INCH EXPOSURES ON NO. 616 ROLL FILM. F 4.5 KODAK ANASTIGMAT OR F 4.5 KODAK ANASTIG-

## EASTMAN KODAK COMPANY (*cont.*)

MAT SPECIAL LENS. KODAMATIC, COMPUR RAPID, OR SUPERMATIC SHUTTER.

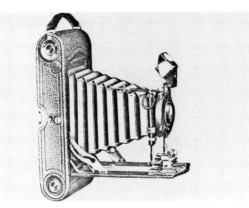

(602) **NO. 1A SIX-THREE KODAK CAMERA.** C. 1913–15. SIZE 2½ X 4¼ INCH EXPOSURES ON NO. 116 ROLL FILM. F 6.3 COOKE KODAK ANASTIGMAT LENS. BAUSCH & LOMB COMPOUND SHUTTER.

(603) **NO. 3 SIX-THREE KODAK CAMERA.** C. 1913–15. SIZE 3¼ X 4¼ INCH EXPOSURES ON NO. 118 ROLL FILM. SIMILAR TO THE NO. 1A SIX-THREE KODAK CAMERA WITH THE SAME LENS AND SHUTTER.

(604) **NO. 3A SIX-THREE KODAK CAMERA.** C. 1913–15. SIZE 3¼ X 5½ INCH EXPOSURES ON NO. 122 ROLL FILM. SIMILAR TO THE NO. 1A SIX-THREE KODAK CAMERA WITH THE SAME LENS AND SHUTTER.

(605) **SIX-20 KODAK CAMERA. FIXED FOCUS MODEL.** C. 1932–34. SIZE 2¼ X 3¼ INCH EXPOSURES ON NO. 620 ROLL FILM. DOUBLET LENS WITH KODON SHUTTER; ⅟₂₅ TO ⅟₁₀₀ SEC., B., T., OR MENISCUS ACHROMATIC LENS WITH KODAL SHUTTER; ⅟₂₅, ⅟₅₀, B., T. SIMILAR TO THE SIX-20 CAMERA, FOCUSING MODEL.

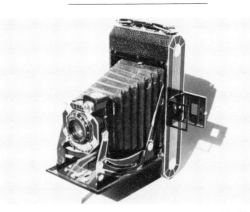

(606) **SIX-20 KODAK CAMERA. FOCUSING MODEL.** C. 1932–37. SIZE 2¼ X 4¼ INCH EXPOSURES ON NO. 620 ROLL FILM. F 6.3 OR F 4.5 KODAK ANASTIGMAT OR DOUBLET LENS. KODON SHUTTER; ⅟₂₅ TO ⅟₁₀₀ SEC., B., T., OR DIODAK OR COMPUR SHUTTER. (KC)

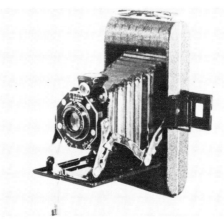

(607) **SIX-20 KODAK JUNIOR CAMERA.** C. 1935–37. SIZE 2¼ X 3¼ INCH EXPOSURES ON NO. 620 ROLL FILM. F 6.3 KODAK ANASTIGMAT OR DOUBLET LENS. KODON SHUTTER ⅟₂₅ TO ⅟₁₀₀ SEC., B., T. (TS)

(608) **SIX-20 KODAK JUNIOR SERIES II CAMERA.** C. 1937–40. SIZE 2¼ X 3¼ INCH EXPOSURES ON NO. 620 ROLL FILM. SIMILAR TO THE SIX-16 KODAK JUNIOR SERIES II CAMERA WITH THE SAME LENSES AND SHUTTERS. ALSO, BIMET (3-POINT FOCUS) LENS.

(609) **SIX-20 KODAK JUNIOR SERIES III CAMERA.** C. 1938–39. SIZE 2¼ X 3¼ INCH EXPOSURES ON NO. 620 ROLL FILM. F 8.8, F 6.3 OR F 4.5 KODAK ANASTIGMAT LENS. KODEX OR DIOMATIC SHUTTER.

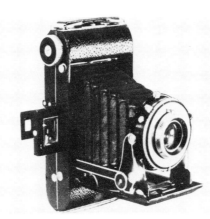

(610) **SIX-20 KODAK SENIOR CAMERA.** C. 1937–39. SIZE 2¼ X 3¼ INCH EXPOSURES ON NO. 620 ROLL FILM. F 7.7, F 6.3, OR F 4.5 KODAK ANASTIGMAT OR BIMAT LENS. KODAMATIC, KODEX, OR DIOMATIC LENS. (TS)

(611) **SIX-20 KODAK SERIES II CAMERA.** C. 1934–40. SIZE 2¼ X 3¼ INCH EXPOSURES ON NO. 620 ROLL FILM.

(612) **SIX-20 KODAK SPECIAL CAMERA.** C. 1937–39. SIZE 2¼ X 3¼ INCH EXPOSURES ON NO. 620 ROLL FILM. SAME LENSES AND SHUTTERS AS THE SIX-16 KODAK SPECIAL CAMERA.

(613) **SPECIAL GLASS PLATE KODAK CAMERA C.** C. 1892–95. SIZE 4 X 5 INCH EXPOSURES ON GLASS PLATES. SIMILAR TO THE C ORDINARY KODAK BOX CAMERA, WITH THE SAME SHUTTER BUT WITH A DOUBLET LENS AND LEATHER COVERED.

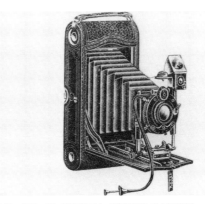

(614) **NO. 1A SPECIAL KODAK CAMERA.** C. 1912–14. SIZE 2½ X 4¼ INCH EXPOSURES ON NO. 116 ROLL FILM. F 6.3 ZEISS KODAK ANASTIGMAT, F 6.3 BAUSCH & LOMB ZEISS TESSAR, OR F 6.5 COOKE ANASTIGMAT LENS. BAUSCH & LOMB COMPOUND SHUTTER; 1 TO ⅟₂₀₀ SEC., B., T.

(615) **NO. 3 SPECIAL KODAK CAMERA.** C. 1911–14. SIZE 3¼ X 4¼ INCH EXPOSURES ON NO. 118 ROLL FILM. SIMILAR TO THE NO. 1A SPECIAL KODAK CAMERA WITH THE SAME LENSES AND SHUTTER.

(616) **NO. 3A SPECIAL KODAK CAMERA.** C. 1910–14. SIZE 3¼ X 5½ INCH EXPOSURES ON NO. 122 ROLL FILM. F 6.3 OR F 5.3 ZEISS TESSAR OR F 6.5 OR F 5.6 COOKE LENS. COMPOUND SHUTTER; 1 to ⅟₂₀₀ SEC., B., T. SIMILAR TO THE NO. 1A SPECIAL KODAK.

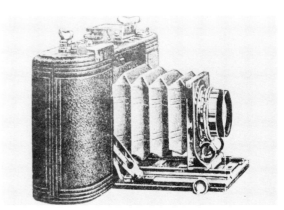

(617) **NO. 1A SPEED KODAK CAMERA.** C. 1909–13. SIZE 2½ X 4¼ INCH EXPOSURES ON No. 116 ROLL FILM. F 6.3 ZEISS KODAK ANASTIGMAT, F 6.3 OR F 4.5 BAUSCH & LOMB ZEISS TESSAR, OR F 6.5 COOKE ANASTIGMAT LENS. GRAFLEX FOCAL PLANE SHUTTER TO ⅟₁₀₀₀ SEC.

## EASTMAN KODAK COMPANY (cont.)

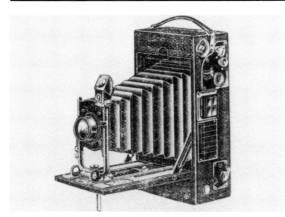

**(618) NO. 4A SPEED KODAK CAMERA.** C. 1908–13. SIZE 4¼ X 6½ INCH EXPOSURES ON NO. 126 ROLL FILM. F 6.3 BAUSCH & LOMB ZEISS TESSAR, F 6.8 GOERZ DAGOR, F 6.3 ZEISS KODAK ANASTIGMAT, OR F 6.5 COOKE ANASTIGMAT LENS. KODAK FOCAL PLANE SHUTTER TO ¹⁄₁₀₀₀ SEC.

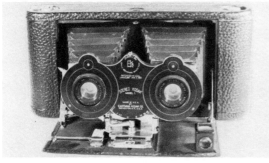

**(619) STEREO KODAK, MODEL 1 CAMERA.** C. 1917–25. SIZE 3⅛ X 6¼ INCH STEREO EXPOSURES ON NO. 101 ROLL FILM. F 7.7 KODAK ANASTIGMAT LENS. STEREO AUTOMATIC SHUTTER FROM 1917–18. BALL-BEARING STEREO SHUTTER FROM 1919–25. (VC)

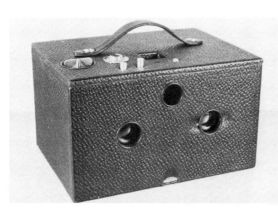

**(620) NO. 2 STEREO KODAK BOX CAMERA.** C. 1901–05. SIZE 3½ X 6 INCH STEREO EXPOSURES ON NO. 101 ROLL FILM. RAPID RECTILINEAR LENS. SPECIAL STEREO SHUTTER.

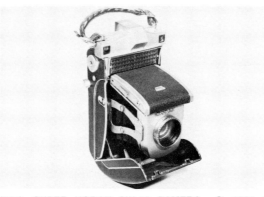

**(621) SUPER KODAK SIX-20 CAMERA.** C. 1938–44. SIZE 2¼ X 3¼ INCH EXPOSURES ON NO. 620 ROLL FILM. THE FIRST CAMERA TO HAVE THE APERTURE AUTOMATICALLY CONTROLLED BY A PHOTO CELL. 100 MM/ F 3.5 KODAK ANASTIGMAT SPECIAL LENS. LEAF-TYPE BETWEEN-THE-LENS SHUTTER; 1 TO ¹⁄₂₀₀ SEC., B. BUILT-IN COUPLED RANGEFINDER. ONLY 716 OF THESE CAMERAS WERE SOLD BY KODAK. (GE)

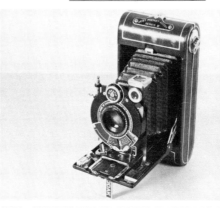

**(622) VANITY KODAK SERIES III (VEST POCKET) CAMERA.** C. 1928–33. SIZE 1⅝ X 2½ INCH EXPOSURES ON NO. 127 ROLL FILM. 83 MM/F 6.3 KODAK ANASTIGMAT LENS. DIOMATIC SHUTTER; ¹⁄₁₀ TO ¹⁄₁₀₀ SEC., B., T. VARIOUS COLORED MODELS.

**(623) VANITY KODAK ENSEMBLE.** C. 1928–31. SIZE 1⅝ X 2½ INCH EXPOSURES ON NO. 127 ROLL FILM. MENISCUS LENS. INSTANT AND TIME ROTARY SHUTTER. ROTARY APERTURE STOPS. THE ENSEMBLE WAS SUPPLIED IN VARIOUS COLORS AND INCLUDED VANITY KODAK CAMERA, MODEL B, MIRROR, LIPSTICK, AND COMPACT. (IH)

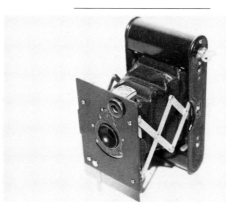

**(624) VEST POCKET KODAK CAMERA.** C. 1912–14. SIZE 1⅝ X 2½ INCH EXPOSURES ON NO. 127 ROLL FILM. KODAK MENISCUS ACHROMATIC OR F 8 KODAK ANASTIGMAT LENS. KODAK BALL-BEARING SHUTTER; ¹⁄₂₅, ¹⁄₅₀, B., T. NO AUTOGRAPHIC FEATURE.

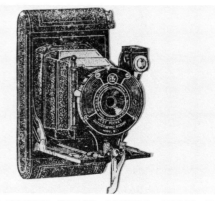

**(625) VEST POCKET KODAK CAMERA. MODEL B.** C. 1925–34. SIZE 1⅝ X 2½ INCH EXPOSURES ON NO. 127 ROLL FILM. KODAK PERISCOPIC, MENISCUS, OR DOUBLET LENS. VEST POCKET ROTARY SHUTTER; INSTANT AND TIME.

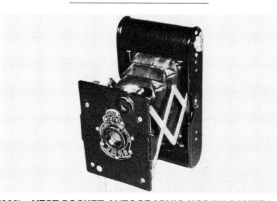

**(626) VEST POCKET AUTOGRAPHIC KODAK CAMERA.** C. 1915–26. SIZE 1⅝ X 2½ INCH EXPOSURES ON NO. 127 ROLL FILM. FIXED-FOCUS MENISCUS ACHROMATIC OR DOUBLE RAPID RECTILINEAR LENS. ALSO, 84 MM/F 7.7 KODAK ANASTIGMAT LENS. KODAK BALL-BEARING SHUTTER; ¹⁄₂₅, ¹⁄₅₀ SEC., B., T.

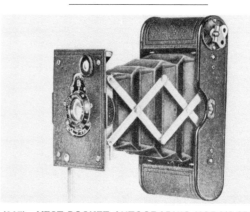

**(627) VEST POCKET AUTOGRAPHIC KODAK SPECIAL CAMERA.** C. 1915–26. SIZE 1⅝ X 2½ INCH EXPOSURES ON NO. 127 ROLL FILM. F 6.9 ZEISS KODAK ANASTIG-

## EASTMAN KODAK COMPANY (*cont.*)

MAT, F 6.9 OR F 7.7 KODAK ANASTIGMAT LENS IN THE FIXED FOCUS MODEL. F 6.9 OR F 7.7 KODAK ANASTIGMAT OR F 6.9 ZEISS KODAK ANASTIGMAT LENS IN THE FOCUSING MODEL. BALL-BEARING SHUTTER IN BOTH MODELS; ½₅, ½₀ SEC., B., T.

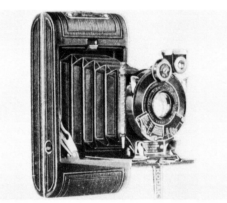

**(628)  VEST POCKET KODAK SPECIAL CAMERA.** C. 1912–35. SIZE 1⅝ X 2½ INCH EXPOSURES ON NO. 127 ROLL FILM. F 4.5 OR F 5.6 KODAK ANASTIGMAT OR F 6.9 ZEISS KODAK ANASTIGMAT LENS. KODAK BALL-BEARING SHUTTER OR DIOMATIC SHUTTER; ⅒ TO ¹⁄₁₀₀ SEC., B., T.

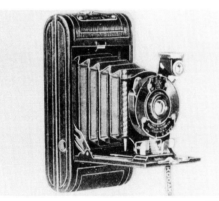

**(629)  VEST POCKET KODAK CAMERA, SERIES III.** C. 1926–34. SIZE 1⅝ X 2½ INCH EXPOSURES ON NO. 127 ROLL FILM. 3⅜ INCH/F 7.9 KODAR LENS OR F 6.3, F 5.6, OR F 4.5 KODAK ANASTIGMAT LENS. KODEX SHUTTER; ½₅, ½₀ SEC., B., T., OR DIOMATIC SHUTTER; ⅒, ½₅, ½₀, ¹⁄₁₀₀ SEC., B., T.

**(630)  VIEW CAMERA.** C. 1892–96. THIS CAMERA WAS AVAILABLE IN 12 MODEL SIZES AS FOLLOWS. 4¼ X 5½, 4¼ X 6½, 5 X 7, 5 X 8, 6½ X 8½, 8 X 10, 10 X 12, 11 X 14, 14 X 17, 17 X 20, 18 X 22, AND 20 X 24 INCH EXPOSURES. DOUBLE RACK & PINION FOCUS. ATTACHABLE ROLL HOLDER. REVERSIBLE BACK. DOUBLE SWING BACK. SEE PHOTO OF CAMERA UNDER EASTMAN DRY PLATE AND FILM COMPANY.

**(631)  VIEW CAMERA.** C. 1909. SIZE 5 X 7 INCH EXPOSURES. BAUSCH & LOMB LENS. DOUBLE PNEUMATIC SHUTTER.

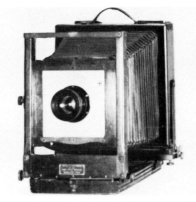

**(632)  VIEW CAMERA.** C. 1915. SIZE 8 X 10 INCH EXPOSURES. PACKARD SHUTTER. (JW)

**(633)  NO. 3 HOME PORTRAIT VIEW CAMERA.** COMBINATION PLATE HOLDER FOR EITHER 5 X 7 OR 8 X 10 INCH EXPOSURES. 12-INCH KODAK ANASTIGMAT LENS. COMPOUND SHUTTER.

**(634)  NO. 1 IMPROVED VIEW CAMERA.** C. 1905. SIZE 5 X 7 INCH EXPOSURES.

**(635)  VIGILANT SIX-16 CAMERA.** C. 1939–48. SIZE 2½ X 4¼ INCH EXPOSURES ON NO. 616 ROLL FILM. F 8.8, F 6.3, OR F 4.5 KODAK ANASTIGMAT LENS. KODEX, KODAMATIC, SUPERMATIC, OR DIOMATIC SHUTTER. SIMILAR TO THE KODAK VIGILANT SIX-20 CAMERA.

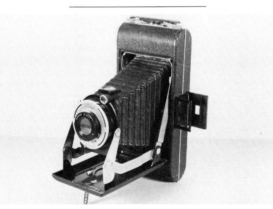

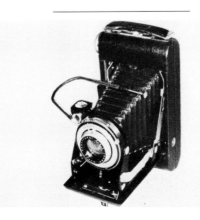

**(636)  VIGILANT JUNIOR SIX-16 CAMERA.** C. 1940–48. SIZE 2½ X 4¼ INCH EXPOSURES ON NO. 616 ROLL FILM. KODAK BIMAT OR KODET LENS. DAK SHUTTER OR DAKON SHUTTER; ½₅, ½₀ SEC., B., T.

**(637)  VIGILANT SIX-20 CAMERA.** C. 1939–49. SIZE 2¼ X 3¼ INCH EXPOSURES ON NO. 620 ROLL FILM. F 8.8, F 6.3, F 4.5 KODAK ANASTIGMAT, F 4.5 KODAK ANASTIGMAT SPECIAL, OR F 6.3 KODAK ANASTON LENS. KODEX, KODAMATIC, SUPERMATIC, DIOMATIC, DAKON, FLASH KODAMATIC, OR FLASH DAKON SHUTTER.

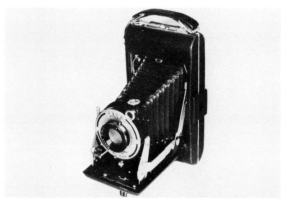

**(638)  VIGILANT JUNIOR SIX-20 CAMERA.** C. 1940–49. SIZE 2¼ X 3¼ INCH EXPOSURES ON NO. 620 ROLL FILM. SAME LENSES AND SHUTTERS AS THE VIGILANT JUNIOR SIX-16 CAMERA.

## EASTMAN KODAK COMPANY — BLAIR CAMERA DIVISION

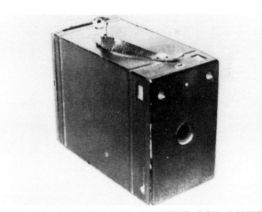

**(639)  NO. 2 FILM PACK HAWKEYE BOX CAMERA.** C. 1910. SIZE 2¼ X 3¼ INCH EXPOSURES ON NO. 520 FILM PACKS. (KC)

## EASTMAN KODAK COMPANY—BLAIR CAMERA DIVISION (cont.)

**(640) NO. 1A FOLDING HAWKEYE CAMERA.** C. 1910. SIZE 2½ X 4¼ INCH EXPOSURES ON NO. 116 ROLL FILM. SINGLE LENS OR RAPID RECTILINEAR LENS. ALSO, F 6.3 ZEISS TESSAR LENS WITH COMPOUND SHUTTER.

**(641) NO. 3 FOLDING HAWKEYE CAMERA.** C. 1910. SIZE 3¼ X 4¼ INCH EXPOSURES ON NO. 118 ROLL FILM. F 6.3 ZEISS KODAK ANASTIGMAT OR ZEISS TESSAR LENS WITH COMPOUND SHUTTER. ALSO, BAUSCH & LOMB OR RAPID RECTILINEAR LENS AND BALL-BEARING SHUTTER; ⅟₂₅ TO ⅟₁₀₀ SEC., B., T. AUTOMATIC SHUTTER ON SOME MODELS.

**(642) NO. 3A FOLDING HAWKEYE CAMERA.** C. 1910. SIZE 3¼ X 5½ INCH EXPOSURES ON NO. 122 ROLL FILM. RAPID RECTILINEAR OR BAUSCH & LOMB LENS WITH AUTO SHUTTER OR KODEX NO. 1 SHUTTER; ⅟₂₅, ⅟₅₀ SEC., B., T. ALSO, F 6.3 ZEISS KODAK ANASTIGMAT LENS WITH COMPOUND SHUTTER.

**(643) NO. 4 FOLDING HAWKEYE CAMERA.** C. 1910. SIZE 4 X 5 INCH EXPOSURES ON NO. 103 ROLL FILM.

HAWKEYE RAPID RECTILINEAR LENS. ALSO, ZEISS PROTAR LENS WITH COMPOUND SHUTTER.

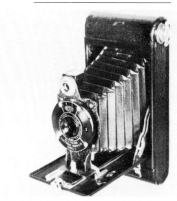

**(644) NO. 2 FOLDING CARTRIDGE HAWKEYE CAMERA.** C. 1910. SIZE 2¼ X 3¼ INCH EXPOSURES ON NO. 120 ROLL FILM. MENISCUS ACHROMATIC, RAPID RECTILINEAR OR F 6.3 KODAK ANASTIGMAT LENS. HAWKEYE OR KODO SHUTTER FOR INSTANT AND TIME EXPOSURES. ALSO, KODEX SHUTTER; ½₅, ⅟₅₀ SEC., B., T.

**(645) NO. 2A FOLDING CARTRIDGE HAWKEYE CAMERA.** C. 1910. SIZE 2½ X 4¼ INCH EXPOSURES ON NO. 116 ROLL FILM. SIMILAR TO THE NO. 2 FOLDING CARTRIDGE HAWKEYE CAMERA WITH THE SAME LENSES AND SHUTTERS.

**(646) NO. 3A FOLDING CARTRIDGE HAWKEYE CAMERA.** C. 1910. SIZE 3¼ X 5½ INCH EXPOSURES ON NO. 122 ROLL FILM. SIMILAR TO THE NO. 2 FOLDING CARTRIDGE HAWKEYE CAMERA WITH THE SAME LENSES AND SHUTTERS.

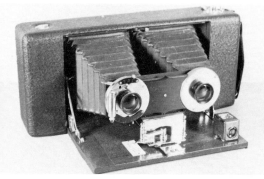

**(647) STEREO HAWKEYE CAMERA. MODEL NO. 3.** (ALSO OTHER NUMBERED MODELS.) C. 1910. SIZE 3¼ X 6½ INCH STEREO EXPOSURES ON NO. 2 BULLSEYE ROLL FILM. BAUSCH & LOMB RAPID RECTILINEAR LENSES. INSTANT, B., T. SHUTTER.

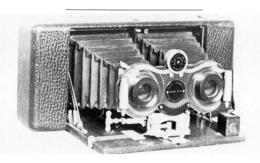

**(648) STEREO HAWKEYE CAMERA. MODEL 4.** (ALSO, OTHER NUMBERED MODELS.) C. 1910. SIZE 3¼ X 6½ INCH STEREO EXPOSURES ON NO. 2 BULLSEYE ROLL FILM. ZEISS TESSAR LENSES. COMPOUND SHUTTER; 1 TO ⅟₁₀₀ SEC., B., T. (TH)

**(649) NO. 2 WENO HAWKEYE BOX CAMERA.** C. 1910. SIZE 3½ X 3½ INCH EXPOSURES ON ROLL FILM. INSTANT ROTARY SHUTTER.

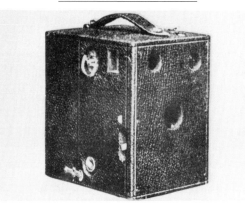

**(650) NO. 4 WENO HAWKEYE BOX CAMERA.** C. 1910. SIZE 4 X 5 INCH EXPOSURES ON NO. 103 ROLL FILM. INSTANT ROTARY SHUTTER.

**(651) NO. 5 WENO HAWKEYE BOX CAMERA.** C. 1910. SIZE 3¼ X 4¼ INCH EXPOSURES ON NO. 118 ROLL FILM. INSTANT ROTARY SHUTTER.

**(652) NO. 6 WENO HAWKEYE BOX CAMERA.** C. 1910.

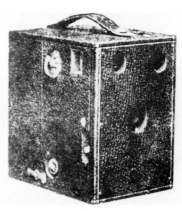

**(653) NO. 7 WENO HAWKEYE BOX CAMERA.** C. 1910. SIZE 3¼ X 5½ INCH EXPOSURES ON NO. 122 ROLL FILM. INSTANT ROTARY SHUTTER.

## EASTMAN KODAK COMPANY—CENTURY CAMERA DIVISION

NOTE: THE CENTURY CAMERA DIVISION OF THE EASTMAN KODAK COMPANY BECAME THE FOLMER-CENTURY DEPARTMENT OF THE SAME IN 1917.

## EASTMAN KODAK COMPANY—CENTURY CAMERA DIVISION (*cont.*)

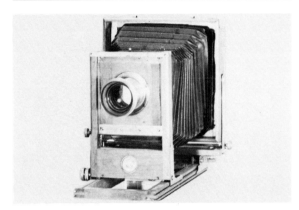

(654) **CENTURY NO. 2 VIEW CAMERA.** C. 1910. SIZE 5 X 7 INCH EXPOSURES. (JW)

---

(655) **CENTURY NO. 6 VIEW CAMERA.** C. 1910. SIZE 8 X 10 INCH EXPOSURES ON PLATES.

---

(656) **UNIVERSAL VIEW CAMERA.** C. 1932. SIZE 8 X 10 INCH EXPOSURES ON PLATES OR FILM PACKS. F 4.5 ILEX PARAGON, F 6.3 BAUSCH & LOMB PROTAR, F 4.5 BAUSCH & LOMB 1C TESSAR, OR F 4.5 WOLLENSAK VELOSTIGMAT LENS. UNIVERSAL, VOLUTE, COMPOUND, PACKARD, OR GRAFLEX FOCAL PLANE SHUTTER. THE REVERSIBLE BACK HAS SLIDING PANELS FOR MAKING TWO OR FOUR EXPOSURES ON EACH 8 X 10 PLATE OR FILM. RISING AND FALLING LENS MOUNT. RACK & PINION FOCUS. GROUND GLASS FOCUS. DOUBLE-HINGE TRIPOD MOUNT.

## EASTMAN KODAK COMPANY—FOLMER & SCHWING DIVISION

NOTE: THE FOLMER & SCHWING DIVISION OF THE EASTMAN KODAK COMPANY BECAME THE FOLMER-CENTURY DEPARTMENT OF THE SAME IN 1917.

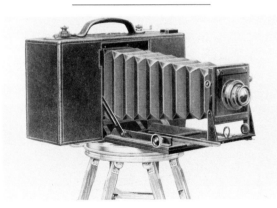

(657) **NO. 5 CIRKUT CAMERA.** C. 1915–22. FIVE-INCH WIDE, 360-DEGREE PANORAMIC EXPOSURES ON ROLL FILM UP TO 42 INCHES IN LENGTH. 6¼, 11, AND 14-INCH TURNER-REICH TRIPLE CONVERTIBLE LENS. A SPRING MOTOR ROTATES THE CAMERA ON A VERTICAL AXIS AND MOVES THE ROLL FILM PAST A FOCAL-PLANE SLIT.

(658) **NO. 10 CIRKUT CAMERA.** C. 1909–26. SIX, EIGHT, OR TEN-INCH WIDE, 360-DEGREE PANORAMIC EXPOSURES ON ROLL FILM UP TO 144 INCHES IN LENGTH. SIMILAR TO THE NO. 5 CIRKUT CAMERA WITH THE SAME LENS.

---

(659) **NO. 16 CIRKUT CAMERA.** C. 1909–21. TEN, 12, AND 16-INCH WIDE, 360-DEGREE PANORAMIC EXPOSURES ON ROLL FILM UP TO 240 INCHES IN LENGTH. SIMILAR TO THE NO. 5 CIRKUT CAMERA WITH THE SAME LENS.

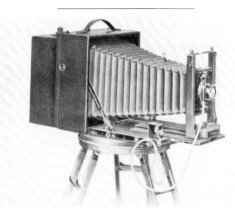

(660) **NO. 6 CIRKUT OUTFIT.** C. 1909–26. SIX AND ONE-HALF INCH WIDE, 360-DEGREE PANORAMIC EXPOSURES ON ROLL FILM UP TO 72 INCHES LONG. TURNER-REICH SERIES II OR RAPID RECTILINEAR LENS. A SPRING MOTOR ROTATES THE CAMERA ON A VERTICAL AXIS AND MOVES THE ROLL FILM PAST A FOCAL-PLANE SLIT. THE CAMERA IS A 5 X 7 CYCLE GRAPHIC WITH ADDED EQUIPMENT NEEDED FOR PANORAMIC CAPABILITY.

---

(661) **NO. 8 CIRKUT OUTFIT.** C. 1909–26. EIGHT-INCH WIDE, 360-DEGREE PANORAMIC EXPOSURES ON ROLL FILM UP TO 96-INCHES LONG. SIMILAR TO THE NO. 6 CIRKUT OUTFIT WITH THE SAME LENSES EXCEPT THE CAMERA IS A 6½ X 8½ CYCLE GRAPHIC CAMERA.

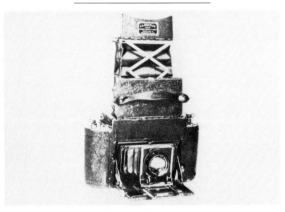

(662) **1A GRAFLEX CAMERA. SINGLE LENS REFLEX.** C. 1909. SIZE 2½ X 4¼ INCH EXPOSURES ON NO. 116 ROLL FILM. 5½ INCH/F 4.5 OR F 6.8 KODAK ANASTIGMAT OR F 6.3 BAUSCH & LOMB KODAK ANASTIGMAT LENS. ALSO, F 4.5 STEINHEIL UNIFOCAL, BAUSCH & LOMB TESSAR, OR COOKE SERIES II LENS. FOCAL PLANE SHUTTER; ⅒ TO ⅟₁₀₀₀ SEC., T.

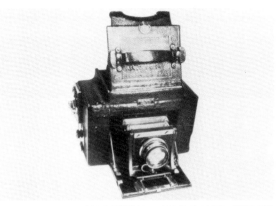

(663) **1A GRAFLEX CAMERA. SINGLE LENS REFLEX.** C. 1920. SIZE 2½ X 4¼ INCH EXPOSURES. 150 MM/F 6.3 DAGOR LENS. FOCAL PLANE SHUTTER; ⅛ TO ⅟₁₀₀₀ SEC. (HA)

---

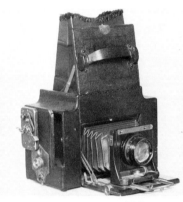

(664) **3A GRAFLEX CAMERA. SINGLE LENS REFLEX.** C. 1907–26. SIZE 3¼ X 5½ INCH EXPOSURES ON NO. 122 ROLL FILM. F 4.5 KODAK ANASTIGMAT OR COOKE ANASTIGMAT, F 4.5 OR F 6.3 BAUSCH & LOMB ZEISS TESSAR, F 6.3 BAUSCH & LOMB ZEISS PROTAR, F 6.8 BAUSCH & LOMB PLASTIGMAT, F 6.5 OR F 5.6 COOKE SERIES III OR SERIES IV, OR F 6.3 ISOSTIGMAT SERIES II LENS. FOCAL PLANE SHUTTER; ⅒ TO ⅟₁₀₀₀ SEC., T. (TH)

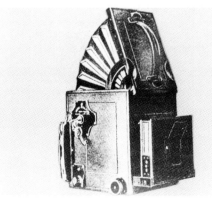

(665) **AUTO GRAFLEX CAMERA. EARLY MODEL. SINGLE LENS REFLEX.** C. 1908. THREE SIZES OF THIS CAMERA FOR 3¼ X 4¼, 4 X 5, OR 5 X 7 INCH EXPOSURES ON ROLL, SHEET, OR PLATE FILM. F. 4.5 OR F 6.3 BAUSCH & LOMB ZEISS TESSAR, F 6.8 BAUSCH & LOMB PLASTIGMAT, F 5.6 COOKE SERIES IV, GOERZ SE-

## EASTMAN KODAK COMPANY—FOLMER & SCHWING DIVISION (cont.)

RIES III, OR ISOSTIGMAR SERIES II LENS. FOCAL PLANE SHUTTER; ⅕ TO ¹⁄₁₀₀₀ SEC., T.

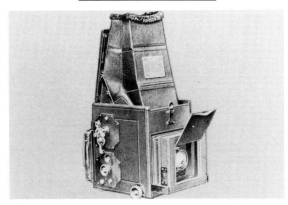

**(666) AUTO GRAFLEX CAMERA. SINGLE LENS REFLEX.** C. 1910–23. THREE SIZES OF THIS CAMERA FOR 3¼ X 4¼, 4 X 5, OR 5 X 7 INCH EXPOSURES ON ROLL, SHEET, OR PLATE FILM. F 4.5 OR F 6.3 KODAK ANASTIGMAT, F 6.3 BAUSCH & LOMB KODAK, F 4.5 BAUSCH & LOMB TESSAR, OR COOKE SERIES II LENS. FOCAL-PLANE SHUTTER; ¹⁄₁₀ TO ¹⁄₁₀₀₀ SEC., T.

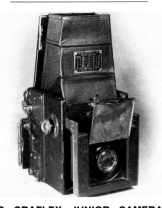

**(667) AUTO GRAFLEX JUNIOR CAMERA. SINGLE LENS REFLEX.** C. 1914–24. SIZE 2¼ X 3¼ INCH EXPOSURES ON ROLL, SHEET, OR PLATE FILM. F 4.5 KODAK ANASTIGMAT, BAUSCH & LOMB TESSAR, OR COOKE SERIES II LENS. ALSO, F 6.3 BAUSCH & LOMB KODAK ANASTIGMAT LENS. FOCAL-PLANE SHUTTER; ¹⁄₁₀ TO ¹⁄₁₀₀₀ SEC., T. (SW)

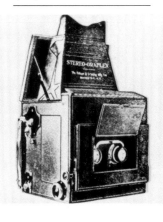

**(668) AUTO GRAFLEX STEREO CAMERA. EARLY MODEL.** C. 1907. SIZE 5 X 7 INCH EXPOSURES ON ROLL, SHEET, OR PLATE FILM. F 6.3 BAUSCH & LOMB ZEISS TESSAR, F 6.8 PLASTIGMAT OR F 6.3 GOERZ SERIES III MATCHED LENSES. FOCAL-PLANE SHUTTER; ⅕ TO ¹⁄₁₀₀₀ SEC., T.

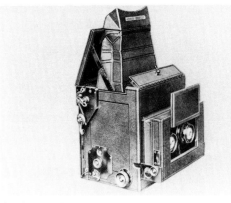

**(669) AUTO GRAFLEX STEREO CAMERA.** C. 1909–22. SIZE 5 X 7 INCH STEREO EXPOSURES ON ROLL, SHEET, OR PLATE FILM. F 6.3 BAUSCH & LOMB KODAK ANASTIGMAT OR BAUSCH & LOMB ZEISS TESSAR LENSES. FOCAL-PLANE SHUTTER; ¹⁄₁₀ TO ¹⁄₁₀₀₀ SEC., T.

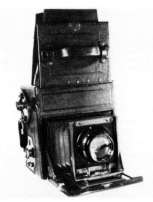

**(670) COMPACT GRAFLEX CAMERA. SINGLE LENS REFLEX.** C. 1915–25. TWO SIZES OF THIS CAMERA FOR 3¼ X 5½ OR 5 X 7 INCH EXPOSURES ON ROLL, SHEET, OR PLATE FILM. F 4.5 KODAK ANASTIGMAT OR BAUSCH & LOMB TESSAR LENS. ALSO, F 6.3 BAUSCH & LOMB KODAK ANASTIGMAT LENS. FOCAL-PLANE SHUTTER; ¹⁄₁₀ TO ¹⁄₁₀₀₀ SEC., T. (VC)

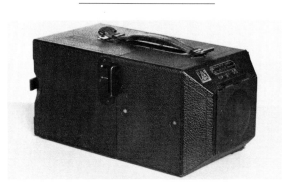

**(671) FINGERPRINT GRAFLEX CAMERA.** C. 1919–30. SIZE 2¼ X 3¼ INCH EXPOSURES ON PLATES, FILM PACKS, CUT FILM, OR ROLL FILM. F 6.3 KODAK ANASTIGMAT LENS. SIMPLE SHUTTER FOR EXPOSURES OF ANY DURATION. THE FRONT OF THE CAMERA IS PRESSED AGAINST THE OBJECT TO BE PHOTOGRAPHED. FOUR ELECTRIC LAMPS BEHIND THE FRONT APERTURE ILLUMINATE THE SUBJECT. BATTERIES ARE LOCATED INSIDE OF THE CAMERA. (TH)

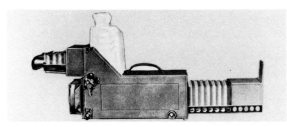

**(672) NATURALIST GRAFLEX CAMERA.** C. 1907–21. SIZE 4 X 5 INCH EXPOSURES ON ROLL, SHEET, OR PLATE FILM. F 6.8 BAUSCH & LOMB TELESTIGMAT, F 6.3 BAUSCH & LOMB ZEISS PROTAR SERIES VIIA, OR F 6.8 GOERZ SERIES III LENS. FOCAL-PLANE SHUTTER; ¹⁄₁₀ TO ¹⁄₁₀₀₀ SEC., T.

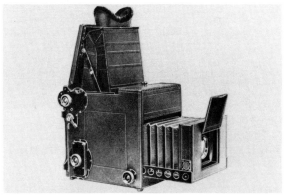

**(673) PRESS GRAFLEX CAMERA. SINGLE LENS REFLEX** C. 1907–23. SIZE 5 X 7 INCH EXPOSURES ON ROLL, SHEET, OR PLATE FILM. F 6.3 BAUSCH & LOMB KODAK ANASTIGMAT, F 4.5 OR F 6.3 BAUSCH & LOMB TESSAR, F 6.3 BAUSCH & LOMB PROTOR, F 6.8 BAUSCH & LOMB PLASTIGMAT, F 4.5 OR F 5.6 COOKE SERIES II OR SERIES IV, OR F 4.5 GOERZ SERIES 1B LENS. FOCAL-PLANE SHUTTER; ¹⁄₁₀ TO ¹⁄₁₅₀₀ SEC., T. SOME MODELS WITH ⅕ TO ¹⁄₁₅₀₀ SEC., T. SHUTTER.

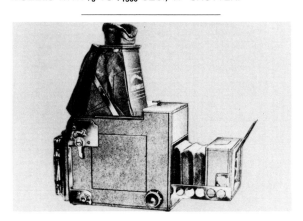

## EASTMAN KODAK COMPANY—FOLMER & SCHWING DIVISION (cont.)

**(674) R.B. AUTO GRAFLEX CAMERA. EARLY MODEL. SINGLE LENS REFLEX.** C. 1908. SIZE 4 X 5 INCH EXPOSURES ON ROLL, SHEET, OR PLATE FILM. F 6.3 OR F 4.5 BAUSCH & LOMB ZEISS TESSAR, F 6.3 BAUSCH & LOMB ZEISS PROTAR, F 6.8 BAUSCH & LOMB PLASTIGMAT, F 5.6 COOKE SERIES IV, F 6.3 GOERZ SERIES III, OR F 5.8 ISOSTIGMAT SERIES II LENS. FOCAL PLANE SHUTTER; 1/5 TO 1/1000 SEC., T. REVOLVING BACK.

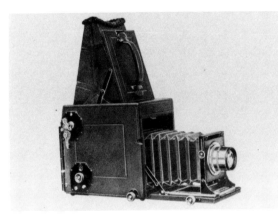

**(675) R.B. AUTO GRAFLEX CAMERA. SINGLE LENS REFLEX.** C. 1909–26. TWO SIZES OF THIS CAMERA FOR 3¼ X 4¼ OR 4 X 5 INCH EXPOSURES ON ROLL, SHEET, OR PLATE FILM. F 4.5 KODAK ANASTIGMAT, BAUSCH & LOMB TESSAR, OR COOKE SERIES II LENS. ALSO, F 6.3 BAUSCH & LOMB KODAK ANASTIGMAT OR BAUSCH & LOMB PROTAR LENS. FOCAL PLANE SHUTTER; 1/10 TO 1/1000 SEC., T. REVOLVING BACK. DROP BED.

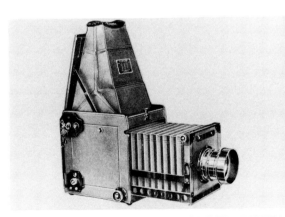

**(676) R.B. HOME PORTRAIT GRAFLEX CAMERA. SINGLE LENS REFLEX.** C. 1912–26. SIZE 5 X 7 INCH EXPOSURES ON ROLL, SHEET, OR PLATE FILM. F 6.3 ZEISS KODAK ANASTIGMAT, F 4.5 BAUSCH & LOMB TESSAR, OR F 4.5 COOKE SERIES II LENS. FOCAL PLANE SHUTTER; 1 TO 1/500 SEC., T. REVOLVING BACK. VERTICAL SWING FRONT.

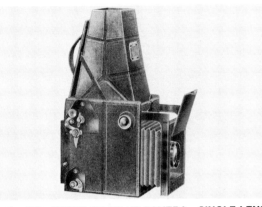

**(677) R.B. JUNIOR GRAFLEX CAMERA. SINGLE LENS REFLEX.** C. 1915–24. SIZE 2¼ X 3¼ INCH EXPOSURES ON ROLL, SHEET, OR PLATE FILM. 6.4 INCH/F 4.5 KODAK ANASTIGMAT OR BAUSCH & LOMB TESSAR LENS. ALSO, F 6.3 BAUSCH & LOMB KODAK ANASTIGMAT LENS. FOCAL PLANE SHUTTER; 1/10 TO 1/1000 SEC., T. REVOLVING BACK.

**(678) R.B. SERIES B. GRAFLEX CAMERA. SINGLE LENS REFLEX.** C. 1923–26. FOUR SIZES OF THIS CAMERA FOR 2¼ X 3¼, 3¼ X 4¼, 4 X 5, OR 5 X 7 INCH EXPOSURES ON ROLL, SHEET, OR PLATE FILM. REVOLVING BACK. SIMILAR TO THE SERIES B GRAFLEX WITH THE SAME LENS AND SHUTTER.

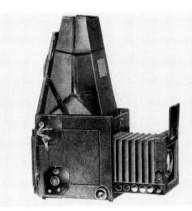

**(679) R.B. TELESCOPIC GRAFLEX CAMERA. SINGLE LENS REFLEX.** C. 1915–23. TWO SIZES OF THIS CAMERA FOR 3¼ X 4¼ OR 4 X 5 INCH EXPOSURES ON ROLL, SHEET, OR PLATE FILM. F 4.5 KODAK ANASTIGMAT OR BAUSCH & LOMB TESSAR LENS. ALSO, F 6.3 BAUSCH & LOMB KODAK ANASTIGMAT LENS. FOCAL PLANE SHUTTER; 1/10 TO 1/1000 SEC., T. REVOLVING BACK.

**(680) SERIES B GRAFLEX CAMERA. SINGLE LENS REFLEX.** C. 1925–26. THREE SIZES OF THIS CAMERA FOR 2¼ X 3¼, 3¼ X 4¼, OR 4 X 5 INCH EXPOSURE ON ROLL, SHEET, OR PLATE FILM. F 4.5 KODAK ANASTIGMAT LENS. FOCAL PLANE SHUTTER; 1/5 TO 1/1000 SEC., T.

**(681) R.B. TELESCOPIC AUTO GRAFLEX CAMERA. SINGLE LENS REFLEX.** C. 1914. SIZE 4 X 5 INCH EXPOSURES ON ROLL, SHEET, OR PLATE FILM. F 6.3 ZEISS KODAK ANASTIGMAT LENS. ALSO, F 4.5 BAUSCH & LOMB ZEISS TESSAR OR COOKE SERIES II LENS. FOCAL PLANE SHUTTER; 1/10 TO 1/1000 SEC., T.

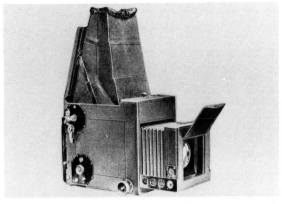

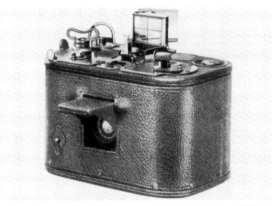

**(682) NO. 0 GRAPHIC CAMERA.** C. 1909–23. SIZE 1⅝ X 2½ INCH EXPOSURES ON ROLL FILM. 3-INCH/F 6.3 ZEISS KODAK ANASTIGMAT LENS. FOCAL PLANE SHUTTER; 1/10 TO 1/500 SEC. (MF)

**(683) CYCLE GRAPHIC CAMERA.** C. 1907–23. SIZE 8 X 10 INCH EXPOSURES ON SHEET OR PLATE FILM. SIMILAR TO THE R.B. CYCLE GRAPHIC CAMERA WITH THE SAME LENSES AND SHUTTERS BUT WITH NO REVOLVING BACK.

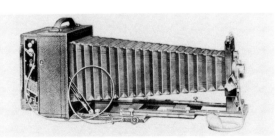

**(684) R.B. CYCLE GRAPHIC CAMERA.** C. 1907–23. THREE SIZES OF THIS CAMERA FOR 4 X 5, 5 X 7, OR 6½ X 8½ INCH EXPOSURES ON SHEET OR PLATE FILM.

## EASTMAN KODAK COMPANY—FOLMER & SCHWING DIVISION (*cont.*)

RAPID RECTILINEAR ZEISS KODAK ANASTIGMAT, BAUSCH & LOMB PLASTIGMAT, BAUSCH & LOMB ZEISS PROTAR SERIES VIIA, OR GOERZ SERIES III LENS. FOCAL PLANE SHUTTER AND/OR AUTOMATIC, COMPOUND, OR VOLUTE LEAF SHUTTER. REVOLVING BACK. TRIPLE EXTENSION BELLOWS. SWING BACK. THIS IS A DUAL-SHUTTER CAMERA.

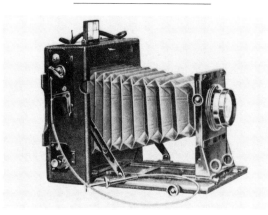

(685)   **SPEED GRAPHIC CAMERA.** C. 1912–25. FOUR SIZES OF THIS CAMERA FOR 3¼ X 4¼, 3¼ X 5½, 4 X 5, OR 5 X 7 INCH EXPOSURES ON SHEET OR PLATE FILM. F 4.5 KODAK ANASTIGMAT, BAUSCH & LOMB TESSAR, OR COOKE SERIES II LENS. ALSO, F 6.3 BAUSCH & LOMB KODAK ANASTIGMAT LENS. FOCAL PLANE SHUTTER; ⅒ TO ¹⁄₁₀₀₀ SEC., T. (⅒ TO ¹⁄₅₀₀ SEC. FOR THE 3¼ X 4¼ EXPOSURE MODEL.) RACK & PINION FOCUS. GROUND GLASS FOCUS. REMOVABLE LENS BOARD. SIZE 3¼ X 3¼ INCH LENS BOARD.

(686)   **SPEED GRAPHIC CAMERA.** C. 1924–26. SIZE 4 X 5 INCH EXPOSURES ON SHEET, FILM PACK, OR PLATES. F 4.5 KODAK ANASTIGMAT AND OTHER LENSES. FOCAL PLANE SHUTTER; ⅒ TO ¹⁄₁₀₀₀ SEC., T. SIZE 4 X 4 INCH LENS BOARD.

(687)   **STEREOSCOPIC GRAPHIC CAMERA.** C. 1907–21. SIZE 5 X 7 INCH STEREO EXPOSURES ON SHEET OR PLATE FILM. F 6.3 BAUSCH & LOMB KODAK ANASTIGMAT, BAUSCH & LOMB TESSAR, F 6.3 BAUSCH & LOMB PROTAR, F 6.8 BAUSCH & LOMB ZEISS PLASTIGMAT, F 6.5 COOKE SERIES III, OR F 6.8 GOERZ SERIES III MATCHED LENSES. FOCAL PLANE SHUTTER; ⅒ TO ¹⁄₁₀₀₀ SEC., T. RACK & PINION FOCUS. GROUND GLASS FOCUS. DROPPING BED. THE STEREO LENSES AND SEPTUM CAN BE REPLACED WITH A SINGLE LENS FOR FULL 5 X 7 INCH EXPOSURES.

(688)   **BANQUET VIEW CAMERA.** C 1913–26. TWO SIZES OF THIS CAMERA FOR 7 X 17 OR 12 X 20 INCH PLATE EXPOSURES. THE CAMERA HAS A VERTICAL SWING FRONT MOVEMENT OF 20-DEGREES FOR TAKING WIDE-ANGLE EXPOSURES. (BC)

(689)   **CROWN ER & C VIEW CAMERA.** C. 1907–26. SIZE 8 X 10 INCH EXPOSURES ON SHEET OR PLATE FILM.

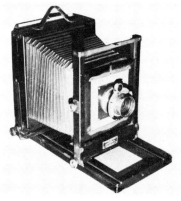

(690)   **NO. 2D VIEW CAMERA.** C. 1910–20. TWO SIZES OF THIS CAMERA FOR 5 X 7 OR 8 X 10 INCH EXPOSURES ON PLATES OR FILM PACKS. F 6.8 BAUSCH & LOMB, F 6.3 VOLTAS, F 4.5 COOKE AVIAR, F 4.5 OR F 6.3 WOLLENSAK VELOSTIGMAT, F 4.5 SCHNEIDER XENAR, F 6.8 TURNER-REICH, OR F 3.5 STEINHEIL CASSAR LENS. BETAX, PACKARD, COMPOUND, UNIVERSAL, OR COMPUR SHUTTER. REVERSIBLE BACK. RISING AND FALLING LENS BOARD. HORIZONTAL AND VERTICAL SWINGS. DOUBLE EXTENSION BELLOWS. (KR)

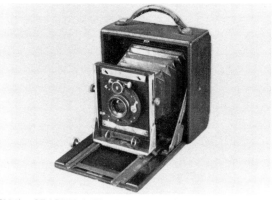

(691)   **GRAPHIC VIEW CAMERA.** C. 1912. SIZE 4 X 5 INCH EXPOSURES ON SHEET FILM PACKS. 125 MM/F 6.8 GOERZ DAGOR LENS. COMPOUND SHUTTER; 1 TO ¹⁄₂₀₀ SEC. (DB)

## EASTMAN KODAK COMPANY—ROCHESTER OPTICAL DIVISION

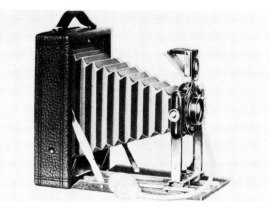

(692)   **PREMO NO. 8 CAMERA.** C. 1915. THREE SIZES OF THIS CAMERA FOR 3¼ X 5½, 4 X 5, OR 5 X 7 INCH

EXPOSURES ON PLATES OR FILM PACKS. F 7.7 KODAK ANASTIGMAT OR BAUSCH & LOMB PLANATOGRAPH LENS. KODAK BALL-BEARING SHUTTER; ¹⁄₂₅, ¹⁄₅₀, ¹⁄₁₀₀ SEC., B.

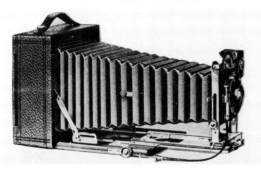

(693)   **PREMO NO. 9 CAMERA.** C. 1915. THREE SIZES OF THIS CAMERA FOR 3¼ X 5½, 4 X 5, OR 5 X 7 INCH EXPOSURES ON PLATES OR FILM PACKS. BAUSCH & LOMB PLANATOGRAPH OR F 7.7 KODAK ANASTIGMAT LENS. ALSO, F 6.3 KODAK ANASTIGMAT OR ZEISS KODAK ANASTIGMAT LENS. COMPOUND SHUTTER. DOUBLE EXTENSION BELLOWS. REVERSIBLE BACK.

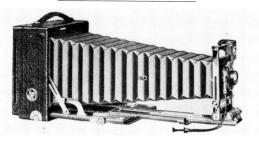

(694)   **PREMO NO. 10 CAMERA.** C. 1915. SIZE 5 X 7 INCH EXPOSURES ON PLATES OR FILM PACKS. BAUSCH & LOMB PLANATOGRAPH LENS. ALSO, F 6.3 ZEISS KODAK ANASTIGMAT OR F 7 BAUSCH & LOMB ZEISS PROTAR LENS. COMPOUND SHUTTER. TRIPLE EXTENSION BELLOWS. REVERSIBLE BACK.

(695)   **PREMO NO. 12 CAMERA.** C. 1917. SIZE 2¼ X 3¼ INCH EXPOSURES ON FILM PACKS. 90 MM/F 4.5 BAUSCH & LOMB TESSAR LENS. WOLLENSAK OPTIMO SHUTTER.

(696)   **PREMO REFLECTING CAMERA.** SINGLE LENS REFLEX. C. 1906. SIZE 4 X 5 INCH PLATE EXPOSURES. FOCAL PLANE SHUTTER SPEEDS TO ¹⁄₁₂₀₀ SEC.

(697)   **PREMO SENIOR CAMERA.** C. 1910. TWO SIZES OF THIS CAMERA FOR 5 X 7 OR 6½ X 8½ INCH EXPOSURES.

(698)   **NO. 0 PREMO JUNIOR BOX CAMERA.** C. 1912. SIZE 2¼ X 3¼ INCH EXPOSURES ON FILM PACKS. MENISCUS LENS.

(699)   **NO. 0 PREMO JUNIOR BOX CAMERA.** C. 1915. SIZE 1¾ X 2⅜ INCH EXPOSURES ON FILM PACKS. MENISCUS LENS. AUTOMATIC SHUTTER. SIMILAR TO THE NO. 1A PREMO JUNIOR MODEL.

## EASTMAN KODAK COMPANY— ROCHESTER OPTICAL DIVISION (*cont.*)

(700) **NO. 1 PREMO JUNIOR BOX CAMERA.** C. 1915. SIZE 2¼ X 3¼ INCH EXPOSURES ON FILM PACKS. MENISCUS LENS. AUTOMATIC SHUTTER. SIMILAR TO THE NO. 1A PREMO JUNIOR MODEL.

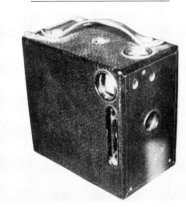

(701) **NO. 1A PREMO JUNIOR BOX CAMERA.** C. 1915. SIZE 2½ X 4¼ INCH EXPOSURES ON FILM PACKS. MENISCUS ACHROMATIC LENS. ROTARY AUTOMATIC SHUTTER. (FL)

(702) **NO. 3 PREMO JUNIOR BOX CAMERA.** C. 1915. SIZE 3¼ X 4¼ INCH EXPOSURES ON FILM PACKS. MENISCUS ACHROMATIC LENS. ROTARY AUTOMATIC SHUTTER. SIMILAR TO THE NO. 1A PREMO JUNIOR MODEL.

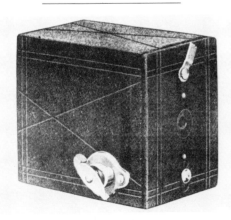

(703) **NO. 00 CARTRIDGE PREMO BOX CAMERA.** C. 1916. SIZE 1¼ X 1¾ INCH EXPOSURES ON ROLL FILM. INSTANT AND TIME SHUTTER.

(704) **NO. 2 CARTRIDGE PREMO BOX CAMERA.** C. 1912. SIZE 2¼ X 3¼ INCH EXPOSURES. SIDE LOADING.

(705) **NO. 2A CARTRIDGE PREMO BOX CAMERA.** C. 1912. SIZE 2½ X 4¼ INCH EXPOSURES. SIDE LOADING.

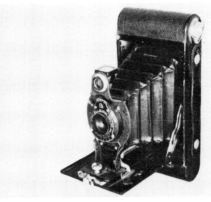

(706) **NO. 2 FOLDING CARTRIDGE PREMO CAMERA.** C. 1917. SIZE 2¼ X 3¼ INCH EXPOSURES ON NO. 120 ROLL FILM. BALL-BEARING SHUTTER; ⅟₂₅, ⅟₅₀ SEC., B., T.

(707) **NO. 2A FOLDING CARTRIDGE PREMO CAMERA.** C. 1917. SIZE 2½ X 4¼ INCH EXPOSURES ON NO. 116 ROLL FILM. KODEX NO. 1 SHUTTER.

(708) **NO. 3A FOLDING CARTRIDGE PREMO CAMERA.** C. 1915. SIZE 3¼ X 5½ INCH EXPOSURES.

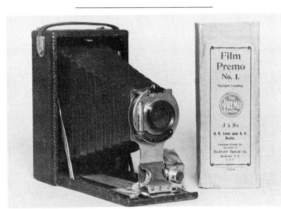

(709) **FILM PREMO NO. 1 CAMERA.** C. 1907–15. FOUR SIZES OF THIS CAMERA FOR 3¼ X 4¼, 3¼ X 5½, 4 X 5, OR 5 X 7 INCH EXPOSURES ON FILM PACKS. BAUSCH & LOMB PLANATOGRAPH, RAPID RECTILINEAR, OR MENISCUS ACHROMATIC LENS. KODAK BALL-BEARING SHUTTER. (TH)

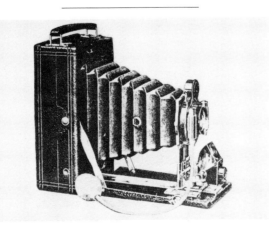

(710) **FILMPLATE PREMO CAMERA.** C. 1910. FOUR SIZES OF THIS CAMERA FOR 3¼ X 4¼, 3¼ X 5½, 4 X 5, OR 5 X 7 INCH EXPOSURES ON PLATES OR FILM PACKS. PLANATOGRAPH LENS.

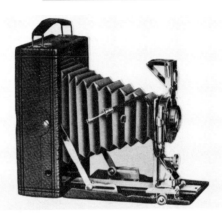

(711) **FILMPLATE PREMO CAMERA.** C. 1915. THREE SIZES OF THIS CAMERA FOR 3¼ X 4¼, 4 X 5, OR 5 X 7 INCH EXPOSURES ON PLATES OR FILM PACKS. F 6.3 ZEISS-KODAK ANASTIGMAT OR PLANATOGRAPH LENS. KODAK COMPOUND OR AUTOMATIC SHUTTER.

(712) **NO. 3A FILMPLATE PREMO CAMERA.** C. 1915. SIZE 3¼ X 5½ INCH EXPOSURES ON PLATES OR FILM PACKS. SIMILAR TO THE FILMPLATE PREMO CAMERA WITH THE SAME LENS AND SHUTTER.

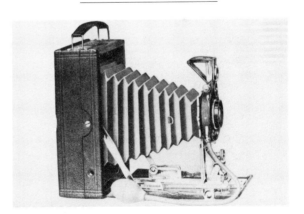

(713) **FILMPLATE PREMO SPECIAL CAMERA.** C. 1915. THREE SIZES OF THIS CAMERA FOR 3¼ X 4¼, 4 X 5, OR 5 X 7 INCH EXPOSURES ON PLATES OR FILM PACKS. F 6.3 ZEISS KODAK ANASTIGMAT, COOKE KODAK ANASTIGMAT, OR BAUSCH & LOMB ZEISS TESSAR SERIES II B LENS. ALSO, F 6.5 COOKE SERIES III A LENS. COMPOUND SHUTTER TO ⅟₂₅₀ SEC. THE 4 X 5 AND 5 X 7 MODELS HAVE SHUTTER SPEEDS TO ⅟₂₀₀ AND ⅟₁₅₀ SEC., RESPECTIVELY.

(714) **NO. 3A FILMPLATE PREMO SPECIAL CAMERA.** C. 1915. SIZE 3¼ X 5½ INCH EXPOSURES ON PLATES OR FILM PACKS. SIMILAR TO THE FILMPLATE PREMO SPECIAL CAMERA WITH THE SAME LENSES BUT WITH COMPOUND SHUTTER TO ⅟₂₀₀ SEC.

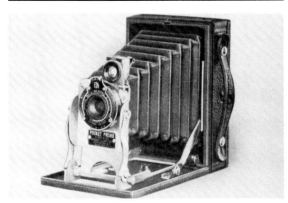

(715)  **POCKET PREMO CAMERA.**  C. 1921.  SIZE 2¼ X 3¼ INCH EXPOSURES ON PLATES OR FILM PACKS. MENISCUS ACHROMATIC LENS.  KODAK BALL-BEARING SHUTTER; ⅟₂₅, ⅟₅₀ SEC., B., T.

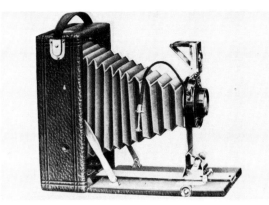

(716)  **POCKET PREMO C CAMERA.**  C. 1915.  SIZE 3¼ X 4¼ INCH EXPOSURES ON PLATES OR FILM PACKS. F 7.7 KODAK ANASTIGMAT OR PLANATOGRAPH LENS. KODAK BALL-BEARING SHUTTER.

(717)  **NO. 3A POCKET PREMO C CAMERA.**  C. 1915. SIZE 3¼ X 5½ INCH EXPOSURES ON PLATES OR FILM PACKS.  SIMILAR TO THE POCKET PREMO C CAMERA WITH THE SAME LENSES AND SHUTTER.

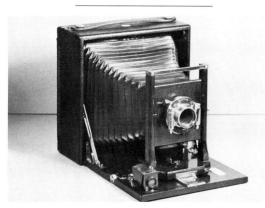

(718)  **PONY PREMO NO. 3 CAMERA.**  C. 1911.  SIZE 5 X 7 INCH EXPOSURES ON SHEET FILM.  RAPID RECTI-

LINEAR LENS.  AUTO DOUBLE PNEUMATIC SHUTTER. (MR)

(719)  **PONY PREMO NO. 4 CAMERA.**  C. 1910.

(720)  **STAR PREMO FOLDING CAMERA.**  C. 1910. SIZE 4 X 5 INCH EXPOSURES ON GLASS PLATES. PLANATOGRAPH LENS.

(721)  **NO. 0 PREMOETTE CAMERA.**  C. 1910.  SIZE 1⅝ X 2¼ INCH EXPOSURES ON FILM PACKS.

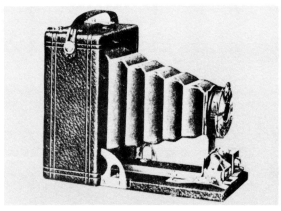

(722)  **NO. 1 PREMOETTE CAMERA.**  C. 1910.  SIZE 2¼ X 3¼ INCH EXPOSURES ON FILM PACKS.  SINGLE LENS.

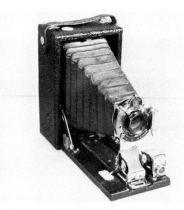

(723)  **NO. 1A PREMOETTE CAMERA.**  C. 1910–13. SIZE 2¼ X 4¼ INCH EXPOSURES ON FILM PACKS. BAUSCH & LOMB PLANATOGRAPH LENS.  KODAK BALL-BEARING SHUTTER.  (MR)

(724)  **NO. 1A PREMOETTE JUNIOR CAMERA.**  C. 1915. SIZE 2½ X 4¼ INCH EXPOSURES ON FILM PACKS. SIMILAR TO THE NO. 1 PREMOETTE JUNIOR CAMERA WITH THE SAME LENSES AND SHUTTER.

(725)  **NO. 1 PREMOETTE JUNIOR SPECIAL CAMERA.** C. 1915.  SIZE 2¼ X 3¼ INCH EXPOSURES ON FILM PACKS.  F 6.3 COOKE KODAK ANASTIGMAT, ZEISS KODAK ANASTIGMAT OR BAUSCH & LOMB LENS.  COMPOUND SHUTTER (CABLE RELEASE) TO ⅟₃₀₀ SEC. SIMILAR TO THE NO. 1 PREMOETTE SPECIAL MODEL.

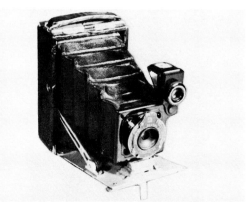

(726)  **NO. 1 PREMOETTE JUNIOR CAMERA.**  C. 1915. SIZE 2¼ X 3¼ INCH EXPOSURES ON FILM PACKS. ALUMINUM CONSTRUCTION.  THREE-SLOT POSITION FOR FOCUS.  PLANATOGRAPH MENISCUS ACHROMATIC OR BAUSCH & LOMB LENS.  BALL-BEARING SHUTTER; ⅟₂₅, ⅟₅₀, ⅟₁₀₀ SEC., B., T.  (MR)

(727)  **NO. 1A PREMOETTE JUNIOR SPECIAL CAMERA.** C. 1915.  SIZE 2½ X 4¼ INCH EXPOSURES ON FILM PACKS.  F 6.3 COOKE KODAK ANASTIGMAT OR ZEISS KODAK ANASTIGMAT LENS.  COMPOUND (CABLE RELEASE) SHUTTER TO ⅟₂₅₀ SEC.  SIMILAR TO THE NO. 1 PREMOETTE JUNIOR SPECIAL CAMERA.

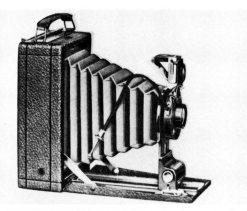

(728)  **PREMOETTE SENIOR CAMERA.**  C. 1915.  SIZE 2½ X 4¼ INCH EXPOSURES ON FILM PACKS.  F 7.7 KODAK ANASTIGMAT LENS.  KODAK BALL-BEARING SHUTTER.

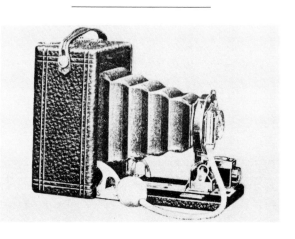

## EASTMAN KODAK COMPANY— ROCHESTER OPTICAL DIVISION (*cont.*)

(729) **NO. 1 PREMOETTE SPECIAL CAMERA.** C. 1910. SIZE 2¼ X 3¼ INCH EXPOSURES ON FILM PACKS. BAUSCH & LOMB RAPID RECTILINEAR LENS. PNEUMATIC SHUTTER.

(730) **NO. 1A PREMOETTE SPECIAL CAMERA.** C. 1910. SIZE 2½ X 4¼ INCH EXPOSURES ON FILM PACKS. BAUSCH & LOMB RAPID RECTILINEAR LENS. SIMILAR TO THE NO. 1 PREMOETTE SPECIAL CAMERA.

(731) **NO. 3A PREMOETTE SENIOR CAMERA.** C. 1915. SIZE 3¼ X 5½ INCH EXPOSURES ON FILM PACKS. SIMILAR TO THE PREMOETTE SENIOR CAMERA WITH THE SAME LENS AND SHUTTER.

(732) **PREMOGRAPH NO. 1 REFLEX BOX CAMERA.** C. 1907. SIZE 3¼ X 4¼ INCH EXPOSURES ON FILM PACKS. FIXED FOCUS. INSTANTANEOUS SHUTTER.

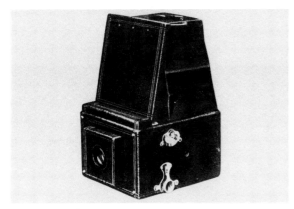

(733) **PREMOGRAPH NO. 2 REFLEX BOX CAMERA.** C. 1908–09. SIZE 3¼ X 4¼ INCH EXPOSURES ON FILM PACKS. BAUSCH & LOMB LENS. FOCAL PLANE SHUTTER; ½ TO 1/1000 SEC.

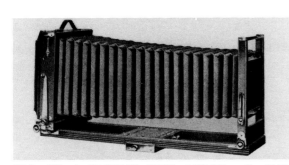

(734) **NO. 2 EASTMAN VIEW CAMERA.** C. 1915. THREE SIZES OF THIS CAMERA FOR 5 X 7, 6½ X 8½, OR 8 X 10 INCH EXPOSURES ON PLATES. SYMMETRICAL LENS. DOUBLE-VALVE AUTO SHUTTER.

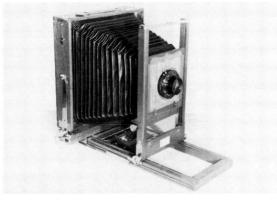

(735) **NO. 2 EMPIRE STATE VIEW CAMERA.** C. 1910. SIZE 5 X 7 INCH EXPOSURES ON SHEET FILM. F 4 LENS. SHUTTER SPEEDS FROM 1 TO 1/100 SEC., B., T. 5 X 7 INCH EXPOSURE REDUCING BACK. (EB)

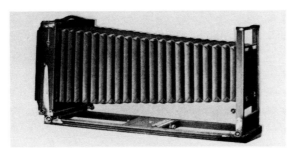

(736) **NO. 1 IMPROVED EMPIRE STATE VIEW CAMERA.** C. 1915. THREE SIZES OF THIS CAMERA FOR 5 X 7, 6½ X 8½, OR 8 X 10 INCH EXPOSURES ON PLATES. SYMMETRICAL LENS. DOUBLE-VALVE AUTO SHUTTER.

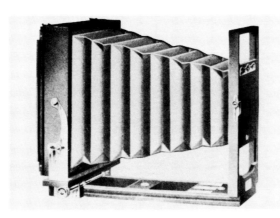

(737) **R.O.C. VIEW CAMERA.** C. 1915. SIZE 5 X 7 INCH EXPOSURES ON PLATES. SYMMETRICAL LENS. D. V. AUTO SHUTTER.

## ELECTRONIC PRODUCTS MANUFACTURING CORPORATION

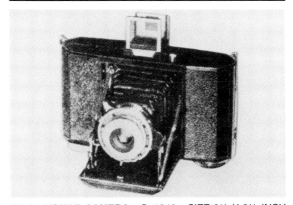

(738) **VOKAR CAMERA.** C. 1940. SIZE 2¼ X 2¼ INCH EXPOSURES ON NO. 120 ROLL FILM. 75 MM/F 6.3 VOKAR TRIPLE ANASTIGMAT LENS. GEARED TYPE SHUTTER; 1/25 TO 1/100 SEC., B. COUPLED APERTURE AND SHUTTER SETTINGS.

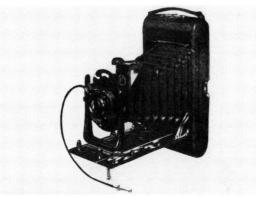

(739) **VORAN CAMERA.** C. 1940. SIZE 2¼ X 3¼ INCH EXPOSURE ON NO. 120 ROLL FILM. 105 MM/F 3.5 RODENSTOCK TRINAR LENS. COMPUR RAPID SHUTTER; 1 TO 1/400 SEC., ST. HELICAL FOCUSING.

## ENTERPRISE OPTICAL MANUFACTURING COMPANY

(740) **ALVAH BOX CAMERA.** C. 1899. SIZE 2 X 2 INCH EXPOSURES ON PLATES. MENISCUS LENS. SINGLE-SPEED SHUTTER. SOLD BY SEARS, ROEBUCK COMPANY. (MA)

## EXPO CAMERA COMPANY

(741) **EXPO EASY-LOAD BOX CAMERA.** C. 1926. EIGHT EXPOSURES, SIZE 1⅝ X 2½ INCHES ON CASSETTE ROLL FILM. MENISCUS LENS. ROTARY SECTOR SHUTTER. (MA)

(742) **EXPO WATCH CAMERA.** C. 1904–10. ORIGINAL MODEL. TWENTY-FIVE EXPOSURES, SIZE ⅝ X ⅞ INCH ON CASSETTE ROLL FILM. 25 MM/F 16 MENISCUS LENS. NON-SELF-CAPPING GUILLOTINE SHUTTER FOR INSTANT AND TIME EXPOSURES. COUPLED FILM COUNTER. THIS MODEL CAN BE IDENTIFIED BY THE NAME "EXPO" ENGRAVED IN LARGE FLOWING SCRIPT LETTERS ON THE BACK OF THE CAMERA. THE NAME "EXPO" IS NOT ENCLOSED BY A CIRCLE AS IS THE CASE FOR THE IMPROVED MODEL OF 1910–36. OTHER FEATURES ARE SIMILAR TO THE IMPROVED MODEL.

## EXPO CAMERA COMPANY (*cont.*)

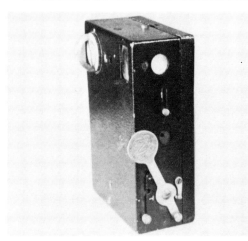

(743) **EXPO POLICE CAMERA.** C. 1911. TWELVE EXPOSURES, SIZE ½ X 1 INCH ON ROLL FILM. ACHROMATIC MENISCUS LENS. FOCAL-PLANE ROLLER-BLIND SHUTTER. (SW)

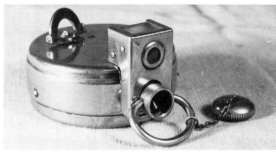

(744) **EXPO WATCH CAMERA.** C. 1910–36. IMPROVED MODEL. TEN OR 20 EXPOSURES, SIZE ⅝ X ⅞ INCH ON CASSETTE ROLL FILM. 25 MM/F 16 MENISCUS LENS. NON-SELF-CAPPING GUILLOTINE SHUTTER FOR INSTANT AND TIME EXPOSURES. THE "WATCH WINDING KNOB" SERVES AS A LENS AND SHUTTER CAP. COUPLED FILM COUNTER. THIS MODEL CAN BE IDENTIFIED BY THE NAME "EXPO" ENGRAVED ON THE BACK AND ENCLOSED BY AN ENGRAVED CIRCLE. (SW)

## FALCON CAMERA COMPANY

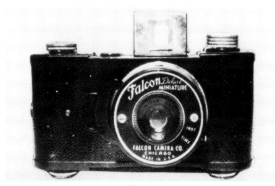

(745) **FALCON DELUXE MINIATURE CAMERA.** C. 1935. SIZE 1⅛ X 1⅝ INCH EXPOSURES ON ROLL FILM. BAKELITE BODY. (HA)

## FOLMER & SCHWING MANUFACTURING COMPANY

(746) **GRAFLEX SINGLE LENS REFLEX CAMERA.** ORIGINAL MODEL. C. 1898. THREE SIZES OF THIS CAMERA FOR 3¼ X 4¼, 4 X 5, OR 5 X 7 INCH EXPOSURES ON PLATES. FOCAL PLANE SHUTTER.

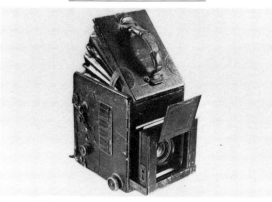

(747) **AUTO GRAFLEX SINGLE LENS REFLEX CAMERA.** C. 1905. TWO SIZES OF THIS CAMERA FOR 3¼ X 4¼ OR 4 X 5 INCH EXPOSURES. GOERZ DAGOR LENS. FOCAL PLANE SHUTTER. DOUBLE MIRRORS FOR EYE-LEVEL OR WAIST-LEVEL VIEWING OF GROUND GLASS. (HW)

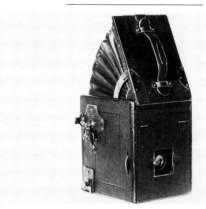

(748) **AUTO GRAFLEX JUNIOR CAMERA.** C. 1906. SIZE 3¼ X 4¼ INCH EXPOSURES ON PLATES. COOKE-GRAFLEX SERIES III LENS. FOCAL PLANE SHUTTER. THE CAMERA HAS NO BELLOWS BUT IS FOCUSED BY MEANS OF A THUMB-WHEEL IN THE CAMERA BODY. BUTTON-TYPE SHUTTER RELEASE. (RP)

(749) **TOURIST GRAFLEX SINGLE LENS REFLEX CAMERA.** C. 1904. SIZE 4 X 5 INCH EXPOSURES.

(750) **AUTO GRAFLEX STEREO CAMERA.** C. 1906. SIZE 5 X 7 INCH STEREO PLATE EXPOSURES. SIMILAR TO THE AUTO GRAFLEX STEREO CAMERA, C. 1907. MANUFACTURED BY THE EASTMAN KODAK COMPANY—FOLMER & SCHWING DIVISION. (BC)

(751) **DECEPTIVE ANGLE GRAPHIC CAMERA.** C. 1901. SIZE 3¼ X 4¼ INCH EXPOSURES ON PLATES OR SHEET FILM. BAUSCH & LOMB RAPID RECTILINEAR LENS. RAUBER & WOLLENSAK AUTOMATIC SHUTTER; 1 TO ¹⁄₁₀₀ SEC., B., T. IRIS DIAPHRAGM. RACK & PINION FOCUSING. OTHER LENSES THAT WERE AVAILABLE FOR THE CAMERA WERE THE GOERZ SERIES III; VOIGTLANDER NO. 2, SERIES III; AND THE ZEISS NO. 4, SERIES VIIA. THE CAMERA APPEARS TO BE A STEREO CAMERA BUT THE "STEREO LENSES" ARE NONFUNCTIONAL. THE ACTUAL LENS TAKES PICTURES AT A 90-DEGREE ANGLE FROM THE APPARENT AIM OF THE CAMERA. (GE)

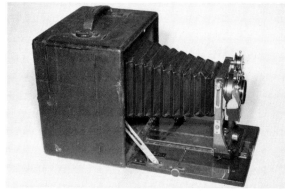

(752) **REVERSIBLE BACK GRAPHIC CAMERA.** C. 1900. FOUR SIZES OF THIS CAMERA FOR 4 X 5, 5 X 7, 6½ X 8½, OR 8 X 10 INCH EXPOSURES ON PLATES OR SHEET FILM. VOIGTLANDER COLLINEAR II OR ZEISS LENS. BAUSCH & LOMB SHUTTER; 3 TO ¹⁄₁₀₀ SEC., T. IRIS DIAPHRAGM. RACK & PINION FRONT AND BACK FOCUSING. DROPPING BED. RISING, FALLING, AND CROSSING LENS MOUNT. SWING BACK. TILT BACK.

## FOLMER & SCHWING MANUFACTURING COMPANY (*cont.*)

WAIST-LEVEL VIEWER. GROUND GLASS FOCUSING. REVERSIBLE BACK. (GE)

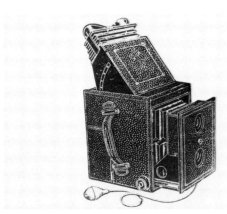

(753) **TWIN-LENS GRAPHIC CAMERA.** C. 1901.

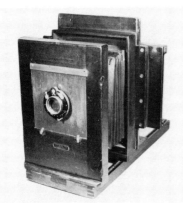

(754) **MULTIPLE STUDIO CAMERA.** C. 1905. SIZE 5 X 7 INCH EXPOSURES ON PLATES. F 6.8 RALPH GOLSEN ANASTIGMAT SERIES II LENS. ACME SHUTTER. (MR)

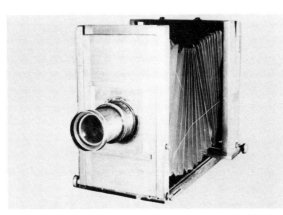

(755) **VIEW CAMERA.** C. 1900. SIZE 11 X 14 INCH EXPOSURES ON GLASS PLATES. (JW)

(756) **BANQUET VIEW CAMERA.** C. 1903. SIZE 7 X 17 INCH EXPOSURES ON GLASS PLATES.

(757) **SENIOR VIEW CAMERA.** C. 1903. SIZE 5 X 7 INCH EXPOSURES. BAUSCH & LOMB LENS. DOUBLE PNEUMATIC SHUTTER.

## FOLMER GRAFLEX CORPORATION

(758) **NO. 6 CIRKUT CAMERA.** C. 1926–43. SIX-INCH WIDE, 360-DEGREE PANORAMIC EXPOSURES ON ROLL FILM. F 7.7 ANASTIGMAT LENS. GROUND GLASS FOCUS. A SPRING MOTOR ROTATES THE CAMERA ON A VERTICLE AXIS AND MOVES THE FILM PAST A FOCAL PLANE SLIT. THE CAMERA CAN BE USED AS A REGULAR NON-PANORAMIC CAMERA WITH DIAL SHUTTER EXPOSURES FROM 1 TO $\frac{1}{100}$ SEC., B., T. SIMILAR TO THE NO. 6 CIRKUT CAMERA OF THE EASTMAN KODAK COMPANY—FOLMER & SCHWING DIVISION.

(759) **NO. 10 CIRKUT CAMERA.** C. 1926–41. SIX, EIGHT, OR TEN-INCH WIDE, 360-DEGREE PANORAMIC EXPOSURES ON ROLL FILM. F 6.8 ANASTIGMAT LENS. SIMILAR TO THE NO. 6 CIRKUT CAMERA WITH THE SAME LENS AND SHUTTER.

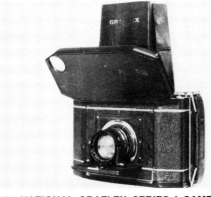

(760) **NATIONAL GRAFLEX SERIES I CAMERA. SINGLE LENS REFLEX.** C. 1933–35. SIZE 2¼ X 2½ INCH EXPOSURES ON NO. 120 ROLL FILM. 75 MM/F 3.5 BAUSCH & LOMB LENS. FOCAL PLANE SHUTTER; $\frac{1}{30}$ TO $\frac{1}{500}$ SEC., B. (MF)

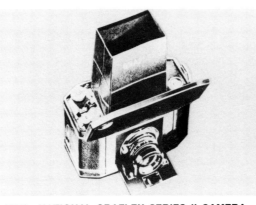

(761) **NATIONAL GRAFLEX SERIES II CAMERA. SINGLE LENS REFLEX.** C. 1935–41. SIZE 2¼ X 2½ INCH EXPOSURES ON NO. 120 ROLL FILM. 75 MM/F 3.5 BAUSCH & LOMB LENS. FOCAL PLANE SHUTTER: $\frac{1}{30}$ TO $\frac{1}{500}$ SEC., B.

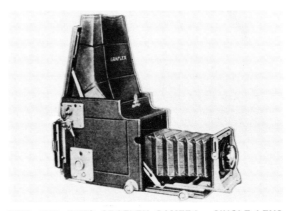

(762) **R.B. AUTO GRAFLEX CAMERA. SINGLE LENS REFLEX.** C. 1926–42. TWO SIZES OF THIS CAMERA FOR 3¼ X 4¼ OR 4 X 5 INCH EXPOSURES ON ROLL, SHEET, OR PLATE FILM. F 4.5 KODAK ANASTIGMAT, BAUSCH & LOMB PROTAR, BAUSCH & LOMB TESSAR, COOKE AVAIR, VELOSTIGMAT SERIES II, SCHNEIDER XENAR, ROSS, OR DALLMEYER LENS. FOCAL PLANE SHUTTER; $\frac{1}{5}$ TO $\frac{1}{1000}$ SEC., T. DOUBLE EXTENSION BELLOWS. RISING FRONT. REVOLVING BACK. (TH)

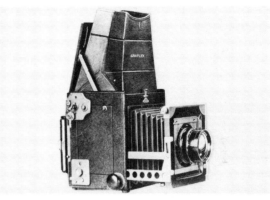

(763) **R.B. HOME PORTRAIT GRAFLEX CAMERA. SINGLE LENS REFLEX.** C. 1926–42. SIZE 5 X 7 INCH EXPOSURES ON ROLL, SHEET, OR PLATE FILM. REVOLVING BACK. F 4.5 KODAK, BAUSCH & LOMB, COOKE, DALLMEYER, GOERZ, ROSS, SCHNEIDER, VOIGTLANDER, OR ZEISS LENS. ALSO, F 3.5 DALLMEYER, SCHNEIDER, VOIGTLANDER, OR ZEISS LENS. FOCAL PLANE SHUTTER; ½ TO $\frac{1}{500}$ SEC., T. ($\frac{1}{10}$ TO $\frac{1}{1000}$ SEC ON SOME MODELS.) SWING AND RISING FRONT.

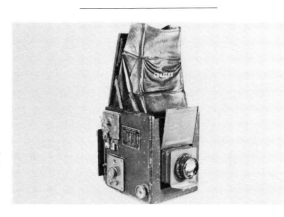

## FOLMER GRAFLEX CORPORATION (*cont.*)

**(764) R.B. SERIES B GRAFLEX CAMERA. SINGLE LENS REFLEX.** C. 1926–42. (EXCEPT THE 2¼ X 3¼ MODEL TO 1951). THREE SIZES OF THIS CAMERA FOR 2¼ X 3¼, 3¼ X 4¼, OR 4 X 5 INCH EXPOSURES ON SHEET OR PLATE FILM. F 4.5 KODAK ANASTIGMAT LENS. FOCAL PLANE SHUTTER; ⅕ TO ¹⁄₁₀₀₀ SEC., T. (SW)

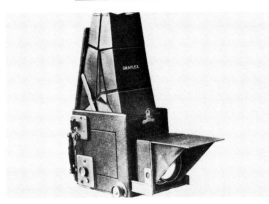

**(765) R.B. SERIES C GRAFLEX CAMERA. SINGLE LENS REFLEX.** C. 1926–35. SIZE 3¼ X 4¼ INCH EXPOSURES ON ROLL, SHEET, OR PLATE FILM. REVOLVING BACK. 6½ INCH F 2.5 COOKE ANASTIGMAT LENS. FOCAL PLANE SHUTTER, ⅕ TO ¹⁄₁₀₀₀ SEC., T.

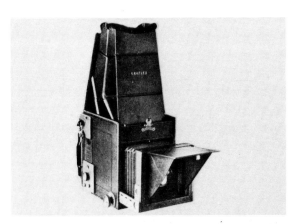

**(766) R.B. SERIES D GRAFLEX CAMERA. SINGLE LENS REFLEX.** C. 1928–41. TWO SIZES OF THIS CAMERA FOR 3¼ X 4¼ OR 4 X 5 INCH EXPOSURES ON ROLL, SHEET, OR PLATE FILM. REVOLVING BACK. F 4.5 KODAK, BAUSCH & LOMB, COOKE, DALLMEYER, ROSS, SCHNEIDER, VOIGTLANDER, OR ZEISS LENS. ALSO, F 3.5 COOKE, DALLMEYER, ROSS, SCHNEIDER, VOIGTLANDER, OR ZEISS LENS. SOME MODELS WITH F 2.9 COOKE OR PLAUBEL LENS. FOCAL PLANE SHUTTER; ¹⁄₁₀ TO ¹⁄₁₀₀₀ SEC., B., T. SOME MODELS WITH ⅕ TO ¹⁄₁₀₀₀ SEC., B., T. SHUTTER.

**(767) CROWN GRAPHIC ER & C CAMERA.** C. 1926–46. SIZE 8 X 10 INCH EXPOSURES ON PLATES OR SHEET FILM.

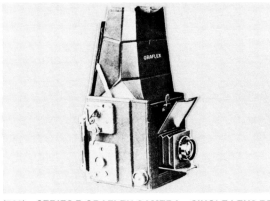

**(768) SERIES B GRAFLEX CAMERA. SINGLE LENS REFLEX.** C. 1926 (2¼ X 3¼), C. 1926–37 (3¼ X 4½ AND 4 X 5), AND C. 1926–42 (5 X 7). EXPOSURES ON ROLL, SHEET, OR PLATE FILM. F 4.5 KODAK ANASTIGMAT LENS. FOCAL PLANE SHUTTER; ¹⁄₁₀ TO ¹⁄₁₀₀₀ SEC., T. STRAIGHT BACK.

**(769) ANNIVERSARY SPEED GRAPHIC CAMERA. SINGLE LENS REFLEX.** C. 1940–47. TWO SIZES OF THIS CAMERA FOR 3¼ X 4¼ OR 4 X 5 INCH EXPOSURES ON SHEET OR PLATE FILM. SIMILAR TO THE R.B. SPEED GRAPHIC WITH THE SAME LENSES AND SHUTTER BUT WITH A GRAFLEX OR GRAPHIC BACK INSTEAD OF A REVOLVING BACK. SOME MODELS WITH A 135 MM/ F4.7 GRAFLEX OPTAR LENS. ACCESSORIES INCLUDE COUPLED RANGEFINDER AND FLASH SYNC.

**(770) R.B. SPEED GRAPHIC CAMERA. SINGLE LENS REFLEX.** C. 1938. SIZE 2¼ X 3¼ INCH EXPOSURES ON SHEET OR PLATE FILM. REVOLVING BACK. F 4.5 KODAK, BAUSCH & LOMB, DALLMEYER, GOERZ, ROSS, SCHNEIDER, VOIGTLANDER, OR ZEISS LENS. ALSO, F 3.5 DALLMEYER, ROSS, SCHNEIDER, VOIGTLANDER, OR ZEISS LENS. FOCAL PLANE SHUTTER; ¹⁄₁₀ TO ¹⁄₁₀₀₀ SEC., T. SIMILAR TO THE SPEED GRAPHIC CAMERA (C. 1935–39).

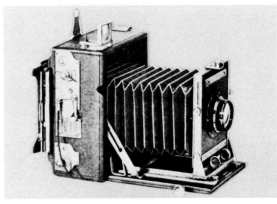

**(771) SPEED GRAPHIC CAMERA. SINGLE LENS REFLEX.** C. 1935–39. SIZE 3¼ X 4¼ INCH EXPOSURES ON SHEET, FILM PACKS, OR PLATES. F 4.5 KODAK ANASTIGMAT, SCHNEIDER, CARL ZEISS, BAUSCH & LOMB, COOKE, DALLMEYER, GOERZ, ROSS, OR VOIGTLANDER LENS. FOCAL PLANE SHUTTER; ¹⁄₁₀ TO ¹⁄₁₀₀₀ SEC., T. GRAPHIC OR GRAFLEX BACK. GROUND GLASS FOCUS. RACK & PINION FOCUS. SIZE 3¼ X 3¼ INCH LENS BOARD.

**(772) SPEED GRAPHIC CAMERA. SINGLE LENS REFLEX.** C. 1926–30. SIZE 4 X 5 INCH EXPOSURES ON SHEET, FILM PACKS, OR PLATE FILM. SIMILAR TO THE SPEED GRAPHIC CAMERA (C. 1935–39) WITH THE SAME LENSES AND SHUTTER. SIZE 4 X 4 INCH LENS BOARD.

**(773) SPEED GRAPHIC CAMERA. SINGLE LENS REFLEX.** C. 1930–39. SIZE 4 X 5 INCH EXPOSURES ON SHEET, FILM PACKS, OR PLATE FILM. SIMILAR TO THE SPEED GRAPHIC CAMERA (C. 1935–39) WITH THE SAME LENSES AND SHUTTER. SIZE 4 X 4 INCH LENS BOARD. THE CAMERA HAS THE HANDLE ON THE SIDE.

**(774) SPEED GRAPHIC CAMERA. SINGLE LENS REFLEX.** C. 1930–39. SIZE 5 X 7 INCH EXPOSURES ON FILM PACKS, SHEET, OR PLATE FILM. SIMILAR TO THE SPEED GRAPHIC CAMERA (C. 1935–39) WITH THE SAME LENSES AND SHUTTER. SIZE 4 X 4 INCH LENS BOARD.

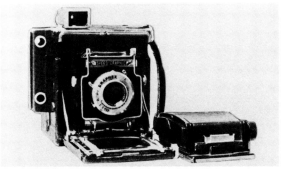

**(775) SPEED GRAPHIC PRESS CAMERA.** C. 1935–55. SIZE 2¼ X 3¼ INCH EXPOSURES ON PLATE, SHEET, OR ROLL FILM WITH ADAPTER. THE CAMERA HAS TWO SHUTTERS, A CENTRAL SHUTTER AND A FOCAL PLANE SHUTTER. COUPLED RANGEFINDER. (HA)

**(776) MULTIPLE CAMERA.** C. 1932. THE CAMERA CAN MAKE 1, 2, 4, 9, 16, OR 20 EXPOSURES OF VARIOUS SIZES ON ONE 5 X 7 INCH FILM PLATE BY MOVING THE PLATE INTO VARIOUS FOCAL PLANE POSITIONS. F 4.5 KODAK ANASTIGMAT LENS. COMPOUND, ILEX, UNIVERSAL, OR PACKARD SHUTTER. REVERSIBLE BACK. RACK & PINION FOCUSING. GROUND GLASS FOCUSING.

**(777) BANQUET VIEW CAMERA.** C. 1932. SIZE 12 X 20 INCH EXPOSURES ON PLATES OR CUT FILM. F 7.5 TURNER-REICH SERIES II ANASTIGMAT LENS. BETAX SHUTTER; ½ TO ¹⁄₁₀₀ SEC., B., T. RISING AND FALLING LENS MOUNT. SWING LENS BOARD. FRONT AND BACK RACK & PINION FOCUSING.

**(778) NO. 4A CENTURY STUDIO OUTFIT VIEW CAMERA.** C. 1936. SIZE 5 X 5 OR 8 X 10 INCH EXPOSURES ON PLATES. VERTICALLY ADJUSTABLE AND TILTING BED. VERTICAL AND HORIZONTAL SWING BACK. REVERSIBLE ADAPTER BACK. SOLD BY EASTMAN KODAK COMPANY.

**(779) NO. 8A CENTURY STUDIO OUTFIT VIEW CAMERA.** C. 1936. SIZE 5 X 7, 8 X 10, OR 11 X 14 INCH EXPOSURES ON PLATES. SAME FEATURES AS THE NO. 4A CENTURY STUDIO OUTFIT VIEW CAMERA BUT WITH A DIFFERENT TYPE OF CAMERA STAND.

## FOLMER GRAFLEX CORPORATION (*cont.*)

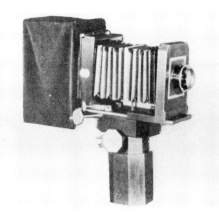

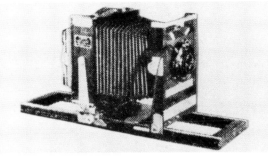

(784) **CROWN VIEW CAMERA.** C. 1940. SIZE 4 X 5 INCH EXPOSURES ON PLATES, CUT FILM, OR FILM PACKS. TRIPLE EXTENSION BELLOWS. RISING, AND CROSSING LENS MOUNT. SWING AND TILTING BACK. REVERSIBLE BACK. REMOVABLE LENS BOARD.

(780) **CENTURY IMPERIAL STUDIO VIEW CAMERA.** C. 1936. SIZE 8 X 10 INCH (OR 5 X 7 INCH WITH ADAPTER BACK) EXPOSURES ON SHEET OR PLATE FILM. THE CAMERA BED CAN BE RAISED, LOWERED, OR TILTED. VERTICAL AND HORIZONTAL SWING BACK. SOLD BY EASTMAN KODAK COMPANY.

(781) **NO. 10A CENTURY STUDIO OUTFIT VIEW CAMERA.** C. 1936. SIZE 5 X 7 OR 8 X 10 INCH EXPOSURES ON PLATES. SAME FEATURES AS THE NO. 4A CENTURY STUDIO OUTFIT VIEW CAMERA BUT WITH A DIFFERENT TYPE OF CAMERA STAND.

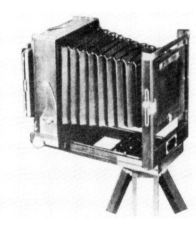

(785) **NO. 33A EASTMAN VIEW CAMERA.** C. 1936. SIZE 5 X 7 INCH EXPOSURES ON SHEET OR PLATE FILM. RISING AND FALLING LENS MOUNT. HORIZONTAL AND VERTICAL SWING BACK. REVERSIBLE BACK. RACK & PINION FOCUSING.

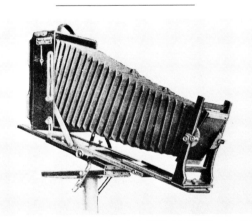

(782) **CENTURY UNIVERSAL VIEW CAMERA.** C. 1936. SIZE 8 X 10 INCH EXPOSURES (5 X 7 INCH WITH REDUCING BACK) ON SHEET OR PLATE FILM. RACK & PINION TRIPLE-EXTENTION BED. SWING BACK. RISING, FALLING, AND TILTING FRONT. GROUND GLASS FOCUS. THE CAMERA WAS SOLD BY THE EASTMAN KODAK COMPANY.

(783) **EASTMAN 2D VIEW CAMERA.** C. 1936. THREE SIZES OF THIS CAMERA FOR 5 X 7, 8 X 10, OR 11 X 14 INCH EXPOSURES ON SHEET OR PLATE FILM. RISING AND FALLING LENS MOUNT. REVERSIBLE BACK. HORIZONTAL AND VERTICAL SWING. DOUBLE EXTENSION BED. RACK & PINION FOCUSING. SIMILAR TO THE NO. 2D VIEW CAMERA MANUFACTURED BY THE EASTMAN KODAK COMPANY—FOLMER & SCHWING DIVISION, C. 1910–20. SOLD BY THE EASTMAN KODAK COMPANY.

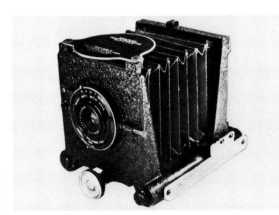

(786) **STUDIO VIEW CAMERA.** C. 1938. SIZE 2¼ X 3¼ INCH EXPOSURES ON PLATES. 75 MM/F 6.3 GRAFLEX PHOTRECORD LENS. WOLLENSAK BETAX SHUTTER; 1½ TO ¹⁄₂₅ SEC. OPTICAL BENCH MOUNT. (HA)

## FOTOSHOP, INCORPORATED

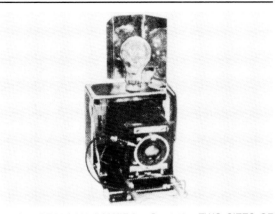

(787) **PRESSCAM CAMERA.** C. 1940. TWO SIZES OF THIS CAMERA FOR 2¼ X 3¼ OR 4 X 5 INCH EXPOSURES ON PLATES, CUT FILM, OR FILM PACKS (WITH ADAPTER). VARIOUS LENSES AND SHUTTERS. DOUBLE EXTENSION BELLOWS. RISING LENS MOUNT. BUILT-IN FLASH SOCKET. COUPLED RANGEFINDER.

## GASSNER & MARX CAMERA COMPANY

(788) **DAYPLATE BOX CAMERA.** C. 1899. SIZE 3¼ X 4¼ INCH PLATE EXPOSURES.

## GENNERT, G. COMPANY

(789) **CYCLE MONTAUK CAMERA.** C. 1899. TWO SIZES OF THIS CAMERA FOR 4 X 5 OR 5 X 7 INCH EXPOSURES. SIMILAR TO THE MONTAUK STYLE 1 CAMERA.

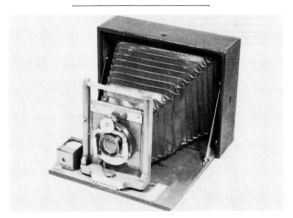

(790) **GOLF MONTAUK CAMERA.** C. 1900. (VC)

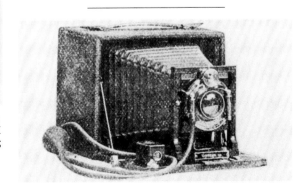

## GENNERT, G. COMPANY (*cont.*)

(791)  **MONTAUK II A CAMERA.** C. 1899. TWO SIZES OF THIS CAMERA FOR 4 X 5 OR 5 X 7 INCH EXPOSURES.

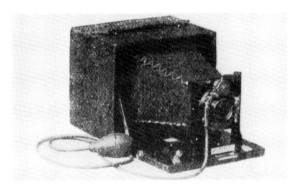

(792)  **MONTAUK II B CAMERA.** C. 1899. TWO SIZES OF THIS CAMERA FOR 4 X 5 OR 5 X 7 INCH EXPOSURES.

(793)  **MONTAUK BOX CAMERA.** C. 1890. SIZE 4 X 5 INCH EXPOSURES ON PLATES. LEVER FOCUSING. ROTARY COCKING SHUTTER.

(794)  **MONTAUK JUNIOR FIXED-FOCUS BOX CAMERA.** C. 1899. SIZE 3¼ X 4¼ INCH EXPOSURES.

(795)  **MONTAUK JUNIOR FOCUSING BOX CAMERA.** C. 1899. SIZE 4 X 5 INCH EXPOSURES.

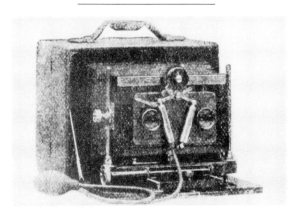

(796)  **MONTAUK STEREO CAMERA.** C. 1899.

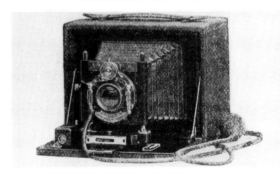

(797)  **MONTAUK STYLE I CAMERA.** C. 1899. TWO SIZES OF THIS CAMERA FOR 4 X 5 OR 5 X 7 INCH EXPOSURES.

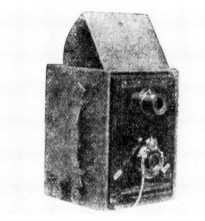

(798)  **MONTAUK TWIN LENS REFLEX CAMERA.** C. 1899.

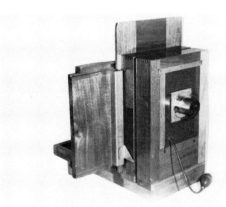

(799)  **MULTI-IMAGE CAMERA.** NINE EXPOSURES ON EACH 5 X 7 INCH FILM SHEET. FOWLER & SLATER LENS. PNEUMATIC SHUTTER. THE FILM HOLDER IS MOVED INTO ANY ONE OF NINE POSITIONS TO MAKE ONE EXPOSURE ALONG THE CENTRAL AXIS OF THE LENS. (EB)

(800)  **PENNY MULTIPLE CAMERA.** C. 1890. A MAXIMUM OF 24 EXPOSURES ON A SINGLE PLATE BY USE OF A MULTIPLE BACK.

(801)  **STEROCO STEREO COLOR CAMERA.** C. 1926. SIZE 45 X 107 MM STEREO PLATE EXPOSURES. F 5.4 TERONAR LENSES.

## GLEN CAMERA COMPANY

(802)  **GLEN BOX CAMERA.** C. 1891. SIZE 2½ X 2½ INCH EXPOSURES ON PLATES.

## GUNDLACH—MANHATTEN OPTICAL COMPANY

(803)  **KORONA JUNIOR CAMERA.** TWO SIZES OF THIS CAMERA FOR 4 X 5 OR 5 X 7 INCH EXPOSURES ON PLATES OR FILM PACKS. F 6.3 ANASTIGMAT LENS. BETAX SHUTTER. REVERSIBLE BACK. RISING AND FALLING LENS MOUNT. GROUND GLASS FOCUSING. DROPPING BED.

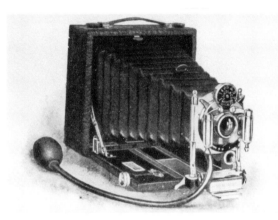

(804)  **IDEAL PETIT CAMERA.** C. 1908. SIZE 3¼ X 4¼ INCH EXPOSURES ON PLATES. F 8 RAPID CONVERTIBLE LENS. KORONA REGULAR SHUTTER; 1 TO ¹⁄₁₀₀ SEC., B., T. REVERSIBLE BACK.

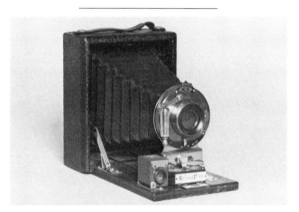

(805)  **KORONA PETIT CAMERA.** C. 1902. SIZE 3½ X 5 INCH EXPOSURES. WOLLENSAK LENS. PNEUMATIC SHUTTER; INSTANT B., T. (TH)

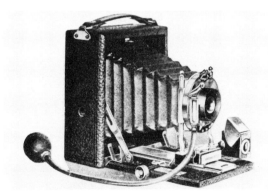

(806)  **KORONA PETIT CAMERA.** C. 1908. TWO SIZES OF THIS CAMERA FOR 3¼ X 4¼ OR 3¼ X 5½ INCH EXPOSURES ON PLATES. TURNER-REICH OR VERASTIGMAT LENS. JUNIOR AUTOMATIC SHUTTER; INSTANT, B., T.

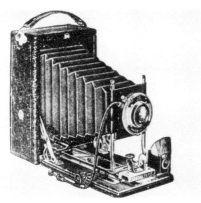

(807) **KORONA PETIT CAMERA.** C. 1920. THREE SIZES OF THIS CAMERA FOR 3¼ X 4¼, 3¼ X 5½, OR 4 X 5 INCH EXPOSURES ON PLATES OR FILM PACKS. RAPID RECTILINEAR LENS. DELTAX SHUTTER. RISING, FALLING, AND CROSSING LENS MOUNT. RACK & PINION FOCUSING. GROUND GLASS FOCUSING.

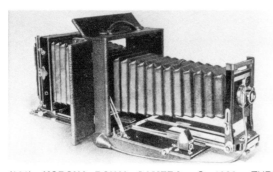

(808) **KORONA ROYAL CAMERA.** C. 1908. THREE SIZES OF THIS CAMERA FOR 5 X 7, 6½ X 8½, OR 8 X 10 INCH EXPOSURES ON PLATES. F 8 RAPID RECTILINEAR, F 6.8 TURNER-REICH II, OR VERASTIGMAT LENS. KORONA AUTOMATIC SHUTTER; 1 TO ⅟₁₀₀ SEC., B., T. FRONT DOUBLE EXTENSION BELLOWS. REAR EXTENSION BELLOWS. REVERSIBLE BACK. DOUBLE SWING BACK. DROPPING BED.

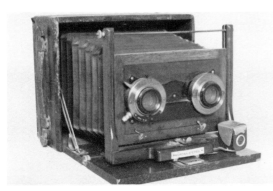

(809) **KORONA STEREO CAMERA.** C. 1902. SIZE 5 X 7 INCH EXPOSURES. WOLLENSAK LENSES. (TH)

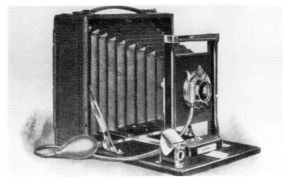

(810) **SERIES I KORONA CAMERA.** C. 1908–20. TWO SIZES OF THIS CAMERA FOR 4 X 5 OR 5 X 7 INCH PLATE EXPOSURES. F 8 RAPID RECTILINEAR LENS. KORONA WINNER SHUTTER; ⅟₂₅, ⅟₅₀, ⅟₁₀₀ SEC., B., T. THE LATER MODELS ALSO USED FILM PACKS.

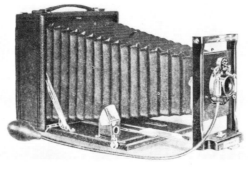

(811) **SERIES II KORONA CAMERA.** C. 1908–20. TWO SIZES OF THIS CAMERA FOR 4 X 5 OR 5 X 7 INCH PLATE EXPOSURES. F 8 RAPID RECTIGRAPHIC, F 6.8 TURNER-REICH II, OR VERASTIGMAT LENS. KORONA REGULAR SHUTTER; 1 TO ⅟₁₀₀ SEC., B., T. DOUBLE EXTENSION BELLOWS. THE LATER MODELS ALSO USED FILM PACKS.

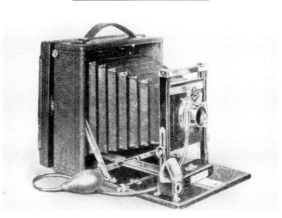

(812) **SERIES III KORONA CAMERA.** C. 1908–20. TWO SIZES OF THIS CAMERA FOR 4 X 5 OR 5 X 7 INCH EXPOSURES ON PLATES. F 8 RAPID RECTIGRAPHIC OR F 6.8 TURNER-REICH SERIES III LENS. KORONA REGULAR SHUTTER; 1 TO ⅟₁₀₀ SEC., B., T. SWING BACK. THE LATER MODELS ALSO USED FILM PACKS.

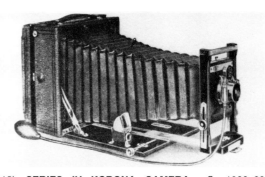

(813) **SERIES IV KORONA CAMERA.** C. 1908–20. THREE SIZES OF THIS CAMERA FOR 4 X 5, 5 X 7, OR 6½ X 8½ INCH PLATE EXPOSURES. F 8 RAPID RECTIGRAPHIC, F 6.8 TURNER-REICH II, OR VERASTIGMAT LENS. KORONA AUTOMATIC SHUTTER; 1 TO ⅟₁₀₀ SEC., B., T. DOUBLE EXTENSION BELLOWS. REVERSIBLE BACK. SWING BACK. THE LATER MODELS ALSO USED FILM PACKS.

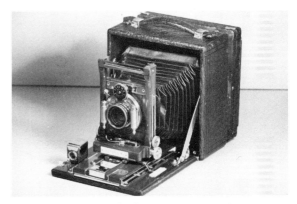

(814) **SERIES V KORONA CAMERA.** C. 1908–20. THREE SIZES OF THIS CAMERA FOR 4 X 5, 5 X 7, OR 6½ X 8½ INCH PLATE EXPOSURES. SAME FEATURES, LENSES, AND SHUTTER AS THE SERIES IV KORONA BUT WITH TRIPLE EXTENSION BELLOWS. (MR)

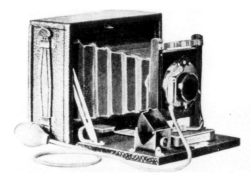

(815) **SERIES VII KORONA CAMERA.** C. 1908. TWO SIZES OF THIS CAMERA FOR 4 X 5 OR 5 X 7 INCH EXPOSURES ON PLATES OR CUT FILM. RAPID ACHROMATIC OR SPECIAL SYMMETRICAL LENS. WOLLENSAK OR JUNIOR AUTOMATIC SHUTTER FOR INSTANT, B., T. EXPOSURES.

## GUNDLACH—MANHATTEN OPTICAL COMPANY (cont.)

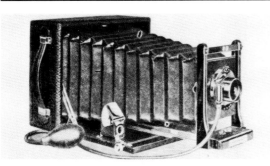

**(816) SERIES VIII KORONA CAMERA.** C. 1908. TWO SIZES OF THIS CAMERA FOR 4 X 5 OR 5 X 7 INCH PLATE EXPOSURES. SPECIAL SYMMETRICAL CONVERTIBLE LENS. KORONA JUNIOR AUTOMATIC SHUTTER FOR INSTANT, B., T. EXPOSURES. DOUBLE EXTENSION BELLOWS.

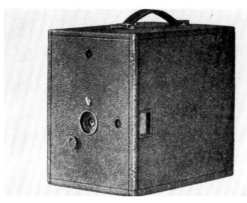

**(817) SERIES X KORONA BOX CAMERA.** C. 1908. SIZE 4 X 5 INCH EXPOSURES ON PLATES. RAPID ACHROMATIC LENS. AUTOMATIC SHUTTER FOR INSTANT AND TIME EXPOSURES. GROUND GLASS FOR VIEWING SUBJECT BEFORE EXPOSURE. FIXED-FOCUS LENS.

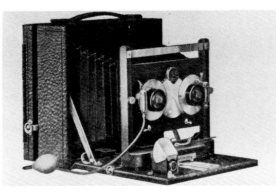

**(818) SERIES III STEREO KORONA CAMERA.** C. 1908. SIZE 5 X 7 INCH STEREO EXPOSURES ON PLATES. SPECIAL SYMMETRICAL, CONVERTIBLE SYMMETRICAL, NO. 0 VERASTIGMAT, 4 X 5 TURNER-REICH, OR 4 X 5 VERASTIGMAT LENSES. WINNER SHUTTER; $\frac{1}{25}$, $\frac{1}{50}$, $\frac{1}{100}$ SEC., B., T. SWING BACK.

**(819) SERIES IV STEREO KORONA CAMERA.** C. 1908. SIZE 5 X 7 INCH EXPOSURES ON PLATES. SIMILAR TO THE SERIES III STEREO KORONA CAMERA WITH THE SAME LENSES AND SHUTTER BUT HAS DOUBLE EXTENSION BELLOWS AND REVERSIBLE BACK.

**(820) SERIES V STEREO KORONA CAMERA.** C. 1908. SIZE 5 X 7 INCH EXPOSURES ON PLATES. SIMILAR TO THE SERIES III STEREO KORONA CAMERA WITH THE SAME LENSES AND SHUTTER BUT HAS TRIPLE EXTENSION BELLOWS AND REVERSIBLE BACK.

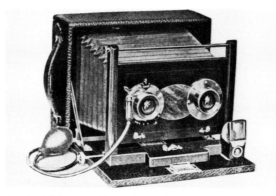

**(821) SERIES VII STEREO KORONA CAMERA.** C. 1908. SIZE 5 X 7 INCH EXPOSURES ON PLATES. 4 X 5 OR 5 X 7 SPECIAL SYMMETRICAL LENSES. KORONA SENIOR OR WINNER SHUTTER FOR INSTANT, BULB, AND TIME EXPOSURES.

**(822) SPEED KORONA CAMERA.** C. 1910. FOCAL PLANE SHUTTER.

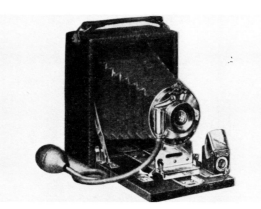

**(823) MARVEL PETIT CAMERA.** C. 1908. TWO SIZES OF THIS CAMERA FOR 3¼ X 4¼ OR 3¼ X 5½ INCH PLATE EXPOSURES. SPECIAL SYMMETRICAL LENS. JUNIOR AUTOMATIC SHUTTER; INSTANT B., T.

**(824) BANQUET VIEW CAMERA.** C. 1905. SIZE 7 X 17 INCH EXPOSURES ON PLATES.

**(825) BANQUET VIEW CAMERA.** C. 1910. SIZE 8 X 20 INCH EXPOSURES ON PLATES.

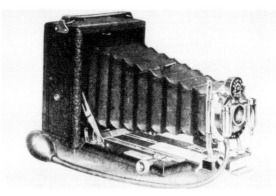

**(826) ROYAL PETIT CAMERA.** C. 1908. SIZE 3¼ X 4¼ INCH EXPOSURES ON PLATES. F 8 RAPID CONVERTIBLE LENS. KORONA REGULAR SHUTTER; 1 to $\frac{1}{100}$ SEC., B., T.

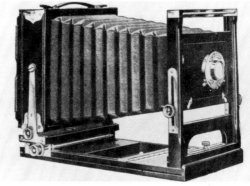

**(827) CRITERION VIEW CAMERA.** C. 1920. THREE SIZES OF THIS CAMERA FOR 5 X 7, 6½ X 8½, OR 8 X 10 INCH EXPOSURES ON PLATES OR FILM PACKS. SAME FEATURES AS THE KORONA VIEW CAMERA (C. 1920) PLUS A RISING, FALLING, AND CROSSING LENS MOUNT.

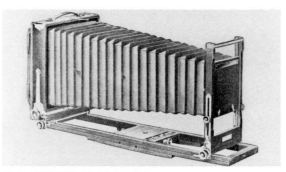

**(828) KORONA VIEW CAMERA.** C. 1920. SIX SIZES OF THIS CAMERA FOR 4 X 5, 5 X 7, 6½ X 8½, 8 X 10, 7 X 11, OR 11 X 14 INCH EXPOSURES ON PLATES OR FILM PACKS. REVERSIBLE BACK. DOUBLE SWING BACK. RACK & PINION FOR RISING AND FALLING LENS MOUNT. DETACHABLE LENS BOARD. GROUND GLASS FOCUSING.

## GUNDLACH—MANHATTEN OPTICAL COMPANY (*cont.*)

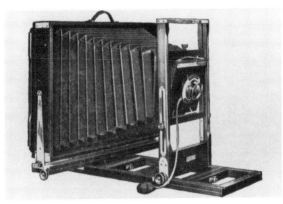

**(829) KORONA BANQUET VIEW CAMERA.** C. 1910–20. SIZE 12 X 20 INCH EXPOSURES ON PLATES OR FILM PACKS. F 7.5 TURNER-REICH SERIES II ANASTIGMAT LENS. RACK & PINION FOR RISING AND FALLING LENS MOUNT. VERTICAL SWING LENS BOARD. DOUBLE SWING BACK. RACK & PINION FRONT AND REAR FOCUSING. GROUND GLASS FOCUSING.

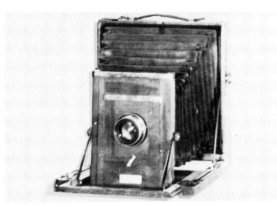

**(830) KORONA COMPACT VIEW CAMERA.** C. 1902. SIZE 8 X 10 INCH EXPOSURES ON GLASS PLATES. TRIPLE CONVERTIBLE LENS. UNICUM DOUBLE PNEUMATIC SHUTTER. (JW)

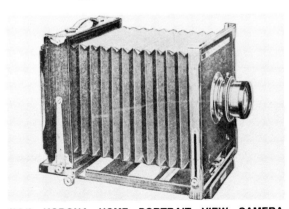

**(831) KORONA HOME PORTRAIT VIEW CAMERA.** C. 1920. THREE SIZES OF THIS CAMERA FOR 5 X 7, 6½ X 8½, OR 8 X 10 INCH EXPOSURES ON PLATES OR FILM PACKS. DOUBLE SWING BACK. REVERSIBLE BACK. RACK & PINION FOR RISING AND FALLING LENS MOUNT PLUS CROSS ADJUSTMENT. RACK & PINION FOCUSING. GROUND GLASS FOCUSING.

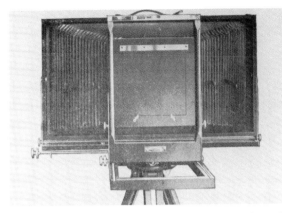

**(832) KORONA PANORAMIC VIEW CAMERA.** C. 1920. THREE SIZES OF THIS CAMERA FOR 5 X 12, 7 X 17, OR 8 X 20 INCH EXPOSURES ON PLATES OR FILM PACKS. TURNER-REICH SERIES II CONVERTIBLE ANASTIGMAT LENS. BETAX OR OPTIMO SHUTTER. DOUBLE SWING BACK. RACK & PINION FOR RISING AND FALLING LENS MOUNT. RACK & PINION FOCUSING. GROUND GLASS FOCUSING.

**(833) KORONA PICTORIAL VIEW CAMERA.** C. 1910. SIZE 8 X 10 INCH EXPOSURES ON PLATES.

**(834) WIZZARD DUPLEX CAMERA.** C. 1910.

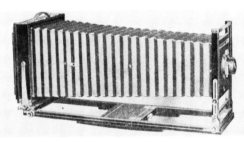

**(835) WIZZARD VIEW CAMERA.** C. 1908. FOUR SIZES OF THIS CAMERA FOR 5 X 7, 6½ X 8½, 8 X 10, OR 11 X 14 INCH PLATE EXPOSURES. CONVERTIBLE SYMMETRICAL, RAPID RECTIGRAPHIC, CONVERTIBLE TURNER-REICH, OR VERASTIGMAT LENS. REGULAR SHUTTER FOR EXPOSURES OF 1 TO ¹⁄₁₀₀ SEC., B., T. REVERSIBLE BACK. DOUBLE SWING BACK. GROUND GLASS FOCUSING SCREEN.

## GUNDLACH MANUFACTURING COMPANY

**(836) KORONA HOME PORTRAIT CAMERA.** C. 1928. THREE SIZES OF THIS CAMERA FOR 5 X 7, 6½ X 8½, OR 8 X 10 INCH PLATE EXPOSURES. F 8 VOLTAS, F 4.5 OR F 6.3 WOLLENSAK VELOSTIGMAT, F 3.5 OR F 4.5 SCHNEIDER XENAR, OR F 4.5 ZEISS TESSAR LENS. BETAX, COMPOUND, COMPUR, OR PACKARD SHUTTER. THE REVERSIBLE BACK HAS TWO SLIDING PANELS FOR MAKING TWO OR FOUR SMALLER EXPOSURES ON ONE PLATE. RISING, FALLING, AND CROSS-ING LENS MOUNT. DOUBLE SWING BACK. GROUND GLASS FOCUSING. COMPUR SHUTTER FOR THE 5 X 7 MODEL ONLY.

**(837) KORONA KRAFT CAMERA.** C. 1926. TWO SIZES OF THIS CAMERA FOR 4 X 5 OR 5 X 7 INCH EXPOSURES ON PLATES OR FILM PACKS. F 6.3 GUNDLACH SERIES IV OR F 6.8 TURNER-REICH ANASTIGMAT LENS. BETAX SHUTTER; ½ TO ¹⁄₁₀₀ SEC., B., T. OR ILEX ACME SHUTTER; 1 TO ¹⁄₃₀₀ SEC., B., T. TRIPLE EXTENSION BELLOWS. RACK & PINION FOCUSING. GROUND GLASS FOCUSING.

**(838) KORONA VIEW CAMERA.** C. 1928. SIX SIZES OF THIS CAMERA FOR 4 X 5, 5 X 7, 6½ X 8½, 7 X 11, 8 X 10, OR 11 X 14 INCH EXPOSURES ON PLATES OR FILM PACKS. F 8 VOLTAS, F 4.5 OR F 6.3 VELOSTIGMAT, F 3.5 OR F 4.5 SCHNEIDER ZENAR, F 6.8 SCHNEIDER SYMMAR, OR F 6.8 TURNER-REICH LENS. BETAX SHUTTER, ½ TO ¹⁄₁₀₀ SEC., B., T.; COMPOUND; OR UNIVERSAL SHUTTER. REVOLVING BACK. RISING AND FALLING LENS MOUNT. RACK & PINION FOCUS. CENTER SWING BACK. GROUND GLASS FOCUS. NO F 3.5 LENS ON MODELS LARGER THAN THE 5 X 7 MODEL.

**(839) KORONA BANQUET VIEW CAMERA.** C. 1928. SIZE 12 X 20 INCH EXPOSURES ON PLATES. F 7.5 TURNER-REICH ANASTIGMAT LENS. GENERAL, OPTIMO, OR ILEX UNIVERSAL SHUTTER. FRONT AND REAR FOCUSING. VERTICAL-SWING LENS BOARD. DOUBLE-SWING REAR FRAME. RISING AND FALLING LENS MOUNT.

**(840) KORONA COMMERCIAL VIEW CAMERA.** C. 1928. SIZE 8 X 10 INCH EXPOSURES ON PLATES OR CUT FILM. F 6.3 TURNER-REICH ANASTIGMAT LENS. ILEX UNIVERSAL SHUTTER; 1 TO ¹⁄₁₅₀ SEC., B., T. RISING, FALLING, AND TILTING LENS BOARD. SWING BACK. RACK & PINION FOCUSING. GROUND GLASS FOCUSING.

**(841) KORONA PANORAMIC VIEW CAMERA.** C. 1928. THREE SIZES OF THIS CAMERA FOR 7 X 17, 8 X 20, OR 12 X 20 INCH EXPOSURES ON PLATES OR CUT FILM. F 6.8 TURNER-REICH CONVERTIBLE ANASTIGMAT LENS. BETAX SHUTTER; ½ TO ¹⁄₁₀₀ SEC., B., T. SLIDING REAR PANEL FOR MAKING TWO EXPOSURES (HALF PLATE SIZE) ON ONE PLATE OR FILM.

## GUNDLACH MANUFACTURING CORPORATION

**(842) KORONA PANORAMIC CAMERA.** C. 1940. TWO SIZES OF THIS CAMERA FOR 7 X 17 OR 8 X 20 INCH EXPOSURES ON CUT FILM. RISING FRONT. SWING BACK. DOUBLE EXTENSION BELLOWS.

**(843) KORONA COMMERCIAL VIEW CAMERA.** C. 1940. TWO SIZES OF THIS CAMERA FOR 5 X 7 OR 8 X 10 INCH EXPOSURES ON CUT FILM. DOUBLE EXTENSION BELLOWS. SWING BACK. RISING AND CROSSING LENS MOUNT. SWING LENS MOUNT. RACK & PINION FOCUS. GROUND GLASS FOCUS.

**(844) KORONA HOME PORTRAIT VIEW CAMERA.** TWO SIZES OF THIS CAMERA FOR 5 X 7 OR 8 X 10 INCH

# AMERICAN CAMERAS

## GUNDLACH MANUFACTURING CORPORATION (*cont.*)

EXPOSURES ON CUT FILM. SWING BACK. RISING LENS MOUNT. SINGLE EXTENSION BELLOWS.

(845) **KORONA PICTORIAL VIEW CAMERA.** C. 1940. TWO SIZES OF THIS CAMERA FOR 5 X 7 OR 8 X 10 INCH EXPOSURES ON CUT FILM. SWING BACK. RISING AND CROSSING LENS MOUNT. DOUBLE EXTENSION BELLOWS. GROUND GLASS FOCUS.

(846) **KORONA PROFESSIONAL VIEW CAMERA.** C. 1940. FOUR SIZES OF THIS CAMERA FOR 4 X 5, 5 X 7, 8 X 10, OR 11 X 14 INCH EXPOSURES ON CUT FILM. SIMILAR TO THE KORONA COMMERCIAL VIEW CAMERA.

## GUNDLACH OPTICAL COMPANY

(847) **FOLDING PLATE CAMERA.** C. 1900. SIZE 4 X 5 INCH EXPOSURES ON PLATES OR FILM PACKS. GUNDLACH RAPID RECTILINEAR LENS. PNEUMATIC SHUTTER; INSTANT AND TIME.

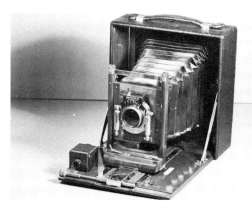

(848) **KORONA LONG-FOCUS CAMERA.** C. 1890. SIZE 5 X 7 INCH EXPOSURES ON PLATES. RAPID RECTIGRAPHIC CONVERTIBLE LENS. GUNDLACH OPTICAL COMPANY SHUTTER; 2 TO ⅟₅₀ SEC. (MR)

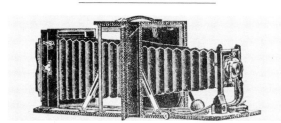

(849) **KORONA SERIES VI LONG-FOCUS CAMERA.** C. 1900. FOUR SIZES OF THIS CAMERA FOR 4 X 5, 5 X 7, 6½ X 8½, OR 8 X 10 INCH EXPOSURES ON PLATES. TURNER-REICH ANASTIGMAT OR RECTIGRAPHIC CONVERTIBLE LENS. AUTOMATIC SHUTTER. DOUBLE-EXTENSION BELLOWS. REVERSIBLE BACK.

(850) **KORONA SERIES II CAMERA.** C. 1900. SIZE 4 X 5 INCH EXPOSURES. F 6.2 LENS. GUNDLACH SHUTTER.

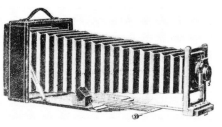

(851) **KORONA CYCLE SERIES VII LONG-FOCUS CAMERA.** C. 1900. TRIPLE EXTENSION BELLOWS. REVERSIBLE BACK.

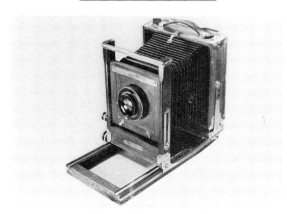

(852) **VIEW CAMERA.** C. 1885. SIZE 5 X 7 INCH EXPOSURES ON PLATES, 7¼ INCH/F 4.5 WOLLENSAK LENS. BETAX NO. 3 SHUTTER; ½ TO ⅟₅₀ SEC. (HW)

## HALL CAMERA COMPANY

(853) **MIRROR REFLEX CAMERA.** C. 1912. FIVE SIZES OF THIS CAMERA FOR 2¼ X 4¼, 3¼ X 4¼, 3¼ X 5½, 4 X 5, OR 5 X 7 INCH EXPOSURES. FOCAL PLANE SHUTTER.

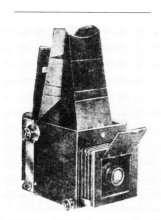

(854) **NEW MODEL MIRROR SINGLE LENS REFLEX CAMERA.** C. 1909–12. TWO SIZES OF THIS CAMERA FOR 4 X 5 OR 5 X 7 INCH PLATE EXPOSURES. FOCAL PLANE SHUTTER; 1 to ⅟₁₅₀₀ SEC.

## HEATHERINGTON AND HIBBEN

(855) **MAGAZINE CAMERA NO. 1.** C. 1892–95. SIZE 4 X 5 INCH EXPOSURES ON PLATES OR SHEET FILM.

165 MM/F 8 DARLET LENS. ROTARY SHUTTER. MECHANICAL CHANGING MAGAZINE. (MA)

## HERZOG, A.

(856) **HERZOG CAMERA.** C. 1876. SIZE 3¼ X 4¼ INCH PLATE EXPOSURES. 100 MM/F 8 PERISCOPIC LENS. (MA)

## HESS-IVES CORPORATION (THE)

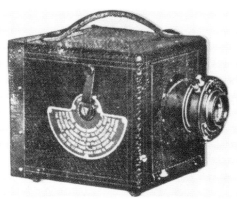

(857) **"HICRO" COLOR CAMERA.** C. 1916. PRODUCED UNDER CONTRACT BY KODAK'S HAWKEYE DIVISION. SIZE 3¼ X 4¼ INCH COLOR EXPOSURES ON PLATES. MENISCUS LENS. WOLLENSAK ULTRO SHUTTER.

## HYATT, H. A.

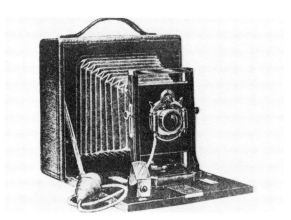

(858) **RIVAL "A" FOLDING PLATE CAMERA.** C. 1903. TWO SIZES OF THIS CAMERA FOR 4 X 5 OR 5 X 7 INCH EXPOSURES ON PLATES. RAPID RECTILINEAR LENS. VARIABLE SPEED SHUTTER WITH BULB AND TIME EXPOSURES. REVERSIBLE BACK, SWING BACK, AND SWING BED.

(859) **STAMP CAMERA.** C. 1887. TWENTY-FIVE SIMULTANEOUS EXPOSURES CAN BE MADE ON A SINGLE PLATE USING ALL OF THE CAMERA'S 25 LENSES.

## IMPERIAL CAMERA & MANUFACTURING COMPANY

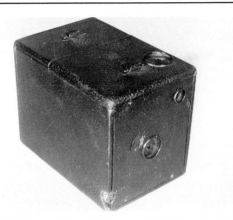

**(860) IMPERIAL BOX CAMERA.** SIZE 3½ X 3½ INCH EXPOSURES ON GLASS PLATES. SIMPLE LENS. INSTANT AND TIME SHUTTER. (EB)

## INTERNATIONAL METAL AND FERRO COMPANY

**(861) DIAMOND POSTCARD CANNON FERROTYPE CAMERA.** C. 1914.

## INTERNATIONAL PHOTOGRAPHIC INDUSTRIES, INC.

**(862) CLARUS MS-35 CAMERA.** C. 1940. SIZE 24 X 36 MM EXPOSURES ON "35MM" ROLL FILM. 50 MM/F 2.8 OR F 3.5 CLARUS ANASTIGMAT LENS. FOCAL PLANE SHUTTER; ½₅ TO ½₀₀₀ SEC., B. COUPLED RANGEFINDER. INTERCHANGEABLE LENSES. AUTOMATIC FILM TRANSPORT.

## INTERNATIONAL RESEARCH CORPORATION

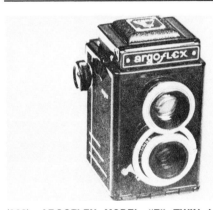

**(863) ARGOFLEX MODEL "E" TWIN LENS REFLEX CAMERA.** INTRODUCED IN 1940. SIZE 2¼ X 2¼ INCH EXPOSURES ON NO. 120, 620, B2, OR PB-20 ROLL FILM. F 4.5 ANASTIGMAT FOCUSING LENS. 75 MM/F 4.5 VAREX ANASTIGMAT TAKING LENS. WOLLENSAK AUTOMATIC SHUTTER; ½₀ TO ½₀₀ SEC., B., T. EYE LEVEL AND REFLEX FOCUSING.

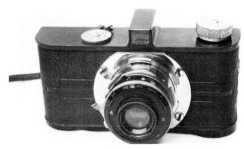

**(864) ARGUS, MODEL "A" CAMERA.** C. 1936. FIRST MODEL OF THE ARGUS CAMERAS. SIZE 24 X 36 MM EXPOSURES ON "35MM" ROLL FILM. 50 MM/F 4.5 ANASTIGMAT LENS. ILEX PRECISE SHUTTER; ½₅ TO ½₀₀ SEC., B., T. FIXED FOCUS. EXPOSURE COUNTER. (TS)

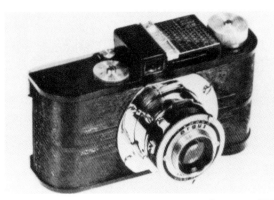

**(865) ARGUS MODEL "A2" CAMERA.** C. 1937. SIZE 24 X 36 MM EXPOSURES ON "35MM" ROLL FILM. SIMILAR TO THE ARGUS MODEL "A" CAMERA EXCEPT IT HAS AN EXTINCTION TYPE EXPOSURE METER AND SPECIAL LENS MOUNT.

**(866) ARGUS MODEL "A2B" CAMERA.** C. 1939. SIZE 24 X 36 MM EXPOSURES ON "35MM" ROLL FILM. SIMILAR TO THE ARGUS MODEL A2F.

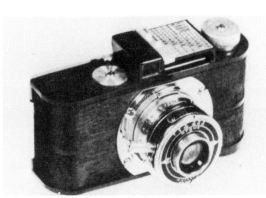

**(867) ARGUS MODEL "A2F" CAMERA.** C. 1938. SIZE 24 X 36 MM EXPOSURES ON "35MM" ROLL FILM. SIMILAR TO THE ARGUS MODEL "A2" EXCEPT IT HAS MANUAL FOCUSING AND SCREW MOUNT LENS.

**(868) ARGUS MODEL "A3" CAMERA.** C. 1940. SIZE 24 X 36 MM EXPOSURES ON "35MM" ROLL FILM. SAME AS THE ARGUS COLORCAMERA BUT WITH AN EXTINCTION TYPE EXPOSURE METER INSTEAD OF THE PHOTO-ELECTRIC TYPE.

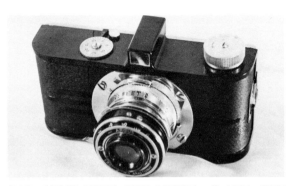

**(869) ARGUS MODEL "AF" CAMERA.** C. 1937. SIZE 24 X 36 MM EXPOSURES ON "35MM" ROLL FILM. 50 MM/F 4.5 LENS. ILEX SHUTTER; ½₅ TO ½₀₀ SEC., B., T. FOCUSING MOUNT. (TS)

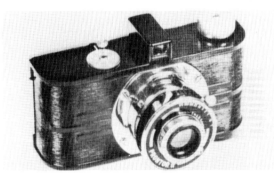

**(870) ARGUS MODEL "B" CAMERA.** C. 1937. SIZE 24 X 36 MM EXPOSURES ON "35MM" ROLL FILM. SIMILAR TO THE ARGUS MODEL "A" CAMERA EXCEPT WITH PRONTOR II SHUTTER.

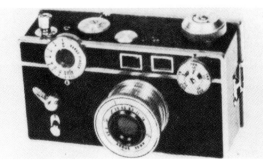

**(871) ARGUS MODEL "C" CAMERA.** C. 1938. SIZE 24 X 36 MM EXPOSURES ON "35MM" ROLL FILM. 50 MM/F 3.5 ARGUS CINTAR LENS. MICROMATIC SHUTTER; ⅕ TO ⅓₀₀ SEC., B., INTERCHANGEABLE LENSES. EXPOSURE COUNTER. NO COUPLED RANGEFINDER.

## INTERNATIONAL RESEARCH CORPORATION (*cont.*)

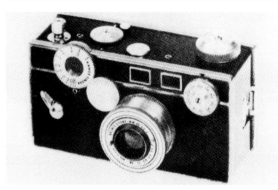

**(872) ARGUS MODEL "C2" CAMERA.** C. 1938. SIZE 24 X 36 MM EXPOSURES ON "35MM" ROLL FILM. F 3.5 ANASTIGMAT LENS. SHUTTER SPEEDS FROM ⅕ TO ⅟₃₀₀ SEC., B., T. SCREW MOUNT. COUPLED RANGE-FINDER.

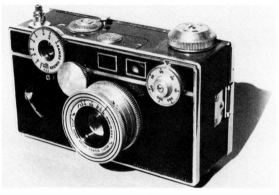

**(873) ARGUS MODEL "C3" CAMERA.** C. 1939. SIZE 24 X 36 MM EXPOSURES ON "35MM" ROLL FILM. F 3.5 CINTAR ANASTIGMAT LENS. ⅕ TO ⅟₃₀₀ SEC. SHUTTER. COUPLED RANGEFINDER. BUILT-IN-FLASH SYNC. EXPOSURE COUNTER. BEHIND-THE-LENS TYPE SHUTTER. (KC)

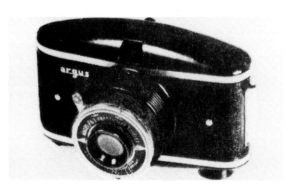

**(874) ARGUS MODEL "M" CAMERA.** C. 1940. SIZE 1 X 1½ INCH OR 1 X ¾ INCH EXPOSURES ON NO. 828 ROLL FILM. F 6.3 ARGUS TRIPLET ANASTIGMAT LENS. BETWEEN-THE-LENS SHUTTER FOR INSTANT AND BULB EXPOSURES.

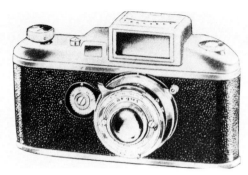

**(875) ARGUS "COLOR CAMERA."** C. 1940. SIZE 24 X 36 MM EXPOSURES ON "35MM" ROLL FILM. F 4 TRIPLE ANASTIGMAT LENS. SHUTTER SPEEDS; ⅟₂₅ TO ⅟₅₀₀ SEC., B., T. PHOTOELECTRIC EXPOSURE METER. HELICAL FOCUSING.

## IRWIN CORPORATION

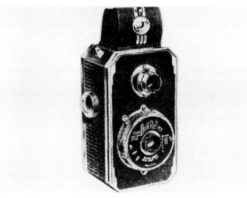

**(876) DUAL REFLEX CAMERA.** TWIN LENS REFLEX. C. 1940. SIZE 1⅝ X 1¼ INCH EXPOSURES ON NO. 127 OR A-8 ROLL FILM. 50 MM EYVAR INSTANT AND TIME SHUTTER.

**(877) KANDOR CAMERA.** C. 1940. SIZE 1⅝ X 1¼ INCH EXPOSURES ON NO. 127 ROLL FILM. 50 MM MENISCUS LENS. INSTANT AND TIME SHUTTER.

**(878) KANDOR KOMET CAMERA.** C. 1940. SIZE 1⅝ X 1¼ INCH EXPOSURES ON NO. 127 OR A-8 ROLL FILM. SAME AS THE IRWIN KANDOR CAMERA BUT WITH THREE APERTURE STOPS.

**(879) LARK CAMERA.** C. 1940. SIZE 1⅝ X 1¼ INCH EXPOSURES ON NO. 127 OR A-8 ROLL FILM. F 7.7

SPEVAR ACHROMATIC LENS. INSTANT AND TIME SHUTTER. FOUR APERTURE STOPS.

**(880) ROYAL DELUXE CAMERA.** C. 1940. SIZE 1⅝ X 1¼ INCH EXPOSURES ON NO. 127 OR A-8 ROLL FILM. 50 MM/F 7.7 SPEVAR LENS. INSTANT AND TIME SHUTTER. FOUR APERTURE STOPS.

**(881) SUPER-TRI REFLEX CAMERA.** TWIN LENS REFLEX. C. 1940. SIZE 1⅝ X 1¼ INCH EXPOSURES ON NO. 127 OR A-8 ROLL FILM. F 3.5 OR F 4.5 ANASTIGMAT LENS. SHUTTER SPEEDS; ⅟₂₅ TO ⅟₂₀₀ SEC., B., T.

## JURNICK, MAX

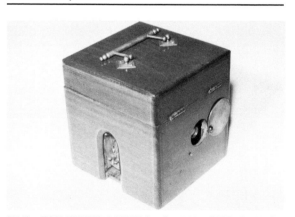

**(882) TOM THUMB CAMERA.** C. 1889. SIZE 2⁷⁄₁₆ X 2⁷⁄₁₆ INCH EXPOSURES ON DRY PLATES. 55 MM/F 11 PERISCOPIC LENS. HEMISPHERICAL GUILLOTINE SHUTTER FOR VARIABLE SPEED OR TIME EXPOSURES. LEVER FOR COCKING THE SHUTTER. THE CAMERA WAS USUALLY CARRIED AND USED IN A WOODEN CARRYING CASE.

## KELLY PHOTO STOCK HOUSE

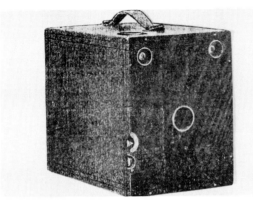

(883) **KELLY'S SPECIAL BOX CAMERA.** C. 1904. SIZE 4 X 5 INCH EXPOSURES ON PLATES OR FILM PACKS WITH ADAPTER. MENISCUS LENS. INSTANT AND TIME SHUTTER.

## KEMPER, ALFRED C.

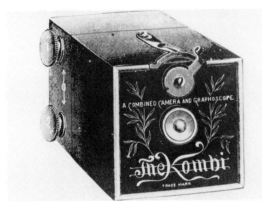

(884) **KOMBI BOX CAMERA.** C. 1893–95. SIZE 1⅛ X 1⅛ INCH SQUARE OR 1⅛ INCH DIAMETER EXPOSURES ON ROLL FILM. BICONVEX SINGLE ELEMENT LENS. NON-CAPPING SECTOR SHUTTER; INSTANT AND TIME EXPOSURES. COCKING-TYPE SHUTTER. MAGAZINE ROLL FILM HOLDER. THE FIRST MINIATURE CAMERA TO USE ROLL FILM. A POSITIVE FILM STRIP MADE FROM THE NEGATIVE COULD BE VIEWED THROUGH THE CAMERA LENS.

## KOMBI CAMERA COMPANY

(885) **KOMBI CAMERA.** C. 1896. SIZE 1⅛ × 1⅛ INCH EXPOSURES OR 1⅛ INCH DIAMETER EXPOSURES ON ROLL FILM. SAME AS THE KOMBI CAMERA MANUFACTURED BY ALFRED C. KEMPER IN 1893–95. SEE PHOTO UNDER ALFRED C. KEMPER CAMERAS.

## KOOPMAN, E. B.

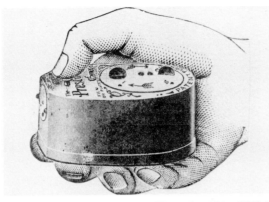

(886) **POCKET PRESTO CAMERA.** C. 1896. SIZE 1¼ X 1¼ INCH EXPOSURES ON PLATES OR ROLL FILM. A MAXIMUM OF FIFTY EXPOSURES ON ONE ROLL OF FILM. MENISCUS LENS. ROTATING APERTURE STOPS. SINGLE SPEED SHUTTER WHICH IS COCKED BY TURNING THE CAMERA UPSIDE DOWN.

## KOZY CAMERA COMPANY

(887) **BEDFORD BOX CAMERA.** C. 1901. SIZE 3½ X 3½ INCH EXPOSURES.

(888) **CHASE MAGAZINE BOX CAMERA.** C. 1900. SIZE 3¼ X 4¼ INCH PLATE EXPOSURES. SIMPLE LENS. INSTANT AND TIME SHUTTER. RACK & PINION OPERATED MAGAZINE. (MA)

(889) **KOZY POCKET CAMERA. ORIGINAL MODEL.** C. 1895. SIZE 3½ X 3½ INCH EXPOSURES ON ROLL FILM. MENISCUS LENS. SINGLE SPEED SHUTTER. A FRONT METAL PLATE HOUSES THE SHUTTER AND DIAPHRAGM CONTROLS. THE CAMERA SIZE (CLOSED) IS 2 X 5 X 6 INCHES.

(890) **KOZY POCKET CAMERA.** C. 1898–1901. SIZE 3½ X 3½ INCH EXPOSURES ON ROLL FILM. 12 EXPOSURES ON EACH ROLL OF FILM. 5-INCH/F 20 SIMPLE MENISCUS LENS. SCISSORS-TYPE SHUTTER FOR SINGLE SPEED OR TIME EXPOSURES. THIS MODEL IS SLIGHTLY SMALLER (SIZE 1⅞ X 4½ X 5¾ INCHES) THAN THE ORIGINAL MODEL OF 1895 (2 X 5 X 6 INCHES).

(891) **LUX CAMERA.** C. 1901. SIZE 4 X 5 INCH PLATE EXPOSURES.

## LAWRENCE, GEORGE R.

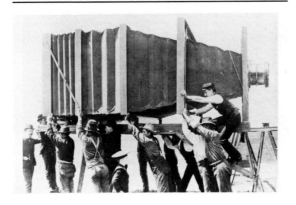

(892) **MAMMOTH CAMERA.** C. 1900. LARGEST PLATE CAMERA EVER BUILT. SIZE 4½ X 8 FOOT EXPOSURE ON A 500-POUND GLASS PLATE. CAMERA WEIGHT; 1400 POUNDS INCLUDING PHOTOGRAHIC PLATE. TEN GALLONS OF CHEMICALS WERE REQUIRED TO DEVELOP THE PLATE. THE CAMERA WAS DESIGNED AND BUILT FOR THE CHICAGO AND ALTON RAILROAD COMPANY TO PHOTOGRAPH THEIR NEWEST LUXURY TRAINS. (CH)

## LEWIS, W. & W. H.

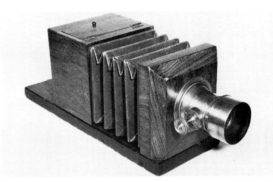

(893) **DAGUERREOTYPE CAMERA.** C. 1851. SIZE 3¼ X 4¼ INCH EXPOSURES ON PLATES. THIS IS THE FIRST CAMERA MADE WITH BELLOWS. 150 MM/F 4 HARRISON DOUBLET LENS. LENS-CAP TYPE SHUTTER. GROUND GLASS FOCUSING. THE TOP REAR SECTION OF THE CAMERA OPENS FOR INSERTING AND REMOVING PLATES. (GE)

## LITTLEWOOD COMPANY

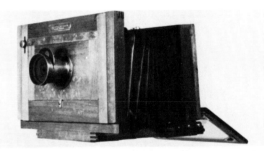

(894) **NEW MODEL VIEW CAMERA.** SIZE 5 x 8 INCH EXPOSURE ON PLATES. IMPROVED VERSION TAILBOARD CAMERA. ROCHESTER OPTICAL COMPANY LENS. WATERHOUSE STOPS. (VC)

## MAGIC INTRODUCTION COMPANY

(895) **PHOTORET CAMERA.** C. 1894. SIZE 13 X 13 MM EXPOSURES ON A 1¾ INCH DIAMETER SHEET OF CELLULOID FILM. SIX EXPOSURES ON EACH FILM SHEET. MENISCUS LENS. SINGLE SPEED SECTOR-TYPE SHUTTER WITH TIME EXPOSURES. THE SHUTTER IS COCKED BY SHIFTING THE "RING" AND "STEM" AND IS RELEASED BY PRESSING THE "WINDING KNOB." THE BACK OF THE CAMERA IS ROTATED 60-DEGREES TO ADVANCE THE FILM DISC.

## MANHATTEN OPTICAL COMPANY

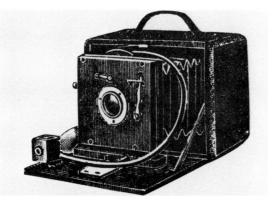

**(896) BO-PEEP PLATE CAMERA.** C. 1894. TWO SIZES OF THIS CAMERA FOR 4 X 5 OR 5 X 7 INCH EXPOSURES ON PLATES. ANASTIGMAT LENS. INSTANT AND TIME SHUTTER. RISING AND FALLING LENS BOARD. SWING BACK. GROUND GLASS FOCUSING.

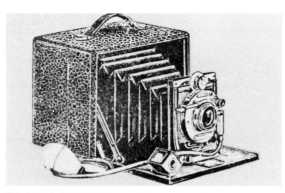

**(897) BO-PEEP B PLATE CAMERA.** C. 1896. SIZE 4 X 5 INCH PLATE EXPOSURES. ANASTIGMAT LENS. INSTANT AND TIME SHUTTER.

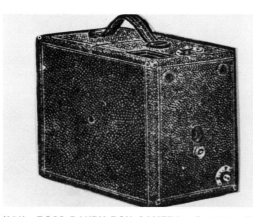

**(898) BOSS DANDY BOX CAMERA.** C. 1896. SIZE 4 X 5 INCH EXPOSURES.

**(899) WIZARD A CAMERA.** C. 1899. SIZE 4 X 5 INCH EXPOSURES. RAPID ACHROMATIC LENS. WIZARD AUTO SHUTTER.

**(900) NIGHT-HAWK BOX CAMERA.** C. 1892. SIZE 4 X 5 INCH EXPOSURES ON PLATES. RAPID ACHROMATIC LENS. INSTANT AND TIME SHUTTER. GROUND GLASS FOCUSING AND FOCUSING DIAL ON THE OUTSIDE OF THE CAMERA.

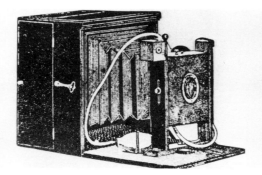

**(901) NIGHT-HAWK FOLDING CAMERA.** C. 1895. TWO SIZES OF THIS CAMERA FOR 4 X 5 OR 5 X 7 INCH PLATE EXPOSURES. RECTILINEAR LENS. REVERSIBLE BACK. SWING BACK. RISING AND FALLING LENS BOARD.

**(902) WIZARD B FOLDING CAMERA.** C. 1898. SIZE 4 X 5 INCH PLATE EXPOSURES. BAUSCH & LOMB UNICUM PNEUMATIC SHUTTER. (MA)

**(903) WIZARD B (IMPROVED) FOLDING CAMERA.** C. 1899. SIZE 4 X 5 INCH PLATE EXPOSURES.

**(904) WIZARD DUPLEX CAMERA.** C. 1904. THE ROLL FILM AND HOLDER CAN BE REMOVED FROM THE FOCAL PLANE AND REPLACED WITH A FOCUSING SCREEN OR PLATE WITHOUT REWINDING THE ROLL FILM.

**(905) WIZARD JUNIOR FOLDING PLATE CAMERA.** C. 1898. SIZE 4 X 5 INCH PLATE EXPOSURES.

**(906) WIZARD SENIOR FOLDING PLATE CAMERA.** C. 1895. SIZE 5 X 7 INCH PLATE EXPOSURES. BAUSCH & LOMB CONVERTIBLE LENS. AUTOMATIC SHUTTER. DOUBLE EXTENSION BELLOWS.

**(907) BABY WIZARD FOLDING PLATE CAMERA.** C. 1896. SIZE 4 X 5 INCH PLATE EXPOSURES.

**(908) CYCLE WIZARD FOLDING PLATE CAMERA.** C. 1898. SIZE 4 X 5 INCH PLATE EXPOSURES.

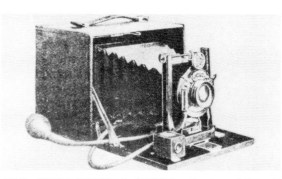

**(909) CYCLE WIZARD A CAMERA.** C. 1899. SIZE 4 X 5 INCH EXPOSURES. RAPID ACHROMATIC LENS.

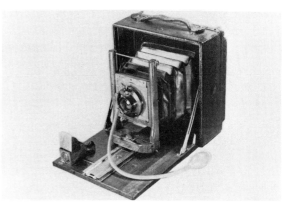

**(910) LONG FOCUS, WIDE ANGLE WIZARD CAMERA.** C. 1895. SIZE 5 X 7 INCH EXPOSURES ON PLATES. DOUBLE EXTENSION BELLOWS. BAUSCH & LOMB RAPID RECTILINEAR LENS. KODAK AUTO SHUTTER FOR INSTANT B., T. EXPOSURES. (HW)

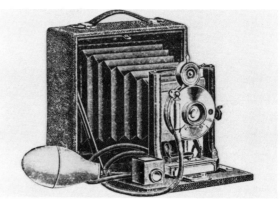

**(911) WEE WIZARD CAMERA.** C. 1898. SIZE 3½ X 3½ INCH EXPOSURES ON PLATES.

**(912) WIDE-ANGLE WIZARD FOLDING PLATE CAMERA.** C. 1896. SIZE 4 X 5 INCH PLATE EXPOSURES.

## MEYER CAMERA & INSTRUMENT COMPANY

(913) **POLYGON CAMERA.** C. 1914. SIZE 2½ X 3½ INCH EXPOSURES. ANASTIGMAT LENS.

## MIROGRAPH CAMERA COMPANY

(914) **MIROGRAPH SINGLE LENS REFLEX CAMERA.** C. 1914. TWO SIZES OF THIS CAMERA FOR 2¼ X 4¼ OR 3¼ X 5½ INCH EXPOSURES ON ROLL FILM. FOCAL PLANE SHUTTER; ⅒ TO ¹⁄₁₀₀₀ SEC.

## MONARCH MANUFACTURING COMPANY

(915) **FLASH-MASTER NO. 110 CAMERA.** C. 1940. SIZE 1⅝ X 1¼ INCH EXPOSURES ON NO. 127 OR A-8 ROLL FILM. SAME AS THE FLASH-MASTER NO. 117 BUT WITH A 50 MM GRAF MENISCUS LENS.

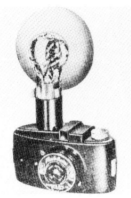

(916) **FLASH-MASTER NO. 117 CAMERA.** C. 1940. SIZE 1⅝ X 1¼ INCH EXOSURES ON NO. 127 OR A-8 ROLL FILM. 50 MM/F 7.7 GRAF ACHROMAT LENS. INSTANT AND TIME SHUTTER. BUILT-IN FLASH SYNCHRONIZATION.

(917) **FLEXMASTER NO. 211 CAMERA.** C. 1940. SIZE 1⅝ X 1¼ INCH EXPOSURES ON NO. 127 OR A-8 ROLL FILM. SAME AS THE FLEXMASTER NO. 248 CAMERA BUT WITH A 50 MM GRAF MENISCUS LENS.

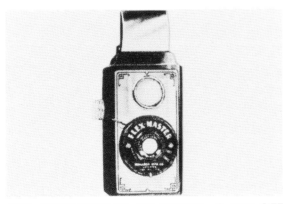

(918) **FLEXMASTER NO. 248 CAMERA.** C. 1940. SIZE 1⅝ X 1¼ INCH EXPOSURES ON NO. 127 OR A-8 ROLL FILM. 50 MM/F 7.7 GRAF ACHROMAT LENS. INSTANT

AND TIME SHUTTER. FIXED FOCUS REFLEX-TYPE VIEWER.

(919) **LINCOLN MODEL 1 CAMERA.** C. 1940. SIZE 1¼ X 1⅝ INCH EXPOSURES ON NO. 127 ROLL FILM. SIMILAR TO THE LINCOLN MODEL 177 CAMERA BUT WITH A 50 MM GRAF MENISCUS LENS.

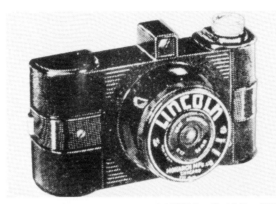

(920) **LINCOLN MODEL 177 CAMERA.** C. 1940. SIZE 1¼ X 1⅝ INCH EXPOSURES ON NO. 127 ROLL FILM. 50 MM/F 7.7 GRAF ACHROMATIC LENS. INSTANT AND TIME SHUTTER. FIXED FOCUS.

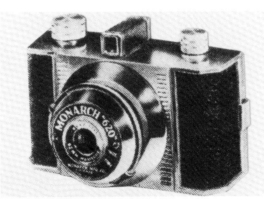

(921) **MONARCH 620 CAMERA.** C. 1940. SIZE 1⅝ X 2¼ INCH EXPOSURES ON NO. 620 OR PB-20 ROLL FILM. 62 MM GRAF MENISCUS LENS. FIXED FOCUS INSTANT AND TIME SHUTTER.

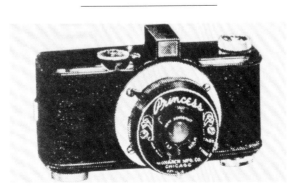

(922) **PRINCESS MODEL 300 CAMERA.** C. 1940. SIZE 1 X 1½ INCH EXPOSURES ON "35MM" ROLL FILM. 50 MM/F 7.7 GRAF ACHROMAT LENS. INSTANT AND TIME SHUTTER. FIXED FOCUS.

## MONROE CAMERA COMPANY

(923) **FOLDING PLATE CAMERA.** C. 1899. FOUR SIZES OF THIS CAMERA FOR 4 X 5, 5 X 7, 6½ X 8½, OR 8 X 10 INCH PLATE EXPOSURES.

(924) **MONROE NO. 4C CAMERA.** C. 1899. SIZE 4 X 5 INCH PLATE EXPOSURES. GROUND GLASS FOCUSING. SINGLE ACHROMATIC LENS. ROYAL SHUTTER.

(925) **MONROE NO. 4D CAMERA.** C. 1899. SAME AS THE NO. 4C CAMERA EXCEPT FOR DOUBLE RAPID RECTILINEAR LENS.

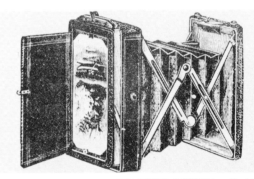

(926) **MONROE NO. 3 "TOURIST" CAMERA.** C. 1899. SIZE 3¼ X 4¼ INCH EXPOSURES ON PLATES OR ROLL FILM. BAUSCH & LOMB SINGLE ACHROMATIC LENS.

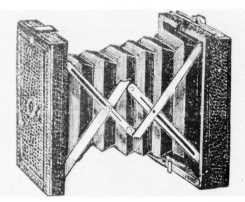

(927) **NO. 1 VEST POCKET CAMERA. ORIGINAL MODEL.** C. 1897. TWO SIZES OF THIS CAMERA FOR 2 X 2½ OR 3½ X 3½ INCH EXPOSURES ON PLATES OR

## MONROE CAMERA COMPANY (*cont.*)

ROLL FILM. F 11 ACHROMATIC MENISCUS LENS. FIXED FOCUS. SELF-CAPPING SECTOR SHUTTER FOR INSTANT AND TIME EXPOSURES. THREE APERTURE STOPS.

(928) **POCKET CAMERA. ORIGINAL MODEL.** C. 1897. SIZE 3½ X 3½ INCH EXPOSURES ON PLATES OR ROLL FILM. ACHROMATIC LENS. SIMILAR TO THE NO. 1 VEST POCKET CAMERA OF 1897.

(929) **POCKET CAMERA.** C. 1899. SIZE 2¼ X 3½ INCH EXPOSURES ON PLATES OR ROLL FILM.

## MULTI-SPEED SHUTTER COMPANY

(930) **SIMPLEX MULTI-EXPOSURE CAMERA.** C. 1914. 400 EXPOSURES SIZE 24 X 36 MM OR 800 EXPOSURES SIZE 18 X 24 MM ON "35MM" CINE FILM. 50 MM/F 3.5 TESSAR LENS. COMPOUND 00 SHUTTER; 1 TO 1/300 SEC. (MA)

## MULTISCOPE & FILM COMPANY

(931) **A1-VISTA PANORAMIC CAMERA. MODEL 3B.** C. 1906. SIZE 3½ X 9 INCH (MAXIMUM) EXPOSURES ON ROLL FILM. RAPID RECTILINEAR LENS. AIR-BRAKE VANES FOR VARIOUS SHUTTER SPEEDS. (MA)

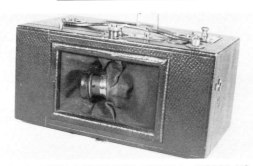

(932) **A1-VISTA PANORAMIC CAMERA. MODEL NO. 4.** C. 1898. SIZE 5 X 12 INCH EXPOSURES ON ROLL FILM. RAPID RECTILINEAR LENS. AIR-BRAKE VANES FOR VARIOUS SHUTTER SPEEDS. (SW)

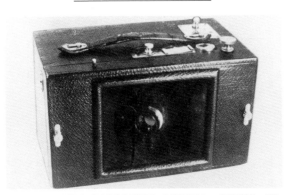

(933) **A1-VISTA PANORAMIC CAMERA. MODEL 4B.** C. 1906. SIZE 4 X 4 INCH (MINIMUM) TO SIZE 4 X 12 INCH (MAXIMUM) EXPOSURES ON ROLL FILM. RAPID

RECTILINEAR LENS. AIR-BRAKE VANES FOR VARIOUS SHUTTER SPEEDS. (HA)

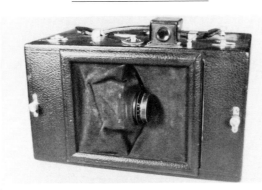

(934) **A1-VISTA PANORAMIC CAMERA. MODEL 5B.** C. 1901. SIZE 5 X 4 (MINIMUM) TO 5 X 12 (MAXIMUM) INCH EXPOSURES ON ROLL FILM. FIVE-SPEED VANES. RAPID RECTILINEAR LENS. (VC)

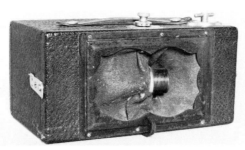

(935) **A1-VISTA BABY PANORAMIC CAMERA.** C. 1906. SIZE 2¼ X 6¾ INCH PANORAMIC EXPOSURES ON ROLL FILM. RAPID RECTILINEAR LENS. (TH)

(936) **TIGER BOX CAMERA.** C. 1895. SIZE 4 X 5 INCH EXPOSURES ON PLATES. FOCUSING BACK.

## MUTSCHLER, ROBERTSON & COMPANY

(937) **QUAD BOX CAMERA.** C. 1896. SIZE 3½ X 3½ INCH EXPOSURES ON PLATES. ACHROMATIC LENS. INSTANT AND TIME SAFETY SHUTTER.

## NATIONAL CINE LABORATORIES

(938) **MAGIC-EYE 35-MM ROLL FILM CAMERA.** C. 1940. 1600 EXPOSURES, SIZE ¾ X 1 INCH ON SPECIAL "35-MM" ROLL FILM. F 3.5 WOLLENSAK ANASTIGMAT LENS. DISC SHUTTER; 1/35 TO 1/4000 SEC. MANUAL FOCUSING.

## NATIONAL PHOTOCOLOR CORPORATION

(939) **COLOR CAMERA. DAYLIGHT FEATHERWEIGHT MODEL.** C. 1940. SIZE 3¼ X 4¼ INCH EXPOSURES ON PLATES, CUT FILM, OR FILM PACKS. F 4.5 GOERZ DOGMAR LENS. COMPOUND SHUTTER; 1 TO 1/100 SEC., B., T. COUPLED RANGEFINDER. COUPLED VIEW FINDER. SIMILAR TO THE COLOR CAMERA, DAYLIGHT MODEL.

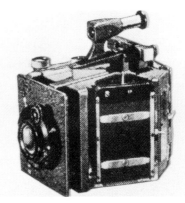

(940) **COLOR CAMERA.** C. 1940. SIZE 2¼ X 3¼ INCH EXPOSURES ON DEFENDER TRI-COLOR FILM. F 4.5 COLOR CORRECTED LENS. SINGLE EXTENSION BELLOWS. COUPLED RANGEFINDER. COUPLED VIEW FINDER.

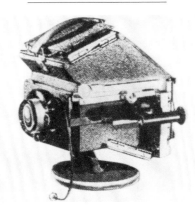

(941) **COLOR CAMERA. DAYLIGHT MODEL.** C. 1940. SIZE 3¼ X 4¼ INCH EXPOSURES ON TRI-COLOR PLATES, CUT FILM, OR FILM PACKS. F 4.5 GOERZ DOGMAR LENS. COMPOUND SHUTTER; 1 TO 1/100 SEC., B., T. SINGLE EXTENSION BELLOWS. COUPLED RANGEFINDER. BALANCED FOR 5400-DEGREE K EXPOSURES.

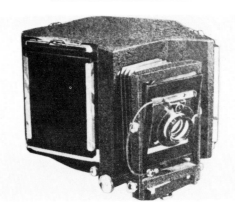

(942) **COLOR CAMERA. STUDIO DELUXE MODEL.** C. 1940. SIZE 5 X 7 INCH EXPOSURES ON CUT FILM OR PLATES. F 9 HUGO MEYER OR GOERZ LENS. COMPOUND SHUTTER; 1 TO 1/100 SEC., B., T. SWING BACK. RISING AND FALLING LENS MOUNT. SINGLE EXTENSION BELLOWS.

## NATIONAL PHOTOCOLOR CORPORATION (*cont.*)

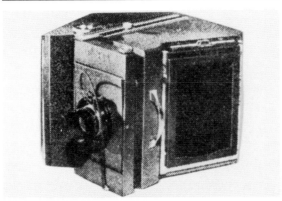

(943) **COLOR CAMERA. TUNGSTON MODEL.** C. 1940. SIZE 3¼ X 4¼ INCH EXPOSURES ON TRI-COLOR PLATES, CUT FILM, OR FILM PACKS. SAME LENS AND SHUTTER AS THE COLOR CAMERA, DAYLIGHT MODEL. BALANCED FOR 3200-DEGREE K EXPOSURES.

## NEW IDEAS MANUFACTURING COMPANY

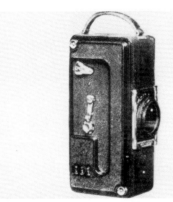

(944) **TOURIST MULTIPLE CAMERA.** C. 1913. SIZE 18 X 24 MM EXPOSURES ON "35MM" ROLL FILM. THE CAMERA TAKES 750 EXPOSURES ON A 50-FOOT FILM ROLL. 50 MM/F 3.5 BAUSCH & LOMB ZEISS TESSAR LENS. VERTICAL-DROP TYPE FOCAL PLANE SHUTTER; ⅟40 TO ⅟200 SEC., B. THE FIRST AMERICAN STILL CAMERA TO USE "35MM" ROLL FILM. ABOUT 1000 CAMERAS WERE MADE.

## NEW YORK FERROTYPE COMPANY

(945) **PROFESSIONAL TINTYPE CAMERA.** C. 1906. THREE-SECTION PLATE HOLDER HOLDS "POSTCARD" SIZE, 1½ X 2½ INCH TINTYPE, OR QUARTER PLATE TINTYPES. TWO-SPEED WOLLENSAK SHUTTER.

## NIAGARA CAMERA COMPANY

(946) **NIAGARA JUNIOR SNAP-SHOT BOX CAMERA.** C. 1905. SIZE 2½ X 2½ INCH EXPOSURES ON PLATES. SINGLE LENS. INSTANT AND TIME SHUTTER.

(947) **NIAGARA NO. 2 CAMERA.** C. 1899. SIZE 3½ X 3½ INCH PLATE EXPOSURES. ACHROMATIC LENS. AUTOMATIC SAFETY SHUTTER; INSTANT AND TIME.

## NORTHERN PHOTO SUPPLY COMPANY

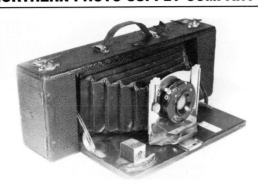

(948) **BELL PANORAMA AND PANEL CAMERA.** C. 1914. FIVE EXPOSURES SIZE 3¼ X 11 INCHES OR TEN EXPOSURES SIZE 3¼ X 5½ INCHES ON NO. 122 ROLL FILM. 150 MM/F 9.5 VELOSTIGMAT OR F 12 ANASTIGMAT LENS. WOLLENSAK REGNO SHUTTER; 1 TO ⅟100 SEC. OR WOLLENSAK VICTO SHUTTER; ⅟10 TO ⅟100 SEC., B., T. IRIS DIAPHRAGM. CLOTH PANELS INSIDE OF THE CAMERA CAN BE PIVOTED TO ALLOW FOR THE SMALL OR LARGE SIZE EXPOSURES. (SW)

(949) **NO. 10 BELL PANORAMA AND PANEL CAMERA.** C. 1914. SIX EXPOSURES SIZE 3¼ X 8½ INCHES OR 12 EXPOSURES SIZE 3¼ X 4¼ INCHES ON NO. 120 ROLL FILM. THE PANORAMIC EXPOSURE COVERS A 90-DEGREE ANGLE.

(950) **BELL STRAIGHT-WORKING PANORAMA CAMERA.** C. 1912. SIZE 3½ X 11 INCH EXPOSURES ON ROLL FILM. SYMMETRICAL LENS. WOLLENSAK JUNIOR SHUTTER. (MA)

(951) **QUEEN CITY PANORAMIC CAMERA.** C. 1912. SIZE 3½ X 12 INCH EXPOSURES ON ROLL FILM. 140-DEGREE PANORAMIC EXPOSURES. FOUR AIR-BRAKE VANES FOR SPEEDS OF ⅟6, ⅟12, ⅟25, OR ⅟50 SEC. THIS CAMERA WAS ALSO SOLD AS THE CONLEY PANORAMIC CAMERA BY SEARS, ROEBUCK COMPANY.

## PDQ CAMERA COMPANY

(952) **MANDEL AUTOMATIC PDQ CAMERA.** C. 1935. SIZE 2¼ X 3¼ INCH EXPOSURES ON AUTOPOSITIVE PAPERS. 135 MM/F 6 WOLLENSAK RAPID RECTILINEAR LENS. THE EXPOSURES ARE DEVELOPED AND FIXED IN CHEMICAL TRAYS CONTAINED INSIDE OF THE CAMERA. (MA)

## PAL-KO INCORPORATED

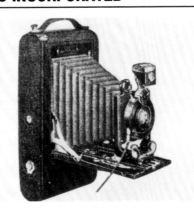

(953) **PALKO ROLL FILM CAMERA.** C. 1926–33. SIZE 3¼ X 5½ INCH (ALSO 3¼ X 3⅝ OR 3¼ X 1¾ INCH) EXPOSURES ON NO. 122 ROLL FILM. F 4.5 ZEISS TESSAR, F 6.3 ILEX ANASTIGMAT, OR F 4.5 PALKO ANASTIGMAT LENS. ACME OR UNIVERSAL SHUTTER. GROUND GLASS FOCUSING. EXPOSURE COUNTER. THE ROLL FILM AND SPOOLS ARE HELD IN THE BOTTOM SECTION OF THE CAMERA WHEN THE BACK OF THE CAMERA IS OPENED TO VIEW THE GROUND GLASS SCREEN. WHEN THE BACK IS CLOSED, A ROD IS PULLED UP WHICH UNROLLS A SECTION OF FILM IN THE FOCAL PLANE. THE DISTANCE THE ROD IS PULLED UP DETERMINES WHICH OF THE THREE SIZES WILL BE EXPOSED.

## PEARSALL, G. FRANK E.

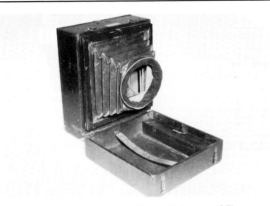

(954) **THE COMPACT CAMERA.** C. 1882. (GE)

(955) **THE NEW COMPACT CAMERA.** C. 1883. SIZE 6½ X 8½ INCH EXPOSURES ON DRY PLATES. THE FRONT PANEL OF THE CAMERA SWINGS DOWN TO ACT AS A SUPPORT FOR THE LENS BOARD. PARALLEL WOODEN TRACKS ON THE BED SERVE AS A GUIDE TO MOVE THE LENS BOARD AND BELLOWS FORWARD. AN ANGLED BRACE ON ONE SIDE SERVES TO SUPPORT THE BED. THIS CAMERA IS ONE OF THE FIRST TO USE THE ABOVE MENTIONED FEATURES THAT WOULD BECOME A STANDARD DESIGN FOR FOLDING CAMERAS. ROLLER-BLIND TYPE FOCUSING SCREEN.

## PELLICLES, INCORPORATED

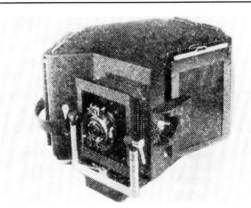

(956) **PELLICLES MODEL 10 COLOR CAMERA.** C. 1940. THE CAMERA USES ILFORD OR WRATTEN TRI-COLOR PLATES. F 9 GOERZ DAGOR LENS. GROUND GLASS FOCUSING.

## PERRY MASON & COMPANY (SOLD BY)

**(957) ARGUS MAGAZINE BOX CAMERA.** C. 1890. SIZE 2½ X 4 INCH EXPOSURES ON PLATES. THE MAGAZINE HOLDS 12 PLATES.

**(958) COMPANION PHOTOGRAPHIC OUTFIT BOX CAMERA.** C. 1887. SIZE 2½ X 4 INCH EXPOSURES ON DRY PLATES. THE CAMERA BODY IS WOOD WITH A SLIDING TOP COVER. (JC)

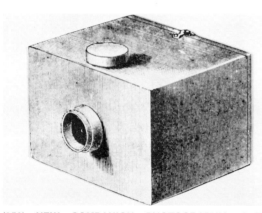

**(959) NEW COMPANION PHOTOGRAPHIC OUTFIT BOX CAMERA.** C. 1887. TWO SIZES OF THIS CAMERA FOR 2½ X 4 OR 4 X 5 INCH EXPOSURES ON DRY PLATES. ACHROMATIC LENS. THE PLATES ARE INSERTED IN THE BACK OF THE CAMERA. METAL BODY. (JC)

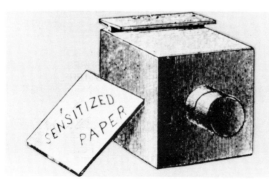

**(960) GEM PHOTOGRAPHIC OUTFIT BOX CAMERA.** C. 1885. THE CAMERA USED DRY PLATES IN A PLATE HOLDER THAT WAS INSERTED IN THE TOP OF THE CAMERA. (JC)

**(961) GEM TIN-TYPE BOX CAMERA.** C. 1891. THE CAMERA HAS SIX LENSES FOR TAKING SIX SIMULTANEOUS EXPOSURES SIZE 2½ X 4 INCHES ON DRY PLATES.

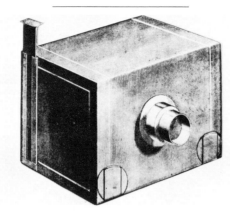

**(962) HARVARD PHOTOGRAPHIC OUTFIT BOX CAMERA.** C. 1888. SIZE 2½ X 4 INCH EXPOSURES ON DRY PLATES. SINGLE MENISCUS LENS. LENS-CAP TYPE SHUTTER. METAL BODY. (JC)

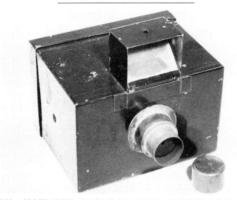

**(963) HARVARD PHOTOGRAPHIC OUTFIT BOX CAMERA.** C. 1890. SIZE 2½ X 4 INCH EXPOSURES ON DRY PLATES. SINGLE MENISCUS LENS. LENS-CAP TYPE SHUTTER. METAL BODY. (GE)

**(964) PHENIX BOX CAMERA.** C. 1891. NEW NAME FOR THE GEM TIN-TYPE BOX CAMERA OF 1891.

**(965) PHOENIX DOLLAR BOX CAMERA.** C. 1892. SIZE 2 X 2½ INCH EXPOSURES ON DRY PLATES

## PHOTO-MATERIALS COMPANY

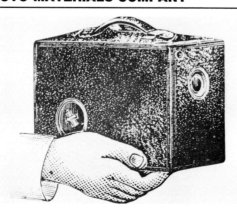

**(966) TROKONET STYLE C BOX CAMERA.** C. 1893. SIZE 4 X 5 INCH EXPOSURES ON PLATES OR SHEET FILM. GUNDLACH DOUBLE RECTILINEAR LENS. VARIABLE SPEED AND TIME SHUTTER. INTERNAL BELLOWS WITH RACK & PINION FOCUSING. EXPOSURE COUNTER.

**(967) TROKONET STYLE D BOX CAMERA.** C. 1893. SIZE 4 X 5 INCH EXPOSURES ON PLATES OR SHEET FILM. SAME AS THE TROKONET STYLE C BOX CAMERA BUT WITH GUNDLACH SINGLE RECTILINEAR LENS.

## PHOTO SEE CORPORATION

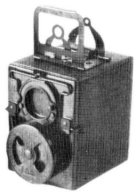

**(968) PHOTO SEE CAMERA.** MODEL 100A. C. 1936. SIZE 1¾ X 2¾ INCH EXPOSURES ON REVERSAL-PAPER SHEETS. A SEPARATE TANK WAS PROVIDED WITH THE CAMERA FOR DEVELOPING THE EXPOSED SHEETS. THE SHEETS WERE CONTAINED IN LIGHT-TIGHT PACKETS FOR TRANSFERRING TO THE DEVELOPING TANK IN DAYLIGHT. FOUR SOLUTIONS WITH RINSES IN BETWEEN WERE POURED INTO THE TANK TO SERVE AS DEVELOPER, BLEACHER, CLEANER, AND TONER. (HA)

## PHOTO UTILITIES INCORPORATED

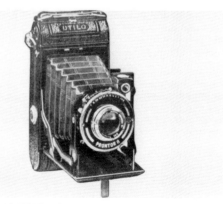

**(969) UTILIO FOLDING ROLL FILM CAMERA.** C. 1940. SIZE 2¼ X 3¼ INCH EXPOSURES ON ROLL FILM. 100 MM/F 4.5 MEYER TRIOPLAN LENS. VARIO SHUTTER; ⅟₂₅ TO ⅟₁₀₀ SEC., B., T. OR PRONTOR II SHUTTER; 1 TO ⅟₁₅₀ SEC., B., T., ST. HELICAL FOCUSING.

## PLUMBE, JOHN

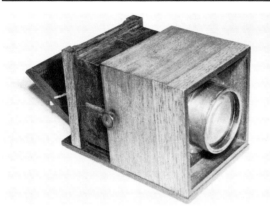

(970) **DAGUERREOTYPE CAMERA.** C. 1841. SIZE 2¾ X 3¼ INCH DAGUERREOTYPE PLATE EXPOSURES. LENS-CAP TYPE SHUTTER. SLIDING BOX AND GROUND GLASS FOCUSING. A MIRROR IS POSITIONED BEHIND THE GROUND GLASS AT A 45-DEGREE ANGLE. (GE)

## POPULAR PHOTOGRAPH COMPANY

(971) **NO DARK TINTYPE CAMERA.** C. 1899. SIZE 2½ X 3½ INCH EXPOSURES ON TINTYPE PLATES. THE CAMERA'S MAGAZINE HOLDS 26 PLATES. 5 INCH/F 10 SINGLE MENISCUS LENS. SECTOR SHUTTER FOR BULB-SPEED EXPOSURES. A KNOB ON THE CAMERA IS TURNED TO MOVE THE PLATES INTO THE FOCAL PLANE. AFTER EXPOSURE, THE PLATE IS DROPPED INTO A TANK IN THE BOTTOM OF THE CAMERA FOR DEVELOPING AND FIXING. (GE)

## PROFESSIONAL CAMERA MANUFACTURING COMPANY

(972) **PROFESSIONAL COLOR CAMERA.** C. 1940. TWO SIZES OF THIS CAMERA FOR 4 X 5 OR 5 X 7 INCH EXPOSURES ON PLATES. F 6.3 BAUSCH & LOMB AN-

ASTIGMAT LENS. RACK & PINION FOCUSING. SWING FRONT.

## PROSCH MANUFACTURING COMPANY

(973) **IDEAL VIEW CAMERA.** C. 1888. SIZE 6½ X 8½ INCH EXPOSURES. WATERHOUSE STOPS. TRIPLEX SHUTTER.

## PUTMAN, E.

(974) **MARVEL PLATE CAMERA.** C. 1900. SIZE 5 X 8 INCH EXPOSURES ON PLATES. SCOVILL WATERBURY LENS. (MR)

(975) **MARVEL STUDIO CAMERA.** C. 1880. SIZE 5 X 7 INCH EXPOSURES ON PLATES. (TH)

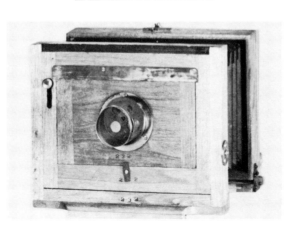

(976) **VIEW CAMERA.** C. 1870. SIZE 5 X 7 INCH EXPOSURES. WATERBURY LENS. WATERHOUSE STOPS. (JW)

## QRS DE VRY CORPORATION

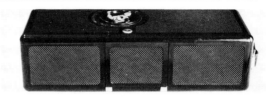

(977) **QRS DE VRY 35MM STILL CAMERA.** C. 1928. THE CAMERA TAKES 40 EXPOSURES, SIZE 24 X 32 MM ON SPECIAL 35MM ROLL FILM IN CASSETTES. F 7.7 OR F 5 VELOSTIGMAT LENS. SINGLE-SPEED, LEAF-TYPE SHUTTER. BAKELITE BODY. (CT)

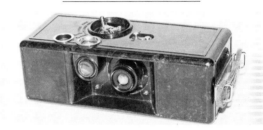

(978) **QRS DE VRY 35MM STILL CAMERA.** C. 1930. THE CAMERA TAKES 40 EXPOSURES, SIZE 24 X 32 MM ON SPECIAL 35MM ROLL FILM. 40 MM/F 7.7. GRAF ANASTIGMAT LENS. SINGLE-SPEED SHUTTER. (DG)

## QUEEN, J. W. & COMPANY

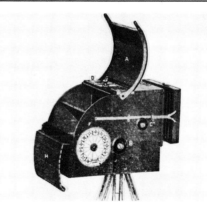

(979) **ACME CAMERA AND CHANGING BOX.** C. 1880. SIZE 3¼ X 4¼ INCH PLATE EXPOSURES. GROUND GLASS FOCUSING. ADDITIONAL SHUTTERS FOR MAKING 2⅛ X 3¼ OR 1⅝ X 2⅛ INCH PLATE EXPOSURES.

(980) **ACME CAMERA AND CHANGING BOX.** C. 1880. SIZE 4 X 5 INCH PLATE EXPOSURES. GROUND GLASS FOCUSING. ADDITIONAL SHUTTERS FOR MAKING 2½ X 4 AND 2 X 2½ INCH PLATE EXPOSURES.

(981) **ACME CAMERA AND CHANGING BOX.** C. 1880. SIZE 5 X 7 INCH PLATE EXPOSURES. GROUND GLASS FOCUSING. ADDITIONAL SHUTTERS FOR MAKING 2½ X 3½ OR 3½ X 5 INCH PLATE EXPOSURES.

## QUEEN, J. W. & COMPANY (cont.)

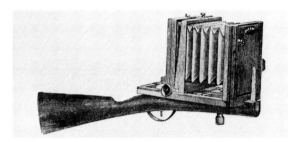

**(982)  KILBURN GUN CAMERA.** C. 1886. SIZE 4 X 5 INCH PLATE EXPOSURES.

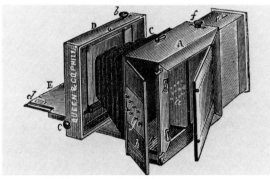

**(983)  LE TOURISTE CAMERA.** C. 1886. SIZE 5 X 7 INCH PLATE EXPOSURES. MOVEABLE GROUND GLASS FOR FOCUSING. EACH OF EIGHT PLATES CAN BE MOVED FROM A GENERAL PLATE HOLDER INTO POSITION FOR EXPOSURE.

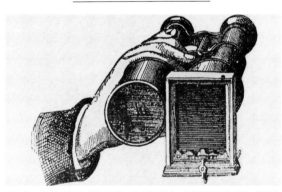

**(984)  MARINE GLASS CAMERA (BINOCULAR CAMERA).** C. 1886. THE INSTRUMENT CAN BE USED AS A BINOCULAR OR PLATE CAMERA. THE EYEPIECE LENSES CAN BE REPLACED WITH PHOTOGRAPHIC LENSES AND SHUTTER. THE OBJECTIVE LENSES CAN BE REPLACED WITH A FILM PLATE HOLDER AND A FOCUSING GROUND GLASS.

**(985)  PEERLESS DETECTIVE CAMERA.** C. 1886. TWO SIZES OF THIS CAMERA FOR 3¼ X 4¼ OR 4 X 5 INCH EXPOSURES ON ROLL FILM OR PLATES. FRANCAIS RAPID RECTILINEAR LENS.

**(986)  TOURISTS' POCKET CAMERA.** C. 1886. TWO SIZES OF THIS CAMERA FOR 4 X 5 OR 5 X 8 INCH DRY PLATE EXPOSURES.

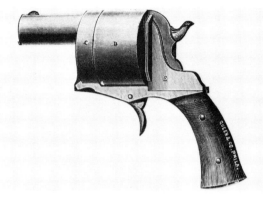

**(987)  PHOTO REVOLVER CAMERA.** C. 1886. SIZE 1⅝ X 1⅝ INCH PLATE EXPOSURES. THE CAMERA HOLDS NINE PLATES. THE TRIGGER ACTIVATES THE INSTANT SHUTTER.

## QUTA CAMERA COMPANY

**(988)  QUTA PHOTO MACHINE CAMERA. ORIGINAL MODEL.** C. 1904. SIZE 2 X 2½ INCH EXPOSURES ON FERROTYPE PLATES. SIMILAR TO THE IMPROVED MODEL OF 1906 EXCEPT FOR A FLAP-TYPE SHUTTER AND SLIGHTLY DIFFERENT EXTERIOR FILLINGS.

**(989)  QUTA PHOTO MACHINE CAMERA. IMPROVED MODEL.** C. 1906. SIZE 2 X 2½ INCH EXPOSURES ON FERROTYPE PLATES. 4 INCH/F 4.5 PETZVAL LENS. TWO-LEAF SCISSORS-TYPE SHUTTER: ½₅ TO ¹⁄₁₀₀ SEC., B., T. THE CAMERA'S MAGAZINE HOLDS 36 PLATES. AFTER A PLATE IS EXPOSED, IT IS TRANSPORTED TO CHEMICAL HOLDING TANKS IN THE BOTTOM OF THE CAMERA FOR DEVELOPING AND FIXING.

**(990)  TAQUAT FERROTYPE CAMERA.** C. 1905. THIS BOX-FORM CAMERA HAS A LOWER COMPARTMENT FOR HOLDING CHEMICAL CONTAINERS FOR DEVELOPING AND FIXING THE EXPOSED PLATES. THE CAMERA WAS SOLD BY JONATHAN FALLOWFIELD. (BC)

## RAY CAMERA COMPANY

**(991)  BOX CAMERA.** C. 1900. SIZE 3½ X 3½ INCH GLASS PLATE EXPOSURES.

**(992)  FOLDING PLATE CAMERA.** C. 1900. SIZE 4 X 5 INCH PLATE EXPOSURES. BAUSCH & LOMB OR WOLLENSAK LENS. CYKO, UNICUM, OR RAY SHUTTER.

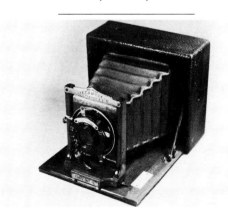

**(993)  RAY NO. 1 FOLDING CAMERA.** C. 1900. SIZE 4 X 5 INCH EXPOSURES. F 8 LENS. RAY SHUTTER; ⅕ TO ¹⁄₁₀₀ SEC. OR INSTANT AND TIME SHUTTER. (DJ)

**(994)  RAY JUNIOR CAMERA.** C. 1897. SIZE 2½ X 2½ INCH PLATE EXPOSURES.

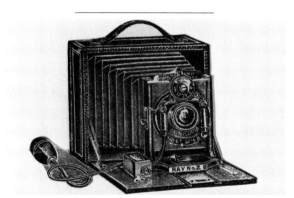

**(995)  RAY PLATE CAMERA.** C. 1896. SIZE 3¼ X 4¼ INCH EXPOSURES ON PLATES. JUNIOR SHUTTER. (HA)

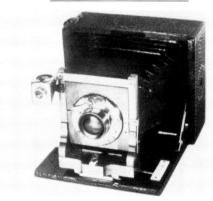

**(996)  RAY SERIES 1, STYLE 2 CYCLE FOLDING CAMERA.** C. 1900. SIZE 4 X 5 INCH EXPOSURES ON PLATES OR FILM PACKS. DOUBLE RAPID SYMMETRICAL LENS. INSTANT AND TIME SHUTTER.

## REFLEX CAMERA COMPANY

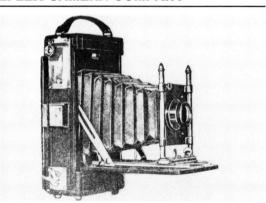

**(997)  FOCAL PLANE POSTCARD CAMERA.** C. 1912. SIZE 3¼ X 5½ INCH EXPOSURES ON PLATES OR FILM PACK. 6½ INCH/F 6.3 RAPID SYMMETRICAL LENS OR COOKE ANASTIGMAT LENS. VICTOR FOCAL PLANE SHUTTER; ⅕ TO ¹⁄₁₀₀₀ SEC., TIME.

## REFLEX CAMERA COMPANY (*cont.*)

(998) **JUNIOR REFLEX CAMERA.** C. 1905–12. SINGLE LENS REFLEX BOX CAMERA. SIZE 3¼ X 4¼ INCH EXPOSURES ON PLATES. ACHROMATIC MENISCUS LENS. SHUTTER SPEEDS FROM ⅒ TO ⅟₁₀₀ SEC. (MA)

(999) **NEW MODEL REFLEX HAND CAMERA.** C. 1908. SINGLE LENS REFLEX. TWO SIZES OF THIS CAMERA FOR 4 X 5 OR 5 X 7 INCH EXPOSURES ON PLATES OR ROLL FILM. REVERSIBLE BACK. FOCAL PLANE SHUTTER; 3 TO ⅟₁₈₀₀ SEC.

(1000) **PATENT REFLEX HAND CAMERA.** C. 1898. TWO SIZES OF THIS CAMERA FOR 4 X 5 OR 5 X 7 INCH PLATE EXPOSURES. F 16 ANASTIGMAT LENS. VARIABLE-SPEED FOCAL PLANE SHUTTER. INTERNAL BELLOWS. (MA)

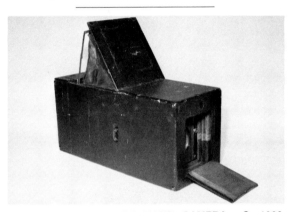

(1001) **PATENT REFLEX HAND CAMERA.** C. 1899. SIZE 4 X 5 INCH EXPOSURES ON PLATES. RAPID RECTILINEAR LENS. NON-SELF-CAPPING CLOTH FOCAL PLANE SHUTTER FOR VARIOUS SPEEDS. INTERNAL BELLOWS. REFLEX FOCUSING OR GROUND GLASS FOCUSING. (GE)

(1002) **PATENT IMPROVED REVERSIBLE BACK REFLEX HAND CAMERA.** C. 1900. THREE SIZES OF THIS CAMERA FOR 4 X 5, 5 X 7, OR 6½ X 8½ INCH EXPOSURES ON PLATES. GOERZ DOUBLE ANASTIGMAT, BAUSCH & LOMB ZEISS CONVERTIBLE, DALLMEYER STIGMAT, VOIGTLANDER COLLINEAR, OR REFLEX RAPID RECTILINEAR LENS. FOCAL PLANE SHUTTER; ½ TO ⅟₁₀₀₀ SEC., T. IRIS DIAPHRAGM. REVERSIBLE BACK. GROUND GLASS FOCUSING. ADAPTER FOR ROLL FILM HOLDER.

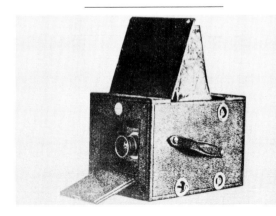

(1003) **REFLEX HAND CAMERA.** C. 1900. THREE SIZES OF THIS CAMERA FOR 4 X 5, 5 X 7, OR 6½ X 8½ INCH PLATE EXPOSURES. RAPID RECTILINEAR LENS. CLOTH FOCAL PLANE SHUTTER WITH VARIABLE SPEEDS. NON-SELF-CAPPING SHUTTER. INTERNAL BELLOWS. OPTIONAL VIEWING ON REAR GROUND GLASS.

(1004) **REFLEX STEREO CAMERA.** C. 1900. SIZE 3¾ X 7 INCH STEREO EXPOSURES ON PLATES.

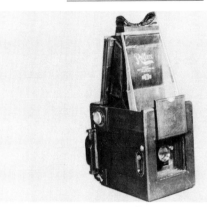

(1005) **SINGLE LENS REFLEX CAMERA.** C. 1910. SIZE 4 X 5 INCH EXPOSURES ON PLATES OR FILM PACKS. 6 INCH/F 4.5 WOLLENSAK VELOSTIGMAT SERIES II LENS. FOCAL PLANE SHUTTER; 1 TO ⅟₁₆₀₀ SEC. THE SHUTTER HAS A FAN DEVICE FOR OBTAINING SLOW SHUTTER SPEEDS FROM 1 TO ⅒ SEC. (RL)

## REICHENBACH, MOREY & WILL COMPANY

(1006) **ALTA-D FOLDING PLATE CAMERA.** C. 1891. TWO SIZES OF THIS CAMERA FOR 4 X 5 OR 5 X 7 INCH PLATE EXPOSURES. BAUSCH & LOMB LENS. UNICUM DOUBLE PNEUMATIC SHUTTER; 1 TO ⅟₁₀₀ SEC., B., T. (HW)

## REPRO ART MACHINERY COMPANY

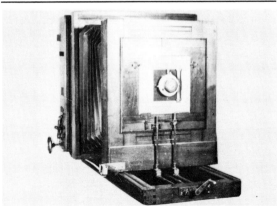

(1007) **LEVY PROCESS VIEW CAMERA.** C. 1905. SIZE 24 X 24 INCH "STICKY BACK" EXPOSURES. (JW)

## REX CAMERA COMPANY

(1008) **REX MAGAZINE CAMERA.** C. 1899. SIZE 4 X 5 INCH EXPOSURES ON PLATES. SIMPLE LENS. SINGLE-SPEED SHUTTER. (MA)

## ROBERTS, JOHN

(1009) **SLIDING-BOX AMERICAN DAGUERROTYPE CAMERA.** C. 1845. SIZE 3¼ X 4¼ INCH EXPOSURES. C. C. HARRISON LENS. LENS-CAP SHUTTER. (SW)

(1010) **SLIDING-BOX TWO-TUBE CAMERA.** C. 1863–68. SIZE 5 X 7 INCH EXPOSURES ON WET-PLATES. 160 MM/ F 3.7 DARLOT LENSES. FLAP SHUTTER. (SW)

(1011) **SLIDING-BOX FOUR-TUBE CAMERA.** C. 1867. SIZE 5 X 7 INCH EXPOSURES ON FERROTYPE WET-PLATES. 160 MM/F 3.7 DARLOT LENSES. FLAP SHUTTER. (MA)

(1012) **SLIDING-BOX SIXTEEN-TUBE CAMERA.** C. 1865. SIXTEEN EXPOSURES SIZE ¾ X 1 INCH ON 3¼ X 4¼ INCH FERROTYPE WET-PLATES. 65 MM/F 4 LENSES. (SW)

## ROCHESTER CAMERA COMPANY

**(1013) ROCAMCO BOX CAMERA.** C. 1936. SIZE 2½ X 3 CM EXPOSURES ON SPECIAL 35MM ROLL FILM. SIMPLE LENS. SIMPLE SHUTTER. (MA)

**(1014) ROCAMCO NO. 3 CAMERA.** C. 1938. SIZE 1¼ X 1¼ INCH EXPOSURES ON SPECIAL 35MM ROLL FILM. SIMPLE LENS. PLASTIC BODY. (MA)

## ROCHESTER CAMERA MANUFACTURING COMPANY

**(1015) POCO CAMERA.** C. 1895. SIZE 4 X 5 INCH EXPOSURES.

**(1016) "THE ROCHESTER CAMERA."** C. 1891–95. TWO SIZES OF THIS CAMERA FOR 4 X 5 OR 5 X 7 INCH EXPOSURES ON PLATES. GUNDLACH RAPID RECTILINEAR OR ROCHESTER SYMMETRICAL LENS. IN-THE-LENS-BOARD SHUTTER. (SW)

## ROCHESTER CAMERA AND SUPPLY COMPANY

**(1017) NO. 4 MAGAZINE CYCLONE BOX CAMERA.** C. 1898. SIZE 3¼ X 4¼ INCH EXPOSURES ON PLATES. THE MAGAZINE HOLDS 12 PLATES. SIMILAR TO THE CYCLONE NO. 4. MAGAZINE BOX CAMERA MANUFACTURED BY THE ROCHESTER OPTICAL AND CAMERA COMPANY (C. 1901).

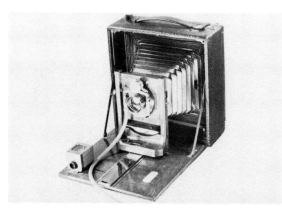

**(1018) CYCLE POCO CAMERA.** C. 1896. THREE SIZES OF THIS CAMERA FOR 3¼ X 4¼, 4 X 5, OR 5 X 7 INCH EXPOSURES ON PLATES OR SHEET FILM. BAUSCH & LOMB RAPID RECTILINEAR LENS. UNICUM PNEUMATIC SHUTTER; 1 TO ¹⁄₁₀₀ SEC., B., T. (HW)

**(1019) NO. 5 MAGAZINE CYCLONE BOX CAMERA.** C. 1898. SIZE 4 X 5 INCH PLATE EXPOSURES. THE MAGAZINE HOLDS 12 PLATES. SIMILAR TO THE CYCLONE NO. 5 MAGAZINE BOX CAMERA MANUFACTURED BY THE ROCHESTER OPTICAL AND CAMERA COMPANY (C. 1901).

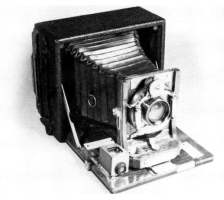

**(1020) CYCLE POCO NO. 1 CAMERA.** C. 1896. SIZE 4 X 5 INCH EXPOSURES ON PLATES. SYMMETRICAL LENS. BAUSCH & LOMB UNICUM SHUTTER. (MR)

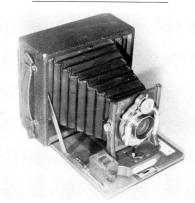

**(1021) CYCLE POCO NO. 3 CAMERA.** C. 1898. TWO SIZES OF THIS CAMERA FOR 3¼ X 4¼ OR 4 X 5 INCH EXPOSURES ON PLATES OR SHEET FILM. F 8 BAUSCH & LOMB RAPID RECTILINEAR LENS. ROCHESTER SHUTTER; 1 TO ¹⁄₁₀₀ SEC. (EB)

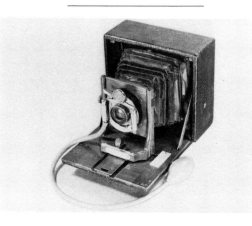

**(1022) CYCLE POCO NO. 4 CAMERA.** C. 1895–98. SIZE 4 X 5 INCH EXPOSURES ON PLATES. BAUSCH & LOMB LENS. KODAK AUTO SHUTTER; 1 TO ¹⁄₁₀₀ SEC., B., T. (HW)

**(1023) CYCLE POCO NO. 2 CAMERA.** C. 1897. TWO SIZES OF THIS CAMERA FOR 4 X 5 OR 5 X 7 INCH EXPOSURES. F 8 SYMMETRICAL OR BAUSCH & LOMB LENS. VICTOR OR UNICUM SHUTTER.

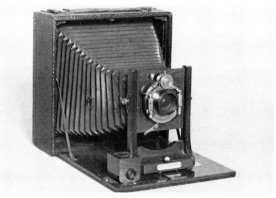

**(1024) CYCLE POCO NO. 5 CAMERA.** C. 1898. SIZE 4 X 5 INCH PLATE EXPOSURES. DOUBLE PNEUMATIC SHUTTER. (TH)

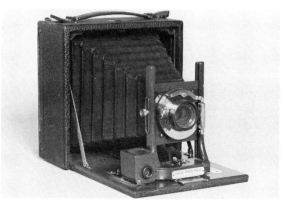

**(1025) CYCLE POCO NO. 6 CAMERA.** C. 1898. SIZE 5 X 7 INCH EXPOSURES. BAUSCH & LOMB RAPID RECTILINEAR LENS. SINGLE PNEUMATIC SHUTTER. (TH)

**(1026) GEM POCO BOX CAMERA.** C. 1897. SIZE 4 X 5 INCH PLATE EXPOSURES.

**(1027) KING POCO CAMERA.** C. 1897. SIZE 5 X 7 INCH PLATE EXPOSURES.

**(1028) NO. 1 POCO CAMERA.** C. 1897. SIZE 5 X 7 INCH EXPOSURES.

**(1029) NO. 5 POCO CAMERA.** C. 1897. SIZE 5 X 7 INCH EXPOSURES.

**(1030) STEREO POCO CAMERA.** C. 1896. SIZE 5 X 7 INCH EXPOSURES. "UNIQUE" STEREO SHUTTER.

## ROCHESTER CAMERA AND SUPPLY COMPANY (*cont.*)

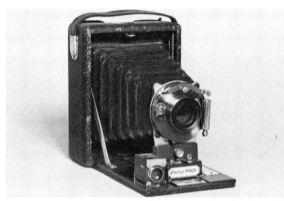

(1031) **POCKET POCO CAMERA.** C. 1898. TWO SIZES OF THIS CAMERA FOR 3¼ X 4¼ OR 3½ X 5 INCH EXPOSURES. BAUSCH & LOMB LENS. (TH)

(1032) **TELEPHOTO CYCLE POCO CAMERA.** C. 1898. SIZE 5 X 7 INCH PLATE EXPOSURES. F 8 SYMMETRICAL LENS. UNICUM SHUTTER, 1 TO ¹⁄₁₀₀ SEC., B., T.

(1033) **TELEPHOTO POCO CAMERA.** C. 1898. SIZE 8 X 10 INCH PLATE EXPOSURES.

(1034) **TELEPHOTO POCO A CAMERA.** C. 1898. SIZE 4 X 5 INCH PLATE EXPOSURES. DOUBLE EXTENSION BELLOWS.

(1035) **TELEPHOTO POCO B CAMERA.** C. 1897. SIZE 5 X 7 INCH EXPOSURES ON PLATES.

(1036) **TELEPHOTO POCO C CAMERA.** C. 1898. SIZE 4 X 5 INCH EXPOSURES.

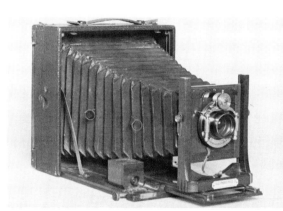

(1037) **TELEPHOTO POCO D CAMERA.** C. 1898. SIZE 5 X 7 INCH EXPOSURES ON PLATES OR SHEET FILM. (TH)

## ROCHESTER OPTICAL AND CAMERA COMPANY

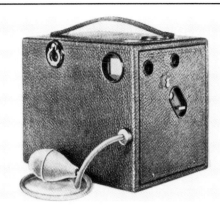

(1038) **CYCLONE NO. 4 MAGAZINE BOX CAMERA.** C. 1901. SIZE 3¼ X 4¼ INCH EXPOSURES ON PLATES. THE MAGAZINE HOLDS 12 PLATES. MENISCUS LENS. PNEUMATIC OR FINGER RELEASE SHUTTER FOR INSTANT AND TIME EXPOSURES.

(1039) **CYCLONE NO. 5 MAGAZINE BOX CAMERA.** C. 1901. SIZE 4 X 5 INCH EXPOSURES ON PLATES. SIMILAR TO THE CYCLONE NO. 4 MODEL WITH THE SAME LENS AND SHUTTER.

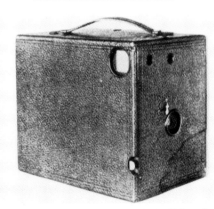

(1040) **CYCLONE JUNIOR BOX CAMERA.** C. 1901. SIZE 3½ X 3½ INCH EXPOSURES ON PLATES. THE CAMERA HOLDS SIX PLATES. MENISCUS LENS. AUTOMATIC SHUTTER FOR INSTANT AND TIME EXPOSURES.

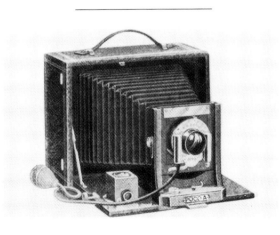

(1041) **POCO SERIES A CAMERA.** C. 1901. FOUR SIZES OF THIS CAMERA FOR 4 X 5, 5 X 7, 6½ X 8½, OR 8 X 10 INCH EXPOSURES ON PLATES OR ROLL FILM. ROCHESTER SYMMETRICAL OR ZEISS ANASTIGMAT SERIES IIA LENS. DOUBLE PNEUMATIC AND FINGER RELEASE AUTO SHUTTER; 1 TO ¹⁄₁₀₀ SEC., B., T. IRIS DIAPHRAGM. DOUBLE SWING BACK. GROUND GLASS FOCUS.

(1042) **CYCLONE SENIOR BOX CAMERA.** C. 1901. SIZE 4 X 5 INCH EXPOSURES ON PLATES. SIMILAR TO THE CYCLONE JUNIOR BOX CAMERA WITH THE SAME LENS AND SHUTTER.

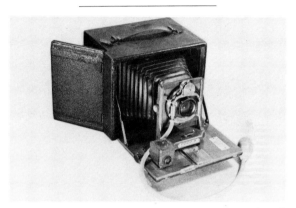

(1043) **POCO SERIES B CAMERA.** C. 1901. TWO SIZES OF THIS CAMERA FOR 4 X 5 OR 5 X 7 INCH EXPOSURES ON PLATES OR ROLL FILM. ROCHESTER SYMMETRICAL LENS. DOUBLE PNEUMATIC AND FINGER RELEASE UNICUM SHUTTER; 1 TO ¹⁄₁₀₀ SEC., B., T. IRIS DIAPHRAGM. SINGLE SWING BACK. GROUND GLASS FOCUS. (HW)

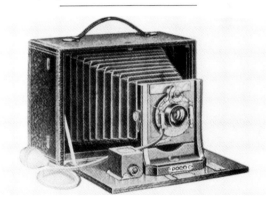

(1044) **POCO SERIES C CAMERA.** C. 1901. TWO SIZES OF THIS CAMERA FOR 4 X 5 OR 5 X 7 INCH PLATE EXPOSURES. RAPID RECTILINEAR LENS. DOUBLE PNEUMATIC AND FINGER RELEASE UNICUM SHUTTER; 1 TO ¹⁄₁₀₀ SEC., B., T. IRIS DIAPHRAGM. SINGLE SWING BACK. GROUND GLASS FOCUS.

(1045) **CYCLE POCO NO. 1 CAMERA.** C. 1899–1901. FOUR SIZES OF THIS CAMERA FOR 4 X 5, 5 X 7, 6½ X 8½, OR 8 X 10 INCH EXPOSURES ON PLATES. ALSO, ROLL FILM HOLDER FOR THE 4 X 5 AND 5 X 7 SIZES. ROCHESTER SYMMETRICAL OR ZEISS ANASTIGMAT SERIES IIA LENS. DOUBLE PNEUMATIC AND FINGER RELEASE AUTO SHUTTER; 1 TO ¹⁄₁₀₀ SEC., B., T. IRIS DIAPHRAGM. DOUBLE SWING BACK. GROUND GLASS FOCUS. SOME MODELS WITH BAUSCH & LOMB UNICUM SHUTTER.

## ROCHESTER OPTICAL AND CAMERA COMPANY (*cont.*)

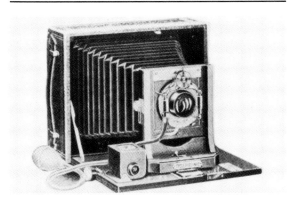

**(1046) CYCLE POCO NO. 2 CAMERA.** C. 1901. TWO SIZES OF THIS CAMERA FOR 4 X 5 OR 5 X 7 INCH PLATE EXPOSURES. ROCHESTER SYMMETRICAL LENS. DOUBLE PNEUMATIC AND FINGER RELEASE UNICUM SHUTTER; 1 TO 1/100 SEC., B., T. IRIS DIAPHRAGM. GROUND GLASS FOCUS.

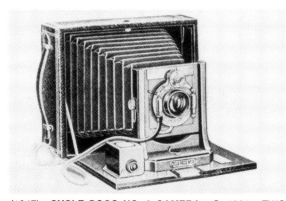

**(1047) CYCLE POCO NO. 3 CAMERA.** C. 1901. TWO SIZES OF THIS CAMERA FOR 4 X 5 OR 5 X 7 INCH PLATE EXPOSURES. RAPID RECTILINEAR LENS. DOUBLE PNEUMATIC AND FINGER RELEASE UNICUM SHUTTER; 1 TO 1/100 SEC., B., T. IRIS DIAPHRAGM. GROUND GLASS FOCUS.

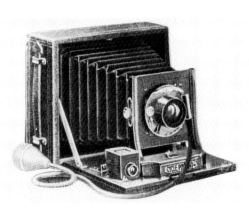

**(1048) CYCLE POCO NO. 4 CAMERA.** C. 1901. TWO SIZES OF THIS CAMERA FOR 4 X 5 OR 5 X 7 INCH PLATE EXPOSURES. RAPID RECTILINEAR OR SINGLE ACHROMATIC LENS. SINGLE PNEUMATIC AND FINGER RE-

LEASE GEM SHUTTER. IRIS DIAPHRAGM. GROUND GLASS FOCUS.

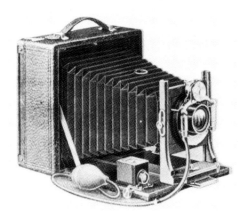

**(1049) CYCLE POCO NO. 5 CAMERA.** C. 1901. TWO SIZES OF THIS CAMERA FOR 4 X 5 OR 5 X 7 INCH PLATE EXPOSURES. RAPID RECTILINEAR LENS. DOUBLE PNEUMATIC AND FINGER RELEASE UNICUM SHUTTER; 1 TO 1/100 SEC., B., T. IRIS DIAPHRAGM. REVERSIBLE BACK. GROUND GLASS FOCUS.

**(1050) KING POCO PRESS/VIEW TYPE CAMERA.** C. 1899. SIZE 4 X 5 INCH EXPOSURES ON PLATES. RAPID RECTILINEAR LENS. VICTOR SHUTTER.

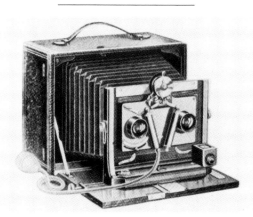

**(1051) STEREO POCO CAMERA.** C. 1901. SIZE 5 X 7 INCH STEREO EXPOSURES ON PLATES. RECTILINEAR LENSES. DOUBLE PNEUMATIC AND FINGER RELEASE BAUSCH & LOMB SHUTTER; 3 TO 1/100 SEC., B., T. OR UNICUM SHUTTER; 1 TO 1/100 SEC., B., T. THE FORMER SHUTTER HAS A ROTARY DIAPHRAGM, THE LATTER HAS AN IRIS DIAPHRAGM. CENTER SWING BACK. GROUND GLASS FOCUS.

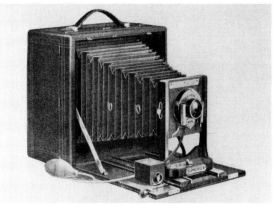

**(1052) TELEPHOTO POCO A CAMERA.** C. 1901. FOUR SIZES OF THIS CAMERA FOR 4 X 5, 5 X 7, 6½ X 8½, OR 8 X 10 INCH PLATE EXPOSURES. ROCHESTER TELE-PHOTO, ZEISS CONVERTIBLE SERIES VII A, GOERZ DOUBLE ANASTIGMAT, OR VOIGTLANDER COLLINEAR LENS. BAUSCH & LOMB DOUBLE PNEUMATIC DIAPHRAGM SHUTTER; 3 TO 1/100 SEC., B., T. OR DOUBLE PNEUMATIC AND FINGER RELEASE AUTO SHUTTER; 1 TO 1/100 SEC., B., T. BOTH SHUTTERS WITH IRIS DIAPHRAGM. REVERSIBLE BACK. DOUBLE SWING BACK. GROUND GLASS FOCUS.

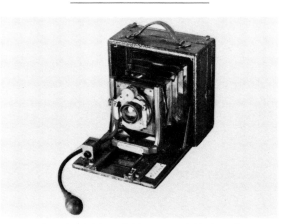

**(1053) TELEPHOTO POCO D CAMERA.** C. 1900. SIZE 4 X 5 INCH EXPOSURES ON PLATES OR SHEET FILM. BAUSCH & LOMB SYMMETRICAL LENS. PNEUMATIC UNICUM SHUTTER TO 1/100 SEC., B., T. (HW)

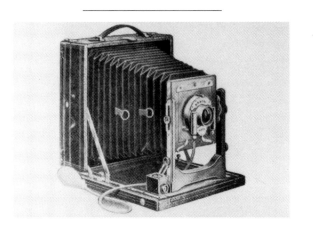

**(1054) TELEPHOTO CYCLE POCO B CAMERA.** C. 1901. FOUR SIZES OF THIS CAMERA FOR 4 X 5, 5 X 7, 6½ X

## ROCHESTER OPTICAL AND CAMERA COMPANY (*cont.*)

8½, OR 8 X 10 INCH PLATE EXPOSURES. TELE-PHOTO THREE-FOCUS, ZEISS ANASTIGMAT SERIES VII A, GOERZ DOUBLE ANASTIGMAT SERIES III, OR VOIGT-LANDER COLLINEAR SERIES II LENS. DOUBLE PNEUMATIC AND FINGER RELEASE AUTO SHUTTER; 1 TO ¹⁄₁₀₀ SEC., B., T. IRIS DIAPHRAGM. REVERSIBLE BACK. DOUBLE SWING BACK. GROUND GLASS FOCUS. SOME MODELS WITH CARTRIDGE ROLL HOLDER. A BAUSCH & LOMB SHUTTER FOR 3 TO ¹⁄₁₀₀ SEC., B., T. EXPOSURES WAS ALSO AVAILABLE FOR THE THREE LARGER SIZE CAMERAS.

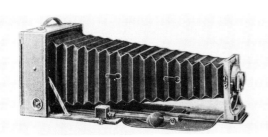

(1055) **TELEPHOTO CYCLE POCO C CAMERA.** C. 1901. FOUR SIZES OF THIS CAMERA FOR 4 X 5, 5 X 7, 6½ X 8½, OR 8 X 10 INCH EXPOSURES ON PLATES. TELE-PHOTO THREE-FOCUS, ZEISS CONVERTIBLE ANASTIG-MAT SERIES VII A, GOERZ DOUBLE ANASTIGMAT SERIES III, OR VOIGTLANDER COLLINEAR SERIES II LENS. DOUBLE PNEUMATIC AND FINGER RE-LEASE AUTO SHUTTER; 1 TO ¹⁄₁₀₀ SEC., B., T. IRIS DIA-PHRAGM. TRIPLE EXTENSION BELLOWS. REVERSI-BLE BACK. SWING BACK. GROUND GLASS FOCUS. ROLL FILM HOLDERS FOR THE 4 X 5 AND 5 X 7 SIZE CAMERAS.

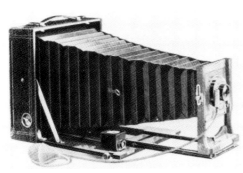

(1056) **TELEPHOTO CYCLE POCO D CAMERA.** C. 1901. FOUR SIZES OF THIS CAMERA FOR 4 X 5, 5 X 7, 6½ X 8½, OR 8 X 10 INCH PLATE EXPOSURES. TELE-PHOTO OR ZEISS ANASTIGMAT SERIES II A LENS. DOUBLE PNEUMATIC AND FINGER RELEASE AUTO SHUTTER; 1 TO ¹⁄₁₀₀ SEC., B., T. IRIS DIAPHRAGM. DOUBLE EXTEN-SION BELLOWS. REVERSIBLE BACK. SWING BACK. GROUND GLASS FOCUS. ROLL FILM HOLDERS FOR THE 4 X 5 AND 5 X 7 SIZE CAMERAS.

(1057) **PREMO FILM CAMERA.** C. 1903. SIZE 3¼ X 4¼ INCH EXPOSURES ON FILM PACKS. THIS CAMERA IS ONE OF THE FIRST AMERICAN CAMERAS TO USE FILM PACKS.

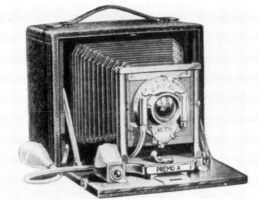

(1058) **PREMO A CAMERA.** C. 1901. FOUR SIZES OF THIS CAMERA FOR 4 X 5, 5 X 7, 6½ X 8½, OR 8 X 10 INCH EXPOSURES ON PLATES. ROCHESTER SYM-METRICAL OR ZEISS ANASTIGMAT SERIES II A LENS. DOUBLE PNEUMATIC AND FINGER RELEASE AUTO SHUTTER; 1 TO ¹⁄₁₀₀ SEC., B., T. IRIS DIAPHRAGM. DOUBLE SWING BACK. GROUND GLASS FOCUS.

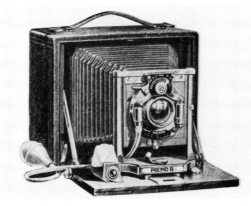

(1059) **PREMO B CAMERA.** C. 1901. THREE SIZES OF THIS CAMERA FOR 3¼ X 4¼, 4 X 5, OR 5 X 7 INCH EX-POSURES ON PLATES OR ROLL FILM. ROCHESTER SYMMETRICAL LENS. DOUBLE PNEUMATIC AND FIN-GER RELEASE VICTOR SHUTTER; 1 TO ¹⁄₁₀₀ SEC., B., T. IRIS DIAPHRAGM. CENTER SWING BACK. GROUND GLASS FOCUS.

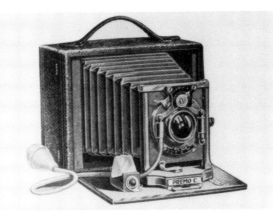

(1060) **PREMO C CAMERA.** C. 1901. TWO SIZES OF THIS CAMERA FOR 4 X 5 OR 5 X 7 INCH PLATE EXPO-SURES. RAPID RECTILINEAR LENS. DOUBLE PNEU-MATIC AND FINGER RELEASE VICTOR SHUTTER; 1 TO

¹⁄₁₀₀ SEC., B., T. IRIS DIAPHRAGM. CENTER SWING BACK. GROUND GLASS FOCUS.

(1061) **PREMO FOLDING FILM CAMERA.** C. 1903. SIZE 3¼ X 4¼ INCH EXPOSURES ON FILM PACKS. THIS CAMERA IS ONE OF THE FIRST AMERICAN CAM-ERAS TO USE FILM PACKS.

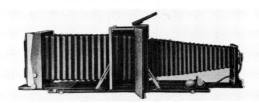

(1062) **LONG FOCUS PREMO CAMERA.** C. 1901. FOUR SIZES OF THIS CAMERA FOR 4 X 5, 5 X 7, 6½ X 8½, OR 8 X 10 INCH PLATE EXPOSURES. ROCHESTER TELE-PHOTO, ZEISS ANASTIGMAT SERIES VII A, GOERZ DOUBLE ANASTIGMAT SERIES III, OR VOIGTLANDER COLLINEAR SERIES II LENS. DOUBLE PNEUMATIC AND FINGER RELEASE AUTO SHUTTER; 1 TO ¹⁄₁₀₀ SEC., B., T. IRIS DIAPHRAGM. FRONT AND REAR EXTENSION BELLOWS. REVERSIBLE BACK. DOUBLE SWING BACK. GROUND GLASS FOCUS.

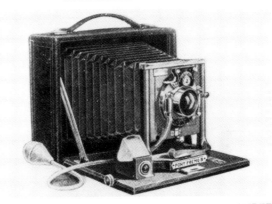

(1063) **PONY PREMO B CAMERA.** C. 1901. THREE SIZES OF THIS CAMERA FOR 3¼ X 4¼, 4 X 5, OR 5 X 7 INCH EXPOSURES ON PLATES OR ROLL FILM WITH HOLDER. ROCHESTER SYMMETRICAL LENS. DOUBLE PNEUMATIC AND FINGER RELEASE VICTOR SHUTTER; 1 TO ¹⁄₁₀₀ SEC., B., T. IRIS DIAPHRAGM. GROUND GLASS FOCUS.

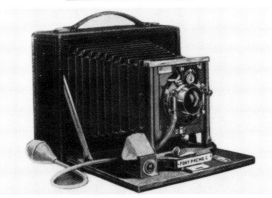

(1064) **PONY PREMO C CAMERA.** C. 1901. TWO SIZES OF THIS CAMERA FOR 4 X 5 OR 5 X 7 INCH EXPOSURES

## ROCHESTER OPTICAL AND CAMERA COMPANY (*cont.*)

ON PLATES OR ROLL FILM WITH HOLDER. RAPID REC-TILINEAR LENS. DOUBLE PNEUMATIC AND FINGER RELEASE VICTOR SHUTTER; 1 TO $\frac{1}{100}$ SEC., B., T. IRIS DIAPHRAGM. GROUND GLASS FOCUS.

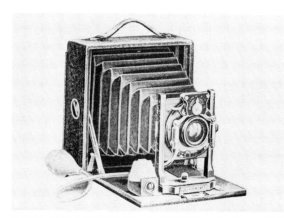

(1065)   **PONY PREMO NO. 3 CAMERA.** C. 1901. SIZE 4 X 5 INCH EXPOSURES ON PLATES OR ROLL FILM WITH HOLDER. RAPID RECTILINEAR LENS. DOUBLE PNEUMATIC AND FINGER RELEASE VICTOR SHUTTER; 1 TO $\frac{1}{100}$ SEC., B., T. IRIS DIAPHRAGM. REVERSIBLE BACK. SWING BACK. SOME CAMERAS WITH CAR-TRIDGE ROLL HOLDER.

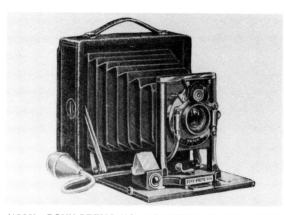

(1066)   **PONY PREMO NO. 4 CAMERA.** C. 1901. TWO SIZES OF THIS CAMERA FOR 4 X 5 OR 5 X 7 INCH EXPO-SURES ON PLATES OR ROLL FILM WITH HOLDER. ROCHESTER SYMMETRICAL LENS. DOUBLE PNEU-MATIC AND FINGER RELEASE VICTOR SHUTTER; 1 TO $\frac{1}{100}$ SEC., B., T. IRIS DIAPHRAGM. REVERSIBLE BACK. CENTRAL SWING BACK.

(1067)   **STEREO PREMO B CAMERA.** C. 1901. SIZE 5 X 7 INCH STEREO EXPOSURES ON PLATES. SAME AS THE STEREO PREMO A MODEL EXCEPT SINGLE SWING BACK INSTEAD OF DOUBLE SWING BACK.

(1068)   **PONY PREMO NO. 5 CAMERA.** C. 1901. THREE SIZES OF THIS CAMERA FOR 4 X 5, 5 X 7, OR 6½ X 8½ INCH PLATE EXPOSURES. ROLL FILM HOLDER FOR THE 4 X 5 AND 5 X 7 CAMERAS. F 8 ROCHESTER SYM-METRICAL OR ZEISS SERIES II A LENS. DOUBLE PNEU-MATIC AND FINGER RELEASE AUTO SHUTTER; 1 TO $\frac{1}{100}$ SEC., B., T. IRIS DIAPHRAGM. DOUBLE EXTENSION BELLOWS. REVERSIBLE BACK. CENTRAL SWING BACK. GROUND GLASS FOCUS.

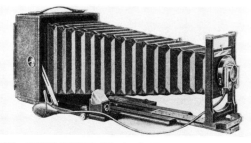

(1069)   **PONY PREMO NO. 6 CAMERA.** C. 1901. FOUR SIZES OF THIS CAMERA FOR 4 X 5, 5 X 7, 6½ X 8½, OR 8 X 10 INCH PLATE EXPOSURES. ROLL FILM HOLDER FOR THE 4 X 5 AND 5 X 7 CAMERAS. ROCHES-TER TELEPHOTO, ZEISS ANASTIGMAT SERIES VII A, GOERZ DOUBLE ANASTIGMAT SERIES III, OR VOIGT-LANDER COLLINEAR SERIES II LENS. DOUBLE PNEU-MATIC AND FINGER RELEASE AUTO SHUTTER; 1 TO $\frac{1}{100}$ SEC., B., T. IRIS DIAPHRAGM. TRIPLE EXTENSION BELLOWS. REVERSIBLE BACK. CENTRAL SWING BACK. GROUND GLASS FOCUS.

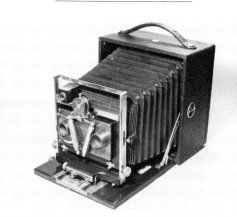

(1070)   **PONY PREMO NO. 6 STEREO CAMERA.** C. 1900. SIZE 5 X 7 INCH STEREO EXPOSURES ON PLATES. F 8 BAUSCH & LOMB LENS. BAUSCH & LOMB SHUTTER; 3 TO $\frac{1}{100}$ SEC. (BS)

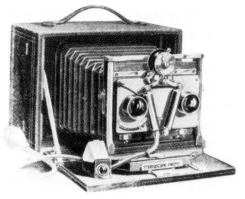

(1071)   **STEREO PREMO A CAMERA.** C. 1901. SIZE 5 X 7 INCH STEREO EXPOSURES ON PLATES. BAUSCH & LOMB DOUBLE PNEUMATIC AND FINGER RELEASE SHUTTER; 3 TO $\frac{1}{100}$ SEC., B., T. OR UNICUM DOUBLE PNEUMATIC OR FINGER RELEASE SHUTTER; 1 TO $\frac{1}{100}$ SEC., B., T. BOTH SHUTTERS HAVE AN IRIS DIA-PHRAGM. DOUBLE SWING BACK. GROUND GLASS FOCUS.

## ROCHESTER OPTICAL COMPANY

(1072)   **AMERICAN CHALLENGE SWIVEL BED (MONO-RAIL) CAMERA.** C. 1883. SIZE 4 X 5 INCH PLATE EXPOSURES. WATERHOUSE STOPS. SQUARE BEL-LOWS. (IH)

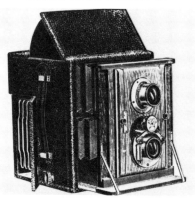

(1073)   **CARLTON TWIN LENS REFLEX CAMERA.** C. 1895. SIZE 4 X 5 INCH EXPOSURES ON PLATES, CUT FILM, OR ROLL FILM WITH HOLDER. DARLOT LENS. STAR SHUTTER. SWING BACK. RACK & PINION FOCUS.

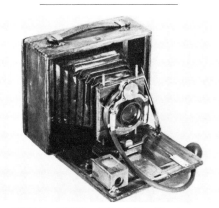

(1074)   **CYCLE REKO FOLDING PLATE CAMERA.** C. 1891. SIZE 4 X 5 INCH EXPOSURES ON PLATES.

## ROCHESTER OPTICAL COMPANY (*cont.*)

UNICUM DOUBLE PNEUMATIC SHUTTER; 1 TO $\frac{1}{100}$ SEC., B., T. (HW)

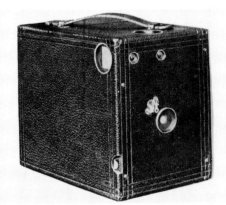

**(1075) CYCLONE JUNIOR BOX CAMERA.** C. 1902. SIZE 3½ X 3½ INCH EXPOSURES ON PLATES. THE CAMERA HOLDS SIX PLATES. MENISCUS LENS. INSTANT AND TIME SHUTTER.

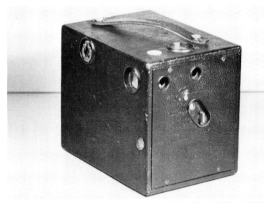

**(1076) NO. 5 MAGAZINE CYCLONE BOX CAMERA.** C. 1902. SIZE 4 X 5 INCH EXPOSURES ON PLATES. MENISCUS LENS. ROTARY SHUTTER. (MR)

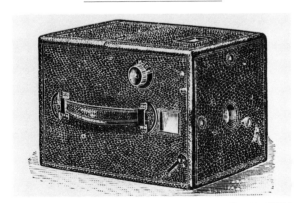

**(1077) HANDY BOX CAMERA.** C. 1895. SIZE 4 X 5 INCH EXPOSURES ON PLATES OR CUT FILM. SINGLE VIEW LENS. INSTANT AND TIME SHUTTER. GROUND GLASS FOCUSING.

**(1078) CYCLONE SENIOR BOX CAMERA.** C. 1902. SIZE 4 X 5 INCH EXPOSURES ON PLATES. THE CAMERA HOLDS SIX PLATES. MENISCUS LENS. INSTANT AND TIME SHUTTER. SIMILAR TO THE CYCLONE JUNIOR BOX CAMERA.

**(1079) NO. 4 MAGAZINE CYCLONE BOX CAMERA.** C. 1902. SIZE 3¼ X 4¼ INCH EXPOSURES ON PLATES. SIMILAR TO THE NO. 5 MAGAZINE CYCLONE BOX CAMERA.

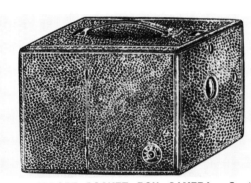

**(1080) MIDGET POCKET BOX CAMERA.** C. 1895. FOUR SIZES OF THIS CAMERA FOR 3¼ X 4¼, 4 X 5, 4¼ X 6½, OR 5 X 7 INCH PLATE EXPOSURES. RACK & PINION FOCUSING. GROUND GLASS FOCUSING.

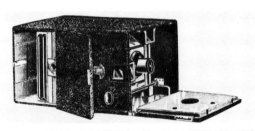

**(1081) PREMARET CAMERA.** C. 1895. SIZE 4 X 5 INCH EXPOSURES ON PLATES, CUT FILM, OR ROLL FILM WITH HOLDER. RAPID RECTILINEAR LENS. PREMIER SHUTTER. SWING BACK. RISING AND FALLING LENS MOUNT. RACK & PINION FOCUSING BY EXTERNAL KNOB WITH DISTANCE SCALE. GROUND GLASS FOCUSING.

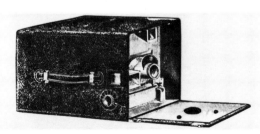

**(1082) PREMIER BOX CAMERA.** C. 1895. SIZE 4 X 5 INCH EXPOSURES ON PLATES, CUT FILM, OR ROLL FILM WITH ROLL HOLDER. RAPID RECTILINEAR LENS. RACK & PINION FOCUSING BY EXTERNAL KNOB WITH

DISTANCE SCALE. GROUND GLASS FOCUSING. ROTARY APERTURES.

**(1083) NO. 2 PREMIER BOX CAMERA.** C. 1895. TWO SIZES OF THIS CAMERA FOR 4 X 5 OR 5 X 7 INCH EXPOSURES ON PLATES, CUT FILM, OR ROLL FILM. SWING BACK. RISING AND FALLING LENS MOUNT. SIMILAR TO THE PREMIER BOX CAMERA (C. 1895) WITH THE SAME LENS AND SHUTTER.

**(1084) PREMIER FOLDING CAMERA.** C. 1892. SIZE 4 X 5 INCH EXPOSURES ON PLATES OR ROLL FILM WITH THE EASTMAN-WALKER ROLL HOLDER. LANDSCAPE LENS. ROTARY SHUTTER. ROTARY APERTURE STOPS. A SMALL DOOR ON THE FRONT OF THIS BOX-FORM CAMERA FOLDS DOWN TO ALLOW THE LENS AND BELLOWS TO BE EXTENDED. (MA)

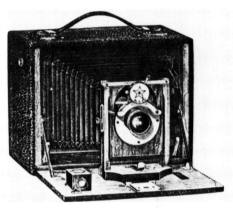

**(1085) PREMIER FOLDING CAMERA.** C. 1895. TWO SIZES OF THIS CAMERA FOR 4 X 5 OR 5 X 7 INCH EXPOSURES ON PLATES, CUT FILM, OR ROLL FILM WITH ROLL HOLDER. RAPID RECTILINEAR LENS. STAR SHUTTER. SWING BACK. RISING AND FALLING LENS MOUNT.

**(1086) PREMIER PLATE CAMERA.** C. 1892. SIZE 5 X 7 INCH EXPOSURES. THE DOOR ON THE FRONT OF THIS BOX-FORM CAMERA FOLDS DOWN AND THE LENS BOARD AND BELLOWS CAN BE PULLED OUT.

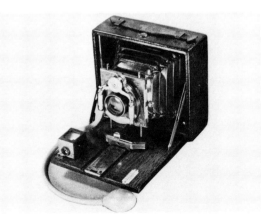

**(1087) PREMO CAMERA.** C. 1895. FOUR SIZES OF THIS CAMERA FOR 3¼ X 4¼, 4 X 5, 5 X 7, OR 6½ X 8½ INCH EXPOSURES ON PLATES, CUT FILM, OR ROLL

## ROCHESTER OPTICAL COMPANY (*cont.*)

FILM WITH HOLDER. RAPID RECTILINEAR LENS. STAR SHUTTER FOR INSTANT, B., T. EXPOSURES. SWING BACK. RISING AND CROSSING LENS MOUNT. GROUND GLASS FOCUSING. (HW)

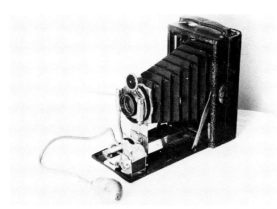

(1088) **PREMO CAMERA.** C. 1905. SIZE 3¼ X 4¼ INCH EXPOSURES ON FILM PACKS. VOIGHTLANDER COLLINEAR SERIES III LENS. BAUSCH & LOMB PNEUMATIC SHUTTER; 1 TO ¹⁄₁₀₀ SEC., B., T. (TS)

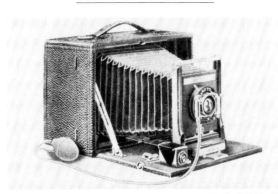

(1089) **PREMO A CAMERA.** C. 1902. TWO SIZES OF THIS CAMERA FOR 4 X 5 OR 5 X 7 INCH PLATE EXPOSURES. PLANATOGRAPH LENS. AUTO OR VICTOR (1 TO ¹⁄₁₀₀ SEC., B., T.) SHUTTER. DOUBLE SWING BACK. GROUND GLASS FOCUSING BACK. PLATE STORAGE SPACE IN THE CAMERA.

(1090) **PREMO B CAMERA.** C. 1895. TWO SIZES OF THIS CAMERA FOR 4 X 5 OR 5 X 7 INCH EXPOSURES ON PLATES, CUT FILM, OR ROLL FILM WITH HOLDER. SIMILAR TO THE PREMO CAMERA, C. 1895, WITH THE SAME LENS AND SHUTTER BUT ALSO AVAILABLE WITH THE ROCHESTER OPTICAL COMPANY SINGLE VIEW LENS.

(1091) **PREMO C CAMERA.** C. 1895. TWO SIZES OF THIS CAMERA FOR 4 X 5 OR 5 X 7 INCH EXPOSURES ON PLATES, CUT FILM, OR ROLL FILM WITH HOLDER. RAPID RECTILINEAR OR SINGLE VIEW LENS. SAFETY SHUTTER. GROUND GLASS FOCUSING. SWING BACK. SIMILAR TO THE PREMO D CAMERA.

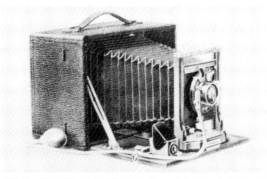

(1092) **PREMO B CAMERA.** C. 1902. TWO SIZES OF THIS CAMERA FOR 4 X 5 OR 5 X 7 INCH EXPOSURS ON PLATES OR ROLL FILM. SYMMETRICAL LENS. VICTOR SHUTTER. BACK PANEL FOCUSING. SINGLE SWING BACK. RISING AND FALLING LENS MOUNT. RACK & PINION FOCUSING.

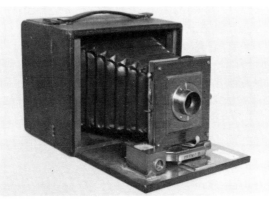

(1093) **PREMO D CAMERA.** C. 1895. TWO SIZES OF THIS CAMERA FOR 4 X 5 OR 5 X 7 INCH EXPOSURES ON PLATES, CUT FILM, OR ROLL FILM WITH HOLDER. (TH)

(1094) **PREMO REFLECTING CAMERA. SINGLE LENS REFLEX.** C. 1905. SIZE 4 X 5 INCH PLATE EXPOSURES. 6-INCH/F 6.8 GOERZ DAGOR SERIES III LENS. FOCAL PLANE SHUTTER; ¹⁄₇₅ TO ¹⁄₁₂₀₀ SEC. (MA)

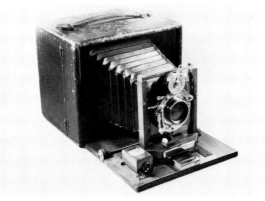

(1095) **PREMO SENIOR CAMERA.** C. 1895. FOUR SIZES OF THIS CAMERA FOR 3¼ X 4¼, 4 X 5, 5 X 7, OR 6½ X 8½ INCH EXPOSURES ON PLATES, CUT FILM, OR ROLL FILM WITH HOLDER. RAPID RECTILINEAR

LENS. STAR SHUTTER; INSTANT, B., T. DOUBLE SWING BACK. DOUBLE SLIDING FRONT. RACK & PINION FOCUSING. GROUND GLASS FOCUSING.

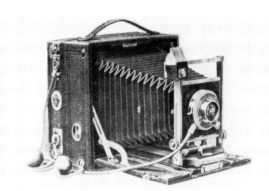

(1096) **PREMO SUPREME CAMERA.** C. 1902. THREE SIZES OF THIS CAMERA FOR 4 X 5, 5 X 7, OR 6½ X 8½ INCH EXPOSURES ON PLATES OR SHEET FILM. BAUSCH & LOMB PLASTIGMAT, ZEISS SERIES VIIA, GOERZ SERIES III, OR VOIGTLANDER COLLINEAR LENS. DOUBLE SHUTTER: BAUSCH & LOMB VOLUTE AND THORNTON-PICKARD FOCAL PLANE SHUTTER. TRIPLE EXTENSION BELLOWS. GROUND GLASS FOCUSING BACK. REVERSIBLE BACK. SWING BACK. DROPPING CAMERA BED.

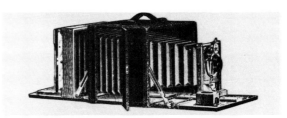

(1097) **LONG-FOCUS PREMO CAMERA.** C. 1895. FOUR SIZES OF THIS CAMERA FOR 4 X 5, 5 X 7, 6½ X 8½, OR 8 X 10 INCH EXPOSURES ON PLATES, CUT FILM, OR ROLL FILM WITH HOLDER. RAPID RECTILINEAR LENS. STAR SHUTTER FOR INSTANT, B., T. EXPOSURES. DOUBLE SWING BACK. DOUBLE SLIDING FRONT. RACK & PINION FOCUSING. GROUND GLASS FOCUSING.

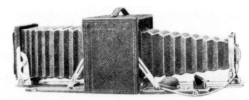

(1098) **LONG-FOCUS PREMO CAMERA.** C. 1902. FOUR SIZES OF THIS CAMERA FOR 4 X 5, 5 X 7, 6½ X 8½, OR 8 X 10 INCH EXPOSURES ON PLATES OR SHEET FILM. BAUSCH & LOMB PLASTIGMAT, VOIGTLANDER COLLINEAR, ZEISS CONVERTIBLE, OR GOERZ DOUBLE ANASTIGMAT LENS. AUTO OR VOLUTE SHUTTER. DOUBLE FRONT AND REAR BELLOWS. REVERSIBLE BACK. SWING BACK. DROPPING BED. GROUND GLASS FOCUSING. DOUBLE RACK & PINION FOCUSING.

## ROCHESTER OPTICAL COMPANY (*cont.*)

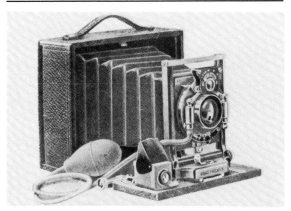

(1099) **PONY PREMO B CAMERA.** C. 1902. THREE SIZES OF THIS CAMERA FOR 3¼ X 4¼, 4 X 5, OR 5 X 7 INCH PLATE EXPOSURES. SYMMETRICAL LENS. VICTOR SHUTTER WITH IRIS DIAPHRAGM. REAR PANEL FOR FOCUSING.

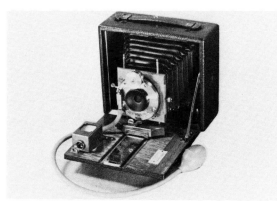

(1100) **PONY PREMO D CAMERA.** C. 1905. SIZE 4 X 5 INCH EXPOSURES ON PLATES. BAUSCH & LOMB LENS. UNICUM SINGLE PNEUMATIC SHUTTER TO 1/100 SEC., B., T.

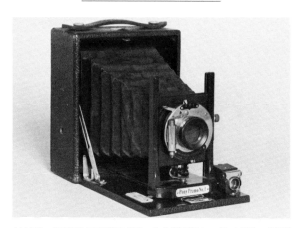

(1101) **PONY PREMO NO. 1 CAMERA.** C. 1905. SIZE 4 X 5 INCH EXPOSURES ON FILM PACKS. BAUSCH & LOMB RAPID RECTILINEAR LENS. (TH)

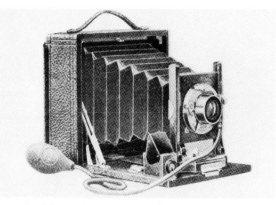

(1102) **PONY PREMO NO. 2 CAMERA.** C. 1902. SIZE 4 X 5 INCH EXPOSURES ON PLATES. RAPID RECTILINEAR LENS. GEM AUTOMATIC SHUTTER. REVERSIBLE BACK. GROUND GLASS FOCUSING.

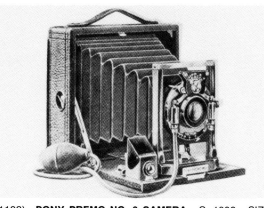

(1103) **PONY PREMO NO. 3 CAMERA.** C. 1902. SIZE 4 X 5 INCH EXPOSURES ON PLATES. RAPID RECTILINEAR LENS. VICTOR SHUTTER. REVERSIBLE BACK. GROUND GLASS FOCUSING. SWING BACK.

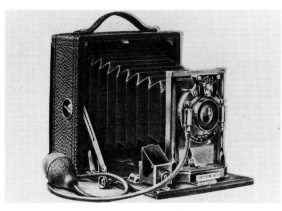

(1104) **PONY PREMO NO. 4 CAMERA.** C. 1902. TWO SIZES OF THIS CAMERA FOR 4 X 5 OR 5 X 7 INCH EXPOSURES ON PLATES. ROCHESTER SYMMETRICAL LENS. VICTOR SHUTTER WITH IRIS DIAPHRAGM. REVERSIBLE BACK. GROUND GLASS FOCUSING. SWING BACK.

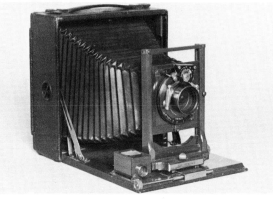

(1105) **PONY PREMO NO. 5 CAMERA.** C. 1902. THREE SIZES OF THIS CAMERA FOR 4 X 5, 5 X 7, OR 6½ X 8½ INCH EXPOSURES ON PLATES. PLANATOGRAPH OR BAUSCH & LOMB PLASTIGMAT LENS. AUTO OR VICTOR DOUBLE PNEUMATIC OR FINGER RELEASE SHUTTER; 1 TO 1/100 SEC., B., T. DOUBLE EXTENSION BELLOWS. REVERSIBLE BACK. GROUND GLASS FOCUSING. SWING BACK. (TH)

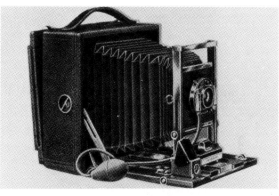

(1106) **PONY PREMO NO. 6 CAMERA.** C. 1902. THREE SIZES OF THIS CAMERA FOR 4 X 5, 5 X 7, OR 6½ X 8½ INCH EXPOSURES ON PLATES. PLANATOGRAPH, BAUSCH & LOMB PLASTIGMAT, VOIGTLANDER COLLINEAR, ZEISS CONVERTIBLE, OR GOERZ DOUBLE ANASTIGMAT LENS. VOLUTE OR AUTO SHUTTER WITH IRIS DIAPHRAGM. REVERSIBLE BACK. GROUND GLASS FOCUSING. CENTRAL SWING BACK. DOUBLE EXTENSION BELLOWS. (JW)

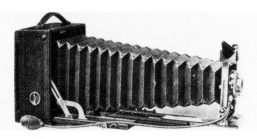

(1107) **PONY PREMO NO. 7 CAMERA.** C. 1902. THREE SIZES OF THIS CAMERA FOR 4 X 5, 5 X 7, OR 6½ X 8½ INCH EXPOSURES ON PLATES. PLANATOGRAPH, BAUSCH & LOMB PLASTIGMAT, VOIGTLANDER COLLINEAR, ZEISS CONVERTIBLE, OR GOERZ DOUBLE ANASTIGMAT LENS. VOLUTE OR AUTO SHUTTER WITH IRIS DIAPHRAGM. REVERSIBLE BACK. GROUND

## ROCHESTER OPTICAL COMPANY (*cont.*)

GLASS FOCUSING BACK. CENTRAL SWING BACK. TRIPLE EXTENSION BELLOWS.

---

(1108) **PONY PREMO NO. 7 COMBINATION STEREO AND 5 X 7 CAMERA.** C. 1895. SIZE 5 X 7 INCH STEREO EXPOSURES OR 5 X 7 INCH SINGLE EXPOSURES ON PLATES. COOKE OR ZEISS PROTAR STEREO LENSES AND BAUSCH & LOMB SINGLE LENS. AUTO GRAFLEX FOCAL PLANE SHUTTER.

---

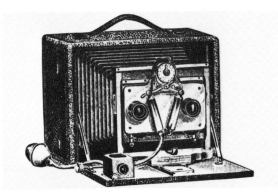

(1109) **STEREO PREMO CAMERA.** C. 1895. TWO SIZES OF THIS CAMERA FOR 5 X 7 OR 6½ X 8½ INCH EXPOSURES ON PLATES, CUT FILM, OR ROLL FILM WITH HOLDER. RAPID RECTILINEAR LENSES. DOUBLE PNEUMATIC SHUTTER; 3 TO ¹⁄₁₀₀ SEC., B., T. RACK & PINION FOCUSING. GROUND GLASS FOCUS.

---

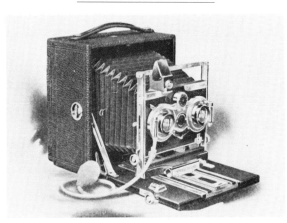

(1110) **STEREO PREMO CAMERA.** C. 1905. SIZE 5 X 7 INCH EXPOSURES ON PLATES. F 8 PLANATOGRAPH LENS. BAUSCH & LOMB DOUBLE PNEUMATIC AUTOMATIC SHUTTER; 1 TO ¹⁄₁₀₀ SEC., B., T.

---

(1111) **STEREO PREMO B CAMERA.** C. 1902. SIZE 5 X 7 INCH STEREO EXPOSURES ON PLATES OR ROLL FILM. AUTO OR VICTOR LENSES. BAUSCH & LOMB STEREO SHUTTER. BACK PANEL FOCUSING. SINGLE SWING BACK. SIMILAR TO THE STEREO PREMO A CAMERA.

---

(1112) **PREMOETTE CAMERA. ORIGINAL MODEL.** C. 1903. SIZE 2¼ X 3¼ INCH EXPOSURES ON FILM

PACKS. SINGLE LENS. THIS CAMERA IS ONE OF THE FIRST AMERICAN CAMERAS TO USE FILM PACKS.

---

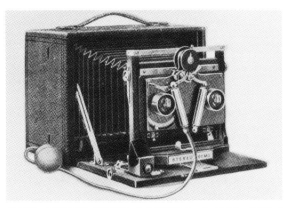

(1113) **STEREO PREMO A CAMERA.** C. 1902. SIZE 5 X 7 INCH STEREO EXPOSURES ON PLATES. AUTO OR VICTOR LENSES. BAUSCH & LOMB STEREO SHUTTER. DOUBLE SWING BACK. GROUND GLASS FOCUSING. PLATE STORAGE SPACE IN THE CAMERA.

---

(1114) **PREMOETTE JUNIOR CAMERA. ORIGINAL MODEL.** C. 1903. SIZE 2¼ X 3¼ INCH EXPOSURES ON FILM PACKS. THIS CAMERA IS ONE OF THE FIRST AMERICAN CAMERAS TO USE FILM PACKS.

---

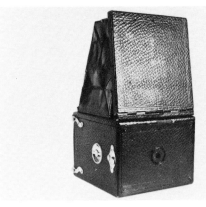

(1115) **PREMOGRAPH NO. 1 REFLEX BOX CAMERA.** C. 1907. SIZE 3¼ X 4¼ INCH EXPOSURES ON FILM PACKS. FIXED-FOCUS LENS. SINGLE-SPEED SHUTTER. (VC)

---

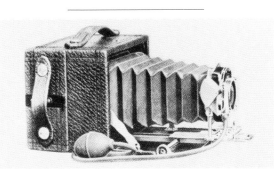

(1116) **SNAPPA CAMERA.** C. 1902. SIZE 3¼ X 4¼ INCH EXPOSURES ON 12 PLATES OR 24 FILM PACK SHEETS.

DAYLIGHT LOADING MAGAZINE. PLANATOGRAPH, GOERZ, PLASTIGMAT OR VOIGTLANDER LENS. AUTO SHUTTER.

---

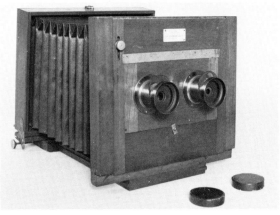

(1117) **NEW MODEL STEREOSCOPIC CAMERA.** C. 1895. SIZE 5 X 8 INCH STEREO EXPOSURES ON PLATES. ROCHESTER OPTICAL COMPANY NO. 1 VIEW LENS. RACK & PINION FOCUSING. FOLDING BED. (TH)

---

(1118) **CARLTON VIEW CAMERA.** C. 1985. EIGHT SIZES OF THIS CAMERA FOR 4 X 5, 4¼ X 6½, 5 X 7, 5 X 8, 6½ X 8½, 8 X 10, 10 X 12, OR 11 X 14 INCH PLATE EXPOSURES. DOUBLE SWING BACK. SIMILAR TO THE CARLTON VIEW CAMERA OF 1902.

---

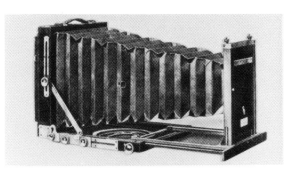

(1119) **CARLTON VIEW CAMERA.** C. 1902. FOUR SIZES OF THIS CAMERA FOR 5 X 7, 6½ X 8½, 8 X 10, OR 11 X 14 INCH PLATE EXPOSURES. SWING BACK.

---

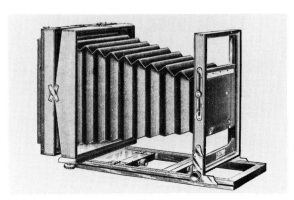

(1120) **EMPIRE STATE VIEW CAMERA.** C. 1895. TEN SIZES OF THIS CAMERA FOR 5 X 7, 5 X 8, 6½ X

## ROCHESTER OPTICAL COMPANY (*cont.*)

8½, 8 X 10, 10 X 12, 11 X 14, 14 X 17, 17 X 20, 18 X 24, OR 20 X 24 INCH PLATE EXPOSURES. REVERSIBLE BACK. SINGLE OR DOUBLE SWING BACK. DROPPING BED. RISING AND FALLING LENS MOUNT.

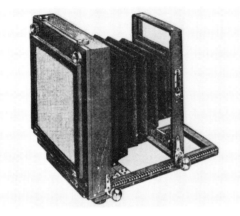

(1121) **IDEAL REVERSIBLE BACK VIEW CAMERA.** C. 1888–95. SIX SIZES OF THIS CAMERA FOR 3¼ X 4¼, 4 X 5, 4¼ X 6½, 5 X 7, 5 X 8, OR 6½ X 8½ INCH EXPOSURES ON DRY PLATES. RACK & PINION FOCUSING.

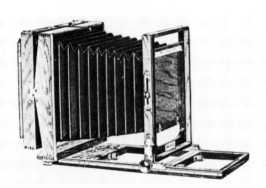

(1122) **IDEAL REVERSIBLE BACK VIEW CAMERA.** C. 1888–95. FIVE MODELS OF THIS CAMERA FOR 8 X 10, 10 X 12, 11 X 14, 14 X 17, OR 17 X 20 INCH EXPOSURES ON PLATES. RACK & PINION FOCUSING.

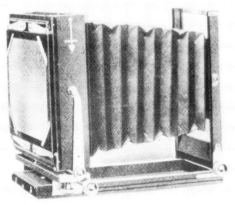

(1123) **IMPROVED EMPIRE STATE VIEW CAMERA.** C. 1902. FIVE SIZES OF THIS CAMERA FOR 5 X 7, 6½

X 8½, 8 X 10, 11 X 14, OR 14 X 17 INCH PLATE EXPO-SURES. DOUBLE SWING BACK. DROPPING CAMERA BED.

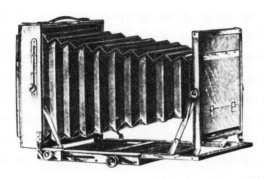

(1124) **KENWOOD VIEW CAMERA.** C. 1895. FOUR SIZES OF THIS CAMERA FOR 5 X 7, 5 X 8, 6½ X 8½, OR 8 X 10 INCH EXPOSURES ON PLATES. REVERSIBLE BACK. DOUBLE SWING BACK. RISING AND FALLING LENS MOUNT. RACK & PINION FOCUS.

(1125) **KING FOLDING VIEW CAMERA.** C. 1898. SIZE 6½ X 8½ INCH PLATE EXPOSURES. BAUSCH & LOMB LENS AND SHUTTER.

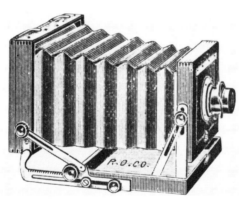

(1126) **MIDGET POCKET VIEW CAMERA.** C. 1895. TWO SIZES OF THIS CAMERA FOR 3¼ X 4¼ or 4 X 5 INCH PLATE EXPOSURES. RAPID RECTILINEAR LENS. STAR SHUTTER FOR INSTANT B., T. EXPOSURES. RISING LENS MOUNT. VERTICAL SWING BACK. RACK & PINION FOCUSING.

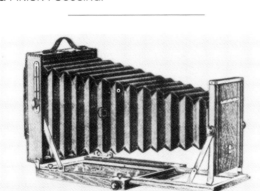

(1127) **MONITOR VIEW CAMERA.** C. 1895. SEVEN SIZES OF THIS CAMERA FOR 4 X 5, 5 X 7, 5 X 8, 6½ X

8½, 8 X 10, 10 X 12, OR 11 X 14 INCH PLATE EXPOSURES. DOUBLE SWING BACK. REVERSIBLE BACK. RISING AND FALLING LENS MOUNT. RACK & PINION FOCUS.

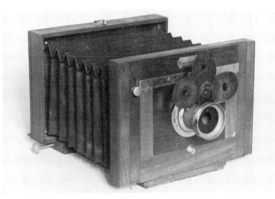

(1128) **NEW MODEL VIEW CAMERA. EARLY MODEL.** C. 1885. FOUR SIZES OF THIS CAMERA FOR 3¼ X 4¼, 4 X 5, 4¼ X 6½, OR 5 X 7 INCH EXPOSURES ON PLATES. ROCHESTER OPTICAL COMPANY LENS. WATERHOUSE STOPS. (TH)

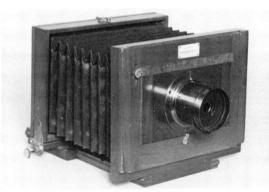

(1129) **NEW MODEL VIEW CAMERA.** C. 1885–95. FOUR SIZES OF THIS CAMERA FOR 5 X 7, 5 X 8, 6½ X 8½, OR 8 X 10 INCH EXPOSURES ON PLATES. ROCH-ESTER OPTICAL COMPANY LENS. THORNWARD SHUT-TER. FOLDING BED. REVERSIBLE BACK. SOME MOD-ELS WITH SINGLE SWING BACK. (TH)

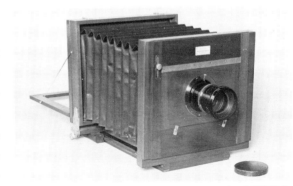

(1130) **NEW MODEL IMPROVED VIEW CAMERA.** C. 1885–95. SEVEN SIZES OF THIS CAMERA FOR 3¼ X 4¼, 4 X 5, 4¼ X 6½, 5 X 7, 5 X 8, 6½ X 8½, OR 8 X 10 INCH EXPOSURES ON PLATES. ROCHESTER OPTI-

## ROCHESTER OPTICAL COMPANY (*cont.*)

CAL COMPANY LENS. FOLDING BED. REVERSIBLE BACK. SOME MODELS WITH SINGLE SWING BACK, SOME WITH DOUBLE SWING BACK. (TH)

(1131) **NEW MODEL STEREO VIEW CAMERA.** C. 1884. TWO SIZES OF THIS CAMERA FOR 5 X 8 OR 6½ X 8½ INCH STEREO EXPOSURES ON PLATES. WATERHOUSE STOPS.

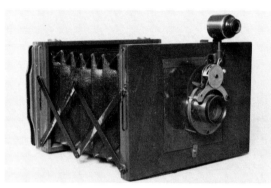

(1132) **SQUARE-BELLOWS TYPE VIEW CAMERA.** C. 1885. SIZE 5 X 7 INCH PLATE EXPOSURES. ROTARY STOPS. SPRING TENSION SHUTTER. (TH)

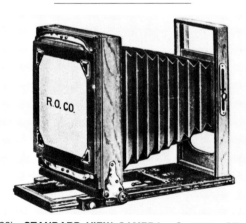

(1133) **STANDARD VIEW CAMERA.** C. 1895. SEVEN SIZES OF THIS CAMERA FOR 3¼ X 4¼, 4 X 5, 4¼ X 6½, 5 X 7, 5 X 8, 6½ X 8½, OR 8 X 10 INCH PLATE EXPOSURES. REVERSIBLE BACK. RISING AND FALLING LENS MOUNT. SWING BACK.

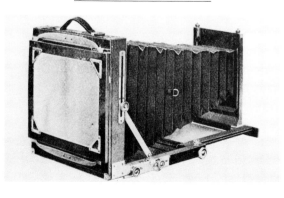

(1134) **UNVERSAL VIEW CAMERA.** C. 1902. SIX SIZES OF THIS CAMERA FOR 5 X 7, 6½ X 8½, 8 X 10, 11 X 14, 14 X 17, OR 17 X 20 INCH PLATE EXPOSURES. REVERSIBLE BACK.

(1135) **UNIVERSAL VIEW CAMERA.** C. 1895. ELEVEN SIZES OF THIS CAMERA FOR 3¼ X 4¼, 4 X 5, 4¼ X 6½, 5 X 7, 5 X 8, 6½ X 8½, 8 X 10, 10 X 12, 11 X 14, 14 X 17, OR 17 X 20 INCH PLATE EXPOSURES. REVERS-!BLE BACK. SINGLE OR DOUBLE SWING BACK. SWING FRONT. RISING AND FALLING LENS MOUNT. SIMILAR TO THE UNIVERSAL VIEW CAMERA OF 1902.

## ROCHESTER PANORAMIC CAMERA COMPANY

NOTE: THIS COMPANY MADE THE ORIGINAL MODEL CIRKUT PANORAMIC CAMERA PATENTED BY WILLIAM J. JOHNSTON IN 1904. THE COMPANY MERGED WITH THE CENTURY CAMERA COMPANY IN 1905. THE CIRKUT CAMERA MADE BY THIS COMPANY WAS PROBABLY SIMILAR TO THE CIRKUT CAMERA SHOWN UNDER THE CENTURY CAMERA COMPANY LISTINGS.

## ROCKFORD SILVER PLATE COMPANY

(1136) **WILLSIE 3½ CAMERA.** C. 1898. SIZE 3½ X 3½ INCH EXPOSURES ON SPECIAL FILM PACKS. FOCUSING MENISCUS LENS. ROTARY SHUTTER. (MA)

## ROLLS CAMERA MANUFACTURING COMPANY

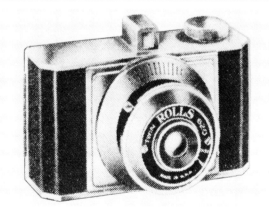

(1137) **ROLLS TWIN 620 CAMERA.** C. 1940. SIZE 1⅝ X 2¼ INCH EXPOSURES ON NO. 620 ROLL FILM. 62MM ROLLAX MENISCUS LENS. INSTANT AND TIME LEAF SHUTTER. FIXED FOCUS.

## SCHULTZE PHOTO EQUIPMENT COMPANY

(1138) **VIEW CAMERA.** C. 1890. SIZE 4¼ X 6½ INCH EXPOSURES ON GLASS PLATES

## SCOVILL & ADAMS COMPANY

(1139) **AMERICAN OPTICAL COMPANY'S LANDSCAPE REVERSIBLE CAMERA.** C. 1892.

(1140) **AMERICAN OPTICAL COMPANY'S MANIFOLD CAMERA.** C. 1892.

(1141) **AMERICAN OPTICAL COMPANY'S MULTIPLYING CAMERA.** C. 1892.

(1142) **AMERICAN OPTICAL COMPANY'S PORTRAIT CAMERA.** C. 1892. THE CAMERA WAS MADE IN THE FOLLOWING PLATE EXPOSURE SIZES: 3¼ X 4¼, 4¼ X 5½, 4¾ X 6½, 6½ X 8½, 8 X 10, 10 X 12, 11 X 14, 12 X 15, 14 X 17, 16 X 20, 17 X 20, 18 X 22, 20 X 24, 22 X 27, 25 X 30, AND 30 X 38 INCHES.

(1143) **AMERICAN OPTICAL COMPANY'S REVOLVING BACK CAMERA.** C. 1892.

(1144) **BOOK DETECTIVE CAMERA.** C. 1892. SIZE 4 X 5 INCH EXPOSURES ON PLATES. THE CAMERA HAS THE APPEARANCE OF THREE BOOKS HELD TOGETHER BY A LEATHER STRAP. BELLOWS ARE LOCATED BETWEEN THE BOOKS AND CAN BE EXPANDED BY RELEASING THE STRAP. A FOCUSING LEVER AND SCALE ARE LOCATED OPPOSITE THE SPINES OF THE "BOOKS." GROUND GLASS FOCUSING SCREEN. WAIST-LEVEL FINDER. 3 INCH/F 12 ACHROMATIZED PERISCOPIC LENS. GUILLOTINE SHUTTER FOR VARIABLE SPEED OR TIME EXPOSURES. (GE)

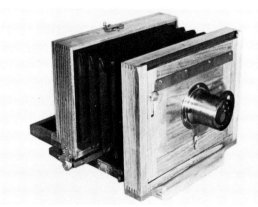

(1145) **FIELD CAMERA.** C. 1895. SIZE 5 X 8 INCH EXPOSURES ON PLATES OR SHEET FILM. WATERBURY LENS. WATERHOUSE STOPS. LENS-CAP TYPE SHUTTER. (EB)

## SCOVILL & ADAMS COMPANY (cont.)

(1146) **KNACK DETECTIVE BOX CAMERA.** C. 1891. SIZE 4 X 5 INCH EXPOSURE ON PLATES. DOUBLE COMBINATION LENS. INSTANT AND TIME SHUTTER. APERTURE STOPS.

(1147) **SOLOGRAPH CAMERA.** C. 1899.

(1148) **SOLOGRAPH STEREO CAMERA.** C. 1899. SIZE 4 X 6½ INCH STEREO EXPOSURES ON PLATES. RAPID RECTILTNEAR LENSES. AUTOMATIC SHUTTER.

(1149) **CYCLE CARTRIDGE SOLOGRAPH CAMERA.** C. 1899. REVERSIBLE BACK. TRIPLE EXTENSION BELLOWS.

(1150) **WATERBURY DETECTIVE CAMERA.** C. 1890. TWO SIZES OF THIS CAMERA FOR 4 X 5 OR 5 X 7 INCH EXPOSURES ON DRY PLATES. SIMILAR TO THE WATERBURY DETECTIVE CAMERA OF 1889 MANUFACTURED BY THE SCOVILLE MANUFACTURING COMPANY.

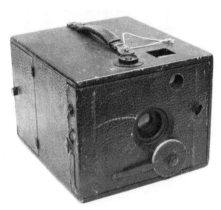

(1151) **IMPROVED WATERBURY DETECTIVE CAMERA.** C. 1894. SIZE 4 X 5 INCH EXPOSURES ON PLATES. (DG)

(1152) **FOLDING VIEW CAMERA.** C. 1890. SIZE 4 X 5 INCH PLATE EXPOSURES. FRONT AND REAR BELLOW EXTENSIONS.

## SCOVILL MANUFACTURING COMPANY

(1153) **ANTIQUE OAK DETECTIVE CAMERA.** C. 1890. SIZE 4 X 5 INCH EXPOSURES ON DRY PLATES. THIS CAMERA IS A CHEAPER VERSION OF THE WATERBURY DETECTIVE CAMERA.

(1154) **BICYCLIST'S CAMERA.** C. 1885.

(1155) **DETECTIVE BOX CAMERA.** C. 1886. TWO SIZES OF THIS CAMERA FOR 3¼ X 4¼ OR 4 X 5 INCH

EXPOSURES ON GLASS PLATES. BECK RECTILINEAR LENS. STRING-SET SHUTTER.

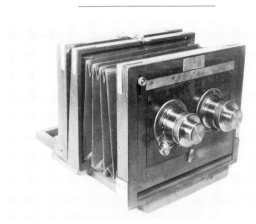

(1156) **CENTENNIAL STEREO CAMERA.** C. 1885. SIZE 5 X 8 INCH EXPOSURES ON PLATES. DARLOT LENS. THIS CAMERA WAS MADE FOR THE AMERICAN OPTICAL COMPANY. (SW)

(1157) **DETECTIVE BOX CAMERA.** C. 1888. SIZE 4 X 5 INCH EXPOSURES ON PLATES. 180 MM/F 5.6 VOIGTLANDER EURYSCOP LENS. VARIABLE-SPEED ROTARY SHUTTER. (GE)

(1158) **KLONDIKE BOX CAMERA.** C. 1898. SIZE 4 X 5 INCH PLATE EXPOSURES. MENISCUS LENS. ROTARY SECTOR SHUTTER. (MA)

(1159) **KNACK DETECTIVE CAMERA.** C. 1891.

(1160) **MASCOT DETECTIVE CAMERA.** C. 1890. SIZE 4 X 5 INCH EXPOSURES ON ROLL FILM. SIMILAR TO THE WATERBURY DETECTIVE CAMERA EXCEPT THE CAMERA HAS AN EASTMAN ROLL FILM HOLDER.

(1161) **TOUROGRAPH WET COLLODION PLATE CAMERA.** C. 1878. ORIGINAL TOUROGRAPH CAMERA PATENTED BY THOMAS H. BLAIR.

(1162) **TRIAD DETECTIVE CAMERA.** C. 1892. SIZE 4 X 5 INCH EXPOSURES ON ROLL, SHEET, OR PLATE FILM.

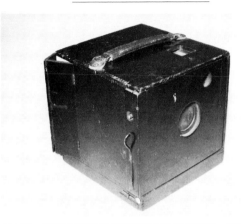

(1163) **WATERBURY DETECTIVE CAMERA. ORIGINAL MODEL.** C. 1888. TWO SIZES OF THIS CAMERA FOR 4 X 5 OR 5 X 7 INCH EXPOSURES ON DRY PLATES. F 16 WALE ACHROMATIZED PERISCOPIC TYPE LENS. ROTARY SHUTTER FOR VARIABLE SPEED AND TIME EXPOSURES. LEVER FOR COCKING THE SHUTTER. EXTERNAL KNOB ON THE UNDERSIDE OF THE CAMERA FOR FOCUSING. GROUND GLASS FOCUSING. WAIST LEVEL FINDER. (GE)

(1164) **WATERBURY DETECTIVE CAMERA. IMPROVED MODEL.** C. 1889. TWO SIZES OF THIS CAMERA FOR 4 X 5 OR 5 X 7 INCH DRY PLATE EXPOSURES. SIMILAR TO THE ORIGINAL MODEL EXCEPT THE CAMERA IS LEATHER COVERED, HAS A LENS OPENING PLUG, AND THE FOCUSING KNOB IS LOCATED ON THE TOP INSTEAD OF THE BOTTOM.

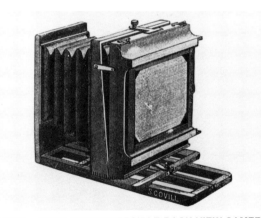

(1165) **ACME NEW REVERSIBLE BACK VIEW CAMERA.** C. 1888. SIX SIZES OF THIS CAMERA FOR 6½ X 8½, 8 X 10, 10 X 12, 11 X 14, 14 X 17, OR 17 X 20 INCH EXPOSURES ON DRY PLATES. RISING LENS MOUNT, FOLDING BED AND REVERSIBLE BACK. SINGLE SWING AND DOUBLE SWING MODELS.

## SCOVILL MANUFACTURING COMPANY (*cont.*)

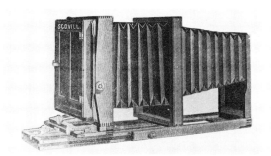

(1166) **AMERICAN OPTICAL COMPANY'S BOSTON IMPERIAL VIEW CAMERA.** C. 1888. THREE SIZES OF THIS CAMERA FOR 11 X 14, 14 X 17, OR 18 X 22 INCH EXPOSURES ON PLATES. TELESCOPIC BED.

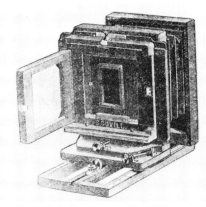

(1167) **AMERICAN OPTICAL COMPANY'S IMPERIAL CARD OR CABINET VIEW CAMERA.** C. 1888. FIVE SIZES OF THIS CAMERA FOR 6½ X 8½, 8 X 10, 10 X 12, 11 X 14, OR 14 X 17 INCH EXPOSURES ON PLATES. DOUBLE SWING BACK.

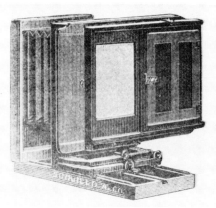

(1168) **AMERICAN OPTICAL COMPANY'S ROYAL VIEW CAMERA.** C. 1888. FOUR SIZES OF THIS CAMERA FOR 8 X 10, 10 X 12, 11 X 14, OR 14 X 17 INCH EXPOSURES ON PLATES. DOUBLE SWING BACK.

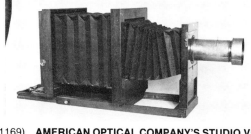

(1169) **AMERICAN OPTICAL COMPANY'S STUDIO VIEW CAMERA.** C. 1880. SIZE 16 X 18 INCH EXPOSURES ON PLATES. (TH)

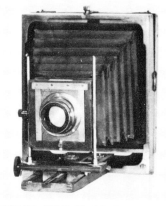

(1170) **AMERICAN OPTICAL COMPANY'S VIEW CAMERA.** C. 1888. SIZE 6½ X 8½ INCH EXPOSURES ON PLATES. GOERZ DOUBLE ANASTIGMAT LENS. (JW)

(1171) **FIELD VIEW CAMERA.** C. 1882. SIZE 8 X 10 INCH EXPOSURES ON PLATES.

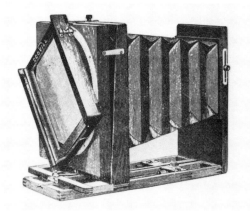

(1172) **FLAMMANG'S PATENT REVOLVING BACK VIEW CAMERA.** C. 1888. TWELVE SIZES OF THIS CAMERA FOR 4 X 5, 4¼ X 5½, 5 X 7, 5 X 8, 6½ X 8½, 8 X 10, 12 X 12, 11 X 14, 14 X 17, 17 X 20, 20 X 24, OR 25 X 30 INCH EXPOSURES ON PLATES. THE PLATE HOLDER REVOLVES ON A CIRCULAR MOUNT.

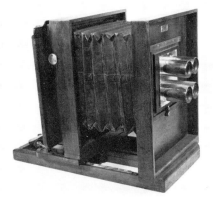

(1173) **FOUR-TUBE STUDIO VIEW CAMERA.** C. 1870. FOUR EXPOSURES, SIZE 2 X 3 INCHES ON EACH 4¼ X 6½ INCH PLATE. (VC)

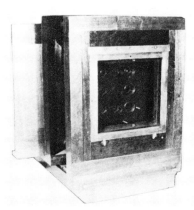

(1174) **NINE-LENS MULTIPLE VIEW CAMERA.** C. 1875. NINE EXPOSURES ON AN 11 X 11 INCH PLATE. (SW)

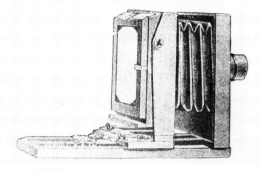

(1175) **PORTRAIT VIEW CAMERA.** C. 1888. SIX SIZES OF THIS CAMERA FOR 11 X 14, 14 X 17, 17 X 20, 18 X 22, 20 X 24, OR 25 X 30 INCH EXPOSURES ON PLATES.

(1176) **SQUARE-BELLOWS VIEW CAMERA.** C. 1886. SIZE 3¼ X 4¼ INCH EXPOSURES ON PLATES. PROSCH SHUTTER.

## SCOVILL MANUFACTURING COMPANY (*cont.*)

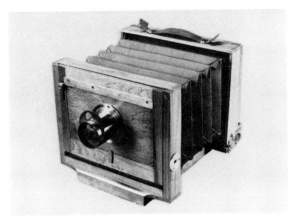

(1177) **SQUARE-BELLOWS VIEW CAMERA.** C. 1870. SIZE 5 X 8 INCH EXPOSURES ON WET PLATES. ACHROMATIC DOUBLET LENS. LENS CAP SHUTTER. (DB)

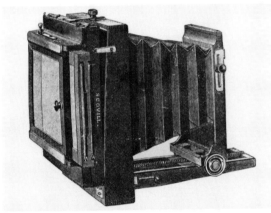

(1178) **ST. LOUIS REVERSIBLE BACK VIEW CAMERA.** C. 1888. FOUR SIZES OF THIS CAMERA FOR 5 X 7, 6½ X 8½, 8 X 10, OR 11 X 14 INCH EXPOSURES ON DRY PLATES. RACK & PINION FOCUS. RISING LENS MOUNT. REVERSIBLE BACK.

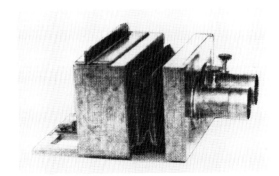

(1179) **STEREO VIEW CAMERA.** C. 1861. SIZE 4 X 8 INCH STEREO EXPOSURES ON WET PLATES. C.C. HARRISON LENSES. THE CAMERA WAS MANUFACTURED FOR THE AMERICAN OPTICAL COMPANY. (GE)

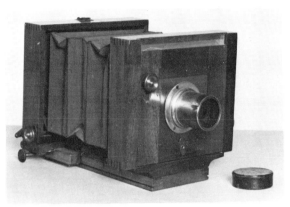

(1180) **STUDENT TYPE VIEW CAMERA.** C. 1880. SIZE 4 X 5 INCH EXPOSURES ON PLATES. (TH)

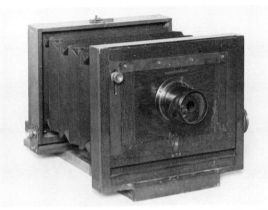

(1181) **STUDIO VIEW CAMERA.** C. 1885. SIZE 5 X 7 INCH EXPOSURES ON PLATES. (TH)

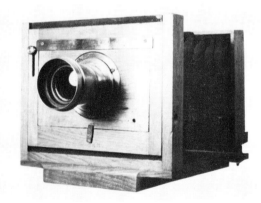

(1182) **TAILBOARD VIEW CAMERA.** C. 1885. SIZE 5 X 8 INCH EXPOSURES ON PLATES. ROCHESTER OPTICAL COMPANY LENS. (VC)

(1183) **VENUS REVERSIBLE BACK VIEW CAMERA.** C. 1888. SIZE 8 X 10 SINGLE OR STEREO EXPOSURES ON DRY PLATES. WIDE-FRONT LENS MOUNT. SIMILAR TO THE ACME REVERSIBLE BACK VIEW CAMERA.

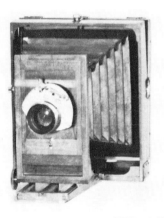

(1184) **VIEW CAMERA.** C. 1887. SIZE 6½ X 8½ INCH EXPOSURES ON GLASS PLATES. PROSCH LENS. DUPLEX SHUTTER. (JW)

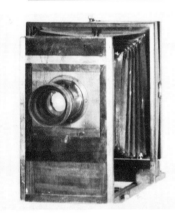

(1185) **VIEW CAMERA.** C. 1888. SIZE 8 X 10 INCH GLASS PLATE EXPOSURES. REVOLVING BACK. PORTRAIT EURYSCOPE LENS. WATERHOUSE STOPS. (JW)

## SEMMENDINGER

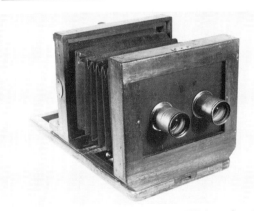

(1186) **EXCELSIOR STEREO CAMERA.** C. 1874. SIZE 6½ X 8½ INCH EXPOSURES ON WET PLATES. DALLMEYER LENS. (SW)

(1187) **EXCELSIOR WET PLATE CAMERA.** C. 1875. SIZE 8 X 10 INCH WET PLATE EXPOSURES.

## SENECA CAMERA MANUFACTURING COMPANY

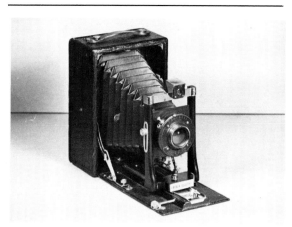

(1188) **BLACK BEAUTY CAMERA.** C. 1905. SIZE 3¼ X 5½ INCH EXPOSURES ON NO. 3A FILM PACKS. 6¾ INCH SYMMETRIC WOLLENSAK LENS. AUTEX SHUTTER. (MR)

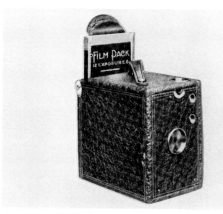

(1189) **BOX FILM CAMERA.** C. 1913. THREE SIZES OF THIS CAMERA FOR 2¼ X 3¼, 3¼ X 4¼, OR 3¼ X 5½ INCH EXPOSURES ON FILM PACKS. MENISCUS ACHROMATIC LENS. INSTANT AND TIME SHUTTER ON THE 2¼ X 3½ CAMERA AND AN AUTOMATIC INSTANT AND TIME SHUTTER ON THE OTHER TWO CAMERA SIZES.

(1190) **FILMETT BOX CAMERA.** C. 1910. THREE SIZES OF THIS CAMERA FOR 2¼ X 3¼, 3¼ X 4¼, OR 3¼ X 5½ INCH EXPOSURES ON FILM PACKS. MENISCUS ACHROMATIC LENS. INSTANT AND TIME SHUTTER.

(1191) **NO. 2A SCOUT BOX CAMERA.** C. 1913–17. SIZE 2½ X 4¼ INCH EXPOSURES ON ROLL FILM. MENISCUS ACHROMATIC LENS. INSTANT AND TIME AUTOMATIC SHUTTER. THREE APERTURE STOPS. SIMILAR TO THE NO. 2 SCOUT BOX CAMERA.

(1192) **NO. 2C SCOUT BOX CAMERA.** C. 1917. SIZE 2⅞ X 4⅞ INCH EXPOSURES ON ROLL FILM. MENISCUS ACHROMATIC LENS. INSTANT AND TIME AUTOMATIC SHUTTER. THREE APERTURE STOPS. SIMILAR TO THE NO. 2 SCOUT BOX CAMERA.

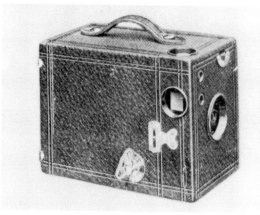

(1193) **NO. 2 SCOUT BOX CAMERA.** C. 1913–17. SIZE 2¼ X 3¼ INCH EXPOSURES ON ROLL FILM. MENISCUS ACHROMATIC LENS. INSTANT AND TIME AUTOMATIC SHUTTER. FIXED FOCUS.

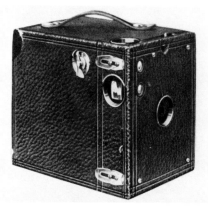

(1194) **NO. 3 SCOUT BOX CAMERA.** C. 1917. SIZE 3¼ X 4¼ INCH EXPOSURES ON ROLL FILM. MENISCUS ACHROMATIC LENS. AUTOMATIC SHUTTER FOR INSTANT AND TIME EXPOSURES. THREE APERTURE STOPS.

(1195) **NO. 3A SCOUT BOX CAMERA.** C. 1917. SIZE 3¼ X 5½ INCH EXPOSURES ON ROLL FILM. SAME FEATURES, LENS, AND SHUTTER AS THE NO. 3 SCOUT BOX CAMERA.

(1196) **BABY FILM SENECA BOX CAMERA. MODEL A.** C. 1905. SIZE 2¼ X 2¼ INCH EXPOSURES ON ROLL

FILM. ACHROMATIC LENS. SINGLE-SPEED AND TIME SHUTTER. DETACHABLE VIEW FINDER.

(1197) **BABY FILM SENECA BOX CAMERA. MODEL B.** C. 1905. SIZE 2¼ X 3¼ INCH EXPOSURES ON ROLL FILM. SINGLE-SPEED AND TIME SHUTTER.

(1198) **FILM SENECA BOX CAMERA. MODEL C.** C. 1905. SIZE 3½ X 3½ INCH EXPOSURES ON ROLL FILM. ACHROMATIC LENS. SHUTTER FOR THREE SPEEDS AND B., T. THREE APERTURE STOPS.

(1199) **FILM SENECA BOX CAMERA MODEL D.** C. 1905. TWO SIZES OF THIS CAMERA FOR 3¼ X 4¼ OR 4 X 5 INCH EXPOSURES ON ROLL FILM. SINGLE ACHROMATIC LENS. AUTOMATIC SHUTTER FOR INSTANT AND TIME EXPOSURES. EXTERNAL FOCUSING KNOB.

(1200) **FILM SENECA BOX CAMERA MODEL E.** C. 1905. SIZE 4 X 5 INCH EXPOSURES ON ROLL FILM. RAPID

## SENECA CAMERA MANUFACTURING COMPANY (*cont.*)

RECTILINEAR LENS. UNO PNEUMATIC SHUTTER. EXTERNAL KNOB FOR FOCUSING.

(1201) **SENECA JUNIOR BOX CAMERA.** C. 1905. SIZE 3½ X 3½ INCH PLATE EXPOSURES. ACHROMATIC LENS. SINGLE-SPEED AND TIME SHUTTER.

(1202) **SENECA JUNIOR BOX CAMERA.** C. 1913. TWO SIZES OF THIS CAMERA FOR 3½ X 3½ OR 3¼ X 4¼ INCH EXPOSURES ON PLATES OR FILM PACKS. THE CAMERA HOLDS SIX PLATES. MENISCUS ACHROMATIC LENS. IMPROVED AUTOMATIC SHUTTER FOR INSTANT AND TIME EXPOSURES.

(1203) **SENECA SENIOR BOX CAMERA.** C. 1913. SIZE 4 X 5 INCH EXPOSURES ON PLATES OR FILM PACKS. THE CAMERA HOLDS SIX PLATES. MENISCUS

ACHROMATIC LENS. IMPROVED AUTOMATIC SHUTTER FOR INSTANT AND TIME EXPOSURES.

(1204) **SENECA SENIOR BOX CAMERA.** C. 1905. SIZE 4 X 5 INCH PLATE EXPOSURES. SAME AS THE SENECA JUNIOR BOX CAMERA, C. 1913, WITH THE SAME LENS AND SHUTTER.

(1205) **CHAUTAUQUA PLATE CAMERA.** C. 1904. THREE SIZES OF THIS CAMERA FOR 3¼ X 4¼, 4 X 5, OR 5 X 7 INCH PLATE EXPOSURES. WOLLENSAK LENS. SENECA UNO SHUTTER. (HW)

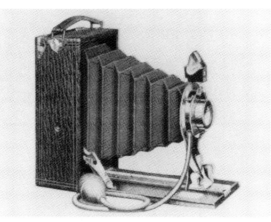

(1206) **FILMETTE FOLDING CAMERA.** C. 1913. FOUR SIZES OF THIS CAMERA FOR 2¼ X 3¼, 3¼ X 4¼, 3¼ X 5½, OR 4 X 5 INCH EXPOSURES ON FILM PACKS. SINGLE ACHROMATIC OR DOUBLE RAPID RECTILINEAR LENS. UNO AUTOMATIC (I., B., T.) OR DOUBLE PNEUMATIC DUO SHUTTER FOR 1 TO ⅟₁₀₀ SEC., B., T. EXPOSURES.

(1207) **PLATE CAMERA.** C. 1916. SIZE 4 X 5 INCH EXPOSURES ON PLATES OR FILM PACKS. MENISCUS ACHROMATIC OR RAPID RECTILINEAR LENS. UNO SHUTTER.

(1208) **POCKET PLATE CAMERA.** C. 1916. FOUR SIZES OF THIS CAMERA FOR 3¼ X 4¼, 4 X 5, 3¼ X 5½, OR 5 X 7 INCH PLATE EXPOSURES. DOUBLE RAPID RECTILINEAR LENS. UNO SHUTTER.

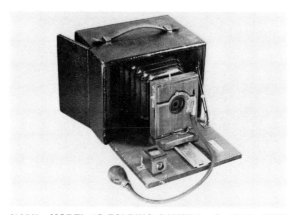

(1209) **MODEL 1C FOLDING CAMERA.** C. 1885. SIZE 4 X 5 INCH EXPOSURES ON PLATES. HOLLOW WOOD LENS BOARD. SINGLE PNEUMATIC SHUTTER. (HW)

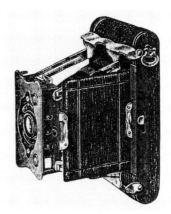

(1210) **NO. 1 JUNIOR FOLDING POCKET CAMERA.** C. 1921. SIZE 2¼ X 3¼ INCH EXPOSURES ON ROLL FILM. MENISCUS ACHROMATIC; RAPID RECTILINEAR; OR F 4.5, F 6.3, OR F 7.5 ANASTIGMAT LENS. SENECA TRIO SHUTTER; ⅟₂₅, ⅟₅₀, ⅟₁₀₀ SEC., B., T. OR OPTIMO SHUTTER. FIXED FOCUS.

(1211) **REVOLVING BACK PLATE CAMERA.** FIVE SIZES OF THIS CAMERA FOR 3¼ X 5½, 4¼ X 6½, 4 X 5, 5 X 7, OR 6½ X 8½ INCH EXPOSURES ON PLATES OR FILM PACKS WITH ADAPTER. SENECA CONVERTIBLE THREE-FOCUS LENS. SENECA AUTIC AUTOMATIC SHUTTER. TRIPLE EXTENSION BELLOWS. DROPPING BED.

(1212) **NO. 2A FOLDING SCOUT CAMERA.** C. 1917. SIZE 2½ X 4¼ INCH EXPOSURES ON ROLL FILM. MENISCUS ACHROMATIC OR RAPID RECTILINEAR LENS. DELTAX OR ILEX MARVEL SHUTTER; ⅟₂₅ TO ⅟₁₀₀ SEC., B., T. SIMILAR TO THE NO. 2 FOLDING SCOUT CAMERA.

**SENECA CAMERA MANUFACTURING COMPANY** (*cont.*)

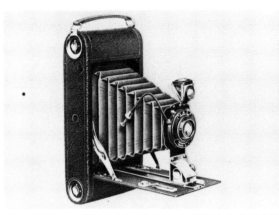

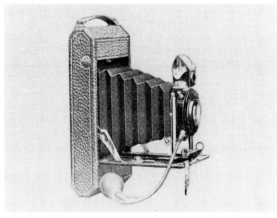

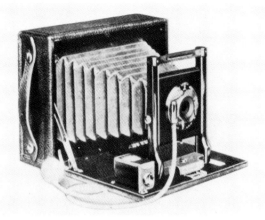

(1213) **NO. 2 FOLDING SCOUT CAMERA.** C. 1917. SIZE 2¼ X 3¼ INCH EXPOSURES ON ROLL FILM. MENISCUS ACHROMATIC OR RAPID RECTILINEAR LENS. TRIO SHUTTER; ⅕ TO ⅟₁₀₀ SEC., B., T. IRIS DIAPHRAGM.

(1214) **NO. 2C FOLDING SCOUT CAMERA.** C. 1917. SIZE 2⅞ X 4⅞ INCH EXPOSURES ON ROLL FILM. MENISCUS ACHROMATIC OR RAPID RECTILINEAR LENS. DELTAX OR ILEX MARVEL SHUTTER; ⅕ TO ⅟₁₀₀ SEC., B., T. SIMILAR TO THE NO. 2 FOLDING SCOUT CAMERA.

(1215) **NO. 3 FOLDING SCOUT CAMERA.** C. 1917. SIZE 3¼ X 4¼ INCH EXPOSURES ON ROLL FILM. MENISCUS ACHROMATIC OR RAPID RECTILINEAR LENS. AUTIC, TRIO, DELTAX, OR ILEX MARVEL SHUTTER. SIMILAR TO THE NO. 2 FOLDING SCOUT CAMERA.

(1216) **NO. 3A FOLDING SCOUT CAMERA.** C. 1917. SIZE 3¼ X 5½ INCH EXPOSURES ON ROLL FILM. MENISCUS ACHROMATIC OR RAPID RECTILINEAR LENS. DELTAX OR ILEX MARVEL SHUTTER; ⅕ TO ⅟₁₀₀ SEC., B., T. SIMILAR TO THE NO. 2 FOLDING SCOUT CAMERA.

(1217) **SEVEN-FIVE FOLDING SCOUT CAMERA.** C. 1917. MODELS 2A, 2C, 3, AND 3A FOR SIZE 2½ X 4¼, 2⅞ X 4⅞, 3¼ X 4¼, AND 3¼ X 5½ INCH EXPOSURES ON ROLL FILM, RESPECTIVELY. F 7.5 ANASTIGMAT LENS. GAMMAX AUTOMATIC, ILEX AUTOMATIC, BETAX AUTOMATIC, OR ILEX GENERAL SHUTTER. SIMILAR TO THE NO. 2 FOLDING SCOUT CAMERA.

(1218) **FOLDING POCKET SENCO NO. 1A (IMPROVED) CAMERA.** C. 1913. SIZE 2½ X 4¼ INCH EXPOSURES ON ROLL FILM. SIMILAR TO THE FOLDING POCKET SENCO NO. 1 (IMPROVED) CAMERA WITH THE SAME LENSES AND SHUTTERS.

(1219) **FOLDING POCKET SENCO NO. 3 (IMPROVED) CAMERA.** C. 1913. SIZE 3¼ X 4¼ INCH EXPOSURES ON ROLL FILM. SIMILAR TO THE FOLDING POCKET SENCO NO. 1 (IMPROVED) CAMERA WITH THE SAME LENSES AND SHUTTERS.

(1220) **FOLDING POCKET SENCO NO. 1 (IMPROVED) CAMERA.** C. 1913. SIZE 2¼ X 3¼ INCH EXPOSURES ON ROLL FILM. MENISCUS ACHROMATIC, RAPID RECTILINEAR, RAPID SYMMETRICAL (F 8) OR SENECA ANASTIGMAT (F 7.5) LENS. UNO AUTOMATIC (I., B., T.), DOUBLE PNEUMATIC DUO (1 TO ⅟₁₀₀ SEC., B., T.), OR AUTIC AUTOMATIC (1 TO ⅟₁₀₀ SEC., B., T.) SHUTTER.

(1221) **FOLDING POCKET SENCO NO. 3A (IMPROVED) CAMERA.** C. 1913. SIZE 3¼ X 5½ INCH EXPOSURES ON ROLL FILM. SIMILAR TO THE FOLDING POCKET SENCO NO. 1 (IMPROVED) CAMERA WITH THE SAME LENSES AND SHUTTERS.

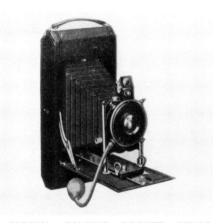

(1222) **SPECIAL FOLDING POCKET SENCO (IMPROVED) CAMERA.** C. 1913. FOUR SIZES OF THIS CAMERA FOR 2¼ X 3¼, 2½ X 4¼, 3¼ X 4¼, OR 3¼ X 5½ INCH EXPOSURES ON ROLL FILM. F 6.3 SENECA EXTRA RAPID ANASTIGMAT OR F 6.8 GOERZ DAGOR LENS. AUTIC SHUTTER; 1 TO ⅟₁₀₀ SEC., B., T. FOR THE 2¼ X 3¼ SIZE CAMERA. BAUSCH & LOMB COMPOUND OR OPTIMO SHUTTER; 1 TO ⅟₃₀₀ SEC., B., T. FOR THE OTHER LARGER SIZE CAMERAS.

(1223) **SENECA NO. 2 CAMERA.** C. 1905. TWO SIZES OF THIS CAMERA FOR 4 X 5 OR 5 X 7 INCH PLATE EXPOSURES. SAME AS THE SENECA NO. 1 CAMERA BUT WITH A RAPID RECTILINEAR LENS.

(1224) **SENECA NO. 1 CAMERA.** C. 1905. TWO SIZES OF THIS CAMERA FOR 4 X 5 OR 5 X 7 INCH PLATE EXPOSURES. SINGLE ACHROMATIC LENS. UNO SINGLE-SPEED, B., T. SHUTTER. RISING AND FALLING LENS MOUNT.

(1225) **SENECA NO. 3 CAMERA.** C. 1905. TWO SIZES OF THIS CAMERA FOR 4 X 5 OR 5 X 7 INCH PLATE EXPOSURES. SIMILAR TO THE SENECA NO. 1 CAMERA BUT WITH RAPID RECTILINEAR LENS AND DUO SHUTTER: 1 TO ⅟₁₀₀ SEC., B., T.

(1226) **SENECA NO. 4 CAMERA.** C. 1905. TWO SIZES OF THIS CAMERA FOR 4 X 5 OR 5 X 7 INCH PLATE EXPOSURES. RAPID RECTILINEAR LENS. UNO SHUTTER. RACK & PINION FOCUS. SIMILAR TO THE SENECA NO. 1 CAMERA.

(1227) **SENECA NO. 5 CAMERA.** C. 1905. TWO SIZES OF THIS CAMERA FOR 4 X 5 OR 5 X 7 INCH PLATE EXPOSURES. SAME AS THE SENECA NO. 4 CAMERA BUT WITH DUO SHUTTER; 1 TO ⅟₁₀₀ SEC., B., T.

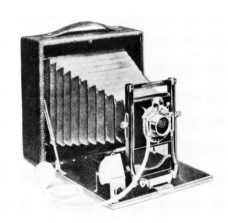

(1228) **SENECA NO. 6 CAMERA.** C. 1905. TWO SIZES OF THIS CAMERA FOR 4 X 5 OR 5 X 7 INCH PLATE EXPOSURES. RAPID RECTILINEAR LENS. UNO OR DUO SHUTTER. RISING AND FALLING LENS MOUNT. OPTIONAL RACK & PINION FOCUS. REVERSIBLE BACK.

## SENECA CAMERA MANUFACTURING COMPANY (*cont.*)

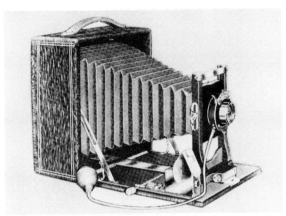

(1229) **SENECA CAMERA NO. 6.** C. 1913. FOUR SIZES OF THIS CAMERA FOR 3½ X 5½, 4 X 5, 4¼ X 6½, OR 5 X 7 INCH EXPOSURES ON PLATES OR FILM PACKS. RAPID RECTILINEAR LENS. UNO SINGLE OR DOUBLE PNEUMATIC SHUTTER; INSTANT, B., T.. RACK & PINION FOCUS. REVERSIBLE BACK. HINGED BED. GROUND GLASS FOCUSING.

(1230) **SENECA NO. 7 CAMERA.** C. 1905. TWO SIZES OF THIS CAMERA FOR 4 X 5 OR 5 X 7 INCH PLATE EXPOSURES. SAME AS THE SENECA NO. 6 CAMERA, C. 1905, BUT WITH SYMMETRICAL LENS AND SWING BACK.

(1231) **SENECA CAMERA NO. 7.** C. 1913. FOUR SIZES OF THIS CAMERA FOR 3¼ X 5½, 4 X 5, 4¼ X 6½, OR 5 X 7 INCH EXPOSURES ON PLATES OR FILM PACKS. F 8 SENECA SYMMETRICAL LENS. DUO SHUTTER; 1 TO ¹⁄₁₀₀ SEC., B., T. REVERSIBLE BACK. SWING BACK. DROPPING BED. RACK & PINION FOCUS. GROUND GLASS FOCUS. SIMILAR TO THE SENECA CAMERA NO. 6, C. 1913.

(1232) **SENECA NO. 8 CAMERA.** C. 1905. THREE SIZES OF THIS CAMERA FOR 4 X 5, 5 X 7, OR 6½ X 8½ INCH PLATE EXPOSURES. SIMILAR TO THE SENECA NO. 6 CAMERA, C. 1905, BUT WITH SENECA TRIPLE CONVERTIBLE LENS. AUTIC SHUTTER; 1 TO ¹⁄₁₀₀ SEC., B., T. RISING, FALLING, AND CROSSING LENS MOUNT. REVERSIBLE AND SWING BACK. RACK & PINION FOCUSING. DOUBLE EXTENSION BELLOWS.

(1233) **SENECA CAMERA NO. 8.** C. 1913. FIVE SIZES OF THIS CAMERA FOR 3¼ X 5½, 4 X 5, 4¼ X 6½, 5 X 7, OR 6½ X 8½ INCH EXPOSURES ON PLATES OR FILM PACKS. F 8 SENECA TRIPLE CONVERTIBLE SYMMETRICAL LENS. SENECA DUO OR AUTIC SHUTTER; 1 TO ¹⁄₁₀₀ SEC., B.,T. DOUBLE EXTENSION BELLOWS. REVERSIBLE BACK. SWING BACK. DROPPING BED. GROUND GLASS FOCUS. SIMILAR TO THE SENECA CAMERA NO. 6, C. 1913.

(1234) **SENECA NO. 9 CAMERA.** C. 1905. THREE SIZES OF THIS CAMERA FOR 4 X 5, 5 X 7, OR 6½ X 8½ INCH PLATE EXPOSURES. SAME AS THE SENECA NO. 8

CAMERA, C. 1905, BUT WITH TRIPLE EXTENSION BELLOWS.

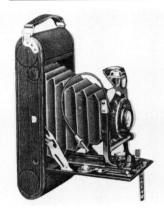

(1235) **SENECA CHIEF CAMERA.** C. 1917. MODELS 1A AND 2C FOR SIZE 2½ X 4¼ AND 2⅞ X 4⅞ INCH EXPOSURES ON ROLL FILM, RESPECTIVELY. F 8 RAPID SYMMETRICAL, F 7.5 OR F 6.3 ANASTIGMAT LENS. GAMMAX AUTOMATIC, ILEX MARVEL, BETAX, OPTIMO, ILEX ACME, OR ILEX GENERAL SHUTTER.

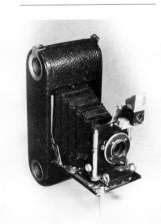

(1236) **NO. 1 SENECA FOLDING CAMERA.** C. 1916. SIZE 2¼ X 3¼ INCH EXPOSURES ON ROLL FILM. SENECA UNO SHUTTER; INSTANT, B., T. (DJ)

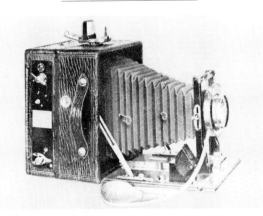

(1237) **SENECA PRESS CAMERA.** C. 1913. TWO SIZES OF THIS CAMERA FOR 4 X 5 OR 5 X 7 INCH EXPOSURES ON PLATES OR FILM PACKS. F 4.5 WOLLENSAK VELO-STIGMAT SERIES II OR F 4.5 ZEISS TESSAR ANASTIGMAT

SERIES 1C LENS. THE CAMERA HAS TWO SHUTTERS, A DOUBLE PNEUMATIC SENECA AUTIC AUTOMATIC SHUTTER FOR 1 TO ¹⁄₁₀₀ SEC., B., T. EXPOSURES AND A SENECA FOCAL PLANE SHUTTER FOR EXPOSURES TO ¹⁄₁₀₀₀ SEC. RACK & PINION FOCUS. REVERSIBLE BACK. SWING BACK. HINGED SWING BED. GROUND GLASS FOCUS.

(1238) **SENECA CAMERA NO. 9.** C. 1913. FIVE SIZES OF THIS CAMERA FOR 3¼ X 5½, 4 X 5, 4¼ X 6½, 5 X 7, OR 6½ X 8½ INCH EXPOSURES ON PLATES OR FILM PACKS. F 8 SENECA TRIPLE CONVERTIBLE OR F 6.3 SENECA ANASTIGMAT LENS. SENECA AUTIC SHUTTER; 1 TO ¹⁄₁₀₀ SEC., B., T. RACK & PINION FOCUS. REVERS-IBLE BACK. SWING BACK. HINGED SWING BED. TRIPLE EXTENSION BELLOWS. GROUND GLASS FO-CUS. SIMILAR TO THE SENECA CAMERA NO. 6, C. 1913.

(1239) **NO. 1 SENECA SAGAMORE CAMERA.** C. 1917. SIZE 2¼ X 3¼ INCH EXPOSURES ON ROLL FILM. F 6.3 OR F 4.5 ANASTIGMAT OR BAUSCH & LOMB TES-SAR LENS. ALSO, F 7.5 ANASTIGMAT LENS. BETAX, ILEX GENERAL, OPTIMO, OR ILEX ACME SHUTTER.

(1240) **NO. 2 SENECA SAGAMORE CAMERA.** C. 1917. SIZE 2¼ X 3¼ INCH EXPOSURES ON ROLL FILM. F 7.5 ANASTIGMAT, SINGLE ACHROMATIC, OR RAPID RECTILINEAR LENS. DELTAX, ILEX MARVEL, GAMMAX, BETAX, OR ILEX GENERAL SHUTTER.

(1241) **SENECA SPECIAL CAMERA.** C. 1905. SIZE 5 X 7 INCH PLATE EXPOSURES. SENECA TRIPLE CON-

## SENECA CAMERA MANUFACTURING COMPANY *(cont.)*

VERTIBLE LENS. UNO SHUTTER. RISING AND FALLING LENS MOUNT. RACK & PINION FOCUSING. SIMILAR TO THE SENECA NO. 8 CAMERA, C. 1905, BUT WITH NICKEL PLATED TRIM.

(1242) **SENECA STEREOSCOPIC CAMERA.** C. 1905–13. SIZE 5 X 7 INCH STEREO EXPOSURES ON FILM PACKS OR PLATES. F 8 SENECA SYMMETRICAL LENSES. DUO SHUTTER; 1 TO 1/100 SEC., B., T. RACK & PINION FOCUSING. SWING BACK. RISING AND FALLING LENS MOUNT. GROUND GLASS FOCUS. THE CAMERA CAN BE CONVERTED TO TAKE REGULAR 5 X 7 INCH EXPOSURES.

(1243) **FILM SENECA CAMERA. MODEL F.** C. 1905. TWO SIZES OF THIS CAMERA FOR 3¼ X 4¼ OR 4 X 5 INCH EXPOSURES ON ROLL FILM. DOUBLE RAPID RECTILINEAR LENS. UNO VARIABLE-SPEED SHUTTER WITH B., T.

(1244) **FILM SENECA CAMERA. MODEL H.** C. 1905. TWO SIZES OF THIS CAMERA FOR 3¼ X 4¼ OR 4 X 5 INCH EXPOSURES ON ROLL FILM. SIMILAR TO THE FILM SENECA CAMERA, MODEL F, BUT WITH AUTIC SHUTTER; 1 TO 1/100 SEC., B., T. RACK & PINION FOCUSING.

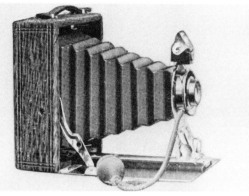

(1245) **POCKET SENECA NO. 29 CAMERA.** C. 1910. SIZE 4 X 5 INCH EXPOSURES ON FILM PACKS OR PLATES. MENISCUS ACHROMATIC OR RAPID RECTILINEAR LENS. SENECA PNEUMATIC UNO SHUTTER; INSTANT, B., T. IRIS DIAPHRAGM. GROUND GLASS FOCUSING.

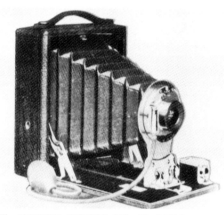

(1246) **POCKET SENECA NO. 30 CAMERA.** C. 1905. TWO SIZES OF THIS CAMERA FOR 3¼ X 4¼ OR 4 X 5 INCH PLATE EXPOSURES. RAPID RECTILINEAR OR SINGLE ACHROMATIC LENS. UNO SHUTTER; INSTANT, B., T.

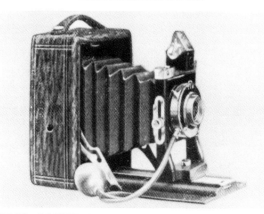

(1247) **POCKET SENECA NO. 30 CAMERA.** C. 1913. FOUR SIZES OF THIS CAMERA FOR 3¼ X 4¼, 3¼ X 5½, 4 X 5, OR 5 X 7 INCH EXPOSURES ON PLATES OR FILM PACKS. SINGLE ACHROMATIC, DOUBLE RAPID RECTILINEAR, OR F 8 RAPID SYMMETRICAL LENS. UNO (I., B., T.), DUO (1 TO 1/100 SEC., B., T.), OR AUTIC (1 TO 1/100 SEC., B., T.) SHUTTER. GROUND GLASS FOCUS.

(1248) **POCKET SENECA NO. 31 CAMERA.** C. 1905. TWO SIZES OF THIS CAMERA FOR 3¼ X 4¼ OR 4 X 5 INCH PLATE EXPOSURES. SAME AS THE POCKET SENECA NO. 30 CAMERA, C. 1905, BUT WITH RACK & PINION FOCUS AND DOUBLE EXTENSION BELLOWS.

(1249) **POCKET SENECA NO. 31 CAMERA.** C. 1913. FOUR SIZES OF THIS CAMERA FOR 3¼ X 4¼, 3¼ X 5½, 4 X 5, OR 5 X 7 INCH EXPOSURES ON PLATES OR FILM PACKS. SAME AS THE POCKET SENECA NO. 30 CAMERA, C. 1913, BUT WITH RACK & PINION FOCUSING AND DOUBLE EXTENSION BELLOWS. ALSO, THIS MODEL DOES NOT HAVE THE SINGLE ACHROMATIC LENS.

(1250) **POCKET SENECA NO. 32 CAMERA.** C. 1913. FOUR SIZES OF THIS CAMERA FOR 3¼ X 4¼, 3¼ X 5½, 4 X 5, OR 5 X 7 INCH EXPOSURES ON PLATES OR FILM PACKS. SENECA F 8 TRIPLE CONVERTIBLE LENS. UNO (I., B., T.) OR AUTIC (1 TO 1/100 SEC., B., T.) SHUTTER. DOUBLE EXTENSION BELLOWS. SWING BACK. GROUND GLASS FOCUSING. RACK & PINION FOCUSING. SIMILAR TO THE POCKET SENECA NO. 30 CAMERA, C. 1913.

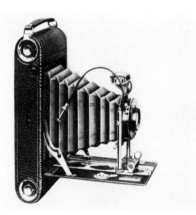

(1251) **NO. 1A ROLL FILM SENECA CAMERA.** C. 1917. SIZE 2½ X 4¼ INCH EXPOSURES. F 8 RAPID SYMMETRICAL OR MENISCUS ACHROMATIC LENS. DELTAX, ILEX MARVEL, BETAX, OR ILEX GENERAL SHUTTER.

(1252) **NO. 3 ROLL FILM SENECA CAMERA.** C. 1917. SIZE 3¼ X 4¼ INCH EXPOSURES. SIMILAR TO THE NO. 1A ROLL FILM SENECA CAMERA WITH THE SAME LENSES AND SHUTTER.

(1253) **NO. 3A ROLL FILM SENECA CAMERA.** C. 1917. SIZE 3¼ X 5½ INCH EXPOSURES. SIMILAR TO THE NO. 1A ROLL FILM SENECA CAMERA WITH THE SAME LENSES AND SHUTTER.

(1254) **SEVEN-FIVE ROLL FILM SENECA CAMERA.** C. 1917. MODELS 1A, 3, AND 3A FOR SIZE 2½ X 4¼, 3¼ X 4¼, AND 3¼ X 5½ INCH EXPOSURES, RESPECTIVELY. SIMILAR TO THE NO. 1A ROLL FILM SENECA CAMERA WITH THE SAME LENS AND SHUTTERS AS THE SEVEN-FIVE FOLDING SCOUT CAMERA.

(1255) **SIX-THREE ROLL FILM SENECA CAMERA.** C. 1917. MODELS 1A, 3, AND 3A FOR SIZE 2½ X 4¼,

## SENECA CAMERA MANUFACTURING COMPANY (cont.)

3¼ X 4¼, AND 3¼ X 5½ INCH EXPOSURES, RESPECTIVELY. F 6.3 EXTRA RAPID ANASTIGMAT OR F 6.3 BAUSCH & LOMB TESSAR SERIES IIB LENS. OPTIMO OR ILEX ACME SHUTTER; 1 TO 1/300 SEC., B., T. SIMILAR TO THE NO. 1A ROLL FILM SENECA CAMERA.

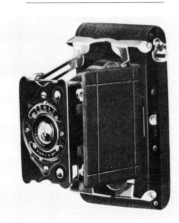

(1256) **LITTLE INDIAN VEST POCKET CAMERA.** C. 1917–21. SIZE 1⅝ X 2½ INCH EXPOSURES ON ROLL FILM. MENISCUS ACHROMATIC, RAPID RECTILINEAR, OR F 7.5 OR F 6.3 ANASTIGMAT LENS. SENECA TRIO, ILEX MARVEL, OR DELTAX SHUTTER; 1/25 TO 1/100 SEC., B., T. IRIS DIAPHRAGM.

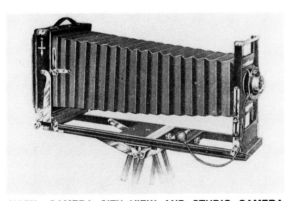

(1257) **CAMERA CITY VIEW AND STUDIO CAMERA.** C. 1913. SIX SIZES OF THIS CAMERA FOR 5 X 7, 6½ X 8½, 8 X 10, 11 X 14, 14 X 17, OR 17 X 20 INCH EXPOSURES ON PLATES. SENECA THREE-FOCUS CONVERTIBLE SYMMETRICAL (F 8), SENECA ANASTIGMAT (F 6.3), GOERZ DAGOR SERIES III (F 6.8), ZEISS TESSAR 1C (F 4.5), OR COOKE SERIES IV (F 5.6) LENS. SENECA DUO, AUTO AUTOMATIC, AUTIC AUTOMATIC, SENECA FOCAL PLANE, OPTIMO, SECTOR, VOLUTE, OR COMPOUND SHUTTER. RACK & PINION FOCUS. CENTER SWING BACK. REVERSIBLE BACK. HALF PLATE AND QUARTER PLATE FOCAL PLANE DIVISION. SOME MODELS WITH A HORIZONTAL SLIDING BED.

(1258) **CAMERA CITY VIEW AND STUDIO CAMERA.** C. 1917. FOUR SIZES OF THIS CAMERA FOR 5 X 7, 6½ X 8½, 8 X 10, OR 11 X 14 INCH PLATE EXPOSURES. F 8 THREE-FOCUS CONVERTIBLE SYMMETRICAL LENS. BETAX OR ILEX UNIVERSAL SHUTTER. SIMILAR

TO THE CAMERA CITY VIEW AND STUDIO CAMERA OF 1913.

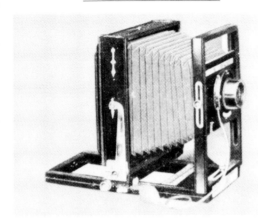

(1259) **COMPETITOR VIEW CAMERA.** C. 1913–17. THREE SIZES OF THIS CAMERA FOR 5 X 7, 6½ X 8½, OR 8 X 10 INCH PLATE EXPOSURES. F 8 RAPID SYMMETRICAL, RAPID RECTILINEAR, OR TRIPLE CONVERTIBLE LENS. UNO, DUO, AUTIC AUTOMATIC, BETAX, OR ILEX UNIVERSAL SHUTTER. CENTER SWING BACK. RACK & PINION FOCUS. REVERSIBLE BACK. SOME MODELS WITH HORIZONTAL SLIDING BED.

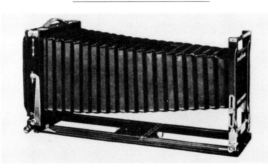

(1260) **NEW IMPROVED SENECA VIEW CAMERA.** C. 1905. SEVEN SIZES OF THIS CAMERA FOR 5 X 7, 5 X 8, 6½ X 8½, 8 X 10, 11 X 14, 14 X 17, OR 17 X 20 INCH PLATE EXPOSURES. HORIZONTAL AND VERTICAL SWING BACK. REVERSIBLE BACK. RACK & PINION FOCUS. RISING AND FALLING LENS MOUNT. RAPID RECTILINEAR OR TRI-FOCUS CONVERTIBLE LENS. AUTOMATIC OR DUO SHUTTER.

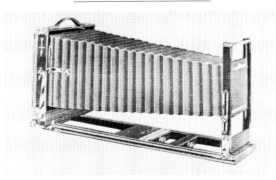

(1261) **NEW IMPROVED SENECA VIEW CAMERA.** C. 1913–17. FOUR SIZES OF THIS CAMERA FOR 5 X 7, 6½ X 8½, 8 X 10, OR 11 X 14 INCH PLATE EXPOSURES. RAPID RECTILINEAR, F 8 SENECA THREE-FOCUS CONVERTIBLE SYMMETRICAL, F 8 SENECA ANASTIGMAT, F

6.3 VELOSTIGMAT, F 6.8 GOERZ DAGOR SERIES III, F 5.5 GOERZ CELOR, F 4.5 COOKE SERIES IV, OR SENECA ANASTIGMAT SERIES II LENS. DUO AUTIC AUTOMATIC, FOCAL PLANE, SECTOR VOLUTE, OR COMPOUND SHUTTER. CENTER SWING BACK. REVERSIBLE BACK. RACK & PINION FOCUS. HALF-PLATE FOCAL PLANE DIVISION. SOME MODELS WITH HORIZONTAL SLIDING BED.

## SEROCO

NOTE: SEROCO CAMERAS WERE SOLD BY SEARS, ROEBUCK & COMPANY AND WERE MANUFACTURED FOR THEM BY DIFFERENT CAMERA MANUFACTURERS.

(1262) **DELMAR PLATE BOX CAMERA.** C. 1902. TWO SIZES OF THIS CAMERA FOR 3¼ X 4¼ OR 4 X 5 INCH PLATE EXPOSURES.

(1263) **MAGAZINE PLATE CAMERA.** C. 1902. SIZE 4 X 5 INCH EXPOSURES ON PLATES. THE CAMERA HOLDS 12 PLATES. SINGLE ACHROMATIC LENS.

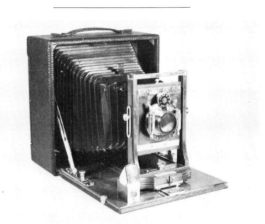

(1264) **PREMO TYPE CAMERA.** C. 1900. TWO SIZES OF THIS CAMERA FOR 4 X 5 OR 5 X 7 INCH EXPOSURES ON PLATES. WOLLENSAK DOUBLE PNEUMATIC SHUTTER. (SW)

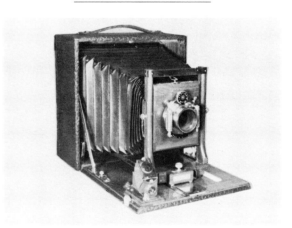

(1265) **PREMO TYPE FOLDING PLATE CAMERA.** C. 1905. SIZE 6½ X 8½ INCH EXPOSURES. WOLLENSAK SYMMETRICAL LENS. SHUTTER SPEEDS FROM 1 TO 1/100 SEC. (SW)

## SEROCO *(cont.)*

(1266) **STEREO PLATE CAMERA.** C. 1905. SIZE 5 X 7 INCH STEREO EXPOSURES ON PLATES. WOLLENSAK LENSES. THE CAMERA HAS AN OPTIONAL LENS BOARD FOR TAKING SINGLE 5 X 7 INCH EXPOSURES.

## SEWARD, J. H. COMPANY

(1267) **PRACTICAL HAND CAMERA.** C. 1895. PLATE EXPOSURES. ROLLER-BLIND SHUTTER.

## SMITH, C. R. & COMPANY

(1268) **PATENT MONOCULAR DUPLEX CAMERA.** C. 1884. FIRST SINGLE-LENS REFLEX CAMERA MANUFACTURED IN THE UNITED STATES. TWO SIZES OF THIS CAMERA FOR 3¼ X 4¼ OR 4 X 5 INCH PLATE EXPOSURES. F 5.6 SMITH & COMPANY RAPID RECTILINEAR LENS. VARIABLE-SPEED (BY ADJUSTING TENSION) GUILLOTINE SHUTTER. (MA)

(1269) **PATENT MONOCULAR DUPLEX CAMERA.** C. 1885–90. SINGLE LENS REFLEX CAMERA. TWO SIZES OF THIS CAMERA FOR 4 X 5 OR 4¼ X 6½ INCH EXPOSURES ON PLATES. A ROLL FILM HOLDER WAS AVAILABLE IN 1887.

## SMITH, J. H.

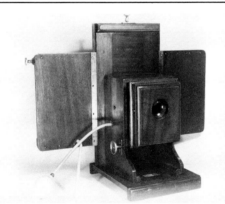

(1270) **MULTIPLYING CAMERA.** C. 1902. SIZE 5 X 7 INCH PLATE EXPOSURES. INTERNAL FLAP SHUTTER. (SW)

## SPECTRA PHOTO PRODUCTS

(1271) **SPECTRA COLOR CAMERA.** C. 1940. SIZE 2¼ X 3¼ INCH EXPOSURES ON PLATES OR CUT FILM. 4¼ INCH/F 4.5 WOLLENSAK VELOSTIGMAT LENS. BETAX SHUTTER; ½ TO ¹⁄₁₀₀ SEC., B., T. GROUND GLASS FOCUSING. FOCUSING ALSO BY REFLEX THROUGH THE TOP OF THE CAMERA. ALL STEEL BODY. SINGLE EXTENSION BELLOWS.

## STANDIFORD, J. F.

(1272) **SUNFLOWER MULTIPLYING WING-TYPE STUDIO CAMERA.** C. 1889. SIZE 5 X 7 INCH EXPOSURES (MAXIMUM) ON 6½ X 8½ INCH PLATES. LOW SHUTTER NO. 5.

## STAR CAMERA COMPANY

(1273) **STAR PANORAMIC CAMERA.** C. 1904. SIZE 12 X 24 INCH EXPOSURES ON FILM IN A FLEXIBLE PLATE HOLDER. 14 INCH/F 8 MORRISON LENS. RISING LENS MOUNT. (MA)

## STIRN, C. P. (NEW YORK)

(1274) **VEST DETECTIVE CAMERA NO. 1.** C. 1886–92. IMPROVED MODEL OF THE R. D. GRAY VEST CAMERA. THE CAMERA WAS WORN UNDER A MAN'S VEST FOR CONCEALMENT. SIX 1¾ INCH DIAMETER EXPOSURES ON A 5½ INCH DIAMETER DRY PLATE. 1⅝ INCH/F 11 FIXED FOCUS LENS. INSTANT ROTARY SHUTTER.

(1275) **VEST DETECTIVE CAMERA NO. 2.** C. 1886–90. IMPROVED MODEL OF THE R. D. GRAY VEST CAMERA. SAME AS THE STIRN VEST CAMERA NO. 1 EXCEPT THE CAMERA TAKES FOUR 2½ INCH DIAMETER EXPOSURES ON A 6½ INCH DIAMETER DRY PLATE.

(1276) **WONDER PANORAMIC CAMERA.** C. 1891. SIZE 3¼ X 18 INCH EXPOSURES.

## STOCK, JOHN & COMPANY

(1277) **STEREOSCOPIC CAMERA.** C. 1864. SIZE 4½ X 8½ INCH STEREO EXPOSURES ON COLLODION WET PLATES. 8 INCH/F 5.5 HARRISON PETZVAL LENS. LENS-CAP TYPE SHUTTER.

(1278) **STEREOSCOPIC CAMERA.** C. 1880. SIZE 4 X 8 INCH STEREO PLATE EXPOSURES. 120 MM/F 9 VOIGTLANDER LENSES. FLAP SHUTTER. (MA)

(1279) **VIEW CAMERA.** C. 1862. SIZE 6½ X 8½ INCH EXPOSURES ON WET COLLODION PLATES. HOLMES, BOOTH & HAYDEN LENS. LENS-CAP SHUTTER.

(1280) **VIEW CAMERA.** C. 1863. SIZE 10 X 10 INCH EXPOSURES ON WET COLLODION PLATES. LENS-CAP SHUTTER. BELLOWS-TYPE VIEW CAMERA.

## SUNART PHOTO COMPANY

(1281) **JUNIOR BOX CAMERA.** C. 1898. SIZE 3½ X 3½ INCH EXPOSURES ON PLATES. THE CAMERA HOLDS 12 PLATES. ACHROMATIC LENS. INSTANT AND TIME SHUTTER.

(1282) **JUNIOR NO. 1 BOX CAMERA.** C. 1898. SIZE 3¼ X 4¼ INCH EXPOSURES ON PLATES. THE CAMERA HOLDS SIX PLATES. ACHROMATIC LENS. INSTANT AND TIME SHUTTER WITH THREE APERTURE STOPS.

(1283) **JUNIOR SPECIAL BOX CAMERA.** C. 1898. SIZE 3½ X 3½ INCH EXPOSURES ON PLATES. THIS CAMERA IS THE SAME AS THE JUNIOR BOX CAMERA EXCEPT IT HAS A RAPID RECTILINEAR OR ZEISS ANASTIGMAT (WITH IRIS DIAPHRAGM) LENS.

(1284) **JUNIOR NO. 1 SPECIAL BOX CAMERA.** C. 1898. SIZE 3¼ X 4¼ INCH EXPOSURES ON PLATES. THIS CAMERA IS THE SAME AS THE JUNIOR NO. 1 BOX CAMERA EXCEPT IT HAS A RAPID RECTILINEAR OR ZEISS ANASTIGMAT (WITH IRIS DIAPHRAGM) LENS.

(1285) **MAGAZINE BOX CAMERA.** C. 1898. SIZE 4 X 5 INCH EXPOSURES ON SHEET FILM. THE CAMERA HOLDS 24 FILM SHEETS. BAUSCH & LOMB LENS. INTERNAL BELLOWS WITH EXTERNAL FOCUS KNOB.

(1286) **CYCLE VICI NO. 1 CAMERA.** C. 1898. TWO SIZES OF THIS CAMERA FOR 4 X 5 OR 5 X 7 INCH EXPOSURES ON PLATES OR ROLL FILM. THIS CAMERA IS THE SAME AS THE CYCLE VICI MODEL FOR SIZE 4 X 5 INCH EXPOSURES EXCEPT THE OVERALL DIMENSIONS ARE SMALLER.

## SUNART PHOTO COMPANY (cont.)

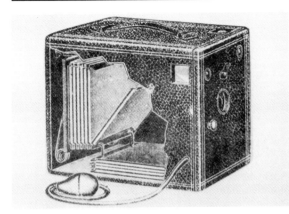

**(1267) VICI MAGAZINE BOX CAMERA.** C. 1900. SIZE 4 X 5 INCH EXPOSURES ON PLATES OR SHEET FILM. ACHROMATIC LENS. IMPROVED PNEUMATIC SHUTTER.

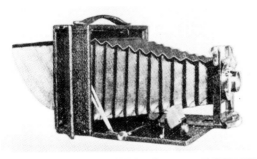

**(1288) CYCLE VICI CAMERA.** C. 1898. THREE SIZES OF THIS CAMERA FOR 4 X 5, 5 X 7, OR 6½ X 8½ INCH EXPOSURES ON PLATES OR ROLL FILM. THE CAMERA HOLDS SIX PLATES OR A ROLL HOLDER. VICI RAPID RECTILINEAR LENS. DOUBLE PNEUMATIC AND FINGER RELEASE BAUSCH & LOMB UNICUM SHUTTER; 1 TO ⅟₁₀₀ SEC., B., T. IRIS DIAPHRAGM. THE BACK DOOR WITH SIDE CURTAINS OPENS FOR GROUND GLASS FOCUSING. DOUBLE EXTENSION BELLOWS. RACK & PINION FOCUSING.

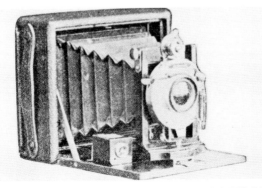

**(1289) CYCLE VIDI CAMERA.** C. 1898. TWO SIZES OF THIS CAMERA FOR 4 X 5 OR 5 X 7 INCH EXPOSURES ON PLATES OR ROLL FILM. THIS CAMERA IS THE SAME AS THE CYCLE VICI CAMERA EXCEPT IT HAS A CENTRAL SLIDE FOR THE LENS BOARD INSTEAD OF

RACK & PINION AND THE SHUTTER DOES NOT HAVE THE BULB AND TIME FEATURE.

**(1290) CYCLE VIDI NO. 1 CAMERA.** C. 1898. TWO SIZES OF THIS CAMERA FOR 4 X 5 OR 5 X 7 INCH EXPOSURES ON PLATES OR ROLL FILM. THIS CAMERA IS THE SAME AS THE CYCLE VIDI CAMERA EXCEPT IT HAS AN ACHROMATIC LENS INSTEAD OF A RAPID RECTILINEAR LENS.

**(1291) CYCLE VIDI NO. 2 CAMERA.** C. 1899. SIZE 4 X 5 INCH EXPOSURES. SINGLE ACHROMATIC LENS.

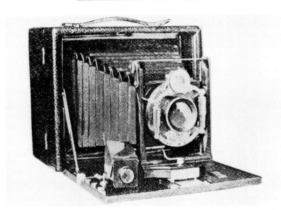

**(1292) VICI CAMERA.** C. 1898. THREE SIZES OF THIS CAMERA FOR 4 X 5, 5 X 7, OR 6½ X 8½ INCH EXPOSURES ON PLATES. BAUSCH & LOMB RAPID RECTILINEAR LENS. DOUBLE PNEUMATIC AND FINGER RELEASE BAUSCH & LOMB UNICUM SHUTTER; 1 TO ⅟₁₀₀ SEC., B., T. OR BAUSCH & LOMB DOUBLE PNEUMATIC SHUTTER; 5 TO ⅟₁₀₀ SEC. IRIS DIAPHRAGM WITH BOTH SHUTTERS. DOUBLE SWING BACK. GROUND GLASS FOCUS. RACK & PINION FOCUSING.

**(1293) VICI NO. 1 CAMERA.** C. 1898. TWO SIZES OF THIS CAMERA FOR 4 X 5 OR 5 X 7 INCH EXPOSURES ON PLATES OR ROLL FILM. THE CAMERA HOLDS SIX PLATES OR A ROLL HOLDER. VICI RAPID RECTILINEAR LENS. DOUBLE PNEUMATIC AND FINGER RELEASE BAUSCH & LOMB UNICUM SHUTTER; 1 TO ⅟₁₀₀ SEC., B., T. IRIS DIAPHRAGM. DOUBLE EXTENSION BELLOWS. CENTER SWING BACK. GROUND GLASS FOCUS. RACK & PINION FOCUSING. SIMILAR TO THE VICI CAMERA.

**(1294) VICI SPECIAL CAMERA.** C. 1898. THREE SIZES OF THIS CAMERA FOR 4 X 5, 5 X 7, OR 6½ X 8½ INCH PLATE EXPOSURES. THIS CAMERA IS THE SAME AS THE VICI CAMERA EXCEPT THE LENS IS A ZEISS ANASTIGMAT SERIES IIA AND THE SHUTTER IS A DOUBLE PNEUMATIC BAUSCH & LOMB DIAPHRAGM SHUTTER; 5 TO ⅟₁₀₀ SEC.

**(1295) VIDI NO. 1 CAMERA.** C. 1898. TWO SIZES OF THIS CAMERA FOR 4 X 5 OR 5 X 7 INCH EXPOSURES ON PLATES OR ROLL FILM. THIS CAMERA IS THE SAME AS THE VIDI CAMERA EXCEPT IT HAS AN ACHROMATIC LENS INSTEAD OF A RAPID RECTILINEAR LENS.

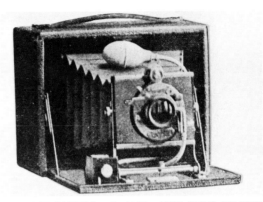

**(1296) VIDI CAMERA.** C. 1898. TWO SIZES OF THIS CAMERA FOR 4 X 5 OR 5 X 7 INCH EXPOSURES ON PLATES OR ROLL FILM. RAPID RECTILINEAR LENS. PNEUMATIC AND FINGER RELEASE SAFETY SHUTTER WITH IRIS DIAPHRAGM. CENTRAL SLIDE FOR THE LENS BOARD INSTEAD OF RACK & PINION. CENTER SWING BACK. GROUND GLASS FOCUS.

## TEDDY CAMERA COMPANY

**(1297) TEDDY BOX CAMERA. MODEL A.** C. 1924. SIZE 2 X 3½ INCH EXPOSURES ON POSITIVE PAPER CARDS. MENISCUS LENS. A DEVELOPING TANK ATTACHES TO THE BOTTOM OF THE CAMERA. (MA)

## THOMPSON, W. J. COMPANY

**(1298) COMBINATION STREET CAMERA.** WOLLENSAK LENS AND SHUTTER.

## THORNWARD

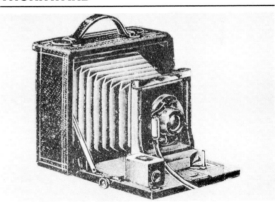

**(1299) PREMIUM FOLDING CAMERA.** C. 1903. SIZE 4 X 5 INCH PLATE EXPOSURES.

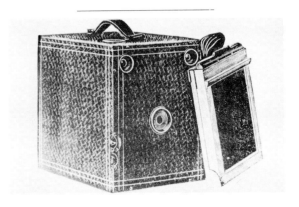

## THORNWARD (cont.)

(1300) **RELIANCE BOX CAMERA.** C. 1903. SIZE 4 X 5 INCH PLATE EXPOSURES.

## TISDELL & WHITTELSEY

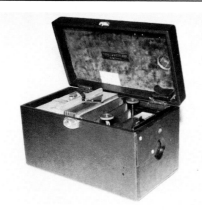

(1301) **DETECTIVE BOX CAMERA.** C. 1888. SIZE 3¼ X 4¼ INCH EXPOSURES ON DRY PLATES. 4½ INCH/F 12 ACHROMATIC MENISCUS LENS. NON-SELF-CAPPING PIVOTING SECTOR SHUTTER; FIVE SPEEDS AND TIME EXPOSURES. THE WAIST-LEVEL REFLECTOR FINDER ON TOP OF THE CAMERA IS HIDDEN BY THE LEATHER HANDLE. (GE)

## TISDELL CAMERA MANUFACTURING COMPANY

(1302) **TISDELL HAND CAMERA.** C. 1893. SIZE 4 X 5 INCH EXPOSURES ON PLATES OR SHEET FILM. TISDELL LENS. WATERHOUSE STOPS.

## TURRET CAMERA COMPANY

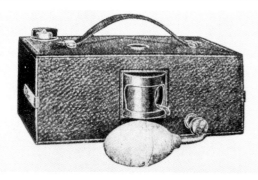

(1303) **TURRET PANORAMIC CAMERA.** C. 1904. SIZE 4 X 10 INCH PANORAMIC EXPOSURES. FOCAL PLANE SHUTTER.

## U.S. CAMERA COMPANY

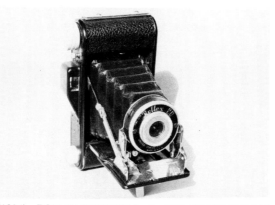

(1304) **ROLLEX 20 CAMERA.** 1/50 SEC. AND TIME SHUTTER. (KC)

## ULCA CAMERA CORPORATION

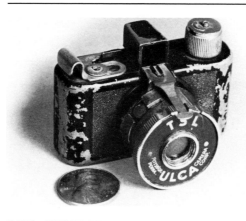

(1305) **MINIATURE NOVELTY CAMERA.** C. 1938. SIZE ¾ X ¾ INCH EXPOSURES ON ROLL FILM. ACHROMATIC LENS. TWO-SPEED AND TIME SHUTTER. (MR)

## UNEXCELLED CAMERA & SUPPLY COMPANY

(1306) **MYSTIC NO. 2 BOX CAMERA.** C. 1899. SIZE 3½ X 3½ INCH EXPOSURES. INSTANT AND TIME SHUTTER.

(1307) **MYSTIC NO. 6 BOX CAMERA.** C. 1899. SIZE 3¼ X 4¼ INCH PLATE EXPOSURES. INSTANT AND TIME SHUTTER.

(1308) **MYSTIC NO. 7 BOX CAMERA.** C. 1899. SIZE 4 X 5 INCH PLATE EXPOSURES. INSTANT AND TIME SHUTTER.

## UNIVERSAL CAMERA CORPORATION

(1309) **ROAMER I CAMERA.** C. 1938. SIZE 2¼ X 3¼ INCH EXPOSURES ON NO. 620 ROLL FILM. F 11 LENS. SINGLE-SPEED SHUTTER.

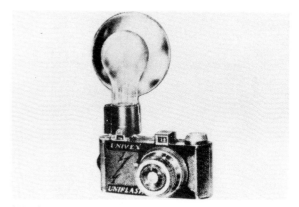

(1310) **UNIFLASH MODEL SC CAMERA.** C. 1940. SIZE 1⅛ X 1½ INCH EXPOSURES ON NO. 00 ROLL FILM. 60 MM VITAR MENISCUS LENS. UNIVEX ROTARY SHUTTER; 1/60 SEC., B. BUILT-IN FLASH SYNC. DETACHABLE FLASH UNIT.

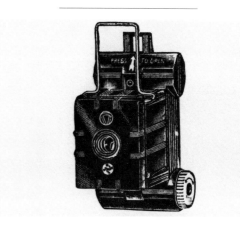

(1311) **UNIVEX BOX MODEL CAMERA.** C. 1936. SIZE 1⅛ X 1½ INCH EXPOSURES ON ROLL FILM.

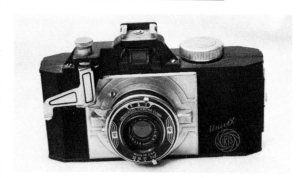

(1312) **UNIVEX IRIS CAMERA.** C. 1938. SIZE 1⅛ X 1½ INCH EXPOSURES ON NO. 00 ROLL FILM. 50 MM/F 7.9 VITAR LENS. ILEX SHUTTER; INSTANT, B., T. (TS)

(1313) **UNIVEX IRIS DELUXE CAMERA.** C. 1940. SIZE 1⅛ X 1½ INCH EXPOSURES ON NO. 00 ROLL FILM. SIMILAR TO THE UNIVEX IRIS CAMERA (C. 1940) WITH THE SAME LENS AND SHUTTER BUT WITH CHROME FINISH.

(1314) **UNIVEX IRIS FLASH DELUXE CAMERA.** C. 1940. SIZE 1⅛ X 1½ INCH EXPOSURES ON NO. 00 ROLL FILM.

## UNIVERSAL CAMERA CORPORATION (*cont.*)

SIMILAR TO THE UNIVEX IRIS DELUXE CAMERA WITH THE SAME LENS AND SHUTTER BUT WITH BUILT-IN FLASH SYNC.

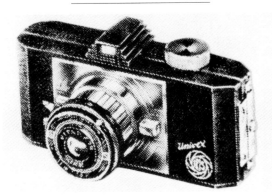

**(1315)  UNIVEX IRIS CAMERA.**  C. 1940.  SIZE 1⅛ X 1½ INCH EXPOSURES ON NO. 00 ROLL FILM.  50 MM/F 7.9 VITAR LENS.  INSTANT, B., T. SHUTTER.  MANUAL FOCUSING.

**(1316)  UNIVEX IRIS FLASH STANDARD CAMERA.** C. 1940.  SIZE 1⅛ X 1½ INCH EXPOSURES ON NO. 00 ROLL FILM.  SIMILAR TO THE UNIVEX IRIS CAMERA (C. 1940) WITH THE SAME LENS AND SHUTTER BUT WITH BUILT-IN FLASH SYNC.

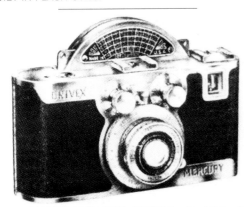

**(1317)  UNIVEX MERCURY CAMERA.**  C. 1939.  FIRST MERCURY MODEL.  THIRTY-SIX EXPOSURES, SIZE 18 X 24 MM ON NO. 200 ROLL FILM.  F 3.5 TRICOR LENS. METAL ROTARY FOCAL PLANE SHUTTER; ½₀ TO ⅟₁₀₀₀ SEC., B., T.  AUTOMATIC FILM TRANSPORT.  PARALLAX ADJUSTMENT.  HELICAL FOCUS.  FLASH SYNC.

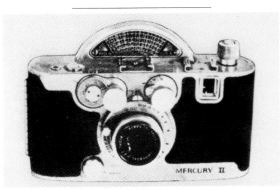

**(1318)  UNIVEX MERCURY II CAMERA.**  C. 1940. SIZE 18 X 24 MM EXPOSURES ON ROLL FILM.  35 MM/ F 2.7 OR F 2.0 TRICOR LENS.  METAL ROTARY FOCAL PLANE SHUTTER; ½₀ TO ⅟₁₀₀₀ SEC., T.  AUTOMATIC FILM TRANSPORT.  PARALLAX ADJUSTMENT.  HELICAL FOCUS.  FLASH SYNC.  (HA)

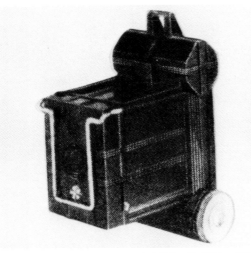

**(1319)  UNIVEX MODEL A CAMERA.**  C. 1939.  SIZE 1⅛ X 1½ INCH EXPOSURES ON NO. 00 ROLL FILM.  F 16 LENS.  ROTARY SHUTTER; ⅟₆₀ SEC.

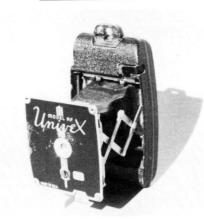

**(1320)  UNIVEX MODEL AF CAMERA.**  C. 1936.  SIZE 1⅛ X 1½ INCH EXPOSURES ON NO. 00 ROLL FILM.  INSTANT AND TIME ROTARY SHUTTER.  (KC)

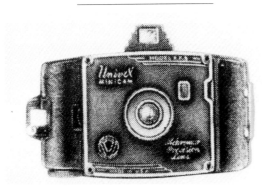

**(1321)  UNIVEX MODEL AF-5 CAMERA.**  C. 1940. SIZE 1⅛ X 1½ INCH EXPOSURES ON NO. 00 ROLL FILM.

FIXED FOCUS ACHROMAT LENS.  ROTARY SHUTTER; ⅟₅₀ SEC., T.

**(1322)  UNIVEX NORTON CAMERA.**  C. 1940.  SIX EXPOSURES SIZE 1⅛ X 1½ INCH ON NO. 00 ROLL FILM. F 16 LENS.  SINGLE-SPEED ROTARY SHUTTER. SIMILAR TO THE UNIVEX MODEL A CAMERA.

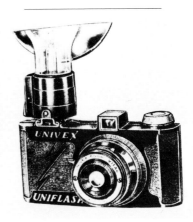

**(1323)  UNIVEX UNIFLASH CAMERA.**  C. 1940.  SIZE 1⅛ X 1½ INCH EXPOSURES ON ROLL FILM.  60 MM VITAR LENS.  UNIVERSAL SHUTTER.  DETACHABLE FLASH UNIT.

**(1324)  UNIVEX ZENITH FLASH CAMERA.**  C. 1940. SIZE 1⅛ X 1½ INCH EXPOSURES ON NO. 00 ROLL FILM. SIMILAR TO THE UNIVEX ZENITH STANDARD CAMERA WITH THE SAME LENS AND SHUTTER BUT WITH BUILT-IN FLASH SYNC.

**(1325)  UNIVEX ZENITH STANDARD CAMERA.**  C. 1940. SIZE 1⅛ X 1½ INCH EXPOSURES ON NO. 00 ROLL FILM. F 4.5 UNIVEX ANASTIGMAT LENS.  BETWEEN-THE-LENS SHUTTER; ⅟₂₅ TO ⅟₂₀₀ SEC., B., T.  MANUAL FOCUS. BODY SHUTTER RELEASE.

## UTILITY MANUFACTURING COMPANY

**(1326)  FALCON-ABBEY CAMERA.**  C. 1940.  SIZE 2¼ X 3¼ INCH EXPOSURES ON NO. 120 OR B-2 ROLL FILM. 115 MM FALTAR LENS.  INSTANT AND TIME SHUTTER. BUILT-IN SYNCHRONIZED FLASH UNIT.

**(1329)  FALCON-FLEX CAMERA.**  C. 1940.  SIZE 2¼ X 2¼ INCH EXPOSURES ON NO. 120 OR B-2 ROLL FILM. F 7.7 ACHROMATIC OR FALTAR PRECISE LENS.  INSTANT AND TIME SHUTTER.  BRILLIANT REFLEX VIEWFINDER.

**(1332)  FALCON MINICAM SENIOR CAMERA.**  C. 1940. SIZE 1⅝ X 1¼ INCH EXPOSURES ON NO. 127 ROLL FILM. 50 MM MINIVAR LENS.  INSTANT AND TIME SHUTTER. BODY SHUTTER RELEASE.  ALUMINUM CONSTRUCTION.

**(1327)  FALCON AUTOMATIC FOLDING CAMERA.** C. 1936.  SIZE 2¼ X 3¼ INCH EXPOSURES ON NO. 120 OR B-2 ROLL FILM.  INSTANT AND TIME SHUTTER. THREE APERTURE STOPS.

**(1330)  FALCON JUNIOR FOLDING CAMERA.**  C. 1936. SIZE 1⅝ X 2½ INCH EXPOSURES ON NO. 127 ROLL FILM. INSTANT AND TIME SHUTTER.  (DJ)

**(1333)  FALCON SUPER-ACTION CAMERA.**  C. 1940. SIZE 1⅝ X 1¼ INCH EXPOSURES ON NO. 127 OR A-8 ROLL FILM.  F 4.5 LENS.  HIGH FIDELITY SHUTTER; ¹⁄₂₅ TO ¹⁄₂₀₀ SEC., B., T.  MODEL F WITHOUT EXPOSURE METER.  MODEL FE WITH BUILT-IN EXPOSURE METER.

**(1328)  FALCON NO. 4 AUTOMATIC FOLDING CAMERA.** C. 1940.  SIZE 2¼ X 3¼ INCH EXPOSURES ON NO. 120 OR B-2 ROLL FILM.  F 11 LENS.  INSTANT AND TIME SHUTTER.  THREE APERTURE STOPS.

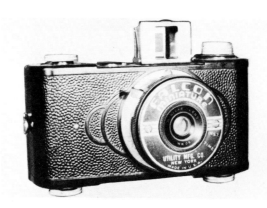

**(1331)  FALCON MINICAM JUNIOR CAMERA.**  C. 1940. SIZE 1⅝ X 1¼ INCH EXPOSURES ON NO. 127 ROLL FILM. 50 MM MINIVAR LENS.  INSTANT AND TIME SHUTTER. FIXED FOCUS.  (FL)

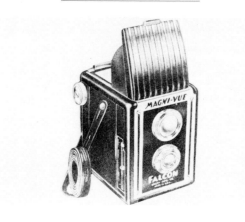

**(1334)  MAGNI-VUE  TWIN-LENS  REFLEX  CAMERA.** C. 1940.  SIZE 2¼ X 2¼ INCH EXPOSURES ON NO. 120 OR B2 ROLL FILM.  INSTANT AND TIME SHUTTER.

## UTILITY MANUFACTURING COMPANY (*cont.*)

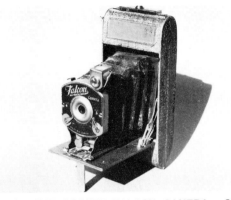

(1335) **VEST POCKET FALCON CAMERA.** C. 1936. SIZE 1⅝ X 2½ INCH EXPOSURES ON NO. 127 ROLL FILM. INSTANT AND TIME SHUTTER. THREE APERTURE STOPS. (KC)

## VIVE CAMERA COMPANY

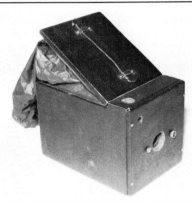

(1336) **NO. 1 VIVE BOX CAMERA. ORIGINAL MODEL.** C. 1897. SIZE 4¼ X 4¼ INCH EXPOSURES ON PLATES. THE CAMERA'S MAGAZINE HOLDS 12 PLATES. 6 INCH/ F 24 ACHROMATIC MENISCUS LENS. NON-SELF-CAPPING MUTSCHLER & ROBERTSON SECTOR SHUTTER FOR SINGLE SPEED EXPOSURES. A RUBBERIZED CLOTH SLEEVE EXTENDING FROM THE TOP REAR OF THE CAMERA ALLOWED THE PHOTOGRAPHER TO REACH INSIDE OF THE CAMERA TO POSITION PLATES FOR EXPOSURE. SHUTTER COCKING LEVER. (GE)

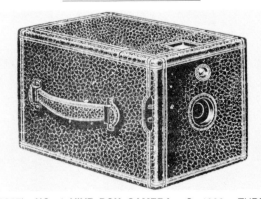

(1337) **NO. 1 VIVE BOX CAMERA.** C. 1899. THREE SIZES OF THIS CAMERA FOR 4¼ X 4¼, 4 X 5, OR 5 X

7 INCH EXPOSURES ON PLATES OR CUT FILM. SIMILAR TO THE NO. 1 VIVE BOX CAMERA, C. 1897, EXCEPT THE SHUTTER IS SELF-CAPPING WITH IRIS DIAPHRAGM.

---

(1338) **VIVE FOLDING CAMERA.** C. 1899.

---

(1339) **VIVE MAGAZINE CAMERA.** C. 1898. THE MAGAZINE HOLDS 12 PLATES. THE PLATES CAN BE CHANGED BY HAND USING THE BLACK CLOTH SLEEVE AT THE REAR OF THE CAMERA.

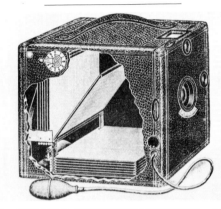

(1340) **VIVE M.P.C. MAGAZINE BOX CAMERA.** C. 1899. TWO SIZES OF THIS CAMERA FOR 4¼ X 4¼ (3¼ X 4¼ WITH MASK) OR 4 X 5 INCH EXPOSURES ON PLATES. INTERIOR BOX WITH RACK & PINION FOR FOCUSING. THE CAMERA'S MAGAZINE USES THE DROP-PLATE METHOD OF CHANGING PLATES. SELF-CAPPING SHUTTER.

---

(1341) **TOURIST VIVE CAMERA.** C. 1899. TWO SIZES OF THIS CAMERA FOR 4¼ X 4¼ OR 4 X 5 INCH EXPOSURES ON PLATES, CUT FILM, OR ROLL FILM.

---

(1342) **TWIN-LENS VIVE STEREO CAMERA.** C. 1899.

## WALKER MANUFACTURING COMPANY

(1343) **TAKIV BOX CAMERA.** C. 1892. SIZE 2½ X 2½ INCH EXPOSURES ON EACH OF FOUR PLATES MOUNTED IN FOUR QUADRANTS IN THE FOCAL PLANE OF THE CAMERA. THE LENS AND SHUTTER ARE MOUNTED ON A DISC THAT CAN BE ROTATED TO EXPOSE EACH OF THE FOUR PLATES SEPARATELY. SIMPLE MENISCUS LENS. ROTARY SHUTTER FOR TWO SPEEDS AND TIME EXPOSURES.

## WALKER, WILLIAM H. & COMPANY

(1344) **WALKER'S POCKET CAMERA.** C. 1881. SIZE 2¾ X 3¼ INCH EXPOSURES ON DRY PLATES. 3½ INCH/ F 7.7 ACHROMATIC MENISCUS LENS. GUILLOTINE DROP-SHUTTER (NOT SHOWN IN PHOTOGRAPH). (GE)

## WESTERN CAMERA MANUFACTURING COMPANY

(1345) **CYCLONE PLATE BOX CAMERA.** C. 1897. NON-MAGAZINE TYPE. SIZE 4 X 5 INCH EXPOSURES ON PLATES. THE CAMERA HAS A TOP REAR DOOR TO INSERT PLATE HOLDERS.

(1346) **CYCLONE SENIOR BOX CAMERA.** C. 1898. SIZE 4 X 5 INCH PLATE EXPOSURES. FIXED FOCUS SUPERIOR LENS. INSTANT AND TIME AUTOMATIC SHUTTER.

## WESTERN CAMERA MANUFACTURING COMPANY (*cont.*)

(1347) **NO. 1 MAGAZINE CYCLONE BOX CAMERA.** C. 1898–99. SIZE 2½ X 2½ INCH PLATE EXPOSURES. THE CAMERA HOLDS 12 PLATES. FIXED FOCUS ACHROMATIC COMBINATION LENS. SELF-COCKING SECTOR SHUTTER FOR SINGLE-SPEED AND TIME EXPOSURES. THE PLATES ARE INSERTED IN THE BACK OF THE CAMERA. AFTER A PLATE IS EXPOSED, A LEVER ON THE CAMERA IS MOVED CAUSING THE EXPOSED PLATE TO FALL FORWARD ON A PIVOT INTO THE BOTTOM OF THE CAMERA. AN UNEXPOSED PLATE IS THEN PUSHED INTO THE FOCAL PLANE BY A SPRING.

(1348) **NO. 2 MAGAZINE CYCLONE BOX CAMERA.** C. 1898–99. SIZE 3¼ X 4¼ INCH EXPOSURES ON PLATES. SIMILAR TO THE NO. 1 MAGAZINE CYCLONE BOX CAMERA.

(1349) **NO. 3 MAGAZINE CYCLONE BOX CAMERA.** C. 1898–99. SIZE 4 X 5 INCH EXPOSURES ON PLATES. THE MAGAZINE HOLDS 12 PLATES. THE MAGAZINE OPERATION IS SIMILAR TO THE NO. 1 MAGAZINE CYCLONE BOX CAMERA. (DG)

(1350) **NO. 4 IMPROVED MAGAZINE CYCLONE BOX CAMERA.** C. 1899. SIZE 3¼ X 4¼ INCH EXPOSURES ON PLATES. THE PLATE CHANGING MECHANISM OPERATES ON THE SAME PRINCIPLE AS DESCRIBED FOR THE NO. 1 MAGAZINE CYCLONE BOX CAMERA.

(1351) **NO. 5 CYCLONE MAGAZINE BOX CAMERA.** C. 1897. SIZE 4 X 5 INCH EXPOSURES ON PLATES.

(1352) **NO. 5 IMPROVED MAGAZINE CYCLONE BOX CAMERA.** C. 1899–1907. SIZE 4 X 5 INCH EXPOSURES ON PLATES. SIMILAR TO THE NO. 4 IMPROVED MAGAZINE CYCLONE BOX CAMERA.

## WESTERN ELECTRIC COMPANY (NEW YORK)

(1353) **GRAY'S ORIGINAL MODEL VEST DETECTIVE CAMERA.** C. 1885. SIX EXPOSURES, 1⅝ INCHES IN DIAMETER ON AN OCTAGONAL GLASS PLATE. THE CAMERA WHICH WAS SIMILAR TO THE IMPROVED MODEL OF 1886 WAS PART OF AN OUTFIT THAT INCLUDED A FALSE HALF-VEST WITH THE CAMERA CONCEALED UNDER THE VEST. THE LENS PROTRUDED THROUGH THE VEST AS A STICK-PIN. THE KNOB ON THE CAMERA FOR COCKING THE SHUTTER AND ROTATING THE FILM PLATE PROTRUDED AS A VEST BUTTON. THE SHUTTER WAS RELEASED BY PULLING A STRING ON THE CAMERA.

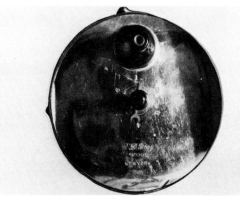

(1354) **GRAY'S VEST DETECTIVE CAMERA.** C. 1886. SIX EXPOSURES, 1⅝ INCHES IN DIAMETER ON A 5½ INCH DIAMETER GLASS PLATE. THE FEATURES AND OPERATION OF THE CAMERA ARE SIMILAR TO THE ORIGINAL MODEL OF 1885 EXCEPT THE CAMERA IS THINNER AND WAS WORN UNDER A MAN'S REGULAR VEST INSTEAD OF THE FALSE VEST THAT CAME WITH THE ORIGINAL MODEL. F 11 SIMPLE PERISCOPIC LENS (FIXED FOCUS). SINGLE SPEED ROTARY SHUTTER. SEE ALSO, VEST DETECTIVE CAMERAS UNDER C. P. STIRN CAMERAS (NEW YORK). (EL)

## WHITEHOUSE PRODUCTS, INCORPORATED

(1355) **BEACON BOX CAMERA.** C. 1935. EXPOSURES ON NO. 127 ROLL FILM.

## WILKIN-WELCH COMPANY

(1356) **CARDBOARD BOX CAMERA.** C. 1897. SIZE 2½ X 2½ INCH PLATE EXPOSURES. MENISCUS LENS. ROTARY SHUTTER. (MA)

## WING, SIMON

(1357) **NEW GEM CAMERA.** C. 1901. SIMILAR TO THE NEW GEM CAMERA (C. 1901) FOR 15 1 X 1¼ INCH EXPOSURES EXCEPT THE EXPOSURE SIZE CAN BE VARIED FROM FOUR 1⅞ X 2¾ INCH EXPOSURES TO 28 ¾ X 1 INCH EXPOSURES.

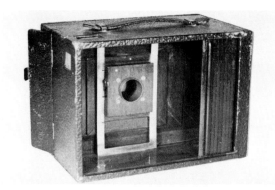

(1358) **MINIATURE GEM CAMERA. (PROTOTYPE).** C. 1900. THE MOVEABLE FRONT PANELS OF THE CAMERA ALLOW THE LENS AND SHUTTER TO BE MOVED TO VARIOUS POSITIONS TO OBTAIN MANY SINGLE EXPOSURES ON ONE 4 X 5 INCH TINTYPE OR GLASS PLATE. (SW)

(1359) **NEW GEM CAMERA.** C. 1901. THE MOVEABLE FRONT PANELS OF THE CAMERA ALLOW THE LENS AND SHUTTER TO BE MOVED TO VARIOUS POSITIONS TO OBTAIN 15 SEPARATE EXPOSURES (SIZE 1 X 1¼ INCH) ON ONE 5 X 7 INCH FERROTYPE PLATE. 120 MM/F 6 DARLOT LENS. SIMON WING TWO-BLADE SCISSORS-TYPE SHUTTER FOR TIME EXPOSURES ONLY. IN-FRONT-OF-LENS SHUTTER. (SW)

(1360) **LITTLE GIANT FRONT FOCUSING FOUR-TUBE CAMERA.** C. 1875. SIZE 7½ X 7½ INCH PLATE EXPOSURES. B. FRENCH LENS. HAND-CONTROLLED DROP-TYPE SHUTTER. (SW)

## WING, SIMON (*cont.*)

(1361) **MULTIPLE CAMERA.** C. 1863. FIFTEEN 5 X 7 INCH EXPOSURES CAN BE MADE ON A SINGLE PLATE BY MOVING THE LENS BOARD VERTICALLY OR HORIZONTALLY BY SLIDING PANELS. DARLOT PETZVAL LENS. SECTOR SHUTTER. (IH)

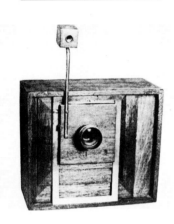

(1362) **MULTIPLE CAMERA.** C. 1865. FIFTEEN 5 X 7 INCH EXPOSURES CAN BE MADE ON A SINGLE PLATE.

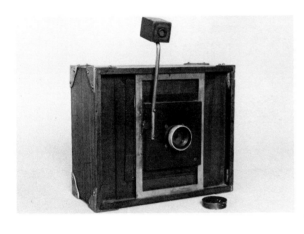

(1363) **MULTIPLE CAMERA.** C. 1880. SIZE 5 X 7 INCH EXPOSURES ON PLATES. (TH)

(1364) **VIEW CAMERA.** C. 1887. SIZE 4 X 5 INCH EXPOSURES ON PLATES.

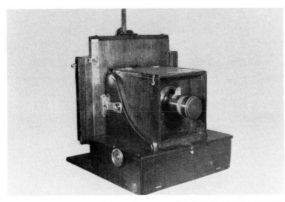

(1365) **VIEW CAMERA.** C. 1865. SIZE 7 X 7 INCH EXPOSURES ON WET PLATES OR TINTYPES. C. C. HARRISON LENS. LENS-CAP SHUTTER. (SW)

## WOLCOTT, A. S.

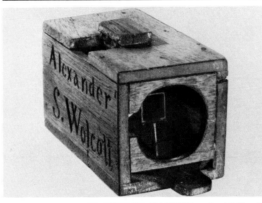

(1366) **WOLCOTT MIRROR CAMERA.** C. 1840. SIZE 1¾ X 2¼ INCH PLATE EXPOSURES. THE CAMERA CONTAINS NO LENS BUT USES INSTEAD A CONCAVE MIRROR FOR FOCUSING THE IMAGE ON THE PHOTOGRAPHIC PLATE LOCATED JUST INSIDE OF THE FRONT OPENING OF THE CAMERA. (SI)

## YALE CAMERA COMPANY

(1367) **MODEL "A" FOLDING CAMERA.** C. 1899. SIZE 4 X 5 INCH EXPOSURES ON PLATES OR ROLL FILM. RAPID RECTILINEAR LENS. PNEUMATIC SHUTTER FOR INSTANT AND TIME.

(1368) **YALE MODEL BOX CAMERA.** C. 1899. SIZE 4 X 5 INCH PLATE EXPOSURES. INSTANT AND TIME SHUTTER.

(1369) **YALE JUNIOR BOX CAMERA.** C. 1899. SIZE 2½ X 2½ INCH PLATE EXPOSURES. ACHROMATIC LENS. INSTANT AND TIME SHUTTER.

(1370) **CYCLE FOLDING CAMERA.** C. 1899. SIZE 4 X 5 INCH PLATE EXPOSURES. PNEUMATIC SHUTTER.

## ZAR CAMERA COMPANY

(1371) **ZAR POCKET CAMERA.** C. 1896. SIZE 2 X 2 INCH EXPOSURES. INSTANT AND TIME SHUTTER.

## MANUFACTURER UNKNOWN

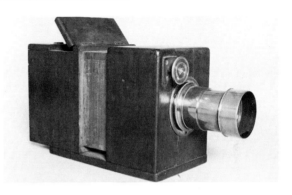

(1372) **DAGUERREAN AMERICAN TYPE SQUARE FRONT CAMERA.** C. 1850. SIZE 3¼ X 4¼ INCH EXPOSURES ON WET PLATES. (TH)

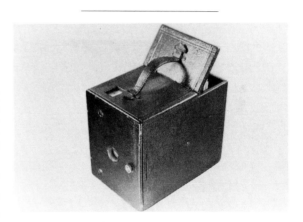

(1373) **HUB BOX CAMERA.** C. 1885. SIZE 4 X 5 INCH EXPOSURES ON PLATES OR SHEET FILM. INSTANT AND TIME SHUTTER. (HW)

(1374) **HUB FOLDING PLATE CAMERA.** C. 1898. SIZE 4 X 5 INCH EXPOSURES. SIMPLE LENS. ROTARY SHUTTER. SWING BACK.

(1375) **LUNDELIUS MAGAZINE PLATE CAMERA.** C. 1895.

## A-LKA COMPANY

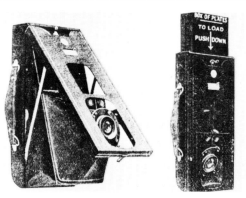

(1376) **DAYLIGHT LOADING MAGAZINE CAMERA.** C. 1912. THE MAGAZINE HOLDS 12 PLATES. RAPID RECTILINEAR LENS. A PLATE IS BROUGHT TO THE FOCAL PLANE BY EXTENDING THE BELLOWS VIA A BOARD HINGED TO THE CAMERA BODY. A FLAT SPRING PLATE AT THE BACK OF THE CAMERA IS THEN PRESSED TO POSITION THE PHOTOGRAPHIC PLATE. AFTER EXPOSURE, THE CAMERA POSITION IS REVERSED AND THE SPRING PLATE IS PRESSED TO RETURN THE EXPOSED PLATE TO THE MAGAZINE.

(1377) **GLEANER HAND CAMERA.** C. 1913. TWO SIZES OF THIS CAMERA FOR 2½ X 3½ OR 3¼ X 4¼ INCH EXPOSURES.

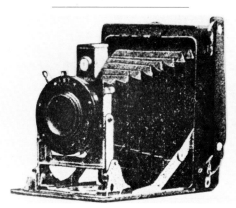

(1378) **REAPER FOLDING HAND CAMERA.** C. 1913. SIZE 3¼ X 4¼ INCH EXPOSURES ON PLATES. RAPID RECTILINEAR LENS. BAUSCH & LOMB SHUTTER. RISING LENS MOUNT.

## ABNEY, SIR WILLIAM

(1379) **THREE-COLOR CAMERA.** C. 1905. SIZE 4½ X 6 INCH COLOR NEGATIVES. THE CAMERA HAS THREE PRIMARY "FRONT" LENSES AND TWO SECONDARY "BACK" LENSES. THE MIDDLE "FRONT" LENS FOCUSES THE IMAGE THROUGH A GREEN FILTER WITHOUT THE USE OF MIRRORS. THE OTHER TWO "FRONT" LENSES FOCUS THE IMAGE VIA TWO PAIRS OF MIR-RORS AND THE "BACK" LENSES WITH ONE NEGATIVE BEING EXPOSED THROUGH A RED FILTER AND THE OTHER THROUGH A BLUE FILTER. BELLOWS FOCUSING. (IH)

## ADAMS & COMPANY

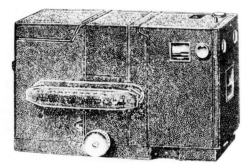

(1380) **ADAMS DELUXE HAND CAMERA.** C. 1899. SIZE 3¼ X 4¼ INCH EXPOSURES.

(1381) **ADAMS MAGAZINE HAND CAMERA.** C. 1892. SIZE 3¼ X 4¼ INCH EXPOSURES ON PLATES, CUT FILM, OR ROLL FILM. ROSS RAPID SYMMETRICAL LENS. NEWMAN'S PATENT PNEUMATIC SHUTTER; ½ TO ¹⁄₁₀₀ SEC. EXTERNAL KNOB FOR FOCUSING. GROUND GLASS FOCUSING. THE MAGAZINE HOLDS 12 PLATES.

(1382) **ADAMS MAGAZINE HAND CAMERA.** C. 1896. THREE SIZES OF THIS CAMERA FOR 3¼ X 4¼, 4 X 5, OR 4¼ X 6½ INCH EXPOSURES ON PLATES OR CUT FILM. THE MAGAZINE HOLDS 12 PLATES OF 24 CUT FILMS. INSTANT AND TIME SHUTTER. RISING AND CROSSING LENS MOUNT. DOUBLE SWING BACK. GROUND GLASS FOCUSING.

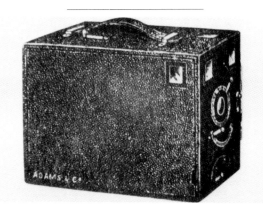

(1383) **AUTO MAGAZINE HAND CAMERA.** C. 1904. TWO SIZES OF THIS CAMERA FOR 3¼ X 4¼ OR 4 X 5 INCH EXPOSURES ON PLATES OR SHEET FILM. THE MAGAZINE HOLDS 12 PLATES OR FILMS. FIXED FOCUS. VARIABLE SPEED AND TIME SHUTTER. MODEL 1; ACHROMATIC LENS. MODEL 2; SUPERIOR LENS AND IRIS DIAPHRAGM. MODEL 3; F 8 RAPID RECTILINEAR LENS. MODEL 3A; F 8 RAPID RECTILINEAR LENS AND RISING AND FALLING LENS MOUNT.

(1384) **HAT DETECTIVE CAMERA.** C. 1892. SIZE 3¼ X 4¼ INCH EXPOSURES ON PLATES. F 11 RECTILINEAR LENS. INSTANT AND TIME SHUTTER. THE CAMERA WAS USUALLY HELD FLAT AGAINST THE CHEST OF THE PHOTOGRAPHER WITH THE LENS (MOUNTED IN THE TOP OF THE HAT) POINTED TOWARD THE SUBJECT. A FOCUSING SCREEN WAS SUPPLIED WITH THE CAMERA.

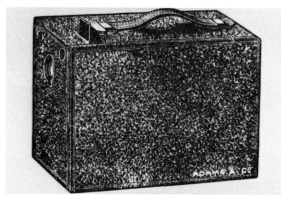

(1385) **IDEAL MAGAZINE HAND CAMERA.** C. 1896. SIZE 3¼ X 4¼ INCH EXPOSURES ON PLATES OR CUT FILM. EVERSET SHUTTER. MODEL 1; FIXED FOCUS WITH RAPID RECTILINEAR LENS. MODEL 2; FOCUSING MODEL WITH WRAY LENS. MODEL 2A; FOCUSING MODEL WITH GOERZ LENS AND RISING AND CROSSING LENS MOUNT. MODEL 3; REFLEX FOCUSING, WRAY LENS, AND RISING AND CROSSING LENS MOUNT.

## ADAMS & COMPANY (cont.)

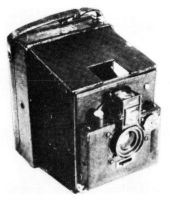

(1386) **IDENTO FOLDING CAMERA.** C. 1907. SIZE 3¼ X 4¼ INCH EXPOSURES ON PLATES OR FILM PACKS. 135 MM/F 6.3 ZEISS PROTAR OR ROSS HOMOCENTRIC LENS. SHUTTER SPEEDS FROM ½ to ⅟₁₀₀ SEC. (HA)

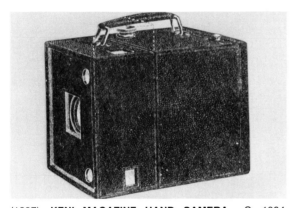

(1387) **KENI MAGAZINE HAND CAMERA.** C. 1904. SIZE 3¼ X 4¼ INCH EXPOSURES ON PLATES OR SHEET FILM. EXTERNAL KNOB FOR FOCUSING ON GROUND GLASS.

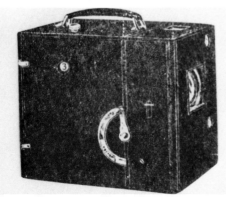

(1388) **LOCKA MAGAZINE HAND CAMERA.** C. 1904. SIZE 3¼ X 4¼ INCH EXPOSURES ON PLATES.

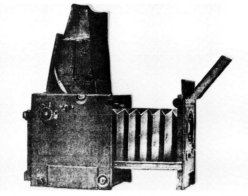

(1389) **MINEX REFLEX CAMERA. ORIGINAL MODEL.** C. 1909. SIZE 4 X 5 INCH PLATE EXPOSURES. REVERSIBLE BACK. GROUND GLASS FOCUSING. FOCAL PLANE SHUTTER; 3 TO ⅟₁₀₀₀ SEC., B., T.

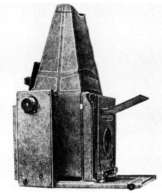

(1390) **MINEX REFLEX CAMERA.** C. 1914. THREE SIZES OF THIS CAMERA FOR 2½ X 3½, 3¼ X 4¼, OR 4¼ X 6½ INCH EXPOSURES ON PLATES. FOCAL PLANE SHUTTER. REVOLVING BACK. RISING LENS MOUNT.

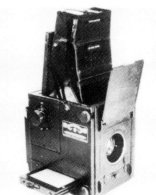

(1391) **MINEX REFLEX CAMERA.** C. 1926. SIZE 3 X 4 INCH EXPOSURES ON SHEET FILM. 150 MM/F 4.5 ZEISS TESSAR LENS. FOCAL PLANE SHUTTER; 8 TO ⅟₁₀₀₀ SEC. (HA)

(1392) **STUDIO MINEX REFLEX CAMERA.** C. 1912. EXPOSURES ON PLATES. A VERTICALLY PIVOTED MIRROR REFLECTS THE IMAGE ONTO A GROUND GLASS ON THE SIDE OF THE CAMERA. A SELF-SUPPORTING

HOOD OVER THE GROUND-GLASS SCREEN HAS A BLUE GLASS WINDOW FOR VIEWING THE SUBJECT. (BC)

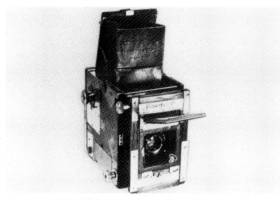

(1393) **MINEX TROPICAL REFLEX CAMERA.** C. 1925. SIZE 2¼ X 3¼ INCH EXPOSURES. 110 MM/F 5.9 ROSS LENS. FOCAL PLANE SHUTTER; 8 TO ⅟₁₀₀₀ SEC. (HA)

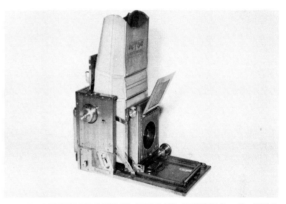

(1394) **MINEX TROPICAL REFLEX CAMERA.** C. 1930. SIZE 2¼ X 3¼ INCH EXPOSURES ON SHEET FILM. F 4.5 TYLOR-HOPSON COOKE AVAIR SERIES II LENS. FOCAL PLANE SHUTTER. (GE)

(1395) **STUDIO MINEX REFLEX CAMERA.** C. 1913. EXPOSURES ON PLATES. SIMILAR TO THE 1912 MODEL EXCEPT THE SELF-SUPPORTING HOOD WAS REPLACED WITH A CLOTH HOOD AND THE CAMERA HAS A SWING FRONT.

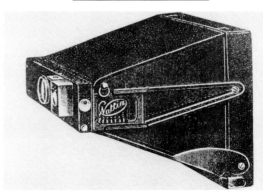

(1396) **NATTIA FOLDING POCKET CAMERA.** C. 1899–1904. SIZE 3¼ X 4¼ INCH EXPOSURES ON PLATES OR SHEET FILM. F 6.3 ROSS HOMOCENTRIC OR F 6.3

## ADAMS & COMPANY (*cont.*)

ZEISS LENS. GUILLOTINE SELF-CAPPING SHUTTER; ½ TO ¹⁄₁₀₀ SEC., T. RACK & PINION FOCUSING. GROUND GLASS FOCUSING. REVERSIBLE BRILLIANT FINDER. THE MAGAZINE HOLDS EIGHT PLATES OR 14 FILMS.

(1397) **OTTO MAGAZINE HAND CAMERA.** C. 1892. SIZE 3¼ X 4¼ INCH EXPOSURES ON PLATES. THE MAGAZINE HOLDS 12 PLATES. INSTANT AND TIME EXPOSURES.

(1398) **STEREO CAMERA.** C. 1916. SIZE 2⁵⁄₁₆ X 5½ INCH STEREO EXPOSURES ON ROLL FILM.

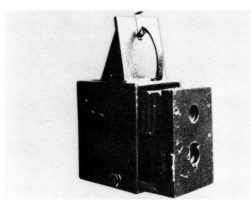

(1399) **TWIN LENS REFLEX CAMERA.** C. 1895. SIZE 3¼ X 4¼ INCH EXPOSURES ON PLATES.

(1400) **VESTA HAND CAMERA.** C. 1893. SIZE 3¼ X 4¼ INCH EXPOSURES ON PLATES OR CUT FILM. 5½ INCH/F 8 WRAY RAPID RECTILINEAR LENS. GUILLOTINE SHUTTER; ½ TO ¹⁄₁₀₀ SEC. (MA)

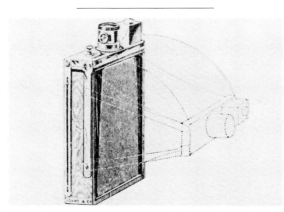

(1401) **VESTA HAND CAMERA.** C. 1896. SIZE 3¼ X 4¼ INCH EXPOSURES ON PLATES OR CUT FILM. GOERZ OR WRAY LENS. PNEUMATIC SHUTTER; 1 TO ¹⁄₁₀₀ SEC., T. IRIS DIAPHRAGM. SWING BACK. GROUND GLASS FOCUSING. THE CAMERA HOLDS SIX PLATES OR 12 CUT FILMS.

(1402) **VESTA POCKET CAMERA.** C. 1914. FOUR SIZES OF THIS CAMERA FOR 1⅝ X 2½, 2⅜ X 3⅜, 3¼ X 4¼ OR 3½ X 5½ INCH EXPOSURES ON ROLL FILM. SIMILAR TO THE VESTA POCKET CAMERA, C. 1913.

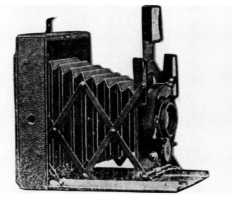

(1403) **VESTA VEST POCKET CAMERA.** C. 1912. SIZE 1¾ X 2¼ INCH EXPOSURES ON PLATES OR FILM PACKS WITH ADAPTER. F 4.5 ZEISS TESSAR LENS. COMPOUND SHUTTER. GROUND GLASS FOCUSING.

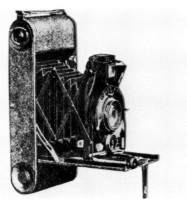

(1404) **VESTA POCKET CAMERA.** C. 1913. SIZE 2⅜ X 3⅜ INCH EXPOSURES ON ROLL FILM. ZEISS TESSAR LENS. COMPOUND SHUTTER. RISING AND FALLING LENS MOUNT.

(1405) **NO. 1 VESTA CAMERA.** C. 1916. SIZE 2⁵⁄₁₆ X 3¾ INCH EXPOSURES ON ROLL FILM. ROSS HOMOCENTRIC OR ZEISS TESSAR LENS. DECKEL COMPOUND SHUTTER.

(1406) **NO. 2 VESTA CAMERA.** C. 1916. SIZE 3¼ X 4½ INCH EXPOSURES ON ROLL FILM. ROSS HOMOCENTRIC OR ZEISS TESSAR LENS. DECKEL COMPOUND SHUTTER.

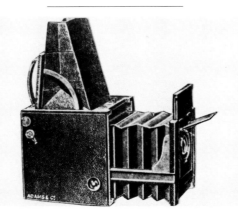

(1407) **VIDEX REFLEX CAMERA.** C. 1903. THREE SIZES OF THIS CAMERA FOR 3¼ X 4¼, 4 X 5, OR 4¼ X 6½ INCH EXPOSURES ON PLATES, FILM PACKS, SHEET, OR ROLL FILM WITH ADAPTER. F 6.3 GOERZ OR ZEISS LENS. FOCAL PLANE SHUTTER; ⅛ TO ¹⁄₁₀₀₀ SEC., T. RISING AND FALLING LENS MOUNT. RACK & PINION FOCUSING. REVOLVING BACK.

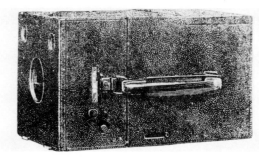

(1408) **YALE HAND CAMERA.** C. 1898. SIZE 3¼ X 4¼ INCH EXPOSURES ON PLATES. COOKE LENS.

## ALLAN, DAVID

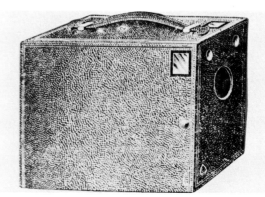

(1409) **D. A. HAND CAMERA.** C. 1897. SIZE 3¼ X 4¼ INCH EXPOSURES ON PLATES. THE MAGAZINE HOLDS 12 PLATES. ACHROMATIC LENS. INSTANT AND TIME EVERSET SHUTTER. ROTARY APERTURE STOPS. EXPOSURE COUNTER.

## AMALGAMATED PHOTOGRAPHIC MANUFACTURERS LIMITED

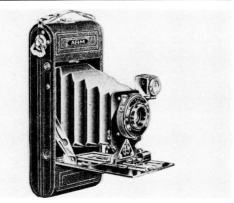

(1410) **ALTREX CAMERA.** C. 1923. SIZE 2¼ X 3¼ INCH EXPOSURES ON ROLL FILM. SINGLE OR RAPID RECTILINEAR LENS. MARVEL OR GENERAL SHUTTER.

## AMALGAMATED PHOTOGRAPHIC MANUFACTURERS LIMITED (*cont.*)

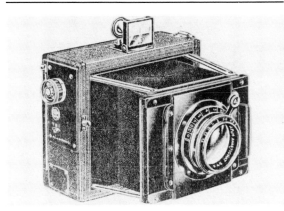

**(1411) APEM FOLDING FOCAL PLANE CAMERA.**
C. 1923. SIZE 3¼ X 4¼ INCH EXPOSURES ON PLATES.
F 4.5 APEM ANASTIGMAT FOCUSING LENS. FOCAL
PLANE SHUTTER; ⅟₁₆ TO ⅟₈₀₀ SEC., B., T.

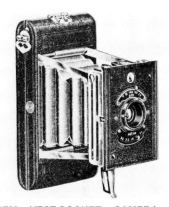

**(1412) APEM VEST-POCKET CAMERA.** C. 1923.
THREE SIZES OF THIS CAMERA FOR 1⅝ X 2½, 2½ X
3½, OR 2½ X 4¼ INCH EXPOSURES ON ROLL FILM.
SINGLE ACHROMATIC, RAPID RECTILINEAR, OR F 7.7
ANASTIGMAT LENS.

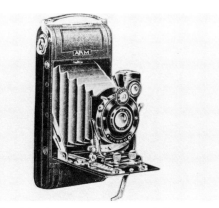

**(1413) BELTREX CAMERA.** C. 1923. SIZE 2¼ X 3¼
INCH EXPOSURES ON ROLL FILM. F 4.5, F 6.3, OR F
7.7 KERSHAW ANASTIGMAT LENS. ILEX SHUTTER; 1 TO
⅟₃₀₀ SEC. RISING LENS MOUNT.

**(1414) CELTREX CAMERA.** C. 1923. SIZE 2½ X 4¼
INCH EXPOSURES ON ROLL FILM. SIMILAR TO THE
ALTREX CAMERA WITH THE SAME LENSES AND
SHUTTERS.

**(1415) DELTREX CAMERA.** C. 1923. SIZE 2½ X 4¼
INCH EXPOSURES ON ROLL FILM. SIMILAR TO THE
BELTREX CAMERA WITH THE SAME LENSES AND
SHUTTER.

**(1416) RAJAR NO. 6 FOLDING CAMERA.** C. 1929.
EXPOSURES ON NO. 120 ROLL FILM. INSTANT AND
TIME SHUTTER. THIS FOLDING STRUT CAMERA HAS
A MOULDED BAKELITE BODY. (BC)

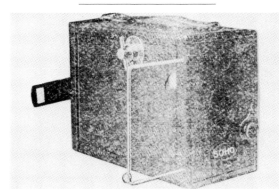

**(1417) SOHO FARNEAR BOX CAMERA.** C. 1929.
SIZE 2¼ X 3¼ INCH EXPOSURES ON ROLL FILM.
SINGLE ACHROMATIC LENS. SINGLE-SPEED AND TIME
SHUTTER.

**(1418) SOHO JUNIOR BOX CAMERA.** C. 1929. SAME
AS THE SOHO FARNEAR BOX CAMERA EXCEPT WITH-
OUT WIRE-FRAME VIEWER AND SUPPLEMENTARY
LENS.

**(1419) SOHO TROPICAL SINGLE LENS REFLEX CAM-
ERA.** C. 1921–29. SIZE 3¼ X 4¼ INCH EXPOSURES
ON SHEET FILM. 6⅜ INCH/F 4.5 BAUSCH & LOMB
TESSAR LENS. FOCAL PLANE SHUTTER; ⅟₁₆ TO ⅟₈₀₀
SEC., T. REVOLVING BACK. FOCUSING BY UPPER
VIEWING SCREEN OR GROUND GLASS ON BACK.
A SIMILAR CAMERA WAS MANUFACTURED BY A. KER-
SHAW FROM 1905 TO 1921 AND BY SOHO LIMITED OF
LONDON FROM 1930 TO 1940. SEE PHOTO OF CAMERA
UNDER SOHO LIMITED CAMERAS.

## AMERICAN CAMERA COMPANY

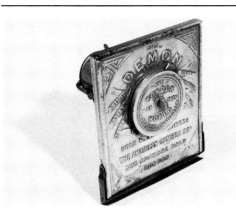

**(1420) DEMON DETECTIVE CAMERA NO. 1.** C. 1889.
SIZE 2¼ INCH DIAMETER EXPOSURES ON 2¼ X 2¼
INCH DRY PLATES. 30 MM/F 10 TWO-ELEMENT LAND-
SCAPE LENS. FLIP-TYPE SHUTTER FOR TIME EXPO-
SURES ONLY. ALL METAL CAMERA BODY. (GE)

**(1421) DEMON DETECTIVE CAMERA NO. 2.** C. 1890.
SIZE 3¾ X 3¾ INCH EXPOSURES ON DRY PLATES.
SIMILAR TO THE DEMON DETECTIVE CAMERA NO. 1
BUT WITH AN ACHROMATIC DOUBLET LENS AND AN
INSTANTANEOUS OR TIME SHUTTER.

## ANSCO, LIMITED

**(1422) ANSCO AUTOMATIC CAMERA.** C. 1924. SIZE
2½ X 4¼ INCH EXPOSURES ON ROLL FILM. THE FILM
IS AUTOMATICALLY ADVANCED BY A SPRING MECHA-
NISM AFTER EACH EXPOSURE.

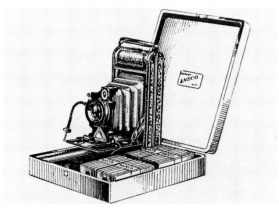

**(1423) ANSCO MEMORY KIT CAMERA.** C. 1923.
VEST-POCKET SIZE EXPOSURES ON ROLL FILM. THE
KIT INCLUDES A VEST-POCKET JUNIOR MODEL CAM-
ERA WITH WOLLENSAK RAPID RECTILINEAR LENS AND
DELTAX SHUTTER OR A VEST-POCKET SPEEDEX NO. 3
MODEL CAMERA WITH AN ANSCO F 6.3 ANASTIGMAT
LENS.

**(1424) ANSCO SEMI-AUTOMATIC CAMERA.** C. 1925.
SIZE 2½ X 4¼ INCH EXPOSURES ON ROLL FILM. F 7.7
RAPID RECTILINEAR OR F 7.5 ANASTIGMAT LENS.

**(1425) NO. 0 ANSCO JUNIORETTE CAMERA.** C. 1925.
SIZE 1⅝ X 2½ INCH EXPOSURES ON ROLL FILM.

**(1426) NO. 1 ANSCO JUNIORETTE CAMERA.** C. 1925.
SIZE 2¼ X 3¼ INCH EXPOSURES ON ROLL FILM.
SINGLE ACHROMATIC LENS. READY-SET OR DELTAX
SHUTTER.

**(1427) "SEVENBOB" BOX CAMERA.** C. 1925. SIZE 1⅝
X 2½ INCH EXPOSURES ON ROLL FILM. SINGLE-SPEED
AND TIME SHUTTER.

## ARCHER, FREDERICK SCOTT

**(1428) WET COLLODION CAMERA.** C. 1853. BLACK VELVET SLEEVES ARE ATTACHED TO THE BACK OF THE CAMERA THROUGH WHICH THE PHOTOGRAPHER COULD PLACE HIS HANDS. BY USE OF THE SLEEVES, A PLATE COULD BE PLACED IN EACH OF THREE VERTICAL BATHS FOR SENSITIZING, DEVELOPING, AND FIXING THE PLATE. (BC)

## ARCHER & SONS

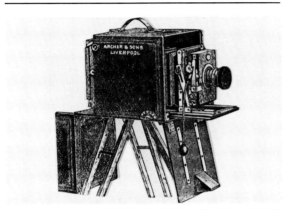

**(1429) HAND AND STAND CAMERA.** C. 1893. PLATE EXPOSURES. DOUBLE EXTENSION BELLOWS. RACK & PINION FOCUSING. RISING LENS MOUNT. DOUBLE-SWING BACK. REVERSING BACK.

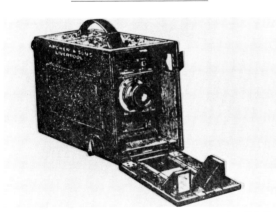

**(1430) TOURIST HAND CAMERA.** C. 1895. PLATE EXPOSURES. RAPID RECTILINEAR LENS. THORNTON-PICKARD SHUTTER. EXTERNAL KNOB FOR RACK & PINION FOCUSING. RISING LENS MOUNT. IRIS DIAPHRAGM.

## ARMY AND NAVY AUXILIARY LIMITED

NOTE: THE CAMERAS LISTED WERE SOLD BY THIS COMPANY.

**(1431) AUXILIARY-JUNIOR HAND CAMERA.** C. 1913. SIZE 3¼ X 4¼ INCH EXPOSURES ON ROLL FILM. F 8 ICA OR F 6.3 ZEISS TESSAR LENS. THREE-SPEED SHUTTER OR COMPOUND SHUTTER. RISING AND CROSSING LENS MOUNT.

**(1432) AUXILIARY SPECIAL HAND CAMERA.** C. 1913. TWO SIZES OF THIS CAMERA FOR 3¼ X 4¼ OR 3½ X 5½ INCH EXPOSURES ON ROLL FILM. F 6.3 ZEISS TESSAR LENS. COMPOUND SHUTTER. DOUBLE EXTENSION BELLOWS. RISING AND CROSSING LENS MOUNT. SIMILAR TO THE AUXILIARY JUNIOR HAND CAMERA.

**(1433) DWARF REFLEX CAMERA.** C. 1913. SIZE 3¼ X 4¼ INCH EXPOSURES ON PLATES. 6 INCH/F 4.5 ROSS XPRES, ZEISS TESSAR, OR COOKE LENS. RACK & PINION FOCUSING. FOCAL PLANE SHUTTER.

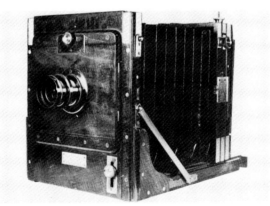

**(1434) TAILBOARD FIELD CAMERA.** C. 1880. SIZE 4¼ X 6½ INCH EXPOSURES ON PLATES. (VC)

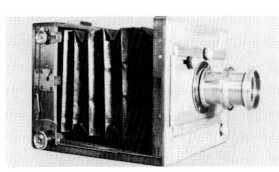

**(1435) VIEW CAMERA.** C. 1910. SIZE 6½ X 8½ INCH EXPOSURES ON PLATES. F 8 RAPID RECTILINEAR LENS. (EL)

## ARNDT AND LOWENGARD

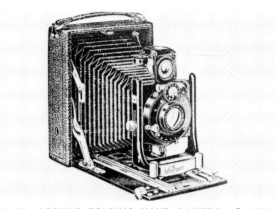

**(1436) LEONAR FOLDING HAND CAMERA.** C. 1914. THREE SIZES OF THIS CAMERA FOR 2½ X 3½, 3¼ X 4¼, OR 3½ X 5½ INCH EXPOSURES ON PLATES. F 8 RAPID RECTILINEAR OR F 16 SINGLE LENS. TWO-SPEED "AUTO" SHUTTER. ALSO, COMPOUND OR SINGLE-SPEED, B., T. SHUTTER. RISING AND CROSSING LENS MOUNT. SOME MODELS WITH DOUBLE EXTENSION BELLOWS.

## AUTOTYPE COMPANY LIMITED

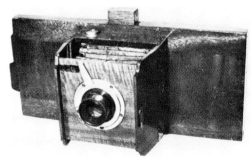

**(1437) THREE-COLOR CAMERA.** C. 1902. SIZE 2½ X 3½ INCH COLOR EXPOSURES. THREE FILMS WERE EXPOSED IN SEQUENCE USING COLOR FILTERS. 110 MM/F 5.6 ROSS LENS. (HA)

## B. P. COMPANY LIMITED

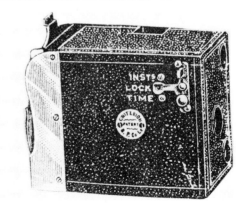

**(1438) CRITERION POCKET CAMERA.** C. 1897. SIZE 1⅝ X 2⅛ INCH EXPOSURES ON PLATES OR SHEET FILM. INSTANT AND TIME EXPOSURES. MENISCUS LENS.

## BAIRD, ANDREW H.

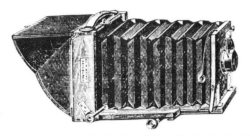

(1439) **LOTHIAN CYCLIST CAMERA.** C. 1894. PLATE EXPOSURES. RACK & PINION FOCUSING. FOCUSING SCREEN COVER CLOTH. SWING BACK.

## BECK, R. & J., LIMITED

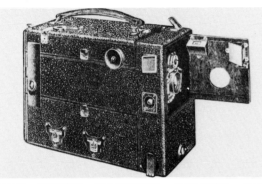

(1440) **CORNEX TELEPHOTO MAGAZINE HAND CAMERA.** C. 1904. THE CAMERA HOLDS 12 PLATES. F 4.5 BECK-STEINHEIL UNIFOCAL SERIES I, F 6 BECK-STEINHEIL UNIFOCAL SERIES II, OR F 6 BECK DOUBLE-SPEED RECTILINEAR LENS. EACH OF THE ABOVE LENSES WAS SUPPLIED WITH A NEGATIVE TELEPHOTO LENS. THE CAMERA CAN BE FOCUSED FROM 2 TO 35 FEET FROM THE CAMERA. PNEUMATIC BRAKE-TYPE SHUTTER; 1 TO 1/100 SEC., B., T. IRIS DIAPHRAGM. INTERNAL BELLOWS. GROUND GLASS FOCUSING.

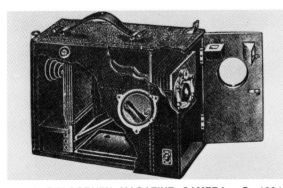

(1441) **DAI-CORNEX MAGAZINE CAMERA.** C. 1904. MODELS A, B, C, D, E, F, FI, AND G. THE MAGAZINE HOLDS A PACKET OF 12 PLATES.

(1442) **DETECTIVE BOX-FORM CAMERA.** C. 1888. EXPOSURES ON PLATES.

(1443) **FOCAL PLANE REFLEX CAMERA.** C. 1906. SINGLE-LENS REFLEX.

(1444) **FRENA BOX CAMERA.** ORIGINAL MODEL. C. 1892. THE FIRST CAMERA TO USE A PACK OF CUT CELLULOID FILM (FILM-PACK). F 8 RAPID RECTILINEAR LENS. ROTARY SHUTTER; 1/5 TO 1/80 SEC. THE CUT FILMS WHICH WERE NOTCHED ON TWO SIDES WERE PLACED IN A BOX INSIDE OF THE CAMERA. WHEN THE BOX WAS ROTATED BY A CRANK ON THE OUTSIDE OF THE CAMERA, THE EXPOSED FILM WOULD SLIP PAST SUPPORTING PINS AND FALL INTO A TRAY. THE RO-TATING FILM BOX ALSO SERVED AS A SWING-BACK. (IH)

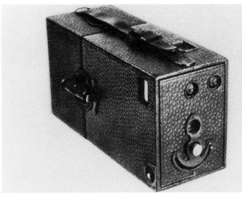

(1445) **FRENA NO. 00 MAGAZINE BOX CAMERA.** C. 1896. SIZE 2⅝ X 3½ INCH EXPOSURES ON FILM PACKS. THE CAMERA'S MAGAZINE HOLDS 40 SHEET FILMS. BECK SINGLE ACHROMATIC LENS. ROTARY SHUTTER; 1/5 TO 1/80 SEC. (HA)

(1446) **FRENA NO. 0 MAGAZINE BOX CAMERA.** C. 1900. SIZE 2⅝ X 3½ INCH EXPOSURES ON SHEET FILM PACKS. SIMILAR TO THE FRENA NO. 00 MAGAZINE BOX CAMERA BUT WITH A RAPID RECTILINEAR LENS.

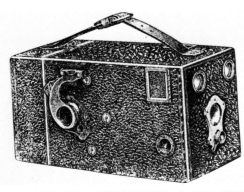

(1447) **FRENA NO. 2 BOX CAMERA.** C. 1893. SIZE 3¼ X 4¼ INCH EXPOSURES ON SHEET FILM PACKS. THE CAMERA'S MAGAZINE HOLDS 40 SHEET FILMS. BECK RAPID RECTILINEAR LENS. SIMILAR ROTATING FILM-PACK BOX AS DESCRIBED FOR THE FRENA BOX CAMERA, C. 1892.

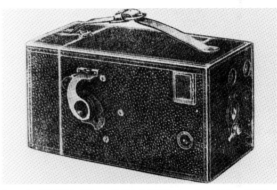

(1448) **FRENA NO. 2 BOX CAMERA.** C. 1900. SIZE 3¼ X 4¼ INCH EXPOSURES ON SHEET FILM PACKS. THE CAMERA'S MAGAZINE HOLDS 40 SHEET FILMS. BECK RAPID RECTILINEAR LENS. SIMILAR ROTATING FILM-PACK BOX AS DESCRIBED FOR THE FRENA BOX CAMERA, 1892.

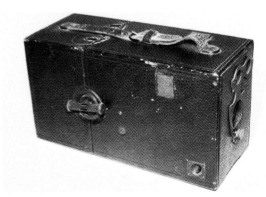

(1449) **FRENA NO. 3 BOX CAMERA.** C. 1896. SIZE 4 X 5 INCH EXPOSURES ON SHEET FILM PACKS. THE CAMERA'S MAGAZINE HOLDS 40 SHEET FILMS. BECK RAPID RECTILINEAR LENS. SIMILAR ROTATING FILM-PACK BOX AS DESCRIBED FOR THE FRENA BOX CAMERA, 1892.

(1450) **FRENA NO. 3 BOX CAMERA. IMPROVED MODEL.** C. 1904. SIZE 4 X 5 INCH EXPOSURES ON SHEET FILM PACKS. THE CAMERA'S MAGAZINE HOLDS 40 SHEET FILMS. BECK RAPID RECTILINEAR LENS. ROTARY SHUTTER; 1/5 TO 1/80 SEC., T. SIMILAR ROTAT-ING FILM-PACK BOX AS DESCRIBED FOR THE FRENA BOX CAMERA, 1892. (GE)

## BECK, R. & J., LIMITED (*cont.*)

(1451) **FRENA NO. 6 FOLDING CAMERA.** C. 1900. BECK FIXED FOCUS SINGLE LENS. THE MODEL NO. 6G HAS A GROUND GLASS BACK WITH DOUBLE PLATE HOLDERS.

(1452) **FRENA NO. 7 FOLDING CAMERA.** C. 1900. BECK RAPID RECTILINEAR LENS WITH ADJUSTABLE FOCUS. THE MODEL NO. 7G HAS A GROUND GLASS BACK WITH DOUBLE PLATE HOLDERS.

(1453) **FRENA NO. 8 FOLDING CAMERA.** C. 1900. STEINHEIL ORTHOSTIGMAT CONVERTIBLE LENS WITH ADJUSTABLE FOCUS. THE MODEL 8G HAS A GROUND GLASS BACK WITH DOUBLE PLATE HOLDERS.

(1454) **HILL'S PANORAMIC CAMERA.** C. 1924. THE CAMERA PRODUCES A PANORAMIC EXPOSURE 2½ INCHES IN DIAMETER ON A 3¼ X 4¼ INCH FLAT PLATE. A CONICAL REFLECTOR WITH ITS AXIS VERTICAL REFLECTS LIGHT ONTO A FIXED LENS MOUNTED ALONG THE AXIS OF THE CONICAL REFLECTOR. (BC)

(1455) **TWIN-LENS REFLEX CAMERA.** C. 1880. SIZE 3¼ X 4¼ INCH PLATE EXPOSURES. THE UPPER VIEWING COMPARTMENT OF THE CAMERA HAS A MIRROR FOR REFLECTING THE IMAGE ONTO A GROUND GLASS ON THE TOP OF THE CAMERA WHICH IS SHIELDED BY A HOOD.

## BELL OF POTTERROW

(1456) **KINNEAR FOLDING CAMERA.** C. 1857. SIZE 10½ X 12½ INCH PLATE EXPOSURES. ONE OF THE FIRST TAPERED BELLOWS CAMERAS.

## BIRNIE, A.

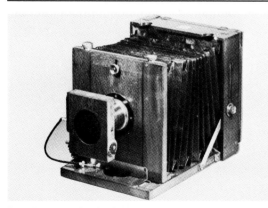

(1457) **FOLDING PLATE CAMERA.** C. 1895. SIZE 4¼ X 6½ INCH EXPOSURES ON PLATES. GUNDLACH RAPID RECTILINEAR LENS. THORNTON-PICKARD ROLLER BLIND SHUTTER. (MR)

## BLAND & COMPANY (BRITISH)

(1458) **BINOCULAR STEREO CAMERA.** C. 1860. SLIDING-BOX CAMERA WITH SPRING BACK.

## BRAINE, J. & SON

(1459) **BOOK-FORM DETECTIVE CAMERA.** C. 1892. PLATE EXPOSURES. THE CAMERA HAS THE APPEARANCE OF A BOOK WITH A HINGED COVER THAT DROPS DOWN AND LOCKS TO FORM A BASEBOARD.

## BRICE, WILLIAM A.

(1460) **PHOTOGRAPHON CAMERA.** C. 1876. COLLODION PLATE EXPOSURES. THE CAMERA HAS TWO HINGED SIDE TRAYS WITH DISHES FOR HOLDING THE SENSITIZING AND DEVELOPING CHEMICALS. THE PLATE WAS DRAWN INTO AND OUT OF THE CAMERA AND DISHES BY MEANS OF STRINGS. (BC)

## BRITISH CAMERA MANUFACTURING COMPANY

(1461) **DUOFLEX REFLEX PLATE CAMERA.** C. 1931. FOCAL PLANE SHUTTER.

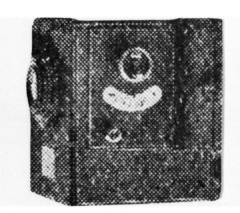

(1462) **DUOFLEX REFLEX ROLL FILM CAMERA.** C. 1930. SIZE 2¼ X 3¼ INCH EXPOSURES. F 4.5 DALLMEYER LENS. METAL FLAP FOCAL PLANE SHUTTER. REFLEX OR EYE-LEVEL FOCUSING.

## BRITISH FERROTYPE COMPANY

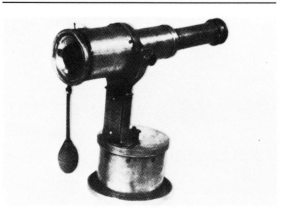

(1463) **TELEPHOT FERROTYPE CAMERA.** C. 1911. FERROTYPE EXPOSURES, TWO CENTIMETERS IN DIAMETER. RAPID RECTILINEAR LENS. THE EXPOSED PLATES ARE DROPPED INTO A METAL TANK BELOW THE CAMERA FOR DEVELOPMENT.

## BRYSON OF EDINBURGH

(1464) **PIAZZI SMYTH CAMERA.** C. 1865. SIZE 1 X 3 INCH PLATE EXPOSURES. F 2.2 DALLMEYER MEDALLION LENS. LENS CAP SHUTTER. WATERHOUSE STOPS. FOUR PLATES ARE GROUPED AROUND A CENTRAL TANK WHICH HOLDS SENSITIZING AND DEVELOPING SOLUTIONS. THUS, EACH PLATE CAN BE SENSITIZED AND DEVELOPED INSIDE OF THE CAMERA. (IH)

## BUSCH, EMIL OPTICAL COMPANY

NOTE: THE BUSCH CAMERA COMPANY WAS INCORPORATED IN THE EMIL BUSCH OPTICAL COMPANY.

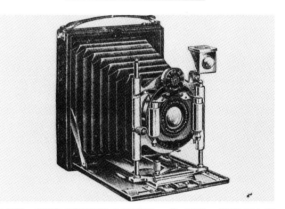

(1465) **CHIC POCKET CAMERA.** C. 1906. SIZE 3¼ X 4¼ INCH EXPOSURES ON PLATES. BUSCH LENS. AUTOMATIC SHUTTER; 1 TO 1/100 SEC. RACK & PINION FOCUSING. RISING AND CROSSING LENS MOUNT. GROUND GLASS FOCUSING.

(1466) **DREI PRIS FOLDING PLATE CAMERA.** C. 1914. SIZE 10 X 15 CM EXPOSURES ON PLATES. 150 MM/F 6.8 BUSCH LENKAR ANASTIGMAT LENS. COMPOUND SHUTTER. TRIPLE EXTENION BELLOWS. GROUND GLASS BACK.

(1467) **FOLDING CAMERA.** SIZE 3¼ X 4¼ INCH EXPOSURES. BUSCH SERIES II ANASTIGMAT 5¼ INCH/F 7.7 LENS. FOCAL PLANE SHUTTER. GROUND GLASS BACK. SPORTSFINDER.

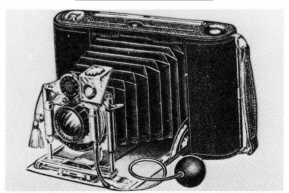

(1468) **FREEWHEEL ROLL FILM AND PLATE CAMERA.** C. 1905. SIZE 3¼ X 4¼ INCH EXPOSURES.

## BUSCH, EMIL OPTICAL COMPANY (*cont.*)

F 6 BUSCH LENS. REGULAR SHUTTER; 1 TO 1/100 SEC., B., T. THE FILM WINDING MECHANISM HAS A FREE-WHEELING DEVICE TO REWIND THE ROLL FILM SO THAT A FOCUSING SCREEN AND PLATE HOLDER CAN BE USED WITHOUT RELOADING THE ROLL FILM.

(1469) **PRESSMAN CAMERA.** SIZE 2¼ X 3¼ INCH EXPOSURES. 101 MM/F 4.5 LENS. RANGEFINDER.

(1470) **PRESSMAN CAMERA.** SIZE 4 X 5 INCH EXPOSURES. 7-INCH/F 4.5 BUTCHER ALDIS LENS.

(1471) **SINGLE-LENS REFLEX CAMERA.** C. 1910. BUSCH BIS-TELAR LONG-FOCUS LENS FOR NATURE PHOTOGRAPHY.

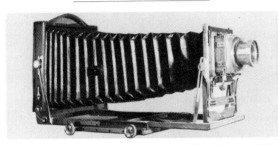

(1472) **BOOTS SPECIAL VIEW CAMERA.** C. 1900. SIZE 5 X 7 INCH EXPOSURES ON PLATES. F 8 BUSCH RAPID LENS. THORNTON-PICKARD ROLLER BLIND SHUTTER. TRIPLE EXTENSION BELLOWS. (EL)

## BUTCHER, W. & SONS, LIMITED

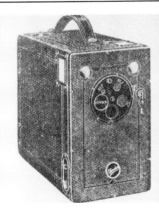

(1473) **CLINCHER BOX CAMERA.** C. 1914. TWO SIZES OF THIS CAMERA FOR 2½ X 3½ OR 3¼ X 4¼ INCH EXPOSURES ON PLATES. THE FIRST MODEL HOLDS SIX PLATES, THE SECOND HOLDS 12 PLATES. BECK RAPID RECTILINEAR OR SINGLE ACHROMATIC LENS. INSTANT AND TIME SHUTTER.

(1474) **CRAVEN MAGAZINE BOX CAMERA.** C. 1905. SIZE 3¼ X 4¼ INCH EXPOSURES ON PLATES. F 8 DOUBLE ACHROMATIC RAPID RECTILINEAR LENS. INSTANT AND TIME SHUTTER. MODEL NO. 2 HAS HALF-PLATE EXPOSURE CAPABILITY BY USE OF A MASK.

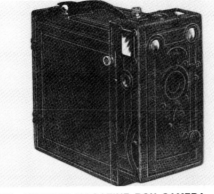

(1475) **EXPRESS MAGAZINE BOX CAMERA.** C. 1905. MODEL NO. 1 FOR SIZE 2½ X 3½ INCH EXPOSURES; MODELS NO. 2, 3, AND 4 FOR SIZES 3¼ X 4¼ INCH EXPOSURES. SINGLE ACHROMATIC LENS. VARIABLE SPEED SHUTTER. MODELS NO. 1 AND 2 HOLD SIX PLATES; MODELS NO. 3 AND 4 HOLD 12 PLATES OR 24 SHEET FILMS. MODEL NO. 4 HAS RISING AND CROSSING LENS MOUNT.

(1476) **LITTLE NIPPER BOX CAMERA.** C. 1926. SIZE 1¾ X X 2⁵⁄₁₆ INCH EXPOSURES. INSTANT AND TIME SHUTTER.

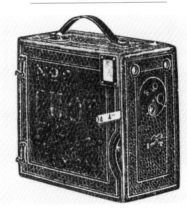

(1477) **PILOT MAGAZINE BOX CAMERA.** C. 1905. MODEL 2: 2½ X 3½ INCH EXPOSURES, SIX PLATES OR 12 FILMS; MODEL 3: 3¼ X 4¼ INCH EXPOSURES, SIX PLATES OR 12 FILMS; MODEL 3A: 3¼ X 4¼ INCH EXPOSURES, 12 PLATES OR 24 FILMS; MODEL 4: 4 X 5 INCH EXPOSURES, 12 PLATES OR 24 FILMS. SINGLE ACHROMATIC LENS. EVERSET SHUTTER FOR INSTANT AND TIME EXPOSURES.

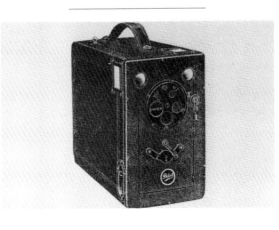

(1478) **PILOT MAGAZINE BOX CAMERA.** C. 1914. TWO SIZES OF THIS CAMERA FOR 2½ X 3½ OR 3¼ X 4¼ INCH EXPOSURES ON PLATES. MODELS 1, 2, AND 4 HOLD SIX PLATES; MODEL 3 HOLDS 12 PLATES. BECK RAPID RECTILINEAR OR SINGLE ACHROMATIC LENS. INSTANT AND TIME SHUTTER. A SET OF SUPPLEMENTARY LENSES ALLOWS THE CAMERA TO FOCUS ON OBJECTS AS CLOSE AS 4 FEET.

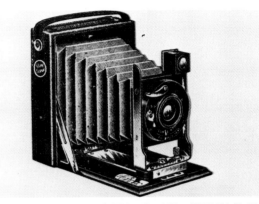

(1479) **BOY SCOUT CAMERA.** C. 1912. SIZE 3¼ X 4¼ INCH EXPOSURES ON PLATES. SINGLE LENS. EVERSET SHUTTER FOR SINGLE-SPEED, B., T. EXPOSURES. GROUND GLASS FOR FOCUSING. IRIS DIAPHRAGM.

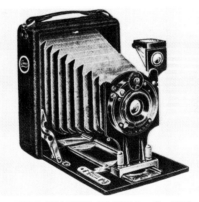

(1480) **CAMEO FOLDING CAMERA.** C. 1915. THREE SIZES OF THIS CAMERA FOR 2½ X 3½, 3¼ X 4¼ INCH, OR 9 X 12 CM EXPOSURES ON PLATES.

(1481) **NO. 1 CAMEO POCKET CAMERA.** C. 1905. SIZE 3¼ X 4¼ INCH EXPOSURES ON PLATES. F 8

## BUTCHER, W. & SONS, LIMITED (*cont.*)

SINGLE ACHROMATIC LENS. EVERSET PNEUMATIC SHUTTER FOR INSTANT, B., T. GROUND GLASS FOCUSING. IRIS DIAPHRAGM.

(1482) **NO. 2 CAMEO POCKET CAMERA.** C. 1905. SIZE 3¼ X 4¼ INCH EXPOSURES ON PLATES. DOUBLE ACHROMATIC APLANAT LENS. INSTANT, B., T. PNEUMATIC SHUTTER. GROUND GLASS FOCUSING. IRIS DIAPHRAGM. SIMILAR TO THE NO. 1 CAMEO POCKET CAMERA.

(1483) **NO. 3 CAMEO POCKET CAMERA.** C. 1905. THREE SIZES OF THIS CAMERA FOR 3¼ X 4¼, 4 X 5, OR 4¼ X 6½ INCH EXPOSURES ON PLATES. BECK RAPID SYMMETRICAL LENS. AUTOMATIC PNEUMATIC SHUTTER; 1 TO ¹⁄₁₀₀ SEC. RACK & PINION FOCUSING. GROUND GLASS FOCUSING. IRIS DIAPHRAGM.

(1484) **NO. 4 CAMEO POCKET CAMERA.** C. 1905. TWO SIZES OF THIS CAMERA FOR 3¼ X 4¼ OR 4¼ X 6½ INCH EXPOSURES ON PLATES. F 6 ALDIS ANASTIGMAT LENS. AUTOMATIC PNEUMATIC SHUTTER; 1 TO ¹⁄₁₀₀ SEC. RISING, CROSSING, AND SWING LENS MOUNT. DOUBLE EXTENSION BELLOWS. RACK & PINION FOCUSING. GROUND GLASS FOCUSING. IRIS DIAPHRAGM. SIMILAR TO THE NO. 3 CAMEO POCKET CAMERA.

(1485) **CAMEO CAMERA. NO. 0 SERIES.** C. 1914. SIZE 3¼ X 4¼ INCH EXPOSURES ON PLATES OR FILM PACKS. F 11 SINGLE ACHROMATIC, F 8 PRIMUS RAPID RECTILINEAR, F 8 BECK RAPID RECTILINEAR, OR F 7.7

ALDIS UNO ANASTIGMAT LENS. LUKOS AUTOMATIC SHUTTER; INSTANT, B., T. GROUND GLASS FOCUS.

(1486) **CAMEO CAMERA. MODEL I.** C. 1914. THREE SIZES OF THIS CAMERA FOR 2½ X 3½, 3¼ X 4¼, OR 3½ X 5½ INCH EXPOSURES ON PLATES OR FILM PACKS. F 11 BECK RAPID RECTILINEAR, F 7.7 ALDIS UNO, F 6 BECK MUTAR, OR F 6.3 ZEISS TRIOTAR LENS. LUKOS SHUTTER; ¹⁄₂₅ TO ¹⁄₁₀₀ SEC., B., T. RISING AND CROSSING LENS MOUNT. GROUND GLASS FOCUS.

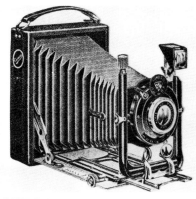

(1487) **CAMEO CAMERA. MODEL II.** C. 1914. THREE SIZES OF THIS CAMERA FOR 2½ X 3½, 3¼ X 4¼, OR 3½ X 5½ INCH EXPOSURES ON PLATES OR FILM PACKS. F 8 BECK RAPID RECTILINEAR, F 7.7 ALDIS UNO, F 6 BECK MUTAR, OR F 6.3 ZEISS TRIOTAR LENS. LUKOS SHUTTER; ¹⁄₂₅, ¹⁄₅₀, ¹⁄₁₀₀ SEC., B., T. DOUBLE EXTENSION BELLOWS. RISING AND CROSSING LENS MOUNT. GROUND GLASS FOCUS. RACK & PINION FOCUS.

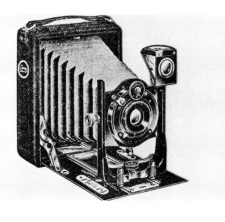

(1488) **CAMEO CAMERA. MODEL IV.** C. 1914. SIZE 3¼ X 4¼ INCH EXPOSURES ON PLATES. F 6.3 ZEISS TRIOTAR LENS. LUKOS II SHUTTER FOR THREE SPEEDS AND B., T. RACK & PINION RISING LENS MOUNT.

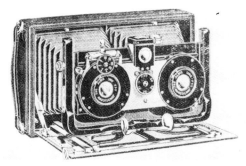

(1489) **CAMEO STEREO CAMERA.** C. 1914. SIZE 3¼ X 6¾ INCH STEREO EXPOSURES ON PLATES. SINGLE ACHROMATIC, F 7.7 ALDIS ANASTIGMAT, F 6 BECK MUTAR, F 6 ALDIS SERIES II, F 6.3 COOKE SERIES III, F 6.8 GOERZ DAGOR, OR F 6.3 ZEISS TESSAR LENSES. EVERSET SHUTTER; INSTANT, B., T. AUTOMATIC SHUTTER; 1 TO ¹⁄₁₀₀ SEC., B., T. COMPOUND SHUTTER; 1 TO ¹⁄₂₅₀ SEC., B., T. DOUBLE EXTENSION BELLOWS. RISING LENS MOUNT. RACK & PINION FOCUSING.

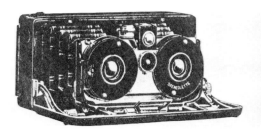

(1490) **CAMEO STEREOLETTE CAMERA.** C. 1911. SIZE 45 X 107 MM STEREO EXPOSURES ON PLATES OR FILM PACKS. F 6 APLANAT, F 7.7 ALDIS UNO ANASTIGMAT, OR F 6.8 PRIMAR ANASTIGMAT LENSES. EVERSET AUTOMATIC SHUTTER. RACK & PINION FOCUSING.

(1491) **UNO CAMEO CAMERA.** C. 1912. SIZE 3¼ X 4¼ INCH EXPOSURES ON PLATES OR FILM PACKS. F 7.7 ALDIS UNO ANASTIGMAT LENS. THREE-SPEED SHUTTER WITH BULB AND TIME EXPOSURES. RISING LENS MOUNT.

## BUTCHER, W. & SONS, LIMITED (*cont.*)

**(1492) NO. 1 CARBINE CAMERA.** C. 1905. SIZE 2¼ X 3¼ INCH EXPOSURES ON ROLL FILM OR PLATES. RAPID SINGLE ACHROMATIC LENS. INSTANT AND TIME SHUTTER. THREE ROTARY APERTURE STOPS.

**(1493) NO. 2 CARBINE CAMERA.** C. 1905. SIZE 3¼ X 4¼ INCH EXPOSURES ON ROLL FILM OR PLATES. RAPID RECTILINEAR LENS. BAUSCH & LOMB PNEUMATIC SHUTTER FOR INSTANT, B., T. EXPOSURES. IRIS DIAPHRAGM.

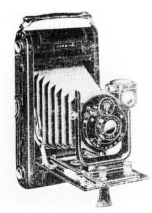

**(1494) NO. 2 CARBINE CAMERA.** C. 1914. FOUR SIZES OF THIS CAMERA FOR 2½ X 3½, 2½ X 4¼, 3¼ X 4¼, OR 3½ X 5½ INCH EXPOSURES ON ROLL FILM OR PLATES WITH ADAPTER. F. 8 BECK RAPID RECTILINEAR LENS. LUKOS AUTOMATIC SHUTTER; INSTANT, B., T.

**(1495) NO. 3 CARBINE CAMERA.** C. 1905. SIZE 3¼ X 4¼ INCH EXPOSURES ON ROLL FILM OR PLATES. SAME AS THE NO. 2 CARBINE CAMERA (C. 1905), EXCEPT WITH A BECK RAPID SYMMETRICAL LENS.

**(1496) NO. 3A CARBINE CAMERA.** C. 1914. FOUR SIZES OF THIS CAMERA FOR 2½ X 3½, 2½ X 4¼, 3¼ X 4¼, OR 3½ X 5½ INCH EXPOSURES ON ROLL FILM OR PLATES. F 8 BECK SYMMETRICAL, BECK MUTAR, ALDIS UNO, OR ZEISS TRIOTAR LENS. LUKOS SHUTTER WITH ADJUSTABLE SPEEDS. SIMILAR TO THE NO. 2 CARBINE (C. 1914).

**(1497) NO. 3B CARBINE CAMERA.** C. 1913. FOUR SIZES OF THIS CAMERA FOR 2½ X 3½, 3¼ X 4¼, 2½ X 4½, OR 3½ X 5½ INCH EXPOSURES ON ROLL FILM. INTERCHANGEABLE BACK FOR PLATES AND CUT FILM. F 7.7 ALDIS LENS. LUKOS SHUTTER; 1 TO ¹⁄₁₀₀ SEC., B., T. RISING LENS MOUNT. SIMILAR TO THE NO. 2 CARBINE (C. 1914).

**(1498) NO. 4 CARBINE CAMERA.** C. 1905. SIZE 3¼ X 4¼ INCH EXPOSURES ON ROLL FILM OR PLATES. BECK SYMMETRICAL LENS. AUTOMATIC SHUTTER; 1 TO ¹⁄₁₀₀ SEC., B., T. RISING AND CROSSING LENS MOUNT. RACK & PINION FOCUSING.

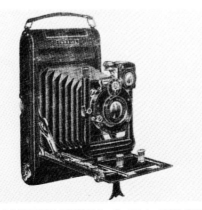

**(1499) NO. 4 CARBINE CAMERA.** C. 1914. TWO SIZES OF THIS CAMERA FOR 3¼ X 4¼ OR 3½ X 5½ INCH EXPOSURES ON ROLL FILM, FILM PACKS, OR PLATES WITH ADAPTER. F 7.7 ALDIS UNO ANASTIGMAT LENS. LUKOS III SHUTTER; 1 TO ¹⁄₁₀₀ SEC., B., T. RACK & PINION FOCUSING. RISING AND CROSSING LENS MOUNT.

**(1500) NO. 5 CARBINE CAMERA.** C. 1914. TWO SIZES OF THIS CAMERA FOR 3¼ X 4¼, OR 3½ X 5½ INCH EXPOSURES ON ROLL FILM, FILM PACKS, OR PLATES WITH ADAPTER. F 7.7 ALDIS UNO ANASTIGMAT, F 6 BECK MUTAR, F 6.3 ZEISS TRIOTAR, F 6.8 ALDIS ANASTIGMAT, F 6.5 COOKE, F 6.3 ROSS HOMOCENTRIC, F 6.8 GOERZ, OR F 6.8 ZEISS AMATAR LENS. LUKOS III SHUTTER; 1 TO ¹⁄₁₀₀ SEC., B., T. SIMILAR TO THE CARBINE NO. 4 CAMERA (C. 1914) BUT WITH DOUBLE EXTENSION BELLOWS.

**(1501) NO. 6 CARBINE CAMERA.** C. 1914. SIZE 4¼ X 6½ INCH EXPOSURES ON ROLL FILM, FILM PACKS, OR PLATES WITH ADAPTER. F 7.7 ALDIS UNO ANASTIGMAT, F 6 BECK MUTAR, F 6.3 ROSS HOMOCENTRIC, OR F 6.8 GOERZ SERIES III LENS. COMPOUND SECTOR SHUTTER. SIMILAR TO THE NO. 5 CARBINE CAMERA, (C. 1914).

**(1502) NO. 4 FLUSH BACK CARBINE CAMERA.** C. 1906. EXPOSURES ON PLATES OR ROLL FILM.

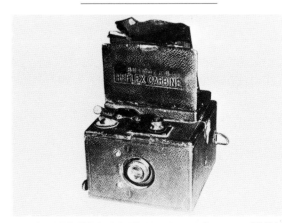

**(1503) MINIMUM CARBINE CAMERA.** C. 1906. SIZE 3¼ X 4¼ INCH EXPOSURES ON ROLL FILM. DR. LIEBER ANASTIGMAT, F 6.8 GOERZ SYNTOR, OR SERIES III LENS. ALSO, ROSS F 6.3 HOMOCENTRIC OR F 6.5 COOKE SERIES III LENS. SECTOR SHUTTER; 1 TO ¹⁄₂₅₀ SEC. RACK & PINION FOCUSING. RISING AND CROSSING LENS MOUNT.

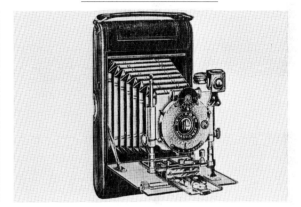

**(1504) REFLEX CARBINE CAMERA.** C. 1926. SINGLE LENS REFLEX BOX-TYPE CAMERA. SIZE 2¼ X 3¼ INCH EXPOSURES ON NO. 120 ROLL FILM. 4.25 INCH/F 6.3 ALDIS UNO ANASTIGMAT LENS. (HA)

## BUTCHER, W. & SONS, LIMITED (*cont.*)

**(1505) REFLEX CARBINE NO. 2 CAMERA.** C. 1931. SINGLE LENS REFLEX BOX-TYPE CAMERA.

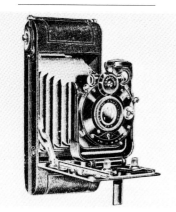

**(1506) WATCH POCKET CARBINE CAMERA.** C. 1914. SIZE 2¼ X 3¼ INCH EXPOSURES ON ROLL FILM. F 7.7 ALDIS UNO ANASTIGMAT LENS. LUKOS II OR COMPOUND SHUTTER. ALL METAL BODY.

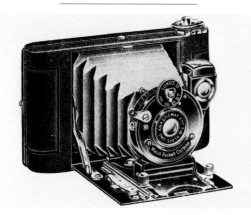

**(1507) WATCH POCKET SQUARE CARBINE CAMERA.** C. 1914. SIZE 2¼ X 2¼ INCH EXPOSURES ON ROLL FILM. F 7.7 ALDIS UNO ANASTIGMAT, F 4.9 BECK MUTAR, F 6.3 ZEISS TRIOTAR, F 5.6 COOKE, F 6.8 ROSS HOMOCENTRIC, F 6.3 DALLMEYER CARFAC, F 6.3 ZEISS TESSAR, OR F 6.8 GOERZ DAGOR LENS. MODEL I WITH A LUKOS SHUTTER; ½₅, ½₀, ½₀₀ SEC., B., T. MODEL II WITH A COMPOUND SHUTTER; 1 TO ½₅₀ SEC., B., T.

**(1508) NO. 10 WATCH POCKET CARBINE CAMERA.** C. 1925. SIZE 2½ X 4¼ INCH EXPOSURES ON ROLL FILM. F 11 SINGLE ACHROMATIC OR F 8 RAPID APLANAT LENS. THREE-SPEED SHUTTER PLUS B., T.

**(1509) NO. 12 WATCH POCKET CARBINE CAMERA.** C. 1925. SIZE 2½ X 4¼ INCH EXPOSURES ON ROLL FILM. F 7.7 ALDIS UNO ANASTIGMAT OR F 6.3 ALDIS-BUTCHER ANASTIGMAT LENS. THREE-SPEED, SIX-SPEED, OR COMPUR SHUTTER. SIMILAR TO THE NO. 10 WATCH POCKET CARBINE CAMERA.

**(1510) DANDYCAM FERROTYPE CAMERA.** C. 1911. THIS BOX-FORM CAMERA PRODUCED BUTTON-TYPE PHOTOS IN FIVE MINUTES BY DEVELOPING AND FIXING THE BUTTONS INSIDE OF THE CAMERA.

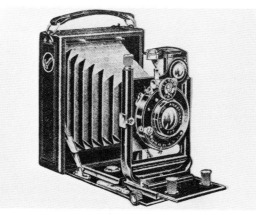

**(1511) KLIMAX CAMERA. MODEL I.** C. 1914. FOUR SIZES OF THIS CAMERA FOR 3¼ X 4¼, 4 X 5, 3½ X 5½, OR 4¼ X 6½ INCH EXPOSURES ON PLATES OR FILM PACKS. F 7.7 ALDIS UNO, F 6 BECK MUTAR, F 6 ALDIS ANASTIGMAT, F 6.3 ZEISS TRIOTAR, F 6.5 COOKE SERIES III, F 6.3 ROSS HOMOCENTRIC, F 6 DALLMEYER STIGMATIC, F. 6.8 GOERZ DAGOR, OR F 6.3 ZEISS TESSAR II LENS. LUKOS SHUTTER; 1 TO ½₀₀ SEC., B., T. OR COMPOUND SECTOR SHUTTER. RACK & PINION FOCUS. RISING AND CROSSING LENS MOUNT. SINGLE EXTENSION BELLOWS.

**(1512) KLIMAX CAMERA. MODEL II.** C. 1914. FOUR SIZES OF THIS CAMERA FOR 3¼ X 4¼, 4 X 5, 3½ X 5½, OR 4¼ X 6½ INCH EXPOSURES ON PLATES OR FILM PACKS. SIMILAR TO THE KLIMAX MODEL I CAMERA WITH THE SAME LENSES AND SHUTTERS BUT WITH DOUBLE EXTENSION BELLOWS.

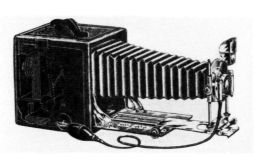

**(1513) MIDG DOUBLE EXTENSION CAMERA. MODEL 4.** C. 1905. SIZE 3¼ X 4¼ INCH EXPOSURES. BECK

SYMMETRICAL LENS. AUTOMATIC SHUTTER. THE MAGAZINE HOLDS 12 PLATES OR 24 SHEET FILMS.

**(1514) KLIMAX CAMERA. MODEL III.** C. 1914. SIZE 3¼ X 4¼ INCH EXPOSURES ON PLATES. F 4.5 ALDIS-BUTCHER ANASTIGMAT, F 4.5 COOKE ANASTIGMAT, F 4.5 ZEISS TESSAR, F 4.5 ROSS HOMOCENTRIC OR F 4.8 GOERZ CELOR LENS. NO. 2 COMPOUND SECTOR SHUTTER; ½₀ TO ½₅₀ SEC. SIMILAR TO THE KLIMAX MODEL I CAMERA BUT WITH DOUBLE EXTENSION BELLOWS.

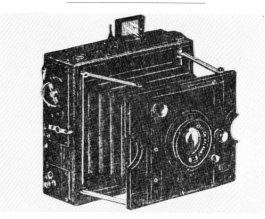

**(1515) MIDG NO. 1 FOCAL PLANE CAMERA.** C. 1904. EXPOSURES ON PLATES. F 6 ALDIS ANASTIGMAT LENS. FOCAL PLANE SHUTTER; ½₅ TO ½₀₀₀ SEC.

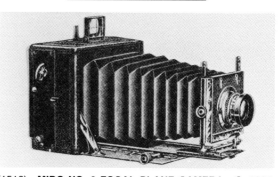

**(1516) MIDG NO. 2 FOCAL PLANE CAMERA.** C. 1904. EXPOSURES ON PLATES. F 6 ALDIS ANASTIGMAT LENS. FOCAL PLANE SHUTTER WITH SPEEDS TO ½₀₀₀ SEC. RACK & PINION FOCUSING.

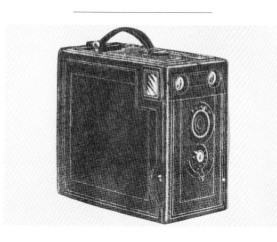

## BUTCHER, W. & SONS, LIMITED (cont.)

(1517) **MIDG MAGAZINE BOX CAMERA. MODELS 0, 00, 1, 1A, AND 2.** C. 1905. SIZE 3¼ X 4¼ INCH EXPOSURES. RAPID RECTILINEAR OR BECK SYMMETRICAL LENS. EVERSET OR AUTOMATIC SHUTTER. MODEL 00 HAS A RISING AND CROSSING LENS MOUNT. THE MAGAZINE HOLDS 12 PLATES OR 24 SHEET FILMS.

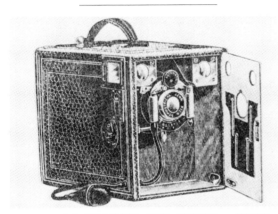

(1518) **MIDG MAGAZINE BOX CAMERA. MODEL 3.** C. 1905. SIZE 3¼ X 4¼ INCH EXPOSURES. BECK SYMMETRICAL LENS. AUTOMATIC SHUTTER. RACK & PINION FOCUSING. WITH OR WITHOUT RISING AND CROSSING LENS MOUNT. THE MAGAZINE HOLDS 12 PLATES OR 24 SHEET FILMS.

(1519) **NO. 00 MIDG MAGAZINE BOX CAMERA.** C. 1914. SIZE 3¼ X 4¼ INCH EXPOSURES ON PLATES. SIMILAR TO THE NO. 0 MIDG MAGAZINE BOX CAMERA FOR SIZE 3¼ X 4¼ INCH EXPOSURES WITH THE SAME SHUTTER BUT WITH AN F 8 RAPID SYMMETRICAL LENS.

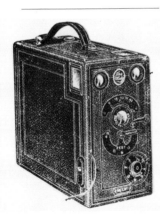

(1520) **NO. 0 MIDG MAGAZINE BOX CAMERA.** C. 1914. TWO SIZES OF THIS CAMERA FOR 3¼ X 4¼ OR 3½ X 5½ INCH EXPOSURES. F 11 RAPID RECTILINEAR LENS. SHUTTER SPEEDS FROM 1 TO ⅟₁₀₀ SEC. THE MAGAZINE HOLDS 12 PLATES OR 24 SHEET FILMS.

(1521) **NO. 2 MIDG MAGAZINE BOX CAMERA.** C. 1914. TWO SIZES OF THIS CAMERA FOR 3¼ X 4¼ OR 3½ X 5½ INCH EXPOSURES. SIMILAR TO THE NO. 1 MIDG MAGAZINE BOX CAMERA WITH THE SAME SHUTTER BUT WITH AN F 7.7 ALDIS UNO ANASTIGMAT LENS.

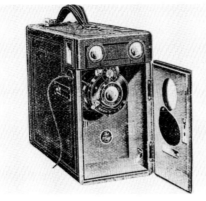

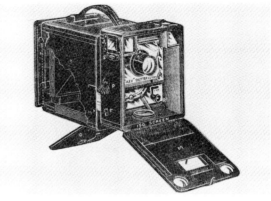

(1522) **NO. 1 MIDG MAGAZINE BOX CAMERA.** C. 1914. TWO SIZES OF THIS CAMERA FOR 3¼ X 4¼ OR 3½ X 5½ INCH EXPOSURES. F 8 PRIMUS RAPID SYMMETRICAL LENS. AUTOMATIC SHUTTER; 1 TO ⅟₁₀₀ SEC., B., T. THE MAGAZINE HOLDS 12 PLATES OR 24 SHEET FILMS.

(1523) **NO. 3 MIDG MAGAZINE BOX CAMERA.** C. 1914. TWO SIZES OF THIS CAMERA FOR 3¼ X 4¼ OR 3½ X 5½ INCH EXPOSURES. SIMILAR TO THE NO. 1 MIDG MAGAZINE BOX CAMERA (C. 1914) BUT WITH AN F 7.7 ALDIS UNO ANASTIGMAT OR F 8 BECK SYMMETRICAL LENS. NO. 3 SECTOR SHUTTER; 1 TO 1⅟₁₀₀ SEC., B., T.

(1524) **MIDG PANORAMIC CAMERA.** C. 1901. SIZE 2½ X 6½ INCH PANORAMIC EXPOSURES ON PLATES. ACHROMATIC LENS. FALLING-PLATE MAGAZINE.

(1525) **NO. 1 MIDGET CAMERA.** C. 1900. SIZE 2½ X 3½ INCH EXPOSURES.

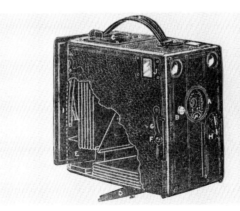

(1526) **NO. 2 MIDGET CAMERA.** C. 1904. SIZE 3¼ X 4¼ INCH EXPOSURES ON PLATES. INSTANT AND TIME SHUTTER. THE MAGAZINE HOLDS 12 PLATES.

(1527) **NO. 4A MIDGET CAMERA.** C. 1908. RAPID RECTILINEAR LENS.

(1528) **NO. 4B MIDGET MAGAZINE CAMERA.** C. 1908. SIZE 3¼ X 4¼ INCH EXPOSURES. ALDIS F 6.0 LENS.

(1529) **NO. 4 MIDGET CAMERA.** C. 1904. SIZE 3¼ X 4¼ INCH EXPOSURES ON PLATES. RAPID RECTILINEAR LENS. VARIABLE-SPEED AND TIME SHUTTER. RACK & PINION FOCUSING. RISING AND CROSSING LENS MOUNT.

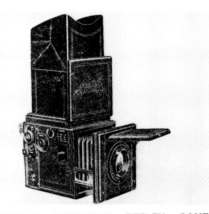

(1530) **POPULAR PRESSMAN REFLEX CAMERA.** C. 1914. TWO SIZES OF THIS CAMERA FOR 3¼ X 4¼ OR 3½ X 5½ INCH EXPOSURES ON PLATES. F 4.5 ALDIS-BUTCHER, COOKE SERIES II, GOERZ CELOR, ROSS TELECENTRIC, OR ZEISS TESSAR LENS. FOCAL PLANE SHUTTER; ⅟₁₅ TO ⅟₁₀₀₀ SEC., T. RISING AND FALLING LENS MOUNT.

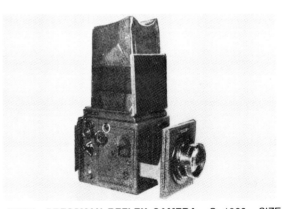

(1531) **PRESSMAN REFLEX CAMERA.** C. 1926. SIZE 3¼ X 4¼ INCH EXPOSURES ON PLATES OR FILM PACKS. 6.5 INCH/F 2.7 CARL ZEISS TESSAR LENS. FOCAL PLANE SHUTTER.

## BUTCHER, W. & SONS, LIMITED (*cont.*)

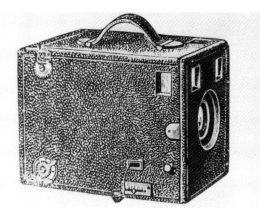

(1532) **PRIMUS FOCAL PLANE HAND CAMERA.** C. 1898. SIZE 3¼ X 4¼ INCH EXPOSURES ON PLATES. F 6 RAPID EURYSCOPE LENS. THE CAMERA HAS TWO SHUTTERS. A SWIFT INSTANT AND TIME FRONT SHUTTER; ⅟₁₅ TO ⅟₉₀ SEC. AND A FOCAL PLANE SHUTTER; ⅟₂₀₀ TO ⅟₁₀₀₀ SEC. EXTERNAL KNOB FOR FOCUSING.

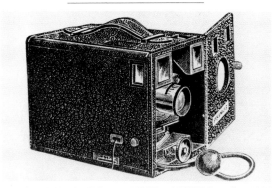

(1533) **PRIMUS NO. 1 HAND CAMERA.** C. 1898. THREE SIZES OF THIS CAMERA FOR 3¼ X 4¼, 4 X 5, OR 4¼ X 6½ INCH EXPOSURES ON PLATES. RAPID RECTILINEAR LENS. SWIFT INSTANTANEOUS SHUTTER. IRIS DIAPHRAGM. EXTERNAL KNOB FOR FOCUSING.

(1534) **PRIMUS NO. 2 HAND CAMERA.** C. 1898. THREE SIZES OF THIS CAMERA FOR 3¼ X 4¼, 4 X 5, OR 4¼ X 6½ INCH EXPOSURES ON PLATES. SIMILAR TO THE PRIMUS NO. 1 HAND CAMERA BUT WITH AN F 6 EURYSCOPE LENS AND A SWIFT INSTANT AND TIME SHUTTER.

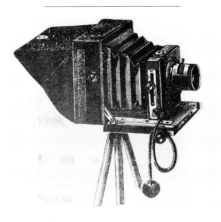

(1535) **PRIMUS NO. 3 FOLDING CAMERA.** C. 1898. THREE SIZES OF THIS CAMERA FOR 3¼ X 4¼, 4 X 5, OR 4¼ X 6½ INCH EXPOSURES ON PLATES.

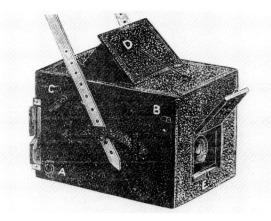

(1536) **PRIMUS REFLECT HAND CAMERA.** C. 1898. SIZE 3¼ X 4¼ INCH EXPOSURES ON PLATES. F 8 RAPID RECTILINEAR LENS. FOCAL PLANE SHUTTER. IRIS DIAPHRAGM. EXTERNAL KNOB FOR FOCUSING.

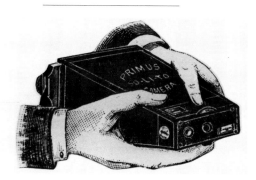

(1537) **PRIMUS SO-LI-TO HAND CAMERA.** C. 1898. SIZE 3¼ X 4¼ INCH EXPOSURES ON PLATES. FIXED-FOCUS SINGLE ACHROMATIC LENS. INSTANT AND TIME SHUTTER. ROTATING DIAPHRAGM WITH THREE APERTURE STOPS.

(1538) **PRIMUS TWIN LENS REFLEX CAMERA.** C. 1898. SIZE 3¼ X 4¼ INCH EXPOSURES ON PLATES. F 8 RAPID RECTILINEAR LENSES. SWIFT INSTANT AND TIME SHUTTER. IRIS DIAPHRAGM. EXTERNAL KNOB FOR FOCUSING.

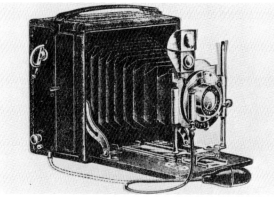

(1539) **NO. 0 RALLI FOCAL PLANE CAMERA.** C. 1905. EXPOSURES ON PLATES. F 7.5 DR. LIEBER ANASTIGMAT LENS. THE CAMERA HAS TWO SHUTTERS. A FOCAL PLANE SHUTTER; ⅟₂₅ TO ⅟₁₀₀₀ SEC. AND A PNEUMATIC SHUTTER FOR INSTANT, B., T. EXPOSURES. RISING AND FALLING LENS MOUNT.

(1540) **ROYAL MAIL COPYING CAMERA.** C. 1907. SIX EXPOSURES ON A SINGLE 3¼ X 4¼ INCH PLATE. THREE MENISCUS LENSES. (MA)

(1541) **ROYAL MAIL COPYING CAMERA.** C. 1908. FIFTEEN EXPOSURES ON A SINGLE 3¼ X 4¼ INCH PLATE. FIFTEEN MENISCUS LENSES.

(1542) **STEREOLETTE STEREO CAMERA.** C. 1910. SIZE 45 X 107 MM STEREO EXPOSURES ON PLATES. MENISCUS LENSES. GUILLOTINE SHUTTER. REFLEX VIEWER. (MA)

(1543) **WATCH POCKET KLIMAX CAMERA.** C. 1913. SIZE 2¼ X 2¼ INCH EXPOSURES. F 7.7 ALDIS UNO ANASTIGMAT OR F 6.3 ZEISS TRIOTAR LENS. LUKOS SHUTTER; ⅟₂₅, ⅟₅₀, ⅟₁₀₀ SEC., B., T.

## CHADWICK, W. I.

(1544) **HAND CAMERA.** C. 1891. PLATE EXPOSURES. RAPID RECTILINEAR LENS. KERSHAW SHUTTER. RACK & PINION FOCUSING.

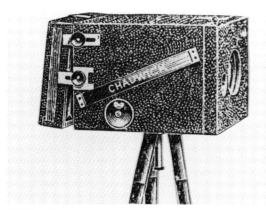

(1545) **HAND CAMERA.** C. 1893. PLATE EXPOSURES. F 11 SINGLE LENS OR F 7 RAPID RECTILINEAR LENS. KERSHAW SHUTTER. RACK & PINION FOCUSING. RISING AND FALLING FRONT. SWING BACK. SIDE SWING.

## CHAPMAN, J.W.

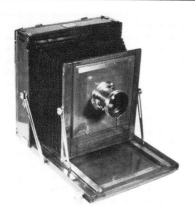

(1546) **"THE BRITISH" FIELD CAMERA.** C. 1890. SIZE 8 X 10 INCH EXPOSURES ON PLATES. DALLMEYER #5 STIGMATIC LENS. IRIS DIAPHRAGM. (GS)

## CITY SALE AND EXCHANGE

(1547) **AUTOLOX CAMERA.** C. 1909. EXPOSURES ON ROLL FILM. THE CAMERA IS SELF-ERECTING WHEN THE BASEBOARD IS LOWERED.

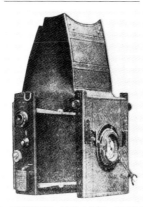

(1548) **CURT BENTZIN FOLDING REFLEX CAMERA.** C. 1927. SIZE 2½ X 3½ INCH EXPOSURES ON PLATES. F 2.9 PLAUBEL ANASTIGMAT OR F 4.5 ZEISS TESSAR LENS. FOCAL PLANE SHUTTER; ⅕ TO ¹⁄₁₀₀₀ SEC. RE-VOLVING BACK. RISING LENS MOUNT.

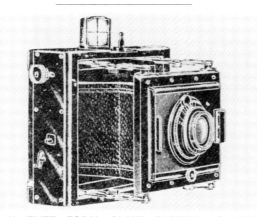

(1549) **ELITE FOCAL PLANE CAMERA.** C. 1906. PLATE EXPOSURES. F 5.6 ROSS HOMOCENTRIC, F 6.8, OR F 4.5 GOERZ LENS. FOCAL PLANE SHUTTER; ¹⁄₁₀ TO ¹⁄₁₀₀₀ SEC.

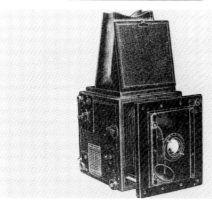

(1550) **PLANEX SINGLE LENS REFLEX CAMERA.** C. 1906. THREE SIZES OF THIS CAMERA FOR 3¼ X 4¼, 4 X 5, OR 4¼ X 6½ INCH EXPOSURES ON PLATES. VARIOUS LENSES BY GOERZ, ROSS, ZEISS, DALL-MEYER, COOKE, AND BUSCH. FOCAL PLANE SHUTTER; ¹⁄₁₀ TO ¹⁄₁₀₀₀ SEC., T. REVERSING BACK. RISING LENS MOUNT.

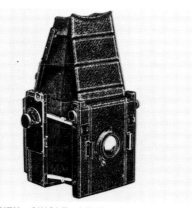

(1551) **PLANEX SINGLE LENS REFLEX CAMERA.** C. 1912. SIZE 3¼ X 4¼ INCH EXPOSURES ON PLATES. FOCAL PLANE SHUTTER. REVOLVING BACK. RISING AND FALLING LENS MOUNT.

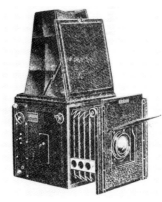

(1552) **PLANEX SINGLE LENS REFLEX CAMERA. IMPROVED MODEL.** C. 1913. FOUR SIZES OF THIS CAMERA FOR 3¼ X 4¼, 3½ X 5½, 4 X 5, OR 4¼ X 6½ INCH EXPOSURES ON PLATES. VARIOUS ANASTIGMAT LENSES. FOCAL PLANE SHUTTER. RISING LENS MOUNT. REVOLVING BACK.

(1553) **PLANEX SINGLE LENS REFLEX CAMERA. IMPROVED MODEL II.** C. 1915. SAME AS THE PLANEX 1913 MODEL BUT WITH A HINGED HOOD FRAME AT THE TOP OF THE CAMERA TO ALLOW ACCESS TO THE MIRROR AND GROUND GLASS FOR CLEANING.

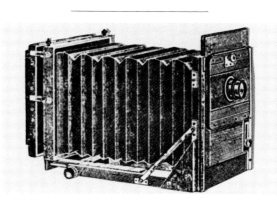

## CITY SALE AND EXCHANGE (*cont.*)

**(1554) SALEX COMMERCIAL SQUARE BELLOWS CAMERA.** C. 1933. SIZE 6½ X 8½ INCH EXPOSURES ON PLATES. RACK & PINION FOCUSING. SWING BACK. REVERSIBLE BACK. RISING AND CROSSING LENS MOUNT.

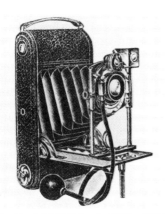

**(1555) SALEX FILM CAMERA.** C. 1905. SIZE 3¼ X 4¼ INCH EXPOSURES ON ROLL FILM OR PLATES. F 8 BUSCH, F 7.7 BUSCH ANASTIGMAT, F 6.3 ROSS HOMOCENTRIC, F 6.8 GOERZ ANASTIGMAT, OR F 6.5 COOKE LENS. UNICUM S SHUTTER; 1 TO ¹⁄₁₀₀ SEC., T. RISING AND CROSSING LENS MOUNT.

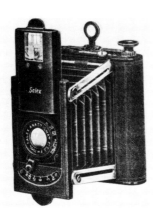

**(1556) SALEX FOLDING FOCAL PLANE CAMERA.** C. 1921. TWO SIZES OF THIS CAMERA FOR 1⅝ X 2½ OR 2½ X 3½ INCH EXPOSURES ON PLATES OR FILM PACKS WITH ADAPTER. F 5.5 ANASTIGMAT LENS. FOCAL PLANE SHUTTER; ¹⁄₁₅ TO ¹⁄₁₀₀₀ SEC.

**(1557) SALEX FOLDING FOCAL PLANE CAMERA.** C. 1924. THREE SIZES OF THIS CAMERA FOR 1⅝ X 2¼, 2½ X 3½, OR 3¼ X 4¼ INCH EXPOSURES ON PLATES OR FILM PACKS. SAME AS THE 1921 SALEX FOLDING FOCAL PLANE CAMERA EXCEPT WITH A 108 MM/F 3.9 SALEX ANASTIGMAT LENS.

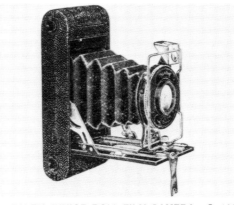

**(1558) SALEX JUNIOR ROLL FILM CAMERA.** C. 1930. SIZE 2¼ X 3¼ INCH EXPOSURES. F 4.5 SALEXON ANASTIGMAT LENS. EVERSET MULCHRO SHUTTER; 1 TO ¹⁄₁₀₀ SEC., B., T.

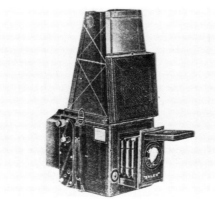

**(1559) SALEX REFLEX CAMERA.** C. 1923. SIZE 2½ X 3½ INCH EXPOSURES ON PLATES. F 4.5 SALEX ANASTIGMAT OR ROSS XPRES LENS. FOCAL PLANE NON-CAPPING SHUTTER. REVOLVING BACK.

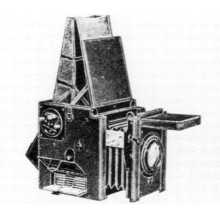

**(1560) SALEX DE LUXE REFLEX CAMERA.** C. 1923. SIZE 2½ X 3½ INCH EXPOSURES ON PLATES. F 4.5 SALEX ANASTIGMAT, F 4.5 COOKE AVIAR, OR F 4.5 ROSS XPRES LENS. FOCAL PLANE SHUTTER; ¹⁄₁₀ TO ¹⁄₁₀₀₀ SEC. REVOLVING BACK. RISING LENS MOUNT. THE BOTTOM OF THE CAMERA CONTAINS A MAGAZINE FOR SIX PLATES.

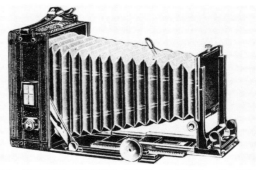

**(1561) TROPEX FOLDING HAND CAMERA.** C. 1914. FOUR SIZES OF THIS CAMERA FOR 2½ X 3½, 3¼ X 4¼, 3½ X 5½, OR 4¼ X 6½ INCH EXPOSURES ON PLATES. TRIPLE EXTENSION BELLOWS. THE DELUXE MODEL HAS A REVOLVING BACK.

## CORONET CAMERA COMPANY

**(1562) BOX CAMERA.** C. 1930. SIZE 1⅝ X 2¼ INCH EXPOSURES ON ROLL FILM. SIMILAR TO THE CONE-STYLE BOX CAMERA.

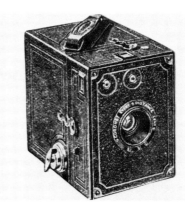

**(1563) BOX CAMERA.** C. 1932. SIZE 2¼ X 3¼ INCH EXPOSURES ON ROLL FILM. TAYLOR-HOBSON LENS. SINGLE-SPEED AND TIME SHUTTER.

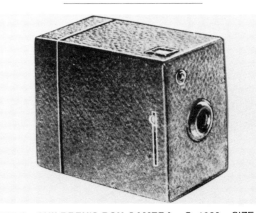

**(1564) CHILDREN'S BOX CAMERA.** C. 1930. SIZE 2½ X 3½ INCH EXPOSURES ON PLATES. BI-CONVEX LENS. SINGLE-SPEED SHUTTER.

## CORONET CAMERA COMPANY (*cont.*)

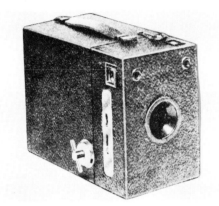

**(1565) CONE-STYLE BOX CAMERA.** C. 1930. SIZE 2¼ X 3¼ INCH EXPOSURES ON ROLL FILM. MENISCUS LENS. SINGLE-SPEED AND TIME SHUTTER.

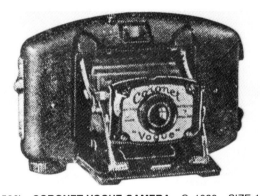

**(1566) CORONET VOGUE CAMERA.** C. 1938. SIZE 1⅛ X 1¹⁵⁄₁₆ INCH EXPOSURES ON ROLL FILM. F 10 LENS. INSTANT AND BULB EXPOSURES. BAKELITE BODY.

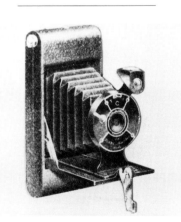

**(1567) FOLDING POCKET CAMERA.** C. 1930. SIZE 2¼ X 3¼ INCH EXPOSURES ON ROLL FILM. MENISCUS LENS. SINGLE-SPEED AND TIME SHUTTER.

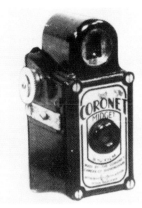

**(1568) MIDGET CAMERA.** C. 1934–40. THE CAMERA TAKES SIX EXPOSURES SIZE 13 X 18 MM ON 16 MM ROLL FILM. F 10 HOBSON MENISCUS LENS. SINGLE SPEED SHUTTER; 1/30 SEC. FIXED FOCUS. (HA)

## COX, FREDERICK

**(1569) SUTTON'S PANORAMIC CAMERA.** C. 1860. FOUR SIZES OF THIS CAMERA FOR 1¾ X 3½, 3 X 7½, 4 X 10½, OR 6 X 15 INCH PANORAMIC EXPOSURES ON CURVED WET-COLLODION PLATES. 120-DEGREE PANORAMIC EXPOSURES. THE SUTTON LENS CONSISTS OF A HOLLOW GLASS SPHERE FILLED WITH A LIQUID. IN 1861, THIS CAMERA WAS MANUFACTURED BY ROSS & COMPANY.

**(1570) BINOCULAR STEREO CAMERA.** C. 1862. DOUBLE SLIDING-BOX CONSTRUCTION. RACK & PINION FOCUSING.

## CRAMB, J.

**(1571) COMBINATION STEREO AND VIEW CAMERA.** C. 1861. THE COMBINATION CONSISTS OF A LARGE-FORMAT VIEW CAMERA WITH A SMALL SINGLE CAMERA ON EACH SIDE OF THE VIEW CAMERA. THE TWO SMALL CAMERAS, TOGETHER, PRODUCE STEREO EXPOSURES. ALL THREE CAMERAS ARE MOUNTED ON A SINGLE BASEBOARD. (BC)

## CUSWORTH, C.

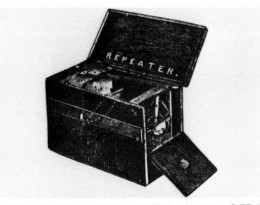

**(1572) REPEATER HAND CAMERA.** C. 1891. SIZE 3¼ X 4¼ INCH EXPOSURES ON PLATES. THE MAGAZINE HOLDS 12 PLATES.

## DALLMEYER, JOHN HENRY

**(1573) MULTIPLE PORTRAIT CAMERA.** C. 1866. FOUR EXPOSURES, 3 X 4 INCHES EACH, CAN BE OBTAINED SIMULTANEOUSLY ON A WET-COLLODION PLATE. 5-INCH/F 3 DALLMEYER LENS. WATERHOUSE STOPS. (BC)

**(1574) STEREOSCOPIC CAMERA.** C. 1862. SIZE 3¼ X 6½ INCH STEREO EXPOSURES ON EITHER WET OR DRY COLLODION PLATES. TRIPLE ACHROMATIC LENSES. FLAP SHUTTER. SLIDING-BOX FOCUSING VIA RACK & PINION. THE CAMERA CAN BE CONVERTED TO A SINGLE-LENS MONORAL CAMERA. (IH)

## DALLMEYER, J. H. LIMITED

**(1575) BABY SPEED REFLEX CAMERA.** C. 1926. VEST-POCKET SIZE EXPOSURES ON PLATES. F 2.9 PENTAC LENS.

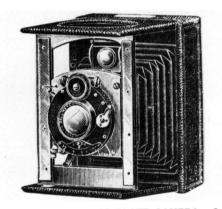

**(1576) CARFAC FOLDING PLATE CAMERA.** C. 1912. THREE SIZES OF THIS CAMERA FOR 2½ X 3½, 3¼ X 4¼, OR 3½ X 5½ INCH EXPOSURES ON PLATES OR FILM PACKS WITH ADAPTER. F 6 DALLMEYER STIGMATIC OR F 6.3 CARFAC ANASTIGMAT LENS. COMPOUND OR EVERSET SHUTTER.

**(1577) CORRESPONDENT'S CAMERA.** C. 1913. FOUR SIZES OF THIS CAMERA RANGING FROM 3¼ X 4¼ to 5 X 7 INCH EXPOSURES. TRIPLE EXTENSION BELLOWS.

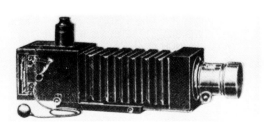

**(1578) NEW NATURALIST'S REFLEX CAMERA.** C. 1900. SIZE 3¼ X 4¼ INCH EXPOSURES ON PLATES. 1B or 2B PATENT PORTRAIT LENS.

**(1579) NATURALIST'S REFLEX CAMERA.** C. 1913. SIZE 3¼ X 4¼ INCH EXPOSURES ON PLATES. SIMILAR TO THE NEW NATURALIST'S REFLEX CAMERA, C. 1900

## DALLMEYER, J. H. LIMITED (*cont.*)

EXCEPT THE BELLOWS ARE REPLACED BY A BOX-TYPE EXTENSION.

(1580) **PENTAC ROLL FILM CAMERA.** C. 1925. F. 2.9 PENTAC LENS.

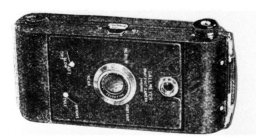

(1581) **ROLL FILM "SNAPSHOT" CAMERA.** C. 1930. SIZE 2¼ X 3¼ INCH EXPOSURES. DALLMEYER AN-ASTIGMAT LENS.

(1582) **"SNAPSHOT" FOLDING CAMERA.** C. 1928. SIZE 2¼ X 3¼ INCH EXPOSURES ON FILM PACKS. 100 MM/F 6 DALLMEYER ANASTIGMAT LENS. I, B, AND T SHUTTER. THE DELUXE MODEL (C. 1929) HAS SEVERAL MINOR IMPROVEMENTS. (SC)

(1583) **SPEED CAMERA.** C. 1924. TWO SIZES OF THIS CAMERA FOR 1¾ X 2⅜ OR 2½ X 3½ INCH EXPOSURES ON SHEET FILM OR PLATES. F 2.9 PENTAC LENS. N & G FOCAL PLANE SHUTTER: ⅛ TO ¹⁄₁₀₀₀ SEC. T.

## DANCER, J. B.

(1584) **BINOCULAR STEREO MAGAZINE CAMERA.** C. 1856. SIZE 3½ X 7 INCH EXPOSURES ON WET COLLODION OR DRY COLLODION-ALBUMEN PLATES. THE CAMERA HOLDS 12 PLATES. MENISCUS LENSES. SEE-SAW SHUTTER. ROTARY DIAGPHRAMS. SLIDING BOX FOCUSING. GROUND GLASS FOCUSING. THE UNEXPOSED PLATES ARE HELD IN THE LOWER SEC-TION OF THE CAMERA. EACH PLATE IS LIFTED, IN TURN, TO THE UPPER SECTION OF THE CAMERA BY USE OF A VERTICAL ROD AND THEN LOWERED TO THE STORAGE POSITION AFTER EXPOSURE.

## EASTMAN PHOTOGRAPHIC MATERIALS COMPANY LIMITED

(1585) **FLAT FOLDING KODAK CAMERA.** C. 1895. SIZE 4 X 5 INCH EXPOSURES ON ROLL FILM. FORTY-EIGHT EXPOSURES PER ROLL OF FILM. RECTILINEAR LENS. MULTI-SPEED SHUTTER. FOUR APERTURE STOPS IN REVOLVING DISC. RACK & PINION FOCUS. EXPOSURE COUNTER. SEE PHOTO UNDER EASTMAN KODAK COMPANY.

## EDWARDS, GEORGE

(1586) **POCKET CAMERA.** C. 1853. THE FRONT AND BACK PANELS OF THE CAMERA ARE MOUNTED ON ½-INCH SQUARE ROD AND CONNECTED BY A TUBULAR CLOTH BODY.

## ELLIOTT, C. E.

(1587) **COOK'S MAGAZINE CAMERA.** C. 1872. THE CAMERA HAS AN UPPER AND LOWER CHAMBER. THE UNEXPOSED PLATES IN THE UPPER CHAMBER ARE EXPOSED ONE AT A TIME BY THE SHUTTER ACTION WHICH UNCOVERS THE PLATE FOR EXPOSURE. THE SHUTTER MECHANISM PUSHES THE EXPOSED PLATE INTO THE LOWER CHAMBER WHERE A SLIDE TRANSFERS THE EXPOSED PLATE INTO THE BACK OF THE UPPER CHAMBER.

## ENSIGN, LIMITED

(1588) **BOX CAMERA.** C. 1931. SIZE 2¼ X 3¼ INCH EXPOSURES ON ROLL FILM. INSTANT AND TIME SHUTTER.

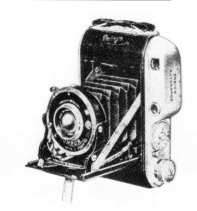

(1589) **ENSIGN AUTORANGE 220 CAMERA.** C. 1938–40. SIZE 2¼ X 2¼ INCH EXPOSURES (1⅝ X 2¼ INCH WITH MASK) ON NO. 120 OR B-2 ROLL FILM. 75 MM/F 4.5 ZEISS TESSAR OR ENSAR ANASTIGMAT LENS. COMPUR SHUTTER; 1 TO ¹⁄₂₅₀ SEC., B., T., ST. COUPLED RANGEFINDER.

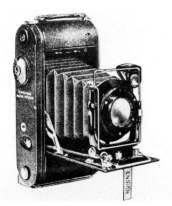

(1590) **ENSIGN AUTOSPEED CAMERA.** C. 1932. SIZE 2¼ X 3¼ INCH EXPOSURES ON ROLL FILM. F 4.5 ALDIS UNO ANASTIGMAT OR ZEISS TESSAR LENS. FOCAL PLANE SHUTTER; ¹⁄₁₅ TO ¹⁄₅₀₀ SEC. THE FILM IS ADVANCED AUTOMATICALLY WHEN THE SHUTTER IS SET FOR THE NEXT EXPOSURE. A KEY-WOUND SPRING ADVANCES THE FILM.

## ENSIGN, LIMITED (*cont.*)

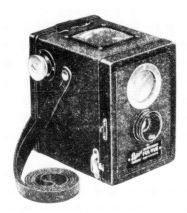

**(1591) ENSIGN FUL-VUE BOX CAMERA.** C. 1939. SIZE 2¼ X 2¼ INCH EXPOSURES ON ROLL FILM. FIXED FOCUS LENS. INSTANT AND TIME SHUTTER.

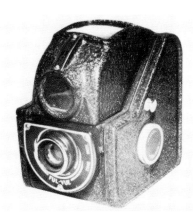

**(1592) ENSIGN FUL-VUE BOX CAMERA.** C. 1940. SIZE 2¼ X 2¼ INCH EXPOSURES ON ROLL FILM. (HA)

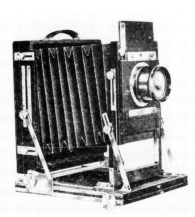

**(1593) ENSIGN IDEAL PORTRAIT AND COMMERCIAL CAMERA.** C. 1939. TWO SIZES OF THIS CAMERA FOR 4¼ X 6½ OR 6½ X 8¼ INCH PLATE EXPOSURES. SWING FRONT. SWING BACK. RISING, FALLING, AND CROSSING LENS MOUNT. RACK & PINION FOCUSING.

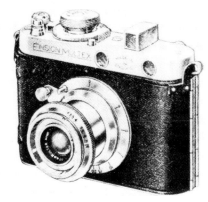

**(1594) ENSIGN MULTEX CAMERA.** C. 1936. SIZE 1¼ X 1⅝ INCH EXPOSURES ON NO. 127 ROLL FILM. F 3.5 ENSIGN MULTAR ANASTIGMAT, F 2.9 OR F 1.9 ROSS XPRES, F 2.8 ZEISS TESSAR, OR F2 ZEISS SONNAR LENS. FOCAL PLANE SHUTTER; 1 TO ¹⁄₁₀₀₀ SEC. COUPLED RANGEFINDER. FILM ADVANCE WITH SHUTTER COCKING. EXPOSURE COUNTER.

**(1595) ENSIGN POCKET E-20 NO. 1 CAMERA.** C. 1938. SIZE 2¼ X 3¼ INCH EXPOSURES ON ROLL FILM. SIMILAR TO THE ENSIGN POCKET E-20 NO. 2. CAMERA.

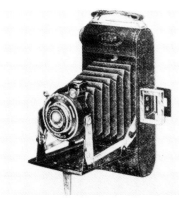

**(1596) ENSIGN POCKET E-20 NO. 2 CAMERA.** C. 1939. SIZE 2¼ X 3¼ INCH EXPOSURES ON ROLL FILM. 105 MM/F 7.7 ENSAR ANASTIGMAT LENS. SINGLE SHUTTER; ¹⁄₂₅, ¹⁄₇₅ SEC., B., T.

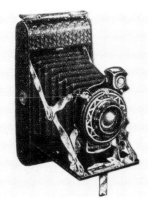

**(1597) ENSIGN SELFIX 20 ROLL FILM CAMERA.** C. 1933. SIZE 2¼ X 3¼ INCH EXPOSURES. F 7.7, F 6.3 OR F 4.5 ENSAR ANASTIGMAT LENS. SHUTTER SPEEDS FROM ¹⁄₂₅ TO ¹⁄₁₀₀ SEC., B., T.

**(1598) ENSIGN SELFIX 220 ROLL FILM CAMERA.** C. 1936.

**(1599) ENSIGN SELFIX 320 ROLL FILM CAMERA.** C. 1937. SIMILAR TO THE ENSIGN SELFIX 420 CAMERA.

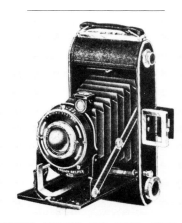

**(1600) ENSIGN SELFIX 420 ROLL FILM CAMERA.** C. 1939. SIZE 2¼ X 3¼ INCH (2¼ X 2¼ INCH WITH MASK) EXPOSURES. F 6.3 ENSAR ANASTIGMAT, F 4.5 ZEISS TESSAR, OR F 3.5 MULTAR ANASTIGMAT LENS. VARIO OR COMPUR SHUTTER.

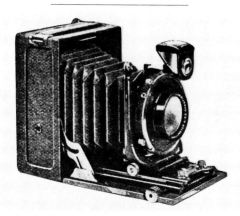

**(1601) ENSIGN SUPER-SPEED CAMEO CAMERA.** C. 1932. SIZE 2½ X 3½ INCH EXPOSURES ON PLATES. F. 3.5 DALLMEYER ANASTIGMAT OR DALMAC LENS. ALSO, F 3.5 ROSS XPRES LENS. COMPUR SHUTTER.

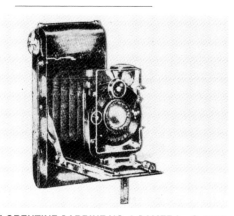

**(1602) FLORENTINE CARBINE NO. 6 CAMERA.** C. 1930. SIZE 2¼ X 3¼ INCH EXPOSURES ON ROLL FILM.

## ENSIGN, LIMITED (*cont.*)

F 4.5 ALDIS UNO OR ALDIS BUTCHER LENS. MULCHRO OR COMPUR SHUTTER. RISING LENS MOUNT. ALL BRASS BODY.

(1603) **FLORENTINE CARBINE NO. 12 CAMERA.** C. 1930. SIZE 2½ X 4¼ INCH EXPOSURES ON ROLL FILM. SIMILAR TO THE FLORENTINE CARBINE NO. 6 WITH THE SAME LENSES AND SHUTTERS.

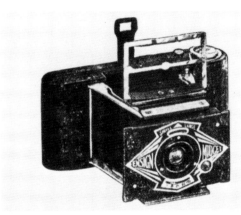

(1604) **MIDGET ROLL FILM CAMERA.** C. 1934. SIZE 1⅜ X 1⅝ INCH EXPOSURES. F 6.3 ANASTIGMAT OR "ALL-DISTANCE" LENS. SHUTTER SPEEDS; ½₅, ½₀, ¹⁄₁₀₀ SEC., B., T.

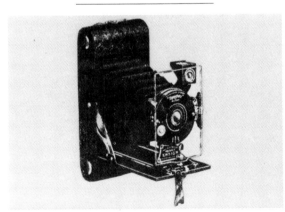

(1605) **POCKET MODEL NO. 1 CAMERA.** C. 1931. SIZE 2¼ X 3¼ INCH EXPOSURES ON ROLL FILM. ALL-DISTANCE LENS. INSTANT, B., T. SHUTTER.

(1606) **POCKET MODEL NO. 2 CAMERA.** C. 1931. SIZE 2¼ X 3¼ INCH EXPOSURES ON ROLL FILM. ALL-DISTANCE LENS. SHUTTER SPEEDS FROM ½₅ TO ¹⁄₁₀₀ SEC., B., T. SIMILAR TO THE POCKET MODEL NO. 1 CAMERA.

## FALLOWFIELD, JONATHAN, LIMITED

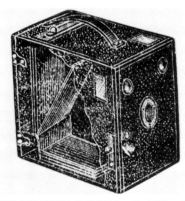

(1607) **DELITE HAND CAMERA.** C. 1898. SIZE 3¼ X 4¼ INCH EXPOSURES ON PLATES. THE MAGAZINE HOLDS SIX PLATES. SINGLE LANDSCAPE LENS. INSTANT AND TIME SHUTTER.

(1608) **FACILE CAMERA.** C. 1890. SIZE 3¾ X 4¼ INCH EXPOSURES ON PLATES. THE MAGAZINE HOLDS 12 PLATES. RAPID LANDSCAPE LENS OR F 8 RAPID RECTILINEAR LENS.

(1609) **FACILE HAND CAMERA.** C. 1893. MAGAZINE FOR PLATES. EXTERNAL KNOB FOR PLATE CHANGING AND A KNOB FOR FOCUSING. VARIABLE-SPEED SHUTTER.

(1610) **FALLOROLL FOLDING CAMERA.** C. 1902. SIZE 3¼ X 4¼ INCH EXPOSURES ON PLATES OR ROLL FILM. FALLOWFIELD F 8 RAPID RECTILINEAR LENS. DOUBLE PNEUMATIC BAUSCH & LOMB UNICUM SHUTTER. RISING AND FALLING LENS MOUNT. ALSO, COOKE, GOERZ, DALLMEYER, AND BUSCH LENSES.

(1611) **FERROTYPE CAMERA.** C. 1890. THE CAMERA BODY IS HINGED TO A LOWER BOX COMPARTMENT CONTAINING A TANK WITH A DEVELOPING SOLUTION AND A TANK WITH FIXING SOLUTION. THE EXPOSED PLATE IS DROPPED INTO THESE TANKS FOR DEVELOPING AND FIXING. 100 MM/F 3.7 PETZVAL LENS. FLAP SHUTTER. (IH)

(1612) **PREMIER HAND CAMERA.** C. 1893. THE MAGAZINE HOLDS 12 PLATES OR 24 SHEET FILMS. 5½ INCH RAPID RECTILINEAR LENS. NEWMAN PNEUMATIC SHUTTER; 1 TO ¹⁄₁₀₀ SEC. PULL-KNOB FOR SHUTTER COCKING. RACK AND PINION FOCUSING.

(1613) **PRISMOTYPE DIRECT POSITIVE CAMERA.** C. 1923. SIZE 2½ X 3½ INCH EXPOSURES ON POSITIVE CARDS. A CARD IS EXPOSED BY REVERSING THE IM-

## FALLOWFIELD, JONATHAN, LIMITED (*cont.*)

AGE THROUGH A PRISM WHICH MAKES A POSITIVE PRINT WHICH DOES NOT HAVE A MIRROR-IMAGE REVERSAL. THE CARD IS DEVELOPED INSIDE OF THE CAMERA IN ONE MINUTE.

(1614) **GEM MULTIPLE CAMERA.** C. 1905. TWELVE SIMULTANEOUS EXPOSURES ON A SINGLE PLATE USING 12 LENSES. THE REPEATING BACK ALLOWED FOR TWICE AS MANY EXPOSURES. SLIDING-BOX FOCUSING. OTHER MODELS OF THIS CAMERA HAD EITHER FOUR OR NINE LENSES. (BC)

(1615) **NO. 1 PERITUS PLATE CAMERA.** C. 1897. SIZE 3¼ X 4¼ INCH EXPOSURES. RECTILINEAR LENS. ROTARY SHUTTER. (MA)

(1616) **SIDE-BRACKET PLATE CAMERA.** C. 1880. SIZE 4¼ X 6½ INCH EXPOSURES ON PLATES. FALLOWFIELD 10 X 8 WIDE ANGLE LENS. ROTARY STOPS. (MR)

## GAMAGE, A. W., LIMITED

(1617) **GAM-CAM MAGAZINE CAMERA.** C. 1906. SIZE 3¼ X 4¼ INCH EXPOSURES ON PLATES. THE MAGAZINE HOLDS 12 PLATES.

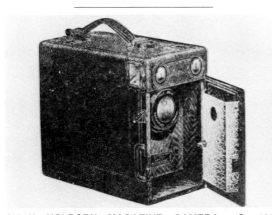

(1618) **HOLBORN MAGAZINE CAMERA.** C. 1905. SIZE 3¼ X 4¼ INCH EXPOSURES ON PLATES. RAPID ACHROMATIC MENISCUS LENS. EVERSET SHUTTER; 1 TO ⅟₁₀₀ SEC., T. IRIS DIAPHRAGM. THE MAGAZINE HOLDS 12 PLATES.

## GARLAND, J.

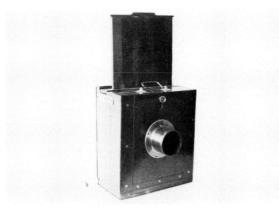

(1619) **WET PLATE CAMERA.** C. 1865. SIZE 8 X 10 INCH EXPOSURES ON WET PLATES. ROSS LENS. LENS-CAP SHUTTER. (VC)

## GOTZ, J. R.

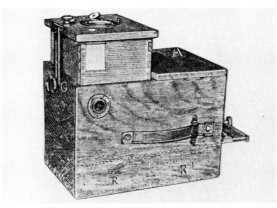

(1620) **PARAGON MAGAZINE HAND CAMERA.** C. 1894. THE MAGAZINE HOLDS 20 PLATES OR 40 SHEET FILMS. 4¾ OR 5 INCH SUTER RAPID APLANATIC LENS. IRIS DIAPHRAGM. SHUTTER SPEEDS FROM 1 to ⅟₁₀₀ SEC.

## GRIFFIN, JOHN J. & SONS, LIMITED

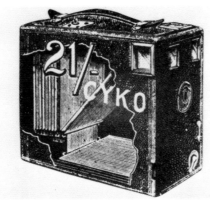

(1621) **CYKO MAGAZINE CAMERA.** C. 1902. SIZE 3¼ X 4¼ INCH EXPOSURES ON PLATES. THE MAGAZINE HOLDS 12 PLATES. THREE-SPEED AND TIME SHUTTER.

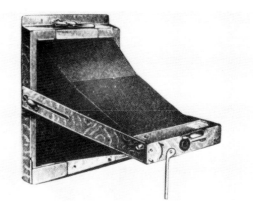

(1622) **CYKO NO. 1 POCKET CAMERA.** C. 1902. SIZE 2½ X 3½ INCH EXPOSURES ON PLATES. APLANATIC LENS. INSTANT AND TIME GUILLOTINE SHUTTER.

(1623) **CYKO NO. 2 POCKET CAMERA.** C. 1903. SIZE 2½ X 3½ INCH EXPOSURES ON PLATES. MENISCUS LENS. INSTANT AND TIME GUILLOTINE SHUTTER. SIMILAR TO THE CYKO NO. 1 POCKET CAMERA EXCEPT THE UNPLEATED BELLOWS ARE SUPPORTED BY TWO METAL PLATES THAT PIVOT ON THE CAMERA'S LENS MOUNT. (IH)

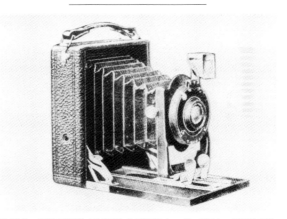

(1624) **FOLDING PLATE CAMERA.** C. 1914. SIZE 3¼ X 4¼ INCH EXPOSURES. RAPID RECTILINEAR LENS. SINGLE SPEED B., T. SHUTTER WITH IRIS DIAPHRAGM. RISING LENS MOUNT. HOODED FOCUSING SCREEN.

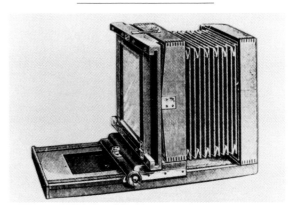

(1625) **GRAPHO STUDIO VIEW CAMERA.** C. 1912. SIZE 6½ X 8½ INCH EXPOSURES ON PLATES. DOUBLE

## GRIFFIN, JOHN J. & SONS, LIMITED (*cont.*)

SWING BACK. RACK & PINION FOCUSING. RISING LENS MOUNT.

## GRIFFITHS, WALTER

(1626) **MAGAZINE BOX CAMERA.** C. 1890. SIZE 3⅜ X 4 INCH EXPOSURES ON PLATES. MENISCUS LENS. GUILLOTINE SHUTTER. (HA)

## GRIFFITHS, W. & COMPANY, LIMITED

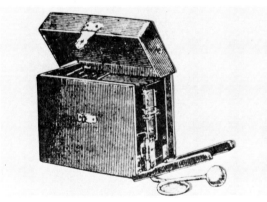

(1627) **GUINEA DETECTIVE CAMERA.** C. 1891. TWO SIZES OF THIS CAMERA FOR 3¼ X 4¼ OR 4 X 5 INCH EXPOSURES ON PLATES. THE MAGAZINE HOLDS 12 PLATES.

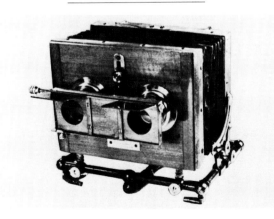

(1628) **STEREO CAMERA.** C. 1896. SIZE 4¼ X 6½ INCH STEREO EXPOSURES ON PLATES. FLIP SHUTTER. (HA)

(1629) **ZODIAC STEREO CAMERA.** C. 1893. EXPOSURES ON PLATES OR FILMS.

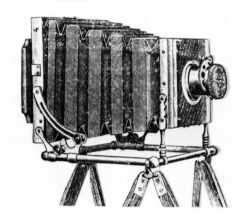

(1630) **ZODIAC VIEW CAMERA.** C. 1893. EXPOSURES ON PLATES OR FILMS. TUBULAR METAL BASE. RISING FRONT.

## HADFIELD, E. AND COMPANY

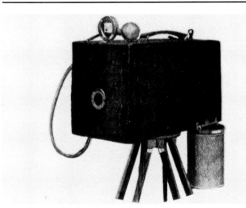

(1631) **MINIATURE FEEROTYPE CAMERA.** C. 1912. SIZE 2 X 3 INCH (OR 1-INCH DIAMETER) FERROTYPE EXPOSURES. EVERSET SHUTTER. IRIS DIAPHRAGM. THE EXPOSED PLATES ARE DROPPED INTO THE TANK BENEATH THE CAMERA WHICH CONTAINS DEVELOPING AND FIXING SOLUTIONS.

## HADLASS, F. W.

(1632) **PNEU AUTOMATIC CAMERA.** C. 1897. THE MAGAZINE HOLDS 12 PLATES. A PNEUMATIC DEVICE CHANGES THE PLATES AUTOMATICALLY. IT WAS REPORTED THAT 12 PLATES COULD BE EXPOSED IN SIX SECONDS.

## HARE, GEORGE

(1633) **FIELD CAMERA.** C. 1885. SIZE 3¼ X 4¼ INCH EXPOSURES ON PLATES. DALLMEYER RAPID RECTILINEAR LENS. ILEX SHUTTER.

(1634) **PORTABLE BINOCULAR STEREO CAMERA.** C. 1860. EXPOSURES ON WET OR DRY PLATES. TWO SETS OF BELLOWS CONNECTING THE LENS PANEL WITH THE CAMERA BACK.

(1635) **SLIDING-PANEL SINGLE-LENS STEREO CAMERA.** C. 1860. TAILBOARD CAMERA. SIZE 3 X 6½ INCH PLATE EXPOSURES. 110 MM/F 11 DALLMEYER RECTILINEAR LENS. PLATE CHANGING BOX. (IH)

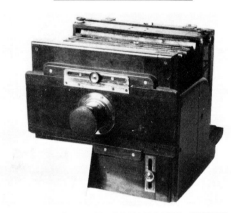

(1636) **SLIDING-PANEL SINGLE-LENS STEREO CAMERA.** C. 1865. TAILBOARD CAMERA. SIZE 6½ X 8½ INCH EXPOSURES ON WET PLATES. DALLMEYER A-1 LENS. LENS CAP SHUTTER. (VC)

(1637) **TOURIST CAMERA.** C. 1870. SIZE 4¼ X 6½ INCH EXPOSURES ON PLATES. FALLOWFIELD RAPID DOUBLET LENS. IRIS DIAPHRAGM.

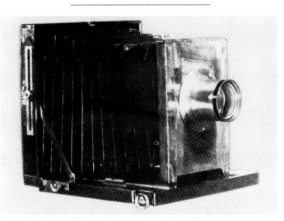

(1638) **VIEW CAMERA.** C. 1882. SEVEN SIZES OF THIS CAMERA FOR 4 X 5, 4¾ X 6½, 5 X 7½, 6½ X 8½, 8 X 10, 10 X 12, OR 12 X 15 INCH EXPOSURES ON PLATES.

(1639) **NEW UNIVERSAL VIEW CAMERA.** C. 1871.

## HARRIS, PHILIP & COMPANY

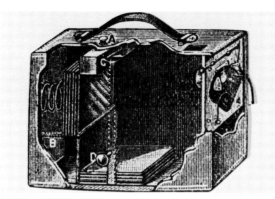

(1640) **CYTOX HAND CAMERA.** C. 1893. THE MAGAZINE HOLDS 12 PLATES. SINGLE LENS WITH IRIS DIAPHRAGM. STRING-SETTING OSCILLATING-PLATE SHUTTER. BUTTON RELEASE SHUTTER.

## HILGER, ADAM LIMITED

(1641) **THREE-COLOR CAMERA.** 158 MM/F 3.5 COOKE ANASTIGMAT LENS. COMPOUND SHUTTER; 1 to $\frac{1}{100}$ SEC. TWO SEMI-TRANSPARENT MIRRORS ARE USED TO SEPARATE THE LIGHT FOR EXPOSING THREE PLATES SIMULTANEOUSLY. (MA)

## HINTON & COMPANY

(1642) **DUAL PANORAMIC CAMERA.** C. 1902. THE CAMERA TAKES EXPOSURES OF TWO SIZES ON ROLL FILM. IF THE FILM IS HELD FLAT IN THE FOCAL PLANE, A 4 X 6 INCH EXPOSURE IS MADE. IF THE FILM IS POSITIONED IN A CURVED FILM HOLDER, THE EXPOSURE SIZE IS 4 X 12 INCHES.

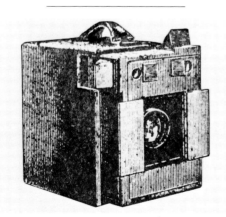

(1643) **HAND AND STAND CAMERA.** C. 1893. SIZE 4¼ X 6½ INCH EXPOSURES ON PLATES.

(1644) **SINGLE-LENS REFLEX CAMERA.** C. 1895. FOCAL PLANE SHUTTER.

## HORNE, G. F.

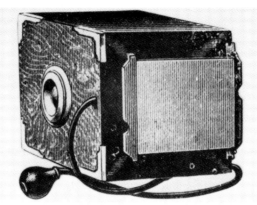

(1645) **POCKET CAMERA.** C. 1896. TWO SIZES OF THIS CAMERA FOR 3¼ X 4¼ OR 4¼ X 6½ INCH EXPOSURES ON PLATES. ACHROMATIC LENS. INSTANT AND TIME PNEUMATIC SHUTTER. THE CAMERA FOLDS TO A THICKNESS OF ONE-INCH.

## HORNE & THORNTHWAITE

(1646) **COLLAPSIBLE CAMERA.** C. 1855. THE SIDES OF THE CAMERA ARE HINGED MAKING THE ENTIRE CAMERA COLLAPSIBLE.

## HOUGHTON, GEORGE & SON, LIMITED

(1647) **NO. 3 ENSIGN FOLDING CAMERA.** C. 1901. SIZE 3¼ X 4¼ INCH EXPOSURES ON ROLL FILM. RAPID RECTILINEAR LENS. SINGLE-SPEED AND TIME SHUTTER. IRIS DIAPHRAGM. WIRE-FRAME FINDER. THERE IS CONSIDERABLE EVIDENCE THAT THIS CAMERA WAS MADE FOR HOUGHTON BY EMIL BUSCH. (BC)

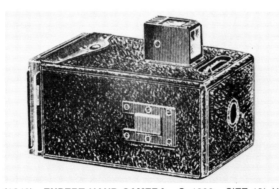

(1648) **EXPERT HAND CAMERA.** C. 1898. SIZE 1⅝ X 2⅛ INCH EXPOSURES ON PLATES. SINGLE ACHROMATIC LENS. INSTANT AND TIME SHUTTER.

(1649) **HOLBORN STAMP CAMERA.** C. 1900. NINE SMALL EXPOSURES ON ONE 3¼ X 4¼ INCH PLATE. (MA)

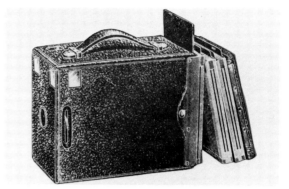

(1650) **EXPERT HAND CAMERA.** C. 1898. SIZE 3¼ X 4¼ INCH EXPOSURES ON PLATES. SINGLE ACHROMATIC LENS. INSTANT AND TIME SHUTTER. ROTARY APERTURE STOPS.

(1651) **POSTAL MAIL COPY CAMERA** C. 1900. NINE EXPOSURES ON EACH PHOTOGRAPHIC PLATE. (HA)

(1652) **SANDERSON COMPACT POPULAR FIELD CAMERA.** C. 1903. SIZE 4¾ X 6½ INCH EXPOSURES ON PLATES.

(1653) **SANDERSON DELUXE HAND AND STAND CAMERA.** C. 1902. THREE SIZES OF THIS CAMERA FOR 3¼ X 4¼, 4 X 5, OR 4¾ X 6½ INCH EXPOSURES ON PLATES.

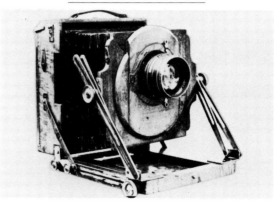

(1654) **SANDERSON FIELD CAMERA.** C. 1898.

(1655) **SANDERSON FOLDING PRESS-TYPE CAMERA.** C. 1895. SIZE 5 X 6½ INCH EXPOSURES ON GLASS PLATES. BAUSCH & LOMB AUTOMAT LENS. STRING-SET SHUTTER.

## HOUGHTON, GEORGE & SON, LIMITED (*cont.*)

(1656) **SANDERSON HAND CAMERA.** C. 1899. DOUBLE-STRUT LENS PANEL. RISING AND SWING LENS PANEL. RACK & PINION FOCUSING. (BC)

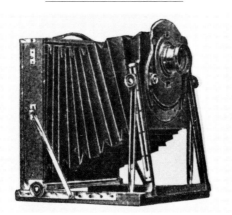

(1657) **SANDERSON MODEL A FIELD CAMERA.** C. 1898. FIVE SIZES OF THIS CAMERA FOR 4¾ X 6½, 6½ X 8½, 8 X 10, 10 X 12, OR 12 X 15 INCH EXPOSURES ON PLATES.

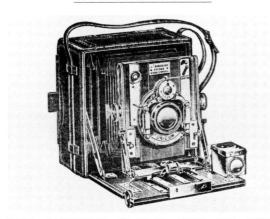

(1658) **SANDERSON REGULAR HAND AND STAND CAMERA.** C. 1902. FOUR SIZES OF THIS CAMERA FOR 3¼ X 4¼, 4 X 5, 3½ X 5½, OR 4¾ X 6½ INCH EXPOSURES ON PLATES.

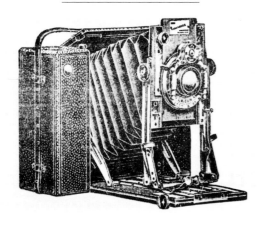

(1659) **SANDERSON ROLL FILM HAND AND STAND CAMERA.** C. 1902. THREE SIZES OF THIS CAMERA FOR 3¼ X 4¼, 4 X 5, OR 3½ X 5½ INCH EXPOSURES. ADAPTER FOR THE USE OF PLATES WITH GROUND GLASS FOCUSING SCREEN.

(1660) **SANDERSON TOURIST HAND AND STAND CAMERA.** C. 1902. FOUR SIZES OF THIS CAMERA FOR 3¼ X 4¼, 4 X 5, 3½ X 5½, OR 4¾ X 6½ INCH EXPOSURES ON PLATES.

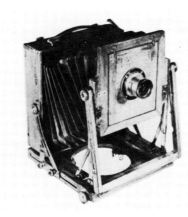

(1661) **JUNIOR SANDERSON CAMERA.** C. 1904. SIZE 3¼ X 4¼ INCH EXPOSURES ON PLATES.

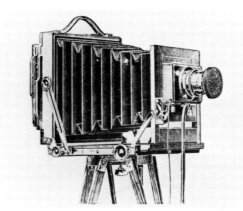

(1662) **VICTO VIEW CAMERA.** C. 1898. SIZE 4¼ X 6½ INCH EXPOSURES ON PLATES. RAPID RECTILINEAR ACHROMATIC LENS. THORNTON-PICKARD SHUTTER. RISING LENS MOUNT. REVERSING FRAME. DOUBLE SWING BACK. IRIS DIAPHRAGM.

## HOUGHTON-BUTCHER MANUFACTURING COMPANY

(1663) **ENSIGN BOX CAMERA.** C. 1926. SIZE 2½ X 3¼ INCH EXPOSURES ON NO. 120 ROLL FILM. INSTANT AND TIME SHUTTER.

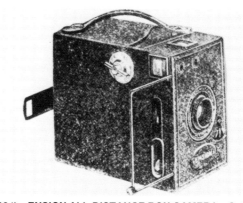

(1664) **ENSIGN ALL-DISTANCE BOX CAMERA.** C. 1927. SIZE 2¼ X 3¼ INCH EXPOSURES ON ROLL FILM. MENISCUS LENS. TWO-POSITION FOCUSING.

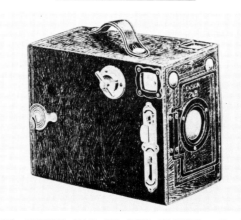

(1665) **ENSIGN 2¼B RR BOX CAMERA.** C. 1924. SIZE 2¼ X 3¼ INCH EXPOSURES ON ROLL FILM. DOUBLET LENS. SINGLE-SPEED AND TIME SHUTTER. TWO APERTURE STOPS.

(1666) **ENSIGN 2½ RR BOX CAMERA.** C. 1924. SIZE 2½ X 4¼ INCH EXPOSURES ON ROLL FILM. SIMILAR TO THE ENSIGN 2¼B RR BOX CAMERA WITH THE SAME LENS AND SHUTTER.

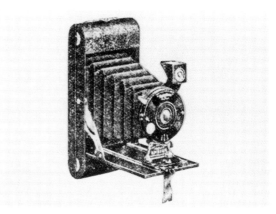

(1667) **ENSIGN ALL-DISTANCE POCKET CAMERA.** C. 1927. SIZE 2¼ X 3¼ INCH EXPOSURES ON ROLL FILM.

## HOUGHTON-BUTCHER MANUFACTURING COMPANY (*cont.*)

(1668) **ENSIGN AUTO SPEED CAMERA.** C. 1928. SIZE 2¼ X 3¼ INCH EXPOSURES ON ROLL FILM. 100 MM/F 4.5 ENSAR LENS. FOCAL PLANE SHUTTER; ⅛ TO ⅟₅₀₀ SEC. RISING LENS MOUNT. (MA)

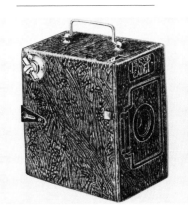

(1669) **ENSIGN CADET CAMERA.** C. 1924. SIZE 1⅝ X 2½ INCH EXPOSURES ON ROLL FILM. MENISCUS ACHROMATIC LENS. SINGLE-SPEED AND TIME SHUTTER.

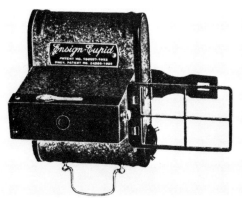

(1670) **ENSIGN CUPID CAMERA.** C. 1922. SIZE 36 X 56 MM EXPOSURES ON NO. 120 ROLL FILM. F 11 SINGLE ACHROMATIC LENS. GUILLOTINE SHUTTER FOR INSTANT AND TIME EXPOSURES.

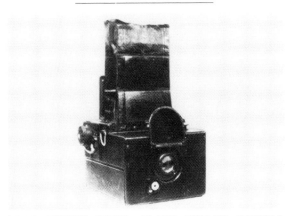

(1671) **ENSIGN FOCAL PLANE REFLEX CAMERA.** C. 1920–28. SIZE 2¼ X 3¼ INCH EXPOSURES ON ROLL FILM. 100 MM/F 4.5 ENSAR LENS. FOCAL PLANE SHUTTER; ⅟₂₅ TO ⅟₅₀₀ SEC. (HA)

(1672) **ENSIGN DELUXE REFLEX CAMERA.** C. 1928. FOCAL PLANE SHUTTER.

(1673) **ENSIGN DOUBLE-8 CAMERA.** C. 1930. SIZE 1³⁄₁₆ X 1⁹⁄₁₆ INCH EXPOSURES ON NO. 127 ROLL FILM. 60 MM/F 4.5 ENSAR LENS. THREE-SPEED SELF-SETTING SHUTTER. (MA)

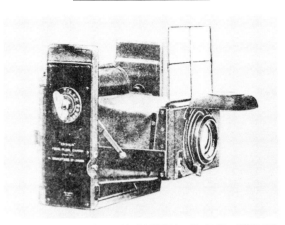

(1674) **ENSIGN FOLDING CAMERA.** C. 1926. SIZE 3¼ X 4¼ INCH EXPOSURES ON SHEET, PLATE, FILM PACK, OR ROLL FILM. F 4.5 CARL ZEISS LENS. FOCAL PLANE SHUTTER, ⅟₁₅ TO ⅟₁₀₀₀ SEC., B., T.

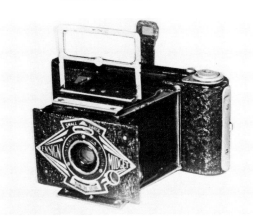

(1675) **ENSIGN MIDGET CAMERA.** C. 1922–30. SIZE 37 X 57 MM EXPOSURES ON NO. E-10 ROLL FILM. 75 MM/F 6.8 ZEISS TESSAR OR ENSAR ANASTIGMAT LENS. THREE SHUTTER SPEEDS FROM ⅟₂₅ TO ⅟₁₀₀ SEC. B., T. (BS)

(1676) **ENSIGN POPULAR PRESSMAN SINGLE LENS REFLEX CAMERA.** C. 1926. F 4.5 ALDIS-BUTCHER LENS. FOCAL PLANE SHUTTER.

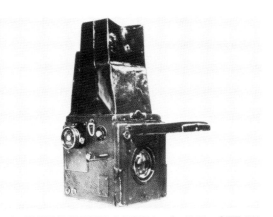

(1677) **ENSIGN REFLEX CAMERA.** C. 1920. SIZE 2½ X 3½ INCH EXPOSURES. 136 MM/F 4.5 ROSS XPRES LENS. FOCAL PLANE SHUTTER WITH SPEEDS TO ⅟₁₀₀₀ SEC. (HA)

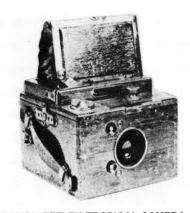

(1678) **ENSIGN REFLEX TROPICAL CAMERA.** C. 1925. SIZE 2¼ X 3¼ INCH EXPOSURES ON ROLL FILM. 4.25-INCH/F 7.7 ALDIS LENS. SINGLE SPEED SHUTTER.

(1679) **ENSIGN ROLL FILM REFLEX CAMERA.** C. 1922. SIZE 2¼ X 3¼ INCH EXPOSURES ON ROLL FILM. FIXED FOCUS F 11 SINGLE ACHROMATIC LENS. INSTANT AND TIME SHUTTER. A HINGED MIRROR ALLOWS FOR REFLEX FOCUSING.

(1680) **ENSIGN ROLL FILM TROPICAL REFLEX CAMERA.** C. 1925. SIZE 2¼ X 3¼ INCH EXPOSURES ON NO. 120 ROLL FILM. 4.25-INCH/F 7.7 ALDIS LENS. SINGLE-SPEED FRONT SHUTTER. (MA)

## HOUGHTON-BUTCHER MANUFACTURING COMPANY (*cont.*)

(1681) **ENSIGN ROLL FILM REFLEX CAMERA.** C. 1926. FOCUSING MODEL. SIZE 2¼ X 3¼ INCH EXPOSURES ON ROLL FILM. F 7.7 OR F 6.3 ALDIS UNO OR F 6.3 ROSS ANASTIGMAT LENS. INSTANT AND TIME SHUTTER. THE 1925 MODEL HAS AN F 7.7 TAYLOR-HOBSON LUXOR ANASTIGMAT LENS.

(1682) **ENSIGN SPECIAL REFLEX CAMERA.** C. 1927. TWO SIZES OF THIS CAMERA FOR 2¼ X 3¼ OR 3¼ X 4¼ INCH EXPOSURES ON PLATES, FILM PACKS, CUT FILM, OR ROLL FILM WITH SPECIAL BACK. F 4.5 ALDIS, F 4.5 OR F 1.7 CARL ZEISS LENS. FOCAL PLANE SHUTTER; ¹⁄₁₅ TO ¹⁄₁₀₀₀ SEC., T. RACK & PINION FOCUS. REVOLVING BACK. RISING AND FALLING LENS MOUNT.

(1683) **ENSIGN NO. 6 SPEED CAMERA.** C. 1929. EXPOSURES ON ROLL FILM. F 4.5 ALDIS-UNO LENS. MULCHRO SHUTTER; 1 to ¹⁄₁₀₀ SEC. IRIS DIAPHRAGM.

(1684) **ENSIGN SPEED FILM REFLEX CAMERA.** C. 1928. F 4.5 LENS. FOCAL PLANE SHUTTER; ¹⁄₂₅ TO ¹⁄₅₀₀ SEC.

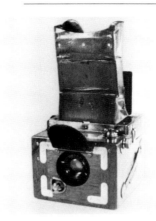

(1685) **ENSIGN TROPICAL REFLEX CAMERA.** C. 1925. SIZE 6 X 9 CM EXPOSURES ON PLATES. F 7.7 ALDIS LENS. ALDIS SINGLE-SPEED SHUTTER. (VC)

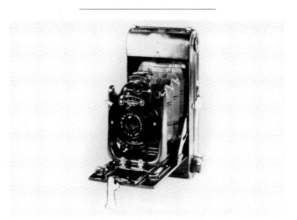

(1686) **ENSIGN TROPICAL WATCH POCKET CAMERA.** C. 1925. THE CAMERA USES NO. 120 ROLL FILM. (VC)

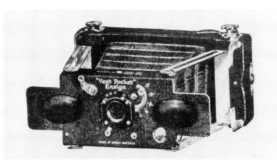

(1687) **VEST POCKET ENSIGN CAMERA.** C. 1926. SIZE 1⅝ X 2½ INCH EXPOSURES ON ROLL FILM. F 11 SINGLE ACHROMATIC OR F 7.7 T.T.H.-LUXOR ANASTIGMAT LENS. EVERSET SHUTTER; ¹⁄₂₀, ¹⁄₄₀, ¹⁄₆₀ SEC., B., T. IRIS DIAPHRAGM.

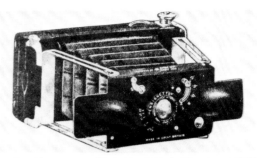

(1688) **NO. 1 ALUMINUM ENSIGNETTE CAMERA.** C. 1926. SIZE 1½ X 2¼ INCH EXPOSURES ON ROLL FILM. F 11 SINGLE ACHROMATIC, F 8 RAPID APLANAT, OR F 7.7 T.T.H.-LUXOR ANASTIGMAT LENS. EVERSET SHUTTER; ¹⁄₂₀, ¹⁄₄₀, ¹⁄₆₀ SEC., B., T. IRIS DIAPHRAGM.

(1689) **NO. 2 ALUMINUM ENSIGNETTE CAMERA.** C. 1926. SIZE 2 X 3 INCH EXPOSURES ON ROLL FILM. SIMILAR TO THE NO. 1 ALUMINUM ENSIGNETTE CAMERA WITH THE SAME LENSES AND SHUTTER.

## HOUGHTONS, LIMITED

(1690) **NO. 1 BRITON BOX CAMERA.** C. 1905. SIZE 2½ X 3½ INCH EXPOSURES ON PLATES. THE MAGAZINE HOLDS SIX PLATES. SINGLE-SPEED SHUTTER.

(1691) **NO. 3 BRITON BOX CAMERA.** C. 1905. SIZE 3¼ X 4¼ INCH EXPOSURES ON PLATES. THE MAGAZINE HOLDS 12 PLATES. RAPID ACHROMATIC LENS. EVERSET INSTANT AND TIME SHUTTER. IRIS DIAPHRAGM.

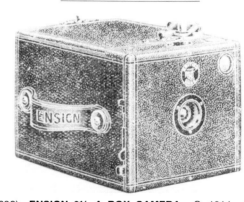

(1692) **ENSIGN 2¼ A BOX CAMERA.** C. 1914. SIZE 2¼ X 2¼ INCH EXPOSURES ON ROLL FILM. ACHROMATIC MENISCUS LENS. EVERSET SHUTTER FOR INSTANT AND TIME EXPOSURES.

(1693) **ENSIGN 2½ BOX CAMERA.** C. 1914. SIZE 2½ X 4¼ INCH EXPOSURES ON ROLL FILM. SIMILAR TO THE ENSIGN 2¼-B BOX CAMERA WITH THE SAME LENS AND SHUTTER.

(1694) **ENSIGN 3¼ BOX CAMERA.** C. 1914. SIZE 3¼ X 4¼ INCH EXPOSURES ON ROLL FILM. SIMILAR TO THE ENSIGN 2¼-B BOX CAMERA WITH THE SAME LENS AND SHUTTER.

## HOUGHTONS, LIMITED (*cont.*)

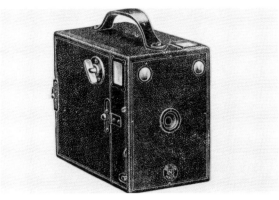

**(1695) ENSIGN 2¼-B BOX CAMERA.** C. 1914. SIZE 2¼ X 3¼ INCH EXPOSURES ON ROLL FILM. ACHROMATIC MENISCUS LENS. EVERSET SHUTTER FOR INSTANT AND TIME EXPOSURES. THREE APERTURE STOPS.

---

**(1696) CAMEO FOLDING PLATE CAMERA.** SIZE 2½ X 3½ INCH EXPOSURES. 4.25 INCH/F 6.3 ALDIS-UNO ANASTIGMAT LENS. TRICHRO SHUTTER.

---

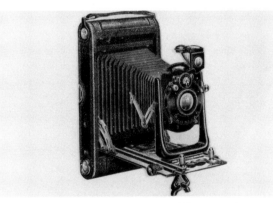

**(1697) ENSIGN 3¼ DELUXE CAMERA.** C. 1914. TWO SIZES OF THIS CAMERA FOR 3¼ X 4¼ OR 3½ X 5½ INCH EXPOSURES ON PLATES OR ROLL FILM. F 7.7, F 6, OR F 5.5 ENSIGN ANASTIGMAT, F 6.8 ALDIS-PLANO, F 6.8 COOKE LUXOR, F 6.3 ZEISS TRIOTAR, F 6.3 ZEISS TESSAR, F 6.8 ZEISS AMATAR, F 6.3 ZEISS PROTAR, F 6.3 DALLMEYER STIGMATIC, F 6.8 GOERZ SYNTOR, F 6.5 COOKE ANASTIGMAT, F 6.3 ROSS HOMO-CENTRIC, OR F 6.8 GOERZ DAGOR LENS. ENSIGN SEC-TOR SHUTTER; 1 to ¹⁄₁₀₀ SEC., B., T.; KOILOS; OR COM-POUND SHUTTER. RISING AND CROSSING LENS MOUNT. DOUBLE EXTENSION BELLOWS. RACK & PIN-ION FOCUSING.

---

**(1698) ENSIGN FLUSH-BACK ROLL FILM CAMERA.** C. 1913. SIZE 3¼ X 4¼ INCH EXPOSURES ON ROLL FILM. RAPID RECTILINEAR OR ZEISS ANASTIGMAT LENS. THREE-SPEED SHUTTER PLUS B., T. RISING AND CROSSING LENS MOUNT. SIMILAR TO THE 3¼ FLUSH-BACK ENSIGN CAMERA. C. 1914.

---

**(1699) 2½ FLUSH-BACK ENSIGN CAMERA.** C. 1915. SIZE 2½ X 4¼ INCH EXPOSURES ON ROLL FILM. RAPID RECTILINEAR OR VARIOUS ANASTIGMAT LENSES. ENSIGN SIMPLEX OR SECTOR SHUTTER. SIMILAR TO THE 3¼ FLUSH-BACK ENSIGN CAMERA, C. 1914.

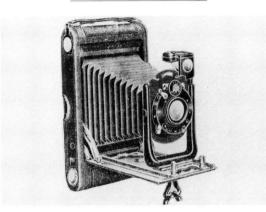

**(1700) 3¼ FLUSH-BACK ENSIGN CAMERA.** C. 1914. TWO SIZES OF THIS CAMERA FOR 3¼ X 4¼ OR 3¼ X 5½ INCH EXPOSURES ON ROLL FILM. F 8 RAPID APLANAT OR F 7.7 OR F 6 ENSIGN ANASTIGMAT LENS. ENSIGN SECTOR SHUTTER; 1 to ¹⁄₁₀₀ SEC., B., T.

---

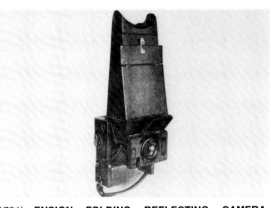

**(1701) ENSIGN FOLDING REFLECTING CAMERA.** C. 1915. SIZE 3¼ X 4¼ INCH EXPOSURES ON PLATES OR FILM PACKS. F 4.5 CARL ZEISS TESSAR LENS. ENSIGN FOCAL PLANE SHUTTER; 1 to ¹⁄₁₀₀₀ SEC., B., T.

---

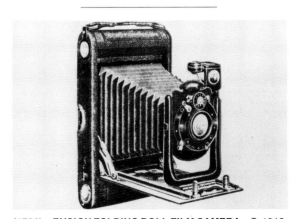

**(1702) ENSIGN FOLDING ROLL FILM CAMERA.** C. 1913. TWO SIZES OF THIS CAMERA FOR 3¼ X 4¼ OR 3½ X 5½ INCH EXPOSURES. SINGLE OR RAPID RECTILINEAR LENS.

---

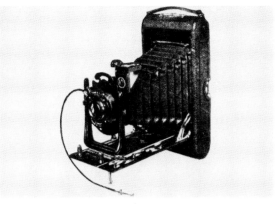

**(1703) ENSIGN FOLDING ROLL FILM CAMERA.** C. 1917. TWO SIZES OF THIS CAMERA FOR 2½ X 4¼ OR 3¼ X 4¼ INCH EXPOSURES. F 7.5 ENSIGN ANASTIGMAT OR RAPID SYMMETRICAL LENS. VICTO SHUTTER; ¹⁄₁₀ to ¹⁄₁₀₀ SEC., B., T. ADAPTER FOR USING PLATES.

---

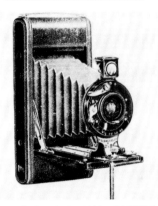

**(1704) 2¼ B FOLDING ENSIGN CAMERA.** C. 1914. SIZE 2¼ X 3¼ INCH EXPOSURES ON ROLL FILM. ACHROMATIC MENISCUS LENS. ENSIGN JUNIOR AUTO SHUTTER FOR INSTANT, B., T. EXPOSURES.

---

**(1705) 2½ FOLDING ENSIGN CAMERA.** C. 1914. SIZE 2½ X 4¼ INCH EXPOSURES ON ROLL FILM. SIMILAR TO THE 2¼ B FOLDING ENSIGN CAMERA WITH THE SAME LENS AND SHUTTER. THE 2½ RR FOLDING ENSIGN MODEL HAS AN F 8 RAPID APLANAT LENS AND SIMPLEX AUTO SHUTTER; ¹⁄₂₅, ¹⁄₅₀, ¹⁄₁₀₀ SEC., B., T.

---

**(1706) 3¼ FOLDING ENSIGN CAMERA.** C. 1914. SIZE 3¼ X 4¼ INCH EXPOSURES ON ROLL FILM. SIMILAR TO THE 2¼ B FOLDING ENSIGN CAMERA BUT WITH ACHROMATIC MENISCUS LENS AND SIMPLEX AUTO SHUTTER; ¹⁄₂₅, ¹⁄₅₀, ¹⁄₁₀₀ SEC., B., T. THE 3¼ RR FOLDING ENSIGN MODEL HAS AN F 8 RAPID APLANAT LENS.

---

**(1707) 3¼ A FOLDING ENSIGN CAMERA.** C. 1914. SIZE 3¼ X 5½ INCH EXPOSURES ON ROLL FILM. ACHROMATIC LENS. SIMPLEX AUTO SHUTTER; ¹⁄₂₅, ¹⁄₅₀, ¹⁄₁₀₀ SEC., B., T. THE 3¼ A RR FOLDING ENSIGN MODEL HAS AN F 8 RAPID APLANAT LENS.

---

**(1708) ENSIGN POST CARD FOLDING CAMERA.** C. 1917. SIZE 3¼ X 5½ INCH ROLL FILM EXPOSURES.

## HOUGHTONS, LIMITED (*cont.*)

SIMILAR TO THE ENSIGN FOLDING ROLL FILM CAMERA (C. 1917) WITH THE SAME LENSES AND SHUTTER BUT WITH BLACK LEATHER BELLOWS.

**(1709) ENSIGN 3¼ POST CARD FOLDING CAMERA.** C. 1917. TWO SIZES OF THIS CAMERA FOR 3¼ X 4¼ OR 3¼ X 5½ INCH ROLL FILM EXPOSURES. F. 6.8 SYLVAR, ZEISS TESSAR, ZEISS TRIOTAR, GOERZ DAGOR, OR COOKE LENS. SIMILAR TO THE FOLDING ROLL FILM CAMERA (C. 1917).

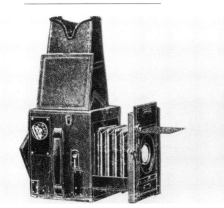

**(1710) ENSIGN A-MODEL REFLEX CAMERA.** C. 1913. FIVE SIZES OF THIS CAMERA FOR 2½ X 3½, 3¼ X 4¼, 3½ X 5½, 4 X 5, OR 4¼ X 6½ INCH EXPOSURES ON PLATES. FOCAL PLANE SHUTTER; ⅒ TO ¹⁄₁₀₀₀ SEC., B., T. RISING LENS MOUNT. REVOLVING BACK EXCEPT FOR THE 3½ X 5½ INCH EXPOSURE SIZE.

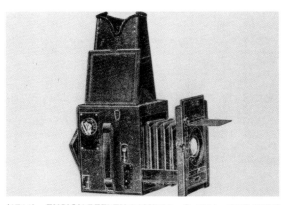

**(1711) ENSIGN REFLEX CAMERA.** C. 1914. FIVE SIZES OF THIS CAMERA FOR 2½ X 3½, 3¼ X 4¼, 4 X 5, 3½ X 5½, OR 4¼ X 6½ INCH EXPOSURES ON PLATES. F 5.8 OR F 4.5 ENSIGN ANASTIGMAT, F 4.5 ZEISS TESSAR, F 4.5 COOKE ANASTIGMAT, F 6.8 GOERZ DAGOR, OR F 4.8 GOERZ CELOR LENS. FOCAL PLANE SHUTTER; ⅒ TO ¹⁄₁₀₀₀ SEC. RACK & PINION FOCUSING. RISING AND FALLING LENS MOUNT. REVOLVING BACK. THE HOOD REVERSES AT RIGHT-ANGLE TO THE LINE OF SIGHT.

**(1712) 3¼ A REGULAR ENSIGN CAMERA.** C. 1914. TWO SIZES OF THIS CAMERA FOR 3¼ X 4¼ OR 3¼ X 5½ INCH EXPOSURES ON PLATES OR ROLL FILM. SIMILAR TO THE 3¼ REGULAR ENSIGN CAMERA WITH

THE SAME LENSES BUT WITH THE ENSIGN SECTOR SHUTTER; 1 TO ¹⁄₁₀₀ SEC., B., T.

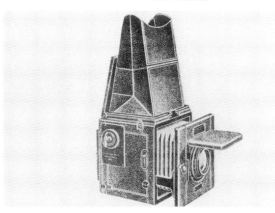

**(1713) ENSIGN POPULAR REFLEX CAMERA.** C. 1915. SIZE 3¼ X 4¼ INCH EXPOSURES ON PLATES. F 4.5 ROSS XPRES, COOKE SERIES II, CARL ZEISS, OR ALDIS LENS. FOCAL PLANE SHUTTER WITH SPEEDS TO ¹⁄₁₀₀₀ SEC., B., T. RISING AND FALLING LENS MOUNT. DETACHABLE REVERSING BACK.

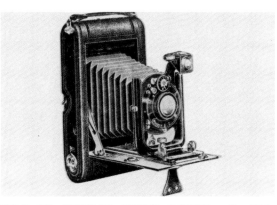

**(1714) 3¼ REGULAR ENSIGN CAMERA.** C. 1914. TWO SIZES OF THIS CAMERA FOR 3¼ X 4¼ OR 3¼ X 5½ INCH EXPOSURES ON PLATES OR ROLL FILM. F 7.7 OR F 6 ENSIGN ANASTIGMAT, F 6.8 ALDIS PLANO, F 6.3 ZEISS TRIOTAR, OR RECTIMAT SYMMETRICAL LENS. SIMPLEX AUTO SHUTTER; ¹⁄₂₅, ¹⁄₅₀, ¹⁄₁₀₀ SEC., B., T. RISING, FALLING, AND CROSSING LENS MOUNT.

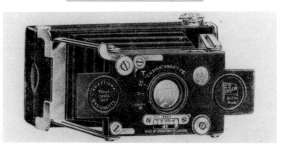

**(1715) NO. 1 ANASTIGMAT ENSIGNETTE CAMERA.** C. 1914. SIZE 1½ X 2¼ INCH EXPOSURES ON ROLL FILM. F 6.8 ALDIS ANASTIGMAT, F 5.8 COOKE ANASTIGMAT, F 6.8 GOERZ SYNTOR ANASTIGMAT, OR F 6.8 ZEISS TESSAR LENS. SCISSORS-TYPE SHUTTER FOR SINGLE-SPEED AND TIME EXPOSURES. THREE APERTURE SIZES. THUMB-WHEEL FOR FOCUSING.

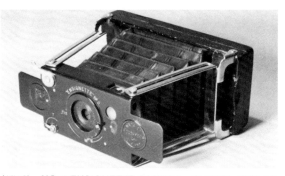

**(1716) NO. 2 ENSIGNETTE CAMERA.** C. 1907. SIZE 2¼ X 3¼ INCH EXPOSURES ON ROLL FILM. F 11 ENSIGN ANASTIGMAT LENS. INSTANT AND TIME SHUTTER. (BS)

**(1717) NO. 2 ANASTIGMAT ENSIGNETTE CAMERA.** C. 1914. SIZE 2 X 3 INCH EXPOSURES ON ROLL FILM. SIMILAR TO THE NO. 1 ANASTIGMAT ENSIGNETTE CAMERA WITH THE SAME LENSES AND SHUTTER.

**(1718) NO. 2K ANASTIGMAT ENSIGNETTE CAMERA.** C. 1914. SIZE 2 X 3 INCH EXPOSURES ON ROLL FILM. SAME AS THE NO. 2 ANASTIGMAT ENSIGNETTE CAMERA EXCEPT THE CAMERA IS NON-FOCUSING AND HAS AN F 7.7 ENSIGN ANASTIGMAT LENS.

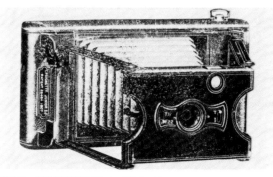

**(1719) ENSIGNETTE JUNIOR NO. 2 CAMERA.** C. 1913. SIZE 2¼ X 3¼ INCH EXPOSURES ON ROLL FILM. SINGLE LENS WITH TWO APERTURE STOPS. EVERSET SHUTTER.

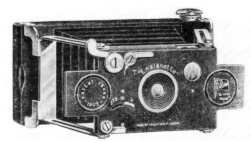

**(1720) NO. 1 ENSIGNETTE VEST POCKET CAMERA.** C. 1910–15. SIZE 1½ X 2¼ INCH EXPOSURES ON ROLL FILM. INSTANT AND TIME SHUTTER. THREE APERTURE STOPS. SOME MODELS ARE NICKEL PLATED.

**(1721) NO. 2 ENSIGNETTE VEST POCKET CAMERA.** C. 1910–15. SIZE 2 X 3 INCH EXPOSURES ON ROLL

## HOUGHTONS, LIMITED (*cont.*)

FILM. SIMILAR TO THE NO. 1 ENSIGNETTE VEST POCKET CAMERA WITH THE SAME LENS AND SHUTTER. SOME MODELS ARE NICKEL PLATED.

---

(1722) **HOLBORN ILEX MAGAZINE PLATE CAMERA.** C. 1905. ALDIS ANASTIGMAT LENS. AUTOMAT LENS. RACK & PINION FOCUSING BY EXTERNAL KNOB. (BC)

---

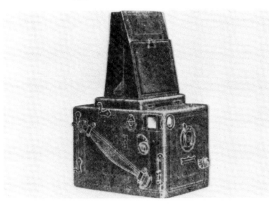

(1723) **HOLBORN REFLEX CAMERA. MODEL NO. 1.** C. 1906. SIZE 3¼ X 4¼ INCH EXPOSURES ON PLATES. F 11 RAPID ACHROMATIC LENS. SHUTTER SPEEDS FROM 1 TO ¹⁄₁₀₀ SEC., T. IRIS DIAPHRAGM. RACK & PINION FOCUSING.

---

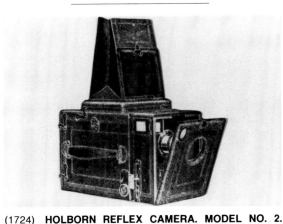

(1724) **HOLBORN REFLEX CAMERA. MODEL NO. 2.** C. 1906. SIZE 3¼ X 4¼ INCH EXPOSURES ON PLATES. SAME FEATURES AS THE MODEL NO. 1 BUT WITH AN F 8 ILEX RAPID RECTILINEAR LENS.

---

(1725) **NO. 000 KLITO BOX CAMERA.** C. 1914. SIZE 2½ X 3½ INCH EXPOSURES ON PLATES. SINGLE ACHROMATIC LENS. INSTANT AND TIME SHUTTER.

---

(1726) **NO. 00A KLITO BOX CAMERA.** C. 1914. SIZE 3¼ X 4¼ INCH EXPOSURES ON PLATES. SIX-PLATE HOLDER. SIMILAR TO THE NO. 000 KLITO BOX CAMERA WITH THE SAME LENS AND SHUTTER.

---

(1727) **NO. 00B KLITO BOX CAMERA.** C. 1914. SIZE 3¼ X 4¼ INCH EXPOSURES ON PLATES. TWELVE-PLATE HOLDER. SIMILAR TO THE NO. 000 KLITO BOX CAMERA WITH THE SAME LENS AND SHUTTER.

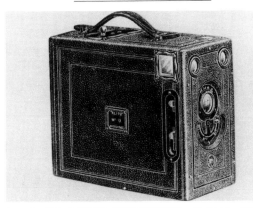

(1728) **NO. 0 KILTO BOX CAMERA.** C. 1914. SIZE 3¼ X 4¼ INCH EXPOSURES ON PLATES. TWELVE-PLATE HOLDER. RAPID RECTILINEAR LENS. IRIS DIAPHRAGM. EVERSET SHUTTER FOR INSTANT AND TIME EXPOSURES. THREE MAGNIFIERS FOR FOCUSING.

---

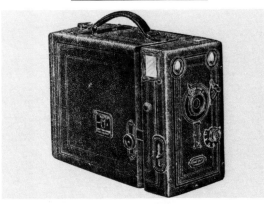

(1729) **NO. 1 KLITO BOX CAMERA.** C. 1905. SIZE 3¼ X 4¼ INCH EXPOSURES ON PLATES OR SHEET FILM. THE MAGAZINE HOLDS 12 PLATES OR 24 SHEET FILMS. RAPID ACHROMATIC LENS. KLITO SHUTTER; 1 TO ¹⁄₁₀₀ SEC. T. IRIS DIAPHRAGM.

---

(1730) **NO. 1 KLITO BOX CAMERA.** C. 1914. SIZE 3¼ X 4¼ INCH EXPOSURES ON PLATES. TWELVE-PLATE HOLDER. ACHROMATIC LENS. IRIS DIAPHRAGM. EVERSET SHUTTER FOR INSTANT AND TIME EXPOSURES. RACK & PINION FOCUSING USING EXTERNAL KNOB. SIMILAR TO THE NO. 0 KLITO BOX CAMERA.

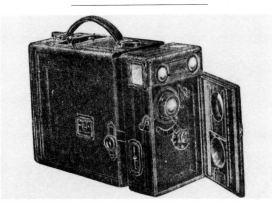

(1731) **NO. 2 KLITO BOX CAMERA.** C. 1905. SIZE 3¼ X 4¼ INCH EXPOSURES ON PLATES OR SHEET FILM. THE MAGAZINE HOLDS 12 PLATES OR 24 SHEET FILMS. F 8 ACHROMATIC RAPID RECTILINEAR LENS. KLITO SHUTTER; 1 TO ¹⁄₁₀₀ SEC., T. IRIS DIAPHRAGM. RACK FOCUSING.

---

(1732) **NO. 2B KLITO BOX CAMERA.** C. 1914. SIZE 3¼ X 4¼ INCH EXPOSURES ON PLATES. SAME AS THE NO. 1 KLITO BOX CAMERA EXCEPT WITH A RAPID RECTILINEAR LENS.

---

(1733) **NO. 3 KLITO BOX CAMERA.** C. 1905. SIZE 3¼ X 4¼ INCH EXPOSURES ON PLATES OR SHEET FILM. SAME AS THE NO. 2 KLITO BOX CAMERA EXCEPT WITH AN F 8 BECK RAPID SYMMETRICAL LENS, MAHOGANY FRONT, AND BRASS FITTINGS.

---

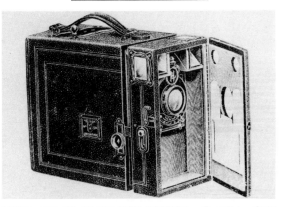

(1734) **NO. 3A KLITO BOX CAMERA.** C. 1914. SIZE 3¼ X 4¼ INCH EXPOSURES ON PLATES. TWELVE-PLATE HOLDER RECTIMAT SYMMETRICAL LENS. IRIS DIAPHRAGM. MULTISPEED ENSIGN SIMPLEX AUTO SHUTTER WITH B. AND T. RACK & PINION FOCUSING WITH EXTERNAL KNOB.

---

(1735) **NO. 5 KLITO BOX CAMERA.** C. 1914. SIZE 3½ X 5½ INCH EXPOSURES ON PLATES. SAME AS THE NO. 3A KLITO BOX CAMERA EXCEPT WITH AN ENSIGN SECTOR SHUTTER AND AN F 8 ILEX RAPID RECTILINEAR LENS.

---

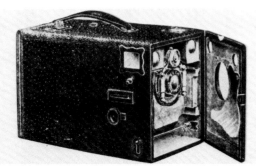

(1736) **NO. 6 KLITO BOX CAMERA.** C. 1905. SIZE 3¼ X 4¼ INCH EXPOSURES ON PLATES OR SHEET FILM. THE MAGAZINE HOLDS 12 PLATES 24 SHEET FILMS. F. 8 BECK RAPID SYMMETRICAL LENS. BAUSCH & LOMB UNICUM SHUTTER; 1 TO ¹⁄₁₀₀ SEC., T. MAHOGANY FRONT.

## HOUGHTONS, LIMITED (*cont.*)

(1737) **NO. 6A KLITO BOX CAMERA.** C. 1914. SIZE 3½ X 5½ INCH EXPOSURES ON PLATES OR SHEET FILM. SAME AS THE NO. 6 KLITO BOX CAMERA EXCEPT WITH AN F 7.7 ENSIGN ANASTIGMAT LENS.

(1738) **NO. 6B KLITO BOX CAMERA.** C. 1914. SIZE 3¼ X 4¼ INCH EXPOSURES ON PLATES. SAME AS THE NO. 3A KLITO BOX CAMERA EXCEPT THE CAMERA HAS A HORIZONTAL FORMAT AND AN F 7.7 ENSIGN ANASTIGMAT LENS.

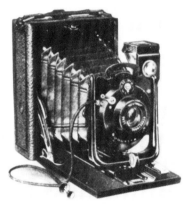

(1739) **KLITO FOLDING CAMERA.** C. 1917. TWO SIZES OF THIS CAMERA FOR 3¼ X 4¼ OR 3¼ X 5½ INCH EXPOSURES ON PLATES OR FILM PACKS. F 11 RECTIMAT SYMMETRICAL LENS. SIMPLEX AUTOMATIC SHUTTER FOR I., B., T. EXPOSURES. GROUND GLASS FOCUSING.

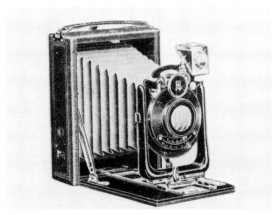

(1740) **KLITO FOLDING CAMERA. MODELS 0, 00, 000, AND 000A.** C. 1914. SIZE 3¼ X 4¼ INCH EXPOSURES ON PLATES OR FILM PACKS. RAPID ACHROMATIC OR RECTIMAT SYMMETRICAL LENS. ENSIGN SIMPLEX AUTO SHUTTER: ½₅, ½₀, ½₀₀ SEC., B. OR ENSIGN JUNIOR AUTO SHUTTER; INSTANT, B., T. RISING LENS MOUNT.

(1741) **KLITO FOLDING CAMERA. MODEL 6.** C. 1914. SIZE 3½ X 5½ INCH EXPOSURES ON PLATES OR FILM PACKS. SIMILAR TO THE KLITO FOLDING CAMERA, MODEL 5 WITH THE SAME LENSES AND SHUTTERS.

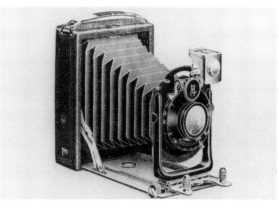

(1742) **KLITO FOLDING CAMERA. MODELS 3 AND 4.** C. 1914. SIZE 3¼ X 4¼ INCH EXPOSURES ON PLATES OR FILM PACKS. RECTIMAT SYMMETRICAL, F 7.7 OR F 6 ENSIGN ANASTIGMAT, OR F 6.8 ALDIS-PLANO ANASTIGMAT LENS. MODEL 3 HAS THE SIMPLEX AUTO SHUTTER; ½₅, ½₀, ½₀₀ SEC., B. MODEL 4 HAS THE ENSIGN SECTOR SHUTTER. BOTH MODELS HAVE RISING AND CROSSING LENS MOUNT. RACK & PINION FOCUSING. GROUND GLASS FOCUSING.

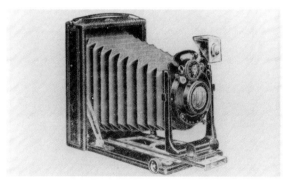

(1743) **KLITO FOLDING CAMERA. MODEL 5.** C. 1914. SIZE 3¼ X 4¼ INCH EXPOSURES ON PLATES OR FILM PACKS WITH ADAPTER. F 8 RAPID APLANAT, F 7.7 OR F 6 ENSIGN ANASTIGMAT, F 6.3 ZEISS TRIOTAR, F 6.8 ZEISS DOUBLE AMATAR, F 6.3 DALLMEYER STIGMATIC, OR F 6.8 GOERZ DAGOR LENS. ENSIGN SECTOR SHUTTER; 1 TO ½₀₀ SEC., B., T. ALSO, KOILOS OR COMPOUND SHUTTER. DOUBLE EXTENSION BELLOWS. RISING AND CROSSING LENS MOUNT. RACK AND PINION FOCUSING.

(1744) **KLITO FOLDING CAMERA. MODEL 10.** C. 1914. SIZE 4¾ X 6½ INCH EXPOSURES ON PLATES. F 8 BECK RAPID SYMMETRICAL, F 7.7 ENSIGN ANASTIGMAT, OR F 6 ENSIGN ANASTIGMAT LENS. ENSIGN SECTOR SHUTTER; 1 TO ½₀₀ SEC., B., T. OR KOILOS SHUTTER. ALL OTHER FEATURES ARE THE SAME AS THE KLITO FOLDING CAMERA, MODEL 5.

(1745) **KLITO FOLDING DE LUXE CAMERA. SINGLE BELLOWS MODEL.** C. 1914. SIZE 3¼ X 4¼ INCH EXPOSURES ON PLATES. F 6 OR F 7.7 ENSIGN ANASTIGMAT, F 6.8 ALDIS-PLANO ANASTIGMAT, OR F 6.8 COOKE-LUXOR ANASTIGMAT LENS. ENSIGN SECTOR SHUTTER; 1 TO ½₀₀ SEC., B., T. RISING AND CROSSING LENS MOUNT. RACK & PINION FOCUSING. GROUND GLASS FOCUSING. SIMILAR TO THE KLITO FOLDING CAMERA, MODEL 3.

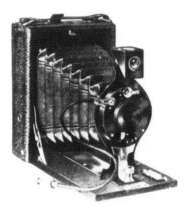

(1746) **KLITO FOLDING DE LUXE CAMERA. DOUBLE BELLOWS MODEL.** C. 1914. TWO SIZES OF THIS CAMERA FOR 3¼ X 4¼ INCH OR 10 X 15 CM EXPOSURES ON PLATES. SIMILAR TO THE KLITO FOLDING CAMERA, MODEL 3 WITH THE SAME LENSES (PLUS F 6.8 GOERZ DAGOR LENS) AND SHUTTER BUT WITH DOUBLE EXTENSION BELLOWS.

(1747) **KLITO FOLDING JUNIOR CAMERA.** C. 1915. THREE SIZES OF THIS CAMERA FOR 2½ X 3½, 3¼ X 4¼, OR 3½ X 5½ INCH EXPOSURES ON PLATES OR FILM PACKS. SINGLE ACHROMATIC OR RAPID RECTILINEAR LENS. SINGLE-SPEED, B., T. SHUTTER OR ENSIGN SIMPLEX SHUTTER.

(1748) **NO. 1 MASCOT BOX CAMERA.** C. 1914. SIZE 2½ X 3½ INCH EXPOSURES ON PLATES. MENISCUS LENS. INSTANT AND TIME SHUTTER.

(1749) **NO. 1A MASCOT BOX CAMERA.** C. 1914. SIZE 3¼ X 4¼ INCH EXPOSURES ON PLATES. SIMILAR TO THE NO. 1 MASCOT BOX CAMERA WITH THE SAME LENS AND SHUTTER.

(1750) **NO. 3 MASCOT BOX CAMERA.** C. 1905. SIZE 3¼ X 4¼ INCH EXPOSURES ON PLATES. THE MAGAZINE HOLDS SIX PLATES. RAPID ACHROMATIC LENS. EVERSET INSTANT AND TIME SHUTTER.

(1751) **MAY FAIR BOX CAMERA.**

(1752) **SANDERSON CHAMBRE DE VOYAGE VIEW CAMERA.** C. 1900. SIZE 8 X 10 INCH PLATE EXPOSURES. SUTER APLANAT NO. 5 LENS. (MA)

(1753) **SANDERSON DELUXE HAND CAMERA.** C. 1914. FOUR SIZES OF THIS CAMERA FOR 3¼ X 4¼, 4 X 5, 4¾ X 6½ INCH EXPOSURES, OR 9 X 12 CM EXPOSURES ON PLATES. SIMILAR TO THE SANDERSON REGULAR HAND CAMERA (C. 1914) WITH THE SAME LENSES AND SHUTTER BUT WITH SPECIAL BODY AND BELLOWS DESIGNS.

(1754) **SANDERSON FIELD CAMERA.** C. 1939. SIZE 10 X 12 INCH EXPOSURES ON PLATES. TEAK BODY.

## HOUGHTONS, LIMITED (*cont.*)

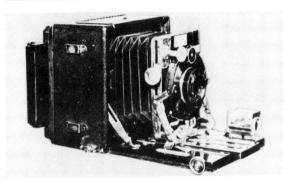

**(1755) SANDERSON HAND AND STAND CAMERA.** C. 1939. SIZE 3¼ X 4¼ INCH EXPOSURES ON PLATES. ZEISS TESSAR LENS. COMPUR SHUTTER.

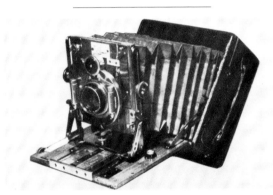

**(1756) SANDERSON JUNIOR HAND CAMERA.** C. 1904. TWO SIZES OF THIS CAMERA FOR 3¼ X 4¼ OR 4 X 5 INCH EXPOSURES ON PLATES. F 7.7 BECK APLANAT LENS. BAUSCH & LOMB SHUTTER TO ¹⁄₁₀₀ SEC. (HA)

**(1757) SANDERSON JUNIOR HAND CAMERA.** C. 1905. SIZE 3½ X 5½ INCH EXPOSURES ON PLATES. F 7.7 BECK APLANAT OR BAUSCH & LOMB LENS. UNICUM SHUTTER. SIMILAR TO THE SANDERSON JUNIOR HAND CAMERA, C. 1904.

**(1758) SANDERSON NEW MODEL DELUXE HAND AND STAND CAMERA.** C. 1905. THREE SIZES OF THIS CAMERA FOR 3¼ X 4¼, 4 X 5, OR 4¾ X 6½ INCH EXPOSURES ON PLATES.

**(1759) SANDERSON NEW MODEL DELUXE HAND AND STAND TROPICAL CAMERA.** C. 1905. THREE SIZES OF THIS CAMERA FOR 3¼ X 4¼, 4 X 5, OR 4¾ X 6½ INCH EXPOSURES ON PLATES.

**(1760) SANDERSON POSTCARD HAND AND STAND CAMERA.** C. 1905. THREE SIZES OF THIS CAMERA FOR 3¼ X 4¼, 4 X 5, OR 4¾ X 6½ INCH EXPOSURES ON PLATES.

**(1761) SANDERSON POSTCARD HAND AND STAND TROPICAL CAMERA.** C. 1905. THREE SIZES OF THIS CAMERA FOR 3¼ X 4¼, 4 X 5, OR 4¾ X 6½ INCH EXPOSURES ON PLATES.

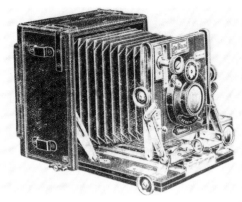

**(1762) SANDERSON REGULAR HAND CAMERA.** C. 1914. FIVE SIZES OF THIS CAMERA FOR 3¼ X 4¼, 4 X 5, 3½ X 5½, 4¾ X 6½ INCH EXPOSURES, OR 9 X 12 CM EXPOSURES ON PLATES. F 7.7, F 6, OR F 5.5 ENSIGN ANASTIGMAT LENS. ALSO, F 6.8 ALDIS-PLANO ANASTIGMAT OR F 6.8 GOERZ DAGOR ANASTIGMAT LENS. ENSIGN SECTOR SHUTTER OR KOILOS SHUTTER; 1 TO ¹⁄₃₀₀ SEC., B., T. RISING LENS MOUNT. RACK & PINION FOCUSING. DROPPING BED.

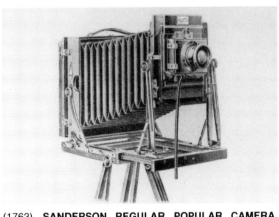

**(1763) SANDERSON REGULAR POPULAR CAMERA.** C. 1914. SEVEN SIZES OF THIS CAMERA FOR 3¼ X 4¼, 4¾ X 6½, 6½ X 8½, 5 X 7, 8 X 10, 10 X 12, OR 12 X 15 INCH EXPOSURES ON PLATES. F 6.8 ALDIS-PLANO ANASTIGMAT, F 6.8 GOERZ DOUBLE ANASTIGMAT, F 6.5 COOKE ANASTIGMAT, OR F 6 ENSIGN ANASTIGMAT LENS. ROLLER-BLIND SHUTTER. THE 6½ X 8½ INCH EXPOSURE CAMERA DOES NOT HAVE THE ALDIS OR ENSIGN LENSES.

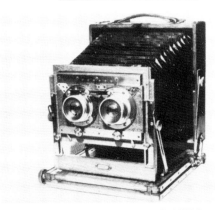

**(1764) SANDERSON STEREO CAMERA.** C. 1910. SIZE 7 X 9 INCH STEREO EXPOSURES ON PLATES. APLANAT LENSES. IRIS DIAPHRAGM. (HA)

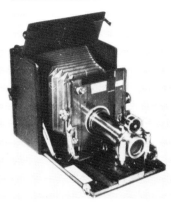

**(1765) SANDERSON TOURIST CAMERA.** C. 1904. SIZE 3¼ X 4¼ INCH EXPOSURES ON PLATES. BAUSCH & LOMB RAPID RECTILINEAR TELEPHOTO LENS. KODAK AUTOMATIC SHUTTER TO ¹⁄₁₀₀ SEC. (HA)

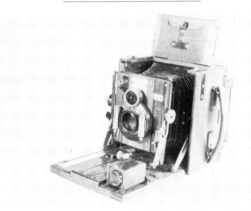

**(1766) SANDERSON TROPICAL HAND CAMERA.** C. 1914. FOUR SIZES OF THIS CAMERA FOR 3¼ X 4¼, 4 X 5, 3½ X 5½, OR 4¾ X 6½ INCH EXPOSURES ON PLATES. F 7.7, F 6, OR F 5.5 ENSIGN ANASTIGMAT, F 6.8 ALDIS-PLANO ANASTIGMAT OR F 6.8 GOERZ DAGOR ANASTIGMAT LENS. ENSIGN SECTOR PNEUMATIC SHUTTER; 1 TO ¹⁄₁₀₀ SEC., B., T. RISING LENS MOUNT. RACK & PINION FOCUSING. TEAK AND BRASS BODY. (VC)

**(1767) SANDERSON TROPICAL POPULAR CAMERA.** C. 1914. SEVEN SIZES OF THIS CAMERA FOR 3¼ X 4¼, 4¾ X 6½, 5 X 7, 6½ X 8½, 8 X 10, 10 X 12, OR 12 X 15 INCH EXPOSURES ON PLATES. SIMILAR TO THE SANDERSON REGULAR POPULAR CAMERA WITH THE SAME LENSES AND SHUTTER. THE SIZE 6½ X 8½ INCH EXPOSURE CAMERA DOES NOT HAVE THE ALDIS OR ENSIGN LENSES.

**(1768) TICKA WATCH POCKET CAMERA. NEW MODEL.** C. 1908. SIMILAR TO THE 1906 MODEL TICKA BUT WITH A FALSE WATCH FACE WITH HANDS THAT INDICATE THE CAMERA'S ANGLE OF VIEW. 25 MM/F 16 MENISCUS LENS. SINGLE-SPEED SHUTTER. (MA)

**(1769) TICKA WATCH POCKET CAMERA. NEW MODEL.** C. 1908. SIMILAR TO THE 1906 MODEL TICKA

## HOUGHTONS, LIMITED (*cont.*)

BUT WITH A FOCAL PLANE SHUTTER WITH SPEEDS TO $\frac{1}{400}$ SEC. AND AN F 6.5 COOKE LENS. (MA)

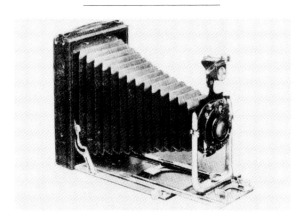

(1770) **SYLVAR PLATE AND FILM PACK CAMERA.** C. 1917. TWO SIZES OF THIS CAMERA FOR 3¼ X 5½ OR 4 X 6 INCH EXPOSURES. F 6.8 SYLVAR ANASTIGMAT OR F 6.3 ZEISS ANASTIGMAT LENS. AUTO OR COMPOUND SHUTTER.

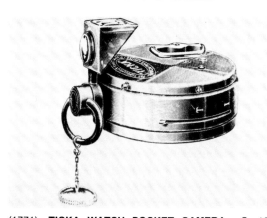

(1771) **TICKA WATCH POCKET CAMERA.** C. 1906. THE CAMERA TAKES 25 EXPOSURES SIZE ⅝ X ⅞ INCH ON ROLL FILM. INSTANT AND TIME SHUTTER. DETACHABLE FINDER.

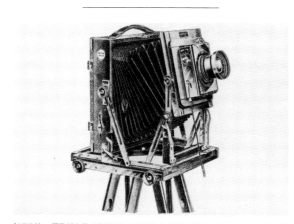

(1772) **TRIPLE VICTO VIEW CAMERA.** C. 1914. TWO SIZES OF THIS CAMERA FOR 4¼ X 6½ OR 6½ X 8½

INCH EXPOSURES ON PLATES. F 8 ENSIGN RAPID SYMMETRICAL OR F 7.9 ENSIGN ANASTIGMAT SERIES VII LENS. ROLLER-BLIND SHUTTER FOR INSTANT AND TIME EXPOSURES. DOUBLE RACK & PINION FOCUSING. TRIPLE EXTENSION BELLOWS. SELF-ERECTING SWING FRONT AND BACK. RISING, FALLING, AND CROSSING LENS MOUNT. REVERSING BACK. DOUBLE SWING BACK.

(1773) **TRIPLE VICTO TROPICAL VIEW CAMERA.** C. 1914. TWO SIZES OF THIS CAMERA FOR 4¼ X 6½ OR 6½ X 8½ INCH EXPOSURES ON PLATES. TEAK WOOD BODY. SIMILAR TO THE TRIPLE VICTO VIEW CAMERA WITH THE SAME LENSES AND SHUTTER.

(1774) **FIELD VIEW CAMERA.** C. 1905. SIZE 4¼ X 6½ INCH EXPOSURES ON PLATES. F 8 ENSIGN SYMMETRICAL LENS. THORNTON-PICKARD SHUTTER. (HA)

## HUMPHRIES, W. H. & COMPANY

(1775) **QUADRANT HAND CAMERA.** C. 1890. SIZE 3¼ X 4¼ INCH EXPOSURES ON PLATES. THE MAGAZINE HOLDS 12 PLATES. F 6 LENS. THE UNEXPOSED PLATES ARE HELD HORIZONTALLY IN THE TOP OF THE CAMERA. PATENT BY HUME AND PARFITT.

## JANOVITCH, M. AND COMPANY

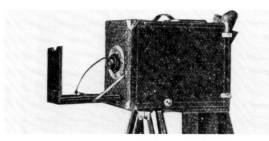

(1776) **JANO POSTCARD CAMERA.** C. 1930. SIZE 3¼ X 5½ INCH EXPOSURES ON NEGATIVE PHOTOGRAPHIC CARDS. F 5.5 LENS. THREE-SPEED VARIO SHUTTER WITH B AND T. REVOLVING BACK. GROUND GLASS FOCUSING. THE EXPOSED CARD IS CHANGED FROM THE CAMERA BOX TO THREE TANKS IN THE BOTTOM OF THE CAMERA FOR DEVELOPING, FIXING, AND WASHING BY MEANS OF A LIGHT-TIGHT CLOTH SLEEVE AT THE REAR OF THE CAMERA. THE NEGATIVE IS PLACED ON A HOLDER IN FRONT OF THE LENS FOR REPHOTOGRAPHING.

## JOHNSON & HARRISON

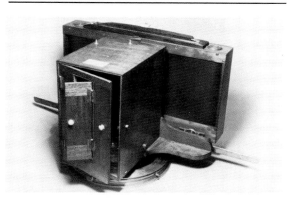

(1777) **PANTASCOPIC CAMERA.** C. 1862. 110-DEGREE PANORAMIC EXPOSURES ON 7.5 X 12 INCH WET-COLLODION PLATES. 83 MM OR 200 MM GRUBB LENS. A CLOCKWORK MOTOR ROTATES THE LENS AND IS REGULATED BY A VANE GOVERNOR. THE PLATE SLIDES PERPENDICULAR TO THE LENS AND IN HARMONY WITH THE ROTATION OF THE CAMERA. (BS)

## KERSHAW, A. & SON LIMITED

(1778) **SOHO SINGLE-LENS REFLEX CAMERA.** C. 1905. PLATE EXPOSURES. FOCAL-PLANE SHUTTER. (BC)

(1779) **SOHO TROPICAL SINGLE-LENS REFLEX CAMERA.** C. 1905–21. SIZE 3¼ X 4¼ INCH EXPOSURES ON CUT FILM. 6⅜ INCH/F 4.5 BAUSCH & LOMB TESSAR LENS. FOCAL PLANE SHUTTER; ¹⁄₁₆ TO ¹⁄₈₀₀ SEC., T. REVOLVING BACK. FOCUSING BY UPPER VIEWING SCREEN OR GROUND GLASS ON BACK. TEAK WOOD AND BRASS BODY WITH RED LEATHER BELLOWS. THIS CAMERA WAS ALSO MANUFACTURED BY AMALGAMATED PHOTOGRAPHIC MANUFACTURERS LIMITED FROM 1921 TO 1929 AND BY SOHO LIMITED FROM 1930–40. SEE PHOTO OF THE CAMERA UNDER SOHO LIMITED CAMERAS.

## KNIGHT-FOSTER

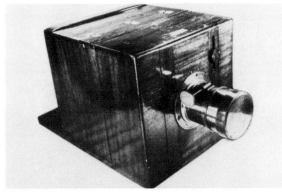

(1780) **SLIDING BOX CAMERA.** C. 1852. SIZE 4¼ X 6½ INCH EXPOSURES ON COLLODION PLATES. VALLA-TIN LENS. (HA)

## KODAK LIMITED

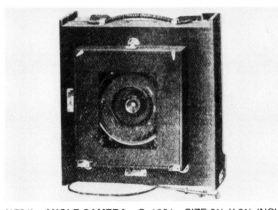

(1781) **ANGLE CAMERA.** C. 1931. SIZE 6½ X 8½ INCH EXPOSURES ON PLATES. ZEISS PROTAR LENS. THE MAXIMUM APERTURE IS F 18. NON-FOCUSING LENS. THE LENS HAS A WIDE ANGLE OF 110-DEGREES. SINGLE-SPEED, BULB, AND TIME SHUTTER. IRIS DIA-PHRAGM. NO FOCUSING SCREEN.

(1782) **NO. 2 BROWNIE CAMERA.** C. 1929–35. SIZE 2¼ X 3¼ INCH EXPOSURES ON NO. 120 ROLL FILM. MENISCUS LENS. EASTMAN ROTARY SHUTTER.

(1783) **NO. 2A BROWNIE CAMERA.** C. 1933–36. SIZE 2½ X 4¼ INCH EXPOSURES ON NO. 116 ROLL FILM. MENISCUS ACHROMATIC LENS. EASTMAN ROTARY SHUTTER.

(1784) **NO. 2 BEAU BROWNIE BOX CAMERA.** C. 1931. SIZE 2¼ X 3¼ INCH EXPOSURES ON ROLL FILM. DOUBLET LENS. SINGLE-SPEED AND BULB SHUTTER. BLACK, BLUE, OR BROWN COLOR.

(1785) **POPULAR BROWNIE CAMERA.** C. 1937–38. SIZE 2¼ X 3¼ INCH EXPOSURES ON NO. 620 ROLL FILM. MENISCUS LENS. SIMPLE SHUTTER.

(1786) **NO. 2 PORTRAIT BROWNIE CAMERA.** C. 1929–35. SIZE 2¼ X 3¼ INCH EXPOSURES ON NO. 120 ROLL FILM. MENISCUS LENS. EASTMAN ROTARY SHUTTER.

(1787) **SIX-20 BROWNIE CAMERA.** C. 1934–40. SIZE 2¼ X 3¼ INCH EXPOSURES ON NO. 620 ROLL FILM. F 11 LENS. SIMPLE SHUTTER.

(1788) **SIX-20 BROWNIE JUNIOR CAMERA.** C. 1934–38. SIZE 2¼ X 3¼ INCH EXPOSURES ON NO. 620 ROLL FILM. MENISCUS LENS. SIMPLE SHUTTER.

(1789) **SIX-20 BROWNIE JUNIOR PORTRAIT CAMERA.** C. 1939–40. SIZE 2¼ X 3¼ INCH EXPOSURES ON NO. 620 ROLL FILM. MENISCUS LENS. SIMPLE SHUTTER.

(1790) **SIX-20 BROWNIE JUNIOR SUPER CAMERA.** C. 1935–40. SIZE 2¼ X 3¼ INCH EXPOSURES ON NO. 620 ROLL FILM. MENISCUS LENS. EASTMAN ROTARY SHUTTER.

(1791) **SIX-20 FOLDING BROWNIE CAMERA. MODEL 1.** C. 1937–39. SIZE 2¼ X 3¼ INCH EXPOSURES ON NO. 620 ROLL FILM. MENISCUS LENS. KODETTE II SHUT-TER.

(1792) **SIX-20 POPULAR BROWNIE CAMERA.** C. 1937–40. SIZE 2¼ X 3¼ INCH EXPOSURES ON NO. 620 ROLL FILM. MENISCUS LENS. KODETTE II SHUTTER.

(1793) **SIX-20 PORTRAIT BROWNIE CAMERA.** C. 1936–40. SIZE 2¼ X 3¼ INCH EXPOSURES ON NO. 620 ROLL FILM. MENISCUS LENS. EASTMAN ROTARY SHUTTER.

(1794) **BOY SCOUT KODAK CAMERA.** C. 1932–35. SIZE 1⅝ X 2½ INCH EXPOSURES ON NO. 127 ROLL FILM. MENISCUS LENS. ROTARY SHUTTER.

(1795) **GIRL GUIDE KODAK CAMERA.** C. 1932–35. SIZE 1⅝ X 2½ INCH EXPOSURES ON NO. 127 ROLL FILM. MENISCUS LENS. ROTARY SHUTTER.

(1796) **SERIES B GRAFLEX CAMERA.** C. 1925. SIZE 2¼ X 3¼ INCH EXPOSURES ON PLATES, FILM PACKS, CUT FILM, OR ROLL FILM WITH ADAPTER. F 4.5 KODAK ANASTIGMAT, ROSS XPRES, OR ZEISS TESSAR LENS. FOCAL-PLANE SHUTTER; 1/10 TO 1/1000 SEC., T. RACK & PINION FOCUSING.

(1797) **NO. 2 HAWKETTE CAMERA.** C. 1930. SIZE 2¼ X 3¼ INCH EXPOSURES ON NO. 120 ROLL FILM. MENISCUS LENS. INSTANT AND TIME SHUTTER.

(1798) **HAWKEYE ACE CAMERA.** C. 1938. SIZE 1⅝ X 2½ INCH EXPOSURES ON NO. 127 ROLL FILM. FIXED-FOCUS LENS. INSTANT AND TIME SHUTTER. DELUXE MODEL WITH MENISCUS LENS AND ROTARY SHUTTER. (BC)

(1799) **NO. 0 HAWKEYE CAMERA.** C. 1938. SIZE 1⅝ X 2½ INCH EXPOSURES ON NO. 127 ROLL FILM.

(1800) **NO. 2 HAWKEYE MODEL C CAMERA.** C. 1927. SIZE 2¼ X 3¼ INCH EXPOSURES ON NO. 120 ROLL FILM. FIXED-FOCUS LENS. FLIP-FLOP SHUTTER.

(1801) **BABY HAWKEYE CAMERA.** C. 1936. SIZE 1⅝ X 2½ INCH EXPOSURES ON NO. 127 ROLL FILM. FIXED FOCUS. FLIP-FLOP SHUTTER.

(1802) **NO. 2 CARTRIDGE HAWKEYE CAMERA.** C. 1927. SIZE 2¼ X 3¼ INCH EXPOSURES ON NO. 120 ROLL FILM. MENISCUS LENS. ROTARY SHUTTER. MODEL B, C. 1929.

(1803) **SIX-20 HAWKEYE CAMERA.** C. 1938. SIZE 2¼ X 3¼ INCH EXPOSURES ON NO. 620 ROLL FILM. MENISCUS LENS. ROTARY SHUTTER.

(1804) **SIX-20 HAWKEYE MODEL HB CAMERA.** C. 1933. SIZE 2¼ X 3¼ INCH EXPOSURES ON NO. 620 ROLL FILM.

(1805) **SIX-20 HAWKEYE MAJOR CAMERA.** C. 1935. SIZE 2¼ X 3¼ INCH EXPOSURES ON NO. 620 ROLL FILM. MENISCUS LENS. ROTARY SHUTTER.

(1806) **SIX-20 PORTRAIT HAWKEYE A-STAR-A CAM-ERA.** C. 1933. SIZE 2¼ X 3¼ INCH EXPOSURES ON NO. 620 ROLL FILM. FIXED FOCUS LENS. FLIP-FLOP SHUTTER.

(1807) **JIFFY KODAK CAMERA.** C. 1934. TWO SIZES OF THIS CAMERA FOR 2¼ X 3¼ OR 2½ X 4¼ INCH EXPOSURES ON ROLL FILM. BY PRESSING A BUTTON, THE LENS MOUNT IS AUTOMATICALLY EXTENDED TO THE MAXIMUM LENGTH OF THE BELLOWS.

(1808) **KODAK NO. 2C SERIES III CAMERA.** C. 1925. SIZE 2⅞ X 4⅞ INCH EXPOSURES ON ROLL FILM. F 7.7 KODAK ANASTIGMAT LENS. DIOMATIC SHUTTER; 1/10 TO 1/100 SEC., B., T.

(1809) **NO. 1 POCKET KODAK CAMERA.** C. 1932–33. SIZE 2¼ X 3¼ INCH EXPOSURES ON NO. 120 ROLL FILM. F 7.9 KODAR OR F 6.3 KODAK ANASTIGMAT LENS. KODEX SHUTTER. ALSO, AN AUTOGRAPHIC MODEL.

(1810) **NO. 1A POCKET KODAK CAMERA.** C. 1932–35. SIZE 2½ X 4¼ INCH EXPOSURES ON NO. 116 ROLL FILM. MENISCUS, F 7.9 KODAR, OR F 6.3 KODAK ANASTIGMAT LENS. KODEX SHUTTER. ALSO, AN AUTOGRAPHIC MODEL.

(1811) **NO. 3A POCKET KODAK CAMERA.** C. 1933–34. SIZE 3¼ X 5½ INCH EXPOSURES ON NO. 122 ROLL FILM. F 7.9 KODAR OR F 6.3 KODAK ANASTIGMAT LENS. KODEX OR KODAK BALL-BEARING SHUTTER. ALSO, AN AUTOGRAPHIC MODEL.

## KODAK LIMITED (*cont.*)

**(1812) NO. 1 POCKET KODAK JUNIOR CAMERA.** C. 1932–33. SIZE 2¼ X 3¼ INCH EXPOSURES ON NO. 120 ROLL FILM. F 7.7 OR F 6.3 KODAK ANASTIGMAT LENS. KODEX OR KODAK BALL-BEARING SHUTTER.

**(1813) NO. 1A POCKET KODAK JUNIOR CAMERA.** C. 1932–33. SIZE 2½ X 4¼ INCH EXPOSURES ON ROLL FILM. DOUBLET OR F 7.7 OR F 6.3 KODAK ANASTIGMAT LENS. KODEX SHUTTER.

**(1814) QUEEN MARY DOLL HOUSE KODAK CAMERA.** C. 1924. THE CAMERA IS A REPLICA OF THE NO. 3A AUTOGRAPHIC KODAK AND WAS PRESENTED TO H. M. QUEEN MARY FOR HER DOLL HOUSE COLLECTION. IT HAS A CRYSTAL LENS, WORKING SHUTTER, REVERSIBLE FINDER, AUTOGRAPHIC PENCIL, PAPER BELLOWS, AND A LEATHER CARRYING CASE. IT REQUIRED THREE MONTHS TO MANUFACTURE USING JEWELER'S TOOLS AND MICROSCOPES. THE CAMERA HEIGHT IS ¾ INCH. THIS IS THE SMALLEST FOLDING CAMERA EVER MANUFACTURED.

**(1815) SIX-16 KODAK CAMERA.** C. 1934–37. SIZE 2½ X 4¼ INCH EXPOSURES ON NO. 616 ROLL FILM. F 6.3 OR F 4.5 KODAK S ANASTIGMAT OR F 4.5 ZEISS TESSAR LENS. COMPUR-S, O.P.S., OR OV SHUTTER.

**(1816) SIX-16 KODAK JUNIOR CAMERA.** C. 1934–40. SIZE 2¼ X 4¼ INCH EXPOSURES ON NO. 616 ROLL FILM. F 6.3 KODAK ANASTIGMAT OR TWINDAR LENS. KODON OR DIODAK SHUTTER.

**(1817) SIX-20 KODAK CAMERA.** C. 1932–37. SIZE 2¼ X 3¼ INCH EXPOSURES ON NO. 620 ROLL FILM. DOUBLET, F 6.3 KODAK ANASTIGMAT, OR F 4.5 COOKE ANASTIGMAT LENS. ALSO, F 4.5 OR F 6.3 KS ANASTIGMAT LENS. KODON, O.P.S., COMPUR-S, OR OV SHUTTER.

**(1818) SIX-20 KODAK JUNIOR CAMERA.** C. 1933–40. SIZE 2¼ X 3¼ INCH EXPOSURES ON NO. 620 ROLL FILM. F 6.3 OR F 7.7 KODAK ANASTIGMAT LENS. ALSO, DOUBLET OR TWINDAR LENS. KODON SHUTTER.

**(1819) SIX-20 KODAK JUNIOR DELUXE CAMERA.** C. 1936–39. SIZE 2¼ X 3¼ INCH EXPOSURES ON NO. 620 ROLL FILM. F 6.3 OR F 4.5 KODAK ANASTIGMAT LENS. KODON OR DAKAR SHUTTER.

**(1820) SIX-20 KODAK 8 CAMERA.** C. 1939–40. SIZE 2¼ X 3¼ INCH EXPOSURES ON NO. 620 ROLL FILM. F 6.3 OR F 4.5 KODAK ANASTIGMAT LENS. COMPUR-S, O.P.S., OR OV SHUTTER.

**(1821) VEST POCKET KODAK CAMERA. SERIES III.** C. 1932–33. SIZE 1⅝ X 2½ INCH EXPOSURES ON NO. 127 ROLL FILM. F 7.9 KODAR LENS. KODEX SHUTTER.

**(1822) VEST POCKET KODAK CAMERA. MODEL B.** C. 1932–33. SIZE 1⅝ X 2½ INCH EXPOSURES ON NO. 127 ROLL FILM. MENISCUS LENS. ROTARY SHUTTER.

**(1823) WIDE-ANGLE CAMERA.** C. 1931. SIZE 6½ X 8½ INCH PLATE EXPOSURES. THE WIDE ANGLE FIXED-FOCUS LENS COVERS AN ANGLE OF 110 DEGREES. THE CAMERA WAS PLACED AGAINST THE WALL OR IN THE CORNER OF A ROOM TO PHOTOGRAPH A LARGE SECTION OF THE ROOM. A FRAME WAS FITTED AROUND THE LENS TO DETERMINE THE CAMERA'S FIELD OF VIEW.

## LANCASTER, J. & SON

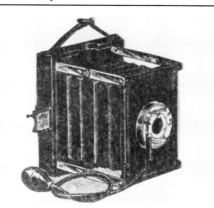

**(1824) NO. 1 CHAMPION FOLDING CAMERA.** C. 1905. SIZE 3¼ X 4¼ INCH EXPOSURES ON PLATES. INSTANTANEOUS LENS. INSTANT AND TIME PNEUMATIC SHUTTER. IRIS DIAPHRAGM.

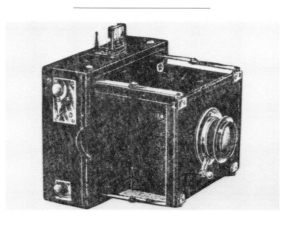

**(1825) NO. 2 CHAMPION FOLDING CAMERA.** C. 1905. SIZE 3¼ X 4¼ INCH EXPOSURES ON PLATES. RECTILINEAR LENS. FOCAL PLANE SHUTTER.

**(1826) BUTLER'S THREE-COLOR CAMERA.** C. 1905. SIZE 3½ X 4¾ INCH COLOR PLATES. 178 MM/F 6.3 TRINAR ANASTIGMAT LENS. COMPOUND SHUTTER; 1 TO ¹⁄₁₅₀ SEC. IRIS DIAPHRAGM. BELLOWS FOCUSING BY RACK & PINION. TWO SEMI-TRANSPARENT MIRRORS ARE USED TO EXPOSE THREE COLOR PLATES. (IH)

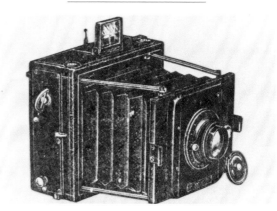

**(1827) NO. 3 CHAMPION FOLDING CAMERA.** C. 1905. SIZE 3¼ X 4¼ INCH EXPOSURES ON PLATES. RECTIGRAPH LENS. FOCAL PLANE SHUTTER WITH SPEEDS TO ¹⁄₁₀₀₀ SEC.

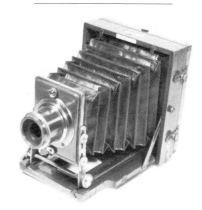

**(1828) FIELD CAMERA.** C. 1890. SIZE 5 X 7 INCH EXPOSURES ON PLATES. ROLLER-BLIND SHUTTER. (VC)

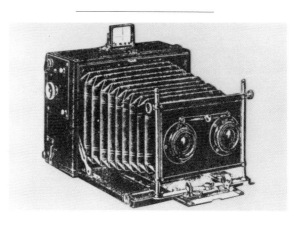

## LANCASTER, J. & SON (cont.)

(1829) **FOCAL PLANE STEREO CAMERA.** C. 1911. THREE SIZES OF THIS CAMERA FOR 3¼ X 4¼, 3½ X 5½, OR 4¼ X 6½ INCH EXPOSURES ON PLATES OR FILM PACKS WITH ADAPTER. F 7.3 RECTIPLAT, F 6 EUROSCOP RECTIGRAPH, ANASTIGMAT RECTIGRAPH, OR ALDIS ANASTIGMAT LENS. ALSO, F 5.3 ANASTIGMAT RECTIGRAPH LENS. FOCAL PLANE SHUTTER; ½ TO ¹/₁₃₀₀ SEC., T. RISING, FALLING, AND CROSSING LENS MOUNT. RACK & PINION FOCUSING. DOUBLE EXTENSION BELLOWS.

(1830) **GEM CAMERA.** C. 1880. TWELVE GEM EXPOSURES, 1-INCH SQUARE, ARE OBTAINED ON A 3¼ X 4¼ INCH PLATE BY USING THE CAMERA'S 12 LENSES. RACK & PINION FOCUSING. (BC)

(1831) **GEM CAMERA.** C. 1882. NINE GEM EXPOSURES, SIZE 1½ X 2 INCHES, ARE OBTAINED ON A SINGLE PLATE. SIMILAR TO THE GEM CAMERA OF 1880.

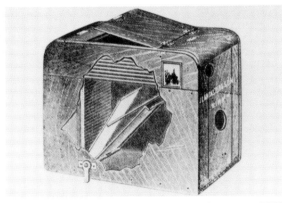

(1832) **HAND MAGAZINE CAMERA.** C. 1898. TWO SIZES OF THIS CAMERA FOR 3¼ X 4¼ OR 4¼ X 6½ INCH EXPOSURES ON PLATES OR SHEET FILM.

(1833) **KAMRET FOLDING PLATE CAMERA.** C. 1900. SIZE 3¼ X 4¼ INCH EXPOSURES ON PLATES.

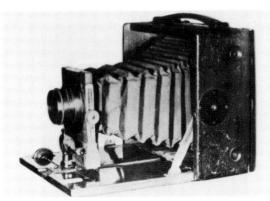

(1834) **KAMAREX HAND AND STAND CAMERA.** C. 1900.

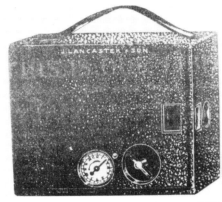

(1835) **KAPAWL HAND CAMERA.** C. 1898. TWO SIZES OF THIS CAMERA FOR 2⅛ X 3¼ OR 3¼ X 4¼ INCH PLATE EXPOSURES. EXTERNAL KNOB FOR FOCUSING.

(1836) **LADIES GEM CAMERA.** C. 1894. SIZE 3¼ X 4¼ INCH PLATE EXPOSURES. THE CAMERA HAS THE APPEARANCE OF A LADIES CROCODILE HANDBAG. THE FRONT COVER FOLDS DOWN TO FORM A BASEPLATE TO EXTEND THE BELLOWS. THE BACK COVER LIFTS UP ON A HINGE FOR VIEWING THE GROUNDGLASS FOR FOCUSING. THE CAMERA WAS MANUFACTURED BY CERTO CAMERA WERKE AND SOLD BY LANCASTER & SON. SEE PHOTO UNDER CERTO CAMERA WERKE LISTINGS. (BC)

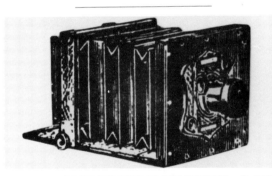

(1837) **"LADIES" FOLDING PLATE CAMERA.** C. 1890. THREE SIZES OF THIS CAMERA FOR 3½ X 4½, 4½ X 6½, OR 6½ X 8½ INCH EXPOSURES ON PLATES.

(1838) **"LADIES" FOLDING PLATE CAMERA.** C. 1897. SIZE 6½ X 8½ INCH EXPOSURES. ACHROMATIC LENS. SINGLE-SPEED PNEUMATIC SHUTTER. REVERSIBLE BACK. (MA)

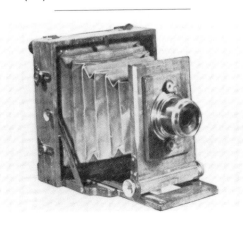

(1839) **LE MERITOIRE FOLDING PLATE CAMERA.** C. 1887. SIZE 4¼ X 6½ INCH EXPOSURES.

(1840) **LE MERITOIRE FOLDING PLATE CAMERA.** C. 1882. ORIGINAL MODEL.

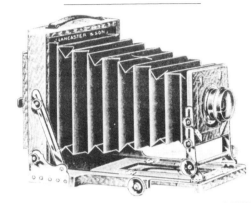

(1841) **LE MERITOIRE FOLDING PLATE CAMERA.** C. 1898. THREE SIZES OF THIS CAMERA FOR 3¼ X 4¼, 4¼ X 6½, OR 6½ X 8½ INCH PLATE EXPOSURES.

(1842) **LE MERVEILLEUX PLATE CAMERA.** C. 1882. ORIGINAL MODEL.

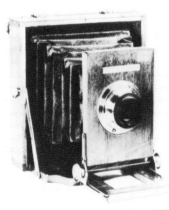

(1843) **LE MERVEILLEUX PLATE CAMERA.** C. 1890. THREE SIZES OF THIS CAMERA FOR 3¼ X 4¼, 4¼ X 6½, OR 6½ X 8½ INCH EXPOSURES ON PLATES.

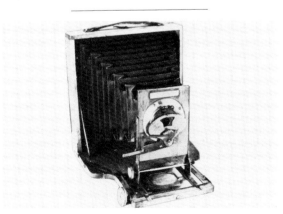

(1844) **LE MERVEILLEUX PLATE CAMERA.** C. 1896. THREE SIZES OF THIS CAMERA FOR 3¼ X 4¼, 4¼ X

## LANCASTER, J. & SON (*cont.*)

6½, OR 6½ X 8½ INCH EXPOSURES ON PLATES. SPECIAL PATENT SHUTTER. (HA)

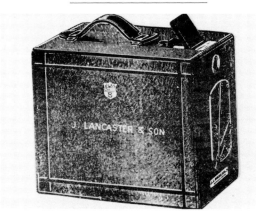

**(1845) OMNIGRAPH HAND CAMERA.** C. 1898. SIZE 3¼ X 4¼ INCH PLATE EXPOSURES.

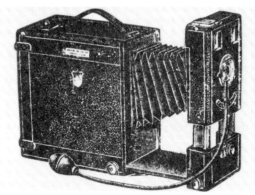

**(1846) PANOKAM HAND CAMERA.** C. 1902. FOUR EXPOSURE SIZES USING FOUR DIFFERENT LENSES. PNEUMATIC SHUTTER FOR INSTANT AND TIME EXPOSURES. RACK & PINION FOCUSING. RISING LENS MOUNT.

**(1847) PATENT POCKET CAMERA.** C. 1888. SIZE 1½ X 2 INCH PLATE EXPOSURES. THE CAMERA HAS A COLLAPSIBLE TUBULAR BODY MADE OF CONCENTRIC RINGS AND ENCLOSED IN A LEATHER COVERED BODY. RUBBER-BAND ROTARY SHUTTER. (BC)

**(1848) PATENT WATCH CAMERA.** C. 1886. SIZE 1½ X 2 INCH EXPOSURES ON PLATES. 60 MM/F 8 LENS. DROP SHUTTER. SIMILAR TO THE PATENT WATCH CAMERA OF 1887. (MA)

**(1849) PATENT WATCH CAMERA. IMPROVED MODEL.** C. 1891–96. TWO SIZES OF THIS CAMERA FOR 1 X 1½ OR 1½ X 2 INCH EXPOSURES ON PLATES. SIMILAR TO THE PATENT WATCH CAMERA (C. 1887) WITH THE SAME LENS BUT WITH A VERTICAL GUILLOTINE SHUTTER AND A NEWLY DESIGNED "WATCH" STEM.

**(1850) PATENT WATCH CAMERA.** C. 1887. TWO SIZES OF THIS CAMERA FOR 1 X 1½ OR 1½ X 2 INCH EXPOSURES ON PLATES. F 22 GRUBB-TYPE ACHROMAT LENS. MANUALLY ROTATED SHUTTER FOR VARIOUS SHUTTER SPEEDS. (GE)

**(1851) PERFECT OMNIGRAPH HAND CAMERA.** C. 1893–98. TWO SIZES OF THIS CAMERA FOR 3¼ X 4¼ OR 4¼ X 6½ INCH EXPOSURES ON PLATES. INSTANTANEOUS LENS. SEE-SAW TYPE SHUTTER. EXTERNAL FOCUSING KNOB.

**(1852) PLANO REFLEX CAMERA.** C. 1906. THREE SIZES OF THIS CAMERA FOR 3¼ X 4¼, 4 X 5, OR 4¼ X 6½ INCH EXPOSURES ON PLATES. ADAPTER FOR FILM PACKS OR ROLL FILM. F 6 EURYSCOPE, F 5.6 RECTIGRAPH ANASTIGMAT, OR RECTIGRAPH LENS. FOCAL-PLANE SHUTTER; ⅒ TO 1/1200 SEC., T. REVOLVING BACK.

**(1853) PLANO REFLEX CAMERA.** C. 1907. SIMILAR TO THE PLANO REFLEX CAMERA OF 1906 EXCEPT THE FRONT PANEL IS HINGED AND DROPS DOWN TO FORM A BASEBOARD. ALSO, THE FOLDING HOOD IS SUPPORTED BY LAZY-TONGS.

**(1854) POCKET GEM CAMERA.** C. 1906. TWO SIZES OF THIS CAMERA FOR 3¼ X 4¼ OR 4¼ X 6½ INCH EXPOSURES ON PLATES. LANCASTER ACHROMATIC OR RAPID RECTILINEAR LENS. LANCASTER SHUTTER; INSTANT AND TIME. BAUSCH & LOMB SHUTTER; ⅟₂₅ TO ⅟₁₀₀ SEC., T. RISING, CROSSING, AND SWING LENS MOUNT. IRIS DIAPHRAGM.

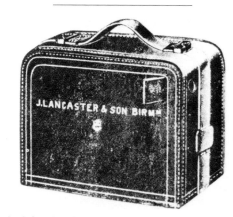

**(1855) ROVER DETECTIVE HAND CAMERA.** C. 1892. TWO SIZES OF THIS CAMERA FOR 3¼ X 3¼ OR 3¼ X 4¼ INCH EXPOSURES ON SHEET FILM. THE MAGAZINE HOLDS 12 PLATES. SEE-SAW TYPE SHUTTER.

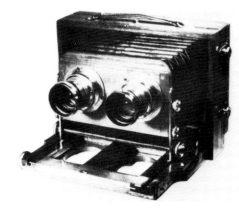

**(1856) STEREO CAMERA.** C. 1900. SIZE 3¼ X 6½ INCH

## LANCASTER, J. & SON (*cont.*)

STEREO EXPOSURES ON PLATES. LANCASTER RECTI-GRAPH LENSES. (HA)

---

**(1857) STEREO CAMERA.** C. 1910. SIZE 3¼ X 7 INCH STEREO PLATE EXPOSURES. 135 MM/F 6.8 LANCASTER RECTIGRAPH LENSES. ROLLER-BLIND SHUTTER; ¹⁄₁₅ TO ¹⁄₉₀ SEC. (MA)

---

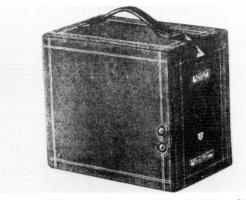

**(1858) "STOPIT" HAND CAMERA.** C. 1898. SIZE 3¼ X 4¼ INCH EXPOSURES ON PLATES. ACHROMATIC LENS. "IRIS" SHUTTER.

---

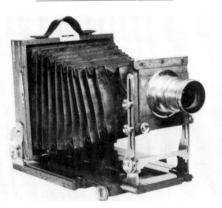

**(1859) "EXTRA SPECIAL" VIEW CAMERA.** C. 1891-98. THREE SIZES OF THIS CAMERA FOR 3¼ X 4¼, 4¼ X 6½, OR 6½ X 8½ INCH EXPOSURES ON PLATES. LANCASTER RECTIGRAPH LENS. (VC)

---

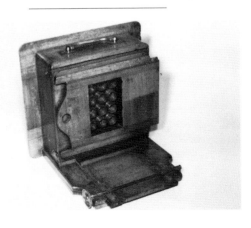

**(1860) GEM FERROTYPE VIEW CAMERA.** C. 1880-90. TWELVE SIMULTANEOUS EXPOSURES, SIZE ¹¹⁄₁₆ X ¹³⁄₁₆ INCH ON 3¼ X 4¼ INCH FERROTYPE PLATES. 2 INCH/ F 4.5 PETZVAL-TYPE LENSES. SLIDING-FRONT-PANEL TYPE SHUTTER. GROUND GLASS FOCUSING. RACK & PINION FOCUSING. (GE)

---

**(1861) INSTANTOGRAPH VIEW CAMERA.** C. 1882. ORIGINAL MODEL.

---

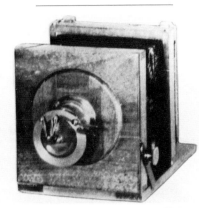

**(1862) INSTANTOGRAPH VIEW CAMERA.** C. 1885. SIZE 3¼ X 4¼ INCH EXPOSURES ON GLASS PLATES. ACHROMATIC MENISCUS LENS. LANCASTER RUBBER-BAND SHUTTER. (JW)

---

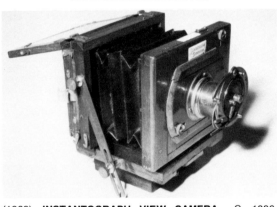

**(1863) INSTANTOGRAPH VIEW CAMERA.** C. 1886. SIZE 3¼ X 4¼ INCH EXPOSURES ON DRY PLATES. 5-INCH/F 11 AHCROMATIC MENISCUS LENS. ROTARY SHUTTER MOUNTED IN FRONT OF THE LENS WITH VARI-ABLE SPEEDS (BY VARYING THE SPRING TENSION) AND TIME EXPOSURES. GROUND GLASS FOCUS. (GE)

---

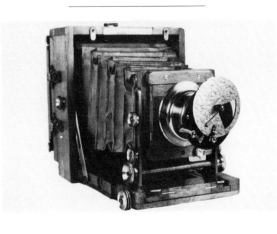

**(1864) INSTANTOGRAPH VIEW CAMERA.** C. 1891. SIZE 3¼ X 4¼ INCH EXPOSURES ON PLATES. LANCAS-TER ROTARY SHUTTER. (VC)

---

**(1865) INSTANTOGRAPH VIEW CAMERA.** C. 1889. THREE SIZES OF THIS CAMERA FOR 4 X 5, 5 X 7½, OR 12 X 15 INCH EXPOSURES ON DRY PLATES.

---

**(1866) INSTANTOGRAPH VIEW CAMERA.** C. 1888-91. TWO SIZES OF THIS CAMERA FOR 6½ X 8½ OR 10 X 12 INCH EXPOSURES ON DRY PLATES.

---

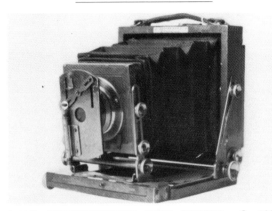

**(1867) INSTANTOGRAPH VIEW CAMERA.** C. 1891. SIZE 3¼ X 4¼ INCH EXPOSURES ON PLATES. LANCAS-TER LENS. SEE-SAW TYPE SHUTTER. (VC)

---

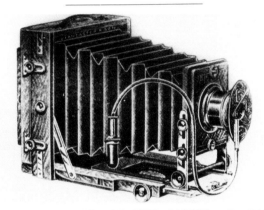

**(1868) INSTANTOGRAPH VIEW CAMERA.** C. 1898. THREE SIZES OF THIS CAMERA FOR 3¼ X 4¼, 4¼ X 6½, OR 6½ X 8½ INCH EXPOSURES ON PLATES.

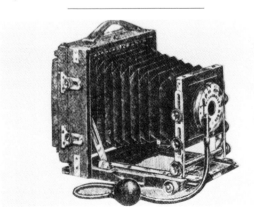

## LANCASTER, J. & SON (*cont.*)

(1869) **INSTANTOGRAPH VIEW CAMERA.** C. 1905. THREE SIZES OF THIS CAMERA FOR 3¼ X 4¼, 4¼ X 6½, OR 6½ X 8½ INCH EXPOSURES ON PLATES. PNEUMATIC SHUTTER.

(1870) **INSTANTOGRAPH VIEW CAMERA.** C. 1894. SIZE 4¼ X 6½ INCH EXPOSURES ON PLATES. LANCASTER & SON LENS. PICKARD LENS-CAP SHUTTER.

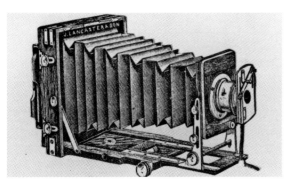

(1871) **INSTANTOGRAPH (ALUMINUM MOUNTED) VIEW CAMERA.** C. 1893. THREE SIZES OF THIS CAMERA FOR 3¼ X 4¼, 4¼ X 6½, OR 6½ X 8½ INCH EXPOSURES ON PLATES. SEE-SAW OR RUBBER-BAND SHUTTER. RISING FRONT. DOUBLE SWING BACK. REVERSING BACK.

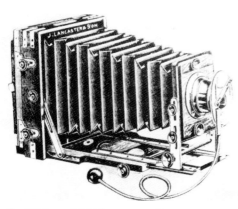

(1872) **INSTANTOGRAPH (ALUMINUM MOUNTED) VIEW CAMERA.** C. 1898. THREE SIZES OF THIS CAMERA FOR 3¼ X 4¼, 4¼ X 6½, OR 6½ X 8½ INCH EXPOSURES ON PLATES. SEE-SAW SHUTTER. RISING FRONT. DOUBLE SWING BACK. REVERSING BACK. RACK & PINION FOCUS.

(1873) **EURYSCOPE INSTANTOGRAPH VIEW CAMERA.** C. 1905. THREE SIZES OF THIS CAMERA FOR 3¼ X 4¼, 4¼ X 6½, OR 6½ X 8½ INCH EXPOSURES ON PLATES. F 6 RECTIGRAPH LENS. PNEUMATIC SHUTTER.

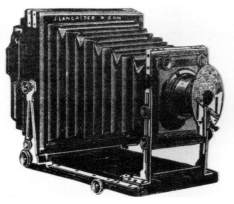

(1874) **BRASS-BOUND SPECIAL INSTANTOGRAPH VIEW CAMERA.** C. 1898. THREE SIZES OF THIS CAMERA FOR 3¼ X 4¼, 4¼ X 6½, OR 6½ X 8½ INCH PLATE EXPOSURES.

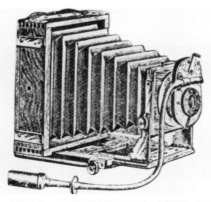

(1875) **CYCLO INSTANTOGRAPH VIEW CAMERA.** C. 1898. SIZE 3¼ X 4¼ INCH EXPOSURES ON PLATES. INSTANTANEOUS OR RECTIGRAPH LENS. THE CAMERA BACK, BELLOWS, LENS, AND SHUTTER REVOLVE TO TAKE EITHER HORIZONTAL OR VERTICAL EXPOSURES WITHOUT MOVING THE CAMERA BASE.

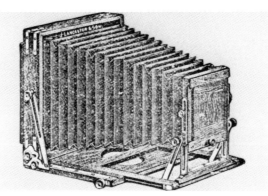

(1876) **IMPERIAL INSTANTOGRAPH VIEW CAMERA.** C. 1899. SIX SIZES OF THIS CAMERA FOR 3¼ X 4¼, 4¼ X 6½, OR 6½ X 8½ INCH OR 8 X 10, 10 X 12, OR 12 X 15 CM EXPOSURES ON PLATES. DOUBLE SWING BACK. RISING AND CROSSING LENS MOUNT.

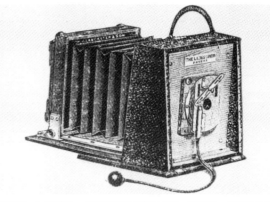

(1877) **LADIES INSTANTOGRAPH VIEW CAMERA.** C. 1893.

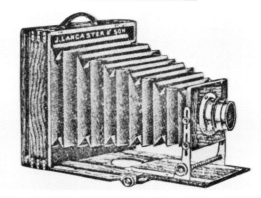

(1878) **POCKET INSTANTOGRAPH VIEW CAMERA.** C. 1893. THREE SIZES OF THIS CAMERA FOR 3¼ X 4¼, 4¼ X 6½, OR 6½ X 8½ INCH EXPOSURES ON PLATES.

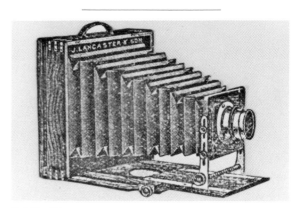

(1879) **POCKET INSTANTOGRAPH VIEW CAMERA.** C. 1898. THREE SIZES OF THIS CAMERA FOR 3¼ X 4¼, 4¼ X 6½, OR 6½ X 8½ INCH EXPOSURES ON PLATES.

## LANCASTER, J. & SON (*cont.*)

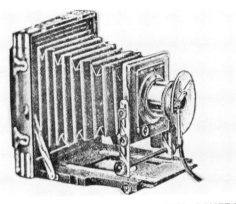

**(1880) POCKET INSTANTOGRAPH VIEW CAMERA.** C. 1904. THREE SIZES OF THIS CAMERA FOR 3¼ X 4¼, 4¼ X 6½, OR 6½ X 8½ INCH EXPOSURES ON PLATES. RECTIGRAPH LENS. RACK & PINION FOCUS. RISING FRONT. DOUBLE SWING BACK. REVOLVING BACK, BELLOWS, LENS, AND SHUTTER FOR VERTICAL OR HORIZONTAL EXPOSURES.

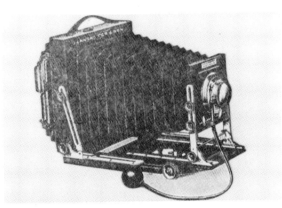

**(1881) ROYAL INSTANTOGRAPH VIEW CAMERA.** C. 1905. THREE SIZES OF THIS CAMERA FOR 3¼ X 4¼, 4¼ X 6½, OR 6½ X 8½ INCH EXPOSURES ON PLATES. PNEUMATIC SHUTTER.

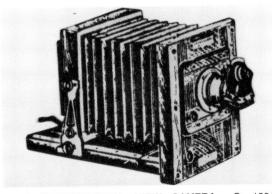

**(1882) INTERNATIONAL VIEW CAMERA.** C. 1891. THREE SIZES OF THIS CAMERA FOR 3¼ X 4¼, 4¼ X 6½, OR 6½ X 8½ INCH EXPOSURES ON PLATES.

**(1883) ZOEGRAPH HAND CAMERA.** C. 1898. TWO SIZES OF THIS CAMERA FOR 3¼ X 4¼ OR 4¼ X 6½ INCH PLATE EXPOSURES.

## LEVI

**(1884) SURPRISE AUTOMATIC HAND CAMERA.** C. 1892. SIZE 3¼ X 4¼ INCH EXPOSURES ON PLATES. THE CAMERA HOLDS SIX PLATES. ACHROMATIC LENS.

## LEVI, JONES & COMPANY

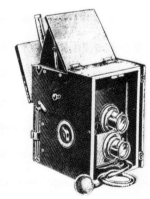

**(1885) RR RECORD TWIN-LENS REFLEX CAMERA.** C. 1895.

## LIZARS, J.

**(1886) CHALLENGE FOCUSING MAGAZINE CAMERA.** C. 1905. SIZE 3¼ X 4¼ INCH EXPOSURES ON PLATES. THE MAGAZINE HOLDS 12 PLATES. BECK SYMMETRI-CAL LENS. UNICUM SHUTTER.

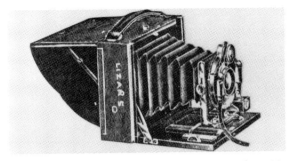

**(1887) CHALLENGE CAMERA. MODEL C.** C. 1898. THREE SIZES OF THIS CAMERA FOR 3¼ X 4¼, 4 X 5, OR 4¼ X 6½ INCH EXPOSURES ON PLATES. CHAL-LENGE OR TAYLOR & HOBSON RAPID RECTILINEAR LENS. BAUSCH & LOMB SHUTTER FOR INSTANT AND TIME EXPOSURES. RISING AND CROSSING LENS MOUNT. RACK & PINION FOCUS. SWING BACK.

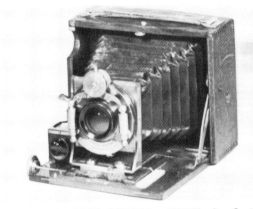

**(1888) CHALLENGE CAMERA. MODEL C.** C. 1900. THREE SIZES OF THIS CAMERA FOR 3¼ X 4¼, 4 X 5, OR 4¼ X 6½ INCH EXPOSURES ON PLATES. BAUSCH & LOMB RAPID RECTILINEAR OR BECK RAPID RECTI-LINEAR LENS. BAUSCH & LOMB SHUTTER OR UNICUM SHUTTER. (MR)

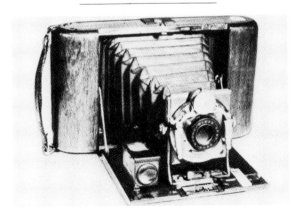

**(1889) CHALLENGE TROPICAL DAYSPOOL CAMERA.** C. 1905. FOUR SIZES OF THIS CAMERA FOR 3¼ X 4¼, 4 X 5, 3½ X 5½, OR 5 X 7 INCH EXPOSURES ON PLATES, SHEET FILM, OR ROLL FILM. F 8 BECK SYMMETRICAL OR F 6.8 ROSS GOERZ LENS. BAUSCH & LOMB UNICUM DOUBLE PNEUMATIC SHUTTER; ½ TO ¹⁄₁₀₀ SEC., B., T. RISING AND CROSSING LENS MOUNT. TEAKWOOD BODY. (HA)

**LIZARS, J. (*cont.*)**

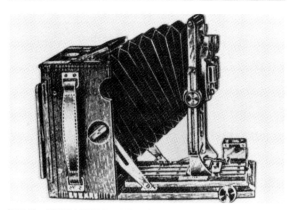

**(1890) CHALLENGE DELUXE CAMERA.** C. 1905. THREE SIZES OF THIS CAMERA FOR 3¼ X 4¼, 4 X 5, OR 4¼ X 6½ INCH EXPOSURES ON PLATES. F 8 LIZARS KRAM CONVERTIBLE LENS. DOUBLE PNEUMATIC SHUTTER; 1 TO ¹⁄₁₀₀ SEC., B., T. RISING AND CROSSING LENS MOUNT.

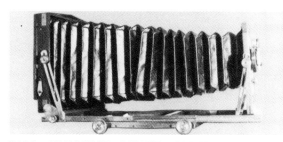

**(1891) CHALLENGE DELUXE CAMERA.** C. 1906. SIZE 4¼ X 6½ INCH EXPOSURES ON PLATES. F 8 LIZARS KRAM CONVERTIBLE LENS. LIZARS DOUBLE PNEUMATIC SHUTTER; 1 TO ¹⁄₁₀₀ SEC., B., T. TRIPLE EXTENSION BELLOWS. (EL)

**(1892) CHALLENGE PLATE CAMERA.** C. 1895. SIZE 2¼ X 3¼ INCH EXPOSURES. BAUSCH & LOMB RAPID RECTILINEAR LENS.

**(1893) CHALLENGE ROLL FILM CAMERA.** C. 1899. ONE OF THE FIRST ROLL FILM CAMERAS MANUFACTURED IN BRITAIN.

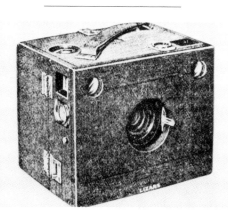

**(1894) CHALLENGE SIMPLEX ROLL FILM HAND CAMERA.** C. 1914. SIZE 3¼ X 4¼ INCH EXPOSURES. F 6.5 COOKE PRIMOPLANE ANASTIGMAT LENS. IBSO SHUTTER. FIXED FOCUS.

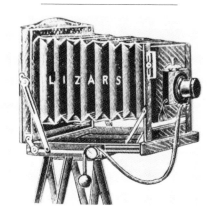

**(1895) CHALLENGE STAND CAMERA.** C. 1898. THREE SIZES OF THIS CAMERA FOR 3¼ X 4¼, 4¼ X 6½, OR 6½ X 8½ INCH EXPOSURES ON PLATES. RAPID RECTILINEAR LENS. THORNTON-PICKARD SHUTTER. IRIS DIAPHRAGM.

**(1896) CHALLENGE STEREOSCOPIC CAMERA. MODEL B.** C. 1895. TWO SIZES OF THIS CAMERA FOR 3¼ X 6¾ (PLATES) OR 4¼ X 6½ (PLATES OR FILMS) INCH EXPOSURES. RAPID RECTILINEAR LENSES. BAUSCH & LOMB AUTOMATIC SHUTTER.

**(1897) CHALLENGE STEREOSCOPIC CAMERA. MODEL 1B.** C. 1905. SIZE 4¼ X 6½ INCH STEREO EXPOSURES ON PLATES. BECK LENSES. GOERZ-ANSCHUTZ FOCAL PLANE SHUTTER.

**(1898) CHALLENGE STEREOSCOPIC OR MONOSCOPIC CAMERA.** C. 1905. TWO SIZES OF THIS CAMERA FOR 3¼ X 6¾ OR 4¼ X 6½ INCH STEREO OR MONO EXPOSURES ON PLATES. CHALLENGE RAPID RECTILINEAR LENSES. THORNTON-PICKARD SHUTTER.

**(1899) CHALLENGE DELUXE STEREO REFLEX CAMERA.** C. 1912. SIZE 3¼ X 6¾ INCH EXPOSURES ON PLATES. F 8 BECK SYMMETRICAL LENSES. FOCAL PLANE SHUTTER. THE CAMERA CAN BE USED FOR TAKING MONOSCOPIC EXPOSURES BY REMOVING THE STEREO SEPTUM AND USING ONLY ONE LENS.

**(1900) CHALLENGE TROPICAL CAMERA.** C. 1895. SIZE 3¼ X 4¼ INCH EXPOSURES ON PLATES OR ROLL FILM. 120 MM GOERZ DOUBLE ANASTIGMAT LENS. BAUSCH & LOMB SHUTTER.

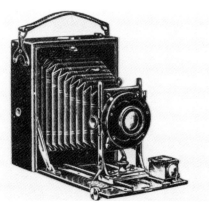

**(1901) CHALLENGE TROPICAL "CELTIC" CAMERA.** C. 1912. SIZE 3¼ X 4¼ INCH EXPOSURES ON PLATES OR FILM PACKS. BECK SYMMETRICAL LENS. BAUSCH & LOMB SHUTTER. RACK & PINION FOCUSING. RISING LENS MOUNT. TEAK WOOD BODY.

## LIZARS, J. (*cont.*)

(1902) **FIELD PLATE CAMERA.** C. 1900. SIZE 4¼ X 6½ INCH EXPOSURES ON PLATES. TRIPLE EXTENSION BELLOWS.

(1903) **FOLDING PLATE CAMERA.** C. 1898. SIZE 3¼ X 4¼ INCH EXPOSURES. 150 MM/F 9 LENS. THORNTON-PICKARD SHUTTER. (MA)

## LONDON STEREOSCOPIC COMPANY

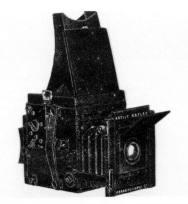

(1904) **ARTIST REFLEX CAMERA. IMPROVED MODEL.** C. 1912. SIZE 3¼ X 4¼ INCH EXPOSURES ON PLATES. F 4.5 VOIGTLANDER HELIAR LENS. FOCAL PLANE SHUTTER. RISING AND FALLING LENS MOUNT. REVOLVING BACK.

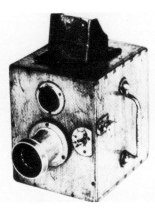

(1905) **ARTIST TWIN LENS REFLEX CAMERA.** C. 1890. THREE SIZES OF THIS CAMERA FOR 3¼ X 4¼, 4 X 5, OR 4¼ X 6½ INCH EXPOSURES ON PLATES. APLANAT LENS. SECTOR SHUTTER. (HA)

(1906) **ARTIST TWIN LENS REFLEX CAMERA.** C. 1892. SIZE 3¼ X 4¼ INCH EXPOSURES ON PLATES. F 6 EURYSCOPE LENSES.

(1907) **BINOCULAR CAMERA.** C. 1896. TWO SIZES OF THIS CAMERA FOR 1¾ X 2⁵⁄₁₆ OR 2½ X 3½ INCH EXPOSURES ON PLATES OR SHEET FILM. MODEL 1 HOLDS 12 PLATES OR 30 FILMS. MODEL 2 HOLDS 18 PLATES. SHUTTER FOR INSTANT, B., T. EXPOSURES.

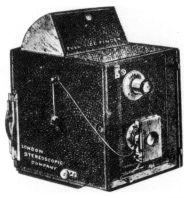

(1908) **ARTIST IMPROVED TWIN LENS REFLEX CAMERA.** C. 1897. THREE SIZES OF THIS CAMERA FOR 3¼ X 4¼, 4 X 5, OR 4¾ X 6½ INCH EXPOSURES ON PLATES OR SHEET FILM. F 5.6 "BLACK BAND" RAPID EURYSCOPE LENSES. THORNTON-PICKARD SHUTTER. GROUND GLASS FOCUSING.

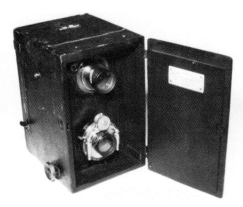

(1909) **ARTIST TWIN LENS REFLEX CAMERA.** C. 1899. THREE SIZES OF THIS CAMERA FOR 3¼ X 4¼, 4 X 5, OR 4¾ X 6½ INCH EXPOSURES ON PLATES OR SHEET FILM. THE MAGAZINE HOLDS 12 PLATES OR 24 FILM SHEETS. F 6 "BLACK BAND" RAPID RECTILINEAR LENSES. BAUSCH & LOMB UNICUM SHUTTER; 1 TO ¹⁄₁₀₀ SEC., B., T. IRIS DIAPHRAGM. RACK & PINION FOCUS. (GE)

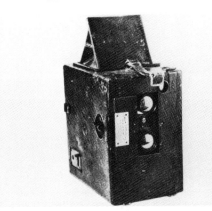

(1910) **CARLTON TWIN LENS REFLEX CAMERA.** C. 1894. SIZE 3¾ X 4¼ INCH EXPOSURES ON PLATES. THE CAMERA HOLDS 12 PLATES. (HA)

(1911) **CARLTON TWIN LENS REFLEX CAMERA.** C. 1895. SIZE 4 X 5 INCH PLATE EXPOSURES. 6-INCH/ F 7.7 ROSS-GOERZ LENS. GUILLOTINE SHUTTER; 1 TO ¹⁄₈₀ SEC. (MA)

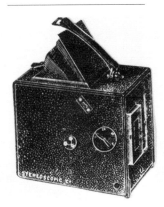

(1912) **CARLTON IMPROVED TWIN LENS REFLEX CAMERA.** C. 1897. THREE SIZES OF THIS CAMERA FOR 3¾ X 4¼, 4 X 5, OR 4¾ X 6½ INCH EXPOSURES ON PLATES. F 5.6 LENS. PNEUMATIC SHUTTER FOR INSTANT AND TIME EXPOSURES. IRIS DIAPHRAGM. THE CAMERA HOLDS 12 PLATES.

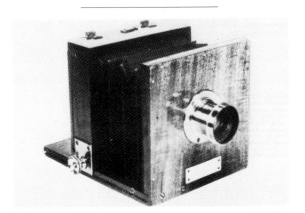

(1913) **FIELD CAMERA.** C. 1900. SIZE 3 X 4 INCH EXPOSURES ON PLATES. RAPID RECTILINEAR LENS. (HA)

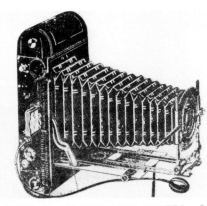

(1914) **FOCAL PLANE STANDARD CAMERA.** C. 1905. EXPOSURES ON PLATES OR ROLL FILM. FOCAL PLANE SHUTTER SPEEDS TO ¹⁄₁₀₀₀ SEC. DOUBLE EXTENSION BELLOWS. RISING AND CROSSING LENS MOUNT.

## LONDON STEREOSCOPIC COMPANY (*cont.*)

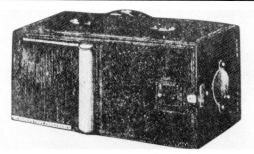

(1915)   **GRAPHIC MAGAZINE HAND CAMERA.** C. 1892. FOUR SIZES OF THIS CAMERA FOR 3¼ X 4¼, 4 X 5, 4¼ X 6½, OR 6½ X 8½ INCH EXPOSURES ON PLATES. THE MAGAZINE HOLDS 12 PLATES. RAPID RECTILINEAR LENS. VARIABLE-SPEED AND TIME SHUTTER. REVOLVING APERTURE STOPS.

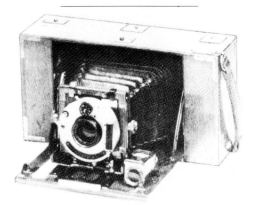

(1916)   **"KING'S OWN" TROPICAL CAMERA.** C. 1912. THE CAMERA USES ROLL FILM OR PLATES. TEAKWOOD AND BRASS TRIM BODY.

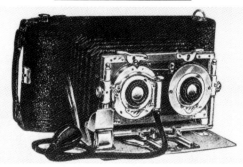

(1917)   **POSTCARD STEREOSCOPIC CAMERA.** C. 1904. SIZE 3½ X 5½ INCH STEREO EXPOSURES ON ROLL FILM OR PLATES. THE CAMERA IS CONVERTIBLE FOR USE AS A PANORAMIC CAMERA.

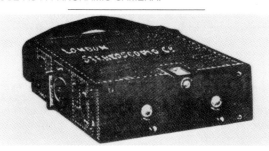

(1918)   **ROYAL STEREOSCOPIC HAND CAMERA.** C. 1900. SIZE 2⅜ X 4¼ INCH STEREO EXPOSURES ON PLATES OR SHEET FILM. THE MAGAZINE HOLDS 12 PLATES. INSTANT AND TIME SHUTTER. EXPOSURE COUNTER.

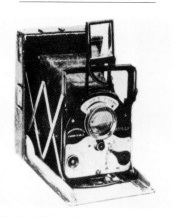

(1919)   **ROYLEX FOLDING PLATE CAMERA.** C. 1915. SIZE 2¼ X 3¼ INCH PLATE EXPOSURES.

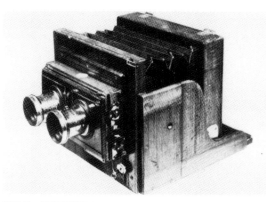

(1920)   **TOURIST STEREO CAMERA.** C. 1899. SIZE 4¼ X 6½ INCH STERO EXPOSURES ON PLATES. THORNTON-PICKARD SHUTTER. (HA)

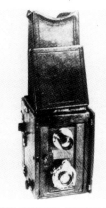

(1921)   **TWIN LENS REFLEX CAMERA.** C. 1889. SIZE 3 X 4 INCH EXPOSURES ON PLATES. THE CAMERA HOLDS 12 PLATES. BAUSCH & LOMB SHUTTER WITH SPEEDS TO ¹⁄₁₀₀ SEC. (HA)

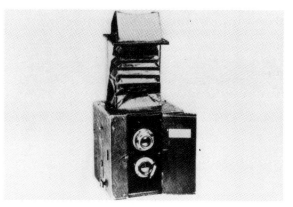

(1922)   **TWIN LENS REFLEX CAMERA.** C. 1910. SIZE 3¼ X 4¼ INCH EXPOSURES ON ROLL FILM. INSTANT, TIME, AND BULB SHUTTER BY EASTMAN KODAK.

## MARION & COMPANY

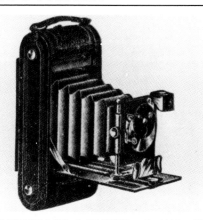

(1923)   **CAMRANA NO. 2 CAMERA.** C. 1898. SIZE 3¼ X 4¼ INCH EXPOSURES ON PLATES.

(1924)   **RADIAL PLATE CAMERA.** C. 1893. SIZE 4¼ X 6½ INCH EXPOSURES. THE MAGAZINE HOLDS 12 PLATES IN RADIAL GROOVES IN THE BACK OF THE CAMERA. WHEN THE CAMERA IS UP-ENDED, A PLATE SLIDES IN A GROOVE INTO A TURN-TABLE WHERE IT IS ROTATED INTO THE FOCAL PLANE. (BC)

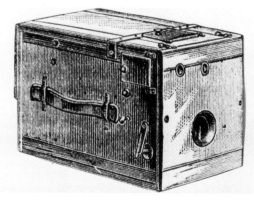

(1925)   **SIMPLEX FILM CAMERA.** C. 1893. THE MAGAZINE HOLDS FIFTY SHEET FILMS. SINGLE SPEED AND TIME SHUTTER. EXTERNAL KNOB FOR FOCUSING. THE 50 FILMS ARE LOADED INTO THE BACK OF THE

## MARION & COMPANY (cont.)

CAMERA WITH A CONTINOUS STRIP OF OPAQUE PAPER RUNNING ZIG-ZAG BETWEEN THE FILMS. NARROW BANDS OF PAPER THAT HAVE BEEN PASTED ON THE OPAQUE PAPER AT SPECIFIC INTERVALS SERVE AS "POCKETS" FOR HOLDING EACH FILM IN POSITION. AFTER EXPOSURE OF A FILM, THE LEADING END OF THE OPAQUE PAPER IS PULLED UP AND BACK THROUGH A REAR SLOT WHICH LIFTS THE EXPOSED FILM UP AND FORWARD INTO A HOLDING TRAY.

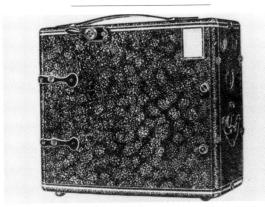

(1926) **SWALLOW CAMERA.** C. 1898. TWO SIZES OF THIS CAMERA FOR 2½ X 3½ OR 3¼ X 4¼ INCH EXPOSURES ON PLATES. MAGAZINES FOR THE CAMERA HOLD EITHER 6 OR 12 PLATES.

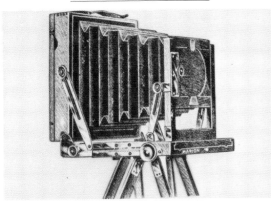

(1927) **PERFECTION VIEW CAMERA.** C. 1898. THREE SIZES OF THIS CAMERA FOR 4¾ X 6½, 6½ X 8½, OR 10 X 12 INCH EXPOSURES ON PLATES.

## MARION & COMPANY, LIMITED

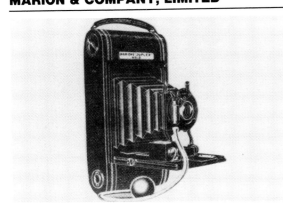

(1928) **DUPLEX HAND CAMERA.** C. 1904. TWO SIZES OF THIS CAMERA FOR 3¼ X 4¼ OR 4 X 5 INCH EXPOSURES ON PLATES OR ROLL FILM. RAPID RECTILINEAR LENS. INSTANT AND TIME PNEUMATIC SHUTTER. THE ROLL FILM AND HOLDER CAN BE REMOVED FROM THE FOCAL PLANE AND REPLACED WITH A FOCUSING SCREEN OR A PLATE WITHOUT REWINDING THE ROLL FILM.

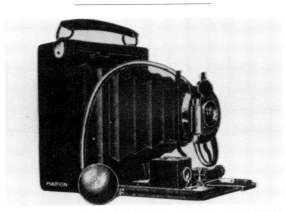

(1929) **DUPLEX HAND CAMERA.** C. 1904. TWO SIZES OF THIS CAMERA FOR 3¼ X 4¼ OR 4 X 5 INCH EXPOSURES ON PLATES OR ROLL FILM. GROUND GLASS FOCUSING.

(1930) **SINNOX CAMERA.** C. 1905. MODELS 1 AND 2 FOR SIZE 2½ X 3½ INCH EXPOSURES AND MODELS 3 AND 4 FOR SIZE 3½ X 4¼ INCH EXPOSURES. SINGLE ACHROMATIC OR F 8 RAPID RECTILINEAR LENS. INSTANT AND TIME PNEUMATIC SHUTTER. IRIS DIAPHRAGM.

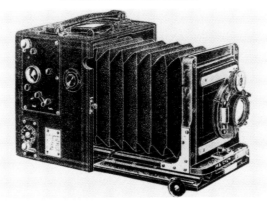

(1931) **SOHO FOCAL PLANE HAND CAMERA.** C. 1904. THREE SIZES OF THIS CAMERA FOR 3¼ X 4¼, 4 X 5, OR 4¼ X 6½ INCH EXPOSURES ON PLATES. FOCAL PLANE SHUTTER SPEEDS TO $\frac{1}{1000}$ SEC., T.

(1932) **SOHO REPEATING BACK CAMERA.** C. 1906. SIX EXPOSURES CAN BE MADE ON A SINGLE 3¼ X 4¼ INCH PLATE. THE PLATE HOLDER CAN BE MOVED HORIZONTALLY OR VERTICALLY BY OPERATING A CABLE RELEASE. (BC)

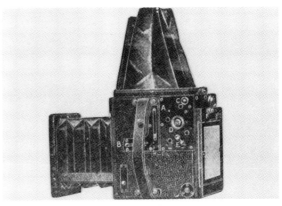

(1933) **SOHO SINGLE LENS REFLEX CAMERA.** C. 1906. FOUR SIZES OF THIS CAMERA FOR 3¼ X 4¼, 3½ X 5½, 4 X 5, OR 4¼ X 6½ INCH EXPOSURES ON PLATES. FOCAL PLANE SHUTTER. REVERSING BACK.

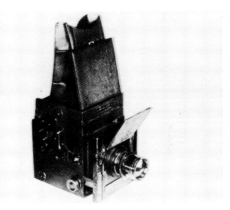

(1934) **SOHO SINGLE LENS REFLEX CAMERA.** C. 1910. SIZE 2¼ X 3¼ INCH EXPOSURES ON PLATES. REVOLVING BACK.

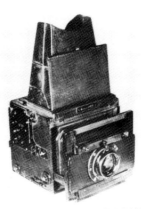

(1935) **SOHO SINGLE LENS REFLEX CAMERA.** C. 1911. SIZE 3½ X 5½ INCH EXPOSURES ON PLATES. CARL ZEISS LENS.

## MARION & COMPANY, LIMITED (*cont.*)

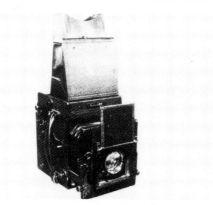

(1936)  **SOHO SINGLE LENS REFLEX CAMERA.** C. 1915. SIZE 3¼ X 4¼ INCH EXPOSURES ON PLATES. 105 MM/F 4.5 ROSS LENS. FOCAL PLANE SHUTTER WITH SPEEDS TO ⅟₁₀₀₀ SEC. (HA)

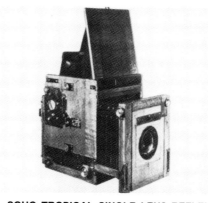

(1939)  **SOHO TROPICAL SINGLE LENS REFLEX CAMERA.** C. 1911. SIZE 4 X 5 INCH EXPOSURES ON PLATES.

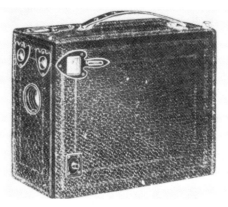

(1942)  **STAR MAGAZINE HAND CAMERA.** C. 1904. SIZE 3¼ X 4¼ INCH EXPOSURES ON PLATES. MODEL 1: BECK SINGLE ACHROMATIC LENS. FOUR-SPEED SHUTTER PLUS TIME EXPOSURES. MODEL 2: BECK SYMMETRIC RAPID RECTILINEAR LENS. BAUSCH & LOMB JUNIOR SHUTTER. THREE MAGNIFIERS FOR THREE OBJECT DISTANCES.

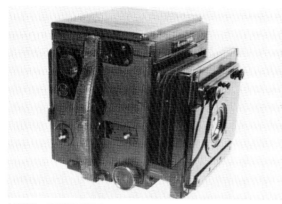

(1937)  **SOHO SINGLE LENS REFLEX CAMERA.** C. 1923. SIZE 3¼ X 4¼ INCH PLATE EXPOSURES. ALSO, FILM PACK ADAPTER. 140 MM/F 4.5 ROSS LENS. CLOTH FOCAL PLANE SHUTTER. (VC)

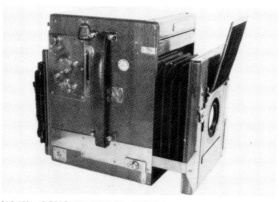

(1940)  **SOHO TROPICAL SINGLE LENS REFLEX CAMERA.** C. 1920. SIZE 4 X 5 INCH EXPOSURES ON PLATES. F 4.5 COOKE ANASTIGMAT LENS. CLOTH FOCAL PLANE SHUTTER; ⅟₁₆ TO ⅟₈₀₀ SEC., T. (VC)

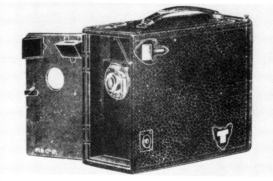

(1943)  **STAR MAGAZINE HAND CAMERA.** C. 1904. SIZE 3¼ X 4¼ INCH EXPOSURES ON PLATES. MODEL 3: BECK SYMMETRIC RAPID RECTILINEAR LENS. BAUSCH & LOMB VARIABLE-SPEED SHUTTER. SCALE FOR FOCUSING. MODEL 4: BECK DOUBLE APLANAT LENS. BAUSCH & LOMB UNICUM SHUTTER. FOCUSING SCALE.

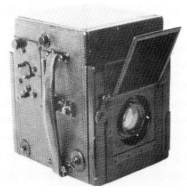

(1938)  **SOHO SINGLE LENS REFLEX CAMERA.** C. 1932. SIZE 3¼ X 4¼ INCH EXPOSURES ON PLATES OR FILM PACKS. 5½ INCH ROSS LENS. CLOTH FOCAL PLANE SHUTTER. (VC)

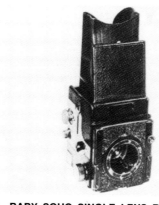

(1941)  **BABY SOHO SINGLE LENS REFLEX CAMERA.** C. 1926. VEST POCKET SIZE EXPOSURES ON PLATES. F 2.9 DALLMEYER PENTAC OR F 2 COOKE LENS.

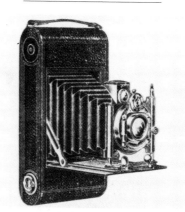

(1944)  **STAR ROLL FILM CAMERA.** C. 1904. SIZE 3¼ X 4¼ INCH EXPOSURES ON ROLL FILM OR PLATES WITH ADAPTER. RAPID RECTILINEAR LENS. BAUSCH & LOMB UNICUM SHUTTER. RISING AND CROSSING LENS MOUNT.

## MARION & COMPANY, LIMITED (*cont.*)

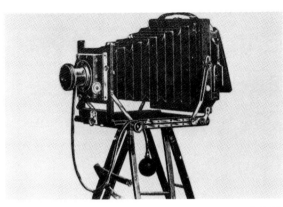

**(1945) CAMBRIDGE VIEW CAMERA.** C. 1904. THREE SIZES OF THIS CAMERA FOR 3¼ X 4¼, 4¼ X 6½, OR 6½ X 8½ INCH EXPOSURES ON PLATES. RAPID RECTILINEAR LENS. INSTANT AND TIME SHUTTER. SWING BACK. RISING AND FALLING LENS MOUNT. REVERSING BACK.

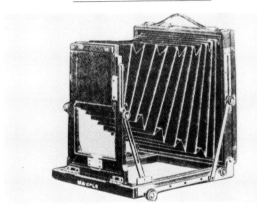

**(1946) DURHAM VIEW CAMERA.** C. 1904. TWO SIZES OF THIS CAMERA FOR 4¼ X 6½ OR 6½ X 8½ INCH EXPOSURES ON PLATES. SWING BACK. SWING FRONT. RISING LENS MOUNT. REVERSING FRAME.

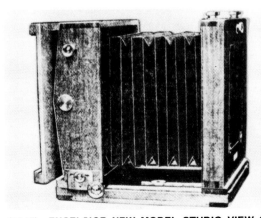

**(1947) EXCELSIOR NEW MODEL STUDIO VIEW CAMERA.** C. 1912. FIVE SIZES OF THIS CAMERA FOR EXPOSURES 12 X 15 INCHES AND LARGER. MAHOGANY BODY.

## MARION & SON

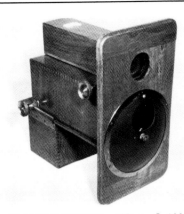

**(1948) ACADEMY CAMERA. NO. 1.** C. 1881. SIZE 1½ X 1½ INCH EXPOSURES ON DRY PLATES. F 5 PETZVAL TYPE LENS. ROTARY SHUTTER FOR THREE SPEEDS AND TIME EXPOSURES. THE UPPER LENS IS FOR VIEWING ON A SCREEN AND THE LOWER LENS IS FOR EXPOSING THE PLATE. THE MAGAZINE WITH A SLIDE REGISTER HOLDS 12 PLATES WHICH ARE RAISED TO THE EXPOSURE POSITION BY A RACK & PINION DEVICE. RACK & PINION FOCUSING. (GE)

**(1949) ACADEMY CAMERA. NOS. 2, 3, AND 4.** C. 1882–86. SIZE 2 X 2, 3¼ X 3¼, AND 3¼ X 4¼ INCH EXPOSURES ON DRY PLATES, RESPECTIVELY. SIMILAR TO THE NO. 1 ACADEMY CAMERA.

**(1950) ACADEMY CAMERA. IMPROVED MODEL. NOS. 1, 2, 3, AND 4.** C. 1887. SIZE 1¼ X 1¼, 2 X 2, 3¼ X 3¼, AND 3¼ X 4¼ INCH EXPOSURES ON DRY PLATES, RESPECTIVELY. SIMILAR TO THE NO. 1 ACADEMY CAMERA EXCEPT THE REAR FOCUSING SCREEN IS REPLACED BY A REFLEX MIRROR FOR VIEWING THE IMAGE FROM A HOLE IN THE TOP OF THE CAMERA. (IH)

**(1951) BROOK'S BOX-FORM LANTERN CAMERA.** C. 1886. SIZE 3¼ X 3¼ INCH EXPOSURES ON PLATES. ROTARY SHUTTER. LARGE-FRAME VIEWFINDER. PIVOTED FOCUSING SCREEN AND HOOD.

**(1952) METAL MINIATURE CAMERA.** C. 1884. SIZE 1¼ X 1¼ INCH EXPOSURES ON DRY PLATES. 50 MM/F 5.6 PETZVAL-TYPE LENS. RACK & PINION FOCUSING. THE CAMERA HAS A BOX FORM WITH A LONG VERTICAL METAL PLATE AS A DROP SHUTTER. RACK & PINION FOCUSING WITH A TUBULAR VIEW FINDER. (IH)

**(1953) METAL MINIATURE CAMERA.** C. 1889. SIZE 4¾ X 6½ INCH EXPOSURES ON DRY PLATES. SIMILAR TO THE METAL MINIATURE CAMERA, C. 1888.

**(1954) PARCEL DETECTIVE CAMERA.** C. 1885. SIZE 3¼ X 4¼ INCH PLATE EXPOSURES. A BOX-FORM CAMERA WITH A BROWN PAPER WRAPPING AND A CORD TIED AROUND THE OUTSIDE TO SIMULATE A PARCEL. FIXED-FOCUS LENS.

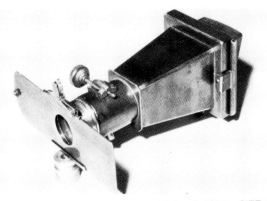

**(1955) METAL MINIATURE CAMERA.** C. 1888. SIZE 2 X 2 INCH EXPOSURES ON DRY PLATES. 100 MM/F 7 PETZVAL LENS. GUILLOTINE SHUTTER IN FRONT OF LENS FOR INSTANT AND TIME EXPOSURES. ALL-METAL CONSTRUCTION. (GE)

**(1956) REPORTER TWIN LENS CAMERA.** C. 1872. SIZE 3¼ X 4¼ INCH PLATE EXPOSURES. THE CAMERA HAS TWO LENSES, EACH ATTACHED TO BELLOWS. THE UPPER LENS IS FOR VIEWING AND THE LOWER LENS IS FOR MAKING THE EXPOSURE.

## MEAGHER, P.

**(1957) COLLAPSIBLE STEREOSCOPIC CAMERA.** C. 1860. EXPOSURES ON PLATES. 137 MM ROSS LENSES. CONNECTING-BAR SHUTTER. RACK & PINION FOCUSING. RISING LENS MOUNT. THE CAMERA COLLAPSES WHEN THE FRONT PANEL IS REMOVED. (IH)

**(1958) TOURIST BINOCULAR STEREO CAMERA.** C. 1861. SIZE 5 X 7 INCH SINGLE OR STEREO EXPOSURES ON PLATES. THE ROLLER-BLIND SEPTUM IS REMOVABLE FOR TAKING SINGLE EXPOSURES.

## MELHUISH, ARTHUR JAMES

**(1959) STEREO SLIDING-BOX CAMERA.** C. 1860. SIZE 3⅜ X 6½ INCH STEREO EXPOSURES. ALL-METAL CONSTRUCTION.

## MERCER, R. & A. J.

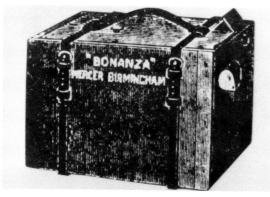

(1960) **BONANZA MAGAZINE HAND DETECTIVE CAMERA.** C. 1891. SIZE 3¼ X 4¼ INCH EXPOSURES ON PLATES OR SHEET FILM. THE MAGAZINE HOLDS 12 PLATES. RAPID LENS. THORNTON-PICKARD ROLLER-BLIND SHUTTER.

## MOORE & COMPANY

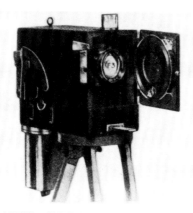

(1961) **APTUS AUTOMATIC FERROTYPE CAMERA.** C. 1921. SIZE 1¾ X 2½ INCH FERROTYPE EXPOSURES FOR MODELS A, B, AND C. ALSO, SIZE 2½ X 3½ INCH EXPOSURES FOR MODEL C. MODEL B HAS A REVOLVING BACK. THE MAGAZINE HOLDS 100 PLATES. THE EXPOSED PLATES ARE DROPPED INTO DEVELOPING AND FIXING TANKS BENEATH THE CAMERA. THE ORIGINAL MODEL WAS INTRODUCED IN 1913.

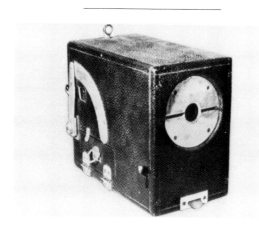

(1962) **FAST DEVELOPING CAMERA.** C. 1895. SIZE 1¾ X 2⅜ INCH FERROTYPE EXPOSURES. THE EXPOSURES ARE DEVELOPED INSIDE OF THE CAMERA. (HA)

(1963) **APTUS AUTOCARD CAMERA.** C. 1932. EXPOSURES ON "POSITIVE" CARDS. THE CAMERA HAS A TAPERED, OCTAGONAL BODY. THE CARDS ARE DEVELOPED AND FIXED INSIDE OF THE CAMERA.

## MOORSE, H.

(1964) **SINGLE LENS STEREOSCOPIC CAMERA.** C. 1865. SIZE 3½ X 7 INCH STEREO EXPOSURES ON WET COLLODION PLATES. MENISCUS LENS. THE CAMERA BODY MOVES SIDEWAYS TO MAKE A PAIR OF EXPOSURES ON A SINGLE PLATE. (IH)

## MORRIS, T.

(1965) **MINIATURE WET-PLATE CAMERA.** C. 1860. THE CAMERA WAS USED TO TAKE ¾-INCH LOCKET PICTURES. THE CAMERA SIZE IS 1½ X 1½ X 2 INCHES.

## MULTIPOSE PORTABLE CAMERAS LIMITED

(1966) **MATON CAMERA.** C. 1930. SIZE 1½ X 2 INCH NEGATIVE OR POSITIVE EXPOSURES ON ROLL FILM. A PRISM IS USED TO INVERT THE IMAGE FROM THE LENS TO PRODUCE A POSITIVE EXPOSURE. BY NOT USING THE PRISM, NEGATIVE EXPOSURES CAN BE MADE. THE EXPOSED ROLLS OF FILM CAN BE PLACED IN A SPECIAL HOLDER ON THE CAMERA WHERE THE FILM PASSES THROUGH FOUR PROCESSING SOLUTIONS FOR DEVELOPING AND FIXING. AN ENLARGING ADAPTER WAS USED FOR MAKING 3½ X 4¾ INCH ENLARGEMENTS. (BC)

## MC BEAN

(1967) **STEREO TOURIST CAMERA.** SIZE 3¼ X 7 INCH STEREO EXPOSURES. STEINHEIL ANTIPLANET LENSES. THORNTON-PICKARD SHUTTER.

## MC KELLEN, S. D.

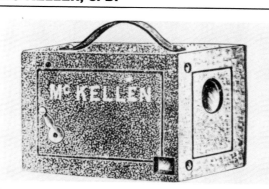

(1968) **INFALLIBLE AUTOMATIC MAGAZINE HAND CAMERA.** C. 1897. THE MAGAZINE HOLDS 12 PLATES OR 24 SHEET FILMS.

## MCLEAN, MELHUISH & COMPANY

(1969) **CARTE-DE-VISITE CAMERA.** C. 1864. THE CAMERA HAS FOUR CARTE-DE-VISITE LENSES FOR MULTIPLE EXPOSURES AND A FIFTH LENS FOR FOCUSING.

## NEWMAN & GUARDIA, LIMITED

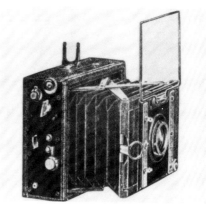

(1970) **CYCLOPS FOCAL PLANE CAMERA.** C. 1906. THREE SIZES OF THIS CAMERA FOR 3¼ X 4¼, 4 X 5, OR 4¼ X 6½ INCH EXPOSURES ON PLATES. F 6.3 ROSS HOMOCENTRIC LENS. FOCAL PLANE SHUTTER: ½ TO ¹⁄₁₀₀₀ SEC., T.

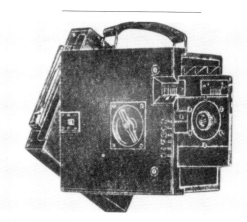

(1971) **DELUXE HAND CAMERA.** C. 1906. SIZE 3¼ X 4¼ INCH EXPOSURES ON PLATES. ZEISS DOUBLE PROTAR LENS.

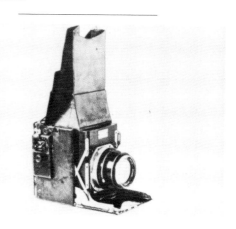

## NEWMAN & GUARDIA, LIMITED (cont.)

(1972) **FOLDING REFLEX CAMERA.** C. 1921. SIZE 2¼ X 3¼ INCH EXPOSURES. 130 MM/F 4.5 ROSS & PRESS LENS. FOCAL PLANE SHUTTER; ⅛ TO ¹⁄₈₀₀ SEC. RISING AND CROSSING LENS MOUNT. (HA)

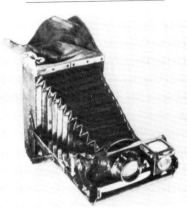

(1973) **NYDIA CAMERA.** C. 1899. SIZE 3¼ X 4¼ INCH EXPOSURES ON PLATES. THE CAMERA HOLDS 12 PLATES. F 8 WRAY APLANAT LENS. SHUTTER SPEEDS FROM ½ TO ¹⁄₁₀₀ SEC. PLATE CHANGING BAG. (HA)

(1974) **PLATE CAMERA.** C. 1895. SIZE 3 X 4 INCH EXPOSURES ON PLATES. 285 MM/F 12.5 ANASTIGMAT LENS. ROTARY SHUTTER. INTERNAL BELLOWS. (HA)

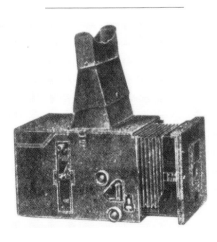

(1975) **REFLEX HAND AND STAND CAMERA.** C. 1905. SIZE 3¼ X 4¼ INCH EXPOSURES ON PLATES, CUT FILM, OR ROLL FILM WITH ADAPTER. ZEISS DOUBLE PROTAR ANASTIGMAT LENS. FOCAL PLANE SHUTTER; ¹⁄₁₀ TO ¹⁄₈₀₀ SEC. DOUBLE RISING FRONT. DOUBLE EXTENSION BELLOWS.

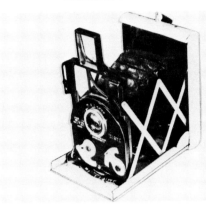

(1976) **SIBYL CAMERA. ORIGINAL MODEL.** C. 1906. SIZE 2½ X 3½ INCH EXPOSURES ON PLATES. F 6.5 COOKE SERIES III LENS.

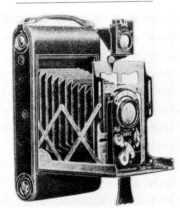

(1977) **SIBYL ROLL FILM CAMERA.** C. 1914. THREE SIZES OF THIS CAMERA FOR 2½ X 3½, 3¼ X 4¼, OR 3½ X 5½ INCH EXPOSURES ON ROLL FILM. F 6.5 COOKE ANASTIGMAT OR F 6.3 ZEISS TESSAR LENS. NEWMAN & GUARDIA PNEUMATIC SHUTTER.

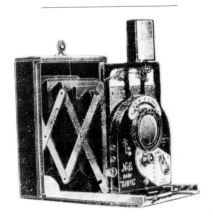

(1978) **BABY SIBYL VEST POCKET CAMERA.** C. 1914. SIZE 1¾ X 2⁵⁄₁₆ INCH EXPOSURES ON PLATES OR FILM PACKS. F 4.5 ZEISS TESSAR, F 4.5 ROSS ZEISS

TESSAR, OR F 5.6 COOKE ANASTIGMAT LENS. SHUTTER SPEEDS FROM ½ TO ¹⁄₂₀₀ SEC., B., T. RISING AND CROSSING LENS MOUNT. ALL-METAL CAMERA BODY.

(1979) **SIBYL CAMERA.** C. 1914. THREE SIZES OF THIS CAMERA FOR 2½ X 3½, 3¼ X 4¼, OR 3½ X 5½ INCH EXPOSURES ON PLATES OR FILM PACKS. F 6.5 COOKE ANASTIGMAT OR F 6.3 ZEISS TESSAR LENS. NEWMAN & GUARDIA PNEUMATIC SHUTTER. SIMILAR TO THE SPECIAL SIBYL CAMERA, IMPROVED MODEL, C. 1914.

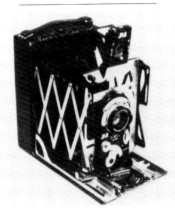

(1980) **DELUXE SIBYL CAMERA.** C. 1911. SIZE 3¼ X 4¼ INCH EXPOSURES ON PLATES OR FILM PACKS. ZEISS PROTARLINSE VII LENS. NEWMAN & GUARDIA SHUTTER; ½ TO ¹⁄₁₀₀ SEC. (HA)

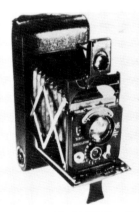

(1981) **EXCELSIOR SIBYL CAMERA.** C. 1912. SIZE 2½ X 4¼ INCH EXPOSURES ON ROLL FILM. 136 MM/F 4.5 ROSS XPRES LENS. NEWMAN & GUARDIA SHUTTER; 2 TO ¹⁄₁₅₀ SEC. (HA)

(1982) **IDEAL SIBYL CAMERA.** SIZE 3¼ X 4¼ INCH PLATE OR ROLL FILM EXPOSURES. 135 MM/F 4.5 ZEISS TESSAR LENS. NEWMAN & GUARDIA SHUTTER.

(1983) **IMPERIAL SIBYL CAMERA.** C. 1914. SIZE 3¼ X 4¼ INCH EXPOSURES ON PLATES OR FILM PACKS. F 6.5 COOKE ANASTIGMAT OR F 6.3 ZEISS TESSAR LENS. NEWMAN & GUARDIA PNEUMATIC SHUTTER. SIMILAR TO THE SPECIAL SIBYL CAMERA, IMPROVED MODEL, C. 1914.

## NEWMAN & GUARDIA, LIMITED (*cont.*)

(1984) **IMPERIAL SIBYL ROLL FILM CAMERA.** C. 1914. SIZE 3¼ X 4¼ INCH EXPOSURES. SIMILAR TO THE SIBYL ROLL FILM CAMERA. C. 1914.

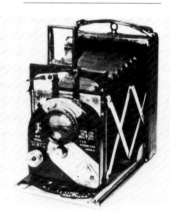

(1985) **SPECIAL SIBYL CAMERA.** C. 1911. SIZE 2¼ X 3¼ INCH EXPOSURES ON PLATES OR FILM PACKS. 112 MM/F 4.5 ROSS XPRESS LENS. NEWMAN & GUARDIA SHUTTER; ½ TO ¹/₁₅₀ SEC. (HA)

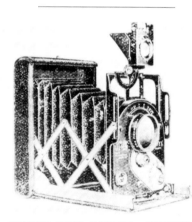

(1986) **SPECIAL SIBYL CAMERA. IMPROVED MODEL.** C. 1914. THREE SIZES OF THIS CAMERA FOR 2½ X 3½, 3¼ X 4¼, OR 3½ X 5½ INCH EXPOSURES ON PLATES OR FILM PACKS. F 4.5 ZEISS TESSAR LENS. NEWMAN & GUARDIA PNEUMATIC SHUTTER.

(1987) **SPECIAL SIBYL ROLL FILM CAMERA.** C. 1914. THREE SIZES OF THIS CAMERA FOR 2½ X 3½, 3¼ X 4¼, OR 3½ X 5½ INCH EXPOSURES ON ROLL FILM. SIMILAR TO THE SIBYL ROLL FILM CAMERA, (C. 1914) BUT WITH AN F 4.5 ZEISS TESSAR LENS AND NEWMAN & GUARDIA SHUTTER.

(1988) **VITESSE SIBYL CAMERA.** C. 1906. SIZE 2¼ X 3¼ INCH PLATE EXPOSURES. 112 MM/F 3.5 ROLL XPRESS LENS. NEWMAN & GUARDIA SHUTTER; ½ TO ¹/₁₅₀ SEC. (MA)

(1989) **NO. 2 STANDARD HAND CAMERA.** C. 1893. SAME AS THE NO. 1 STANDARD HAND CAMERA EXCEPT WITH CROSSING LENS MOUNT AND DOUBLE EXTENSION BELLOWS.

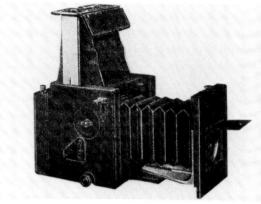

(1990) **SQUARE REFLECTOR REFLEX CAMERA.** C. 1906. SIZE 3¼ X 4¼ INCH EXPOSURES ON PLATES. ZEISS DOUBLE PROTAR LENS. REVOLVING BACK. RACK & PINION FOCUSING.

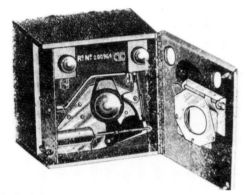

(1991) **NO. 1 STANDARD HAND CAMERA.** C. 1893. EXPOSURES ON PLATES OR SHEET FILM. DETACHABLE CHANGING BOX MAGAZINE. WRAY RAPID RECTILINEAR LENS. IRIS DIAPHRAGM. SELF-CAPPING SHUTTER; ½ TO ¹/₁₀₀ SEC. RACK & PINION FOCUSING. FOCUSING SCREEN. RISING FRONT.

(1992) **NO. 3 STANDARD HAND CAMERA.** C. 1893. SAME AS THE NO. 1 STANDARD HAND CAMERA EXCEPT WITH SWING BACK.

(1993) **NO. 4 STANDARD HAND CAMERA.** C. 1893. SAME AS THE NO. 1 STANDARD HAND CAMERA EXCEPT THE CAMERA FOLDS AND COLLAPSES TO HALF THE USUAL LENGTH.

(1994) **NO. 5 STANDARD STEREOSCOPIC CAMERA.** C. 1893. SIZE 3¼ X 4¼ INCH SINGLE OR STEREOSCOPIC EXPOSURES ON PLATES OR SHEET FILM. CHANGING BOX MAGAZINE. RISING LENS MOUNT. DOUBLE EXTENSION BELLOWS.

(1995) **NO. 6 STANDARD TWIN-LENS HAND CAMERA.** C. 1893. EXPOSURES ON PLATES OR SHEET FILM. THE UPPER LENS FOCUSES THE SUBJECT ON A SCREEN TO WHICH A CONE AND EYE-PIECE LENS IS ATTACHED FOR FINE FOCUSING.

(1996) **STEREOSCOPIC DETECTIVE CAMERA.** C. 1895. SIZE 3¼ X 6½ INCH STEREO PLATE EXPOSURES. 120 MM/F 8 WRAY RAPID RECTILINEAR LENSES. NEWMAN & GUARDIA PNEUMATIC SHUTTER; ½ TO ¹/₁₀₀ SEC. CHANGING BOX FOR 12 PLATES. (IH)

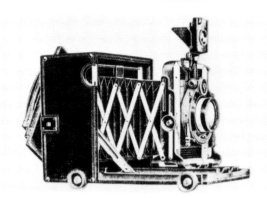

(1997) **TRELLIS HAND AND STAND CAMERA.** C. 1912. SIZE 3¼ X 4¼ INCH EXPOSURES ON PLATES. F 4.5 ZEISS TESSAR LENS. COMPOUND SHUTTER. REVOLVING BACK. RISING LENS MOUNT. DROPPING BED.

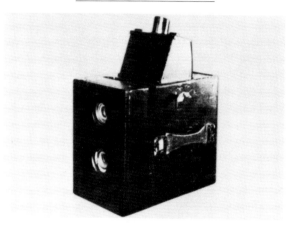

(1998) **TWIN-LENS REFLEX CAMERA.** C. 1895. SIZE 3¼ X 4¼ INCH EXPOSURES ON PLATES.

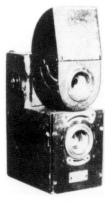

(1999) **TWIN-LENS REFLEX CAMERA.** C. 1925. THE REFLEX VIEWER AND LENS ROTATE 90 DEGREES FOR TAKING HORIZONTAL OR VERTICAL FORMAT EXPOSURES.

## NEWMAN & GUARDIA, LIMITED (*cont.*)

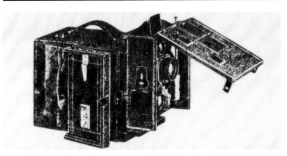

(2000) **UNIVERSAL HAND CAMERA.** C. 1906. SIZE 3¼ X 4¼ INCH EXPOSURES ON PLATES. ZEISS TESSAR LENS.

(2001) **UNIVERSAL MODEL A HAND CAMERA.** C. 1894. SIZE 3¼ X 4¼ INCH PLATE EXPOSURES. MAGAZINE AND PLATE-CHANGING BAG. RACK & PINION FOCUSING. TWO REFLECTING FINDERS. RISING LENS MOUNT.

(2002) **UNIVERSAL MODEL B HAND CAMERA.** C. 1894. THREE SIZES OF THIS CAMERA FOR 3¼ X 4¼, 3½ X 4¾, OR 4 X 5 INCH EXPOSURES ON PLATES. MAGAZINE AND PLATE-CHANGING BAG. RACK & PINION FOCUSING. RISING AND CROSSING LENS MOUNT. TWO REFLECTING FINDERS.

(2003) **UNIVERSAL MODEL B HAND CAMERA.** C. 1896. SIZE 4 X 5 INCH EXPOSURES ON PLATES. ZEISS PROTAR SERIES VII LENS. PNEUMATIC SHUTTER; 1 TO ⅟₁₀₀ SEC.

(2004) **UNIVERSAL SPECIAL MODEL B HAND CAMERA.** C. 1894. FOUR SIZES OF THIS CAMERA FOR 3¼ X 4¼, 3½ X 4¾, 4 X 5, OR 4¾ X 6½ INCH PLATE EXPOSURES. ZEISS PROTAR CONVERTIBLE LENS. SIMILAR TO THE UNIVERSAL MODEL B CAMERA. (BC)

(2005) **UNIVERSAL MODEL C HAND CAMERA.** C. 1896. TWO SIZES OF THIS CAMERA FOR 3¼ X 4¼ OR 4 X 5 INCH PLATE EXPOSURES. SIMILAR TO THE UNIVERSAL MODEL B HAND CAMERA WITH THE SAME FEATURES PLUS A VERTICAL SWING BACK.

(2006) **UNIVERSAL HIGH SPEED HAND CAMERA.** C. 1899. EXPOSURES ON PLATES. F 3.8 PLANAR LENS. FOCAL PLANE SHUTTER AND ALSO A NEWMAN PNEUMATIC BETWEEN-THE-LENS SHUTTER.

## NEWMAN & SINCLAIR

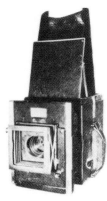

(2007) **FRONT-SHUTTER SINGLE LENS REFLEX CAMERA.** C. 1910. PNEUMATIC PISTON-CONTROLLED SHUTTER FOR SPEEDS FROM ½ TO ⅟₁₀₀ SEC.

## NEWTON, H.

(2008) **DETECTIVE BOX CAMERA.** C. 1887. THREE SIZES OF THIS CAMERA FOR 3¼ X 4¼, 4 X 5, OR 4¾ X 6½ INCH EXPOSURES ON PLATES OR ROLL FILM USING THE EASTMAN-WALKER ROLL HOLDER. TWO REFLECTING FINDERS. INTERNAL BELLOWS. EXTERNAL BELLOWS FOR FOCUSING.

(2009) **PERFECTION VIEW CAMERA.** C. 1885. REVOLVING BACK.

## OTTEWILL, JAMES

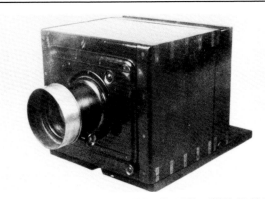

(2010) **WET-PLATE CAMERA.** C. 1850. SIZE 23 X 27 CM EXPOSURES ON WET-PLATES. ROSS LENS. (HA)

## OTTEWILL, THOMAS & COMPANY

(2011) **FOWKE CAMERA.** C. 1856. SIZE 8 X 10 INCH EXPOSURES ON WET PLATES. SQUARE BELLOWS DESIGN. THE WOODEN LENS BOARD AND EXTENSION ARE COLLAPSIBLE. (IH)

(2012) **SINGLE-LENS STEREO CAMERA.** C. 1857. EXPOSURES ON WET COLLODION PLATES. PETZVAL LENS. THE CAMERA BODY SLIDES SIDEWAYS ON A BROAD BASE TO ALLOW A PAIR OF STEREO EXPOSURES TO BE MADE ON A SINGLE PLATE. (IH)

(2013) **SLIDING BOX CAMERA.** C. 1853. SIZE 8 X 10 INCH EXPOSURES ON WET PLATES. SQUIRE & SHEPARD LENS. THE CAMERA SIDES AND TOP ARE COLLAPSIBLE. (IH)

(2014) **TAPERED BELLOWS VIEW CAMERA.** C. 1859. PROBABLY THE FIRST CAMERA TO USE THE SWING-BACK PRINCIPLE.

## PARKINSON, W. L., LIMITED

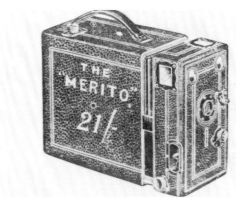

(2015) **MERITO MAGAZINE HAND CAMERA.** C. 1905. SIZE 3¼ X 4¼ INCH EXPOSURES ON PLATES. MENISCUS ACHROMATIC LENS. SHUTTER SPEEDS FROM 1 TO ⅟₁₀₀ SEC. RACK & PINION FOCUSING.

## PEARSON AND DENHAM

(2016) **CIRCUMBRA VIEW CAMERA.** C. 1890. REVOLVING BACK.

## PERKEN, SON & RAYMENT

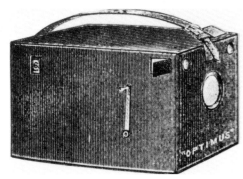

(2017) **OPTIMUS FILM HAND CAMERA.** C. 1893. EXPOSURES ON SHEET FILM OR PLATES. THE MAGAZINE HOLDS 48 FILMS.

(2018) **OPTIMUS BOOK CAMERA.** C. 1886. THE FIRST BOOK-TYPE CONCEALED CAMERA. THE LENS IS IN THE "SPINE" OF THE BOOK AND THE TWO COVERS OF THE BOOK OPEN TO FORM A TRIANGLE. A GLASS PLATE IS INSERTED AT THE BASE OF THE "TRIANGLE."

(2019) **OPTIMUS CHEAP FOLDING CAMERA.** C. 1887. ONE OF THE EARLY CAMERAS TO HAVE BELLOWS WITH CHAMFERED CORNERS.

## PERKEN, SON & RAYMENT (*cont.*)

(2020) **OPTIMUS DETECTIVE CAMERA.** C. 1888. SIZE 3¼ X 4¼ INCH EXPOSURES ON PLATES. INTERNAL BELLOWS. EXTERNAL KNOB AT THE BOTTOM OF THE CAMERA FOR FOCUSING.

(2021) **OPTIMUS REFLECTIVE CAMERA.** C. 1887. SINGLE-LENS REFLEX. DETACHABLE HOOD FOR THE FOCUSING SCREEN.

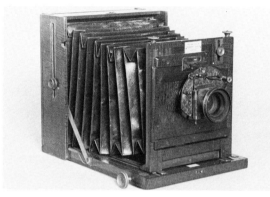

(2022) **STUDIO CAMERA.** C. 1890. SIZE 5 X 7 INCH EXPOSURES ON PLATES. PNEUMATIC TRIPLEX SHUTTER. (TH)

(2023) **STUDIO PLATE CAMERA.** C. 1890. SIZE 6½ X 8½ INCH EXPOSURES ON PLATES.

## PETSCHLER, H.

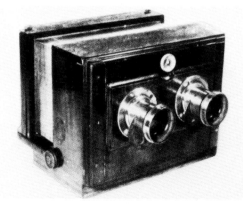

(2024) **SLIDING-BOX STEREO CAMERA.** C. 1858. SIZE 2 X 4¼ INCH EXPOSURES ON COLLODION PLATES. (HA)

## PLATINOTYPE COMPANY

(2025) **KEY STEREOSCOPIC CAMERA.** C. 1895. SIZE 3½ X 7 INCH STEREO EXPOSURES ON PLATES. 150 MM/F 8 RAPID RECTILINEAR LENSES. GUILLOTINE SHUTTER. (MA)

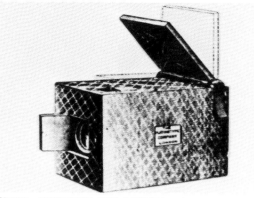

(2026) **IMPROVED KEY CAMERA.** C. 1891. SIZE 3¼ X 4¼ INCH EXPOSURES ON PLATES.

## PUMPHREY, ALFRED

(2027) **FILMOGRAPH CAMERA.** C. 1881. THE MAGAZINE HOLDS 100 GELATIN SHEET FILMS. THE BOX-FORM CAMERA HAS A LIGHT-TIGHT SLEEVE IN THE SIDE THROUGH WHICH THE OPERATOR COULD PLACE AN UNEXPOSED FILM IN THE FOCAL PLANE AFTER FOCUSING THE IMAGE ON A GROUND GLASS BY LOOKING THROUGH RED, NON-ACTINIC WINDOWS IN THE TOP OF THE CAMERA. (BC)

## PURMA CAMERAS LIMITED

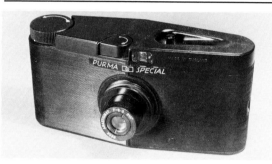

(2028) **PURMA SPECIAL CAMERA.** C. 1937–40. SIZE 1¼ X 1¼ INCH EXPOSURES ON ROLL FILM. 2¼ INCH/ F 6.3 BECK APLANAT ANASTIGMAT LENS. SPECIAL METAL FOCAL PLANE SHUTTER. A WEIGHT AND SPRING ATTACHED TO THE SHUTTER PROVIDES SHUTTER SPEEDS OF ⅟₂₅, ⅟₁₅₀ OR ⅟₄₅₀ SEC. DEPENDING ON WHETHER THE CAMERA IS HELD HORIZONTALLY, VERTICALLY CLOCKWISE, OR VERTICALLY COUNTER-CLOCKWISE WITH RESPECT TO THE LENS AXIS. (BS)

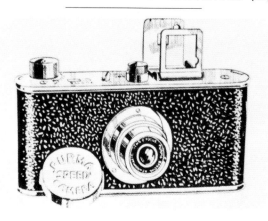

(2029) **PURMA SPEED CAMERA.** C. 1936. SIZE 1 X 1 INCH EXPOSURES ON ROLL FILM. F 13 DOUBLE RECTILINEAR LENS. THE METAL FOCAL PLANE SHUTTER PROVIDES SIX SHUTTER SPEEDS FROM ⅟₂₅ TO ⅟₂₀₀ SEC. PLUS TIME. IF THE CAMERA IS HELD HORIZONTALLY, VERTICALLY CLOCKWISE, OR VERTICALLY COUNTER-CLOCKWISE, THE SPRING WEIGHTED SHUTTER PROVIDES THREE SPEEDS. IF THE SHUTTER WINDING KNOB IS PULLED OUT, THREE ADDITIONAL SPEEDS ARE PROVIDED FOR THE ABOVE MENTIONED CAMERA POSITIONS.

(2030) **PURMA PLUS CAMERA.** C. 1940. SIZE 1¼ X 1¼ INCH EXPOSURES ON NO. 127 ROLL FILM. F 6 BECK ANASTIGMAT LENS. THREE-SPEED METAL FOCAL PLANE SHUTTER. (MA)

## QUTA PHOTO MACHINE COMPANY

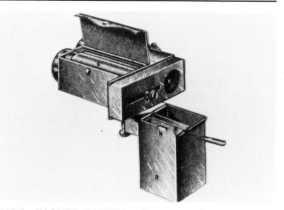

(2031) **TAQUTA CAMERA.** C. 1905. FOUR SIZES OF THIS CAMERA FOR 2 X 2½, 2¾ X 3¼, 3¼ X 4¼, OR 4 X 5 INCH FERROTYPE EXPOSURES. THE CAMERA HOLDS 45 PLATES. A PLATE CAN BE EXPOSED AND DEVELOPED IN THE CAMERA IN 2 MINUTES.

## REDDING & GYLES

(2032) **LUZO-REDDING BOX CAMERA.** C. 1896. FOUR SIZES OF THIS CAMERA FOR 3¼ X 3¼, 3¼ X 4¼, 4 X 5, OR 4¼ X 6½ INCH EXPOSURES.

## REFLEX CAMERA COMPANY, LIMITED

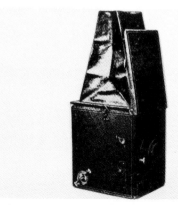

(2033) **CHIC REFLEX CAMERA.** C. 1912. SIZE 2¼ X 2¼ INCH EXPOSURES ON ROLL FILM. F 8 RAPID RECTILINEAR LENS.

## RILEY, T. & SON

(2034) **UNIT DETECTIVE HAND CAMERA.** C. 1891. SIZE 3¼ X 4¼ INCH EXPOSURES ON PLATES. F 11 ACRO VIEW LENS OR F 8 RAPID RECTILINEAR LENS. INSTANT AND TIME SHUTTER. THE MAGAZINE HOLDS 12 PLATES.

## ROBINSON, J. & SONS

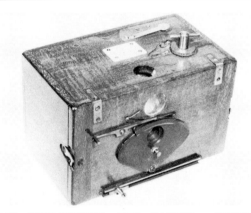

(2035) **LUZO-REDDING BOX CAMERA. ORIGINAL MODEL.** C. 1889. THE CAMERA WAS ORIGINALLY REFERRED TO AS "THE NEW DETECTIVE CAMERA." 100 EXPOSURES, SIZE 2⅜ INCHES IN DIAMETER ON ROLL FILM. 2½ INCH/F 11 APLANAT LENS. ELASTIC BAND SECTOR-TYPE SHUTTER FOR VARIABLE-SPEED OR TIME EXPOSURES. WAIST-LEVEL FINDER. (GE)

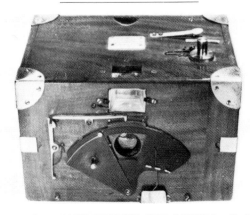

(2036) **No. 1 LUZO-REDDING BOX CAMERA.** C. 1890. 60 EXPOSURES SIZE 3¼ X 3¼ INCHES (OR 3¼ INCHES

IN DIAMETER) ON ROLL FILM. RAPID RECTILINEAR LENS. SECTOR SHUTTER FOR INSTANT AND TIME EXPOSURES. WAIST-LEVEL VIEWER. (HA)

(2037) **NO. 1 LUZO-REDDING BOX CAMERA.** C. 1895. SIZE 3¼ X 3¼ INCH EXPOSURES ON ROLL FILM. THIS MODEL DID NOT TAKE ROUND EXPOSURES AS DID THE NO. 1 MODEL OF 1890. SIMILAR TO THE NO. 1 MODEL OF 1890.

(2038) **NO. 2 LUZO-REDDING BOX CAMERA.** C. 1890. 48 EXPOSURES SIZE 3¼ X 4¼ INCHES ON ROLL FILM. OTHER FEATURES SIMILAR TO THE NO. 1 MODEL OF 1890.

(2039) **NO. 3 LUZO-REDDING BOX CAMERA.** C. 1890. 48 EXPOSURES SIZE 3¼ X 4¼ INCHES ON ROLL FILM. OTHER FEATURES SIMILAR TO THE NO. 1 MODEL OF 1890.

(2040) **NO. 4 LUZO-REDDING BOX CAMERA.** C. 1890. 48 EXPOSURES SIZE 3¼ X 4¼ INCHES ON ROLL FILM. SIMILAR TO THE NO. 1 MODEL OF 1890 BUT WITH RACK & PINION FOCUSING AND A DIAL DISTANCE INDICATOR.

(2041) **NO. 5 LUZO-REDDING BOX CAMERA.** C. 1890. SIZE 3¼ X 4¼ INCH EXPOSURES ON ROLL FILM. SIMILAR TO THE NO. 1 MODEL OF 1890.

(2042) **LUZO-REDDING BOX CAMERA.** C. 1893. TWO SIZES OF THIS CAMERA FOR 4 X 5 OR 4¼ X 6½ INCH EXPOSURES. SIMILAR TO THE NO. 1 MODEL OF 1890.

## ROSS & COMPANY

(2043) **FILM HAND CAMERA.** C. 1896. EXPOSURES ON SHEET FILM.

(2044) **NO. 1 INFALLIBLE MAGAZINE BOX CAMERA.** C. 1896. SIZE 4 X 5 INCH EXPOSURES ON PLATES OR SHEET FILM. RAPID RECTILINEAR, GOERZ, COOKE, DALLMEYER, ROSS, OR WRAY LENS. SIMPLE SHUTTER. SINGLE FINDER. BLACK MAHOGANY. SIMILAR TO THE NO. 2 INFALLIBLE MAGAZINE BOX CAMERA.

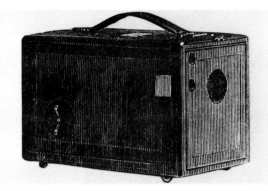

(2045) **NO. 2 INFALLIBLE MAGAZINE BOX CAMERA.** C. 1896. SIZE 4 X 5 INCH EXPOSURES ON PLATES OR SHEET FILM. RAPID RECTILINEAR, GOERZ, COOKE, DALLMEYER, ROSS, OR WRAY LENS. SIMPLE SHUTTER. TWO FINDERS. LEATHER COVERED.

(2046) **NO. 3 INFALLIBLE MAGAZINE BOX CAMERA.** C. 1896. SIZE 4 X 5 INCH EXPOSURES ON PLATES OR SHEET FILM. SIMILAR TO THE NO. 2 INFALLIBLE MAGAZINE BOX CAMERA WITH THE SAME LENSES BUT WITH AUTOMATIC OR ROLLER-BLIND SHUTTER.

(2047) **NO. 4 INFALLIBLE MAGAZINE BOX CAMERA.** C. 1896. SIZE 4 X 5 INCH EXPOSURES ON PLATES OR SHEET FILM. RACK & PINION FOCUSING. SIMILAR TO THE NO. 2 INFALLIBLE MAGAZINE BOX CAMERA WITH THE SAME LENSES BUT WITH AUTOMATIC OR ROLLER-BLIND SHUTTER.

(2048) **NO. 6 INFALLIBLE MAGAZINE BOX CAMERA.** C. 1896. SIZE 4¼ X 6½ INCH EXPOSURES ON PLATES OR SHEET FILM. RACK & PINION FOCUSING. SIMILAR TO THE NO. 2 INFALLIBLE MAGAZINE BOX CAMERA WITH THE SAME LENSES BUT WITH AUTOMATIC OR ROLLER-BLIND SHUTTER.

(2049) **MEAGHER-STYLE FIELD CAMERA.** C. 1890. SIZE 4¼ X 6½ INCH EXPOSURES ON PLATES. 6-INCH ROSS SYMMETRICAL LENS.

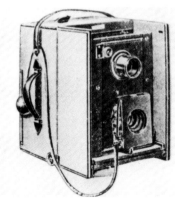

(2050) **NEW FORM PATENT TWIN-LENS CAMERA.** C. 1896. SIZE 4¾ X 6½ INCH PLATE EXPOSURES. 7-INCH ROSS LENS. ALSO, ZEISS AND GOERZ LENSES.

## ROSS & COMPANY *(cont.)*

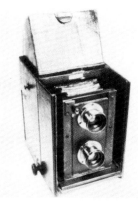

**(2051) NEW FORM TWIN-LENS REFLEX CAMERA.** C. 1898. SIZE 3¼ X 4¼ INCH EXPOSURES ON PLATES. 196 MM/F 8 ANASTIGMAT LENS. THORNTON-PICKARD SHUTTER. (HA)

**(2052) PORTABLE DIVIDED TWIN-LENS REFLEX CAMERA.** C. 1890. SIZE 4¾ X 6½ INCH EXPOSURES ON PLATES. WATERHOUSE STOPS. SIMILAR TO THE 1893 MODEL. (IH)

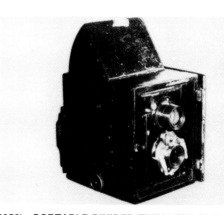

**(2053) PORTABLE DIVIDED TWIN-LENS REFLEX CAMERA.** C. 1893. SIX SIZES OF THIS CAMERA FOR 3¼ X 3¼, 3¼ X4¼, 4 X 5, 4¾ X 6½, 5 X 7½, OR 6½ X 8½ INCH EXPOSURES ON PLATES. ROSS RAPID SYMMETRICAL LENS. BAUSCH & LOMB UNICUM PNEUMATIC SHUTTER. RACK & PINION FOCUS. RISING LENS MOUNT. AUXILIARY DOUBLE SWING BACK.

**(2054) PORTABLE FIELD CAMERA.** C. 1895. SIZE 10 X 12 INCH PLATE EXPOSURES.

**(2055) TWIN-LENS REFLEX CAMERA.** C. 1907. SIZE 4 X 5 INCH PLATE EXPOSURES. 7-INCH/F 6.3 HOMOCENTRIC LENS. BAUSCH & LOMB PNEUMATIC SHUTTER; 1 TO ¹⁄₁₀₀ SEC. ROTATING BACK. (MA)

**(2056) KING COLLEGE SET VIEW CAMERA.** C. 1861. CENTER-PIVOT SWING BACK.

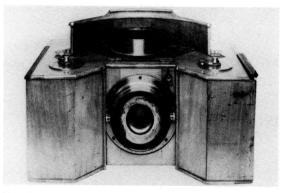

**(2057) SUTTON'S PANORAMIC CAMERA.** C. 1861–62. THREE SIZES OF THIS CAMERA FOR 5 X 9, 6 X 12, OR 8 X 16 INCH PANORAMIC EXPOSURES ON CURVED WET-COLLODION PLATES. 120-DEGREE PANORAMIC EXPOSURES. THE SUTTON F 12 LENS CONSISTS OF A HOLLOW GLASS SPHERE FILLED WITH A LIQUID. THIS CAMERA WAS MANUFACTURED IN 1860 BY FREDERICK COX.

## ROSS, LIMITED

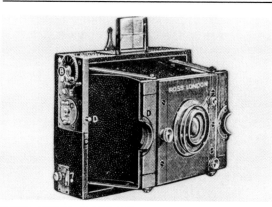

**(2058) FOCAL PLANE CAMERA.** C. 1904. SIZE 3¼ X 4¼ INCH EXPOSURES ON PLATES.

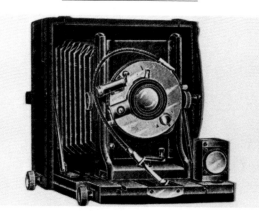

**(2059) KEROS HAND CAMERA.** C. 1912. SIZE 3¼ X 4¼ INCH EXPOSURES ON PLATES. F 4.5, F 6.3, OR F 6.8 ROSS HOMOCENTRIC LENS. KOILOS, COMPOUND, OR IBSO SHUTTER. REVOLVING BACK. DROPPING BED. RISING LENS MOUNT. RACK & PINION FOCUSING.

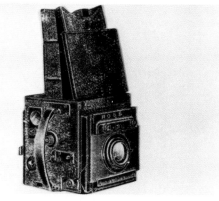

**(2060) KERSHAW FOCAL PLANE REFLEX CAMERA.** C. 1914. SIZE 2½ X 3½ INCH EXPOSURES ON PLATES OR FILM PACKS WITH ADAPTER. F 6.8, F 6.3, F 5.6, OR F 4.5 ROSS HOMOCENTRIC LENS. ALSO, F 6.3 OR F 4.5 ROSS-ZEISS TESSAR LENS. FOCAL PLANE SHUTTER. SOME MODELS WITH REVOLVING BACK.

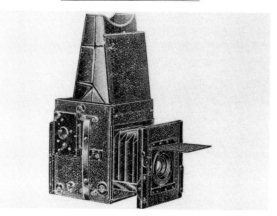

**(2061) KERSHAW FOCAL PLANE REFLEX CAMERA.** C. 1914. FOUR SIZES OF THIS CAMERA FOR 3¼ X 4¼, 3½ X 5½, 4 X 5, OR 4¼ X 6½ INCH EXPOSURES ON PLATES OR FILM PACKS WITH ADAPTER. F 6.8 GOERZ SYNTOR, F 6.5 COOKE, F 6.3 OR F 4.5 ROSS HOMOCENTRIC, F 6.8 OR F 4.8 GOERZ DOUBLE ANASTIGMAT, F 4.5 ROSS-ZEISS TESSAR, OR F 6 DALLMEYER LENS. FOCAL PLANE SHUTTER; ¹⁄₁₆ TO ¹⁄₈₀₀ SEC., T. REVOLVING BACK EXCEPT FOR THE 3½ X 5½ INCH EXPOSURE MODEL.

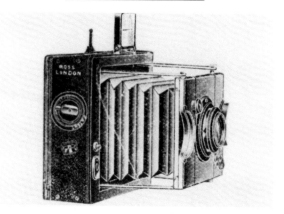

**(2062) PANROSS CAMERA.** C. 1914. THREE SIZES OF THIS CAMERA FOR 3¼ X 4¼, 4 X 5, OR 3½ X 5½ INCH

## ROSS, LIMITED (cont.)

EXPOSURES ON PLATES OR FILM PACKS. F 6.8, F 6.3, F 5.6, OR F 4.5 ROSS HOMOCENTRIC LENS. FOCAL PLANE SHUTTER; 1/10 TO 1/1000 SEC., T. PLUS PNEUMATIC RELEASE EXPOSURES FROM 3 TO 1/3 SEC. GROUND GLASS FOCUSING.

(2063) **PANROSS PRESS CAMERA.** C. 1915. SIZE 2¼ X 3¼ INCH EXPOSURES. 4.75-INCH/F 4.5 XPRESS LENS. FOCAL PLANE SHUTTER.

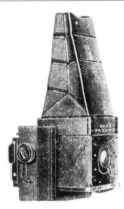

(2064) **PATENT FOLDING REFLEX CAMERA.** C. 1914. SIZE 3¼ X 4¼ INCH EXPOSURES ON PLATES. F 5.6 ROSS HOMOCENTRIC LENS. FOCAL PLANE SHUTTER. REVOLVING BACK. WOOD BODY.

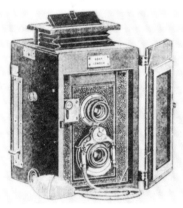

(2065) **TWIN-LENS REFLEX CAMERA.** C. 1904. SIZE 3¼ X 4¼ INCH EXPOSURES ON PLATES.

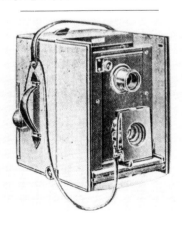

(2066) **PORTABLE TWIN-LENS CAMERA.** C. 1897. SIX SIZES OF THIS CAMERA FOR 3¼ X 3¼, 3¼ X 4¼, 4 X 5, 4¾ X 6½, 5 X 7, OR 6½ X 8½ INCH EXPOSURES ON PLATES. F 8 ROSS RAPID SYMMETRICAL, F 8 ROSS-ZEISS ANASTIGMAT SERIES II A, OR F 7.7 ROSS-GOERZ DOUBLE ANASTIGMAT LENS.

## ROSS, THOMAS

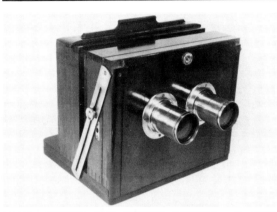

(2067) **SLIDING BOX STEREO CAMERA.** C. 1860. SIZE 6 X 8½ INCH STEREO EXPOSURES ON SENSITIZED PAPER OR PLATES. DALLMEYER LENS. (SW)

(2068) **SLIDING BOX STEREO CAMERA.** C. 1862. SIZE 7 X 13 INCH STEREO PLATE EXPOSURES.

(2069) **SUTTON (THOMAS) REFLEX CAMERA.** C. 1861. SIZE 3¼ X 4¼ INCH EXPOSURES. THE FIRST TRUE SINGLE-LENS REFLEX CAMERA. THIS BOX-FORM CAMERA HAS BELLOWS AND A HINGED MIRROR AT A 45-DEGREE ANGLE TO THE FOCAL PLANE AND REFLECTS THE IMAGE ONTO A VIEWING SCREEN ON THE TOP OF THE CAMERA. (BC)

(2070) **UNIVERSAL BINOCULAR STEREO CAMERA.** C. 1862. SIZE 4½ X 8 INCH SINGLE EXPOSURES OR 3¼ X 6¾ INCH STEREO EXPOSURES. SOME MODELS WITH A CENTRALLY PIVOTED SWING BACK.

## ROUCH, W. W. & COMPANY

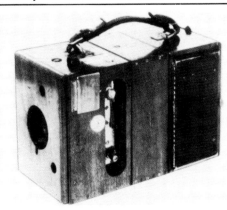

(2071) **EXCELSIOR BOX CAMERA.** C. 1890.

(2072) **EUREKA SLIDING BOX DETECTIVE CAMERA.** C. 1888. SIZE 3¼ x 3¼ INCH EXPOSURES ON PLATES. 150 MM/F 6 ROUCH DOUBLET LENS. BEHIND-THE-LENS ROLLER-BLIND SHUTTER. THE MAGAZINE HOLDS 12 PLATES. (MA)

(2073) **NEW BINOCULAR STEREO CAMERA.** C. 1862. DOUBLE-FLAP SHUTTER.

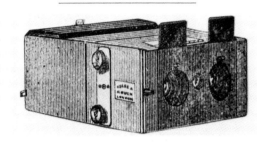

(2074) **STEREOSCOPIC HAND CAMERA.** C. 1894. TWO SIZES OF THIS CAMERA FOR 3¼ X 6¾ OR 4¼ X 6½ INCH STEREO EXPOSURES ON PLATES OR SHEET FILM. THE MAGAZINE HOLDS 12 PLATES OR 24 SHEET FILMS. RAPID RECTILINEAR LENSES, VARIABLE-SPEED AND TIME SHUTTER.

(2075) **UNIVERSAL IMPROVED KINNEAR CAMERA.** C. 1858. SEVEN SIZES OF THIS CAMERA FOR EXPO-SURES FROM 6½ X 8½ TO 16 X 18 INCHES. TAPERED BELLOWS DESIGN.

## SANDERS & CROWHURST

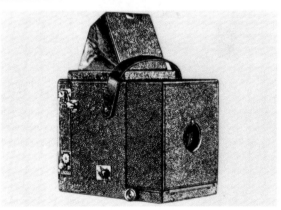

(2076) **BIRDLAND REFLEX CAMERA.** C. 1905.

## SANDS & HUNTER

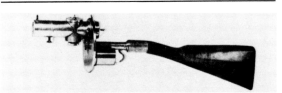

(2077) **PHOTOGRAPHIC GUN CAMERA.** C. 1885. 1½-INCH DIAMETER EXPOSURES ON DRY GELATIN PLATES. ROSS OR DALLMEYER RAPID RECTILINEAR LENS. THE LENS AND CYLINDRICAL SHUTTER ARE HOUSED IN THE "GUN BARREL." ANY ONE OF THREE

## SANDS & HUNTER (*cont.*)

BRASS CYLINDERS CAN BE BROUGHT INTO REGISTER BY ROTATING THE LARGE CYLINDER. ONE CYLINDER. CONTAINS A GROUND-GLASS SCREEN, ONE IS A MAGAZINE FOR THE UNEXPOSED PLATES, AND THE THIRD HOUSES THE EXPOSED PLATES. THE MAGAZINE HOLDS 18 PLATES. (SM)

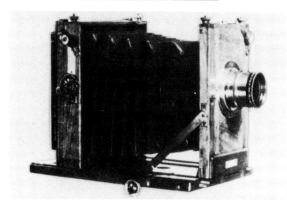

(2078)   **IMPERIAL TAILBOARD CAMERA.** C. 1888.

## SANGER-SHEPHERD & COMPANY, LIMITED

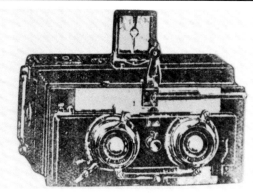

(2079)   **MYRIOSCOPE STERESCOPIC AND PANORAMIC CAMERA.** C. 1911. SIZE 2⅜ X 5⅛ INCH EXPOSURES ON PLATES. THE MAGAZINE HOLDS 12 PLATES. ZEISS TESSAR LENSES. SHUTTER SPEEDS FROM 2 TO ¹⁄₂₅₀ SEC., T. GROUND GLASS FOCUSING. PANORAMIC EXPOSURES CAN BE MADE BY USING ONE LENS AND REMOVING THE STEREO PARTITION INSIDE OF THE CAMERA.

(2080)   **ONE-EXPOSURE THREE-COLOR CAMERA.** C. 1911. TWO SIZES OF THIS CAMERA FOR 2 X 2⅜ OR 2½ X 3⅓ INCH COLOR EXPOSURES. THREE FILMS ARE EXPOSED SIMULTANEOUSLY AND THEN ARE SANDWICHED TOGETHER TO MAKE A COLOR FILM.

(2081)   **ONE-EXPOSURE THREE-COLOR CAMERA.** C. 1902. SIZE 2¾ X 2¾ INCH EXPOSURES. THREE FILMS ARE EXPOSED SIMULTANEOUSLY AND THEN ARE SANDWICHED TOGETHER TO MAKE A COLOR FILM. THE CAMERA USES SEMITRANSPARENT MIRRORS. (MA)

## SCIENTIFIC HAND CAMERA COMPANY

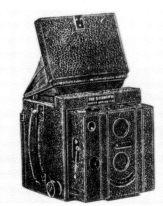

(2082)   **SCIENTIFIC TWIN-LENS REFLEX HAND CAMERA.** C. 1896. THREE SIZES OF THIS CAMERA FOR 3¼ X 4¼, 4 X 5, OR 4¼ X 6½ INCH PLATE EXPOSURES. BECK RAPID RECTILINEAR LENS. THORNTON-PICKARD INSTANT AND TIME SHUTTER. IRIS DIAPHRAGM. GROUND GLASS FOCUSING. ADAPTER FOR USE OF ROLL FILM.

## SHARP & HITCHMOUGH

(2083)   **APTUS PANORAMIC CAMERA.** C. 1902. SIZE 2½ X 6½ INCH PANORAMIC EXPOSURES ON PLATES OR CUT FILMS. THE MAGAZINE HOLDS 12 PLATES OR 24 FILMS. (BC)

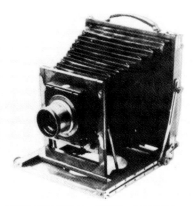

(2084)   **TILT-AND-FOLD VIEW CAMERA.** C. 1900. SIZE 6½ X 8½ INCH EXPOSURES ON PLATES.

## SHEW, J. F. & COMPANY

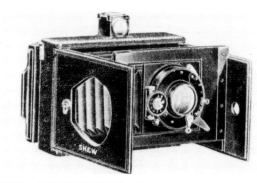

(2085)   **DAY-XIT CAMERA.** C. 1914. SIZE 3¼ X 4¼ INCH EXPOSURES ON PLATES OR FILM PACKS WITH ADAPTER. F 6.5 COOKE SERIES III LENS. SHEW SECTOR SHUTTER; 1 TO ¹⁄₁₀₀ SEC., B., T. OR COMPOUND SHUTTER; 1 TO ¹⁄₂₅₀ SEC., B., T. GROUND GLASS FOCUSING.

(2086)   **DETECTIVE BOX-FORM CAMERA.** C. 1888. EXPOSURES ON PLATES.

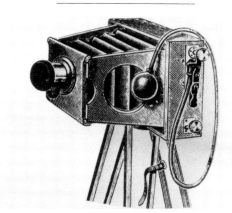

(2087)   **ECLIPSE FOCAL PLANE CAMERA.** C. 1899. FIVE SIZES OF THIS CAMERA FOR 3¼ X 4¼, 4 X 5, 4¾ X 6½, 5 X 7½, OR 6½ X 8½ INCH EXPOSURES ON PLATES. ROSS, GOERZ, ZEISS, SATZ-ANASTIGMAT, PLANOGRAPH, OR ECLIPSE LENS. FOCAL PLANE SHUTTER. INTERCHANGEABLE BACKS FOR PLATES, SHEET, OR ROLL FILM.

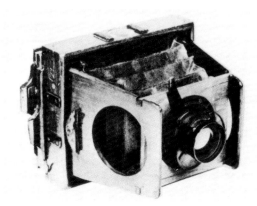

(2088)   **ECLIPSE FOLDING STRUT CAMERA.** C. 1885–1902. TWO SIZES OF THIS CAMERA FOR 3¼ X 4¼ OR

## SHEW, J. F. & COMPANY (*cont.*)

4¾ X 6½ INCH EXPOSURES ON PLATES OR ROLL FILM WITH ROLL FILM HOLDER. WOOD STRUTS. 100 MM/ F 8 DARLOT RAPID RECTILINEAR LENS. ROTARY BETWEEN-THE-LENS SHUTTER FOR INSTANT AND TIME EXPOSURES. WAIST-LEVEL MIRROR FINDER.

---

**(2089) ECLIPSE FOLDING STRUT CAMERA.** C. 1889. FIVE SIZES OF THIS CAMERA FOR 3¼ X 3¼ OR 4 X 5 INCH OR 9 X 12, 12 X 16, OR 13 X 18 CM EXPOSURES ON PLATES OR ROLL FILM WITH THE EASTMAN-WALKER ROLL HOLDER. SIMILAR TO THE ECLIPSE FOLDING STRUT CAMERA, C. 1885–1902.

---

**(2090) ECLIPSE FOLDING STRUT CAMERA.** C. 1898. FIVE SIZES OF THIS CAMERA FOR 3¼ X 4¼, 4 X 5, 4¾ X 6½, 5 X 7½, OR 6½ X 8½ INCH EXPOSURES ON PLATES OR ROLL FILM WITH ROLL FILM HOLDER. SIMILAR TO THE ECLIPSE FOLDING STRUT CAMERA, C. 1885–1902.

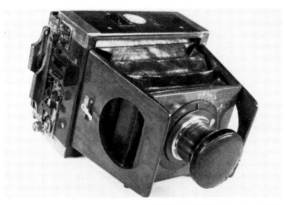

**(2091) ECLIPSE FOLDING STRUT CAMERA.** C. 1900. SIZE 3¼ X 4¼ INCH EXPOSURES ON PLATES. NO. 2 DALLMEYER LENS. FOCAL PLANE SHUTTER. (VC)

---

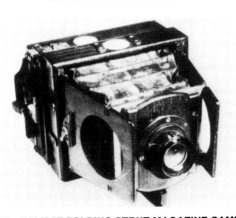

**(2092) ECLIPSE FOLDING STRUT MAGAZINE CAMERA.** C. 1889. SIZE 3¼ X 4¼ INCH EXPOSURES ON PLATES. THE MAGAZINE HOLDS 12 PLATES. 150 MM/F 9 SHEW LENS. ROTARY SHUTTER. (HA)

---

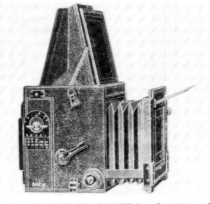

**(2093) ECLIPSE REFLEX CAMERA.** C. 1914. FOUR SIZES OF THIS CAMERA FOR 3¼ X 4¼, 3½ X 5½, 4 X 5, OR 4¾ X 6½ INCH EXPOSURES ON PLATES. COOKE, ROSS, ZEISS, OR GOERZ LENS. FOCAL PLANE SHUTTER; ⅟₁₅ TO ⅟₁₀₀₀ SEC.

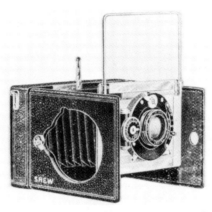

**(2094) EUXIT VEST POCKET CAMERA.** C. 1914. TWO SIZES OF THIS CAMERA FOR 2½ X 3½ OR 3¼ X 4¼ INCH PLATE EXPOSURES. F 6.5 COOKE SERIES III, F 6.3 ZEISS TESSAR, OR F 6.8 GOERZ DAGOR SERIES III LENS. COMPOUND SHUTTER; 1 TO ⅟₂₅₀ SEC., B., T. RISING AND CROSSING LENS MOUNT.

---

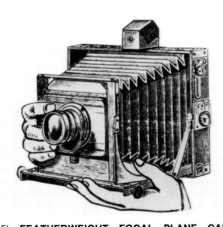

**(2095) FEATHERWEIGHT FOCAL PLANE CAMERA.** C. 1899. TWO SIZES OF THIS CAMERA FOR 4¾ X 6½ OR 6½ X 8½ INCH PLATE EXPOSURES. THORNTON-PICKARD FOCAL PLANE SHUTTER.

---

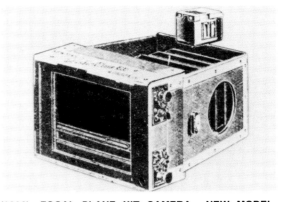

**(2096) FOCAL PLANE XIT CAMERA. NEW MODEL.** C. 1905. THREE SIZES OF THIS CAMERA FOR 3¼ X 4¼, 4 X 5, OR 4¾ X 6½ INCH EXPOSURES ON PLATES. FOCAL PLANE SHUTTER; 5 to ⅟₁₀₀₀ SEC., T.

---

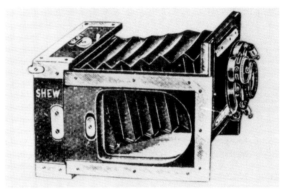

**(2097) POCKET XIT CAMERA.** C. 1905. TWO SIZES OF THIS CAMERA FOR 3¼ X 4¼ OR 4 X 5 INCH EXPOSURES ON PLATES.

---

**(2098) POSTCARD XIT CAMERA.** C. 1905. SIZE 3½ X 5½ INCH EXPOSURES ON PLATES.

---

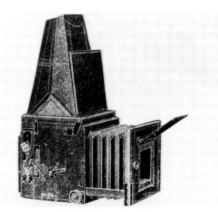

**(2099) PRESS REFLECTOR REFLEX CAMERA.** C. 1914. SIZE 4¼ X 6½ INCH EXPOSURES ON PLATES. COOKE, ROSS, ZEISS, OR GOERZ LENS. GOERZ ANSCHUTZ TROPICAL FOCAL PLANE SHUTTER; ⅟₁₀ TO ⅟₁₀₀₀ SEC. PLUS AUTOMATIC EXPOSURES FROM 5 TO ½ SEC. RISING LENS MOUNT. MODEL A, DOUBLE EXTENSION BELLOWS. MODEL B, TRIPLE EXTENSION BELLOWS.

## SHEW, J. F. & COMPANY (cont.)

(2100) **PRESS REFLECTOR REFLEX CAMERA. SQUARE MODEL WITH REVOLVING BACK.** C. 1914. THREE SIZES OF THIS CAMERA FOR 3¼ X 4¼, 4 X 5, OR 4¼ X 6½ INCH EXPOSURES ON PLATES. SIMILAR TO THE PRESS REFLECTOR REFLEX CAMERA WITH THE SAME LENSES AND SHUTTER.

(2101) **QUARTER PLATE CAMERA.** C. 1900. SIZE 3¼ X 4¼ INCH EXPOSURES ON PLATES. 5¾ INCH/F 4 COOKE LUXOR ANASTIGMAT LENS. FOCAL PLANE SHUTTER TO ¹⁄₁₀₀₀ SEC.

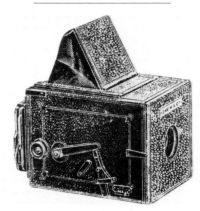

(2102) **REFLECTOR REFLEX CAMERA.** C. 1899. TWO SIZES OF THIS CAMERA FOR 3¼ X 4¼ OR 4 X 5 INCH EXPOSURES ON PLATES, CUT FILM, OR ROLL FILM WITH ADAPTER. F 6 DALLMEYER STIGMATIC, F 6.3 ZEISS TESSAR, F 6.5 COOKE, F 8 SHEW EXTRA RAPID RECTILINEAR, OR F 6 EURYSCOPE LENS. RACK AND PINION FOCUSING. REVERSING BACK. ADJUSTABLE-SPEED SHUTTER.

(2103) **UNIVERSAL HAND CAMERA.** C. 1891. SIZE 3¼ X 4¼ INCH PLATE EXPOSURES. 100 MM/F 8 DARLOT LENS. ROTARY SHUTTER. (MA)

(2104) **MODEL TOURIST VIEW CAMERA.** C. 1887. SWING BACK.

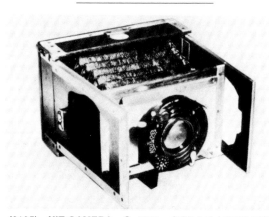

(2105) **XIT CAMERA.** C. 1898. SIZE 3 X 4 INCH EXPOSURES ON PLATES. 125 MM/F 4.8 GOERZ CELOR LENS. KOILOS SHUTTER WITH SPEEDS TO ¹⁄₃₀₀ SEC. (HA)

(2106) **XIT CAMERA.** C. 1898. SIZE 3 X 4 INCH PLATE EXPOSURES. 135 MM/F 6 DALLMEYER LENS. BAUSCH & LOMB CENTRAL SHUTTER; ½ TO ¹⁄₁₀₀ SEC. IRIS DIA-PHRAGM. HELICAL FOCUSING. WOOD AND ALUMINUM BODY. (IH)

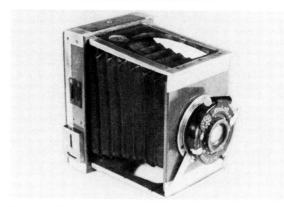

(2107) **XIT CAMERA.** C. 1903. SIZE 3¼ X 4¼ INCH EXPOSURES ON PLATES. 6 INCH/F 8 COOKE LENS. KOILOS SHUTTER; 1 TO ¹⁄₃₀₀ SEC., B., T. (VC)

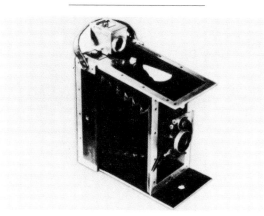

(2108) **XIT CAMERA.** C. 1905. SIZE 3½ X 5½ INCH EXPOSURES ON PLATES.

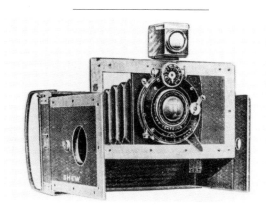

(2109) **XIT CAMERA.** C. 1914. FIVE SIZES OF THIS CAMERA FOR 2⅓ X 3½, 3¼ X 4¼, 4 X 5, 3½ X 5½, OR 4¼ X 6½ INCH EXPOSURES ON PLATES OR FILM PACKS WITH ADAPTER. F 6.5 OR F 5.6 COOKE, F 6.3 ROSS HOMOCENTRIC, F 6.3 OR F 4.5 ZEISS TESSAR, F 6.8 GOERZ DAGOR, OR F 6.3 ALDIS LENS. COMPOUND SHUTTER; 1 TO ¹⁄₂₅₀ SEC., B., T. RISING AND CROSSING LENS MOUNT.

## SICHEL, O. & COMPANY

(2110) **STUDIO REFLEX CAMERA.** C. 1909. EXPO-SURES ON PLATES. FOCAL PLANE SHUTTER. THE IM-AGE IS REFLECTED ONTO A SCREEN ON THE SIDE OF THE CAMERA.

## SINCLAIR, JAMES A. & COMPANY, LIMITED

(2111) **CENTUM FILM CAMERA.** C. 1915. 100 EXPO-SURES, SIZE 36 X 57 MM, ON "35MM" ROLL FILM. F 6.8 ROSS LENS. N & S SHUTTER FOR EXPOSURES FROM 1 TO ¹⁄₁₀₀ SEC. WIRE-FRAME VIEW FINDER.

(2112) **CENTUM FILM CAMERA.** C. 1919. SIMILAR TO THE CENTUM CAMERA OF 1915 EXCEPT THE EXPO-SURE SIZE IS 70 X 86 MM ON LARGER ROLL FILM.

(2113) **UNA CAMERA.** C. 1895. SIZE 3¼ X 4¼ INCH EXPOSURES. 7-INCH/F 6.8 GOERZ DOUBLE ANA-STIGMAT LENS. WOOD CONSTRUCTION. REVOLVING BACK.

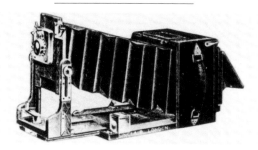

(2114) **UNA CAMERA.** C. 1906. THREE SIZES OF THIS CAMERA FOR 3¼ X 4¼, 4 X 5, OR 4¼ X 6½ INCH EXPO-SURES ON PLATES, FILM PACKS, OR ROLL FILM WITH HOLDER. F 6 ALDIS ANASTIGMAT, F 6.3 ROSS HOMO-CENTRIC, OR F 6.3 ZEISS PROTAR LENS. BAUSCH & LOMB AUTOMATIC OR COMPOUND SHUTTER.

(2115) **UNA TRAVELER BOX CAMERA.** C. 1912. SIZE 3¼ X 4¼ INCH EXPOSURES ON ROLL FILM. 90 MM/F 6.8 ROSS GOERZ LENS. BAUSCH & LOMB AUTOMAT SHUTTER; 1 TO ¹⁄₁₀₀ SEC., T. (MA)

(2116) **UNA TRAVELER CAMERA.** C. 1930. SIZE 2½ X 3½ INCH PLATE EXPOSURES. 8-INCH/F 11 ROSS LENS. N & S "PERFECT" SHUTTER. RISING AND CROSSING LENS MOUNT. REVOLVING BACK. (MA)

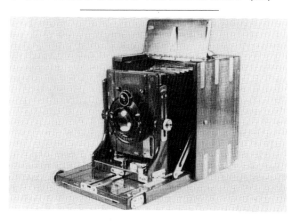

## SINCLAIR, JAMES A. & COMPANY, LIMITED (cont.)

(2117) **UNA TROPICAL CAMERA.** C. 1920. SIZE 3¼ X 4¼ INCH EXPOSURES ON PLATES. 135 MM/F 4.5 LENS. COMPUR SHUTTER; 1 TO ⅓₀₀ SEC., B., T. RISING LENS MOUNT. (VC)

## SKAIFE, THOMAS

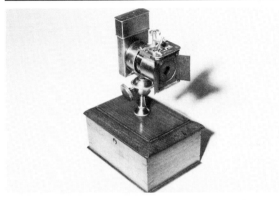

(2118) **PISTOLGRAPH ALL-METAL CAMERA.** C. 1859–66. SIZE 1⅛ INCH DIAMETER EXPOSURES ON WET-COLLODION PLATES. 40 MM/F 2.2 PETZVAL-TYPE LENS BY DALLMEYER. WATERHOUSE STOPS. RUBBER-BAND OPERATED SHUTTER. THE PLATES WERE SENSITIZED AND DEVELOPED IN THE TANK AT THE REAR OF THE CAMERA. A WOODEN BOX SERVES AS A BASE WHEN THE CAMERA IS USED AND IS ALSO USED TO STORE THE CAMERA (DISASSEMBLED) WHEN NOT IN USE. LATER MODELS HAD AN F 1.1 DALLMEYER LENS. (GE)

## SMITH, W. A. C.

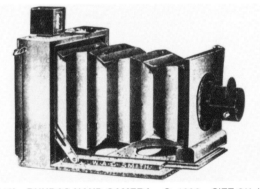

(2119) **DUNDAS HAND CAMERA.** C. 1896. SIZE 3¼ X 4¼ INCH EXPOSURES ON PLATES. MENISCUS ACHROMATIC LENS. SINGLE-SPEED SHUTTER.

(2120) **LANDSCAPE CAMERA.** C. 1886. ONE OF THE EARLY CAMERAS TO HAVE BELLOWS WITH CHAMFERED CORNERS.

## SOHO, LIMITED

(2121) **SOHO ALTREX FOLDING CAMERA.** C. 1930. SIZE 2¼ X 3¼ INCH EXPOSURES ON ROLL FILM. F 6.3 KERSHAW ANASTIGMAT LENS. ILEX GENERAL SHUTTER; ⅕ TO ⅒₀ SEC.

(2122) **SOHO FARNEAR BOX CAMERA.** C. 1930. SIZE 2¼ X 3¼ INCH EXPOSURES ON ROLL FILM. SINGLE ACHROMATIC LENS. SINGLE SPEED AND TIME SHUTTER. SEE PHOTO OF THE SAME MODEL NAME CAMERA UNDER AMALGAMATED PHOTOGRAPHIC MANUFACTURERS LTD.

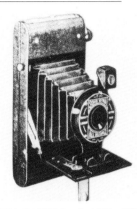

(2123) **SOHO MYNA CAMERA.** C. 1938. SIZE 2¼ X 3¼ INCH EXPOSURES ON ROLL FILM. MENISCUS LENS. SINGLE-SPEED AND TIME SHUTTER.

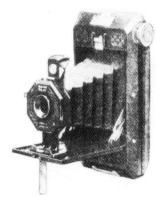

(2124) **SOHO PILOT FOLDING CAMERA.** C. 1932. SIZE 2¼ X 3¼ INCH EXPOSURES ON ROLL FILM. SINGLE-SPEED AND TIME SHUTTER.

(2125) **SOHO SINGLE-LENS REFLEX CAMERA.** C. 1905. ORIGINAL MODEL. SIZE 3¼ X 4¼ INCH EXPOSURES.

(2126) **SOHO SINGLE-LENS REFLEX CAMERA.** C. 1920. SIZE 2¼ X 3¼ INCH EXPOSURES ON SHEET FILM. 120 MM/F 4.5 TESSAR LENS.

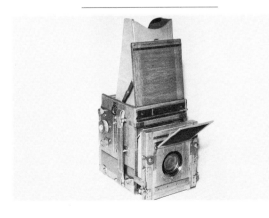

(2127) **SOHO TROPICAL SINGLE-LENS REFLEX CAMERA.** C. 1930–40. SIZE 3¼ X 4¼ INCH EXPOSURES ON SHEET FILM. 6⅜-INCH/F 4.5 BAUSCH & LOMB TESSAR LENS. FOCAL PLANE SHUTTER; ⅟₁₆ TO ⅟₈₀₀ SEC., T. THE SHUTTER SPEEDS WERE EXTENDED TO THE RANGE FROM ¼ TO 3 SECONDS IN 1932. REVOLVING BACK. FOCUSING BY UPPER VIEWING SCREEN OR GROUND GLASS ON BACK. TEAKWOOD AND BRASS BODY WITH RED LEATHER BELLOWS. THIS CAMERA WAS ALSO MANUFACTURED BY A. KERSHAW FROM 1905 TO 1921 AND BY AMALGAMATED PHOTOGRAPHIC MANUFACTURERS LIMITED FROM 1921 TO 1929. (GE)

## STANLEY, W. F.

(2128) **ENGINEER'S CAMERA.** C. 1887. THE CAMERA HAS A FOCUSING DISTANCE SCALE WHICH CAN BE SET ACCORDING TO THE DISTANCE MEASURED BETWEEN THE CAMERA AND THE SUBJECT.

(2129) **PATENT PORTABLE TOURIST CAMERA.** C. 1886.

## STEWARD, H.

(2130) **ERAC AUTOMATIC PISTOL CAMERA.** C. 1938. SIZE 18 X 18 MM EXPOSURES ON 20 MM ROLL FILM. A MOULDED PLASTIC BOX-FORM CAMERA WITH "TRIGGER" AND PISTOL-GRIP. THE "TRIGGER" RELEASES THE SHUTTER AND MOVES THE NEXT FRAME OF FILM INTO THE FOCAL PLANE. (BC)

## STEWART, R. W.

(2131) **PATENT PANORAMIC CAMERA.** C. 1895. BOX-FORM PANORAMIC CAMERA.

## SUN CAMERA COMPANY, LIMITED

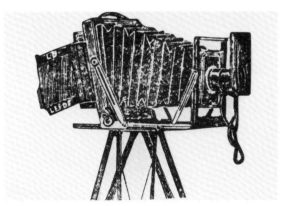

(2132) **LANGTRY OUTFIT VIEW CAMERA.** C. 1895. TWO SIZES OF THIS CAMERA FOR 4¼ X 6½ OR 6½ X 8½ INCH EXPOSURES ON PLATES. RAPID RECTILINEAR LENS. IRIS DIAPHRAGM.

## SUN CAMERA COMPANY, LIMITED (*cont.*)

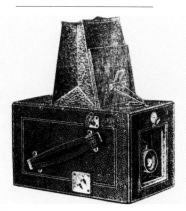

(2133) **NORTHERN OUTFIT VIEW CAMERA.** C. 1895. TWO SIZES OF THIS CAMERA FOR 4¼ X 6½ OR 6½ X 8½ INCH EXPOSURES ON PLATES. RAPID RECTILINEAR LENS. WATER-HOUSE STOPS. SOME CAMERAS WITH IRIS DIAPHRAGM.

## SWEET, WALLACH & COMPANY

(2134) **TURN-OVER MAGAZINE PLATE CAMERA.** C. 1890. SIZE 4 X 5 INCH EXPOSURES. THE PLATES ARE CHANGED BY INVERTING THE CAMERA.

## SWINDEN, E. V.

(2135) **MONARCH MAGAZINE BOX CAMERA.** C. 1894. SIZE 3¼ X 4¼ INCH EXPOSURES ON PLATES. EXTERNAL KNOB FOR FOCUSING. (BC)

## TALBOT & EAMER

(2136) **NO. 2 DIAMOND HAND CAMERA.** C. 1890. SIZE 3¼ X 4¼ INCH EXPOSURES ON PLATES. RECTILINEAR LENS, INSTANT AND TIME SHUTTER. THE MAGAZINE HOLDS 12 PLATES.

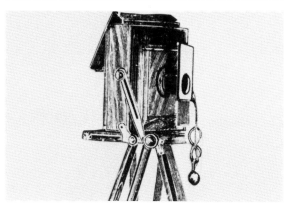

(2137) **MIRAL REFLEX HAND CAMERA. STANDARD MODEL NO. 2.** C. 1903. TWO SIZES OF THIS CAMERA FOR 3¼ X 4¼ OR 4 X 5 INCH EXPOSURES ON PLATES OR SHEET FILM. RICHMOND RAPID RECTILINEAR LENS. SELF-CAPPING SHUTTER; ⅒ TO ¹⁄₁₀₀ SEC., T. RACK & PINION FOCUSING. RISING LENS MOUNT.

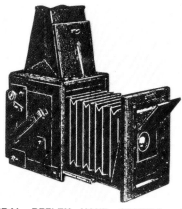

(2138) **MIRAL REFLEX HAND CAMERA.** C. 1907. SEVEN SIZES OF THIS CAMERA FOR 2 X 2½, 2½ X 3½, 3¼ X 3¼, 3¼ X 4¼, 3½ X 5½, 4 X 5, OR 4¼ X 6½ INCH EXPOSURES ON PLATES.

(2139) **TALMER HAND CAMERA.** C. 1890. SIZE 3¼ X 4¼ INCH EXPOSURES ON PLATES. THE MAGAZINE HOLDS 12 PLATES. RAPID ACHROMATIC LENS. INSTANT AND TIME SHUTTER.

## TALBOT, FOX

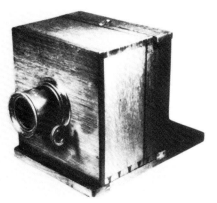

(2140) **SLIDING BOX CAMERA.** C. 1846. SIZE 4 X 5 INCH EXPOSURES ON CALOTYPE PLATES. CHARLES CHEVALIER LENS. (HA)

## TELLA CAMERA COMPANY

(2141) **TELLA BOX CAMERA.** C. 1899.

## THEOBALD, J. & COMPANY

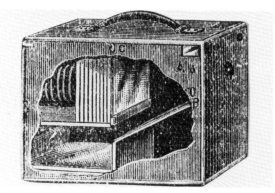

(2142) **METEOR HAND CAMERA.** C. 1893. THE MAGAZINE HOLDS 12 PLATES OR SHEET FILMS. SINGLE-SPEED AND TIME SHUTTER.

## THORNTON, JOHN EDWARD

(2143) **JUBILEE VIEW CAMERA.** C. 1887. ROLLER-BLIND TYPE FOCUSING SCREEN. REVOLVING BACK.

## THORNTON-PICKARD MANUFACTURING COMPANY

(2144) **AUTOMAN CAMERA.** C. 1901. THE FIRST ROLL FILM CAMERA TO USE THE SELF ERECTING PRINCIPLE. THORNTON-PICKARD DOUBLE-PNEUMATIC SHUTTER. (BC)

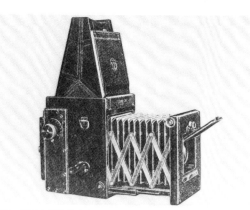

(2145) **DUPLEX DELUXE REFLEX CAMERA.** C. 1932. DOUBLE EXTENSION BELLOWS.

(2146) **DUPLEX RUBY TROPICAL SINGLE-LENS REFLEX CAMERA.** SIZE 3¼ X 4¼ INCH EXPOSURES. DOUBLE EXTENSION BELLOWS. F 6.3 COOKE ANASTIGMAT LENS. FOCAL PLANE SHUTTER TO ¹⁄₁₀₀₀ SEC.

(2147) **FOLDING PLATE CAMERA.** C. 1890. SIZE 5 X 7 INCH PLATE EXPOSURES. 210 MM/F 5 ZEISS UNAR LENS. FOCAL PLANE SHUTTER.

## THORNTON-PICKARD MANUFACTURING COMPANY (*cont.*)

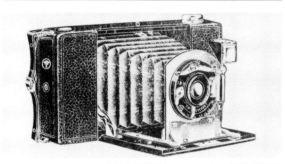

(2148) **FILMA FOLDING CAMERA.** C. 1913. TWO SIZES OF THIS CAMERA FOR 3¼ X 4¼ OR 3½ X 5½ INCH EXPOSURES ON FILMS OR PLATES. SINGLE LENS. INSTANT, B., T. SHUTTER.

(2151) **IMPERIAL CAMERA.** C. 1908. SIZE 4¼ X 6½ INCH EXPOSURES ON PLATES. TRIPLE EXTENSION BELLOWS. RACK & PINION FOCUSING. HORIZONTAL TILTING FRONT AND BACK. RISING FRONT.

(2154) **IMPERIAL ROLL FILM CAMERA.** C. 1924. SIZE 2⅛ X 3 INCH EXPOSURES ON SIZE 2¼ X 3¼ INCH ROLL FILM. SINGLE ACHROMATIC LENS. SINGLE-SPEED AND TIME SHUTTER. THREE APERTURE STOPS.

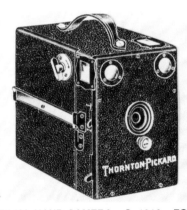

(2149) **FILMA HAND CAMERA.** C. 1912. FOUR SIZES OF THIS CAMERA FOR 2¼ X 3¼, 2½ X 4¼, 3¼ X 4¼, OR 3½ X 3½ INCH EXPOSURES ON ROLL FILM. T-P SINGLE LENS. EVERSET SHUTTER. THREE APERTURE STOPS.

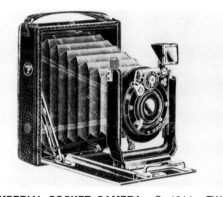

(2152) **IMPERIAL POCKET CAMERA.** C. 1914. TWO SIZES OF THIS CAMERA FOR 3¼ X 4¼ OR 3¼ X 5½ INCH EXPOSURES. T-P ACHROMATIC OR F 7.7 ALDIS ANASTIGMAT LENS. AUTOMATIC SHUTTER; 3 TO ⅟₃₀₀ SEC., T. OR SECTOR SHUTTER; 1 TO ⅟₁₀₀ SEC. ALSO, COMPOUND AND KOILOS SHUTTERS. GROUND GLASS FOCUSING. MODELS 1 THROUGH 6 HAVE SINGLE EXTENSION BELLOWS, MODELS 7 THROUGH 9 HAVE DOUBLE EXTENSION BELLOWS, AND MODELS 4 THROUGH 7 HAVE RACK & PINION FOCUSING.

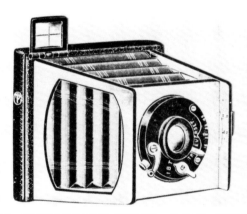

(2155) **KLIPPA FOLDING CAMERA.** C. 1913. SIZE 2½ X 3½ INCH EXPOSURES ON PLATES. SINGLE LENS OR RAPID RECTILINEAR LENS. SINGLE-SPEED, B., T. SHUTTER. RISING AND FALLING LENS BOARD.

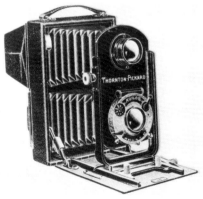

(2150) **FOLDING TWIN-LENS CAMERA.** C. 1912. SIZE 2½ X 3½ INCH EXPOSURES ON PLATES. T-P PAN-TOPLANAT LENSES. MULTISPEED, B., T. KOILOS SHUTTER. RISING AND CROSSING LENS MOUNT. RACK & PINION FOCUSING.

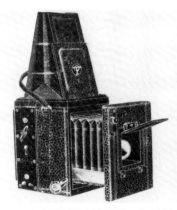

(2153) **IMPERIAL REFLEX CAMERA.** C. 1914. SIZE 3¼ X 4¼ INCH EXPOSURES ON PLATES OR FILM PACKS WITH ADAPTER. F 4.5 ALDIS, F 6.5 OR F 4.5 THORNTON-PICKARD RUBY ANASTIGMAT, OR F 4.5 ZEISS TESSAR LENS. FOCAL PLANE SHUTTER; ⅟₂₅ TO ⅟₁₀₀₀ SEC., T. REVOLVING BACK.

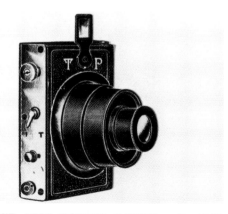

(2156) **LIMIT VEST POCKET CAMERA.** C. 1912. SIZE 1¾ X 2⅜ INCH EXPOSURES ON PLATES OR FILM PACKS WITH ADAPTER. F 6.5 COOKE ANASTIGMAT, T-P PANTOPLANAT, OR SINGLE ACHROMATIC LENS. ROLLER-BLIND FOCAL PLANE SHUTTER; ⅟₁₅ TO ⅟₁₀₀ SEC. ALL METAL BODY.

## THORNTON-PICKARD MANUFACTURING COMPANY (*cont.*)

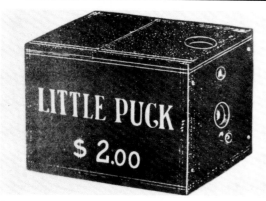

(2157) **LITTLE PUCK BOX CAMERA.** C. 1897. SIZE 2½ X 2½ INCH EXPOSURES ON PLATES. ACHROMATIC LENS. INSTANT AND TIME SAFETY SHUTTER.

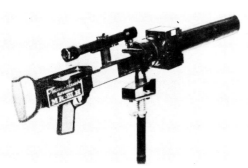

(2158) **PHOTOGRAPHIC RIFLE CAMERA.** C. 1915. SIZE 1¾ X 2⅜ INCH EXPOSURES ON NO. 120 ROLL FILM. 300 MM/F 8 LENS. SINGLE-SPEED SHUTTER. THE CAMERA WAS USED TO TRAIN MACHINE-GUNNERS IN THE R.A.F. DURING WORLD WAR I.

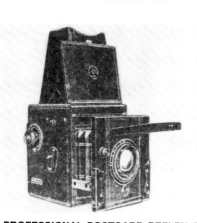

(2159) **PROFESSIONAL POSTCARD REFLEX CAMERA.** C. 1931. SIZE 3½ X 5½ INCH EXPOSURES ON PLATES. F 4.5 DALLMEYER SERRAC, COOKE ANASTIGMAT, ROSS XPRES, OR ZEISS TESSAR LENS. FOCAL PLANE SHUTTER. REVERSING BACK.

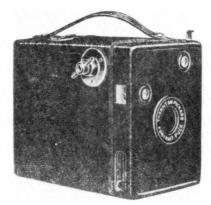

(2160) **PUCK BOX CAMERA.** C. 1931. SIZE 1⅝ X 2¼ INCH (1⅛ X 1⅝ INCH WITH MASK) EXPOSURES ON ROLL FILM.

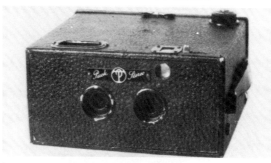

(2161) **STEREO PUCK BOX CAMERA.** C. 1932. SIZE 2¼ X 3¼ INCH EXPOSURES ON NO. 120 ROLL FILM. INSTANT AND TIME SHUTTER. (VC)

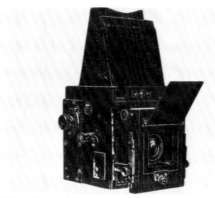

(2162) **RUBY DELUXE REFLEX CAMERA.** C. 1933. EXPOSURES ON PLATES. FOCAL PLANE SHUTTER; ¹⁄₁₀ TO ¹⁄₁₀₀₀ SEC., T. DOUBLE SWING LENS MOUNT.

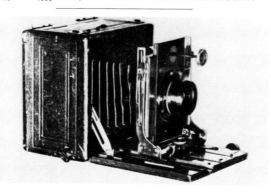

(2163) **RUBY HAND AND STAND CAMERA.** C. 1909. SIZE 3¼ X 4¼ INCH EXPOSURES ON PLATES.

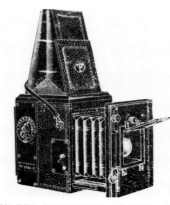

(2164) **RUBY REFLEX CAMERA.** C. 1914. FIVE SIZES OF THIS CAMERA FOR 3¼ X 4¼, 3½ X 5½, 4 X 5, 4¾ X 6½ INCH, OR 9 X 12 CM EXPOSURES ON PLATES. F 6.5 OR F 4.6 THORNTON-PICKARD RUBY ANASTIGMAT, F 6 ALDIS, F 6.8 BECK, F 4.5 COOKE, F 6 DALLMEYER, F 6.8 GOERZ DAGOR, F 4.5 GOERZ CELOR, F 4.5 ROSS, F 5.4 VOIGTLANDER COLLINEAR, F 4.5 VOIGTLANDER HELIAR, F 6.3 ZEISS PROTAR, F 4.5 ZEISS TESSAR, OR F 4 LACOUR-BERTHIOT LENS. FOCAL PLANE SHUTTER; ¹⁄₁₀ TO ¹⁄₁₀₀₀ SEC., T. SOME MODELS WITH REVERSING BACK.

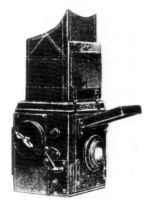

(2165) **HORIZONTAL RUBY REFLEX CAMERA.** C. 1932. SIZE 2½ X 3½ INCH EXPOSURES ON PLATES OR FILM PACKS OR 2¼ X 3¼ INCH EXPOSURES ON ROLL FILM WITH ROLL HOLDER. F 4.5, F 3.5 OR F 2.9 DALLMEYER, F 4.5 OR F 3.5 ROSS XPRES; OR F 4.5 OR F 3.5 ZEISS TESSAR LENS. RUBY FOCAL PLANE SHUTTER. RACK & PINION FOCUSING.

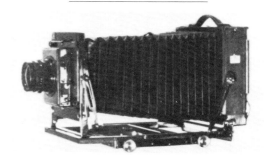

(2166) **ROYAL RUBY CAMERA.** C. 1905. TRIPLE EXTENSION BELLOWS. TILTING LENS BOARD. RACK & PINION FOCUSING.

## THORNTON-PICKARD MANUFACTURING COMPANY (*cont.*)

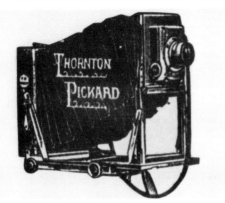

(2167) **SPECIAL RUBY CAMERA.** C. 1905. SIZE 4¼ X 6½ INCH EXPOSURES ON PLATES. F 8 BECK RAPID SYMMETRICAL LENS. INSTANT AND TIME SHUTTER.

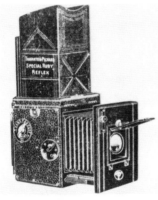

(2168) **SPECIAL RUBY REFLEX CAMERA.** C. 1914. SIZE 3¼ X 4¼ INCH EXPOSURES ON PLATES. F 6.5 RUBY ANASTIGMAT LENS. FOCAL PLANE SHUTTER. REVOLVING BACK.

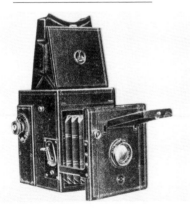

(2169) **JUNIOR SPECIAL RUBY REFLEX CAMERA.** C. 1924. PLATE EXPOSURES. F 4.5 COOKE- T.P. ANASTIGMAT LENS. THORNTON-PICKARD FOCAL PLANE SHUTTER. REVOLVING BACK.

(2170) **SINGLE-LENS REFLEX CAMERA.** C. 1925. SIZE 2¼ X 3¼ INCH EXPOSURES. DALLMEYER OR COOKE LENS.

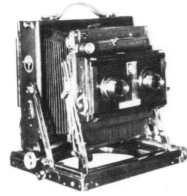

(2171) **SPECIAL RUBY STEREO CAMERA.** C. 1915. SIZE 4¼ X 6¼ INCH STEREO EXPOSURES ON PLATES.

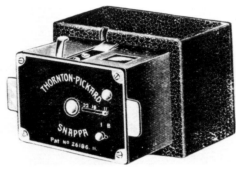

(2172) **SNAPPA CAMERA.** C. 1914. SIZE 1¾ X 2⁵⁄₁₆ INCH EXPOSURES ON SHEET OR PLATE FILM. SINGLE ACHROMATIC LENS. THREE APERTURE STOPS. INSTANT AND TIME SHUTTER. SLIDING-BOX FOCUS.

(2173) **TWIN-LENS HAND CAMERA.** C. 1894. SIZE 3¼ X 4¼ INCH PLATE EXPOSURES. EACH OF THE TWO LENSES, ONE FOR MAKING EXPOSURES AND ONE FOR FOCUSING, ARE ATTACHED TO SEPARATE BELLOWS. THE BELLOWS ARE POSITIONED SIDE-BY-SIDE. ROLLER-BLIND SHUTTER. RACK & PINION FOCUSING. THE CAMERA CAN ALSO BE USED AS A STEREOSCOPIC CAMERA.

(2174) **TWIN-LENS REFLEX CAMERA.** C. 1912. THE CAMERA HAS TWO LENSES, ONE FOR MAKING EXPOSURES AND ONE FOR FOCUSING, EACH OF WHICH IS ATTACHED TO SEPARATE BELLOWS. THE BELLOWS ARE POSITIONED ONE ABOVE THE OTHER. RISING LENS MOUNT FOR BOTH LENSES. (BC)

(2175) **VIEW CAMERA.** C. 1893. SIZE 4¼ X 6½ INCH EXPOSURES. BECK SYMMETRICAL LENS. STRING-COCKING SHUTTER.

(2176) **IMPERIAL VIEW CAMERA.** C. 1885. SIZE 4½ X 6½ INCH EXPOSURES ON PLATES. THORNTON-PICKARD SYMMETRICAL LENS. THORNTON-PICKARD ROLLER-BLIND SHUTTER. REVERSIBLE BACK.

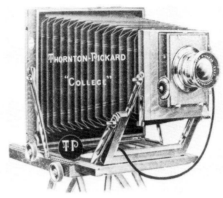

(2177) **COLLEGE VIEW CAMERA.** C. 1914. FOUR SIZES OF THIS CAMERA FOR 3¼ X 4¼, 4¾ X 6½, 5 X 7, OR 6½ X 8½ INCH EXPOSURES ON PLATES. F 8 RECTOPLANAT, F 8 BECK RAPID SYMMETRICAL, F 8 T-P PANTOPLANAT OR F 7.7 ALDIS ANASTIGMAT LENS. THORNTON-PICKARD ROLLER-BLIND SHUTTER; ¹⁄₁₅ TO ¹⁄₉₀ SEC., T. EXTENDING AND SWINGING FRONT. DOUBLE SWING BACK. REVERSING BACK. DOUBLE RACK & PINION FOCUSING. RISING AND FALLING LENS MOUNT.

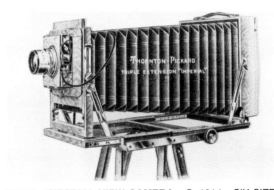

(2178) **IMPERIAL VIEW CAMERA.** C. 1914. SIX SIZES OF THIS CAMERA FOR 3¼ X 4¼, 4 X 5, 3½ X 5½, 4¾ X 6½, 5 X 7, OR 6½ X 8½ INCH EXPOSURES ON PLATES. F 8 BECK SYMMETRICAL, F 8 T-P PANTOPLANAT, F 8 T-P RECTOPLANAT, OR F 7.7 ALDIS ANASTIGMAT LENS. THORNTON-PICKARD ROLLER-BLIND SHUTTER; ¹⁄₁₅ TO ¹⁄₉₀ SEC., T. TRIPLE EXTENSION BELLOWS. TRIPLE SWING BACK. TRIPLE SWING FRONT. RISING, FALLING, AND CROSSING LENS MOUNT. REVERSING BACK. DOUBLE RACK & PINION FOCUS. GROUND GLASS FOCUS.

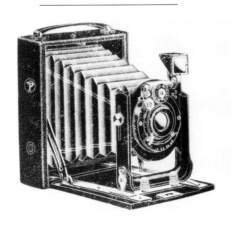

## THORNTON-PICKARD MANUFACTURING COMPANY (cont.)

(2179) **WEENIE CAMERA.** C. 1914. SIZE 3¼ X 4¼ INCH EXPOSURES ON SHEET OR PLATE FILM. SINGLE ACHROMATIC, RECTOPLANAT, OR F 6 OR F 7.7 ALDIS ANASTIGMAT LENS. AUTOMATIC SHUTTER; 3 TO ⅓₀₀ SEC. OR SECTOR SHUTTER; 1 TO ¹⁄₁₀₀ SEC. GROUND GLASS FOCUSING.

(2180) **IMPERIAL PERFECTA VIEW CAMERA.** C. 1885. SIZE 6½ X 8½ INCH EXPOSURES ON PLATES. THORNTON-PICKARD PANTOPLANAX LENS. ROLLER-BLIND "MOUSE TRAP" TYPE SHUTTER.

## TYLER, WILLIAM T.

(2181) **DETECTIVE CAMERA.** C. 1890. SIZE 3¼ X 4¼ INCH PLATE EXPOSURES. SINGLE-SPEED GUILLOTINE SHUTTER. (MA)

(2182) **REVOLVER PHOTO CAMERA.** C. 1904. THREE SIZES OF THIS CAMERA FOR 3¼ X 4¼, 4 X 5, OR 4¼ X 6½ INCH PLATE EXPOSURES. FOUR EXPOSURES ARE OBTAINED ON EACH PLATE BY ROTATING THE LENS PANEL.

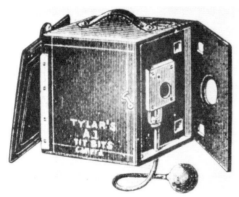

(2183) **TIT-BIT NO. 1A HAND CAMERA.** C. 1896. TWO SIZES OF THIS CAMERA FOR 3¼ X 4¼ OR 4¼ X 6½ INCH EXPOSURES ON PLATES. SINGLE OR RAPID RECTILINEAR LENS. PNEUMATIC SHUTTER FOR INSTANT AND TIME EXPOSURES.

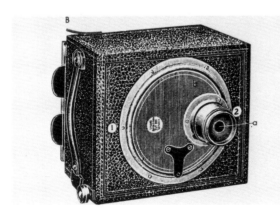

(2184) **TIT-BIT PORTRAIT CAMERA.** C. 1904. TWO EXPOSURES ARE MADE ON A 3¼ X 4¼ INCH PLATE BY ROTATING THE LENS 180 DEGREES. THE LENS IS MOUNTED ON A CIRCULAR LENS BOARD.

(2185) **TIT-BIT HAND CAMERA.** C. 1896. TWO SIZES OF THIS CAMERA FOR 3¼ X 4¼ OR 4¼ X 6½ INCH EXPOSURES ON PLATES. SIMILAR TO THE TIT-BIT NO. 1A HAND CAMERA.

## UNDERWOOD, E. & T.

(2186) **ARGOSY MAGAZINE BOX CAMERA.** C. 1895. SIZE 3¼ X 4¼ INCH EXPOSURES ON PLATES. THE MAGAZINE HOLDS 12 PLATES. ACHROMATIC LENS. SINGLE-SPEED OR VARIABLE-SPEED SHUTTER. SIMILAR TO THE IDLER BOX CAMERA.

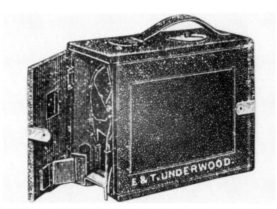

(2187) **AUTOMAT HAND CAMERA.** C. 1896. SIZE 3¼ X 4¼ INCH EXPOSURES ON PLATES.

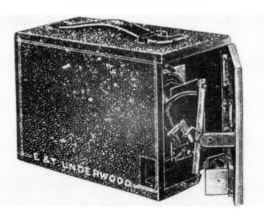

(2188) **CITY HAND CAMERA.** C. 1896. SIZE 3¼ X 4¼ INCH EXPOSURES ON PLATES OR CUT FILM. ACHROMATIC LENS. SINGLE-SPEED OR VARIABLE-SPEED SHUTTER.

(2189) **TRIPLE EXTENSION FOLDETTE CAMERA.** C. 1905. TWO SIZES OF THIS CAMERA FOR 3¼ X 4¼ OR 4 X 5 INCH EXPOSURES ON PLATES. SIMILAR TO THE FOLDETTE CAMERA WITH THE SAME LENS AND SHUTTER BUT WITH TRIPLE EXTENSION BELLOWS.

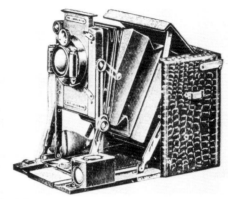

(2190) **FOLDETTE CAMERA.** C. 1905. TWO SIZES OF THIS CAMERA FOR 3¼ X 4¼ OR 4 X 5 INCH EXPOSURES ON PLATES. RAPID RECTILINEAR LENS. AUTOMATIC SHUTTER. REVERSING BACK. RISING AND SWING FRONT. RACK & PINION FOCUS.

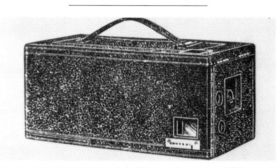

(2191) **IDLER HAND CAMERA.** C. 1896. SIZE 3¼ X 4¼ INCH EXPOSURES ON PLATES.

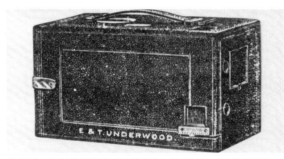

(2192) **SPHYNX HAND CAMERA.** C. 1896. SIZE 3¼ X 4¼ INCH EXPOSURES ON PLATES. EURYSCOPE LENS. INSTANT AND TIME ROLLER-BLIND SHUTTER. IRIS DIAPHRAGM. OUTSIDE FOCUSING KNOB.

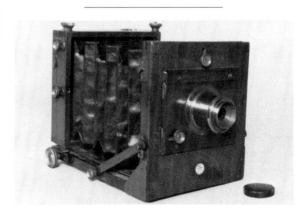

## UNDERWOOD, E. & T. (*cont.*)

(2193) **VIEW CAMERA.** C. 1886. SIZE 4 X 5 INCH EXPOSURES ON PLATES. (TH)

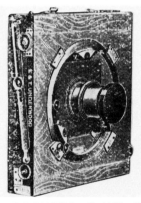

(2194) **VIEW CAMERA.** C. 1896. SIZE 4¼ X 6½ INCH EXPOSURES ON PLATES. THORNTON-PICKARD TYPE CURTAIN SHUTTER. F 8 UNDERWOOD LENS. (EL)

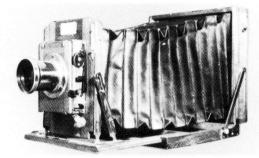

(2195) **CLUB VIEW CAMERA.** C. 1896. TWO SIZES OF THIS CAMERA FOR 4¼ X 6½ OR 6½ X 8½ INCH EXPOSURES ON PLATES.

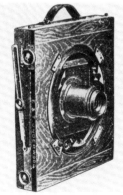

(2196) **FIELD VIEW CAMERA.** C. 1896. TWO SIZES OF THIS CAMERA FOR 4¼ X 6½ OR 6½ X 8½ INCH EXPOSURES ON PLATES.

(2197) **INSTANTO VIEW CAMERA.** C. 1886. SWING BACK.

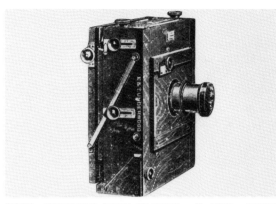

(2198) **INSTANTO VIEW CAMERA.** C. 1896. THREE SIZES OF THIS CAMERA FOR 3¼ X 4¼, 4¼ X 6½, OR 6½ X 8½ INCH EXPOSURES ON PLATES.

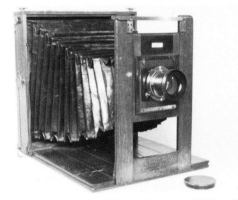

(2199) **STUDIO VIEW CAMERA.** C. 1885. SIZE 11 X 14 INCH EXPOSURES ON PLATES. VOIGTLANDER LENS. FLAPPER-TYPE SHUTTER. (TH)

## VEVERS, C. C.

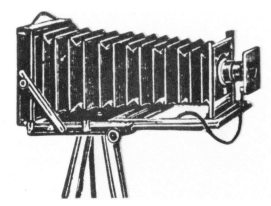

(2200) **PHOEBUS OUTFIT STAND CAMERA.** C. 1904. SIZE 4¼ X 6½ INCH EXPOSURES ON PLATES. RECTILINEAR LENS. IRIS DIAPHRAGM. PNEUMATIC INSTANT AND TIME SHUTTER. RACK & PINION FOCUS. REVERSING BACK. SWING BACK.

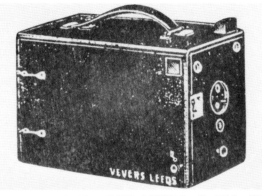

(2201) **VEVEO NO. 1 HAND CAMERA.** C. 1904. SIZE 3¼ X 4¼ INCH EXPOSURES ON PLATES. THE MAGAZINE HOLDS 12 PLATES. RAPID RECTILINEAR LENS. INSTANT AND TIME SHUTTER.

## WATSON, W. & SONS LIMITED

(2202) **ACME TOURIST'S CAMERA.** C. 1930.

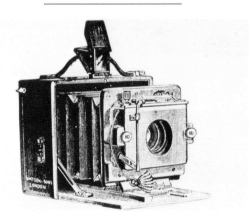

(2203) **ALPHA CAMERA.** C. 1893–99. THREE SIZES OF THIS CAMERA FOR 3¼ X 4¼, 4 X 5, OR 4¾ X 6½ INCH EXPOSURES ON PLATES. RAPID RECTILINEAR LENS. IRIS DIAPHRAGM. GROUND GLASS FOCUSING.

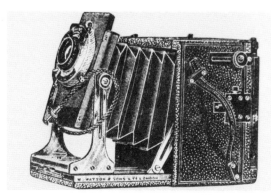

(2204) **ALPHA DELUXE MODEL CAMERA.** C. 1930. SIZE 3¼ X 4¼ INCH EXPOSURES ON PLATES. HOLOSTIGMAT LENS. REVERSING BACK. RACK & PINION FOCUS. SWING BACK. DROPPING BED. DOUBLE EXTENSION BELLOWS.

## WATSON, W. & SONS LIMITED (*cont.*)

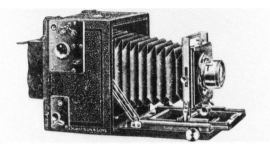

**(2205) ALPHA FOCAL PLANE CAMERA.** C. 1904. TWO SIZES OF THIS CAMERA FOR 3¼ X 4¼ OR 4 X 5 INCH EXPOSURES ON PLATES. F 6.1 HOLOSTIGMAT LENS. FOCAL PLANE SHUTTER; ⅕ TO ¹⁄₁₀₀₀ SEC., T.

**(2206) NO. 2 ALPHA CAMERA.** C. 1899. THREE SIZES OF THIS CAMERA FOR 3¼ X 4¼, 4 X 5, OR 4¾ X 6½ INCH EXPOSURES ON PLATES. SIMILAR TO THE ALPHA CAMERA (C. 1893–99) WITH THE SAME LENS AND SHUTTER.

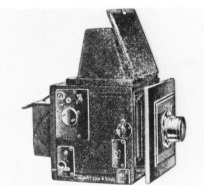

**(2207) ARGUS REFLEX CAMERA.** C. 1904. TWO SIZES OF THIS CAMERA FOR 3¼ X 4¼ OR 4 X 5 INCH EXPOSURES ON PLATES. F 6.1 HOLOSTIGMAT LENS. FOCAL PLANE SHUTTER; ⅕ TO ¹⁄₁₀₀₀ SEC., T.

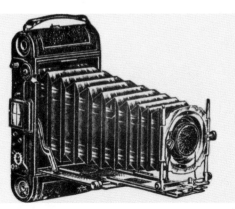

**(2208) DEFT FOCAL PLANE CAMERA.** C. 1906. EXPOSURES ON PLATES OR ROLL FILM. WATSON HOLOSTIGMAT LENS. FOCAL PLANE SHUTTER WITH SPEEDS TO ¹⁄₂₀₀₀ SEC.

**(2209) DETECTIVE BOX CAMERA.** C. 1886. SIZE 3¼ X 4¼ INCH EXPOSURES ON PLATES. INTERNAL BELLOWS. EXTERIOR FOCUSING KNOB. VERTICAL AND HORIZONTAL "BRILLIANT" FINDERS. MAGAZINE FOR HOLDING THREE DOUBLE PLATES. (IH)

**(2210) FIELD CAMERA.** C. 1885. SIZE 4¼ X 6½ INCH EXPOSURES ON PLATES. F 8 WATSON LENS. THORNTON-PICKARD ROLLER-BLIND SHUTTER.

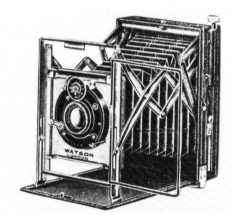

**(2211) FOLDING HAND CAMERA.** C. 1912. SIZE 3¼ X 4¼ INCH EXPOSURES ON PLATES. F 6.8 APLANAT OR F 6 HOLOSTIGMAT LENS. COMPOUND OR IBSO SHUTTER. RISING AND FALLING LENS MOUNT. HOODED FOCUSING SCREEN.

**(2212) FRAM HAND CAMERA.** C. 1899. SIZE 3¼ X 4¼ INCH EXPOSURES. RAPID RECTILINEAR LENS. EXTERNAL KNOB FOR FOCUSING.

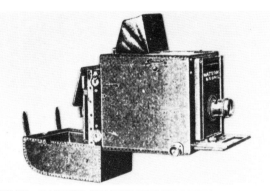

**(2213) GAMBIER BOLTON REFLEX CAMERA.** C. 1898. THREE SIZES OF THIS CAMERA FOR 3¼ X 4¼, 4 X 5, OR 4¼ X 6½ INCH EXPOSURES ON PLATES OR SHEET FILM. THE MAGAZINE HOLDS 12 PLATES. F 6.5 HOLOSTIGMAT OR RAPID RECTILINEAR LENS. IRIS DIAPHRAGM. FOCAL PLANE SHUTTER. RISING LENS MOUNT.

**(2214) MAGAZINE DETECTIVE BOX CAMERA.** C. 1890. SIZE 3 X 4 INCH EXPOSURES.

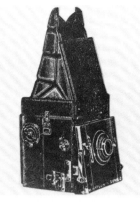

**(2215) PERSPECT FOCAL PLANE REFLEX CAMERA.** C. 1918. SIZE 3¼ X 4¼ INCH EXPOSURES ON PLATES. FOCAL PLANE SHUTTER. REVOLVING BACK. RACK & PINION FOCUSING. RISING LENS MOUNT.

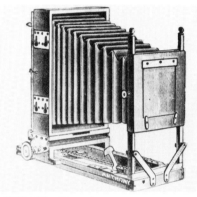

**(2216) PREMIER STUDIO AND OUTDOOR CAMERA.** C. 1893–98. FIVE SIZES OF THIS CAMERA FOR 4¾ X 6½, 6½ X 8½, 8 X 10, 10 X 12, OR 12 X 15 INCH EXPOSURES ON PLATES. REVERSING BACK. DOUBLE SWING BACK. RACK & PINION FOCUS. IN 1893, THIS CAMERA WAS ALSO AVAILABLE IN THE 16 X 18 INCH EXPOSURE SIZE.

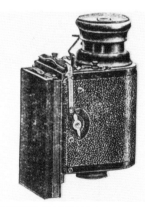

**(2217) SPORTSMAN DETECTIVE CAMERA.** C. 1922. SIZE 4.5 X 6 CM EXPOSURES ON PLATES OR FILM PACKS. F 4.5 LENS. THREE-SPEED SHUTTER; ¹⁄₂₅, ¹⁄₅₀, ¹⁄₁₀₀ SEC., T. EXTERNAL KEY FOR FOCUSING. THE CAMERA IN THE FORM OF A MONOCULAR FIELD GLASS IS POINTED AT A 90-DEGREE ANGLE FROM THE SUBJECT TO BE PHOTOGRAPHED.

## WATSON, W. & SONS LIMITED (cont.)

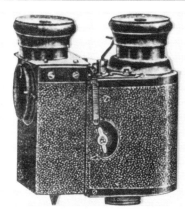

**(2218) SPORTSMAN DETECTIVE MAGAZINE CAMERA.** C. 1922. TWO SIZES OF THIS CAMERA FOR 4.5 X 6 OR 4.5 X 10.7 CM EXPOSURES ON PLATES OR FILM PACKS. F 6.3 LENS. THE 4.5 X 6 CM EXPOSURE MODEL HAS EITHER A SIX-PLATE OR 12-PLATE MAGAZINE, WHEREAS THE 4.5 X 10.7 CM MODEL HAS A 12-PLATE MAGAZINE. EXTERNAL KEY FOR FOCUSING. THE CAMERA IN THE FORM OF A BINOCULAR IS POINTED AT A 90-DEGREE ANGLE FROM THE SUBJECT TO BE PHOTOGRAPHED.

**(2219) STEREOSCOPIC CAMERA.** C. 1852. STEREO EXPOSURES ON PLATES. TWO TAILBOARD BELLOWS CAMERAS ARE MOUNTED ON AN ANGLED BASE. (IH)

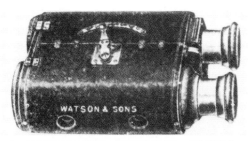

**(2220) STEREOSCOPIC BINOCULAR CAMERA.** C. 1901. SIZE 2 X 4¾ INCH STEREO EXPOSURES ON PLATES. THE MAGAZINE HOLDS 12 PLATES. RAPID RECTILINEAR LENSES. SHUTTER SPEEDS FROM ¹⁄₂₅ to ¹⁄₈₀ SEC., T. THE CAMERA IS POINTED AS A BINOCULAR AT A RIGHT ANGLE FROM THE SUBJECT TO BE PHOTOGRAPHED.

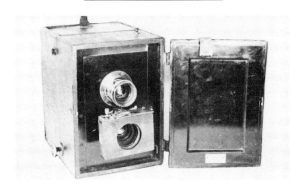

**(2221) TWIN-LENS REFLEX CAMERA.** C. 1899. THREE SIZES OF THIS CAMERA FOR 3¼ X 4¼, 4 X 5, OR 4¾ X 6½ INCH PLATE EXPOSURES. WATSON RAPID RECTILINEAR LENSES. THORNTON-PICKARD ROLLER-BLIND SHUTTER. IRIS DIAPHRAGM. (SW)

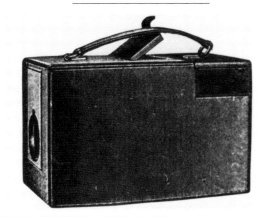

**(2222) VANNECK HAND CAMERA.** C. 1899. TWO SIZES OF THIS CAMERA FOR 3¼ X 3¼ OR 3¼ X 4¼ INCH EXPOSURES ON PLATES.

**(2223) VANNECK SINGLE-LENS REFLECT CAMERA.** C. 1890. SIZE 3¼ X 4¼ INCH EXPOSURES ON PLATES. TAYLOR & HOBSON LENS. THE SHUTTER IS THE UP AND DOWN MOVEMENT OF THE REFLEX MIRROR. THE MAGAZINE HOLDS 12 PLATES WITH A CHANGING BAG.

**(2224) VIEW CAMERA.** C. 1900. SIZE 4 X 6 INCH EXPOSURES ON PLATES. RAPID RECTILINEAR LENS. IRIS DIAPHRAGM. (HA)

**(2225) ACME VIEW CAMERA.** C. 1896. SIX SIZES OF THIS CAMERA FOR 4¾ X 6½, 5 X 7½, 6½ X 8½, 8 X 10, 10 X 12, OR 12 X 15 INCH EXPOSURES ON PLATES. RAPID RECTILINEAR LENS. IRIS DIAPHRAGM.

**(2226) PREMIER SQUARE-BELLOWS VIEW CAMERA.** C. 1930.

**(2227) PREMIER TOURIST VIEW CAMERA.** C. 1883. SWING BACK.

**(2228) UNIVERSAL STUDIO VIEW CAMERA.** C. 1897. FOUR SIZES OF THIS CAMERA FOR 4¼ X 6½, 6½ X 8½, 8 X 10, OR 10 X 12 INCH EXPOSURES ON PLATES. SWING BACK.

## WESTMINSTER PHOTOGRAPHIC EXCHANGE LIMITED

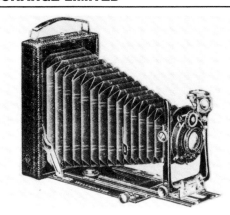

## WESTMINSTER PHOTOGRAPHIC EXCHANGE LIMITED (*cont.*)

(2229) **FOLDING CAMERA.** C. 1914. THREE SIZES OF THIS CAMERA FOR 3¼ X 4¼, 3½ X 5½ INCH, OR 10 X 15 CM EXPOSURES ON PLATES OR FILM PACKS. F 7.7 DOUBLE APLANAT, F 6.8 ROSS COMPOUND HOMOCENTRIC OR GOERZ DAGOR SERIES III ANASTIGMAT LENS. ALSO, F 6.5 COOKE SERIES III ANASTIGMAT LENS. COMPOUND SHUTTER; 1 TO ⅟₂₅₀ SEC. GROUND GLASS FOCUSING. DOUBLE EXTENSION BELLOWS.

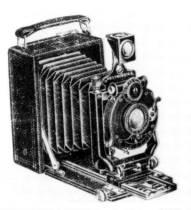

(2230) **MINIATURE CAMERA.** C. 1914. SIZE 1¾ X 2⁵⁄₁₆ INCH EXPOSURES ON PLATES OR FILM PACKS. F 6.8 WESTMINSTER ANASTIGMAT LENS. THE SINGLE BELLOWS EXTENSION MODEL HAS A SHUTTER FOR SPEEDS FROM ⅟₂₅ TO ⅟₁₀₀ SEC., B., T. THE DOUBLE BELLOWS EXTENSION MODEL HAS A COMPOUND SECTOR SHUTTER FOR SPEEDS OF 1 TO ⅟₃₀₀ SEC., B., T. AND RACK & PINION FOCUSING.

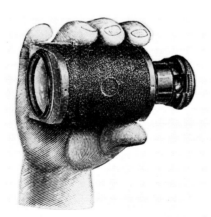

(2231) **MONOCULAR DETECTIVE CAMERA.** C. 1914. SIZE 1¾ X 2⅜ INCH PLATE EXPOSURES. THE CAMERA TAKES PICTURES AT RIGHT ANGLES TO THE DIRECTION THE "MONOCULAR" WOULD NORMALLY BE POINTED. THE MAGAZINE HOLDS 12 PLATES. F 6.5 COOKE SERIES II ANASTIGMAT LENS. INSTANT AND TIME SHUTTER. GROUND GLASS FOCUSING.

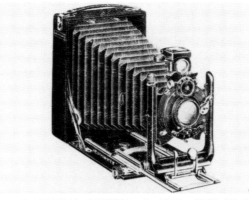

(2232) **SPECIAL CAMERA.** C. 1914. SIZE 3¼ X 4¼ INCH EXPOSURES ON PLATES OR FILM PACKS. F 8 WESTMINSTER APLANAT, F 6.8 WESTMINSTER ANASTIGMAT, F 6.8 ROSS COMPOUND HOMOCENTRIC, F 6.3 OR F 6 DALLMEYER STIGMATIC, F 6.8 GOERZ DAGOR ANASTIGMAT, OR F 6.3 OR F 4.5 ZEISS TESSAR LENS. COMPOUND SECTOR SHUTTER; 1 TO ⅟₂₅₀ SEC., B., T. SOME MODELS WITH SHUTTERS TO ⅟₂₀₀ SEC. RISING AND CROSSING FRONT. GROUND GLASS FOCUS.

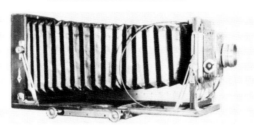

(2233) **VIEW CAMERA.** C. 1900. SIZE 5 X 7 INCH EXPOSURES ON PLATES. TAYLOR & HOPSON LENS. THORNTON-PICKARD ROLLER-BLIND SHUTTER. TRIPLE EXTENSION BELLOWS. (EL)

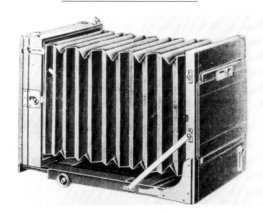

(2234) **SQUARE BELLOWS VIEW CAMERA.** FIVE SIZES OF THIS CAMERA FOR 4¼ X 6½, 6½ X 8½, 8 X 10, 10 X 12, OR 12 X 15 INCH PLATE EXPOSURES.

## WILLATS, T. & R.

(2235) **COLLAPSIBLE CAMERA.** C. 1852.

## WILLIAMSON MANUFACTURING COMPANY, LIMITED

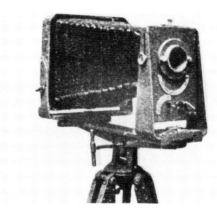

(2236) **ALL-METAL STAND CAMERA.** C. 1931. SIZE 6½ X 8½ INCH EXPOSURES ON PLATES. SINGLE-SPEED (⅟₂₅ SEC.) AND TIME SHUTTER. THE TRIPOD-MOUNTED CAMERA CAN BE TILTED TO PHOTOGRAPH OBJECTS DIRECTLY DOWNWARD OR DIRECTLY UPWARDS (PARALLEL TO VERTICAL AXIS OF THE TRIPOD). REVOLVING BACK. MICROMETER FOCUSING SCREEN.

## WINDOW, F. R.

(2237) **DIAMOND CAMEO CAMERA.** C. 1864. THE CAMERA HAS A REPEATING BACK THAT CAN BE MOVED VERTICALLY OR HORIZONTALLY FOR MAKING MULTIPLE CAMEO EXPOSURES ON A SINGLE PLATE.

## WOOLLEY, JAMES SONS & COMPANY, LIMITED

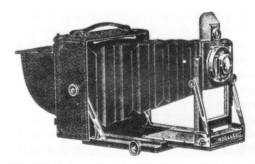

(2238) **NO. 5 VICTORIA FOLDING CAMERA.** C. 1905. SIZE 3¼ X 4¼ INCH EXPOSURES ON PLATES. RAPID RECTILINEAR LENS. SHUTTER SPEEDS FROM ⅟₅ TO ⅟₁₀₀ SEC. IRIS DIAPHRAGM. REVERSIBLE BACK. RISING AND FALLING LENS MOUNT.

## WRATTEN AND WAINWRIGHT

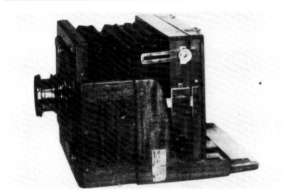

(2239)  **TAILBOARD CAMERA.**  C. 1890.

## MANUFACTURER UNKNOWN

(2240)  **BRIN'S PATENT CAMERA.**  C. 1891.  EXPOSURES ON A 25 MM DIAMETER PLATE.  A DUAL-PURPOSE CAMERA WHICH ALSO SERVES AS A MONOCULAR MOUNTED ON A LONG METAL HANDLE.  WHEN THE PHOTOGRAPHIC PLATE IS REMOVED, THE INSTRUMENT CAN BE USED AS A MONOCULAR WITH EYE-PIECE FOCUSING.  50 MM/F 3.5 LENS.  (IH) (MA)

(2241)  **GLOBE TWIN-LENS CAMERA.**  C. 1898.  SIZE 3¼ X 4¼ OR 4¼ X 6½ INCH EXPOSURES ON PLATES, CUT FILM, OR ROLL FILM.  THE CAMERA CAN BE USED AS A STEREOSCOPIC CAMERA, A PLATE CAMERA, OR AN AUTOMATIC MAGAZINE CAMERA.

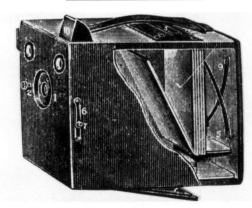

(2242)  **LIGHTNING HAND CAMERA.**  C. 1897.  SIZE 3¼ X 4¼ INCH EXPOSURES ON PLATES.  THE MAGAZINE HOLDS 12 PLATES.  SINGLE ACHROMATIC OR RAPID RECTILINEAR LENS.  INSTANT AND TIME SHUTTER.

(2243)  **NO. 1A LIGHTNING HAND CAMERA.**  C. 1904.  TWO SIZES OF THIS CAMERA FOR 3¼ X 4¼ OR 4 X 5 INCH EXPOSURES ON PLATES.  F 8 RAPID RECTILINEAR LENS.  EVERSET SHUTTER; ⅕ TO ¹⁄₁₀₀ SEC.  REVOLVING APERTURE STOPS.  THE MAGAZINE HOLDS 12 PLATES.

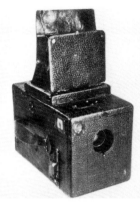

(2244)  **MAGAZINE REFLEX BOX CAMERA.**  C. 1895.  SIZE 3¼ X 4¼ INCH EXPOSURES ON PLATES.  THE MAGAZINE HOLDS 12 PLATES.  FOUR-SPEED SHUTTER.  (HA)

(2245)  **MORLEY'S STUDENT CAMERA.**  C. 1885.  SIZE 4¼ X 6½ INCH EXPOSURES ON PLATES.  DALLMEYER LENS.  WATERHOUSE STOPS.  LENS-CAP SHUTTER.

(2246)  **MORLEY'S UNIVERSAL CAMERA.**  C. 1885.  SIZE 8 X 10 INCH EXPOSURES ON PLATES.  DALLMEYER LENS.  WATERHOUSE STOPS.  LENS-CAP SHUTTER.

(2247)  **NATIONAL FOLDING FIELD CAMERA.**  SIZE 4¼ X 6½ INCH EXPOSURES.  REVERSIBLE BACK.  7-INCH/ F 6.3 ROSS HOMOCENTRIC LENS.  THORNTON-PICKARD ROLLER BLIND SHUTTER.

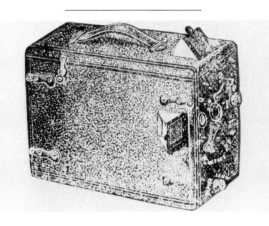

(2248)  **SPEEDY HAND CAMERA.**  C. 1897.  SIZE 3¼ X 4¼ INCH EXPOSURES ON PLATES.  THE MAGAZINE HOLDS 12 PLATES.  SINGLE OR RAPID RECTILINEAR LENS.  INSTANT AND TIME SHUTTER.

(2249)  **STEREOSCOPIC CAMERA.**  C. 1865.  SIZE 90 X 170 MM STEREO EXPOSURES ON WET COLLODION PLATES.  ROSS LENSES.  SLIDING-BOX FOCUSING.  RISING LENS MOUNT.  (MA)

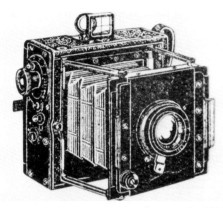

(2250)  **ZODEL PRESS CAMERA.**  C. 1924.  PLATE EXPOSURES.  F 3.5 STEINHEIL CASSAR ANASTIGMAT LENS.  FOCAL PLANE SHUTTER; ¹⁄₁₅ TO ¹⁄₁₀₀₀ SEC.

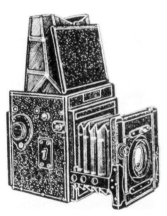

(2251)  **ZODEL SUPER REFLEX CAMERA.**  C. 1924.  F 3.6 STEINHEIL CASSAR LENS.  FOCAL PLANE SHUTTER; ¹⁄₁₀ TO ¹⁄₁₀₀₀ SEC., T.  RISING AND FALLING LENS MOUNT.  REVOLVING BACK.

## AIVAS, A.

**(2252) BEGINNER'S VIEW CAMERA.** C. 1910. SIZE 9 X 13 CM EXPOSURES ON PLATES OR SHEET FILM. MENISCUS LENS. (MA)

## AIVAS & CHAUVET

**(2253) LE FIN DE SIÉCLE FOLDING MAGAZINE CAMERA.** C. 1892. SIZE 9 X 12 CM EXPOSURES ON PLATES. 150 MM/F 8 APLANAT LENS. NO SHUTTER. (MA)

## ALIBERT, CHARLES

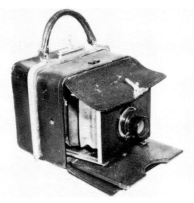

**(2254) PHOTO-SAC Á MAIN CAMERA.** C. 1895. SIZE 9 X 12 CM EXPOSURES ON PLATES. 150 MM/F 12 RAPID RECTILINEAR LENS. NON-SELF-CAPPING ROTARY SHUTTER FOR SINGLE SPEED AND TIME EXPOSURES. THE LEATHER CASE FOR THE CAMERA RESEMBLES A LADY'S HANDBAG. HELICAL FOCUSING LENS. GROUND GLASS FOCUSING. DETACHABLE VIEWER. (GE)

## ANTOINE, R. S.

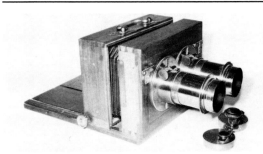

**(2255) STEREO CAMERA.** C. 1868. SIZE 11.5 X 19 CM EXPOSURES ON WET PLATES. GASC. & CHARCONNET LENSES. (GE)

## BARDON

**(2256) MANGIN'S PÉRIGRAPHE INSTANTANÉ PANORAMIC CAMERA.** C. 1875. 360-DEGREE PANORAMIC

EXPOSURES ON A FILM STRIP. THE "LIGHT-HOUSE" TYPE LENS IS CONTAINED IN THE TOP SECTION OF THE CAMERA WITH THE FILM STRIP POSITIONED DIRECTLY BELOW THE LENS. (IH)

## BAZIN & LEROY

**(2257) STEREOCYCLE STEREOSCOPIC CAMERA.** C. 1898. TWO 6.5 X 9 CM STEREO EXPOSURES ON PLATES. 85 MM/F 9 ZEISS PROTAR LENSES. ROTARY SECTOR SHUTTER. (MA)

## BELLIENI, H.

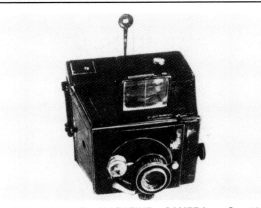

**(2258) JUMELLE MAGAZINE CAMERA.** C. 1899. SIZE 9 X 14 CM EXPOSURES ON PLATES. 136 MM/F 8 ZEISS PROTAR LENS. FIVE-SPEED PNEUMATIC SHUTTER. RISING AND CROSSING LENS MOUNT. MAGAZINE BACK. (HA)

**(2259) PLATE CAMERA.** C. 1889. SIZE 13 X 18 CM EXPOSURES ON PLATES. 195 MM/F 7.2 ZEISS JENA ANASTIGMAT LENS. JOUSSET SHUTTER; 1/15 TO 1/90 SEC.

**(2260) STEREOSCOPIC CAMERA.** C. 1892. SIZE 9 X 18 CM STEREO EXPOSURES ON PLATES. 100 MM/F 11 APLANAT LENSES. VARIABLE-SPEED GUILLOTINE SHUTTER. (MA)

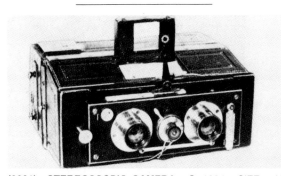

**(2261) STEREOSCOPIC CAMERA.** C. 1894. SIZE 6 X 13 CM EXPOSURES ON PLATES. THE MAGAZINE HOLDS 12 PLATES. 90 MM/F 4.6 GOERZ LENSES. SIX-SPEED SHUTTER. (HA)

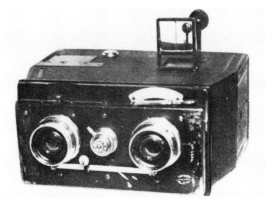

**(2262) STEREOSCOPIC CAMERA.** C. 1894. SIZE 6 X 13 CM EXPOSURES ON PLATES. THE MAGAZINE HOLDS 12 PLATES. 90 MM/F 6.4 GOERZ DOUBLE ANASTIGMAT LENSES. FIVE-SPEED GUILLOTINE SHUTTER. (HA)

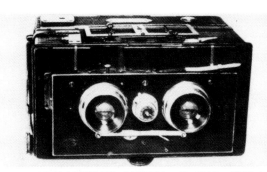

**(2263) STEREOSCOPIC CAMERA.** C. 1896. SIZE 9 X 18 CM EXPOSURES ON PLATES. THE MAGAZINE HOLDS 12 PLATES. 110 MM/F 8 ZEISS PROTAR LENSES. SIX-SPEED ROTARY SHUTTER. THE CAMERA CAN ALSO TAKE SINGLE PANORAMIC EXPOSURES. (HA)

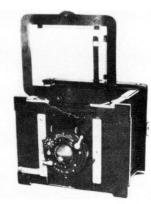

**(2264) STRUT CAMERA.** C. 1910. TWO SIZES OF THIS CAMERA FOR 9 X 12 OR 10 X 15 CM EXPOSURES ON SHEET FILM. F 6.3 ZEISS TESSAR OR GOERZ LENS. KOILOS SHUTTER WITH SPEEDS TO 1/300 SEC. RISING, FALLING, AND CROSSING LENS MOUNT. (HA)

## BERTSCH, ADOLPHE

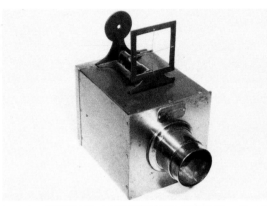

**(2265) CHAMBRE AUTOMATIQUE CAMERA.** C. 1860. SIZE 6.4 X 6.4 CM EXPOSURES ON COLLODION WET PLATES. 100 MM/F 20 ACHROMATIC FIXED FOCUS MENISCUS LENS. LENS-CAP TYPE SHUTTER. THE CAMERA IS ALL BRASS CONSTRUCTION. THE CAMERA CAME WITH A DOUBLE WOODEN CASE (INNER CASE AND OUTER CASE) WHICH CONTAINED THE NECESSARY EQUIPMENT AND CHEMICALS FOR SENSITIZING AND DEVELOPING THE PLATES. THE CAMERA DIMENSIONS ARE 4 X 4 X 4 INCHES. (GE)

**(2266) CHAMBRE AUTOMATIQUE CAMERA.** C. 1861. CIRCULAR EXPOSURES, 3 CM IN DIAMETER ON 3.8 X 3.8 CM COLLODION WET PLATES. ALL BRASS CONSTRUCTION. FIXED-FOCUS ACHROMATIC MENISCUS LENS. TUBULAR FINDER. THE CAMERA'S DIMENSIONS ARE 2 X 2 X 2⅛ INCHES. (MA)

**(2267) CHAMBRE AUTOMATIQUE CAMERA.** C. 1861. SIZE 6 X 6.5 CM COLLODION WET PLATE EXPOSURES. THE MAGAZINE HOLDS 12 PLATES. ALL BRASS CONSTRUCTION. THE CAMERA DIMENSIONS ARE 3¾ X 3¾ X 5⅛ INCHES.

**(2268) CHAMBRE AUTOMATIQUE CAMERA.** C. 1861. SIZE 8 X 9 CM COLLODION WET-PLATE EXPOSURES. ALL BRASS CONSTRUCTION.

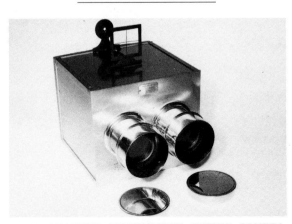

**(2269) CHAMBRE AUTOMATIQUE STEREO CAMERA.** C. 1860. SIZE 12 X 15 CM STEREO EXPOSURES ON COLLODION WET PLATES. ALL BRASS CONSTRUCTION. F 16 ACHROMATIC DOUBLET LENSES. (GE)

## BLOCK, E.

**(2270) LE SHERLOCK HOLMES CAMERA.** C. 1912. THE MAGAZINE HOLDS SIX PLATES, SIZE 6.5 X 9 CM. FIXED-FOCUS CLOSE-UP MENISCUS LENS. GUILLOTINE SHUTTER. (MA)

**(2271) PHOTO-BOUQUIN STEREOSCOPIQUE CAMERA.** C. 1904. SIZE 45 X 107 MM STEREO EXPOSURES ON PLATES. JENA ACHROMATIC LENSES. VARIABLE-SPEED ROTARY SHUTTER. THE CAMERA IS IN THE FORM OF A BOOK WITH THE LENSES AND SHUTTER IN THE SPINE OF THE "BOOK." THE CAMERA IS HELD HORIZONTALLY WITH THE COVER RAISED FOR SUBJECT VIEWING AS IF THE "BOOK" WERE BEING READ. (IH)

**(2272) PHOTO-CRAVATE DETECTIVE CAMERA.** C. 1890. SIZE 23 X 23 MM EXPOSURES ON PLATES. THE CAMERA HOLDS SIX PLATES. THE CAMERA IS HIDDEN BY A CLOTH CRAVATE. THE LENS AND THE PLATE CHANGING KNOB APPEAR AS BUTTONS. 25 MM/F 16 PERISCOPIC LENS. EVERSET SECTOR SHUTTER FOR TIME EXPOSURES ONLY. PNEUMATIC SHUTTER RELEASE.

## BLOCK, LEON

**(2273) PHYSIO-POCKET CAMERA.** C. 1904. SIZE 4.5 X 6 CM PLATE EXPOSURES. 51 MM/F 6.3 KRAUSS TESSAR LENS. SINGLE-SPEED AND TIME CYLINDRICAL SHUTTER. THE CAMERA HAS THE APPEARANCE OF A MONOCULAR FIELD GLASS. (MA)

**(2274) PHYSIOGRAPHE DETECTIVE CAMERA.** C. 1922. SIZE 4.5 X 6 CM PLATE EXPOSURES. 90 MM/F 8 SIMPLE LENS. VARIABLE-SPEED CYLINDRICAL SHUTTER. THE CAMERA HAS THE APPEARANCE OF A PAIR OF BINOCULARS. (MA)

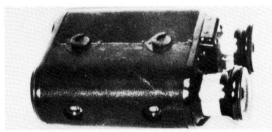

**(2275) PHYSIOGRAPHE STEREO DETECTIVE CAMERA.** C. 1900. SAME FEATURES AS THE 1896 MODEL EXCEPT THIS MODEL HAS F 4.5 ZEISS TESSAR LENSES AND A PUSH-PULL PLATE CHANGER.

**(2276) PHYSIOGRAPHE STEREO DETECTIVE CAMERA.** C. 1896. SIZE 45 X 107 MM STEREO EXPOSURES ON PLATES. 51 MM/F 6.3 KRAUSS LENSES. SINGLE-SPEED ROTATING SHUTTER. THE STEREO LENSES ARE IN THE SIDE OF THE BINOCULAR-TYPE CAMERA AND AT A 90-DEGREE ANGLE FROM THE APPARENT OPTICAL PATH OF THE BINOCULAR. BAG-TYPE PLATE CHANGING MAGAZINE. SIMILAR TO THE PHYSIOGRAPHE STEREO DETECTIVE CAMERA, C. 1900.

## BOUCHER, P.

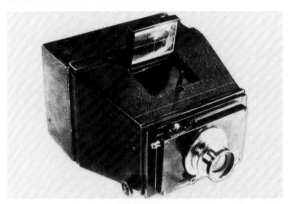

**(2277) JUMELLE MAGAZINE CAMERA.** C. 1898. SIZE 9 X 12 CM EXPOSURES ON PLATES. (HA)

**(2278) MONOBLOC STEREO CAMERA.** C. 1911.

## BOURDIN, G. J.

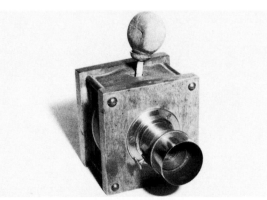

**(2279) DUBRONI APPARATUS NO. 1 CAMERA.** C. 1865. SINGLE WET PLATE COLLODION EXPOSURES 4 CM IN DIAMETER. 60 MM/F 3.5 LACHENAL LENS. LENS-CAP TYPE SHUTTER. GROUND GLASS FOR FOCUSING. THE CAMERA BODY CONSISTS OF AN AMBER GLASS "BOTTLE" MOUNTED BETWEEN THE FRONT AND BACK WOOD PANELS. THE PLATE IS SENSITIZED, EXPOSED, AND DEVELOPED INSIDE OF THE "BOTTLE." THE CHEMICALS ARE PLACED IN THE "BOTTLE" WITH A SQUEEZE BULB PIPETTE THROUGH A HOLE IN THE TOP OF THE CAMERA. THE BACK OF THE CAMERA OPENS FOR THE PLATE INSERTION. (GE)

**(2280) DUBRONI CAMERA.** C. 1865. SIZE 5 X 5 CM EXPOSURES ON WET COLLODION PLATES. THE CAMERA IS SIMILAR TO THE DUBRONI APPARATUS NO. 1 CAMERA.

## BOURDIN, G. J. (*cont.*)

(2281) **DUBRONI CAMERA.** C. 1865. THREE SIZES OF THIS CAMERA FOR 5 X 5, 5.9 X 6.8, OR 9 X 12 CM EXPOSURES ON WET COLLODION PLATES. THE CAMERA IS SIMILAR TO THE DUBRONI APPARATUS NO. 1 CAMERA EXCEPT THE "BOTTLE" IS ENCLOSED IN A WOODEN BOX.

(2282) **DUBRONI CAMERA.** C. 1868. SIZE 9 X 12 CM EXPOSURES ON WET COLLODION PLATES. SIMILAR TO THE DUBRONI APPARATUS NO. 1 CAMERA EXCEPT THE CAMERA HAS BELLOWS AND A DETACHABLE DEVELOPING BACK.

(2283) **DUBRONI CAMERA.** C. 1868. SIZE 9 X 12 CM EXPOSURES ON WET COLLODION PLATES. 120 MM/F 3.5 DUBRONI LENS. (MA)

(2284) **DUBRONI PHOTO-SPORT CAMERA.** C. 1889. SIZE 9 X 12 CM EXPOSURES ON PLATES. 210 MM/F 9 DARLOT PLANIGRAPHE LENS. ROTARY SECTOR SHUTTER. ROTARY APERTURE STOPS. A CLOTH (INSTEAD OF BELLOWS) IS HELD IN POSITION BY STRUTS. (IH)

## BOURQUIN

(2285) **DAGUERREOTYPE CAMERA.** C. 1845. SIZE 8 X 10.5 CM EXPOSURES. F 4 PETZVAL-TYPE LENS. RACK & PINION FOCUSING. (IH)

## BRIOIS, A.

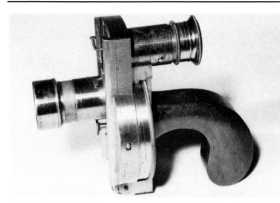

(2286) **REVOLVER PHOTOGRAPHIQUE CAMERA.** C. 1862. DESIGNED BY THOMPSON OF ENGLAND. FOUR SEPARATE EXPOSURES, 23 MM IN DIAMETER, ON A 7.5 CM DIAMETER WET COLLODION PLATE. 40 MM/F 2 PETZVAL LENS. SINGLE-SPEED ROTARY BEHIND-THE-LENS SHUTTER. BY RAISING THE LENS TUBE TO THE UPPER POSITION THE SHUTTER IS COCKED AND THE EYE PIECE LENS IS USED TO VIEW A GROUND GLASS IMAGE FORMED BY THE TAKING LENS. A RELEASE MECHANISM ALLOWS THE LENS TUBE TO FALL TO THE PLATE POSITION AND THE SHUTTER IS AUTOMATICALLY RELEASED. (GE)

## BRIZET, ANDRÉ

(2287) **PHYSIOSCOPE STEREO CAMERA.** C. 1922. SIZE 60 X 130 MM STEREO EXPOSURES ON PLATES.

THE MAGAZINE HOLDS 12 PLATES. 75 MM/F 6.3 KRAUSS TESSAR LENSES. COMPUR SHUTTER; 1 TO ¹⁄₁₅₀ SEC. RISING LENS MOUNT. (MA)

## CABOSSEL & HUDE

(2288) **L'IMPERIA ROLL FILM CAMERA.** C. 1930. SIZE 6 X 9 CM EXPOSURES.

(2289) **LA DYNA ROLL FILM CAMERA.** C. 1930. SIZE 6.5 X 11 CM EXPOSURES.

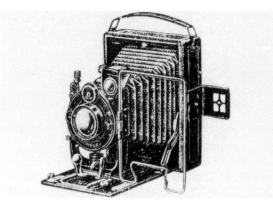

(2290) **LA MINERVA PLATE AND SHEET FILM CAMERA.** C. 1930. SIZE 9 X 12 CM EXPOSURES.

(2291) **LA SELECTA PLATE AND SHEET FILM CAMERA.** C. 1930. SIZE 6.5 X 9 CM EXPOSURES. SIMILAR TO THE LA MINERVA CAMERA.

(2292) **LA SUPERIA PLATE AND SHEET FILM CAMERA.** C. 1930. SIZE 10 X 15 CM EXPOSURES. SIMILAR TO THE LA MINERVA CAMERA.

(2293) **LE PYGMA ROLL FILM CAMERA.** C. 1930. SIZE 6 X 9 CM EXPOSURES.

## CADOT, A.

(2294) **CYCLOS CAMERA.** C. 1895. SIZE 9 X 12 CM EXPOSURES ON PLATES. DEROGY ORTHOSCOPIC LENS. VARIABLE-SPEED SHUTTER. TOP AND BOTTOM "TAIL-BOARDS" CAN BE SWUNG OUT FROM THE BACK OF THE CAMERA TO ALLOW THE BELLOWS AND CAMERA BACK TO BE EXTENDED TO THE FOCAL PLANE. (IH)

(2295) **LE DODECAGRAPHE CAMERA.** C. 1893. SIZE 9 X 12 PLATE EXPOSURES. THE MAGAZINE HOLDS 12 PLATES. APLANAT LENS. VARIABLE-SPEED GUILLOTINE SHUTTER. (MA)

(2296) **SCÉNOGRAPHE STEREO CAMERA.** C. 1900. SIZE 9 X 18 CM STEREO EXPOSURES ON PLATES. 150 MM/F 11 APLANATIC LENSES. GUILLOTINE SHUTTER. RISING LENS MOUNT. (MA)

(2297) **STEREO PANORAMIQUE JUMELLE-STYLE CAMERA.** C. 1900. SIZE 9 X 18 CM PLATE EXPOSURES.

ONE LENS ROTATES TO THE CENTER POSITION FOR PANORAMIC EXPOSURES.

## CAILLON, E.

(2298) **BIOSCOPE STEREO CAMERA.** C. 1915. SIZE 45 X 107 MM STEREO EXPOSURES ON PLATES. BALBRECK LENSES. FIVE-SPEED GUILLOTINE SHUTTER. RISING LENS MOUNT. PUSH-PULL MAGAZINE FOR PLATES. (MA)

(2299) **LE BIOSCOPE STEREO CAMERA.** C. 1915. STEREO EXPOSURES ON PLATES. 85 MM/F 6.8 LACOUR BERTHIOT LENSES. ALSO, PANORAMIC EXPOSURES. PUSH-PULL PLATE CHANGER. (MA)

(2300) **BIOSCOPE STEREO CAMERA.** C. 1920. SIZE 45 x 107 MM STEREO EXPOSURES. PUSH-PULL PLATE CHANGING MAGAZINE. (BC)

(2301) **LE MEGASCOPE STEREO CAMERA.** C. 1915. SIZE 6 X 13 CM STEREO EXPOSURES ON PLATES. 85 MM/F 6.3 HERMAGIS LENSES. VARIABLE-SPEED GUILLOTINE SHUTTER. RISING LENS MOUNT. (MA)

(2302) **SCOPEA STEREO CAMERA.** C. 1915. SIZE 45 X 107 MM STEREO EXPOSURES ON PLATES. BALBRECK RECTILINEAR LENSES. THREE-SPEED GUILLOTINE SHUTTER. (MA)

(2303) **SCOPEA STEREO CAMERA.** C. 1920. SIZE 6 X 13 CM STEREO EXPOSURES ON PLATES. 85 MM/F 6.8 BERTHIOT OLOR LENSES. THREE-SPEED GUILLOTINE SHUTTER. (MA)

(2304) **STEREO MAGAZINE CAMERA.** C. 1895. SIZE 9 X 16 CM STEREO EXPOSURES ON PLATES. E. KRAUSS LENSES.

## CARMEN

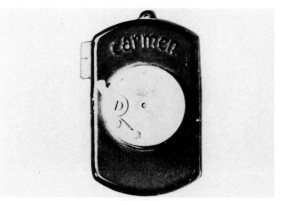

(2305) **CARMEN ALL-METAL CAMERA.** C. 1915. SIZE 24 X 24 MM EXPOSURES ON ROLL FILM. (HA)

## CARPENTER, J.

(2306) **JUMELLE STEREO CAMERA.** C. 1900. SIZE 6 X 13 CM EXPOSURES ON PLATES.

## CARPENTER, J. (*cont.*)

**(2307) OV2 THREE-COLOR CAMERA.** C. 1935. SIZE 6.5 X 9 CM EXPOSURES ON PLATES. 135 MM/F 4.5 ROUSSEL STYLOR LENS. COMPOUND SHUTTER. A SPRING-WOUND CLOCKWORKS AUTOMATICALLY BRINGS EACH OF THE THREE COLOR FILTERS AND PLATES IN FRONT OF THE LENS IN SEQUENCE. (IH)

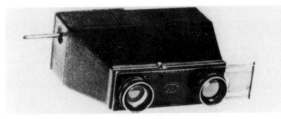

**(2308) PHOTO-JUMELLE CAMERA.** C. 1892. SIZE 4.5 X 6 CM EXPOSURES. THE CAMERA MAGAZINE HOLDS 12 PLATES OR 30 CUT FILMS. 70 MM/F 11 RAPID RECTILINEAR OR ZEISS ANASTIGMAT LENSES. SINGLE-SPEED GUILLOTINE SHUTTER. ONE LENS IS USED FOR VIEWING THE IMAGE ON A GROUND GLASS. THE OTHER LENS FORMS THE IMAGE ON THE FILM.

**(2309) PHOTO-JUMELLE CAMERA.** C. 1894. SIZE 6.5 X 9 CM EXPOSURES ON PLATES OR CUT FILM. SIMILAR TO THE PHOTO-JUMELLE CAMERA, C. 1892, WITH THE SAME LENSES BUT THE SHUTTER HAS A COCKING LEVER.

**(2310) PHOTO-JUMELLE CAMERA.** C. 1895. TWO SIZES OF THIS CAMERA FOR 4.5 X 6 OR 6.5 X 9 CM EXPOSURES ON PLATES OR CUT FILM. SIMILAR TO THE PHOTO-JUMELLE CAMERA, C. 1892, EXCEPT THE CAMERA HAS VARIABLE SHUTTER SPEEDS AND THE LENSES HAVE HELICAL FOCUSING.

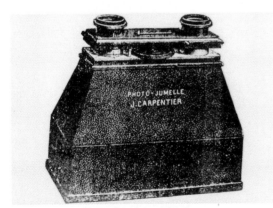

**(2311) PHOTO-JUMELLE CAMERA.** C. 1906. TWO SIZES OF THIS CAMERA FOR 4.5 X 6 OR 6.5 X 9 CM EXPOSURES ON PLATES. RECTILINEAR OR ZEISS LENSES. ONE LENS IS FOR VIEWING.

## CHASTÉ, RUDOLPH

**(2312) MONAX II CAMERA.** C. 1913. A LAZY-TONGS STRUT CAMERA.

## CHEVALIER, CHARLES

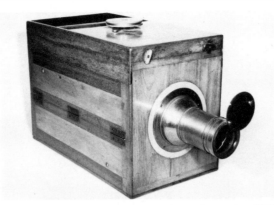

**(2313) DAGUERREOTYPE CAMERA.** C. 1840. SIZE 16.5 X 21.5 CM EXPOSURES ON SILVERED COPPER DAGUERREOTYPE PLATES. 290 MM/F 5.6 FIXED-STOP CONVERTIBLE LENS. LENS-CAP SHUTTER. SLIDING INNER BOX FOR FOCUSING. GROUND GLASS FOCUSING. THE SIDES OF THE CAMERA ARE HINGED AND FOLD INWARD WITH THE TOP COLLAPSING DOWNWARD FOR EASY TRANSPORTING. (GE)

## CLEMENT & GILMER

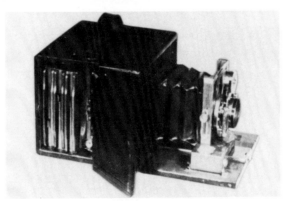

**(2314) "ULTRA" HAND AND STAND CAMERA.** C. 1895.

## COMPAGNIE FRANCAISE DE PHOTOGRAPHIE

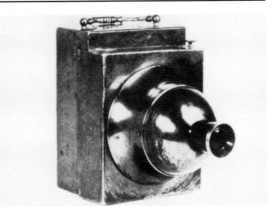

**(2315) PHOTOSPHERE CAMERA.** C. 1888. TWO SIZES OF THIS CAMERA FOR 8 X 9 OR 9 X 12 CM DRY PLATE EXPOSURES. F 7.7 KRAUSS OR F 13 PERISCOPIC LENS. HEMISPHERICAL SHUTTER FOR VARIABLE-SPEED AND TIME EXPOSURES. THE CAMERA'S MAGAZINE HOLDS 12 PLATES. ALL-METAL CONSTRUCTION.

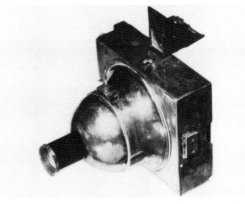

**(2316) PHOTOSPHERE CAMERA.** C. 1889. THREE SIZES OF THIS CAMERA FOR 8 X 9, 9 X 12, OR 13 X 18 CM EXPOSURES ON PLATES. PERISCOPIC OR ZEISS ANASTIGMAT LENS ON THE 9 X 12 AND 13 X 18 CM CAMERAS. THE CAMERA'S MAGAZINE (EXCEPT FOR THE 8 X 9 CM MODEL) HOLDS 12 PLATES. VIEW FINDER. GUILLOTINE SHUTTER FOR VARIABLE SPEED AND TIME EXPOSURES. SOME MODELS WITH PUSH-PULL PLATE-CHANGING MAGAZINE.

**(2317) PHOTOSPHERE CAMERA.** C. 1895. FOUR SIZES OF THIS CAMERA FOR 8 X 9, 9 X 12, 9 X 13, OR 9 X 18 CM EXPOSURES ON PLATES. ZEISS-KRAUS OR RECTILINEAR LENS. FIVE-SPEED AND TIME HEMISPHERICAL SHUTTER. TWO BUILT-IN VIEW FINDERS. (IH)

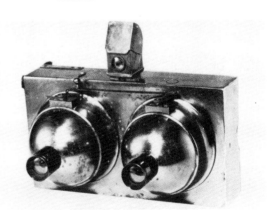

**(2318) PHOTOSPHERE STEREO CAMERA.** C. 1888. SIZE 9 X 18 CM STEREO EXPOSURES ON PLATES. 95 MM/F 13 APLANATE LENSES. HEMISPHERICAL GUILLOTINE SHUTTER. ALL-METAL CAMERA BODY. (HA)

## COMPTOIR PHOTOGRAPHIC COLONIAL

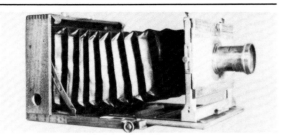

(2319) **VIEW CAMERA.** C. 1910. SIZE 13 X 20 CM EXPOSURES ON PLATES. F. AUDONIN NO. 3 LENS. DOUBLE EXTENSION BELLOWS. (EL)

## CORNU

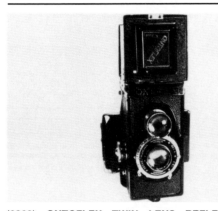

(2320) **ONTOFLEX TWIN LENS REFLEX CAMERA.** C. 1939. SIZE 6 X 9 CM EXPOSURES ON ROLL FILM. 90 MM/F 3.5 ZEISS TESSAR LENS. COMPUR RAPID SHUTTER; 1 TO ¼₀₀ SEC., B., T. IRIS DIAPHRAGM. ROTATING BACK. (HA).

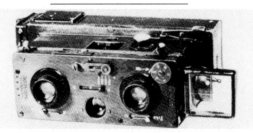

(2321) **ONTOSCOPE STEREO CAMERA.** C. 1923. SIZE 45 X 107 MM EXPOSURES ON PLATES. THE MAGAZINE HOLDS 12 PLATES. 55 MM/F 4.5 ROUSSEL STYLOR LENSES. GUILLOTINE SHUTTER. PUSH-PULL PLATE CHANGING MAGAZINE. (HA)

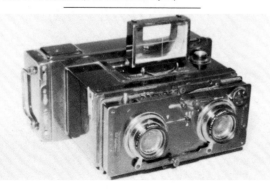

(2322) **ONTOSCOPE STEREO CAMERA.** C. 1925. SIZE 60 X 130 MM STEREO EXPOSURES ON PLATES. 90 MM/F 4.5 KRAUSS TESSAR OR FLOR BERTHIOT LENSES. GUILLOTINE SHUTTER; ⅕ TO ¼₀₀ SEC. OR ⅕ TO ⅟₃₀₀ SEC. PANORAMIC SETTING. RISING LENS MOUNT. PUSH-PULL PLATE CHANGING MAGAZINE. (GE)

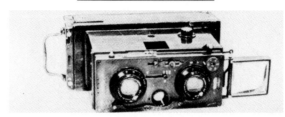

(2323) **ONTOSCOPE STEREO CAMERA.** C. 1925. SIZE 45 X 107 MM EXPOSURES ON PLATES. THE MAGAZINE HOLDS 12 PLATES. 55 MM/F 4.5 ZEISS TESSAR LENSES. GUILLOTINE SHUTTER; ⅕ TO ¼₀₀ SEC. PUSH-PULL PLATE CHANGING MAGAZINE. (HA)

## DAGRON, RENÉ PRUDENT

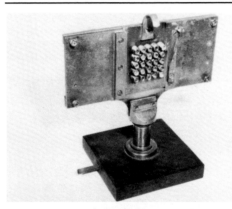

(2324) **MICROPHOTOGRAPHIC CAMERA.** C. 1860. THE CAMERA MAKES 450 EXPOSURES ON 4.5 X 8.5 CM WET-COLLODION PLATES. THE LENS BOARD WHICH CONTAINS 25 LENSES CAN BE SHIFTED VERTICALLY WHILE THE PLATE HOLDER CAN BE MOVED HORIZONTALLY TO OBTAIN A MAXIMUM OF 450 IMAGES ON ONE PLATE. EACH LENS HAS A FOCAL LENGTH OF 12.7 MM AND AN F NUMBER OF 3.5. THE BACK OF THE CAMERA SWINGS OPEN FOR PLATE LOADING. ALL BRASS CONSTRUCTION. (GE)

## DAMOIZEAU, M.

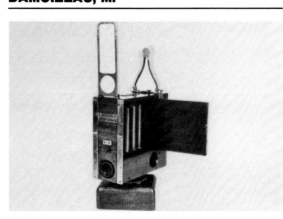

(2325) **CYCLOGRAPHE Á FOYER FIXE PANORAMA CAMERA.** C. 1893. FIXED FOCUS MODEL. SIZE 9 OR 13 CM BY 80 CM LONG PANORAMIC 360-DEGREE EXPOSURES ON ROLL FILM. A SPRING MOTOR ROTATES THE CAMERA IN ONE DIRECTION WHILE THE FILM STRIP MOVES PAST THE FOCAL PLANE IN THE OPPOSITE DIRECTION. 130 MM/F 11 ACHROMATIC MENISCUS (DARLOT) LENS. THE CAMERA BODY HOLDS 10 SPARE SPOOLS OF FILM.

(2326) **CYCLOGRAPHE BELLOWS-FOCUSING PANORAMIC CAMERA.** C. 1890. TWO SIZES OF THIS CAMERA FOR 18 CM OR 23 CM WIDE ROLL FILM. 360-DEGREE PANORAMIC EXPOSURES. A SPRING MOTOR ROTATES THE CAMERA IN ONE DIRECTION WHILE THE FILM STRIP MOVES IN THE OPPOSITE DIRECTION PAST THE FOCAL PLANE. RACK & PINION FOR BELLOWS FOCUSING. (BC)

## DARLOT, ALPHONSE

(2327) **RAPIDE CHANGING BOX CAMERA.** C. 1887. SIZE 8 X 9 CM PLATE EXPOSURES. THE MAGAZINE HOLDS 12 PLATES. DARLOT RECTILINEAR DOUBLET LENS. ROTARY SHUTTER. THE CAMERA IS TURNED UP-SIDE-DOWN TO POSITION A PLATE IN THE FOCAL PLANE FOR EXPOSURE. THE PROCESS IS REVERSED TO REPLACE AN EXPOSED PLATE IN THE MAGAZINE AT THE BOTTOM OF THE CAMERA. (IH)

(2328) **RAPIDE CHANGING BOX CAMERA.** C. 1887. SIZE 9 X 12 CM PLATE EXPOSURES. 135 MM/F 8 DARLOT RECTILINEAR LENS. SAME PLATE CHANGING METHOD AS DESCRIBED FOR THE SIZE 8 X 9 CM EXPOSURE MODEL. (MA)

## DEBRIE, ANDRE

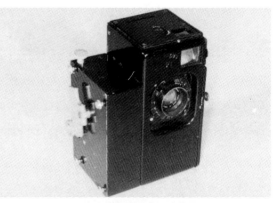

(2329) **SEPT STILL OR MOVIE CAMERA.** C. 1922. 250 EXPOSURES, SIZE 18 X 24 MM ON 35 MM CINE FILM. 50 MM/F 3.5 BERTHIOT STELLOR OR 50 MM/F 3.5 H. ROUSSEL STYLOR LENS. ROTARY SHUTTER FOR SINGLE-SPEED, TIME, OR MOVIE SEQUENCE EXPOSURES. IRIS DIAPHRAGM. WAIST-LEVEL REFLECTOR VIEWER. EXPOSURE COUNTER. A CLOCKWORK SPRING ADVANCES THE FILM FOR MOVIE OR STILL EXPOSURES. THE CAMERA CAN ALSO BE USED TO PRINT THE NEGATIVE ON POSITIVE FILM OR AS AN ENLARGER. (EB)

## DEBRIE, ANDRE (*cont.*)

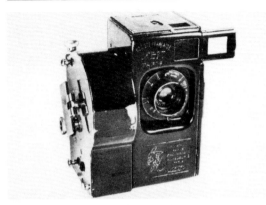

(2330) **SEPT STILL OR MOVIE CAMERA.** C. 1925. 250 EXPOSURES, SIZE 18 X 24 MM ON 35 MM CINE FILM. SAME FEATURES AS THE SEPT CAMERA OF 1923 BUT WITH A LARGER SPRING MOTOR. A 50 MM/F 3.5 KRAUSS TESSAR LENS WAS AVAILABLE. (HA)

## DEHORS, A.

(2331) **MINIMA CHANGING-BOX CAMERA.** C. 1896. SIZE 7.5 X 10 CM EXPOSURES ON PLATES. ACHROMATIC TRIPLET LENS. GUILLOTINE SHUTTER. A LIGHTTIGHT BAG AT THE REAR OF THE CAMERA IS USED TO CHANGE PLATES. (IH)

## DEHORS & DESLANDES

(2332) **LE PHOTO GIBUS CAMERA.** C. 1892. SIZE 10 X 15 CM PLATE EXPOSURES. ACHROMATIC LENS. CIRCULAR SHUTTER. (MA)

## DELOYE

(2333) **LE PRISMAC STEREO CAMERA.** C. 1906. EXPOSURES ON ROLL FILM. 54 MM KENNGOTT ANASTIGMAT LENSES. VARIABLE-SPEED GUILLOTINE SHUTTER. 90-DEGREE PRISMS REFLECT THE IMAGE ONTO THE ROLL FILM WHICH IS AT VERTICAL RIGHT ANGLES TO THE LENSES. (IH)

## DEMARIA FRÉRES

(2334) **CALEB PANORAMIC CAMERA.** C. 1900. SIZE 9 X 27 CM EXPOSURES ON ROLL FILM. 120 MM/F 5.4 VOIGTLANDER COLLINEAR II LENS. 120-DEGREE PANORAMIC EXPOSURES. (MA)

(2335) **PLATE AND ROLL FILM CAMERA.** C. 1905. SIZE 9 X 12 CM EXPOSURES. 135 MM/F 6.8 DEMARIA FRÉRES LENS. BETWEEN-THE-LENS SHUTTER. (MA)

## DEMARIA-LAPIERRE

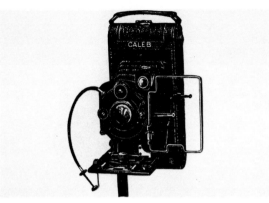

(2336) **CALEB FILM PACK CAMERA. MODEL B.** C. 1928.

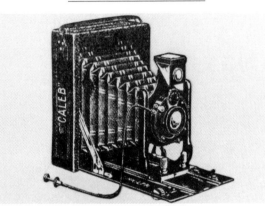

(2337) **CALEB ROLL FILM CAMERA. MODEL R.** C. 1928.

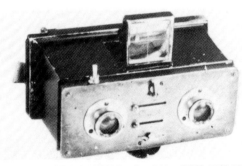

(2338) **STEREO CAMERA.** C. 1908. SIZE 45 X 107 MM STEREO EXPOSURES ON PLATES. 55 MM/F 8 DEMARIA LAPIERRE RECTILINEAR LENSES. GUILLOTINE SHUTTER FOR VARIABLE SPEEDS. (HA)

## DELARIA-LAPIERRE & MOLLIER

(2339) **DEHEL FOLDING CAMERA.** C. 1940. SIZE 6 X 9 MM EXPOSURES ON NO. 120 OR B-2 ROLL FILM. F 4.5 RYSOOR ANASTIGMAT LENS. SHUTTER SPEEDS; $\frac{1}{25}$ TO $\frac{1}{150}$ SEC., B., T. MANUAL FOCUS.

## DEROGY, EUGÉNE

(2340) **VERCAK CAMERA.** C. 1897. SIZE 6.5 X 9 CM

EXPOSURES ON PLATES. ORTHOPERISCOPIQUE LENS. PLASTIC BODY. (IH)

## DEYROLLE FILS, E.

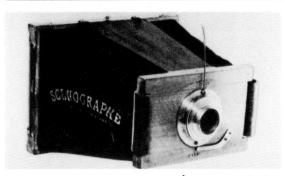

(2341) **SCENOGRAPHE (DR. CANDÉZE) FOLDING CAMERA.** C. 1875–80. SIZE 10–15 CM SINGLE EXPOSURES ON DRY PLATES. NON-PLEATED CLOTH BELLOWS AND WOODEN STRUTS. 80 MM/F 20 MENISCUS ACHROMATIC LENS. CAP-OVER-LENS SHUTTER. (GE)

## DUBOSCQ, LOUIS JULES

(2342) **POLICONOGRAPH CAMERA.** C. 1861. FIFTEEN EXPOSURES CAN BE MADE ON A SINGLE PLATE BY MOUNTING THE LENS ON EACH OF THE FIVE HORIZONTAL PANELS. THE SLIDING OF EACH PANEL INTO A DIFFERENT POSITION ALLOWS FOR A MAXIMUM OF 15 EXPOSURES.

## ENJALBERT, E.

(2343) **ALPINISTE CAMERA.** C. 1886. THIS BELLOWS CAMERA WAS ONE OF THE FIRST TO USE A LIGHTTIGHT BAG FOR CHANGING EXPOSED PLATES INSIDE OF THE CAMERA.

(2344) **LE TOURISTE MAGAZINE CAMERA.** C. 1880. TWO SIZES OF THIS CAMERA FOR 13 X 18 OR 21 X 27 CM EXPOSURES ON PLATES. STEINHEIL LENS. WATERHOUSE STOPS. THE PLATE TO BE EXPOSED IS HELD IN POSITION BY TURNING A SMALL SCREW AND THEN DRAWING OUT THE MAGAZINE DRAWER. (BC) (IH)

(2345) **MAGAZINE CAMERA.** C. 1882. TWO SIZES OF THIS CAMERA FOR 13 X 18 OR 21 X 27 CM EXPOSURES ON PLATES. THIS BELLOWS CAMERA HAS A PLATE CHANGING BACK WITH A MAGAZINE FOR EIGHT PLATES. EACH UNEXPOSED PLATE IS HELD IN THE FOCAL PLANE BY A SCREW IN THE SIDE OF THE CAMERA. THE PUSH-PULL MAGAZINE HOLDS THE REMAINING PLATES AT THE SIDE OF THE PLATE TO BE EXPOSED. (BC)

(2346) **POSTPACKET BOX-FORM DETECTIVE CAMERA.** C. 1886. THE CAMERA HAS THE APPEARANCE OF A POSTAL PACKET INCLUDING A CORD TIED AROUND THE CAMERA AND A MAILING LABEL ON THE SIDE OF THE CAMERA. (BC)

## ENJALBERT, E. (*cont.*)

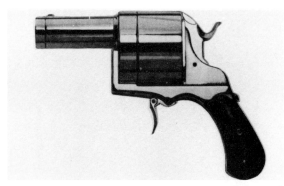

**(2347) PHOTO-REVOLVER CAMERA.** C. 1883. TWO SIZES OF THIS CAMERA FOR 20 X 20 OR 40 X 40 MM EXPOSURES ON PLATES. F 10 ACHROMATIZED PERISCOPIC LENS. THE CAMERA MAGAZINE HOLDS 10 PLATES. BY ROTATING THE CYLINDER, A PLATE IS BROUGHT INTO POSITION FOR EXPOSURE AND THE SHUTTER IS COCKED. THE "TRIGGER" RELEASES THE SHUTTER. THE LENS IS MOUNTED IN THE "REVOLVER" BARREL.

## ETABLISSEMENTS LANCART

**(2348) L'AS STRUT CAMERA.** C. 1912. SIZE 4.5 X 6 CM PLATE EXPOSURES. ACHROMATIC MENISCUS LENS. SIMPLE ROTARY SHUTTER. (MA)

**(2349) XYZ CAMERA.** C. 1935. SIZE 12 X 15 CM EXPOSURES. 22 MM/F 7.7 XYZOR LENS. SINGLE-SPEED AND BULB SHUTTER. (IH)

## ETS. GUÉRIN & CIE

**(2350) FURET CAMERA.** C. 1923. SIZE 24 X 36 MM EXPOSURES ON "35MM" ROLL FILM. 40 MM/F 4.5 HERMAGIS LENS. THREE-SPEED ROTARY DIAPHRAGM SHUTTER. (IH)

## FALLER, EUGEN

**(2351) FALLER FERROTYPE CAMERA.** C. 1895. SIZE 4 X 7 CM EXPOSURES ON FERROTYPE PLATES. PETZVAL-TYPE LENS. FLAPPER-TYPE SHUTTER. (MA)

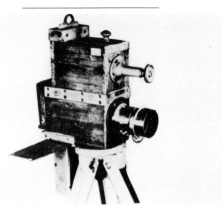

**(2352) FALLER FERROTYPE CAMERA.** C. 1900. SIZE 3 X 5 CM EXPOSURES ON FERROTYPE PLATES. THE PLATES ARE DEVELOPED IN THE TANK BENEATH THE CAMERA.

## FETTER, J.

**(2353) FOLDING CAMERA.** C. 1910. SIZE 6.5 X 9 CM EXPOSURES. 90 MM/F 8 DUPLOVICH PRIOR LENS. THREE-SPEED GUILLOTINE SHUTTER. (MA)

**(2354) PHOTO-ECLAIR VEST CAMERA.** C. 1886. SIZE 3 X 3 CM PLATE EXPOSURES. THE CAMERA HOLDS FIVE PLATES ON A ROTATING DISC. 40 MM/F 8 RECTILINEAR LENS. ROTARY SHUTTER. THE CAMERA WAS CONCEALED BEHIND A MAN'S VEST. (IH)

**(2355) PHOTO-ECLAIR VEST CAMERA.** C. 1892. IMPROVED MODEL. SIMILAR TO THE PHOTO-ECLAIR VEST CAMERA OF 1886 EXCEPT THE LENS IS AT THE BOTTOM OF THE CAMERA RATHER THAN THE TOP.

## FLEURY-HERMAGIS, J.

**(2356) INSTANTANEOUS STEREOSCOPIC CAMERA.** C. 1888. SIZE 8 X 16 CM STEREO EXPOSURES ON PLATES. THE MAGAZINE HOLDS 12 PLATES. F 8 HERMAGIS APLANAT LENSES. EIGHT-SPEED GUILLOTINE SHUTTER. (MA)

**(2357) LE VÉLOCIGRAPHE CAMERA.** C. 1888. SIZE 9 X 12 CM PLATE EXPOSURES. ROTARY SHUTTER. WOOD STRUTS FOR LENS MOUNT SUPPORT. REFLECTING FINDER. HANDGRIP. (BC)

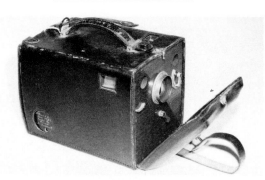

**(2358) LE VÉLOCIGRAPHE CAMERA.** C. 1891. SIZE 9 X 12 CM EXPOSURES ON PLATES. THE CAMERA'S MAGAZINE HOLDS 12 PLATES. 140 MM/F 8 HERMAGIS RAPID RECTILINEAR LENS. SELF-CAPPING SECTOR SHUTTER FOR SEVEN SPEEDS AND TIME EXPOSURES. LEVER FOR COCKING THE SHUTTER. (GE)

**(2359) LE VÉLOCIGRAPHE CAMERA.** C. 1895. FIVE SIZES OF THIS CAMERA FOR 9 X 12, 9 X 13, 9 X 18, 12 X 15, OR 13 X 18 CM EXPOSURES ON PLATES. HERMAGIS APLANASTIGMAT LENS. FOUR-SPEED SHUTTER. SIMILAR TO THE LE VÉLOCIGRAPHE CAMERA OF 1891.

**(2360) LE VÉLOCIGRAPHE STEREOGRAPHIC CAMERA.** C. 1892. SIZE 8 X 15.5 CM STEREO EXPOSURES ON PLATES.

**(2361) MICROMEGAS COLLAPSIBLE FIELD CAMERA.** C. 1875. SIZE 8 X 10 CM EXPOSURES ON PLATES. APLANAT LENS. HELICAL FOCUSING. (IH)

## FRANCAIS, E.

**(2362) KINÉGRAPHE CAMERA.** C. 1887. TWO SIZES OF THIS CAMERA FOR 8 X 9 OR 9 X 12 CM EXPOSURES ON DRY PLATES. RECTILINEAR LENS. WATERHOUSE STOPS. FOUR-SPEED ROTARY SHUTTER WITH TIME EXPOSURES. FOCUSING BY SLIDING-LENS TUBE. WAIST-LEVEL REFLECTOR VIEWER WITH FOLDING HOOD. (MA)

**(2363) KINÉGRAPHE STÉRÉOSCOPIQUE STEREO CAMERA.** C. 1887. SIZE 9 X 18 CM STEREO EXPOSURES OR 10 X 18 CM SINGLE EXPOSURES ON DRY PLATES.

**(2364) KINÉGRAPHE WIDE-ANGLE CAMERA.** C. 1887. SIZE 9 X 12 CM EXPOSURES ON DRY PLATES. SIMILAR TO THE KINÉGRAPHE STÉRÉOSCOPIQUE STEREO CAMERA BUT WITH WIDE-ANGLE (70 DEGREES) LENS.

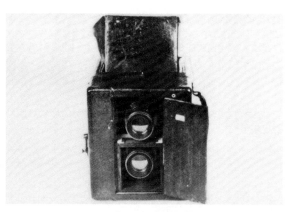

**(2365) LE COSMOPOLITE TWIN-LENS REFLEX CAMERA.** C. 1887. SIZE 9 X 12 CM EXPOSURES ON PLATES. 150 MM/F 7 RAPID RECTILINEAR LENSES. VARIABLE-SPEED ROTARY SHUTTER WITH TIME EXPOSURES. RACK & PINION FOCUSING. WATERHOUSE STOPS.

**(2366) LE COSMOPOLITE TWIN-LENS REFLEX CAMERA.** C. 1892. SIZE 13 X 18 CM EXPOSURES ON PLATES. SIMILAR TO THE LE COSMOPOLITE CAMERA, C. 1887.

**(2367) STEREO MAGAZINE CAMERA.** C. 1898. SIZE 6 X 13 CM STEREO EXPOSURES ON PLATES. 80 MM/F 8 FRANCAIS APLANAT LENSES. GUILLOTINE SHUTTER. (MA)

## FRANCK-VALÉRY

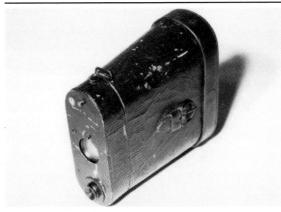

(2368) **PHOTO ÉTUI-JUMELLE CAMERA.** C. 1891. SIZE 9 X 12 CM EXPOSURES ON PLATES. 120 MM/F 12 RAPID RECTILINEAR LENS. GUILLOTINE SHUTTER FOR SINGLE-SPEED OR TIME EXPOSURES. THE CAMERA HAS THE APPEARANCE OF A BINOCULAR CASE. THE LARGE END OF THE CASE OPENS TO ERECT THE PLATE HOLDER AND BELLOWS. (GE)

## FRÉRES, JAPY & CIE

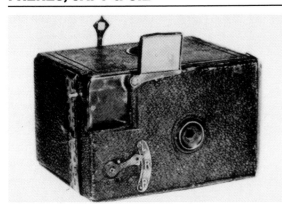

(2369) **PASCAL BOX CAMERA.** C. 1899. SIZE 40 X 55 MM EXPOSURES ON ROLL FILM. MENISCUS LENS. TWO-SPEED ROTARY SHUTTER. THE ROLL FILM IS WOUND ON A TAKE-UP SPOOL IN THE CAMERA WHICH ALSO WINDS UP A CLOCKWORK MOTOR SPRING. THE MOTOR ADVANCES THE FILM ONE FRAME AFTER EACH EXPOSURE. THE FIRST CAMERA TO MAKE USE OF THE AUTOMATIC FILM TRANSPORT.

## GAILLARD, C.

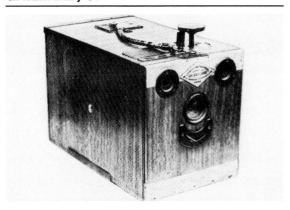

(2370) **MAGAZINE BOX CAMERA.** C. 1896. SIZE 9 X 12 CM EXPOSURES. THE MAGAZINE HOLDS 12 FILMS. (HA)

## GALLUS, USINES

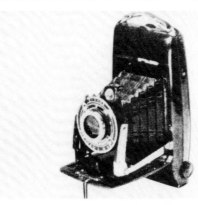

(2371) **GALLUS FOLDING CAMERA.** C. 1940. SIZE 6 X 9 CM EXPOSURES ON NO. 120 OR B-2 ROLL FILM. F 4.5 BOYER LENS. GALLUS SHUTTER TO $\frac{1}{100}$ SEC.

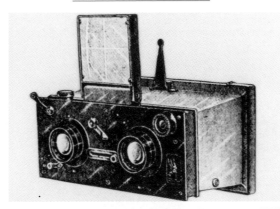

(2372) **GALLUS STEREO CAMERA.** C. 1922–30. TWO SIZES OF THIS CAMERA FOR 45 X 107 OR 60 X 130 MM STEREO EXPOSURES ON PLATES. INSTANT AND BULB SHUTTER OR GUILLOTINE SHUTTER; $\frac{1}{5}$ TO $\frac{1}{200}$ SEC. 75 MM/F 6.3 ANASTIGMATIC LENSES. ALL-METAL CONSTRUCTION.

## GAUMONT & CIE

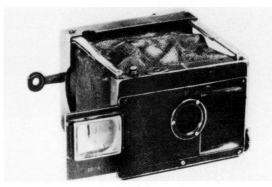

(2373) **BLOCK NOTES CAMERA.** C. 1903. TWO SIZES OF THIS CAMERA FOR 4.5 X 6 OR 6.5 X 9 CM EXPOSURES ON PLATES OR FILM PACKS. F 9 ZEISS PROTAR, F 6.8

ZEISS TESSAR, F 6.8 HERMAGIS APLANASTIGMAT, F 6 OLOR BERTHIOT, F 6.3 KRAUSS TESSAR, F 6 COOKE, OR F 10 DARLOT RECTILINEAR LENS. VARIABLE-SPEED GUILLOTINE SHUTTER. IRIS DIAPHRAGM.

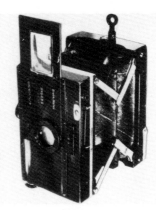

(2374) **BLOCK NOTES CAMERA.** C. 1905. TWO SIZES OF THIS CAMERA FOR 4.5 X 6 OR 6.5 X 9 CM EXPOSURES ON PLATES OR FILM PACKS. SAME LENSES AND SHUTTER AS THE 1903 MODEL. (HA)

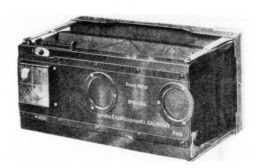

(2375) **BLOCK NOTES STEREO CAMERA.** C. 1904. TWO SIZES OF THIS CAMERA FOR 45 X 107 OR 60 X 130 MM EXPOSURES ON PLATES. F 6.3 KRAUSS TESSAR, F 6 OLOR BERTHIOT, OR F 5.5 ELGE ANASTIGMAT LENSES. SIX-SPEED GUILLOTINE SHUTTER. THE ELGE LENS WAS NOT AVAILABLE FOR THE 60 X 130 MM MODEL.

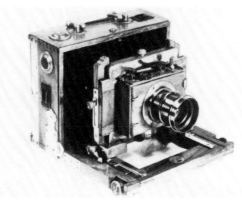

(2376) **FIELD CAMERA.** C. 1900. SIZE 8 X 11 CM EXPOSURES ON PLATES. FALLER RAPID RECTILINEAR LENS. ROTARY SHUTTER. (HA)

**GAUMONT & CIE (*cont.*)**

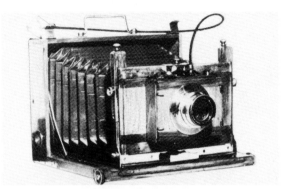

**(2377) FIELD CAMERA.** C. 1900. SIZE 12 X 17 CM EXPOSURES ON PLATES. 180 MM/F 6.8 GOERZ DAGOR DOUBLE ANASTIGMAT LENS. ROTARY SHUTTER. (HA)

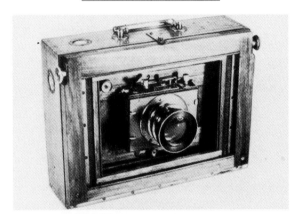

**(2378) FIELD CAMERA.** C. 1900. SIZE 12 X 17 CM EXPOSURES ON PLATES. PLANASYMETRIQUE LENS. (HA)

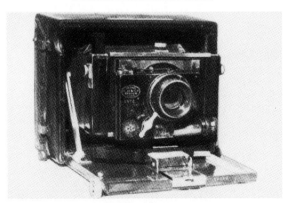

**(2379) FOLDING PLATE CAMERA.** C. 1900. SIZE 9 X 12 CM EXPOSURES ON PLATES. DECAUX PNEUMATIC FIVE-SPEED SHUTTER. (HA)

**(2380) GRAND PRIX TOURIST CAMERA.** C. 1900. SIZE 16 X 21 CM EXPOSURES ON PLATES.

**(2381) HEMERASCOPE CAMERA.** C. 1897. SIZE 9 X 12 CM PLATE EXPOSURES. 136 MM/F 8 ZEISS ANASTIG-

MAT LENS. AFTER A PLATE WAS EXPOSED, THE CAMERA WAS TURNED WITH THE BACK-SIDE DOWN TO DEVELOP AND FIX THE PLATE IN SOLUTIONS CONTAINED IN TANKS WITHIN THE CAMERA BODY. (IH)

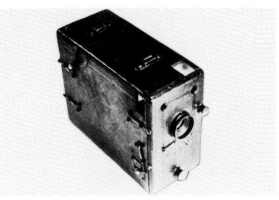

**(2382) MAGAZINE BOX CAMERA.** C. 1900. SIZE 6.5 X 9 CM EXPOSURES ON PLATES. THE MAGAZINE HOLDS 12 PLATES. GUILLOTINE SHUTTER. (HA)

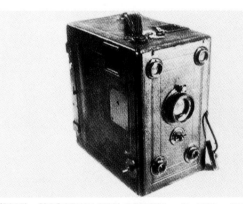

**(2383) MAGAZINE BOX CAMERA.** C. 1908. SIZE 9 X 12 CM EXPOSURES. STEINHEIL LENS. SEVEN-SPEED GUILLOTINE SHUTTER. (HA)

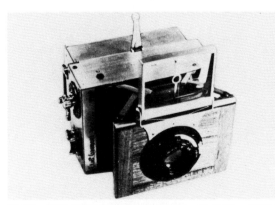

**(2384) MAGAZINE PLATE CAMERA.** C. 1924. SIZE 9 X 12 CM EXPOSURES ON PLATES. THE MAGAZINE HOLDS 12 PLATES. 135 MM/F 4.5 KRAUSS TESSAR LENS. FOCAL PLANE SHUTTER WITH SPEEDS TO $\frac{1}{2000}$ SEC. (HA)

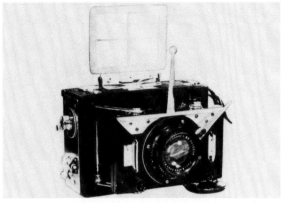

**(2385) MAGAZINE PLATE CAMERA.** C. 1925. SIZE 6 X 9 CM EXPOSURES ON PLATES. 105 MM/F 3.5 TESSAR LENS. FOCAL PLANE SHUTTER WITH SPEEDS TO $\frac{1}{2000}$ SEC. (HA)

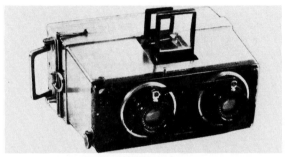

**(2386) MAGAZINE STEREO CAMERA.** C. 1900. SIZE 6 X 13 CM STEREO EXPOSURES ON PLATES. 85 MM/F 6.3 ROUSSEL-TRYLOR LENSES. FIVE-SPEED GUILLOTINE SHUTTER. (HA)

**(2387) PANORAMIC CAMERA.** C. 1905 KRAUSS-ZEISS TESSAR LENSES.

**(2388) PASCAL BOX CAMERA.** C. 1900. SIZE 4.5 X 6 CM EXPOSURES ON ROLL FILM. THE ROLL FILM IS WOUND ON A TAKE-UP SPOOL IN THE CAMERA WHICH ALSO WINDS A CLOCK-WORK MOTOR SPRING. THE MOTOR ADVANCES THE FILM ONE FRAME AFTER EACH EXPOSURE.

**(2389) REPORTER CAMERA.** C. 1924. SIZE 9 X 12 CM EXPOSURES. 135 MM/F 3.5 FLOR LENS. BALMELLE ROLLER-BLIND SHUTTER; $\frac{1}{25}$ TO $\frac{1}{1000}$ SEC. (MA)

**(2390) REPORTER TROPICAL CAMERA.** C. 1924. SIZE 9 X 14 CM PLATE EXPOSURES. 165 MM/F 3.5 ZEISS TESSAR LENS. KLOPCIC ROLLER-BLIND SHUTTER; 1 TO $\frac{1}{2000}$ SEC. (MA)

**(2391) SPIDO PLIANT CONTINENTAL CAMERA.** C. 1905. TWO SIZES OF THIS CAMERA FOR 9 X 12 OR 10 X 15 CM EXPOSURES ON FILM PACKS. F 3.5 OR F 4.5 TESSAR OR F 4.5 FLOR LENS. FOCAL PLANE SHUTTER; 1 TO $\frac{1}{2000}$ SEC. IRIS DIAPHRAGM. SIMILAR TO THE SPIDO PLIANT NEW MODEL CAMERA.

## GAUMONT & CIE (*cont.*)

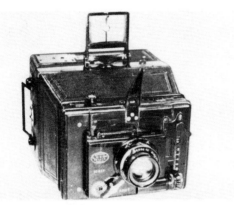

**(2392) SPIDO JUMELLE CAMERA.** C. 1898. FOUR SIZES OF THIS CAMERA FOR 6.5 X 9, 8.5 X 10, 9 X 12, OR 11 X 15 CM EXPOSURES ON PLATES. THE MAGAZINE HOLDS 12 PLATES. F 6 OLOR BERTHIOT; F 6.3 TESSAR; F 6.3, F 8, OR F 9 KRAUSS PROTAR; OR F 6.8 HERMAGIS APLANASTIGMAT LENS. DECAUX SIX-SPEED SHUTTER. IRIS DIAPHRAGM. RISING AND CROSSING LENS MOUNT.

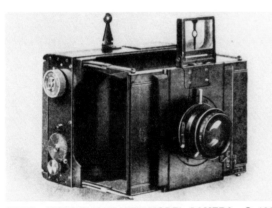

**(2393) SPIDO PLIANT NEW MODEL CAMERA.** C. 1905. SIZE 9 X 12 CM EXPOSURES ON PLATES. 135 MM/F 4.5 LENS. FOCAL PLANE SHUTTER WITH VARIABLE SPEEDS TO $\frac{1}{1000}$ SEC. IRIS DIAPHRAGM.

**(2394) SPIDO PLIANT TROPICAL CAMERA.** C. 1905. THREE SIZES OF THIS CAMERA FOR 6.5 X 9, 9 X 12, OR 10 X 15 CM EXPOSURES ON FILM PACKS. SAME LENSES AND SHUTTER AS THE SPIDO PLIANT CONTINENTAL CAMERA. SIMILAR TO THE SPIDO PLIANT NEW MODEL CAMERA BUT WITH TEAKWOOD BODY.

**(2395) STEREOSPIDO BOIS GAINE STEREO CAMERA.** C. 1905. SIZE 6 X 13 CM EXPOSURES ON PLATES OR SHEET FILM. SIMILAR TO THE STEREOSPIDO METALLIQUE STEREO CAMERA WITH THE SAME LENSES AND SHUTTER.

**(2396) STEREOSPIDO METALLIQUE STEREO CAMERA.** C. 1905. SIZE 6 X 13 CM EXPOSURES ON PLATES OR SHEET FILM. THE MAGAZINE HOLDS 12 PLATES OR 24 FILM SHEETS. F 4.5 OR F 6.3 TESSAR, F 4.5 FLOR, F 5.7 OLOR, F 6.3 SAPHIR, OR F 6.3 STYLOR LENS. DECAUX SHUTTER FOR EXPOSURES TO $\frac{1}{175}$ SEC.

SCALE FOR MANUAL FOCUSING. GROUND GLASS FOCUSING. IRIS DIAPHRAGM.

**(2397) STEREOSPIDO MODEL D STEREO CAMERA.** C. 1905. SIZE 6 X 13 CM EXPOSURES ON PLATES OR SHEET FILM. THE MAGAZINE HOLDS 12 PLATES OR 24 SHEET FILMS. F 6 GAUMONT ANASTIGMAT, F 6.3 TRYLOR, TRIANAR, HERMAGIS, SAPHIR, OR STYLOR LENS. SHUTTER SPEEDS FROM 1 TO $\frac{1}{100}$ SEC. IRIS DIAPHRAGM. GROUND GLASS FOCUS.

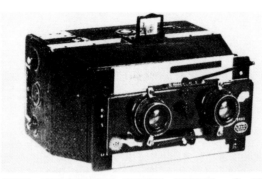

**(2398) STEREOSPIDO STEREO CAMERA.** C. 1900. SIZE 9 X 18 CM STEREO EXPOSURES ON PLATES. THE MAGAZINE HOLDS 12 PLATES. F 6.8 DAGOR LENSES. DECAUX SIX-SPEED SHUTTER. PANORAMIC SETTING. RISING AND CROSSING LENS MOUNT.

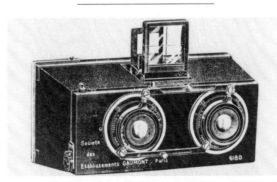

**(2399) STEREOSPIDO STEREO CAMERA. MODEL D.** C. 1921. SIZE 60 X 130 MM STEREO EXPOSURES ON PLATES. F 6.8 ROUSSEL ANASTIGMAT LENS. VARIABLE-SPEED GUILLOTINE SHUTTER.

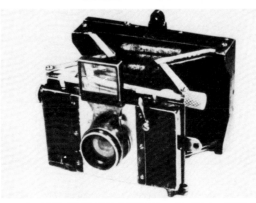

**(2400) STRUT PLATE CAMERA.** C. 1900. SIZE 6 X 9 CM EXPOSURES ON PLATES. AINE & FILS BALBRECK LENS. SIX-SPEED GUILLOTINE SHUTTER. (HA)

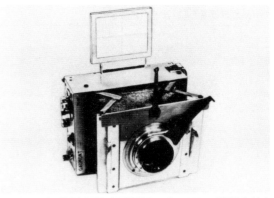

**(2401) STRUT PLATE CAMERA.** C. 1925. SIZE 6 X 9 CM EXPOSURES ON PLATES. 105 MM/F 3.5 BERTHIOT LENS. FOCAL PLANE SHUTTER WITH SPEEDS TO $\frac{1}{2000}$ SEC. ALL-METAL BODY. (HA)

## GERSCHEL

**(2402) MOSAIC CAMERA.** C. 1906. TWO SIZES OF THIS CAMERA. TWELVE EXPOSURES, SIZE 3 X 3 CM ON A 9 X 12 CM PLATE OR 12 EXPOSURES, SIZE 4 X 4 CM ON A 13 X 18 CM PLATE. 60 MM RECTILINEAR LENS. BAUSCH & LOMB SHUTTER FOR SINGLE-SPEED AND TIME EXPOSURES. THE LENS CAN BE MOVED HORIZONTALLY ON A SLIDING STRIP AND VERTICALLY ON A SLIDING PANEL. (MA)

## GEYMET & ALKER

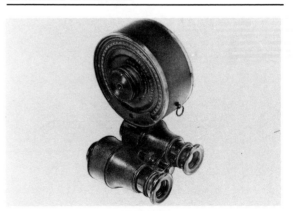

**(2403) JUMELLE DE NICOUR BINOCULAR DETECTIVE CAMERA.** C. 1867. SIZE 4 X 4 CM EXPOSURES ON PLATES. ONE LENS SYSTEM SERVES AS A CAMERA AND ONE AS A VIEWER. A 12.7 CM DIAMETER MAGAZINE HOLDS 50 DRY COLLODION PLATES. 65 MM/F 6.5 PETZVAL-TYPE LENS. BETWEEN-THE-LENS ROTARY SHUTTER. (HA)

## GILLES-FALLER

**(2404) TAILBOARD STAND CAMERA.** C. 1865. SIZE 18 X 24 CM PLATE EXPOSURES. 300 MM/F 5.6 KOMURA LENS. BETWEEN-THE-LENS SHUTTER WITH SPEEDS TO $\frac{3}{100}$ SEC. DOUBLE EXTENSION BELLOWS. (IH)

## GILLES-FALLER (*cont.*)

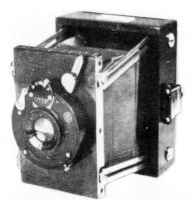

**(2405) GILFA PLATE CAMERA.** C. 1922. SIZE 6 X 8 CM EXPOSURES ON PLATES. 110 MM/F 6.3 TOPAZ-BOYER OR 105 MM/F 4.5 VIRLOT ANASTIGMATIC LENS. GITZO SHUTTER; 1/25 TO 1/100 SEC. TEAK OR MAHOGANY BODY. (HA)

## GIROUX, ALPHONSE

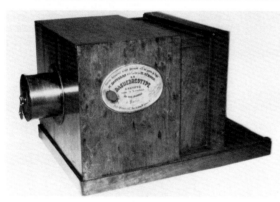

**(2406) DAGUERREOTYPE CAMERA.** C. 1839. THE CAMERA WAS DESIGNED BY LOUIS JACQUES MAUDE DAGUERRE OF PARIS. SIZE 16.5 X 21.5 CM EXPOSURES ON SILVERED COPPER (DAGUERREOTYPE) PLATES. 380 MM/F 15 CHEVALIER ACHROMATIC TELESCOPIC OBJECTIVE LENS. MANUALLY OPERATED METAL PLATE SHUTTER THAT PIVOTS ON THE FRONT OF THE LENS TUBE. SLIDING BOX DESIGN. GROUND GLASS FOCUSING. A HINGED MIRROR ATTACHED TO THE BOTTOM OF THE GROUND GLASS IS HELD AT A 45-DEGREE ANGLE TO THE GROUND GLASS BY A METAL HOOK. (GE)

## GORDE

**(2407) CARNET PHOTO-RAPIDE (LE ROY'S) CAMERA.** C. 1889. THIS CAMERA WAS MARKETED IN 1888 AS THE VÉLOGRAPHE CAMERA.

---

**(2408) VÉLOGRAPHE (LE ROY'S) CAMERA.** C. 1888. THE CAMERA HAS SIX DOUBLE PLATE HOLDERS MOUNTED IN A SINGLE PLANE WHICH PROVIDES A TOTAL OF 12 EXPOSURES, SIZE 4 X 4.5 CM. ALSO, ONE LARGE DOUBLE PLATE CAN BE MOUNTED IN THE CAMERA FOR MAKING SIX EXPOSURES ON EACH SIDE OF THE PLATE. THE CAMERA BODY WITH LENS,

SHUTTER, AND REFLECTING FINDER CAN BE MOUNTED ON ANY ONE OF THE 12 EXPOSURE POSITIONS. THIS CAMERA WAS SOLD UNDER THE MODEL NAME "CARNET PHOTO-RAPIDE" IN 1889. (BC)

## GUERIN, EMILE

**(2409) LE FURET CAMERA.** C. 1928. SIZE 24 X 36 MM EXPOSURES ON SPECIAL 35 MM CASSETTS. 60 MM/F 3.5 OPTIS LENS. COMPUR SHUTTER; 1 TO 1/250 SEC. (MA)

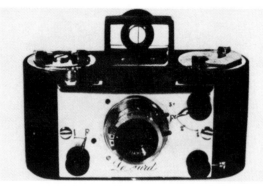

**(2410) LE FURET CAMERA.** C. 1929. SIZE 24 X 36 MM EXPOSURES ON ROLL FILM. 40 MM/F 4.5 SAPHIR LENS. ROTARY SHUTTER. (HA)

## GUILLEMINOT & CIE

**(2411) DETECTIVE CAMERA.** C. 1900. SIZE 9 X 12 CM PLATE EXPOSURES. 150 MM/F 9 APLANAT LENS. EIGHT-SPEED ROTARY SECTOR SHUTTER. (MA)

---

**(2412) SPHINX (AUTOMATIC) CAMERA.** C. 1891. SIZE 9 X 12 CM EXPOSURES ON PLATES. THE MAGAZINE HOLDS 12 PLATES. APLANAT LENS. ROTARY SECTOR SHUTTER. A SPRING AND CLOCKWORK MOTOR AUTOMATICALLY CHANGES THE PLATES AND COCKS THE SHUTTER. TWELVE EXPOSURES IN 30-SECONDS ARE POSSIBLE. PATENTED BY GEORGE MARONIEZ. (IH)

## GUYARD

**(2413) HAND AND STAND CAMERA.** C. 1887. SIZE 13 X 18 CM EXPOSURES ON PLATES OR ROLL FILM WITH SPECIAL ROLL FILM HOLDER. 290 MM/F 16 BALBRECK RECTILINEAR LENS. MULTI-SPEED BETWEEN-THE-LENS SHUTTER. (IH)

## HANAU, EUGÉNE

**(2414) LE MARSOUIN MAGAZINE CAMERA.** C. 1901. SIZE 4.5 X 8 CM EXPOSURES ON PLATES. 90 MM/F 6.8 GOERZ ANASTIGMAT LENS. ROLLER-BLIND SHUTTER; 1/25, 1/50, 1/80 SEC., B. THE MAGAZINE HOLDS 18 PLATES.

---

**(2415) LE MARSOUIN MAGAZINE STEREO CAMERA.** C. 1901. SIZE 45 X 107 MM STEREO EXPOSURES ON PLATES. PUSH-PULL MAGAZINE. 55 MM/F 6.3 TESSAR LENSES. THREE-SPEED GUILLOTINE SHUTTER. (MA)

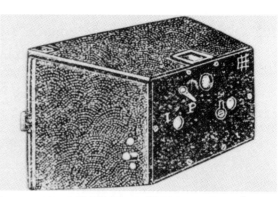

**(2416) CALYPSO JUMELLE STEREO CAMERA.** C. 1907. SIZE 60 X 130 MM STEREO EXPOSURES ON PLATES. ACHROMATIC LENSES.

**(2417) OMNIGRAPHE CAMERA.** C. 1887. PROBABLY THE FIRST STRUT CAMERA TO BE MARKETED. TWO SIZES OF THIS CAMERA FOR 8 X 8 OR 9 X 12 CM EXPOSURES ON GLASS PLATES. THE MAGAZINE HOLDS 12 PLATES. F 10 RAPID RECTILINEAR LENS. GUILLOTINE-TYPE SHUTTER FOR SINGLE-SPEED AND TIME EXPOSURES. (IH)

**(2418) PASSE-PARTOUT CAMERA.** C. 1889. SIZE 6 X 6 CM PLATE EXPOSURES. BETWEEN-THE-LENS ROTARY SECTOR SHUTTER. (IH)

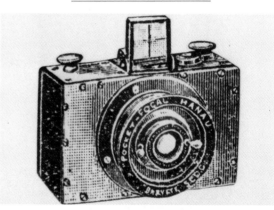

**(2419) POCKET-FOCAL-HANAU CAMERA.** C. 1907. SIZE 4.5 X 6 CM EXPOSURES ON ROLL FILM.

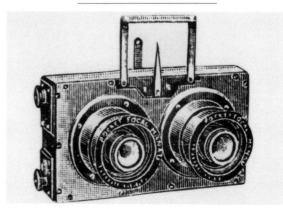

**(2420) STEREO-POCKET-FOCAL-HANAU CAMERA.** C. 1907. SIZE 45 X 107 MM STEREO EXPOSURES.

## HANAU, EUGÉNE (cont.)

**(2421) PERFECT REPORTER CAMERA.** C. 1894. THE MAGAZINE HOLDS 12 PLATES. AFTER A PLATE IS EXPOSED, A SPRING PUSHES THE PLATE FORWARD AND FALLS TO THE BOTTOM OF THE CAMERA.

## HERMAGIS, J. H.

**(2422) CARTE-DE-VISITE CAMERA.** C. 1859. FOUR EXPOSURES SIZE 51 X 83 MM CAN BE MADE ON A SINGLE 16.5 X 21.5 CM PLATE SIMULTANEOUSLY BY USING THE FOUR CAMERA LENSES. (BC)

**(2423) COLLAPSIBLE BOX CAMERA.** C. 1875. THE SIDES OF THE CAMERA ARE HINGED TO ALLOW THE CAMERA BODY TO BE FOLDED FLAT.

## HOUSSIN, VICTOR

**(2424) PHOTOTANK CAMERA.** C. 1921. SIZE 24 X 24 MM EXPOSURES ON "35MM" ROLL FILM. 50 MM/F 3.5 BERTHIOT STELLER LENS. FOCAL PLANE SHUTTER. (IH)

## JEANNERET & COMPANY

**(2425) MONOBLOC STEREO CAMERA.** C. 1925. SIZE 6 X 13 CM EXPOSURES ON PLATES. 75 MM/F 4.5 SAPHIR LENSES. STEREO COMPUR SHUTTER; 1 TO ⅟₁₅₀ SEC. INTERCHANGEABLE AND RISING LENS PANEL. (MA)

## JONTE

**(2426) L'AUTOMATIQUE CAMERA.** C. 1880. STEINHEIL LENS. (MA)

**(2427) PHOTO-REVOLVER CAMERA.** C. 1876. THE CAMERA HAS AN UPPER BELLOWED CHAMBER WITH LENS AND A LOWER SLIDING PLATE-BOX CHAMBER. A PINION WHEEL DRIVEN BY AN OUTSIDE KNOB LIFTS EACH PLATE INTO THE FOCAL PLANE BY TWO RODS ATTACHED TO THE PLATE HOLDER. (IH)

## JOUX, L. & CIE

**(2428) ALETHOSCOPE STEREO CAMERA.** C. 1905.

**(2429) ALETHOSCOPE STEREO CAMERA.** C. 1912. SIZE 45 X 107 MM EXPOSURES. THE CAMERA'S MAGAZINE HOLDS 12 PLATES. BALBRECK RECTILINEAR LENSES. WATERHOUSE STOPS. FIVE-SPEED GUILLOTINE SHUTTER. SIMILAR TO THE ALETHOSCOPE STEREO CAMERA (C. 1914) FOR SIZE 6 X 13 CM EXPOSURES. (MA)

**(2430) ORTHO JUMELLE DUPLEX STEREO CAMERA.** C. 1895. SIZE 6 X 9 CM EXPOSURES. 110 MM/F 8 ZEISS KRAUSS ANASTIGMAT LENSES. GUILLOTINE SHUTTERS.

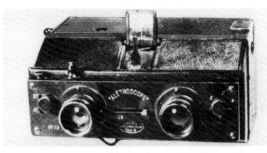

**(2431) ALETHOSCOPE STEREO CAMERA.** C. 1914. SIZE 60 X 130 MM EXPOSURES. THE CAMERA'S MAGAZINE HOLDS 12 PLATES. BALBRECK RECTILINEAR LENSES. FIVE-SPEED GUILLOTINE SHUTTER. (HA)

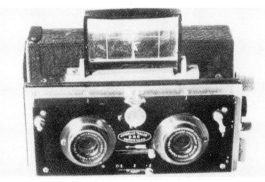

**(2432) JUMELLE STEREO CAMERA.** C. 1896. SIZE 6 X 13 CM EXPOSURES. 110 MM/F 8 KRAUSS TESSAR LENS. SIX-SPEED GUILLOTINE SHUTTER. (HA)

**(2433) STENO-JUMELLE CAMERA.** C. 1895. 6.5 X 9 CM EXPOSURES ON PLATES. THE CAMERA'S MAGAZINE HOLDS 18 PLATES. 110 MM/F 8 KRAUSS-ZEISS ANASTIGMAT LENS. GUILLOTINE SHUTTER FOR FIVE INSTANTANEOUS SPEEDS AND TIME EXPOSURE. BY LIFTING THE TOP SECTION OF THE CAMERA, WHICH IS HINGED AT THE FRONT, THE FORWARD-MOST PLATE IN THE MAGAZINE IS POSITIONED IN THE FOCAL PLANE. WHEN THE TOP SECTION IS RETURNED TO THE CLOSED POSTION, THE EXPOSED PLATE IS PLACED IN THE REAR OF THE MAGAZINE. SIMILAR TO THE 1899 MODEL.

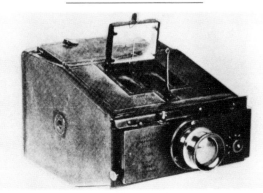

**(2434) STENO-JUMELLE CAMERA.** C. 1899. THREE SIZES OF THIS CAMERA FOR 6.5 X 9, 9 X 12, OR 8 X 16 CM EXPOSURES ON PLATES. 110 MM/F 8 KRAUSS-ZEISS ANASTIGMAT OR 130 MM/F 8 GOERZ ANASTIGMAT LENS. GUILLOTINE SHUTTER FOR FIVE SPEEDS AND TIME EXPOSURES. THE 6.5 X 9 MODEL HOLDS 18 PLATES WHILE THE OTHER TWO MODELS HOLD 12 PLATES. THE MAGAZINE OPERATION IS SIMILAR TO THE 1895 MODEL.

## JUMEAU AND JANNIN

**(2435) CRISTALLOS CAMERA.** C. 1890. TWO SIZES OF THIS CAMERA FOR 6 X 9 OR 9 X 12 CM EXPOSURES ON ROLL FILM. MENISCUS LENS. ROTARY SHUTTER. FOLDING TYPE-CAMERA WITH BELLOWS. (IH)

## KAUFFER

**(2436) LE PHOTO SAC-A-MAIN CAMERA.** C. 1895. SIZE 9 X 12 CM EXPOSURES ON PLATES. 150 MM/F 8 COLMONT LENS. ROTARY SHUTTER. (MA)

## KLISCOPE

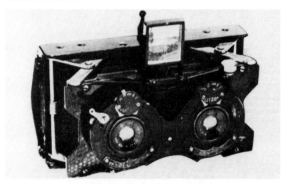

**(2437) LE KLISCOPE STEREO CAMERA.** C. 1920. SIZE 7 X 13 CM STEREO EXPOSURES ON PLATES. F 8 EXTRA RAPID APLANAT LENSES. SHUTTER SPEEDS; ⅟₂₅ TO ⅟₁₀₀ SEC. (HA)

## KOCH

**(2438) STEREOSCOPIC CAMERA.** C. 1860. SIZE 9 X 21 CM STEREO EXPOSURES ON COLLODION PLATES. 125 MM/F 11 JAMIN SIMPLE LENSES. RISING AND CROSSING LENS MOUNT. (MA)

## KORSTEN

**(2439) LA LITOTE STEREO CAMERA.** C. 1908. TWO SIZES OF THIS CAMERA FOR 45 X 107 OR 60 X 130 MM EXPOSURES ON PLATES. F 9 KRAUSS LENSES. THREE-SPEED GUILLOTINE SHUTTER. (HA)

## KRAUSS, EUGÉNE

**(2440) DEUBRESSE PANORAMIC CAMERA.** C. 1906. THE CAMERA IS OF BOX-FORM WITH A LENS-PRISM "PERISCOPE" DEVICE MOUNTED ON TOP. THE "PERISCOPE" ROTATES BY MEANS OF A SPRING CLOCKWORK. THE FILM IS HELD IN A CURVED HOLDER INSIDE OF THE CAMERA. (BC)

**(2441) EKA CAMERA.** C. 1924. SIZE 35 X 45 MM EXPOSURES ON UNPERFORATED 35 MM CINE ROLL FILM. 100 EXPOSURES PER ROLL OF FILM. 50 MM/F 3.5 OR F 4.5 KRAUSS TESSAR LENS. COMPUR SHUTTER; 1 TO 1/300 SEC., B., T. IRIS DIAPHRAGM. HELICAL FOCUSING.

**(2442) PHOTO-REVOLVER CAMERA.** C. 1921. SIZE 18 X 35 MM EXPOSURES ON PLATES OR ROLL FILM. THE CAMERA HOLDS 48 PLATES OR ROLL FILM FOR 100 EXPOSURES. 40 MM/F 4.5 TESSAR-KRAUSS, TESSAR-PROTAR, OR TRIANAR-KRAUSS LENS. SHUTTER SPEEDS OF 1/25, 1/50, AND 1/100 SEC. (HA)

**(2443) TAKYR CAMERA.** C. 1906. SIZE 9 X 12 CM EXPOSURES ON PLATES. ZEISS-KRAUSS PROTAR CONVERTIBLE LENS. SIGRISTE-TYPE SHUTTER. RISING AND CROSSING LENS MOUNT.

**(2444) TAKYR REFLEX CAMERA.** C. 1907.

**(2445) TAKYR STEREO AND PANORAMIC CAMERA.** C. 1907.

## L. F. G. & CIE

**(2446) LE FRANCAIS BOX CAMERA.** C. 1910. THE CAMERA HOLDS TWO 4 X 5 CM PLATES ON A PIVOTING DEVICE. 55 MM/F 11 MENISCUS LENS. SIMPLE SHUTTER. (MA)

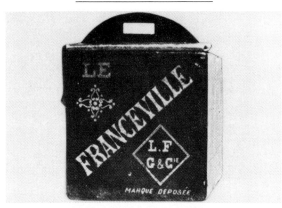

**(2447) LE FRANCEVILLE BOX CAMERA.** C. 1908. SIZE 4 X 4 CM EXPOSURES ON PLATES. 60 MM/F 11 MENISCUS LENS. SIMPLE PIVOTING SHUTTER. THE CAMERA BODY IS PRESSED PAPER BOARD. (HA)

**(2448) LE FRANCEVILLE BOX CAMERA.** C. 1908. SIZE 4 X 4 CM EXPOSURES ON PLATES. 45 MM/F 18 MENISCUS LENS. SLIDING-PLATE SHUTTER. PLASTIC BODY. (MA)

## LA SOCIETE F.A. P.

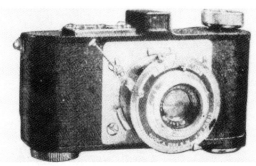

**(2449) NORCA MINIATURE CAMERA.** C. 1939. EXPOSURES ON ROLL FILM. F 3.5 BERTHIOT STELLOR LENS. SHUTTER SPEEDS FROM 1/25 TO 1/300 SEC., B., T. EXPOSURE COUNTER.

## LE GOUSSET, J. V.

**(2450) FILM PACK CAMERA.** C. 1910. SIZE 4.5 X 6 CM EXPOSURES. ACHROMATIC LENS. SINGLE-SPEED SHUTTER. (MA)

**(2451) PLATE CAMERA.** C. 1910. SIZE 4.5 X 6 CM EXPOSURES. PERISCOPIC LENS. SINGLE-SPEED SHUTTER. (MA)

## LE SEUL

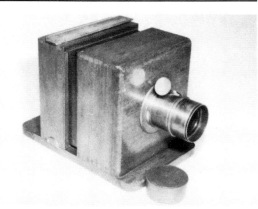

**(2452) LE SEUL CAMERA.** C. 1900. A SERIES OF EXPOSURES ARE MADE ON A FILM STRIP. (HA)

## LEREBOURS, N. P.

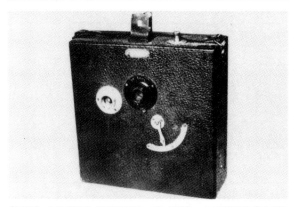

**(2453) NOUVEL APPAREIL GAUDIN CAMERA.** C. 1841. SIZE 7 CM DIAMETER EXPOSURES ON 7 X 8 CM DAGUERREOTYPE PLATES. 80 MM DOUBLET LENS. A BLACK CLOTH FASTENED ABOVE THE LENS ON THE CAMERA FRONT IS RAISED AND LOWERED FOR USE AS A SHUTTER. A CIRCULAR DISC WITH THREE APERTURE STOPS (F 4, F 8, AND F 24) IS LOCATED IN FRONT OF THE LENS. (GE)

## LEROY, LUCIEN

**(2454) LE STEREOCYCLE STEREO CAMERA.** C. 1898. SIZE 6 X 13 CM STEREO EXPOSURES ON PLATES. 85 MM/F 9 KOCH LENSES. IRIS DIAPHRAGM. GUILLOTINE SHUTTER. MAGAZINE FOR PLATES. (IH)

**(2455) STÉRÉO-PANORAMIQUE CAMERA.** C. 1903. SIZE 6 X 13 CM SINGLE OR STEREO EXPOSURES ON PLATES. ONE OF THE LENSES IS MOUNTED ON A ROTATABLE CIRCULAR PANEL. BY ROTATING THIS LENS, THE POSITION OF THE SEPTUM IS CHANGED AND EITHER SINGLE OR STEREO EXPOSURES CAN BE MADE. (BC)

## LEROY, LUCIEN (*cont.*)

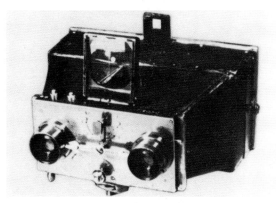

**(2456) LE STEREOCYCLE STEREO CAMERA.** C. 1898. SIZE 6 X 13 CM STEREO EXPOSURES ON PLATES. 75 MM/F 6 GOERZ DOUBLE ANASTIGMAT LENS. FIVE-SPEED GUILLOTINE SHUTTER. (HA)

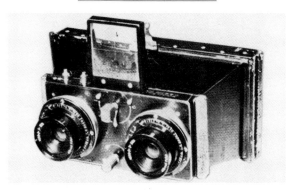

**(2457) STEREO CAMERA.** C. 1897. SIZE 60 X 130 MM STEREO EXPOSURES ON PLATES. 72 MM/F 6.8 GOERZ DAGOR LENS. FIVE-SPEED ROTARY SHUTTER. (HA)

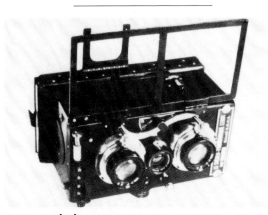

**(2458) STÉRÉO-PANORAMIQUE CAMERA.** C. 1905. SIZE 6 X 13 CM STEREO EXPOSURES. 85 MM/F 4.5 KRAUSS TESSAR LENSES. THE CENTER LENS IS AN 82 MM/F 9 ZEISS PROTAR LENS FOR TAKING SINGLE PANORAMIC EXPOSURES. (HA)

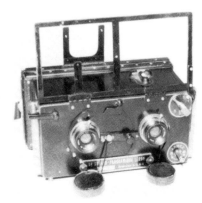

**(2459) STÉRÉO-PANORAMIQUE CAMERA.** C. 1906. SIZE 6 X 13 STEREO EXPOSURES ON PLATES. 82 MM/ F 9 KRAUSS ZEISS PROTAR OR DARLOT LENS. FIVE-SPEED ROTARY SHUTTER PLUS TIME EXPOSURES. THE RIGHT LENS IS MOUNTED ON A DISC THAT CAN BE ROTATED, THUS BRINGING IT TO THE CENTER OF THE CAMERA. IN THE CENTER POSITION THE SEPTUM CAN BE MOVED TO COVER THE LEFT LENS AND THE CAMERA IS READY FOR PANORAMIC EXPOSURES. THE LENS IN THE CENTER POSITION COVERS AN ANGLE OF 80 DEGREES. (GE)

**(2460) STÉRÉO-PANORAMIQUE CAMERA.** C. 1908. SIZE 6 X 13 CM STEREO EXPOSURES ON PLATES. 85 MM/F 6.8 HERMAGIS APLANASTIGMAT OR 85 MM/F 6.3 ZEISS TESSAR LENSES. THE CAMERA CAN BE CONVERTED FROM STEREO TO PANORAMIC AS DESCRIBED FOR THE LEROY STEREO-PANORAMIC CAMERA OF 1906.

## LESUEUR, L. & DUCOS DE HAURON, LOUIS

**(2461) MELANOCHROMOSCOPE THREE-COLOR CAMERA.** C. 1899. THREE EXPOSURES SIZE 35 X 35 MM ON ONE 50 X 130 MM PLATE. ONE-SHOT COLOR EXPOSURES BY THE USE OF PARTIALLY SILVERED OR FULLY SILVERED MIRRORS. THE CAMERA CAN ALSO BE USED AS A CHROMOSCOPE FOR VIEWING THE COLOR EXPOSURES. (IH)

## LEULIER, LOUIS

**(2462) SUMMUM STEREO CAMERA.** C. 1924. SIZE 60 X 130 MM EXPOSURES ON PLATES. 75 MM/F 4.5 BER-THIOT STELLOR LENSES. COMPUR SHUTTER WITH SPEEDS TO $\frac{1}{150}$ SEC. (HA)

**(2463) SUMMUM STEREO CAMERA.** C. 1925. SIZE 60 X 130 MM STEREO EXPOSURES ON PLATES. 85 MM/F 4.5 BOYER SAPHIR LENSES. COMPUR SHUTTER; 1 TO $\frac{1}{150}$ SEC. RISING LENS MOUNT. (HA)

**(2464) SUMMUM STEREO CAMERA.** C. 1928. SIZE 60 X 130 MM EXPOSURES ON PLATES.

## LIEBE, F.

(2465) **MONOBLOC STEREO MAGAZINE CAMERA.** C. 1920. SIZE 60 X 130 MM EXPOSURES ON PLATES. 85 MM/F 5.7 BERTHIOT LENSES. DECAUX SIX-SPEED SHUTTER. THE CAMERA CAN BE SET TO TAKE PANORAMIC EXPOSURES. RISING LENS MOUNT. (HA)

## LUMIÉRE

(2466) **AUTOMATIQUE CAMERA.** C. 1890. THIS BOX-FORM CAMERA HOLDS 12 PLATES VERTICALLY IN THE REAR OF THE CAMERA. AFTER A PLATE IS EXPOSED, A KNOB ON THE OUTSIDE OF THE CAMERA IS TURNED WHICH ROTATES NOTCHED DISCS. THE DISCS CARRY THE PLATE FORWARD UNTIL IT DROPS TO THE BOTTOM OF THE CAMERA. (BC)

(2467) **NO. 49 BOX CAMERA.** EXPOSURES ON NO. 122 ROLL FILM.

(2468) **SCOUT BOX CAMERA.** C. 1935. SIZE 6 X 9 CM EXPOSURES ON NO. 120 ROLL FILM. SIMPLE LENS. SINGLE-SPEED SHUTTER. THREE APERTURE STOPS. (MA)

(2469) **ELJY CAMERA.** C. 1937–40. SIZE 24 X 36 MM EXPOSURES ON ROLL FILM. 42 MM/F 3.5 OR F 4.5 LYPAR ANASTIGMAT LENS. CENTRAL SHUTTER; $\frac{1}{10}$ TO $\frac{1}{150}$ SEC., B., T. SOME MODELS WITH LUMIÉRE SHUTTER; $\frac{1}{25}$ TO $\frac{1}{125}$ SEC., B., T. FOCUSING BY MARKED SCALE.

(2470) **LE PERIPHOTE PANORAMIC CAMERA.** C. 1901. SIZE 7 X 38 CM PANORAMIC EXPOSURES. THE CAMERA LENS ROTATES AROUND THE CAMERA BODY BY MEANS OF A SPRING MOTOR WHILE THE FILM REMAINS STATIONARY TO MAKE A 180-DEGREE OR 360-DEGREE EXPOSURE. 55 MM/F 5.6 JARRETT ANASTIGMAT LENS. THE MAXIMUM EXPOSURE SIZE IS 70 X 381 MM.

(2471) **LUMIÉREBOX JUNIOR CAMERA.** C. 1940. SIZE 6 X 9 CM EXPOSURES ON ROLL FILM. LUMIÉRE FIXED-FOCUS LENS. INSTANT AND BULB SHUTTER.

(2472) **LUMIÉREBOX SENIOR CAMERA.** C. 1940. SIZE 6 X 9 CM EXPOSURES ON ROLL FILM. SAME AS THE LUMIÉREBOX JUNIOR CAMERA EXCEPT FOR NICKEL FINISH AND A DELAYED ACTION SHUTTER.

(2473) **LUMIÉRE JUNIOR ROLL FILM CAMERA.** C. 1940. SIZE 6 X 9 CM EXPOSURES ON ROLL FILM. F 6.8 LUMIÉRE FIDOR ANASTIGMAT LENS. RIM-SET SHUTTER; $\frac{1}{25}$ TO $\frac{1}{125}$ SEC., B., T.

(2474) **LUMIX ROLL FILM CAMERA.** C. 1940. SIZE 6 X 9 CM EXPOSURES ON ROLL FILM. LUMIÉRE FIXED-FOCUS LENS. LUMIÉRE SHUTTER; $\frac{1}{25}$ TO $\frac{1}{75}$ SEC., B.

(2475) **STERELUX STEREO CAMERA.** C. 1934–38. SIZE 6 X 13 CM EXPOSURES ON NO. 116 OR D-6 ROLL FILM. LUMIÉRE SHUTTER; $\frac{1}{25}$ TO $\frac{1}{100}$ SEC., B., T. SIMILAR TO THE STERELUX DELUXE STEREO CAMERA, C. 1939.

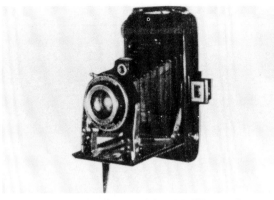

(2476) **LUMIREX ROLL FILM CAMERA.** C. 1940. SIZE 6 X 9 CM EXPOSURES ON ROLL FILM. 105 MM/F 6.3 LUMIÉRE FIDOR ANASTIGMAT OR 105 MM/F 4.5 SPECTOR LENS. RIM-SET SHUTTER: $\frac{1}{10}$ TO $\frac{1}{125}$ OR $\frac{1}{150}$ SEC., B., T., ST. MANUAL FOCUSING.

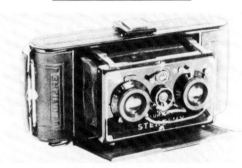

(2477) **STERLUX DELUXE STEREO CAMERA.** C. 1939. SIZE 6 X 13 CM EXPOSURES ON NO. 116 OR D-6 ROLL FILM. 80 MM/F 4.5 LUMIÉRE SPECTOR ANASTIGMAT LENSES. LUMIÉRE RIM-SET SHUTTER; 1 TO $\frac{1}{100}$ SEC., B., T., ST. SINGLE EXTENSION BELLOWS. MANUAL FOCUSING BY SCALE.

## MACKENSTEIN

(2478) **CHROMOGRAPHOSCOPE COLOR CAMERA.** C. 1897. RED, GREEN, AND BLUE FILTERS ARE USED TO MAKE THREE IMAGES ON ONE TRANSPARENT FILM. THE FILMS WERE SANDWICHED TOGETHER TO MAKE ONE COLOR FILM SIZE 9 X 11 CM. THE CAMERA CAN ALSO BE USED AS A CHROMOSCOPE FOR VIEWING THE COLOR FILMS. (IH)

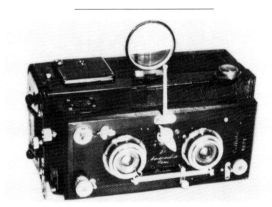

(2479) **JUMELLE KALLISTA STEREO CAMERA.** C. 1896. SIZE 6 X 13 CM STEREO EXPOSURES ON

## MACKENSTEIN (cont.)

PLATES. THE MAGAZINE HOLDS 12 PLATES. 55 MM/F 6.8 LACOUR BERTHIOT PERIGRAPHE LENS. FIVE-SPEED GUILLOTINE SHUTTER. (HA)

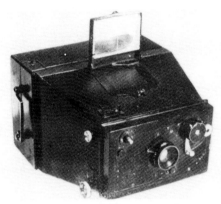

**(2480) JUMELLE MAGAZINE CAMERA.** C. 1895. SIZE 9 X 12 CM EXPOSURES ON PLATES. THE MAGAZINE HOLDS 12 PLATES. 136 MM/F 8 CARL ZEISS ANASTIGMAT LENS. SIX-SPEED GUILLOTINE SHUTTER. (HA)

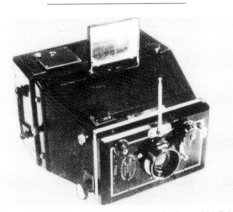

**(2481) JUMELLE PHOTOGRAPHIQUE MAGAZINE CAMERA.** C. 1896. SIZE 9 X 12 CM EXPOSURES ON PLATES. THE MAGAZINE HOLDS 12 PLATES. 120 MM/F 4.6 GOERZ DOUBLE ANASTIGMAT SERIES III LENS. FIVE-SPEED GUILLOTINE SHUTTER. (HA)

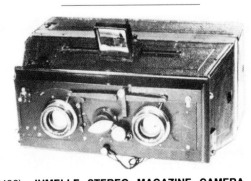

**(2482) JUMELLE STEREO MAGAZINE CAMERA.** C. 1893. SIZE 8 X 17 CM STEREO EXPOSURES ON PLATES. THE MAGAZINE HOLDS 12 PLATES. 110 MM/F 6.3 ZEISS KRAUSS PROTAR LENSES. SIX-SPEED GUILLOTINE SHUTTER. (HA)

**(2483) JUMELLE MAGAZINE CAMERA.** C. 1896. SIZE 6 X 9 CM EXPOSURES ON PLATES. 110 MM/F 8 ZEISS KRAUSS LENS. EIGHT-SPEED ROLLER-BLIND SHUTTER. THE LEFT LENS IS USED FOR VIEWING VIA THE FOLDING OPTICAL FINDER. THE MAGAZINE HOLDS 18 PLATES. (IH)

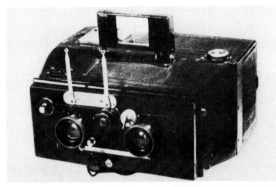

**(2484) JUMELLE STEREO AND PANORAMA CAMERA.** C. 1894. SIZE 6 X 13 CM STEREO EXPOSURES ON PLATES. THE MAGAZINE HOLDS 12 PLATES. 90 MM/F 6.4 GOERZ DOUBLE ANASTIGMAT LENSES. FOUR-SPEED GUILLOTINE SHUTTER. (HA)

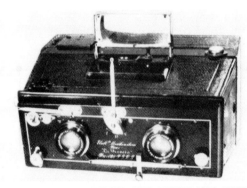

**(2485) JUMELLE STEREO AND PANORAMA CAMERA.** C. 1895. SIZE 8 X 17 CM STEREO EXPOSURES ON PLATES. THE MAGAZINE HOLDS 12 PLATES. ZEISS KRAUSS PROTAR LENSES. GUILLOTINE SHUTTER. (HA)

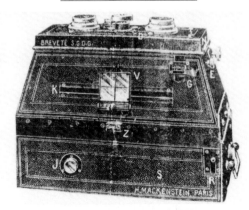

**(2486) JUMELLE STEREO AND PANORAMA CAMERA.** C. 1905. TWO SIZES OF THIS CAMERA FOR 6.5 X 9 OR 9 X 12 CM STEREO EXPOSURES ON PLATES.

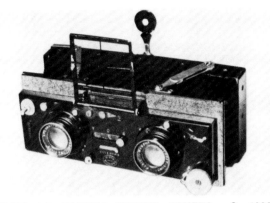

**(2487) LA FRANCIA STEREO CAMERA.** C. 1906. SIZE 45 X 107 MM STEREO EXPOSURES ON PLATES. SUMO APLANAT OR MAX BALBRECK APLANATIC LENSES. FIVE-SPEED GUILLOTINE SHUTTER. (HA)

**(2488) PHOTO-LIVRE "BOOK" CAMERA.** C. 1890. SIZE 4 X 4 CM PLATE EXPOSURES. 60 MM/F 12 RECTILINEAR LENS. GUILLOTINE SHUTTER. THE CAMERA IS DISGUISED AS A BOOK. (MA)

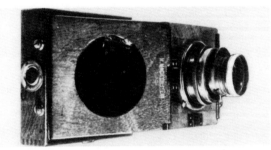

**(2489) PLATE CAMERA.** C. 1889. SIZE 9 X 12 CM EXPOSURES ON PLATES. 150 MM/F 9 APLANAT LENS. ROTARY SHUTTER. ROTARY APERTURE STOPS. SCALE FOR DISTANCE DETERMINATION. (HA)

**(2490) VIEW CAMERA.** C. 1900. SIZE 13 X 18 CM PLATE EXPOSURES. RECTILINEAR LENS. ROTARY SHUTTER. RISING AND CROSSING LENS MOUNT. (MA)

## MACRIS-BOUCHER

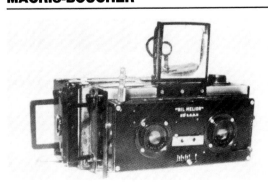

**(2491) NIL MELIOR MAGAZINE STEREO CAMERA.** C. 1924. SIZE 6 X 13 CM EXPOSURES ON PLATES. THE MAGAZINE HOLDS 12 PLATES. 85 MM/F 5.7 BERTHIOT OLOR LENSES. EIGHT-SPEED SHUTTER. (HA)

## MARTENS, FRÉDÉRIC

(2492) **PANORAMIC CAMERA.** C. 1844. THE CAMERA TAKES 150-DEGREE DAGUERREOTYPE EXPOSURES ON CURVED PLATES. (IH)

## MAZO

(2493) **GRAPHOSTÉRÉOCHROME STEREO AND COLOR CAMERA.** C. 1910. TWO 6 X 13 CM STEREO OR ONE 10 X 15 MONO EXPOSURES ON PLATES. THE CAMERA CAN BE USED TO MAKE STEREO EXPOSURES OR THREE-COLOR EXPOSURES USING BUILT-IN COLOR FILTERS. (IH)

(2494) **JUMELLE CAMERA.** C. 1900. THE MAGAZINE HOLDS 12 PLATES. 135 MM/F 6.5 DOUBLE TRIPLET LENS. RISING AND CROSSING LENS MOUNT. (MA)

## MENDEL

(2495) **DETECTIVE PLATE CAMERA.** SIZE 9 X 11 CM PLATE EXPOSURES. RAPID RECTILINEAR LENS. ROTARY SHUTTER.

## MENDOZA, MARCO

(2496) **L'OPERATEUR SELF-CONTAINED AUTOMATIC CAMERA.** C. 1893. SIZE 3.7 X 4.8 CM FERROTYPE EXPOSURES. THE CAMERA'S MAGAZINE HOLDS 30 PLATES. THE UPPER SECTION OF THE CAMERA IS FOR STORAGE AND EXPOSURE OF THE PLATES. THE LOWER SECTION HAS THREE GLASS CONTAINERS OF CHEMICALS FOR DEVELOPING, WASHING, AND FIXING THE EXPOSED PLATES. THE FINISHED PLATES ARE REMOVED AT THE BOTTOM OF THE CAMERA. 35 MM/F 4.5 ACHROMATIC MENISCUS LENS. GUILLOTINE SHUTTER.

(2497) **BEGINNER'S VIEW CAMERA.** C. 1895. SIZE 9 X 12 CM PLATE EXPOSURES. LANDSCAPE LENS. FRONT APERTURE STOP. (MA)

## MOËSSARD, P.

(2498) **CYLINDROGRAPHIE PANORAMIC CAMERA.** C. 1885. 170-DEGREE PANORAMIC EXPOSURES ON CURVED NEGATIVE BROMIDE PAPER. 150 MM/F 8 RECTILINEAR LENS. A SWIVEL-LENS IS ROTATED MANUALLY BY TURNING THE FRAME VIEWFINDER ON TOP OF THE CAMERA. (IH)

## MOLLIER

(2499) **CENT-VUES CAMERA.** C. 1924. SIZE 18 X 24 MM EXPOSURES ON "35MM" ROLL FILM. 45 MM/F 3.5 HERMAGIS LYNX LENS. SINGLE-SPEED GUILLOTINE SHUTTER. (IH)

(2500) **CENT-VUES CAMERA.** C. 1926. SIZE 18 X 24 MM EXPOSURES ON "35MM" ROLL FILM. 40 MM/F 3.5 HERMAGIS ANASTIGMAT LENS. COMPUR SHUTTER; 1 TO 1/300 SEC. (MA)

(2501) **CENT-VUES CAMERA.** C. 1928. SIZE 18 X 24 MM EXPOSURES ON "35MM" ROLL FILM. COMPUR SHUTTER; 1 TO 1/500 SEC. (MA)

## MOLTENI

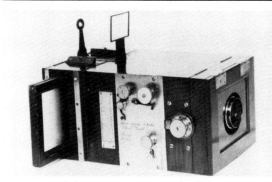

(2502) **AUTOMATIC DRY PLATE MAGAZINE CAMERA.** C. 1885. (SI)

## MONTE-CARLO

(2503) **MONTE-CARLO FOLDING CAMERA.** C. 1940. SIZE 6 X 9 CM EXPOSURES. 90 MM/F 3.5 LENS.

## MONTI, CHARLES

(2504) **LUMIÉRE MAGAZINE CAMERA.** C. 1892. SIZE 9 X 12 CM EXPOSURES ON PLATES. THE CAMERA'S MAGAZINE HOLDS 12 PLATES. 135 MM/F 11 RAPID RECTILINEAR LENS. TWO-LEAF SCISSORS-TYPE SHUTTER FOR SIX VARIABLE SPEEDS. DETACHABLE WAIST-LEVEL FINDER. WATERHOUSE STOPS.

(2505) **STEREOSCOPIC BELLOWS CAMERA.** C. 1895. EXPOSURES ON PLATES. RAPID RECTILINEAR LENSES. EXTERNAL-GEAR SHUTTER. (IH)

## MULTI-PHOTO COMPANY

(2506) **MULTI-PHOTO CAMERA.** C. 1924. MULTIPLE EXPOSURES SIZE 27 X 27 MM ON A SINGLE 10 X 15 CM PLATE. 40 MM/F 4.5 BOYER SAPHIR LENSES. FOCAL PLANE SHUTTER; 1/70 TO 1/500 SEC. THE CAMERA CAN TAKE THREE STEREOSCOPIC EXPOSURES AND THREE REGULAR EXPOSURES OR NINE REGULAR EXPOSURES ON A SINGLE PLATE. (IH)

## NACHET

(2507) **THREE-COLOR CAMERA.** C. 1895. SIZE 13 X 18 CM EXPOSURES. F 8 BERTHIOT EURYGRAPHE LENS. NO SHUTTER. (MA)

## NADAR (GASPARD FÉLIX TOURNACHON)

(2508) **BOX CAMERA.** C. 1888. EXPOSURES ON PLATES OR ROLL FILM USING THE EASTMAN-WALKER ROLL HOLDER. (IH)

(2509) **EXPRESS DETECTIVE BOX CAMERA.** C. 1888. SIZE 9 X 12 CM EXPOSURES ON PLATES OR ROLL FILM USING THE EASTMAN-WALKER ROLL HOLDER. STEINHEIL GRUPPEN ANTIPLANET LENS. SECTOR SHUTTER. (MA)

(2510) **EXPRESS DETECTIVE NADAR BOX CAMERA.** C. 1887. EXPOSURES ON PLATES OR ROLL FILM USING THE EASTMAN-WALKER ROLL HOLDER. (BC)

(2511) **CHAMBER EXPRESS-NADAR CAMERA.** C. 1889. FOUR SIZES OF THIS CAMERA FOR 13 X 18, 18 X 24, 24 X 30, OR 30 X 40 CM EXPOSURES ON PLATES. 86 MM/F 18 ZEISS ANASTIGMAT LENS. ROTATING APERTURE STOPS. RISING AND TILTING LENS MOUNT. REVERSING BACK. (IH)

(2512) **VIEW CAMERA.** C. 1885. SIZE 30 X 40 CM PLATE EXPOSURES. (MA)

## NINET

(2513) **SLIDING-BOX STEREO CAMERA.** C. 1852. SIZE 12 X 24 CM STEREO PLATE EXPSOURES. DEROGY PETZVAL-TYPE LENSES. WASHER-TYPE APERTURE STOPS. (IH)

## NOEL

(2514) **FOLDING STEREO MAGAZINE CAMERA.** C. 1905. SIZE 13 X 18 CM STEREO EXPOSURES ON PLATES. 100 MM/F 7 DUPLOVICH ANASTIGMAT LENSES. DUPLOVICH GUILLOTINE SHUTTER. (MA)

## PAPIGNY

(2515) **JUMELLE STEREO CAMERA.** C. 1902. SIZE 8 X 16.5 MM STEREO EXPOSURES ON PLATES. 100 MM/F 6.5 CHEVALIER LENSES. VARIABLE SPEED GUILLOTINE SHUTTER. (MA)

## PHOTO-HALL

(2516) **JUMELLE MAGAZINE CAMERA.** C. 1900. SIZE 9 X 12 CM EXPOSURES ON PLATES. F 8 ZEISS PROTAR LENS. FIVE-SPEED GUILLOTINE SHUTTER. IRIS DIAPHRAGM. EXPOSURE COUNTER. THE MAGAZINE HOLDS 12 PLATES.

## PHOTO-PLAIT

(2517) **MIXO BOX CAMERA.** C. 1928. SIZE 6 X 9 CM EXPOSURES ON ROLL FILM. MENISCUS LENS. INSTANT AND TIME SIMPLE SHUTTER. (MA)

## PHOTOGRAPHIE VULGARISATRICE

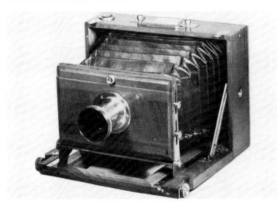

(2518) **FOLDING CAMERA.** C. 1880. SIZE 13 X 18 CM EXPOSURES ON PLATES. HERMAGIS LENS. (MR)

## PILLEUX

(2519) **SIX-TREIZE STEREO CAMERA.** C. 1902. SIZE 60 X 130 MM STEREO PLATE EXPOSURES. 80 MM/F 9 CHEVALIER RECTILINEAR LENSES. IRIS DIAPHRAGM. GUILLOTINE SHUTTER. BRASS BODY. (IH)

## PIPON, A. J.

(2520) **FOLDING PHOTO-JUMELLE CAMERA.** C. 1905. SIZE 6.5 X 9 CM PLATE EXPOSURES. 135 MM/F 11 PIPON APLANASCOPE LENS. VARIABLE-SPEED GUILLOTINE SHUTTER. (MA)

## PIPON, EMILE

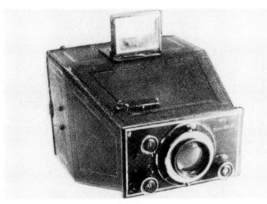

(2521) **JUMELLE CAMERA.** C. 1900. SIZE 9 X 12 CM EXPOSURES ON PLATES. 160 MM/F 8 EXTRA RAPID LENS. THREE-SPEED GULLIOTINE SHUTTER. (HA)

(2522) **JUMELLE STEREO CAMERA.** C. 1912. SIZE 45 X 107 MM STEREO EXPOSURES ON PLATES. GUILLO-TINE SHUTTER. (MA)

## RAACO

(2523) **MIGNON BOX CAMERA.** C. 1929. TWO SIZES OF THIS CAMERA FOR 4.5 X 6 OR 6.5 X 9 CM EXPOSURES ON PLATES.

(2524) **REFORM FOLDING PLATE CAMERA.** C. 1929. FOUR SIZES OF THIS CAMERA FOR 4.5 X 6, 6.5 X 9, 9 X 12, OR 10 X 15 CM EXPOSURES ON PLATES. DOUBLE ANASTIGMAT LENS. VARIO, IBSOR, OR COMPUR SHUTTER.

(2525) **ROLLKA FOLDING CAMERA.** C. 1929. SIZE 6 X 9 CM EXPOSURES ON ROLL FILM. F 11 ACHROMATIC OR F 6.3 ANASTIGMAT LENS. VARIO SHUTTER.

## RICHARD, JULES

(2526) **BUSCH VERASCOPE STEREO CAMERA.** THE CAMERA USES "35MM" ROLL FILM. 50 MM/F 3.5 BERTHIOT LENSES.

(2527) **GLYPHOSCOPE STEREO CAMERA.** C. 1905. SIZE 4.5 X 10.7 CM STEREO EXPOSURES. MENISCUS LENSES. GUILLOTINE SHUTTER. BY REMOVING THE SHUTTER MECHANISM, THE CAMERA CAN BE USED FOR VIEWING STEREO PHOTOS. (MA)

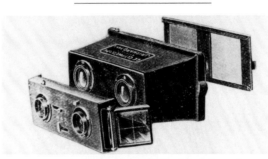

(2528) **GLYPHOSCOPE STEREO CAMERA.** C. 1914. SIZE 4.5 X 10.7 CM STEREO EXPOSURES ON PLATES OR FILM PACKS. 54 MM STEREO LENSES. SINGLE-SPEED AND TIME SHUTTER. THREE APERTURE STOPS. BY REMOVING THE SHUTTER MECHANISM, THE CAM-ERA CAN BE USED FOR VIEWING STEREO PHOTOS.

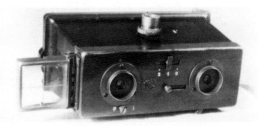

(2529) **GLYPHOSCOPE STEREO CAMERA.** C. 1920. SIZE 6 X 13 CM STEREO EXPOSURES ON ROLL FILM OR PLATES. DOUBLE ACHROMATIC LENSES. (SW)

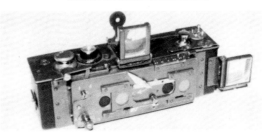

(2530) **HOMÉOS STEREOSCOPIC CAMERA.** C. 1914–

20. SIZE 1.9 X 2.5 CM STEREO EXPOSURES ON "35MM" ROLL FILM. 28 MM/F 4.5 KRAUSS TESSAR LENSES. GUILLOTINE SHUTTER; ⅒ TO ¹⁄₁₅₀ SEC., T. PROBABLY THE FIRST SUCCESSFULLY PRODUCED EUROPEAN CAMERA TO USE "35MM" ROLL FILM. (GE)

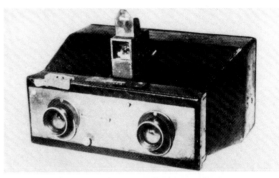

(2531) **HOMEOSCOPE STEREO MAGAZINE CAMERA.** C. 1896. SIZE 8 X 18 CM STEREO EXPOSURES. RECTI-LINEAR LENSES. GUILLOTINE SHUTTER. (HA)

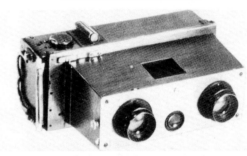

(2532) **VERASCOPE STEREO CAMERA.** C. 1894. ORIGINAL MODEL. SIZE 45 X 107 MM STEREO EXPO-SURES ON PLATES. 55 MM/F 8 RECTILINEAR LENSES. THE GUILLOTINE SHUTTER IS COCKED BY PULLING A KNOB FOR INSTANT AND TIME EXPOSURES. THE MAG-AZINE HOLDS SIX PLATES. EYE-LEVEL SPOT VIEWER AND A WAIST-LEVEL VIEWER BETWEEN THE LENSES. (HA)

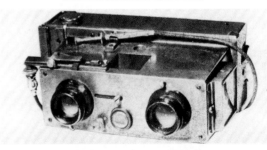

(2533) **VERASCOPE STEREO CAMERA. IMPROVED MODEL.** C. 1903. SIZE 45 X 107 MM STEREO EXPO-SURES ON PLATES. THE MAGAZINE HOLDS 12 PLATES. 55 MM/F 8 RECTILINEAR LENSES. GUILLOTINE SHUT-TER FOR INSTANT AND TIME EXPOSURES. SOME MODELS WITH MULTI-SPEED SHUTTERS. (HA)

(2534) **VERASCOPE 40 STEREO CAMERA.** C. 1938. SIZE 24 X 36 MM STEREO EXPOSURES ON "35MM" ROLL FILM. 40 MM/F 3.5 BERTHIOT FLOR LENSES. SHUTTER SPEEDS FROM 1 TO ¹⁄₂₅₀ SEC., B., T. COUPLED RANGE-FINDER. (IH)

## RICHARD, JULES (*cont.*)

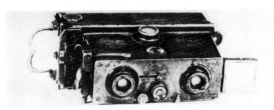

**(2535) VERASCOPE STEREO CAMERA. IMPROVED MODEL.** C. 1905. SIZE 45 X 107 MM STEREO EXPOSURES ON PLATES. THE MAGAZINE HOLDS 12 PLATES. 55 MM/F 8 RECTILINEAR LENSES. GUILLOTINE SHUTTER FOR INSTANT AND TIME EXPOSURES. EYE-LEVEL SPORTS FINDER AND ALSO A WAIST-LEVEL VIEWER BETWEEN THE LENSES. SOME MODELS WITH MULTI-SPEED SHUTTER.

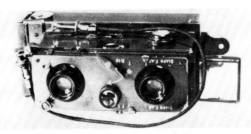

**(2536) VERASCOPE STEREO CAMERA.** C. 1905-28. TWO SIZES OF THIS CAMERA FOR 45 X 107 OR 60 X 130 MM STEREO EXPOSURES ON PLATES OR ROLL FILM WITH SPECIAL HOLDER. F 6.8 GOERZ DOUBLE ANASTIGMAT, F 4.5 BERTHIOT, OR ZEISS TESSAR LENSES. SIX-SPEED GUILLOTINE SHUTTER OR CHRONOMOS SHUTTER; ⅑ TO ¹⁄₁₅₀ SEC. EYE-LEVEL SPORTS FINDER OR WAIST-LEVEL VIEWER BETWEEN THE LENSES. (HA)

## ROUSSEL

**(2537) STELLA JUMELLE CAMERA.** C. 1900. SIZE 9 X 12 CM PLATE EXPOSURES. 150 MM/F 7.7 ANTI SPECTROSCOPIQUE LENS. GUILLOTINE SHUTTER. CHANGING PLATE MAGAZINE. (MA)

## SCHAEFFNER, A.

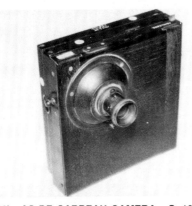

**(2538) AS DE CARREAU CAMERA.** C. 1892. SIZE 4.5 X 4.5 CM EXPOSURES ON PLATES. THE CAMERA HOLDS FOUR DOUBLE PLATES. THE PLATES ARE MOUNTED IN A FOCAL PLANE COMPARTMENT DIVIDED INTO FOUR QUARTERS. THE COMPARTMENT IS ROTATED 90-DEGREES AFTER EACH EXPOSURE FOR FOUR EXPOSURES AND THEN THE PLATES ARE REVERSED. 50 MM/F 8 PERISCOPIC LENS. NON-SELF-CAPPING SHUTTER FOR SINGLE-SPEED AND TIME EXPOSURES. (GE)

**(2539) FIN DE SIÉCLE CHANGING BOX CAMERA.** C. 1892. SIZE 9 X 12 CM EXPOSURES ON PLATES. 150 MM/F 8 RAPID RECTILINEAR LENS. (IH)

**(2540) FIN DE SIÉCLE TRAVELING CAMERA.** C. 1898. SIZE 13 X 18 CM EXPOSURES ON PLATES.

**(2541) LE PHOTOALBUM CAMERA.** C. 1892. SIZE 9 X 12 CM EXPOSURES ON PLATES. THE CAMERA IS SHAPED LIKE A BOOK WITH THE LENS, VIEWFINDER, AND SHUTTER LOCATED IN THE SPINE OF THE "BOOK." THE COVERS OF THE "BOOK" OPEN OUT TO FORM A TRIANGLE AND ARE HELD IN POSITION BY STRUTS. THE PLATE IS POSITIONED AT THE BASE OF THE TRIANGLE. 120 MM/F 11 RECTILINEAR LENS. SINGLE-SPEED GUILLOTINE SHUTTER. (BC)

## SCHRAMBACH

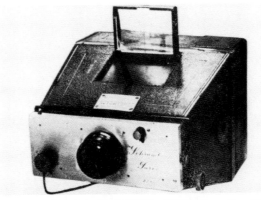

**(2542) JUMELLE MAGAZINE CAMERA.** C. 1898. SIZE 9 X 12 CM EXPOSURES ON PLATES. THE MAGAZINE HOLDS 12 PLATES. 136 MM/F 8 TESSAR LENS. FIVE-SPEED GUILLOTINE SHUTTER. (HA)

## SCHULLER, L.

**(2543) PANORAMIC CAMERA.** C. 1855. THE CAMERA IS SIMILAR TO THE FRÉDÉRIC MARTINS PANORAMIC CAMERA OF 1844 EXCEPT IT USES FLAT COLLODION PLATES.

## SIÉME

**(2544) LE XXÉME CAMERA.** C. 1895. SIZE 9 X 12 CM PLATE EXPOSURES. 136 MM/F 6.3 KRAUSS TESSAR LENS. PNEUMATIC CENTRAL SHUTTER. ALL-WOOD BODY. (MA)

## SOCIÉTÉ ANONYME DES APPAREILS PHOTOGRAPHIQUE Á RENDEMENT MAXIMUM

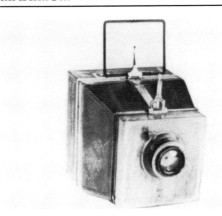

**(2545) SIGRISTE CAMERA.** C. 1899. TWO SIZES OF THIS CAMERA FOR 6.5 X 9 OR 9 X 12 CM EXPOSURES ON PLATES. F 3.6 KRAUSS-ZEISS PLANAR LENS. UNIQUE FOCAL PLANE SHUTTER FOR EXPOSURES FROM ¹⁄₄₀ TO ¹⁄₅₀₀₀ SEC. WITH POSSIBLE EXPOSURES TO ¹⁄₁₀,₀₀₀ SEC. THE SHUTTER SPEEDS ARE OBTAINED BY VARYING THE SHUTTER SPRING TENSION AS WELL AS THE WIDTH OF THE SHUTTER SLIT. INTERNAL BELLOWS. THE CAMERA'S MAGAZINE HOLDS 12 PLATES.

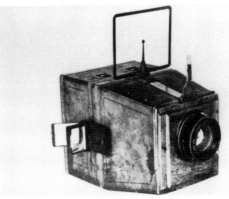

**(2546) SIGRISTE IMPROVED CAMERA.** C. 1900-09. TWO SIZES OF THIS CAMERA FOR 6.5 X 9 OR 9 X 12 CM EXPOSURES ON PLATES. THE 9 X 12 CM EXPOSURE CAMERA WAS OFFERED AFTER 1908. F 3.6 OR F 4.5 KRAUSS ZEISS PLANAR LENS. FOCAL PLANE SHUTTER; ¹⁄₄₀ TO ¹⁄₂₅₀₀ SEC.

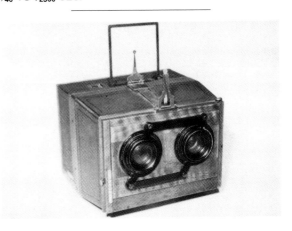

## SOCIÉTÉ ANONYME DES APPAREILS PHOTOGRAPHIQUE Á RENDEMENT MAXIMUM (cont.)

(2547) **SIGRISTE JUMELLE STEREO CAMERA.** C. 1898. SIZE 60 X 130 MM STEREO EXPOSURES ON PLATES. 85 MM/F 4.5 VOIGTLANDER HELIAR, 100 MM/F 3.5 ZEISS TESSAR, OR 150 MM/F 4.5 QUATRYL LENSES. FOCAL PLANE SHUTTER; 1/60 TO 1/4000 SEC. IRIS DIAPHRAGM. DETACHABLE MAGAZINE FOR PLATES. (GE)

## ST. ETIENNE

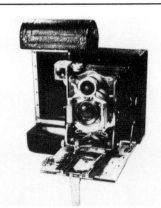

(2548) **UNIVERSALLE CAMERA.** C. 1908. SIZE 8 X 11 CM EXPOSURES ON PLATES OR ROLL FILM. 135 MM/F 6.8 ROUSSEL SYMMETRICAL ANASTIGMAT LENS. PNEUMATIC SHUTTER; 1 TO 1/100 SEC. IRIS DIAPHRAGM. THE ROLL-HOLDER BACK IS SLID SIDEWAYS WHEN USING THE GROUND GLASS SCREEN FOR FOCUSING. A PLATE COVERS THE ROLL FILM TO PREVENT EXPOSURE DURING FOCUSING. (HA)

## STEBBING, E.

(2549) **AUTOMATIC PAPER ROLL FILM CAMERA.** C. 1883. SIZE 57 X 74 MM EXPOSURES ON PAPER ROLL FILM OR PLATES. A STRIP OF SENSITIZED PAPER OR SPECIAL STRIPPING FILM WAS WOUND ON TWO BUILT-IN ROLL HOLDERS IN THE CAMERA. THE WIND-ON ROLLER GAVE AN AUDIBLE SIGNAL WHEN A SUFFICIENT AMOUNT OF FILM HAD BEEN WOUND. THE FILM WAS PERFORATED AT EACH EXPOSURE POSITION. (IH)

## THEM-STEYER, A.

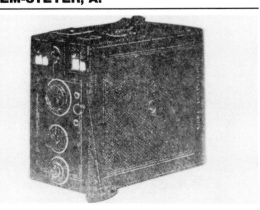

(2550) **PHOTO-SPORT NO. 1 DETECTIVE CAMERA.**

C. 1914. SIZE 9 X 12 CM EXPOSURES ON PLATES. THE MAGAZINE HOLDS 12 PLATES. IRIS DIAPHRAGM.

(2551) **PHOTO-SPORT CAMERA.** C. 1926. SIZE 24 X 30 MM EXPOSURES ON "35MM" ROLL FILM IN CASSETTES. 45 MM/F 4.5 LAAKO DYALITAR LENS. COMPUR SHUTTER; 1 TO 1/300 SEC. (MA)

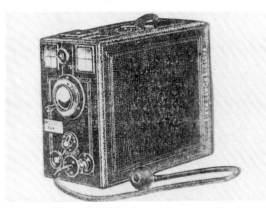

(2552) **PHOTO-SPORT NO. 2 DETECTIVE CAMERA.** C. 1914. SIZE 9 X 12 CM EXPOSURES ON PLATES. THE MAGAZINE HOLDS 12 PLATES. EXTRA RAPID RECTILINEAR, F 6.8 DOUBLE ANASTIGMAT, OR F 6.3 ZEISS TESSAR LENS. PNEUMATIC SHUTTER. IRIS DIAPHRAGM.

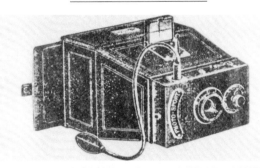

(2553) **PHOTO-SPORT NO. 1 JUMELLE CAMERA.** C. 1914. SIZE 9 X 12 CM EXPOSURES ON PLATES. ACHROMATIC LENS. PNEUMATIC SHUTTER. IRIS DIAPHRAGM.

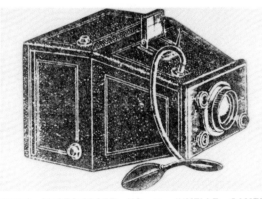

(2554) **PHOTO-SPORT NO. 2 JUMELLE CAMERA.** C. 1914. TWO SIZES OF THIS CAMERA FOR 6.5 X 9 OR 9 X 12 CM EXPOSURES ON PLATES. RAPID RECTILINEAR OR F 6.3 ANASTIGMAT LENS. IRIS DIAPHRAGM.

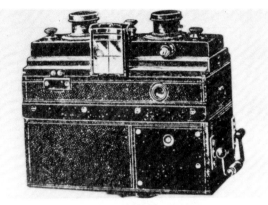

(2555) **PHOTO-SPORT STEREO JUMELLE CAMERA.** C. 1914. SIZE 45 X 107 CM STEREO EXPOSURES ON PLATES. MODEL 1 HOLDS SINGLE PLATES. MODEL 2 HOLDS 12 PLATES. BALBRECK OR F 6.3 ZEISS TESSAR LENSES.

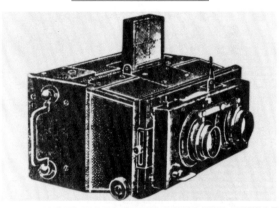

(2556) **PHOTO-SPORT STEREO PANORAMIC JUMELLE CAMERA.** C. 1914. TWO SIZES OF THIS CAMERA FOR 6 X 13 OR 8 X 16 CM EXPOSURES. BALBRECK OR F 6.3 ZEISS TESSAR LENSES.

## TIRANTY

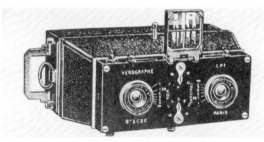

(2557) **VEROGRAPHE STEREO CAMERA.** C. 1920. TWO SIZES OF THIS CAMERA FOR 45 X 107 OR 60 X 130 MM STEREO EXPOSURES. 90 MM/F 6.3 KRAUSS TESSAR LENSES. FIVE-SPEED GUILLOTINE SHUTTER.

## TURILLON, LOUIS

(2558) **PHOTO-TICKET NO. 2 CAMERA.** C. 1905. SIZE 4 X 5 CM EXPOSURES ON ROLL FILM. 95 MM/F 4.5 PETZVAL LENS. FOCAL PLANE SHUTTER. ALUMINUM BODY. (IH)

## UNION DES FABRICANTS

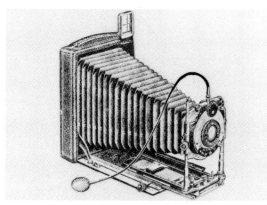

**(2559)  L'EXTRA-MINCE PLATE CAMERA.**  C. 1905. SIZE 9 X 12 CM EXPOSURES ON PLATES OR FILM PACKS. F 7.7 ROUSSEL ANASTIGMAT, F 6.8 GOERZ SYNTOR, OR F 6.3 ZEISS TESSAR LENS.  SHUTTER SPEEDS FROM 1 TO $\frac{1}{1000}$ SEC.

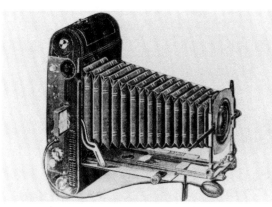

**(2560)  SPEEDY FOCAL PLANE CAMERA.**  C. 1905. SIZE 8.3 X 10.8 CM EXPOSURES ON SHEET FILM OR FILM PACKS OR 9 X 12 CM EXPOSURES ON PLATES.  F 6.8 OR F 5.4 ROUSSEL, F 6.8 GOERZ DAGOR, OR F 4.5 GOERZ CELOR LENS.  ALSO, F 6.3 ZEISS TESSAR OR F 4.7 ZEISS UNAR LENS.  FOCAL PLANE SHUTTER; 5 MIN. TO $\frac{1}{2200}$ SEC.  RISING AND CROSSING LENS MOUNT.  DOUBLE EXTENSION BELLOWS.  RACK & PINION FOCUSING.

## VALETTE, J.

**(2561)  COLLODION WET-PLATE BELLOWS CAMERA.** C. 1873.  SIZE 13 X 18 CM EXPOSURES ON WET COLLODION PLATES.  THE FLIP-TYPE SHUTTER IN BOX FORM IS HINGED TO THE FRONT OF THE CAMERA.  GROUND GLASS FOCUSING.  RACK & PINION FOCUSING.  THE BOTTOM SECTION OF THE CAMERA IS LIGHT-TIGHT AND HAS FOUR CONTAINERS FOR THE CHEMICALS NEEDED TO SENSITIZE AND DEVELOP THE COLLODION PLATES.  THE PLATES ARE RAISED AND LOWERED BEFORE AND AFTER EXPOSURE BY MEANS OF A STRING.  THE LOWER SECTION HOLDS SIX PLATES. (GE)

## WERNER, A.

**(2562)  APPAREIL COFFRET CAMERA.**  C. 1890.  SIZE 13 X 18 CM EXPOSURES ON PLATES.  240 MM/F 6.8 RODENSTOCK EURYNAR LENS.  RISING AND CROSSING LENS MOUNT.  WHEN THE CAMERA IS CLOSED IT LOOKS LIKE A BLACK HANDBAG.  (MA)

## ZION, J.

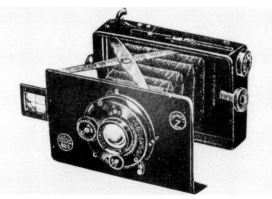

**(2563)  POCKET-Z CAMERA.**  C. 1928.  SIZE 6.5 X 9 CM EXPOSURES.  ZION ROUSSEL, BOYER, OR BERTHIOT LENS.  VARIO, IBSOR, OR COMPUR SHUTTER.

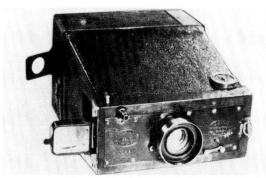

**(2564)  SIMILI JUMELLE MAGAZINE CAMERA.**  C. 1893. TWO SIZES OF THIS CAMERA FOR 6.5 X 9 OR 9 X 12 CM EXPOSURES ON PLATES.  THE MAGAZINE HOLDS 15 PLATES.  F 7.7 OR F 8 ZION ANASTIGMAT LENS. FOUR-SPEED GUILLOTINE SHUTTER.  IRIS DIAPHRAGM. (HA)

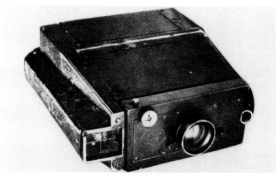

**(2565)  SIMILI JUMELLE MAGAZINE CAMERA.**  C. 1893. SIZE 9 X 12 CM EXPOSURES ON PLATES.  THE MAGAZINE HOLDS 12 PLATES.  150 MM/F 8 ZEISS KRAUSS ANASTIGMAT LENS.  FOUR-SPEED ROLLER-BLIND SHUTTER.  (HA)

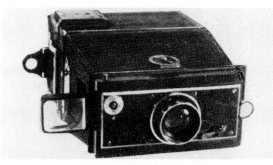

**(2566)  SIMILI JUMELLE MAGAZINE CAMERA.**  C. 1895. SIZE 6.5 X 9 CM EXPOSURES ON PLATES.  THE MAGAZINE HOLDS 12 PLATES.  F 9 ZION ANASTIGMAT LENS. FOUR-SPEED GUILLOTINE SHUTTER.  (HA)

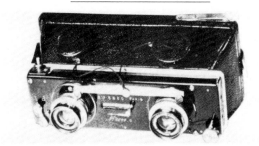

**(2567)  ZIONSCOPE STEREO CAMERA.**  C. 1915. SIZE 45 X 107 MM STEREO EXPOSURES ON PLATES. 65 MM/F 6.3 ZION SYMETRIQUE ANASTIGMAT LENSES. SIX-SPEED GUILLOTINE SHUTTER.  (HA)

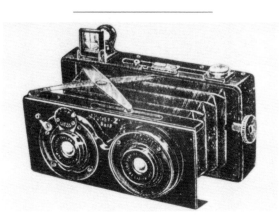

## ZION, J. (*cont.*)

(2568) **ZIONSCOPE STEREO CAMERA.** C. 1928. SIZE 60 X 130 MM STEREO EXPOSURES. COMPUR SHUTTER.

## MANUFACTURER UNKNOWN

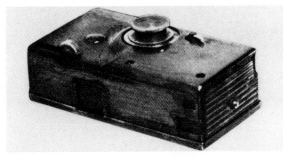

(2569) **ESPIONAGE (SPY) CAMERA.** C. 1940. THE CAMERA USES 16 MM ROLL FILM. SHUTTER SPEEDS FROM ½₀ TO ½₅₀ SEC. (HA)

(2570) **JIDÉ STEREO CAMERA.** SIZE 45 X 107 MM STEREO EXPOSURES ON PLATES. MENISCUS LENSES. TWO-SPEED GUILLOTINE SHUTTER. (MA)

(2571) **KLOPSIC PRESS CAMERA.** C. 1903. SIZE 4 X 6 CM PLATE EXPOSURES. 135 MM/F 4.5 BERTHIOT LENS. FOCAL PLANE SHUTTER; ½ TO ⅟₁₂₀₀ SEC. (IH)

(2572) **L'AIGLON CAMERA.** C. 1934. EXPOSURES ON ROLL FILM. MENISCUS LENS. SINGLE-SPEED SHUTTER. (MA)

(2573) **LA HANDY CAMERA.** C. 1900. SIZE 9 X 12 CM EXPOSURES. 135 MM/F 7.7 LEMARDELEY LENS. GUILLOTINE SHUTTER; ⅟₂₅ TO ⅟₁₀₀ SEC. HELICAL FOCUSING. (MA)

(2574) **LE CLOPIC REPORTER FOCAL PLANE CAMERA.** C. 1903. TWO SIZES OF THIS CAMERA FOR 6.5 X 9 OR 9 X 12 CM PLATE EXPOSURES. F 8 ZEISS KRAUSS OR F 4.5 BERTHIOT FLOR LENS. FOCAL PLANE SHUTTER; 2 TO ⅟₂₀₀₀ SEC.

(2575) **LE MULTICOLORE COLOR CAMERA.** COLMONT EXTRA-RAPID RECTILINEAR LENS. GUILLOTINE SHUTTER. THE PLATES ARE CHANGED BY A KEY. (MA)

(2576) **LE PARFAIT DETECTIVE CAMERA.** C. 1902. SIZE 9 X 12 CM EXPOSURES ON PLATES. STEINHEIL ANASTIGMAT LENS. MAGAZINE FOR PLATES. (MA)

(2577) **LE PHOTOCHROME THREE-COLOR CAMERA.** C. 1907. SIZE 9 X 12 CM EXPOSURES. CHROMOSTIGMAT SERIES A LENS. GUILLOTINE SHUTTER. BUILT-IN FILTER SELECTOR. (MA)

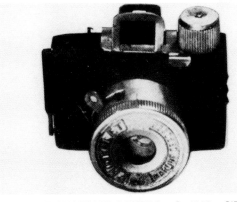

(2578) **LE PHOTOLET CAMERA.** C. 1935. SIZE 20 X 20 MM EXPOSURES ON ROLL FILM. 31 MM/F 8 MENISCUS LENS. EVERSET SHUTTER. (HA)

(2579) **LE PYGMÉE CAMERA.** C. 1935. SIZE 24 X 24 MM EXPOSURES ON "35MM" NON-PERFORATED ROLL FILM. MENISCUS LENS. SIMPLE SHUTTER. (MA)

(2580) **LE PYGMÉE STEREO CAMERA.** C. 1905. SIZE 45 X 107 MM STEREO EXPOSURES ON PLATES. MENISCUS LENSES. SLIDING SHUTTER. (MA)

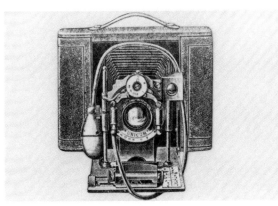

(2581) **LE REVE FOLDING CAMERA.** C. 1903. F ∂ LENS. UNICUM SHUTTER; 1 TO ⅟₁₀₀ SEC., B., T.

(2582) **LE REVE FOLDING PLATE CAMERA.** C. 1908. SIZE 9 X 12 CM EXPOSURES ON PLATES OR ROLL FILM. F 6.8 BECKERS ANASTIGMAT LENS. UNICUM SHUTTER. (MA)

(2583) **LORILLON CAMERA.** C. 1925. SIZE 9 X 12 CM PLATE EXPOSURES. BALMETTE FOCAL PLANE SHUTTER; ⅟₂₅ TO ⅟₁₀₀₀ SEC. LENSES WITH A MAXIMUM FOCAL LENGTH OF 600 MM CAN BE USED ON THE CAMERA. (MA)

(2584) **PETIT POUCET MAGAZINE BOX CAMERA.** SIZE 3 X 4 CM EXPOSURES ON PLATES. MENISCUS LENS. ROTARY SHUTTER. (IH)

(2585) **PHOTO-CYCLE ROLL FILM CAMERA.** C. 1895. SIZE 10 X 12 CM EXPOSURES. 135 MM/F 8 BERTHIOT

EURIGRAPHE LENS. THORNTON-PICKARD SHUTTER; ⅟₁₅ TO ⅟₉₀ SEC. (MA)

(2586) **PHOTO-VELO CAMERA.** C. 1892. THREE SIZES OF THIS CAMERA FOR 9 X 12, 9 X 18, OR 13 X 18 CM EXPOSURES ON PLATES. MENISCUS LENS. ROTARY APERTURE STOPS. RACK & PINION FOCUSING. NON-SELF-CAPPING SHUTTER. (IH)

(2587) **PHOTOLET CAMERA.** C. 1935. SIZE 20 X 20 MM EXPOSURES ON ROLL FILM. 31 MM/F 8 MENISCUS LENS. ROTARY SINGLE-SPEED SHUTTER. (MA)

(2588) **PICCOLO JUMELLE CAMERA.** SIZE 4 X 5 CM EXPOSURES ON ROLL FILM. MENISCUS LENS. GUILLOTINE SHUTTER. (IH)

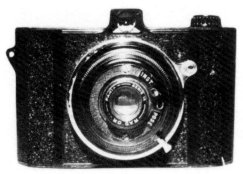

(2589) **ROLL FILM CAMERA.** C. 1939. SIZE 4 X 6.5 CM EXPOSURES. BAKELITE BODY. (HA)

(2590) **STADO JUMELLE STEREO AND VIEWER CAMERA.** C. 1903. SIZE 60 X 130 MM STEREO PLATE EXPOSURES. THE CAMERA CAN BE USED AS AN OPERA GLASS, STEREOSCOPE, OR VIEWER FOR TRANSPARENCIES. (IH)

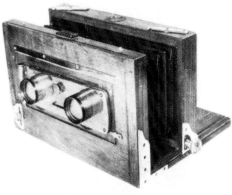

(2591) **STEREO PLATE CAMERA.** C. 1900. SIZE 6 X 18 CM STEREO EXPOSURES. SYMETRIONE LENSES. FIVE-SPEED GUILLOTINE SHUTTER. (HA)

(2592) **VA ET VIENT STEREO CAMERA.** C. 1898. SIZE 7 X 15 CM STEREO EXPOSURES ON PLATES. THE PUSH-PULL MAGAZINE HOLDS 18 PLATES. FOCUSABLE LENSES. SINGLE SPEED SHUTTER. APERTURE STOPS. (MA)

## AGFA CAMERAWERK

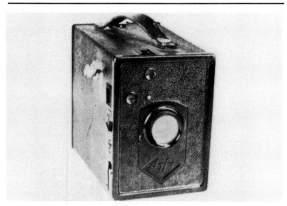

**(2593) AGFA BOX CAMERA.** C. 1930. SIZE 6 X 9 CM EXPOSURES ON NO. 120 ROLL FILM. F 11 LENS. SINGLE-SPEED AND TIME SHUTTER.

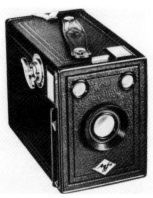

**(2594) AGFA BOX I CAMERA.** C. 1932. SIZE 6 X 9 CM EXPOSURES ON ROLL FILM. MENISCUS LENS. SINGLE-SPEED SHUTTER. FIXED FOCUS.

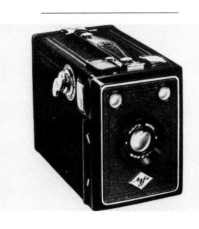

**(2595) AGFA BOX SPECIAL CAMERA.** C. 1932. SIZE 6 X 9 CM EXPOSURES ON ROLL FILM. MENISCUS LENS. SINGLE-SPEED SHUTTER. THREE-POSITION FOCUSING.

**(2596) AGFA BOX 45 CAMERA.** C. 1939. SIZE 6 X 9 CM EXPOSURES ON ROLL FILM. SINGLE-SPEED AND BULB SHUTTER. FIXED FOCUS. BUILT-IN YELLOW FILTER.

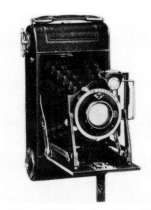

**(2597) BILLETTE CAMERA.** C. 1932. SIZE 6 X 9 CM EXPOSURES ON ROLL FILM. F 4.5 AGFA SOLINAR OR AGFA OPPAR LENS. COMPOUND SHUTTER; 1 TO $\frac{1}{300}$ SEC., B., T. LENS-RING FOCUSING.

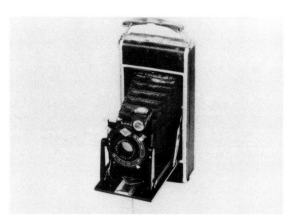

**(2598) BILLY CAMERA.** C. 1928. SIZE 6 X 9 CM EXPOSURES ON ROLL FILM. 105 MM/F 8.8 AGFA IGESTAR LENS. SHUTTER SPEEDS; $\frac{1}{25}$, $\frac{1}{50}$, $\frac{1}{100}$ SEC., B.

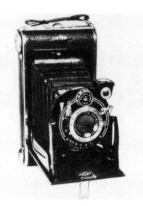

**(2599) BILLY CAMERA.** C. 1932. SIZE 7.5 X 10.5 CM EXPOSURES ON ROLL FILM. 130 MM/F 6.3 IGESTAR LENS. PRONTO SHUTTER; $\frac{1}{25}$ TO $\frac{1}{100}$ SEC. (HA)

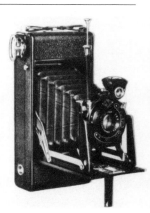

**(2600) BILLY I CAMERA.** C. 1932. SIZE 6 X 9 CM EXPOSURES ON ROLL FILM. F 8.8 AGFA ANASTIGMAT IGESTAR LENS. BILLY SHUTTER; $\frac{1}{25}$, $\frac{1}{50}$, $\frac{1}{100}$ SEC., B., T. SELF-ERECTING LENS MOUNT. THREE APERTURE STOPS.

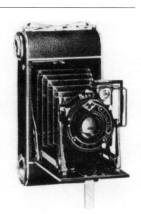

## AGFA CAMERAWERK (*cont.*)

**(2601) BILLY II CAMERA.** C. 1932. SIZE 6 X 9 CM EXPOSURES ON ROLL FILM. F 7.7 AGFA ANASTIGMAT IGESTAR LENS. BILLY SHUTTER; 1/25, 1/50, 1/100 SEC., B., T. THREE APERTURE STOPS. SELF-ERECTING LENS MOUNT.

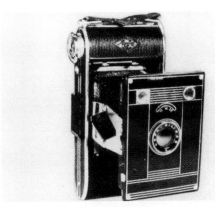

**(2602) BILLY CLACK CAMERA.** C. 1934. TWO SIZES OF THIS CAMERA FOR 4.5 X 6 OR 6 X 9 CM EXPOSURES ON ROLL FILM. F 11 BILINEAR OR F 8.8 IGENAR LENS. SINGLE-SPEED SHUTTER. (HA)

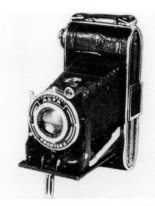

**(2603) BILLY RECORD CAMERA.** C. 1935. SIZE 6 X 9 CM EXPOSURES ON ROLL FILM. 105 MM/F 4.5 APOTAR LENS. PRONTOR SHUTTER; 1 TO 1/150 SEC., B., T. (HA)

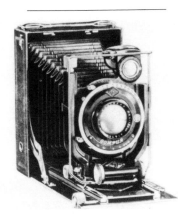

**(2604) ISOLAR CAMERA.** C. 1932. SIZE 9 X 12 CM EXPOSURES ON PLATES OR FILM PACKS. F 4.5 AGFA SOLINAR LENS. COMPUR SHUTTER; 1 TO 1/200 SEC., B., T. RACK & PINION FOCUS. RISING AND CROSSING LENS MOUNT.

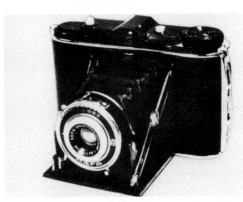

**(2605) ISORETTE ROLL FILM CAMERA.** C. 1938–40. SIZE 6 X 6 CM (4.5 X 6 CM WITH MASK) EXPOSURES. 85 MM/F 4.5 APOTAR ANASTIGMAT OR F 6.3 IGESTAR LENS. VARIO SHUTTER; 1/25 TO 1/125 SEC. B., T. OR COMPUR SHUTTER; 1 TO 1/300 SEC., B., T. ALSO, PRONTO SHUTTER; 1 TO 1/175 SEC. BUILT-IN RANGEFINDER FOR THE 1940 MODEL. (HA)

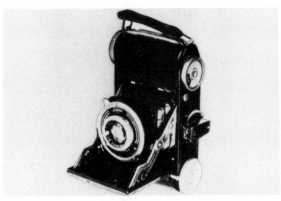

**(2606) JUBILETTE CAMERA.** C. 1935. EXPOSURES ON ROLL FILM. F 2.9 BALTAR LENS. COMPUR SHUTTER; 1 TO 1/300 SEC., B., T.

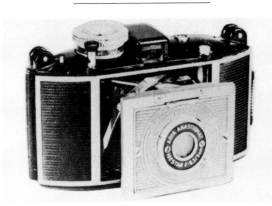

**(2607) KARAT CAMERA.** C. 1937. SIZE 24 X 36 MM EXPOSURES ON "35MM" ROLL FILM. 50 MM/F 6.3 AGFA IGESTAR OR AGFA ANASTIGMAT LENS. SHUTTER SPEEDS; 1/25, 1/50, 1/100, SEC., B., T.

**(2608) KARAT CAMERA.** C. 1938. SIZE 24 X 36 MM EXPOSURES ON "35MM" ROLL FILM. 50 MM/F 3.5 SOLINAR OR 55 MM/F 4.5 OPPAR LENS. COMPUR SHUTTER; 1 TO 1/300 SEC., B.; COMPUR RAPID SHUTTER; 1 TO 1/500 SEC.; OR AGFA SHUTTER WITH SPEEDS FROM 1/25 TO 1/125 SEC., B. (IH)

**(2609) KARAT CAMERA WITH COUPLED RANGEFINDER.** C. 1939. SIZE 24 X 36 MM ROLL FILM EXPOSURES. 50 MM/F 2.8 SCHNEIDER LENS. COMPUR RAPID SHUTTER; 1 TO 1/500 SEC. (MA)

**(2610) OPAL LUXUS PLATE CAMERA.** C. 1925. SIZE 6.5 X 9 CM EXPOSURES. 105 MM/F 4.5 RIETZSCHEL SOLINEAR LENS. COMPUR SHUTTER; 1 TO 1/250 SEC. (MA)

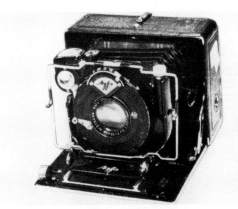

**(2611) PLATE CAMERA.** C. 1928. SIZE 6.5 X 9 CM EXPOSURES ON PLATES. 105 MM/F 4.5 DOUBLE ANASTIGMAT LENS. AGFA SHUTTER; 1/2 TO 1/100 SEC. (HA)

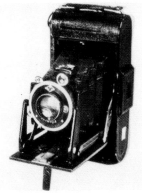

**(2612) ROLL FILM CAMERA.** C. 1932. SIZE 6 X 9 CM EXPOSURES. 95 MM/F 4.5 SOLINAR LENS. COMPUR SHUTTER; 1 TO 1/300 SEC., B., T. (HA)

**(2613) SPEEDEX CLACK NO. 51 CAMERA.** C. 1936. SIZE 3 X 4 CM EXPOSURES ON ROLL FILM. SIMILAR TO THE SPEEDEX CLACK NO. 74 CAMERA EXCEPT WITH AGFA BILINEAR LENS.

## AFGA CAMERAWERK (*cont.*)

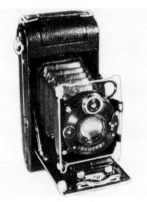

(2614) **ROLL FILM AND PLATE CAMERA.** C. 1927. SIZE 6 X 9 CM EXPOSURES. 105 MM/F 4.5 HELOSTAR LENS. COMPUR SHUTTER WITH SPEEDS TO ½₅₀ SEC. (HA)

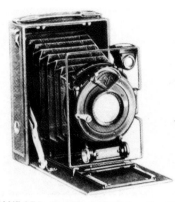

(2617) **STANDARD PLATE CAMERA.** C. 1930. TWO SIZES OF THIS CAMERA FOR 6.5 X 9 OR 9 X 12 CM EXPOSURES ON FILM PACKS. F 6.3 OR F 4.5 AGFA TRILINEAR OR AGFA HELOSTAR LENS. AUTOMAT SHUTTER; ½ TO 1/100 SEC. OR COMPUR SHUTTER.

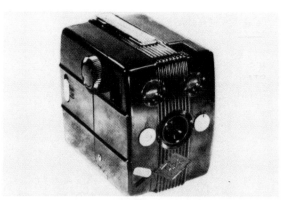

(2620) **TROLIX BOX CAMERA.** C. 1936. SIZE 6 X 9 CM EXPOSURES ON ROLL FILM. TWO APERTURE STOPS AND BUILT-IN FILTER. (HA)

## ANNACKER, I. H.

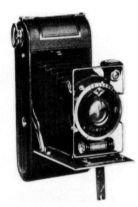

(2615) **SPEEDEX CAMERA.** C. 1934. SIZE 6 X 9 CM EXPOSURES ON ROLL FILM. F 4.5 APOTAR LENS. COMPUR SHUTTER WITH SPEEDS TO ½₅₀ SEC. PLUS DELAYED ACTION SETTING. BUTTONS FOR SELF-ERECTING AND REFOLDING LENS MOUNT.

(2618) **STANDARD ROLL FILM CAMERA.** C. 1932. TWO SIZES OF THIS CAMERA FOR 6 X 9 OR 6.5 X 11 CM EXPOSURES. F 6.3 OR F 4.5 AGFA TRILINEAR ANASTIGMAT LENS. AUTOMAT SHUTTER; ½ TO 1/100 SEC., B., T. OR COMPUR SHUTTER; 1 TO ½₅₀ SEC., B., T. AN F 4.5 AGFA HELOSTAR OR SOLINAR LENS WAS ALSO AVAILABLE FOR THE LARGER FORMAT CAMERA. SOME MODELS WITH COUPLED RANGEFINDER.

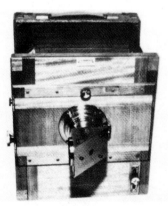

(2621) **FIELD VIEW CAMERA.** C. 1925. SIZE 18 X 24 CM EXPOSURES ON PLATES. 295 MM/F 8 CARL ZEISS PROTAR LENS. A 90-DEGREE PRISM IS MOUNTED IN FRONT OF THE CAMERA LENS. (HA)

## ANSCHÜTZ, OTTOMAR

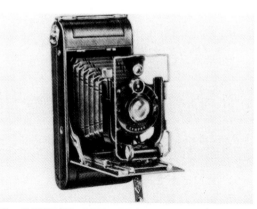

(2616) **SPEEDEX CLACK NO. 74 CAMERA.** C. 1936. SIZE 6 X 9 CM EXPOSURES ON ROLL FILM. AGFA JGE-NAR LENS. SINGLE-SPEED, B., T. SHUTTER. PUSH-BUTTON FOR SELF-ERECTING LENS MOUNT.

(2619) **SUPERIOR ROLL FILM CAMERA.** C. 1932. SIZE 8 X 14 CM EXPOSURES. F 6.3 AGFA TRILINEAR OR F 4.5 AGFA SOLINEAR LENS. COMPUR SHUTTER.

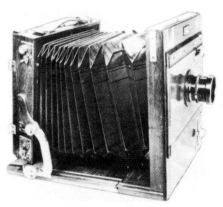

(2622) **FIELD CAMERA.** C. 1910. SIZE 18 X 24 CM EXPOSURES ON PLATES. 180 MM/F 7.7 GOERZ DOUBLE ANASTIGMAT LENS. FOCAL PLANE SHUTTER. IRIS DIAPHRAGM. (HA)

## ARNOLD, KARL

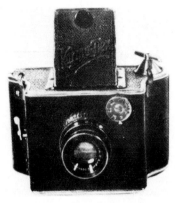

(2623) **KARMA-FLEX SPIEGEL-REFLEX CAMERA.** C. 1932. SIZE 4 X 4 CM EXPOSURES ON ROLL FILM. 60 MM/F 4.5 VIDAR LENS. KARMA SHUTTER; $\frac{1}{25}$, $\frac{1}{50}$, $\frac{1}{100}$ SEC., T. (HA)

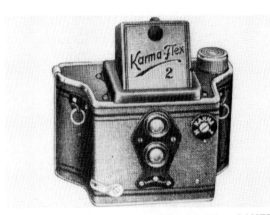

(2624) **KARMA-FLEX SPIEGEL-REFLEX CAMERA. MODEL I.** C. 1933. TWIN-LENS REFLEX. SIZE 4 X 4 CM EXPOSURES ON ROLL FILM. F 4.5 VIDAR OR F 4.5 REGULYT LENS. INSTANT AND TIME SHUTTER.

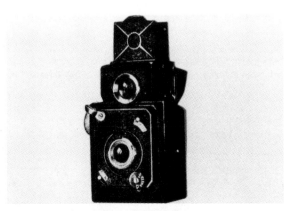

(2625) **KARMA-FLEX SPIEGEL-REFLEX CAMERA.** C. 1936. TWIN-LENS REFLEX. SIZE 6 X 6 CM EXPOSURES ON ROLL FILM. F 7.7 THREE-LINSIGEM LENS.

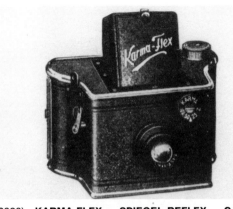

(2626) **KARMA-FLEX SPIEGEL-REFLEX CAMERA. MODEL I.** C. 1936. SINGLE-LENS REFLEX. SIZE 4 X 4 CM EXPOSURES ON ROLL FILM. F 4.5 VICTAR ANASTIGMAT OR REGULYT ANASTIGMAT LENS. KARMA SHUTTER; $\frac{1}{25}$ TO $\frac{1}{100}$ SEC., T.

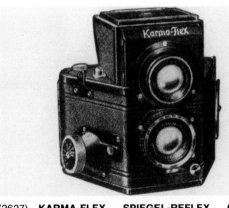

(2627) **KARMA-FLEX SPIEGEL-REFLEX CAMERA. MODEL II.** C. 1936. TWIN-LENS REFLEX. SIZE 6 X 6 CM EXPOSURES ON ROLL FILM. F 3.5 VICTAR ANASTIGMAT OR F 3.5 POLOLYT ANASTIGMAT LENS. FOCAL PLANE SHUTTER WITH SPEEDS TO $\frac{1}{500}$ SEC.

## BALDA-WERK

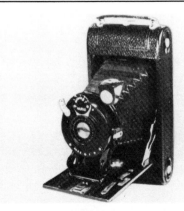

(2628) **BALDA CAMERA.** C. 1928. SIZE 6 X 9 CM EXPOSURES ON ROLL FILM. 105 MM/F 6.3 BALDA PRIMAR LENS. VARIO SHUTTER; $\frac{1}{25}$ TO $\frac{1}{100}$ SEC., B., T. (HA)

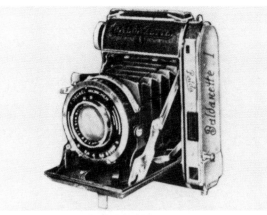

(2629) **BALDARETTE I CAMERA.** C. 1937. SIZE 6 X 6 CM EXPOSURES ON ROLL FILM. 75 MM/F 2.9 TRINAR LENS. COMPUR SHUTTER; 1 TO $\frac{1}{250}$ SEC., B., T. COUPLED RANGEFINDER. (HA)

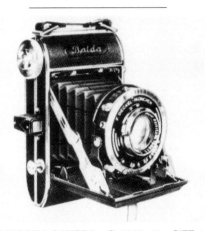

(2630) **BALDAX I CAMERA.** C. 1938–40. SIZE 4.5 X 6 CM EXPOSURES ON NO. 120 ROLL FILM. 75 MM/F 4.5 TRIOPLAN, F 3.5 ZEISS TESSAR, F 2.9 VIDANAR OR TRIOPLAN, OR F 2.8 ZEISS TESSAR OR XENAR LENS. PRONTOR I, PRONTOR II, WITH ST., PRONTOR II WITHOUT ST., COMPUR OR COMPUR RAPID WITH ST., OR COMPUR OR COMPUR RAPID WITHOUT ST. SHUTTER. SELF-ERECTING LENS MOUNT. SOME MODELS WITH HELICAL FOCAL MOUNT.

(2631) **BALDAX II CAMERA.** C. 1938–40. SIZE 6 X 6 CM EXPOSURES ON NO. 120 ROLL FILM. SAME LENSES, SHUTTERS, AND FEATURES AS THE BALDAX I CAMERA.

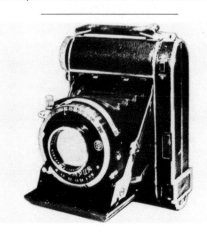

## BALDA-WERK (*cont.*)

**(2632) BALDAXETTE CAMERA.** C. 1936. SIZE 4.5 X 6 CM EXPOSURES ON ROLL FILM. 75 MM/F 2.8 SCHNEIDER XENAR LENS. COMPUR SHUTTER; 1 TO 1/250 SEC., B., T. COUPLED RANGEFINDER. (HA)

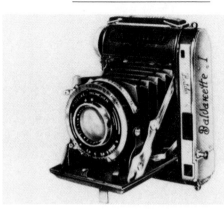

**(2633) BALDAXETTE I CAMERA.** C. 1938. SIZE 4.5 X 6 CM EXPOSURES ON NO. 120 ROLL FILM. 75 MM/F 2.9 TRIOPLAN OR RADIONAR, F 2.8 ZEISS TESSAR OR XENAR, OR F 3.5 ZEISS TESSAR LENS. COMPUR SHUTTER; 1 TO 1/250 SEC., B., T., ST. OR COMPUR RAPID SHUTTER; 1 TO 1/400 SEC., B., T., ST. COUPLED RANGE-FINDER. SELF-ERECTING LENS MOUNT. AUTOMATIC FILM TRANSPORT. HELICAL LENS MOUNT.

**(2634) BALDAXETTE II CAMERA.** C. 1938. SIZE 6 X 6 CM EXPOSURES ON NO. 120 ROLL FILM. SIMILAR TO THE BALDAXETTE I CAMERA WITH THE SAME LENSES AND SHUTTERS.

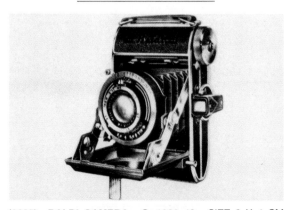

**(2635) BALDI CAMERA.** C. 1938–40. SIZE 3 X 4 CM EXPOSURES ON NO. 127 OR A-8 ROLL FILM. 50 MM/F 3.5 OR F 2.9 TRIOPLAN, F 2.9 RADIONAR, OR F 2.8 OR F 4.5 ZEISS TESSAR LENS. COMPUR SHUTTER; 1 TO 1/300 SEC., B., T. OR COMPUR RAPID SHUTTER; 1 TO 1/500 SEC., B., T. LENS-RING FOCUSING. SELF-ERECTING LENS MOUNT.

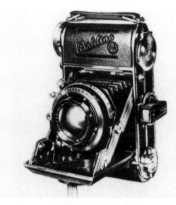

**(2636) BALDINA CAMERA.** C. 1938. SIZE 24 X 36 MM EXPOSURES ON "35MM" ROLL FILM. 50 MM/F 3.5 XE-NAR; F 2.9 TRIOPLAN, RADIONAR, OR XENAR; OR F 2 XENON LENS. PRONTOR II SHUTTER; 1 TO 1/175 SEC., B., T., ST. ALSO, COMPUR OR COMPUR RAPID SHUT-TERS. SELF-ERECTING LENS MOUNT. AUTOMATIC FILM TRANSPORT. HELICAL FOCUSING OR FRONT LENS FOCUSING.

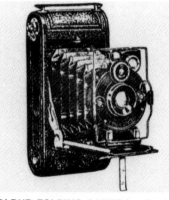

**(2637) BALDUR FOLDING CAMERA.** C. 1929. SIZE 6 X 9 CM EXPOSURES ON ROLL FILM. F 6.3 OR F 4.5 HERMAGIS, BERTHIOT, ROUSSEL, OR BOYER LENS. GITZO SHUTTER; 1/25 TO 1/100 SEC., B., T. OR IBSOR SHUTTER; 1 TO 1/125 SEC., B., T.

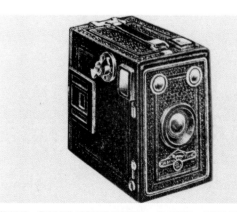

**(2638) BALDA BOX CAMERA.** C. 1931. SIZE 2¼ X 3¼ INCH (1½ X 2⅜ INCH WITH MASK) EXPOSURES ON ROLL FILM. DOUBLET LENS.

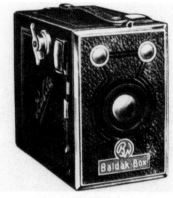

**(2639) BALDAK BOX CAMERA.** C. 1938. SIZE 6 X 9 CM EXPOSURES ON NO. 120 ROLL FILM. DOUBLE LENS. SINGLE-SPEED SHUTTER.

**(2640) FRONT BOX CAMERA.** C. 1938. SIZE 6 X 9 CM EXPOSURES ON NO. 120 ROLL FILM. PERISCOPE LENS. SINGLE-SPEED SHUTTER. TWO APERTURE STOPS.

**(2641) MICKY BOX CAMERA.** C. 1931. SIZE 4 X 6.5 CM (3 X 4 CM WITH MASK) EXPOSURES ON NO. 127 ROLL FILM. 85 MM/F 11 UNIVERSAL DOPPEL LENS. SINGLE-SPEED SHUTTER. (MA)

**(2642) MICKY BOX 0 CAMERA.** C. 1938. SIZE 4 X 6.5 CM EXPOSURES ON ROLL FILM. MENISCUS LENS. SINGLE-SPEED SHUTTER. SIMILAR TO THE MICKY BOX CAMERA, C. 1931.

**(2643) MICKY BOX I CAMERA.** C. 1938. SIZE 4 X 6.5 CM EXPOSURES ON ROLL FILM. SAME LENS, SHUTTER, AND APERTURE STOPS AS THE FRONT BOX CAMERA.

**(2644) MICKY BOX II CAMERA.** C. 1938. SIZE 4 X 6.5 CM EXPOSURES ON ROLL FILM. SAME LENS, SHUT-TER, AND FEATURES AS THE POKA II BOX CAMERA.

**(2645) MICKYRELLE BOX CAMERA.** C. 1938. SIZE 4 X 6.5 CM EXPOSURES (2 X 3.5 CM WITH MASK) ON ROLL FILM. SAME AS THE POKA II BOX CAMERA BUT HAS DUAL EXPOSURE SIZES.

**(2646) POKA DUPLEX BOX CAMERA.** C. 1938. TWO EXPOSURE SIZES, 6 X 9 OR 4 X 6 CM, CAN BE SELECTED

## BALDA-WERK (cont.)

BY MOVING A LEVER ON THE OUTSIDE OF THE CAMERA. ALL OTHER FEATURES ARE THE SAME AS THE POKA II BOX CAMERA.

**(2647) POKA II BOX CAMERA.** C. 1938. SIZE 6 X 9 CM EXPOSURES ON NO. 120 ROLL FILM. DOUBLE LENS. SINGLE-SPEED SHUTTER WITH TIME AND FLASH SETTINGS.

**(2648) POKARELLE BOX CAMERA.** C. 1938. SIZE 6 X 9 CM EXPOSURES (4 X 6 CM WITH MASK) ON NO. 120 ROLL FILM. SAME AS THE POKA II BOX CAMERA BUT WITH DUAL EXPOSURE SIZES.

**(2649) ROLL BOX CAMERA.** C. 1938. SIZE 6 X 9 CM EXPOSURES ON ROLL FILM. MENISCUS LENS. SINGLE-SPEED SHUTTER.

**(2650) THREE-SIZE BOX CAMERA.** C. 1938. THE CAMERA CAN TAKE SIZE 6 X 9, 6 X 6, OR 4 X 6 CM EXPOSURES BY USE OF A FILM MASK ON NO. 120 ROLL FILM.

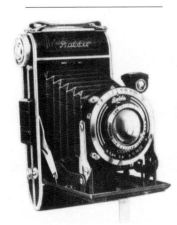

**(2651) FIXFOCUS ROLL FILM CAMERA.** C. 1938. SIZE 6 X 9 CM EXPOSURES. 105 MM/F 6.3 TRIOPLAN; F 4.5 TRIOPLAN, TRINAR, OR RADIONAR; OR F 3.8 TRIOPLAN OR TRINAR LENS. VARIO, PRONTO, PRONTOR I, PRONTOR II, COMPUR, OR COMPUR RAPID SHUTTER. SELF-ERECTING LENS MOUNT.

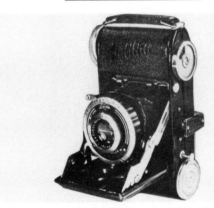

**(2652) JUBILETTE CAMERA.** C. 1935. SIZE 24 X 36 MM EXPOSURES ON "35MM" ROLL FILM. 50 MM/F 2.9 BALDA-BALTAR LENS. COMPUR SHUTTER; 1 TO 1/300 SEC., B., T. (HA)

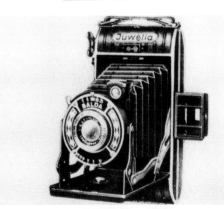

**(2653) JUWELLA CAMERA.** C. 1937. SIZE 6 X 9 CM EXPOSURES ON ROLL FILM. 105 MM/F 6.3 OR F 4.5 ANASTIGMAT LENS. BALDA SHUTTER; 1/25 TO 1/100 SEC.,

B., T. OR PRONTO SHUTTER; 1/25 TO 1/125 SEC., B., T., ST. SELF-ERECTING LENS MOUNT. (HA)

**(2654) NIZZA CAMERA.** C. 1938. SIZE 9 X 12 CM EXPOSURES ON PLATES OR FILM PACKS. F 4.5 ZEISS TESSAR OR XENAR LENS. COMPUR SHUTTER; 1 TO 1/200 SEC., B., T., ST. SOME MODELS WITH COMPUR RAPID SHUTTER. SIMILAR TO THE VENUS CAMERA.

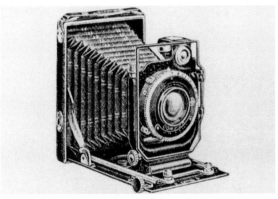

**(2655) PATENT CAMERA.** C. 1931. SIZE 2½ X 3½ INCH EXPOSURES ON PLATES OR ROLL FILM WITH ADAPTER. COMPUR SHUTTER WITH SELF-TIMER.

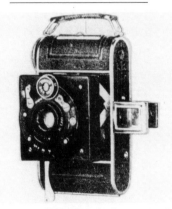

**(2656) PICCOCHIC CAMERA.** C. 1932. SIZE 3 X 4 CM EXPOSURES ON ROLL FILM. F 4.5 OR F 2.9 VIDAR ANASTIGMAT; F 2.9, F 3.5, OR F 4.5 MEYER TRIOPLAN; F 3.5 MEYER PRIMOTAR, F 3.5 OR F 2.9 SCHNEIDER XENAR; F 2.9 STEINHEIL CASSAR; OR F 2.7 MEYER MAKRO PLASMAT LENS. PRONTO (1/25, 1/50, 1/100 SEC., B., T., ST.), IBSOR, OR COMPUR SHUTTER. THE CAMERA OPENS AUTOMATICALLY BY PUSHING A BUTTON.

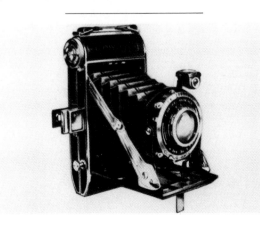

## BALDA-WERK (*cont.*)

(2657) **PONTINA CAMERA.** C. 1938. SIZE 6 X 9 CM EXPOSURES ON ROLL FILM. 105 MM/F 4.5 TRIOPLAN, TRINAR, RADIONAR, OR ZEISS TESSAR; F 3.8 TRIOPLAN; OR ZEISS TESSAR LENS. PRONTOR I, PRONTOR II, COMPUR, OR COMPUR RAPID SHUTTER. ALL SHUTTERS WITH ST. SELF-ERECTING LENS MOUNT. SOME MODELS WITH FILM TRANSPORT.

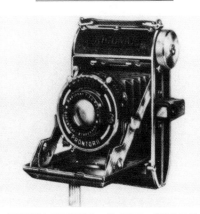

(2658) **RIGONA CAMERA.** C. 1938. SIZE 3 X 4 CM EXPOSURES ON ROLL FILM. F 4.5 ANASTIGMAT OR F 2.9 RADIONAR OR TRIOPLAN LENS. VARIO SHUTTER; $\frac{1}{25}$ TO $\frac{1}{100}$ SEC., B., T. OR PRONTOR II SHUTTER; 1 TO $\frac{1}{175}$ SEC., B., T., ST.

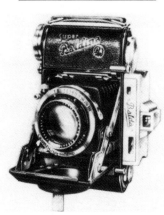

(2659) **SUPER BALDINA CAMERA.** C. 1935–40. SIZE 24 X 36 MM EXPOSURES ON "35MM" ROLL FILM. F 2.9 MEYER TRIOPLAN, F 2.8 ZEISS TESSAR, F 2.9 XENAR, OR F 2 XENON LENS. COMPUR SHUTTER; 1 TO $\frac{1}{300}$ SEC., B., T. OR COMPUR RAPID SHUTTER; 1 TO $\frac{1}{500}$ SEC., B., T. BOTH SHUTTERS WITH SELF-TIMER. COUPLED RANGEFINDER. SELF-ERECTING LENS MOUNT. AUTOMATIC FILM TRANSPORT. HELICAL LENS MOUNT.

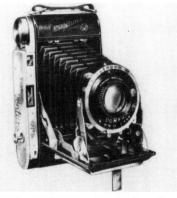

(2660) **SUPER PONTURA CAMERA.** C. 1936–39. SIZE 6 X 9 CM (4 X 6 CM WITH MASK) EXPOSURES ON ROLL FILM. 100 MM/F 3.5 MEYER TRIOPLAN (1936) OR 105 MM/F 3.8 TRIOPLAN, F 4.5 TRIOPLAN, RADIONAR, OR ZEISS TESSAR LENS. COMPUR SHUTTER; 1 TO $\frac{1}{250}$ SEC., B., T., ST. OR COMPUR RAPID SHUTTER; 1 TO $\frac{1}{400}$ SEC., B., T., ST. COUPLED RANGEFINDER. SELF-ERECTING LENS MOUNT. AUTOMATIC FILM TRANSPORT. HELICAL LENS MOUNT.

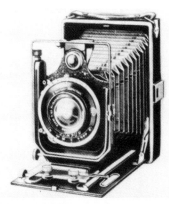

(2661) **VENUS CAMERA.** C. 1938. SIZE 6.5 X 9 CM EXPOSURES ON PLATES OR FILM PACKS. A ROLL FILM HOLDER WAS AVAILABLE. F 4.5 EURYNAR, ZEISS TESSAR, OR XENAR LENS. COMPUR SHUTTER; 1 TO $\frac{1}{250}$ SEC., B., T., ST. RACK & PINION FOCUSING. RISING AND CROSSING LENS MOUNT. SOME MODELS WITH COMPUR RAPID SHUTTER.

## BARDORF, HERMANN

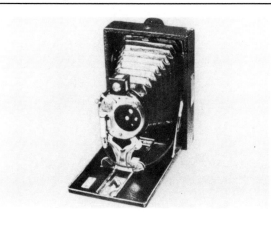

(2662) **PLATE CAMERA.** C. 1901. SIZE 9 X 12 CM EXPOSURES ON PLATES. PERISCOP RAPID APLANAT LENS. THREE-SPEED SHUTTER. REVOLVING APERTURE STOPS. (HA)

## BAYER, WALDEMAR

(2663) **BAYERFLEX TWIN-LENS REFLEX CAMERA.** C. 1936. SIZE 6 X 6 CM ROLL FILM EXPOSURES. 75 MM/F 3.5 RATHENOW POLOLYT LENSES. FOCAL PLANE SHUTTER; $\frac{1}{25}$ TO $\frac{1}{500}$ SEC. (IH)

## BEIER, W

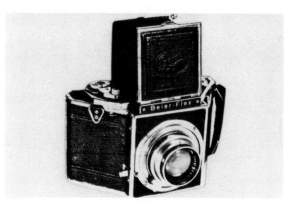

(2664) **BEIER-FLEX SINGLE LENS REFLEX CAMERA.** C. 1938–40. SIZE 6 X 6 CM EXPOSURES ON NO. 120 OR B-2 ROLL FILM. 75 MM/F 2.8 SCHNEIDER XENAR OR 75 MM/F 3.5 LUDWIG VICTAR LENS. FOCAL PLANE SHUTTER; $\frac{1}{25}$ TO $\frac{1}{500}$ SEC. AUTOMATIC FILM TRANSPORT. (HA)

(2665) **BEIRA "35MM" CAMERA.** C. 1931. SIZE 24 X 36 MM EXPOSURES ON UNPERFORATED "35MM" ROLL FILM. 50 MM/F 2.9 MEYER TRIOPLAN LENS. COMPUR SHUTTER; 1 TO 1/300 SEC. (MA)

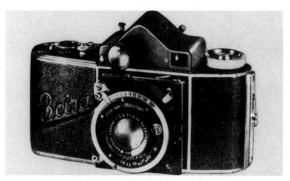

(2666) **BEIRA "35MM" CAMERA.** C. 1935–38. SIZE 24 X 36 MM EXPOSURES ON "35MM" ROLL FILM. 50 MM/ F 2.7 DIALYTAR, F 3.5 LEITZ ELMAR, F 2.9 CASSAR, F 2.9 OR F 3.5 XENAR, OR F 2 XENON LENS. COMPUR SHUTTER; 1 TO $\frac{1}{300}$ SEC., B., T. OR COMPUR RAPID SHUTTER; 1 TO $\frac{1}{500}$ SEC., B., T. COUPLED RANGEFINDER.

## BEIER, W (*cont.*)

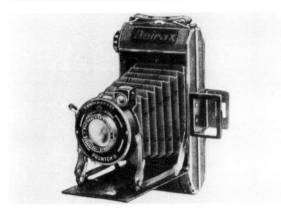

**(2667) BEIRAX CAMERA.** C. 1937. SIZE 6 X 9 CM EXPOSURES ON ROLL FILM. 105 MM/F 4.5 VICTAR LENS. PRONTOR II SHUTTER; 1 TO ½₅₀ SEC., B., T. (HA)

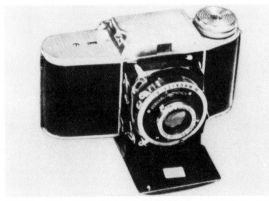

**(2668) BEIRETTE CAMERA.** C. 1939. SIZE 24 X 36 MM EXPOSURES ON "35MM" ROLL FILM. 50 MM/F 2.9 STEINHEIL CASSAR LENS. COMPUR SHUTTER; 1 TO ⅓₀₀ SEC., B., T. (HA)

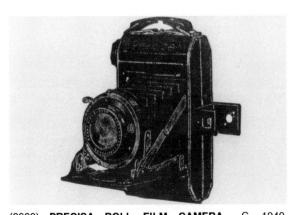

**(2669) PRECISA ROLL FILM CAMERA.** C. 1940. SIZE 6 X 6 CM (3 X 6 CM WITH MASK) EXPOSURES ON NO. 120 OR B-2 ROLL FILM. 75 MM/F 2.9 RODENSTOCK TRINAR LENS. COMPUR S SHUTTER; 1 TO ½₅₀ SEC., ST. HELICAL FOCUSING.

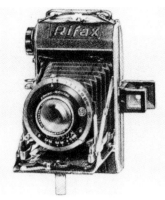

**(2670) RIFAX CAMERA.** C. 1937. SIZE 6 X 6 CM EXPOSURES ON ROLL FILM. 75 MM/F 2.9 RODENSTOCK TRINAR LENS. COMPUR SHUTTER; 1 TO ½₅₀ SEC., B., T. (HA)

**(2671) RIFAX CAMERA. MODEL E.** C. 1937. SIZE 4.5 X 6 CM EXPOSURES ON ROLL FILM. 75 MM/F 4.5 XENAR LENS. COMPUR SHUTTER; 1 TO ½₅₀ SEC., B., T. COUPLED RANGEFINDER. SIMILAR TO THE RIFAX CAMERA (C. 1937) FOR SIZE 6 X 6 CM EXPOSURES.

**(2672) RIFAX CAMERA.** C. 1938. SIZE 6 X 9 CM EXPOSURES ON NO. 120 ROLL FILM. MODEL I: 75 MM/F 2.9 TRINAR ANASTIGMAT LENS. COMPUR RAPID SHUTTER; 1 TO ¼₀₀ SEC., B., T., ST. MODEL II: 105 MM/F 3.8 TRINAR LENS. COMPUR SHUTTER; 1 TO ½₅₀ SEC., B., T., ST. BOTH MODELS WITH COUPLED RANGEFINDER. SIMILAR TO THE RIFAX CAMERA, C. 1937.

**(2673) RIFAX CAMERA. MODEL R-F.** C. 1940. SIZE 6 X 6 CM (4 X 6 CM WITH MASK) EXPOSURES ON NO. 120 OR B-2 ROLL FILM. F 2.9 RODENSTOCK TRINAR LENS. SIMILAR TO THE RIFAX CAMERA (C. 1937) BUT WITH A COMPUR SHUTTER; 1 TO ¼₀₀ SEC., B., T., ST. COUPLED RANGEFINDER.

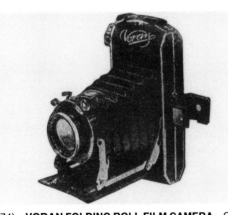

**(2674) VORAN FOLDING ROLL FILM CAMERA.** C. 1940. SIZE 2¼ X 3¼ INCH (1⅝ X 2¼ INCH WITH MASK) EXPOSURES ON NO. 120 OR B-2 ROLL FILM. 105 MM/F 3.5 RODENSTOCK TRINAR LENS. COMPUR RAPID SHUTTER; 1 TO ¼₀₀ SEC., B., T., ST. HELICAL FOCUSING.

## BENTZIN, CURT

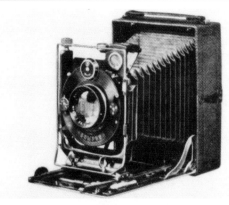

**(2675) FAVORITA PRIMAR CAMERA.** C. 1936–40. SIZE 9 X 12 CM EXPOSURES ON PLATES, CUT FILM, OR FILM PACKS. 135 MM/F 3.5 OR F 4.5 ZEISS TESSAR OR F 4.5 MEYER TRIOPLAN LENS. IBSOR SHUTTER OR COMPUR SHUTTER; 1 TO ½₅₀ SEC., B., T., ST. DOUBLE EXTENSION BELLOWS. RISING FRONT. RACK & PINION FOCUSING.

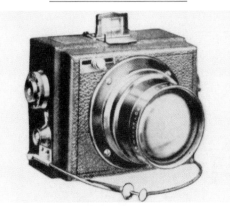

**(2676) FOKAL PRIMAR CAMERA.** C. 1936. SIZE 6.5 X 9 CM EXPOSURES ON PLATES OR SHEET FILM. 90 MM/F 1.5 PLASMAT LENS. FOCAL PLANE SHUTTER; ⅛ TO ¼₀₀₀ SEC., T.

**(2677) FOKAL PRIMAR STRUT CAMERA.** C. 1936. FIVE SIZES OF THIS CAMERA FOR 2½ X 3½, 3¼ X 4¼ INCH OR 9 X 12, 10 X 15, OR 13 X 18 CM EXPOSURES ON PLATES OR FILM PACKS. F 3.5 OR F 4.5 ZEISS TESSAR LENS. SOME MODELS WITH F 2.8 ZEISS BIOTESSAR LENS. FOCAL PLANE SHUTTER WITH SPEEDS TO ¼₀₀₀ SEC. RISING LENS MOUNT.

## BENTZIN, CURT (*cont.*)

**(2678)   KLAPP REFLEX PRIMAR CAMERA.**  C. 1914–36. FOUR SIZES OF THIS CAMERA FOR 2½ X 3½, 3¼ X 4¼ INCH, OR 9 X 12 OR 10 X 15 CM EXPOSURES ON PLATES OR FILM PACKS.  F 3.5 OR F 4.5 ZEISS TESSAR LENS. SOME MODELS WITH F 2.8 ZEISS BIOTESSAR LENS. FOCAL PLANE SHUTTER WITH SPEEDS TO ⅟₁₀₀₀ SEC.

**(2679)   PLAN PRIMAR CAMERA.**  C. 1930–40.  SIZE 6.5 X 9 CM EXPOSURES ON PLATES, CUT FILM, OR FILM PACKS WITH ADAPTER.  105 MM/F 6.3 OR F 4.5 MEYER TRIOPLAN LENS.  VARIO, PRONTO, OR COMPUR SHUTTER.  RISING LENS MOUNT.  SIMILAR TO THE PLAN PRIMAR (DELUXE) CAMERA BUT WITHOUT RACK & PINION FOCUS.

**(2680)   PLAN PRIMAR DELUXE CAMERA.**  C. 1936–40. SIZE 6.5 X 9 CM EXPOSURES ON PLATES, CUT FILM, OR FILM PACKS WITH ADAPTER.  105 MM/F 4.5 ZEISS TESSAR OR F 3.5 MEYER TRIOPLAN LENS.  COMPUR SHUTTER; 1 TO ⅟₂₅₀ SEC., B., T. (ST. ON SOME MODELS). DOUBLE EXTENSION BELLOWS.  RISING LENS MOUNT. RACK & PINION FOCUS.

**(2681)   PRIMAR CAMERA.**  C. 1928.  SIZE 6.5 X 9 CM EXPOSURES.  90 MM/F 1.5 MEYER PLASMAT LENS. FOCAL PLANE SHUTTER; ⅛ TO ⅟₁₀₀₀ SEC.  (MA)

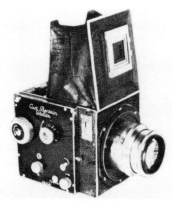

**(2682)   PRIMARETTE CAMERA.**  C. 1930–37. SIZE 4 X 6.5 CM EXPOSURES ON ROLL FILM.  75 MM/F 3.5 MEYER TRIOPLAN OR F 2.8 ZEISS TESSAR LENS.  COMPUR SHUTTER; 1 TO ⅟₃₀₀ SEC. OR COMPUR RIM-SET SHUTTER; 1 TO ⅟₂₅₀ SEC.  THE UPPER LENS IS USED FOR FOCUSING ON A GROUND GLASS.  (HA)

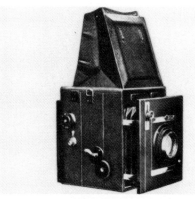

**(2683)   PRIMARFLEX SINGLE-LENS REFLEX CAMERA.** C. 1935–38.  SIZE 6 X 6 CM EXPOSURES ON NO. 120 ROLL FILM OR 4.5 X 6 CM OR 6 X 6 CM EXPOSURES ON PLATES.  100 MM/F 2.8 MEYER TRIOPLAN, 105 MM/ F 3.5 OR F 4.5 ZEISS TESSAR, 135 MM/F 2.8 ZEISS BIOTESSAR, OR 80 MM/F 3.5 MEYER TRIOPLAN LENS. FOCAL PLANE SHUTTER; 1 TO ⅟₁₀₀₀ SEC., B., T. (ST ON SOME MODELS).  INTERCHANGEABLE LENSES.  AUTOMATIC FILM TRANSPORT.  (HA)

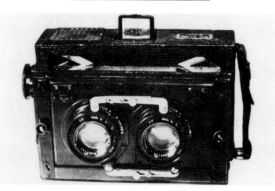

**(2684)   SPIEGEL REFLEX PRIMAR CAMERA.**  C. 1936. SIX SIZES OF THIS CAMERA FOR 2½ X 3½, 3¼ X 4¼ INCH OR 9 X 12, 10 X 15, 12 X 16.5, OR 13 X 18 CM EXPOSURES ON PLATES OR FILM PACKS.  F 3.5 OR F

4.5 ZEISS TESSAR LENS.  SOME MODELS WITH F 2.8 ZEISS BIOTESSAR LENS.  FOCAL PLANE SHUTTER WITH SPEEDS TO ⅟₁₀₀₀ SEC.

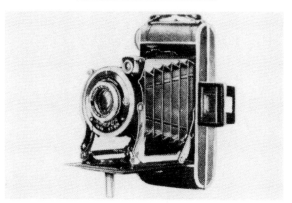

**(2685)   SPRING PRIMER ROLL FILM CAMERA.**  C. 1940. SIZE 6 X 9 CM EXPOSURES ON NO. 120 OR B-2 ROLL FILM.  HALF-FRAME EXPOSURES WITH MASK.  F 4.5 MEYER TRIOPLAN LENS.  COMPUR SHUTTER; 1 TO ⅟₂₅₀ SEC., B., T., ST.  HELICAL FOCUSING.

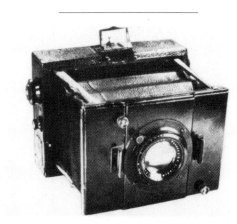

**(2686)   STEREO CAMERA.**  C. 1908.  SIZE 6 X 13 CM STEREO EXPOSURES ON PLATES.  120 MM/F 4.5 ZEISS TESSAR LENSES.  FOCAL PLANE SHUTTER; ⅟₂₀ TO ⅟₁₀₀₀ SEC.  (HA)

**(2687)   STEREO REFLEX CAMERA.**  C. 1915.  SIZE 6 X 13 CM STEREO PLATE EXPOSURES.  120 MM/F 4.5 ZEISS TESSAR LENSES.  FOCAL PLANE SHUTTER; ⅛ TO ⅟₁₀₀₀ SEC.  (MA)

**(2688)   STRUT CAMERA.**  C. 1905.  SIZE 10 X 15 CM

## BENTZIN, CURT (*cont.*)

EXPOSURES ON PLATES. 165 MM/F 4.5 TESSAR LENS. FOCAL PLANE SHUTTER; ⅕ TO ¹⁄₁₀₀₀ SEC. (HA)

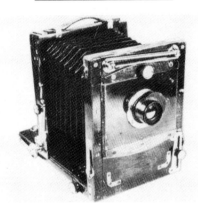

(2689) **LUXUS VIEW CAMERA.** C. 1915. SIZE 9 X 12 CM EXPOSURES ON PLATES. EMIL BUSCH SERIES III LENS. REVOLVING APERTURE STOPS. (HA)

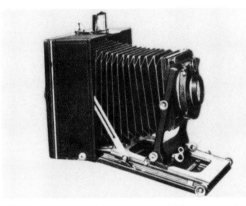

(2690) **UNIVERSAL QUADRAT PRIMAR VIEW CAMERA.** C. 1936. THREE SIZES OF THIS CAMERA FOR 9 X 12, 10 X 15, OR 13 X 18 CM EXPOSURES ON PLATES, CUT FILM, OR FILM PACKS. F 3.5, F 4.5, OR F 6.3 ZEISS TESSAR OR F 6.3, F 7, OR F 7.7 ZEISS DOPPEL PROTAR LENS. FOCAL PLANE SHUTTER; ¼ TO ¹⁄₁₀₀₀ SEC., T. (⅓ TO ¹⁄₁₀₀₀ SEC., T. FOR THE 13 X 18 CM MODEL).

(2691) **VISITING-CARD MULTIPLE CAMERA.** C. 1880. FOUR EXPOSURES ON AN 18 X 24 CM PLATE.

## BERMPOHL, W.

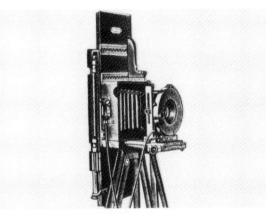

(2692) **MIETHE THREE-COLOR CAMERA.** C. 1905–32. SIZE 9 X 12 CM COLOR EXPOSURES. THE CAMERA TAKES THREE EXPOSURES IN SEQUENCE. A PNEUMATIC DEVICE MOVES THE FILM HOLDER INTO THREE POSITIONS.

(2693) **MIETHE THREE-COLOR CAMERA.** C. 1934. SIZE 7.5 X 8.5 CM COLOR EXPOSURES. 150 MM/F 3.5 GOERZ DOUBLE ANASTIGMAT LENS. IRIS DIAPHRAGM. A PNEUMATIC DEVICE MOVES THE FILM HOLDER INTO THREE POSITIONS. (IH)

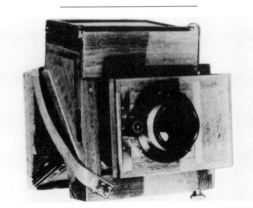

(2694) **NATURAL COLOR CAMERA.** C. 1934. SIZE 13 X 18 CM COLOR EXPOSURES. THREE FILMS ARE EXPOSED SIMULTANEOUSLY USING COLOR FILTERS AND PARTIALLY SURFACED MIRRORS. 300 MM/F 4 GOERZ DOPPEL PLASMAT LENS. COMPOUND SHUTTER; ¹⁄₅₀ SEC.

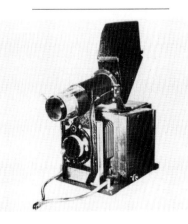

(2695) **NATURAL COLOR CAMERA.** C. 1935. SIZE 9 X 12 CM COLOR EXPOSURES. THREE FILMS ARE EXPOSED SIMULTANEOUSLY USING COLOR FILTERS AND PARTIALLY SURFACED MIRRORS. 215 MM/F 4 MEYER DOPPEL PLASMAT LENS. REFLEX VIEWER. (HA)

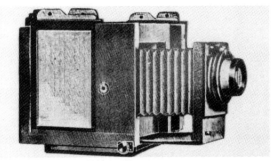

(2696) **THREE-COLOR CAMERA.** C. 1933. THREE COLOR PLATES ARE EXPOSED SIMULTANEOUSLY.

(2697) **THREE-COLOR CAMERA.** C. 1935. SIZE 9 X 12 CM PLATE EXPOSURES. 215 MM/F 4 MEYER PLASMATIC LENS. COMPOUND SHUTTER; 1 TO ¹⁄₇₅ SEC. BELLOWS FOCUSING VIA RACK & PINION. TWO SEMI-TRANSPARENT MIRRORS ARE USED TO EXPOSE THREE PLATES. (IH)

(2698) **THREE-COLOR CAMERA. IMPROVED MODEL.** C. 1935. THREE SIZES OF THIS CAMERA FOR 9 X 12 OR 10 X 15 CM OR 5 X 7 INCH EXPOSURES. THE SHUTTER SPEED IS ¹⁄₂₅ SEC. FOR DAYLIGHT EXPOSURES. THREE COLOR PLATES ARE EXPOSED SIMULTANEOUSLY. SIMILAR TO THE THREE-COLOR CAMERA, C. 1933.

## BERNING, OTTO & COMPANY

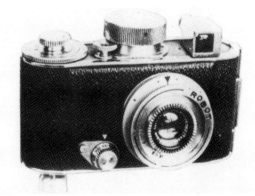

(2699) **ROBOT I CAMERA.** INTRODUCED IN 1934. SIZE 24 X 24 MM EXPOSURES ON "35 MM" ROLL FILM. SPRING MOTOR FOR AUTOMATIC FILM ADVANCE. MONOCHROMATIC VIEW FINDER. BUILT-IN YELLOW-GREEN FILTER. 30 MM/F 2.8 ZEISS TESSAR OR F 3.5 MEYER PRIMOTAR LENS. ROTATING DISC SHUTTER; 1 TO ¹⁄₅₀₀ SEC., B.

## BERNING, OTTO & COMPANY (*cont.*)

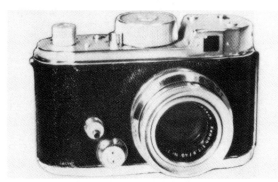

(2700) **ROBOT II CAMERA.** INTRODUCED IN 1938. SIZE 24 X 24 MM EXPOSURES ON "35 MM" ROLL FILM. SPRING MOTOR FOR AUTOMATIC FILM ADVANCE. FLASH SYNC. 40 MM/F 2 ZEISS BIOTAR, 32.5 OR 37.5 MM/F 2.8 ZEISS TESSAR, 30 MM/F 3.5 ZEISS TESSAR OR PRIMOTAR, OR 37.5 MM/F 3.5 SCHNEIDER RADIO-NAR LENS. ROTATING DISC SHUTTER; ½ TO ¹/₅₀₀ SEC., B. SOME MODELS WITH CHROME TRIM. (HA)

## BICKENBACH & COMPANY G.M.B.H.

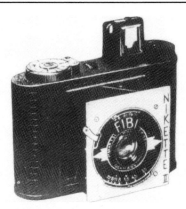

(2701) **FIBI-NIKETTE II CAMERA.** C. 1936. SIZE 3 X 4 CM EXPOSURES ON ROLL FILM. 50 MM/F 3.5 MAXAR ANASTIGMAT LENS. SHUTTER SPEEDS; ¹/₂₅, ¹/₅₀, ¹/₁₀₀ SEC., B., T. PLASTIC BODY.

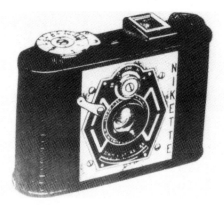

(2702) **NIKETTE CAMERA.** C. 1932–35. SIZE 3 X 4 CM EXPOSURES ON ROLL FILM. F 3.5 ANASTIGMAT LENS. SHUTTER SPEEDS; ¹/₂₅, ¹/₅₀, ¹/₁₀₀ SEC., B., T. PLASTIC BODY.

## BILDSICHT-CAMERAWERK

(2703) **BILDSICHT-ANSATZ CAMERA.** C. 1914–26. TWO SIZES OF THIS CAMERA FOR 9 X 12 OR 10 X 15 CM PLATE EXPOSURES.

(2704) **SPORT BILDSICHT CAMERA.** C. 1924. SIZE 9 X 12 CM EXPOSURES ON PLATES.

(2705) **SPREIZEN-BILDSICHT CAMERA.** C. 1914. TWO SIZES OF THIS CAMERA FOR 9 X 12 OR 10 X 15 CM PLATE EXPOSURES.

(2706) **SPREIZEN-BILDSICHT CAMERA.** C. 1926. THREE SIZES OF THIS CAMERA FOR 6.5 X 9, 9 X 12, OR 10 X 15 CM PLATE EXPOSURES.

(2707) **UNIVERSAL-BILDSICHT CAMERA.** C. 1914. TWO SIZES OF THIS CAMERA FOR 9 X 12 OR 10 X 15 CM PLATE EXPOSURES.

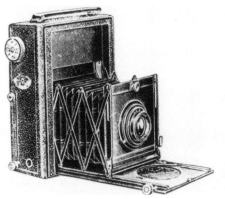

(2708) **UNIVERSAL-BILDSICHT CAMERA.** C. 1926. THREE SIZES OF THIS CAMERA FOR 6.5 X 9, 9 X 12, OR 10 X 15 CM PLATE EXPOSURES.

## BITTNER, L. O.

(2709) **FOLDING PLATE CAMERA.** SIZE 6 X 9 CM EXPO-SURES. 105 MM/F 4.8 ORTOKLINEAR LENS. COMPUR SHUTTER; 1 TO ¹/₂₅₀ SEC. (MA)

## BRANDT & WILDE

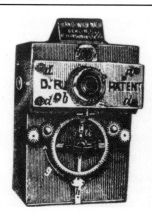

(2710) **BAEDEKER CAMERA.** C. 1890. SIZE 9 X 12 CM EXPOSURES ON PLATES. THE CAMERA MAGAZINE HOLDS 12 PLATES.

## BRUNS, CHRISTIAN

(2711) **PATENT MAGAZINE CAMERA.** C. 1893. SIZE 12 X 15 CM PLATE EXPOSURES. THE MAGAZINE HOLDS 12 PLATES. 150 MM/F 6.3 OR F 7.7 ANASTIGMAT LENS. VARIABLE-SPEED ROTARY SHUTTER. THE CAMERA HAS A SEPARATE LENS, BELLOWS AND GROUND GLASS SYSTEM MOUNTED ON TOP OF THE CAMERA FOR VIEWING. (MA)

## BÜLTER & STAMMER

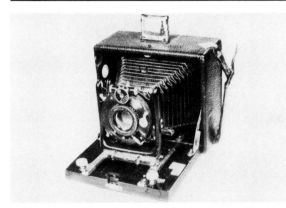

(2712) **FOLDING PLATE CAMERA.** C. 1910. SIZE 10 X 15 CM EXPOSURES ON PLATES. 168 MM/F 6.8 SYNTOR DOUBLE ANASTIGMAT LENS. COMPOUND SHUTTER WITH SPEEDS TO ½₀₀ SEC. (HA)

## BUSCH, EMIL A. G.

(2713) **CYCAM-CYCLIST'S CAMERA.** C. 1899. EXPOSURES ON ROLL FILM.

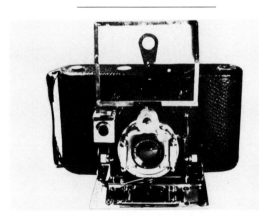

(2714) **POCKAM CAMERA.** C. 1902. SIZE 8 X 10 CM EXPOSURES ON ROLL FILM. BAUSCH DETECTIVE APLANAT LENS. DOUBLE PNEUMATIC BAUSCH & LOMB SHUTTER WITH SPEEDS TO ½₀₀ SEC. (HA)

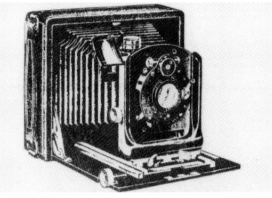

(2715) **PREIS CAMERA.** C. 1914. TWO SIZES OF THIS CAMERA FOR 9 X 12 OR 10 X 15 CM EXPOSURES ON PLATES OR FILM PACKS. THE LENSES FOR THE 9 X 12 CAMERA ARE: F 8 REKTIPLANAT; F 6.5 RAPID APLANAT; F 6.8 DOUBLE LEUKAR ANASTIGMAT; OR F 6.8, F 5.5, OR F 4.5 OMNAR ANASTIGMAT LENS. FOR THE 10 X 15 CAMERA: F 7 RAPID APLANAT, F 6.8 DOUBLE LEUKAR ANASTIGMAT, OR F 6.8 OMNAR ANASTIGMAT LENS. EBUSCH, IBSO, OR COMPOUND SHUTTER.

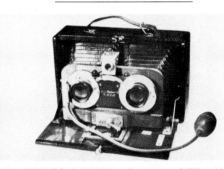

(2716) **STEREO CAMERA.** C. 1897. SIZE 9 X 18 CM EXPOSURES ON PLATES. BUSCH PERIPLANAT LENS. BAUSCH & LOMB INSTANT AND TIME SHUTTER. (HA)

(2717) **TRIBEES ROLL FILM CAMERA.** C. 1900.

## CERTO CAMERAWERK

(2718) **DOPPEL BOX CAMERA.** C. 1935. SIZE 6 X 9 CM (4.5 X 6 CM WITH MASK) EXPOSURES ON ROLL FILM. CERTOMAT LENS. SINGLE-SPEED SHUTTER. (MA)

(2719) **BROOKS DUBLA CAMERA.** C. 1932. TWO SIZES OF THIS CAMERA FOR 9 X 12 OR 10 X 15 CM EXPOSURES ON PLATES OR FILM PACKS. F 3.5 ZEISS XENAR LENS. DUAL-SHUTTER CAMERA. FOCAL PLANE SHUTTER TO ⅟₁₀₀₀ SEC. AND COMPUR LEAF SHUTTER FOR SLOWER SPEEDS. TRIPLE EXTENSION BELLOWS. RISING, FALLING, AND CROSSING LENS MOUNT. RACK & PINION FOCUSING.

(2720) **CERTO (BROOKS) HIGH-SPEED CAMERA.** C. 1932. THREE SIZES OF THIS CAMERA FOR 6.5 X 9, 9 X 12, OR 10 X 15 CM EXPOSURES ON PLATES OR FILM PACKS. F 2.9 OR F 3.5 SCHNEIDER XENAR LENS. COMPUR SHUTTER. RISING AND FALLING LENS MOUNT. GROUND GLASS FOCUSING.

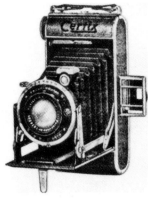

(2721) **CERTIX CAMERA.** C. 1940. SIZE 6 X 9 OR 4.5 X 6 CM (WITH MASK) EXPOSURES ON NO. 120 OR B-2 ROLL FILM. 105 MM/F 4.5 ZEISS TESSAR OR CERTAR LENS IN COMPUR SHUTTER; 1 TO ½₅₀ SEC., B., T. ALSO, F 4.5 OR F 6.3 CERTAR LENS IN VARIO SHUTTER; ½₅ TO ⅟₁₀₀ SEC., B., T.

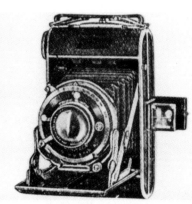

(2722) **CERTO SUPER-SPORT CAMERA.** C. 1934. SIZE 2¼ X 2¼ INCH (1¾ X 2¼ INCH WITH MASK) EXPOSURES ON ROLL FILM OR 1¾ X 2¼ INCH EXPOSURES ON PLATES OR FILM PACKS. F 3.5 TRIOPLAN OR F 3.8 ZEISS TESSAR LENS. COMPUR SHUTTER WITH DELAYED ACTION SETTING.

(2723) **CERTODIX CAMERA.** C. 1932. SIZE 9 X 12 CM EXPOSURES ON PLATES OR FILM PACKS. F 4.5 SCHNEIDER RADIONAR LENS. COMPUR SHUTTER; 1 TO ½₀₀ SEC., B., T. DOUBLE EXTENSION BELLOWS. RACK & PINION FOCUS. GROUND GLASS FOCUSING. RISING, FALLING, AND CROSSING LENS MOUNT.

(2724) **CERTONET FOLDING CAMERA.** C. 1925. SIZE 6 X 9 CM EXPOSURES ON ROLL FILM. F 4.5 SCHNEIDER RADIONAR OR STEINHEIL UNIFOCAL LENS. COMPUR OR VARIO SHUTTER.

(2725) **CERTOSPORT CAMERA.** C. 1938. TWO SIZES OF THIS CAMERA FOR 6.5 X 9 OR 9 X 12 CM EXPOSURES. F 4.5 MEYER TRIOPLAN OR STEINHEIL DOPPEL ANASTIGMAT LENS. DIAL-SET COMPUR SHUTTER; 1 TO ½₀₀ SEC., B., T. DOUBLE EXTENSION BELLOWS. SPORTSFINDER. RISING AND CROSSING LENS MOUNT. GROUND GLASS FOCUSING.

## CERTO CAMERAWERK (*cont.*)

(2726) **CERTOTROP CAMERA.** C. 1930. SIZE 6.5 X 9 CM EXPOSURES ON PLATES. 105 MM/F 2.9 TRIOPLAN LENS. COMPUR SHUTTER; 1 TO $\frac{1}{200}$ SEC., B., T. DOUBLE EXTENSION BELLOWS. FILM PACK ADAPTER. (HA)

(2727) **DAMEN-KAMERA.** C. 1906. TWO SIZES OF THIS CAMERA FOR 6.5 X 9 OR 9 X 12 CM PLATE EXPOSURES. F 8 CERTOMAT LENS. THREE-SPEED SHUTTER; $\frac{1}{25}$, $\frac{1}{50}$, $\frac{1}{100}$ SEC. RISING AND CROSSING LENS MOUNT.

(2728) **DOLLINA CAMERA.** C. 1935. SIZE 24 X 36 MM EXPOSURES ON "35MM" ROLL FILM. 50 MM/F 2.9 STEINHEIL CASSAR LENS. COMPUR SHUTTER; 1 TO $\frac{1}{300}$ SEC., B., T. (HA)

(2729) **DOLLINA O CAMERA.** C. 1939. SIZE 24 X 36 MM EXPOSURES ON "35MM" ROLL FILM. 50 MM/F 2.9

CERTAR LENS IN COMPUR B SHUTTER; 1 TO $\frac{1}{300}$ SEC., B., T. OR 50 MM/F 4.5 CERTAR LENS IN VARIO SHUTTER; $\frac{1}{25}$ TO $\frac{1}{100}$ SEC., B., T. AUTOMATIC FILM TRANSPORT. EXPOSURE COUNTER.

(2730) **DOLLINA II CAMERA.** C. 1936. SIZE 24 X 36 MM EXPOSURES ON "35MM" ROLL FILM. SAME LENSES, SHUTTER, AND FEATURES AS THE SUPER DOLLINA CAMERA, BUT WITH A SLIGHTLY DIFFERENT DESIGN.

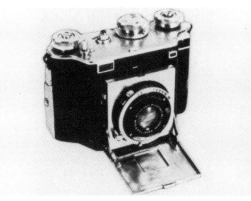

(2731) **DOLLINA III CAMERA.** C. 1937. SIZE 24 X 36 MM EXPOSURES ON "35MM" ROLL FILM. 50 MM/F 2.8 XENAR LENS. COMPUR SHUTTER; 1 TO $\frac{1}{300}$ SEC., B., T. OR COMPUR RAPID SHUTTER; 1 TO $\frac{1}{500}$ SEC., B., T. COUPLED RANGEFINDER. EXPOSURE COUNTER. (HA)

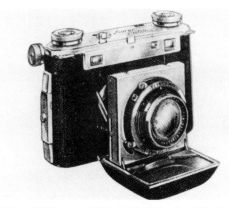

(2732) **SUPER DOLLINA CAMERA.** C. 1938–40. SIZE 24 X 36 MM EXPOSURES ON "35MM" ROLL FILM.

50 MM/F 2 SCHNEIDER XENON, F 2.8 ZEISS TESSAR, OR SCHNEIDER XENAR LENS. COMPUR RAPID SHUTTER; 1 TO $\frac{1}{500}$ SEC., B., T. ALSO, COMPUR SHUTTER. COUPLED RANGEFINDER. AUTOMATIC FILM TRANSPORT. EXPOSURE COUNTER.

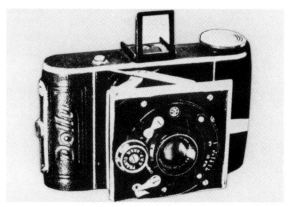

(2733) **DOLLY CAMERA.** C. 1930. SIZE 3 X 4 CM EXPOSURES ON ROLL FILM. 50 MM/F4.5 STEINHEIL ANASTIGMAT ACTINAR LENS. PRONTO SHUTTER; $\frac{1}{25}$ TO $\frac{1}{100}$ SEC. (HA)

(2734) **DOLLY CAMERA.** C. 1932–35. SIZE 3 X 4 CM EXPOSURES ON NO. 127 ROLL FILM. 50 MM/F 2.9 SCHNEIDER RADIONAR, F 2 OR F 2.9 SCHNEIDER XENAR, F 3.5 ZEISS TESSAR, OR F 4.5 CERTAR ANASTIGMAT LENS. COMPUR SHUTTER; 1 TO $\frac{1}{300}$ SEC., B., T. OR VARIO SHUTTER. (IH)

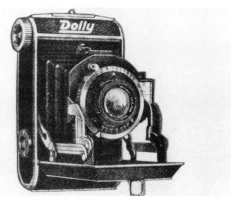

(2735) **DOLLY MODEL A CAMERA.** C. 1933. SIZE 3 X 4 CM EXPOSURES ON ROLL FILM. F 4.5 CERTAR LENS. VARIO SHUTTER. THE FRONT EXTENDS AUTOMATICALLY ON STRUTS BY PRESSING A RELEASE BUTTON.

(2736) **DOLLY SUPER SPORT CAMERA.** C. 1940. SIZE 6 X 6 CM OR 4 X 6 CM (WITH MASK) EXPOSURES ON NO. 120 OR B-2 ROLL FILM. SAME AS THE DOLLY SUPER SPORT RANGEFINDER CAMERA BUT WITHOUT THE RANGEFINDER OR BUILT-IN EXPOSURE METER. SHUTTER SPEEDS TO $\frac{1}{250}$ SEC. ONLY.

## CERTO CAMERAWERK (*cont.*)

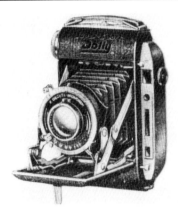

**(2737) DOLLY SUPER SPORT RANGEFINDER CAMERA.** C. 1940. SIZE 6 X 6 CM OR 4 X 6 CM (WITH MASK) EXPOSURES ON NO. 120 OR B-2 ROLL FILM. 75 MM/F 2.9 MEYER TRIOPLAN LENS. ALSO, 75 MM/F 2.8 ZEISS TESSAR OR SCHNEIDER XENAR LENS. COMPUR SHUTTER; 1 TO 1/250 SEC., B., T. AND DELAYED TIMER. ALSO, COMPUR RAPID SHUTTER; 1 TO 1/400 SEC., B., T. AND DELAYED TIMER. COUPLED RANGEFINDER. BUILT-IN EXPOSURE METER. INTERCHANGEABLE BACK FOR CUT FILM. SOME MODELS WITH FLASH SYNC.

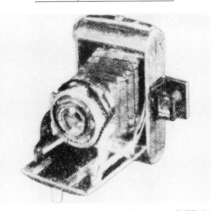

**(2738) V. P. DOLLY CAMERA.** C. 1938. SIZE 3 X 4 CM EXPOSURES (HALF FRAME) ON NO. 127 ROLL FILM. F 3.5 CORYGON ANASTIGMAT OR F 4.5 CERTAR LENS. COMPUR SHUTTER; 1 TO 1/300 SEC., B., T. OR VARIO SHUTTER; 1/25 TO 1/100 SEC., B., T. MANUAL FOCUS.

## CONTESSA-CAMERA-WERK G.M.B.H.

**(2739) ARGUS DETECTIVE OPERA-GLASS CAMERA.** C. 1911. SIMILAR TO THE ERGO DETECTIVE OPERA-GLASS CAMERA MANUFACTURED BY CONTESSA-NETTEL A.G. IN 1924.

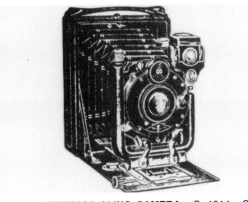

**(2740) CONTESSA ALINO CAMERA.** C. 1914. SIZE 6 X 9 CM EXPOSURES ON PLATES OR FILM PACKS. F 7.7 APLANAT, F 6.3 ZEISS TESSAR OR CITOPLAST, F 5.8 ISOPLAST, OR F 6.8 GOERZ DAGOR LENS. DERVAL, IBSO, KOILOS, OR COMPOUND SHUTTER. RACK & PINION FOCUSING.

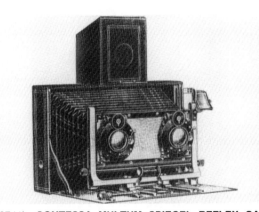

**(2741) CONTESSA MULTUM SPIEGEL REFLEX CAMERA.** C. 1910. SIZE 9 X 12 CM SINGLE EXPOSURES, 8.5 X 17 CM STEREO EXPOSURES, OR 12 X 16.5 CM EXPOSURES ON PLATES.

**(2742) CONTESSA STEREO CAMERA.** C. 1914. SIZE 45 X 107 MM STEREO EXPOSURES ON PLATES OR FILM PACKS. F 6.8 DETEKTIV-APLANAT OR GOERZ DAGOR, F 6.3 CITOPLAST OR ZEISS TESSAR, F 5.5 TESSAPLAST OR F 4.5 HELLAPLAST, OR ZEISS TESSAR LENS. DERVAL OR COMPOUND SHUTTER.

**(2743) TRIOCA FOLDING PLATE CAMERA.** C. 1913. SIZE 9 X 12 CM EXPOSURES. TRIPLE-EXTENSION BELLOWS.

**(2744) CONTESSA-WESTCA CAMERA.** C. 1914. SIZE 4.5 X 6 CM EXPOSURES ON PLATES OR FILM PACKS. F 6.8 DETEKTIV APLANAT OR F 5.8 DOUBLE ANASTIGMAT ISOPLAST LENS. SHUTTER SPEEDS; 1/25 TO 1/100 SEC., B., T.

## CONTESSA-NETTEL A.G.

**(2745) ALTURA CAMERA.** C. 1924. SIZE 9 X 14 CM EXPOSURES. CITONAR LENS. DIAL-SET COMPUR SHUTTER. GROUND GLASS FOCUSING.

**(2746) CITOSKOP STEREO CAMERA.** C. 1926. SIZE 45 X 107 MM STEREO EXPOSURES ON PLATES. 65 MM/F 4.5 TESSAR LENSES. COMPUR SHUTTER; 1 TO 1/300 SEC. (MA)

**(2747) COCARETTE CAMERA.** C. 1923. TWO SIZES OF THIS CAMERA FOR 6 X 9 OR 6.5 X 11 CM EXPOSURES ON ROLL FILM. F 4.5 OR F 6.3 CARL ZEISS LENS. ALSO, OTHER LENSES FROM F 4.5 TO F 11. COMPUR, DERVAL, OR PERI SHUTTER.

## CONTESSA-NETTEL A.G. (*cont.*)

(2748) **COCARETTE CAMERA.** C. 1926. SIZE 6 X 9 CM EXPOSURES ON ROLL FILM. 105 MM/F 5.4 TERONAR LENS. COMPUR SHUTTER WITH SPEEDS TO $\frac{1}{250}$ SEC. (HA)

(2749) **COCARETTE TROPICAL CAMERA.** C. 1923. FOUR SIZES OF THIS CAMERA FOR 6 X 9, 7 X 12, 9 X 12, OR 9 X 14 CM EXPOSURES ON ROLL FILM. F 4.5 ZEISS TESSAR LENS. COMPUR SHUTTER.

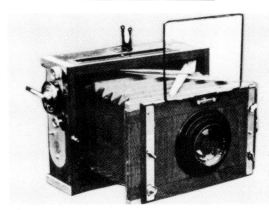

(2750) **CONTESSA-NETTEL TROPICAL CAMERA.** C. 1926.

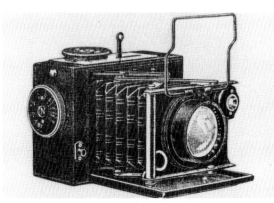

(2751) **DECKRULLO CAMERA.** C. 1925. SIZE 4.5 X 6 CM EXPOSURES. F 2.7 ZEISS TESSAR OR F 3.5 ZEISS TRIOTAR LENS. FOCAL PLANE SHUTTER.

(2752) **DECKRULLO NETTEL CAMERA.** C. 1923. FOUR SIZES OF THIS CAMERA FOR 6.5 X 9, 9 X 12, 10 X 15, OR 13 X 18 CM EXPOSURES. F 4.5 CARL ZEISS ANASTIGMAT LENS. FOCAL PLANE SHUTTER.

(2753) **DONATA CAMERA.** C. 1925. SIZE 6.5 X 9 CM EXPOSURES ON FILM PACKS. F 6.3 ZEISS TESSAR LENS. COMPUR SHUTTER.

(2754) **DUROLL CAMERA.** C. 1923. TWO SIZES OF THIS CAMERA FOR 9 X 12 OR 9 X 14 CM EXPOSURES ON PLATES OR ROLL FILM. F 4.5 OR F 6.3 CARL ZEISS LENS. COMPUR SHUTTER. DOUBLE EXTENSION BELLOWS.

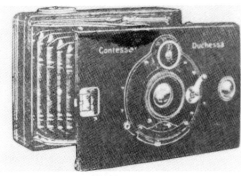

(2755) **DUCHESSA CAMERA.** C. 1912. TWO SIZES OF THIS CAMERA FOR 4.5 X 6 OR 6.5 X 9 CM EXPOSURES ON PLATES OR FILM PACKS. F 5.8 ISOPLAST, F 5.5 TESSARPLAST, F 4.5 HELLAPLAST, F 6.8 GOERZ DAGOR, OR F 6.3 ZEISS TESSAR LENS. ALSO, F 4.5 ZEISS TESSAR LENS FOR THE 4.5 X 6 CM EXPOSURE CAMERA ONLY. COMPOUND SHUTTER.

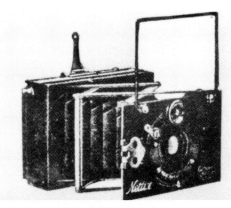

(2756) **DUCHESSA CAMERA.** C. 1923. SIZE 4.5 X 6 CM EXPOSURES ON PLATES OR FILM PACKS. 75 MM/F 6.3 CITONAR ANASTIGMAT, F 5.4 TERONAR ANASTIGMAT, OR F 6.3 OR F 4.5 ZEISS TESSAR LENS. COMPUR SHUTTER.

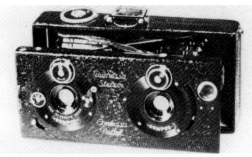

(2757) **DUCHESSA STEREO CAMERA.** C. 1920. SIZE 45 X 107 MM STEREO EXPOSURES ON PLATES. 65 MM/F 6.3 CITONAR LENSES. COMPUR SHUTTER WITH SPEEDS TO $\frac{1}{250}$ SEC. (HA)

(2758) **KLAPP CAMERA. TROPICAL MODEL.** C. 1920. SIZE 6.5 X 9 CM EXPOSURES ON PLATES. 120 MM/F 4.5 ZEISS TESSAR LENS.

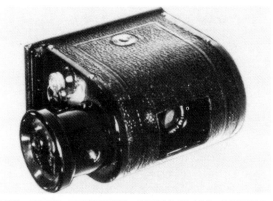

(2759) **ERGO DETECTIVE OPERA-GLASS CAMERA.** C. 1924. SIZE 4.5 X 6 CM EXPOSURES ON PLATES. 55 MM/F 4.5 ZEISS TESSAR LENS. SHUTTER SPEEDS FROM $\frac{1}{25}$ TO $\frac{1}{100}$ SEC. (HA)

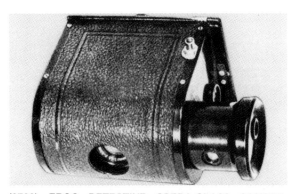

(2760) **ERGO DETECTIVE OPERA-GLASS CAMERA.** C. 1924. SIZE 4.5 X 6 CM EXPOSURES ON PLATES. 55 MM/F 4.5 ZEISS TESSAR LENS. SHUTTER SPEEDS FROM $\frac{1}{25}$ TO $\frac{1}{100}$ SEC. (HA)

(2761) **MICROFLEX CAMERA.** C. 1926. SIZE 6 X 9 CM EXPOSURES ON PLATES OR FILM PACKS. 150 MM/F 4.5 ZEISS TESSAR LENS. FOCAL PLANE SHUTTER. RISING LENS MOUNT. SIMILAR TO THE MICROFLEX BY ZEISS IKON. (IH)

(2762) **NETTIX VEST POCKET TROPICAL CAMERA.** C. 1923. SIZE 4.5 X 6 CM EXPOSURES ON PLATES OR FILM PACKS. F 6.8 NETTAR OR F 6.3 CITONAR LENS. DERVAL SHUTTER.

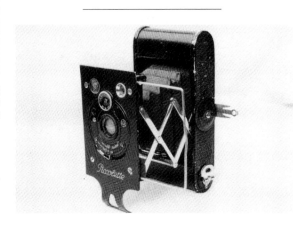

## CONTESSA-NETTEL A.G. (*cont.*)

(2763) **PICCOLETTE CAMERA.** C. 1921–23. SIZE 4 X 6.5 CM EXPOSURES ON NO. 127 ROLL FILM. F 4.5 OR F 6.3 CARL ZEISS LENS. ALSO F 5.4 TO F 11 TRITOTAR, TERONAR, CITONAR, NETTAR, OR ACHROMAT LENSES. DERVAL SHUTTER; $\frac{1}{25}$ TO $\frac{1}{100}$ SEC., B., T. ALSO, ACRO OR COMPUR SHUTTERS. (TS)

(2764) **ODORO CAMERA.** C. 1920. SIZE 9 X 12 CM EXPOSURES ON PLATES. F 4.5 ZEISS TESSAR LENS. COMPUR SHUTTER.

(2765) **PICCOLETTE DELUXE CAMERA.** C. 1924. SIZE 4 X 6.5 CM EXPOSURES ON NO. 127 ROLL FILM. SIMILAR TO THE PICOLETTE CAMERA, C. 1921–23, BUT WITH A HINGED BASEBOARD SUPPORT IN ADDITION TO THE LAZY-TONGS FOR ADDED LENS BOARD STABILITY.

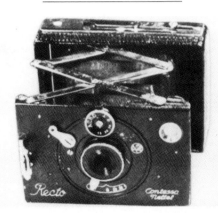

(2766) **RECTO CAMERA.** C. 1920. TWO SIZES OF THIS CAMERA FOR 4.5 X 6 OR 6.5 X 9 CM EXPOSURES ON PLATES. MENISCUS LENS. ACRO SHUTTER; $\frac{1}{25}$ TO $\frac{1}{75}$ SEC. (HA)

(2767) **ROLLCO CAMERA.** C. 1923. TWO SIZES OF THIS CAMERA FOR 9 X 12 OR 9 X 14 CM EXPOSURES ON PLATES OR ROLL FILM. F 6.3 CITONAR OR F 7.7 ERA LENS. DERVAL OR IBSO SHUTTER.

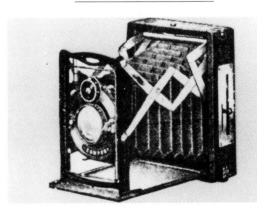

(2768) **SONNET CAMERA.** C. 1923. FOUR SIZES OF THIS CAMERA FOR 4.5 X 6, 6.5 X 9, 9 X 12, OR 10 X 15 CM EXPOSURES ON PLATES OR FILM PACKS. F 4.5 CARL ZEISS ANASTIGMAT LENS. COMPUR SHUTTER.

(2769) **STEREAX STEREO CAMERA.** C. 1923. TWO SIZES OF THIS CAMERA FOR 45 X 107 OR 60 X 130 MM STEREO OR PANORAMIC EXPOSURES.

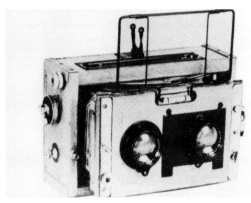

(2770) **STEREO CAMERA.** C. 1920. SIZE 6 X 13 CM STEREO EXPOSURES ON FILM PACKS. 90 MM/F 4.5 ZEISS TESSAR LENSES. FOCAL PLANE SHUTTER; $\frac{1}{10}$ TO $\frac{1}{1200}$ SEC. THE CAMERA TAKES PANORAMIC AND STEREO EXPOSURES.

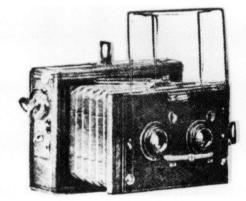

(2771) **STEREO DECKRULLO-NETTEL CAMERA.** C. 1923. SIZE 10 X 15 STEREO EXPOSURES. F 4.5 CARL ZEISS LENSES. FOCAL PLANE SHUTTER.

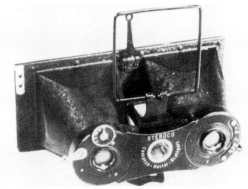

(2772) **STEROCO STEREO CAMERA.** C. 1920. SIZE 45 X 107 MM STEREO EXPOSURES ON PLATES. 55 MM/F 6.3 ZEISS TESSAR OR F 5.4 TERONAR LENSES. IBSOR SHUTTER; $\frac{1}{25}$, $\frac{1}{50}$, $\frac{1}{100}$ SEC., B., T. FIXED FOCUS. (HA)

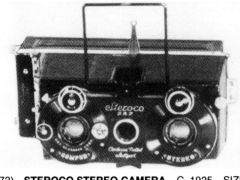

(2773) **STEROCO STEREO CAMERA.** C. 1925. SIZE 45 X 107 MM STEREO EXPOSURES ON PLATES. F 4.5 CITONAR, F 5.4 TERONAR, OR F 6.3 ZEISS TESSAR LENSES. COMPUR SHUTTER; 1 TO $\frac{1}{250}$ SEC. (HA)

(2774) **TROPEN ADORO CAMERA.** C. 1925. SIZE 6 X 9 CM PLATE EXPOSURES. 120 MM/F 4.5 ZEISS TESSAR LENS. COMPUR SHUTTER; 1 TO $\frac{1}{250}$ SEC. RISING AND CROSSING LENS MOUNT. TEAKWOOD BODY. (IH)

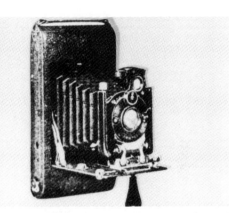

(2775) **UNITAK CAMERA.** C. 1923. TWO SIZES OF THIS CAMERA FOR 9 X 12 OR 9 X 14 CM EXPOSURES ON PLATES OR ROLL FILM. F 4.5 OR F 6.3 CARL ZEISS LENS. ALSO, F 4.5 TERONAR OR F 6.8 NETTAR LENS. DERVAL OR COMPUR SHUTTER.

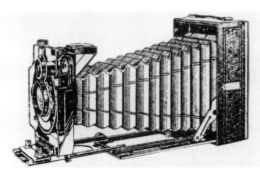

(2776) **ZODEL-TESSCO CAMERA.** C. 1925. SIZE 2½ X 3½ INCH EXPOSURES ON PLATES. F 4.5 ZEISS TESSAR LENS. COMPUR SHUTTER. DOUBLE EXTENSION BELLOWS. SOLD BY W. HEATON, LTD., LONDON.

## DRESSLER & HEINEMANN

(2777) **KLAPP PLATE CAMERA.** C. 1895. SIZE 9 X 12 CM EXPOSURES. 120 MM/F 11 STEINHEIL PERISCOPIC LENS. CHANGING-BAG MAGAZINE. (MA)

## DREXLER & NAGEL

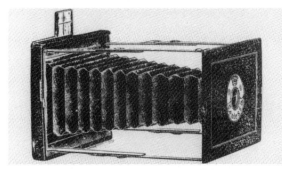

(2778) **CONTESSA VEST POCKET CAMERA.** C. 1908. THE CAMERA FOLDS TO A VERY COMPACT SIZE, APPROXIMATELY 1-CM THICK.

## EBNER, ALBERT & COMPANY

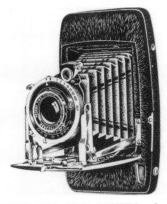

(2779) **EBNER ROLL FILM CAMERA.** C. 1934. SIZE 6 X 9 CM EXPOSURES ON ROLL FILM. F 4.5 ANASTIG-MAT, F 3.5 MEYER TRIOPLAN, OR F 3.8 ZEISS TESSAR LENS. PRONTO S OR COMPUR S SHUTTER; 1 TO ½₅₀ SEC., B., T. BAKELITE BODY.

(2780) **EBNER ROLL FILM CAMERA.** C. 1936. SIZE 4.5 X 6 CM EXPOSURES ON NO. 620 ROLL FILM. 75 MM/F 6.3 EBNER ANASTIGMAT LENS. THREE-SPEED VARIO SHUTTER. (MA)

## EDER PRAZISIONS-KAMERA G.M.B.H.

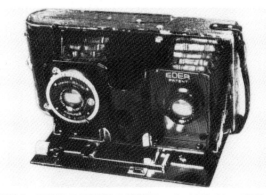

(2781) **EDER PATENT CAMERA.** C. 1928–33. SIZE 6 X 6 CM EXPOSURES ON ROLL FILM. 75 MM/F 4.5 ZEISS TESSAR TAKING LENS AND A 75 MM/F 4.5 EDER AN-ASTIGMAT VIEWING LENS. COMPUR SHUTTER WITH SPEEDS TO ⅟₃₀₀ SEC. (HA)

## EHO-KAMERAFABRIK B. ALTMAN

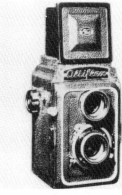

(2782) **ALTIFLEX TWIN LENS REFLEX CAMERA.** C. 1937–39. SIZE 6 X 6 CM EXPOSURES ON NO. 120 ROLL FILM. F 4.5 VICTAR, F 3.5 OR F 2.9 TRINAR, OR F 2.9 STEINHEIL OR VICTAR LENS. AUTO SHUTTER; ⅟₂₅ TO ⅟₁₀₀ SEC., B., T. COMPUR SHUTTER; 1 TO ⅟₂₅₀ SEC., B., T., OR COMPUR RAPID SHUTTER.

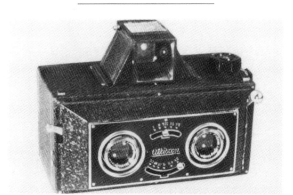

(2783) **ALTISCOP STEREO CAMERA.** C. 1936–40. TWELVE SINGLE EXPOSURES, SIZE 6 X 6 CM OR SIX STEREO EXPOSURES, 6 X 13 CM ON NO. 120 OR B-2 ROLL FILM. 80 MM/F 4.5 VICTAR LENSES. VARIO SHUTTER; ⅟₂₅ TO ⅟₁₀₀ SEC. MANUAL FOCUS. (HA)

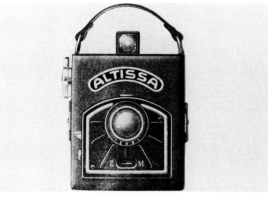

(2784) **ALTISSA BOX CAMERA.** C. 1935. SIZE 6 X 6 CM EXPOSURES ON ROLL FILM. SINGLE-SPEED AND TIME SHUTTER.

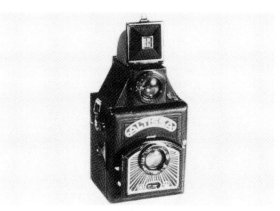

(2785) **ALTISSA BOX CAMERA.** C. 1938. SIZE 6 X 6 CM EXPOSURES ON ROLL FILM. F 8 RODENSTOCK PERISCOP LENS. SINGLE-SPEED SHUTTER. (HA)

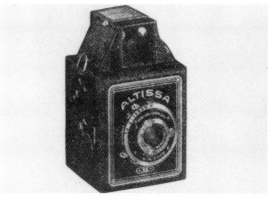

(2786) **ALTISSA BOX CAMERA.** C. 1938. SIZE 6 X 6 CM EXPOSURES ON ROLL FILM. F 4.5 VICTAR OR F 3.5 TRINAR LENS. AUTO SHUTTER; ⅟₂₅ TO ⅟₁₀₀ SEC., B., T. OR RIM-SET COMPUR SHUTTER; 1 TO ⅟₂₅₀ SEC., B., T.

(2787) **EHO BOX CAMERA.** C. 1932. SIZE 3 X 4 CM EXPOSURES ON NO. 127 ROLL FILM. 50 MM/F 11 DUPLAR LENS. SINGLE-SPEED SHUTTER. (MA)

## EHO-KAMERAFABRIK B. ALTMAN (cont.)

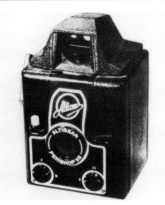

(2788) **ALTISSA BOX CAMERA.** C. 1940. SIZE 6 X 6 CM EXPOSURES ON ROLL FILM. F 8 PERISKOP LENS. SHUTTER; 1/25 SEC., B. TWO APERTURE STOPS. (HA)

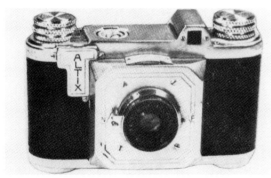

(2789) **ALTIX MINIATURE CAMERA.** C. 1940. SIZE 24 X 24 MM EXPOSURES ON ROLL FILM. 35 MM/F 3.5 LAACK-POLOLYT LENS. SHUTTER SPEEDS FROM 1/25 TO 1/150 SEC. (HA)

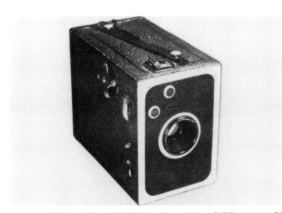

(2790) **EHO BOX CAMERA.** C. 1937. SIZE 6 X 9 CM EXPOSURES ON ROLL FILM. 110 MM/F 11 LENS. SINGLE-SPEED AND TIME SHUTTER. (HA)

(2791) **EHO NO. 175 BOX CAMERA.** C. 1933. SIZE 4 X 6 CM EXPOSURES ON ROLL FILM.

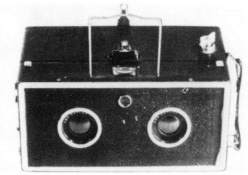

(2792) **EHO STEREO BOX CAMERA.** C. 1932–37. SIZE 6 X 13 CM STEREO EXPOSURES ON NO. 120 ROLL FILM. 80 MM/F 11 DUPLAR LENSES. SINGLE-SPEED SHUTTER. (HA)

(2793) **EHO STEREO CAMERA.** C. 1933–40. 75 MM DUPLAR LENSES. LEAF SHUTTER. FIXED FOCUS. SIMILAR TO THE ALTISCOP STEREO CAMERA.

## ERNEMANN, HEINRICH, A. G.

(2794) **ARCHIMEDES STEREOSCOP CAMERA.** C. 1901. SIZE 9 X 18 CM STEREO EXPOSURES ON PLATES. THE CAMERA HOLDS 12 PLATES. SIMILAR TO THE DOVE STEREOSCOP CAMERA.

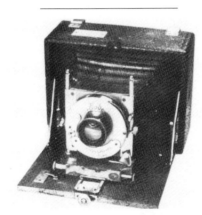

(2795) **BOB FOLDING PLATE CAMERA.** C. 1910. SIZE 9 X 12 CM EXPOSURES ON PLATES. ERNEMANN DETECTIVE APLANAT LENS. ERNEMANN SHUTTER. (HA)

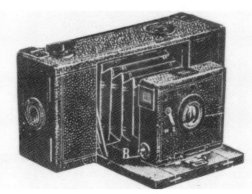

(2796) **BOB I FOLDING CAMERA.** C. 1901. SIZE 6.5

X 9 CM EXPOSURES ON PLATES OR ROLL FILM. PARISER APLANAT LENS. INSTANT AND TIME SHUTTER. IRIS DIAPHRAGM.

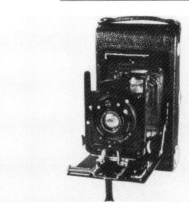

(2797) **BOB I FOLDING CAMERA.** C. 1916. SIZE 8 X 11 CM EXPOSURES ON PLATES OR ROLL FILM. 135 MM/F 6.8 ERNEMANN VILAR LENS. SHUTTER SPEEDS TO 1/250 SEC. (HA)

(2798) **BOB II FOLDING CAMERA.** C. 1901. SIZE 6.5 X 9 CM EXPOSURES ON PLATES AND 9 X 9 CM EXPOSURES ON ROLL FILM. ACHROMATIC LENS. IRIS DIAPHRAGM. SIMILAR TO THE BOB I FOLDING CAMERA, (C. 1901).

(2799) **BOB III FOLDING CAMERA.** C. 1901. SIZE 9 X 12 CM EXPOSURES ON PLATES AND 10 X 12.5 CM EXPOSURES ON ROLL FILM. UNIVERSALAPLANAT, F 8 BUSCH DETEKTIVAPLANAT, OR GOERZ DOPPEL ANASTIGMAT LENS. PNEUMATIC CENTRAL SHUTTER. SIMILAR TO THE BOB I FOLDING CAMERA, (C. 1901).

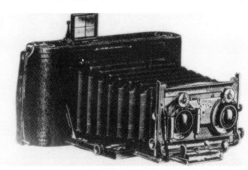

(2800) **BOB IV PANORAM AND STEREO CAMERA.** C. 1908. SIZE 9 X 14 CM EXPOSURES ON PLATES OR 8.5 X 14 CM EXPOSURES ON SHEET OR ROLL FILM.

(2801) **BOB V FOLDING STEREO CAMERA.** C. 1909.

(2802) **BOB XV FOLDING CAMERA.** C. 1914. SIZE 9 X 12 CM EXPOSURES ON PLATES OR ROLL FILM. F 6.8 ERNEMANN DETEKTIVE APLANAT LENS. AUTOMATIC SHUTTER.

(2803) **FILM K BOX CAMERA.** C. 1912. SIZE 6 X 9 CM ROLL FILM EXPOSURES. MENISCUS LENS. SINGLE-SPEED AND TIME SHUTTER.

**ERNEMANN, HEINRICH, A. G. (*cont.*)**

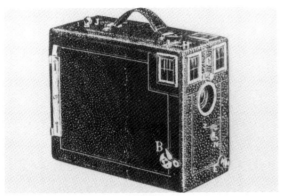

**(2804) EUROPA BOX CAMERA.** C. 1901. SIZE 9 X 12 CM EXPOSURES ON PLATES. THE CAMERA HOLDS 12 PLATES. ACHROMATIC LENS. INSTANT AND TIME SHUTTER. IRIS DIAPHRAGM.

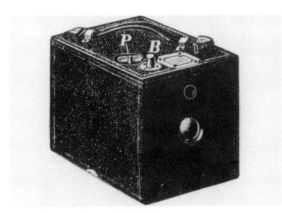

**(2805) FILM BOX CAMERA.** C. 1901. SIZE 9 X 12 CM EXPOSURES ON ROLL FILM. PARISER APLANAT, VOIGTLANDER COLLINEAR, GOERZ DOPPEL-ANASTIGMAT, OR ZEISS ANASTIGMAT LENS.

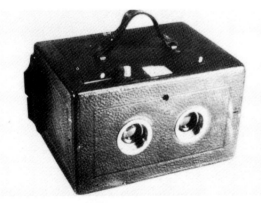

**(2806) DOVE STEREOSCOP CAMERA.** C. 1901–06. SIZE 9 X 18 CM STEREO EXPOSURES ON FILM PACKS. MENISCUS LENSES. TWO-SPEED SHUTTER.

**(2807) EDISON MAGAZINE CAMERA.** C. 1895. SIZE 9 X 12 CM EXPOSURES ON PLATES. THE MAGAZINE HOLDS 12 PLATES. ZEISS ANASTIGMAT SERIES III

LENS. SINGLE KNOB FOR CHANGING PLATES AND RESETTING SHUTTER. LEATHER COVERED BODY.

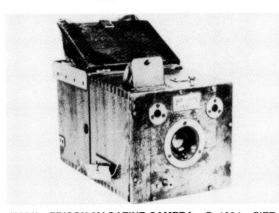

**(2808) EDISON MAGAZINE CAMERA.** C. 1894. SIZE 9 X 12 CM PLATE EXPOSURES. THE MAGAZINE HOLDS 12 PLATES. RECTILINEAR LENS. GUILLOTINE SHUTTER. LEATHER PLATE-CHANGING BAG. WOOD BODY.

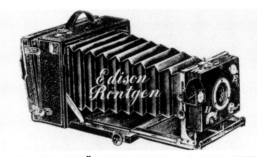

**(2809) EDISON RÖUTGEN CAMERA.** C. 1898. SIZE 13 X 18 CM EXPOSURES ON PLATES. UNIVERSAL-APLANAT OR VOIGTLANDER COLLINEAR SERIES III LENS.

**(2810) FILM STEREOSCOP CAMERA.** C. 1901. SIZE 9 X 18 CM EXPOSURES ON SHEET FILM. SIMILAR TO THE DOVE STEREOSCOP CAMERA.

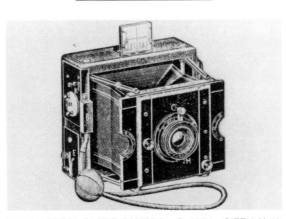

**(2811) FOCAL PLANE CAMERA.** C. 1904. SIZE 9 X 12 CM EXPOSURES ON PLATES. F 6.8 ANASTIGMAT LENS. FOCAL PLANE SHUTTER; $\frac{1}{20}$ TO $\frac{1}{2000}$ SEC. RISING AND CROSSING LENS MOUNT.

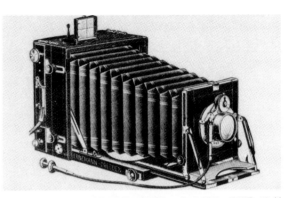

**(2812) FOCAL PLANE CAMERA.** C. 1905. SIZE 10 X 13 CM EXPOSURES ON PLATES. FOCAL PLANE SHUTTER WITH SPEEDS TO $\frac{1}{2500}$ SEC., T. FRONT PNEUMATIC SHUTTER FOR SLOWER SPEEDS. DOUBLE EXTENSION BELLOWS.

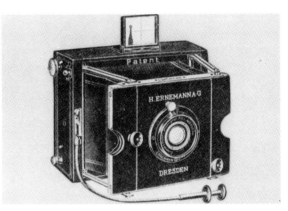

**(2813) FOCAL PLANE CAMERA. TROPICAL MODEL.** C. 1905. SIZE 4 X 5 INCH EXPOSURES ON PLATES. F 6.8 ERNEMANN ANASTIGMAT OR GOERZ ANASTIGMAT LENS. ALSO, F 4.5 ZEISS UNAR LENS. FOCAL PLANE SHUTTER WITH SPEEDS TO $\frac{1}{2500}$ SEC., T. ALL-METAL CAMERA BODY COVERED WITH LEATHER.

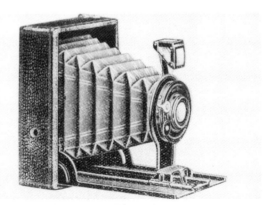

**(2814) FOLDING CAMERA. MODEL 00.** C. 1914. SIZE 9 X 12 CM EXPOSURES ON PLATES OR FILM PACKS. ERNEMANN DOUBLET LENS. INSTANT, B., T. SHUTTER. IRIS DIAPHRAGM. GROUND GLASS FOCUSING.

## ERNEMANN, HEINRICH, A. G. (*cont.*)

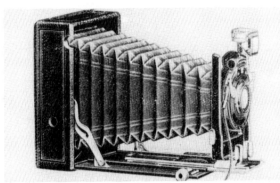

(2815) **FOLDING CAMERA. MODELS I AND II.** C. 1914. THREE SIZES OF THIS CAMERA FOR 9 X 12, 10 X 15, OR 13 X 18 CM EXPOSURES ON PLATES OR FILM PACKS. F 6.8 ERNEMANN DETECTIVE APLANAT LENS. BOB SHUTTER TO ⅟₁₀₀ SEC., AUTOMAT SHUTTER TO ⅟₁₀₀ SEC., OR SECTOR SHUTTER TO ⅟₃₀₀ SEC. RACK & PINION FOCUS. GROUND GLASS FOCUS. RISING AND CROSSING FRONT. MODEL I HAS SINGLE EXTENSION BELLOWS, MODEL II HAS DOUBLE EXTENSION BELLOWS.

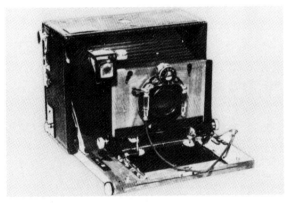

(2816) **FOLDING PLATE CAMERA.** C. 1906. SIZE 10 X 15 CM EXPOSURES ON PLATES. 150 MM/F 6.8 ERNON LENS. DOUBLE PNEUMATIC SHUTTER WITH SPEEDS TO ⅟₁₀₀ SEC. AND FOCAL PLANE SHUTTER WITH SPEEDS TO ⅟₂₅₀₀ SEC. (HA)

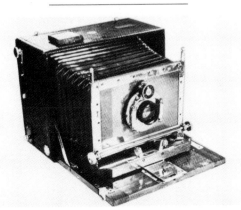

(2817) **FOLDING PLATE CAMERA.** C. 1907. SIZE 13 X 18 CM EXPOSURES ON PLATES. 180 MM/F 6.8 GOERZ DAGOR LENS. DOUBLE PNEUMATIC SHUTTER

WITH SPEEDS TO ⅟₁₀₀ SEC. AND A FOCAL PLANE SHUTTER. (HA)

(2818) **FOLDING PLATE CAMERA.** C. 1910. SIZE 4.5 X 6 CM EXPOSURES ON PLATES OR FILM PACKS. 80 MM/F 6.8 ERNON LENS. ERNEMANN SHUTTER; 1 TO ⅟₃₀₀ SEC., B., T. (HA)

(2819) **FOLDING PLATE CAMERA.** C. 1910. SIZE 6.5 X 9 CM EXPOSURES ON PLATES. F 6.8 ERNEMANN DETECTIVE APLANAT LENS. SHUTTER SPEEDS FROM ½ TO ⅟₁₀₀ SEC. (HA)

(2820) **FOLDING PLATE CAMERA.** C. 1910. SIZE 13 X 18 CM EXPOSURES ON PLATES. 120 MM/F 6.8 ARISTOSTIGMAT LENS. ERNEMANN SHUTTER WITH SPEEDS TO ⅟₃₀₀ SEC. (HA)

(2821) **FOLDING PLATE CAMERA.** C. 1912. SIZE 9 X 12 CM EXPOSURES ON PLATES. TWO-SPEED SHUTTER. ALL-METAL BODY. (HA)

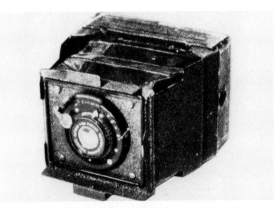

(2822) **FOLDING PLATE CAMERA.** C. 1915. SIZE 4.5 X 6 CM EXPOSURES ON PLATES. 80 MM/F 6.8 DETECTIVE-APLANAT LENS. SHUTTER SPEEDS; ⅟₂₅, ⅟₅₀, ⅟₁₀₀ SEC. (HA)

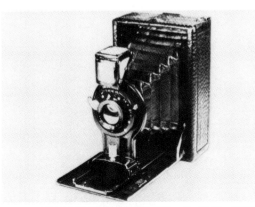

(2823) **FOLDING PLATE CAMERA.** C. 1915. SIZE 6 X 9 CM EXPOSURES ON PLATES. F 11 ERNEMANN DOUBLE LENS. SHUTTER SPEEDS FROM ⅟₂₅ TO ⅟₁₀₀ SEC. (HA)

(2824) **FOLDING STEREO CAMERA.** C. 1915. SIZE 45 X 107 MM STEREO EXPOSURES ON PLATES. MENISCUS LENSES. SINGLE-SPEED GUILLOTINE SHUTTER. (MA)

## ERNEMANN, HEINRICH, A. G. (*cont.*)

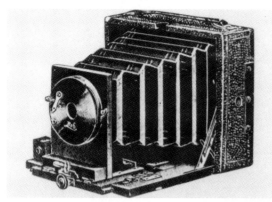

(2825) **HEAG I CAMERA.** C. 1901. SIZE 9 X 12 CM EXPOSURES ON PLATES. ACHROMATIC LENS. BOB-CENTRAL SHUTTER.

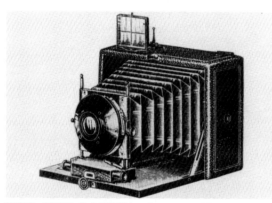

(2826) **HEAG II CAMERA.** C. 1901. SIZE 9 X 12 CM EXPOSURES ON PLATES. APLANAT LENS. BOB-CENTRAL SHUTTER.

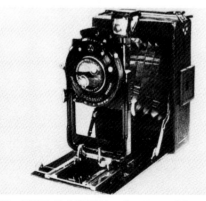

(2827) **HEAG II CAMERA.** C. 1914. SIZE 9 X 12 CM EXPOSURES ON PLATES. 135 MM/F 4.5 EUROPLAST LENS. CRONOS-C SHUTTER WITH SPEEDS TO 1/250 SEC. (HA)

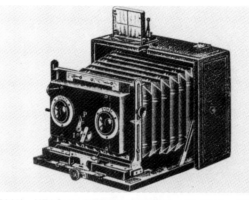

(2828) **HEAG III STEREO CAMERA.** C. 1901. SIZE 9 X 12 CM SINGLE OR STEREO EXPOSURES ON PLATES. INTERCHANGEABLE SINGLE LENS OR STEREO LENS BOARD. PAAR ACHROMATIC LENSES OR UNIVERSAL APLANAT SINGLE LENS. BOB-CENTRAL SHUTTER. RISING, FALLING, AND CROSSING LENS MOUNT.

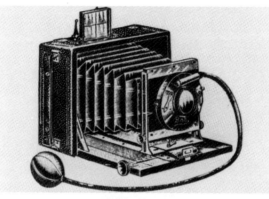

(2829) **HEAG IV CAMERA.** C. 1901. SIZE 9 X 12 CM EXPOSURES ON PLATES. UNIVERSAL APLANAT EXTRA RAPID LENS. PNEUMATIC BOB-CENTRAL SHUTTER.

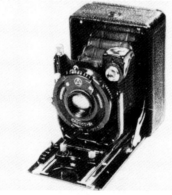

(2830) **HEAG V CAMERA.** C. 1915. SIZE 4.5 X 6 CM EXPOSURES ON PLATES. 75 MM/F 4.5 ERNOPLAST LENS. CRONOS-B SHUTTER; 1 TO 1/100 SEC., T. (HA)

(2831) **HEAG XII CAMERA.** C. 1911. SIZE 10 X 15 CM PLATE EXPOSURES. 150 MM/F 6.8 ERNON LENS. ERNEMANN CENTRAL SHUTTER. TWO LENSES CAN BE MOUNTED ON THE LENS BOARD FOR STEREO EXPOSURES. (MA)

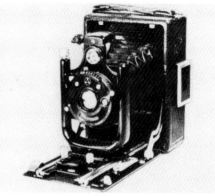

(2832) **HEAG VII CAMERA.** C. 1915. SIZE 6 X 9 CM EXPOSURES ON PLATES. 100 MM/F 6.3 GOERZ DOGMAR LENS. CRONOS-C SHUTTER WITH SPEEDS TO 1/300 SEC. (HA)

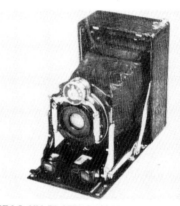

(2833) **HEAG XV PLATE CAMERA.** C. 1909. SIZE 4.5 X 6 CM EXPOSURES ON PLATES. 80 MM/F 6.8 MEYER ARISTOSTIGMAT LENS. ERNEMANN DOUBLE PNEUMATIC SHUTTER; 1/2 TO 1/100 SEC. (HA)

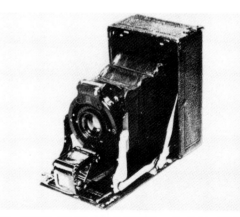

(2834) **HEAG XV PLATE CAMERA.** C. 1910 SIZE 4.5 X 6 CM EXPOSURES ON PLATES. 80 MM/F 6.3 LENS. ERNEMANN SHUTTER WITH SPEEDS TO 1/100 SEC. (HA)

## ERNEMANN, HEINRICH, A. G. (*cont.*)

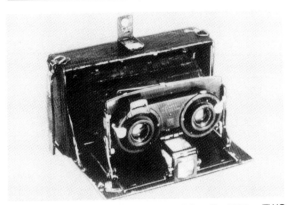

(2835) **HEAG XV STEREO CAMERA.** C. 1914. TWO SIZES OF THIS CAMERA FOR 45 X 107 OR 60 X 130 MM STEREO EXPOSURES ON PLATES OR FILM PACKS. F 6.8 DETEKTIV APLANAT OR DOUBLE ANASTIGMAT ERNON, F 6 OR F 7.2 ERNEMANN ANASTIGMAT, OR F 6.8 VILAR LENSES. SHUTTER SPEEDS OF 1/100 AND 1/300 SEC. (HA)

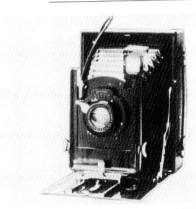

(2836) **HEAG OB CAMERA.** C. 1915. SIZE 9 X 12 CM EXPOSURES ON PLATES. 135 MM/F 6.8 ERNASTIGMAT LENS. SHUTTER SPEEDS FROM 1/25 TO 1/100 SEC.

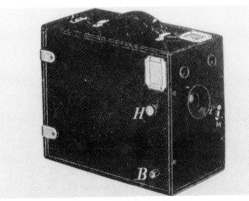

(2837) **ITALIA BOX CAMERA.** C. 1901. SIZE 9 X 12 CM EXPOSURES ON PLATES. INSTANT AND TIME SHUTTER. THE CAMERA HOLDS 12 PLATES.

(2838) **ITALIA STEREOSCOP CAMERA.** C. 1901. SIZE 9 X 18 CM STEREO EXPOSURES ON PLATES.

THE CAMERA HOLDS 12 PLATES. SIMILAR TO THE DOVE STEREOSCOP CAMERA.

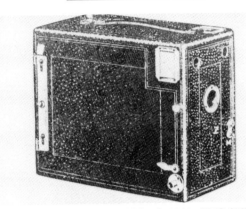

(2839) **ITALIA BOX CAMERA.** C. 1914. TWO SIZES OF THIS CAMERA FOR 6.5 X 9 OR 9 X 12 CM EXPOSURES ON PLATES. INSTANT AND TIME SHUTTER. THE SMALLER FORMAT CAMERA HOLDS SIX PLATES AND THE LARGER CAMERA HOLDS 12 PLATES.

(2840) **KLAPP FOLDING CAMERA.** C. 1914. TWO SIZES OF THIS CAMERA FOR 6.5 X 9 OR 9 X 12 CM EXPOSURES. F 3.5 ERNON LENS. FOCAL PLANE SHUTTER.

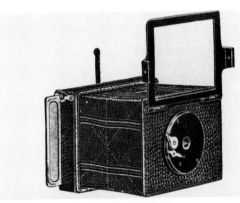

(2841) **LILIPUT FOLDING CAMERA.** C. 1912-13. TWO SIZES OF THIS CAMERA FOR 4.5 X 6 OR 6.5 X 9 CM EXPOSURES ON PLATES OR FILM PACKS. MENISCUS OR ACHROMATIC SINGLE LENS. INSTANT AND TIME SHUTTER. GROUND GLASS FOCUS.

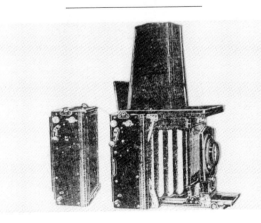

(2842) **LONG-FOCUS FOLDING REFLEX CAMERA.** C. 1913. SIZE 9 X 12 CM EXPOSURES ON PLATES. F 4.5 OR F 6.8 ANASTIGMAT LENS. ALSO, F 4.5 ZEISS TESSAR LENS. FOCAL PLANE SHUTTER. REVOLVING BACK. RACK & PINION FOCUSING.

(2843) **LILIPUT STEREO CAMERA.** C. 1919.

(2844) **MIGNON CAMERA.** C. 1914. SIZE 4.5 X 6 CM EXPOSURES. 80 MM/F 6.8 APLANAT LENS.

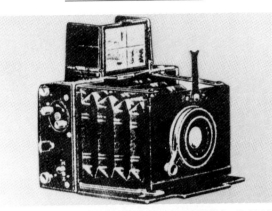

(2845) **MINIATURE FOLDING PLATE CAMERA.** C. 1914. SIZE 4.5 X 6 CM EXPOSURES ON PLATES OR· FILM PACKS. F 4.5, F 6, OR F 6.8 ERNEMANN DOUBLE ANASTIGMAT LENS. ALSO, F 6.8 GOERZ DAGOR OR F 4.5 OR F 6.3 ZEISS TESSAR LENS. FOCAL PLANE SHUTTER FOR SPEEDS TO 1/2500 SEC., T.

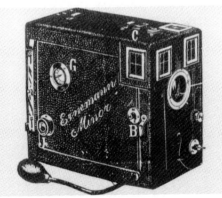

(2846) **MINOR BOX CAMERA.** C. 1901. SIZE 9 X 12 CM EXPOSURES ON PLATES. THE CAMERA HOLDS 12 PLATES. UNIVERSAL-APLANAT, ZEISS ANASTIGMAT, GOERZ DOPPEL ANASTIGMAT, OR VOIGTLANDER COLLINEAR III LENS. PNEUMATIC SHUTTER. IRIS DIAPHRAGM.

(2847) **MOSER STEREOSCOP CAMERA.** C. 1901. SIZE 9 X 18 CM EXPOSURES ON FILM PACKS. SIMILAR TO THE DOVE STEREOSCOP CAMERA.

(2848) **NANSEN STEREOSCOP CAMERA.** C. 1901. SIZE 9 X 18 CM EXPOSURES ON PLATES. THE CAMERA HOLDS 12 PLATES. SIMILAR TO THE DOVE STEREOSCOP CAMERA.

## ERNEMANN, HEINRICH, A. G. (*cont.*)

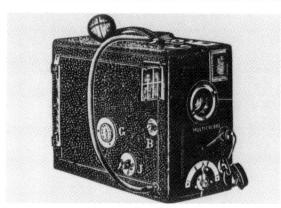

**(2849) MULTICOLORE CAMERA.** C. 1901. SIZE 9 X 12 CM COLOR EXPOSURES ON SPECIAL PLATES. UNIVERSALAPLANAT LENS.

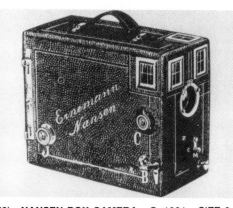

**(2850) NANSEN BOX CAMERA.** C. 1901. SIZE 9 X 12 CM EXPOSURES ON PLATES OR SHEET FILM. THE CAMERA HOLDS 12 PLATES OR 24 SHEET FILMS. CENTRAL SHUTTER. IRIS DIAPHRAGM.

**(2851) PANORAMIC CAMERA.** C. 1907. THIS IS AN L-SHAPE, BOX-FORM CAMERA FOR TAKING 360-DEGREE EXPOSURES. THE FILM LENGTH FOR A 360-DEGREE EXPOSURE IS 100 CM. A SPRING CLOCKWORK ROTATES THE CAMERA AND MOVES THE FILM THROUGH THE FOCAL PLANE.

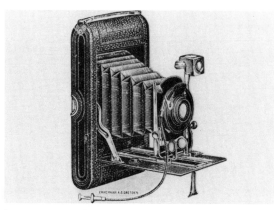

**(2852) ROLL FILM CAMERA. MODEL 0.** C. 1914.

SIZE 9 X 12 CM EXPOSURES ON ROLL FILM. F 6.8 ERNEMANN DETECTIVE APLANAT OR ERNEMANN DOUBLE LENS. AUTOMATIC SHUTTER FOR INSTANT, B., T. EXPOSURES. ALSO, BOB SHUTTER; 1 TO 1/100 SEC., B., T. RISING LENS MOUNT. ADAPTER FOR PLATES AND FOCUSING SCREEN.

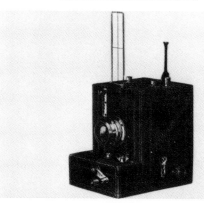

**(2853) ROLL FILM CAMERA. MODEL I.** C. 1914. TWO SIZES OF THIS CAMERA FOR 9 X 12 OR 9 X 14 CM EXPOSURES ON ROLL FILM OR PLATES WITH ADAPTER. F 6.8 ERNEMANN DETECTIVE APLANAT LENS. AUTO OR BOB SHUTTER; 1 TO 1/100 SEC., B., T. ALSO, AUTO SECTOR SHUTTER. RISING AND CROSSING LENS MOUNT. RACK & PINION FOCUSING.

**(2854) ROLL FILM DUAL-SHUTTER CAMERA.** C. 1910. SIZE 4.5 X 6 CM EXPOSURES. F 6.8 DETECTIVE APLANAT LENS. TWO SHUTTERS: ONE FOCAL PLANE SHUTTER WITH SPEEDS TO 1/2500 SEC. AND ONE BETWEEN-THE-LENS SHUTTER. (MA)

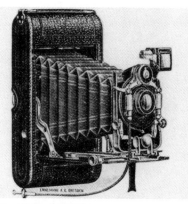

**(2855) RUNDBLICK PANORAMIC CAMERA.** C. 1907. THE CAMERA TAKES 360-DEGREE PANORAMIC EXPOSURES ON ROLL FILM.

**(2856) STEREO KLAPP CAMERA.** C. 1914. SIZE 45 X 107 MM STEREO EXPOSURES ON ROLL FILM. 80 MM/ F 6.8 GOERZ DAGOR LENSES. ERNEMANN SHUTTER; 1/2 TO 1/300 SEC. (MA)

**(2857) STEREO KLAPP MAGAZINE CAMERA.** C. 1911. SIZE 45 X 107 MM STEREO EXPOSURES ON PLATES. THE MAGAZINE HOLDS 12 PLATES. 55 MM/F 4.5 TESSAR LENSES. FOCAL PLANE SHUTTER. (MA)

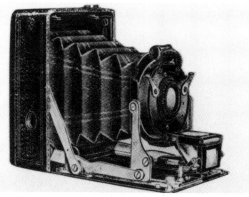

**(2858) SPRING VEST POCKET CAMERA.** C. 1914. TWO SIZES OF THIS CAMERA FOR 4.5 X 6 OR 6.5 X 9 CM EXPOSURES ON PLATES OR FILM PACKS. ERNEMANN F 6.8 DETECTIVE APLANAT, F 7.2 ANASTIGMAT, F 5.4 OR F 6 DOUBLE ANASTIGMAT, OR F 6.8 ERNON LENS. ALSO, F 6.3 ZEISS TESSAR OR F 6.8 GOERZ DAGOR LENS. AUTOMATIC SHUTTER; 1/25, 1/50, 1/100 SEC., B., T.; BOB SHUTTER; 1 TO 1/100 SEC., B., T.; OR SECTOR SHUTTER; 1 TO 1/300 SEC., B., T. GROUND GLASS FOCUSING. THE ERNON AND TESSAR LENSES WERE NOT AVAILABLE ON THE 6.5 X 9 MODEL.

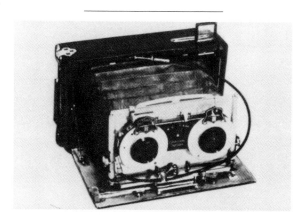

**(2859) STEREO KLAPP CAMERA.** C. 1910. SIZE 9 X 18 CM STEREO EXPOSURES. 120 MM/F 6.8 MEYER ARISTOSTIGMAT LENSES. SHUTTER SPEEDS; 1/2 TO 1/100 SEC. (HA)

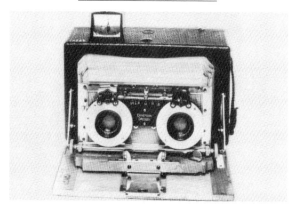

**(2860) STEREO KLAPP CAMERA.** C. 1910. SIZE 9 X 18 CM STEREO EXPOSURES. 120 MM/F 6.8 HUGO MEYER ARISTOSTIGMAT LENSES. SHUTTER SPEEDS FROM 1/2 TO 1/100 SEC., T.

## ERNEMANN, HEINRICH, A. G. (*cont.*)

(2861) **STEREO REFLEX CAMERA.** C. 1908. SIZE 100 X 150 MM STEREO EXPOSURES ON PLATES. FOCAL PLANE SHUTTER WITH SPEEDS TO 1/2500 SEC.

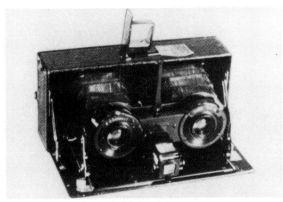

(2862) **STEREO KLAPP CAMERA.** C. 1914. SIZE 45 X 107 MM STEREO EXPOSURES ON PLATES. 65 MM/F 6.8 DETECTIV APLANAT LENSES. SHUTTER SPEEDS TO 1/100 SEC. (HA)

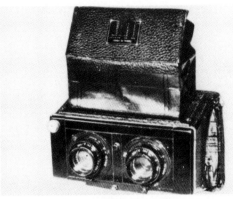

(2863) **STEREO REFLEX CAMERA.** C. 1913. SIZE 6 X 13 CM STEREO EXPOSURES ON PLATES. 90 MM/F 4.5 ZEISS TESSAR LENSES. FOCAL PLANE SHUTTER WITH SPEEDS TO 1/2500 SEC. (HA)

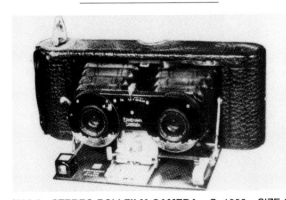

(2864) **STEREO ROLLFILM CAMERA.** C. 1906. SIZE 8 X 14 CM STEREO EXPOSURES. 90 MM/F 6.8 ERNON DOUBLE ANASTIGMAT LENS. SHUTTER SPEEDS TO 1/100 SEC. (HA)

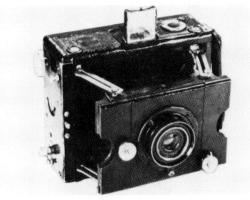

(2865) **STRUT CAMERA.** C. 1904. SIZE 6 X 9 CM EXPOSURES ON PLATES. 90 MM/F 6.8 MEYER DOUBLE ANASTIGMAT LENS. FOCAL PLANE SHUTTER. (HA)

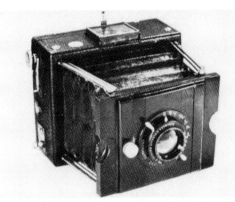

(2866) **STRUT CAMERA.** C. 1906. SIZE 9 X 12 CM EXPOSURES ON PLATES. 135 MM/F 6.8 ERNEMANN DETECTIV APLANAT LENS. FOCAL PLANE SHUTTER. (HA)

(2867) **STRUT CAMERA.** C. 1914. SIZE 4.5 X 6 CM PLATE EXPOSURES. 75 MM/F 4.5 ZEISS TESSAR LENS. FOCAL PLANE SHUTTER; 1/50 TO 1/1000 SEC. (MA)

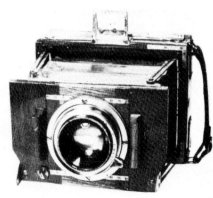

(2868) **TROPICAL STRUT CAMERA.** C. 1904. SIZE 10 X 15 CM EXPOSURES ON PLATES. 165 MM/F 4.5 DOUBLE ANASTIGMAT LENS. FOCAL PLANE SHUTTER. TEAKWOOD BODY. (HA)

(2869) **VELO-KLAPP FOLDING STRUT CAMERA.** C. 1913. SIZE 9 X 12 CM EXPOSURES ON PLATES.

F 6.8 APLANAT LENS. FOCAL PLANE SHUTTER WITH SPEEDS TO 1/2500 SEC. SIMILAR TO THE VELO-KLAPP TROPICAL FOLDING STRUT CAMERA (C. 1913).

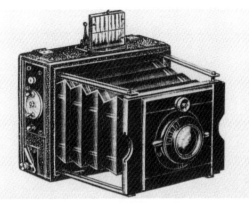

(2870) **VELO-KLAPP FOLDING STRUT CAMERA.** C. 1901. SIZE 9 X 12 CM EXPOSURES ON PLATES. F 8 BUSCH DETEKTIV APLANAT OR UNIVERSAL APLANAT LENS. FOCAL PLANE SHUTTER TO 1/1000 SEC. RISING, FALLING, AND CROSSING LENS MOUNT.

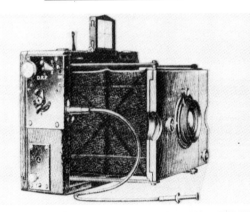

(2871) **VELO-KLAPP TROPICAL FOLDING STRUT CAMERA.** C. 1913. THREE SIZES OF THIS CAMERA FOR 9 X 12, 10 X 15, OR 13 X 18 CM EXPOSURES ON PLATES. F 6.8, F 6, OR F 5.4 ANASTIGMAT LENS. FOCAL PLANE SHUTTER WITH SPEEDS TO 1/2500 SEC. RISING AND FALLING LENS MOUNT. TEAKWOOD BODY.

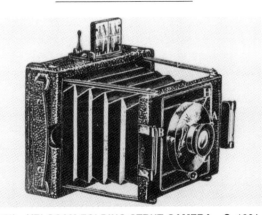

(2872) **VELOCAM FOLDING STRUT CAMERA.** C. 1901. SIZE 9 X 12 CM EXPOSURES ON PLATES. PARISER

## ERNEMANN, HEINRICH, A. G. (*cont.*)

APLANAT LENS. BOB-CENTRAL SHUTTER. RISING, FALLING, AND CROSSING LENS MOUNT.

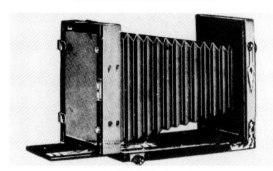

(2873) **BERRY VIEW CAMERA.** C. 1901. SIZE 13 X 18 CM EXPOSURES ON PLATES. BOB SHUTTER.

(2874) **GLOBUS VIEW CAMERA.** C. 1900. SIZE 24 X 30 CM PLATE EXPOSURES. SUTER APLANATIC NO. 4 LENS. RISING AND CROSSING LENS MOUNT. SWING BACK. (MA)

(2875) **VIEW CAMERA.** C. 1905. SIZE 20 X 25 CM EXPOSURES ON PLATES. F 4.8 GOERZ LENS. PNEUMATIC SHUTTER.

## ERNEMANN-WERKE, A. G.

(2876) **BOB OO CAMERA.** C. 1924. SIZE 6 X 9 CM EXPOSURES ON PLATES OR ROLL FILM. F 6.8 APLANAT, ANASTIGMAT, OR RAPID RECTILINEAR LENS. THREE-SPEED SHUTTER WITH BULB AND TIME EXPOSURES OR A SHUTTER FOR SPEEDS FROM 1 to $\frac{1}{100}$ SEC., B., T. GROUND GLASS FOCUSING FOR PLATE EXPOSURES.

(2877) **BOB O CAMERA.** C. 1926. SIZE 9 X 12 CM EXPOSURES ON PLATES OR ROLL FILM. F 8 ERID, F 6.8 ERNASTIGMAT, OR VILAR ANASTIGMAT LENS. CRONOS OR AUTOMATIC SHUTTER.

(2878) **BOB I CAMERA.** C. 1926. TWO SIZES OF THIS CAMERA FOR 9 X 12 OR 9 X 14 CM EXPOSURES ON PLATES OR ROLL FILM. F 6.8 ERNASTIGMAT OR VILAR LENS. ALSO, F 6.3 ERNAR OR ZEISS TESSAR LENS. CRONOS SHUTTER. RACK & PINION FOCUSING. RISING, FALLING, AND CROSSING LENS MOUNT.

(2879) **BOB II CAMERA.** C. 1926. TWO SIZES OF THIS CAMERA FOR 9 X 12 OR 9 X 14 CM EXPOSURES ON PLATES OR FILM PACKS. SAME AS THE BOB I CAMERA EXCEPT WITH DOUBLE EXTENSION BELLOWS.

(2880) **BOB III CAMERA.** C. 1926. SIZE 6 X 9 CM EXPOSURES ON ROLL FILM. F 8 ERID, F 6.8 ERNASTIGMAT, OR VILAR LENS. ALSO, F 6.3 ERNAR OR F 4.5 ERNOPLAST LENS. CRONOS SHUTTER.

(2881) **BOB IV CAMERA.** C. 1926. SIZE 6 X 9 CM EXPOSURES ON ROLL FILM. SAME AS THE BOB III CAMERA

BUT WITH RISING AND FALLING LENS MOUNT. THE F 8 ERID LENS WAS NOT AVAILABLE ON THIS MODEL.

(2882) **BOB V CAMERA.** C. 1926. FIVE SIZES OF THIS CAMERA FOR 4 X 6.5, 6 X 6, 6 X 9, 6.5 X 11 OR 7.5 X 12.5 CM EXPOSURES ON ROLL FILM. F 6.8 ERNEMANN VILAR OR ERNOSTIGMAT LENS. ALSO, F 6.3 ZEISS TESSAR OR ERNAR; F 4.5 ZEISS TESSAR, ERNOPLAST, OR ERNOTAR LENS. CRONOS SHUTTER. RISING, FALLING, AND CROSSING LENS MOUNT. FOCUSING LEVER. SINGLE EXTENSION BELLOWS.

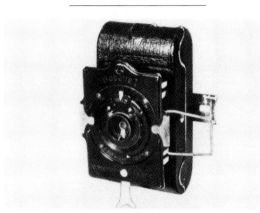

(2883) **BOBETTE I MINIATURE CAMERA.** C. 1925. SIZE 22 X 31 MM EXPOSURES ON ROLL FILM. STRUT SUPPORTED BELLOWS. 50 MM/F 4.5 ERNOPLAST, OR F 8 ERNEMANN ERID LENS. AUTOMATIC SHUTTER; $\frac{1}{25}$, $\frac{1}{50}$, $\frac{1}{100}$ SEC., T. OR CENTRAL SHUTTER; $\frac{1}{25}$ TO $\frac{1}{100}$ SEC., T. (HA)

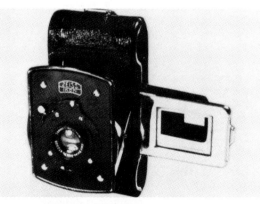

(2884) **BOBETTE I MINIATURE CAMERA.** C. 1928. SIZE 22 X 31 MM EXPOSURES ON ROLL FILM. 40 MM/F 3.5 ZEISS TESSAR, 50 MM/F 4.5 ERNOPLAST, OR 50 MM/F 9 FRONTAR LENS. DIAL SHUTTER; $\frac{1}{25}$, $\frac{1}{50}$, $\frac{1}{100}$ SEC., T. OR TWO-SPEED SHUTTER; $\frac{1}{25}$, $\frac{1}{50}$ SEC., T. (HA)

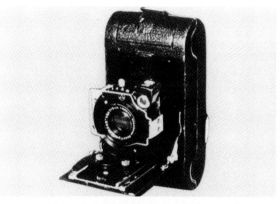

(2885) **BOBETTE II MINIATURE CAMERA.** C. 1929. SIZE 22 X 31 MM EXPOSURES ON ROLL FILM. 50 MM/F 3.5 ERNON OR 42 MM/F 2 ERNOSTAR LENS. RADIAL SHUTTER; $\frac{1}{2}$ TO $\frac{1}{100}$ SEC., T. (HA)

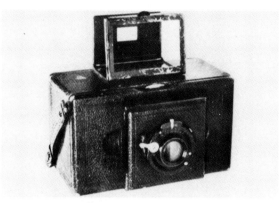

(2886) **BOX CAMERA.** C. 1918. SIZE 6 X 9 CM EXPOSURES ON ROLL FILM. 105 MM/F 8 ERID LENS. ERNEMANN SHUTTER; $\frac{1}{25}$ TO $\frac{1}{100}$ SEC. (HA)

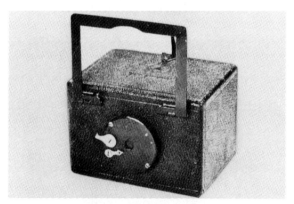

(2887) **BOX CAMERA.** C. 1920. SIZE 4.5 X 6 CM EXPOSURES ON PLATES. ERNEMANN SHUTTER FOR INSTANT AND TIME EXPOSURES. (HA)

## ERNEMANN-WERKE, A. G. (cont.)

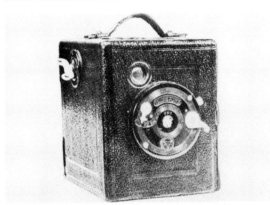

(2888) **BOX CAMERA.** C. 1924. SIZE 6.5 X 6.5 CM EXPOSURES ON ROLL FILM. ERNEMANN TWO-SPEED SHUTTER. (HA)

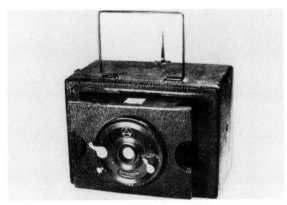

(2889) **BOX CAMERA.** C. 1924. SIZE 9 X 12 CM EXPOSURES ON PLATES. ERNEMANN SHUTTER FOR INSTANT AND TIME EXPOSURES. (HA)

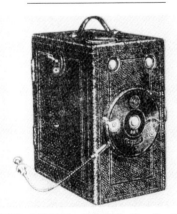

(2890) **BOX CAMERA. MODEL K.** C. 1924. FOUR SIZES OF THIS CAMERA FOR 6 X 6, 6 X 9, 6.5 X 11, OR 7.5 X 12.5 CM EXPOSURES ON ROLL FILM. INSTANT AND TIME SHUTTER.

(2891) **ERNI PLATE AND FILMPACK CAMERA.** C. 1926. THREE SIZES OF THIS CAMERA FOR 4 X 6, 6.5 X 9, OR 9 X 12 CM EXPOSURES. F 12.5 ACHROMATIC LENS. INSTANT AND BULB SHUTTER.

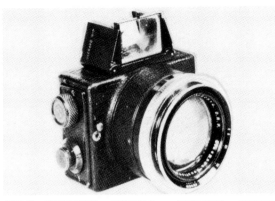

(2892) **ERMANOX CAMERA. ORIGINAL MODEL.** C. 1924. SIZE 4.5 X 6 CM EXPOSURES ON PLATES OR CUT FILM. 105 MM/F 2 OR 85 MM/F 1.8 ERNOSTAR LENS. FOCAL PLANE SHUTTER; 1/20 TO 1/1000 SEC. GROUND GLASS FOCUSING.

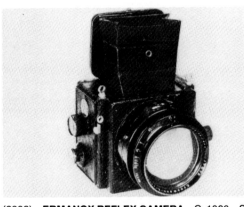

(2893) **ERMANOX REFLEX CAMERA.** C. 1926. SIZE 4.5 X 6 CM EXPOSURES ON PLATES OR FILM PACKS. 105 MM/F 1.8 ERNOSTAR LENS. FOCAL PLANE SHUTTER; 1/20 TO 1/1200 SEC.

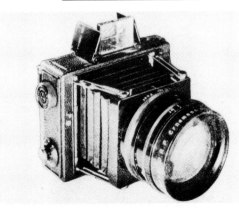

(2894) **ERMANOX STRUT CAMERA.** C. 1926. FIVE SIZES OF THIS CAMERA FOR 4.5 X 6 , 6.5 X 9, 9 X 12, 9 X 14, OR 12 X 18 CM EXPOSURES ON PLATES OR FILM PACKS. F 1.8 ERNOSTAR LENS. AN F 2 ERNOSTAR LENS WAS AVAILABLE FOR THE 4.5 X 6 CAMERA. FOCAL PLANE SHUTTER; 1/20 TO 1/1000 SEC.

(2895) **ERNI STEREO CAMERA.** C. 1926. SIZE 45 X 107 MM STEREO EXPOSURES ON PLATES. SIMILAR TO THE ERNI PLATE AND FILMPACK CAMERA.

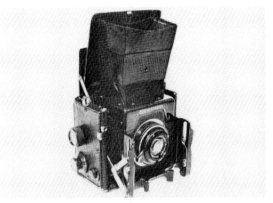

(2896) **ERNOFLEX FOLDING REFLEX CAMERA.** C. 1925. FOUR SIZES OF THIS CAMERA FOR 4.5 X 6, 6.5 X 9, 9 X 12, OR 10 X 15 CM EXPOSURES ON PLATES. F 3.5 ERNON LENS. FOCAL PLANE SHUTTER; 1/20 TO 1/1000 SEC. (HA)

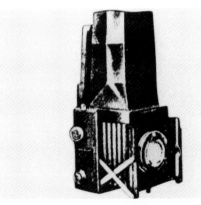

(2897) **ERNOFLEX FOLDING REFLEX CAMERA. MODEL I.** C. 1926. FOUR SIZES OF THIS CAMERA FOR 4.5 X 6, 6.5 X 9, 9 X 12 CM OR 45 X 107 MM EXPOSURES ON PLATES OR FILM PACKS. F 4.5 ERNOTAR OR F 3.5 ERNON LENS. AN F 4.5 ZEISS TESSAR LENS WAS AVAILABLE FOR THE 6.5 X 9 AND 9 X 12 MODELS. FOCAL PLANE SHUTTER TO 1/1000 SEC. SINGLE EXTENSION BELLOWS.

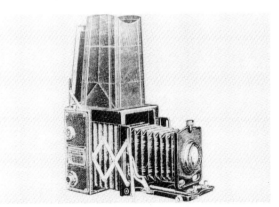

(2898) **ERNOFLEX FOLDING REFLEX CAMERA. MODEL II.** C. 1926. TWO SIZES OF THIS CAMERA FOR 9 X 12 OR 10 X 15 CM EXPOSURES. F 4.5 ERNOTAR, OR ZEISS TESSAR LENS. ALSO, F 3.5 ERNON LENS. FOCAL PLANE SHUTTER TO 1/1000 SEC. TRIPLE EXTENSION BELLOWS.

## ERNEMANN-WERKE, A. G. (*cont.*)

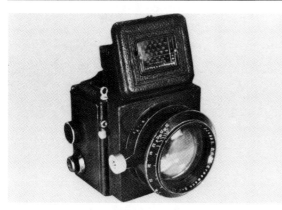

**(2899) ERNOFLEX REFLEX CAMERA.** C. 1927. SIZE 4.5 X 6 CM EXPOSURES ON PLATES. 105 MM/F 1.8 ERNOSTAR LENS. FOCAL PLANE SHUTTER; 1/20 TO 1/1200 SEC. (HA)

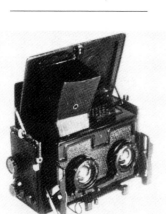

**(2900) ERNOFLEX STEREO CAMERA.** C. 1929. SIZE 45 X 107 MM STEREO EXPOSURES ON PLATES. 75 MM/ F 4.5 ERNOTAR, F 3.5 ERNON, OR F 3.5 ZEISS TESSAR LENSES. FOCAL PLANE SHUTTER; 1/20 TO 1/1200 SEC. REFLEX FOCUSING WITH THE RIGHT-HAND LENS. (HA)

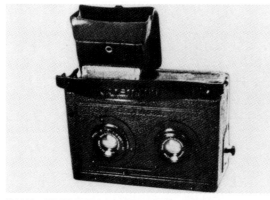

**(2901) ERNOFLEX STEREO BOX CAMERA.** C. 1923. SIZE 45 X 107 MM STEREO EXPOSURES ON PLATES. 80 MM/F 4.5 ZEISS TESSAR LENSES. FOCAL PLANE SHUTTER; 1/25 TO 1/1000 SEC.

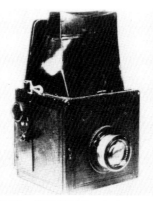

**(2902) SIMPLEX ERNOFLEX CAMERA.** C. 1925. FOUR SIZES OF THIS CAMERA FOR 4.5 X 6, 6.5 X 9, 9 X 12, OR 45 X 107 MM EXPOSURES ON PLATES OR FILM PACKS. F 4.5 ERNOPLAST OR F 3.5 ERNON LENS. FOCAL PLANE SHUTTER WITH SPEEDS TO 1/1000 SEC. FOCUSING LENS.

**(2903) SIMPLEX ERNOFLEX CAMERA.** C. 1926. SIZE 6.5 X 9 CM EXPOSURES ON PLATES. 100 MM/F 6.8 TRIPLE ANASTIGMAT LENS. FOCAL PLANE SHUTTER; 1/20 TO 1/1000 SEC. (HA)

**(2904) SIMPLEX-ERNOFLEX STEREO CAMERA.** C. 1929. SIZE 45 X 107 MM STEREO EXPOSURES ON PLATES. 75 MM/F 3.5 ERNON OR 75 MM/F 4.5 ZEISS TESSAR LENSES. FOCAL PLANE SHUTTER TO 1/1000 SEC. REFLEX FOCUSING WITH THE RIGHT-HAND LENS.

**(2905) FOCAL PLANE TROPICAL CAMERA.** C. 1926. FOUR SIZES OF THIS CAMERA FOR 6.5 X 9, 9 X 12, 10 X 15, OR 13 X 18 CM EXPOSURES ON PLATES OR FILM PACKS. SAME AS THE FOCAL PLANE CAMERA (C. 1926) BUT WITH TEAKWOOD BODY AND BRASS FITTINGS.

**(2906) FOCAL PLANE CAMERA.** C. 1926. FIVE SIZES OF THIS CAMERA FOR 4.5 X 6, 6.5 X 9, 9 X 12, 10 X 15, OR 13 X 18 CM EXPOSURES ON PLATES OR FILM PACKS. F 4.5 ERNOTAR OR ZEISS TESSAR LENS. ALSO, F 3.5 ERNON, ZEISS TESSAR OR F 2.7 ERNOSTAR LENS. FOCAL PLANE SHUTTER; 1/10 TO 1/1000 SEC. RISING, FALLING, AND CROSSING LENS MOUNT. (HA)

**(2907) FOLDING REFLEX CAMERA.** C. 1925. SIZE 9 X 12 CM EXPOSURES ON PLATES OR FILM PACKS. 210 MM/F 4.5 SCHNEIDER XENAR OR F 4.5 ERNEMANN ERNOTAR LENS. FOCAL PLANE SHUTTER; 1/10 TO 1/1000 SEC. REVOLVING BACK. (VC)

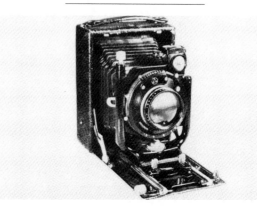

**(2908) HEAG CAMERA.** C. 1919. SIZE 9 X 12 CM EXPOSURES ON PLATES. 150 MM/F 3.5 ERNON LENS.

## ERNEMANN-WERKE, A. G. (*cont.*)

CRONOS-C SHUTTER WITH SPEEDS TO ½₀₀ SEC. (HA)

(2909) **HEAG I CAMERA.** C. 1926. TWO SIZES OF THIS CAMERA FOR 6.5 X 9 OR 9 X 12 CM EXPOSURES ON PLATES OR FILM PACKS. F 8 ERNEMANN ERID OR ERNASTIGMAT LENS. AUTOMATIC OR CRONOS SHUTTER.

(2910) **HEAG II CAMERA.** C. 1926. THREE SIZES OF THIS CAMERA FOR 6.5 X 9, 9 X 12, OR 9 X 14 CM EXPOSURES ON PLATES OR FILM PACKS. F 6.8 ERNASTIGMAT OR VILAR LENS. ALSO, F 6.3 ERNAR; ZEISS TESSAR; F 4.5 ERNOPLAST, ERNOTAR, OR ZEISS TESSAR LENS. CRONOS SHUTTER. RISING, FALLING, AND CROSSING LENS MOUNT. DOUBLE EXTENSION BELLOWS.

(2911) **HEAG III CAMERA.** C. 1926. TWO SIZES OF THIS CAMERA FOR 6.5 X 9 OR 9 X 12 CM EXPOSURES ON PLATES OR FILM PACKS. F 8 ERID, F 6.8 ERNASTIGMAT, OR VILAR LENS. ALSO, F 6.3 ERNAR OR F 4.5 ERNOPLAST LENS. CRONOS SHUTTER. RISING LENS MOUNT.

(2912) **HEAG IV CAMERA.** C. 1926. THIS CAMERA HAS THE SAME EXPOSURE SIZES, LENSES (EXCEPT THE F 8 ERID), AND SHUTTER AS THE HEAG III CAMERA BUT WITH A FOCUSING LEVER.

(2913) **HEAG V CAMERA.** C. 1926. THREE SIZES OF THIS CAMERA FOR 4 X 6, 6.5 X 9, OR 9 X 12 CM EXPOSURES ON PLATES OR FILM PACKS. SAME LENSES AND SHUTTER AS THE HEAG II CAMERA. SINGLE EXTENSION BELLOWS AND FOCUSING LEVER.

(2914) **HEAG VII CAMERA.** C. 1926. TWO SIZES OF THIS CAMERA FOR 6.5 X 9 OR 9 X 12 CM EXPOSURES ON PLATES OR FILM PACKS. SAME LENSES AS THE HEAG II CAMERA PLUS AN F 4.5 ERNOTAR OR F 3.6 ERNON LENS. CRONOS SHUTTER. RISING, FALLING, AND CROSSING LENS MOUNT. DOUBLE EXTENSION BELLOWS.

(2915) **HEAG XI CAMERA.** C. 1926. TWO SIZES OF THIS CAMERA FOR 9 X 14 OR 12 X 16.5 CM EXPOSURES ON PLATES OR FILM PACKS. SAME LENSES AND SHUTTER AS THE HEAG II CAMERA. RISING, FALLING, AND CROSSING LENS MOUNT. INTERCHANGEABLE LENS MOUNT. DOUBLE EXTENSION BELLOWS.

(2916) **HEAG XI TROPICAL CAMERA.** C. 1926. SIZE 9 X 12 CM EXPOSURES ON PLATES OR FILM PACKS. SAME AS THE HEAG XI CAMERA BUT WITH TEAKWOOD BODY AND BRASS FITTINGS.

(2917) **LILIPUT PLATE AND FILMPACK CAMERA.** C. 1926. TWO SIZES OF THIS CAMERA FOR 4 X 6 OR 6.5 X 9 CM EXPOSURES. F 12.5 ACHROMATIC LENS. INSTANT AND BULB SHUTTER. LEATHER BELLOWS. FOCUSING SCREEN.

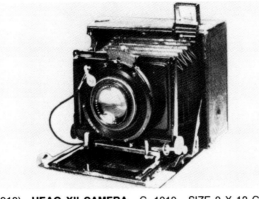

(2918) **HEAG XII CAMERA.** C. 1919. SIZE 9 X 12 CM EXPOSURES ON PLATES. 150 MM/F 4.5 ZEISS TESSAR LENS. ERNEMANN SHUTTER WITH SPEEDS TO ½₀₀ SEC. (HA)

(2919) **LILIPUT STEREO FOLDING CAMERA.** C. 1919. SIZE 45 X 107 MM EXPOSURES ON PLATES. 60 MM/F 12 MENISCUS LENS. GUILLOTINE SELF-COCKING SHUTTER FOR SINGLE SPEED OR TIME EXPOSURES.

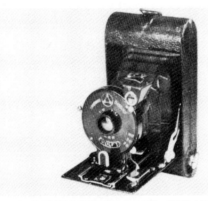

(2920) **ROLF I CAMERA.** C. 1926. SIZE 4 X 6 CM EXPOSURES ON ROLL FILM. F 12 RAPID RECTILINEAR LENS. SINGLE-SPEED SHUTTER. (HA)

(2921) **ROLF II CAMERA.** C. 1926. SIZE 4 X 6 CM EXPOSURES ON ROLL FILM. F 6.8 ERNASTIGMAT OR VILAR DOUBLE ANASTIGMAT, F 6.3 ERNAR DOUBLE ANASTIGMAT, OR F 4.5 ERNOPLAST LENS. CRONOS SHUTTER WITH SPEEDS TO ½₀₀ SEC. SIMILAR TO THE ROLF I CAMERA.

(2922) **SIMPLEX PLATE AND FILMPACK CAMERA.** C. 1926. TWO SIZES OF THIS CAMERA FOR 6.5 X 9 OR 9 X 12 CM EXPOSURES. F 11 ERID DOUBLE LENS. INSTANT AND BULB SHUTTER. TWO APERTURE STOPS.

(2923) **STEREO REFLEX CAMERA.** C. 1920. SIZE 6 X 13 CM EXPOSURES ON PLATES OR SHEET FILM. 90 MM/F 4.5 ZEISS TESSAR LENSES. FOCAL PLANE SHUTTER; ½₀ TO ½₅₀₀ SEC. (MA)

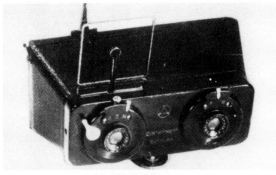

(2924) **SIMPLEX STEREO CAMERA.** C. 1920. SIZE 45 X 107 MM STEREO EXPOSURES ON PLATES. 60 MM/F 8 ERID LENSES. INSTANT AND BULB SHUTTER. TWO APERTURE STOPS. (HA)

(2925) **STRUT CAMERA.** C. 1923–25. SIZE 4.5 X 6 CM EXPOSURES ON PLATES OR FILM PACKS. 75 MM/F 2.7 ERNOSTAR LENS. ALSO, F 3.5 OR F 4.5 LENSES. FOCAL PLANE SHUTTER WITH SPEEDS TO ½₀₀₀ SEC. (HA)

(2926) **STRUT TROPICAL CAMERA.** C. 1925. TWO SIZES OF THIS CAMERA FOR 4.5 X 6 OR 6.5 X 9 CM EXPOSURES ON PLATES. 120 MM/F 3.5 ERNON LENS. FOCAL PLANE SHUTTER; ½₀ TO ½₀₀₀ SEC. (HA)

## ERNEMANN-WERKE, A. G. (*cont.*)

(2927) **UNETTE MINIATURE CAMERA.** C. 1926. SIZE 22 X 33 MM EXPOSURES ON ROLL FILM. F 12.5 ERNEMANN LENS. ½25 SEC. AND TIME SHUTTER. THREE APERTURE STOPS.

## EUSEBIUS

(2928) **STEREO REFLEX CAMERA.** C. 1897. SIZE 9 X 18 CM STEREO EXPOSURES ON ROLL FILM. 110 MM/ F 8 APLANATE LENSES. (HA)

## FOTH, C. F. & COMPANY

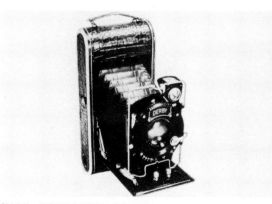

(2929) **FOTH DERBY CAMERA.** C. 1930. SIZE 6 X 9 CM EXPOSURES ON ROLL FILM. 105 MM/F 4.5 DOUBLE ANASTIGMAT LENS. (HA)

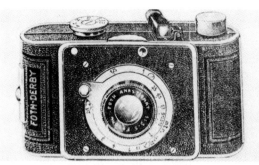

(2930) **FOTH DERBY CAMERA MODEL I.** C. 1931. SIXTEEN EXPOSURES SIZE 3 X 4 CM ON NO. 127 ROLL FILM. 50 MM/F 3.5 FOTH ANASTIGMAT LENS. FOCAL PLANE SHUTTER; ½25 TO ½500 SEC., B.

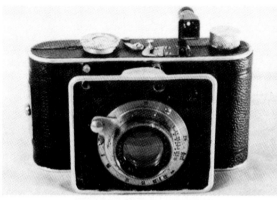

(2931) **FOTH DERBY CAMERA. MODEL II.** C. 1931–40. SIXTEEN EXPOSURES SIZE 3 X 4 CM ON NO. 127 ROLL FILM. 50 MM/F 2.5 OR F 3.5 FOTH ANASTIGMAT LENS. FOCAL PLANE SHUTTER; ½25 TO ½500 SEC., B., ST. (TS)

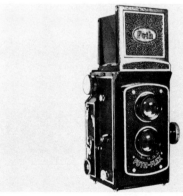

(2932) **FOTH-FLEX CAMERA. TWIN-LENS REFLEX.** C. 1932. SIZE 6 X 6 CM EXPOSURES ON NO. 120 ROLL FILM. 75 MM/F 3.5 FOTH ANASTIGMAT LENS. FOCAL PLANE SHUTTER; ½25 TO ½500 SEC., B., ST. EXPOSURE COUNTER. (HA)

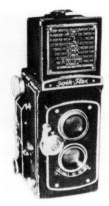

(2933) **FOTH-FLEX CAMERA. TWIN LENS REFLEX.** C. 1934. SIZE 6 X 6 CM EXPOSURES ON ROLL FILM. 75 MM/F 3.5 FOTH ANASTIGMAT LENS. FOCAL PLANE SHUTTER; ½25 TO ½500 SEC., B., ST. (HA)

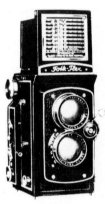

(2934) **FOTH-FLEX II CAMERA. TWIN LENS REFLEX.** C. 1938. SIZE 6 X 9 CM (6 X 6 CM WITH MASK) EXPOSURES ON NO. 120 ROLL FILM. 75 MM/F 3.5 OR F 2.5 FOTH ANASTIGMAT LENS. FOCAL PLANE SHUTTER; 2 TO ½500 SEC., B., T., ST.

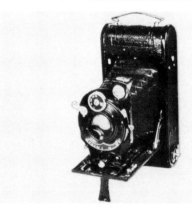

(2935) **FOTH ROLL FILM CAMERA.** C. 1929–33. TWO SIZES OF THIS CAMERA FOR 6 X 9 OR 6 X 11 CM EXPOSURES. F 4.5 FOTH ANASTIGMAT LENS. PRONTO SHUTTER; ½25, ½50, ½100 SEC., ST. (HA)

## FOTOFEX-KAMERAS (FRITZ KAFTANSKI)

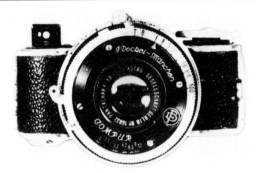

**(2936) MINIFEX CAMERA.** C. 1932. SIZE 13 X 18 MM EXPOSURES ON "16MM" ROLL FILM. 25 MM/F 1.8 AS-TRO PANTACHAR OR F 4.5 VICTAR LENS. ALSO, 52 MM/F 0.95 ASTRO TACHON OR F 3.5 TRIOPLAN LENS. PRONTO SHUTTER; $\frac{1}{25}$ TO $\frac{1}{100}$ SEC., B., T. OR COMPUR SHUTTER; 1 TO $\frac{1}{300}$ SEC., B., T. ASTRO FOKUSKOT RANGEFINDER. (HA)

**(2937) MINIFEX MG MINIATURE CAMERA.** C. 1934. SIZE 24 X 36 MM EXPOSURES ON ROLL FILM.

**(2938) VISORFEX CAMERA.** C. 1932. SIZE 6 X 9 CM EXPOSURES (4.5 X 6 CM WITH MASK) ON ROLL FILM, PLATES, OR FILM PACKS. F 4.5 ZEISS TESSAR OR F 4.5 RADIONAR LENS. DERVAL SHUTTER WITH SELF-TIMER OR COMPUR SHUTTER. GROUND GLASS FOCUS. BY TILTING THE CAMERA FORWARD, A HOODED GROUND GLASS BACK CAN BE USED WITH-OUT REMOVING ROLL FILM FROM THE CAMERA.

## FRANKA KAMERAWERK

**(2939) BONAFIX CAMERA.** C. 1937. SIZE 6 X 9 CM EXPOSURES (4.5 X 6 CM WITH MASK) ON ROLL FILM. 105 MM/F 6.3 ANASTIGMAT LENS. VARIO SHUTTER; $\frac{1}{25}$ TO $\frac{1}{100}$ SEC., B., T. (HA)

**(2940) SOLIDA FOLDING ROLL FILM CAMERA.** C. 1940. SIZE 4 X 6 CM EXPOSURES ON NO. 120 OR B-2 ROLL FILM. F 2.9 STEINHEIL CASSAR LENS. COMPUR S SHUTTER; 1 TO $\frac{1}{250}$ SEC., B., T. ST. HELICAL FOCUS.

## FRANKE & HEIDECKE

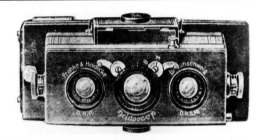

**(2941) HEIDOSCOP REFLEX STEREO CAMERA.** C. 1921. SIZE 45 X 107 MM STEREO EXPOSURES ON PLATES OR CUT FILM. 55 MM/F 4.5 ZEISS TESSAR LENSES. COMPOUND SHUTTER; 1 TO $\frac{1}{300}$ SEC. PUSH-PULL PLATE CHANGING MAGAZINE FOR 12 PLATES. REFLEX VIEWING THROUGH THE CENTER LENS.

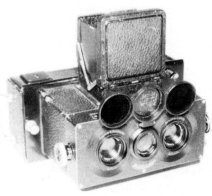

**(2942) HEIDOSCOP REFLEX STEREO CAMERA. IM-PROVED MODEL.** C. 1925–40. SIZE 60 X 130 MM STEREO EXPOSURES ON PLATES OR SHEET FILM. THE PUSH-PULL TYPE MAGAZINE HOLDS 12 PLATES. 75 MM/F 4.5 ZEISS TESSAR LENSES. COMPOUND SHUTTER; 1 TO $\frac{1}{300}$ SEC., B., T. IRIS DIAPHRAGM. (GE)

**(2943) HEIDOSCOP REFLEX STEREO CAMERA.** C. 1927. STEREO EXPOSURES ON NO. 127 ROLL FILM. SIMILAR TO THE HEIDOSCOP REFLEX STEREO CAM-ERA, C. 1921.

**(2944) ROLLEICORD I TWIN LENS REFLEX CAMERA.** C. 1932. SIZE 6 X 6 CM EXPOSURES ON NO. 120 ROLL FILM. 75 MM/F 3.5 OR F 4.5 ZEISS TRIOTAR LENS. COMPUR SHUTTER; 1 TO $\frac{1}{300}$ SEC., B., T. EXPOSURE COUNTER. (HA)

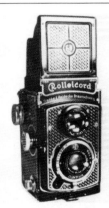

**(2945) ROLLEICORD I TWIN LENS REFLEX CAMERA.** C. 1933. SIZE 6 X 6 CM EXPOSURES ON NO. 120 ROLL FILM. SAME LENSES AND SHUTTER AS THE ROLLEI-CORD I CAMERA, C. 1932. (HA)

**(2946) ROLLEICORD IA TWIN LENS REFLEX CAMERA.** INTRODUCED IN 1935. SAME AS THE ROLLEICORD I EXCEPT THE CAMERA ACCEPTS PLATES AND CUT FILM WITH AN ADAPTER.

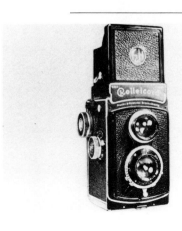

## FRANKE & HEIDECKE (*cont.*)

**(2947) ROLLEICORD II TWIN LENS REFLEX CAMERA.** C. 1936. SIZE 6 X 6 CM EXPOSURES ON NO. 120 ROLL FILM. FLASH SYNC. 75 MM/F 3.5 TRITAR LENS. COMPUR SHUTTER; 1 TO ⅟₃₀₀ SEC., B., T. AUTOMATIC FILM TRANSPORT. (HA)

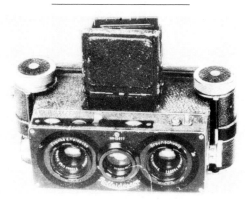

**(2948) ROLLEIDOSCOP STEREO CAMERA.** C. 1926–40. TWO SIZES OF THIS CAMERA FOR 45 X 107 OR 60 X 130 MM STEREO EXPOSURES ON ROLL FILM. F 4.5 ZEISS TESSAR LENSES. COMPOUND SHUTTER; 1 TO ⅟₃₀₀ SEC.

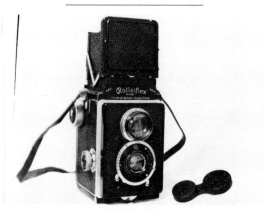

**(2949) ROLLEIFLEX TWIN LENS REFLEX CAMERA. ORIGINAL MODEL.** C. 1928. SIZE 6 X 6 CM EXPOSURES ON NO. 117 ROLL FILM. 75 MM/F 3.8 OR F 4.5 ZEISS TESSAR LENS. COMPUR SHUTTER; 1 TO ⅟₃₀₀ SEC., B., T. (MF)

**(2950) ROLLEIFLEX II TWIN LENS REFLEX CAMERA.** C. 1932. SIZE 6 X 6 CM EXPOSURES ON ROLL FILM.

75 MM/F 3.8 ZEISS TESSAR LENS. COMPUR SHUTTER; 1 TO ⅟₃₀₀ SEC., B., T. SHUTTER COCKING WITH FILM ADVANCE. EXPOSURE COUNTER. (HA)

**(2951) ROLLEIFLEX TWIN LENS REFLEX CAMERA.** C. 1938. SIZE 4 X 4 CM EXPOSURES ON ROLL FILM. SAME AS THE ROLLEIFLEX "BABY" MODEL CAMERA EXCEPT THE LENS ACCEPTS BAYONET-MOUNTED ACCESSORIES.

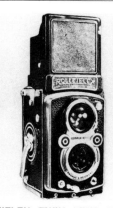

**(2952) ROLLEIFLEX TWIN LENS REFLEX CAMERA. AUTOMATIC MODEL.** INTRODUCED IN 1937. SIZE 6 X 6 CM EXPOSURES ON NO. 120 ROLL FILM, CUT FILM, OR PLATES WITH ADAPTER. FILM ADVANCE WITH SHUTTER COCKING. 75 MM/F 3.5 ZEISS TESSAR LENS. COMPUR RAPID SHUTTER; 1 TO ⅟₅₀₀ SEC., B., T., ST. (HA)

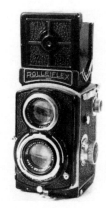

**(2953) ROLLEIFLEX TWIN-LENS REFLEX CAMERA. "BABY" MODEL.** C. 1931–38. SIZE 4 X 4 CM EXPOSURES ON NO. 127 ROLL FILM, CUT FILM, OR PLATES WITH ADAPTER. 60 MM/F 2.8 OR F 3.5 ZEISS TESSAR LENS. COMPUR SHUTTER; 1 TO ⅟₃₀₀ SEC., B., T. COMPUR RAPID SHUTTER; 1 TO ⅟₅₀₀ SEC., B., T. AFTER 1933. AUTOMATIC FILM ADVANCE WITH SHUTTER COCKING. (MF)

**(2954) ROLLEIFLEX TWIN-LENS REFLEX CAMERA. SPORT MODEL.** C. 1932. SIZE 6 X 6 CM EXPOSURES ON ROLL FILM. 75 MM/F 3.5 ZEISS TESSAR LENS. COMPUR SHUTTER; 1 TO ⅟₃₀₀ SEC. THE FIRST ROLLEIFLEX WITH A CRANK FOR FILM ADVANCE. (IH)

**(2955) ROLLEIFLEX TWIN-LENS REFLEX CAMERA. STANDARD MODEL.** C. 1932–39. SIZE 6 X 6 CM EXPO-

SURES ON NO. 120 ROLL FILM. 75 MM/F 3.8 OR F 4.5 ZEISS TESSAR LENS. COMPUR SHUTTER; 1 TO ⅟₃₀₀ SEC., B., T. COMPUR RAPID SHUTTER TO ⅟₅₀₀ SEC. AFTER 1933. CRANK FOR FILM ADVANCE WITH SHUTTER COCKING. (IH)

**(2956) ROLLEIFLEX TWIN-LENS REFLEX CAMERA. NEW STANDARD MODEL.** INTRODUCED IN 1939. SIZE 6 X 6 CM EXPOSURES ON NO. 120 ROLL FILM. 75 MM/F 3.5 ZEISS TESSAR LENS. SYNCHRO-COMPUR SHUTTER; 1 TO ⅟₅₀₀ SEC., B.

## FREITWIRTH, O.

**(2957) PRIZMA DETECTIVE CAMERA.** C. 1890. SIZE 6 X 8 CM EXPOSURES ON ROLL FILM. THIS BOX-FORM CAMERA HAS A LARGE OUTSIDE HAND WHEEL TO TURN A TRIANGULAR WOODEN BLOCK INSIDE OF THE CAMERA. A SECTION OF THE ROLL FILM IS WOUND AGAINST ONE SIDE OF THE BLOCK WHICH HOLDS THE FILM IN THE FOCAL PLANE. (IH)

## GLUNZ & BÜLTER

**(2958) GLUNZ 60 FOLDING CAMERA.** C. 1930. TWO SIZES OF THIS CAMERA FOR 6.5 X 9 OR 9 X 12 CM EXPOSURES ON SHEET FILM. F 4.5 ZEISS TESSAR LENS. COMPUR SHUTTER; 1 TO ⅟₂₅₀ SEC., B., T. GROUND GLASS FOCUSING.

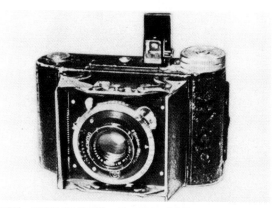

**(2959) INGO CAMERA.** C. 1932. SIZE 3 X 4 CM EXPOSURES ON ROLL FILM. 50 MM/F 2.9 RODENSTOCK TRINAR LENS. COMPUR SHUTTER WITH SPEEDS TO ⅟₃₀₀ SEC., B., T. (HA)

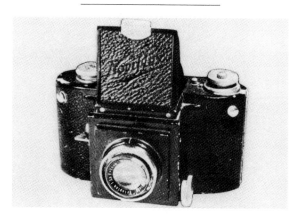

## GLUNZ & BÜLTER (*cont.*)

**(2960) NOVIFLEX SINGLE-LENS REFLEX CAMERA.** C. 1935. SIZE 6 X 6 CM EXPOSURES ON ROLL FILM. 75 MM/F 3.5 OR F 2.8 MEYER-GÖRLITZ TRIOPLAN LENS. FOCAL PLANE SHUTTER; $\frac{1}{20}$ TO $\frac{1}{1000}$ SEC. (HA)

## GLUNZ, G. & SOHN

**(2961) ZENITH POCKET CAMERA.** C. 1907.

## GOERZ, C. P.

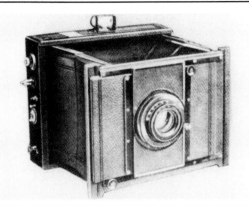

**(2962) ANGO CAMERA.** C. 1906–16. SIZE 10 X 15 CM EXPOSURES ON PLATES. F 4.5 OR F 6.8 GOERZ DAGOR OR F 4.8 GOERZ CELOR LENS. FOCAL PLANE SHUTTER WITH SPEEDS TO $\frac{1}{1000}$ SEC. (HA)

**(2963) ANGO FOLDING REFLEX CAMERA.** C. 1909. SIZE 9 X 12 CM PLATE EXPOSURES. FOCAL PLANE SHUTTER. STRUT-TYPE CAMERA.

**(2964) ANGO STEREO CAMERA.** C. 1906. TWO SIZES OF THIS CAMERA FOR 90 X 140 OR 90 X 180 MM STEREO PLATE EXPOSURES. F 6.8 DAGOR LENSES. IRIS DIAPHRAGM. ANSCHUTZ FOCAL PLANE SHUTTER; $\frac{1}{10}$ TO $\frac{1}{1000}$ SEC. ALSO, FOCAL PLANE SHUTTER; $\frac{1}{5}$ TO $\frac{1}{1000}$ SEC. RISING AND CROSSING LENS MOUNT. A SINGLE LENS CAN BE USED FOR MAKING PANORAMIC EXPOSURES. (IH)

**(2965) ANGO STEREO CAMERA.** C. 1914. SIZE 60 X 130 MM STEREO EXPOSURES. DOPPEL ANASTIGMAT LENSES. FOCAL PLANE SHUTTER.

**(2966) ANSCHUTZ CAMERA. ORIGINAL MODEL.** C. 1888. THE FIRST LARGE FORMAT PRESS CAMERA WITH FOCAL PLANE SHUTTER. GOERZ RAPID APLANAT, PORTRAIT-EURYSCOPE, OR VOIGTLANDER PORTRAIT LENS. SHUTTER SPEEDS FROM $\frac{1}{4}$ TO $\frac{1}{1000}$ SEC. WOOD BODY. RACK & PINION FOCUSING.

**(2967) ANSCHUTZ CAMERA. IMPROVED MODEL.** C. 1889. SIZE 9 X 12 CM EXPOSURES ON PLATES. LYNKEIOSKOP LENS. ROLLER-BLIND FOCAL PLANE SHUTTER. EYE-LEVEL WIREFRAME FINDER. (HA)

**(2968) ANSCHUTZ FOLDING CAMERA.** C. 1899. THREE SIZES OF THIS CAMERA FOR 3¼ X 4¼, 4¼ X 6½, OR 6½ X 9 INCH EXPOSURES ON PLATES. GOERZ DOUBLE ANASTIGMAT LENS. FOCAL PLANE SHUTTER FOR EXPOSURES TO $\frac{1}{1000}$ SEC.

**(2969) ANSCHUTZ FOLDING CAMERA.** C. 1904. SIZE 3¼ X 4¼ INCH EXPOSURES ON PLATES. FOCAL PLANE SHUTTER; 5 TO $\frac{1}{1000}$ SEC.

**(2970) ANSCHUTZ FOLDING CAMERA.** C. 1909. THREE SIZES OF THIS CAMERA FOR 3¼ X 4¼, 4 X 5, OR 5 X 7 INCH EXPOSURES ON PLATES. FOCAL PLANE SHUTTER; $\frac{1}{5}$ TO $\frac{1}{1000}$ SEC., B., T. SIMILAR TO THE ANSCHUTZ FOLDING CAMERA, C. 1914.

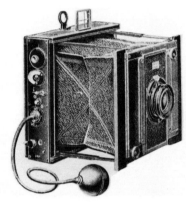

**(2971) ANSCHUTZ FOLDING CAMERA.** C. 1914. SIX SIZES OF THIS CAMERA FOR 3¼ X 4¼, 4 X 5, 3½ X 5½, 4¾ X 6½, 6½ X 8½ INCH, OR 10 X 15 CM EXPOSURES ON PLATES, FILM PACKS, OR ROLL FILM WITH ADAPTER. F 4.8 CELOR, F 6.8 DAGOR, F 6.8 SYNTOR, OR F 6.3 PENTAR LENS. FOCAL PLANE SHUTTER; 5 TO $\frac{1}{1200}$ SEC., B., T. GROUND GLASS FOCUSING. THE 6½ X 8½ INCH MODEL HAS THE CELOR OR DAGOR LENS ONLY.

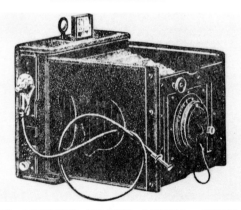

**(2972) ANSCHUTZ FOLDING CAMERA. MODEL A.** C. 1920. TWO SIZES OF THIS CAMERA FOR 9 X 12 OR 10 X 13 CM EXPOSURES ON PLATES OR FILM PACKS WITH ADAPTER. F 4.5 COOKE AVIAR ANASTIGMAT LENS. FOCAL PLANE SHUTTER; $\frac{1}{8}$ TO $\frac{1}{1000}$ SEC., B., T. RISING AND CROSSING LENS MOUNT. GROUND GLASS FOCUSING. STRUTS FOR BELLOWS SUPPORT.

**(2973) ANSCHUTZ FOLDING CAMERA. MODEL B.** C. 1920. SAME AS THE ANSCHUTZ FOLDING CAMERA, MODEL A, EXCEPT SIDE WINGS INSTEAD OF STRUTS ARE USED FOR THE BELLOWS SUPPORT.

**(2974) ANSCHUTZ FOLDING STEREO CAMERA.** C. 1914. THREE SIZES OF THIS CAMERA FOR 3½ X 5½ OR 3¼ X 6¾ INCH OR 10 X 15 CM STEREO EXPOSURES ON PLATES, FILM PACKS, OR ROLL FILM WITH ADAPTER. SIMILAR TO THE ANSCHUTZ FOLDING CAMERA, C. 1914 WITH THE SAME LENSES (EXCEPT THE F 6.3 PANTAR) AND SHUTTER.

## GOERZ, C. P. (*cont.*)

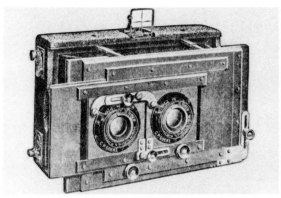

(2975) **ANSCHUTZ FOLDING STEREO CAMERA.** C. 1904. STEREO OR PANORAMIC EXPOSURES ON PLATES. FOCAL PLANE SHUTTER; 5 TO 1/1000 SEC., T.

---

(2976) **ANSCHUTZ STEREOSCOPIC CAMERA.** C. 1890. SIZE 8 X 17 INCH STEREO EXPOSURES ON PLATES. 120 MM/F 12 GOERZ WIDE-ANGLE APLANAT LENSES. FOCAL PLANE SHUTTER. (MA)

---

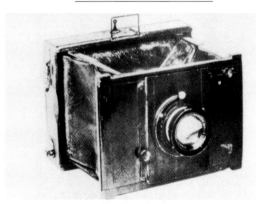

(2977) **ANSCHUTZ STRUT CAMERA.** C. 1900. SIZE 13 X 18 CM EXPOSURES ON PLATES. FOCAL PLANE SHUTTER.

---

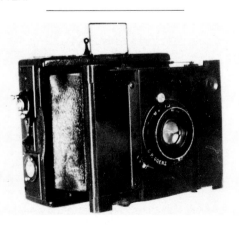

(2979) **JAGO-ANGO REFLEX CAMERA.** C. 1909. SIZE 13 X 18 CM PLATE EXPOSURES. LYNKEIOSKOP LENS. FOCAL PLANE SHUTTER.

---

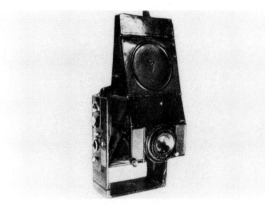

(2980) **KLAPP REFLEX CAMERA.** C. 1923. SIZE 10 X 15 CM EXPOSURES ON PLATES. 168 MM/F 4.8 GOERZ CELOR LENS. FOCAL PLANE SHUTTER; 1/10 TO 1/1200 SEC. (HA)

---

(2981) **PHOTO-STEREO BINOCULAR CAMERA.** C. 1899. SIZE 45 X 50 MM STEREO EXPOSURES ON PLATES. 75 MM/F 6.8 GOERZ DAGOR LENSES. THE BINOCULAR CAN BE CONVERTED FOR USE AS A CAMERA BY SWINGING THE TWO OBJECTIVE LENSES UPWARD AND INSERTING PLATES IN A PLATE HOLDER. THE BINOCULAR EYE-PIECES SERVE AS THE CAMERA LENSES. THE CAMERA HAS AN OPTICAL FRAME FINDER. (IH)

---

(2982) **REPORTER BOOK-FORM CAMERA.** C. 1890. SIZE 4 X 5.5 CM EXPOSURES ON EASTMAN ROLL FILM. STRING-SETTING DROP SHUTTER. THE LENS IS LOCATED IN THE "SPINE" OF THE BOOK AND THE SHUTTER RELEASE IS ON THE BOTTOM BENEATH THE "SPINE." THE "BOOK" COVER OPENS TO WIND THE ROLL FILM. (BC)

---

(2983) **AUTOFOC TENAX CAMERA.** C. 1914. TWO SIZES OF THIS CAMERA FOR 3¼ X 4¼ OR 3¼ X 5½ INCH EXPOSURES ON PLATES OR FILM PACKS WITH ADAPTER. SIMILAR TO THE MANUFOC TENAX CAMERA (C. 1914) WITH THE SAME LENSES AND SHUTTER EXCEPT THE INFINITY SETTING IS AUTOMATICALLY SET WHEN THE CAMERA IS OPENED.

---

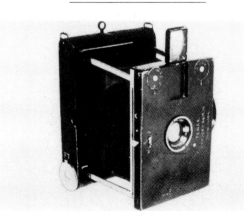

(2984) **COAT POCKET TENAX CAMERA.** C. 1908–14. SIZE 2½ X 3½ INCH EXPOSURES ON PLATES OR 2¼ X 3¼ INCH EXPOSURES ON FILM PACKS. 100 MM/F 6.3 GOERZ DOGMAR LENS. SHUTTER SPEEDS FROM ½ TO 1/250 SEC. (HA)

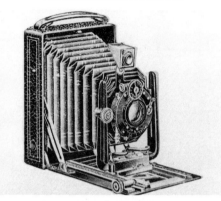

(2985) **MANUFOC TENAX CAMERA.** C. 1914. FOUR SIZES OF THIS CAMERA FOR 3¼ X 4¼, 4 X 5, 3½ X 5½, OR 5 X 7 INCH EXPOSURES ON PLATES OR FILM PACKS WITH ADAPTER. F 6.8 GOERZ SYNTOR, F 6.8 GOERZ DAGOR, OR F 4.5 GOERZ CELOR LENS. COMPOUND SHUTTER; 1 TO 1/250 SEC., B., T. DOUBLE EXTENSION BELLOWS. RISING AND FALLING LENS MOUNT.

---

(2986) **MANUFOC TENAX TROPICAL CAMERA.** C. 1925. TWO SIZES OF THIS CAMERA FOR 9 X 12 OR 9 X 14 CM EXPOSURES ON PLATES OR FILM PACKS. DOUBLE EXTENSION BELLOWS. F 4.5 DOGMAR OR F 6.8 DAGOR LENS. COMPUR SHUTTER.

---

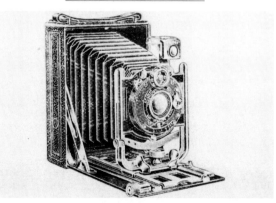

(2987) **TARO TENAX CAMERA.** C. 1914. TWO SIZES OF THIS CAMERA FOR 9 X 12 OR 9 X 14 CM EXPOSURES ON PLATES OR FILM PACKS WITH ADAPTER. F 6.8 GOERZ TENASTIGMAT OR F 6.8 GOERZ DAGOR LENS. COMPOUND SHUTTER; 1 TO 1/250 SEC., B., T. OR IBSO SHUTTER; 1 TO 1/100 SEC., B., T. RISING AND FALLING LENS MOUNT. DOUBLE EXTENSION BELLOWS.

---

(2988) **TARO TENAX CAMERA.** C. 1925. TWO SIZES OF THIS CAMERA FOR 9 X 12 OR 9 X 14 CM EXPOSURES ON PLATES OR FILM PACKS. GOERZ KALOSTIGMAT OR TENAXIAR LENS. THREE-SPEED SHUTTER PLUS B. AND T.

---

(2989) **TENAX C.D.V. CAMERA.** C. 1914. SIZE 6.5 X 9 CM EXPOSURES ON PLATES OR FILM PACKS. SIMILAR

## GOERZ, C. P. (*cont.*)

TO THE TENAX VEST POCKET CAMERA, C. 1912, WITH THE SAME LENSES AND SHUTTER.

**(2990) TENAX C.D.V. TROPICAL CAMERA.** C. 1914. SIZE 6.5 X 9 CM EXPOSURES ON PLATES OR FILM PACKS. SIMILAR TO THE TENAX C.D.V. CAMERA WITH THE SAME LENSES AND SHUTTER.

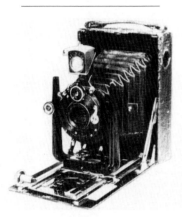

**(2991) TENAX PLATE CAMERA.** C. 1910. SIZE 9 X 12 CM EXPOSURES ON PLATES. 130 MM/F 6.8 GOERZ DAGOR LENS. COMPOUND SHUTTER WITH SPEEDS TO ½₂₅₀ SEC. (HA)

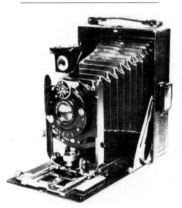

**(2992) TENAX PLATE CAMERA.** C. 1912. SIZE 9 X 12 CM EXPOSURES ON PLATES. 130 MM/F 6.8 GOERZ KALOSTIGMAT LENS. IBSOR SHUTTER WITH SPEEDS TO ½₁₀₀ SEC. (HA)

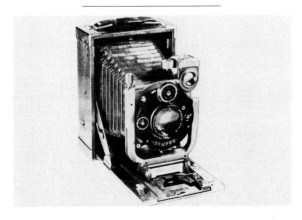

**(2993) TENAX PLATE CAMERA.** C. 1923. SIZE 9 X 12 CM EXPOSURES ON PLATES. 135 MM/F 4.5 GOERZ DOGMAR LENS. COMPUR SHUTTER WITH SPEEDS TO ½₂₀₀ SEC. (HA)

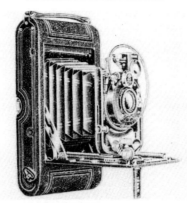

**(2994) TENAX ROLL FILM CAMERA.** C. 1914. TWO SIZES OF THIS CAMERA FOR 3¼ X 4¼ OR 3½ X 5½ INCH EXPOSURES ON ROLL FILM OR FILM PACKS WITH ADAPTER. DOUBLE EXTENSION BELLOWS ON THE 3½ X 5½ MODEL. F 6.8 GOERZ DAGOR, F 4.8 GOERZ CELOR OR F 6.8 GOERZ TENASTIGMAT LENS. COMPOUND OR IBSO SHUTTER.

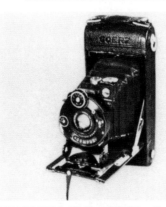

**(2995) TENAX ROLL FILM CAMERA.** C. 1925. SIZE 6 X 9 CM EXPOSURES. 100 MM/F 6.3 GOERZ DOGMAR LENS. COMPUR SHUTTER WITH SPEEDS TO ½₂₅₀ SEC. (HA)

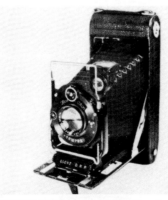

**(2996) TENAX ROLL FILM CAMERA.** C. 1925. SIZE 8 X 14 CM EXPOSURES ON ROLL FILM. 165 MM/F 4.8 GOERZ DOGMAR LENS. COMPUR SHUTTER WITH SPEEDS TO ½₂₀₀ SEC. (HA)

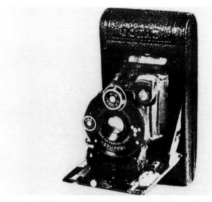

**(2997) TENAX ROLL FILM CAMERA.** C. 1927. SIZE 4 X 6 CM EXPOSURES ON ROLL FILM. 75 MM/F 6.3 GOERZ TENASTIGMAT LENS. COMPUR SHUTTER WITH SPEEDS TO ½₃₀₀ SEC. (HA)

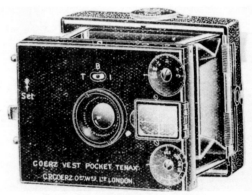

**(2998) TENAX VEST POCKET CAMERA.** C. 1912. SIZE 4.5 X 6 CM EXPOSURES ON PLATES OR FILM PACKS. 75 MM/F 6.8 DOPPEL ANASTIGMAT DAGOR OR SYNTOR LENS. ALSO, 75 MM/F 4.5 DOPPEL ANASTIGMAT CELOR LENS. COMPOUND SHUTTER; ½ TO ½₂₅₀ SEC., B., T.

**(2999) TENAX VEST POCKET TROPICAL CAMERA.** C. 1912. SIZE 4.5 X 6 CM EXPOSURES ON PLATES OR FILM PACKS. SIMILAR TO THE TENAX VEST POCKET CAMERA, C. 1912, WITH THE SAME LENSES AND SHUTTER.

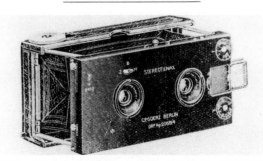

**(3000) TENAX STEREO VEST POCKET CAMERA.** C. 1909–14. SIZE 45 X 107 MM EXPOSURES ON PLATES OR FILM PACKS. F 4.5 CELOR OR DAGOR LENSES. ALSO, F 6.8 DAGOR OR SYNTOR LENSES. EARLY MODELS WITH CENTRAL SHUTTER TO ½₁₀₀ SEC. LATER MODELS WITH SHUTTER SPEEDS FROM 1 TO ½₂₅₀ SEC., B., T. IRIS DIAPHRAGM.

## GOERZ, C. P. (*cont.*)

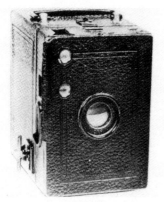

**(3001) TENGOR BOX CAMERA.** C. 1923. SIZE 6 X 9 CM EXPOSURES ON ROLL FILM. 110 MM/F 11 GOERZ-FRONTAR LENS. INSTANT AND TIME SHUTTER.

**(3002) TENGOR BOX CAMERA.** C. 1924. SIZE 6.5 X 11 CM EXPOSURES ON ROLL FILM. HAHN-GOERZ FRONTAR LENS. SINGLE-SPEED SHUTTER. (MA)

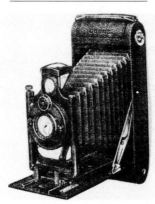

**(3003) TENGOR FOLDING ROLL FILM CAMERA.** C. 1925. TWO SIZES OF THIS CAMERA FOR 9 X 12 OR 9 X 14 CM EXPOSURES ON ROLL FILM. F 9 HAHN-GOERZ LENS OR F 6.8 KALOSTIGMAT LENS WITH COMPUR SHUTTER.

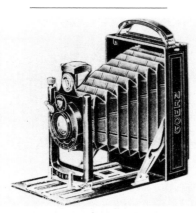

**(3004) TENGOR PLATE CAMERA.** C. 1925. TWO SIZES OF THIS CAMERA FOR 9 X 12 OR 9 X 14 CM EXPOSURES ON PLATES. F 6.8 TENAXIAR LENS.

**(3005) TROPICAL FOLDING PLATE CAMERA.** SIZE 9 X 12 CM EXPOSURES. 135 MM/F 4.5 DOPPEL ANASTIGMAT CORMAR LENS. COMPUR SHUTTER.

## GOLTZ & BREUTMANN

**(3006) MENTOR BROOKS REFLEX CAMERA.** C. 1932. SIZE 6 X 9 CM EXPOSURES ON ROLL FILM OR FILM PACKS. F 4.5 MEYER TRIOPLAN LENS.

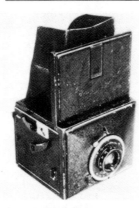

**(3007) MENTOR COMPUR REFLEX CAMERA.** C. 1928. SIZE 6.5 X 9 CM EXPOSURES ON PLATES. 105 MM/F 4.5 ZEISS TESSAR LENS. COMPUR SHUTTER; 1 TO 1/250 SEC., B., T. (HA)

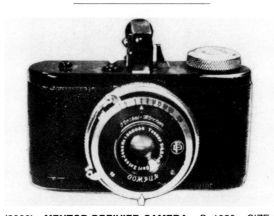

**(3008) MENTOR DREIVIER CAMERA.** C. 1930. SIZE 3 X 4 CM EXPOSURES ON ROLL FILM. 50 MM/F 3.5 OR F 4.5 ZEISS TESSAR LENS. COMPUR SHUTTER; 1 TO 1/300 SEC., B., T. (HA)

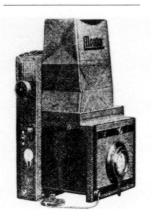

**(3009) MENTOR KLAPP REFLEX CAMERA.** C. 1911–24. FOUR SIZES OF THIS CAMERA FOR 6.5 X 9, 9 X 12, 9 X 14, OR 12 X 18 CM EXPOSURES ON ROLL, SHEET, OR PLATE FILM. F 4.5 ZEISS TESSAR LENS. FOCAL PLANE SHUTTER; 1/8 TO 1/1300 SEC. OR 1/5 TO 1/1300 SEC. SOME LATER MODELS WITH REVOLVING BACK.

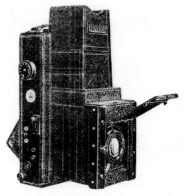

**(3010) MENTOR KLAPP REFLEX CAMERA.** C. 1925. FOUR SIZES OF THIS CAMERA FOR 6.5 X 9, 9 X 9, 8 X 10.5, OR 9 X 12 CM EXPOSURES ON PLATES. FOCAL PLANE SHUTTER.

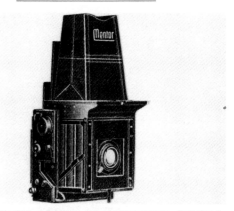

**(3011) MENTOR PATENT KLAPP REFLEX CAMERA.** C. 1927. FOUR SIZES OF THIS CAMERA FOR 6.5 X 9, 9 X 9, 9 X 12, OR 10 X 15 CM EXPOSURES ON PLATES. F 4.5 ZEISS TESSAR LENS. FOCAL PLANE SHUTTER; 1/8 TO 1/1300 SEC.

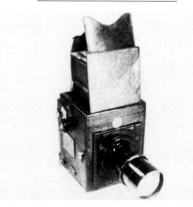

**(3012) MENTOR REFLEX CAMERA.** C. 1918. SIZE 9 X 9 CM EXPOSURES ON PLATES OR FILM PACKS. 130 MM/F 6.3 TELEROS LENS. FOCAL PLANE SHUTTER; 1/5 TO 1/1300 SEC. (HA)

## GOLTZ & BREUTMANN (cont.)

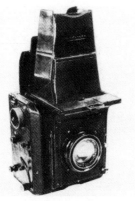

**(3013)  MENTOR REFLEX CAMERA.**  C. 1925.  SIZE 6.5 X 9 CM EXPOSURES ON PLATES.  120 MM/F 4.5 ZEISS TESSAR LENS.  FOCAL PLANE SHUTTER; $\frac{1}{5}$ TO $\frac{1}{1300}$ SEC. (HA)

**(3014)  MENTOR REFLEX CAMERA.**  C. 1927.  SIZE 6.5 X 9 CM EXPOSURES ON PLATES.  135 MM/F 1.9 RIETZSCHEL PROLINEAR LENS.  FOCAL PLANE SHUTTER; $\frac{1}{8}$ TO $\frac{1}{1300}$ SEC.  REVOLVING BACK.  (IH)

**(3015)  MENTOR SINGLE-LENS REFLEX CAMERA.** C. 1906.  VARIABLE-SLIT FOCAL PLANE SHUTTER.

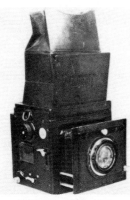

**(3016)  MENTOR SPIEGEL REFLEX CAMERA.**  C. 1922. SIZE 6 X 9 CM EXPOSURES ON PLATES OR FILM PACKS. 105 MM/F 4.5 ZEISS TESSAR LENS.  FOCAL PLANE SHUTTER; $\frac{1}{5}$ TO $\frac{1}{1300}$ SEC.  (HA)

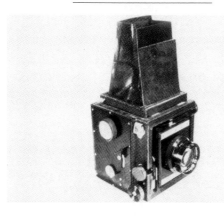

**(3017)  MENTOR SPIEGEL REFLEX CAMERA.**  C. 1936. SIZE 6 X 9 CM EXPOSURES ON PLATES.  165 MM/F 3.5 ZEISS TESSAR LENS.  FOCAL PLANE SHUTTER; $\frac{1}{5}$ TO $\frac{1}{1300}$ SEC.  (HA)

**(3018)  MENTOR SPORT REFLEX CAMERA.**  C. 1925–33. SIZE 6 X 9 CM EXPOSURES ON FILM PACKS.  F 4.5 MEYER GOERLITZ TRIOPLAN LENS.  PRONTO SHUTTER; $\frac{1}{25}$, $\frac{1}{50}$ SEC., ST. OR PRONTO SHUTTER; $\frac{1}{25}$ TO $\frac{1}{100}$ SEC., ST.  (IH)

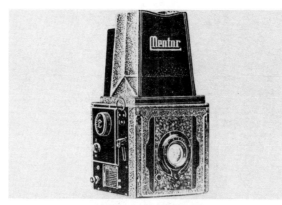

**(3019)  MENTOR SPORT AND SPIEGEL REFLEX CAMERA.**  C. 1927.  TWO SIZES OF THIS CAMERA FOR 6.5 X 9 OR 9 X 12 CM EXPOSURES ON PLATES.  F 4.5 ZEISS TESSAR LENS.  FOCAL PLANE SHUTTER; $\frac{1}{5}$ TO $\frac{1}{1300}$ SEC.

**(3020)  MENTOR STEREO REFLEX CAMERA.**  C. 1920. TWO SIZES OF THIS CAMERA FOR 6 X 13 OR 10 X 17 CM STEREO EXPOSURES ON PLATES.  F 4.5 ZEISS TESSAR LENSES.  FOCAL PLANE SHUTTER; $\frac{1}{4}$ TO $\frac{1}{1300}$ SEC.

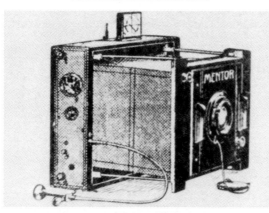

**(3021)  MENTOR II FOCAL PLANE CAMERA.**  C. 1914. FOUR SIZES OF THIS CAMERA FOR 6 X 9, 9 X 12, 10 X 15, OR 13 X 18 CM EXPOSURES ON PLATES OR FILM PACKS.  FOCAL PLANE SHUTTER WITH SPEEDS TO $\frac{1}{1300}$ SEC.

**(3022)  MENTORETTE SINGLE-LENS REFLEX CAMERA.** C. 1935.  SIZE 6 X 6 CM EXPOSURES ON ROLL FILM. THE CAMERA HAS A SERIES OF SMALL CIRCULAR WINDOWS ON THE FRONT WHICH GIVE VARIOUS APERTURE SHUTTER SETTING, AND EXPOSURE NUMBERS.  F 2.4 LENS.  COMPUR RAPID SHUTTER; 1 TO $\frac{1}{500}$ SEC.  (BC)

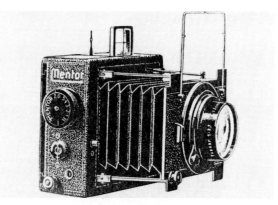

**(3023)  MENTOR II FOCAL PLANE CAMERA.**  C. 1925. TWO SIZES OF THIS CAMERA FOR 6.5 X 9 OR 9 X 12 CM EXPOSURES ON PLATES.  F 2.7 ZEISS TESSAR LENS.  FOCAL PLANE SHUTTER.

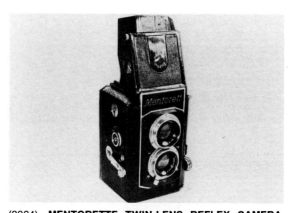

**(3024)  MENTORETTE TWIN-LENS REFLEX CAMERA.** C. 1935.  SIZE 6 X 6 CM EXPOSURES ON ROLL FILM. 75 MM/F 3.5 MENTOR SPECIAL LENS.  FOCAL PLANE SHUTTER; $\frac{1}{15}$ TO $\frac{1}{600}$ SEC.  (HA)

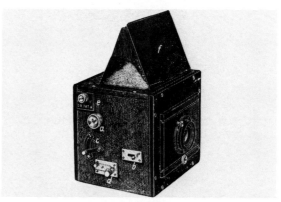

**(3025)  SPIEGEL REFLEX CAMERA.**  C. 1898.

## GÖRLITZER CAMERA-WERKE

**(3026)  QUILLETTE SPIEGEL REFLEX CAMERA.**  C. 1924.  FOCAL PLANE SHUTTER TO $\frac{1}{1000}$ SEC.

## HARBERS, THEODOR

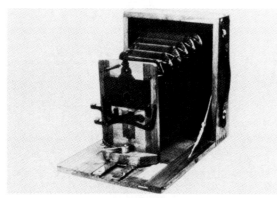

(3027) **KLIMAX PLATE CAMERA.** C. 1905. SIZE 9 X 12 CM EXPOSURES ON PLATES. TWO-SPEED SHUTTER. SLIDING APERTURE STOPS. (HA)

## HEINEMANN & DRESSLER

(3028) **COLIBRI BOX CAMERA.** C. 1893. SIZE 3.5 X 4 CM PLATE EXPOSURES.

---

(3029) **MIGNON CHANGING BOX DETECTIVE CAMERA.** C. 1889. SIZE 35 X 40 MM EXPOSURES ON PLATES. 50 MM/F 14 MENISCUS LENS. FRONT-MOUNTED GUILLOTINE SHUTTER. (IH)

## HERBST & FIRL

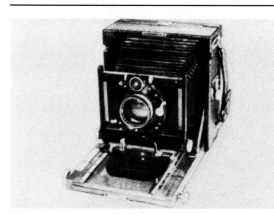

(3030) **JOCHIM SPECIAL COMPACT CAMERA.** C. 1908. SIZE 9 X 12 CM EXPOSURES ON PLATES. 240 MM/F 6.8 GOERZ DAGOR LENS. COMPOUND SHUTTER WITH SPEEDS TO 1/150 SEC. (HA)

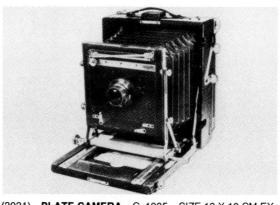

(3031) **PLATE CAMERA.** C. 1905. SIZE 13 X 18 CM EXPOSURES ON PLATES. 150 MM/F 6.8 RIESE DOUBLE ANASTIGMAT LENS. FOCAL PLANE SHUTTER WITH EIGHT SPEEDS. (HA)

## HESEKIEL, DR.

(3032) **REFLEX CAMERA.** C. 1895. SIZE 9 X 12 CM EXPOSURES ON PLATES. 140 MM/F 6.3 GOERZ DOUBLE ANASTIGMAT LENS. SINGLE-SPEED ROLLER-BLIND SHUTTER. (HA)

## HÜTTIG, R. & SON

(3033) **ATOM FOLDING PLATE CAMERA.** C. 1908. SIZE 4.5 X 6 CM EXPOSURES ON PLATES. 90 MM/F 8 LENS. COMPOUND SHUTTER; 1 TO 1/250 SEC. (MA)

---

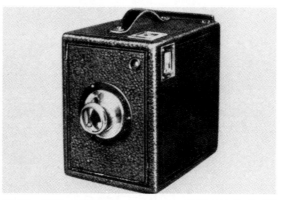

(3034) **BOX CAMERA.** C. 1910. SIZE 6.5 X 9 CM EXPOSURES ON PLATES. (HA)

---

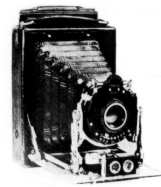

(3035) **CUPIDO CAMERA.** C. 1907–10. SIZE 9 X 12 CM EXPOSURES ON PLATES. 125 MM/F 8 HELIOS RAPID RECTILINEAR OR BALDOUR LENS. LLOYD PNEUMATIC SHUTTER; 1 TO 1/100 SEC., B., T. OR COMPOUND SHUTTER TO 1/250 SEC.

---

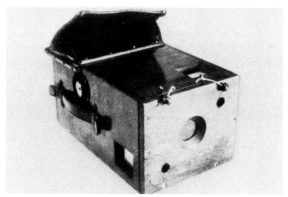

(3036) **DETECTIVE MAGAZINE CAMERA.** C. 1893. THE CAMERA'S MAGAZINE HOLDS 12 PLATES. STRING OPERATED ROTARY SHUTTER. (HA)

---

(3037) **DETECTIVE MAGAZINE CAMERA.** C. 1895. SIMILAR TO THE 1893 MODEL EXCEPT THE CAMERA HAS A BUTTON OPERATED SHUTTER.

---

(3038) **FICHTER'S EXELCIOR DETECTIVE CAMERA.** C. 1893. SIZE 9 X 12 CM EXPOSURES ON PLATES. THE MAGAZINE HOLDS 12 PLATES. RECTILINEAR LENS. ROTATING SHUTTER. (IH)

---

(3039) **HELIOS STEREO AND PANORAMIC CAMERA.** C. 1907. SIZE 9 X 18 CM PANORAMIC OR STEREO EXPOSURES ON PLATES. A CENTRAL LENS POSITIONED BETWEEN THE STEREO LENSES IS USED FOR PANORAMIC EXPOSURES. STRUT-TYPE CONSTRUCTION.

---

(3040) **IDEAL STEREO CAMERA.** C. 1906. SIZE 60 X 130 MM STEREO EXPOSURES. 90 MM/F 6.8 LLOYD ANASTIGMATIC LENSES. PNEUMATIC CENTRAL SHUTTER; 1 TO 1/100 SEC. (MA)

---

(3041) **LLOYD STEREO CAMERA.** C. 1906. SIZE 9 X 18 CM STEREO EXPOSURES ON ROLL FILM OR PLATES. 90 MM/F 8 BUSCH ROJA APLANATIC LENSES. COMPOUND SHUTTER; 1 TO 1/200 SEC. (MA)

## HÜTTIG, R. & SON (*cont.*)

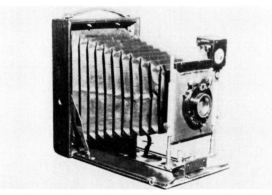

**(3042) IDEAL FOLDING CAMERA.** C. 1905. SIZE 13 X 18 CM EXPOSURES. F 8 EXTRA RAPID LENS. SHUTTER SPEEDS FROM 1 TO $\frac{1}{150}$ SEC., B., T. (SC)

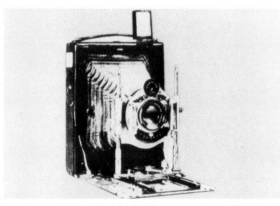

**(3043) LLOYD PLATE CAMERA.** C. 1905. SIZE 9 X 12 CM PLATE EXPOSURES. 125 MM/F 8 BALDOUR LENS. SHUTTER SPEEDS FROM ½ TO $\frac{1}{100}$ SEC.

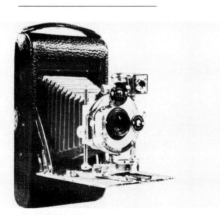

**(3044) LLOYD ROLL FILM AND PLATE CAMERA.** C. 1910. SIZE 8 X 10 CM EXPOSURES. 120 MM/F 4.8 GOERZ DOUBLE ANASTIGMAT LENS. COMPOUND SHUTTER WITH SPEEDS TO $\frac{1}{250}$ SEC. (HA)

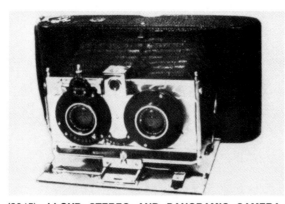

**(3045) LLOYD STEREO AND PANORAMIC CAMERA.** C. 1908. SIZE 9 X 15 CM STEREO OR PANORAMIC EXPOSURES ON PLATES OR ROLL FILM. 125 MM/ F 8 BALDOUR EXTRA RAPID APLANAT LENSES. SHUTTER SPEEDS TO $\frac{1}{100}$ SEC. (HA)

**(3046) MONOPOL MAGAZINE CAMERA.** C. 1895. SIZE 9 X 12 CM PLATE EXPOSURES. RECTILINEAR LENS. VARIABLE-SPEED ROTARY SECTOR SHUTTER. (MA)

**(3047) MONOPOL MAGAZINE CAMERA.** C. 1898. SIZE 9 X 12 CM PLATE EXPOSURES. RECTILINEAR LENS. FOCUSING KNOB. VARIABLE-SPEED ROTARY SECTOR SHUTTER. (MA)

**(3048) MONOPOL MAGAZINE CAMERA.** C. 1907. SIZE 9 X 12 CM PLATE EXPOSURES. FOCUSING RECTILINEAR LENS. VARIABLE-SPEED ROTARY SECTOR SHUTTER. DROP-PLATE CHANGING MAGAZINE. (MA)

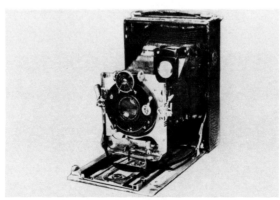

**(3049) NELSON PLATE CAMERA.** C. 1907. SIZE 9 X 12 CM EXPOSURES ON PLATES. 135 MM/F 6.8 GOERZ SYNTOR LENS. COMPOUND SHUTTER SPEEDS TO $\frac{1}{250}$ SEC. (HA)

**(3050) PLATE CAMERA.** C. 1880. SIZE 9 X 12 CM PLATE EXPOSURES. TRIPLE EXTENSION BELLOWS.

**(3051) RECORD CAMERA.** C. 1908. FOLDING-STRUT TYPE CAMERA.

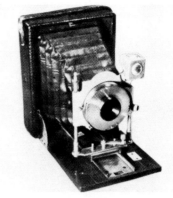

**(3052) STANDARD MODEL PLATE CAMERA.** C. 1905. SIZE 9 X 12 CM EXPOSURES ON PLATES. 135 MM/F 9 PERISCOP LENS. SINGLE-SPEED SHUTTER. ROTARY APERTURE STOPS. (HA)

## ICA A. G.

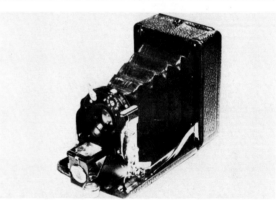

**(3053) ATOM CAMERA.** C. 1910. SIZE 4.5 X 6 CM EXPOSURES ON PLATES OR FILM PACKS. 90 MM/F 8 ICA HELIOS LENS. ICA SHUTTER; $\frac{1}{25}$ TO $\frac{1}{100}$ SEC., B., T. THE CAMERA IS SELF-ERECTING. (HA)

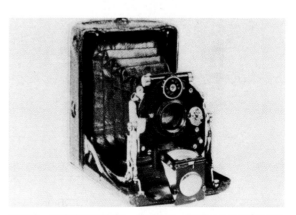

**(3054) ATOM CAMERA.** C. 1913. SIZE 4.5 X 6 CM EXPOSURES ON PLATES. 90 MM/F 6.3 ZEISS TESSAR LENS. COMPOUND SHUTTER FOR SPEEDS TO $\frac{1}{250}$ SEC., B., T. THE CAMERA IS SELF-ERECTING.

## ICA A. G. (*cont.*)

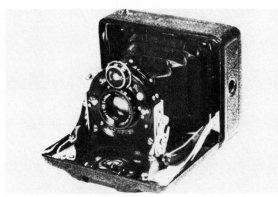

(3055)  **ATOM CAMERA.**  C. 1918.  SIZE 4.5 X 6 CM EXPOSURES ON PLATES.  65 MM/F 4.5 OR F 6.3 ZEISS TESSAR LENS.  COMPUR SHUTTER; 1 TO 1/300 SEC., B., T.  THE CAMERA IS SELF-ERECTING.  (HA)

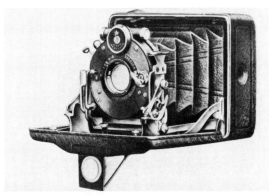

(3056)  **ATOM CAMERA.**  C. 1924.  SIZE 4.5 X 6 CM EXPOSURES ON PLATES OR FILM PACKS.  F 6.8 HEKLA ANASTIGMAT, F 4.5 DOMINAR ANASTIGMAT, OR F 6.3 OR F 4.5 CARL ZEISS LENS.  COMPUR SHUTTER; 1 TO 1/300 SEC., B., T.  THE CAMERA IS SELF-ERECTING.

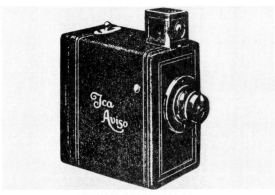

(3057)  **AVISO CAMERA.**  C. 1912.  FOUR SIZES OF THIS CAMERA FOR 4.5 X 6, 9 X 12, 10 X 15, OR 13 X 18 CM EXPOSURES ON PLATES OR FILM PACKS.  70 MM/F 11 MENISCUS LENS.  ROTARY SHUTTER FOR INSTANT AND TIME.

(3058)  **AVISO CAMERA.**  C. 1917.  SIZE 4.5 X 6 CM EXPOSURES ON PLATES OR FILM PACKS.  SAME LENS AND SHUTTER AS THE 1912 AVISO MODEL.  (MA)

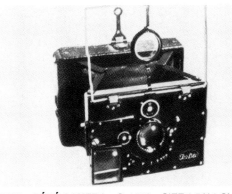

(3059)  **BÉBÉ CAMERA.**  C. 1910.  SIZE 6.5 X 9 CM EXPOSURES ON PLATES.  150 MM/F 4.5 ZEISS TESSAR LENS.  COMPUR SHUTTER WITH SPEEDS TO 1/250 SEC. (HA)

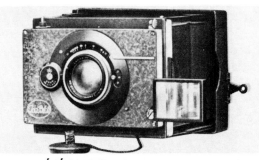

(3060)  **BÉBÉ CAMERA.**  C. 1924.  THREE SIZES OF THIS CAMERA FOR 4.5 X 6, 6.5 X 9, OR 9 X 12 CM EXPOSURES ON PLATES OR FILM PACKS.  F 4.5 ZEISS TESSAR OR F 2.9 MEYER GORLITZ TRIOPLAN LENS.  COMPUR SHUTTER; 1 TO 1/200 SEC., B., T.

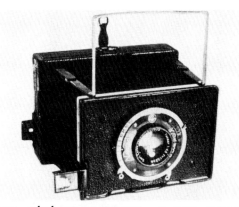

(3061)  **BÉBÉ SPORT CAMERA.**  C. 1930.  SIZE 6 X 9 CM EXPOSURES ON PLATES OR FILM PACKS.  105 MM/F 4.5 ZEISS TESSAR LENS.  COMPUR SHUTTER; 1 TO 1/250 SEC., B., T.  (HA)

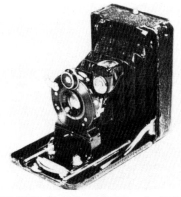

(3062)  **FOLDING PLATE CAMERA.**  C. 1913.  SIZE 4.5 X 6 CM EXPOSURES ON PLATES.  90 MM/F 8 ICA HELIOS LENS.  ICA SHUTTER; 1/25 TO 1/100 SEC.  (HA)

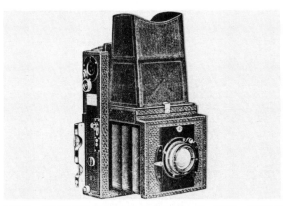

(3063)  **FOLDING REFLEX CAMERA.**  C. 1923.  SIZE 9 X 12 CM EXPOSURES.  150 MM/F 4.5 ZEISS TESSAR LENS.  FOCAL PLANE SHUTTER; 1/15 TO 1/1000 SEC., T. NON-SELF-CAPPING SHUTTER.

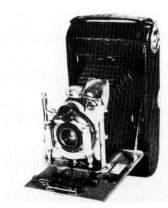

(3064)  **FOLDING ROLL FILM AND PLATE CAMERA.** C. 1902.  SIZE 8 X 10 CM EXPOSURES.  F 6 BUSCH RATE-NOW RAPID APLANAT LENS.  BAUSCH & LOMB CENTRAL SHUTTER WITH SPEEDS TO 1/100 SEC.  (HA)

(3065)  **ICARETTE CAMERA.**  C. 1912.  SIZE 6 X 6 CM EXPOSURES ON ROLL FILM.  75 MM/F 8 HELIOS LENS. COMPOUND SHUTTER.  SIMILAR TO THE ICARETTE CAMERA, C. 1924.

## ICA A. G. (cont.)

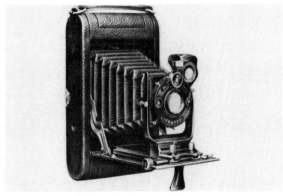

(3066) **HALLOH CAMERA.** C. 1924. SIZE 9 X 12 CM EXPOSURES ON ROLL FILM. THE CAMERA HAS THE SAME LENSES AND SHUTTER AS THE ICARETTE C CAMERA BUT ALSO HAS A RISING AND CROSSING LENS MOUNT AND RACK & PINION FOCUSING.

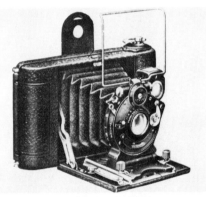

(3067) **ICARETTE CAMERA. MODELS A AND B.** C. 1924. MODEL A: SIZE 6 X 6 CM EXPOSURES ON ROLL FILM. MODEL B: SIZE 4.5 X 6 CM EXPOSURES ON PLATES. F 6.8 NOVAR OR HEKLA ANASTIGMAT, F 6.3 CARL ZEISS, OR F 4.7 CARL ZEISS OR DOMINAR AN-ASTIGMAT LENS. COMPUR SHUTTER: 1 TO 1/300 SEC., B., T. OR AUTOMATIC SHUTTER.

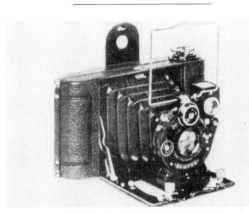

(3068) **ICARETTE A FOLDING CAMERA.** C. 1925. SIZE 6 X 6 CM EXPOSURES ON NO. 117 ROLL FILM. 75 MM/F 4.5 CARL ZEISS TESSAR OR DOMINAR LENS WITH COMPUR SHUTTER; 1 TO 1/300 SEC. ALSO, 75 MM/F 6.3 CARL ZEISS LENS WITH THE ABOVE COMPUR

SHUTTER; 75 MM/F 6.8 HEKLA ANASTIGMAT LENS WITH COMPOUND SHUTTER; 1 TO 1/300 SEC. OR ICA NOVAR ANASTIGMAT LENS WITH ICA SHUTTER; 1 TO 1/100 SEC.

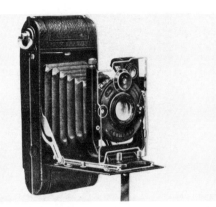

(3069) **ICARETTE MODEL C CAMERA.** C. 1924. SIZE 6 X 9 CM EXPOSURES ON ROLL FILM. F 6.8 HEKLA ANASTIGMAT, F 6.3 CARL ZEISS, OR F 4.5 CARL ZEISS OR DOMINAR ANASTIGMAT LENS. COMPUR SHUTTER; 1 TO 1/250 SEC., B., T. RISING LENS MOUNT.

(3070) **ICARETTE MODEL D CAMERA.** C. 1924. SIZE 6.5 X 11 CM EXPOSURES ON ROLL FILM. SIMILAR TO THE ICARETTE MODEL C CAMERA WITH THE SAME LENSES AND SHUTTER.

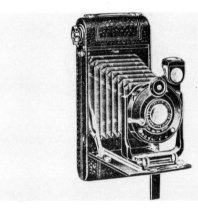

(3071) **ICARETTE ROLL FILM CAMERA.** C. 1924. TWO SIZES OF THIS CAMERA FOR 6 X 9 OR 6.5 X 11 CM EXPOSURES. F 6.8 ICA NOVAR ANASTIGMAT LENS. THREE-SPEED PLUS B., T. AUTOMATIC SHUTTER.

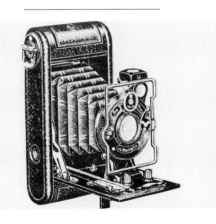

(3072) **ICARETTE VEST POCKET CAMERA.** C. 1924. SIZE 4 X 6.5 CM EXPOSURES ON ROLL FILM. F 4.5 ZEISS TESSAR OR DOMINAR LENS. ALSO, F 6.8 NOVAR ANASTIGMAT LENS. COMPUR SHUTTER.

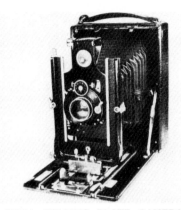

(3073) **IDEAL FOLDING PLATE CAMERA.** C. 1910. SIZE 13 X 18 CM EXPOSURES ON PLATES. 190 MM/F 8 HELIOS-HÜTTIG LENS. COMPOUND SHUTTER TO 1/200 SEC. (HA)

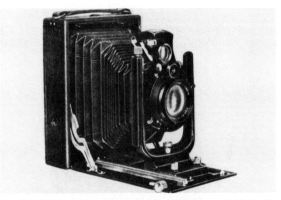

(3074) **IDEAL FOLDING PLATE CAMERA. MODEL A.** C. 1924. SIZE 6.5 X 9 CM EXPOSURES ON PLATES OR FILM PACKS WITH ADAPTER. F 6.8 HEKLA ANASTIG-MAT; F 4.5 DOMINAR ANASTIGMAT; OR F 6.8, F 6.3, OR F 4.5 CARL ZEISS LENS. COMPUR SHUTTER; 1 TO 1/250 SEC., B., T.

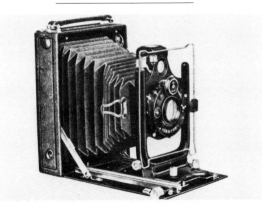

(3075) **IDEAL FOLDING PLATE CAMERA. MODEL B.** C. 1924. SIZE 9 X 12 EXPOSURES ON PLATES OR FILM PACKS. SAME LENSES AND SHUTTER AS THE TRONA CAMERA. RISING, FALLING, AND CROSSING LENS

## ICA A. G. (*cont.*)

MOUNT. VERTICAL SWING BACK. RACK & PINION FOCUS. DOUBLE EXTENSION BELLOWS.

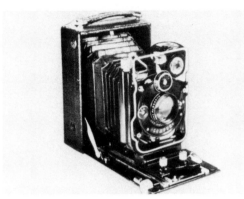

(3076) **IDEAL FOLDING PLATE CAMERA.** C. 1926. TWO SIZES OF THIS CAMERA FOR 6.5 X 9 OR 9 X 12 CM EXPOSURES ON PLATES. 120 MM/F 4.5 ZEISS TESSAR LENS. COMPUR SHUTTER: 1 TO ¹⁄₂₅₀ SEC., B., T. (HA)

(3077) **IDEAL STEREO CAMERA.** C. 1923. SIZE 6 X 13 CM STEREO EXPOSURES ON ROLL, SHEET, OR PLATE FILM. 90 MM/F 4.5 ZEISS TESSAR OR DOMINAR LENSES. GROUND GLASS FOCUSING.

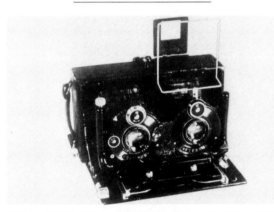

(3078) **IDEAL 651 STEREO CAMERA.** C. 1912. TWO SIZES OF THIS CAMERA FOR 6 X 13 OR 9 X 18 CM STEREO EXPOSURES ON PLATES. F 4.5 OR F 6.3 TESSAR LENSES. COMPUR SHUTTER WITH SPEEDS TO ¹⁄₁₅₀ SEC. RISING LENS MOUNT. (HA)

(3079) **IDEAL 660 STEREO CAMERA.** C. 1910. SIZE 9 X 18 CM STEREO EXPOSURES ON PLATES. 130 MM/F 8 ICA HELIOS LENSES. ICA SHUTTER; 1 TO ¹⁄₁₀₀ SEC. RISING LENS MOUNT. (MA)

(3080) **L'ARTISTE REFLEX CAMERA.** C. 1910. SINGLE-LENS REFLEX. 150 MM/F 4.5 ZEISS TESSAR LENS. FOCAL PLANE SHUTTER. SIMILAR TO THE ICA REFLEX 756 CAMERA. (IH)

(3081) **LLOYD CAMERA.** C. 1924. SIZE 9 X 14 CM EX-POSURES ON ROLL FILM. SIMILAR TO THE HALLOH

CAMERA WITH THE SAME LENSES (EXCEPT THE F 4.5 LENSES) AND SHUTTER.

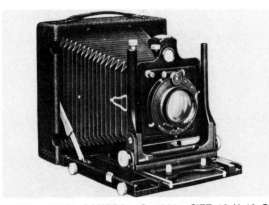

(3082) **JUWEL CAMERA.** C. 1924. SIZE 13 X 18 CM EXPOSURES ON PLATES OR FILM PACKS. F 6.8, F 6.3, OR F 4.5 CARL ZEISS OR F 4.5 DOMINAR ANASTIGMAT LENS. COMPUR SHUTTER; 1 TO ¹⁄₁₅₀ SEC., B., T. RISING AND CROSSING LENS MOUNT. SWING BACK. TILTING FRONT. HOODED GROUND GLASS BACK.

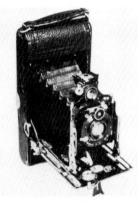

(3083) **LLOYD CUPIDO CAMERA.** C. 1916. SIZE 7.5 X 10.5 CM EXPOSURES ON ROLL FILM OR PLATES. 135 MM/F 6.3 TESSAR LENS. ICA SHUTTER WITH SPEEDS TO ¹⁄₁₀₀ SEC. (HA)

(3084) **LLOYD STEREO CAMERA.** C. 1910. SIZE 8 X 14 CM STEREO EXPOSURES ON ROLL FILM. 90 MM/F 6.8 MAXIMAR DOUBLE ANASTIGMAT LENSES. COMPUR SHUTTER; 1 TO ¹⁄₁₀₀ SEC. RISING AND CROSSING LENS MOUNT. PANORAMIC EXPOSURES. (MA)

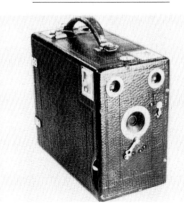

(3085) **MAGAZINE BOX CAMERA.** C. 1905. SIZE 9 X 12 CM EXPOSURES ON PLATES. THE MAGAZINE HOLDS 12 PLATES. THREE APERTURE STOPS. IN-STANT AND TIME GUILLOTINE SHUTTER. (HA)

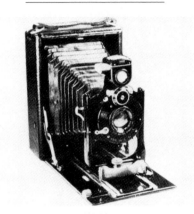

(3086) **MAXIMAR 207 CAMERA.** C. 1925. SIZE 9 X 12 CM EXPOSURES ON PLATES. 135 MM/F 6.8 ICA-HEKLA LENS. AUTOMAT SHUTTER WITH SPEEDS TO ¹⁄₁₀₀ SEC. (HA)

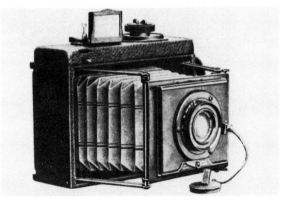

(3087) **MINIMUM PALMOS CAMERA.** **MODEL A.** C. 1912–24. SIZE 6 X 9 CM EXPOSURES ON PLATES OR FILM PACKS. 120 MM/F 4.5 ZEISS TESSAR LENS. FOCAL PLANE SHUTTER WITH SPEEDS TO ¹⁄₇₅₀ SEC.

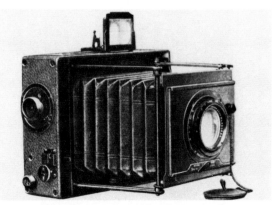

(3088) **MINIMUM PALMOS CAMERA.** **MODEL B.** C. 1924. SIZE 9 X 12 CM EXPOSURES ON PLATES OR FILM PACKS. F 4.5 OR F 6.3 CARL ZEISS LENS. FOCAL PLANE SHUTTER; ¹⁄₂ TO ¹⁄₁₀₀₀ SEC., T.

## ICA A. G. (*cont.*)

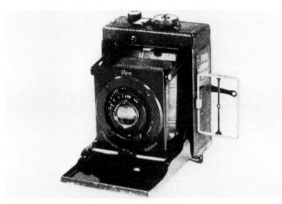

**(3089) MINIMUM PALMOS CAMERA.** C. 1927. SIZE 4.5 X 6 CM EXPOSURES ON PLATES. 80 MM/F 4.5 OR F 2.7 ZEISS TESSAR LENS. FOCAL PLANE SHUTTER; $\frac{1}{50}$ TO $\frac{1}{1000}$ SEC. (HA)

**(3090) NIXE CAMERA.** C. 1914. SIZE 9 X 12 CM EXPOSURES ON ROLL FILM OR PLATES. F 4.5 ZEISS TESSAR LENS. COMPUR SHUTTER; 1 TO $\frac{1}{150}$ SEC., B., T.

**(3091) NIXE A CAMERA.** C. 1924. SIZE 9 X 12 CM EXPOSURES ON ROLL FILM. SIMILAR TO THE HALLOH CAMERA WITH THE SAME LENSES, SHUTTER, AND FEATURES BUT WITH EXTRA LONG BELLOWS.

**(3092) NIXE B CAMERA.** C. 1924. SIZE 9 X 14 CM EXPOSURES ON ROLL FILM. SIMILAR TO THE HALLOH CAMERA WITH THE SAME LENSES (EXCEPT THE F 4.5 LENSES), SHUTTER, AND FEATURES BUT WITH EXTRA LONG BELLOWS.

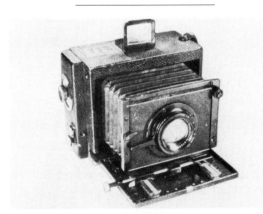

**(3093) PALMOS PLATE CAMERA.** C. 1912. SIZE 9 X 12 CM EXPOSURES ON PLATES. 150 MM/F 4.5 ZEISS TESSAR LENS. FOCAL PLANE SHUTTER; $\frac{1}{15}$ TO $\frac{1}{1000}$ SEC. (HA)

**(3094) PALMOS STEREO CAMERA.** C. 1910. SIZE 9 X 17 PANORAMIC OR STEREO PLATE EXPOSURES. 180 MM/F 6.3 ZEISS TESSAR LENSES. THE CENTRAL LENS IS USED FOR PANORAMIC EXPOSURES. THE STEREO LENS SEPARATION IS ADJUSTED AUTOMATICALLY DURING FOCUSING. (MA)

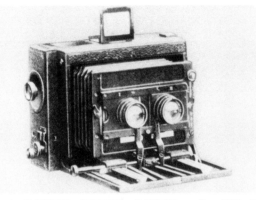

**(3095) PALMOS STEREO CAMERA.** C. 1901–10. SIZE 9 X 12 CM STEREO EXPOSURES ON PLATES OR FILM PACKS. 90 MM/F 6.3 OR F 4.5 ZEISS TESSAR OR F 6.8 ZEISS DOUBLE AMATAREN LENS. FOCAL PLANE SHUTTER; $\frac{1}{2}$ TO $\frac{1}{1000}$ SEC. RACK & PINION FOCUSING. RISING LENS MOUNT. (HA)

**(3096) PALMOS STEREO CAMERA.** C. 1915. SIZE 6 X 13 CM STEREO PLATE EXPOSURES. 80 MM/F 4.5 ZEISS TESSAR LENSES. FOCAL PLANE SHUTTER; $\frac{1}{30}$ TO $\frac{1}{1000}$ SEC. (MA)

**(3097) PLATE CAMERA.** C. 1911. SIZE 13 X 18 CM EXPOSURES ON PLATES. CARL ZEISS PROTAR LENS. COMPOUND SHUTTER WITH SPEEDS TO $\frac{1}{150}$ SEC. (HA)

**(3098) PLATE CAMERA.** C. 1925. SIZE 9 X 12 CM EXPOSURES. 135 MM/F 4.5 ZEISS TESSAR LENS. COMPUR SHUTTER; 1 TO $\frac{1}{200}$ SEC. (MA)

**(3099) POLYSCOP STEREO CAMERA.** C. 1910. SIZE 45 X 107 MM STEREO PLATE EXPOSURES. 65 MM/F 4.5 LENSES. ICA SHUTTER; $\frac{1}{2}$ TO $\frac{1}{250}$ SEC. (MA)

**(3100) POLYSCOP STEREO CAMERA.** C. 1912. SIZE 45 X 107 MM EXPOSURES ON PLATES OR FILM PACKS. MENISCUS OR F 6.5 ACHROMATIC LENSES. GUILLOTINE SHUTTER. (HA)

**(3101) POLYSCOP STEREO CAMERA.** C. 1912–16. TWO SIZES OF THIS CAMERA FOR 4.5 X 10.7 OR 6 X 13 CM EXPOSURES ON PLATES OR FILM PACKS. F 4.5 ZEISS TESSAR OR F 6.8 NOVAR LENSES. GUILLOTINE SHUTTER; $\frac{1}{2}$ TO $\frac{1}{250}$ SEC., T. IRIS DIAPHRAGM. REFLEX VIEWER. (HA)

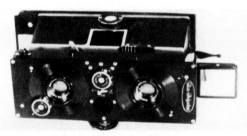

**(3102) POLYSCOP STEREO CAMERA.** C. 1916. SIZE 45 X 107 MM STEREO EXPOSURES ON PLATES. 60 MM/F 6.8 NOVAR LENSES. GUILLOTINE SHUTTER; $\frac{1}{3}$ TO $\frac{1}{250}$ SEC. REFLEX VIEWER. (HA)

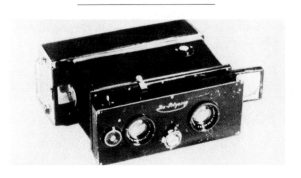

**(3103) POLYSCOP STEREO CAMERA.** C. 1920. SIZE 6 X 13 CM STEREO EXPOSURES ON PLATES. THE MAGAZINE HOLDS 12 PLATES. 75 MM/F 4.5 OR F 6.3 TESSAR LENSES. SHUTTER SPEEDS TO $\frac{1}{150}$ SEC. REFLEX VIEWER. (HA)

## ICA A. G. (*cont.*)

**(3104)  POLYSCOP STEREO CAMERA.** C. 1920. SIZE 6 X 13 CM STEREO EXPOSURES ON PLATES. THE MAGAZINE HOLDS 12 PLATES. 90 MM/F 4.5 TESSAR LENSES. SHUTTER SPEEDS TO 1/150 SEC. (HA)

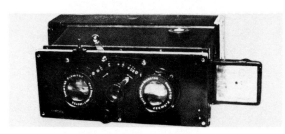

**(3105)  POLYSCOP STEREO CAMERA.** C. 1920. SIZE 6 X 13 CM STEREO EXPOSURES ON PLATES. THE MAGAZINE HOLDS 12 PLATES. 90 MM/F 4.5 TESSAR LENSES. SHUTTER SPEEDS TO 1/150 SEC. (HA)

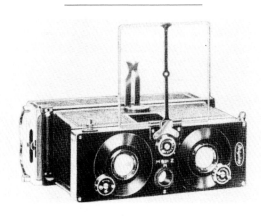

**(3106)  POLYSCOP STEREO CAMERA.** C. 1920. SIZE 6 X 13 CM STEREO EXPOSURES ON PLATES. THE MAGAZINE HOLDS 12 PLATES. 75 MM/F 4.5 TESSAR LENSES. SHUTTER SPEEDS TO 1/150 SEC. REFLEX VIEWER. (HA)

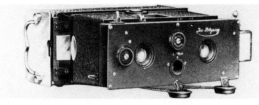

**(3107)  POLYSCOP A STEREO CAMERA.** C. 1920–24. SIZE 45 X 107 MM STEREO EXPOSURES ON PLATES OR FILM PACKS WITH ADAPTER. THE MAGAZINE HOLDS 12 PLATES. F 4.5 OR F 6.3 CARL ZEISS LENSES. COMPUR SHUTTER WITH SPEEDS TO 1/250 SEC.

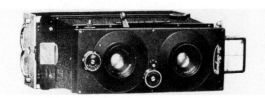

**(3108)  POLYSCOP B STEREO CAMERA.** C. 1924. SIZE 60 X 130 MM STEREO EXPOSURES ON PLATES OR FILM PACKS WITH ADAPTER. F 4.5 CARL ZEISS LENSES. COMPOUND SHUTTER. THE FRONT PANEL CAN BE REPOSITIONED SIDEWAYS TO MAKE PANORAMIC EXPOSURES USING ONE LENS.

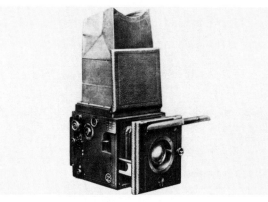

**(3109)  REFLEX CAMERA.** C. 1924. FIVE SIZES OF THIS CAMERA FOR 6.5 X 9, 8.3 X 10.8, 9 X 12, 9 X 14, OR 10 X 15 CM EXPOSURES ON PLATES OR FILM PACKS WITH ADAPTER. F 4.5 CARL ZEISS, ORIX, OR DOMINAR ANASTIGMAT LENS. ALSO, F 6.3 CARL ZEISS TELEPHOTO LENS. FOCAL PLANE SHUTTER; 1/15 TO 1/1000 SEC., T. REVERSIBLE BACK.

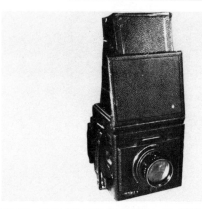

**(3110)  REFLEX 756 CAMERA.** C. 1910. SIZE 9 X 12 CM EXPOSURES ON PLATES. 180 MM/F 3.5 ZEISS TRIOTAR LENS. FOCAL PLANE SHUTTER; 11 TO 1/1000 SEC. (HA)

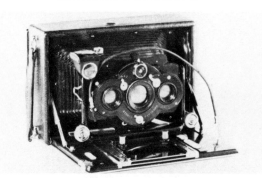

**(3111)  REICA STEREO AND MONO PLATE CAMERA.** C. 1912. SIZE 100 X 150 MM STEREO OR MONO EXPOSURES ON PLATES. 165 MM/F 6.8 HEKLA MONO LENS AND 120 MM/F 6.8 HEKLARE STEREO LENSES. COMPOUND SHUTTER WITH SPEEDS TO 1/150 SEC. RISING AND CROSSING LENS MOUNT. (HA)

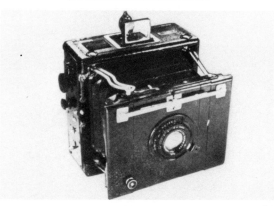

**(3112)  REPORTER CAMERA.** C. 1908. SIZE 9 X 12 CM EXPOSURES ON PLATES. 135 MM/F 6.3 ZEISS TESSAR LENS. FOCAL PLANE SHUTTER WITH SPEEDS TO 1/1000 SEC. (HA)

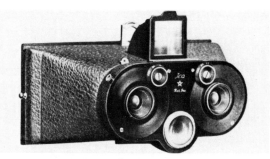

**(3113)  STEREOFIX CAMERA.** C. 1912–24. SIZE 45 X 107 MM STEREO EXPOSURES ON PLATES. THE MAGAZINE HOLDS 12 PLATES. F 6.8 NOVAR LENSES. AUTOMATIC SHUTTER; 1/25 TO 1/100 SEC., B., T. IRIS DIAPHRAGM ON THE LATER MODELS.

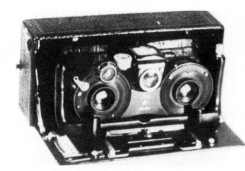

**(3114)  STEREOLETTE STEREO CAMERA.** C. 1911. SIZE 45 X 107 MM STEREO EXPOSURES ON PLATES. 60 MM/F 6.8 ICA NOVAR ANASTIGMAT LENSES. SHUTTER SPEEDS FROM 1/25 TO 1/100 SEC. (HA)

## ICA A. G. (*cont.*)

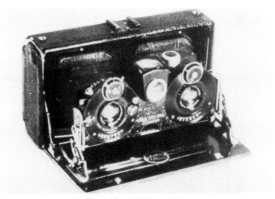

**(3115) STEREOLETTE STEREO CAMERA.** C. 1912. SIZE 45 X 107 MM STEREO EXPOSURES ON PLATES OR FILM PACKS. 65 MM/F 4.5 TESSAR LENSES. COMPUR SHUTTER WITH SPEEDS TO ⅟₂₅₀ SEC. (HA)

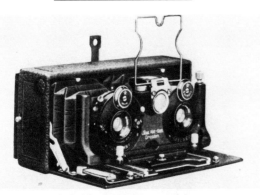

**(3116) STEREOLETTE STEREO CAMERA.** C. 1924. SIZE 45 X 107 MM STEREO EXPOSURES ON PLATES, CUT FILM, OR FILM PACKS. F 6.8 HEKLA ANASTIGMAT, F 4.5 DOMINAR, OR CARL ZEISS; OR F 6.3 CARL ZEISS LENSES. COMPUR SHUTTER; 1 TO ⅟₂₅₀ SEC., B., T. RISING LENS MOUNT. GROUND GLASS BACK.

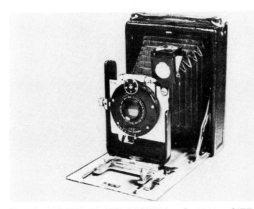

**(3117) TOSKA PLATE CAMERA.** C. 1910. SIZE 9 X 12 CM EXPOSURES ON PLATES. 130 MM/F 8 HELIOS LENS. SHUTTER SPEEDS FROM ⅟₂₅ TO ⅟₁₀₀ SEC. (HA)

**(3118) TRIX CAMERA.** C. 1914. SIZE 9 X 12 CM EXPO-SUREES ON PLATES OR FILM PACKS. 135 MM/F 4.5

ZEISS TESSAR LENS. COMPOUND SHUTTER; 1 TO ⅟₁₅₀ SEC., B., T. GROUND GLASS BACK.

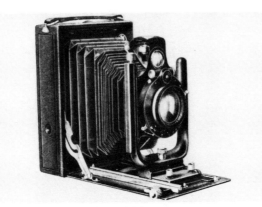

**(3119) TRIX CAMERA. MODEL B.** C. 1924. SIZE 10 X 15 CM EXPOSURES ON PLATES OR FILM PACKS. F 6.8 HEKLA OR CARL ZEISS, F 6.3 CARL ZEISS, OR F 4.5 DOMINAR OR CARL ZEISS LENS. COMPUR SHUT-TER: 1 TO ⅟₂₀₀ SEC., B., T. OR COMPUR SHUTTER; 1 TO ⅟₁₅₀ SEC., B., T. RISING AND CROSSING LENS MOUNT. RACK & PINION FOCUSING. HOODED GROUND GLASS BACK.

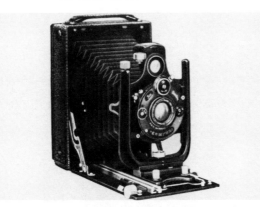

**(3120) TRONA CAMERA.** C. 1924. SIZE 9 X 12 CM EX-POSURES ON PLATES OR FILM PACKS. F 6.8 HEKLA OR CARL ZEISS LENS. ALSO, F 4.5 DOMINAR OR CARL ZEISS OR F 6.3 CARL ZEISS LENS. COMPUR SHUTTER; 1 TO ⅟₂₅₀ SEC., B., T. RACK & PINION FOCUSING. RISING, FALLING, AND CROSSING LENS MOUNT.

**(3121) UNIVERSAL JUWEL CAMERA.** C. 1925. SIZE 9 X 12 CM EXPOSURES ON PLATES OR FILM PACKS. 165 MM/F 4.5 ZEISS TESSAR LENS. COMPUR SHUT-TER; 1 TO ⅟₂₅₀ SEC. ROTATING BACK. DOUBLE EX-TENSION BELLOWS. RISING AND CROSSING LENS MOUNT. (MA)

**(3122) VIEW CAMERA.** C. 1895. SIZE 18 X 23 CM EXPOSURES ON PLATES. DALLMEYER RAPID RECTI-LINEAR LENS. WATERHOUSE STOPS.

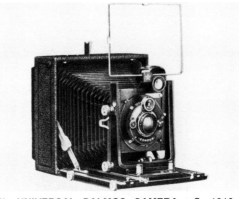

**(3123) UNIVERSAL PALMOS CAMERA.** C. 1910–24. SIZE 9 X 12 CM EXPOSURES ON PLATES OR FILM PACKS. F 4.5 DOMINAR ANASTIGMAT OR CARL ZEISS, OR F 6.8 CARL ZEISS LENS. COMPUR SHUTTER; 1 TO ⅟₁₅₀ SEC., B., T. REVERSIBLE BACK. SWING BACK. DOUBLE EXTENSION BELLOWS. RISING AND CROSS-ING LENS MOUNT. RACK & PINION FOCUSING.

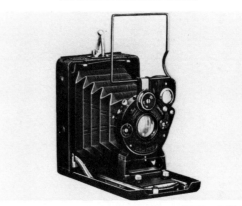

**(3124) VICTRIX CAMERA.** C. 1924. SIZE 4.5 X 6 CM EXPOSURES ON PLATES OR FILM PACKS. F 4.5 OR F 6.3 CARL ZEISS TESSAR: F 4.5 DOMINAR ANASTIG-MAT, OR F 6.8 HEKLA ANASTIGMAT LENS. COMPUR SHUTTER; 1 TO ⅟₃₀₀ SEC., B., T. GROUND GLASS FOCUSING.

## IHAGEE KAMERAWERK

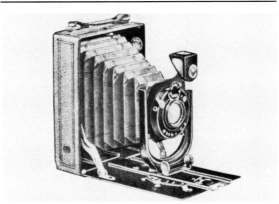

**(3125) AMA CAMERA.** C. 1930. SIZE 9 X 12 CM EXPOSURES ON PLATES OR FILM PACKS. F 11 PERI-SCOPIC; OR 6.8 OR F 6.3 IHAGEE ANASTIGMAT LENS. SHUTTER SPEEDS FROM ⅟₂₅ TO ⅟₁₀₀ SEC., T. FOCUS-ING SCREEN WITH LIGHT HOOD.

## IHAGEE KAMERAWERK (*cont.*)

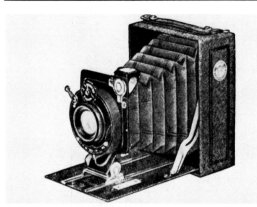

**(3126)  DERBY CAMERA.** C. 1930. SIZE 6.5 X 9 CM EXPOSURES ON PLATES OR FILM PACKS. F 11 PERISCOPIC; F 6.8, F 6.3, OR F 4.5 IHAGEE ANASTIGMAT LENS. FOCUSING SCREEN WITH LIGHT HOOD. SHUTTER SPEEDS FROM ¹⁄₂₅ TO ¹⁄₁₀₀ SEC., T.

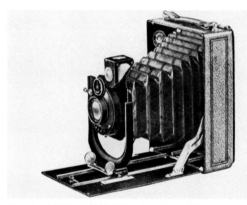

**(3127)  DERBY CAMERA.** C. 1930. SIZE 9 X 12 CM EXPOSURES ON PLATES OR FILM PACKS. F 11 PERISCOPIC, OR F 6.8 OR F 6.3 IHAGEE ANASTIGMAT LENS. FOCUSING SCREEN WITH LIGHT HOOD. SHUTTER SPEEDS FROM ¹⁄₂₅ TO ¹⁄₁₀₀ SEC., T.

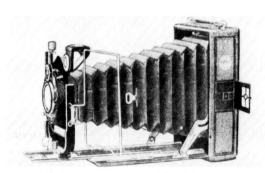

**(3128)  DUPLEX CAMERA. MODELS V, I, AND C.** C. 1930–40. SIZE 6.5 X 9 CM EXPOSURES ON PLATES. DOUBLE EXTENSION BELLOWS. MODEL V: F 6.8, F 6.3, OR F 4.5 IHAGEE ANASTIGMAT, F 6.8 DOUBLE ANASTIGMAT VERAPLAN LENS. AUTOMATIC SHUTTER. MODEL I: F 6.3 OR F 4.5 DOUBLE ANASTIGMAT VERAPLAN LENS. IBSOR SHUTTER. MODEL C: F 4.5 IHAGEE ANASTIGMAT, F 3.5 IHAGEE TRIOPLAN, F 6.8 OR F 4.5 DOUBLE ANASTIGMAT VERAPLAN, OR F 6.3 OR F 4.5 ZEISS TESSAR

LENS; COMPUR SHUTTER. FOCUSING SCREEN WITH LIGHT HOOD.

**(3129)  DUPLEX CAMERA. MODELS V, I, AND C.** C. 1930–40. SIZE 9 X 12 CM EXPOSURES ON PLATES. DOUBLE EXTENSION BELLOWS. MODEL V: F 6.8 OR F 6.3 IHAGEE ANASTIGMAT OR F 6.8 DOUBLE ANASTIGMAT VERAPLAN LENS. AUTOMATIC SHUTTER. MODEL I: F 6.3 OR F 4.5 IHAGEE ANASTIGMAT, F 4.5 IHAGEE DOUBLE ANASTIGMAT, OR F 6.8 DOUBLE ANASTIGMAT VERAPLAN LENS. IBSOR SHUTTER. MODEL C: F 4.5 IHAGEE ANASTIGMAT, F 4.5 IHAGEE DOUBLE ANASTIGMAT, F 3.5 IHAGEE TRIOPLAN, F 6.8 OR F 4.5 DOUBLE ANASTIGMAT VERAPLAN, OR F 6.3 OR F 4.5 ZEISS TESSAR LENS. COMPUR SHUTTER. FOCUSING SCREEN WITH LIGHT HOOD. SIMILAR TO THE DUPLEX 6.5 X 9 CM EXPOSURE MODEL.

**(3130)  DUPLEX CAMERA. MODELS V, I, AND C.** C. 1930. SIZE 10 X 15 CM EXPOSURES ON PLATES. DOUBLE EXTENSION BELLOWS. MODEL V: F 6.8 OR F 6.3 IHAGEE ANASTIGMAT OR F 6.8 DOUBLE ANASTIGMAT VERAPLAN LENS. AUTOMATIC SHUTTER. MODEL I: F 6.8 DOUBLE ANASTIGMAT VERAPLAN LENS. IBSOR SHUTTER. MODEL C: F 4.5 IHAGEE ANASTIGMAT, F 6.8 OR F 4.5 DOUBLE ANASTIGMAT VERAPLAN, OR F 6.3 OR F 4.5 ZEISS TESSAR LENS. COMPUR SHUTTER. FOCUSING SCREEN WITH LIGHT HOOD. SIMILAR TO THE DUPLEX 6.5 X 9 CM EXPOSURE MODEL.

**(3131)  DUPLEX CAMERA. MODELS V, I, AND C.** C. 1930. SIZE 13 X 18 CM EXPOSURES ON PLATES. DOUBLE EXTENSION BELLOWS. MODEL V: F 6.8 DOUBLE ANASTIGMAT VERAPLAN LENS. AUTOMATIC SHUTTER. MODEL I: F 6.8 DOUBLE ANASTIGMAT VERAPLAN LENS. IBSOR SHUTTER. MODEL C: F 6.8 DOUBLE ANASTIGMAT VERAPLAN LENS. COMPUR SHUTTER. FOCUSING SCREEN WITH LIGHT HOOD. SIMILAR TO THE DUPLEX 6.5 X 9 CM EXPOSURE MODEL.

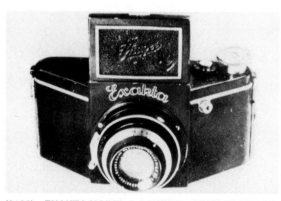

**(3132)  EXAKTA MODEL A CAMERA. SINGLE LENS REFLEX. ORIGINAL MODEL.** INTRODUCED IN 1933. SIZE 4 X 6.5 CM EXPOSURES ON NO. 127 ROLL FILM. 75 MM/F 2.8 ZEISS TESSAR LENS. FOCAL PLANE SHUTTER; ¹⁄₂₅ TO ¹⁄₁₀₀₀ SEC., B., T. KNOB WIND FOR FILM. NO FLASH CAPABILITY.

**(3133)  EXAKTA MODEL B CAMERA. SINGLE-LENS REFLEX.** C. 1934. SIZE 4 X 6.5 CM EXPOSURES ON NO. 127 ROLL FILM. SIMILAR TO THE EXAKTA MODEL A, C. 1934. WITH THE SAME INTERCHANGEABLE LENSES

BUT WITH FOCAL PLANE SHUTTER SPEEDS FROM 12 TO ¹⁄₁₀₀₀ SEC., B., T. KNOB WIND FOR FILM. NO FLASH CAPABILITY.

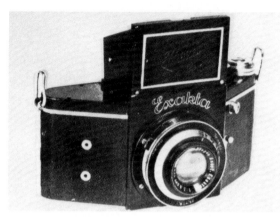

**(3134)  EXAKTA MODEL A CAMERA. SINGLE LENS REFLEX.** C. 1934. SIZE 4 X 6.5 CM EXPOSURES ON NO. 127 ROLL FILM. SAME AS THE ORIGINAL EXAKTA MODEL A BUT WITH FLASH SYNC. AND LEVER FOR SHUTTER COCKING AND FILM ADVANCE.

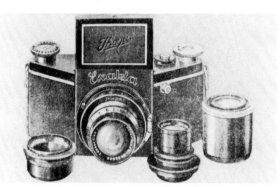

**(3135)  EXAKTA MODEL A CAMERA. SINGLE-LENS REFLEX.** INTRODUCED IN 1934. SIZE 4 X 6.5 CM EXPOSURES ON NO. 127 ROLL FILM. 70 MM/F 3.5 CASSAR, 75 MM/F 2.9 CASSAR, 75 MM/F 3.5 XENAR, 75 MM/F 2.8 XENAR, 75 MM/F 3.5 PRIMOTAR, 75 MM/F 3.5 TESSAR, 75 MM/F 2.8 TESSAR, 80 MM/F 2 XENON OR 80 MM/F 2 BIOTAR LENS. FOCAL PLANE SHUTTER; ¹⁄₂₅ TO ¹⁄₁₀₀₀ SEC., B., T. INTERCHANGEABLE LENSES. KNOB WIND FOR FILM. NO FLASH CAPABILITY.

**(3136)  EXAKTA MODEL B CAMERA. SINGLE-LENS REFLEX.** C. 1935–40. SIZE 4 X 6.5 CM EXPOSURES ON NO. 127 ROLL FILM. SAME AS THE EXAKTA MODEL B OF 1934 EXCEPT WITH FLASH SYNC. AND A LEVER FOR SHUTTER COCKING AND FILM ADVANCE. THE CAMERA HAS A THREE-HOLE FLASH SYNC. AFTER 1937.

**(3137)  EXAKTA MODEL C CAMERA. SINGLE-LENS REFLEX.** C. 1936. SIZE 4 X 6.5 CM EXPOSURES ON NO. 127 ROLL FILM, PLATES, OR CUT FILM. SAME AS THE EXAKTA MODEL B EXCEPT WITH A BACK PLATE ADAPTER FOR PLATES OR CUT FILM.

## IHAGEE KAMERAWERK (cont.)

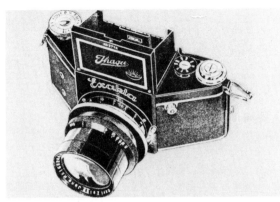

**(3138) NIGHT EXAKTA MODEL B CAMERA. SINGLE-LENS REFLEX.** C. 1935. SIZE 4 X 6.5 CM EXPOSURES ON NO. 127 ROLL FILM. 80 MM/F 2 XENON, 80 MM/F 2 BIOTAR, 80 MM/F 1.9 PRIMOPLAN, OR 75 MM/F 2.8 ZEISS TESSAR LENS. SPECIAL LENS MOUNT. FOCAL PLANE SHUTTER; 12 TO 1/1000 SEC., B., T., ST. FLASH SYNC. LEVER FOR SHUTTER COCKING AND FILM ADVANCE. INTERCHANGEABLE LENSES. SOME MODELS WITH SPECIAL BACK FOR USE WITH PLATE FILM. THREE-HOLE FLASH SYNC. AFTER 1937.

**(3139) EXAKTA JUNIOR CAMERA. SINGLE-LENS REFLEX.** INTRODUCED IN 1934. SIZE 4 X 6.5 CM EXPOSURES ON NO. 127 ROLL FILM. 75 MM/F 4.5 OR F 3.5 IHAGEE ANASTIGMAT LENS. KNOB WIND FOR FILM.

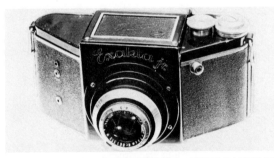

**(3140) EXAKTA JUNIOR CAMERA. SINGLE-LENS REFLEX.** INTRODUCED IN 1937. SIZE 4 X 6.5 CM EXPOSURES ON NO. 127 ROLL FILM. SAME LENSES AS THE EXAKTA JUNIOR, C. 1934. FOCAL PLANE SHUTTER: 1/25 TO 1/500 SEC., B., T. THREE-HOLE FLASH SYNC. LEVER WIND FOR SHUTTER. BLACK FINISH.

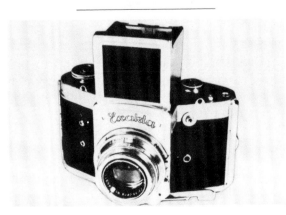

**(3141) "SQUARE" EXAKTA CAMERA. SINGLE-LENS REFLEX.** C. 1937–38. SIZE 6 X 6 CM EXPOSURES ON NO. 120 ROLL FILM. 80 MM/F 3.5 ZEISS TESSAR OR 85 MM/F 3.5 IHAGEE ANASTIGMAT LENS. ALSO, CANTER 75 MM/F 3.5 LENS. FOCAL PLANE SHUTTER; 12 TO 1/1000 SEC., B., T., ST. FLASH SYNC. LEVER WIND FOR FILM. (HA)

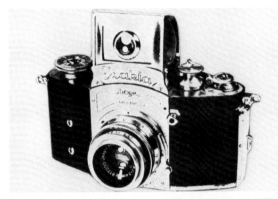

**(3142) STANDARD EXAKTA (KINE EXAKTA) CAMERA. SINGLE-LENS REFLEX.** C. 1935. SIZE 24 X 36 MM EXPOSURES ON "35MM" ROLL FILM. 54 MM/F 3.5 EXAKTAR ANASTIGMAT LENS. FOCAL PLANE SHUTTER; 12 TO 1/1000 SEC., B., T. CHROME TRIM. (HA)

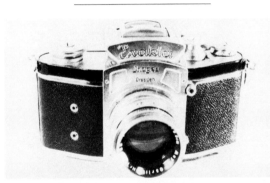

**(3143) STANDARD EXAKTA (KINE EXAKTA) CAMERA. SINGLE-LENS REFLEX.** INTRODUCED IN 1936. SIZE 24 X 36 MM EXPOSURES ON "35MM" ROLL FILM. 50 TO 58 MM, F 1.9 TO F 3.5 ZEISS, MEYER, SCHNEIDER, AND IHAGEE LENSES. FOCAL PLANE SHUTTER; 12 TO 1/1000 SEC., B., T., ST. INTERCHANGEABLE LENSES. FLASH SYNC. LEVER WIND FOR FILM. FILM CUTTING DEVICE. CHROME TRIM. (TS)

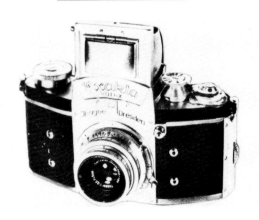

**(3144) EXAKTA VAREX CAMERA. SINGLE-LENS REFLEX.** C. 1938. SIZE 24 X 36 MM EXPOSURES ON "35MM" ROLL FILM. 50 MM/F 3.5 ZEISS TESSAR LENS. FOCAL PLANE SHUTTER; 12 TO 1/1000 SEC., B., T., ST. LEVER WIND FOR FILM. CHROME FINISH. (HA)

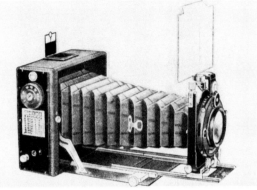

**(3145) FOCAL PLANE DUPLEX CAMERA.** C. 1930. THREE SIZES OF THIS CAMERA FOR 6.5 X 9, 9 X 12, OR 10 X 15 CM EXPOSURES ON PLATES OR FILM PACKS. DOUBLE EXTENSION BELLOWS. F 4.5 IHAGEE ANASTIGMAT, MEYER DOUBLE ANASTIGMAT VERAPLAN, OR ZEISS TESSAR LENS. ALSO, F 3.5 IHAGEE TRIOPLAN OR ZEISS TESSAR LENSES. DOUBLE SHUTTER SYSTEM. FOCAL PLANE SHUTTER; 1/15 TO 1/1000 SEC. PLUS FRONT SHUTTER FOR SLOWER SPEEDS TO ONE-SECOND. FOCUSING SCREEN WITH LIGHT HOOD. MODEL I: IBSOR SHUTTER. MODEL C: COMPUR SHUTTER AND FOCAL PLANE SHUTTER COMBINATION ONLY.

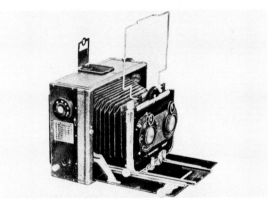

**(3146) FOCAL PLANE STEREO CAMERA.** C. 1930 MODELS V, I, AND C. DUAL-SHUTTER CAMERA. SIZE 10 X 15 CM EXPOSURES ON PLATES OR FILM PACKS. MODEL V: F 6.3 IHAGEE ANASTIGMAT LENS WITH FOCAL PLANE SHUTTER AND SERIES V SHUTTER. MODEL I: F 6.3 IHAGEE ANASTIGMAT LENS WITH FOCAL PLANE SHUTTER AND IBSOR SHUTTER. MODEL C: F 4.5 MEYER DOUBLE ANASTIGMAT VERAPLAN OR ZEISS TESSAR LENS WITH FOCAL PLANE SHUTTER AND COMPUR SHUTTER. FOCAL PLANE SHUTTER SPEEDS; 1/15 TO 1/1000 SEC., B., T. WOODEN BODY.

**(3147) FOLDING STRUT CAMERA.** C. 1925. SIZE 4.5 X 6 CM EXPOSURES ON PLATES. 65 MM/F 6.3 IHAGEE ANASTIGMAT LENS. PRONTO SHUTTER; 1/25 TO 1/100 SEC. (MA)

## IHAGEE KAMERAWERK (*cont.*)

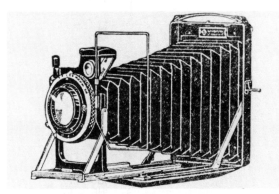

**(3148) KAWEE FOLDING PLATE CAMERA.** C. 1932. TWO SIZES OF THIS CAMERA FOR 6.5 X 9 OR 9 X 12 CM EXPOSURES ON PLATES OR FILM PACKS. F 4.5 ZEISS TESSAR, F 4.5 MEYER TRIO-PLANE, F 3.9 SCHNEIDER XENAR, OR F 4.5 SCHNEIDER RADIONAR LENS. COMPUR OR PRONTO SHUTTER. BOTH WITH SELF-TIMER. DOUBLE EXTENSION BELLOWS. RACK & PINION FOCUSING. RISING LENS MOUNT. THE CAMERA IS VERY THIN WHEN CLOSED.

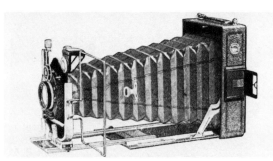

**(3149) LUXUS DUPLEX CAMERA.** C. 1930. THREE SIZES OF THIS CAMERA FOR 6.5 X 9, 9 X 12, OR 10 X 15 CM EXPOSURES ON PLATES OR FILM PACKS. F 4.5 IHAGEE ANASTIGMAT, F 3.5 IHAGEE TRIOPLAN, F 4.5 MEYER DOUBLE ANASTIGMAT VERAPLAN, OR F 4.5 ZEISS TESSAR LENS. COMPUR SHUTTER. DOUBLE EXTENSION BELLOWS. FOCUSING SCREEN WITH LIGHT HOOD.

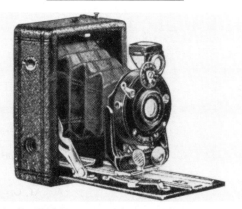

**(3150) MIKROBIE VEST POCKET CAMERA.** MODELS V AND C. C. 1930. SIZE 4.5 X 6 CM EXPOSURES ON PLATES OR FILM PACKS. MODEL V: F 6.8 IHAGEE ANASTIGMAT OR DOUBLE ANASTIGMAT VERAPLAN LENS WITH AUTOMATIC SERIES V SHUTTER. MODEL C: F 6.8 OR F 4.5 DOUBLE ANASTIGMAT LENS WITH COMPUR SHUTTER.

---

**(3151) LUXUS DUPLEX CAMERA.** C. 1930. SIZE 13 X 18 CM EXPOSURES ON PLATES OR FILM PACKS. F 4.5 MEYER DOUBLE ANASTIGMAT VERAPLAN OR F 4.5 ZEISS TESSAR LENS. COMPUR SHUTTER. DOUBLE EXTENSION BELLOWS. FOCUSING-SCREEN WITH LIGHT HOOD.

---

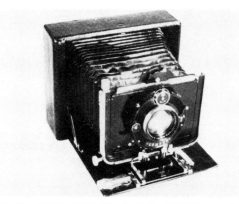

**(3152) MONO-STEREO PLATE CAMERA.** C. 1927. SIZE 10 X 15 CM MONO OR STEREO EXPOSURES ON PLATES. 165 MM/F 4.5 RODENSTOCK EURYNER LENS. COMPUR SHUTTER WITH SPEEDS TO 1/200 SEC. (HA)

---

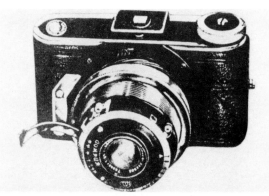

**(3153) PARVOLA CAMERA.** C. 1931. SIZE 3 X 4 CM EXPOSURES ON NO. 127 ROLL FILM. F 6.3, F 4.5, OR F 3.5 IHAGEE ANASTIGMAT; F 3.5 PRIMOTAR; F 4.5, F 3.5, F 2.9, OR F 2 SCHNEIDER XENAR; F 4.5, F 3.5, OR F 2.8 ZEISS TESSAR; OR F 2 BIOTAR LENS. PROTAR I SHUTTER TO 1/125 SEC. PROTAR II SHUTTER TO 1/150 SEC. COMPUR SHUTTER TO 1/300 SEC., OR COMPUR RAPID SHUTTER TO 1/500 SEC. ALL SHUTTERS WITH BULB AND TIME. HELICAL FOCUSING.

---

**(3154) PARVOLA CAMERA.** C. 1931. SIZE 4 X 6.5 CM EXPOSURES ON ROLL FILM. SAME LENSES (EXCEPT THE F 2.9 XENAR, F 2 XENON, AND F 2 BIOTAR LENSES) AND SHUTTERS AS THE PARVOLA 3 X 4 CM EXPOSURE MODEL.

---

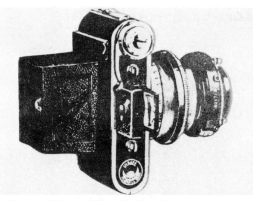

**(3155) PARVOLA ROLL FILM AND PLATE CAMERA.** C. 1931. SIZE 3 X 4 CM OR 4 X 6.5 CM EXPOSURES ON ROLL FILM AND 4 X 6.5 CM EXPOSURES ON PLATES. SAME LENSES (EXCEPT THE F 2.9 XENAR, F 2 XENON AND F 2 BIOTAR LENSES) AND SHUTTERS AS THE PARVOLA 3 X 4 CM EXPOSURE MODEL.

---

**(3156) PARVOLA A CAMERA.** C. 1939. SIZE 4 X 6.5 CM EXPOSURES ON NO. 127 ROLL FILM. F 3.5 IHAGEE ANASTIGMAT, F 3.5 ZEISS TESSAR OR F 2 SCHNEIDER XENON LENS. COMPUR SHUTTER; 1 TO 1/200 SEC., B., T., ST., OR COMPUR RAPID SHUTTER; 1 TO 1/500 SEC., B., T., ST.

---

**(3157) PARVOLA C CAMERA.** C. 1939. SIZE 4 X 6.5 CM EXPOSURES (3 X 4 CM EXPOSURES WITH MASK) ON NO. 127 ROLL FILM. 75 MM/F 2.8 OR F 3.5 ZEISS TESSAR OR F 3.5 IHAGEE ANASTIGMAT LENS. COMPUR SHUTTER TO 1/300 SEC. OR COMPUR RAPID SHUTTER; 1 TO 1/400 SEC., B., T., ST. DOUBLE EXTENSION BELLOWS.

---

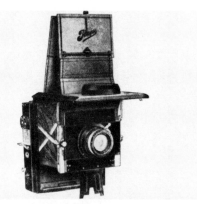

**(3158) PATENT FOLDING REFLEX CAMERA. SINGLE-LENS REFLEX.** C. 1925–30. THREE SIZES OF THIS CAMERA FOR 6.5 X 9, 9 X 12, OR 10 X 15 CM EXPOSURES ON PLATES OR FILM PACKS. F 4.5 MEYER DOUBLE ANASTIGMAT VERAPLAN, MEYER PLASMAT, OR ZEISS TESSAR LENS. FOCAL PLANE SHUTTER (SELF-CAPPING); 1/15 TO 1/1000 SEC., T.

## IHAGEE KAMERAWERK (*cont.*)

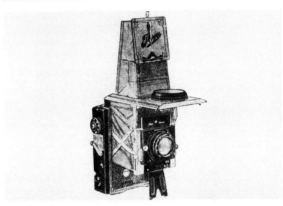

(3159) **PATENT FOLDING REFLEX REVOLVING BACK CAMERA.** C. 1925–30. TWO SIZES OF THIS CAMERA FOR 6.5 X 9 OR 9 X 12 CM EXPOSURES ON PLATES OR FILM PACKS. F 4.5 MEYER DOUBLE ANASTIGMAT VERAPLAN, MEYER PLASMAT, OR ZEISS TESSAR LENS. FOCAL PLANE SHUTTER (SELF-CAPPING); 1/5 TO 1/1000 SEC., T.

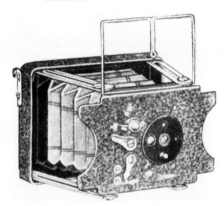

(3160) **PHOTOKNIPS CAMERA. MODEL A.** C. 1930. SIZE 4.5 X 6 CM EXPOSURES ON PLATES OR FILM PACKS. ALUMINUM BODY. IHAGEE ACHROMATIC LENS. SHUTTER SPEEDS FROM 1/25 TO 1/100 SEC., T.

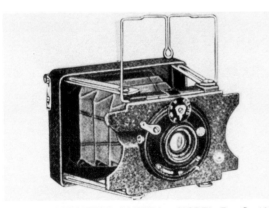

(3161) **PHOTOKNIPS CAMERA. MODEL B.** C. 1930. SIZE 4.5 X 6 CM EXPOSURES ON PLATES OR FILM PACKS. ALUMINUM BODY. IHAGEE ANASTIGMAT LENS. SHUTTER SPEEDS FROM 1/25 TO 1/100 SEC., T.

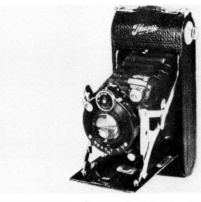

(3162) **PIONIER AUTOMAT CAMERA.** C. 1934. SIZE 6 X 9 CM EXPOSURES ON ROLL FILM. 105 MM/F 4.5 IHAGEE ANASTIGMAT LENS. ZENITH SHUTTER; 1/25 TO 1/100 SEC. (HA)

(3163) **PIONIER AUTOMAT CAMERA.** C. 1936. SIZE 6 X 9 CM EXPOSURES ON ROLL FILM. 105 MM/F 4.5 IHAGEE ANASTIGMAT LENS. PRONTO SHUTTER; 1/25 TO 1/100 SEC. (HA)

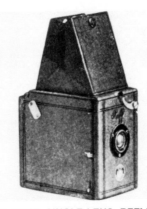

(3164) **PLAN PAFF SINGLE-LENS REFLEX CAMERA.** C. 1921–30. TWO SIZES OF THIS CAMERA FOR 4.5 X 6 OR 6.5 X 9 CM EXPOSURES ON FILM PACKS OR PLATES. F 6.8 MENISCUS, ACHROMATIC, MEYER-GOERLITZ ANASTIGMAT, OR TRIOPLAN ANASTIGMAT LENS. INSTANT AND TIME SHUTTER.

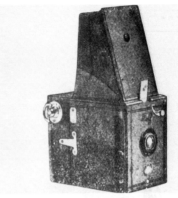

(3165) **ROLL PAFF SINGLE-LENS REFLEX CAMERA.** C. 1921–30. SIZE 6 X 6 CM EXPOSURES ON NO. 117 ROLL FILM. F 6.8 MENISCUS, ACHROMATIC, MEYER-GOERLITZ ANASTIGMAT, OR TRIOPLAN ANASTIGMAT LENS. INSTANT AND TIME SHUTTER.

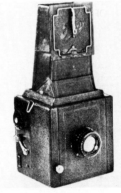

(3166) **SERIEN REFLEX CAMERA. SINGLE-LENS REFLEX.** C. 1920. SIZE 6.5 X 9 CM EXPOSURES ON PLATES. 120 MM/F 4.5 VERAPLAN LENS. FOCAL PLANE SHUTTER; 1/15 TO 1/100 SEC. (HA)

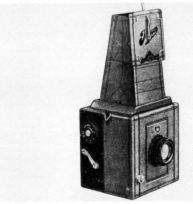

(3167) **SERIEN REFLEX CAMERA. SINGLE-LENS REFLEX.** C. 1930. TWO SIZES OF THIS CAMERA FOR 6.5 X 9 OR 9 X 12 CM EXPOSURES ON PLATES OR FILM PACKS. WOODEN BODY. ROTATING GROUND-GLASS FRAME. F 4.5 IHAGEE ANASTIGMAT, MEYER DOUBLE ANASTIGMAT VERAPLAN, MEYER PLASMAT, OR ZEISS TESSAR LENS. ALSO, F 3.5 IHAGEE TRIOPLAN OR ZEISS TESSAR LENS. FOCAL PLANE SHUTTER (SELF-CAPPING); 1/15 TO 1/1000 SEC., B., T.

## IHAGEE KAMERAWERK (*cont.*)

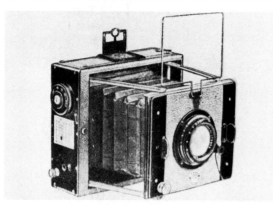

**(3168) SPORT CAMERA.** C. 1930. SIZE 9 X 12 CM EXPOSURES ON PLATES OR FILM PACKS. WOODEN BODY. F 4.5 IHAGEE ANASTIGMAT, MEYER DOUBLE ANASTIGMAT VERAPLAN, MEYER PLASMAT, OR ZEISS TESSAR LENS. ALSO, F 3.5 IHAGEE TRIOPLAN OR ZEISS TESSAR LENS. FOCAL PLANE SHUTTER (SELF-CAPPING); ¹⁄₁₅ TO ¹⁄₁₀₀₀ SEC., B., T.

**(3169) STEREO CAMERA.** C. 1920. SIZE 8 X 14 CM STEREO EXPOSURES ON ROLL FILM. 80 MM/F 6.3 TRIOPLAN ANASTIGMAT LENSES. PRONTO SHUTTER; ¹⁄₂₅ TO ¹⁄₁₀₀ SEC. SIMILAR TO THE ULTRIX STEREO CAMERA (C. 1930).

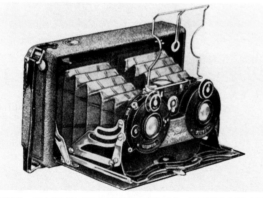

**(3170) STEREO AUTOMAT CAMERA. MODELS V AND C.** C. 1930. SIZE 6 X 13 CM EXPOSURES ON PLATES OR ROLL FILM. MODEL V: F 6.8 IHAGEE ANASTIGMAT LENS AND AUTOMATIC SERIES V SHUTTER. MODEL C: F 6.3 ZEISS TRIOTAR OR ZEISS TESSAR OR F 4.5 MEYER DOUBLE ANASTIGMAT VERAPLAN LENS. COMPUR SHUTTER. FOCUSING SCREEN WITH LIGHT HOOD.

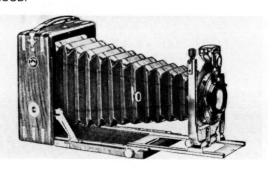

**(3171) TROPEN NEUGOLD TROPICAL CAMERA.** C. 1930. THREE SIZES OF THIS CAMERA FOR 6.5 X 9, 9 X 12, OR 10 X 15 CM EXPOSURES ON PLATES OR FILM PACKS. F 4.5 IHAGEE ANASTIGMAT, MEYER DOUBLE ANASTIGMAT VERAPLAN, OR ZEISS TESSAR LENS. ALSO, F 6.8 MEYER DOUBLE ANASTIGMAT VERAPLAN OR F 3.5 IHAGEE TRIOPLAN LENS. COMPUR SHUTTER. DOUBLE EXTENSION BELLOWS. TEAKWOOD BODY. FOCUSING SCREEN WITH LIGHT HOOD.

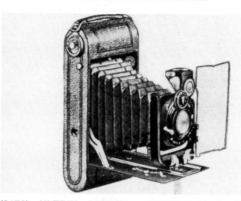

**(3172) ULTRIX CAMERA. MODELS V, I, AND C.** C. 1930. FIVE SIZES OF THIS CAMERA FOR 6 X 9, 6.5 X 11, 8 X 10.5, 7.5 X 12.5, OR 8 X 14 CM EXPOSURES ON ROLL FILM. F 6.8, F 6.3, OR F 4.5 IHAGEE ANASTIGMAT; F 6.8 DOUBLE ANASTIGMAT VERAPLAN; OR F 6.3 OR F 4.5 ZEISS TESSAR LENS. MODEL V: AUTOMATIC SHUTTER. MODEL I: IBSOR SHUTTER. MODEL C: COMPUR SHUTTER.

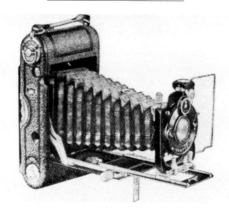

**(3173) ULTRIX DUPLEX CAMERA. MODELS V, I, AND C.** C. 1930. SIZE 6 X 9 CM EXPOSURES ON ROLL FILM OR 6.5 X 9 CM EXPOSURES ON PLATES. SAME LENSES AND SHUTTERS AS THE ULTRIX CAMERA, C. 1930, BUT AN F 4.5 DOUBLE ANASTIGMAT LENS WAS ALSO AVAILABLE. DOUBLE EXTENSION BELLOWS.

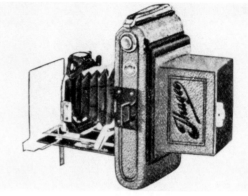

**(3174) ULTRIX ROLL FILM AND PLATE CAMERA. MODELS V, I, AND C.** C. 1930. SIZE 6 X 9 CM EXPOSURES ON ROLL FILM OR 6.5 X 9 CM EXPOSURES ON PLATES. GROUND GLASS FOCUSING. SAME LENSES AND SHUTTERS AS THE ULTRIX CAMERA, C. 1930.

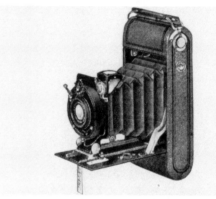

**(3175) ULTRIX SIMPLEX CAMERA.** C. 1930. TWO SIZES OF THIS CAMERA FOR 6 X 9 OR 6.5 X 11 CM EXPOSURES ON ROLL FILM. F 11 PERISCOPIC LENS. ALSO, F 6.8, F 6.3, OR F 4.5 IHAGEE ANASTIGMAT LENS. SHUTTER SPEEDS FROM ¹⁄₂₅ TO ¹⁄₁₀₀ SEC., T.

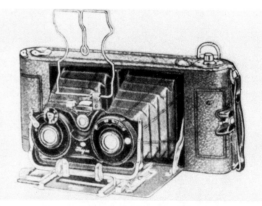

**(3176) ULTRIX STEREO CAMERA. MODELS V AND C.** C. 1930. SIZE 7.25 X 12.5 CM EXPOSURES ON ROLL FILM. MODEL V: F 6.8 IHAGEE ANASTIGMAT LENS AND AUTOMATIC SERIES V SHUTTER. MODEL C: F 4.5 MEYER DOUBLE ANASTIGMAT VERAPLAN OR F 6.3 ZEISS TRIOTAR OR ZEISS TESSAR LENS WITH COMPUR SHUTTER.

## IHAGEE KAMERAWERK (cont.)

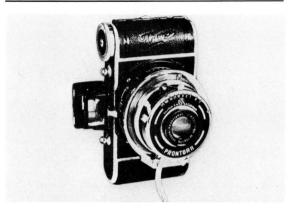

**(3177) AUTO ULTRIX CAMERA.** C. 1931. SIZE 4 X 6.5 CM EXPOSURES ON ROLL FILM. 70 MM/F 4.5 ANASTIGMAT LENS. PRONTOR II SHUTTER; 1 TO 1/175 SEC., B., T. HELICAL FOCUSING. (HA)

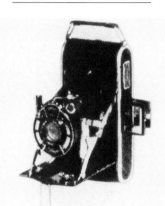

**(3178) AUTO ULTRIX CAMERA.** C. 1940. SIZE 6 X 9 CM EXPOSURES ON NO. 120 ROLL FILM. F 4.5 OR F 3.8 IHAGEE ANASTIGMAT OR F 4.5 ZEIS TESSAR LENS. ZENITH SHUTTER; 1/25 TO 1/100 SEC., PRONTOR I SHUTTER; 1 TO 1/125 SEC., B., T., PRONTOR II SHUTTER; 1 TO 1/150 SEC., B., T., OR COMPUR SHUTTER; 1 TO 1/250 SEC., B., T., ST. HELICAL FOCUSING.

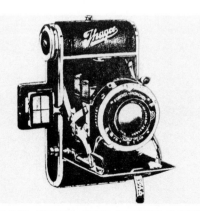

**(3179) AUTO ULTRIX VEST POCKET CAMERA.** C. 1931–40. SIZE 4 X 6.5 CM EXPOSURES ON NO. 127 ROLL FILM. F 4.5 IHAGEE ANASTIGMAT OR XENAR; OR F 3.5 IHAGEE ANASTIGMAT, PRIMOTAR, XENAR, OR TESSAR LENS. COMPUR SHUTTER (1 TO 1/300

SEC., B., T.) OR COMPUR RAPID SHUTTER (1 TO 1/500 SEC., B., T.). ALSO, PRONTOR SHUTTER; 1/25 TO 1/125 SEC. SOME SHUTTER WITH ST.

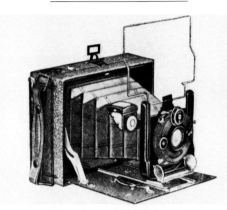

**(3180) VENUS CAMERA. MODELS V, I, AND C.** C. 1930. SIZE 6.5 X 9 CM EXPOSURES ON PLATES OR FILM PACKS. MODEL V: F 6.8, F 6.3, OR F 4.5 IHAGEE ANASTIGMAT; OR F 6.8 DOUBLE ANASTIGMAT VERAPLAN LENS; AUTOMATIC SHUTTER. MODEL I: F 6.3 OR F 4.5 IHAGEE ANASTIGMAT; OR F 6.8 DOUBLE ANASTIGMAT LENS. IBSOR SHUTTER. MODEL C: F 4.5 IHAGEE ANASTIGMAT; F 6.8 OR F 4.5 DOUBLE ANASTIGMAT; OR F 6.3 ZEISS TESSAR LENS. COMPUR SHUTTER.

**(3181) VENUS FOLDING PLATE CAMERA.** C. 1940. SIZE 6 X 9 CM EXPOSURES ON PLATES, FILM PACKS, OR CUT FILM WITH ADAPTER. 105 MM/F 4.5 ZEISS TESSAR LENS. COMPUR SHUTTER; 1 TO 1/250 SEC., B., T., ST. DOUBLE EXTENSION BELLOWS. RISING FRONT.

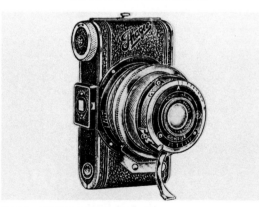

**(3182) VEST POCKET CAMERA.** C. 1932. SIZE 4 X 6.5 CM EXPOSURES ON ROLL FILM. F 4.5 IHAGEE ANASTIGMAT OR F 3.5 ZEISS TESSAR LENS. COMPUR SHUTTER. HELICAL FOCUSING VIA GEARED METAL BELLOWS.

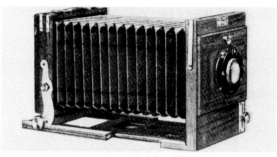

**(3183) CORONA VIEW CAMERA.** C. 1930. FOUR SIZES OF THIS CAMERA FOR 10 X 15, 12 X 16.5, 13 X 18, OR 18 X 24 CM EXPOSURES ON PLATES OR FILM PACKS. F 6.8, F 5.4, OR F 4.5 MEYER DOUBLE ANASTIGMAT VERAPLAN LENS. COMPUR SHUTTER. MAHOGANY BODY. DOUBLE EXTENSION BELLOWS. TILTING FOCUSING SCREEN FRAME.

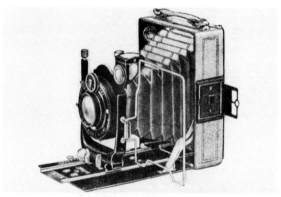

**(3184) VIKTOR CAMERA. MODELS V AND I.** C. 1930. THREE SIZES OF THIS CAMERA FOR 6.5 X 9, 9 X 12, OR 10 X 15 CM EXPOSURES ON PLATES OR FILM PACKS. MODEL V: F 11 PERISCOPIC; F 6.8, F 6.3, OR F 4.5 IHAGEE ANASTIGMAT; OR F 6.8 DOUBLE ANASTIGMAT VERAPLAN LENS. AUTOMATIC SHUTTER. MODEL I: F 6.3 OR F 4.5 IHAGEE ANASTIGMAT OR F 6.8 DOUBLE ANASTIGMAT LENS. IBSOR SHUTTER. FOCUSING SCREEN WITH LIGHT HOOD.

**(3185) ZODEL STEREO ROLL FILM CAMERA.** C. 1925. SIZE 60 X 130 MM STEREO EXPOSURES. F 4.5 ZODELLAR CONVERTIBLE ANASTIGMAT LENS. COMPUR SHUTTER; 1 TO 1/250 SEC. RACK & PINION FOCUSING.

## JUNKA-WERK

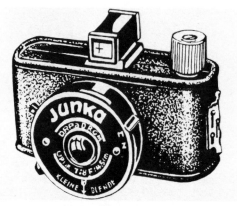

(3186) **JUNKA ROLL FILM CAMERA.** C. 1937. SIZE 28 X 38 MM EXPOSURES ON ROLL FILM. 45 MM/F 8 LENS. INSTANT AND TIME SHUTTER.

## KAMERA-WERKSTÄTTEN, GUTHE & THORSCH

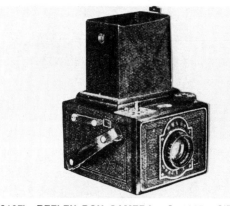

(3187) **REFLEX BOX CAMERA.** C. 1935. SIZE 6 X 9 CM EXPOSURES ON ROLL FILM. F 4.5 OR F 6.3 STEIN-HEIL ANASTIGMAT LENS. METAL-SLIT SHUTTER; 1/25 TO 1/100 SEC., B., T. EXTERNAL KNOB FOR FOCUSING. IRIS DIAPHRAGM OR ROTATING APERTURE STOPS.

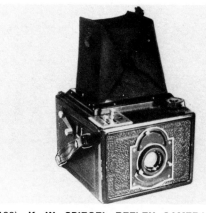

(3188) **K. W. SPIEGEL REFLEX CAMERA.** C. 1932. SIZE 6 X 9 CM EXPOSURES ON ROLL FILM. F 6.3 OR F 4.5 ENATAR LENS. SHUTTER SPEEDS FROM 1/25 TO 1/100 SEC. (HA)

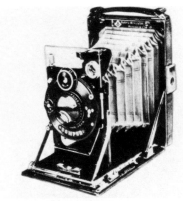

(3189) **PATENT-ETUI CAMERA.** C. 1929–34. TWO SIZES OF THIS CAMERA FOR 6.5 X 9 OR 9 X 12 CM EXPOSURES ON PLATES OR FILM PACKS. F 4.5 OR F 6.3 ZEISS TESSAR OR F 4.5 SCHNEIDER XENAR LENS. DIAL-SET COMPUR SHUTTER; 1 TO 1/250 SEC., B., T. OR RIM-SET COMPUR SHUTTER; 1 TO 1/250 SEC., B., T. ALSO, VARIO OR IBSOR SHUTTERS. (HA)

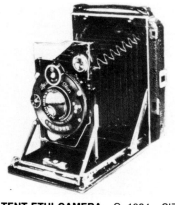

(3190) **PATENT-ETUI CAMERA.** C. 1934. SIZE 6.5 X 9 CM EXPOSURES ON PLATES OR FILM PACKS. RANGE-FINDER WITH COUPLED METER SCALE. SAME LENSES AND SHUTTERS AS THE PATENT-ETUI CAMERA, C. 1929–34. (HA)

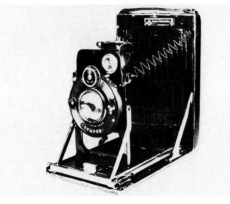

(3191) **PATENT-ETUI CAMERA.** C. 1935. SIZE 9 X 12 CM EXPOSURES ON PLATES OR FILM PACKS. 135 MM/ F 4.5 SCHNEIDER DOPPEL-ANASTIGMAT JACONAR LENS. DIAL-SET COMPUR SHUTTER; 1 TO 1/200 SEC., B., T. (HA)

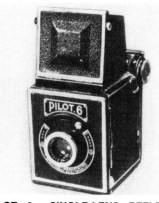

(3192) **PILOT 6. SINGLE-LENS REFLEX CAMERA.** C. 1935–39. SIZE 6 X 6 CM EXPOSURES ON ROLL FILM. 75 MM/F 3.5, F 4.5, OR F 6.3 K. W. ANASTIGMAT LENS. METAL FOCAL PLANE SHUTTER; 1/25, 1/50, 1/100 SEC., B., T. EYE-LEVEL WIRE-FRAME FINDER AND REFLEX FOCUSING. SOME MODELS WITH SHUTTER SPEEDS TO 1/200 SEC. (HA)

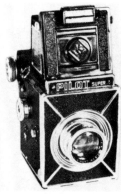

(3193) **PILOT SUPER REFLEX CAMERA.** C. 1938–39. SIZE 6 X 6 EXPOSURES (3 X 6 CM WITH MASK) ON NO. 120 ROLL FILM. 75 MM/F 2.9 PILOTAR LENS. ALSO, F 2.9, F 3.5, OR F 4.5 K. W. ANASTIGMAT LENS. INTERCHANGEABLE LENSES. METAL FOCAL PLANE SHUTTER; 1/20 TO 1/200 SEC. BUILT-IN EXPOSURE METER. (HA)

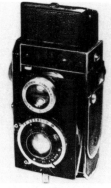

(3194) **PILOT TWIN-LENS REFLEX CAMERA.** C. 1931–35. SIZE 3 X 4 CM EXPOSURES ON NO. 127 ROLL FILM. F 3.5 MEYER PRIMOTOR, F 2.9 SCHNEIDER XENAR, F 2.8 OR F 3.5 ZEISS TESSAR, OR F 2 ANASTIGMAT LENS. COMPUR SHUTTER; 1 TO 1/300 SEC., B., T. (HA)

## KAMERA-WERKSTÄTTEN, GUTHE & THORSCH (*cont.*)

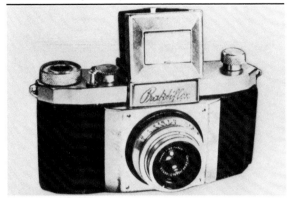

(3195) **PRACTIFLEX CAMERA.** C. 1939. SIZE 24 X 36 MM EXPOSURES ON "35MM" ROLL FILM. 50 MM/F 3.5 ZEISS TESSAR LENS. FOCAL PLANE SHUTTER; ½₅ TO ¹⁄₅₀₀ SEC. (HA)

## KENNGOTT, W.

(3196) **PHOENIX TROPICAL CAMERA.** C. 1924. SIZE 9 X 14 CM EXPOSURES. 165 MM/F 6.8 BUSCH LEUKAR ANASTIGMAT LENS. COMPOUND SHUTTER; 1 TO ¹⁄₁₀₀ SEC. RISING AND CROSSING LENS MOUNT. DOUBLE EXTENSION BELLOWS. LEMON WOOD BODY. (IH)

## KOCHMANN, FRANZ

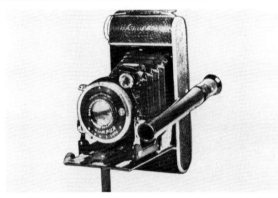

(3197) **ENOLDE CAMERA.** C. 1928–30. SIZE 6 X 9 CM EXPOSURES ON ROLL FILM. 105 MM/F 4.5 ZEISS TESSAR OR ENOLDE ANASTIGMAT LENS. THREE-SPEED SHUTTER. RACK & PINION FOCUSING. (HA)

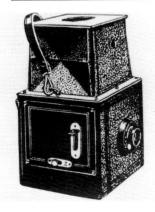

(3198) **ENOLDE SPIEGEL REFLEX CAMERA.** C. 1924. SIZE 9 X 12 CM EXPOSURES ON PLATES.

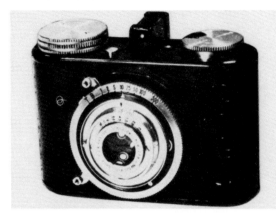

(3199) **KORELLE CAMERA.** C. 1932. SIZE 18 X 24 MM EXPOSURES ON ROLL FILM. 100 EXPOSURES ON EACH ROLL OF FILM. 35 MM/F 2.9 SCHNEIDER XENAR LENS. COMPUR SHUTTER WITH SPEEDS TO ¹⁄₃₀₀ SEC. (HA)

(3200) **KORELLE FOLDING CAMERA.** C. 1925. SIZE 3 X 4 CM EXPOSURES ON NO. 127 ROLL FILM. 50 MM/F 3.5 RADIONAR LENS.

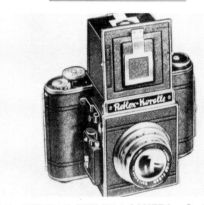

(3201) **KORELLE REFLEX I CAMERA.** C. 1933. SIZE 6 X 6 CM EXPOSURES ON NO. 120 OR B-2 ROLL FILM. F 3.5 SCHNEIDER VICTAR, F 2.9 SCHNEIDER RADIONAR, F 3.5 CASSAR, OR F 2.8 ZEISS TESSAR LENS. FOCAL PLANE SHUTTER; ½₅ TO ¹⁄₅₀₀ SEC., B. INTERCHANGEABLE LENSES. AUTOMATIC FILM TRANSPORT.

(3202) **KORELLE REFLEX II CAMERA.** C. 1936. SIZE 6 X 6 CM EXPOSURES ON NO. 120 OR B-2 ROLL FILM. SIMILAR TO THE KORELLE REFLEX I CAMERA WITH THE SAME LENSES BUT THE SHUTTER HAS A SELF-TIMER AND SPEEDS OF 2 TO ¹⁄₅₀₀ SEC. WITH A LEVER FILM WINDER.

(3203) **KORELLE REFLEX III CAMERA.** C. 1939. SIZE 6 X 6 CM EXPOSURES ON NO. 120 OR B-2 ROLL FILM. SIMILAR TO THE KORELLE REFLEX I CAMERA WITH THE SAME LENSES BUT THE SHUTTER HAS A SELF-TIMER WITH SPEEDS FROM 2 TO ¹⁄₁₀₀₀ SEC. AND THE BODY HAS HEAVIER CHROME TRIM.

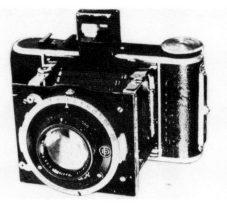

(3204) **KORELLE ROLL FILM CAMERA.** C. 1930. SIZE 4 X 6 CM EXPOSURES. 75 MM/F 2.9 SCHNEIDER RADIONAR LENS. COMPUR SHUTTER; 1 TO ¹⁄₂₅₀ SEC., B., T. (HA)

(3205) **KORELLE STRUT CAMERA.** C. 1930. SIZE 3 X 4.5 CM EXPOSURES ON NO. 120 ROLL FILM. F 2.8 XENAR LENS. COMPUR RAPID SHUTTER; 1 TO ¹⁄₄₀₀ SEC.

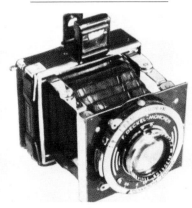

(3206) **KORELLE-P CAMERA.** C. 1934. SIZE 4.5 X 6 CM EXPOSURES ON PLATES OR FILM PACKS. 75 MM /F 2.9, F 3.5, OR F 4.5 ENOLDAR ANASTIGMAT; 75 MM /F 2.9, F 3.5, OR F 4.5 SCHNEIDER RADIONAR; 75 MM /F 2.9, F 3.5, OR F 4.5 XENAR; 75 MM/F 2.9 OR 3.5 STEINHEIL CASSAR; OR 75 MM/F 2.9, F 3.5, OR F 4.5 ZEISS TESSAR LENS. VARIO, PRONTO S, IBSOR, OR COMPUR S SHUTTER. (HA)

## KODAK A. G.

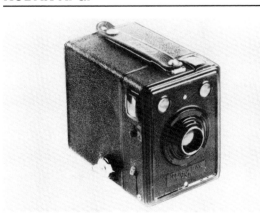

## KODAK A. G. (*cont.*)

**(3207) BOX 620 CAMERA.** C. 1936–39. SIZE 6 X 9 CM EXPOSURES ON NO. 620 ROLL FILM. MENISCUS LENS. SINGLE-SPEED AND TIME SHUTTER. THE BOX 620B CAMERA HAS NICKEL TRIM.

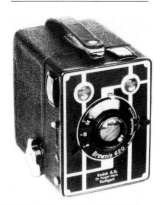

**(3208) BROWNIE 620 BOX CAMERA.** C. 1933–36. SIZE 6 X 9 CM EXPOSURES ON ROLL FILM. F 8 OR F 11 LENS. INSTANT AND TIME SHUTTER.

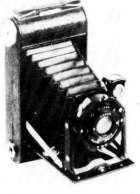

**(3209) BROWNIE JUNIOR 620 BOX CAMERA.** C. 1934–36. SIZE 6 X 9 CM EXPOSURES ON ROLL FILM. MENISCUS LENS. SINGLE-SPEED AND TIME SHUTTER. (HA)

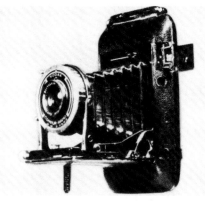

**(3210) DUO SIX-20 CAMERA.** C. 1933–37. SIZE 4.5 X 6 CM EXPOSURES ON NO. 620 ROLL FILM. 75 MM/F 4.5 OR F 3.5 KODAK ANASTIGMAT, SCHNEIDER XENAR, OR ZEISS TESSAR LENS. KODAK S, PRONTO S, COMPUR, OR COMPUR S SHUTTER.

**(3211) DUO SIX-20 SERIES II CAMERA.** C. 1937–39. WITH RANGEFINDER, C. 1939–40. SIZE 4.5 X 6 CM EXPOSURES ON NO. 620 ROLL FILM. F 3.5 KODAK ANASTIGMAT LENS. COMPUR RAPID SHUTTER; 1 TO ⅟₅₀₀ SEC., B., T. SIMILAR TO THE DUO SIX-20 CAMERA.

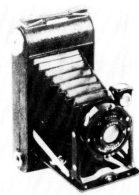

**(3212) JUNIOR O CAMERA.** C. 1939. SIZE 6 X 9 CM EXPOSURES ON ROLL FILM. F 11 KODAK TRISKOP LENS. SINGLE-SPEED AND BULB SHUTTER.

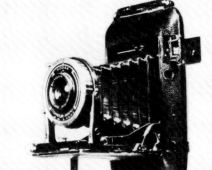

**(3213) REGENT CAMERA.** C. 1935–39. SIZE 6 X 9 CM EXPOSURES (4.5 X 6 CM WITH MASK) ON ROLL FILM. 105 MM/F 3.8 OR F 4.5 SCHNEIDER XENAR OR F 4.5 ZEISS TESSAR LENS. COMPUR S SHUTTER; 1 TO ⅟₂₅₀ SEC., B., T. OR COMPUR RAPID SHUTTER. COUPLED RANGEFINDER.

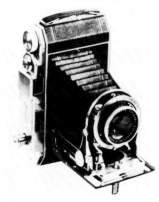

**(3214) REGENT II CAMERA.** C. 1939. SIZE 6 X 9 CM EXPOSURES (4.5 X 6 CM WITH MASK) ON ROLL FILM. 105 MM/F 3.5 SCHNEIDER XENAR LENS. COMPUR

RAPID SHUTTER. COUPLED RANGEFINDER. EXPOSURE COUNTER.

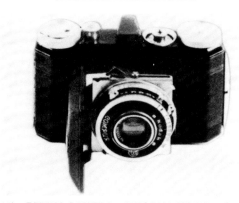

**(3215) RETINA CAMERA. ORIGINAL MODEL.** C. 1934–35. SIZE 24 X 36 MM EXPOSURES ON "35MM" ROLL FILM. 50 MM/F 3.5 SCHNEIDER XENAR LENS. COMPUR SHUTTER; 1 TO ⅟₃₀₀ SEC., B., T. BLACK TRIM. FILM TRANSPORT KNOB.

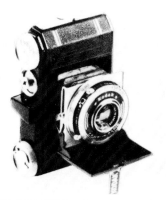

**(3216) RETINA I CAMERA.** C. 1935–36. SIZE 24 X 36 MM EXPOSURES ON " 35MM" ROLL FILM. 50 MM /F 3.5 SCHNEIDER XENAR LENS. COMPUR RAPID SHUTTER. BLACK TRIM.

**(3217) RETINA I CAMERA.** C. 1936–38. SIZE 24 X 36 MM EXPOSURES ON "35MM" ROLL FILM. 50 MM/F 3.5 KODAK EKTAR OR SCHNEIDER XENAR LENS. COMPUR OR COMPUR RAPID SHUTTER. BLACK TRIM. SIMILAR TO THE RETINA I CAMERA IN CHROME TRIM, C 1936–38.

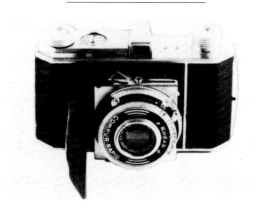

## KODAK A. G. (*cont.*)

**(3218) RETINA I CAMERA.** C. 1936–38. 24 X 36 MM EXPOSURES ON "35MM" ROLL FILM. 50 MM/F 3.5 KODAK EKTAR, SCHNEIDER XENAR, OR ZEISS TESSAR LENS. COMPUR RAPID SHUTTER; 1 TO $\frac{1}{500}$ SEC., B., T. CHROME TRIM.

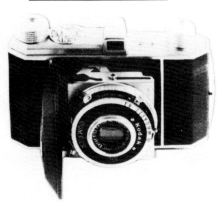

**(3219) RETINA I CAMERA.** C. 1937–39. SIZE 24 X 36 MM EXPOSURES ON "35MM" ROLL FILM. 50 MM/F 3.5 KODAK EKTAR OR SCHNEIDER XENAR LENS. COMPUR OR COMPUR RAPID SHUTTER. THE WINDING KNOBS ARE TALLER THAN THOSE ON THE RETINA I CAMERA OF 1936–38. SOME MODELS WITH CHROME TRIM, OTHERS WITH BLACK TRIM.

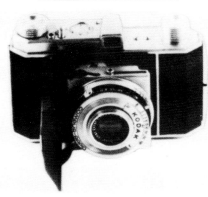

**(3220) RETINA I CAMERA.** C. 1939. SIZE 24 X 36 MM EXPOSURES ON "35MM" ROLL FILM. 50 MM/F 3.5 OR F 4.5 KODAK EKTAR OR SCHNEIDER XENAR LENS. COMPUR OR COMPUR RAPID SHUTTER. SOME MODELS WITH CHROME TRIM, OTHERS WITH BLACK TRIM.

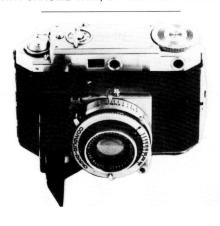

**(3221) RETINA II CAMERA.** C. 1936–37. SIZE 24 X 36 MM EXPOSURES ON "35MM" ROLL FILM. 50 MM/F 3.5 KODAK EKTAR, F 2.8 OR F 2 SCHNEIDER XENAR LENS. COMPUR RAPID SHUTTER; 1 TO $\frac{1}{500}$ SEC., B., T. COUPLED RANGEFINDER.

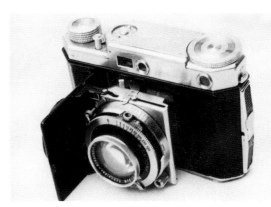

**(3222) RETINA II CAMERA.** C. 1937–39. SIZE 24 X 36 MM EXPOSURES ON "35MM" ROLL FILM. SAME LENSES AND SHUTTER AS THE RETINA II CAMERA, C. 1936–37. COUPLED RANGEFINDER. (TS)

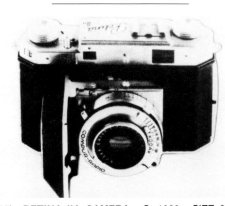

**(3223) RETINA IIA CAMERA.** C. 1939. SIZE 24 X 36 MM EXPOSURES ON "35MM" ROLL FILM. 50 MM/F 3.5 KODAK EKTAR, OR F 2.8 OR F 2 SCHNEIDER XENON LENS. COMPUR RAPID SHUTTER. COUPLED RANGEFINDER.

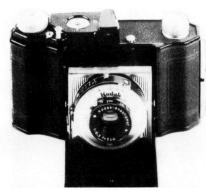

**(3224) RETINETTE CAMERA.** C. 1939. SIZE 24 X 36 MM EXPOSURES ON "35MM" ROLL FILM. 50 MM/F 6.3 KODAK ANASTIGMAT LENS. KODAK K-3 SHUTTER; $\frac{1}{25}$, $\frac{1}{50}$, $\frac{1}{100}$ SEC., B.

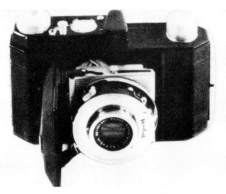

**(3225) RETINETTE II CAMERA.** C. 1939. SIZE 24 X 36 MM EXPOSURES ON "35MM" ROLL FILM. 50 MM/F 4.5 OR F 3.5 KODAK ANASTIGMAT LENS. KODAK K-4S OR COMPUR SHUTTER.

**(3226) SIX-16 KODAK CAMERA.** C. 1934–38. SIZE 6.5 X 11 CM EXPOSURES ON NO. 616 ROLL FILM. F 6.3 OR F 4.5 KODAK ANASTIGMAT, F 4.5 SCHNEIDER XENAR, OR ZEISS TESSAR LENS. KODAK K-4S OR COMPUR S SHUTTER.

**(3227) SIX-16 KODAK JUNIOR CAMERA.** C. 1934–39. SIZE 6.5 X 11 CM EXPOSURES ON NO. 616 ROLL FILM. 105 MM/F 7.7 OR F 6.3 KODAK ANASTIGMAT LENS. KODAK K1 OR K8S SHUTTER.

## KODAK A. G. (*cont.*)

**(3228) SIX-20 KODAK CAMERA.** C. 1933–37. SIZE 6 X 9 CM EXPOSURES ON NO. 620 ROLL FILM. F 6.3 OR F 4.5 KODAK ANASTIGMAT, F 4.5 SCHNEIDER XENAR, OR ZEISS TESSAR LENS. PRONTO S OR COMPUR S SHUTTER.

**(3229) SIX-20 KODAK JUNIOR CAMERA.** C. 1933–39. SIZE 6 X 9 CM EXPOSURES ON NO. 620 ROLL FILM. F 8.8, F 7.7, F 6.3, OR F 4.5 KODAK ANASTIGMAT LENS. KODAK K1, K2, K3, K4S, OR K8S SHUTTER.

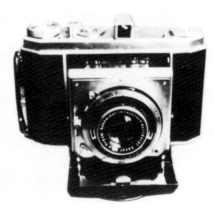

**(3230) SUPREMA CAMERA.** C. 1938–40. SIZE 6 X 6 CM EXPOSURES ON NO. 620 ROLL FILM. 80 MM/F 3.5 SCHNEIDER XENAR LENS. COMPUR RAPID SHUTTER; 1 TO ⅟₄₀₀ SEC., B. ONLY ABOUT 2000 OF THESE CAMERAS WERE MANUFACTURED. (MB)

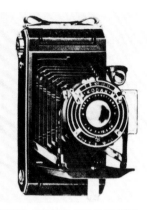

**(3231) VOLLENDA JUNIOR 616 CAMERA.** C. 1934–37. SIZE 6.5 X 11 CM EXPOSURES ON NO. 616 ROLL FILM. F 6.3 OR F 4.5 KODAK ANASTIGMAT LENS. PRONTO-S SHUTTER.

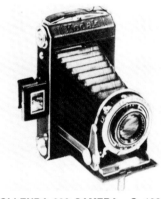

**(3232) VOLLENDA 620 CAMERA.** C. 1934–39. SIZE 6 X 9 CM EXPOSURES ON NO. 620 ROLL FILM. 105 MM/ F 4.5 KODAK ANASTIGMAT, F 4.5 OR F 6.3 KODAR ANASTIGMAT, F 4.5 SCHNEIDER XENAR, OR F 4.5 ZEISS TESSAR LENS. KODAK K4S, K8S, COMPUR, COMPUR S, OR COMPUR RAPID SHUTTER. BODY MOUNTED SHUTTER RELEASE ON MODELS FROM 1936.

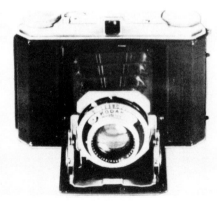

**(3233) VOLENDA 620 CAMERA.** C. 1940–41. SIZE 6 X 6 CM EXPOSURES ON NO. 620 ROLL FILM. 75 MM/F 3.5 SCHNEIDER XENAR LENS. COMPUR SHUTTER; 1 TO ⅟₃₀₀ SEC., B.

**(3234) VOLLENDA 620 CAMERA.** C. 1940–41. SIZE 6 X 6 CM EXPOSURES ON NO. 620 ROLL FILM. 75 MM/F 4.5 KODAK ANASTIGMAT LENS. COMPUR SHUTTER. (TS)

**(3235) VOLLENDA JUNIOR 620 CAMERA.** C. 1933–37. SIZE 6 X 9 CM EXPOSURES ON ROLL FILM. F 6.3 OR F 4.5 KODAK ANASTIGMAT LENS. KODAK K4, K8, PRONTO S, COMPUR S, OR COMPUR RAPID SHUTTER.

## KÖRNER & MEYER

**(3236) NETTEL CAMERA.** C. 1909. SIZE 9 X 12 CM EXPOSURES ON PLATES. 80 MM/F 9 WEITWINKEL ARISTOSTIGMAT LENS. DECKRULLO FOCAL PLANE SHUTTER; ⅕ TO ⅟₁₀₀₀ SEC. (HA)

## KRAUSS, G. A.

**(3237) NANOS PLATE CAMERA.** C. 1923. SIZE 4.5 X 6 CM EXPOSURES ON PLATES. 75 MM/F 5.4 MEYER HELIOPLAN LENS. PRONTO SHUTTER; $\frac{1}{25}$ TO $\frac{1}{100}$ SEC. (HA)

**(3238) PEGGY CAMERA.** C. 1932. SIZE 24 X 36 MM EXPOSURES ON "35MM" ROLL FILM. 50 MM/F 3.5 ZEISS TESSAR LENS. COMPUR SHUTTER WITH SPEEDS TO $\frac{1}{300}$ SEC. (HA)

**(3239) PEGGY II CAMERA.** C. 1933. SIZE 24 X 36 MM EXPOSURES ON "35MM" ROLL FILM. 50 MM/F 2.8 ZEISS TESSAR LENS. COMPUR SHUTTER; 1 TO $\frac{1}{300}$ SEC. COUPLED RANGEFINDER. (MA)

**(3240) POLYSKOP STEREO CAMERA.** C. 1906. SIZE 45 X 107 MM STEREO EXPOSURES ON PLATES.

**(3241) ROLLETTE VEST-POCKET CAMERA.** C. 1923. SIZE 4.5 X 7.5 CM EXPOSURES ON ROLL FILM. 75 MM/ F 4.5 SCHNEIDER XENAR LENS. COMPUR SHUTTER; 1 TO $\frac{1}{300}$ SEC. (HA)

**(3242) STEREO-SPIEGEL REFLEX CAMERA.** C. 1923. SIZE 45 X 107 MM EXPOSURES. CENTRAL STEREO SHUTTER; 1 TO $\frac{1}{300}$ SEC. IRIS DIAPHRAGM. ONE LENS ALSO SERVES AS A REFLEX VIEWER.

## KRICHELDORFF, FRITZ

**(3243) KLAPP REFLEX CAMERA.** C. 1903. SIMILAR TO THE 1910 MODEL.

**(3244) KLAPP REFLEX CAMERA.** C. 1910. SIZE 9 X 12 CM EXPOSURES. 150 MM/F 4.5 TESSAR LENS. FOCAL PLANE SHUTTER. (HA)

## KRÜGENER, DR. R.

**(3245) CINQUANTE-PLAQUES MAGAZINE CAMERA.** C. 1900. THE MAGAZINE CONSISTS OF A LONG ACCORDION-PLEATED STRIP OF BLACK PAPER WITH EACH OF THE 50 CUT FILMS HELD VERTICALLY BY A SINGLE PLEAT. AFTER A FILM WAS EXPOSED, THE END OF THE PAPER STRIP WAS PULLED WHICH DEPOSITED THE FILM IN A TRAY. (IH)

**(3246) DELTA FOLDING PLATE CAMERA.** C. 1895. SIZE 9 X 12 CM EXPOSURES. MENISCUS LENS. THREE-SPEED ROTARY SHUTTER. (MA)

**(3247) DELTA KLAPP CAMERA.** C. 1904. SIZE 9 X 12 CM PLATE EXPOSURES. RAPID APLANATIC LENS. PNEUMATIC SHUTTER; $\frac{1}{15}$ TO $\frac{1}{100}$ SEC. SPECIAL REAR BELLOWS FOR CLOSE-UP EXPOSURES. (MA)

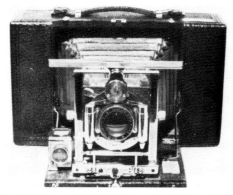

**(3248) DELTA HORIZONTAL FOLDING CAMERA.** C. 1905. SIZE 9 X 12 CM EXPOSURES ON PLATES OR ROLL FILM. EXTRA RAPID APLANAT LENS. DOUBLE PNEUAMTIC SHUTTER WITH SPEEDS TO $\frac{1}{250}$ SEC. RISING AND FALLING LENS MOUNT. GROUND GLASS FOCUSING. (HA)

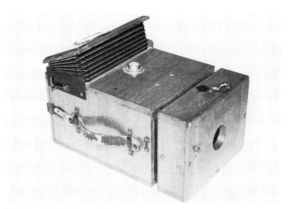

**(3249) DELTA MAGAZINE CAMERA.** C. 1892. TWO SIZES OF THIS CAMERA FOR 9 X 12 OR 13 X 18 CM EXPOSURES ON PLATES. THE MAGAZINE HOLDS 12 PLATES. BOX-IN-BOX FOCUSING. THE REAR BELLOWS ALLOWS FOR PLATE CHANGING. 145 MM/F 13 "PERISCOPE" LENS. SELF-CAPPING SECTOR SHUTTER FOR SINGLE-SPEED OR TIME EXPOSURES. STRING-COCKING SHUTTER. (GE)

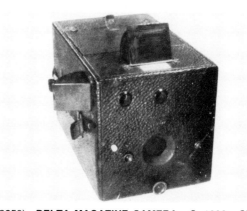

**(3250) DELTA MAGAZINE CAMERA.** C. 1893. SIZE 9 X 12 CM EXPOSURES ON PLATES. THE MAGAZINE HOLDS 12 PLATES. BUTTON ACTIVATED SHUTTER. (HA)

**KRÜGENER, DR. R. (*cont.*)**

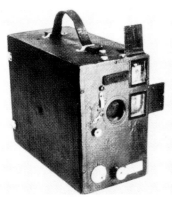

(3251)　**DELTA MAGAZINE BOX CAMERA.**　C. 1900. SIZE 9 X 12 CM EXPOSURES ON PLATES. THE MAGAZINE HOLDS 12 PLATES. THREE-SPEED GUILLOTINE SHUTTER.　(HA)

(3252)　**DELTA PATRONEN FLACH CAMERA.**　C. 1903. SIZE 9 X 12 CM EXPOSURES ON PLATES OR ROLL FILM.　RAPID RECTILINEAR LENS.　CENTRAL SHUTTER; 1 TO $\frac{1}{100}$ SEC.　(IH)

(3253)　**DELTA PERISCOP CAMERA.**　C. 1900.　SIZE 6 X 8 CM EXPOSURES ON ROLL FILM.　100 MM/F 12 FIXED-FOCUS LENS.　GUILLOTINE SHUTTER.　(HA)

(3254)　**DELTA PERISCOP CAMERA.**　C. 1900.　SIZE 8 X 10 CM EXPOSURES ON ROLL FILM OR PLATES. F 12 RAPID PERISCOP LENS.　INSTANT AND TIME SHUTTER.　(HA)

(3255)　**DELTA PLATE CAMERA.**　C. 1898.　SIZE 9 X 12 CM EXPOSURES.　ROTARY SHUTTER.　(HA)

(3256)　**DELTA PLATE CAMERA.**　C. 1898.　SIZE 9 X 12 CM EXPOSURES.　ROTARY APERTURE STOPS.　(HA)

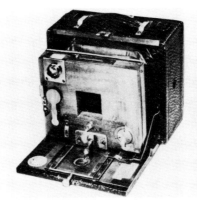

(3257)　**DELTA PLATE CAMERA.**　C. 1900.　SIZE 9 X 12 CM EXPOSURES.　150 MM/F 9 EXTRA RAPID APLANAT LENS.　THREE-SPEED GUILLOTINE SHUTTER.　(HA)

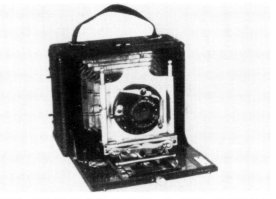

(3258)　**DELTA PLATE CAMERA.**　C. 1902.　SIZE 9 X 12 CM EXPOSURES.　F 9 EXTRA-RAPID APLANAT LENS. SINGLE-SPEED SHUTTER.　(HA)

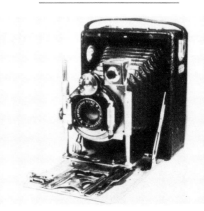

(3259)　**DELTA PLATE CAMERA.**　C. 1903.　SIZE 9 X 12 CM EXPOSURES.　F 6 DELTA ANASTIGMAT LENS. BAUSCH & LOMB DOUBLE PNEUMATIC SHUTTER WITH SPEEDS TO $\frac{1}{100}$ SEC.　(HA)

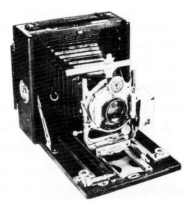

(3260)　**DELTA PLATE CAMERA.**　C. 1904.　SIZE 9 X 12 CM EXPOSURES.　150 MM/F 6.8 GOERZ DAGOR LENS. DOUBLE PNEUMATIC KRÜGENER SHUTTER WITH SPEEDS TO $\frac{1}{250}$ SEC.　(HA)

## KRÜGENER, DR. R. (*cont.*)

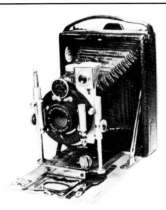

(3261) **DELTA PLATE CAMERA.** C. 1904. SIZE 9 X 12 CM EXPOSURES. F 9 RAPID APLANAT LENS. DOUBLE PNEUMATIC SHUTTER; 1 TO 1/100 SEC., B., T. (HA)

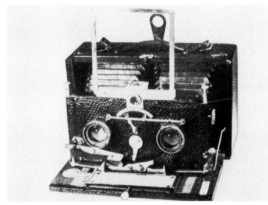

(3262) **DELTA STEREO CAMERA.** C. 1900. SIZE 9 X 18 CM STEREO EXPOSURES ON PLATES. F 9 JENENSER EXTRA RAPID APLANAT LENSES. (HA)

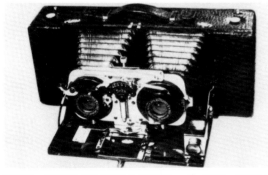

(3263) **DELTA STEREO CAMERA.** C. 1903. SIZE 9 X 18 CM STEREO EXPOSURES ON PLATES OR ROLL FILM. JENENSER EXTRA RAPID LENSES. SHUTTER SPEEDS; 1/25 TO 1/100 SEC. (HA)

(3264) **DELTA STEREO MAGAZINE CAMERA.** C. 1893. SIZE 9 X 18 CM STEREO EXPOSURES ON PLATES. THE MAGAZINE HOLDS 12 PLATES. ANTIPLANET LENSES. GUILLOTINE SHUTTER. (MA)

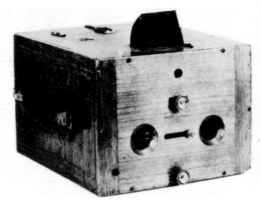

(3265) **DELTA STEREO MAGAZINE CAMERA.** C. 1895. SIZE 9 X 18 CM STEREO EXPOSURES ON PLATES.

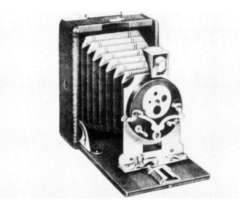

(3266) **DELTA-TEDDY PLATE CAMERA.** C. 1899. SIZE 9 X 12 CM EXPOSURES ON PLATES. (HA)

(3267) **ELECTUS TWIN-LENS REFLEX CAMERA.** C. 1890. THIS CAMERA IS A SIMPLIFIED VERSION OF DR. KRÜGENER'S SIMPLEX SLR CAMERA. THE MAGAZINE HOLDS 18 PLATES.

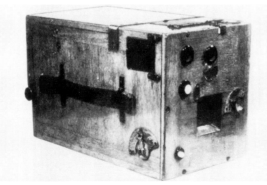

(3268) **MAGAZINE HAND CAMERA.** C. 1895. SIZE 9 X 12 CM EXPOSURES ON SHEET FILM. THE MAGAZINE HOLDS 50 FILM SHEETS. SIX-SPEED SHUTTER. (HA)

(3269) **MILLION STEREO CAMERA.** C. 1903. SIZE 90 X 180 MM STEREO EXPOSURES ON ROLL FILM. RAPID PERISKOP LENSES. GUILLOTINE SHUTTER. (MA)

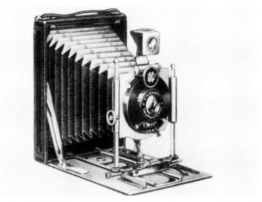

(3270) **MINIMUM DELTA CAMERA.** C. 1908. SIZE 9 X 12 CM EXPOSURES ON PLATES. F 8 DR. KRÜGENER EXTRA-RAPID APLANAT LENS. KRÜGENER SHUTTER; 1/25 TO 1/100 SEC. (HA)

(3271) **NORMAL REFLEX CAMERA.** C. 1891. SINGLE-LENS REFLEX.

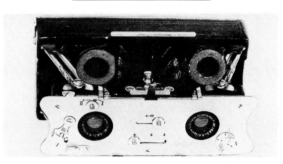

(3272) **PLASTOSCOP STEREO CAMERA.** C. 1900–06. SIZE 45 X 107 MM STEREO EXPOSURES ON PLATES. 60 MM/F 8.8 OR F 7.7 SIMPLEX ANASTIGMAT LENSES. TWO-SPEED OR FOUR-SPEED SHUTTER.

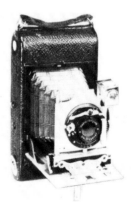

(3273) **ROLL FILM CAMERA.** C. 1902. SIZE 8 X 10.5 CM EXPOSURES ON ROLL FILM. RAPID PERISCOP LENS. SHUTTER SPEEDS FROM 1/2 TO 1/100 SEC.

(3274) **SIMPLEX TWIN-LENS REFLEX CAMERA.** C. 1889. TWO SIZES OF THIS CAMERA FOR 6 X 8 OR 9 X 12 CM EXPOSURES ON PLATES. THE MAGAZINE HOLDS 24 PLATES. 90 MM/F 9 STEINHEIL ANTIPLANET OR 100 MM/F 10 PERISCOPIC LENSES. SELF-CAPPING SECTOR SHUTTER FOR SINGLE-SPEED AND

## KRÜGENER, DR. R. (*cont.*)

TIME EXPOSURES. THE VIEWING LENS IS NON-FOCUSING. (IH)

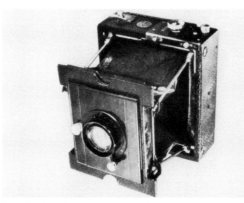

(3275) **SPECIAL STRUT CAMERA.** C. 1903. SIZE 9 X 12 CM EXPOSURES ON PLATES. 140 MM/F 8 UNIVERSAL APLANAT LENS. SIX-SPEED FOCAL PLATE SHUTTER. (HA)

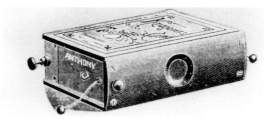

(3276) **TASCHENBUCH (BOOK) CAMERA.** C. 1888–92. SIZE 4 X 4 CM EXPOSURES ON PLATES. 65 MM/F 12 ACHROMATIZED PERISCOPIC LENS. GUILLOTINE SHUTTER FOR INSTANT AND TIME EXPOSURES. PULL-STRING FOR COCKING THE SHUTTER. THE CAMERA MAGAZINE HOLDS 24 PLATES. THE CAMERA WAS MANUFACTURED FOR OTHER COMPANIES SUCH AS MACKENSTEIN, PARIS; SEB. GECELE, BRUSSELS; A. SCHAEFFNER, PARIS; MARION & COMPANY, LONDON; AND ANTHONY & COMPANY, NEW YORK IN SIZES FOR 1⅝ X 1⅝ AND 3¼ X 3¼ INCH EXPOSURES.

## KRÜGENER, W.

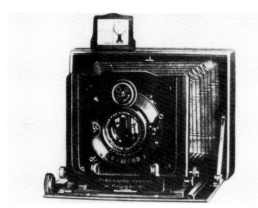

(3277) **PRÄZISION KRONOS CAMERA.** C. 1920. SIZE 9 X 12 CM EXPOSURES. RACK & PINION FOCUS-ING. GROUND GLASS FOCUSING. RISING AND CROSSING LENS MOUNT. IBSO OR COMPUR SHUTTER.

## KUEHN KAMERAWERK

(3278) **LOMARA CAMERA.** C. 1900. THE CAMERA HAS 13 LENSES FOR FOUR OR NINE EXPOSURES ON PLATES. (HA)

(3279) **LOMARA STEREO REFLEX CAMERA.** C. 1921. SIZE 45 X 107 MM STEREO EXPOSURES. FOCAL PLANE SHUTTER.

## LAUSA, LUDWIG E.

(3280) **KORMA-FLEX REFLEX CAMERA.** SIZE 4 X 4 CM ROLL FILM EXPOSURES. 60 MM/F 4.5 VIDAR LENS. GUILLOTINE SHUTTER; ⅟₂₅ TO ⅟₁₀₀ SEC. (MA)

## LECHNER, R. (W. MÜLLER)

(3281) **STRUT CAMERA.** C. 1905. SIZE 9 X 12 CM EXPOSURES ON PLATES. 130 MM/F 5.5 BUSCH ANASTIGMAT LENS. EIGHT-SPEED FOCAL PLANE SHUTTER. (HA)

## LEHMANN, A.

(3282) **CANE-HANDLE DETECTIVE CAMERA.** C. 1903. SIZE 13 X 25 MM EXPOSURES ON ROLL FILM. 35 MM/F 9 MENISCUS LENS. SELF-CAPPING SECTOR SHUTTER FOR SINGLE-SPEED OR TIME EXPOSURES. THE LENS AND SHUTTER ARE LOCATED IN FRONT OF THE CANE HANDLE WITH THE SHUTTER RELEASE LOCATED UNDER THE SHUTTER. THE HANDLE HOLDS THREE EXTRA ROLLS OF FILM.

## LEITZ

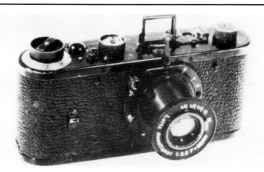

(3283) **LEICA MODEL "O" CAMERA.** C. 1923. PRE-PRODUCTION MODEL. SIZE 24 X 36 MM EXPOSURES ON "35MM" ROLL FILM. 50 MM/F 3.5 ELMAR ANASTIGMAT LENS. FOCAL PLANE SHUTTER; ⅟₂₀ TO ⅟₅₀₀ SEC. NON-SELF-CAPPING SHUTTER.

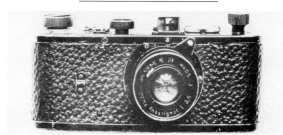

(3284) **LEICA MODEL "O" CAMERA.** C. 1923. SIMILAR TO THE EARLY MODEL "O" EXCEPT WITH A REVERSE GALLEAN-TELESCOPE TYPE FINDER.

(3285) **COMPUR LEICA CAMERA.** C. 1929–30. SIZE 24 X 36 MM EXPOSURES ON "35MM" ROLL FILM.

## LEITZ (*cont.*)

THIS CAMERA IS THE SAME AS THE COMPUR LEICA, C. 1926–29, EXCEPT THE SHUTTER SPEEDS (1 TO $\frac{1}{300}$ SEC.) AND B. OR T. SELECTION IS MADE BY A SINGLE RIM-SETTING DIAL.

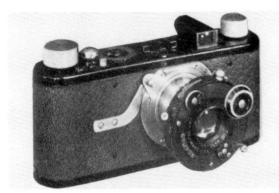

**(3286) COMPUR LEICA CAMERA.** C. 1926–29. SIZE 24 X 36 MM EXPOSURES ON "35MM" ROLL FILM. 50 MM/F 3.5 ELMAR LENS. COMPUR SHUTTER WITH ONE DIAL FOR SHUTTER SPEED SELECTION AND A SECOND DIAL FOR INSTANT, B., OR T. SELECTION. SHUTTER SPEEDS FROM 1 TO $\frac{1}{300}$ SEC. (HA)

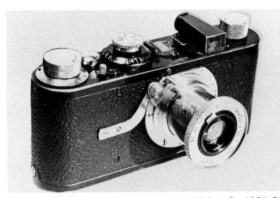

**(3287) LEICA I, MODEL "A" CAMERA.** C. 1924–31. SIZE 24 X 36 MM EXPOSURES ON "35MM" ROLL FILM. 50 MM/F 3.5 ANASTIGMAT, ELMAX, OR ELMAR LENS. FOCAL PLANE SHUTTER; $\frac{1}{25}$ TO $\frac{1}{500}$ SEC. FOR THE 1924–1925 MODELS. ALL OTHER MODELS HAD A FOCAL PLANE SHUTTER OR COMPUR SHUTTER; $\frac{1}{20}$ TO $\frac{1}{500}$ SEC., T. (FZ)

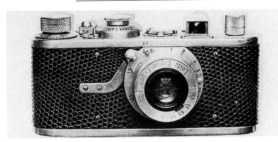

**(3288) LEICA I, MODEL "A" DELUXE CAMERA.** C. 1930. SAME AS THE REGULAR LEICA I, MODEL "A" EXCEPT WITH BROWN OR GREEN LIZARD LEATHER AND GOLD PLATED METAL TRIM.

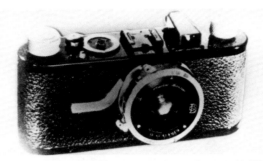

**(3289) LEICA I, MODEL "B" CAMERA.** C. 1926–29 FOR THE DIAL SET SHUTTER, C. 1929–30 FOR THE RIM SET SHUTTER. SIZE 24 X 36 MM EXPOSURES ON "35MM" ROLL FILM. 50 MM/F 3.5 ELMAR LENS. DIAL SET COMPUR SHUTTER; 1 TO $\frac{1}{300}$ SEC., B., T. OR RIM SET COMPUR SHUTTER; 1 TO $\frac{1}{300}$ SEC., B., T.

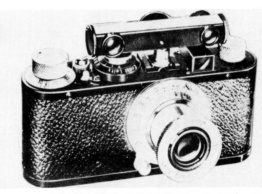

**(3290) LEICA I, MODEL "C" CAMERA.** C. 1931. SIZE 24 X 36 MM EXPOSURES ON "35MM" ROLL FILM. THE FIRST LEICA WITH INTERCHANGEABLE LENSES. ATTACHED RANGEFINDER. 50 MM/F 3.5 ELMAR OR 50 MM/F 2.5 HEKTOR LENS. FOCAL PLANE SHUTTER; $\frac{1}{20}$ TO $\frac{1}{500}$ SEC.

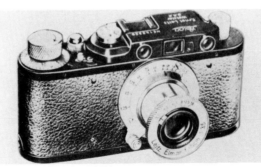

**(3291) LEICA II, MODEL "D" CAMERA.** C. 1932–34. SIZE 24 X 36 MM EXPOSURES ON "35MM" ROLL FILM. THE FIRST LEICA WITH COUPLED RANGEFINDER. 50 MM/F 3.5 ELMAR OR 50 MM/F 2.5 HEKTOR LENS. FOCAL PLANE SHUTTER; $\frac{1}{20}$ TO $\frac{1}{500}$ SEC., T. INTERCHANGEABLE LENSES.

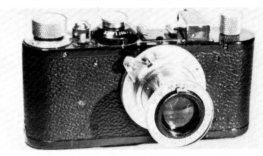

**(3292) LEICA STANDARD MODEL "E" CAMERA.** C. 1932–48. SIZE 24 X 36 MM EXPOSURES ON "35MM" ROLL FILM. 50 MM/F 3.5 ELMAR OR F 2.5 HEKTOR LENS. FOCAL PLANE SHUTTER; $\frac{1}{20}$ TO $\frac{1}{500}$ SEC., T. INTERCHANGEABLE LENSES. BLACK OR CHROME TRIM MODELS. (FZ)

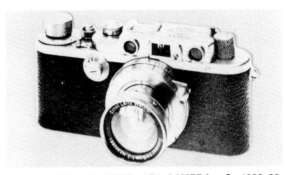

**(3293) LEICA III, MODEL "F" CAMERA.** C. 1933–39. SIZE 24 X 36 MM EXPOSURES ON "35MM" ROLL FILM. 50 MM/F 3.5 ELMAR, 50 MM/F 2 SUMMAR, OR 50 MM/F 2 SUMMITAR LENS. FOCAL PLANE SHUTTER; 1 TO $\frac{1}{500}$ SEC., T. INTERCHANGEABLE LENSES. COUPLED RANGEFINDER.

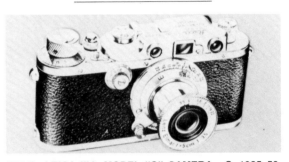

**(3294) LEICA IIIA, MODEL "G" CAMERA.** C. 1935–50. SIZE 24 X 36 MM EXPOSURES ON "35MM" ROLL FILM. COUPLED RANGEFINDER. 50 MM/F 3.5 ELMAR OR 50 MM/F 2 SUMMAR LENS. FOCAL PLANE SHUTTER; 1 TO $\frac{1}{1000}$ SEC., T. INTERCHANGEABLE LENSES.

## LEITZ (*cont.*)

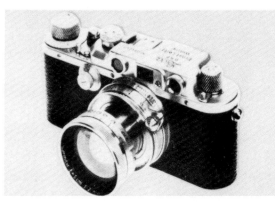

**(3295)** **LEICA IIIB, MODEL "G" CAMERA.** C. 1937–46. SIZE 24 X 36 MM EXPOSURES ON "35MM" ROLL FILM. COUPLED RANGEFINDER. 50 MM/F 3.5 ELMAR, 50 MM/F 2 SUMMAR, 50 MM/F 2 SUMMITAR, OR 50 MM/F 1.5 SCHNEIDER XENON LENS. FOCAL PLANE SHUTTER; 1 TO $\frac{1}{1000}$ SEC., T. INTERCHANGEABLE LENSES.

**(3296)** **LEICA IIIC CAMERA.** C. 1940–51. SIZE 24 X 36 MM EXPOSURES ON "35MM" ROLL FILM. COUPLED RANGEFINDER. 50 MM/F 3.5 ELMAR, 50 MM/F 2 SUMMITAR, OR 50 MM/F 1.5 XENON LENS. FOCAL PLANE SHUTTER; 1 TO $\frac{1}{1000}$ SEC., T. INTERCHANGE-ABLE LENSES. (MF)

**(3297)** **LEICA IIID CAMERA.** INTRODUCED IN 1940. THIS CAMERA IS ESSENTIALLY THE SAME AS THE LEICA IIIC EXCEPT IT HAS A DELAYED ACTION TIMER. (FZ)

**(3298)** **LEICA 250 REPORTER CAMERA.** C. 1934–43. SIZE 24 X 36 MM EXPOSURES ON "35MM" ROLL FILM. (250 FRAMES PER ROLL). COUPLED RANGEFINDER. 50 MM/F 3.5 ELMAR OR 50 MM/F 1.5 XENON LENS. FOCAL PLANE SHUTTER; 1 TO $\frac{1}{500}$ SEC., T. SHUTTER SPEEDS TO $\frac{1}{1000}$ SEC. BEGINNING IN 1935. SOME MODELS WITH MECHANICAL MOTOR DRIVE.

## LEONAR-WERKE

**(3299)** **PLATE AND FILMPACK CAMERA.** C. 1914. TWO SIZES OF THIS CAMERA FOR 9 X 12 OR 10 X 15 CM EXPOSURES. MODEL CV: F 16 LEONAR ACHRO-MAT, F 11 PERISKOP, OR F 8 EXTRA RAPID APLANAT LENS. LEONAR AUTO SHUTTER. MODEL CIV: F 11 LEONAR PERISKOP APLANAT, F 8 EXTRA RAPID APLANAT, OR F 6.8 DOUBLE ANASTIGMAT LENS. AUTO SHUTTER; $\frac{1}{25}$ TO $\frac{1}{100}$ SEC.

## LEVY-ROTH

**(3300)** **MINIGRAPH CAMERA.** C. 1915. THE FIRST GERMAN CAMERA FOR "35MM" ROLL FILM. SIZE 18 X 24 MM EXPOSURES. 54 MM/F 3.5 MINIGRAPH AN-ASTIGMAT LENS. THE FLAP SHUTTER IS COCKED WHEN THE FILM IS ADVANCED. (HA)

## LINHOF-KARPF

**(3301)** **ACTIS MONO AND STEREO CAMERA.** C. 1928. SIZE 9 X 12 CM MONO OR STEREO EXPOSURES. 90 MM/F 6.3 ZEISS TESSAR LENSES. COMPUR SHUTTER; 1 TO $\frac{1}{250}$ SEC. SWINGING, RISING, AND CROSSING LENS MOUNT. THE CAMERA HAS TWO LENS BOARDS, ONE FOR MONOSCOPIC AND ONE FOR STEREOSCOPIC EXPOSURES. (MA)

**(3302)** **LINHOF CAMERA.** C. 1920. SIZE 9 X 12 CM EX-POSURES ON PLATES. 150 MM/F 4.5 ZEISS TESSAR LENS. COMPOUND SHUTTER; ½ TO $\frac{1}{150}$ SEC. (HA)

**(3303)** **LINHOF CAMERA.** C. 1925. SIZE 13 X 18 CM EXPOSURES ON PLATES. THE CAMERA IS CAPABLE OF TAKING MONO OR STEREO EXPOSURES. (HA)

## LINHOF-KARPF (*cont.*)

(3304) **LINHOF CAMERA.** C. 1932. FOUR SIZES OF THIS CAMERA FOR 6.5 X 9, 9 X 12, 10 X 15, OR 13 X 18 CM EXPOSURES ON PLATES OR FILM PACKS. F 3.5 SCHNEIDER XENAR OR F 4.5 ZEISS TESSAR LENS. NO SCHNEIDER LENS FOR THE 13 X 18 CM MODEL. TRIPLE EXTENSION BELLOWS. REVOLVING BACK. RISING, FALLING, AND CROSSING LENS MOUNT. GROUND GLASS FOCUSING. RACK & PINION FOCUSING. DROPPING BED.

(3305) **STANDARD CAMERA.** C. 1936–40. FOUR SIZES OF THIS CAMERA FOR 6.5 X 9, 9 X 12, 10 X 15, OR 13 X 18 CM EXPOSURES ON PLATES, CUT FILM, OR FILM PACKS. F 4.5 ZEISS TESSAR, SATZPLASMAT, OR SCHNEIDER XENAR LENS. COMPUR SHUTTER. SIMILAR TO THE TECHNIKA II CAMERA.

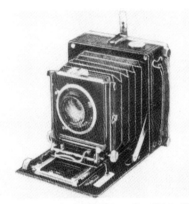

(3306) **TECHNIKA II CAMERA.** C. 1936–40. FOUR SIZES OF THIS CAMERA FOR 6.5 X 9, 9 X 12, 10 X 15, OR 13 X 18 CM EXPOSURES ON PLATES, CUT FILM, OR FILM PACKS. F 3.5 SCHNEIDER XENAR OR F 4.5 ZEISS TESSAR LENS. COMPUR OR COMPOUND SHUTTER. SWING BACK. RISING LENS MOUNT. REMOVABLE LENS BOARD. TRIPLE EXTENSION BELLOWS. COUPLED RANGEFINDER. (HA)

## LINHOF, VALENTIN

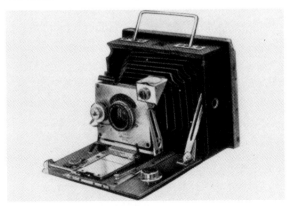

(3307) **LINHOF CAMERA.** C. 1903. SIZE 9 X 12 CM EXPOSURES ON PLATES. 135 MM/F 5.4 VOIGTLANDER COLLINEAR LENS. LINHOF PNEUMATIC SHUTTER WITH SPEEDS TO ¹⁄₂₅₀ SEC. (HA)

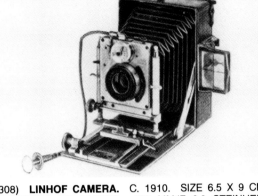

(3308) **LINHOF CAMERA.** C. 1910. SIZE 6.5 X 9 CM EXPOSURES ON PLATES. 105 MM/F 6.8 STEINHEIL ORTHOSTIGMAT LENS. LINHOF PNEUMATIC SHUTTER WITH SPEEDS TO ¹⁄₂₅₀ SEC. (HA)

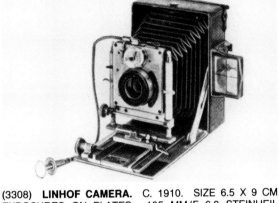

(3309) **LINHOF CAMERA.** C. 1914. SIZE 6.5 X 9 CM EXPOSURES ON PLATES. 112 MM/F 6.3 ZEISS TESSAR LENS. LINHOF PNEUMATIC SHUTTER WITH SPEEDS TO ¹⁄₂₅₀ SEC. (HA)

(3310) **LINHOF STEREO-PANORAMA CAMERA.** SIZE 9 X 14 CM STEREO OR PANORAMIC EXPOSURES ON PLATES.

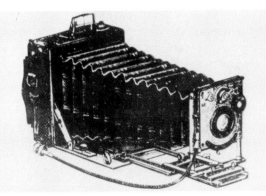

(3311) **LINHOF UNIVERSAL CAMERA.** C. 1909. TWO SIZES OF THIS CAMERA FOR 6.5 X 9 OR 9 X 12 CM EXPOSURES ON PLATES.

## LORENZ

(3312) **LORENZA CAMERA.** C. 1938–40. SIZE 24 X 24 MM EXPOSURES ON ROLL FILM. 33 MM/F 3 ASTRO BERLIN ASTAN LENS. FOCAL PLANE SHUTTER; ¹⁄₁₆ TO ¹⁄₅₀₀ SEC. (AH)

## LÜTTKE, DR. & ARNDT

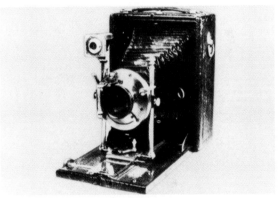

(3313) **FOLDING PLATE CAMERA.** C. 1902. SIZE 9 X 12 CM EXPOSURES ON PLATES. UNIVERSAL RAPID APLANAT LENS. (HA)

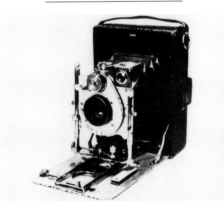

(3314) **FOLDING PLATE CAMERA.** C. 1905. SIZE 9 X 12 CM EXPOSURES ON PLATES. F 8 UNIVERSAL-RAPID APLANAT LENS. SHUTTER SPEEDS TO ¹⁄₃₀₀ SEC. (HA)

## LÜTTKE, DR. & ARNDT (*cont.*)

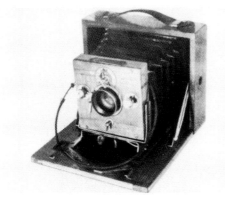

**(3315) LINOS CAMERA.** C. 1898. SIZE 9 X 12 CM EXPOSURES ON PLATES. 165 MM/F 8 APLANAT LENS. MULTI-SPEED SHUTTER. (HA)

## MADER, H.

**(3316) INVINCIBLE CAMERA.** C. 1889. SIZE 13 X 18 CM EXPOSURES ON PLATES. 180 MM/F 6 APLANAT LENS. DOUBLE-ACTION ROTARY SHUTTER. (IH)

## MARTIN, H.

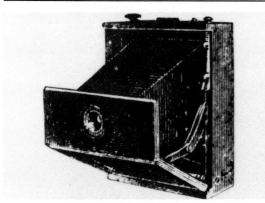

**(3317) TASCHENKAMERA.** C. 1896. TWO SIZES OF THIS CAMERA FOR 9 X 12 OR 12 X 16.5 CM PLATE EXPOSURES. FOCAL PLANE SHUTTER.

## MERKEL, F.

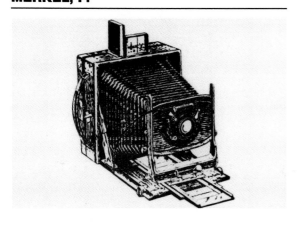

**(3318) TRIUMPH TROPICAL CAMERA.** C. 1920. TWO SIZES OF THIS CAMERA FOR 9 X 12 OR 10 X 15 CM EXPOSURES.

## MEYER, HUGO & COMPANY

**(3319) PAFF REFLEX CAMERA.** SINGLE-LENS REFLEX. C. 1922. EXPOSURES ON NO. 120 ROLL FILM OR FILM PACKS. F 6.8 ANASTIGMAT LENS.

**(3320) PRESS SUPERSPEED CAMERA.** C. 1924. FOLDING-STRUT TYPE CAMERA. F 3 MEYER LENS.

**(3321) UNIVERSAL SILAR CAMERA.** C. 1932–40. FIVE SIZES OF THIS CAMERA FOR 4.5 X 6, 6.5 X 9, 9 X 12, 10 X 15, OR 13 X 18 CM EXPOSURES ON PLATES OR FILM PACKS. F 4.5 PLASMAT TRIPLE CONVERTIBLE LENS. TRIPLE EXTENSION BELLOWS. REVOLVING BACK. GROUND GLASS FOCUSING. RISING AND FALLING LENS MOUNT. DROPPING BED. COMPUR SHUTTER. COUPLED RANGEFINDER ON THE LATER MODELS.

## MIKUT, OSKAR

**(3322) MIKUT COLOR CAMERA.** C. 1937. SIZE 4.5 X 13 CM EXPOSURES. 130 MM/F 3.5 MIKUTAR LENS. COMPUR SHUTTER. COUPLED RANGEFINDER ON THE LATER MODELS.

## NAGEL CAMERAWERK

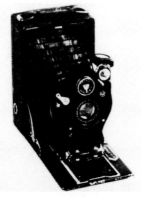

**(3323) NAGEL "ANCA" NO. 10 CAMERA.** C. 1928–34. SIZE 6.5 X 9 CM EXPOSURES ON PLATES. F 6.8, F 6.3, OR F 4.5 NAGEL ANASTIGMAT LENS. NAGEL, PRONTO, PRONTO S, IBSOR, OR COMPUR SHUTTER. ANCA NO. 10 MODEL AFTER 1930.

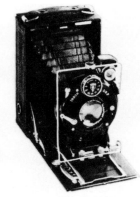

**(3324) NAGEL "ANCA" NO. 14 CAMERA.** C. 1928–34. SIZE 6.5 X 9 CM EXPOSURES ON PLATES. F 6.8, F 6.3, OR F 4.5 NAGEL ANASTIGMAT LENS. ALSO, F 4.5 LAUDAR, F 6.3 RADIONAR, OR F 4.5 XENAR LENS. PRONTO, PRONTO S, IBSOR, COMPUR, OR COMPUR S SHUTTER. ANCA MODEL NO. 14 AFTER 1930.

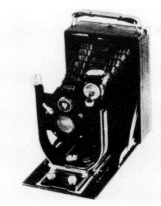

**(3325) NAGEL "ANCA" NO. 25 CAMERA.** C. 1928–34. SIZE 9 X 12 CM EXPOSURES ON PLATES. F 6.8 OR F 6.3 NAGEL ANASTIGMAT OR F 4.5 LAUDAR LENS. PRONTO, PRONTO S, IBSOR, OR COMPUR SHUTTER. ANCA MODEL NO. 25 AFTER 1930.

**(3326) NAGEL "ANCA" NO. 28 CAMERA.** C. 1928–34. SIZE 9 X 12 CM EXPOSURES ON PLATES. F 6.8, F 6.3, OR F 4.5 NAGEL ANASTIGMAT LENS. ALSO, F 4.5 LAUDAR, F 6.3 RADIONAR, OR F 4.5 XENAR LENS. PRONTO, PRONTO S, IBSOR, COMPUR, OR COMPUR S SHUTTER. ANCA MODEL NO. 28 AFTER 1930. SIMILAR TO THE "ANCA" MODEL NO. 25.

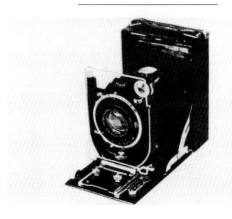

## NAGEL CAMERAWERK (cont.)

**(3327) NAGEL FORNIDAR NO. 30 CAMERA.** C. 1930–31. SIZE 9 X 12 CM EXPOSURES ON PLATES. F 6.3 NAGEL ANASTIGMAT, F 4.5 NAGEL DOUBLE ANASTIGMAT, OR LAUDAR LENS. ALSO, F 4.5 SCHNEIDER XENAR OR LEITZ ELMAR LENS. IBSOR, COMPUR, OR COMPUR S SHUTTER.

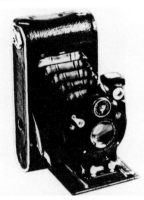

**(3328) NAGEL LIBRETTE NO. 65 CAMERA.** C. 1928–31. SIZE 6 X 9 CM EXPOSURES ON ROLL FILM. F 6.8, F 6.3, OR F 4.5 NAGEL ANASTIGMAT LENS. NAGAL, PRONTO, PRONTO S, IBSOR, OR COMPUR SHUTTER.

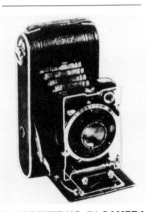

**(3329) NAGEL LIBRETTE NO. 74 CAMERA.** C. 1928–31. SIZE 6 X 9 CM EXPOSURES ON ROLL FILM. F 6.8, F 6.3, OR F 4.5 NAGEL ANASTIGMAT LENS. ALSO, F 4.5 NAGEL LAUDAR, F 4.5 XENAR, OR F 4.5 ELMAR LENS. PRONTO, PRONTO S, IBSOR, COMPUR, OR COMPUR S SHUTTER.

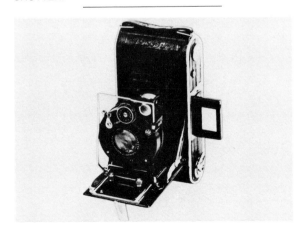

**(3330) NAGEL LIBRETTE NO. 75 CAMERA.** C. 1933. SIZE 6 X 9 CM EXPOSURES ON ROLL FILM. F 4.5 RADIONAR, XENAR, OR TESSAR LENS. PRONTO, PRONTO S, OR COMPUR S SHUTTER.

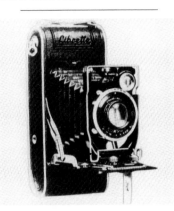

**(3331) NAGEL LIBRETTE NO. 79 CAMERA.** C. 1930–31. SIZE 6.5 X 11 CM EXPOSURES ON ROLL FILM. F 6.3 NAGEL ANASTIGMAT, F 4.5 NAGEL LAUDAR OR F 4.5 XENAR LENS. PRONTO, IBSOR, COMPUR, OR COMPUR S SHUTTER.

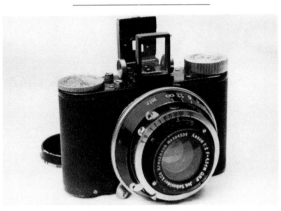

**(3332) NAGEL PUPILLE CAMERA.** C. 1931–35. SIZE 3 X 4 CM EXPOSURES ON ROLL FILM. F 3.5, F 2.9, OR F 2 SCHNEIDER XENAR; F 3.5 OR F 2.8 ZEISS TESSAR; OR F 3.5 LEITZ ELMAR LENS. COMPUR SHUTTER; 1 TO $\frac{1}{300}$ SEC., B., T. (TS)

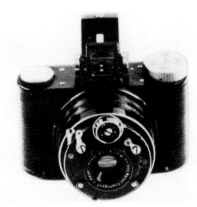

**(3333) NAGEL RANCA NO. 46 CAMERA.** C. 1930–31. SIZE 3 X 4 CM EXPOSURES ON ROLL FILM. 50 MM/F 4.5 NAGEL ANASTIGMAT LENS. NAGEL SHUTTER. THE MODEL NO. 46/1 HAS A NAGEL, IBSOR, OR PRONTO SHUTTER.

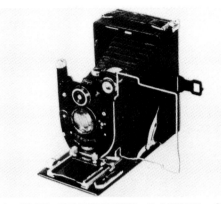

**(3334) NAGEL "RECOMAR" NO. 18 CAMERA.** C. 1928–39. SIZE 6.5 X 9 CM EXPOSURES ON PLATES. F 6.8, F 6.3, OR F 4.5 NAGEL ANASTIGMAT LENS. ALSO, F 4.5 NAGEL DOUBLE ANASTIGMAT, LAUDAR, SCHNEIDER LEXAR, XENAR, ZEISS TESSAR, LEITZ ELMAR, OR F 3.8 XENAR LENS. RECOMAR MODEL NO. 18 AFTER 1930.

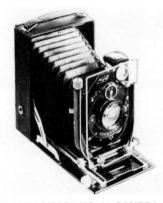

**(3335) NAGEL "RECOMAR" NO. 33 CAMERA.** C. 1928–39. SIZE 9 X 12 CM EXPOSURES ON PLATES. F 6.8, F 6.3, OR F 4.5 NAGEL ANASTIGMAT LENS. ALSO, F 4.5 NAGEL DOUBLE ANASTIGMAT, SCHNEIDER XENAR, LEXAR, ZEISS TESSAR, LEITZ ELMAR, OR F 3.8 OR 3.5 SCHNEIDER XENAR LENS. COMPUR SHUTTER. RECOMAR NO. 33 MODEL AFTER 1930.

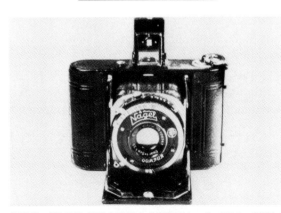

**(3336) NAGEL VOLLENDA CAMERA.** C. 1932. SIZE 3 X 4 CM EXPOSURES ON ROLL FILM. 50 MM/F 3.5 LEITZ ELMAR LENS. COMPUR SHUTTER WITH SPEEDS TO $\frac{1}{300}$ SEC., B., T. (HA)

## NAGEL CAMERAWERK (*cont.*)

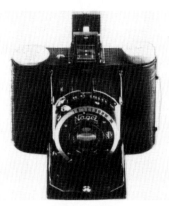

**(3337)** **NAGEL VOLLENDA NO. 48 CAMERA.** C. 1931–37. SIZE 3 X 4 CM EXPOSURES ON ROLL FILM. F 3.5 OR F 4.5 SCHNEIDER RADIONAR, F 3.5 OR F 2.9 XENAR, F 2.8 OR F 3.5 ZEISS TESSAR, OR F 3.5 LEITZ ELMAR LENS. NAGLE, PRONTO S, OR COMPUR (1 TO 1/300 SEC., B., T.) SHUTTER.

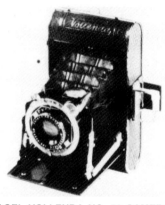

**(3338)** **NAGEL VOLLENDA NO. 52 CAMERA.** C. 1932–37. SIZE 4 X 6.5 CM EXPOSURES ON ROLL FILM. F 4.5 SCHNEIDER RADIONAR, F 4.5 OR F 3.5 XENAR, OR F 4.5 OR F 3.5 ZEISS TESSAR LENS. NAGEL, PRONTO S, OR COMPUR SHUTTER.

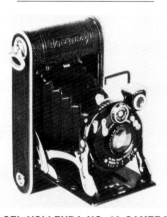

**(3339)** **NAGEL VOLLENDA NO. 60 CAMERA.** C. 1930–31. SIZE 5 X 7.5 CM EXPOSURES ON ROLL FILM. F 6.3 OR F 4.5 NAGEL ANASTIGMAT, F 4.5 NAGEL LAUDAR, OR SCHNEIDER XENAR LENS. NAGEL, IBSOR, PRONTO, PRONTO S, OR COMPUR SHUTTER.

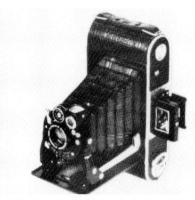

**(3340)** **NAGEL VOLLENDA NO. 68 CAMERA.** C. 1930–34. SIZE 6 X 9 CM EXPOSURES ON ROLL FILM. F 6.3 SCHNEIDER RADIONAR LENS. NAGEL OR PRONTO S SHUTTER.

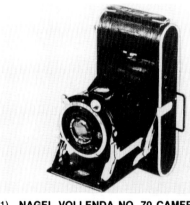

**(3341)** **NAGEL VOLLENDA NO. 70 CAMERA.** C. 1930–34. SIZE 6 X 9 CM EXPOSURES ON ROLL FILM. F 6.3 OR F 4.5 NAGEL ANASTIGMAT, F 4.5 NAGEL LAUDER, SCHNEIDER XENAR, OR LEITZ ELMAR LENS. NAGEL, PRONTO, PRONTO S, IBSOR, COMPUR, OR COMPUR S SHUTTER.

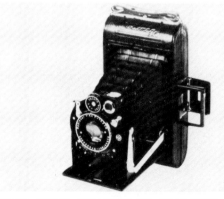

**(3342)** **NAGEL VOLLENDA NO. 72 CAMERA.** C. 1930–34. SIZE 6 X 9 CM EXPOSURES ON ROLL FILM. F 4.5 SCHNEIDER RADIONAR, XENAR, OR ZEISS TESSAR LENS. PRONTO S OR COMPUR S SHUTTER.

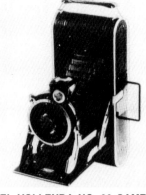

**(3343)** **NAGEL VOLLENDA NO. 80 CAMERA.** C. 1930–31. SIZE 6.5 X 11 CM EXPOSURES ON ROLL FILM. F 6.3 OR F 4.5 NAGEL ANASTIGMAT, F 4.5 NAGEL LAUDER, OR F 4.5 SCHNEIDER XENAR LENS. IBSOR, PRONTO, PRONTO S, COMPUR, OR COMPUR S SHUTTER.

## NETTEL-CAMERAWERK

**(3344)** **ARGUS TELESCOPE DETECTIVE CAMERA.** C. 1907. SIZE 4.5 X 6 CM EXPOSURES ON PLATES. 50 MM/F 4.5 ZEISS TESSAR LENS. SINGLE SPEED SHUTTER. THE CAMERA'S LENS IS IN THE SIDE OF THE "TELESCOPE." (HA)

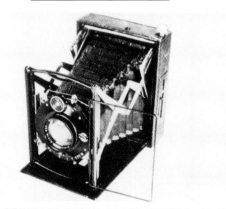

**(3345)** **CONTESSA-NETTEL PLATE CAMERA.** C. 1918. SIZE 9 X 12 CM EXPOSURES ON PLATES. 150 MM/F 4.5 ZEISS TESSAR LENS. COMPUR SHUTTER WITH SPEEDS TO 1/150 SEC. (HA)

**(3346)** **NETTEL CAMERA. ORIGINAL MODEL.** C. 1904. SIZE 10 X 15 CM EXPOSURES ON PLATES.

## NETTEL-CAMERAWERK (cont.)

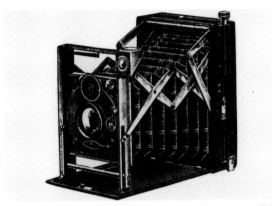

**(3347) KIBITZ FOLDING CAMERA.** C. 1911. TWO SIZES OF THIS CAMERA FOR 6 X 9 OR 9 X 12 CM EXPOSURES ON SHEET FILM OR FILM PACKS. F 5.6 OR F 6.8 EURYPLAN LENS. COMPOUND SHUTTER. RISING LENS MOUNT.

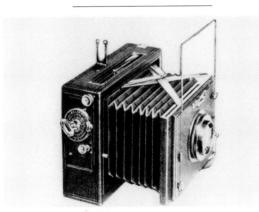

**(3348) NETTEL DECKRULLO CAMERA.** C. 1910. THREE SIZES OF THIS CAMERA FOR 9 X 12, 10 X 15, OR 13 X 18 CM EXPOSURES ON PLATES. F 6.8 NETTEL ANASTIGMAT OR ZEISS DOPPEL AMATAR; F 6.5 OR F 4.5 NETTEL ANASTIGMAT; OR F 6.3 OR F 4.5 ZEISS TESSAR LENS. DECKRULLO FOCAL PLANE SHUTTER: ½ TO ¹⁄₂₈₀₀ SEC. (HA)

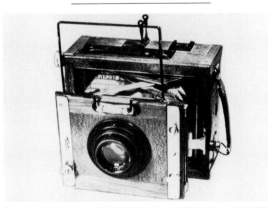

**(3349) NETTEL DECKRULLO TROPICAL CAMERA.** C. 1910. SIZE 9 X 12 CM EXPOSURES ON PLATES. 120 MM/F 4.5 TESSAR LENS. DECKRULLO FOCAL PLANE SHUTTER; ½ TO ¹⁄₂₃₀₀ SEC. (HA)

**(3350) NETTEL STEREO DECKRULLO CAMERA.** C. 1912. STEREO OR PANORAMIC EXPOSURES ON PLATES. ONE LENS IS MOUNTED ON A SQUARE PANEL WHICH CAN BE ROTATED 180-DEGREES TO BRING THE LENS TO THE CENTER OF THE CAMERA FOR PANORAMIC EXPOSURES.

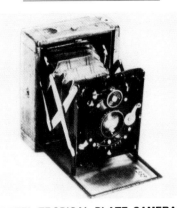

**(3351) NETTEL TROPICAL PLATE CAMERA.** C. 1915. SIZE 4.5 X 6 CM EXPOSURES ON PLATES. 75 MM/F 4.5 ZEISS TESSAR LENS. COMPOUND SHUTTER WITH SPEEDS TO ¹⁄₃₀₀ SEC. TEAKWOOD BODY. (HA)

**(3352) SONNET PLATE CAMERA.** C. 1909. SIZE 9 X 12 CM EXPOSURES. STRUT-SUPPORTED BELLOWS.

**(3353) SONNET PLATE CAMERA.** C. 1912. SIZE 4.5 X 6 CM PLATE EXPOSURES. 75 MM/F 4.5 ZEISS TESSAR LENS. COMPOUND SHUTTER; 1 TO ¹⁄₃₀₀ SEC. (MA)

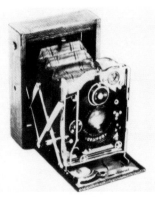

**(3354) SONNET TROPICAL PLATE CAMERA.** C. 1920. SIZE 4.5 X 6 CM EXPOSURES ON PLATES. 75 MM /F 4.5 ZEISS TESSAR LENS. COMPUR SHUTTER WITH SPEEDS TO ¹⁄₃₀₀ SEC. TEAKWOOD BODY. (HA)

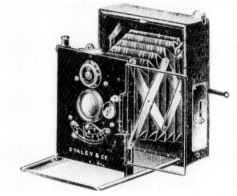

**(3355) SONNET VEST POCKET CAMERA.** C. 1914. SIZE 4.5 X 6 CM EXPOSURES ON PLATES OR FILM PACKS WITH ADAPTER. F 4.5 EURYPLAN LENS. COMPOUND SHUTTER FOR INSTANT, B., T. EXPOSURES. FOCUSING ADJUSTMENT.

## NEUBRONNER, DR. JULIUS

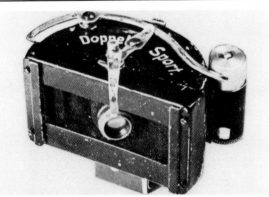

**(3356) DOPPEL-SPORT PANORAMIC CAMERA.** C. 1907. SIZE 3 X 8 CM PANORAMIC EXPOSURES. PNEUMATIC SHUTTER. (HA)

## NEUE GORLITZER KAMERAWERK

**(3357) BERTHILLON CAMERA.** C. 1904. SIZE 18 X 24 CM EXPOSURES ON PLATES.

**(3358) VIEW CAMERA.** C. 1898. SIZE 13 X 18 CM EXPOSURES.

## NORISAN G. M. B. H.

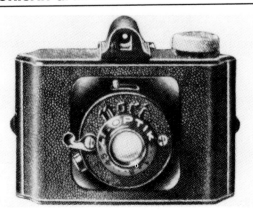

## NORISAN G. M. B. H. (*cont.*)

(3359) **NORI II CAMERA.** C. 1937. SIZE 2.5 X 3.2 CM EXPOSURES ON ROLL FILM. 40 MM/F 8 LENS. INSTANT AND TIME SHUTTER. (HA)

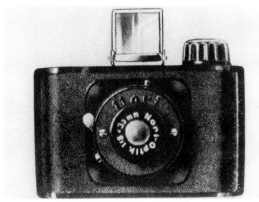

(3360) **NORI VEST POCKET CAMERA.** C. 1935. SIZE 2.5 X 2.5 CM EXPOSURES ON "35MM" ROLL FILM. F 8 LENS.

## ORIONWERK A. G.

(3361) **ORION KLAPP REFLEX CAMERA.** C. 1925. SIZE 9 X 12 CM EXPOSURES.

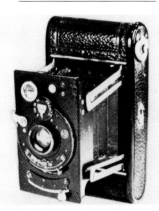

(3362) **ORION ROLL FILM CAMERA.** C. 1920. SIZE 4.5 X 6.5 CM EXPOSURES. 75 MM/F 6.3 RADIONAR LENS. PRONTO SHUTTER; ½₅ TO ⅟₁₀₀ SEC., B., T. (HA)

(3363) **ORION TROPICAL PLATE CAMERA.** C. 1925. SIZE 9 X 12 CM EXPOSURES ON PLATES. DAGOR LENS.

(3364) **ORION VEST POCKET CAMERA.** C. 1920. SIZE 4 X 6.5 CM ROLL FILM EXPOSURES. 72 MM/F 4.2 PLAUBEL ANTICOMAR LENS. COMPUR SHUTTER; 1 TO ⅟₃₀₀ SEC. GOLD-PLATED METAL BODY. (IH)

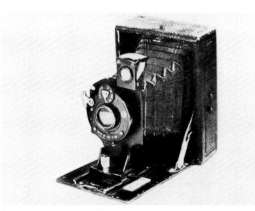

(3365) **RIO FOLDING PLATE CAMERA.** C. 1926. SIZE 6 X 9 CM EXPOSURES ON PLATES. 105 MM /F 6.3 MEYER TRIOPLAN LENS. PRONTO SHUTTER; ½₅ TO ⅟₁₀₀ SEC. (HA)

## PALMOS-WERK

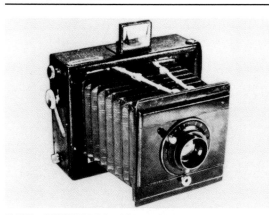

(3366) **MINIMUM-PALMOS CAMERA.** C. 1900. SIZE 9 X 12 CM EXPOSURES ON PLATES. EIGHT-SPEED FOCAL PLANE SHUTTER. LEATHER COVERED WOOD BODY. (HA)

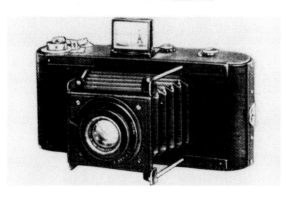

(3367) **PALMOS CAMERA.** C. 1900. SIZE 6 X 9 CM EXPOSURES ON ROLL FILM. 112 MM/F 4.5 ZEISS UNAR LENS. FOCAL PLANE SHUTTER; ½₀ TO ⅟₂₀₀ SEC. FILM TRANSPORT WITH SHUTTER COCKING. (HA)

## PETER, JOSEPH

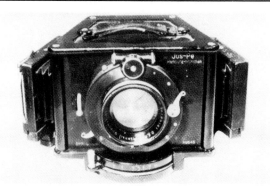

(3368) **JOS-PE COLOR CAMERA.** C. 1925. TWO SIZES OF THIS CAMERA FOR 4.5 X 6 OR 9 X 12 CM COLOR EXPOSURES. 105 MM/F 2.5 STEINHEIL QUINAR OR 180 MM/F 3 STEINHEIL CASSAR LENS. COMPOUND SHUTTER; 1 TO ⅟₁₀₀ SEC. OR A SHUTTER WITH SPEEDS FROM 1 TO ⅟₅₀ SEC. PARTIALLY-SURFACED MIRRORS AND COLOR FILTERS ARE USED TO EXPOSE THREE COLOR PLATES. (HA)

(3369) **JOS-PE COLOR CAMERA.** C. 1925. SIZE 9 X 12 CM PLATE EXPOSURES. 180 MM/F 3 STEINHEIL CASSAR LENS. BETWEEN-THE-LENS SHUTTER; 1 TO ⅟₅₀ SEC. TWO PARTIALLY-SURFACED MIRRORS ARE USED TO EXPOSE THREE COLOR PLATES. (MA)

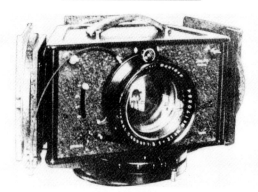

(3370) **JOS-PE COLOR CAMERA.** C. 1940. SIZE 9 X 12 CM EXPOSURES ON TRI-COLOR PLATES. 180 MM/ F 3 STEINHEIL CASSAR LENS. BETWEEN-THE-LENS SHUTTER; 1 TO ⅟₅₀ SEC. PARTIALLY-SURFACED MIRRORS ARE USED TO SPLIT THE LIGHT BEAM INTO THREE PARTS TO EXPOSE THREE COLOR PLATES.

## PHOTAVIT WERK

(3371) **PHOTAVIT CAMERA.** C. 1930. TWENTY EXPOSURES SIZE 24 X 24 MM ON SPECIAL ROLL FILM CASSETTES. 37.5 MM/F 3.5 RADIONAR LENS. PRONTO II SHUTTER; 1 TO ⅟₂₀₀ SEC., B., T. (IH)

## PHOTAVIT WERK (*cont.*)

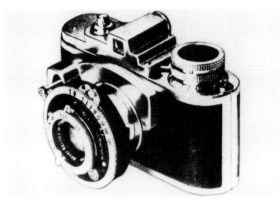

**(3372) PHOTAVIT MODEL I CAMERA.** C. 1928. SIZE 24 X 24 MM EXPOSURES ON ROLL FILM. 40 MM/F 7.7 SPEZIAL LENS, F 4.5 CORYPON, OR F 3.5 TRIOPLAN LENS. SPEZIAL SHUTTER 1/25, 1/50, 1/100 SEC., B.

**(3373) PHOTAVIT MODEL II CAMERA.** C. 1928. SIZE 24 X 24 MM EXPOSURES ON ROLL FILM. 40 MM/F 2.9 CORYPON OR TRIOPLAN LENS. ALSO, 42 MM/F 2.8 PRIMOTAR LENS. PRONTO SHUTTER; 1/25 TO 1/125 SEC., B. OR PRONTOR SHUTTER; 1 TO 1/175 SEC., B., T. ALSO, COMPUR SHUTTER; 1 TO 1/300 SEC., B., T. SIMILAR TO THE PHOTAVIT MODEL I CAMERA.

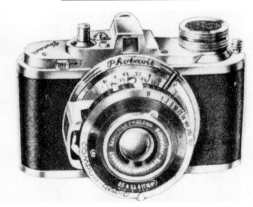

**(3374) PHOTAVIT MODEL IV CAMERA.** C. 1938. FIFTY EXPOSURES SIZE 24 X 24 MM ON "35MM" ROLL FILM. 37.5 MM/F 3.5 SCHNEIDER RADIONAR LENS. COMPUR RAPID SHUTTER; 1 TO 1/500 SEC., B. (HA)

## PLASMAT G. M. B. H.

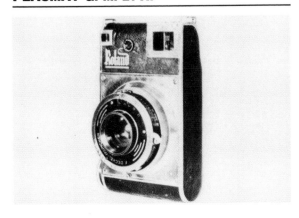

**(3375) ROLAND CAMERA.** C. 1931. SIZE 4.5 X 6 CM EXPOSURES ON NO. 120 ROLL FILM. 70 MM/F 2.7 PLASMAT LENS. COMPUR SHUTTER: 1 TO 1/250 SEC. OR COMPUR SHUTTER; 1 TO 1/400 SEC. COUPLED RANGEFINDER. (HA)

---

**(3376) MINATURE REFLEX CAMERA.** C. 1926. SINGLE-LENS REFLEX. F 1.5 MEYER KINO-PLASMAT LENS. HELICAL FOCUSING. (BC)

## PLAUBEL A. G.

**(3377) MAKINA CAMERA. ORIGINAL MODEL.** C. 1914. SIZE 4.5 X 6 CM EXPOSURES.

---

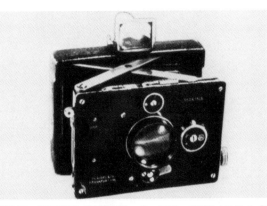

**(3378) MAKINA CAMERA.** C. 1926. SIZE 4.5 X 6 CM EXPOSURES. 75 MM/F 2.8 ANTICOMAR LENS. COMPUR SHUTTER WITH SPEEDS TO 1/250 SEC. (HA)

---

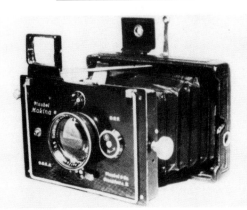

**(3379) MAKINA CAMERA.** C. 1927. SIZE 6.5 X 9 CM EXPOSURES ON PLATES OR SHEET FILM. 100 MM/F 2.9 ANTICOMAR LENS. COMPUR SHUTTER WITH SPEEDS TO 1/200 SEC. (HA)

---

**(3380) MAKINA II CAMERA.** C. 1933–39. SIZE 6 X 9 CM EXPOSURES ON SHEET, PLATE, OR ROLL FILM. COUPLED RANGEFINDER. INTERCHANGEABLE FRONT LENS. 100 MM/F 2.9 ANTICOMAR OR F 4.5 PLAUBEL REFLEX LENS. COMPUR SHUTTER; 1 TO 1/200 SEC., B., T., ST. ROLL FILM ADAPTER. (IH)

---

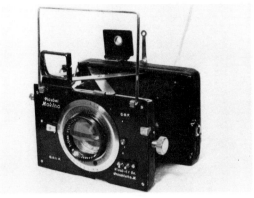

**(3381) MAKINA CAMERA.** C. 1928–33. SIZE 6.5 X 9 CM EXPOSURES ON PLATES OR SHEET FILM. 100 MM/F 2.9 ANTICOMAR LENS. COMPUR SHUTTER; 1 TO 1/200 SEC., B., T. INTERCHANGEABLE FRONT LENS. GROUND GLASS FOCUS. SOME MODELS WITH COUPLED RANGEFINDER. (MF)

---

**(3382) MAKINA II S CAMERA.** C. 1936–48. SIZE 6.5 X 9 CM EXPOSURES ON SHEET, PLATE, OR ROLL FILM. 100 MM/F 2.9 OR F 4.2 ANTICOMAR LENS. COMPUR SHUTTER, 1 TO 1/200 SEC., B., T., ST. COUPLED RANGE-FINDER. INTERCHANGEABLE LENSES. GROUND GLASS FOCUSING. ROLL FILM ADAPTER. A SPECIAL FOCAL PLANE SHUTTER (1/100 TO 1/1000 SEC.) COULD BE ATTACHED TO THE BACK OF THE CAMERA.

---

**(3383) MAKINA STEREO CAMERA.** C. 1911. SIZE 45 X 107 MM STEREO EXPOSURES ON PLATES. STRUT-TYPE FOLDING CAMERA.

---

**(3384) MAKINA STEREO CAMERA.** C. 1926. SIZE 45 X 107 MM STEREO EXPOSURES ON PLATES. 60 MM/F

## PLAUBEL A. G. (*cont.*)

6 DOUBLE ORTHAR LENSES. SHUTTER SPEEDS FROM
⅕ TO ¹⁄₁₅₀ SEC. (HA)

**(3385) MAKINETTE CAMERA.** C. 1930. SIXTEEN EX-
POSURES SIZE 3 X 4 CM ON NO. 127 ROLL FILM.
50 MM/F 2.7 ANTICOMAR OR 45 MM/F 2 SUPRACOMAR
LENS. COMPUR SHUTTER; 1 TO ¹⁄₃₀₀ SEC., B., T.
(TS)

**(3386) PECO FOLDING CAMERA.** C. 1925. SIZE 9 X
12 CM EXPOSURES. 105 MM/F 6.3 MEYER TRIOPLAN
LENS. DOUBLE EXTENSION BELLOWS. DROPPING
BED.

**(3387) PRECISION PECO FOLDING CAMERA.** C. 1932.
SIZE 9 X 12 CM EXPOSURES ON PLATES OR FILM
PACKS. F 2.9 OR F 3.9 ANTICOMAR ANASTIGMAT
LENS. COMPUR SHUTTER. RISING AND CROSSING
LENS MOUNT.

**(3388) ROLL-OP CAMERA.** C. 1935. SIZE 4.5 X 6 CM
EXPOSURES ON ROLL FILM. 75 MM/F 2.8 ANTICOMAR
LENS. COMPUR RAPID SHUTTER; 1 TO ¹⁄₄₀₀ SEC., B.,
T. COUPLED RANGEFINDER. (HA)

**(3389) VEST POCKET CAMERA.** C. 1925. SIZE 6.5 X
9 CM EXPOSURES. F 2.8 OR F 2.9 LENS.

## RECKMEIER & SCHÜNEMANN

**(3390) THREE COLOR CAMERA.** C. 1937. SIZE 6.7 X
9 CM COLOR EXPOSURES. THREE FILMS ARE EX-
POSED SIMULTANEOUSLY USING COLOR FILTERS.
150 MM/F 3.5 VOIGTLANDER HELIAR LENS. COMPUR
SHUTTER; 1 TO ¹⁄₂₀₀ SEC. (MA)

## REICHARDT, PAUL

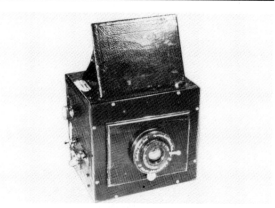

**(3391) REFLEX BOX CAMERA.** C. 1898. SIZE 9 X 12
CM EXPOSURES ON PLATES. F 6 BUSCH DETECTIV
APLANAT LENS. SIX-SPEED FOCAL PLANE SHUTTER.
(HA)

## REINHOLD ZOLLER G. M. B. H.

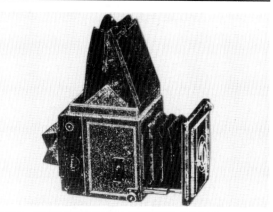

**(3392) "REFLEX NORMAL" SPIEGEL REFLEX CAMERA.**
C. 1907. TWO SIZES OF THIS CAMERA FOR 6.5 X 9 OR
9 X 14 CM EXPOSURES ON PLATES.

## REISER, LUCIAN

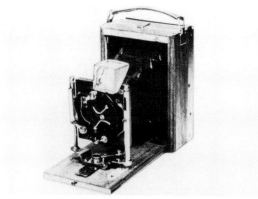

**(3393) FULGUR PLATE CAMERA.** C. 1903. SIZE 6.5
X 9 CM EXPOSURES ON PLATES. TWO-SPEED SHUT-
TER. REVOLVING APERTURE STOPS. (HA)

## RIETZSCHEL, A. HEINRICH, G. M. B. H.

**(3394) CLACK 1900 CAMERA.** C. 1903. SIZE 10 X 12.5
CM EXPOSURES ON SHEET FILM OR 9 X 12 CM EXPO-
SURES ON PLATES. 140 MM/F 8 RIETZSCHEL AN-
ASTIGMAT LENS.

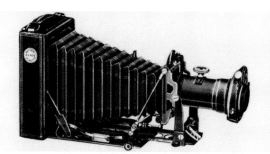

**(3395) AUTO-CLACK CAMERA.** C. 1918. SIZE 9 X 12
CM EXPOSURES ON PLATES OR FILM PACKS WITH
ADAPTER. 190 MM/F 6.3 LINEAR OR APOTAR, F 6.8 SEX-
TAR, OR F 5.5 LINEAR LENS. IBSO OR COMPOUND
SHUTTER; 1 TO ¹⁄₂₅₀ SEC. DOUBLE EXTENSION BEL-
LOWS. RACK & PINION FOCUSING. RISING AND
CROSSING LENS MOUNT.

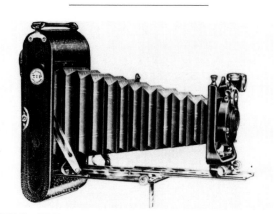

**(3396) FILM-TIP I CAMERA.** C. 1918. SIZE 9 X 12 CM
EXPOSURES ON PLATES OR ROLL FILM. F 7.5 OR F

## RIETZSCHEL, A. HEINRICH, G. M. B. H. (*cont.*)

6.8 DIALYT ANASTIGMAT LENS. IBSO OR PRONTO SHUTTER. DOUBLE EXTENSION BELLOWS. RISING, FALLING, AND CROSSING LENS MOUNT. RACK & PINION FOCUSING.

(3397) **FILM-TIP II CAMERA.** C. 1918. SIZE 9 X 12 CM EXPOSURES ON PLATES OR ROLL FILM. SAME AS THE FILM-TIP I CAMERA BUT WITH SINGLE EXTENSION BELLOWS.

(3398) **FILMOGRAPH CAMERA.** C. 1902. SIX SIZES OF THIS CAMERA USING ROLL FILM. THIS CAMERA WAS SOLD IN BRITAIN BY LANCASTER.

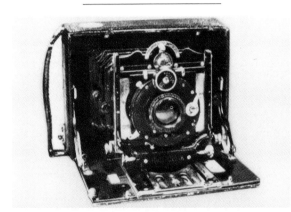

(3399) **HELI-CLACK (HORIZONTAL TYPE) CAMERA.** C. 1918. SAME EXPOSURE SIZES, LENSES, AND SHUTTERS AS THE HELI-CLACK VERTICAL TYPE CAMERA. TRIPLE EXTENSION BELLOWS. RISING AND CROSSING LENS MOUNT. DOUBLE RACK & PINION FOCUSING. (HA)

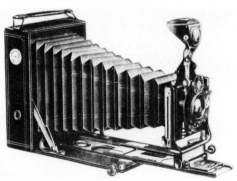

(3400) **HELI-CLACK (VERTICAL TYPE) CAMERA.** C. 1918. THREE SIZES OF THIS CAMERA FOR 9 X 12, 9 X 14, OR 13 X 18 CM EXPOSURES ON PLATES OR FILM PACKS WITH ADAPTER. F 6.3, F 5.5, OR 4.8 LINEAR; F 6.3 APOTAR; OR F 6.8 SEXTAR LENS. IBSO OR COMPOUND SHUTTER. RISING LENS MOUNT. DOUBLE RACK & PINION FOCUSING.

(3401) **HELI-TIP II (VERTICAL TYPE) CAMERA.** C. 1918. SAME AS THE HELI-TIP I (VERTICAL TYPE) CAMERA BUT WITH SINGLE EXTENSION BELLOWS.

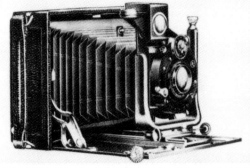

(3402) **HELI-TIP I (HORIZONTAL TYPE) CAMERA.** C. 1918. SIZE 9 X 12 CM EXPOSURES ON PLATES OR FILM PACKS WITH ADAPTER. SAME LENSES, SHUTTERS, AND FEATURES AS THE HELI-TIP I (VERTICAL TYPE) CAMERA.

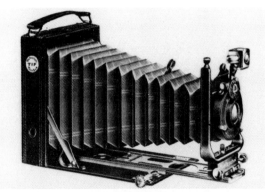

(3403) **HELI-TIP I (VERTICAL TYPE) CAMERA.** C. 1918. FOUR SIZES OF THIS CAMERA FOR 6.5 X 9, 9 X 12, 9 X 14, OR 13 X 18 CM EXPOSURES ON PLATES OR FILM PACKS. F 7.5 OR F 6.8 DIALYT ANASTIGMAT LENS. PRONTO OR IBSO SHUTTER. DOUBLE EXTENSION BELLOWS. RACK & PINION FOCUSING. RISING, FALLING, AND CROSSING LENS MOUNT. GROUND GLASS FOCUSING BACK.

(3404) **HELI-TIP III (VERTICAL TYPE) CAMERA.** C. 1918. SAME AS THE HELI-TIP I (VERTICAL TYPE) CAMERA BUT WITH SINGLE EXTENSION BELLOWS AND WITHOUT RACK & PINION FOCUSING.

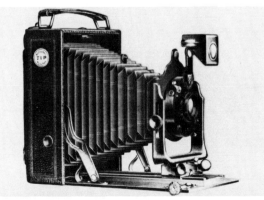

(3405) **SPECIAL TIP I (VERTICAL TYPE) CAMERA.** C. 1918. SIZE 9 X 12 CM EXPOSURES ON PLATES OR FILM PACKS WITH ADAPTER. SAME LENSES AND SHUTTERS AS THE HELI-TIP I (VERTICAL TYPE)

CAMERA. RISING AND CROSSING LENS MOUNT. DOUBLE EXTENSION BELLOWS.

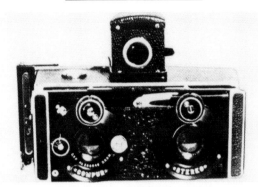

(3406) **KOSMO CLACK STEREO CAMERA.** C. 1914. SIZE 45 X 107 MM STEREO EXPOSURES ON PLATES OR FILM PACKS. 60 MM/F 4.5 LINEAR LENSES. ALSO, 65 MM/F 6.3 SEXTAR DOUBLE ANASTIGMAT LENSES. COMPUR SHUTTER; 1 TO 1/250 SEC. PANORAMIC SETTING. RISING LENS MOUNT. (HA)

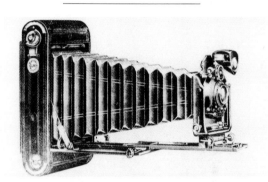

(3407) **MARINE-CLACK FOLDING CAMERA.** C. 1911. SIZE 10 X 12.5 CM EXPOSURES ON PLATES, FILM PACKS, OR ROLL FILM. F 6.8 RIETZSCHEL SEXTAR ANASTIGMAT, APOTAR ANASTIGMAT, OR LINEAR ANASTIGMAT LENS. ALSO, F 6.3, F 5.5, OR F 4.8 LINEAR ANASTIGMAT LENS. IBSO OR COMPOUND SHUTTER. DOUBLE EXTENSION BELLOWS. RISING AND FALLING LENS MOUNT.

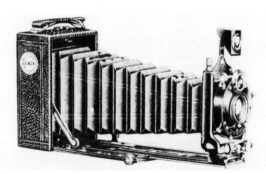

(3408) **MINIATURE CLACK I CAMERA.** C. 1918. SIZE 4.5 X 6 CM EXPOSURES ON PLATES OR FILM PACKS WITH ADAPTER. F 6.8 SEXTAR; F 6.3 APOTAR; OR F 6.3, F 5.5, OR F 4.5 LINEAR LENS. COMPOUND SHUTTER. DOUBLE EXTENSION BELLOWS. DOUBLE RACK & PINION FOCUSING.

## RIETZSCHEL, A. HEINRICH, G. M. B. H. (*cont.*)

**(3409) MINIATURE CLACK II CAMERA.** C. 1918. SIZE 4.5 X 6 CM EXPOSURES ON PLATES OR FILM PACKS WITH ADAPTER. SAME LENSES (PLUS F 7.5 DIALYT ANASTIGMAT) AND SHUTTER AS THE MINIATURE CLACK I CAMERA. SINGLE EXTENSION BELLOWS. RACK & PINION FOCUSING.

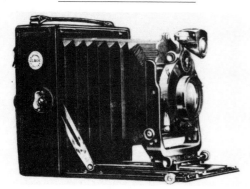

**(3410) MULTI-CLACK CAMERA.** C. 1918. THREE SIZES OF THIS CAMERA FOR 9 X 12, 9 X 14, OR 13 X 18 CM EXPOSURES ON PLATES OR FILM PACKS WITH ADAPTER. F 6.3, F 5.5, OR F 4.8 LINEAR; F 6.8 SEXTAR OR F 6.3 APOTAR LENS. COMPOUND SHUTTER. TRIPLE EXTENSION BELLOWS. DROPPING BED. RISING LENS MOUNT. REVERSIBLE BACK. ATTACHABLE FOCAL PLANE SHUTTER ON SOME MODELS.

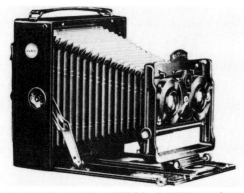

**(3411) MULTI-CLACK STEREO CAMERA.** C. 1918. THREE SIZES OF THIS CAMERA FOR 9 X 12, 9 X 14, OR 13 X 18 CM STEREO EXPOSURES ON PLATES OR FILM PACKS WITH ADAPTER. SAME LENSES AND SHUTTER AS THE MULTI-CLACK CAMERA.

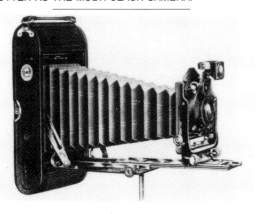

**(3412) POCKET-CLACK II CAMERA.** C. 1918. SIZE 9 X 12 CM EXPOSURES ON PLATES OR ROLL FILM. SAME LENSES AS THE MULTI-CLACK CAMERA. IBSO OR COMPOUND SHUTTER. DOUBLE EXTENSION BELLOWS. DOUBLE RACK & PINION FOCUS. RISING, FALLING, AND CROSSING LENS MOUNT. GROUND GLASS FOCUSING BACK.

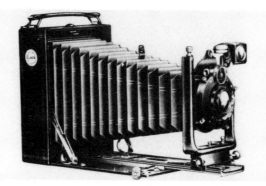

**(3413) REFORM-CLACK CAMERA.** C. 1918. FOUR SIZES OF THIS CAMERA FOR 6.5 X 9, 9 X 12, 9 X 14, OR 13 X 18 CM EXPOSURES ON PLATES OR FILM PACKS WITH ADAPTER. SAME LENSES AS THE MULTI-CLACK CAMERA. PRONTO, COMPOUND, OR IBSO SHUTTER. DOUBLE EXTENSION BELLOWS. RACK & PINION FOCUS. RISING LENS MOUNT. GROUND GLASS FOCUSING BACK.

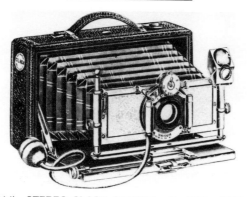

**(3414) STEREO CLACK CAMERA.** C. 1910. SIZE 8.5 X 17 CM STEREO OR PANORAMIC EXPOSURES ON PLATES. F 6.8 RIETZSCHEL SEXTAR, APOTAR, OR LINEAR LENS. ALSO, F 6.3, F 5.5, OR F 4.8 RIETZSCHEL LINEAR LENS.

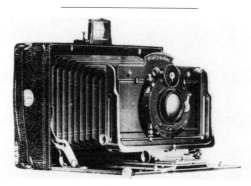

**(3415) UNIVERSAL HELI-CLACK PANORAM CAMERA.** C. 1918. SIZE 9 X 14 CM EXPOSURES ON PLATES OR FILM PACKS WITH ADAPTER. SAME LENSES AS

THE HELI-CLACK (VERTICAL TYPE) CAMERA. ALSO, AN F 6.8 DIALYT LENS. COMPOUND SHUTTER. RISING LENS MOUNT. RACK & PINION FOCUSING.

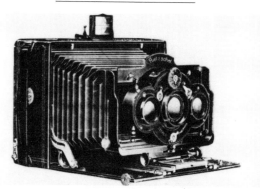

**(3416) UNIVERSAL HELI-CLACK PANORAMIC AND STEREOSCOPIC CAMERA.** C. 1918. SIZE 9 X 14 CM EXPOSURES ON PLATES OR FILM PACKS WITH ADAPTER. SAME LENSES AS THE HELI-CLACK (VERTICAL TYPE) CAMERA. ALSO, AN F 6.8 DIALYT LENS. COMPOUND SHUTTER. RISING LENS MOUNT. RACK & PINION FOCUSING.

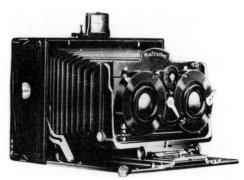

**(3417) UNIVERSAL HELI-CLACK STEREOSCOPIC CAMERA.** C. 1918. SIZE 9 X 14 CM STEREO EXPOSURES ON PLATES OR FILM PACKS WITH ADAPTER. SAME LENSES AS THE HELI-CLACK (VERTICAL TYPE) CAMERA. ALSO, AN F 6.8 DIALYT LENS. COMPOUND SHUTTER. RISING LENS MOUNT. RACK & PINION FOCUSING.

## RODENSTOCK, G.

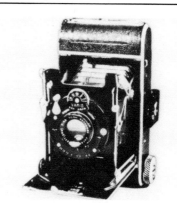

**(3418) BAFO CAMERA.** C. 1931. SIZE 4 X 6 CM EXPOSURES ON ROLL FILM. 70 MM/F 4.5 ZECANAR LENS. VARIO SHUTTER; 1/25 TO 1/100 SEC., B., T. (HA)

## RODENSTOCK, G. (*cont.*)

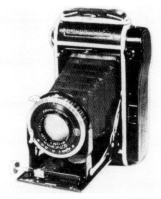

(3419) **CLAROVID ROLL FILM CAMERA.** C. 1933. SIZE 6 X 9 CM EXPOSURES ON ROLL FILM. 105 MM/F 3.8 RODENSTOCK TRINAR LENS. COMPUR SHUTTER; 1 TO $\frac{1}{250}$ SEC., B., T. (HA)

(3420) **CLAROVID II ROLL FILM CAMERA.** C. 1935. SIZE 6 X 9 CM (4.5 X 6 CM WITH MASK) EXPOSURES ON NO. 120 ROLL FILM. COUPLED RANGEFINDER AND DIRECT-VISION OPTICAL FINDER.

(3421) **PLANITTA PLATE CAMERA.** C. 1930. SIZE 6.5 X 9 CM EXPOSURES. 105 MM/F 4.5 TRINAR LENS. COMPUR RAPID SHUTTER; 1 TO $\frac{1}{400}$ SEC. RISING LENS MOUNT. (MA)

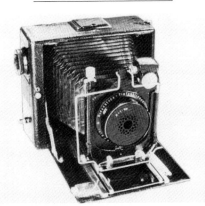

(3422) **PLATE CAMERA.** C. 1931. SIZE 9 X 12 CM EXPOSURES ON PLATES. 200 MM/F 5.4 RODENSTOCK TIEFENBILDER-IMAGON LENS. FOCAL PLANE SHUTTER; $\frac{1}{10}$ TO $\frac{1}{1000}$ SEC. (HA)

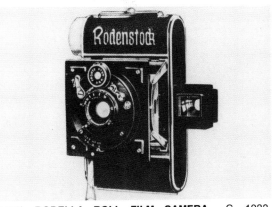

(3423) **RODELLA ROLL FILM CAMERA.** C. 1932. SIZE 3 X 4 CM EXPOSURES ON ROLL FILM. F 2.9 OR F 4.5 TRINAR ANASTIGMAT LENS. VARIO, PRONTO, OR COMPUR SHUTTER.

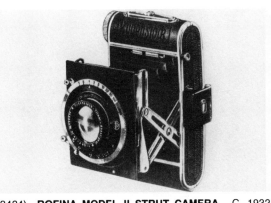

(3424) **ROFINA MODEL II STRUT CAMERA.** C. 1932. SIZE 4 X 6.5 CM EXPOSURES ON ROLL FILM. 75 MM/F 2.9 TRINAR LENS. COMPUR SHUTTER; 1 TO $\frac{1}{250}$ SEC., B., T.

(3425) **ROFINA FOLDING ROLL FILM CAMERA.** C. 1932. SIZE 4 X 6.5 CM EXPOSURES. 70 MM/F 4.5 TRINAR LENS. COMPUR SHUTTER; 1 TO $\frac{1}{250}$ SEC., B., T.

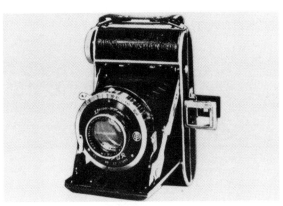

(3426) **ROLL FILM CAMERA.** C. 1933. SIZE 4.5 X 6 CM EXPOSURES. 75 MM/F 2.9 RODENSTOCK TRINAR LENS. COMPUR SHUTTER; 1 TO $\frac{1}{250}$ SEC., B., T. (HA)

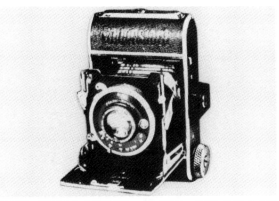

(3427) **YSELLA CAMERA.** C. 1932. SIZE 3 X 4 CM EXPOSURES ON NO. A-8 ROLL FILM. F 2.9 TO F 4.5 RODENSTOCK TRINAR LENS. VARIO, PRONTO, OR COMPUR SHUTTER; 1 TO $\frac{1}{300}$ SEC., B., T. (HA)

(3428) **YSETTE CAMERA.** C. 1934. SIZE 4.5 X 6 CM EXPOSURES ON ROLL FILM. 75 MM/F 2.9, F 3.5, OR F 4.5 RODENSTOCK TRINAR LENS. PRONTO OR COMPUR SHUTTER.

## RUBERG & RENNER

(3429) **FIBITURO CAMERA.** C. 1934. SIZE 4 X 6.5 CM (3 X 4 CM WITH MASK) EXPOSURES ON ROLL FILM. F 11 RODENSTOCK PERISCOP LENS. INSTANT AND TIME SHUTTER. (HA)

(3430) **FUTURO CAMERA.** C. 1933. SIZE 4 X 6.5 CM EXPOSURES ON ROLL FILM.

## RUBERG & RENNER (*cont.*)

(3431)　**PRASENT CAMERA.**　C. 1933.　SIZE 6 X 9 CM EXPOSURES ON PLATES.

(3432)　**RUBETTE TASCHENKAMERA.**　C. 1934.　SIZE 3 X 4 CM EXPOSURES ON ROLL FILM.　F 11 RODENSTOCK LENS.

## SACHS, JOHN & COMPANY

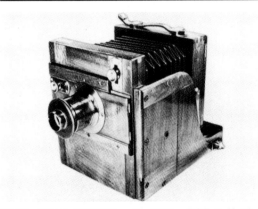

(3433)　**FIELD CAMERA.**　C. 1905.　SIZE 9 X 12 CM EXPOSURES ON PLATES.　(HA)

## SALZBERG, HEINRICH

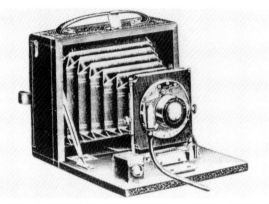

(3434)　**ELEGANT KLAPP CAMERA.**　C. 1906.　SIZE 9 X 12 CM EXPOSURES.

## SCHATZ & SOHNE

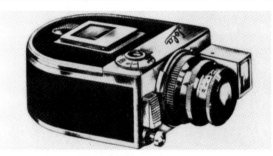

(3435)　**SOLA MINIATURE CAMERA.**　C. 1938–40. TWENTY-FOUR EXPOSURES, SIZE 13 X 18 MM ON 16 MM ROLL FILM.　25 MM/F 2 SCHNEIDER XENON LENS. SHUTTER SPEEDS TO 1/300 SEC.　SHUTTER SPEEDS TO 1/500 SEC. IN 1939 AND 1940 MODELS.

## SCHIFFMACHER

(3436)　**REFLEX BOX CAMERA.**　C. 1897.　SIZE 9 X 9 CM EXPOSURES ON EASTMAN ROLL FILM.　100 MM/F 8 APLANAT LENS.　(IH)

## SCHLEISSNER

(3437)　**BOWER X FOLDING CAMERA.**　SIZE 6 X 6 CM (4.5 X 6 CM WITH MASK) EXPOSURES ON NO. 120 OR 620 ROLL FILM.　105 MM/F 4.5 SCHNEIDER RADIONAR LENS.　PRONTO OR VARIO SHUTTER.

## SCHLICHT (VON), E.

(3438)　**BLITZ BOX-FORM CAMERA.**　C. 1887.　SIZE 9 X 12 CM PLATE EXPOSURES.　EXTERNAL ROTARY SHUTTER.

(3439)　**MOMENTOGRAPH CAMERA.**　C. 1886.　SIZE 7 X 7 CM EXPOSURES ON PLATES.　EXTERNAL ROTARY SHUTTER.　THE BOX-FORM CAMERA HAS A KNOB-LIKE HANDGRIP.　(BC)

## SCHMIDT & THIENEMANN

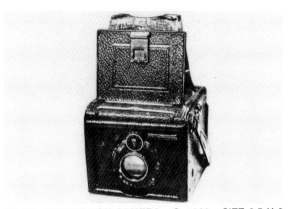

(3440)　**REFLEX BOX CAMERA.**　C. 1926.　SIZE 6.5 X 9 CM EXPOSURES ON PLATES.　105 MM/F 3.8 MEYER-GORLITZ TRIOPLAN LENS.　IBSOR SHUTTER WITH SPEEDS TO 1/125 SEC.　(HA)

(3441)　**UNIFLEX SINGLE LENS REFLEX CAMERA.** C. 1933.　SIZE 4.5 X 6 CM PLATE EXPOSURES.　F 4.5 UNAR LENS.　PRONTO SHUTTER; 1 TO 1/100 SEC. SHUTTER COCKING COUPLED TO THE REFLEX MIRROR.　(IH)

## SIDA G. M. B. H.

(3442)　**EXTRA CAMERA.**　C. 1936.　SIZE 24 X 24 MM ROLL FILM EXPOSURES.　SINGLE-SPEED GUILLOTINE SHUTTER.　(MA)

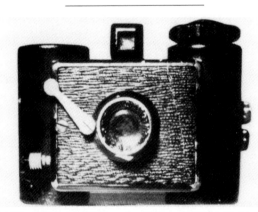

(3443)　**SIDA CAMERA.**　C. 1936.　SIZE 24 X 24 MM EXPOSURES ON ROLL FILM.　35 MM/F 8 SIDA LENS. (HA)

## SPITZER, OTTO

(3444)　**DON JUAN FOLDING PLATE CAMERA.**　C. 1906. SIZE 9 X 12 CM EXPOSURES.

(3445)　**SCHÜLER-KAMERA "PHOTOLA" BOX CAMERA.** C. 1926.　THREE SIZES OF THIS CAMERA FOR 4.5 X 6, 6.5 X 9, OR 9 X 12 CM EXPOSURES ON PLATES OR FILM PACKS.　SINGLE-SPEED AND TIME SHUTTER.

## SPITZER, OTTO (*cont.*)

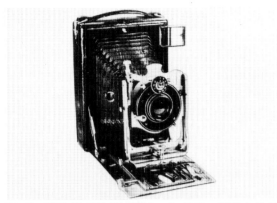

(3446) **ESPI PLATE CAMERA.** C. 1908. SIZE 9 X 12 CM EXPOSURES ON PLATES. F 8 ESPI EXTRA RAPID LENS. CBT SHUTTER WITH SPEEDS TO ¹⁄₁₀₀ SEC. (HA)

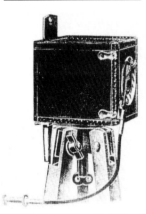

(3447) **FERROTYPE CAMERA.** C. 1913. THE CAMERA MAKES 25 FERROTYPE EXPOSURES AND DEVELOPS THEM IN A TANK ATTACHED TO THE CAMERA.

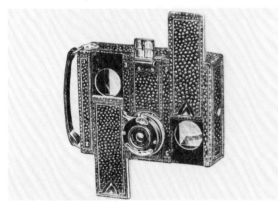

(3448) **SIXTOGRAPH CAMERA.** C. 1910. SIX EXPOSURES ON EACH 9 X 12 CM PLATE OR SHEET FILM. F 7.7 EXTRA RAPID APLANAT, F 6.8 NORMAL POLYNAR, OR F 4.5 OR F 6.5 ESPI DOUBLE ANASTIGMAT LENS. MIDGET, IBSO, OR KOILOS SHUTTER. THE LENS BOARD CAN BE MOVED VERTICALLY IN EITHER OF THE TWO POSITIONS IN THE CENTER, LEFT SIDE, OR RIGHT SIDE OF THE CAMERA FOR A TOTAL OF SIX EXPOSURES. SLIDING PANELS ARE USED TO COVER THE UNUSED OPENINGS.

(3449) **TEDDY FOLDING PLATE CAMERA.** C. 1906. SIZE 9 X 12 CM EXPOSURES.

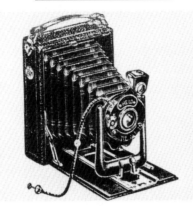

(3450) **WALHALLA FOLDING CAMERA.** C. 1925. TWO SIZES OF THIS CAMERA FOR 6.5 X 9 OR 9 X 12 CM EXPOSURES ON PLATES OR FILM PACKS. LANDSCHAFTSLINSE, SPEZIAL APLANAT, ACHROMAT, OR POLYPLAN LENS. SIMPLEX, VARIO, OR HELO SHUTTER.

## STECKELMANN, MAX

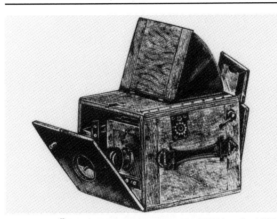

(3451) **PHÖNIX SPIEGEL REFLEX CAMERA.** C. 1896. EXPOSURES ON PLATES. FOCAL PLANE SHUTTER. EXTERNAL KNOB FOR FOCUSING.

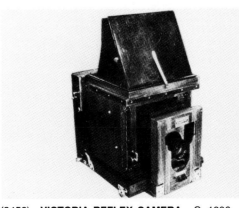

(3452) **VICTORIA REFLEX CAMERA.** C. 1896. SIZE 9 X CM EXPOSURES ON PLATES. 125 MM/F 7.2 ANASTIGMAT LENS. FOCAL PLANE SHUTTER. (AH)

## STEGEMANN, A.

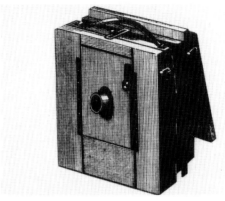

(3453) **FIELD CAMERA.** C. 1891. SIX SIZES OF THIS CAMERA FOR 18 X 24, 21 X 27, 24 X 30, 29 X 34, 30 X 40, OR 40 X 50 CM EXPOSURES ON PLATES. MAHOGANY BODY.

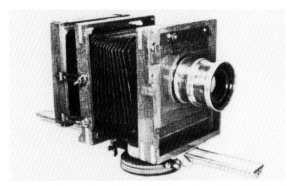

(3454) **KÜHN STUDENT CAMERA.** C. 1930. SIZE 9 X 12 CM EXPOSURES ON PLATES. 240 MM/F 7.7 GOERZ DOUBLE ANASTIGMAT LENS. THE CAMERA IS MOUNTED ON A TRIANGLE-TYPE OPTICAL BENCH FOR FOCUSING. (HA)

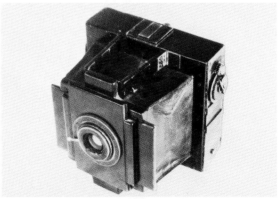

(3455) **STEGEMANN'S SECRET CAMERA.** C. 1897. SIZE 9 X 12 CM EXPOSURES ON PLATES. GOERZ DOUBLE ANASTIGMAT LENS. FOCAL PLANE SHUTTER. (HA)

## STEINER, KURT AND DR. S. HECKELMANN

(3456) **POCKET WATCH CAMERA.** C. 1939. ROUND EXPOSURES ON CIRCULAR FILM. THE LENS AND SHUTTER ARE HOUSED IN THE "WATCH" STEM. AN INTERNAL MIRROR REFLECTS THE IMAGE ONTO THE FILM. THE CAMERA HAS THE APPEARANCE OF A POCKET WATCH. (IH)

## STEINHEIL (VON), C. A.

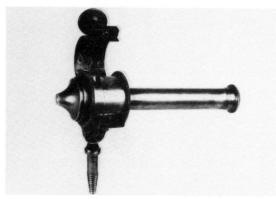

(3457) **DAGUERREOTYPE CAMERA.** C. 1840. SIZE 8.5 X 11 MM EXPOSURES.

## STEINHEIL, C. A. (SÖHNE)

(3458) **ALTO-STEREO-QUART CAMERA.** C. 1902. STEREO OR PANORAMIC EXPOSURES.

---

(3459) **DETECTIVE MAGAZINE CAMERA.** C. 1888. SIZE 9 X 12 CM EXPOSURES ON PLATES. THE MAGAZINE HOLDS 12 PLATES. STEINHEIL ACHROMATIC DOUBLET OR GRUPPEN ANTIPLANET LENS. ROTARY SECTOR SHUTTER. (IH)

---

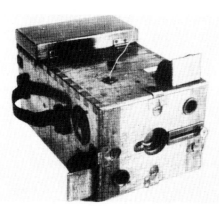

(3460) **DETECTIVE MAGAZINE CAMERA.** C. 1890. SIZE 9 X 12 CM EXPOSURES ON PLATES. THE MAGAZINE HOLDS 12 PLATES. ACHROMAT LENS. ROTARY SHUTTER. (HA)

---

(3461) **DETECTIVE MAGAZINE CAMERA.** C. 1896. SIZE 9 X 12 CM EXPOSURES ON PLATES. THE MAGAZINE HOLDS 12 PLATES. ROTARY SHUTTER. (HA)

---

(3462) **DETECTIVE STEREO MAGAZINE CAMERA.** C. 1890. THE MAGAZINE HOLDS 12 PLATES. STEINHEIL ACHROMATE LENSES. ROTARY SHUTTER. (HA)

---

(3463) **ESCO CAMERA.** C. 1927. FOUR HUNDRED EXPOSURES SIZE 18 X 24 MM ON CINE ROLL FILM. MODEL I: 35 MM/F 3.5 CASSAR ANASTIGMAT LENS IN COMPUR SHUTTER; 1 TO 1/300 SEC. MODEL II: 35 MM/F 6.3 CASSAR ANASTIGMAT LENS IN PRONTO SHUTTER.

(3464) **KLEINFILM CAMERA.** C. 1930. SIZE 3 X 4 CM EXPOSURES ON ROLL FILM. MODEL I: 50 MM/F 2.9 CASSAR LENS IN COMPUR SHUTTER; 1 TO 1/300 SEC., B., T. MODEL II: 50 MM/F 4.5 ACTINAR LENS IN COMPUR SHUTTER; 1 TO 1/300 SEC., B., T. OR PRONTO SHUTTER.

---

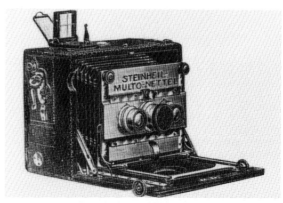

(3465) **MULTO-NETTEL STEREO CAMERA.** C. 1906. SIZE 7 X 9 CM SINGLE EXPOSURES OR 9 X 14 CM STEREO EXPOSURES ON PLATES. F 6.8 ORTHO-STIGMAT LENSES. FOCAL PLANE SHUTTER; 1/8 TO 1/1375 SEC. CENTRAL LENS FOR PANORAMIC EXPOSURES.

(3466) **PRÄZISIONS-METALL STEREO CAMERA.** C. 1920. SIZE 10 X 15 CM EXPOSURES ON PLATES OR FILM PACKS. F 6.8 TYRAR, UNOFOCAL, OR ORTHO-STIGMAT ANASTIGMAT LENS. ALSO; F 6, F 5.4, OR F 4.5 UNIFOCAL ANASTIGMAT LENS. IBSO OR COMPUR SHUTTER.

## STIEHL, MAX

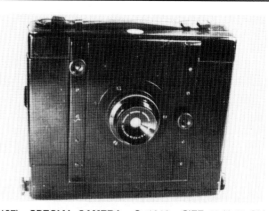

(3467) **SPECIAL CAMERA.** C. 1918. SIZE 13 X 18 CM EXPOSURES. 85 MM/F 9 STEINHEIL WEITWINKLE UNOFOKAL LENS. (HA)

## STIRN, C. P. AND RUDOLF STIRN (BERLIN)

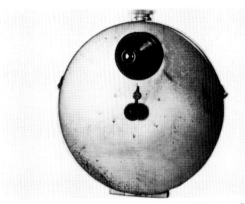

(3468) **VEST DETECTIVE CAMERA NO. 1.** C. 1888. IMPROVED MODEL OF THE AMERICAN R. D. GRAY VEST CAMERA. THE CAMERA WAS WORN UNDER A MAN'S VEST FOR CONCEALMENT. SIX 4.5 CM DIAMETER EXPOSURES ON A 14 CM DIAMETER DRY PLATE. 40 MM/F 11 FIXED FOCUS LENS. INSTANT ROTARY SHUTTER. (BS)

## STIRN, RUDOLF

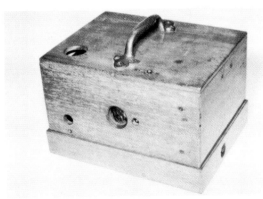

(3469) **"AMERICA" DETECTIVE CAMERA.** C. 1888. TWENTY-FIVE EXPOSURES, SIZE 7.5 X 10 CM ON ROLL FILM. 105 MM/F 17 PERISCOPIC LENS. SECTOR-TYPE SHUTTER MOUNTED IN FRONT OF THE LENS WITH A REMOVABLE WINDING KEY FOR COCKING THE SHUTTER. THE CAMERA USES A UNIQUE MECHANICAL DEVICE TO INDICATE THE NUMBER OF EXPOSURES TAKEN ON THE ROLL OF FILM. A SPIRALLY-GROVED FLAT GEAR ATTACHED TO THE FILM ROLL GUIDES A PIVOTED POINTER OVER A SCALE INDICATING THE NUMBER OF EXPOSURES. WAIST-LEVEL VIEWER. ORIGINAL PATENT BY R. D. GRAY AND H. E. STAMMER. (GE)

(3470) **STEREO DETECTIVE CAMERA.** C. 1891. SIZE 9 X 18 CM STEREO PLATE EXPOSURES. RAPID RECTILINEAR LENSES. ROTARY SHUTTER. FIXED FOCUS. THE MAGAZINE HOLDS SIX PLATES. CHANGING BAG. (IH)

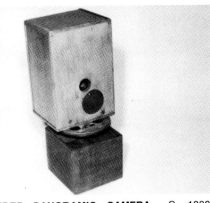

(3471) **WONDER PANORAMIC CAMERA.** C. 1890. PANORAMIC EXPOSURES COVERING 90, 180, 270, AND 360-DEGREES CAN BE OBTAINED ON 9 CM-WIDE ROLL FILM. 75 MM/F 12 PERISCOPIC LENS. A MECHANICAL SPRING AND GEAR MECHANISM IS USED TO ROTATE THE CAMERA IN ONE DIRECTION WHILE THE ROLL FILM MOVES PAST A FOCAL-PLANE SLIT IN THE OPPOSITE DIRECTION. A 360-DEGREE EXPOSURE REQUIRES A FILM LENGTH OF 46 CM. (GE)

## STÖCKIG & COMPANY

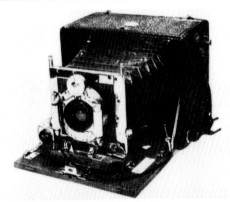

(3472) **PLATE CAMERA.** C. 1906. SIZE 10 X 15 CM EXPOSURES ON PLATES. 135 MM/F 7.2 MEYER ANASTIGMAT LENS. STÖCKIG DOUBLE PNEUMATIC SHUTTER WITH SPEEDS TO 1/100 SEC. AND A FOCAL PLANE SHUTTER WITH SPEEDS TO 1/2500 SEC. (HA)

## STROHLEIN, SCHLESICKY

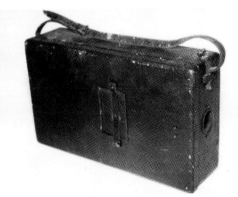

(3473) **COMFORT CAMERA.** C. 1890. SIZE 6 X 7.3 CM EXPOSURES ON DRY PLATES. 80 MM/F 7.5 ACHROMATIC MENISCUS LENS. NON-CAPPING VERTICAL GUILLOTINE SHUTTER FOR SINGLE SPEED OR TIME EXPOSURES. A STRING IS PULLED TO COCK THE SHUTTER. EIGHT PLATES ARE MOUNTED ON AN OCTAGON SOLID WOODEN WHEEL WHICH CAN BE ROTATED AND THUS EXPOSE EACH PLATE ONE AT A TIME. (GE)

## STRUHLER, MICHAIL

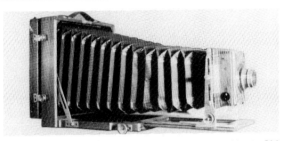

(3474) **VIEW CAMERA.** C. 1900. SIZE 13 X 18 CM EXPOSURES ON PLATES. F 8 STEINHEIL MUNCHEN LENS. THORNTON-PICKARD ROLLER BLIND SHUTTER. DOUBLE EXTENSION BELLOWS. (EL)

## TALBOT, ROMAIN

(3475) **DUPLEX FERROTYPE CAMERA.** C. 1912. THIS BOX-FORM CAMERA HAS TWO COMPLETE CAMERA SYSTEMS—TWO LENSES, TWO SHUTTERS, AND TWO DEVELOPING AND FIXING TANKS FOR PROCESSING 25 MM DIAMETER OR 45 X 63 MM FERROTYPE EXPOSURES.

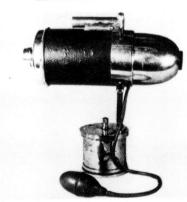

(3476) **ERTEE BUTTON CAMERA.** C. 1910. ONE-INCH DIAMETER EXPOSURES ON TIN-TYPE PLATES. 60 MM/F 4.5 LAAK LENS. SINGLE SPEED LEAF SHUTTER. THE EXPOSED PLATES DROP DIRECTLY INTO THE PROCESSING TRAY BENEATH THE CAMERA FOR DEVELOPING AND FIXING. THE CAMERA HOLDS 100 FERROTYPE PLATES. (SW)

(3477) **ESSEM FOLDING CAMERA.** C. 1902. SIZE 5 X 7 INCH EXPOSURES. RAPID RECTILINEAR LENS.

(3478) **RÄDERKANONE FERROTYPE CAMERA.** C. 1912. THE CAMERA HAS THE APPEARANCE OF A CANNON ON WHEELS. THE MAGAZINE HOLDS 25 MM DIAMETER FERROTYPE "BUTTONS" WHICH ARE DEVELOPED AND FIXED IN A TANK BENEATH THE CAMERA. F 4 PORTRAIT LENS. (BC)

## TALBOT, WALTER

**(3479) INVISIBLE BELT CAMERA.** C. 1911–29. THE LATER MODELS USED 35 MM CINE FILM. A LONG, NARROW BELT-LIKE CAMERA WITH CYLINDRICAL ROLL FILM HOLDERS AT THE ENDS. THE LENS IS MOUNTED IN A CONICAL TUBE AT THE CENTER OF THE CAMERA. THE SHUTTER IS SET, RELEASED, AND THE FILM WOUND BY A CABLE RELEASE. THE CAMERA WAS WORN AT WAIST LEVEL UNDER A COAT WITH THE LENS PROTRUDING THROUGH A BUTTON-HOLE. (IH)

## TAUBER

**(3480) FOLDING PLATE CAMERA.** C. 1920. SIZE 9 X 12 CM EXPOSURES ON PLATES. 135 MM/F 8 RAPID APLANAT LENS.

## THOMAS-WERKE

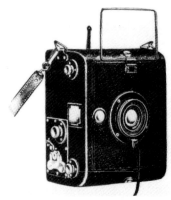

**(3481) THOWE-REBI DRP CAMERA.** C. 1921. SIZE 6 X 11 CM EXPOSURES ON ROLL FILM. F 4.5 THOWE-DOPPEL ANASTIGMAT, ALKUNAR, LAACKS, GOERZ DOGMAR, OR ZEISS TESSAR LENS. ALSO, F 4 MEYER ARISTOSTIGMAT OR MEYER PLASMAT LENS. SIZE 6 X 6 CM EXPOSURES BY USE OF A FILM MASK.

## VOIGTLANDER & SON

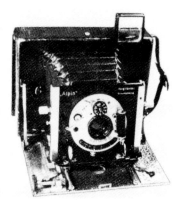

**(3482) ALPIN CAMERA.** C. 1905. SIZE 9 X 12 CM EXPOSURES ON PLATES. 120 MM/F 6.8 VOIGTLANDER COLLINEAR III LENS. KOILOS SHUTTER WITH SPEEDS TO ¹⁄₃₀₀ SEC. (HA)

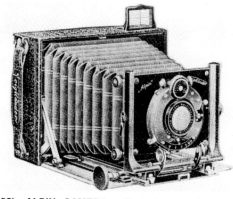

**(3483) ALPIN CAMERA.** C. 1914. TWO SIZES OF THIS CAMERA FOR 9 X 12 OR 10 X 15 CM EXPOSURES ON PLATES OR FILM PACKS. F 4.5 SCHNEIDER XENAR, F 6.3 VOIGTLANDER COLLINEAR, F 4.5 HELIAR, OR DYNAR LENS. COMPUR SHUTTER; 1 TO ¹⁄₂₀₀ SEC., B., T. OR COMPOUND SHUTTER; 1 TO ¹⁄₂₅₀ SEC., T. TRIPLE EXTENSION BELLOWS. RACK & PINION FOCUSING. RISING, FALLING, AND CROSSING LENS MOUNT.

**(3484) ALPIN STEREO-PANORAMIC CAMERA.** C. 1911. PLATE EXPOSURES. A CENTRAL LENS POSITIONED BETWEEN THE STEREO LENSES IS USED FOR PANORAMIC EXPOSURES.

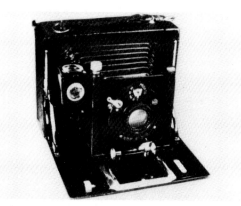

**(3485) AVUS PLATE CAMERA.** C. 1912. SIZE 9 X 12 CM EXPOSURES ON PLATES. 135 MM/F 7.5 VOIGTLANDER AVUSKOP LENS. PRONTO SHUTTER; ¹⁄₂₅ TO ¹⁄₁₀₀ SEC. (HA)

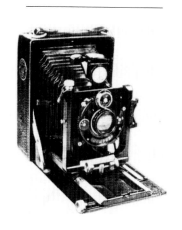

**(3486) AVUS PLATE CAMERA.** C. 1912. SIZE 9 X 12 CM EXPOSURES ON PLATES. 135 MM/F 6.3 VOIGTAR LENS. COMPUR SHUTTER WITH SPEEDS TO ¹⁄₂₅₀ SEC. (HA)

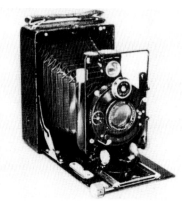

**(3487) AVUS PLATE AND FILM PACK CAMERA.** C. 1920–33. THREE SIZES OF THIS CAMERA FOR 6.5 X 9, 9 X 12, OR 10 X 15 CM EXPOSURES ON PLATES OR FILM PACKS. 105 MM/F 4.5 SKOPAR ANASTIGMAT LENS. COMPUR SHUTTER: 1 TO ¹⁄₂₅₀ SEC., B., T. (1 TO ¹⁄₂₀₀ SEC., B., T. ON SOME MODELS.) DOUBLE EXTENSION BELLOWS. RISING AND CROSSING LENS MOUNT. GROUND GLASS FOCUSING. RACK & PINION FOCUSING.

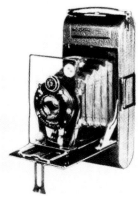

**(3488) AVUS ROLL FILM CAMERA.** C. 1928. TWO SIZES OF THIS CAMERA FOR 6 X 9 OR 6.5 X 11 CM EXPOSURES. F 4.5 SKOPAR ANASTIGMAT OR F 6.3 VOIGTAR LENS. IBSOR SHUTTER; 1 TO ¹⁄₁₂₅ SEC., B., T. OR EMBEZET SHUTTER; ¹⁄₂₅ TO ¹⁄₁₀₀ SEC. (HA)

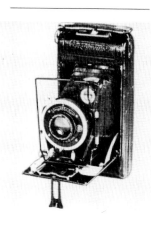

## VOIGTLANDER & SON (*cont.*)

**(3489) AVUS ROLL FILM CAMERA.** C. 1928. FOUR SIZES OF THIS CAMERA FOR 5 X 8, 6 X 9, 6 X 11, OR 9 X 14 CM EXPOSURES ON ROLL FILM. F 6.3 VOIGTAR, F 4.5 SKOPAR, OR F 4.5 HELIAR LENS. EMBEZET OR COMPUR SHUTTER; 1 TO ½₅₀ SEC., B., T. SOME MODELS WITH SELF-TIMER. (HA)

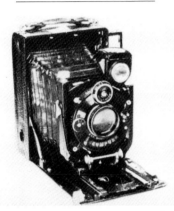

**(3490) BERGHEIL CAMERA.** C. 1913. SIZE 6.5 X 9 CM EXPOSURES ON PLATES. 105 MM/F 4.5 HELIAR LENS. COMPUR SHUTTER WITH SPEEDS TO ½₅₀ SEC. (HA)

**(3491) BERGHEIL CAMERA.** C. 1925. SIZE 4.5 X 6 CM EXPOSURES ON PLATES OR FILM PACKS. 75 MM/F 4.5 HELIAR LENS. COMPUR SHUTTER WITH SPEEDS TO ⅓₀₀ SEC.

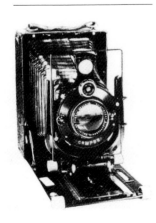

**(3492) BERGHEIL CAMERA.** C. 1925–28. SIZE 10 X 15 CM EXPOSURES ON PLATES OR FILM PACKS. 165 MM/ F 4.5 HELIAR OR F 4.5 SKOPAR ANASTIGMAT LENS. COMPUR SHUTTER; 1 TO ½₀₀ SEC., B., T. DOUBLE EXTENSION BELLOWS. RISING, FALLING, AND CROSSING LENS MOUNT. RACK & PINION FOCUSING. GROUND GLASS FOCUSING.

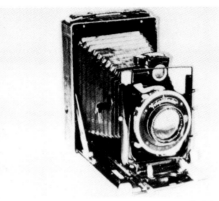

**(3493) BERGHEIL CAMERA.** C. 1930. SIZE 9 X 12 CM EXPOSURES ON PLATES. 135 MM/F 4.5 HELIAR LENS. COMPUR SHUTTER; 1 TO ⅓₀₀ SEC., B., T.

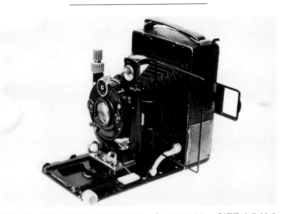

**(3494) BERGHEIL CAMERA.** C. 1930–38. SIZE 6.5 X 9 CM EXPOSURES ON PLATES. 105 MM/F 3.5 OR 4.5 HELIAR LENS. COMPUR SHUTTER; 1 TO ½₀₀ SEC., B., T. OR 1 TO ½₅₀ SEC., B., T. (TS)

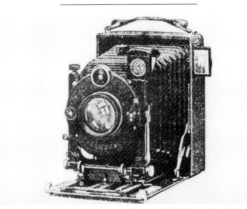

**(3495) BERGHEIL TOURIST CAMERA.** C. 1911–24. TWO SIZES OF THIS CAMERA FOR 6.5 X 9 OR 9 X 12 CM EXPOSURES ON PLATES OR FILM PACKS. 105 MM/F 4.5 HELIAR OR 135 MM/F 6.8 RADIAR LENS.

COMPUR SHUTTER; 1 TO ½₅₀ SEC. DOUBLE EXTENSION BELLOWS.

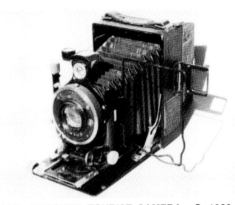

**(3496) BERGHEIL TOURIST CAMERA.** C. 1938. SIZE 6.5 X 9 CM EXPOSURES ON FILM PACKS. 105 MM/F 4.5 ANASTIGMAT SKOPAR LENS. COMPUR SHUTTER. GROUND GLASS FOCUSING BACK. (KC)

**(3497) BESSA CAMERA.** C. 1929–33. TWO SIZES OF THIS CAMERA FOR 6 X 9 OR 6.5 X 11 CM EXPOSURES ON ROLL FILM. F 6.3 VOIGTAR OR F 7.7 VOIGTLANDER ANASTIGMAT LENS. AUTOMATIC SHUTTER OR EMBEZET SHUTTER; ½₅, ½₀, ½₀₀ SEC., B., T. (HA)

**(3498) BESSA CAMERA.** C. 1932. SIZE 6 X 9 CM EXPOSURES ON ROLL FILM. 105 MM/F 4.5 HELIAR LENS. COMPUR SHUTTER; 1 TO ½₅₀ SEC., B., T. (HA)

## VOIGTLANDER & SON (cont.)

(3499) **BESSA CAMERA.** C. 1936. SIZE 6 X 9 CM EXPOSURES ON ROLL FILM. 105 MM/F 7.7 VOIGTAR LENS. SINGLO SHUTTER; ½5, ½5 SEC., B., T. (TS)

(3500) **BESSA CAMERA.** C. 1936. SIZE 6 X 9 CM EXPOSURES ON NO. 120 ROLL FILM. 105 MM/F 3.5 HELIAR OR F 3.5 HELOMAR LENS. COMPUR RAPID SHUTTER; 1 TO ¼₀₀ SEC., B., T. AND DELAYED TIMER. COUPLED RANGEFINDER. (HA)

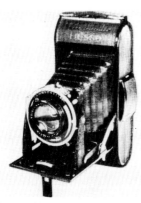

(3501) **BESSA CAMERA.** C. 1937–40. SIZE 6 X 9 CM (6 X 4.5 CM WITH MASK) EXPOSURES ON NO. 120 OR 620 ROLL FILM. 105 MM/F 7.7, F 6.3, F 4.5, OR F 3.5 VOIGTAR OR F 4.5 OR F 3.5 SKOPAR LENS. SINGLO SHUTTER; ½5 TO ½5 SEC., B., T.; PRONTO SHUTTER; ½5 TO ½25 SEC., B., T.; PRONTO SHUTTER; 1 TO ½50 SEC., B., T.; COMPUR SHUTTER; 1 TO ½50 SEC., B., T.; OR COMPUR RAPID SHUTTER; 1 TO ¼00 SEC., B., T. ALL SHUTTERS WITH DELAYED TIMER. EYE-LEVEL AND WAIST-LEVEL FINDERS. (HA)

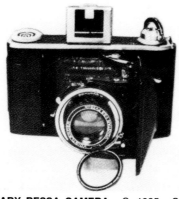

(3502) **BABY BESSA CAMERA.** C. 1935. SIZE 6 X 6 CM EXPOSURES ON NO. 120 OR B-2 ROLL FILM. 75 MM/F 3.5 VOIGTAR LENS. PRONTAR SHUTTER; 1 TO ⅟₁75 SEC., B., T., ST. BUILT-IN FILTER. (HA)

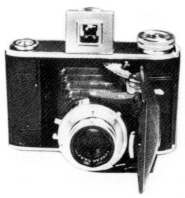

(3503) **BABY BESSA CAMERA.** C. 1936. SIZE 6 X 6 CM EXPOSURES ON ROLL FILM. 75 MM/F 4.5 VAS-KAR LENS. PRONTOR S SHUTTER; 1 TO ⅓₀₀ SEC., B.,T. (HA)

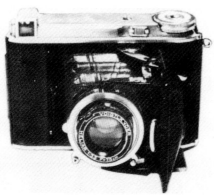

(3504) **BABY BESSA CAMERA.** C. 1936–40. SIZE 6 X 6 CM EXPOSURES (4 X 6 CM WITH MASK) ON NO. 120 OR B-2 ROLL FILM. 75 MM/F 3.5 VOIGTAR, SKOPAR, OR HELIAR LENS. COMPUR SHUTTER; 1 TO ⅓₀₀ SEC., B., T. OR COMPUR RAPID SHUTTER; 1 TO ⅕₀₀ SEC., B., T. AUTOMATIC FILM TRANSPORT. BUILT-IN FILTER. (HA)

(3505) **BIJOU REFLEX CAMERA.** C. 1908. FIRST "MINIATURE" SINGLE-LENS REFLEX CAMERA. SIZE 4.5 X 6 CM PLATE EXPOSURES. F 4.5 HELIAR LENS. HELICAL FOCUSING. FOCAL PLANE SHUTTER.

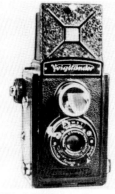

(3506) **BRILLIANT CAMERA.** C. 1932. SIZE 6 X 6 CM EXPOSURES ON ROLL FILM. F 7.7 OR F 6.3 VOIGTAR OR F 4.5 SKOPAR LENS. COMPUR SHUT-TER; 1 TO ⅓₀₀ SEC., B., T. OR EMBEZIT SHUTTER; ½5, ½₀, ¼00 SEC., B., T. EXPOSURE COUNTER. NON-FOCUSING, BRILLIANT, REFLEX FINDER. (HA)

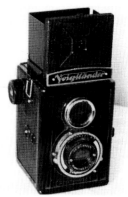

(3507) **BRILLIANT CAMERA.** C. 1935. SIZE 6 X 6 CM EXPOSURES ON ROLL FILM. 75 MM/F 4.5 VOIGTAR LENS. SHUTTER SPEEDS FROM 1 TO ⅟₁75 SEC., B., T. (TS)

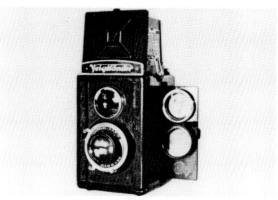

(3508) **BRILLIANT CAMERA.** C. 1937. SIZE 6 X 6 CM EXPOSURES ON ROLL FILM. 75 MM/F 3.5, F 4.5, OR F 6.3 VOIGTAR OR F 4.5 SKOPAR LENS. PRONTO SHUTTER; 1 TO ⅟₁75 SEC., B., T., ST. COMPUR SHUT-TER; 1 TO ⅓₀₀ SEC., B., T. COMPUR RAPID SHUTTER; 1 TO ⅕₀₀ SEC., B., T. SINGLO SHUTTER; ½5 TO ½5 SEC., B., T., ST. THE SIDE COMPARTMENT HOLDS A FILTER AND EXPOSURE METER. (HA)

## VOIGTLANDER & SON (*cont.*)

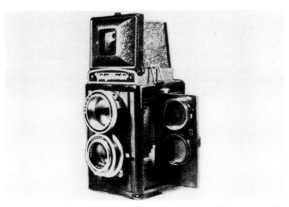

**(3509) BRILLIANT CAMERA.** C. 1938. SIZE 6 X 6 CM EXPOSURES ON ROLL FILM. 75 MM/F 3.5 SKOPAR, F 3.5 OR F 4.5 VOIGTAR, OR F 3.5 HELIAR LENS. COMPUR SHUTTER; 1 TO $\frac{1}{300}$ SEC., B., T. OR COMPUR RAPID SHUTTER; 1 TO $\frac{1}{500}$ SEC., B., T. THE SIDE COMPARTMENT HOLDS A FILTER AND EXPOSURE METER. AUTOMATIC FILM TRANSPORT. (HA)

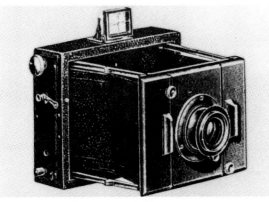

**(3510) FAVOURITE FOLDING POCKET CAMERA.** C. 1904. TWO SIZES OF THIS CAMERA FOR 9 X 12 OR 12 X 18 CM EXPOSURES ON PLATES. F 6.8 VOIGTLANDER COLLINEAR LENS. FOCAL PLANE SHUTTER.

**(3511) FAVOURITE STEREOSCOPIC CAMERA.** C. 1904. EXPOSURES ON PLATES.

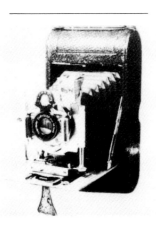

**(3512) FOLDING CAMERA.** C. 1910–20. SIZE 9 X 12 CM EXPOSURES ON ROLL OR SHEET FILM. VOIGT-EURISKOP F 6.8 LENS. WOLLENSAK SHUTTER. 1 TO $\frac{1}{50}$ SEC. (MF)

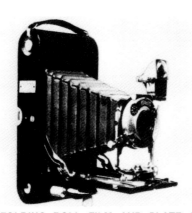

**(3513) FOLDING ROLL FILM AND PLATE CAMERA.** C. 1905. SIZE 8 X 11 CM EXPOSURES. 120 MM/F 6.8 COLLINEAR LENS. KOILOS SHUTTER WITH SPEEDS TO $\frac{1}{200}$ SEC. (HA)

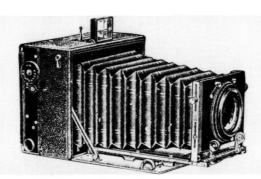

**(3514) HELIAR CAMERA.** C. 1905. SIZE 9 X 12 CM EXPOSURES ON PLATES. HELIAR LENS. FOCAL PLANE SHUTTER. RACK & PINION FOCUSING.

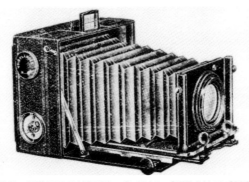

**(3515) HELIAR CAMERA.** C. 1914. SIZE 9 X 12 CM EXPOSURES ON PLATES OR FILM PACKS. F 4.5 HELIAR OR F 5.4 COLLINEAR II LENS. FOCAL PLANE SHUTTER; $\frac{1}{12}$ TO $\frac{1}{1000}$ SEC. RISING LENS MOUNT. RACK & PINION FOCUSING.

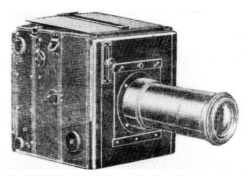

**(3516) HELIAR REFLEX CAMERA.** C. 1902–07. TWO SIZES OF THIS CAMERA FOR 9 X 12 OR 12 X 16.5 CM PLATE EXPOSURES. F 4.5 HELIAR LENS. FOCAL PLANE SHUTTER TO $\frac{1}{1000}$ SEC., T. REVERSIBLE BACK. TELEPHOTO LENS AVAILABLE AS SHOWN.

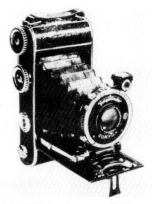

**(3517) INOS CAMERA.** C. 1931. SIZE 6 X 9 CM (4.5 X 6 CM WITH MASK) EXPOSURES ON ROLL FILM. 105 MM/F 4.5 HELIAR OR F 4.5 SKOPAR LENS. COMPUR SHUTTER; 1 TO $\frac{1}{250}$ SEC., B., T. PROBABLY THE FIRST DUAL-FORMAT ROLL FILM CAMERA TO BE WIDELY ACCEPTED. (HA)

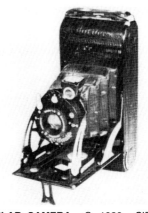

**(3518) JUBILAR CAMERA.** C. 1930. SIZE 6 X 9 CM EXPOSURES ON ROLL FILM. F 9 VOIGTAR LENS. EMBEZET SHUTTER; $\frac{1}{25}$, $\frac{1}{50}$ SEC., B., T. (HA)

## VOIGTLANDER & SON (*cont.*)

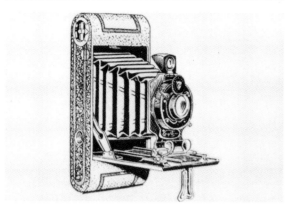

(3519) **NO. 1 JUNIOR CAMERA.** C. 1925. SIZE 6 X 9 CM EXPOSURES ON ROLL FILM. F 6.3 ANASTIGMAT LENS. PRONTO SHUTTER.

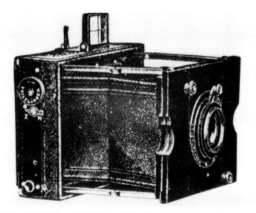

(3520) **METAL SPRING STRUT CAMERA.** C. 1905. SIZE 9 X 12 CM EXPOSURES ON PLATES. COLLINEAR LENS. FOCAL PLANE SHUTTER.

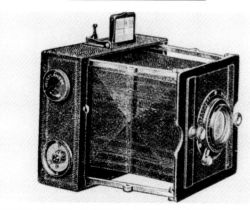

(3521) **METAL SPRING STRUT CAMERA.** C. 1914. FOUR SIZES OF THIS CAMERA FOR 9 X 12 OR 13 X 18 CM OR 3¼ X 4¼ OR 4¼ X 6½ INCH EXPOSURES ON PLATES OR FILM PACKS. F 6 DYNAR, F 6.8 COLLINEAR III, F 5.4 COLLINEAR II, OR F 4.5 HELIAR LENS. FOCAL PLANE SHUTTER; ¹⁄₁₂ TO ¹⁄₁₀₀₀ SEC. THE CAMERA OPENS BY SPRING ACTION WHEN A LEVER IS PRESSED. METAL BODY. RISING AND CROSSING LENS MOUNT.

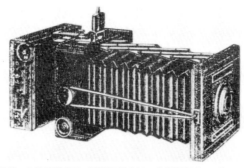

(3522) **PATENTED UNIVERSAL CAMERA.** C. 1903. SIZE 9 X 12 CM EXPOSURES ON PLATES. HELIAR OR COLLINEAR LENS. FOCAL PLANE SHUTTER.

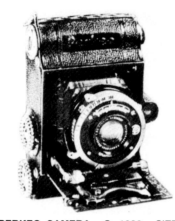

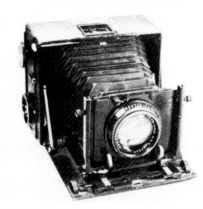

(3523) **PERKEO CAMERA.** C. 1932. SIZE 3 X 4 CM EXPOSURES ON ROLL FILM. 55 MM/F 3.5 OR F 4.5 SKOPAR LENS. ALSO, F 3.5 HELIAR LENS. COMPUR SHUTTER; 1 TO ¹⁄₃₀₀ SEC., B., T. (HA)

(3524) **PLATE CAMERA.** C. 1908. SIZE 9 X 12 CM EXPOSURES ON PLATES. 180 MM/F 4.5 HELIAR LENS. FOCAL PLANE SHUTTER; ¹⁄₂₀ TO ¹⁄₁₀₀₀ SEC. (HA)

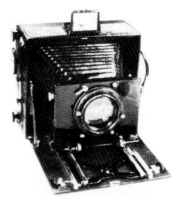

(3525) **PLATE CAMERA.** C. 1910. SIZE 9 X 12 CM EXPOSURES ON PLATES. 180 MM/F 4.5 HELIAR LENS. FOCAL PLANE SHUTTER; ¹⁄₁₂ TO ¹⁄₁₀₀₀ SEC. (HA)

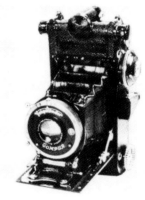

(3526) **PROMINENT CAMERA.** C. 1933. SIZE 6 X 9 CM EXPOSURES ON NO. 120 ROLL FILM. ALSO, HALF-FRAME EXPOSURES, SIZE 4.5 X 6 CM. 105 MM/F 4.5 HELIAR LENS. COMPUR SHUTTER; 1 TO ¹⁄₂₅₀ SEC., B., T. COUPLED RANGEFINDER AND EXTINCTION EXPOSURE METER. SELF-ERECTING BY A PUSH-BUTTON. (HA)

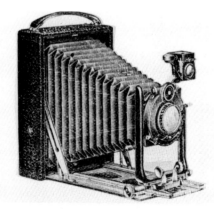

(3527) **RADIAR FOLDING CAMERA.** C. 1914. TWO SIZES OF THIS CAMERA FOR 10 X 15 CM OR 3½ X 5½ INCH EXPOSURES ON PLATES OR FILM PACKS. F 6.8 RADIAR ANASTIGMAT LENS. COMPOUND SHUTTER. RISING AND CROSSING LENS MOUNT. DOUBLE EXTENSION BELLOWS. GROUND GLASS FOCUSING.

## VOIGTLANDER & SON (*cont.*)

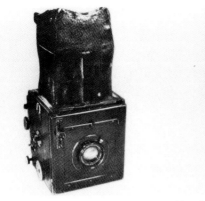

(3528) **REFLEX CAMERA.** C. 1912. SIZE 6.5 X 9 CM EXPOSURES ON PLATES. 120 MM/F 4.5 HELIAR LENS. NINE-SPEED FOCAL PLANE SHUTTER. (HA)

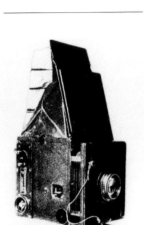

(3529) **REFLEX CAMERA.** C. 1915. SIZE 10 X 15 CM EXPOSURES ON PLATES. 180 MM/F 4.5 HELIAR LENS. FOCAL PLANE SHUTTER; 20 TO ⅟₁₀₀₀ SEC. (HA)

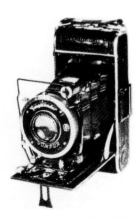

(3530) **ROLL FILM CAMERA.** C. 1932. SIZE 6 X 9 CM EXPOSURES. 105 MM/F 4.5 HELIAR LENS. COMPUR SHUTTER; 1 TO ⅟₂₅₀ SEC., B., T. (HA)

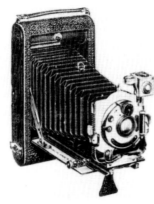

(3531) **ROLL FILM AND PLATE CAMERA.** C. 1906. THREE SIZES OF THIS CAMERA FOR 9 X 12, 9 X 14, OR 10 X 13 CM EXPOSURES. F 6.8 COLLINEAR OR F 6 DYNAR LENS. KOILOS SHUTTER WITH SPEEDS TO ⅟₃₀₀ SEC. RACK & PINION FOCUS. GROUND GLASS FOCUS.

(3532) **STEREFLEKTOSKOP STEREO CAMERA.** C. 1913. SIZE 45 X 105 MM STEREO EXPOSURES ON PLATES. REFLEX VIEWING THROUGH THE CENTER LENS. HELIAR LENSES. PUSH/PULL PLATE CHANGING MAGAZINE. (BC)

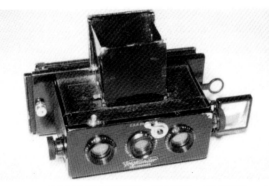

(3533) **STEREFLEKTOSKOP STEREO CAMERA.** C. 1916–24. TWO SIZES OF THIS CAMERA FOR 45 X 107 OR 60 X 130 MM EXPOSURES ON PLATES OR FILM PACKS WITH ADAPTER. THE CAMERA'S MAGAZINE HOLDS 12 PLATES. F 4.5 VOIGTLANDER HELIAR LENS. THREE-LEAF SECTION SHUTTER (1 TO ⅟₂₅₀ SEC., T.) ON MODELS TO 1923. COMPUR SHUTTER (1 TO ⅟₂₅₀ SEC.) AFTER 1923. 1:1 REFLEX VIEWER. RACK & PINION FOCUSING. (GE)

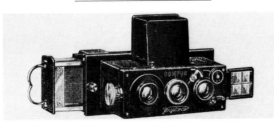

(3534) **STEREFLEKTOSKOP STEREO CAMERA.** C. 1925. SIZE 45 X 107 MM STEREO EXPOSURES ON PLATES OR FILM PACKS. REFLEX VIEWING THROUGH THE CENTER LENS. PUSH/PULL PLATE CHANGING MAGAZINE.

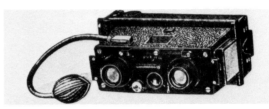

(3535) **STEREOPHOTOSCOP STEREO MAGAZINE CAMERA.** C. 1904. SIZE 45 X 107 MM STEREO EXPOSURES ON PLATES. VOIGTLANDER HELIAR LENSES.

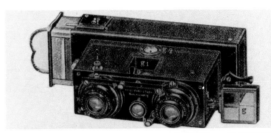

(3536) **STEREOPHOTOSCOP STEREO MAGAZINE CAMERA.** C. 1914. SIZE 45 X 107 MM STEREO EXPOSURES ON PLATES. THE MAGAZINE HOLDS 12 PLATES. F 4.5 HELIAR OR F 6.8 COLLINEAR III LENSES. RISING LENS MOUNT. IRIS DIAPHRAGMS.

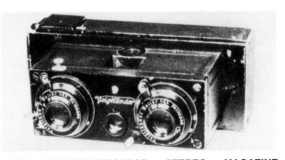

(3537) **STEREOPHOTOSCOP STEREO MAGAZINE CAMERA.** C. 1918. SIZE 45 X 107 MM STEREO EXPOSURES ON PLATES. THE MAGAZINE HOLDS 12 PLATES. 55 MM/F 4.5 HELIAR LENSES. SHUTTER SPEEDS TO ⅟₂₀₀ SEC. (HA)

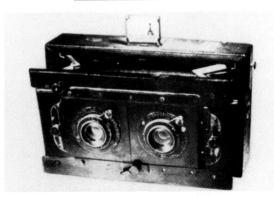

(3538) **STEREOSCOP STEREO CAMERA.** C. 1902. SIZE 9 X 18 CM STEREO EXPOSURES ON PLATES. 120 MM/F 6.8 VOIGTLANDER COLLINEAR LENSES. FOCAL PLANE SHUTTER. (HA)

## VOIGTLANDER & SON (*cont.*)

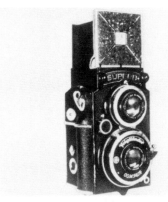

**(3539) SUPERB TWIN-LENS REFLEX CAMERA.** C. 1933–39. EIGHT EXPOSURES, SIZE 6 X 9 CM OR 12 EXPOSURES, SIZE 6 X 6 (WITH MASK) ON ROLL FILM. 75 MM/F 3.5 VOIGTLANDER SKOPAR ANASTIGMAT OR 75 MM/F 3.5 HELIAR LENS. COMPUR SHUTTER; 1 TO $\frac{1}{300}$ SEC., B., T., ST. OR COMPUR SHUTTER; 1 TO $\frac{1}{250}$ SEC., B., T. AUTOMATIC PARALLAX ADJUSTMENT FOR FOCUSING. (VC)

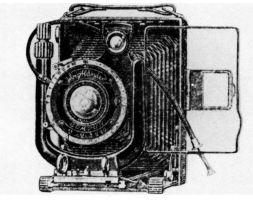

**(3540) TOURIST DELUXE CAMERA.** C. 1932. THREE SIZES OF THIS CAMERA FOR 6.5 X 9, 9 X 12, OR 10 X 15 CM EXPOSURES ON PLATES OR FILM PACKS WITH ADAPTER. F 3.5 OR F 4.5 HELIAR LENS. COMPUR SHUTTER; 1 TO $\frac{1}{200}$ SEC., B., T., ST. SOME MODELS WITH A 1 TO $\frac{1}{250}$ SEC. B., T., ST. SHUTTER. RACK & PINION FOCUSING.

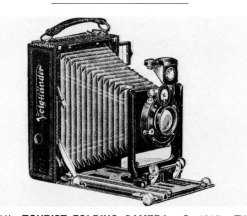

**(3541) TOURIST FOLDING CAMERA.** C. 1913. TWO SIZES OF THIS CAMERA FOR 9 X 12 CM OR 3¼ X 4¼

INCH EXPOSURES ON PLATES OR FILM PACKS. F 7.7 VOIGTLANDER EURYSCOPE, F 6.8 RADIAR ANASTIGMAT, OR F 4.5 HELIAR LENS. PRONTO, IBSO, OR COMPOUND SHUTTER. RISING AND CROSSING LENS MOUNT. DOUBLE EXTENSION BELLOWS.

**(3542) TWIN-LENS REFLEX CAMERA.** EXPOSURES ON NO. 120 ROLL FILM. 75 MM/F 7.7 TAKING LENS. CENTRAL SHUTTER; $\frac{1}{25}$ TO $\frac{1}{50}$ SEC. DIAPHRAGM APERTURE STOP. (IH)

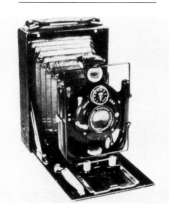

**(3543) VAG CAMERA.** C. 1925–33. TWO SIZES OF THIS CAMERA FOR 6.5 X 9 OR 9 X 12 CM EXPOSURES ON PLATES OR FILM PACKS WITH ADAPTER. F 4.5 SKOPAR OR F 6.3 VOIGTAR LENS. IBSOR SHUTTER; 1 TO $\frac{1}{250}$ SEC. B., T. OR EMBEZET SHUTTER; $\frac{1}{25}$ TO $\frac{1}{100}$ SEC. B., T. (HA)

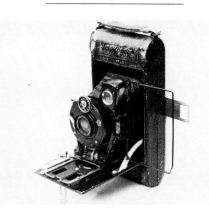

**(3544) VEST POCKET CAMERA.** C. 1924. SIZE 4.5 X 6 CM EXPOSURES ON ROLL FILM. 90 MM/F 6.3 VOIGTAR LENS. EMBEZET SHUTTER; $\frac{1}{25}$ TO $\frac{1}{100}$ SEC., B., T. (TS)

**(3545) VIDA REFLEX CAMERA.** C. 1909. SIZE 9 X 12 CM PLATE EXPOSURES. FOCAL PLANE SHUTTER.

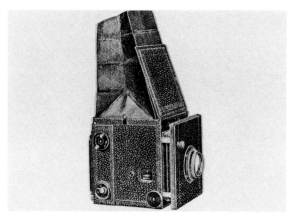

**(3546) VIDA REFLEX CAMERA.** C. 1914. THREE SIZES OF THIS CAMERA FOR 6.5 X 9, 9 X 12, OR 11 X 18 CM EXPOSURES ON PLATES. F 4.5 HELIAR LENS. FOCAL PLANE SHUTTER; $\frac{1}{12}$ TO $\frac{1}{1000}$ SEC., T.

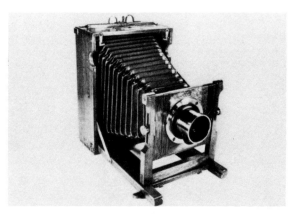

**(3547) VIEW CAMERA.** C. 1890. SIZE 13 X 18 CM EXPOSURES. VOIGTLANDER LANDSCHAFTS LENS. ROTARY APERTURE STOPS. (HA)

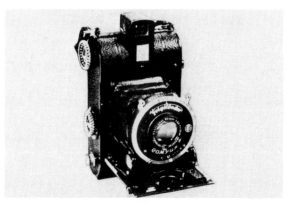

**(3548) VIRTUS CAMERA.** C. 1933. SIZE 4 X 6.5 CM EXPOSURES ON NO. 120 ROLL FILM. 75 MM/F 3.5 SKOPAR OR HELIAR LENS. COMPUR SHUTTER; 1 TO $\frac{1}{250}$ SEC., B., T. AUTOMATIC PARALLAX ADJUSTMENT FOR FOCUSING. (HA)

## VOIGTLANDER & SON (*cont.*)

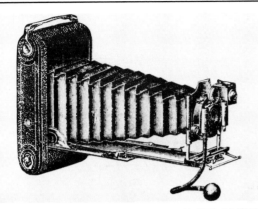

(3549) **WELCOME ROLL FILM AND PLATE CAMERA.** C. 1903. SIZE 9 X 12 CM EXPOSURES ON ROLL FILM OR PLATES. HELIAR OR COLLINEAR LENS.

## WALCH, T.

(3550) **TRICROMA COLOR CAMERA.** C. 1939. SIZE 6.5 X 9 CM EXPOSURES. 150 MM/F 4 DOPPEL PLASMAT LENS. A PLATE-CHANGING DEVICE ALLOWS FOR THREE PLATE EXPOSURES TO BE MADE AUTOMATICALLY. (MA)

## WAUCKOSIN & COMPANY

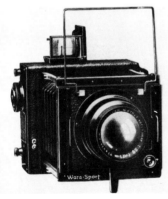

(3551) **WARA SPORT CAMERA.** C. 1930. TWO SIZES OF THIS CAMERA FOR 6 X 9 OR 9 X 12 CM EXPOSURES ON FILM PACKS. F 2.9 PLAUBEL ANTICOMAR LENS. FOCAL PLANE SHUTTER; 1/15 TO 1/1000 SEC. THE 9 X 12 CAMERA ALSO HAS AN F 3.5 PLAUBEL ANTICOMAR LENS.

## WELTA-KAMERAWERKE

(3552) **FOLDING PLATE CAMERA.** SIZE 9 X 12 CM EXPOSURES ON PLATES. 135 MM/F 3.5 RODENSTOCK EURYNAR LENS. COMPUR SHUTTER.

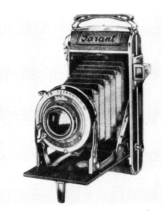

(3553) **GARANT FOLDING CAMERA.** C. 1940. SIZE 6 X 9 CM (4.5 X 6 CM WITH MASK) EXPOSURES ON NO. 120 OR B-2 ROLL FILM. F 4.5 MEYER TRIOPLAN LENS IN COMPUR S SHUTTER; 1 TO 1/250 SEC., B., T., ST. OR F 3.8 RODENSTOCK TRINAR LENS IN COMPUR RAPID SHUTTER; 1 TO 1/400 SEC., B., T., ST.

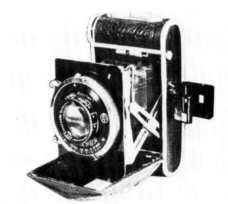

(3554) **GUCKI CAMERA.** C. 1932. SIZE 4 X 6.5 CM EXPOSURES ON ROLL FILM. 75 MM/F 2.9 SCHNEIDER XENAR LENS. COMPUR SHUTTER; 1 TO 1/250 SEC., B., T. (HA)

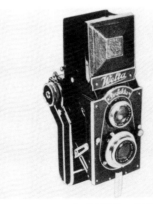

(3555) **PERFEKTA TWIN-LENS REFLEX CAMERA.** C. 1934. SIZE 6 X 6 CM EXPOSURES ON NO. 120 ROLL FILM. 75 MM/F 3.5 MEYER TRIOPLAN LENS. COMPUR SHUTTER; 1 TO 1/300 SEC. (HA)

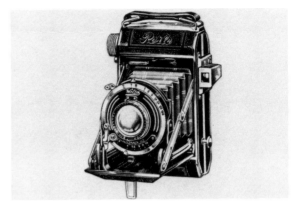

(3556) **PERLE CAMERA.** C. 1937. SIZE 6 X 6 CM EXPOSURES ON NO. 120 OR B-2 ROLL FILM. 75 MM/F 2.9 CASSAR LENS. COMPUR SHUTTER; 1 TO 1/100 SEC., B., T. PARALLAX COMPENSATION VIEWER. (HA)

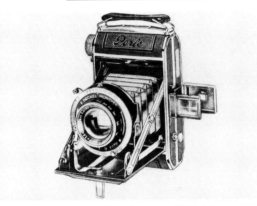

(3557) **PERLE CAMERA.** C. 1940. SIZE 4.5 X 6 CM EXPOSURES ON NO. 120 ROLL FILM. 75 MM/F 4.5 OR F 2.9 ANASTIGMAT, 75 MM/F 2.9 STEINHEIL CASSAR, 75 MM/F 2.8 ZEISS TESSAR, OR F 4.5 MEYER TRIOPLAN LENS. COMPUR SHUTTER; 1 TO 1/100 SEC., B., T.; COMPUR SHUTTER; 1 TO 1/250 SEC., B., T.; COMPUR RAPID SHUTTER; 1 TO 1/400 SEC., B., T.; OR PRONTOR II SHUTTER; 1 TO 1/150 SEC., B., T. ALL SHUTTERS WITH DELAYED ACTION.

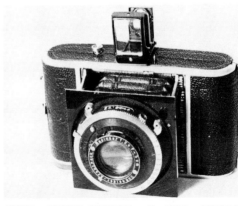

(3558) **QUICKI CAMERA.** C. 1935. SIXTEEN EXPOSURES SIZE 28 X 40 MM ON 127 ROLL FILM. 50 MM/F 2.9 SCHNEIDER RADONAR LENS. COMPUR SHUTTER; 1 TO 1/300 SEC., B., T. (TS)

## WELTA-KAMERAWERKE (*cont.*)

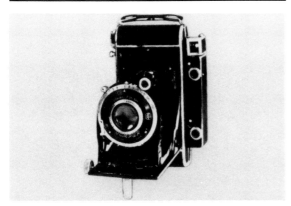

(3559) **SOLIDA CAMERA.** C. 1933. SIZE 6 X 9 CM EXPOSURES ON ROLL FILM. 105 MM/F 4.5 SCHNEIDER RADIONAR LENS. COMPUR SHUTTER; 1 TO $\frac{1}{250}$ SEC., B., T. COUPLED RANGEFINDER. (HA)

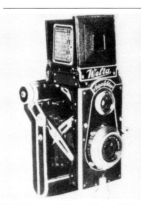

(3560) **SUPERFEKTA, TWIN-LENS REFLEX CAMERA.** C. 1934. SIZE 6 X 9 CM EXPOSURES ON ROLL FILM. REVOLVING BACK. 100 MM/F 3.8 MEYER TRIOPLAN OR ZEISS TESSAR LENS. COMPUR SHUTTER; 1 TO $\frac{1}{250}$ SEC. OR COMPUR RAPID SHUTTER; 1 TO $\frac{1}{500}$ SEC.

(3561) **WATSON 35MM CANDID CAMERA.** C. 1940. SIZE 24 X 36 MM EXPOSURES ON "35MM" ROLL FILM. F 2.9 CASSAR LENS. PRONTO SHUTTER ($\frac{1}{25}$ TO $\frac{1}{125}$ SEC.), PRONTOR II SHUTTER (1 TO $\frac{1}{175}$ SEC.), OR COMPUR SHUTTER (1 TO $\frac{1}{300}$ SEC.). SELF-ERECTING LENS MOUNT. EXPOSURE COUNTER. LENS-RING FOCUSING. SOME MODELS WITH RANGEFINDER. SIMILAR TO THE WELTI CAMERA.

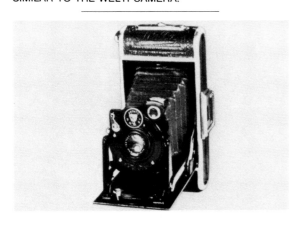

(3562) **WELTA CAMERA.** C. 1931. SIZE 4.5 X 7 CM EXPOSURES ON ROLL FILM. 90 MM/F 6.3 WELTAR LENS. PRONTO SHUTTER; $\frac{1}{25}$ TO $\frac{1}{100}$ SEC. (HA)

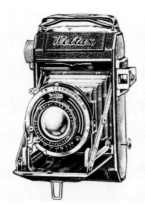

(3563) **WELTAX CAMERA.** C. 1938–40. SIZE 6 X 6 CM (4.5 X 6 CM WITH MASK) EXPOSURES ON NO. 120 OR B-2 ROLL FILM. F 2.9 OR F 4.5 ANASTIGMAT, F 2.9 STEINHEIL CASSAR, F 2.8 XENAR, OR F 2.8 ZEISS TESSAR LENS. COMPUR S SHUTTER; 1 TO $\frac{1}{250}$ SEC., B., T. OR COMPUR RAPID SHUTTER; 1 TO $\frac{1}{400}$ SEC., B., T., ST. PARALLAX COMPENSATED VIEWER. (HA)

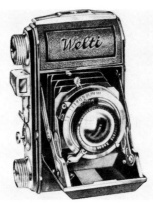

(3564) **WELTI CAMERA.** C. 1940. SIZE 24 X 36 MM EXPOSURES ON "35MM" ROLL FILM. F 2 ZEISS BIOTAR, F 2 SCHNEIDER XENON, F 2.8 ZEISS TESSAR, OR F 2.9 STEINHEIL CASSAR LENS. COMPUR S SHUTTER; 1 TO $\frac{1}{300}$ SEC., B., T. OR COMPUR RAPID SHUTTER; 1 TO $\frac{1}{500}$ SEC., B., T. SELF-ERECTING LENS MOUNT. EXPOSURE COUNTER.

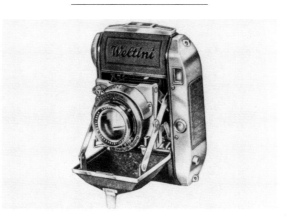

(3565) **WELTINI CAMERA.** C. 1939. SIZE 24 X 36 MM EXPOSURES ON "35MM" ROLL FILM. COUPLED RANGEFINDER. EXPOSURE COUNTER. F 2 SCHNEIDER XENON, F 2.8 ZEISS TESSAR, SCHNEIDER XENAR, OR F 2.9 STEINHEIL CASSAR LENS. COMPUR RAPID SHUTTER; 1 TO $\frac{1}{500}$ SEC., B. ALSO, COMPUR S SHUTTER; 1 TO $\frac{1}{300}$ SEC., B., T.

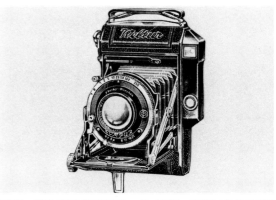

(3566) **WELTUR CAMERA.** C. 1937. SIZE 4.5 X 6 CM EXPOSURES ON ROLL FILM. 75 MM/F 4.5 XENAR LENS. COMPUR SHUTTER; 1 TO $\frac{1}{250}$ SEC., B., T. COUPLED RANGEFINDER. (HA)

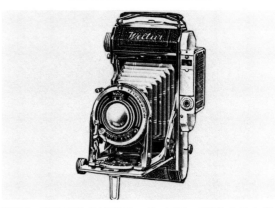

(3567) **WELTUR CAMERA.** C. 1939. SIZE 6 X 6 CM (4.5 X 6 CM WITH MASK) EXPOSURES ON NO. 120 OR B-2 ROLL FILM. F 2.8 ZEISS TESSAR, F 2.8 SCHNEIDER XENAR, OR F 2.9 STEINHEIL CASSAR LENS. COMPUR SHUTTER; 1 TO $\frac{1}{250}$ SEC., B., T., COMPUR S SHUTTER; 1 TO $\frac{1}{300}$ SEC., B., T., OR COMPUR RAPID SHUTTER; 1 TO $\frac{1}{400}$ SEC., B., T. COUPLED RANGE-FINDER. (HA)

(3568) **WELTUR "C" CAMERA.** C. 1940. SIZE 6 X 9 CM (4.5 X 6 CM WITH MASK) EXPOSURES ON ROLL FILM. SIMILAR TO THE WELTUR CAMERA (C. 1939) WITH THE SAME LENSES AND SHUTTERS.

## WELTA-KAMERAWERKE (*cont.*)

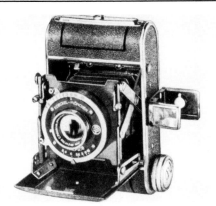

(3569) **WESTON CANDID R.F. CAMERA.** C. 1940. TWO SIZES OF THIS CAMERA FOR 3 X 4 OR 4 X 6 CM EXPOSURES ON NO. 127 ROLL FILM. F 4.5 LENS AND VARIO SHUTTER FOR THE 3 X 4 CM MODEL. F 2.9 OR 3.5 TRIOPLAN LENS AND COMPUR SHUTTER WITH SPEEDS TO $\frac{1}{300}$ SEC. FOR THE 4 X 6 CM MODEL. SELF-ERECTING LENS MOUNT.

## WIRGIN

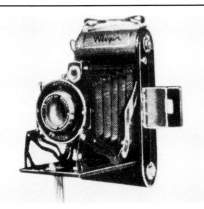

(3570) **AUTA FOLDING CAMERA.** C. 1940. EIGHT EXPOSURES, SIZE 6 X 9 CM ON NO. 120 OR B-2 ROLL FILM. F 6.3 LENS IN VARIO SHUTTER; $\frac{1}{25}$ TO $\frac{1}{100}$ SEC. BUILT-IN EXPOSURE METER. MANUAL FOCUS.

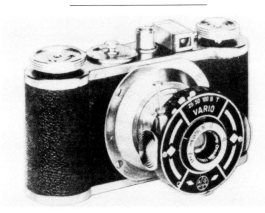

(3571) **CANDID MIDGET CAMERA.** C. 1939. SIZE 24 X 36 MM EXPOSURES ON "35MM" ROLL FILM. F 4.5 ANASTIGMAT LENS. VARIO SHUTTER; $\frac{1}{25}$ TO $\frac{1}{100}$ SEC., B., T.

(3572) **EDIFLEX CAMERA.** C. 1940. SIZE 6 X 6 CM EXPOSURES ON NO. 120 ROLL FILM. F 2.9 LENS IN COMPUR SHUTTER. BUILT-IN EXPOSURE METER.

(3573) **EDINEX MINIATUREMERA.** C. 1938. THIRTY-SIX EXOSURES ON "35MM" ROLL FILM. F 4.5, F 3.5, OR F 2.9 ANASTIGMAT LENS. VARIO SHUTTER WITH SPEEDS TO $\frac{1}{100}$ SEC., B., T.; COMPUR SHUTTER; 1 TO $\frac{1}{300}$ SEC., B., T.; OR PRONTOR SHUTTER; 1 TO $\frac{1}{175}$ SEC., B., T.

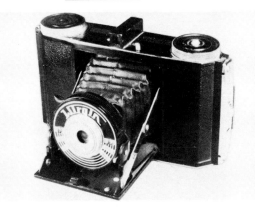

(3574) **FOLDING ROLL FILM CAMERA.** C. 1938. SIZE 6 X 6 CM EXPOSURES ON NO. 120 OR B-2 ROLL FILM. 75 MM MENISCAR LENS. SHUTTER SPEED, $\frac{1}{50}$ SEC., B. (DJ)

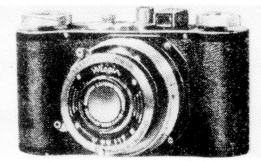

(3575) **GEWIRETTE CAMERA.** C. 1940. SIZE 3 X 4 CM EXPOSURES ON NO. 127 OR A-8 ROLL FILM. F 3.5 LENS IN COMPUR SHUTTER; 1 TO $\frac{1}{300}$ SEC.

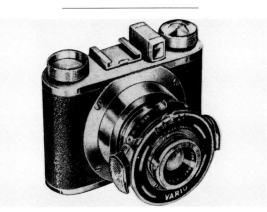

(3576) **GEWIRETTE MINATURE SPECIAL CAMERA.** C. 1940. EXPOSURES ON NO. 127 ROLL FILM. F 2.9 OR F 4.5 ANASTIGMAT LENS. VARIO SHUTTER;

$\frac{1}{25}$ TO $\frac{1}{100}$ SEC., B., T. OR PRONTOR II SHUTTER; 1 TO $\frac{1}{75}$ SEC., B., T.

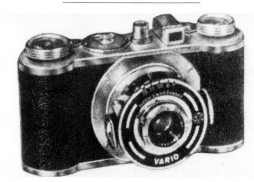

(3577) **MIDGET MARVEL CAMERA.** C. 1940. SIZE 24 X 36 MM EXPOSURES ON "35MM" ROLL FILM. F 2.9 OR F 4.5 LENS. VARIO SHUTTER; $\frac{1}{25}$ TO $\frac{1}{100}$ SEC. OR PRONTOR II SHUTTER; 1 TO $\frac{1}{175}$ SEC.

## WÜNSCHE, EMIL

(3578) **ALPI PLATE CAMERA.** C. 1908. SIZE 9 X 14 CM EXPOSURES. 150 MM/F 8 APLANAT LENS. COMPOUND SHUTTER; $\frac{1}{2}$ TO $\frac{1}{250}$ SEC. THE LENS BOARD IS INTERCHANGEABLE FOR A STEREO FORMAT. (MA)

(3579) **BOSCO ROLLFILM CAMERA.** C. 1900. SIZE 9 X 9 CM EXPOSURES ON ROLL FILM. REVOLVING APERTURE STOPS. (HA)

(3580) **DETECTIVE MAGAZINE CAMERA.** C. 1889. SIZE 9 X 12 CM EXPOSURES ON PLATES. (HA)

## WÜNSCHE, EMIL (cont.)

(3581) **ELITE STEREO CAMERA.** C. 1900. SIZE 9 X 18 CM STEREO EXPOSURES ON PLATES. THE MAGAZINE HOLDS 12 PLATES. PERISCOP LENSES. TWO-SPEED SHUTTER. (HA)

(3582) **FOLDING PLATE CAMERA.** C. 1908. SIZE 9 X 12 CM EXPOSURES ON PLATES. 120 MM/F 5.5 LENS. BAUSCH & LOMB SHUTTER WITH SPEEDS TO 1/100 SEC. (HA)

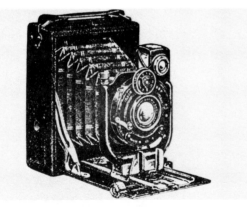

(3583) **MARS FOLDING CAMERA.** C. 1929. SIZE 6.5 X 9 CM EXPOSURES ON PLATES OR FILM PACKS. F 6.3 HERMAGIS, BERTHIOT, ROUSSEL, OR BOYER ANASTIGMAT LENS. GITZO SHUTTER; 1/25 TO 1/100 SEC., B., T. OR IBSOR SHUTTER; 1 TO 1/125 SEC., B., T.

(3584) **MARS MAGAZINE CAMERA.** C. 1902. SIZE 8 X 10 CM EXPOSURES. THE MAGAZINE HOLDS 12 FILMS. (HA)

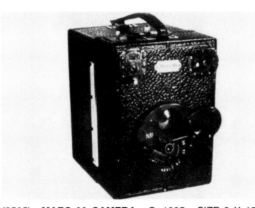

(3585) **MARS 99 CAMERA.** C. 1895. SIZE 9 X 13 CM EXPOSURES ON PLATES. 150 MM/F 12 APLANAT LENS. ROTARY SHUTTER. RISING, FALLING, AND CROSSING LENS MOUNT. (HA)

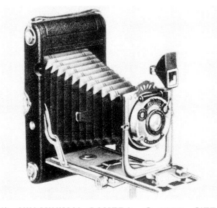

(3586) **NIX-MINIMAL CAMERA.** C. 1907. SIZE 8 X 11 CM EXPOSURES ON ROLL FILM OR PLATES. F 6 ALDIS ANASTIGMAT LENS. NO. 2 KOILOS SHUTTER WITH SPEEDS TO 1/200 SEC.

(3587) **POSTAGE STAMP CAMERA.** C. 1900. TWELVE EXPOSURES, SIZE 24 X 30 MM, ARE OBTAINED SIMULTANEOUSLY ON ONE 13 X 18 CM PLATE. (MA)

(3588) **POSTAGE STAMP CAMERA.** C. 1900. TWELVE EXPOSURES ARE OBTAINED SIMULTANEOUSLY ON ONE 12 X 16.5 CM PLATE USING THE CAMERA'S 12 LENSES. EACH EXPOSURE IS APPROXIMATELY 24 X 30 MM.

(3589) **REICKA FOLDING CAMERA.** C. 1907. PLATE EXPOSURES. THE CAMERA IS SELF-ERECTING WHEN THE BASEBOARD IS DROPPED.

(3590) **SPEEDY CAMERA.** C. 1907. SIZE 9 X 12 CM EXPOSURES ON ROLL FILM OR PLATES. FOCAL PLANE SHUTTER.

## ZEH CAMERA FABRIK

(3591) **FECA-BELLAX FOLDING CAMERA.** C. 1934. SIZE 6 X 9 CM (4.5 X 6 CM WITH MASK) EXPOSURES ON ROLL FILM. F 4.5 RADIONAR TRINAR LENS. PRONTO OR COMPUR SHUTTER.

(3592) **FECA FOLDING CAMERA.** C. 1934. SIZE 6 X 9 CM EXPOSURES. F 4.5 TESSAR LENS. COMPUR RAPID SHUTTER. DOUBLE EXTENSION BELLOWS. GROUND GLASS FOCUSING.

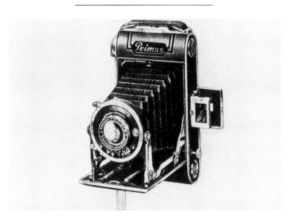

(3593) **PRIMUS CAMERA.** C. 1937. SIZE 4.5 X 6 CM EXPOSURES ON ROLL FILM. 105 MM/F 2.9 RADIONAR LENS. COMPUR SHUTTER; 1 TO 1/250 SEC., B., T. (HA)

(3594) **ZECA BETTAX CAMERA.** C. 1938.

## ZEH CAMERA FABRIK (*cont.*)

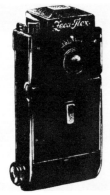

(3595) **ZECA-FLEX REFLEX CAMERA.** C. 1936. SIZE 6 X 6 CM EXPOSURES. COMPUR SHUTTER.

(3596) **ZECCA FOLDING FILM PACK CAMERA.** C. 1935. SIZE 9 X 12 CM EXPOSURES. XENAR LENS. DIAL-SET COMPUR SHUTTER. GROUND GLASS FOCUSING.

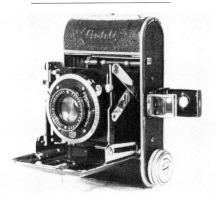

(3597) **ZECA GOLDI CAMERA.** C. 1935–39. SIXTEEN EXPOSURES SIZE 28 X 40 MM ON NO. 127 ROLL FILM. 50 MM/F 2.9 SCHNEIDER RADIONAR OR F 4.5 LENS. COMPUR SHUTTER; 1 TO $\frac{1}{300}$ SEC., B., T.; VARIO SHUTTER; $\frac{1}{25}$ TO $\frac{1}{100}$ SEC., B., T.; OR PRONTO II SHUTTER WITH SPEEDS TO $\frac{1}{175}$ SEC., B., T. (TS)

(3598) **ZECA PRIMUS CAMERA.** C. 1938.

(3599) **ZECA SPORT CAMERA.** C. 1938.

## ZEISS, CARL

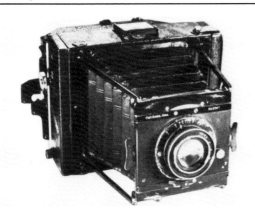

(3600) **MINIMUM PALMOS CAMERA.** C. 1903. SIZE 9 X 12 CM EXPOSURES ON PLATES OR ROLL FILM CASSETTES. 155 MM/F 6.3 ZEISS UNAR LENS. FOCAL PLANE SHUTTER. (HA)

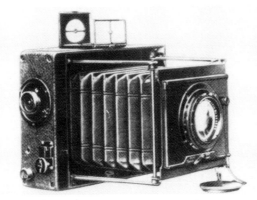

(3601) **MINIMUM PALMOS CAMERA.** C. 1905. TWO SIZES OF THIS CAMERA FOR 9 X 12 OR 10 X 15 CM EXPOSURES ON PLATES OR FILM PACKS. F 4.5 ZEISS TESSAR LENS. FOCAL PLANE SHUTTER. (HA)

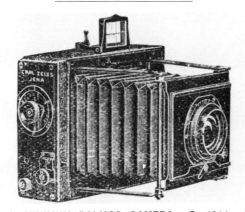

(3602) **MINIMUM PALMOS CAMERA.** C. 1914. SIX SIZES OF THIS CAMERA FOR 2½ X 3½, 3¼ X 4¼, 3½ X 5½ OR 4 X 5 INCH EXPOSURES OR 9 X 12 OR 10 X 15 CM EXPOSURES ON PLATES OR FILM PACKS. F 4.5 ZEISS TESSAR LENS. FOCAL PLANE SHUTTER.

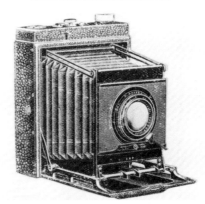

(3603) **MINIMUM PALMOS CAMERA. MODEL II.** C. 1914. TWO SIZES OF THIS CAMERA FOR 9 X 12 CM EXPOSURES OR 3¼ X 4¼ INCH EXPOSURES ON PLATES OR FILM PACKS. F 4.5 ZEISS TESSAR LENS. FOCAL PLANE SHUTTER.

(3604) **PALMOS STEREO CAMERA.** C. 1909. SIZE 9 X 12 CM STEREO EXPOSURES ON PLATES. RACK & PINION FOCUSING. THE LENS SEPARATION IS ADJUSTED AUTOMATICALLY AS THE LENSES ARE PLACED IN THE PROPER FOCUS. (BC)

## ZEISS IKON

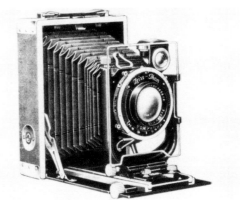

(3605) **ADORO TROPICAL CAMERA.** C. 1927–30. THREE SIZES OF THIS CAMERA FOR 6 X 9, 9 X 12, OR 10 X 15 CM EXPOSURES ON PLATES. F 3.5 ZEISS TESSAR LENS. COMPUR SHUTTER; 1 TO $\frac{1}{200}$ SEC., B., T. (HA)

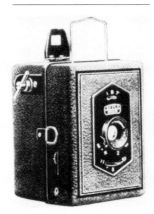

(3606) **BABY BOX CAMERA.** C. 1931. SIZE 3 X 4 CM EXPOSURES ON ROLL FILM. INSTANT, B., T. SHUTTER. (HA)

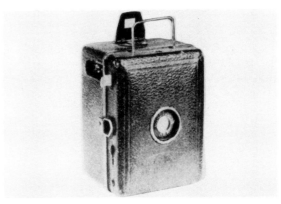

(3607) **BABY BOX CAMERA.** C. 1931–35. SIZE 3 X 4 CM EXPOSURES ON ROLL FILM. FRONTAR LENS. ROTARY SINGLE-SPEED SHUTTER.

**ZEISS IKON (cont.)**

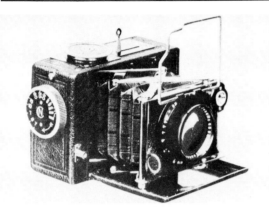

**(3608) BABY DECKRULLO CAMERA.** C. 1928. SIZE 4.5 X 6 CM EXPOSURES ON PLATES OR FILM PACKS. 80 MM/F 2.7 ZEISS TESSAR LENS. FOCAL PLANE SHUTTER WITH GEAR BRAKE; ½ TO 1/1200 SEC., B., T.

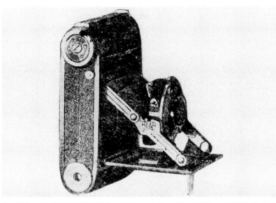

**(3609) BABY IKOMAT CAMERA.** C. 1932. SIZE 3 X 4 CM EXPOSURES ON ROLL RILM. F 4.5 NOVAR AN-ASTIGMAT LENS. DERVAL SHUTTER; 1/25, 1/50 AND 1/75 SEC.

**(3610) BABY IKONTA CAMERA.** C. 1937–40. SIZE 2 X 2.8 CM EXPOSURES (HALF FRAME) ON NO. 127 ROLL FILM. F 3.5 ZEISS TESSAR LENS. COMPUR RAPID SHUTTER.

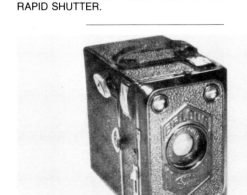

**(3611) BALDUR BOX CAMERA.** C. 1934. SIZE 6 X 9 CM EXPOSURES ON ROLL FILM. 110 MM/F 11 GOERZ FRONTAR LENS. SINGLE-SPEED AND TIME SHUTTER. (HA)

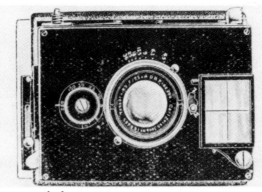

**(3612) BÉBÉ CAMERA.** C. 1914. TWO SIZES OF THIS CAMERA FOR 4.5 X 6 OR 6.5 X 9 EXPOSURES ON PLATES OR FILM PACKS. F 4.5 ZEISS TESSAR LENS. COMPOUND SHUTTER; 1 TO 1/250 SEC. THE 6.5 X 9 CAMERA HAS SHUTTER SPEEDS TO 1/200 SEC. AND A RISING LENS MOUNT. BOTH SIZES HOLD 12 PLATES.

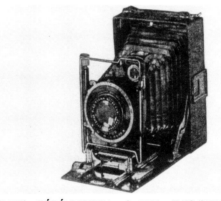

**(3613) BÉBÉ CAMERA.** C. 1938. TWO SIZES OF THIS CAMERA FOR 6.5 X 9 OR 9 X 12 CM EXPOSURES ON PLATES OR FILM PACKS. F 4.5 RADIONAR, F 4.5 TESSAR, OR F 2.9 TRIOPLAN LENS FOR THE 6.5 X 9 CM MODEL. F 4.5 RADIONAR, F 4.5 TESSAR, OR F 3.5 XENAR LENS FOR THE 9 X 12 CM MODEL. RIM-SET COMPUR SHUTTER.

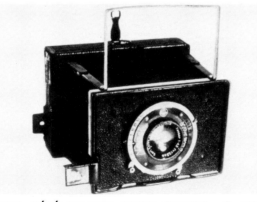

**(3614) BÉBÉ FOLDING STRUT CAMERA.** C. 1928. SIZE 6 X 9 CM EXPOSURES ON PLATES OR FILM PACKS WITH ADAPTER. 105 MM/F 4.5 ZEISS TESSAR LENS. COMPUR SHUTTER; 1 TO 1/250 SEC., B., T. (HA)

**(3615) BÉBÉ "A" FOLDING CAMERA.** C. 1940. SIZE 6.5 X 9 CM EXPOSURES ON PLATES, FILM PACKS, OR ROLL FILM WITH ADAPTER. F 3.5 OR 4.5 ZEISS TESSAR, F 3.5 OR F 4.5 MEYER TRIOPLAN, F 3 SCHNEIDER XENAR, OR F 4.5 SCHNEIDER RADIO-NAR LENS. COMPUR SHUTTER; 1 TO 1/200 SEC., B., T.; COMPUR SHUTTER; 1 TO 1/250 SEC., B., T.; OR COMPUR RAPID SHUTTER; 1 TO 1/400 SEC., B., T. ALL SHUTTERS WITH SELF-TIMER. DOUBLE EXTENSION BELLOWS. SIMILAR TO THE BÉBÉ CAMERA. C. 1938.

**(3616) BÉBÉ "B" FOLDING CAMERA.** C. 1940. SIZE 9 X 12 CM EXPOSURES ON PLATES, FILM PACKS, OR ROLL FILM WITH ADAPTER. SIMILAR TO THE BÉBÉ "A" FOLDING CAMERA WITH THE SAME LENSES AND SHUTTERS.

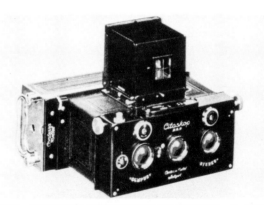

**(3617) BOB V CAMERA.** C. 1927. SIZE 4 X 6 CM EXPO-SURES ON ROLL FILM. 75 MM/F 6.8 ERNEMANN DOUBLE ANASTIGMAT LENS. CRONOS A SHUTTER; 1/10 TO 1/100 SEC. (HA)

**(3618) CITOSKOP STEREO REFLEX CAMERA.** C. 1928. SIZE 45 X 107 MM STEREO EXPOSURES ON PLATES OR FILM PACKS. 65 MM/F 4.5 ZEISS TESSAR LENSES. STEREO COMPUR SHUTTER; 1 TO 1/250 SEC., B., T.

**(3619) COCARETTE B CAMERA.** C. 1928. SIZE 9 X 14 CM EXPOSURES ON ROLL FILM. 150 MM/F 4.5 ZEISS TESSAR LENS. COMPUR SHUTTER; 1 TO 1/200 SEC., B., T. SIMILAR TO THE COCARETTE A CAMERA.

## ZEISS IKON (*cont.*)

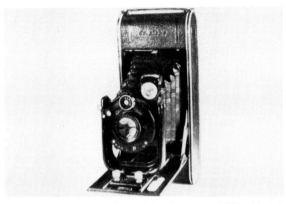

**(3620) COCARETTE CAMERA.** C. 1929. SIZE 8 X 10.5 CM EXPOSURES ON ROLL FILM. 125 MM/F 6.3 NOVAR LENS. DERVAL SHUTTER; ⅟₂₅ TO ⅟₁₀₀ SEC. (HA)

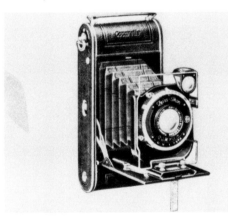

**(3621) COCARETTE CAMERA.** C. 1930. SIZE 6.5 X 11 CM EXPOSURES ON ROLL FILM. 120 MM/F 4.5 ZEISS TESSAR LENS. COMPUR SHUTTER; 1 TO ⅟₂₅₀ SEC., B., T. (HA)

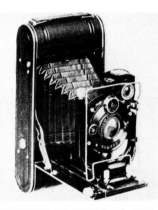

**(3622) COCARETTE A CAMERA.** C. 1928. SIZE 9 X 12 CM EXPOSURES ON ROLL FILM. 120 MM/F 4.5 ZEISS TESSAR LENS. COMPUR SHUTTER; 1 TO ⅟₂₅₀ SEC., B., T.

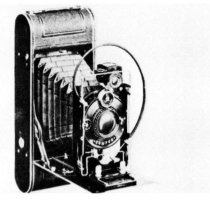

**(3623) COCARETTE C CAMERA.** C. 1928. SIZE 6 X 9 CM EXPOSURES ON ROLL FILM. 105 MM/F 4.5 ZEISS TESSAR LENS. COMPUR SHUTTER; 1 TO ⅟₂₅₀ SEC., B., T. A CASSETTE FILM HOLDER IS INSERTED IN THE SIDE OPENING OF THE CAMERA. FOCUSING BY BELL CRANK LEVER. RISING LENS MOUNT.

**(3624) COCARETTE D CAMERA.** C. 1928. SIZE 6.5 X 11 CM EXPOSURES ON ROLL FILM. 120 MM/F 4.5 ZEISS TESSAR LENS. COMPUR SHUTTER; 1 TO ⅟₂₅₀ SEC., B., T. SIMILAR TO THE COCARETTE C CAMERA.

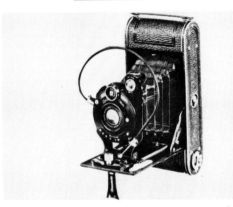

**(3625) JUNIOR COCARETTE C CAMERA.** C. 1928–33. SIZE 6 X 9 CM EXPOSURES ON ROLL FILM. 110 MM/F 6.8 TRINASTIGMAT OR F 6.3 NOVAR LENS. DERVAL AUTOMATIC SHUTTER; ⅟₂₅ TO ⅟₁₀₀ SEC., B., T.

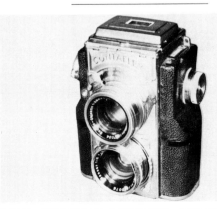

**(3626) CONTAFLEX TWIN-LENS REFLEX CAMERA.** C. 1934–40. SIZE 24 X 36 MM EXPOSURES ON "35MM" ROLL FILM. THIS IS THE FIRST CAMERA WITH A BUILT-IN EXPOSURE METER. INTERCHANGEABLE LENS MOUNT. 50 MM/F 2.8 ZEISS TESSAR OR F 2 OR F 1.5 SONNAR LENS. ALL-METAL FOCAL PLANE SHUTTER; ½ TO ⅟₁₀₀₀ SEC., B., ST. (FL)

**(3627) JUNIOR COCARETTE D CAMERA.** C. 1928. SIZE 6.5 X 11 CM EXPOSURES ON ROLL FILM. SIMILAR TO THE JUNIOR COCARETTE C CAMERA FOR SIZE 6 X 9 CM EXPOSURES WITH THE SAME LENSES AND SHUTTER.

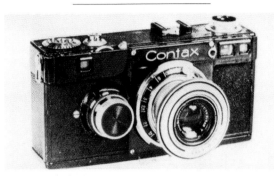

**(3628) CONTAX I CAMERA.** C. 1932–36. SIZE 24 X 36 MM EXPOSURES ON "35MM" ROLL FILM. 50 MM/F 3.5 ZEISS TESSAR, OR F 2 OR F 1.5 SONNAR LENS. FOCAL PLANE SHUTTER; ⅟₂₅ TO ⅟₁₀₀₀ SEC., B. THE FIRST "35MM" CAMERA WITH COUPLED RANGEFINDER. INTERCHANGEABLE BAYONET LENS MOUNT. ALL METAL SHUTTER. THE MODELS AFTER 1933 HAVE SHUTTER SPEEDS FROM ½ TO ⅟₁₀₀₀ SEC.

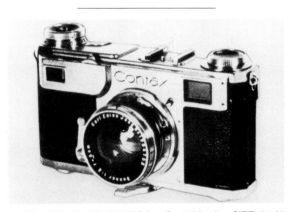

**(3629) CONTAX II CAMERA.** C. 1936–40. SIZE 24 X 36 MM EXPOSURES ON "35MM" ROLL FILM. 50 MM/F 3.5 OR F 2.8 ZEISS TESSAR OR F 2 OR F 1.5 SONNAR LENS. METAL FOCAL PLANE SHUTTER; ½ TO ⅟₁₂₅₀ SEC., B., ST. COUPLED RANGEFINDER. INTERCHANGEABLE LENSES. AUTOMATIC FILM TRANSPORT. EXPOSURE COUNTER. (HA)

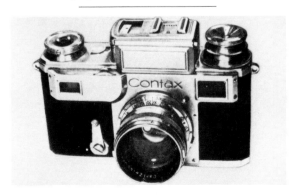

## ZEISS IKON (*cont.*)

(3630) **CONTAX III CAMERA.** C. 1936–40. SIZE 24 X 36 MM EXPOSURES ON "35MM" ROLL FILM. SAME LENSES, SHUTTER, AND FEATURES AS THE CONTAX II CAMERA PLUS BUILT-IN EXPOSURE METER.

(3631) **DECKRULLO A CAMERA.** C. 1928. SIZE 6.5 X 9 CM EXPOSURES ON PLATES OR 6 X 9 CM EXPOSURES ON FILM PACKS. 120 MM/F 2.7 OR F 4.5 ZEISS TESSAR LENS. FOCAL PLANE SHUTTER WITH GEAR BRAKE; ⅒ TO ¹⁄₂₀₀ SEC., T. SIMILAR TO THE DECKRULLO B CAMERA.

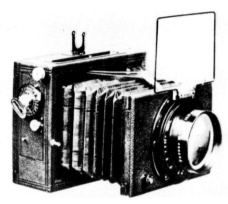

(3632) **DECKRULLO B CAMERA.** C. 1928. SIZE 9 X 12 CM EXPOSURES ON PLATES OR FILM PACKS. 165 MM/ F 2.7 OR F 4.5 ZEISS TESSAR LENS. FOCAL PLANE SHUTTER WITH GEAR BRAKE; ⅒ TO ¹⁄₂₈₀₀ SEC., T.

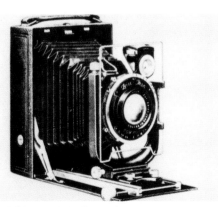

(3633) **DONATA CAMERA.** C. 1928. TWO SIZES OF THIS CAMERA FOR 6.5 X 9 OR 9 X 12 CM EXPOSURES ON FILM PACKS. F 4.5 DOMINAR LENS. COMPUR SHUTTER WITH SPEEDS TO ¹⁄₂₀₀ SEC. (HA)

(3634) **DUCHESSA CAMERA.** C. 1929. SIZE 4.5 X 6 CM EXPOSURES ON PLATES.

(3635) **ERMANOX BELLOWS CAMERA.** C. 1926–29. SIZE 4.5 X 6 CM EXPOSURES ON PLATES. F 1.8 LENS.

(3636) **ERNI BOX CAMERA.** C. 1929. TWO SIZES OF THIS CAMERA FOR 4.5 X 6 OR 6.5 X 9 CM PLATE EXPOSURES.

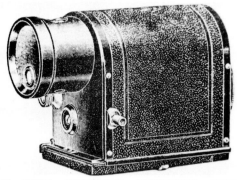

(3637) **ERGO DETECTIVE TELESCOPE CAMERA.** C. 1926–30. SIZE 4.5 X 6 CM EXPOSURES ON ROLL FILM, PLATES, OR FILM PACKS. 55 MM/F 4.5 ZEISS TESSAR LENS. SHUTTER SPEEDS; ¹⁄₂₅ TO ¹⁄₁₀₀ SEC., B., T. GROUND GLASS FOCUSING AID.

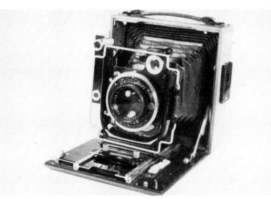

(3638) **FAVORIT 265 TROPICAL CAMERA.** C. 1927. SIZE 9 X 12 CM EXPOSURES ON PLATES. 150 MM/F 4.5 ZEISS TESSAR LENS. COMPUR SHUTTER; 1 TO ¹⁄₂₀₀ SEC., B., T. RANGEFINDER. (VC)

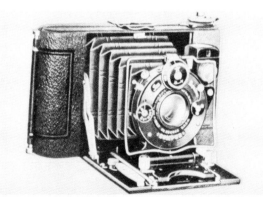

(3639) **ICARETTE B CAMERA.** C. 1928. SIZE 6 X 6 CM EXPOSURES ON PLATES OR ROLL FILM. 75 MM/F 4.5 ZEISS TESSAR LENS. COMPUR SHUTTER; 1 TO ¹⁄₃₀₀ SEC., B., T.

(3640) **ICARETTE C CAMERA.** C. 1928–33. SIZE 6 X 9 CM EXPOSURES ON ROLL FILM OR FILM PACKS OR 6.5 X 9 CM EXPOSURES ON PLATES. SIMILAR TO THE ICARETTE L CAMERA WITH THE SAME LENS AND SHUTTER BUT WITH SINGLE EXTENSION BELLOWS.

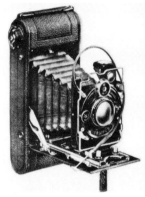

(3641) **ICARETTE D CAMERA.** C. 1928–33. SIZE 6.5 X 12 CM EXPOSURES ON ROLL FILM, PLATES, OR FILM PACKS. SAME LENS AND SHUTTER AS THE ICARETTE L CAMERA BUT WITH SINGLE EXTENSION BELLOWS, VERTICAL LENS BOARD MOVEMENT, RACK & PINION MOVEMENT, AND GROUND GLASS FOCUSING.

(3642) **ICARETTE DA CAMERA.** C. 1928. SIZE 6.5 X 12 CM EXPOSURES ON ROLL FILM, 6 X 9 CM EXPOSURES ON FILM PACKS, OR 6.5 X 9 CM EXPOSURES ON PLATES OR CUT FILM. 120 MM/F 4.5 ZEISS TESSAR LENS. COMPUR SHUTTER; 1 TO ¹⁄₂₅₀ SEC., B., T. SIMILAR TO THE ICARETTE D CAMERA.

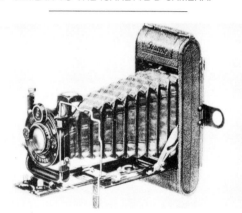

(3643) **ICARETTE L CAMERA.** C. 1928–33. SIZE 6 X 9 CM EXPOSURES ON ROLL FILM OR FILM PACKS OR SIZE 6.5 X 9 CM EXPOSURES ON PLATES. 105 MM/F 4.5 ZEISS TESSAR LENS. COMPUR SHUTTER; 1 TO ¹⁄₂₅₀ SEC., B., T. DOUBLE EXTENSION BELLOWS. VERTICAL AND HORIZONTAL LENS BOARD MOVEMENT. RACK & PINION FOCUSING. GROUND GLASS FOCUSING.

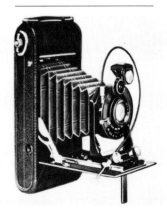

## ZEISS IKON (*cont.*)

**(3644) JUNIOR ICARETTE C CAMERA.** C. 1928. SIZE 6 X 9 CM EXPOSURES ON ROLL FILM. 110 MM/F 6.3 NOVAR LENS. AUTOMATIC SHUTTER; $\frac{1}{25}$ TO $\frac{1}{100}$ SEC., B., T.

**(3645) JUNIOR ICARETTE D CAMERA.** C. 1928. SIZE 6.5 X 11 CM EXPOSURES ON ROLL FILM. 135 MM/ F 6.3 NOVAR LENS. AUTOMATIC SHUTTER; $\frac{1}{25}$ TO $\frac{1}{100}$ SEC., B., T. THE CAMERA IS SIMILAR TO THE JUNIOR ICARETTE C MODEL.

**(3646) IDEAL CAMERA.** C. 1924–30. TWO SIZES OF THIS CAMERA FOR 6.5 X 9 OR 9 X 12 CM EXPOSURES ON PLATES OR FILM PACKS. SIMILAR TO THE IDEAL A CAMERA WITH THE SAME LENSES AND SHUTTER LISTED FOR THE IDEAL CAMERA FOR SIZE 10 X 15 OR 13 X 18 CM EXPOSURES.

**(3647) IDEAL CAMERA.** C. 1924–30. TWO SIZES OF THIS CAMERA FOR 10 X 15 OR 13 X 18 CM EXPOSURES ON PLATES OR FILM PACKS. F 4.5 OR F 6.3 ZEISS TESSAR, F 4.5 ZEISS DOMINAR, OR F 6.3 OR F 7 ZEISS DOPPEL PROTAR LENS. COMPUR SHUTTER. DOUBLE EXTENSION BELLOWS. GROUND GLASS FOCUSING. RACK & PINION FOCUSING. SIMILAR TO THE IDEAL B CAMERA.

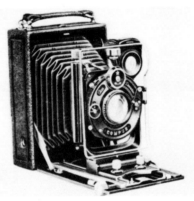

**(3648) IDEAL A CAMERA.** C. 1928–39. SIZE 6.5 X 9 CM EXPOSURES ON PLATES OR 6 X 9 CM EXPOSURES ON FILM PACKS. 120 MM/F 4.5 ZEISS TESSAR LENS. COMPUR SHUTTER; 1 TO $\frac{1}{250}$ SEC., B., T. OR 1 TO $\frac{1}{400}$ SEC., B., T., ST. ON LATER MODELS. DOUBLE EXTENSION BELLOWS. GROUND GLASS FOCUSING. RACK & PINION FOCUSING.

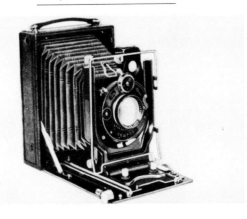

**(3649) IDEAL B CAMERA.** C. 1928–39. SIZE 9 X 12 CM EXPOSURES ON PLATES OR FILM PACKS. 135 OR 150 MM/F 4.5 ZEISS TESSAR LENS. COMPUR SHUTTER; 1 TO $\frac{1}{200}$ SEC., B., T. (ST ON LATER MODELS.) DOUBLE EXTENSION BELLOWS. GROUND GLASS FOCUSING. RACK & PINION FOCUSING. RISING AND CROSSING LENS MOUNT.

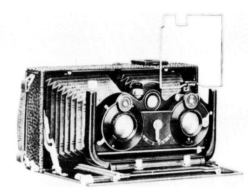

**(3650) STEREO IDEAL CAMERA.** C. 1928. SIZE 6 X 13 CM EXPOSURE ON PLATES. GROUND GLASS FOCUSING. 90 MM/F 4.5 ZEISS TESSAR LENSES. COMPUR SHUTTER; 1 TO $\frac{1}{150}$ SEC., B., T.

**(3651) IKOFLEX TWIN-LENS REFLEX CAMERA.** INTRODUCED IN 1934. SIZE 6 X 6 CM EXPOSURES ON ROLL FILM. 80 MM/F 6.3 OR F 4.5 NOVAR LENS. DERVAL SHUTTER; $\frac{1}{25}$ TO $\frac{1}{100}$ SEC. EXPOSURE COUNTER. (HA)

**(3652) IKOFLEX I, TWIN-LENS REFLEX CAMERA.** C. 1936. SIZE 6 X 6 CM EXPOSURES ON NO. 120 ROLL FILM. 75 MM/F 3.5 ZEISS TESSAR OR NOVAR LENS.

ALSO, 80 MM/F 6.3 NOVAR OR 75 MM/F 3.8 ZEISS TRIOTAR LENS. COMPUR SHUTTER; 1 TO $\frac{1}{300}$ SEC., B.; KLIO SHUTTER; 1 TO $\frac{1}{250}$ SEC., B.; OR CENTRAL SHUTTER; $\frac{1}{25}$ TO $\frac{1}{100}$ SEC. (HA)

**(3653) IKOFLEX II, TWIN-LENS REFLEX CAMERA.** C. 1937–39. SIZE 6 X 6 CM EXPOSURES ON NO. 120 ROLL FILM. 75 MM/F 3.5 ZEISS TESSAR OR TRIOTAR LENS. COMPUR RAPID SHUTTER; 1 TO $\frac{1}{500}$ SEC., B. DOUBLE EXPOSURE PREVENTION.

**(3654) IKOFLEX III, TWIN-LENS REFLEX CAMERA.** C. 1939–40. SIZE 6 X 6 CM EXPOSURES ON NO. 120 ROLL FILM. 80 MM/F 2.8 ZEISS TESSAR LENS. COMPUR RAPID SHUTTER; 1 TO $\frac{1}{400}$ SEC., B., ST. FILM ADVANCE WITH SHUTTER COCKING. (HA)

**(3655) IKOMAT CAMERA.** C. 1932. TWO SIZES OF THIS CAMERA FOR 6 X 9 OR 6.5 X 11 CM EXPOSURES ON ROLL FILM. F 6.3 NOVAR ANASTIGMAT LENS. MULTISPEED SHUTTER.

## ZEISS IKON (*cont.*)

**(3656) IKONETTE CAMERA.** C. 1929. SIZE 4 X 6.5 CM EXPOSURES ON ROLL FILM. 80 MM/F 9 FRONTAR LENS. TWO-SPEED SHUTTER. (HA)

**(3657) IKONTA CAMERA.** C. 1930. SIZE 6 X 9 CM EXPOSURES ON ROLL FILM. 105 MM/F 4.5 DOMINAR LENS. THELMA SHUTTER. (HA)

**(3658) IKONTA CAMERA.** C. 1934. SIZE 3 X 4 CM EXPOSURES ON ROLL FILM. 50 MM/F 4.5 NOVAR-ANASTIGMAT LENS. DERVAL SHUTTER; 1/25 TO 1/75 SEC. (HA)

**(3659) IKONTA CAMERA.** C. 1934–35. FOUR SIZES OF THIS CAMERA FOR 3 X 4, 4.5 X 6, 6 X 9, OR 6.5 X 11 CM EXPOSURES ON ROLL FILM. F 3.5 OR F 4.5 ZEISS TESSAR OR F 4.5 NOVAR ANASTIGMAT LENS. THELMA SHUTTER (1934); 1/25 TO 1/100 SEC. OR COMPUR RAPID SHUTTER (1935); 1 TO 1/500 SEC., B., T. (HA)

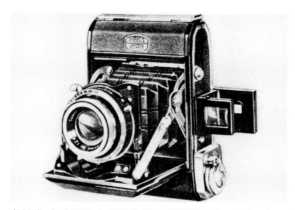

**(3660) IKONTA A SPECIAL CAMERA.** C. 1938. SIZE 4.5 X 6 CM EXPOSURES ON NO. 120 OR B-2 ROLL FILM. 70 MM/F 3.5 ZEISS TESSAR LENS. COMPUR RAPID SHUTTER; 1 TO 1/500 SEC., B., T. (HA)

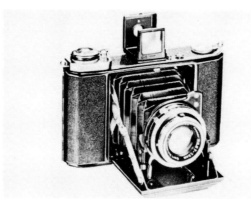

**(3661) IKONTA B CAMERA.** C. 1939. SIZE 6 X 6 CM EXPOSURES ON NO. 120 OR B-2 ROLL FILM. 75 MM/F 3.5 ZEISS TESSAR OR NOVAR ANASTIGMAT LENS. ALSO, 75 MM/F 4.5 NOVAR ANASTIGMAT LENS. COMPUR RAPID SHUTTER; 1 TO 1/500 SEC., B.; COMPUR SHUTTER; 1 TO 1/300 SEC., B.; OR KLIO SHUTTER; 1/25 TO 1/175 SEC., B., ST.

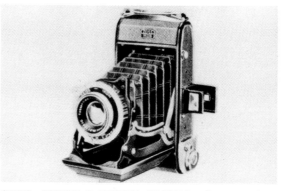

**(3662) IKONTA C SPECIAL CAMERA.** C. 1938. SIZE 6 X 9 CM EXPOSURES ON NO. 120 OR B-2 ROLL FILM. F 3.8 OR F 4.5 ZEISS TESSAR LENS. COMPUR SHUTTER; 1 TO 1/250 SEC., B., ST. OR COMPUR RAPID SHUTTER; 1 TO 1/400 SEC., B., T.

**(3663) IKONTA 521/8 CAMERA.** C. 1938. SIZE 6 X 9 CM EXPOSURES ON NO. 120 OR 620 ROLL FILM. 105 MM/F 4.5 ZEISS TESSAR LENS. COMPUR SHUTTER; 1 TO 1/250 SEC., B., T. SIMILAR TO THE IKONTA C SPECIAL CAMERA.

**(3664) IKONTA 521/16 CAMERA.** C. 1938. SIZE 6 X 6 EXPOSURES ON NO. 120 OR 620 ROLL FILM. 75 MM/F 4.5 NOVAR ANASTIGMAT LENS. KLIO SHUTTER; 1 TO 1/200 SEC., B. SIMILAR TO THE IKONTA C SPECIAL CAMERA.

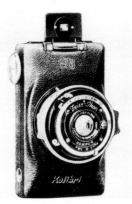

**(3665) KOLIBRI CAMERA.** C. 1930. SIZE 3 X 4 CM EXPOSURES ON ROLL FILM. 50 MM/F 3.5 ZEISS TESSAR OR F 4.5 NOVAR LENS. COMPUR SHUTTER; 1 TO 1/300 SEC., B., T. OR THELMA SHUTTER; 1/25 TO 1/100 SEC., ST. HELICAL FOCUSING.

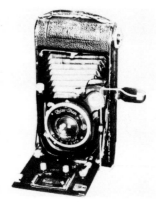

**(3666) LLOYD ROLL FILM AND PLATE CAMERA.** C. 1930. ROLL FILM OR PLATE EXPOSURES. RIM-SET COMPUR SHUTTER.

**(3667) MAXIMAR CAMERA.** C. 1930–40. SIZE 10 X 15 CM EXPOSURES ON PLATES OR FILM PACKS. F 4.5 ZEISS TESSAR LENS.

**(3668) MAXIMAR B FOLDING CAMERA.** C. 1932–39. SIZE 9 X 12 CM EXPOSURES ON PLATES OR FILM PACKS. SIMILAR TO THE MAXIMAR A FOLDING CAMERA WITH THE SAME LENS BUT WITH A COMPUR SHUTTER; 1 TO 1/200 SEC., B., T.

## ZEISS IKON (*cont.*)

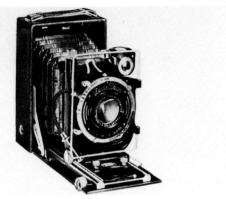

**(3669) MAXIMAR A FOLDING CAMERA.** C. 1932–39. SIZE 6.5 X 9 CM EXPOSURES ON PLATES OR FILM PACKS. 105 MM/F 4.5 ZEISS TESSAR LENS. COMPUR SHUTTER; 1 TO 1/250 SEC., B., T., ST. OR COMPUR RAPID SHUTTER; 1 TO 1/400 SEC., B., T., ST. GROUND GLASS FOCUSING. DOUBLE EXTENSION BELLOWS. RISING LENS MOUNT.

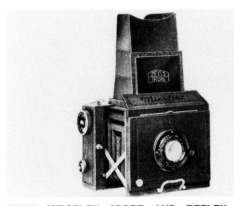

**(3670) MIROFLEX SPORT AND REFLEX CAMERA.** C. 1926–36. SINGLE LENS REFLEX. TWO SIZES OF THIS CAMERA FOR 6.5 X 9 OR 9 X 12 CM EXPOSURES ON PLATES OR FILM PACKS. F 4.5, F 3.5, OR F 2.7 ZEISS TESSAR OR F 2.8 BIOTESSAR LENS. FOCAL PLANE SHUTTER WITH GEAR BREAK; 1/3 TO 1/2000 SEC., B., T. RISING AND CROSSING LENS MOUNT. (HA)

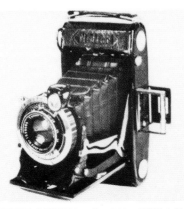

**(3671) NETTAR CAMERA.** C. 1936. SIZE 6 X 9 CM EXPOSURES ON ROLL FILM. 105 MM/F 4.5 ZEISS TESSAR

OR F 4.5 OR F 6.3 NOVAR LENS. COMPUR SHUTTER; 1 TO 1/250 SEC., B., T. (HA)

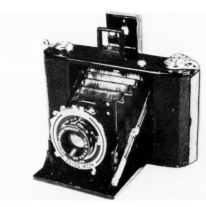

**(3672) NETTAR CAMERA.** C. 1937. SIZE 6 X 6 CM EXPOSURES ON ROLL FILM. 75 MM/F 6.3 NOVAR ANASTIGMAT LENS. TELMA SHUTTER; 1/25 TO 1/125 SEC., B., T. (HA)

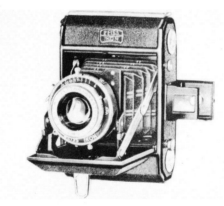

**(3673) NETTAR A CAMERA.** C. 1937. SIZE 4.5 X 6 CM EXPOSURES ON NO. 120 OR B-2 ROLL FILM. 75 MM/F 4.5 NETTAR ANASTIGMAT LENS. KLIO SHUTTER; 1 TO 1/175 SEC., B., T., ST. MANUAL FOCUS.

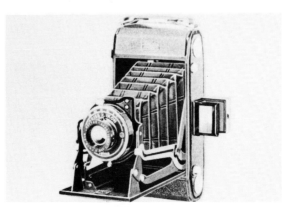

**(3674) NETTAR C CAMERA.** C. 1938. SIZE 6 X 9 CM EXPOSURES ON NO. 120 OR B-2 ROLL FILM. 105 MM/F 6.3 NETTAR ANASTIGMAT LENS. TELMA SHUTTER; 1/25 TO 1/125 SEC., B., T., ST.

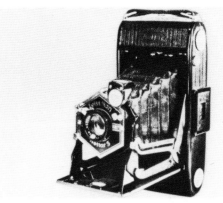

**(3675) NETTAR S CAMERA.** C. 1933. SIZE 6 X 9 CM EXPOSURES ON ROLL FILM. 105 MM/F 6.3 NETTAR LENS. SHUTTER SPEEDS FROM 1/25 TO 1/100 SEC. (HA)

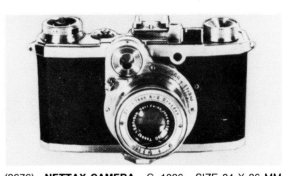

**(3676) NETTAX CAMERA.** C. 1936. SIZE 24 X 36 MM EXPOSURES ON ROLL FILM. 50 MM/F 2.8 ZEISS TESSAR LENS. METAL FOCAL PLANE SHUTTER; 1/5 TO 1/1000 SEC. RANGEFINDER. (HA)

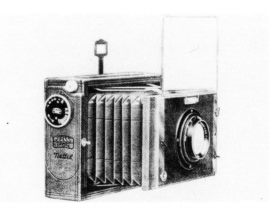

**(3677) NETTEL CAMERA.** C. 1930. SIZE 9 X 12 CM EXPOSURES ON PLATES. 150 MM/F 4.5 ZEISS TESSAR LENS. FOCAL PLANE SHUTTER WITH SPEEDS TO 1/2000 SEC. (HA)

**ZEISS IKON** (*cont.*)

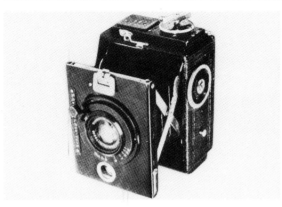

(3678) **NETTEL CAMERA.** C. 1932. SIZE 4.5 X 6 CM EXPOSURES ON PLATES. 75 MM/F 4.5 ZEISS TESSAR LENS. FOCAL PLANE SHUTTER SPEEDS TO $\frac{1}{1200}$ SEC. (HA)

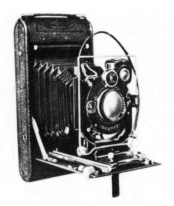

(3679) **NIXE A CAMERA.** C. 1928–33. SIZE 9 X 12 CM EXPOSURES ON PLATES, FILM PACKS, OR ROLL FILM. 135 MM/F 4.5 ZEISS TESSAR LENS. COMPUR SHUTTER; 1 TO $\frac{1}{200}$ SEC., B., T. DOUBLE EXTENSION BELLOWS.

(3680) **NIXE B CAMERA.** C. 1928–33. SIZE 9 X 14 CM EXPOSURES ON ROLL FILM, FILM PACKS, OR PLATES. 150 MM/F 4.5 ZEISS TESSAR LENS. COMPUR SHUTTER; 1 TO $\frac{1}{150}$ SEC., B., T. DOUBLE EXTENSION BELLOWS. SIMILAR TO THE NIXE A CAMERA.

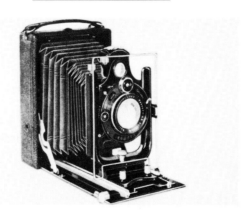

(3681) **ORIX CAMERA.** C. 1928. SIZE 10 X 15 CM EXPOSURES ON PLATES OR FILM PACKS. 165 MM/F 4.5 ZEISS TESSAR LENS. COMPUR SHUTTER; 1 TO $\frac{1}{200}$ SEC., B., T.

(3682) **NIXE 595 CAMERA.** SIZE 9 X 14 CM EXPOSURES ON NO. 122 ROLL FILM. 150 MM/F 6.8 ICA MAXIMAR ANASTIGMAT LENS. COMPUR SHUTTER. GROUND GLASS FOCUSING.

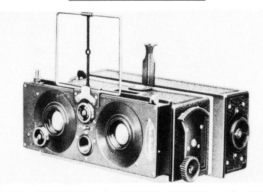

(3683) **PALMOS O CAMERA.** C. 1928. SIZE 4.5 X 6 CM EXPOSURES ON PLATES OR FILM PACKS. 80 MM/F 2.7 ZEISS TESSAR LENS. FOCAL PLANE SHUTTER; $\frac{1}{50}$ TO $\frac{1}{1000}$ SEC., T.

(3684) **PLASKOP STEREO CAMERA.** C. 1927.

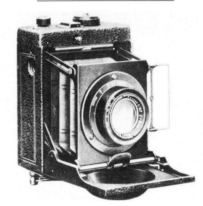

(3685) **POLYSCOP A STEREO CAMERA.** C. 1928. SIZE 45 X 107 MM STEREO EXPOSURES ON PLATES OR FILM PACKS. 65 MM/F 4.5 ZEISS TESSAR LENSES. COMPUR SHUTTER; 1 TO $\frac{1}{250}$ SEC., B., T.

(3686) **REFLEX CAMERA.** C. 1928. SIZE 9 X 12 CM EXPOSURES ON PLATES OR FILM PACKS. 165 MM/F 2.7, 180 MM/F 3.5, OR 150 MM/F 4.5 ZEISS TESSAR LENS. FOCAL PLANE SHUTTER; $\frac{1}{15}$ TO $\frac{1}{1000}$ SEC., T. REVERSIBLE BACK.

(3687) **SIRENE CAMERA.** SIZE 9 X 11 CM EXPOSURES ON SHEET FILM. 135 MM/F 4.5 OR F 6.3 ZEISS TESSAR LENS.

(3688) **SONNET CAMERA.** C. 1929. SIZE 6.5 X 9 CM EXPOSURES ON PLATES. TEAKWOOD BODY.

(3689) **STEREO ERNOFLEX CAMERA.** C. 1927–30. SIZE 4.5 X 10.7 CM EXPOSURES. F 3.5 ZEISS TESSAR LENSES.

(3690) **STEREO SIMPLEX-ERNOFLEX CAMERA.** C. 1927–30. SIZE 4.5 X 10.7 CM STEREO EXPOSURES. F 4.5 ZEISS TESSAR LENSES.

(3691) **STEROCO STEREO CAMERA.** C. 1929. SIZE 4.5 X 10.7 CM EXPOSURES ON PLATES OR FILM PACKS. 55 MM/F 6.3 ZEISS TESSAR LENS. COMPUR SHUTTER; 1 TO $\frac{1}{250}$ SEC. SIMILAR TO THE CONTESSA-NETTEL STEROCO STEREO CAMERA, C. 1925.

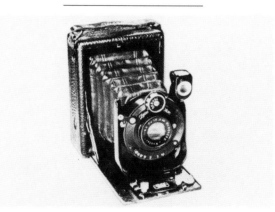

(3692) **SUEVIA CAMERA.** C. 1926. SIZE 6.5 X 9 CM EXPOSURES ON PLATES. 105 MM/F 6.8 NOSTAR LENS. DERVAL SHUTTER; $\frac{1}{25}$ TO $\frac{1}{100}$ SEC. (HA)

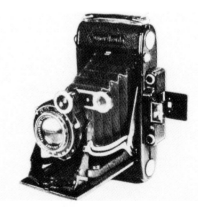

(3693) **SUPER IKONTA CAMERA.** C. 1933. TWO SIZES OF THIS CAMERA FOR 6 X 9 CM (4.5 X 6 CM WITH

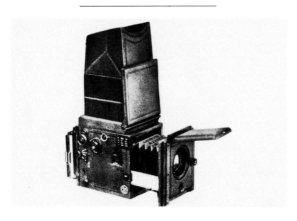

## ZEISS IKON (*cont.*)

MASK) OR 6.5 X 11 CM EXPOSURES ON ROLL FILM. 105 MM/F 4.5 ZEISS TESSAR LENS. COMPUR RAPID SHUTTER WITH SPEEDS TO ¼₀₀ SEC. COUPLED RANGEFINDER. (HA)

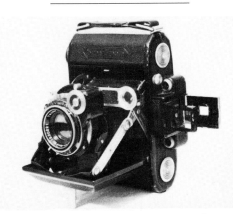

(3694) **SUPER IKONTA A CAMERA.** C. 1934–38. SIZE 4.5 X 6 CM EXPOSURES ON NO. 120 OR B-2 ROLL FILM. COUPLED RANGEFINDER. 70 OR 75 MM/F 3.5 TESSAR LENS. COMPUR RAPID SHUTTER; 1 TO ⅟₅₀₀ SEC., B., T. ALSO, SUPER IKONTA 530 SHUTTER; 1 TO ⅟₃₀₀ SEC. (MF)

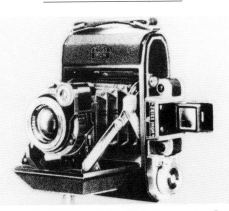

(3695) **SUPER IKONTA A SPECIAL CAMERA.** C. 1939. SIZE 4 X 6 CM EXPOSURES ON NO. 120 OR B-2 ROLL FILM. COUPLED RANGEFINDER. DOUBLE EXPOSURE PREVENTION. 75 MM/F 3.5 ZEISS TESSAR LENS. COMPUR RAPID SHUTTER; 1 TO ⅟₅₀₀ SEC., B.

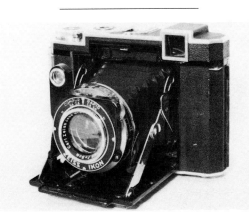

(3696) **SUPER IKONTA B CAMERA.** INTRODUCED IN 1935. ORIGINALLY THE SUPER IKOMAT CAMERA. SIZE 6 X 6 CM EXPOSURES ON NO. 120 ROLL FILM. COUPLED RANGEFINDER. 80 MM/F 3.5 OR 2.8 ZEISS TESSAR LENS. COMPUR RAPID SHUTTER; 1 TO ¼₀₀ SEC., B., ST. (MF)

(3697) **SUPER IKONTA BX CAMERA.** INTRODUCED IN 1937. SIZE 6 X 6 CM EXPOSURES ON NO. 120 ROLL FILM. SINGLE WINDOW RANGEFINDER. BUILT-IN EXPOSURE METER. 80 MM/F 2.8 ZEISS TESSAR LENS. COMPUR RAPID SHUTTER; 1 TO ¼₀₀ SEC., B., ST.

(3698) **SUPER IKONTA C CAMERA.** C. 1934–38. SIZE 6 X 9 CM OR 4.5 X 6 CM (WITH MASK) EXPOSURES ON NO. 120 OR B-2 ROLL FILM. COUPLED RANGEFINDER. 105 MM/F 4.5, F 3.8, OR F 3.5 ZEISS TESSAR LENS. COMPUR SHUTTER; 1 TO ⅟₂₅₀ SEC., B., T., ST OR COMPUR RAPID SHUTTER; 1 TO ¼₀₀ SEC., B., T. (OR ST). SIMILAR TO THE SUPER IKONTA D CAMERA.

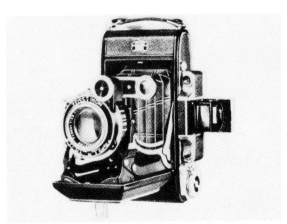

(3699) **SUPER IKONTA C CAMERA.** C. 1939. SIZE 6 X 9 CM (4.5 X 6 CM WITH MASK) EXPOSURES ON NO. 120 OR B-2 ROLL FILM. COUPLED RANGEFINDER. DOUBLE-EXPOSURE PREVENTION. 105 MM/F 3.5 TESSAR LENS. COMPUR RAPID SHUTTER; 1 TO ¼₀₀ SEC., B., ST.

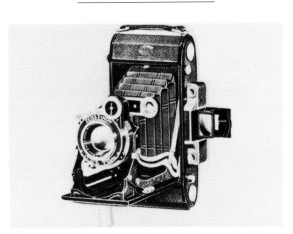

(3700) **SUPER IKONTA D CAMERA.** C. 1936–39. SIZE 6 X 11 CM (5.5 X 6 CM WITH MASK) EXPOSURES ON NO. 116 OR PD-16 ROLL FILM. COUPLED RANGEFINDER. 120 MM/F 4.5 ZEISS TESSAR LENS. COMPUR

SHUTTER; 1 TO ⅟₂₅₀ SEC., B., T., ST. OR COMPUR RAPID SHUTTER; 1 TO ¼₀₀ SEC., B., T., ST.

(3701) **SUPER IKONTA 530 CAMERA.** C. 1935. SIZE 6 X 6 CM EXPOSURES ON ROLL FILM. 80 MM/F 2.8 ZEISS TESSAR LENS. COMPUR RAPID SHUTTER; 1 TO ¼₀₀ SEC., B. COUPLED RANGEFINDER. (HA)

(3702) **SUPER IKONTA 531/2 CAMERA. MODEL C.** C. 1937. EIGHT EXPOSURES SIZE 6 X 9 CM OR 16 EXPOSURES SIZE 4.5 X 6 CM WITH MASK ON NO. 120 OR 620 ROLL FILM. 105 MM/F 3.5 ZEISS TESSAR LENS. COMPUR RAPID SHUTTER; 1 TO ¼₀₀ SEC., B. COUPLED RANGEFINDER. DOUBLE-EXPOSURE PREVENTION. (TS)

(3703) **SUPER IKONTA 533 CAMERA.** C. 1936. SIZE 6 X 6 CM EXPOSURES ON ROLL FILM. 80 MM/F 2.8 ZEISS TESSAR LENS. COMPUR RAPID SHUTTER; 1 TO ¼₀₀ SEC., B. COUPLED RANGEFINDER. EXPOSURE METER. (HA)

## ZEISS IKON (cont.)

(3704) **SUPER NETTEL CAMERA.** INTRODUCED IN 1934. SIZE 24 X 36 MM EXPOSURES ON "35MM" ROLL FILM. 50 MM/F 2.8 OR F 3.5 TESSAR LENS. ALL-METAL FOCAL PLANE SHUTTER; 1/5 TO 1/1000 SEC., B. CUT FILM ADAPTER AVAILABLE. COUPLED RANGE-FINDER. (MF)

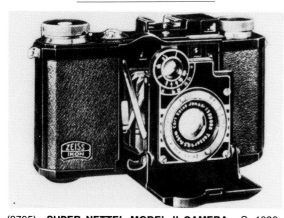

(3705) **SUPER NETTEL MODEL II CAMERA.** C. 1936–38. SIZE 24 X 36 MM EXPOSURES ON "35MM" ROLL FILM. 50 MM/F 2.8 OR F 3.5 ZEISS TESSAR LENS. ALL-METAL FOCAL PLANE SHUTTER; 1/5 TO 1/1000 SEC., T. COUPLED RANGEFINDER. FILM ADVANCE WITH SHUTTER COCKING. CUT FILM ADAPTER AVAILABLE. THE 1938 MODEL HAS SHUTTER SPEEDS FROM 1 TO 1/1000 SEC. (HA)

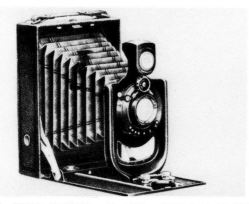

(3706) **TAXO CAMERA.** C. 1929. SIZE 9 X 12 CM EXPOSURES ON SHEET FILM. 135 MM/F 4.5 OR F 6.3 ZEISS TESSAR LENS. DERVAL SHUTTER. (HA)

(3707) **TELE-CAMERA.** C. 1908. APPROXIMATELY 10 X 13 CM EXPOSURES ON ROLL FILM. 800 MM/F 10 MAGNAR LENS. FOCAL PLANE SHUTTER. THE CAMERA WEIGHS APPROXIMATELY 12 POUNDS.

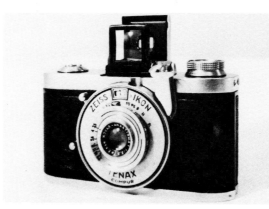

(3708) **TENAX I CAMERA.** C. 1938–40. SIZE 24 X 24 MM EXPOSURES ON "35MM" ROLL FILM. FILM ADVANCE WITH SHUTTER COCKING. 35 MM/F 3.5 ZEISS NOVAR LENS. COMPUR SHUTTER; 1 TO 1/300 SEC., B. (MF)

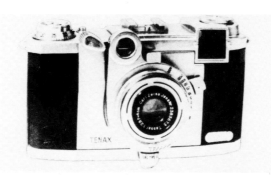

(3709) **TENAX II CAMERA.** C. 1938–40. SIZE 24 X 24 MM EXPOSURES ON "35MM" ROLL FILM. 40 MM/F 2.8 ZEISS TESSAR, OR 40 MM/F 2 SONNAR LENS. COMPUR RAPID SHUTTER; 1 TO 1/400 SEC., B., ST. FILM ADVANCE WITH SHUTTER COCKING. INTERCHANGEABLE LENSES. COUPLED RANGEFINDER. (MF)

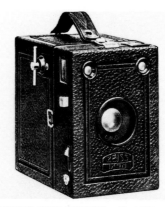

(3710) **TENGOR BOX CAMERA.** C. 1930. SIZE 5 X 7.5 CM EXPOSURES ON "N" ROLL FILM. (HA)

(3711) **TENGOR BOX CAMERA.** C. 1930. SIZE 6 X 9 CM EXPOSURES ON ROLL FILM. 110 MM/F 11 GOERZ TRONTAR LENS. SINGLE-SPEED AND TIME SHUTTER. SIMILAR TO THE TENGOR BOX CAMERA BY C. P. GO-ERZ, C. 1923.

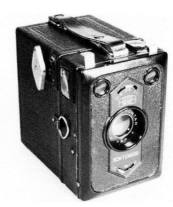

(3712) **TENGOR BOX CAMERA.** C. 1935. TWO SIZES OF THIS CAMERA FOR 4.5 X 6 OR 6 X 9 CM EXPO-SURES ON ROLL FILM. F 11 GOERZ FRONTAR LENS. INSTANT AND TIME ROTARY SHUTTER. THREE SET-TINGS FOR FOCUSING. (MR)

(3713) **TENGOR BOX CAMERA.** C. 1939. SIZE 6 X 9 CM EXPOSURES ON NO. 120 ROLL FILM. GOERZ FRONTAR LENS. SINGLE-SPEED SHUTTER. AN EX-TRA LENS PROVIDES ADJUSTABLE FOCUS. (MA)

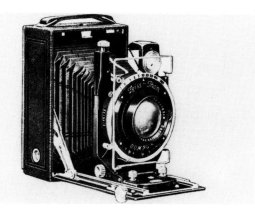

(3714) **TRONA CAMERA.** C. 1928–35. TWO SIZES OF THIS CAMERA FOR 6.5 X 9 OR 9 X 12 CM EXPO-SURES ON PLATES OR FILM PACKS. F 3.5 OR F 4.5 ZEISS TESSAR LENS. COMPUR SHUTTER; 1 TO 1/100 SEC., B., T; OR 1 TO 1/200 SEC., B., T. DOUBLE EXTEN-SION BELLOWS. RACK & PINION FOCUSING. (HA)

(3715) **TROPICA SQUARE CAMERA.** C. 1929. TWO SIZES OF THIS CAMERA FOR 9 X 12 OR 10 X 15 CM EXPOSURES.

(3716) **TROPICAL DECKRULLO B CAMERA.** C. 1928. SAME AS THE REGULAR DECKRULLO B CAMERA EX-CEPT THE BODY IS MADE OF TEAKWOOD.

## ZEISS IKON (*cont.*)

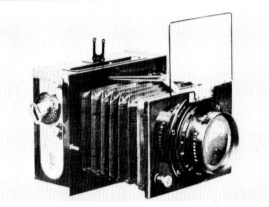

**(3717) TROPICAL DECKRULLO A CAMERA.** C. 1928. SAME AS THE REGULAR DECKRULLO A CAMERA EXCEPT THE BODY IS MADE OF TEAKWOOD.

**(3718) UNETTE MINIATURE BOX CAMERA.** C. 1927–30. SIZE 22 X 31 MM EXPOSURES ON ROLL FILM. F 12.5 LENS. 1/25, 1/75, 1/125 SEC., AND TIME SHUTTER.

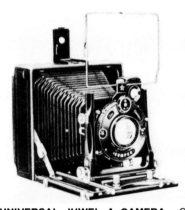

**(3719) UNIVERSAL JUWEL A CAMERA.** C. 1928–38. SIZE 9 X 12 CM EXPOSURES ON PLATES OR FILM PACKS. 150 MM OR 165 MM/F 4.5 ZEISS TESSAR LENS. COMPUR SHUTTER; 1 TO 1/200 SEC., B., T. DOUBLE EXTENSION BELLOWS. GROUND GLASS FOCUSING. RACK & PINION FOCUSING. RISING AND FALLING LENS MOUNT. DROPPING BED.

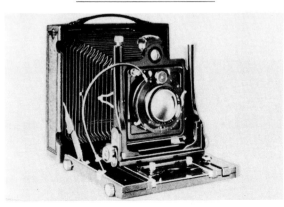

**(3720) UNIVERSAL JUWEL B CAMERA.** C. 1926–39. SIZE 13 X 18 CM EXPOSURES ON PLATES OR FILM

PACKS. 210 MM/F 4.5 ZEISS TESSAR LENS. COMPOUND SHUTTER; 1 TO 1/100 SEC., B., T. TRIPLE EXTENSION BELLOWS. GROUND GLASS FOCUSING. RACK & PINION FOCUSING. RISING AND FALLING LENS MOUNT. DROPPING BED. REVOLVING BACK ON THE LATER MODELS.

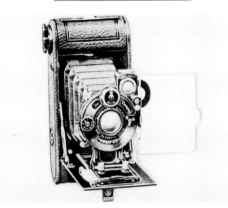

**(3721) VEST POCKET ICARETTE CAMERA.** C. 1928. SIZE 4 X 6.5 CM EXPOSURES ON ROLL FILM. 75 MM/F 4.5 ZEISS TESSAR LENS. COMPUR SHUTTER; 1 TO 1/300 SEC., B., T.

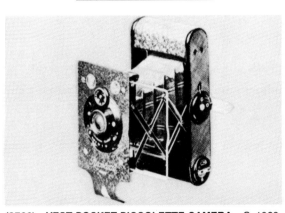

**(3722) VEST POCKET PICCOLETTE CAMERA.** C. 1928. SIZE 4 X 6.5 CM EXPOSURES ON ROLL FILM. 75 MM/F 6.3 NETTAR ANASTIGMAT LENS. DERVAL SHUTTER; 1/25, 1/50, 1/100 SEC., B., T.

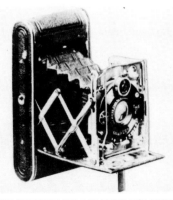

**(3723) VEST POCKET PICCOLETTE DELUXE CAMERA.** C. 1928. SIZE 4 X 6.5 CM EXPOSURES ON ROLL FILM. 75 MM/F 4.5 ZEISS TESSAR LENS. COMPUR SHUTTER; 1 TO 1/300 SEC., B., T.

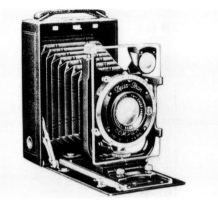

**(3724) VOLTA CAMERA.** C. 1930. SIZE 9 X 12 CM EXPOSURES ON FILM PACKS. 135 MM/F 4.5 ZEISS TESSAR LENS. COMPUR SHUTTER WITH SPEEDS TO 1/250 SEC. (HA)

## MANUFACTURER UNKNOWN

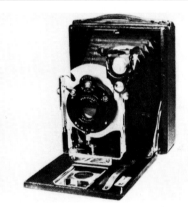

**(3725) AUSTE FOLDING PLATE CAMERA.** C. 1912. SIZE 9 X 12 CM EXPOSURES ON PLATES. 135 MM/F 9.8 PERISCOP-APLANAT LENS. AUSTE SHUTTER WITH SPEEDS FROM 1/25 TO 1/100 SEC. (HA)

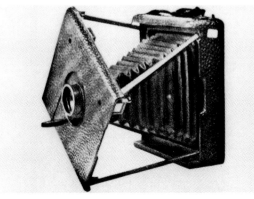

**(3726) BARTH SPECIAL POCKET CAMERA.** C. 1903. SIZE 9 X 12 CM EXPOSURES ON PLATES OR ROLL FILM. 120 MM/F 6.8 ORTHOSTIGMAT LENS. COMPOUND SHUTTER. (HA)

## MANUFACTURER UNKNOWN (*cont.*)

(3727)  **FALT STEREO CAMERA.** C. 1906. SIZE 9 X 18 CM STEREO EXPOSURES ON PLATES. GUILLOTINE SHUTTER. (HA)

(3728)  **MECUM STEREO CAMERA.** C. 1910. SIZE 9 X 12 CM STEREO EXPOSURES ON PLATES. SIMPLE LENSES. SINGLE-SPEED SHUTTER. (MA)

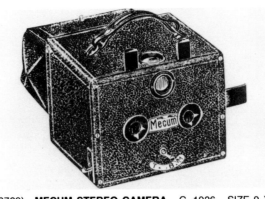

(3729)  **MECUM STEREO CAMERA.** C. 1926. SIZE 9 X 12 CM EXPOSURES ON PLATES OR FILM PACKS. INSTANT, B., T. SHUTTER.

(3730)  **MERIT BOX CAMERA.** C. 1935. SIZE 4 X 6.5 CM EXPOSURES ON NO. 127 ROLL FILM. 75 MM/F 11 RODENSTOCK LENS. SINGLE-SPEED SHUTTER. BAKELITE BODY. (MA)

(3731)  **PIFF PAFF BOX CAMERA.** C. 1905. SIZE 6 X 8 CM PLATE EXPOSURES. 80 MM/F 11 MENISCUS LENS. NO SHUTTER. (MA)

(3732)  **THREE-COLOR CAMERA.** C. 1939. SIZE 3.5 X 3.5 CM EXPOSURES. THREE LENSES ARE POSITIONED ON A HELICAL MOUNT. COMPOUND SHUTTER; 1 TO $\frac{1}{100}$ SEC. (MA)

## GERSTENDÖRFER, R.

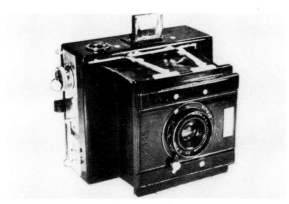

(3733) **PICOFLEX TWIN-LENS REFLEX CAMERA.** C. 1930. SIZE 4 X 4 CM EXPOSURES ON ROLL FILM. 50 MM/F 2.9 SCHNEIDER XENAR LENS. COMPUR SHUTTER; 1 TO 1/300 SEC., B., T. (HA)

## GOLDMANN, R. A.

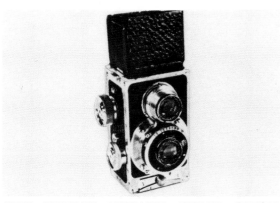

(3734) **STRUT CAMERA.** C. 1905. SIZE 9 X 12 CM EXPOSURES ON PLATES. 120 MM/F 4.6 GOERZ DOUBLE ANASTIGMAT LENS. FOCAL PLANE SHUTTER. (HA)

(3735) **UNIVERSAL DETECTIVE CAMERA.** C. 1889. SIZE 13 X 18 CM EXPOSURES ON PLATES. FRANCAIS RAPID RECTILINEAR LENS. DROP SHUTTER. BELLOWS FOCUSING. RISING LENS MOUNT. BRILLANT VIEWFINDER. (IH)

(3736) **VIEW CAMERA.** C. 1900. SIZE 13 X 18 CM PLATE EXPOSURES. APLANAT LENS. REVERSIBLE BACK. TILTING LENS MOUNT. REAR SLIDE AND SWING. (MA)

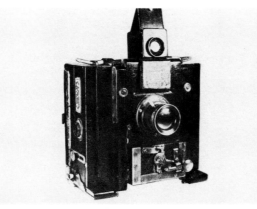

(3737) **UNIVERSAL DETECTIVE CAMERA.** C. 1890. SIZE 9 X 12 CM EXPOSURES ON PLATES. 25 MM STEINHEIL GRUPPEN ANTIPLANAT LENS. FALL SHUTTER. (HA)

## LECHNER, R.

(3738) **POCKET STRUT CAMERA.** C. 1900. SIZE 9 X 12 CM PLATE EXPOSURES. 120 MM/F 6.8 STEINHEIL ORTHOSTIGMAT LENS. HELICAL FOCUSING. FOCAL PLANE SHUTTER. (MA)

## OSTERREICHISCHE TELEPHON A. G.

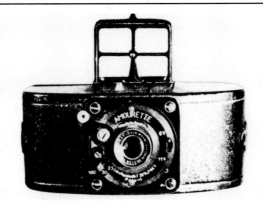

(3739) **AMOURETTE CAMERA.** C. 1925. SIZE 24 X 30 MM EXPOSURES ON CASSETTE ROLL FILM. FIFTY EXPOSURES PER ROLL OF FILM. 35 MM/F 6.3 DOUBLE MINISCOPE LENS. SHUTTER SPEEDS FROM 1/25 TO 1/100 SEC. (HA)

(3740) **AMOURETTE CAMERA.** C. 1930. SIZE 24 X 30 MM EXPOSURES ON CASSETTE ROLL FILM. FIFTY EXPOSURES PER ROLL OF FILM. 42 MM/F 3.5 LAAK DIALYTAR LENS. COMPUR SHUTTER WITH SPEEDS TO 1/300 SEC. SIMILAR TO THE AMOURETTE MODEL, C. 1925.

## PETZVAL, JOSEF

(3741) **MONORAIL CAMERA.** C. 1857. THE CAMERA IS SUPPORTED ON A MONORAIL AND TRIPOD. DOUBLE BELLOWS BODY.

## UNITIS

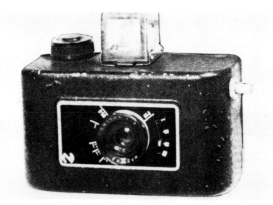

(3742) **UNITIS MINIATURE CAMERA.** C. 1934. SIZE 24 X 24 MM EXPOSURES ON ROLL FILM. 42 MM/F 8 LENS. SHUTTER SPEEDS FROM 1/25 TO 1/100 SEC. (HA)

## VELOPHOT-HERLANGO

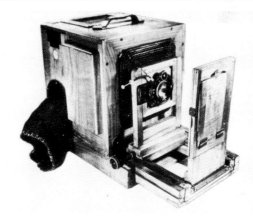

(3743) **FAST DEVELOPING CAMERA.** C. 1920. SIZE 9 X 12 CM EXPOSURES. THE PAPER NEGATIVE AND A PAPER POSITIVE PRINT ARE DEVELOPED AND PRINTED INSIDE OF THE CAMERA. (HA)

## VOIGTLANDER & SON

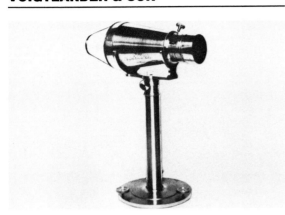

**(3744) ALL METAL DAGUERREOTYPE PLATE CAMERA.** C. 1841. THE FIRST VOIGTLANDER CAMERA. 9 CM DIAMETER DAGUERREOTYPE PLATE EXPOSURES. 149 MM/F 3.7 LENS DESIGNED BY JOSEF PETZVAL. EXPOSURE TIME FROM 1.5 TO 2 MINUTES. MADE IN VIENNA.

## WANAUS, JOSEPH & COMPANY

**(3745) DR. ROTH'S FIELD CAMERA.** C. 1883. ONE OF THE FIRST CAMERAS TO HAVE BELLOWS WITH CAMFERED CORNERS.

**(3746) UNIVERSAL STEREOSKOP CAMERA.** C. 1893. SIZE 10 X 20 CM STEREO EXPOSURES ON PLATES. 105 MM/F 6.3 CARL ZEISS ANASTIGMAT LENSES. GUILLOTINE SHUTTER. (MA)

**(3747) VIEW CAMERA.** C. 1900. SIZE 16.5 X 21.5 CM EXPOSURES ON PLATES.

## ARMAND LE DOCTE

(3748) **EXELL TWIN-LENS REFLEX DETECTIVE CAMERA.** C. 1889. SIZE 8 X 10.5 CM PLATE EXPOSURES. 135 MM/F 8 RECTILINEAR LENS. GUILLOTINE SHUTTER. THE MAGAZINE HOLDS 18 PLATES. (MA)

(3749) **PHOTO DETECTIVE TWIN-LENS REFLEX CAMERA.** C. 1889. SIZE 8.3 X 10.8 CM PLATE EXPOSURES. 180 MM/F 8 RECTILINEAR LENSES. FLAP SHUTTER. THE MAGAZINE HOLDS 18 PLATES. CHANGING BAG. (MA)

## DE NECK, J.

(3750) **HAT CAMERA.** C. 1886. 45 X 45 MM EXPOSURES ON PLATES. THE MAGAZINE WITH CHANGING BAG HOLDS SIX PLATES. THE ROLLER-BLIND SHUTTER IS RELEASED BY PULLING A CORD. STEINHEIL LENS. THE CAMERA IS FITTED INSIDE OF A MAN'S HAT WITH A HOLE IN THE FRONT SECTION OF THE HAT THROUGH WHICH THE EXPOSURE IS MADE. (BC)

## FREMY

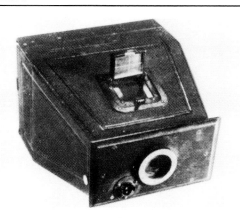

(3751) **JUMELLE CAMERA.** C. 1900. SIZE 9 X 12 CM EXPOSURES ON PLATES. 140 MM/F 8 LENS. SINGLE-SPEED GUILLOTINE SHUTTER. (HA)

## FRENNET, J.

(3752) **CHANGING BOX REFLEX CAMERA.** C. 1905. SIZE 9 X 12 CM PLATE EXPOSURES. FOCAL PLANE SHUTTER. (IH)

(3753) **STEREO REFLEX CAMERA.** C. 1910. SIZE 6 X 13 CM STEREO PLATE EXPOSURES. 120 MM/F 4.5 CARL ZEISS TESSAR LENSES. FOCAL PLANE SHUTTER. (MA)

## LE DOCTE, A.

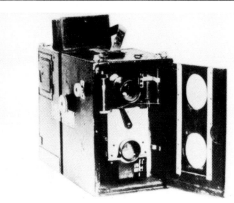

(3754) **PHOTO-DETECTIVE TWIN-LENS REFLEX CAMERA.** C. 1889. SIZE 8.3 X 10.8 CM EXPOSURES ON PLATES.

## SIMONS, NIÉLL

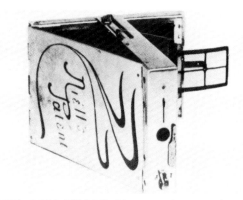

(3755) **LOPA FOLDING CAMERA.** C. 1900. SIZE 6.5 X 9 CM EXPOSURES ON PLATES. 120 MM/F 11 MENISCUS LENS. SINGLE-SPEED GUILLOTINE SHUTTER.

## KUH, FRITZ

(3756) **AUTOFLEX TWIN-LENS REFLEX CAMERA.**
C. 1940.  SIZE 6 X 6 CM EXPOSURES ON NO. 120 OR
B-2 ROLL FILM.  75 MM/F 2.9 MEYER TRIOPLAN LENS.
COMPUR SHUTTER; 1 TO ¼₀₀ SEC., B., T., ST.  AUTO-
MATIC FILM ADVANCE.  EXPOSURE COUNTER.

(3757) **FLEXETTE TWIN-LENS REFLEX CAMERA.**
C. 1940.  SIZE 6 X 6 CM EXPOSURES ON NO. 120 OR
B-2 ROLL FILM.  78 MM/F 4.5 MEYER TRIOPLAN LENS.
PRONTOR II SHUTTER; 1 TO ⅟₁₅₀ SEC., B., T., ST.

## DUCATI

(3758) **DUCATI CAMERA.** C. 1938. SIZE 18 X 24 MM EXPOSURES ON "35MM" CASSETTE ROLL FILM. 35 MM/F 3.5 VICTOR LENS. FOCAL PLANE SHUTTER; $\frac{1}{20}$ TO $\frac{1}{500}$ SEC. COUPLED RANGEFINDER. INTERCHANGEABLE LENSES. (IH)

## MURER & DURONI

(3759) **MURER EXPRESS BOX CAMERA.** C. 1900. SIZE 6 X 9 CM EXPOSURES. (MA)

(3760) **MURER EXPRESS CAMERA.** C. 1907–13. FOUR SIZES OF THIS CAMERA FOR 6.5 X 9, 9 X 12, 9 X 14, OR 13 X 18 CM EXPOSURES ON PLATES. F 7 MURER ANASTIGMAT LENS. FOCAL PLANE SHUTTER WITH SPEEDS TO $\frac{1}{1000}$ SEC. (HA)

(3761) **MURER EXPRESS CAMERA.** C. 1909. SIZE 4.5 X 6 CM EXPOSURES ON PLATES. F 8 APLANAT LENS.

(3762) **MURER FOLDING POCKET CAMERA.** C. 1909. ORIGINAL MODEL. SIZE 4.5 X 6 CM EXPOSURES ON PLATES OR FILM PACKS. SIMILAR TO THE MURER FOLDING POCKET CAMERA, C. 1914, EXCEPT THE SHUTTER IS A BETWEEN-THE-LENS TYPE.

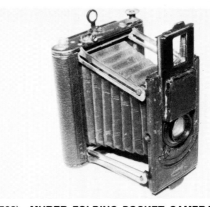

(3763) **MURER FOLDING POCKET CAMERA.** C. 1914. TWO SIZES OF THIS CAMERA FOR 4.5 X 6 OR 6.5 X 9 CM EXPOSURES ON PLATES OR FILM PACKS. 102 MM/ F 6.5 MURER DOPPIO ANASTIGMAT, F 5.5 KORISTKA, OR F 5 SUTER LENS. FOCAL PLANE SHUTTER; $\frac{1}{30}$ TO $\frac{1}{1000}$ SEC., B., T. (GE)

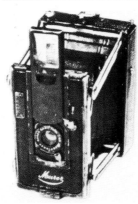

(3764) **MURER PLATE CAMERA.** C. 1914. SIZE 4.5 X 6 CM EXPOSURES ON PLATES. 70 MM/F 6.5 MURER ANASTIGMAT LENS. (HA)

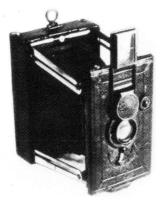

(3765) **MURER PLATE CAMERA.** C. 1914. SIZE 6.5 X 9 CM EXPOSURES ON PLATES. 105 MM/F 8 EXTRA RAPID APLANAT LENS. SHUTTER SPEEDS FROM $\frac{1}{25}$ TO $\frac{1}{100}$ SEC. (HA)

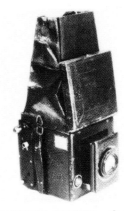

(3766) **MURER REFLEX CAMERA.** C. 1912. SIZE 6.5 X 9 CM EXPOSURES ON PLATES. 120 MM/F 3.9 MURER ANASTIGMAT LENS. FOCAL PLANE SHUTTER. (HA)

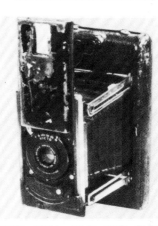

(3767) **MURER ROLL FILM AND PLATE CAMERA.** C. 1915. SIZE 6.5 X 9 CM EXPOSURES ON ROLL FILM OR PLATES. 102 MM/F 6.5 MURER ANASTIGMAT LENS. WOLLENSAK SHUTTER; $\frac{1}{10}$ TO $\frac{1}{100}$ SEC. (HA)

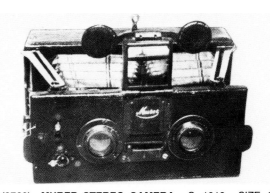

(3768) **MURER STEREO CAMERA.** C. 1918. SIZE 45 X 107 MM STEREO EXPOSURES ON PLATES. 80 MM/F 8 MURER APLANAT LENSES. GUILLOTINE SHUTTER. (HA)

## MURER & DURONI (*cont.*)

(3769) **MURER STEREO STRUT CAMERA.** C. 1920. SIZE 45 X 107 MM STEREO EXPOSURES ON PLATES. 60 MM/F 4.5 ANASTIGMAT LENSES. FOCAL PLANE SHUTTER; $\frac{1}{15}$ TO $\frac{1}{1000}$ SEC. (MA)

## VALSTS ELECTRO-TECHNISKA FABRIKA

(3770) **MINOX SUBMINIATURE CAMERA. ORIGINAL MODEL.** C. 1937. FIFTY EXPOSURES, SIZE 8 X 11 MM ON CASSETTE ROLL FILM. 15 MM/F 3.5 MINOSTIGMAT LENS. GUILLOTINE SHUTTER; ½ TO $\frac{1}{1000}$ SEC., B., T. FILM ADVANCE BY SHUTTER COCKING. BUILT-IN YELLOW FILTER. STAINLESS STEEL CONSTRUCTION.

## BOISSONAS, F.

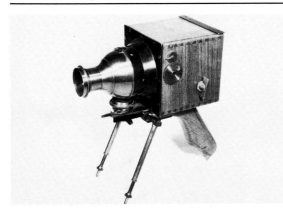

**(3771) ESCOPETTE (PISTOLET) CAMERA.** C. 1888. SIZE 6.8 X 7.2 CM EXPOSURES ON ROLL FILM. THE FIRST EUROPEAN CAMERA TO EMPLOY THE EASTMAN ROLL-HOLDER PRINCIPLE FOR ROLL FILM. THE CAMERA TAKES 110 EXPOSURES ON EACH ROLL OF FILM. 100 MM/F 8 STEINHEIL RAPID RECTILINEAR LENS. VARIABLE SPEED REVOLVING SPHERE SHUTTER WITH TIME EXPOSURES. THE CAMERA DESIGN WAS PATENTED BY ALBERT DARIER OF SWITZERLAND. (GE)

## BOREUX, A.

**(3772) NINA STEREO CAMERA.** C. 1913. SIZE 45 X 107 MM STEREO EXPOSURES ON PLATES. 62 MM/F 6.8 SUTER LENSES. SIX-SPEED GUILLOTINE SHUTTER. (MA)

## CHAPUIS, L.

**(3773) VIEW CAMERA.** C. 1910. SIZE 13 X 18 CM EXPOSURES ON PLATES. GOERZ LYNKEIOSKOP SERIES F, NO. 0 LENS. ALUMINUM BODY. (MA)

## ENGEL FEITKNECHT & COMPANY

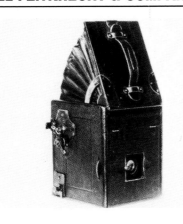

**(3774) STUDIO CAMERA.** C. 1900. SIZE 30 X 40 CM PLATE EXPOSURES. 450 MM/F 3.7 HERMAGIS LENS. GRUNDNER SHUTTER. FRONT AND BADK RACK & PINION FOCUSING. TILTING FRONT AND BACK. (RP)

**(3775) PORTRAIT CAMERA.** C. 1895. SIZE 13 X 18 CM EXPOSURES ON PLATES. 320 MM PETZVAL HERMAGIS LENS. RISING LENS MOUNT. DOUBLE SWING BACK. (MA)

## GOLDSCHMID

**(3776) BINOCULAR CAMERA.** C. 1889. SIZE 5 X 6 CM PLATE EXPOSURES. 150 MM/F 6.3 STEINHEIL LENSES. GUILLOTINE SHUTTER. ONE LENS SYSTEM SERVES AS THE VIEW FINDER, THE OTHER LENS IS FOR MAKING EXPOSURES. (IH)

## KERN

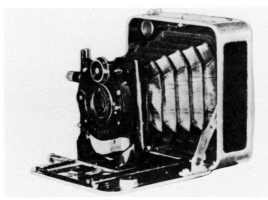

**(3777) BIJOU CAMERA.** C. 1925. SIZE 9 X 12 CM EXPOSURES ON PLATES. 120 MM/F 4.5 KERN ANASTIGMAT LENS. COMPUR SHUTTER; 1 TO $\frac{1}{200}$ SEC. RACK & PINION FOCUSING. DOUBLE EXTENSION BELLOWS. RISING AND FALLING LENS MOUNT. REVOLVING BACK. ALUMINUM BODY.

**(3778) KERN STEREO SS CAMERA.** C. 1920–32. STEREO EXPOSURES ON "35MM" ROLL FILM. 35 MM/F 3.5 KERNOUS LENSES. SHUTTER SPEEDS FROM $\frac{1}{25}$ TO $\frac{1}{300}$ SEC. IRIS DIAPHRAGM. (IH)

## LE COULTRE & CIE

**(3779) COMPASS I CAMERA.** C. 1937–38. 24 X 36 MM EXPOSURES ON "35MM" PLATES, SHEET, OR ROLL FILM. THIS ORIGINAL MODEL COMPASS CAMERA WAS MARKETED BEFORE THE IMPROVED COMPASS II CAMERA WAS MANUFACTURED IN 1938. THE COMPASS I HAS A SLIGHTLY DIFFERENT DESIGN THAN THE COMPASS II. ALL OTHER FEATURES INCLUDING THE LENS AND SHUTTER ARE THE SAME AS THE COMPASS II CAMERA.

**(3780) COMPASS II CAMERA.** C. 1938–40. 24 X 36 MM EXPOSURES ON "35MM" PLATES, SHEET, OR ROLL FILM. 37 MM/F 3.5 KERN ANASTIGMAT LENS. 22-SPEED SHUTTER; $4\frac{1}{2}$ TO $\frac{1}{500}$ SEC., TIME. COUPLED RANGEFINDER. EXTINCTION METER. DIRECT RIGHT-ANGLE OR GROUND GLASS FOCUSING. THREE BUILT-IN FILTERS. STEREOSCOPIC AND PANORAMIC HEADS. ROLL FILM PACK ADAPTER.

## RAUSER, CHARLES

**(3781) FIELD CAMERA.** C. 1895. SIZE 13 X 18 CM PLATE EXPOSURES. 180 MM/F 7.2 HEMI ANASTIGMAT LENS. (MA)

## SIMONS, W.

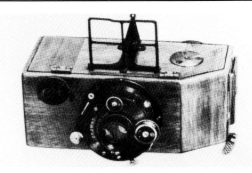

**(3782) SICO CAMERA.** C. 1920. SIZE 32 X 40 MM EXPOSURES ON UNPERFORATED, PAPER-BACKED 35MM ROLL FILM. 60 MM/F 3.5 RUDERSDORF ANASTIGMAT LENS. COMPUR SHUTTER; 1 TO $\frac{1}{300}$ SEC., B., T. IRIS DIAPHRAGM. HELICAL FOCUSING. WOOD BODY.

## SOCIÉTÉ ANONYME DE PHOTOGRAPHIC ET D'OPTIQUE

**(3783) TELEPHOT VEGA CAMERA.** C. 1901. THREE SIZES OF THIS CAMERA FOR 9 X 12, 13 X 18, OR 18 X 24 CM EXPOSURES ON PLATES. THE CAMERA SIZE IS VERY COMPACT FOR ITS LONG FOCAL LENGTH (750 MM/F 12) TELEPHOTO LENS. THIS IS

## SOCIÉTÉ ANONYME DE PHOTOGRAPHIC ET D'OPTIQUE (cont.)

ACCOMPLISHED BY USING MIRRORS TO REFLECT THE IMAGE BACK AND FORTH BETWEEN THE LENS AND THE FOCAL PLANE. THORNTON-PICKARD FOCAL PLANE SHUTTER. (IH)

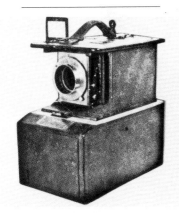

(3784) **TELEPHOT VEGA CAMERA.** C. 1902. THREE SIZES OF THIS CAMERA FOR 9 X 12, 13 X 18, OR 18 X 24 CM EXPOSURES ON PLATES. THIS CAMERA HAS THE SAME MIRROR FEATURES AS THE 1901 MODEL. 60 MM/F 12.5 BERTHIOT ACHROMAT LENS. (HA)

(3785) **TELEPHOT VEGA REFLEX CAMERA.** C. 1908. SIZE 9 X 12 CM EXPOSURES ON PLATES. 600 MM/F 9.6 VEGA LENS. THORNTON-PICKARD FOCAL PLANE SHUTTER. THE COMPACT SIZE OF THE CAMERA IS ACHIEVED BY USING MIRRORS TO REFLECT THE IMAGE BACK AND FORTH BETWEEN THE LENS AND THE FOCAL PLANE.

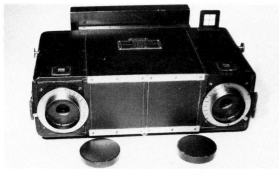

(3786) **TELEPHOT VEGA STEREOSCOPIC CAMERA.** C. 1905. SIZE 8 X 16 CM STEREO EXPOSURES ON

PLATES. 560 MM BERTHIOT DAGOR-TYPE LENS. LENS-CAP TYPE SHUTTER. IRIS DIAPHRAGM. RACK & PINION FOCUSING. GROUND GLASS FOCUSING. THE CAMERA WAS DESIGNED FOR TAKING STEREO EXPOSURES OF OBJECTS AT GREAT DISTANCES. TWO PAIRS OF MIRRORS (ONE FRONT AND ONE BACK) REFLECT THE IMAGE TWICE BEFORE REACHING THE FOCAL PLANE. THIS ALLOWS THE COMPACT SIZE CAMERA TO USE LONG FOCAL LENGTH LENSES. (GE)

(3787) **VEGA FOLDING CAMERA.** C. 1903. SIZE 9 X 12 CM EXPOSURES ON FILM PACKS. 180 MM/F 7.8 APLANTIC LENS. GUILLOTINE SHUTTER; ½ TO ¹⁄₁₀₀ SEC.

(3788) **VEGA FOLDING CAMERA NO. 1.** C. 1900. SIZE 9 X 12 CM EXPOSURES ON PLATES. A PLATE-CHANGING MECHANISM OPERATES BY OPENING AND CLOSING THE CAMERA. 180 MM/F 7.8 APLANTIC LENS. GUILLOTINE SHUTTER; ½ TO ¹⁄₁₀₀ SEC. (HA)

(3789) **VEGA FOLDING CAMERA NO. 2.** C. 1902. SIMILAR TO THE VEGA FOLDING CAMERA NO. 1.

## SUTER, E.

(3790) **DETECTIVE MAGAZINE CAMERA.** C. 1892. SIZE 9 X 12 CM PLATE EXPOSURES. THE CAMERA HAS A LIGHT-PROOF CHANGING BAG AT THE REAR OF THE CAMERA. A BUTTON ON THE FRONT OF THE CAMERA REGULATES THE SHUTTER SPEEDS. (IH)

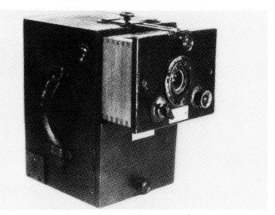

(3791) **DETECTIVE MAGAZINE CAMERA.** C. 1893. SIZE 9 X 12 CM EXPOSURES ON PLATES. SUTER-APLANAT LENS. ROTARY SHUTTER. (HA)

(3792) **FOLDING PLATE CAMERA.** C. 1910. SIZE 9 X 12 CM EXPOSURES. 135 MM/F 6.3 SUTER ANASTIGMAT LENS. TWO-SHUTTER CAMERA. CENTRAL FRONT SHUTTER AND FOCAL PLANE SHUTTER. WOOD AND METAL BODY. (MA)

(3793) **STEREO DETECTIVE CAMERA.** C. 1897. SIZE 90 X 180 MM STEREO EXPOSURES ON PLATES. 90 MM/F 10 RECTILINEAR LENSES. ROTARY SHUTTER. THE PLATE-CHANGING MECHANISM HOLDS SIX PLATES. (IH)

## THURY & AMEY

(3794) **FOLDING STEREO CAMERA.** C. 1890. EXPOSURES ON PLATES. 120 MM/F 9 ZEISS LENSES. FOUR-SPEED T & A GUILLOTINE SHUTTER. (MA)

## WOLF, BERNARD

(3795) **VEST POCKET CAMERA.** C. 1918. EXPOSURES ON PLATES. MENISCUS LENS. SINGLE-SPEED SHUTTER. SLIDING APERTURE STOP. THE TWO METAL SECTIONS OF THE CAMERA OPEN TO FORM A WEDGE WHICH HOLDS THE UNPLEATED BELLOWS. (IH)

## MANUFACTURER UNKNOWN

(3796) **ADOX ADRETTE CAMERA.** C. 1939. SIZE 24 X 36 MM ROLL FILM EXPOSURES. 50 MM/F 2.9 SCHNEIDER RADIONAR LENS. COMPUR RAPID SHUTTER TO 1/500 SEC. GROUND GLASS WINDOW ON THE BACK FOR FOCUSING. (MA)

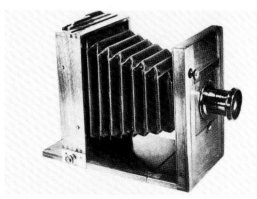

(3797) **AMATEUR FIELD CAMERA.** C. 1899. SIZE 13 X 18 CM EXPOSURES ON PLATES. SUTER APLANAT LENS. (HA)

(3798) **APPOLO DUPLEX CAMERA.** C. 1890. THE CAMERA HOLDS 50 PLATES, HALF OF THE PLATES IN THE LOWER COMPARTMENT AND HALF IN THE UPPER COMPARTMENT. THE PLATES ARE MOVED ONE AT A TIME FROM THE UPPER TO THE LOWER COMPARTMENT FOR EXPOSURE AND THE LOWER PLATES ARE MOVED ONE AT A TIME TO THE UPPER LEVEL. (BC)

(3799) **ARGUS CAMERA.** C. 1926. SIZE 24 X 36 MM EXPOSURES ON "35MM" ROLL FILM. 48.7 MM/F 4.5 VOIGTLANDER LENS. COMPUR SHUTTER; 1 TO 1/300 SEC. (MA)

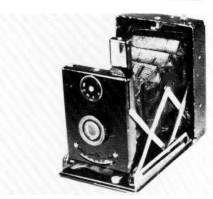

(3800) **BABY VEST POCKET CAMERA.** C. 1914. SIZE 4.5 X 6 CM EXPOSURES ON PLATES. 80 MM/F 7.5 RAPID RECTILINEAR LENS. SHUTTER SPEEDS FROM 1/25 TO 1/100 SEC. (HA)

(3801) **BEFO CAMERA.** C. 1915. SIZE 6 X 9 CM PLATE EXPOSURES. 100 MM/F 16 MENISCUS LENS. SINGLE-SPEED ROTARY SHUTTER. (MA)

(3802) **BELFOCA JUNIOR CAMERA.** SIZE 6 X 6 CM EXPOSURES.

(3803) **BOLTAVIT CAMERA.** C. 1936. SIZE 25 X 25 MM EXPOSURES ON "35MM" ROLL FILM. 40 MM/F 7.7 BOLTAR LENS. SHUTTER SPEEDS FROM 1/25 TO 1/100 SEC. (MA)

(3804) **BOX CAMERA.** C. 1910. SIZE 6 X 9 CM EXPOSURES ON PLATES. MENISCUS LENS. GUILLOTINE SHUTTER. (HA)

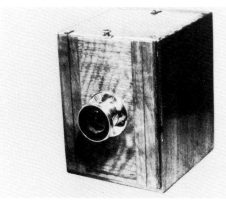

(3805) **BOX PLATE CAMERA.** C. 1900. SIZE 9 X 12 CM EXPOSURES ON PLATES. THE SIDES, TOP, AND BOTTOM OF THE CAMERA CAN BE DISASSEMBLED FOR EASY CARRYING OR FOR STORGAGE. (HA)

(3806) **CHEVILLON DROP-PLATE MAGAZINE CAMERA.** C. 1905. SIZE 3¼ X 4¼ INCH EXPOSURES. RAPID RECTILINEAR LENS. ROTATING SHUTTER. (MA)

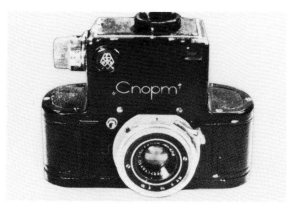

(3807) **CNOPM, SINGLE-LENS REFLEX CAMERA.** C. 1935. FIFTY EXPOSURES ON ROLL FILM. 50 MM/F 3.5 INDUSTAR LENS. FOCAL PLANE SHUTTER; 1/25 TO 1/500 SEC. (HA)

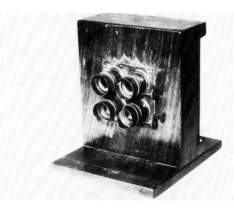

(3808) **CARTE-DE-VISITE CAMERA.** C. 1850. FOUR EXPOSURES ON AN 8 X 8 CM PLATE. DEROGY LENSES. THE CAMERA WAS USED TO MAKE MULTIPLE PORTRAIT PHOTOGRAPHS. (HA)

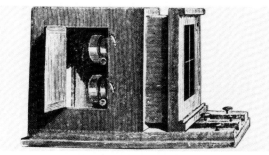

(3809) **CARTE-DE-VISITE CAMERA.** C. 1854. FOUR EXPOSURES ON EACH SIDE OF A 16 X 20 CM DOUBLE PLATE. 180 MM/F 5 PETZVAL-TYPE LENSES. THE CAMERA WAS USED TO MAKE MULTIPLE PORTRAIT PHOTOGRAPHS.

## MANUFACTURER UNKNOWN (*cont.*)

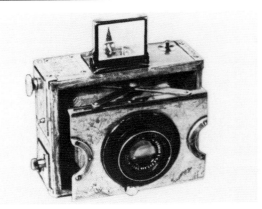

**(3810) CLARISSA STRUT CAMERA.** C. 1910. SIZE 4.5 X 6 CM EXPOSURES ON PLATES. 75 MM/F 4.5 GOERZ DAGOR LENS. FOCAL PLANE SHUTTER. (HA)

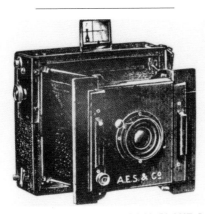

**(3811) COLLAPSIBLE ROYAL FOCAL PLANE CAMERA.** C. 1905. SIZE 4 X 5 INCH EXPOSURES ON PLATES. F 6.8 PLASTIGMAT LENS. FOCAL PLANE SHUTTER.

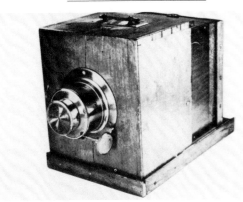

**(3812) DAGUERREOTYPE CAMERA.** C. 1845. SIZE 8 X 10 CM EXPOSURES ON DAGUERREOTYPE PLATES. DARLOT LENS. (HA)

**(3813) DEFRANNE SPORT FOLDING ROLL FILM CAMERA.** SIZE 2¼ X 3¼ INCH (1⅝ X 2¼ INCH WITH MASK) EXPOSURES ON NO. 120 ROLL FILM. F 3.8 RODENSTOCK TRINAR ANASTIGMAT LENS. PRONTAR II SHUTTER; 1 TO ¹⁄₁₅₀ SEC., B., T., ST.

**(3814) DEFRANNE TWIN-LENS REFLEX CAMERA.** C. 1938. SIZE 6 X 6 CM EXPOSURES ON ROLL FILM. F 4.5 ANASTIGMAT LENS.

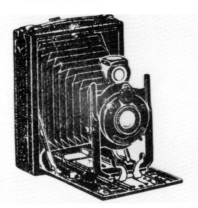

**(3815) DE LARUE CAMERA.** C. 1929. TWO SIZES OF THIS CAMERA FOR 9 X 12 OR 10 X 15 CM EXPOSURES ON PLATES OR FILM PACKS. F 6.8 HERMAGIS OR BOYER; F 5.5 VIRLOT; OR F 6.3 HERMAGIS, ROUSSEL, BOYER, OR BERTHIOT LENS. GITZO SHUTTER; ¹⁄₂₅ TO ¹⁄₁₀₀ SEC., B., T. OR IBSOR SHUTTER; 1 TO ¹⁄₁₂₅ SEC., B., T.

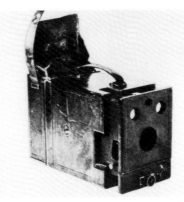

**(3816) DETECTIVE CAMERA.** C. 1895. SIZE 9 X 12 CM EXPOSURES ON PLATES. F 8 EXTRA RAPID UNIVERSAL APLANAT LENS. UNICUM SHUTTER. (HA)

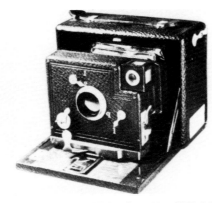

**(3817) DIAMANT CAMERA.** C. 1903. SIZE 8 X 11 CM EXPOSURES ON PLATES. MENISCUS LENS. FIVE-SPEED GUILLOTINE SHUTTER. (HA)

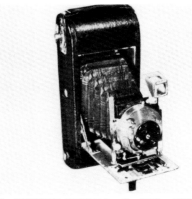

**(3818) DUMONT CAMERA.** C. 1903. SIZE 6 X 9 CM EXPOSURES ON ROLL FILM. 105 MM/F 8 LENS. TWO-SPEED SHUTTER. ROTARY APERTURE STOPS. (HA)

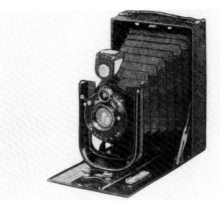

**(3819) ENTOR FILM PACK CAMERA.** C. 1938. SIZE 9 X 12 CM EXPOSURES. F 6.3 NOVAR ANASTIGMAT LENS. DERVAL SHUTTER; ¹⁄₂₅ TO ¹⁄₁₀₀ SEC., B., T. GROUND GLASS FOCUSING.

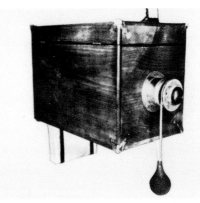

**(3820) FERROTYPE BOX CAMERA.** C. 1920. SIZE 9 X 12 CM FERROTYPE EXPOSURES. 120 MM/F 5.5 LAAK DIALYTAR LENS. THE FERROTYPE EXPOSURES ARE DEVELOPED INSIDE OF THE CAMERA BOX. (HA)

## MANUFACTURER UNKNOWN (*cont.*)

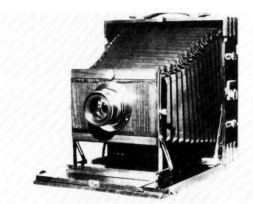

(3821) **FIELD CAMERA.** C. 1900. SIZE 18 X 24 CM EXPOSURES ON PLATES. WECHSEL TRIPLEX-APLANAT LENS. TILTING FRONT AND BACK. (HA)

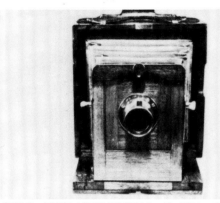

(3822) **FIELD VIEW CAMERA.** C. 1890. SIZE 18 X 24 CM EXPOSURES ON PLATES. SIMPLEX APLANAT LENS. (HA)

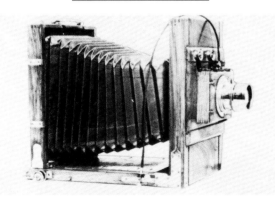

(3823) **FIELD VIEW CAMERA.** C. 1910. SIZE 13 X 18 CM EXPOSURES ON PLATES. F 7.7 DOUBLE ANASTIGMAT LENS. VICTORIA-ROULEAU SHUTTER. REVOLVING BACK AND BELLOWS. (HA)

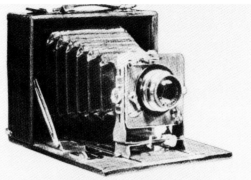

(3824) **FOLDING PLATE CAMERA.** C. 1905. SIZE 9 X 12 CM EXPOSURES ON PLATES. GOERZ DOUBLE-ANASTIGMAT LENS. FOUR-SPEED SHUTTER. (HA)

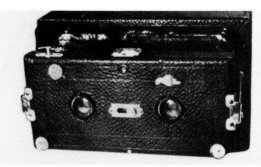

(3825) **FOLDING STEREO CAMERA.** C. 1902. SIZE 9 X 18 CM STEREO EXPOSURES ON PLATES. 105 MM/F 8 LENSES. SIX-SPEED GUILLOTINE SHUTTER. (HA)

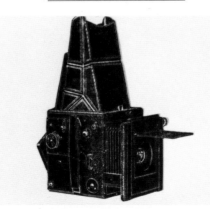

(3826) **FULMENAR SINGLE-LENS REFLEX CAMERA.** C. 1912. TWO SIZES OF THIS CAMERA FOR 3¼ X 4¼ OR 4¼ X 6½ INCH EXPOSURES ON PLATES. FOCAL PLANE SHUTTER; ⅒ TO 1/800 SEC. RACK & PINION FOCUSING. RISING AND FALLING LENS MOUNT. REVOLVING BACK.

(3827) **KIND CAMERA.** C. 1900. THE PILL-BOX-SHAPE CAMERA HOLDS FIVE PLATES FOR 4.5 X 4.5 CM EXPOSURES. MENISCUS LENS. (MA)

(3828) **KNIRPS CAMERA.** C. 1935. SIZE 35 X 35 MM EXPOSURES ON ROLL FILM. 42 MM/F 6.3 LAAK POLYNAR LENS. SINGLE-SPEED SHUTTER. (MA)

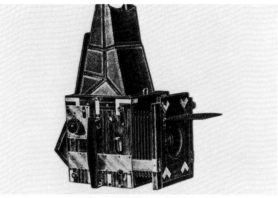

(3829) **FULMENAR TROPICAL SINGLE-LENS REFLEX CAMERA.** C. 1912. TWO SIZES OF THIS CAMERA FOR 3¼ X 4¼ OR 4¼ X 6½ INCH PLATE EXPOSURES. FOCAL PLANE SHUTTER. REVOLVING BACK. RISING AND FALLING LENS MOUNT. REVERSIBLE FOCUSING HOOD.

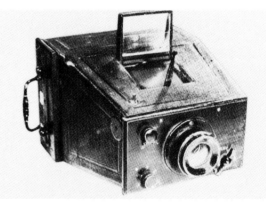

(3830) **JUMELLE MAGAZINE CAMERA.** C. 1896. SIZE 9 X 12 CM EXPOSURES ON PLATES. THE MAGAZINE HOLDS 12 PLATES. 130 MM/F 8 ZEISS KRAUSS ANASTIGMAT LENS. SIX-SPEED GUILLOTINE SHUTTER. (HA)

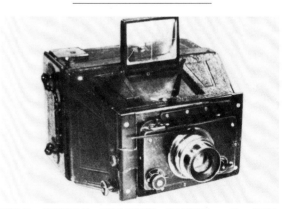

(3831) **JUMELLE MAGAZINE CAMERA.** C. 1897. SIZE 9 X 12 CM EXPOSURES ON PLATES. THE MAGAZINE HOLDS 12 PLATES. 120 MM/F 8 KOCH LENS. FIVE-SPEED GUILLOTINE SHUTTER. (HA)

(3832) **"LA BELLE GAMINE" STEREO CAMERA.** C. 1920. SIZE 45 X 107 MM STEREO EXPOSURES. BALBRECK RECTILINEAR LENSES. THREE-SPEED GUILLOTINE SHUTTER. (MA)

## MANUFACTURER UNKNOWN (*cont.*)

**(3833) LAFAYETTE FOLDEX PLATE AND FILM PACK CAMERA.** C. 1940. TWO SIZES OF THIS CAMERA FOR 6.5 X 9 OR 9 X 12 CM EXPOSURES. F 4.5 ZEISS TESSAR LENS. COMPUR SHUTTER; 1 TO ⅟₂₀₀ SEC., B., T., ST. DOUBLE EXTENSION BELLOWS. RISING AND SWINGING LENS MOUNT.

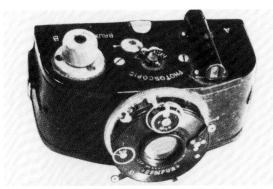

**(3834) LE PHOTOSCOPIC CAMERA.** C. 1930. SIZE 24 X 24 MM EXPOSURES ON ROLL FILM. 50 MM/F 3.5 GOERZ HYPAR OR 45 MM/F 3.5 OIP GAND LABOR LENS. IBSOR SHUTTER; 1 TO ⅟₁₅₀ SEC. OR COMPUR SHUTTER WITH SPEEDS TO ⅟₃₀₀ SEC. (HA)

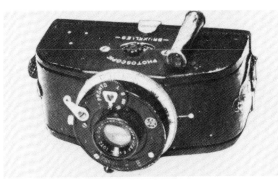

**(3835) LE PHOTOSCOPIC CAMERA.** C. 1930. SIZE 24 X 24 MM EXPOSURES ON ROLL FILM. 50 MM/F 3.5 GOERZ HYPAR LENS. PRONTO SHUTTER; ⅟₂₅ TO ⅟₁₀₀ SEC. FILM ADVANCE WITH SHUTTER COCKING. (HA)

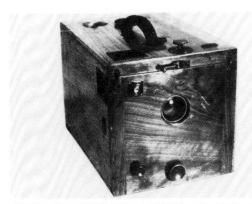

**(3836) MAGAZINE BOX CAMERA.** C. 1895. SIZE 13 X 18 CM EXPOSURES ON PLATES. THE MAGAZINE HOLDS 12 PLATES. GUILLOTINE SHUTTER. (HA)

**(3837) LOMAN'S HAND CAMERA.** C. 1889. SINGLE LENS REFLEX. TWO SIZES OF THIS CAMERA FOR 3½ X 4¾ OR 4¼ X 6½ INCH PLATE EXPOSURES. APLANAT OR PORTRAIT LENS.

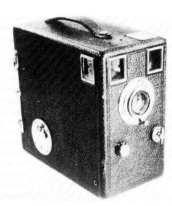

**(3838) MAGAZINE BOX CAMERA.** C. 1908. SIZE 9 X 12 CM EXPOSURES ON PLATES. THE MAGAZINE HOLDS 12 PLATES. F 8 LENS. SEVEN-SPEED SHUTTER. (HA)

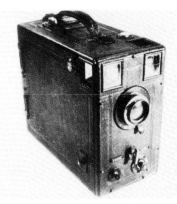

**(3839) MAGAZINE BOX CAMERA.** C. 1910. SIZE 9 X 12 CM EXPOSURES ON PLATES. THE MAGAZINE HOLDS 11 PLATES. FIVE-SPEED GUILLOTINE SHUTTER. (HA)

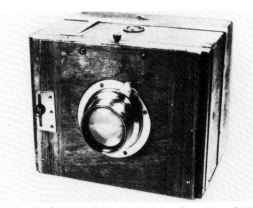

**(3840) MAGAZINE BOX CAMERA.** C. 1920. SIZE 9 X 12 CM EXPOSURES ON PLATES. THE MAGAZINE HOLDS 12 PLATES. RÜO-CALEINAR LENS. FOCAL PLANE SHUTTER WITH SPEEDS TO ⅟₂₀₀₀ SEC. (HA)

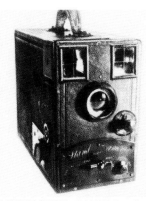

**(3841) MAGAZINE HAND CAMERA.** C. 1910. SIZE 9 X 12 CM EXPOSURES ON PLATES. THE MAGAZINE HOLDS 12 PLATES. ORTHO SYMETRIOUE LENS. FIVE-SPEED SHUTTER. (HA)

**(3842) MAGDA POCKET CAMERA.** C. 1920. SIZE 4.5 X 6 CM PLATE EXPOSURES. MENISCUS LENS. SIMPLE SHUTTER. THE LENS MOUNT AND BELLOWS FOLD INTO A METAL CASE. (MA)

**(3843) MEPHISTO CAMERA.** C. 1900. THE CAMERA HOLDS FIVE PLATES. MENISCUS LENS.

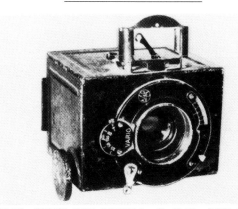

**(3844) METAL BOX CAMERA.** C. 1920. SIZE 4.5 X 6 CM EXPOSURES ON PLATES. 65 MM/F 5.4 ERNEMANN DOPPEL-ANASTIGMAT LENS. VARIO SHUTTER; ⅟₂₅ TO ⅟₁₀₀ SEC., B., T. (HA)

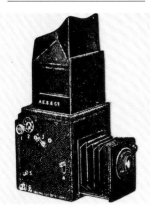

**(3845) MITE DE LUXE REFLEX CAMERA.** C. 1907. SIZE 3¼ X 4¼ INCH EXPOSURES ON PLATES. RE-

## MANUFACTURER UNKNOWN (*cont.*)

VOLVING BACK. RACK & PINION FOCUSING. RISING AND CROSSING LENS MOUNT.

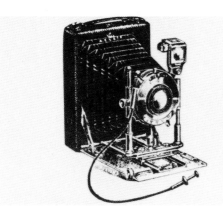

**(3846) MITE FOLDING PLATE CAMERA.** C. 1907. TWO SIZES OF THIS CAMERA FOR 3¼ X 4¼ OR 3½ X 5½ INCH EXPOSURES. SINGLE OR DOUBLE EXTENSION BELLOWS.

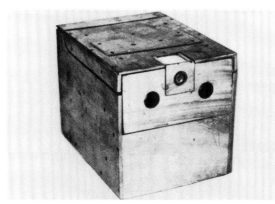

**(3847) MONO AND STEREO BOX CAMERA.** C. 1885. SIZE 4.5 X 4.5 CM MONO EXPOSURES OR 4.5 X 9 CM STEREO EXPOSURES OR PLATES. (HA)

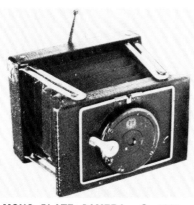

**(3848) MONO PLATE CAMERA.** C. 1924. SIZE 4.5 X 6 CM EXPOSURES ON PLATES. INSTANT AND TIME SHUTTER. (HA)

**(3849) ORMOND B FOLDING CYCLE CAMERA.** C. 1901. SIZE 4 X 5 INCH EXPOSURES. DOUBLE RAPID RECTILINEAR LENS. DOUBLE PNEUMATIC SHUTTER. IRIS DIAPHRAGM. REVERSIBLE BACK.

**(3850) ORMOND FOLDING CYCLE JUNIOR CAMERA.** C. 1901. SIZE 4 X 5 INCH EXPOSURES. DOUBLE RAPID RECTILINEAR LENS. JUNIQR AUTOMATIC SHUTTER. IRIS DIAPHRAGM. REVERSIBLE BACK.

**(3851) OSICO ROLL FILM AND PLATE CAMERA.** C. 1905. SIZE 3¼ X 4¼ INCH EXPOSURES. RAPID RECTILINEAR LENS.

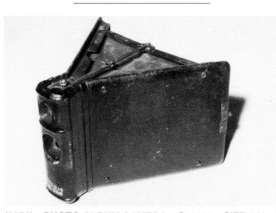

**(3852) PHOTO-ALBUM CAMERA.** C. 1892. SIZE 9 X 12 CM EXPOSURES ON PLATES. 120 MM/F 12 GRUBB-TYPE ACHROMAT OR RAPID RECTILINEAR LENS. GUILLOTINE SHUTTER FOR SINGLE-SPEED OR TIME EXPOSURES. WAIST-LEVEL FINDER. (GE)

**(3853) PHOTO OMNIA STEREO CAMERA.** C. 1925. SIZE 45 X 107 MM STEREO EXPOSURES ON PLATES. 60 MM/F 6 ANASTIGMATIC LENSES. VARIABLE-SPEED GUILLOTINE SHUTTER. (MA)

**(3854) PHOTO-RETTE CAMERA.** C. 1924. SIZE 24 X 24 MM EXPOSURES ON CASSETTE 35MM ROLL FILM. 42 MM/F 6.3 LAAK POLYNAR LENS. SHUTTER SPEEDS FROM ⅟₂₅ TO ⅟₂₅₀ SEC. (MA)

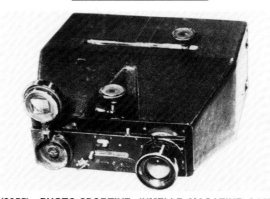

**(3855) PHOTO-SPORTIVE JUMELLE MAGAZINE CAMERA.** C. 1893. SIZE 6 X 9 CM EXPOSURES ON PLATES. THE MAGAZINE HOLDS 30 PLATES. SIX-SPEED SHUTTER. IRIS DIAPHRAGM. (HA)

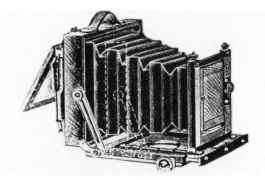

**(3856) PICKWICK VIEW CAMERA.** C. 1897. TWO SIZES OF THIS CAMERA FOR 3¼ X 4¼ OR 4¼ X 6½ INCH EXPOSURES ON PLATES. RACK & PINION FOCUSING.

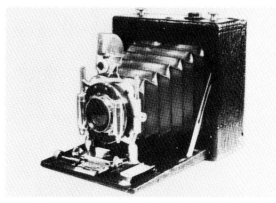

**(3857) PLATE CAMERA.** C. 1900. SIZE 9 X 12 CM EXPOSURES ON PLATES. 150 MM/F 6 BUSCH RATHENOW LENS. DOUBLE PNEUMATIC SHUTTER WITH SPEEDS TO ⅟₁₀₀ SEC. (HA)

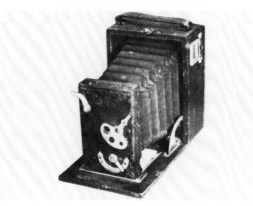

**(3858) PLATE CAMERA.** C. 1905. SIZE 6.5 X 9 CM EXPOSURES ON PLATES. FIXED-FOCUS MENISCUS LENS. (HA)

## MANUFACTURER UNKNOWN (*cont.*)

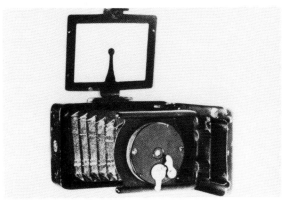

(3859) **PLATE CAMERA.** C. 1920. SIZE 4.5 X 6 CM EXPOSURES ON PLATES. SINGLE-SPEED AND TIME SHUTTER. ALL METAL BODY. (HA)

(3860) **PLATE CAMERA.** C. 1920. SIZE 4.5 X 6 CM EXPOSURES ON PLATES. SINGLE-SPEED AND TIME SHUTTER. WOOD BODY. (HA)

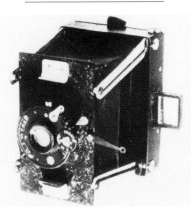

(3861) **PLATE CAMERA.** C. 1923. SIZE 6.5 X 9 CM EXPOSURES ON PLATES. 100 MM/F 6.8 ROUSSEL LENS. PRONTO SHUTTER; ⅕₂₅ TO ⅟₁₀₀ SEC. (HA)

(3862) **PLÜCKER'S POCKET STEREOGRAPH CAMERA.** C. 1871. SIZE 13 X 18 CM PLATE EXPOSURES. 210 MM/F 8 DARLOT PLANIGRAPH LENS. BUILT-IN CIRCULAR SHUTTER. (MA)

(3863) **PLI REFLEX CAMERA.** C. 1925. SIZE 8 X 12 CM EXPOSURES ON PLATES. THE MAGAZINE HOLDS 6 PLATES. 150 MM/F 6 GIORNO ANASTIGMAT LENS. FOCAL PLANE SHUTTER. (HA)

(3864) **POCKET BOX CAMERA.** C. 1915. SIZE 6 X 9 CM EXPOSURES ON PLATES. 85 MM/F 6.8 BERTHIOT SERIES IIB LENS. SINGLE-SPEED SHUTTER. (HA)

(3865) **POLYFOTO MULTIPLE CAMERA.** C. 1933. FORTY-EIGHT EXPOSURES, 1.3 X 1.3 CM, CAN BE MADE ON A SINGLE 13 X 18 CM PLATE. AN EXTERNAL HAND CRANK IS TURNED WHICH MOVES THE PLATE INTO VARIOUS POSITIONS FOR EXPOSURE. SHUTTER SPEED OF ½₂₅ SEC. (BC)

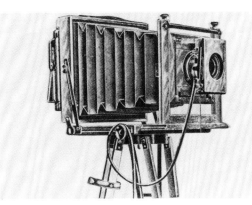

(3866) **PRESTOGRAPH PLATE CAMERA.** C. 1896. SIZE 4¼ X 6½ INCH EXPOSURES ON PLATES. RAPID RECTILINEAR LENS. THORNTON-PICKARD SHUTTER.

(3867) **REFLECTA TWIN-LENS REFLEX CAMERA.** C. 1939. SIZE 6 X 9 CM (6 X 6 CM WITH MASK) EXPOSURES ON ROLL FILM. F 3.5 OR F4.5 TRIOLAR ANASTIGMAT OR F 3.5 MEYER TRIOPLAN LENS. STELO, PRONTOR II, OR COMPUR SHUTTER.

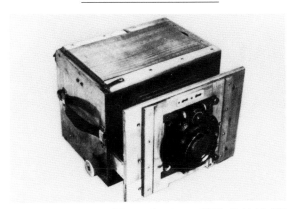

(3868) **REFLEX CAMERA.** C. 1910. SIZE 10 X 15 CM EXPOSURES ON PLATES. 210 MM/F 4.5 HELIAR LENS. COMPOUND SHUTTER TO ⅟₁₀₀ SEC. (HA)

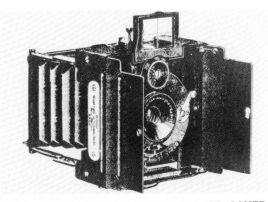

(3869) **RIDAN PRECISION VEST POCKET CAMERA.** C. 1912.

## MANUFACTURER UNKNOWN (*cont.*)

(3870) **ROLL FILM AND PLATE CAMERA.** C. 1900. SIZE 9 X 12 CM EXPOSURES. 130 MM/F 7.7 RAPID ANASTIGMAT LENS. TWO-SPEED SINGLE PNEUMATIC SHUTTER. (HA)

(3871) **ROTH PRIMAR FOCAL PLANE CAMERA.** C. 1932. SIZE 2½ X 3½ INCH EXPOSURES ON PLATES, CUT FILM, OR FILM PACKS. SIZE 1⅝ X 2¼ INCH EXPOSURES WHEN THE CAMERA IS USED AT F 1.5. F 1.5 MEYER PLASMAT LENS. FOCAL PLANE SHUTTER; ½ TO ¹⁄₁₀₀₀ SEC.

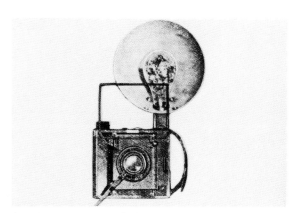

(3872) **ROTH SUPER-SPEED PRESS CAMERA.** C. 1932. SYNCHRONIZED FLASH UNIT.

(3873) **ROYAL FOCAL PLANE CAMERA.** C. 1906. SIZE 3¼ X 4¼ INCH EXPOSURES ON PLATES. F 6.8 PLANASTIGMAT, SYMMETRICAL PLANASTIGMAT, OR ANASTIGMAT LENS. DUAL-SHUTTER CAMERA. BAUSCH & LOMB AUTOMATIC SHUTTER AND FOCAL PLANE SHUTTER. RACK & PINION FOCUSING. RISING LENS MOUNT.

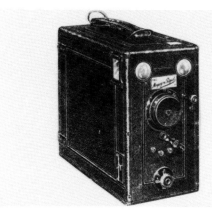

(3874) **ROYAL MAGAZINE HAND CAMERA.** C. 1905. SIZE 3¼ X 4¼ INCH EXPOSURES ON PLATES. THE MAGAZINE HOLDS 12 PLATES. F 8 RAPID RECTILINEAR LENS. SHUTTER SPEEDS TO ¹⁄₁₀₀ SEC. FOUR-POSITION FOCUSING LEVER.

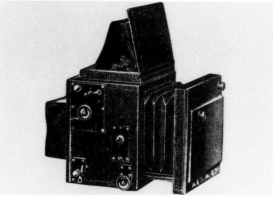

(3875) **ROYAL REFLEX CAMERA.** C. 1905. SIZE 3¼ X 4¼ INCH EXPOSURES ON PLATES. F 6.8 PLANASTIGMAT LENS. FOCAL PLANE SHUTTER WITH SPEEDS TO ¹⁄₁₂₀₀ SEC., T.

(3876) **ROYAL REFLEX HAND CAMERA.** MODEL 3. C. 1906. THREE SIZES OF THIS CAMERA FOR 3¼ X 4¼, 4 X 5, OR 4¼ X 6½ INCH EXPOSURES ON PLATES. FOCAL PLANE SHUTTER. RACK & PINION FOCUSING.

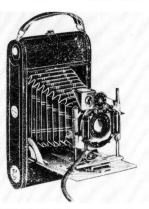

(3877) **SANDRINGHAM ROLL FILM AND PLATE CAMERA.** C. 1906. SIZE 3¼ X 4¼ INCH EXPOSURES. F 8 BUSCH RAPID RECTILINEAR LENS. WOLLENSAK DOUBLE PNEUMATIC SHUTTER; 1 TO ¹⁄₁₀₀ SEC., B., T. RISING AND CROSSING LENS MOUNT.

(3878) **SANDRINGHAM TOURIST CAMERA.** C. 1906. TWO SIZES OF THIS CAMERA FOR 3¼ X 4¼ OR 4¼ X 6½ INCH EXPOSURES.

(3879) **SICKLE A MAGAZINE HAND CAMERA.** C. 1905. SIZE 3¼ X 4¼ INCH EXPOSURES ON PLATES OR CUT FILM.

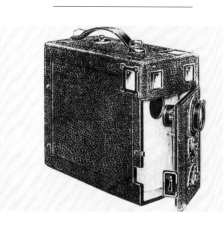

## MANUFACTURER UNKNOWN (cont.)

(3880) **SICKLE B MAGAZINE HAND CAMERA.** C. 1905. SIZE 3¼ X 4¼ INCH EXPOSURES ON PLATES OR CUT FILM. RAPID RECTILINEAR LENS. INSTANT AND TIME SHUTTER. THREE-POSITION FOCUSING.

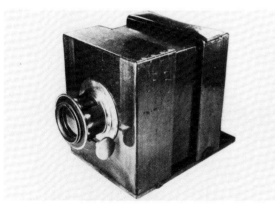

(3881) **SICKLE FOCAL PLANE CAMERA.** C. 1904. SIZE 4 X 5 INCH EXPOSURES ON PLATES OR SHEET FILM. F 6.8 BECK FOCAL PLANAT LENS. DUAL SHUTTERS. SICKLE FOCAL PLANE SHUTTER WITH SPEEDS TO ¹⁄₁₀₀₀ SEC. AND UNICUM SHUTTER TO ¹⁄₁₀₀ SEC. RISING, FALLING, AND CROSSING LENS MOUNT.

(3882) **SICKLE ROLL FILM AND PLATE CAMERA.** C. 1904. SIZE 3¼ X 4¼ INCH EXPOSURES. F 8 BECK SYMMETRICAL LENS.

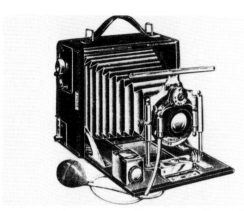

(3883) **SLIDING BOX CAMERA.** C. 1850. SIZE 8 X 12 CM EXPOSURES ON COLLODIAN PLATES. CHARLES CHEVALIER LENS. (HA)

(3884) **SMART STEREO CAMERA.** C. 1910. SIZE 8 X 17 CM STEREO EXPOSURES ON PLATES. 110 MM/F 11 MENISCUS LENSES. GUILLOTINE SHUTTER; ¹⁄₁₀ TO ¹⁄₁₀₀ SEC. (MA)

(3885) **"THE SELF-WORKER" STEREO CAMERA.** C. 1895. SIZE 8 X 17 CM STEREO EXPOSURES ON PLATES. 110 MM GOERZ SERIES III LENSES. VARIABLE GUILLOTINE SHUTTER. (MA)

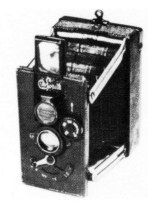

(3886) **SPRITS PLATE CAMERA.** C. 1915. SIZE 4.5 X 6 CM EXPOSURES ON PLATES. 75 MM/F 5.6 COOKE LENS. SHUTTER SPEEDS FROM ¹⁄₂₅ TO ¹⁄₁₀₀ SEC. (HA)

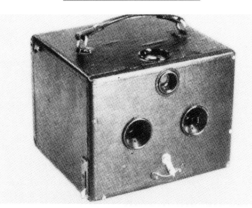

(3887) **STEREO BOX CAMERA.** C. 1920. SIZE 9 X 12 CM STEREO EXPOSURES. SINGLE-SPEED, B., T. SHUTTER. THREE APERTURE STOPS. (HA)

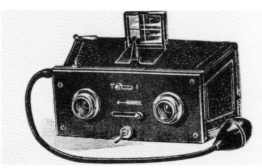

(3888) **STEREOSCOPIC HAND CAMERA.** C. 1905. EXPOSURES ON PLATES. RAPID RECTILINEAR LENSES. SHUTTER FOR VARIABLE SPEEDS AND TIME EXPOSURES.

(3889) **NO. 2 TUDOR FOLDING CAMERA.** C. 1905. SIZE 3¼ X 4¼ INCH EXPOSURES ON PLATES. SAME AS THE NO. 1 TUDOR FOLDING CAMERA BUT WITH A RAPID RECTILINEAR LENS.

(3890) **NO. 3 TUDOR FOLDING CAMERA.** C. 1905. SIZE 3¼ X 4¼ INCH EXPOSURES ON PLATES. SAME AS THE NO. 5 TUDOR FOLDING CAMERA BUT WITH-

OUT THE BUSCH LENS, UNICUM SHUTTER, AND REVERSING BACK.

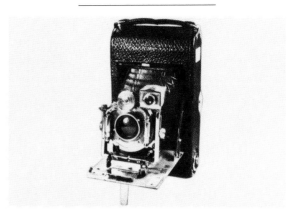

(3891) **TIP ROLL FILM AND PLATE CAMERA.** C. 1902. SIZE 8 X 10 CM EXPOSURES. F 8 DOUBLE PERISCOP LENS. BAUSCH & LOMB CENTRAL SHUTTER FOR SPEEDS TO ¹⁄₁₀₀ SEC. (HA)

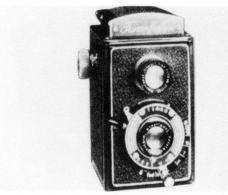

(3892) **TRUMPFREFLEX TWIN LENS REFLEX CAMERA.** C. 1940. TWELVE EXPOSURES ON NO. 120, S-20, OR B-2 ROLL FILM. F 3.5 MEYER TRIOPLAN OR F 4.5 TRIOLAR LENS. COMPUR SHUTTER; 1 TO ¹⁄₃₀₀ SEC., B., T. OR STELO SHUTTER; ¹⁄₂₅ TO ¹⁄₁₀₀ SEC., B., T. SOLD BY SEARS, ROEBUCK COMPANY.

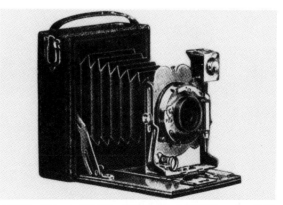

(3893) **NO. 1 TUDOR FOLDING CAMERA.** C. 1905. SIZE 3¼ X 4¼ INCH EXPOSURES ON PLATES. RAPID ACHROMATIC LENS. INSTANT AND TIME SHUTTER. RISING AND CROSSING LENS MOUNT. GROUND GLASS FOCUSING.

## MANUFACTURER UNKNOWN (*cont.*)

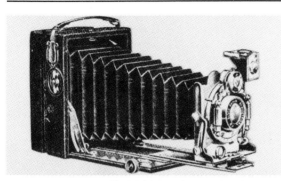

(3894) **NO. 5 TUDOR FOLDING CAMERA.** C. 1905. SIZE 3¼ X 4¼ INCH EXPOSURES ON PLATES. BUSCH RAPID SYMMETRICAL LENS. UNICUM DOUBLE PNEUMATIC SHUTTER. RACK & PINION FOCUSING. DOUBLE EXTENSION BELLOWS. DOUBLE SWING BACK. RISING AND CROSSING LENS MOUNT.

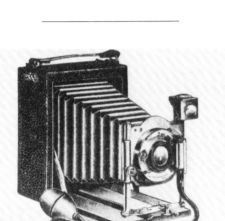

(3895) **TUKA CAMERA.** C. 1906. SIZE 3¼ X 4¼ INCH EXPOSURES ON PLATES, SHEET FILM, OR FILM PACKS. PNEUMATIC SHUTTER. MODEL 2 HAS RACK & PINION FOCUSING.

(3896) **UNICUM BOX CAMERA.** C. 1900. TWO SIZES OF THIS CAMERA FOR 6 X 9 OR 9 X 12 CM EXPOSURES ON PLATES. APLANAT LENS.

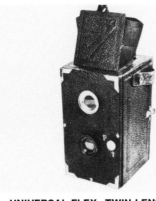

(3897) **UNIVERSAL-FLEX TWIN-LENS REFLEX CAMERA.** C. 1933. SIZE 2¼ X 3 INCH EXPOSURES ON ROLL FILM. UNIVERSAL-FLEX SUPER ACROMAT LENS. INSTANT AND TIME SHUTTER. (HA)

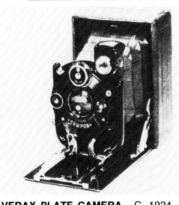

(3898) **VERAX PLATE CAMERA.** C. 1924. SIZE 4.5 X 6 CM EXPOSURES ON PLATES OR FILM PACKS. 75 MM/F 4.5 STEINHEIL UNOFOCAL LENS. COMPUR SHUTTER WITH SPEEDS TO ¹⁄₃₀₀ SEC. (HA)

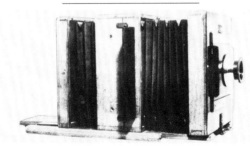

(3899) **VIEW CAMERA.** C. 1890. SIZE 24 X 30 CM EXPOSURES ON PLATES. GOERZ EXTRA RAPID LYNKEIO-SKOP LENS. (HA)

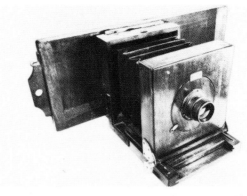

(3900) **VIEW CAMERA.** C. 1910. THREE PLATES, SIZE 8 X 14 ARE HELD IN THE HORIZONTAL PLATE HOLDER. 240 MM/F 4.6 GOERZ DOUBLE ANASTIGMAT LENS. IRIS DIAPHRAGM. (HA)

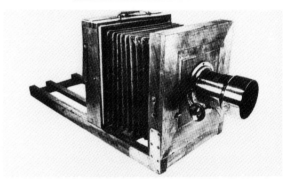

(3901) **SQUARE BELLOWS VIEW CAMERA.** C. 1855. SIZE 13 X 18 CM EXPOSURES ON COLLODION PLATES. VALLENTIN LENS. (HA)

(3902) **VOLAPÜK COLLAPSIBLE CAMERA.** C. 1893. SIZE 9 X 12 CM PLATE EXPOSURES. ACHROMATIC LENS. DROP SHUTTER. THE LEATHER SECTIONS OF THE CAMERA ARE COLLAPSIBLE. (MA)

(3903) **WEEK-END BOX CAMERA.** C. 1939. SIZE 6 X 9 CM EXPOSURES ON NO. 120 ROLL FILM. MENISCUS LENS. SINGLE-SPEED SHUTTER. (MA)

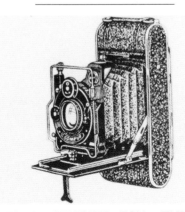

(3904) **ZODEL CERTONET ROLL FILM CAMERA.** C. 1927. SIZE 2¼ X 3¼ INCH EXPOSURES. F 3.8 XENAR LENS. COMPUR SHUTTER.

## MANUFACTURER UNKNOWN (*cont.*)

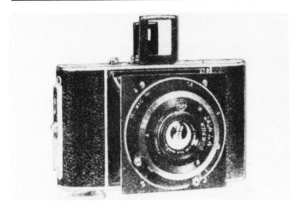

(3905) **ZODELETTE VEST-POCKET CAMERA.** C. 1931.
SIZE 1³⁄₁₆ X 1⁹⁄₁₆ INCH EXPOSURES ON NO. 127 ROLL
FILM. F 4.5 OR F 3.5 ZODELLAR ANASTIGMAT OR F
11 SINGLE LENS. VARIO OR COMPUR SHUTTER.
HELICAL FOCUSING. AUTOMATIC "POP-OUT" LENS
MOUNT ATTACHED TO THE BELLOWS.

# INDEX

# B

# INDEX

# INDEX

# H

# M

# O

# P

#  W

# X

# Y

# Z